THE CREATIVE IMPULSE

Third Edition

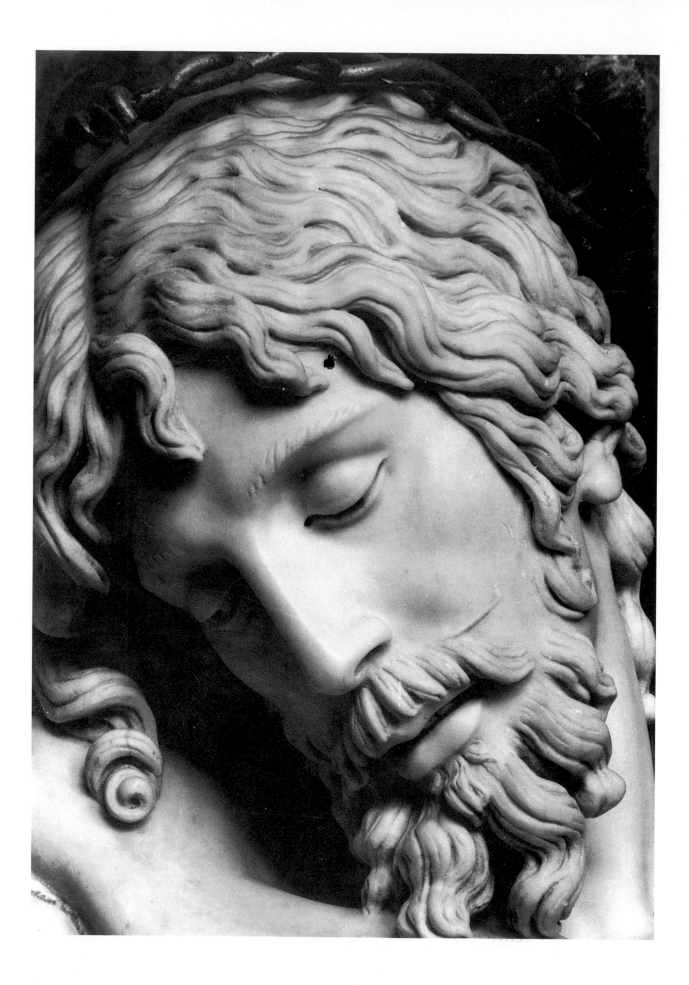

THE CREATIVE IMPULSE

An Introduction to the Arts

Volume Two

DENNIS J. SPORRE

Ball State University

Third Edition

Prentice Hall, Englewood Cliffs, NJ 07632

This book was designed and produced by
CALMANN & KING LTD
71 Great Russell Street, London WC1B 3BN

Designed by Karen Osborne
Literature research by Val Glenn
Typeset by Wyvern Typesetting, Bristol, England
Printed and bound in Hong Kong

Front cover: Detail of Pierre-Auguste Renoir, *Les Parapluies*,
c.1881–85. Canvas, 5 ft 11 ins × 3 ft 9 ins (1.8 × 1.15 m).
National Gallery, London.

Back cover: Ricardo Bofill, Les Echelles du Baroque, Paris,
detail of courtyard elevation, 1979–86. Ricardo Bofill/Taller de
Arquitectura.

Frontispiece: Benvenuto Cellini, detail of crucifix, 1556–62.
Marble. Monastery of S. Lorenzo, El Escorial, near Madrid,
Spain.

Acknowledgements

The author, the publishers and Calmann &
King Ltd wish to thank the museums, galleries,
collectors and other owners who have kindly
allowed their works to be reproduced in this
book. In general, museums have supplied their
own photographs; other sources are listed
below:

Actors' Theatre of Louisville/David S. Talbott:
15.29, 15.30; AEG Aktiengesellschaft, Frankfurt:
14.38; Archivi Alinari, Florence: 10.28; Ancient
Art & Architecture Collection, London: 11.40;
Wayne Andrews, Chicago: 12.32, 13.45, 14.36;
The Architectural Association, London: 14.35,
14.40, 15.35, 15.40; BBC Hulton Picture Library,
London 10.31, 12.33; Bildarchiv Preussischer
Kulturbesitz, Berlin: 12.34; Bilderberg/Wolfgang
Volz, Hamburg: 15.26; Bridgeman Art Library,
London 10.11, 10.14, 12.13, 12.14, 13.5, 13.12,
13.23, 15.1; The Carnegie Museum of Art
(Museum purchase; gift of Kaufmann's, the
Women's Committee and the Fellows of the
Museum of Art 85.62): 15.14; Cement &
Concrete Association, Slough: 15.41; Martin
Charles, Middlesex: 13.52; Trudy Lee Cohen ©
1986, Philadelphia: 13.37; Courtauld Institute of
Art, London: 11.26; John Donat, London: 14.39;
Esto Photographics, Inc., Mamaroneck, New
York: 15.36; Fisk University, (Vechten Gallery of
Fine Arts) Nashville, Tennessee: 14.20;
Solomon R. Guggenheim Museum, New York:
15.37; Hal Tiné, South Salem, New York: 15.31;
Robert Harding Picture Library, London: 10.40,
11.38, 11.39; Clive Hicks, London: 9.10;
Hirshhorn Museum and Sculpture Garden,
Smithsonian Institution, Gift of Joseph H.
Hirshhorn, 1972 (photo Lee Stalsworth): 15.10;
Holly Solomon Gallery, New York: 15.27; By
courtesy of the Trustees of Sir John Soane's
Museum, London: 12.8; A. F. Kersting, London:
9.1, 9.11, 9.12, 10.36, 11.1, 11.29, 11.30, 11.31,
12.29, 13.47; G. E. Kidder Smith, New York:
13.43; Lauros-Giraudon/Bridgeman, London:
9.6, 9.7, 9.9; Ralph Liebermann, North Adams,
MA: 14.34, 14.37, 15.38; Louisiana Office of
Tourism/Al Godoy: 15.44; The Mansell
Collection, London/Alinari: 9.4, 10.10, 10.12,
10.21, 10.25, 10.26, 10.27, 10.29, 10.34, 10.35,
10.37, 11.13, 11.14, 11.15, 13.26; Bildarchiv Foto
Marburg, Germany: 12.28, 12.37, 12.38; Menil
Collection: 15.11; Lucia Moholy, Zürich: 14.41,
14.42; Peter Moore, New York: 15.28; National
Film Archive, London: 14.30, 14.31; Prestel
Verlag, Munich: 15.25; Quattrone Mario
Fotostudio, Florence: 10.9; Réunion des
Musées Nationaux, Paris: 11.6, 11.16, 11.37,
12.11; Scala, Florence: 10.1, 10.6, 10.16, 10.19,
10.24, 10.39, 10.46, 11.5, 11.27, 11.28, 11.35,
11.36; Bob Schalkwijk, Mexico City: 14.22;
Schomburg Center for Research in Black
Culture (Art & Artifacts Division); The New York
Public Library; Astor, Lenox, and Tilden
Foundations: 14.21; Edwin Smith, Saffron
Walden: 12.35, 12.36; Sperone Westwater:
15.13; Vatican Museums: 10.41, 10.47;
Weidenfeld & Nicolson, London: 12.30; Peter
Wexler, Inc. New York: 15.33; Whitney Museum
of American Art, New York (photo Geoffrey
Clements): 15.9; Whitney Museum of American
Art, New York (photo Sandak, Inc./G. K. Hall,
Boston, Massachusetts): 15.23.

The following illustrations are © ADAGP 1986;
14.12, 14.13, 14.25, 14.26, 15.19, 15.24; ©
ADAGP, Paris & COSMOPRESS, Geneva 1986:
15.20; © DACS 1986: 13.29, 14.6, 14.7, 14.8,
14.9, 14.10, 14.14, 14.15, 14.16, 14.18, 14.24,
15.8, 15.15.

CONTENTS

CONTENTS

PREFACE

The purpose of this book is to present an overview of the visual arts, literature, music, theatre, dance, film, and architecture by focusing on selected developments in the context of the philosophy, religion, aesthetic theory, and political events surrounding them. It is an historical introduction to the humanities. The reader of this text should gain a basic familiarity with major styles, some understanding of the ideological, chronological, and technical implications of those styles, and also a feeling for the historical development of individual arts disciplines. In addition, this work attempts to provide the humanities instructor with a helpful textbook for courses which touch upon the arts in an inter- or multi-disciplinary manner. To achieve these ends I have necessarily been selective. This text should not be considered an attempt to develop a profound or detailed history. It gives an overview from prehistory to the present day, treating all the arts as consistently as possible.

The Creative Impulse is not a completely self-contained humanities course. It cannot substitute for the classroom teacher, whose responsibility it is to shape and mold a course according to the needs of local curricula and to assist the student to focus on what is important for the thrust of that particular course. No textbook can be relied upon to answer all the students' questions and include all key points. A good text can only *suggest* the breadth of the offerings available.

Material is organized vertically and horizontally. One may isolate any subdivision, such as the general history or sculpture sections, and study the overview of that area from ancient to modern times. Or one may read entire chapters so as to gain a basic understanding and comparison of events and elements within a particular era.

On the multisided debate concerning how a teacher should approach the arts, of course, this text takes a definite point of view. My focus, format, and choice of materials are based on the belief that one ought to be able to describe before attempting to theorize. The issue is not a matter of right or wrong. Nearly all approaches have some merit. The issue, which is up to the individual instructor, is how and when a particular approach is applicable.

In discussing artworks I have for the most part kept to description and compositional analysis. By so doing I hope to assist readers in polishing their skills of technical observation. By avoiding meaning and relationships I have left room for the classroom instructor to move discussion in whatever direction is deemed appropriate to the course. At the end of each chapter there is a section entitled "Synthesis." Here I have narrowed my vision to one specific location whose arts (or, in two cases, art) provide us in some way with a microcosm of the period or part of the period. Here we may gain a fuller understanding of interrelationships than the broad treatment in the remainder of the chapter allows.

A significant problem in developing any inter- or multi-disciplinary arts text is balancing thematic, chronological, and practical considerations. A strictly chronological approach works fairly well for histories of single or closely related disciplines because major movements tend to be compressed. When all the arts are included however, we find a progression of shifting, sliding, overlapping, and recurring fits and starts which do not conform to convenient chronological patterns. A strictly thematic approach, on the other hand, tends to leave the reader in limbo. Chronological guideposts simply cannot be ignored. So I have tried to maintain a broad and traditional chronological framework within which certain liberties have been taken to benefit thematic considerations.

Basic to this discussion is a belief that teachers of arts survey courses should assist students to view the arts as reflections of the human condition. A work of art is a view of the universe, a search for reality, revealed in a particular medium and shared with others. Men and women similar to ourselves have struggled to understand the universe, as we do; and often, though separated by centuries, their concerns and questions, as reflected in their artworks, are alike.

Therefore, I trust that those who read this text will go beyond its facts and struggle with the potential meanings of the artworks included or suggested here. They should ask questions about what the artist may have been trying to accomplish; draw relationships from the social and intellectual contexts and concepts as they relate to the artworks; and, finally, seek to understand how they as individuals see these creative expressions in relation to their understanding of the universe.

To keep the text as flexible as possible I have not drawn detailed cause and effect relationships between the arts and history. Significant uncertainty exists in many quarters as to whether art is a reflection of the society in which it is produced or whether it derives entirely from internal necessity, without recourse to any circumstances other than artistic ones. I believe that both cases have occurred throughout history and do not consider it within my purpose here to try to argue which or where. I also find continual linkages of general events to six (or seven) arts

disciplines problematically repetitive. Therefore, I begin each chapter with a brief historical summary to provide a context for the arts of that period. Some relationships of style to political, philosophical, literary, and/or religious developments are obvious; others are not entirely clear, or may be questionable.

One further point is implicit in my approach. Artworks affect us in the present tense. Whatever the current vogue, the art of the past can stimulate meaningful contemporary responses to life and to the ideas of other people who tried or try to deal with life and death and the cosmos. Nonetheless, discussing dance, music, painting, sculpture, drama, film, and architecture falls far short of the marvelous satisfaction of experiencing them. Black-and-white and even color reproductions cannot stimulate the range of responses possible from the artwork itself. No reproduction can convey the scale and mystery of a Gothic cathedral or capture the glittering translucence of a mosaic or a stained-glass window. No text can transmit the power of the live drama or the strains of a symphony. One can only hope that the pages that follow will open a door or two, and perhaps stimulate the reader to experience the intense satisfaction of observing actual works of art, of whatever era.

I have tried to keep descriptions and analyses of individual artworks as nontechnical as possible, but technical vocabulary cannot be avoided entirely. For that reason a Glossary is included. I have endeavored to define technical terms either in the text or in the Glossary. (Instructors using this book might wish to consider *Perceiving the Arts* [Prentice Hall, 4th ed., 1992] as a collateral text.) In addition, my approach sometimes varies from discipline to discipline and era to era. Although that variation creates some inconsistency, I have tried to let the nature of artistic activity dictate the treatment given. Sometimes a broad summary of a wide-ranging style suffices; at other times an ethnographic separation is necessary; at still other times a more individualized or subdisciplinary approach is required.

I have separated the visual arts into architecture, sculpture, and two-dimensional art. The first two are fairly obvious, but the third is less so. At all stages in the history of art, pictorial art has encompassed more than easel painting. Drawing, printmaking, manuscript illumination, vase and mural painting, photography, and mixed media have also played a role, and I note this where appropriate. Traditional painting, however, has formed the backbone of the discipline, and is the primary focus.

Theatre as an artform or discipline must be seen as a live performance, which actuates a script with live actors in a physical environment. So the descriptions of theatre try to illuminate production, with a ready acknowledgement that the script is the basis, the style of which often determines the production style. As theatre is examined, I focus on the contemporary production of plays, but occasionally revivals of earlier plays give strong indications of the idea or style of production in that period.

Dance presents a problem because, although it has been an intimate part of creative expression since the dawn of history, it is also an ephemeral art and a social activity. Even though I have a fundamentally relativistic approach to the question "What is art?", for the purposes of this text I have tried to limit dance to what we may call "theatre dance," that is, dance which involves a performer, a performance, and an audience. Such a limitation, still, is not entirely satisfactory: certain dances may, in some cases, be theatre dance; in other cases, social dancing; and in still other cases, both or neither. However, I hope the reader will understand that my choices are more or less practical, and that my purpose is to provide a general overview and not to argue for or against any particular theory.

Architecture and sculpture raise only a few minor problems in definition and description. Both disciplines have the properties of longevity and, in general, have excellent examples to draw upon, even from the earliest days of the human race. Music, though also ephemeral, poses few problems, at least from the Middle Ages on. Finally, Chapters 14 and 15 present a new subject—film. A 20th-century discipline, film has developed its own aesthetics and form, and is fully a part, if only a recent one, of western arts history. So I include it as such.

I am guilty, as are most textbook writers, of robbing the arts of much of their excitement and rich interrelationships by using neat, taxonomical divisions in each chapter. A history of the arts should read like a complex novel, because this is a lively story—a story of humankind—full of life, breath, and passion. The ebb and flow of artistic history has created intricate crosscurrents of influence from society to individual to art; from other arts, to individuals, to society or societies, and so on, in infinite variety. I would challenge those who use this book, again, to go beyond its covers to try to capture that excitement.

It should be clear that a work such as this does not spring fully from the general knowledge or primary source research of its author. Some of it does, because of my long-term and close affiliation with the various arts disciplines. Much is the result of notes accumulated here and there as well as research specifically directed at this project. However, in the interest of readability and in recognition of the generalized purpose of this text, copious footnoting has been avoided. I hope the method I have chosen for presentation and documentation of others' works meets the needs of both responsibility and practicality. The bibliography at the end is a comprehensive list of cited works. I am indebted to many of these authors, to my colleagues around the country, and specifically to John Myers, Sherrill Martin, and David Kechley.

D.J.S.

PREFACE TO THE SECOND EDITION

In this second edition I have made two major changes in format, and a number of additions to the text and illustrations, in response to suggestions from those who have used the first edition. I have expanded the analysis of artworks in the text and in the new "Masterworks" sections, which focus on individual works of art in each chapter. I have eliminated the listings of artists and artworks not discussed in the text, as some individuals found them frustrating for students. "Focus" sections have been added at the end of each "Contexts and Concepts" section, to help students to focus on important terminology and key questions, such as People to Know, Dates to Remember, and so on.

Additional material has also been provided to assist those whose approach to humanities includes musical description and/or reading of literary examples. Musical works have now been included among the artworks featured in the new "Masterworks" sections, and some analyses of musical works have been added to the general discussion. For ease of access to recordings of these works, musical examples analyzed are included on a cassette available from Prentice Hall. In the case of literature, I have placed the literature and theatre sections together within the main body of each chapter, and added much new material, including several extracts from the literary works discussed. Further extracts can be found in *The Literary Spirit* (Prentice Hall, 1988), an anthology which was designed to accompany this text.

Finally, I have learned over the years that, despite care and a battery of copy editors and professional proof readers, mistakes do find their way into final copy. We've corrected this edition to the best of our ability, but I have no doubt that it still falls short of perfection. The best I can do is apologize and hope that any occasional error will not mar the overall value of the work.

D.J.S.

PREFACE TO THE THIRD EDITION

This is the third edition of a book that has, in its previous editions, received acclaim around the world. It has enjoyed separate editions in Britain and Australia. All of this has been highly gratifying for me as an author. Nonetheless, times change and expectations change. As a result, we have undertaken a complete rewrite of the book, from beginning to end. The style is, I hope, reflective of the transparency that the current generation of students and faculty expect. We have also improved the maps and charts, added new color plates, brought the modern era up to date, added more material on Aegean civilizations (thereby creating two new chapters), and paid further attention to the issue of cultural diversity.

The most obvious change, however, is the expansion of the book to two volumes by adding over 70 pieces of literature—extracts and complete works—which encompass the earliest known texts of the *Gilgamesh Epic* to contemporary poetry. A concise version of the last chapter in Volume One has been inserted at the start of Volume Two, to link it with earlier periods, and to provide an insight into the historical and cultural conditions that led from the Middle Ages to the birth of the Renaissance.

Any book of this scope is far more than the work of its author, and I want to acknowledge at least some of the individuals who have made major contributions to this edition. First is my wife, Hilda, without whose patience, advice, and editing the project could not have been completed. Next is Cheryl Kupper, whose perception, knowledge, and copy editing brought the manuscript to its final form. Ursula Sadie provided the oversight, expertise, and coaching necessary to put together the thousands of pieces that comprise the final product. Always present in the background were Bud Therien, Publisher of Art and Music, at Prentice Hall—friend and mentor for nearly 15 years—and the entire staff at Calmann & King in London, who, through three editions of *The Creative Impulse* and *Reality Through the Arts*, have come to seem like a second family.

D.J.S.

INTRODUCTION

This book is a story about us. It is a story about our perceptions of the world as we, the human race, have come to see it, both cognitively and intuitively. It describes how we respond to it and communicate our understandings of it to other people. We have been doing this as part of our humanity since the great Ice Age more than 35,000 years ago. We have not developed human qualities since then—archeological and anthropological evidence from the past 100 years shows that the characteristics of "being human" have been with us from the earliest times. Certainly we have learned, in a cognitive way, more about our world and how it functions. We have changed our patterns of existence and interdependence. But we have not changed in our humanity. Art illustrates this in terms that are inescapable. So a story of human ventures down the millennia is our story.

I hope that this book's content will suggest to the reader that creativity in the artistic sense is an intrinsic part of being human, and so we are all led by a basic "creative impulse." Try as we may in these modern times to escape from the suggestions of our right cerebral hemisphere to the absolutes of the left part of the brain (the cognitive part), we cannot escape the fact that we can, and do, know and communicate at an affective or intuitive level. The mistake of insisting only on cognitive knowing and development may already have robbed us of something of our capacity for being human.

Courses entitled "an introduction to the arts" exist widely, and this text is directed at them, together with all general readers interested in the arts and their history.

THE HUMANITIES AND THE ARTS

The humanities can very broadly be defined as those aspects of culture that humanize, that look into the human spirit. But despite our desire to categorize, there really is no clear boundary between the humanities and the sciences. The basic difference lies in the approach, which separates investigation of the natural universe, technology, and social science from the sweeping search of the arts for human reality and truth.

Within the educational system, the humanities have traditionally included the fine arts, literature, philosophy, and, sometimes, history. These subjects are all oriented toward exploring what it is to be human, what human beings think and feel, what motivates their actions and

shapes their thoughts. Many of the "answers" lie in the millions of artworks all round the globe, from the earliest sculpted fertility figures to the video art of the 1990s. These artifacts and images are themselves expressions of the humanities, not merely illustrations of past or present ways of life.

How can one define what is, and what is not, an artwork, without imposing one's own subjective, 20th-century view? Here is a possible definition: a work of art is some sight, sound, or movement (or combination), intended as human expression. This is wide-ranging enough to accept as art whatever is intended as such, without placing it on a pedestal. It encompasses the banal and the profound, the simple and the sophisticated, the comic and the tragic—these adjectives are not limiting factors, but serve to describe artworks.

Styles and schools and conventions are the stuff of art history. But change in the arts differs from change in the sciences in one significant way: new technology usually displaces the old, new scientific theory explodes the old, but new art does not invalidate earlier human expression.

Obviously not all styles and forms can survive indefinitely, but a Picasso cannot do to a Rembrandt what an Einstein did to a Newton, nor can the serialism of Schoenberg banish the tonality of Mozart as the evolutionary evidence of Darwin banished the 18th-century world of William Paley. The arts, even more than literature, survive by direct impact, and continue to swell the evergrowing reservoir of human manifestations. Times and customs change, the passions that shaped the artist's work disappear, his cherished beliefs become fables, but all of these are preserved in the form of his work. "All the assertions get disproved sooner or later," Bernard Shaw observed, "and so we find the world full of a magnificent debris of artistic fossils, with the matter-of-fact credibility gone clean out of them, but the form still splendid."[1]

Works of art also remain, in a curious way, always in the present. We react *now* to the sound of a symphony, or to the color and composition of a painting. No doubt a historical perspective on the composer or painter, a knowledge of the circumstances in which the art was created, enhance the understanding and appreciation. But it is today's reaction that is important when it comes to the arts.

Beyond the immediate reaction, there is a complex web of questions and interrelationships. How does the artwork relate to the artist? To society? To nature? Why was it created? What is its focal point? Does it have a message or not? Many more questions could, of course, be asked, some concerning the work itself, and others

concerning its relationship to external factors. And they could be asked of any work of art, from a child's effort to an acknowledged masterpiece. It may be best to avoid such questions as "Is it really art?" or "Will it survive the test of time?" More constructive is "What can we get out of it now?" Look for your response, and avoid giving everything a label of good or bad. This relativistic approach may enlarge your understanding, as the parameters of art constantly shift. History has shown that there is no reliable way of knowing what artforms will survive. In our ignorance of the future, it is probably wisest to leave the widest possible range of options open. Our descendants may well still appreciate Shakespeare, Michelangelo, and Mozart, but we cannot guess how their art will take shape.

The arts can be approached with all the subtlety we normally apply to human relationships. We learn very young that people cannot simply be categorized as "good" or "bad," as "friends," "acquaintances," or "enemies." We relate in a complex way. Some friendships are pleasant but superficial, some people are easy to work with, others (but few) are lifelong companions. Similarly with art—and when we have gone beyond the textbook categories and learned this sort of sensitivity, we shall find that art, like friendship, has a major place in our growth and quality of life.

THINGS COGNITIVE AND AFFECTIVE

Language and communication come in many forms. Most familiar to us is the language of the written and spoken word, followed by the signs and symbols of science and mathematics. In addition there exists the language of sound, that is, music, and the language of gesture, which we could call dance, although gesture or body language in fact occurs all the time in circumstances other than dance. Nonverbal modes of communication comprise significant and meaningful avenues for our understanding of the world. In coming to grips with the variety of means of communication available to us, we often separate these not only into verbal and nonverbal categories but also into cognitive and affective realms. The term cognitive connotes generally those things which are factual and objective; affective connotes feelings, intuition, and emotions. Each of these areas—that is, the cognitive and the affective—represents a separate way of coming to understand or to know, as well as a way of communicating. They appear to be directly related to activities of either the left or right cerebral hemispheres. Roger Sperry, among others, has shown that

The left and right hemispheres of the brain are each found to have their own specialized form of intellect. The left is highly verbal and mathematical, and performs with analytic, symbolic, and computer-like sequential logic. The right, by contrast, is spatial, mute, and performs with a synthetic, spatioperceptual and mechanical kind of information processing not yet simulatable in computers.[2]

Sperry tells us that there is a scientific basis for our assumptions that we can know and communicate through affective experiences, which do not conform to verbal, mathematical, or sequential cognitive systems.

Finally, let us consider one further, related concept. That is the concept of aesthetic knowledge—the total experience surrounding our involvement with a work of art and/or its creation. Aesthetic knowledge stems from a unique synthesis of affective and cognitive, of emotive and intellectual skills that deal with the relationships between colors, images, sounds, forms, and movements. As we move through the material ahead of us in this textbook, we need to keep in mind that the facts and descriptions presented here are only the beginnings of an experience with our cultural heritage. We really must go beyond these facts and try to discern meaning. In the classroom that task will require discussion and some help on the part of the instructor. For those reading this book purely for pleasure, it will entail some additional reading.

WHAT IS STYLE?

Our discussion of arts history will focus to a large degree on style. So before we begin, we need to understand some of the things the term "style" implies. A standard dictionary definition would indicate that style refers to those characteristics of an artwork that identify it with a period of history, a nation, a school of artists, and/or a particular artist. We might say, too, that style is the individual personality of the artwork. That definition is fairly concise, but how does it affect us? How do we use it? When we look at a painting, for example, or listen to a piece of music, we respond to a complex combination of all the elements that make up the work—elements of form and of content. In the painting we see, among other things, colors, lines, and even perhaps the marks made by the brush as the paint was applied. In the musical piece we hear melodies, rhythms, harmonies, and so on. No two artists use these elements of their medium identically. Each artist has individual preferences and techniques. So when experts compare several paintings by more than one artist, they can tell which paintings were painted by which artists. Experts extract clues from the artwork itself: are the colors bright, dull, or some combination of the two? Are the lines hard or fuzzy, the contrasts soft or hard? Are the rhythms simple or complex? These individual clues help to indicate the artist's style, a style which may or may not be a reflection of society or philosophy, of biographical or artistic considerations.

Groups of artists often work in close contact with each other. They may study with the same teacher, or they may

share ideas of how their medium of expression can overcome technical limitations or more adequately convey the messages or concerns they all share. As a result, their artworks may show characteristics of such similarity that trained individuals can isolate them as a "school." The similarities which allow for such identification comprise the style of the group. Further expert examination could also identify the works of individuals within the group. This same process of isolation and identification can be applied to artworks from certain nations, and even to rather large slices of history, as we shall see.

Finally, how does a style get its name? Why is some art called classical, some pop, some baroque, and some impressionist? Some styles were named hundreds of years after they occurred, with the definition accruing from extended common usage or from an historical viewpoint. The Athenian Greeks, whose works we know as classical, were centuries removed from the naming of their style. Some labels were coined by artists themselves. Many stylistic terms are attributed to individual critics, who, having experienced the emerging works of several artists and noting a common or different approach, invented a word (sometimes a derogatory one) to describe that approach. Because of the influence of the critic or the catchiness of the term, the name was adopted by others, and commonly used. Thus, a style was born.

We must be careful, however, when we use the labels by which we commonly refer to artworks. Occasionally such labels imply stylistic characteristics; occasionally they identify broad attitudes or tendencies which are not really stylistic. Often debate rages as to which is which. For example, Romanticism has stylistic characteristics in some art disciplines, but the term connotes a broad philosophy toward life in general. Often a stylistic label is really a composite of several styles whose characteristics may be dissimilar, but whose objectives are the same. Terminology is convenient, but not always agreed upon in fine detail. Occasionally experts disagree as to whether certain artworks fall within the descriptive parameters of one style or another, even while agreeing on the definition of the style itself.

In addition, we can ask how the same label might identify stylistic characteristics of two or more unrelated art disciplines, such as painting and music. Is there an aural equivalent to visual characteristics, or vice versa? These are difficult questions, and potential answers can be troublesome as well as debatable. More often than not, similarity of objectives, as opposed to directly transferable technical characteristics, results in the use of the same stylistic label for works in quite different disciplines. Nevertheless, some transference is possible, especially in a perceptual sense. For example, undulating line in painting is similar in its sense-stimuli to undulating melodic contours in music. However, the implications of such similarities have many hidden difficulties, and we must be careful in our usage, regardless of how attractive similarities in vocabulary may seem.

Styles do not start and stop on specific dates, nor do they recognize national boundaries. Some styles reflect deeply held convictions or creative insights; some are imitations of previous styles. Some styles are profound; others are superficial. Some styles are intensely individual. However, merely dissecting artistic or stylistic characteristics can be dull. What makes the analysis come alive is the actual experience of artworks themselves. What are our reactions to the work of art; what is the deepest level of meaning we can find? Within every artwork lies the reflection of another human being attempting to express some view of the human condition. We can try to place that viewpoint in the context of the time or the specific biography that produced it and speculate upon why its style is as it is. We can attempt to compare those contexts with our own. We may never know the precise stimuli that caused a particular artistic reflection, but our attempts at understanding make our responses more informed and exciting, and our understanding of our own existence more profound.

CREATIVITY AND CULTURAL DIVERSITY

The desire, in fact the need, to create is a part of our humanness. Creativity and its expressions can be found in every culture in every time. Our examination of the creative impulse in the pages that follow focuses on essentially what has been called "the western or Euro-centered tradition." That focus has practical reasons at its center. But all of the cultures not included in this volume have their own rich and deep traditions, and we shall now briefly glance at Asian and African art.

Asian art

In East Asia, the cultural tradition emerges from the social heritage of China, wherein the concepts of family subordinate the individual and result in particular political and ethical systems. From approximately 1400 to 1100 BC, verifiable Chinese history was beginning, with the emergence of the Shang dynasty. In the third or Zhou (Chou) dynasty, from approximately 1100 to 256 BC, accurate documentation of Chinese history begins. The earliest Chinese books date to early in the first millennium BC. They weave a pattern of ethics, philosophy, and mythology. From this strong sense of history came an ideal of political unity and a belief in the uniqueness of the "Central Country," or *Chung-kuo*.

Shang bronzes from approximately 1400 BC fall into two categories: weapons and ceremonial vessels. Both are frequently covered with elaborate designs, either incised or in high relief. The craftsmanship of the design

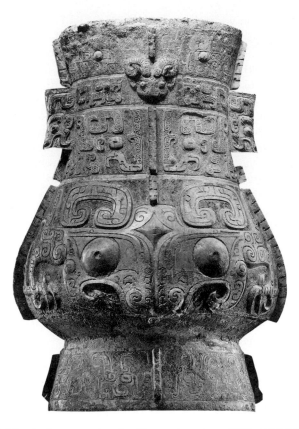

0.1 Ritual wine vessel or *hu*, Shang dynasty, c.1300–1100 BC. Bronze, 16 ins (140.6 cm) high, 11 ins (27.9 cm) wide. Nelson Gallery, Atkins Museum, Kansas City.

is exquisite and surpasses the quality of virtually every era, including the western Renaissance. Each line has perfectly perpendicular sides and a flat bottom, meeting at a precise 90-degree angle. This contrasts, for example, with incision, which forms a groove. The approach to design seen in animal representation illustrates a vision unlike that of western culture, and similar to later East Asian and Pacific Northwest Indian design, in which the animal appears as if it had been skinned and laid out with the pelt divided on either side of the nose. A rigid bilateral balance occurs. The bronze ritual vessel of the shape known as *hu* (Fig. 0.1) exhibits grace and symmetry, with subtle patterns carefully balanced and delicately crafted.

0.2 Elephant feline head, Shang dynasty, c.1200 BC. Jade, 1⅝ ins (4 cm) long. The Cleveland Museum of Art, Anonymous Gift, 52.573.

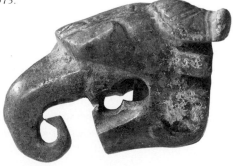

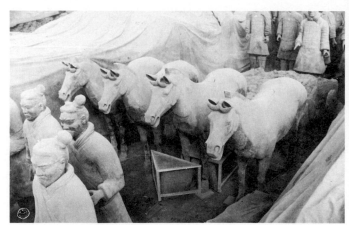

0.3 Terracotta warriors, Qin dynasty, third century BC. Life-size. Courtesy, People's Republic of China.

The graceful curves of the vessel are broken by deftly placed ridges and gaps, and while the designs are delicate, the overall impression exhibits solidity and stability.

Another innovation of the Shang culture is stone sculpture in high relief or in the round. Most numerous are small-scale images in jade. They represent a broad vocabulary, from fish, owls, and tigers, for example, as single units, to combinations and metamorphoses such as the elephant head of Figure 0.2. This design expresses a simplicity of form with incised, subtle detail. We can easily see the metamorphic intention of the piece as we note the feline head with large, sharp teeth, elephant's trunk, and bovine horns.

Although the Qin dynasty lasted less than 50 years, during the third century BC, the emperor spent that entire time preparing his palace and mausoleum. Over the years, minor pilfering and excavation have occurred, since the location of the underground vaults was well known. In March 1974, however, a major discovery was made during the digging of a well near the vaults. Life-size and lifelike pottery figures were unearthed from vaults containing terracotta warriors, horses, and bronze chariots. In one vault (measuring 760 by 238 feet) alone, 6000 terracotta warriors and horses were found. A total of three vaults contain over 8000 figures (Fig. 0.3).

African art

For thousands of years, African artists and craftsmen have created objects of sophisticated vision and masterful technique. The modern banalities of so-called primitive "airport art," sold to tourists, belie the rich cultural history of the African continent. Africans were trading with the Middle East and Asia as early as AD 600, as documented by Chinese Tang dynasty coins found on the maritime coast of East Africa. Climate, materials, and the very nature of tribal culture doomed much of African art to

extinction; only a fraction remains. Nonetheless, what has survived traces a rich vision which varies from culture to culture and which has a style that runs from abstract to naturalistic. Its purposes range from the magical to the utilitarian, adding layer upon layer to its potential meaning. It portrays levels and visions of reality that we may be ill-equipped to understand, inasmuch as our culture views reality differently. Nonetheless, if we know how to look, we can find profound human statements and great satisfaction in these works.

During the first millennium BC, on the Jos plateau of northern Nigeria, the Noks, a nonliterate culture of farmers, entered the Iron Age and developed an accomplished artistic style. Working in terracotta, they produced boldly designed sculptures (Fig. **0.4**) apparently nearly as sophisticated in firing technique as the Qin dynasty terracotta warriors of China. Some works represent animals in naturalistic form and others portray life-size human heads. Although stylized, with flattened noses and segmented lower eyelids, for example, each work reveals individualized character. Facial expressions and hairstyles differ, and it is this unusual combination of human individuality and artistic stylization that gives them their peculiar power. Probably these heads are portraits of ancestors of the ruling class. The technique and medium of execution seem to have been chosen to ensure permanence and for magical rather than artistic reasons. The Nok style appears seminal to several West African styles.

The level of skill achieved by the ninth and tenth centuries AD can be seen in a ritual water pot from the village of Igbo-Ukwu in eastern Nigeria (Fig. **0.5**). Cast using the *cire-perdue* or lost-wax process, this leaded bronze artifact is amazing in its virtuosity. The graceful

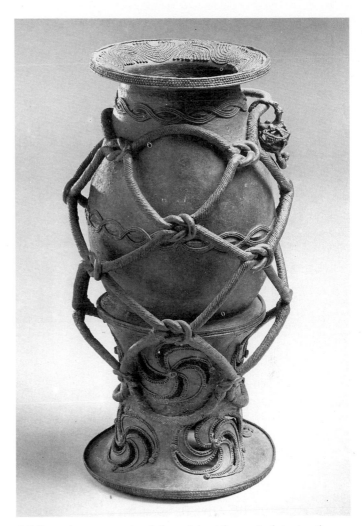

0.5 Roped pot on a stand, from Igbo-Ukwu, ninth to tenth century AD. Leaded bronze, 12½ ins (32 cm) high. The National Museum, Lagos.

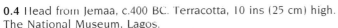

0.4 Head from Jemaa, c.400 BC. Terracotta, 10 ins (25 cm) high. The National Museum, Lagos.

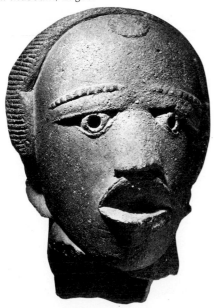

design of its recurved lines and flaring base are in themselves exquisite, but the addition of the delicate and detailed rope overlay reflects sophistication of both technique and vision.

Whatever cultural roots we may view as our own, we are part of a human search for understanding of our own and infinite reality. One of the ways we can pursue this search is through our creative impulses. We seek to reflect and interpret our human reality—however we may ultimately view it—in a myriad of objects that we call "art." We make and experience art in a variety of ways, some of which carry with them broader contextual relationships with society, politics, science, and philosophy. Others are personal and direct—our own subjective responses to a work of art which we experience for the first time, and without much thought about what brought it about. This book tries to assimilate some of that vast outpouring of human creativity.

CHAPTER NINE

THE LATE MIDDLE AGES

Humanity in the late Middle Ages seemed to undergo a spiritual and intellectual revival which had a profound influence on the creative spirit. In the Gothic cathedral, the mystery of faith was embodied in the mystery of space. Stone was transubstantiated into ethereal tracery defining open space, which was flooded by the colored light streaming in through stained-glass windows. The austere and fortress-like massiveness of the Romanesque style was thus transformed, and the human spirit seemed to blossom as attention shifted from the oppressive wrath of God to the sweetness and mercy of the loving Savior and the Virgin Mary. Meanwhile, the vigorous growth of towns and cities accelerated the pace of life. As the focus of wealth and power shifted away from the feudal countryside, the new universities in the cities replaced monasteries as centers of learning.

9.1 Salisbury Cathedral, England, from the southwest, begun 1220.

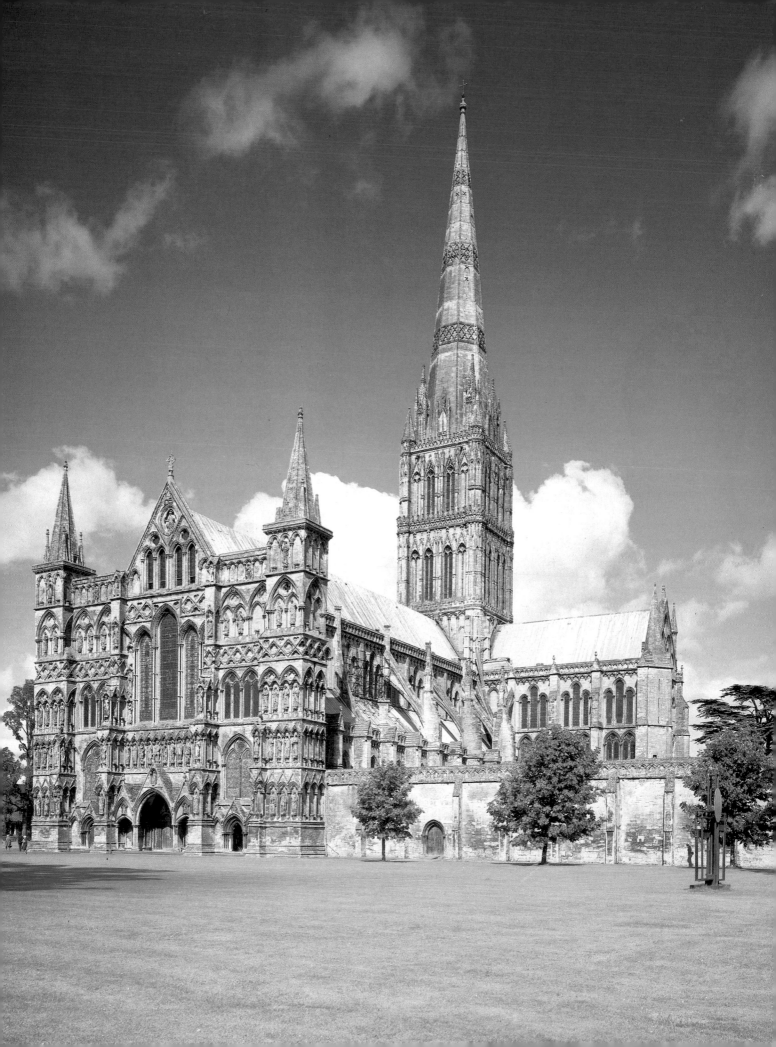

CONTEXTS AND CONCEPTS

The constant search for a better definition of reality yielded some remarkable results in the 12th to 15th centuries, and ushered in a new age, at least in the western world. Perhaps human beings possess certain ideas of what ought to be, and no matter how oppressive the circumstances, these ideas struggle to be fulfilled. Perhaps life is, as some have said, a search for personal freedom. Just whose freedom is concerned, and under what conditions, seems generally to be subject to circumstances.

Circumstance certainly colors a people's image of reality, and the circumstances of the mid-Middle Ages were unique. The effects of the conversion of Europe to Christianity and the approach of the end of the millennium (AD 1000) cannot be underestimated. The desperate conditions of feudal society and faith in a life beyond this vale of tears led to a widespread belief that the Second Coming of Christ and the end of the world would occur at the close of the millennium. One might think that the Second Coming and the end of the world would be a joyous fulfillment for a Christian. However, when Europe awoke to discover that the world had not ended with the millennium, rather than disappointment there seems to have been a great sense of relief. Humankind had been granted a new lease of life here on earth, and this was reflected in significant changes in the climate of feeling and thought.

REFORM IN THE CHRISTIAN CHURCH

The development of western culture, including its artistic institutions in the late Middle Ages, was profoundly affected, if not controlled, by the Christian Church. By the middle of the 11th century, the Church had become very powerful.

Although the tenth-century Church had become feudalized and corrupt, with many of its secular clergy seeking only wealth and power, this corruption did not go unchallenged. Cries for reform came loudest from the monasteries. The founding of the Abbey of Cluny by William of Aquitaine in 910 signalled the start of a major reform movement. The strict discipline and high moral standards of Cluny's Benedictine monks and abbots made Cluny a model of reform, and its influence spread across Europe.

While monastic life was successfully reformed to its original standards, however, the secular clergy changed their behavior very little. Feudal lords and the lesser nobility appointed priests and bishops, often choosing the highest bidder. Bishoprics were treated as family property, and the secular clergy, many of whose priests were married, did not place a high priority on their religious duties.

Conditions were ripe for reform, and the reformers vehemently attacked the evils of the secular clergy. Their objective was to free the Church from lay control and to reduce the secular interests of the clergy. The reform movement crossed national boundaries. Led by the papacy from the mid-11th century onward, it transformed the structure of the Medieval Church. Success depended on the reestablishment of the papacy as a central force in Christendom, and this was a position it had not enjoyed for some time, despite recognition of the primacy of the Roman See.

Circumstances changed in 1046 under Emperor Henry III of Germany. Henry championed the cause of the reformers, and in 1049 he appointed Pope Leo IX, who ruled until 1054. During those five years, Leo introduced a brilliant ecclesiastical reorganization, including the creation of a body of cardinals. Creation of the rank of cardinal made it possible for the papacy to exercise control over those bishops who had been named by lay rulers. After a series of synods in Rome, Leo took a personal tour of the empire, during which he publicized his reforms. As he put them into practice, he both consolidated his program and rid the clergy of many of its most offensive bishops.

Conflict between papacy and laity over the investiture of ecclesiastical office was not solved so easily, however. At the heart of the matter lay the issue of the basis of royal authority. The resulting struggle became known as the "Investiture conflict." Through a series of negotiated settlements with the various monarchs of Europe, the relationships between nobility and clergy, and clergy and papacy, were stabilized. The outcome was a compromise in which kings gave up their ancient claim to represent God's will in appointing senior clergy. They did continue to nominate bishops, but they had greater difficulty in presenting candidates considered unsuitable by the Church. From the 12th century onward, the quality of ecclesiastical appointments improved substantially.

The papacy emerged from the conflict with greatly enhanced prestige, and the importance of the Church in Medieval affairs, artistic and otherwise, continued to grow.

ST BERNARD OF CLAIRVAUX AND MYSTICISM

Many new religious orders were founded during this period, and the status of women in religious and secular thought also grew. The Virgin Mary assumed a new importance in religious life, and the cult of Mary Magdalene spread through Europe. A key figure in the changing religious thought was a young nobleman, Bernard of Clairvaux (1090–1153), who entered the order of Cîteaux, the most influential new monastic movement of the 12th century.

Bernard was an enthusiast, perhaps even a fanatic, having no doubt in his own mind that his views were correct. He entered into eager combat with anyone who disagreed with him, and those individuals included the most influential clerics and philosophers of the times: men such as the scholar and theologian Peter Abelard; the monk and abbot, Suger, of St Denis; and the entire order of Cluny. At the same time, Bernard could show great patience and common sense. He treated his monks with patience and forgiveness, and reportedly turned down the Duke of Burgundy's request to become a monk by saying that the world had many virtuous monks, but few pious dukes.

Bernard had a widespread reputation for holiness and eloquence, and was often asked to solve disputes in the public arena. He also occasionally intervened in public affairs without being asked. He was an advisor to the French king, Louis VII, founded the order of Knights Templar, and took an active role in promoting the Second Crusade. The unfortunate outcome of the crusade was one of the few stains on his public life. He was also profoundly upset by the fact that his preaching in favor of the crusade led to new massacres of the Jews.

His religious teaching set a new tone for 12th-century Christianity through emphasis on a more mystical and personal sense of piety than had existed previously. In his writings he described a way of "ascent to God," consisting of four stages of love by which a soul could gain union with God. In his sermons for the common people, he treated more ordinary themes and vividly retold familiar stories from the New Testament. Rather than treating Jesus, Mary, and the apostles as remote images, Bernard described them as living personalities. He sought to create in his listener an emotional love for the person Jesus. He emphasized the role of Mary as an intercessor who could lead people to Jesus. Recognizing that a sinner might be afraid to approach a sternly just God directly, Bernard created the image of a sympathetic, merciful lady to whom the sinner could turn, without guilt, for help. During this same time, collections of stories about Mary, called "Miracles of the Virgin," and the Mary-plays became popular. Bernard's preaching was an important stimulant for the spread of the Mary cults.

Bernard's popularity and leadership proved an important stimulant also for the growth and spread of the Cistercian order. In the 38 years between 1115 and Bernard's death in 1153 the order went from five houses to 343. By the end of the 13th century that number had doubled. The number of monks in each house was large too, with some approaching 700 monks.[1]

THE CRUSADES

Many of us have the notion that the crusades featured knights in shining armor setting out on glorious quests to free the Holy Land from Infidels. The crusades were far from a romantic quest, however. Instead, they illustrate clearly a new and practical energy and optimism in Europe in a new millennium and a new era. A strengthened Church leadership emerged from the period of the crusades.

As early as the tenth century, popes had led armies against the Saracens in Italy. By the end of the 11th century, the Church was able to put forward several reasons why a Christian army might march against the Muslims. Constantinople had been rescued from the Turks, and a healing of the east–west schism seemed possible. Furthermore, pilgrimages to the Holy Land as a form of penance had become increasingly popular in this age of religious zeal, and the safety of these pilgrims was ample reason for interference by the popes. A more practical benefit closer to home was the removal of troublesome nobles from the local scene. An opportunity came in 1095 at the Council of Clermont. When envoys of the eastern emperor Alexius Comnenus supposedly asked Pope Urban II for aid, Urban set about mounting a crusading army. The response to his call was astonishing. Thousands came forward to take up the cross. Men, women, and children clamored to take part, and the aforementioned nobles also went riding off to war.

The First Crusade, which ultimately led to the capture of Jerusalem and a bloody massacre, wound its way through Hungary, Greece, Constantinople, Syria, Nicea, the southern coast of Asia Minor, Edessa, and Antioch. Beset by infighting and other self-inflicted problems, the crusaders stumbled onward. When they finally conquered Jerusalem, even more problems appeared. What was Jerusalem to become? Was it to be a secular kingdom or Church property, like Rome? How was it to be defended? Most of the crusaders rushed home after their pilgrimages, however, and the wide-ranging Christian conquests proved virtually indefensible. As time went on, closer and closer association with the local people led any Christians who stayed on to adopt the customs of the country. Very little was settled, and no centralized authority was set up. By 1144, the Muslims had reunited and the Christian state was under siege. Edessa fell, sending shock waves through Europe. The clamor for another crusade

coincided with the reform movement of St Bernard of Clairvaux. The Second Crusade set out in 1147, but ended in disarray and defeat. After that, Europe lost its enthusiasm for such ventures, for a generation.

In the interim, the Muslims gathered their forces and set about driving out the Christians. On 3 October 1187, led by Saladin, the Muslims conquered Jerusalem, ending 83 years of Christian rule. Again the news shocked Europe, and again the Pope took the opportunity to attempt to make peace among warring nobles in Europe. But their only major accomplishment was the capture of Acre after a two-year siege. The Third Crusade clearly demonstrated the limitations of the papal program. Alliances betwen warring powers during a crusade were only temporary. Once they dissolved, France, England, and Europe in general, went right back to their old quarrels and could not refrain from new ones. Papal hopes for a united Christendom under the military leadership of Rome thus died with the end of the Third Crusade.

CHIVALRY

Society was feudal throughout Europe over this period. The Carolingian and Ottonian Empires had suggested that a wider stability and order were possible. But life remained polarized in a rigid class system. The clergy and nobility ruled, and the serf labored. In between, there was a vacuum. Gradually, however, this vacuum came to be filled by the town and the town guild. When this happened, another new age was born.

At the same time, another Medieval phenomenon was born of a change in attitude that permeated society and the arts. Feudalism was a masculine, "men-at-arms" code of behavior. But by the 12th century, a distinctly feminine point of view ruled ethics and personal conduct —that of chivalry and the courtly tradition. Men were away from their homes or castles for long periods of time, whether they were off trading or off warring. It fell to women to run their households and control domestic matters and manners. If Eleanor of Aquitaine (1122–1204) is a representative example, women managed this very well. Society thus took on a gentler, more civil tone than under the rough code of feudalism, and elaborate codes of conduct and etiquette emerged which culminated in "courts of love."

We may speculate that the code of chivalry was a practical and euphemistic way of glossing over illicit love affairs while husbands were away. Most aristocratic marriages were arranged for political convenience, anyway, while those of the lower classes had economic advantages as their goal.

More important than its impact on morals was the impact of the courtly tradition on religious philosophy. The early Middle Ages were fixated on devils and death, faith notwithstanding. As time passed, however, we find a

warmer feeling, a quality of mercy. Christ the Savior and Mary, his compassionate mother, became the focal points of the faith. This change in viewpoint is reflected very clearly in the arts of the time.

THE MIDDLE CLASS

Amid the changing values a new and important middle class arose to fill the vacuum between nobility and peasantry. Thousands flocked into emerging towns and cities, which offered a new hope of escape from slavery to the land. The crusades had opened Europe's barricaded mentality to new horizons. Returning soldiers brought tales of the east and of marvelous fabrics and goods that caught the fancy of nobles and commoners alike. The demand for trade goods and services exploded. Response could be almost instantaneous because the Italian trading cities, such as Pisa, Genoa, and Venice, had never fully declined as centers of commerce and shipping.

Within the emerging towns and cities, very powerful guilds of artisans and merchants rapidly developed. No order gives up power easily, and struggles, sometimes violent, pitted burgher against nobleman. The crusades had financially ruined many feudal landholders, and a taste of potential power and wealth strengthened the resolve of the middle-class citizens. They needed a more dynamic society than feudalism could offer, and they threw their wealth and power behind strengthening monarchies that favored them. As a result, administration became more centralized, society was stabilized, and a rudimentary democracy emerged. The 13th century witnessed the *Magna Carta*, which built upon 12th-century English common law, and also, in 1295, the establishment of an English parliament. Democracy began to emerge in Switzerland, and, in 1302, the Estates General were founded in France, igniting a spark of democracy.

INTELLECTUAL LIFE

Many universities gained their charters in the 12th and 13th centuries, for example, Oxford University in England, the University of Salamanca in Spain, the University of Bologna in Italy, and the University of Paris in France. Many had existed previously in association with monasteries, but their formal chartering made the public more aware of them. Medieval universities were not like today's institutions. They had no buildings or classrooms. Rather, they were guilds of scholars and teachers who gathered their students together wherever space permitted. University life spawned people with trained minds who sought knowledge for its own sake and who could not accept a society that walled itself in and rigidly resisted any questioning of authority.

	GENERAL EVENTS	LITERATURE & PHILOSOPHY	VISUAL ART	THEATRE & DANCE	MUSIC	ARCHITECTURE
1000	Henry III of Germany Pope Leo IX First Crusade	Abelard				
1100	Bernard of Clairvaux Muslim conquest of Edessa Second Crusade Muslim conquest of Jerusalem Eleanor of Aquitaine, chivalry Third Crusade		Gothic style West portal jamb statues—Chartres Cathedral (9.6)	Courtly tradition Mystery, miracle, morality plays Antecriste Adam Play Second Shepherd's Play	Ars antiqua Organa Cantilena Motet	Gothic style Abbey Church of St Denis Chartres Cathedral (9.10) Notre Dame de Paris (9.9)
1200	Magna Carta	St Thomas Aquinas Dante Roger Bacon	Nicola Pisano (9.8)	Danse Macabre	Troubadours Minnesänger	Amiens Cathedral (9.11) Salisbury Cathedral (9.1)
1300	Hundred Years' War begins The Plague	Chaucer Froissart	Cimabue (9.5) Giotto (9.4) Jean Pucelle (9.3)		Ars nova	Doges' Palace (9.12)
1400			International Gothic	Confrérie de la Passion Everyman·		

9.2 Timeline of the Late Middle Ages.

This environment bred new philosophies. As we shall see, St Thomas Aquinas built a philosophical structure that accommodated divergent points of view. Dante suggested a new mix of views in the *Divine Comedy*. Aristotle was rediscovered and introduced throughout Europe, and Roger Bacon began a study of "reality" simply as physical phenomena. As intellectual walls collapsed, light and fresh air flooded into western culture. New freedoms, new comforts, both physical and spiritual, and a new confidence in the future pervaded every level of society. Thirteenth-century philosophy reconciled reason and revelation, the human and the divine, the kingdom of heaven and the kingdoms on earth. Each took its place in a universal, harmonious order of thought.

PHILOSOPHY AND THEOLOGY
Abelard and realism

Abelard (1079–1142) has become a figure of both philosophy and romance. His life-long correspondence and late-in-life love affair with Héloïse accounts for the romantic element. As for the philosophy, he studied with William of Champeaux and with Roscellinus, but disagreed with the conclusions of each of his masters. Abelard denied that objects are merely imperfect imitations of universal ideal models to which they owe their reality. Instead, he argued for the concrete nature of reality. That is, objects as we know them have *real* Individuality which makes each a substance "in its own right."

Abelard went beyond this, to argue that universals do exist, and that they comprise the "Form of the universe"

as conceived by the mind of God. They are patterns, or types, after which individual substances are created and which make these substances the *kinds* of things they are.

Abelard has been called a "moderate realist," or, sometimes, a "conceptualist," even though that term is usually applied to later teaching. His views were adopted and modified by St Thomas Aquinas, and in this revised form they constitute part of Roman Catholic Church dogma today. Abelard believed that philosophy had a responsibility to define Christian doctrine and to make it intelligible. He also believed that philosophers should be free to criticize theology and to reject beliefs that are contrary to reason.

Abelard regarded Christianity as a way of life, but he was very tolerant of other religions as well. He considered Socrates and Plato to have been "inspired." The essence of Christianity was not its dogma, but the way Christ had lived his life. Those who lived prior to Jesus were, in a sense, already Christians if they had lived the kind of life Christ did. An individual act should be understood as good or evil "solely as it is well or ill intended," he argued in his treatise *Know Thyself*. However, lest anyone excuse acts on the basis of "good intentions," Abelard insisted on some sort of standard for judging whether intentions were good or bad. Such a standard existed in a natural law of morality, "manifested in the conscience possessed by every man, and founded upon the will of God." When opinions differed over the interpretation of the law of God, each person must obey his or her own conscience. Therefore, "anything a man does that is against his own conscience is sinful, no matter how much his act may commend itself to the consciences of others."[2]

21

St Thomas Aquinas and Aristotelianism

The rediscovery of Aristotle in the 13th century marked a new era in Christian thought. With the exception of Aristotle's treatises on logic, called the *Organon*, his writings were inaccessible to the west until the late 12th century. Their reintroduction created turmoil. Some centers of education, such as the University of Paris, forbade Aristotle's metaphysics and physics. Others championed Aristotelian thought. Their scholars asserted the eternity of the world and denied the existence of divine providence and the foreknowlege of contingent events. In the middle were thinkers such as Albertus Magnus who, though orthodox in their acceptance of the traditional Christian faith, regarded the rediscovery of Aristotle in a wholly positive light. Magnus' first pupil was Thomas Aquinas (1227–74).

A prolific writer, Aquinas produced philosophical and theological works and commentaries on Aristotle, the Bible, and Peter Lombard. His most influential works are the *Summa contra Gentiles* and the *Summa Theologiae*. Aquinas, like Magnus, was a modernist, and he sought to reinterpret the Christian system in the light of Aristotle—in other words to synthesize Christian theology and Aristotelian thought. He believed that the philosophy of Aristotle would prove acceptable to intelligent men and women, and further, that if Christianity were to maintain the confidence of the majority of educated people, it would have to come to terms with and accommodate Aristotle. Aquinas was a very devout and orthodox believer. He had no wish to sacrifice Christian truth, whether to Aristotle or any other philosopher.

In dealing with God and the universe, Aquinas carefully defined the fields of theology and philosophy. Philosophy was limited to whatever lay open to argument, and its purpose was to establish such truth as could be discovered and demonstrated by human reason. Theology, on the other hand, was restricted to the "content of faith," or "revealed truth," which is beyond the ability of reason to discern or demonstrate, and "about which there can be no argument." There was, nonetheless, an area of overlap.

Aquinas concentrated upon philosophical proofs of God's existence and nature. The existence of God could be proved by reason, he thought, and Aristotle had inadvertently done just that. The qualities to which Aristotle reduced all the activities of the universe become intelligible "only on the supposition that there is an unmoved . . . self-existent . . . form of being whose sheer perfection sets the whole world moving in pursuit of it."

Beyond this, Aquinas moved the philosophical knowledge of God's nature beyond the Aristotelian viewpoint. He turned, instead, to Plato. Aristotle's view that God knows only his own Form is replaced with the idea that God's self-knowledge comprises a knowledge of the whole formal structure of the universe. On this point, Aquinas follows Augustine in his belief that the formal structure of the universe is a plan in the divine mind in accordance with which the world is created.

SECULARISM

By the 14th century, revelation and reason, and God and the state, were considered separate spheres of authority, neither subject to the other. Such a separation, of what had previously been the full realm of the Church, was the beginning of secularism—that is, a rejection of religion and religious considerations. Individual nations (in contrast to feudal states or holy empires) had arisen throughout Europe. Social and economic progress was disrupted by two events, however. The Plague (1348–50) killed half the population of Europe. The Hundred Years' War (1338–1453) was the other disruptive event. During this time, secular arts gained prominence, respectability, and significance. These changes were, of course, gradual, and they reflected a shifting emphasis rather than a reversal of values.

The terms "ebb and flow" and "shifting and sliding" quite adequately describe the manner in which the arts have crossed the centuries. Until this point in our examination, the lack of records has made this difficult to see. From the 12th century onward, we understand most of the arts fairly well. We can at least tell whether characteristics of style may or may not adhere to all forms in all places in the same time. A major style may refer to a rather broad chronological period even though that style may have come and gone in some places or may never have arrived at all in some places or in some art forms.

FOCUS

TERMS TO DEFINE

Abbey of Cluny	Chivalry	Aristotelianism
Humanism	Middle class	Secularism
Mysticism		

PEOPLE TO KNOW

St Thomas Aquinas	Peter the Hermit
Abelard	St Bernard of Clairvaux
Eleanor of Aquitaine	

DATES TO REMEMBER

The First, Second, and Third Crusades

THE ARTS
OF THE LATE MIDDLE AGES

TWO-DIMENSIONAL ART
Gothic style

In the 12th to the 15th centuries, traditional fresco painting returned to prominence. Manuscript illumination also continued. Two-dimensional art flowed from one style into another without any clearly dominant identity emerging. Because this period is so closely identified with Gothic architecture, and because painting found its primary outlet within the Gothic cathedral, however, we need to ask what qualities identify a Gothic style in painting. The answer is not as readily apparent as it is in architecture and sculpture, but several characteristics can be identified. One is the beginnings of three-dimensionality in figure representation. Another is a striving to give figures mobility and life within three-dimensional space. Space is the essence of Gothic style. Gothic painters and illuminators had not mastered perspective, and their compositions do not exhibit the spatial rationality of later works. But if we compare these painters with their predecessors of the earlier Medieval eras, we discover that they have more or less broken free from the frozen two-dimensionality of earlier styles. Gothic style also exhibits spirituality, lyricism, and a new humanism. In other words, it favors mercy over irrevocable judgment. Gothic style is less crowded and frantic —its figures are less entangled with each other. It was a changing style with many variations.

The Gothic style of two-dimensional art found magnificent expression in manuscript illumination. The Court Style of France and England is represented by some truly exquisite works. In the French style, figures are gracefully elongated and delicate. Set against gold backgrounds, the compositions are carefully balanced and, while somewhat crowded, show a relaxed comfort in their spatial relationships. Precision and control characterize the technique. Colors are rich. Human figures and architectural details are blended in the same manner that church sculpture both decorated and became a part of its architectural environment.

The artists who made these works were professionals living in Paris. They were influenced by Italian style, and they clearly had a new interest in pictorial space, which begins to distinguish them from their Medieval predecessors. This Parisian style, in turn, influenced English manuscript illumination. But the English painters frequently altered their French models, giving them "more angular treatment of the folds and exaggerated poses and even expressions."[3]

In the later years of the Gothic period, Italian manuscript illuminators experimented with three-dimensional space. The work of Jean Pucelle, the Parisian illuminator, graphically demonstrates this change in his *Book of Hours of Queen Jeanne d'Evreux* (Fig. **9.3**). Here, the Virgin is rendered in a deep space with remarkably accurate linear perspective.

9.3 Jean Pucelle, *The Annunciation*, from the Hours of Jeanne d'Evreux, 1325–28. Grisaille and color on vellum. $3\frac{1}{2} \times 2\frac{7}{16}$ ins (8.9 × 6.2 cm). The Metropolitan Museum of Art, New York (The Cloisters Collection, 1954).

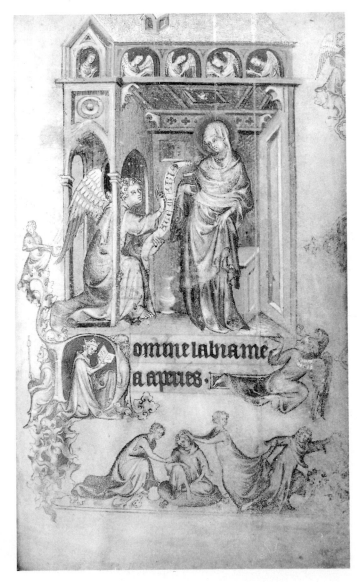

The Gothic style in painting spread throughout continental Europe, but the center of activity and the area of greatest influence was Italy. The new sense of space, three-dimensionality, and mobility are clear in Giotto's masterpiece *Lamentation* (Fig. 9.4). The figures are skillfully grouped in a simple and coherent scene. Giotto's fabrics retain a decorative quality from an earlier time, but they also show an increased realism. Figures are crowded, but they still seem free to move within the space. For all its emotion and intensity, the fresco remains human, individualized, and controlled. What makes Giotto's fresco so compelling is his unique mastery of three-dimensional space. He employs atmospheric perspective for the background, but unlike other painters who created deep space behind the primary focal plane, Giotto brings the horizon to our eye-level. As a result, we can move into a three-dimensional scene that also moves out to us.

Cimabue's *Madonna Enthroned* (Fig. 9.5), on the other hand, embodies Gothic, upward-striving monumentality. Its hierarchical design places the Virgin Mary at the very top center, surrounded by angels, with the Christ child supported on her lap. Below her elaborate throne, four half-length prophets display their scrolls. The verticality of the composition is reinforced by the rows of inlaid wood in the throne and by the ranks of angels rising, one behind the other, on each side. The figures in the top rank bend inward to reinforce the painting's exterior form and the focus on the Virgin's face. The delicate folds of the blue mantle and dark red robe, which are highlighted with

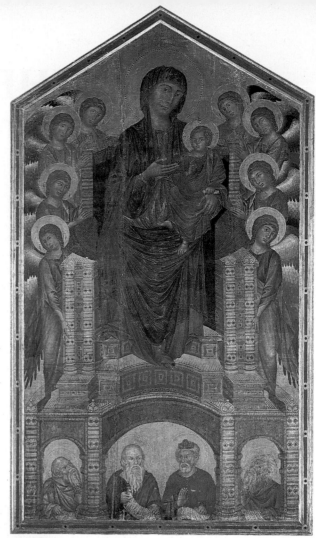

9.5 Cimabue, *Madonna Enthroned*, c.1280–90. Tempera on wood, c.12 ft 7½ ins × 7 ft 4 ins (3.84 × 2.24 m). Uffizi Gallery, Florence, Italy.

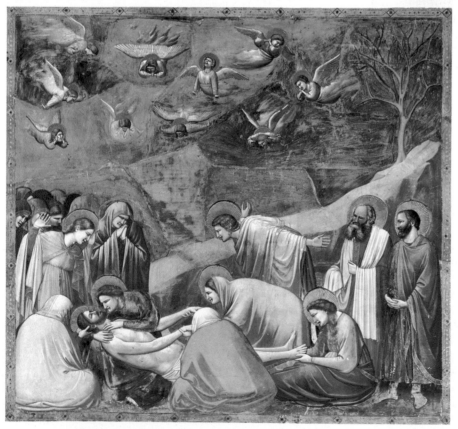

9.4 Giotto, *The Lamentation*, 1305–06. Fresco. Arena Chapel, Padua, Italy.

gold, encircle the upper torso, drawing attention in to the Madonna's face and to the child. In a convention appropriate to the theology of the time, the Christ child is depicted as a wise and omniscient presence, with a patriarchal face beyond his infant years. The clean precision of the execution gives the work a delicacy and lightness reflective of the traceries in stone that characterize Gothic architecture.

By the turn of the 15th century, Italian and northern European Gothic had merged into an International Gothic style. The term is applied to elegant courtly art with delicate coloring and beautiful clarity of definition.

SCULPTURE
Gothic style

Gothic sculpture again reveals the changes in attitude of the period. It portrays serenity, idealism, and simple naturalism. Gothic sculpture, like painting, has a human quality. Life now seems to be more valuable. The vale of tears, death, and damnation are replaced by conceptions

9.6 Chartres Cathedral, France, jamb statues, c.1145–70.

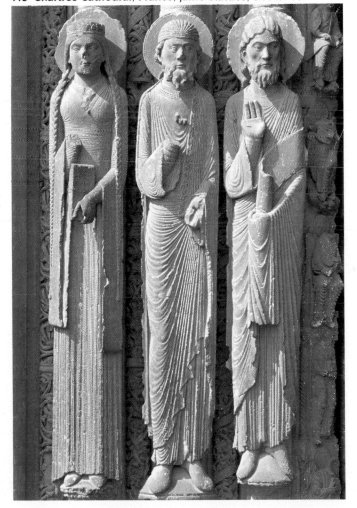

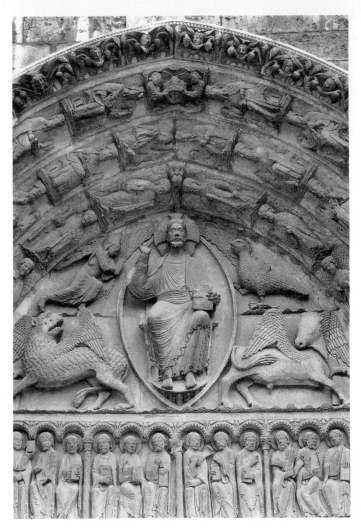

9.7 Chartres Cathedral, central tympanum, c.1145–70.

of Christ as a benevolent teacher and of God as awesome in his beauty rather than in his vengeance. There is a new order, symmetry, and clarity. Visual images carry over a distance with greater distinctness. Sculpted figures stand away from their backgrounds (Fig. **9.6**).

Schools of sculpture developed throughout France. Thus, although individual stone carvers worked alone, their links with a particular school gave their works the character of that school. The work from Rheims, for example, had an almost classical quality; that from Paris was dogmatic and intellectual, perhaps reflecting the role of Paris as a university city. As time went on, sculpture became more naturalistic. Spiritual meaning was sacrificed to everyday appeal, and sculpture increasingly reflected secular interests, both middle-class and aristocratic. A comparison of the figure of Christ in the central tympanum at Chartres (Fig. **9.7**) with that in the Vézelay tympanum illustrates this point. At Chartres, Christ has a calm solemnity, in contrast to the emotion-charged, elongated, twisting figure at Vézelay.

Compositional unity also changed over time. Early Gothic architectural sculpture was subordinate to the overall design of the building. As later work gained in emotionalism, it began to claim attention on its own.

The content of Gothic sculpture is also noteworthy. Like most Church art, it was didactic, or designed to teach. Many of its lessons are straightforward. Above the main doorway of Chartres Cathedral, for example, Christ appears as a ruler and judge of the universe, along with a host of symbols of the apostles and others (Fig. **9.7**). Also decorating the portals are the prophets and kings of the Old Testament. These figures proclaim the harmony of secular and spiritual rule, and thus suggest that the kings of France are spiritual descendants of biblical rulers—a message much like that of San Vitale, built by Justinian at Ravenna.

Other lessons of Gothic cathedral sculpture are more complex and less obvious. According to some scholars, much of this art was created according to specific conventions, codes, and sacred mathematical calculations. These formulas govern positioning, grouping, numbers, and symmetry. For example, the numbers three, four, and seven (which often appear as groupings in compositions of post-Gothic periods) symbolize the Trinity, the Gospels, the sacraments, and the deadly sins (the last two both number seven). The placement of figures around Christ shows their relative importance, with the position on Christ's right being the most important. These codes and symbols, consistent with the tendency toward mysticism, and finding allegorical and hidden meanings in holy sources, became more and more complex.

The Gothic style was fairly similar in France, Germany, and Spain. In Italy, it was quite different. Italian sculpture had a classical quality, partly due to the influence of the German Emperor Frederick II, who ruled southern Italy and Sicily. The works of one of the major Italian sculptors of the period, Nicola Pisano, have both Roman and

Medieval qualities in their crowded use of space (Fig. **9.8**).

By the turn of the 15th century, the international style noted in painting dominated virtually all European Gothic art, including the Italian. Like the figures brought forward from deep space in Gothic painting, figures in sculpture were brought even further forward, not by detaching them from their background, but by treating the background as an empty space.

LITERATURE
Dante and other vernacular poets

The greatest poet of the age was Dante (1265–1321). Dante wrote a few lyric poems and the story of his passion for his unattainable love, Beatrice, in *La Vita Nuova*. But the *Divine Comedy* was the major work of his life. It is a description of heaven, hell, and purgatory. It is a vision of the state of souls after death told in an allegory, demonstrating the human need for spiritual illumination and guidance. Part of Dante's significance lies in the fact that he elevated vernacular Italian to the status of a rich and expressive language suitable for poetry. It was no longer necessary for writers to use Latin. The Italian poet Petrarch (1304–74), who created the sonnet form, wrote in both Latin and his native Tuscan dialect. Soon poets all over Europe were following Dante's lead and exploring the poetic resources of their own everyday languages.

A popular genre of literature was the Medieval chronicle. A chronicle is history told in a "romantic" way, and in the contemporary language of the country. The *Chronicles of England, France, and Spain* by Froissart (c.1333–c.1400) is an outstanding example of this genre. Froissart's work covers the history of the 14th century and the wars between England and France. It was not written as a factual account but, in the words of its author, "to encourage all valorous hearts and to show them honorable examples."

Chaucer

Geoffrey Chaucer (c.1340–1400) is the father of English poetry. His best known work, *The Canterbury Tales*, is a collection of stories set in a framing tale about a band of pilgrims on their way from London to the shrine of Thomas à Becket in Canterbury. The framework resembles that of Boccaccio's *Decameron*, with which Chaucer was familiar, but Chaucer's cultivated irony and robust comedy are unprecedented. Each pilgrim tells a tale which is funny or serious, satirical or philosophical, but always insightful. Each tale reveals the character of the pilgrim telling it.

9.8 Nicola Pisano, T*he Crucifixion*, detail of pulpit, 1259–60. Marble, whole pulpit c.15 ft (4.6 m) high; relief 34 ins (86 cm) high. Baptistry, Pisa, Italy.

THEATRE

Probably because of their relationship to the Church, major movements in the arts in the 12th to 15th centuries were reasonably unified and widespread. Although local diversity was common, styles were generally alike. The theatre was no exception. As the Middle Ages progressed, drama associated with the Church followed the example of painting and included more and more Church-related material. Earliest Church drama, that is, the TROPE, was a simple elaboration and illustration of the Mass. The subject matter of later drama included Bible stories (mystery plays), lives of the saints (miracle plays), and didactic allegories (morality plays), which had characters such as Lust, Pride, Sloth, Gluttony, and Hatred.

Theatrical development throughout Europe (including Germany, Italy, and Spain) appears to have followed a similar route, although the dates were different. Tropes were performed in the sanctuary, using niches around the church as specific scenic locations. On special occasions, cycles of plays were performed, and the congregation moved to see different parts of the cycle. It is hard to pinpoint specific developments, even in specific churches, but clearly these dramatizations quickly became very popular.

Over the years, production standards for the same plays changed drastically. At first only priests performed the roles; later laymen were allowed to act in liturgical drama. Female roles were usually played by boys, but some evidence suggests that women did participate occasionally. The popularity of church drama soon made it impractical, if not impossible, to contain the audience within the church building. Evidence also suggests that as laymen assumed a greater role, certain vulgarities were introduced. Comedy and comic characters appeared, even in the Easter tropes. For example, on their way to Jesus' tomb, the three Marys stop to buy ointments and cloths from a merchant. This merchant developed into one of the earliest Medieval comic characters. The most popular comic character of all, of course, was the devil.

Church drama eventually moved outside the sanctuary and, like Church architecture and sculpture, opened up to the common man and woman.

As time progressed, theatrical production became more and more elaborate and realistic. Many productions were extremely complicated in detail and direction. Live birds, rabbits, and lambs gave life to the play, as did elaborate costumes that represented specific characters. Bloody executions, wounds, and severed heads and limbs were very common in later Medieval drama.

When drama moved out of the church, local guilds began to assume responsibility for various plays. Usually the topic of the specific play dictated which guild took charge of it. For example, the watermen performed the Noah play, and cooks presented The Harrowing of Hell because things—in this case, sinners—were baked, boiled, and put into and out of fires. Increasing secularization and philosophical division of the 14th-century Church and state gave rise to a separate secular theatrical tradition which led, in the 15th century, to French farce. Even religious drama came under secular professional control in France when King Charles VI granted a charter in 1402 to the Confrérie de la Passion.

A typical mystery play was the Adam of early 12th-century France. It was performed in the vernacular, and began by reminding the actors to pick up their lines, to pay attention so as not to add or subtract any syllables in the verses, and to speak distinctly. The play told the biblical story of Adam, and was probably played in the square outside the church, with the actors retiring into the church when not directly involved in the action.

A play of the 13th century, Le Jeu de Saint-Nicolas by John Bodel of Arras, illustrates the expanding subject matter of Christian drama. The play is set in the Holy Land amid the battles between the Christian crusaders and the Infidels. In the battle, all the Christians are killed except a Monsieur Prudhomme who prays to St Nicholas in the presence of the Saracen king. The king is told that St Nicholas will safeguard his treasure, and when St Nicholas actually intervenes to foil a robbery attempt, the king is converted. Similar plays dealing with the conversion of historical figures (usually amidst attempts to ridicule Christianity or vilify Christians) were very popular, as were plays about the intercessions of Mary, called "Mary-plays." The most famous play of this era is Everyman, a morality play in which the hero undertakes a journey to his death. He seeks the company of those earthly things on which he has counted: Fellowship, Kindred, Goods, for example. However, they refuse. Beauty, Strength, Discretion, and Five Wits all desert him as he approaches the grave. Good Deeds alone accompanies him.

MUSIC

Paris was the center of musical activity in the 12th and 13th centuries. Perhaps in response to the additional stability and increasing complexity of life, music now became more formal in notation and in structure, and also it increased in textural complexity. Improvization had formed the basis of musical composition. Gradually musicians felt the need to write down compositions—as opposed to making up each piece anew along certain melodic patterns every time it was performed. As a result, in the late Middle Ages "musical composition" became a specific and distinct undertaking.

Music was often transmitted from performer to performer or from teacher to student. Standardized notation now made it possible for the composer to transmit ideas directly to the performer. The role of performers thus changed, making them vehicles of transmission and interpretation in the process of musical communication.

As the structure of musical composition became more formal during this period, conventions of rhythm, harmony and mode (similar to our concept of key) were established. Polyphony began to replace monophony, although the latter continued in chants, hymns, and other forms during this time.

Ars antiqua and Ars nova

Each of these developments contributed so distinctly to music that modern scholars refer to the mid-12th and 13th centuries as *ars antiqua*, or the "old art." In the 14th century, music underwent notable change, and came to be described as *ars nova*, or "new art."

Music of *ars antiqua* was affected by the same change of attitude as two-dimensional art and sculpture—a more rational, as opposed to emotional, underlying approach and feeling. A number of forms typify 12th- and 13th-century music. Among these are *organum*, an early sacred form of music, sung in Latin. At first *organum* used two parallel melodic lines, based on a plainsong theme, moving in exactly the same rhythm, and separated by a fixed interval. Later, a third or fourth voice was added. By the 12th century, the various voices were no longer restricted to singing parallel lines. The plainsong melody remained in long notes in a low voice, as the basis of the music structure. Meanwhile the upper voices had more interesting, freely flowing lines to sing.

Alongside *organum* existed secular songs such as BALLADES and RONDEAUX. These were vernacular songs in set forms, usually easy to listen to and direct in appeal. Some were dance-like, often in triple meter. The tradition of the troubadour and the wandering entertainer continued, and the courtly approach found in music and poetry an exquisite forum for its love-centered philosophy. But the most important new form of the 13th century was the MOTET, whose name probably derives from the French word *mot*, meaning "word." As in *organum*, the motet used a plainsong melody in long held notes in a low voice, while upper parts were more elaborate. Motets were written not only for the Church, but also for secular use, with the upper voices singing non-religious words over the plainsong.

The 14th century witnessed a distinct change in musical style. Music of the *ars nova* was more diverse in its harmonies and rhythms. Passages of parallel fifths, with the bare, haunting sound characteristic of Medieval music, were used less frequently than passages of parallel thirds and sixths, which sound more harmonious to modern listeners. In this period the MADRIGAL began to emerge. It was a poetic form, with texts about love and the beauty of nature. Written initially for two or three voices, it was usually lively and polyphonic, with all the voices imitating each other.

As music, like theatre, moved out of the Church sphere, it reflected the philosophical separation of revelation and reason and the political separation of Church and state. In addition, by the turn of the 15th century, the previously distinct French and Italian Medieval musical styles were starting to merge into an international style.

Instruments

We still have much to learn about the instruments of this period. Their timbres were probably clear and shrill. But about all we can add to our description of early Medieval instruments is the observation that performing ensembles, whether vocal or instrumental, seem to have had few members. Composition was formal, but composers apparently did not indicate on a score the instrument for a given part. Tradition was so strong that composers did not need to write out directions. (Or it could be that several options would have been equally acceptable in a given situation.)

We should note in passing the invention in the 14th century of the first keyboard instruments of the harpsichord variety. These did not come into wide use until a century later, however.

DANCE

Dance was part of Medieval religious and secular activity, but with the exception of pantomime, examples of which have perished, theatre dance was less important than forms of group dancing. Fascinating illustrations survive of the "ring dance," for example, in which 12 dancers representing the apostles and the zodiac danced in a circle. Amid the ravages of the Plague, the DANSE MACABRE, or dance of death, appeared. Whipped by hysteria, people danced in a frenzy until some dropped dead of exhaustion. *Choreomania*, an English version of the *danse macabre*, seems to have expressed a kind of group psychosis in the throes of which the participants engaged in all kinds of demented behavior, including self-flagellation. Numerous folk and court dances also existed.

Within the courtly tradition, theatre dance was reborn. Dances done at court were performed to instrumental accompaniment. A certain degree of expressiveness and spontaneity marked these court dances, but increasingly they conformed to specific rules. Dance that was performed in the course of court theatricals employed professional entertainers. These performances depended to a large degree upon the guiding hand of the dancing master, who was perhaps more like a square-dance caller than a ballet master or choreographer.

Documentation of theatre dance adequate for any detailed discussion of the form, however, must wait for a later age.

ARCHITECTURE
Gothic style

Although Gothic style in architecture took many forms, it is best exemplified by the Gothic cathedral. In its synthesis of intellect, spirituality, and engineering, the cathedral perfectly expresses the Medieval mind. Gothic style was widespread in Europe. Like the other arts it was not uniform in application, nor was it uniform in date. Initially a very local style, on the Île de France in the late 12th century, it spread outward to the rest of Europe. It had died as a style in some places before it was adopted in others. The "slipping, sliding, and overlapping" pattern of artistic development fully applies to Gothic architecture.

The cathedral was, of course, a Church building whose purpose was the service of God. However, civic pride as well as spirituality inspired the cathedral builders. Local guilds contributed their services in financing or in building the churches, and guilds were often memorialized in special chapels and stained-glass windows. The Gothic church occupied the central, often elevated, area of the town or city. Its position symbolized the dominance of the universal Church over all human affairs, both spiritual and secular. Probably no other architectural style has exercised such an influence across the centuries. The story of the Gothic church is an intricate and fascinating one, only a few details of which we can highlight here.

The beginnings of Gothic architecture can be pinpointed to between 1137 and 1144, in the rebuilding of the royal Abbey Church of St Denis near Paris. There is ample evidence that Gothic style was a physical extension of philosophy, rather than a practical response to the structural limitations of the Romanesque style. That is, Gothic theory preceded its application. The philosophy of the Abbot Suger, who was advisor to Louis VI and a driving force in the construction of St Denis, held three main points. Harmony, the perfect relationship of parts, is the source of beauty; divine light is a mystic revelation of God; and space is symbolic of God's mystery. The composition of St Denis and subsequent Gothic churches clearly expressed that philosophy. As a result, Gothic architecture is more unified than Romanesque. Gothic cathedrals use refined, upward-striving lines to symbolize humanity's upward striving to escape the bounds of earth and enter the mystery of space (the kingdom of heaven).

The pointed arch is the most easily identifiable characteristic of this style. It represents not only a symbol of Gothic spirituality, but also an engineering practicality. The round arch of the previous era places tremendous pressure on its keystone, which then transfers thrust outward to the sides. But the pointed arch redistributes the thrust of downward force in more equal and controllable directions. It controls thrust by sending it downward through its legs, and it also makes flexibility of design possible. The Gothic arch also increases the sense of height in its vaults. Some have said that Gothic structure actually made increased heights possible, but this is not quite correct. Some Romanesque churches had vaults as high as those in Gothic churches. It is the possibility of changing the proportion of height to width that increases the *apparent* height of the Gothic church.

Engineering advances implicit in the new form made possible larger clerestory windows, which let in more light. And more slender ribbing placed greater emphasis on space, as opposed to mass. On the exterior, the outward thrust of the vaults is carried gracefully to the ground through a delicate network of ribs, vaults, and flying buttresses. Every detail of the decorative tracery is carefully integrated into a system that emphasizes mysterious space.

Three examples characterize Gothic style and illustrate the marvelous diversity that existed within it. The four-square power of Notre Dame de Paris (Fig. **9.9**) reflects the strength and solidity of an urban cathedral in Europe's greatest city of the age. Its careful design is highly mathematical—each level is equal to the one below it, and its three-part division is clearly symbolic of the Trinity. Arcs (whose radii are equal to the width of the

9.9 Notre Dame, Paris, west front, 1163–1250.

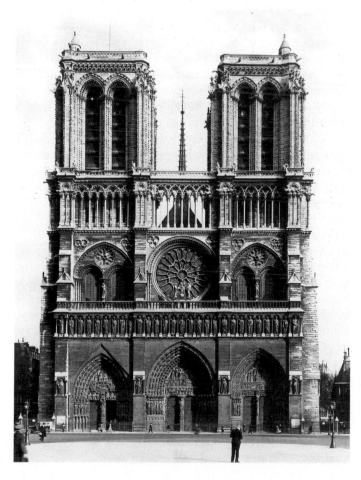

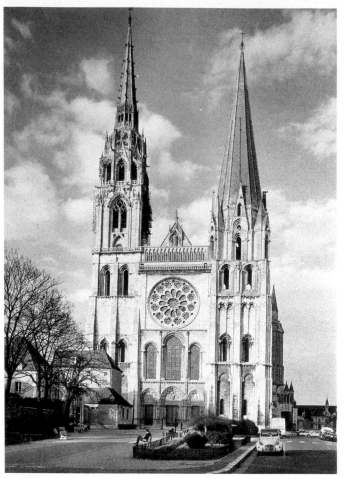

9.10 Chartres Cathedral, west front, 1145–1220.

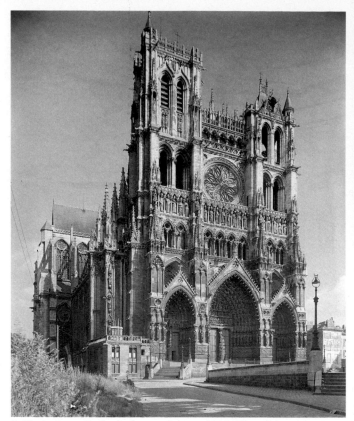

9.11 Amiens Cathedral, west front, c.1220–59.

building) drawn from the lower corners meet at the top of the circular window at the second level. The effect of this design is to draw the eye inward and slowly upward. The exterior structure clearly reveals the interior space, as it did not in Romanesque buildings.

Chartres Cathedral (Fig. **9.10**) stands in remarkable contrast. Chartres is a country cathedral that rises above the centre of a small city. Just as its sculptures illustrate a progression of style, so does its architectural design. At first glance we wonder why its cramped entry portal is so small in comparison with the rest of the building. The reason is that Chartres was not built all at once. Rather, it was built cumulatively over many years, as fire destroyed one part of the church after another. The main entry portal and the windows above it date back to its Romanesque beginnings. The porch of the south transept (with statues of the warrior saints) is much larger and more in harmony with the rest of the building.

Our biggest question, however, concerns the incongruity of the two unmatched spires. Again, fire was responsible. The early spire, on the right, illustrates faith in its simple upward lines rising, unencumbered, to disappear at the tip into the ultimate mystery of space. The later spire is more ornate and complex. The eye travels up it with increasing difficulty, its progress halted and held by decoration and detail.

The Cathedral at Amiens (Fig. **9.11**) is similar to Notre Dame. Rather than creating a sense of power, however, it has a delicate feel. Amiens Cathedral illustrates late developments in Gothic style similar to those that appear in the left spire of Chartres. In scale and proportion, however, Amiens is more like Notre Dame. The differences between Amiens and Notre Dame provide an important lesson in the ways design can be used to elicit a response. Amiens is more delicate than Notre Dame, and this feeling is enhanced by the greater detail that focuses our attention on space rather than flat stone. Both cathedrals are divided into three very obvious horizontal and vertical sections of roughly the same proportion. Notre Dame appears to rest heavily on its lowest section, the proportions of which are apparently diminished by the horizontal band of sculptures above the portals. Amiens, on the other hand, carries its portals upward to the full height of the lower section. In fact, the lines of the central portal, which is much larger than the central portal of Notre Dame, combine with the lines of the side portals to form a pyramid whose apex penetrates into the section above. The roughly similar size of the portals of Notre Dame reinforces its horizontality, and this is what gives it stability. Every use of line, form, and proportion in Amiens reinforces lightness and action. Everything about Notre Dame reinforces stability and strength. One design is no better than the other, of course. Nevertheless, both cathedrals are unquestionably Gothic, and the qualities that make them so are easy to identify.

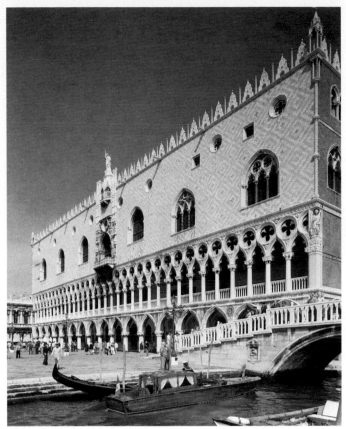

9.12 The Doges' Palace, Venice, Italy, c.1345–1438.

Secular Gothic

A unique version of the Gothic style in architecture developed in Venice in the 14th century, specifically for the palaces of the rich and powerful merchant class. One of the most delightful examples is the Doges' Palace (Fig. 9.12). Begun in the 1340s, it was designed to serve the function of a large meeting hall for the *Maggior Consiglio*, the elective assembly of the Republic of Venice. Remarkable for this time is the sense of openness and tranquility the building exhibits. The absence of fortress features and function reflects the relative peace that the republic enjoyed at the time. The solidity of the upper storeys above the open colonnades gives the building an almost top-heavy appearance; the rather squat proportions of the lower arcade detract from the delicacy of the overall design. The treatment of the Gothic arch and style is mixed with an eastern influence in the patterning of the brickwork. The result illustrates a particularly Venetian inventiveness, which one can often find in the city, as European and Moorish influences intermix.

> This concise version of Chapter 9 has been included here to provide a link with the earlier periods covered in Volume One. For the full discussion of the late Middle Ages, please refer to Volume One or to the one-volume edition of *Creative Impulse*.

SUGGESTIONS FOR THOUGHT AND DISCUSSION

The struggle for supremacy between popes and monarchs in the late Middle Ages reflected the increasing division between things secular and things spiritual. The struggle became more intense as an increasingly international Church clashed with growing nationalistic claims. Yet a sense of stability and order was also emerging, and a drastic change in attitude occurred with the transition from the values of feudalism to the code of chivalry. The rise of the middle class became a balancing weight between the aristocracy and clergy on the one hand and the serf on the other.

Space and light replaced the cloistered darkness of the early Middle Ages. An age of greater tolerance and rationalism was fueled by the ideas of Bernard of Clairvaux, Abelard, and Thomas Aquinas. Revelation and reason were seen as alternative ways of knowing, and the search for a synthesis of Platonic and Aristotelian thought with Christian theology dominated intellectual activity.

Mysticism, spirituality, and allegory existed alongside rationality, space, and relaxation in the arts and in late Medieval life in general. Sacred numbers dominated design. A new attempt to comprehend the infinite and to bring humanity together with deity in a comfortable relationship found expression in intellectual life, in the visual and performing art, and, above all, in the Gothic cathedral—the great symbol of Medieval intellect, engineering, and spirituality.

■ What is the difference between cognitive truth and revealed truth?

■ What inter-relationships can you find among the arts, chivalry, and the teachings of Bernard of Clairvaux?

■ How do these concepts differ from the concepts and their artistic reflections of the early Middle Ages?

■ How does Thomas Aquinas further develop Augustine's neo-Platonic ideas? How do these contrast with Aristotelian ideas?

■ How do the new concepts of space and light illustrate the attitudes and arts of the late Middle Ages?

■ How did Gothic sculpture further both Church and secular aims?

■ How does Gothic architecture reflect the theology and philosophy of the times?

CHAPTER TEN
THE RENAISSANCE

The Renaissance was explicitly seen by its leading figures as a rebirth of our understanding of ourselves as social and creative beings. "Out of the sick Gothic night our eyes are opened to the glorious touch of the sun," was how Rabelais expressed what most of his educated contemporaries felt. At the center of Renaissance concerns were the visual arts, and these new ways of looking at the world soon spread to the performing arts as well. Florence, the crucible of the Renaissance in Italy, was called the "New Athens." Here is where the fine arts, or "liberal arts," were first redefined as art, in contrast to their lowlier status as crafts in the Middle Ages. Now, accepted among the intellectual disciplines, the arts became an essential part of learning and literary culture. Artists, architects, composers, and writers gained confidence from their new status and from the technical mastery they were achieving. For the first time, it seemed possible not merely to imitate the works of the classical world, but to surpass them.

10.1 Andrea Mantegna, detail of the ceiling of the Camera degli Sposi, 1474. Fresco. Ducal Palace, Mantua, Italy.

CONTEXTS AND CONCEPTS

The word "Renaissance" has many meanings. Its most literal translation is "rebirth," but, in any given epoch, a rebirth of what? Does "Renaissance," like "Gothic," imply one artistic style, or can it include many similar styles? Is it an historical term or a philosophical one? Is it merely a natural extension of forces from the previous period?

Definitions of the Renaissance have been debated for centuries. Certainly the term describes a new sense of self and self-awareness achieved by western European people who had come to see themselves as no longer part of the Middle Ages. But where and how the Renaissance began, and what specifically it was, are as difficult to answer as the question of where and how it ended—if it ended at all.

The period of the Renaissance encompasses roughly 200 years, from approximately 1400 to about 1600. Within these boundaries are vestiges of eras past—for example, the Gothic era, which ended in some places before it began in others—and a renewed interest in classical antiquity. But we also find new explorations and scientific discovery, dramatic changes in religion and philosophy, innovation in politics and economics, and revolutionary developments in artistic styles. Some of these styles we can call "Renaissance" and "High Renaissance," and here the term has a much more specific meaning than it has, say, in the title of this chapter. Other artistic ventures within this historical period have other names: Mannerism, for example. Some of these labels are traditional, some are debatable, and some refer simply to peculiarities of a style. Whatever the circumstances, "the Renaissance," as an historical or philosophical concept, very broadly describes an age in which enlightenment brought humanity to the threshold of a world view increasingly similar to our own.

The Renaissance was an age of conflict and inquisitiveness, vitality, and change. It is often compared with the 20th century, and the two ages do share at least one thing in common: then, as now, people saw themselves in a particularly favorable light in comparison with those who preceded them in history. But the Renaissance is an accomplished historical fact, whereas we cannot define our own age while we are still living in it. We cannot even state when the modern era began.

HUMANISM

The roots of humanism can be traced back to the slowly developing separation of organized religion and the state in the Gothic world of the 14th century. Its specific origins can be found in Petrarch's writings of around 1341 in Italy. From there it spread throughout the western world. Humanism as a philosophy is not, as some have ventured, a denial of God or faith. Rather, it is an attempt to discover humankind's own earthly fulfillment. The biblical idea "O Adam, you may have whatever you shall desire," expressed it perfectly. The Medieval view of life as a vale of tears, with no purpose other than preparing for salvation and the afterlife, gave way to the liberating ideal of people playing important roles in *this* world.

Concern for diversity and individuality did emerge in the late Middle Ages. Expanding horizons in Medieval Europe and the increasing complexity of life provoked new debate about human responsibility for a stable moral order and for the management of events. Such discussion yielded a philosophy consistent with Christian principles, which focused on the dignity and intrinsic value of the individual. Human beings are both good and ultimately perfectible. They are capable of finding worldly fulfillment and intellectual satisfaction. Humanism developed an increasing distaste for dogma, and embraced a figurative interpretation of the scriptures and an attitude of tolerance toward all viewpoints.

THE RENAISSANCE VIEWPOINT

In the Renaissance, as in other times, attitudes and events are interrelated in very complex ways. If certain aspects of society—politics, religion, and the arts—are treated separately here, it does not mean that they were isolated from each other.

The revived interest in antiquity normally associated with the Renaissance was not its first revival. Charlemagne had already rekindled an interest in antiquity. As we noted earlier, the German nun, Hrosvitha, had access to Terence and used his works as models for her plays, for example. Scholars had studied Aristotle in the late Middle Ages. The 15th-century interest in classical antiquity was more intense and more widespread than before, however. Renaissance men and women found kindred spirits in the Greeks and Romans. They were, after all, interested in things of this world. The Roman emphasis on civic responsibility and intellectual competence helped revivify the social order. A desire grew to reinterpret the ancient writings, which many believed had been corrupted in the service of Church dogma.

Aristotle's work held out an appealing balance of

active living and sober reflection, and the Periclean Greeks offered an idealized model of humankind that could, for example, be expressed in painting and sculpture. These ideals of nobility, intellect, and physical perfection led to new conceptions of what constituted beauty. As scholars pursued an understanding of classical art and architecture, they became enamored of measuring things. "True proportions" were revealed when the Roman architect Vitruvius' treatise *De Architectura* was rediscovered, in 1414. Scientific curiosity and concern for detail led to a fascination with anatomy. Scientific investigation led to a new system of mechanical perspective. All this measuring and codifying spawned a set of rules of proportion and balance. In the arts, unity, form, and perfect proportion were codified as a set of laws (to which Michelangelo, as we shall see shortly, objected strongly).

CAPITALISM

In all facets of society, the Renaissance placed new emphasis on the individual and on individual achievement. The rising middle classes, with their new-found wealth and power, were not long in discovering that, salvation or not, life was a great deal more worth living if one had a good house, good clothes, good food, and reasonable control over one's own existence. Such comfort seemed to stem directly from material wealth. Thus,

amid all other aspects of Renaissance life and perfectly in tune with them, there developed a new economic system of capitalism, or mercantilism. To a large degree, capitalism pursued wealth and power as its goals. In its broadest and perhaps lowest form, it is a corporate endeavor with goals that can never be satisfied. The corporation is not an individual, but an extension of one, and therefore it is not constrained by individual needs or limitations on the consumption of wealth.

Capitalism was only starting during the Renaissance, and it did not develop fully. It was, however, based on the tenets of pursuing wealth and power as ends in themselves. In contrast to Medieval feudalism, capitalism offered a person reasonable freedom to pursue a better material standard of living to the extent of one's wits and abilities. Capitalism challenged Renaissance men and women to pursue their own individual goals. As a result, there was an explosion of economic activity in the trading of goods and services previously unavailable or previously unheard of.

Capitalism depends on the creation of markets as well as the supply of goods, in contrast with the guild system, which produced only what was necessary. Therefore, it encouraged an increasing diversification of occupations and social positions. It flourished best in urban settings, and home and the workplace now became separate. Expansion of trade, capitalism, and commerce in the 14th and 15th centuries brought high prosperity to

10.2 Renaissance Europe.

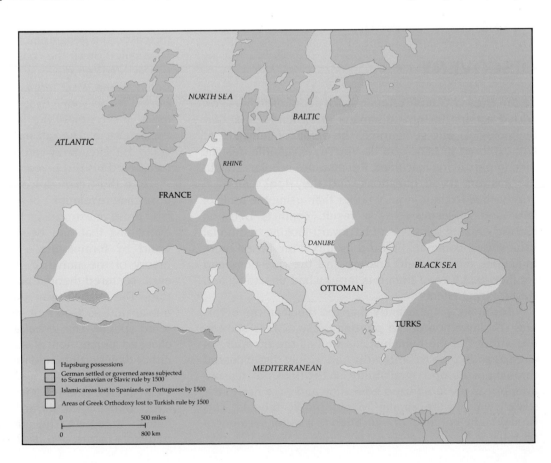

Hapsburg possessions
German settled or governed areas subjected to Scandinavian or Slavic rule by 1500
Islamic areas lost to Spaniards or Portuguese by 1500
Areas of Greek Orthodoxy lost to Turkish rule by 1500

0 500 miles
0 800 km

	GENERAL EVENTS	LITERATURE & PHILOSOPHY	VISUAL ART	THEATRE & DANCE	MUSIC	ARCHITECTURE
1300		Petrarch Boccaccio				
1400 *Early Renaissance*	Vitruvius' *De Architectura* rediscovered Invention of the printing press Lorenzo de' Medici Diaz Ferdinand and Isabella of Spain	Pico della Mirandola	Ghiberti (10.23–24) Masaccio (10.9) Donatello (10.21–22) Van Eyck (10.5) Van der Weyden (10.6) Fra Angelico Fra Filippo Lippi Mantegna (10.10) Botticelli (10.8) Dürer (10.7)	Sotties *Confrérie de la Passion* Mummeries *Maître Pierre Pathélin* Guglielmo Ebreo	Dufay Isaac Josquin des Prez	Brunelleschi (10.33–34) Alberti (10.35)
1495 *High Renaissance* **1527**	Luther	Castiglione Erasmus Thomas More Rabelais Ariosto Machiavelli	Leonardo da Vinci (10.11–14) Michelangelo (10.15–17) Raphael (10.18–19) Titian			Bramante (10.36) Michelangelo (10.41) Raphael (10.46)
1550 *Late Renaissance*	The Reformation begins Henry VIII of England Sack of Rome by Spain Copernicus Inquisition		Bronzino (10.20)	*Commedia dell'arte* Sebastiano Serlio	Johann Walter	Lescot (10.37) Palladio (10.38)
1600	Counter-Reformation Elizabeth I of England	Sir Philip Sidney Edmund Spenser		Teatro Olimpico Shakespeare Marlowe Ben Jonson		

10.3 Timeline of the Renaissance.

four locations in western Europe in particular—northern Italy; southern Germany; the "Low Countries" that are now Belgium, Holland, and Flanders; and England.

DISCOVERY

To the already complex Renaissance social order was now added a thirst for new discovery of all kinds, scientific, technological, and geographic. The dream of human flight was explored in Leonardo da Vinci's remarkable designs for complex flying machines. Renaissance scholars sought the answers to all questions, and they took empirical approaches to their inquiry rather than using the tools of faith and philosophy. As a result, conflicts between forward-looking science and backward-looking traditional values were common. Spirited inquiry often raised more questions than it could answer, and the questions and conflicts that flowed from this inquiry had unsettling and destabilizing effects.

Technology significantly changed the character of this era. The invention of the printing press in 1445 allowed the writings of the humanists as well as the literature of Greece and Rome to be rapidly and widely disseminated throughout Europe. Availability of textbooks at reasonable prices revolutionized education and gave rise to the *scholas*, which were similar to our public schools. This brought a higher level of education to a wider segment of society.

Technology, science, curiosity, and increased individual self-confidence took humankind to the furthest reaches of the globe. Renaissance explorers vastly increased the geographical knowledge of the age. In 1486, Diaz sailed down the coast of Africa, ending the isolation of the Mediterranean world. Six years later, Columbus sailed to the West Indies. In 1499, Vasco da Gama completed a two-year voyage around the horn of Africa to India. At the turn of the 16th century Balboa reached the Pacific Ocean. The full impact of the fact that the globe could be circumnavigated hit in 1522, when Magellan completed his three-year voyage around the world.

Into the Renaissance universe burst the even more unsettling revelations of scientific discovery, and particularly those of astronomy. In 1530, Copernicus transformed everything that had been known or thought about the world by formulating a heliocentric, or sun-centered, theory of the universe. This directly contradicted the earth-centered theory that had been universally believed true. The insight was devastating to those who saw humankind as God's ultimate creation in an earth-centered sphere. The visual arts, especially, reacted to this changed perception of a universe existing in limitless, rather than in contained and controlled, space.

There was also a new and critical approach to the basic questions of life. Montaigne in his *Essays* states that every person "carries in himself the entire form of the human state," and he emphasizes doubt and the contradictory nature of truth. Niccolò Machiavelli's *The Prince*,

written early in the 16th century, extols the virtues of double standards, of doing whatever works, and of taking advantage of people's fundamental wickedness.

POLITICAL DEVELOPMENTS

Political changes in Europe profoundly influenced all the circumstances of life at this time. In the late Gothic period, the Church's hold over social life had begun to loosen. People were willing to render unto God that which they considered his, but they also wished to render something unto Caesar. The notion of national identity took hold, although identities varied greatly. The feudal system stayed alive in Germany, while in Flanders we find an early form of democracy. France, England, and Spain moved toward strong monarchies, for example, that of Ferdinand and Isabella of Spain (1474–1516).

In Italy, which is mountainous, independent city–states had retained their autonomy and port cities had continued to grow, even during the Middle Ages. Great rivalries, intrigue, and warfare prevailed, but the expanding commerce of the early Renaissance reinforced the dominance of these cities. Capitalism brought individual families to great wealth and power in most of the Italian port cities. The most important in terms of the arts was the Medici family under Lorenzo (the Magnificent) de' Medici (1449–92).

The arts in Italy suffered shifting fortunes during the last years of the 15th century. Florence had dominated Italian Renaissance culture during that century. But by 1498, the tyrannical Medicis had been expelled, and the reformer Savonarola had been burned at the stake. Briefly thereafter the papacy again became a central force, a champion of Italian nationalism, and a great patron of the arts. Artists from many locations moved to Rome where schools of artists were established. Artistic production proliferated and spread throughout Europe. The High Renaissance was at hand.

In Paris on 15 February 1515, upon the death of King Louis XII, Francis I assumed the French throne. Full of youthful vigor, he and his army set out to conquer Milan. Bolstered by the papacy, supported by Swiss mercenaries, and relieved by Venetian armies, however, Milan did not fall so easily. By 14 September 1515, Francis had nevertheless defeated the most renowned armies of Europe. A frightened Pope Leo X made peace and granted Francis the right to nominate bishops, thereby strengthening the French monarchy and French nationalism and further weakening papal authority.

In 1519, Emperor Maximilian died, leaving vacant the throne of the Holy Roman Empire, now a patchwork of kingdoms scattered across Europe. Three claimants sought the prize—Francis I, Charles (Carlos) I of Spain, then 19 years old, and another young monarch, Henry VIII of England. The electorate selected the Spanish ruler, who became Emperor Charles V. His succession began a bitter struggle among the three monarchs which tore at Europe for a generation. In France, meanwhile, Francis I was sympathetic to humanist ideas and the strong tradition of Renaissance art, although he became fanatically preoccupied with the Protestant revolt as a threat to his own authority. Leonardo spent his last years at the court of Francis, and later Italian artists brought changing styles of art to France.

By the mid-16th century, Italy had been invaded not only by the French, but by the Spanish as well. Rome was sacked in 1527, and that date essentially marks the close of an era in the visual arts. Under papal patronage there had been a remarkable, if brief, outpouring which we call the High Renaissance. After that, visual art, especially, turned in a different direction to express the spiritual and political turmoil of its age.

THE REFORMATION

Amidst the cacophony of the Renaissance period came perhaps the most shattering and lasting blow the Christian Church has ever experienced: the Reformation. It did not just appear out of the blue, of course. It was, in fact, the climax of centuries of sectarian agitation. In the 14th century, English cries for reform and resentment of papal authority produced an English translation of the Bible. But reform and separation are worlds apart, and we must understand that the Reformation did not begin as an attempt to start a new branch of Christianity, but as a sincere attempt to reform what were perceived as serious religious problems at that time.

The Roman Church had always been dominated by Italy, and, given the diverse and unique political climate of the Italian peninsula, the Catholic Church had responded to newly emerging Renaissance ideas with an increasing worldliness and political intrigue that was of great concern to many, especially in Germany. The selling of indulgences was widespread, and this practice of selling forgiveness was particularly repugnant to a monk named Martin Luther. In 1517, Luther summarized his contentions in his 95 *theses*, which he tacked to the chapel door at Wittenberg, Germany. The furor caused by the Church's response to Luther turned into a battle, public and royal, which eventually led to a complete split within the Roman Church and the founding of Lutheranism.

Luther's 95 *theses* identified itself as a "Disputation on the Power and Efficacy of Indulgences." The introduction gives us a good idea of their tone and intent: "Out of love and zeal for truth and the desire to bring it to light, the following theses will be publicly discussed at Wittenberg under the chairmanship of the reverend father Martin Luther, Master of Arts and Sacred Theology and regularly appointed Lecturer on these subjects at that place. He requests that those who cannot be present to debate

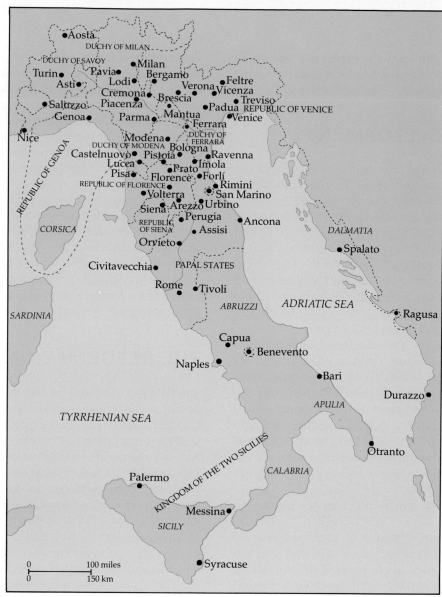

10.4 Renaissance Italy.

orally with us will do so by letter. In the name of our Lord Jesus Christ, Amen." The *theses* are a logical series of arguments for the primacy of repentance in Christian faith and how the Church deals with and should deal with that issue. Theology and canon law are scrutinized carefully. For example, in thesis 28 Luther writes, "It is certain that when money clinks in the money chest, greed and avarice can be increased." Thesis 33 says that "Men must especially be on their guard against those who say that the pope's pardons are the inestimable gift by which man is reconciled to him."

Clearly the Reformation at this stage was a political power struggle as well as a theological schism. Many people found existing Church dogma indefensible, especially in the light of widely disseminated opposing views. Popular resentment of central ecclesiastical authority was widespread, and even in areas still essentially feudal, there was enough political stability to resist domination by Rome. Later in the Reformation, further

breaks with Catholicism occurred. John Calvin's *Institutes of the Christian Religion* affected mid-16th-century Switzerland. Finally a break with Rome—political rather than religious—occurred in England under Henry VIII. It resulted in the confiscation of all Roman Church property in the Act of Dissolution. Bloody conflicts between Protestants and Catholics laid the groundwork for conditions which drove a set of emigrants to the shores of North America less than a century later.

The discord of religious rebellion became more clangorous as various Protestant groups arose, some of them more dogmatic and intolerant than Roman Catholicism. Many of them had a significant effect on the arts. Zwingli, in Zürich, modeled his church on the New Testament and decreed that music was meant to put babies to sleep, not to praise God. In 1524 he also persuaded the Zürich city council to remove all works of art from the city's churches. Some Protestant groups persecuted others, and radical groups such as the Anabaptists

suffered at the hands of Protestants and Catholics alike. In Geneva, John Calvin's revolt gave birth to a church–city and to an austere Protestant movement that quickly spread throughout Europe and eventually to North America. Geneva had just overthrown the Dukes of Savoy, but had not joined the Swiss confederation. Calvin's zealots gained political power and passed religious laws in the city council—church attendance became mandatory, and heresy was punishable by death or life imprisonment. Calvin called upon the capitalistic spirit of labor to toil unceasingly in gainful pursuits for the glory of God. Schisms and intolerance brought a frenzy of religious conviction, the break-up of commercial relationships, and wars. Protestant Reformation led to Roman Catholic Counter-Reformation. Religious wars spread, and, in 1542, the Roman Catholic Inquisition was established in an attempt literally to destroy all non-Catholic belief.

Conditions in Germany and England reflected some of the underlying economic motivations of the Reformation. Throughout Roman Catholic Europe, the huge body of clergy had amassed considerable tax-free wealth, through the sale of indulgences, among other things. Secular governments and a growing number of the citizenry chafed at this. The injury was compounded by the fact that the Church taxed the civil sector heavily.

Although no direct cause-and-effect relationship exists between the revolution in the Church and the emotional disarray in the visual arts, the coincidence of the Reformation with the end of a significant style in the visual arts and the beginnings of new styles in the performing arts makes it a useful marker.

HUMANISM AND THE REFORMATION

Humanism did much to prepare the way for the Reformation, although the two should not be identified too closely. The influence of the humanists can be seen most clearly in their techniques of studying language, gained through their interest in classical literature, and in their work on the Bible and texts by the Church fathers. Looking at early Christianity, they compared the contemporary Church unfavorably with it, noting the hair-splitting of scholars, the hierarchical structure, and the secular activities of the clergy. As a consequence, they campaigned for reform, and sought for a return to the simple good news of Jesus, for moral living, and for peace.

The Church of the day believed in a tiered system of morality, demanding higher standards from the clergy than from the rest of the populace. The Christian humanists were quick to condemn immorality among the clergy, and this helped to intensify the general dissatisfaction of European people with the Catholic Church. The humanists were aware of the gap between Christian standards and natural human inclinations, and they sought to bring the two closer together. Their ethics were based on Jesus' words in the Sermon on the Mount, supplemented by Stoic moral philosophy.

Another point of great significance to the humanists was the inwardness of religion. As a consequence, they cut down on external aspects of worship such as festivals, sacraments, music, and imagery. For example, long before Luther raised the issue, Erasmus and Melanchthon both expressed doubt about whether the sacraments of bread and wine actually turned into or just represented the body and blood of Jesus at the service of Mass. But Erasmus distanced himself from the Protestant reformers so as not to endanger the unity of the Christian Church.

Amidst the turmoil, most Christian humanists tried to reform the Church from within, rather than leading a popular revolution from outside. Humanism was primarily an intellectual movement, whose followers preferred religious contemplation to political action.

There was one major doctrinal difference between the humanists and the reformers. The humanists believed in the fundamental goodness of the human race, and ignored Augustine's teaching on original sin. They were very positive about human development based on a combination of Christianity and the classics. In contrast, Luther emphasized faith as the way to salvation from sin, and Calvin focused on predestination—God's choice of those whom he would save. Although humanism did not hold sway during this period, it was to reemerge later in a new form, basing its optimism upon the scientific achievements of the 16th and 17th centuries.[1]

FOCUS

TERMS TO DEFINE

Renaissance	Heliocentricity
Humanism	Reformation
Capitalism	

PEOPLE TO KNOW

Rabelais	Ferdinand Magellan
John Calvin	Petrarch
Martin Luther	Copernicus
Lorenzo de' Medici	Henry VIII of England

DATES TO REMEMBER
Invention of the printing press
Circumnavigation of the globe
Luther's 95 *theses*

QUESTIONS TO ANSWER
1 What constitutes the "Renaissance viewpoint"?
2 How did Humanism relate to the Reformation?

THE ARTS
OF THE RENAISSANCE

TWO-DIMENSIONAL ART
Early Renaissance

Flanders and the north

In the north of Europe lies a small area known as the Low Countries. In the 15th century, the Low Countries included Flanders. There, amid a dominant atmosphere of late Gothic architecture and sculpture, Flemish painters and musicians forged new approaches, which departed significantly from the International Gothic style, formed a link with their contemporaries in northern Italy, and influenced European painters and musicians for the next century. Many scholars believe that early 15th-century Flemish arts remained totally a part of the late Gothic style. But clearly the painters of this locale had significant contact with Italy, the heart of the Early Renaissance in art. Clearly, too, the Italians of this new Renaissance spirit admired Flemish painting.

Flemish painting of this period was revolutionary. In Gothic art, painters had attempted to create realistic sensations of deep space. For all their ingenuity, however, they essentially retained a two-dimensional feeling, and their use of perspective lacked continuity. Gothic work has a certain child-like, fairy-tale quality. Giotto attempted to show us a three-dimensional world, but we are not for a moment convinced that his depiction is realistic. Flemish painters did achieve pictorial realism, through rational perspective, and the sense of completeness and continuity found in Flemish works marked a new and clearly different style. Line, form, and color were painstakingly controlled to create subtle, varied, three-dimensional representations.

Part of the drastic change in Flemish painting stemmed from a new development in painting media—oil paint. The versatile properties of oil paints gave Flemish painters new opportunities to vary surface texture and brilliance, and to create far greater subtlety of form. Oils allowed blending of color areas because they remained wet and could be worked on the canvas for a while. Egg tempera, the earlier medium, dried almost immediately upon application.

Gradual transitions between color areas made possible by oil paints allowed 15th-century Flemish painters to use aerial perspective, that is, the increasingly hazy appearance of objects farthest from the viewer. This helped them to control this most effective indicator of deep space. Blending between color areas also helped them achieve realistic modeling, or light and shade, by which all objects assume three-dimensionality. (Without

MASTERWORK
Van Eyck—The Arnolfini Marriage

Jan van Eyck's *Arnolfini Marriage* (Fig. **10.5**) illustrates the best qualities of Flemish painting. Van Eyck used the full range of values from darkest darks to lightest lights and blended them with extreme subtlety to achieve a soft and realistic appearance. His colors are rich, varied, and predominantly warm in feeling. The only exception to the reds and red–brown derivatives is the rich green gown of the bride. He has used strong perspective in the bedroom to create a sense of great depth. All forms achieve three-dimensionality through subtle color blending and softened shadow edges. Natural highlights originate from the window, and this ties the figures and objects together.

As realistic as this painting appears, however, it is a selective portrayal of reality. It is an artist's vision of an event, a portrayal very clearly staged for pictorial purposes. The location of objects, the drape of fabric, and the nature of the figures themselves are beyond reality. Van Eyck's work achieves what much art does, that is, it gives the surface appearance of reality while revealing a deeper essence of the scene or the subject matter—in this case, man, woman, marriage, and their place within Christian society and philosophy.

The case has been made many times that this work contains an elaborate symbolism commenting on marriage and the marriage ceremony. Two people could execute a perfectly valid marriage without a priest. The painting depicts a solemn young couple taking a marriage vow in the sanctity of the bridal chamber, and the painting is thus both a portrait and a marriage certificate. The artist has signed the painting in legal script above the mirror "Johannes de Eyck fuit hic. 1434" (Jan van Eyck was here, 1434), and in fact, we can see the artist and another witness reflected in the mirror. The burning candle is part of the oath-taking ceremony and symbolizes marriage, the dog represents marital faith, and the figure on the bedhead is of St Margaret, the patron saint of childbirth. There is considerable debate about the accuracy or appropriateness of all these symbols and on whether the bride is pregnant or not. Inasmuch as clothing design and posture of the period emphasized the stomach, most experts agree she is not.

10.5 (opposite) Jan van Eyck, *The Arnolfini Marriage* (*Giovanni Arnolfini and his Bride*), 1434. Oil on panel, 33 × 22½ ins (83.8 × 57.1 cm). The National Gallery, London.

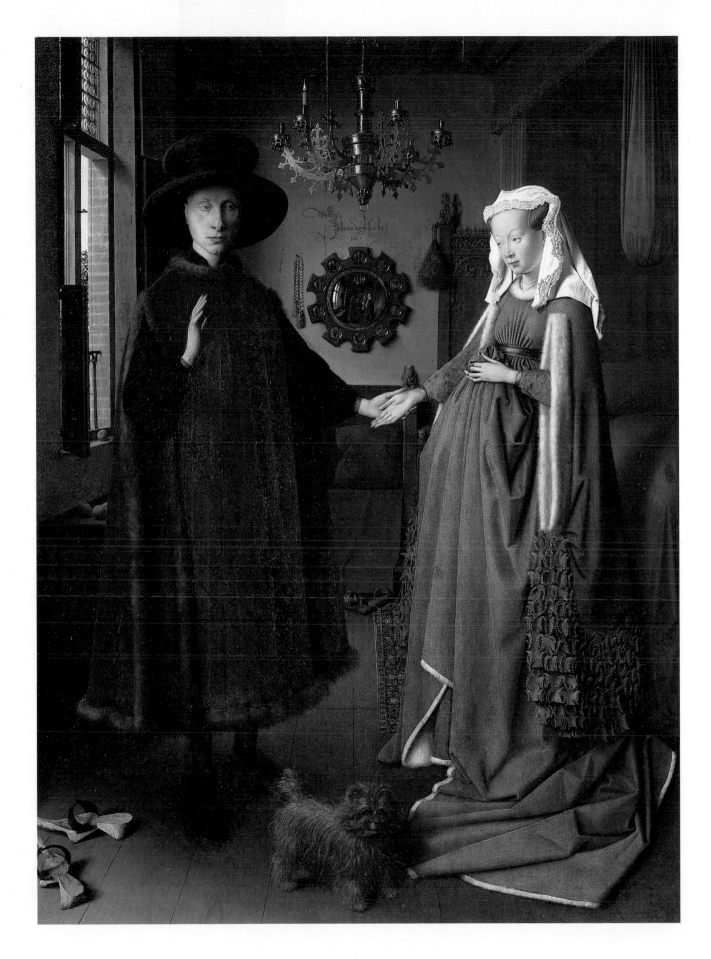

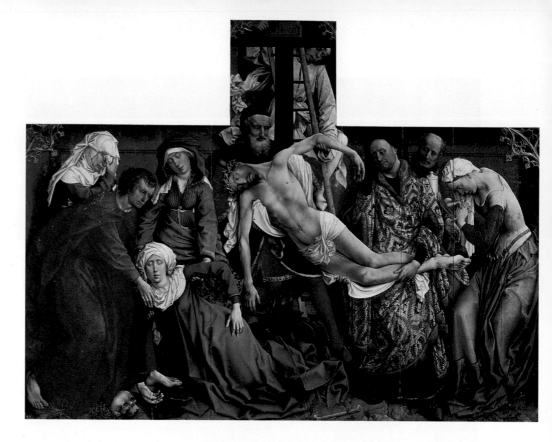

10.6 Rogier van der Weyden, *The Descent from the Cross,* c.1435. Oil on panel, 7 ft 2⅜ ins × 8 ft ⅞ ins (2.2 × 2.46 m). The Prado, Madrid.

10.7 Albrecht Dürer, *The Four Horsemen of the Apocalypse,* c.1497–98. Woodcut, 15⅖ × 11 ins (39.2 × 27.9 cm). Museum of Fine Arts, Boston (Bequest of Francis Bullard).

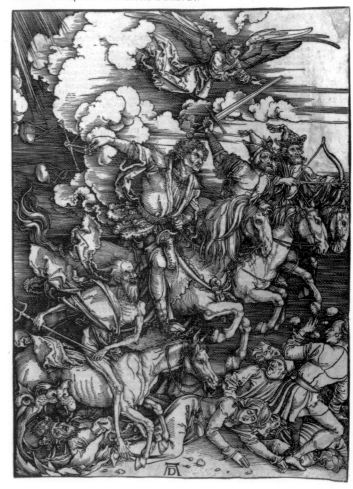

highlight and shadow, the appearance of realistic relief disappears.) Early 15th-century Flemish painters used sophisticated light and shade, not only to heighten three-dimensionality, but also to achieve perceptual unity in their compositions. Pictures without consistent light sources or without natural shadows on surrounding objects create very strange effects, even if they depict individual forms very realistically. The new skill in creating realistic three-dimensionality separated 15th-century Flemish style from the Gothic style and tied it to the Renaissance.

"The prince of painters of our age," was the way one of his contemporaries described Jan van Eyck (c.1385–1441). His work advances the new naturalism of the age. Although little is known about his life, he seems to have been an active and highly placed functionary of the Duke of Burgundy. On one of his trips in the duke's service, van Eyck visited Italy, where he met Masaccio and other Florentine artists. Without doubt, van Eyck was one of the greatest artists of any age, and he brought a new "reality" to painting.

Although slightly different in style from van Eyck's work, Rogier van der Weyden's *Descent from the Cross* (Fig. **10.6**) displays softly shaded forms and three-dimensionality. Its surface realism is quite unlike that of Gothic style. Carefully controlled line and form create soft, undulating S-curves around the borders and diagonally through the center. The painter explores the full range of the color spectrum, from reds and golds to blues and greens, and the full extent of the value scale from dark to light. Composition, balance, and unity are extremely subtle. The figures are depicted almost in the manner of

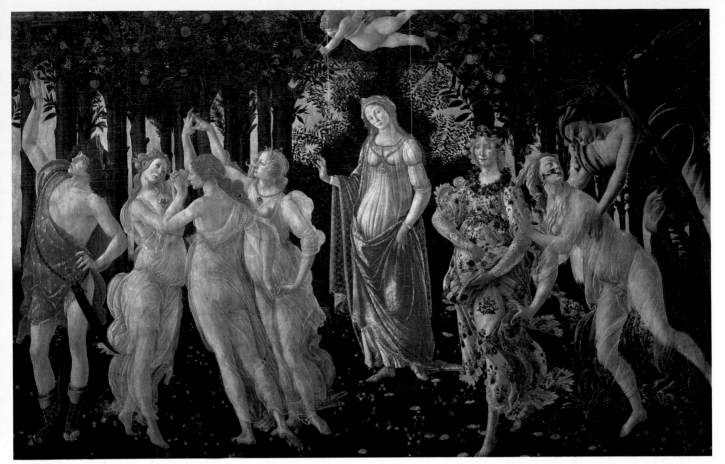

10.8 Sandro Botticelli, La Primavera (Spring), c.1478. Tempera on panel, 6 ft 8 ins × 10 ft 4 ins (2.03 × 3.15 m). Galleria degli Uffizi, Florence.

statues, yet the shallow drapery folds exhibit a nervous, broken linearity.

The striking feature in this painting, however, is its individualized presentation of human emotion. Each character displays a particularized reaction to the emotion-charged situation. These figures are not types—they are individual people so fully portrayed that we might expect to encounter them on the street.

Van der Weyden's linear style particularly influenced the masterly woodcuts and engravings of Albrecht Dürer. In contrast to the works of van der Weyden and van Eyck, Dürer's works reflect the tensions rampant throughout northern Europe at the end of the 15th and in the early 16th centuries. The emotionalism of the *Four Horsemen of the Apocalypse* (Fig. **10.7**), for example, with its Medieval fascination with superstition, famine, fear, and death, typifies German art of this period. The fourth work in a series of woodcuts, this print presents a frightening vision of doomsday and the omens that predict it, as described in the Revelation of St John, the last book of the Bible. In the foreground, Death's horse tramples a bishop. Working toward the background, Famine swings a pair of scales, War brandishes a sword, and Pestilence draws a bow. Underneath, trampled by the horses' hoofs, lies the human race. The crowding and angularity of shapes are reminiscent of Late Gothic style, and yet the foreshortening and the three-dimensionality of the figures reflect an Italian influence.

Florence

It was in Italy, and more precisely in Florence, that the Renaissance found its early spark and heart in about 1400. Florence was a wealthy river-port and commercial center, and, like Athens, it leapt into its golden age on a soaring spirit of victory as the city successfully resisted the attempts of the Duke of Milan to subjugate it. Under the patronage of the Medici family, an outpouring of art made Florence the focal point of the early Italian Renaissance.

Two general trends in Florentine painting can be identified in this period. The first, which more or less continued Medieval tendencies, was lyrical and decorative. Its adherents were the painters Fra Angelico, Fra Filippo Lippi, Benozzo Gozzoli, and Sandro Botticelli. This tradition is probably best expressed in the paintings of Botticelli. The linear quality of *La Primavera*, or *Spring* (Fig. **10.8**), suggests an artist apparently unconcerned with deep space or subtle plasticity in light and shade. Rather, forms emerge through outline. The composition moves gently across the picture through a lyrical combination of undulating, curved lines, with focal areas in each grouping. Mercury, the Three Graces, Venus, Flora, Spring, and Zephyrus—each part of this human, mythical composition carries its own emotion: contemplation, sadness, or happiness. Note the apparently non-Christian subject matter. But in fact the painting is using allegory to equate Venus with the Virgin Mary. Beyond the immediate qualities, there is a deeper symbolism, relating also

to the Medici family, the patron rulers of Florence.

Botticelli's figures are anatomically quite simple. There is little concern with detailed musculature. Although these figures are rendered three-dimensionally and shaded subtly, they seem almost weightless, floating in space without anatomical definition.

The second tradition in Florentine and other Italian painting of this period belongs much more clearly to the Renaissance. The works of Masaccio (1401–28) have a gravity and monumentality that make them larger than life-size. The use of deep perspective, plasticity, and modeling to create dramatic contrasts gives solidity to the figures and unifies the painting. Atmospheric perspective enhances the deep spatial realism. Figures

MASTERWORK
Masaccio—The Tribute Money

Masaccio's perception of the universe exploded into life in the decoration of the chapel of the Brancacci family in the Church of Sta Maria del Carmine in Florence. Late Renaissance artists such as Michelangelo came to view these frescos and to study the new art developed by Masaccio.

The most famous of these frescos is The Tribute Money (Fig. 10.9). Its setting makes full use of the new discovery of linear perspective, as the rounded figures move freely in unencumbered deep space. The Tribute Money employs continuous narration, where a series of events unfolds across a single picture. Here Masaccio depicts a New Testament story from Matthew (17:24–27). In the center, Christ instructs Peter to catch a fish, whose mouth will contain the tribute money for the tax collector. On the far left, Peter takes the coin from the fish's mouth; on the right he gives it to the tax collector. Masaccio has changed the story somewhat, so that the

tax collector appears directly before Christ and the Apostles, who are not "at home," but in a landscape of the Arno Valley. Masaccio's choice of subject matter may relate to a debate over taxation going on at the time in Florence. A contemporary interpretation of the fresco held that Christ had instructed all people, including clerics, to pay taxes to earthly rulers for the support of military defense.

The presentation of the figures in this fresco is remarkably accomplished. They are like "clothed nudes," dressed in fabric which falls like real cloth. Weight and volume are depicted in an entirely new way. Each figure stands in classical contrapposto stance, and the sense of motion is not particularly remarkable, but the accurate rendering of the feet and the anatomically correct weight distribution make these the first painted figures to seem to stand solidly on the ground. The narrative, like that on the Hildesheim Cathedral doors, comes across through pantomimic gestures and intense glances. Nonetheless, the figures do encapsulate an astonishing energy and reality. Comparing these figures

10.9 Masaccio, The Tribute Money, c.1427. Fresco (after restoration 1989), 8 ft 4 ins × 19 ft 8 ins (2.54 × 5.9 m). S. Maria del Carmine, Florence.

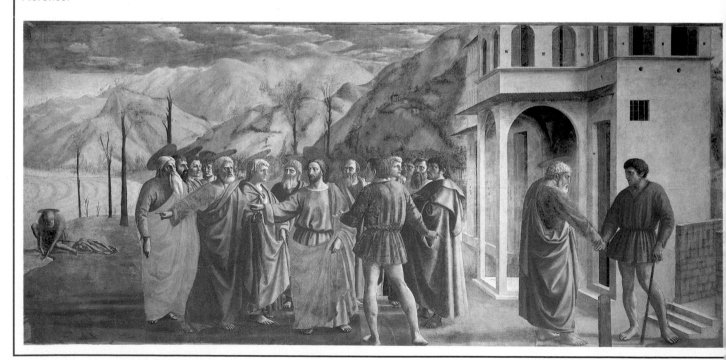

are strong, detailed, and very human. At the same time, the composition carefully subordinates the parts of the painting to the whole.

The approach to figure depiction initiated by Masaccio occurred in the early 1420s, and in a space of two years, Florence had progressed from the International Gothic style to this radically different approach.

with those of Botticelli, we see that whereas Botticelli reveals form and volume through line, Masaccio uses the play of light and shade on an object, that is, by modeling. The key to this is the artist's establishment of a source for the light, inside or outside the painting, which strikes the figures. That source might be the sun or a candle, for example, but the artist must then render the objects in the painting so that all highlights and shadows occur consistently as if caused by that single light source. In *The Tribute Money*, Masaccio does not include a light source in the fresco itself; rather, he uses a nearby window in the chapel to act as a light source, and the highlights and shadows are rendered accordingly (compare Rembrandt's *The Night Watch*, Fig. **11.10**). In addition, the figures form a circular and three-dimensional grouping rather than a flat line across the surface of the work as in the Botticelli. Even the halos of the apostles appear in the new perspective and overlap at odd angles.

Masaccio's setting is local and his figures are clothed in Italian Renaissance costume. Any expectation of historical accuracy in works of art was unknown to these artists. Until the 18th century, history was considered irrelevant to art. The apostles appear as Florentine "men in the street" with sympathetic and human features.

Compositionally, the single vanishing point, by which the linear perspective is controlled, sits at the head of Christ. We shall see this device for achieving focus again in Leonardo da Vinci's *Last Supper* (Fig. **10.12**). In addition, Masaccio has rediscovered aerial perspective, in which distance is indicated through diminution of light and blurring of outlines. We can also see Masaccio's skill in handling landscape as well as figures. There is a grandeur about this previously unknown and seldom rivaled. As one art historian describes it:

The background is filled with soft atmosphere. Misty patches of woodland are sketched near the banks. Masaccio's brush moves with an ease and freedom unexampled in Italian art since ancient Roman times. It represents not hairs but hair, not leaves but foliage, not waves but water, not physical entities but optical impressions. . . . Each stroke of Masaccio's brush, in fact, is equivalent to a separate reflection of light on the retina.[2]

10.10 Andrea Mantegna, *St James Led to Execution*, c.1455. Fresco. Ovetari Chapel, Church of the Eremitani, Padua, Italy (destroyed 1944).

Perhaps the most breathtaking example of early Italian Renaissance monumentalism is Mantegna's *St James Led to Execution* (Fig. **10.10**). Here the forces of scale, CHIAROSCURO, perspective, detail, unity, and drama are overpowering. Much of the effect of this work is created by the artist's placement of the horizon line, that is, the assumed eye level of the viewer, below the lower border of the painting. Mantegna's classical knowledge is clear from the details of the triumphal arch and the soldiers' costumes. In his handling of perspective, Mantegna deliberately sacrifices the strict accuracy of mechanical reality for dramatic effect.

The High Renaissance

As important and revolutionary as the 15th century was, both in Flanders and in Italy, the high point of the Renaissance came in the early 16th century, as papal authority was reestablished and artists were called to Rome. The importance of this period as the apex of Renaissance style has led scholars to call it the High Renaissance. Painters of the High Renaissance include the giants of western visual art: Leonardo da Vinci, Michelangelo, Raphael, Giorgione, and Titian.

We have not yet touched on a concept of particular

importance to our overview of visual art in the High Renaissance style—the concept of genius. In Italy between 1495 and 1520, everything done in the visual arts was subordinate to the overwhelming genius of two men, Leonardo da Vinci and Michelangelo Buonarroti. The great genius of these two giants has led many to argue whether the High Renaissance of visual art was a culmination of earlier Renaissance style or a new kind of art entirely.

By 1500, the courts of the Italian princes had become centers of cultural activity and important sources of patronage. Machiavelli found these centers and their leaders soft and effeminate. He accused them of deliberately living in an unreal world. The Italian courtiers, however, needed artists, writers, and musicians to pursue their ideals of beauty, whether real or unreal. The arts of the Early Renaissance now seemed vulgar and naïve. A more aristocratic, elegant, dignified, and lofty art was demanded, and this accounts, at least in part, for the new style found in the works of the playwright Ariosto, and the painters Castiglione, Raphael, and Titian, for example.

The wealth of the popes and their desire to rebuild and transform Rome on a grand scale also contributed significantly to the shift in style and the emergence of Rome as the center of High Renaissance patronage. Music came of age as a major art, finding a great patron in Pope Leo X. Ancient Roman sculptural and architectural style was revived. There were also important discoveries of ancient sculptures such as the *Apollo Belvedere* and the *Laocoön*. Because the artists of the High Renaissance had such a rich immediate inheritance of art and literature from the Early Renaissance period, and felt they had developed even further, they considered themselves to be on an equal footing with the artists of the antique period. Their approach to the antique in arts and letters was therefore different from that of their Early Renaissance predecessors.

High Renaissance painting sought a universal ideal achieved through impressive themes and styles. Tricks of perspective or stunning renditions of anatomy were no longer enough. Figures became types again, rather than individuals—god-like human beings in the Greek classical tradition. Artists and writers of the High Renaissance sought to capture the essence of classical art and literature without resorting to copying, which would have captured only the externals. They tried to emulate rather than imitate. As a result, High Renaissance art idealizes all forms and delights in composition. Its impact is one of stability without immobility, variety without confusion, and definition without dullness. High Renaissance artists carefully observed how the ancients borrowed motifs from nature. They then set out to develop a system of mathematically defined proportion and compositional beauty emanating from a harmony of parts. This faith in harmonious proportions reflected a belief among artists,

writers, and composers that the world of nature, not to mention the universe, also possessed perfect order.

This human-centered attitude also included a certain artificiality and emotionalism that reflected the conflicts of the times. High Renaissance style also departed from previous styles in its meticulous composition, that was based almost exclusively on geometric devices. Compositions were closed—that is, line, color, and form kept the viewer's eye continually redirected into the work, as opposed to leading the eye off the canvas. The organizing principle of a painting was usually a geometric shape, such as a central triangle or an oval.

Leonardo da Vinci

The work of Leonardo da Vinci (1452–1519) has an ethereal quality which he achieved by blending light and shadow, a technique called SFUMATO. His figures hover between reality and illusion as one form disappears into another, with only the highlighted portions emerging. In *The Madonna of the Rocks*, or *Virgin of the Rocks* (Fig. **10.11**), Leonardo interprets the doctrine of the immaculate conception, which proposed that Mary was freed from original sin by the immaculate conception in order to be a worthy vessel for the incarnation of Christ. Mary sits in the midst of a dark world and shines forth from it. She protects the Infant Christ, who blesses John the Baptist, to whom the angel points. The gestures and eye direction create movement around the perimeter of a single central triangle outlined in light. Leonardo takes the central triangle and gives it enough depth to make it a three-dimensional pyramid of considerable weight. Light and shade are delicately used, even though the highlights and shadows do not flow from a consistent light source. The portrayal of rocks, foliage, and cloth displays meticulous attention to detail.

It is difficult to say which of Leonardo's paintings is the most admirable, but certainly *The Last Supper* (Fig. **10.12**) ranks among the greatest. It captures the moment at which the apostles are responding with disbelief to Christ's prophecy that "one of you shall betray me." Leonardo's choice of medium proved most unfortunate because, unlike fresco, his own mixtures of oil, varnish, and pigments were not suited to the damp wall. The painting began to flake, and was reported to be perishing as early as 1517. Since then it has been clouded by retouching, defaced by a door cut through the wall at Christ's feet, and bombed during World War II. Miraculously, it survives.

In *The Last Supper*, human figures, not architecture, are the focus. Christ dominates the center of the painting. All lines, actual and implied, lead outward from his face, pause at various subordinate focal areas, reverse direction at the edges of the work, and return to the central figure. Various postures, gestures, and groupings of the disciples direct the eye from point to point. Figures emerge from the architectural background in strongly accented relief; it is surprising how much psychological

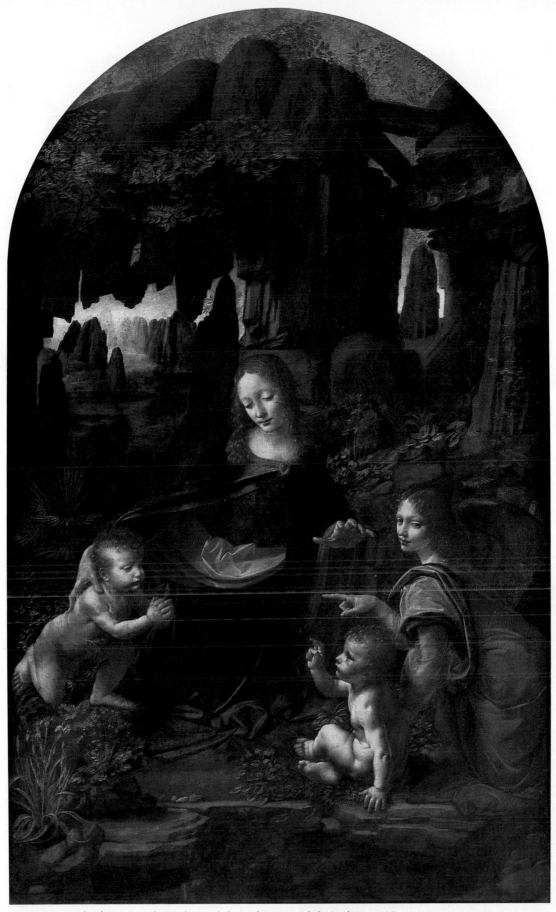

10.11 Leonardo da Vinci, *The Madonna of the Rocks* (*Virgin of the Rocks*), c.1485.
Oil on panel, 6 ft 3 ins × 3 ft 7 ins (1.91 × 1.09 m). Louvre, Paris.

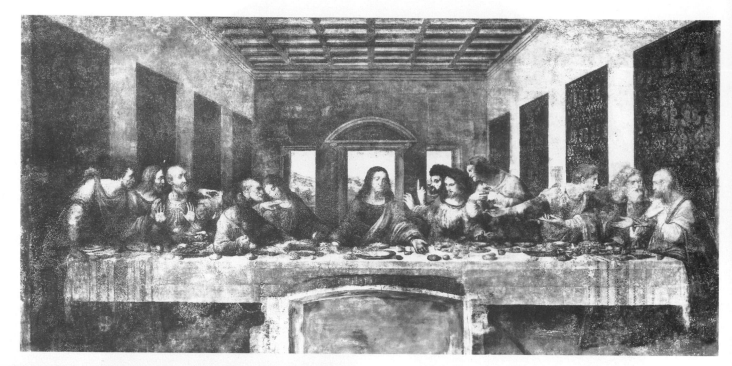

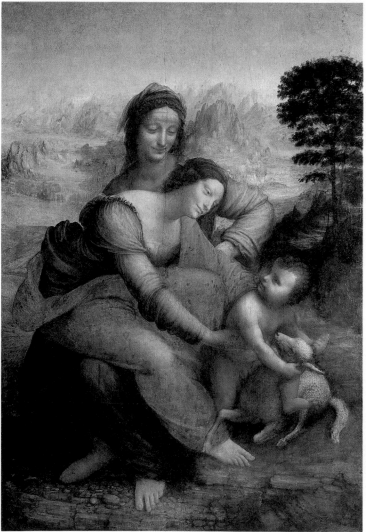

10.12 Leonardo da Vinci, *The Last Supper*, c.1495–98. Mural painting, 15 ft 1⅛ ins × 28 ft 10½ ins (4.6 × 8.56 m). S. Maria della Grazie, Milan.

10.13 (left) Leonardo da Vinci, *Virgin and Child with St Anne*, 1508–10. Panel painting, 5 ft 6⅛ ins × 4 ft 3⅛ ins (1.68 × 1.3 m). Louvre, Paris.

drama the mathematical format allows. Yet, despite the drama, the mood in this work and others is calm, belying the turbulence of Leonardo's own personality and his times.

Leonardo reverts to the pyramid as the basis of the composition in his *Virgin and Child with St Anne* (Fig. **10.13**). The Virgin Mary sits on the lap of her mother, St Anne. St Anne becomes the apex of the triangle whose right side flows downward to the Christ child, who embraces a lamb, symbolic of his sacrificial death.

The famous *Mona Lisa* (Fig. **10.14**) was painted at about the same time as the *Virgin and Child with St Anne*. We are drawn to this work not so much by the subject as by the background. As if to emphasize the serenity of the subject, and in common with the *Virgin and Child with St Anne*, the background reveals an exciting mountain setting, full of dramatic crags and peaks, winding roads which disappear, and exquisitely detailed natural forms receding into the mists. The composition is unusual in its treatment of the full torso with the hands and arms pictured, completing the unity of the gentle spiral turn. Three-quarters of the figure is pictured, not just a bust. This marked a new format in Italian portraiture and provided a model which has been followed ever since. The result is a larger, grander, and more natural portrait, in keeping with the new sense of human dignity implicit in Renaissance idealism.

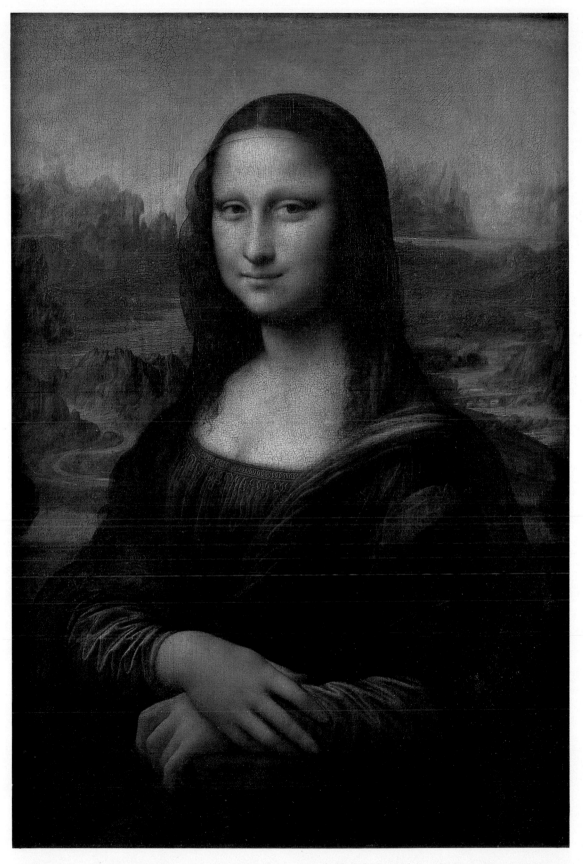

10.14 Leonardo da Vinci, *Mona Lisa*, c.1503–05. Oil on panel, 30 × 21 ins (76.2 × 53.3 cm). Louvre, Paris.

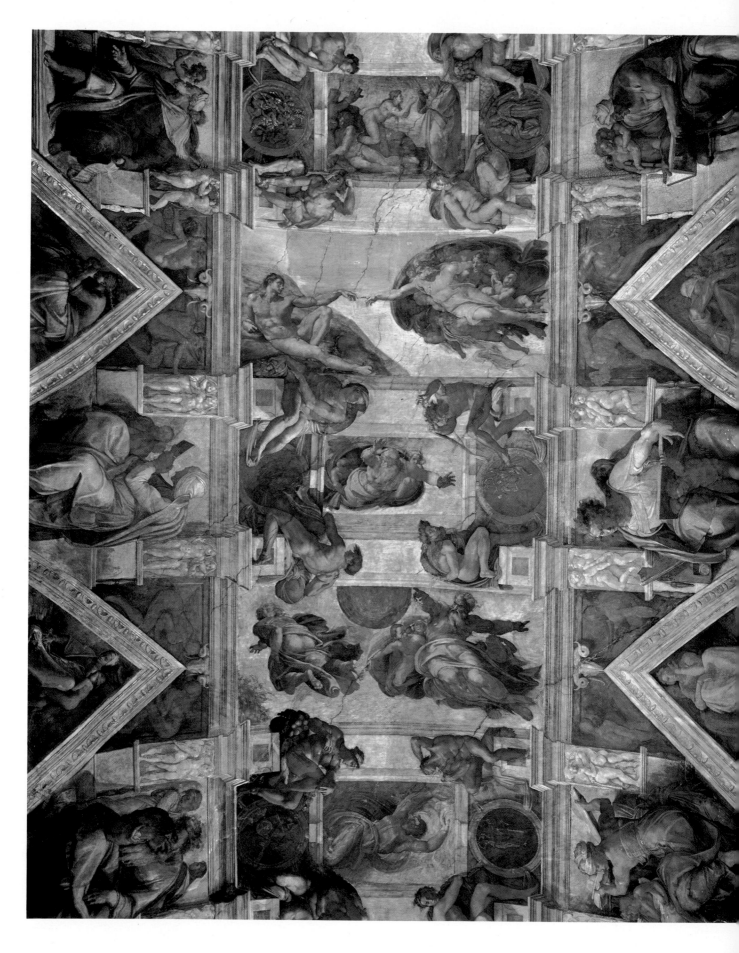

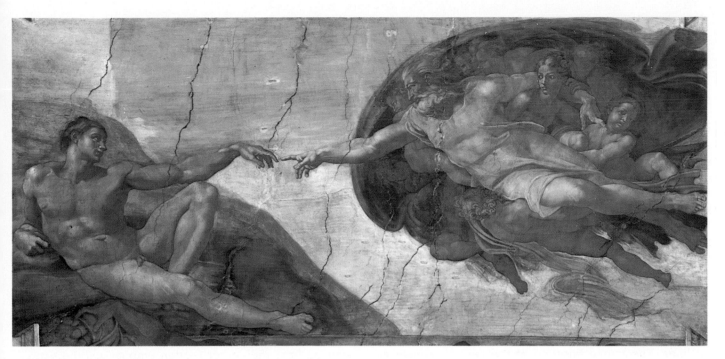

10.16 Michelangelo, *The Creation of Adam*, detail from the Sistine Chapel ceiling, 1508–12. Fresco. The Vatican, Rome.

10.15 (opposite) Michelangelo, Sistine Chapel ceiling, 1508–12. Fresco. The Vatican, Rome.

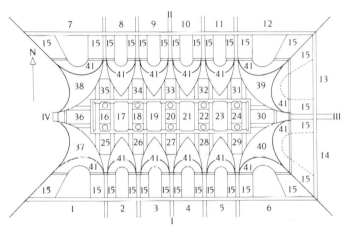

10.17 Diagram of the Sistine Chapel ceiling.

I	South wall with scenes from the life of Moses (1–6)
II	North wall with scenes from the life of Christ (7–12)
III	East wall with entrance (13–14)
IV	West wall with *Last Judgment* (1534–41)
15	Window niches with 24 portraits of the first popes
41	Lunettes above the windows with portraits of the ancestors of Christ and scenes from the Old Testament

The Frescos on the Ceiling

16	God Separates Light and Darkness	27	Cumaean Sibyl
17	God Creates the Sun and the Moon and the Plants on Earth	28	Isaiah
		29	Delphic Sibyl
18	God Separates the Water and Earth and Blesses his Work	30	Zechariah
		31	Joel
19	Creation of Adam	32	Eritrean Sibyl
20	Creation of Eve	33	Ezekiel
21	Fall of Human Race and Expulsion from Paradise	34	Persian Sibyl
		35	Jeremiah
22	Sacrifice of Noah	36	Jonah
23	The Flood	37	The Brazen Serpent
24	The Intoxication of Noah	38	The Punishment of Haman
25	Libyan Sibyl	39	David Slaying Goliath
26	Daniel	40	Judith with the Head of Holofernes

Michelangelo

Perhaps the dominant figure of the High Renaissance, however, was Michelangelo Buonarroti (1475–1564). Michelangelo was entirely different in character from Leonardo. Leonardo was a skeptic, while Michelangelo was a man of great faith. Leonardo was fascinated by science and natural objects; Michelangelo showed little interest in anything other than the human form.

Michelangelo's Sistine Chapel ceiling (Figs **10.15–10.17**) perfectly exemplifies the ambition and genius of this era. Some scholars see in this monumental work a blending of Christian tradition and a neo-Platonist view of the soul's progressive ascent through contemplation and desire. In each of the triangles along the sides of the chapel, the ancestors of Christ await the Redeemer. Between them, amidst *trompe l'oeil* architectural elements, are the sages of antiquity. In the corners, Michelangelo depicts various biblical stories, and across the center of the ceiling he unfolds the episodes of Genesis. The center of the ceiling captures the creation of Adam at the moment of fulfillment (Fig. **10.16**). The human forms display sculpturally modeled anatomical detail. God stretches outward from his angels to a reclining, but dynamic Adam, awaiting the divine infusion, the spark of the soul. The fingers do not touch, but we can anticipate the electrifying power of God's physical contact with a mortal man.

The Sistine Chapel ceiling creates a breathtaking visual panoply. It is impossible to get a comprehensive view of the entire ceiling from any point in the chapel. If we look upward and read the scenes back toward the altar, the prophets and sibyls appear on their sides. If we

view one side as upright, the other appears upside down. These opposing directions are held together by the structure of simulated architecture, whose transverse arches and diagonal bands separate the painted vault compartments. Nudes appear at the intersections and tie the composition together because they can be read either with the prophets and sibyls below them or with the Genesis scenes, at whose corners they appear. We thus see a prime example of the basic High Renaissance principle of composition unified by the interaction of component elements.

Raphael

Raphael (1483–1520) is generally regarded as the third painter in the High Renaissance triumvirate, though it has been argued that he did not reach the same level of genius and accomplishment as Leonardo and Michelangelo. In *The Alba Madonna* (Fig. **10.18**), the strong central triangle appears within the geometric parameters of a TONDO, or circular shape. The tendency of a circle to roll (visually) is counteracted by strong, parallel horizontal lines. The strong baseline of the central triangle is described by the leg of the infant John the Baptist (left),

the foot of the Christ child, the folds of the Madonna's robes, and the rock and shadow at the right. The left side of the central triangle comprises the eyes of all three figures and carries along the back of the child to the border. The right side of the triangle is created by the edge of the Madonna's robe, joining the horizontal shadow at the right border.

Within this formula Raphael depicts a comfortable, subtly modeled, and idealized Mary and Christ child. Textures are soft and warm. Raphael's treatment of skin creates an almost tactile sensation: we feel we can discern the warm blood flowing beneath it, a characteristic relatively new to two-dimensional art. Raphael's figures express lively power, and his mastery of three-dimensional form and deep space is unsurpassed.

In *The Deliverance of St Peter* (Fig. **10.19**) Raphael again accepted the challenge of a constraining space. To accommodate the intrusion of the window into the semicircular area of the wall, Raphael divided the composition into three sections representing the three phases of the miracle of St Peter's escape from prison. The intense light shining from the center section emphasizes the expressiveness of this depiction.

10.18 Raphael, *The Alba Madonna*, c.1510. Canvas (originally oil on panel), diameter 37¼ ins (94.5 cm). National Gallery of Art, Washington DC (Andrew W. Mellon Collection).

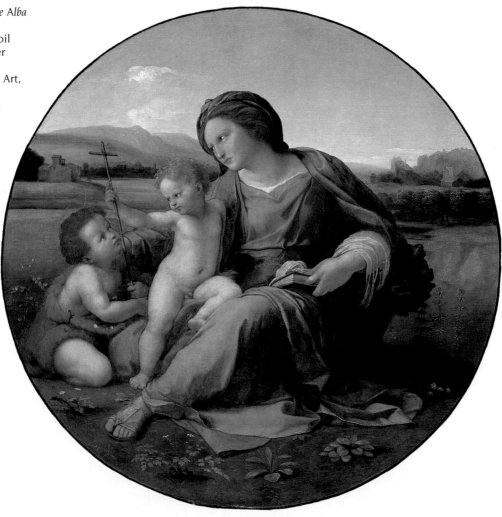

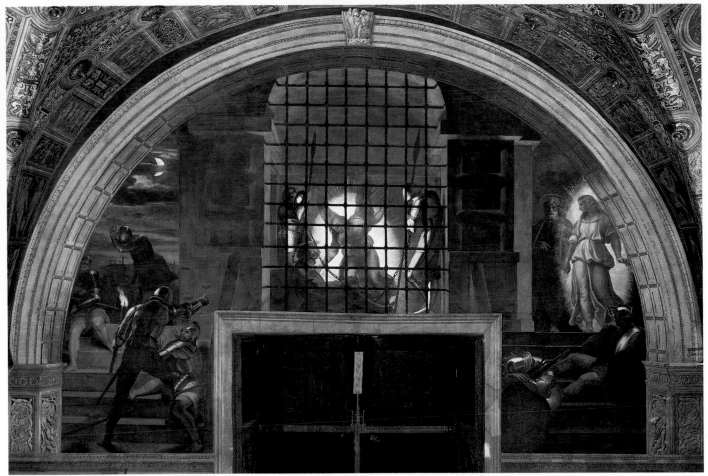

10.19 Raphael, *The Deliverance of St Peter*. 1512–14. Fresco. Stanza dell'Eliodoro, Vatican, Rome.

Mannerism

Papal patronage had assembled great genius in Rome at the turn of the 16th century. It had also ignited and supported a brilliant fire of human genius in the arts. The Spanish invasion and sack of Rome doused the flame of Italian art in 1527 and scattered its ashes across Europe, contributing to the disillusionment and turmoil of religious and political strife that marked the next 70 years.

The turmoil of this last three-quarters of the 16th century is reflected in painting. Considerable debate exists about the nature of the period between the clearly developed style of the High Renaissance and the baroque style. The prevalent view today is positive. This era in painting is seen as a response to the conflicts of the time and not as a decadent and affected imitation of the High Renaissance.

The name attached to the most significant trend, if not style, of the period is Mannerism. The term originates from the mannered, or affected, appearance of subjects in paintings. These works are coldly formal and inward looking. Their wrongly proportioned forms, icy stares, and subjective viewpoint can be puzzling yet intriguing when they are seen out of context. Nevertheless, we find an

appealing modernism in their emotional, sensitive, subtle, and elegant content. At the same time, Mannerism has an intellectual component that distorts reality, alters space, and makes often obscure cultural allusions. Anti-classical emotionalism and the abandonment of classical balance and form, alongside clear underpinnings of formality and geometry, suggest the troubled nature of this style and the times in which it flourished.

Bronzino's *Portrait of a Young Man* (Fig. **10.20**) makes the point. A strong High Renaissance central triangle dominates the basic composition of this work. Its lines, however, have a nervous and unstable quality; incongruous, juxtaposed rectangular and curved forms create an uneasy feeling. The greens and blacks of the painting are very cold, and the starkness of the background adds to the feeling of discomfort. Shadows are harsh, and skin quality is cold. Light and shade create some dimension, but the absence of perspective brings background objects inappropriately into the forward plane of the picture. The human form is attenuated and disproportionate. The young man's head is too small for his body, and particularly for his hands. Finally, his pose and affected stare are typical of the artificiality that gave this movement its name.

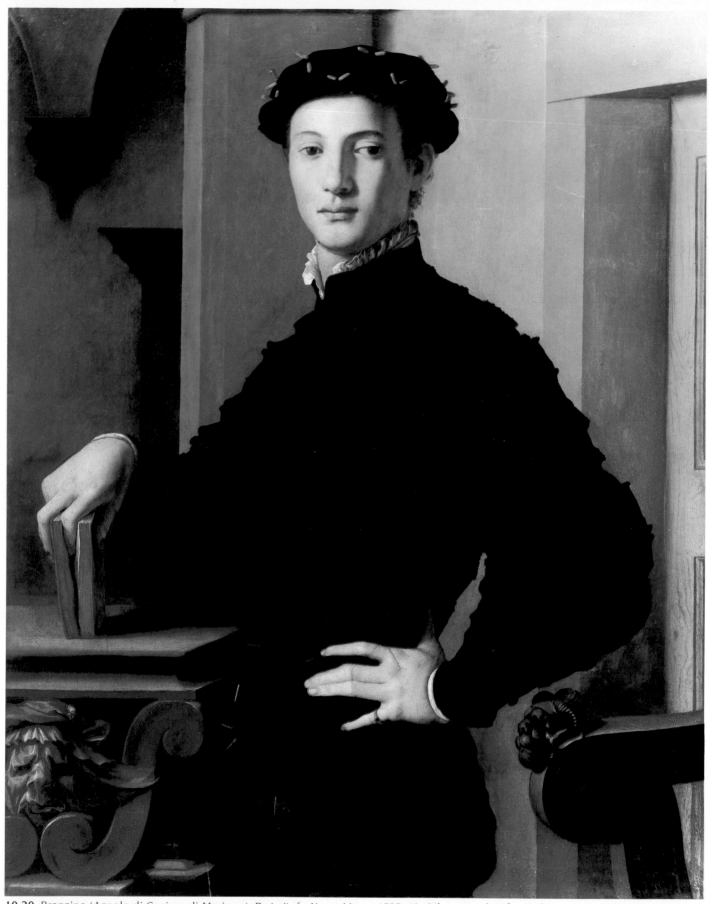

10.20 Bronzino (Agnolo di Cosimo di Mariano), *Portrait of a Young Man*, c.1535–40. Oil on wood, 37⅝ × 29½ ins (95.6 × 73 cm). The Metropolitan Museum of Art, New York (Bequest of Mrs. H. O. Havemeyer, 1929).

SCULPTURE
Early Renaissance

The essence of European sculpture in the Early Renaissance can, once again, best be examined by looking to 15th-century Florence. There, sculpture also enjoyed the patronage of the Medicis.

The Early Renaissance sculptors had developed the skills to create images of great verisimilitude. Their goal, however, was not the same as that of the Greeks, with their idealization of the human form. Rather, Renaissance sculptors found their ideal in individuality—the glorious individual, even if not quite the perfect individual. Sculpture of this style presented a particularly clear-eyed and uncompromising view of humankind—complex, balanced, and full of action.

Relief sculpture, like painting, came up with a new means of representing deep space through a systematic use of scientific perspective. But it was free-standing statuary, long out of favor, that returned to dominance.

10.22 Donatello, *Equestrian Monument to Gattamelata*, 1445–50. Bronze, c.11 × 13 ft (3.4 × 4 m). Piazza del Santo, Padua.

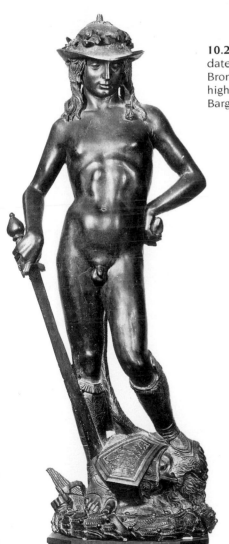

10.21 Donatello, *David*, dated variously 1430–40. Bronze, 5 ft 2¼ ins (1.58 m) high. Museo Nationale del Bargello, Florence.

Scientific inquiry and interest in anatomy were reflected in sculpture as well as painting. The nude, full of character and charged with energy, made its first reappearance since ancient times. The human form was approached layer by layer, through an understanding of its skeletal and muscular framework. Even when clothed, 15th-century sculpture revealed the body under the outer surface.

The greatest masterpieces of 15th-century Italian Renaissance sculpture came from the unsurpassed master of the age, Donatello (1386–1466). His magnificent *David* (Fig. **10.21**) was the first free-standing nude since classical times. However, unlike most classical figures, the *David* is partially clothed. His armor and helmet, along with his bony elbows and adolescent features, invest him with a highly individual presence. The *David* exhibits a return to classical *contrapposto* stance, in its refined form. The work symbolizes Christ's triumph over Satan. The laurel crown on the helmet and laurel wreath on which the work stands allude to the Medici family, in whose palace the statue was displayed in 1469.

Perhaps Donatello's greatest achievement is the *Equestrian Monument to Gattamelata* (Fig. **10.22**). In this work, a larger-than-life monument to a deceased general, we see the influence of Roman monumental statuary, and in particular the statue of *Marcus Aurelius on Horseback*. But here there is a unique concentration on both human and animal anatomy. Donatello skillfully directs the focus of the viewer not to the powerful mass of the horse, but to the overpowering presence of the person astride it. His triangular composition anticipates the geometric approach to sculpture in the High Renaissance.

Another notable sculptor was Ghiberti. His *Gates of*

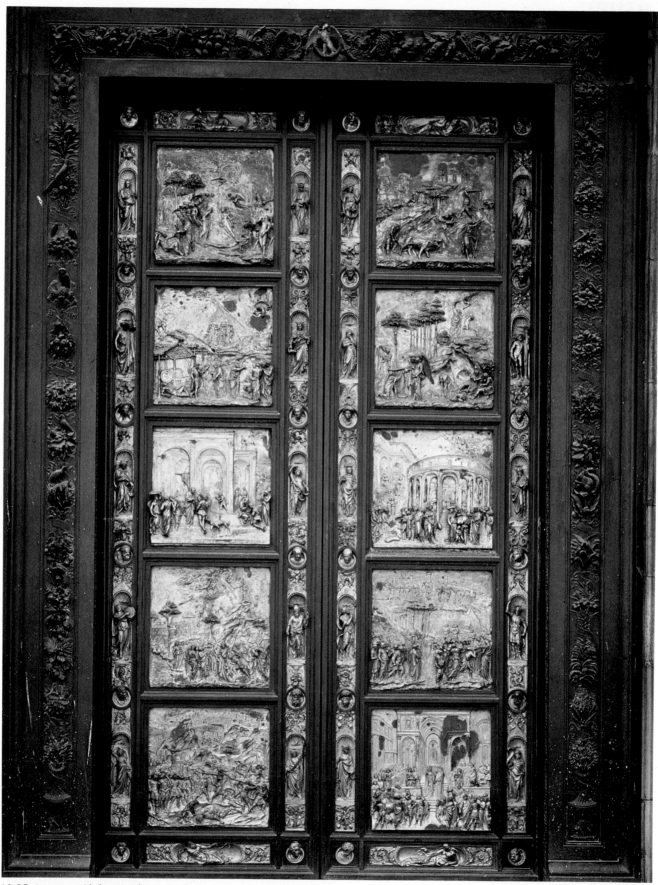

10.23 Lorenzo Ghiberti, *The Gates of Paradise*, 1424–52. Gilt bronze, c.17 ft (5.2 m) high. Baptistry, Florence.

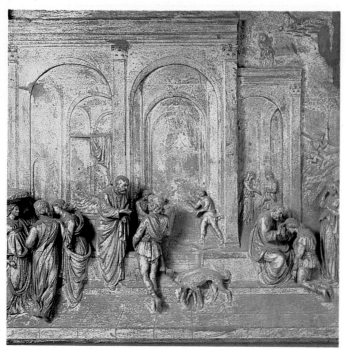

10.24 Lorenzo Ghiberti, *The Story of Jacob and Esau*, panel of *The Gates of Paradise*, c.1435. Gilt bronze, 31¼ ins (79.4 cm) square. Baptistry, Florence.

Paradise (Figs **10.23** and **10.24**) show the same enthusiasm for rich detail, human variety, and feats of perspective that we saw in Florentine painting. In these doors for the Baptistry in Florence, Ghiberti, who was trained as a goldsmith and painter, created beautiful surfaces with delicate and careful detail. He also conveys a tremendous sense of space in each of the ten panels. In *The Story of Jacob and Esau* (Fig. **10.24**), for example, he uses receding arcades to create depth and perspective. Every detail is exact, and the bold relief of these scenes took Ghiberti 21 years to complete.

The High Renaissance

The papal summons of artists to Rome gave impetus to a High Renaissance style in sculpture as well as painting. High Renaissance sculpture, however, was synonymous with one name, Michelangelo Buonarroti. Michelangelo's ideal was the full realization of individuality—a reflection of his own unique genius. He epitomized the quality of *terribilità*, a supreme confidence that allows a person to accept no authority but his or her own genius. Critical of his own work, he was jealous of Raphael, disliked Leonardo, and clashed constantly with his patrons. Yet in his letters he expresses a real sympathy and concern for those close to him.

His works reveal a deep understanding of humanity and reflect his neo-Platonic philosophy. He captures the Platonic idea of potential energy imprisoned in the earthly body. Further, Michelangelo believed, as did Plato, that the image from the artist's hand must spring from the Idea in his or her mind. The Idea is the reality, and it is revealed by the genius of the artist. The artist does not create the Ideas, but finds them in the natural world, which reflects the absolute Idea: Beauty. So, to the neo-Platonist, *when art imitates nature, it reveals Truths hidden within nature*.

Michelangelo broke with earlier Renaissance artists in his insistence that measurement was subordinate to judgment. He believed that measurement and proportion should be kept "in the eyes." This rationale for genius to do what it would, free from any pre-established "rules," enabled him to produce works such as *David* (Fig. **10.26**), a colossal figure and the earliest monumental sculpture of the High Renaissance. Its impact on the viewer is as overpowering today as it was then.

In contrast to the energy of *David* is the quiet simplicity of the *Pietà* (Fig. **10.25**). This is the only work Michelangelo ever signed. Here High Renaissance triangularity contrasts with what many believe to be a late Medieval subject matter and figure treatment. The size of the Madonna compared to Jesus reflects the cult of the Virgin characteristic of the late Medieval period.

Beyond these considerations, however, lies the absolute perfection of surface texture. Michelangelo's polish has so enlivened the marble that it seems to assume the warmth of real human flesh. Skin becomes even more sensuous in its contrast to rough stone. Cloth

10.25 Michelangelo, *Pietà*, 1498–99. Marble, 5 ft 9 ins (1.75 m) high. St Peter's, Rome.

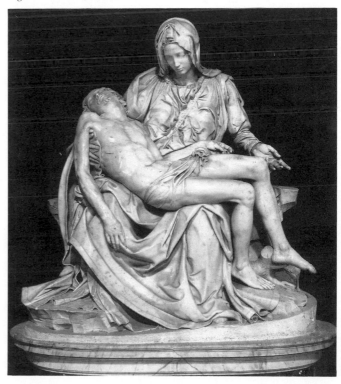

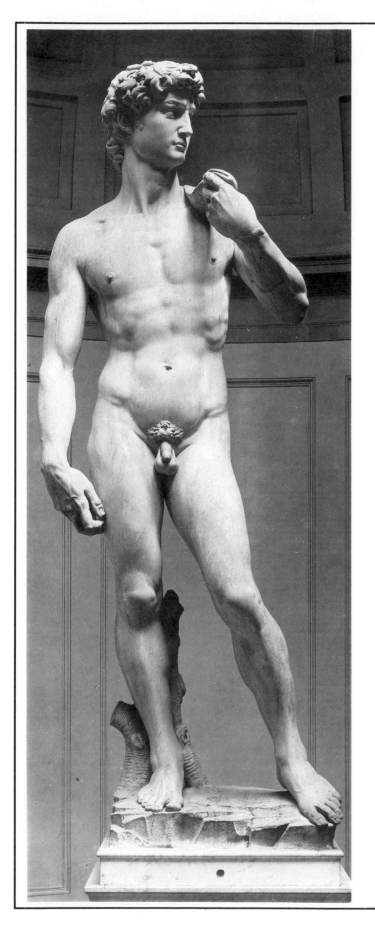

MASTERWORK
Michelangelo—David

Towering some 18 feet above the floor, Michelangelo's *David* awesomely exemplifies *terribilità*. This nude champion exudes a pent-up energy, as the body seems to exist merely as a neo-Platonic earthly prison for the soul. The upper body moves in opposition to the lower. The viewer's eye is led downward by the right arm and leg, then upward along the left arm. The entire figure seeks to break free from its confinement through thrust and counterthrust.

Much of the effect of the *David*—the bulging muscles, exaggerated rib cage, heavy hair, undercut eyes, and frowning brow—may be due to the fact that these features were intended to be read from a distance. The work was originally meant to be placed high above the ground on a buttress for Florence Cathedral. Instead, the city leaders, believing it to be too magnificent to be placed so high, put it in front of the Palazzo Vecchio. It also had to be protected from the rain since the soft marble rapidly began to deteriorate.

The political symbolism of the work was recognized from the outset. The *David* stood for the valiant Florentine Republic. It also stood for all of humanity, elevated to a new and superhuman power, beauty, and grandeur. However, its revolutionary "total and triumphant nudity," which reflected Michelangelo's belief in the divinity of the human body, kept it hidden from the public for two months. When it did appear, a brass girdle with 28 copper leaves hung around the waist.

Inspired by the Hellenistic sculptures he had seen in Rome, Michelangelo set out in pursuit of an emotion-charged, heroic ideal. The scale, musculature, emotion, and stunning beauty and power of those earlier works became a part of Michelangelo's style. In contrast to the Hellenistic approach, in which the "body 'acts' out the spirit's agony" (compare the *Laocoön*, by Hagesandrus, Polydorus, and Athenodorus), however, "David, at once calm and tense, shows the action-in-repose so characteristic of Michelangelo."[3]

10.26 Michelangelo, *David*, 1501–04. Marble. 14 ft 3 ins (4.34 m) high. Academy, Florence.

has an exquisite softness, and the expressive sway of drape reinforces the compositional line of the work. Emotion and energy are captured within the contrasting forces of form, line, and texture.

Mannerism

The late 16th century produced relatively little sculpture of major significance. The twisting, elongated form of *Mercury* (Fig. **10.27**) by Giovanni da Bologna (1529–1608), however, shows us qualities that are equivalent to the Mannerist tendencies in painting of the same era. The affected pose, the upward-striving line, the linear emphasis, and the nearly total detachment from earth suggest tension and nervous energy. Mercury races through the air seeking the escape of flight, supported by a puff of breath from a mask symbolizing the wind.

10.27 Giovanni da Bologna, *Mercury*, c.1567. Bronze, 5 ft 9 ins (1.75 m) high. Bargello, Florence.

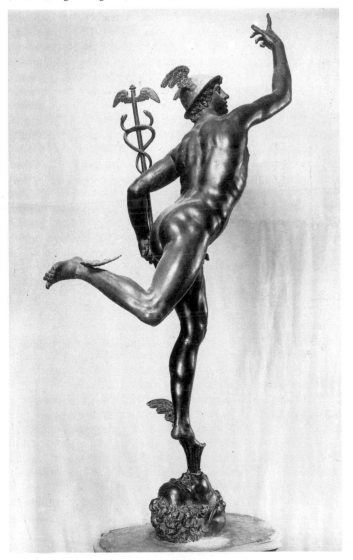

LITERATURE
Early Renaissance

The writers of Early Renaissance literature concentrated largely on form and style. In the 14th century, early Italian writers such as Boccaccio and Petrarch began to develop the works of ancient writers in a new way. They borrowed ideas, stories, figures of speech, and general style, and tried to recreate ancient poetic and prose styles. Renaissance writers clearly achieved a more penetrating investigation and analysis of ancient literature and art than had their Medieval predecessors. The result was an ordered plan, integrated structure, symmetry, and lofty style which 14th-century writers believed created a classical type of beauty. Various rules were laid down, for example, that the epic must begin in the middle of its plot, must contain supernatural elements, and must end with a victory for the hero. The Italian model had a strong influence on Spanish, French, English, and German literature.

Boccaccio

The work of Giovanni Boccaccio (1313–75) culminated in the *Decameron*. In the framing tale, ten young people flee from the plague in Florence in 1348 to sit out the danger in the countryside. To amuse themselves, they tell 100 stories over a 14-day period.

Here we include the first tale from day I, a lively one spent in witty conversation. Days II and III are focused on tales of adventure. Day IV presents unhappy love, and V treats the same subject in a somewhat lighter vein. Day VI returns to the happiness of day I, and days VII, VIII, and IX comprise laughter, trickery, and license. Day X ties the previous themes together in a conclusion. In total, the *Decameron* extols the virtue of humankind, proposing that to be noble one must accept life as one finds it, without bitterness. Above all, one must accept the responsibility for and consequences of one's own actions. Clearly the *Decameron* is an early reflection of the Renaissance spirit.

The Decameron, Day 1
Master Ciappelletto dupeth a holy friar with a false confession and dieth; and having been in his lifetime the worst of men, he is, after his death, reputed a saint and called Saint Ciappelletto.

"It is a seemly thing, dearest ladies, that whatsoever a man doth, he give it beginning from the holy and admirable name of Him who is the maker of all things. Wherefore, it behoving me, as the first, to give commencement to our story-telling, I purpose to begin with one of His marvels, to the end, that, this being heard, our hope in Him, as in a thing immutable, may be confirmed and His name be ever praised of us. It is a manifest that, like as things temporal are all transitory and mortal, even so both within and without are they full of annoy and anguish and travail and subject to infinite perils, against which it is indubitable that we, who live enmingled therein and who are indeed part and parcel thereof, might avail neither to endure nor to defend ourselves, except God's especial grace lent us

strength and foresight; which latter, it is not to be believed, descendeth unto us and upon us by any merit of our own, but of the proper motion of His own benignity and the efficacy of the prayers of those who were mortals even as we are and having diligently ensued His commandments, what while they were in life, are now with Him become eternal and blessed and unto whom we,—belike not daring to address ourselves unto the proper presence of so august a judge,—proffer our petitions of the things which we deem needful unto ourselves, as unto advocates informed by experience of our frailty. And this more we discern in Him, full as He is of compassionate liberality towards us, that, whereas it chanceth whiles (the keenness of mortal eyes availing not in any wise to penetrate the secrets of the Divine intent), that we peradventure, beguiled by report, make such an one our advocate unto His majesty, who is outcast from His presence with an eternal banishment,—nevertheless He, from whom nothing is hidden, having regard rather to the purity of the suppliant's intent than to his ignorance or to the reprobate estate of him whose intercession he invoketh, giveth ear unto those who pray unto the latter, as if he were in very deed blessed in His aspect. The which will manifestly appear from the story which I purpose to relate; I say manifestly, ensuing, not the judgment of God, but that of men.

It is told, then, that Musciatto Franzesi, being from a very rich and considerable merchant in France become a knight and it behoving him thereupon go into Tuscany with Messire Charles Sansterre, brother to the King of France, who had been required and bidden thither by Pope Boniface, found his affairs in one part and another sore embroiled (as those of merchants most times are), and was unable lightly or promptly to disentangle them; wherefore he bethought himself to commit them unto diverse persons and made shift for all, save only he abode in doubt whom he might leave sufficient to the recovery of the credits he had given to certain Burgundians. The cause of his doubt was that he knew the Burgundians to be litigious, quarrelsome fellows, ill-conditioned and disloyal, and could not call one to mind, in whom he might put any trust, curst enough to cope with their perversity. After long consideration of the matter, there came to his memory a certain Master Ciapperello da Prato, who came often to his house in Paris and whom, for that he was little of person and mighty nice in his dress, the French, knowing not what Cepparello meant and thinking it be the same with Cappello, to wit, in their vernacular, Chaplet, called him, not Cappello, but Ciappelletto, and accordingly as Ciappelletto he was known every where, whilst few knew him for Master Ciapperello.

Now this said Ciappelletto was of this manner life, that, being a scrivener, he thought very great shame whenas any of his instruments was found (and indeed he drew few such) other than false; whilst of the latter he would have drawn as many as might be required of him and these with a better will by way of gift than any other for a great wage. False witness he bore with especial delight, required or not required, and the greatest regard being in those times paid to oaths in France, as he recked nothing of forswearing himself, he knavishly gained all the suits concerning which he was called upon to tell the truth upon his faith. He took inordinate pleasure and was mighty diligent in stirring up troubles and enmities and scandals between friends and kinsfolk and whomsoever else, and the greater the mischiefs he saw ensue thereof, the more

he rejoiced. If bidden to manslaughter or whatsoever other naughty deed, he went about it with a will, without ever saying nay thereto; and many a time of his proper choice he had been known to wound men and do them to death with his own hand. He was a terrible blasphemer of God and the saints and that for every trifle, being the most choleric man alive. To church he went never and all the sacraments thereof he flouted in abominable terms, as things of no account; whilst, on the other hand, he was still fain to haunt and use taverns and other lewd places. Of women he was as fond as dogs of the stick; but in the contrary he delighted more than any filthy fellow alive. He robbed and pillaged with as much conscience as a godly man would make oblation to God; he was a very glutton and a great wine bibber, insomuch that bytimes it wrought him shameful mischief, and to boot, he was a notorious gamester and a caster of cogged dice. But why should I enlarge in so many words? He was belike the worst man that ever was born. His wickedness had long been upheld by the power and interest of Messer Musciatto, who had many a time safeguarded him as well from private persons, to whom he often did a mischief, as from the law, against which he was a perpetual offender.

This Master Ciappelletto, then, coming to Musciatto's mind, the latter, who was very well acquainted with his way of life, bethought himself that he should be such an one as the perversity of the Burgundians required and accordingly, sending for him, he bespoke him thus: 'Master Ciappelletto, I am, as thou knowest, about altogether to withdraw hence, and having to do, amongst others, with certain Burgundians, men full of guile, I know none whom I may leave to recover my due from them more fitting than myself, more by token that thou dost nothing at this present; wherefore, an thou wilt undertake this, I will e'en procure thee the favor of the Court and give thee such part as shall be meet of that which thou shalt recover.'

Dan Ciappelletto, who was then out of employ and ill provided with the goods of the world, seeing him who had long been his stay and his refuge about to depart thence, lost no time in deliberation, but, as of necessity constrained, replied that he would well. They being come to an accord, Musciatto departed and Ciappelletto, having gotten his patron's procuration and letters commendatory from the king, betook himself into Burgundy, where well nigh none knew him, and there, contrary to his nature, began courteously and blandly to seek to get in his payments and do that wherefor he was come thither as if reserving choler and violence for a last resort. Dealing thus and lodging in the house of two Florentines, brothers, who there lent at usance and who entertained him with great honor for the love of Messer Musciatto, it chanced that he fell sick, whereupon the two brothers promptly fetched physicians and servants to tend him and furnished him with all that behoved unto the recovery of his health.

But every succor was in vain, for that, by the physicians' report, the good man, who was now old and had lived disorderly, grew daily worse, as one who had a mortal sickness; wherefore the two brothers were sore concerned and one day, being pretty near the chamber where he lay sick, they began to take counsel together, saying one to the other, 'How shall we do with yonder fellow? We have a sorry bargain on our hands of his affair, for that to send him forth of our house, thus sick, were a sore reproach to us and a manifest sign of little wit on our part, if the folk, who have seen us first receive him and after let tend and medicine him with such solitude, should now

see him suddenly put out of our house, sick unto death as he is, without it being possible for him to have done aught that should displease us. On the other hand, he hath been so wicked a man that he will never consent to confess or take any sacrament of the church; and he dying without confession, no church will receive his body; nay, he will be cast into a ditch, like a dog. Again, even if he do confess, his sins are so many and so horrible that the like will come of it, for that there is nor priest nor friar who can or will absolve him thereof; wherefore, being unshriven, he will still be cast into the ditches. Should it happen thus, the people of the city, as well on account of our trade, which appeareth to them most iniquitous and of which they missay all day, as of their itch to plunder us, seeing this, will rise up in riot and cry out, "These Lombard dogs, whom the church refuseth to receive, are to be suffered here no longer";—and they will run to our houses and despoil us not only of our good, but may be of our lives, to boot; wherefore in any case it will go ill with us, if yonder fellow die.'

Master Ciappelletto, who as we have said lay near the place where the two brothers were in discourse, being quick of hearing, as is most times the case with the sick, heard what they said of him and calling them to him, bespoke them thus: 'I will not have you unwise misdoubt of me nor fear to take any hurt by me. I have heard what you say of me and am well assured that it would happen even as you say, should matters pass as you expect; but it shall go otherwise. I have in my lifetime done God the Lord so many an affront that it will make neither more nor less, an I do Him yet another at the point of death; wherefore do you make shift to bring me the holiest and worthiest friar you may avail to have, if any such there be, and leave the rest to me, for that I will assuredly order your affairs and mine own on such wise that all shall go well and you shall have good cause to be satisfied.'

The two brothers, albeit they conceived no great hope of this, nevertheless betook themselves to a brotherhood of monks and demanded some holy and learned man to hear the confession of a Lombard who lay sick in their house. There was given them a venerable brother of holy and good life and a past master in Holy Writ, a very reverend man, for whom all the townsfolk had a very great and special regard, and they carried him to their house; where, coming to the chamber where Master Ciappelletto lay and seating himself by his side, he began first tenderly to comfort him and after asked him how long it was since he had confessed last; whereto Master Ciappelletto, who had never confessed in his life, answered, 'Father, it hath been my usance to confess every week once at the least and often more; it is true that, since I fell sick, to wit, these eighty days past, I have not confessed, such is the annoy that my sickness hath given me.' Quoth the friar, 'My son, thou hast done well and so must thou do henceforward. I see, since thou confessest so often, that I shall be at little pains either of hearing or questioning.' 'Sir,' answered Master Ciappelletto, 'say not so; I have never confessed so much nor so often, but I would still fain make a general confession of all my sins that I could call to mind from the day of my birth to that of my confession; wherefore I pray you, good my father, question me as punctually of everything, nay, everything, as if I had never confessed; and consider me not because I am sick, for that I had far liefer displease this my flesh than, in consulting its ease, do aught that might be the perdition of my soul, which my Savior redeemed with His precious blood.'

These words much pleased the holy man and seemed to him to argue a well-disposed mind; wherefore, after he had much commended Master Ciappelletto for that his usance, he asked him if he had ever sinned by way of lust with any woman. 'Father,' replied Master Ciappelletto, sighing, 'on this point I am ashamed to tell you the truth, fearing to sin by way of vainglory.' Quoth the friar, 'Speak in all security, for never did one sin by telling the truth, whether in confession or otherwise.' 'Then,' said Master Ciappelletto, 'since you certify me of this, I will tell you; I am yet a virgin, even as I came forth of my mother's body.' 'O blessed be thou of God!' cried the monk. 'How well hast thou done! And doing thus, thou hast the more deserved, inasmuch as, an thou wouldst, thou hadst more leisure to do the contrary than we and whatsoever others are limited by any rule.'

After this he asked him if he had ever offended against God in the sin of gluttony; whereto Master Ciappelletto answered, sighing, Ay had he, and that many a time; for that, albeit, over and above the Lenten fasts that are yearly observed of the devout, he had been wont to fast on bread and water three days at the least in every week,—he had oftentimes (and especially whenas he had endured any fatigue, either praying or going a-pilgrimage) drunken the water with as much appetite and as keen a relish as great drinkers do wine. And many a time he had longed to have such homely salads of potherbs as women make when they go into the country; and whiles eating had given him more pleasure than himseemed it should do to one who fasteth for devotion, as did he. 'My son,' said the friar, 'these sins are natural and very slight and I would not therefore have thee burden thy conscience withal more than behoveth. It happeneth to every man, how devout soever he be, that, after long fasting, meat seemeth good to him, and after travail, drink.'

'Alack, father mine,' rejoined Ciappelletto, 'tell me not this to comfort me; you must know I know that things done for the service of God should be done sincerely and with an ungrudging mind; and whoso doth otherwise sinneth.' Quoth the friar, exceeding well pleased, 'I am content that thou shouldst thus apprehend it and thy pure and good conscience therein pleaseth me exceedingly. But, tell me, hast thou sinned by way of avarice, desiring more than befitted or withholding that which it behoved thee not to withhold?' 'Father mine,' replied Ciappelletto, 'I would not have you look to my being in the house of these usurers; I have naught to do here; nay, I came hither to admonish and chasten them and turn them from this their abominable way of gain; and methinketh I should have made shift to do so, had not God thus visited me. But you must know that I was left a rich man by my father, of whose good, when he was dead, I bestowed the most part in alms, and after, to sustain my life and that I might be able to succor Christ's poor, I have done my little traffickings, and in these I have desired to gain; but still with God's poor have I shared that which I gained, converting my own half to my occasions and giving them the other, and in this so well hath my Creator prospered me that my affairs have still gone from good to better.'

'Well hast thou done,' said the friar, 'but hast thou often been angered?' 'Oh,' cried Master Ciappelletto, 'that I must tell you I have very often been! And who could keep himself therefrom, seeing men do unseemly things all day long, keeping not the commandments of God neither fearing His

judgments? Many times a day I had liefer been dead than alive, seeing young men follow after vanities and hearing them curse and forswear themselves, haunting the taverns, visiting not the churches and ensuing rather the ways of the world than that of God.' 'My son,' said the friar, 'this is a righteous anger, nor for my part might I enjoin thee any penance therefor. But hath anger at any time availed to move thee to do any manslaughter or to bespeak any one unseemly or do any other unright?' 'Alack, sir,' answered the sick man, 'you, who seem to me a man of God, how can you say such words? Had I ever had the least thought of doing any one of the things whereof you speak, think you I believe that God would so long have forborne me? These be the doings of outlaws and men of nought, whereof I never saw any but I said still, "Go, may God amend thee!"'

Then said the friar, 'Now tell me, my son (blessed be thou of God!), hast thou never borne false witness against any or missaid of another or taken others' good, without leave of him to whom it pertained?' 'Ay, indeed, sir,' replied Master Ciappelletto; 'I have missaid of others; for that I had a neighbor aforetime, who, with the greatest unright in the world, did nought but beat his wife, insomuch that I once spoke ill of him to her kinsfolk, so great was the compassion that overcame me for the poor woman, whom he used as God alone can tell, whenassoever he had drunken overmuch.' Quoth the friar, 'Thou tellest me thou hast been a merchant. Hast thou never cheated any one, as merchants do whiles?' 'I' faith, yes, sir,' answered Master Ciappelletto; 'but I know not whom, except it were a certain man, who once brought me monie which he owed me for cloth I had sold him and which I threw into a chest, without counting. A good month after, I found that they were four farthings more than they should have been; wherefore, not seeing him again and having kept them by me a full year, that I might restore them to him, I gave them away in alms.' Quoth the friar, 'this was a small matter, and thou didst well to deal with it as thou didst.'

Then he questioned him of many other things, all of which he answered after the same fashion, and the holy father offering to proceed to absolution, Master Ciappelletto said, 'Sir, I have yet sundry sins that I have not told you.' The friar asked him what they were, and he answered, 'I mind me that one Saturday, afternone, I caused my servant sweep out the house and had not that reverence for the Lord's holy day which it behoved me have.' 'Oh,' said the friar, 'that is a light matter, my son.' 'Nay,' rejoined Master Ciappelletto, 'call it not a light matter, for that the Lord's Day is greatly to be honored, seeing that on such a day our Lord rose from the dead.' Then said the friar, 'Well, hast thou done aught else?' 'Ay, sir,' answered Master Ciappelletto; 'once, unthinking what I did, I spat in the church of God.' Thereupon the friar fell a-smiling and said, 'My son, that is no thing to be reckoned of; we who are of the clergy, we spit there all day long.' 'And you do very ill,' rejoined Master Ciappelletto; 'for that there is nought which it so straitly behoveth to keep clean as the holy temple wherein is rendered sacrifice to God.'

Brief, he told him great plenty of such like things and presently fell a-sighing and after weeping sore, as he knew full well to do, whenas as he would. Quoth the holy friar, 'What aileth thee, my son?' 'Alas, sir,' replied Master Ciappelletto, 'I have only one sin left, whereof I never yet confessed me, such shame have I to tell it; and every time I call it to mind, I weep,

even as you see, and meseemeth very certain that God will never pardon it me.' 'Go to, son,' rejoined the friar; 'what is thou sayest? If all the sins that were ever wrought or are yet to be wrought of all mankind, what while the world endureth, were all in one man and he repented him thereof and were contrite therefor, as I see thee, such is the mercy and lovingkindness of God that, upon confession He would freely pardon them to him. Wherefore do thou tell it in all assurance.' Quoth Master Ciappelletto, still weeping sore, 'Alack, father mine, mine is too great a sin, and I can scarce believe that it will ever be forgiven me of God, except your prayers strive for me.' Then said the friar, 'Tell it me in all assurance, for I promise thee to pray God for thee.'

Master Ciappelletto, however, still wept and said nought; but, after he had thus held the friar a great while in suspense, he heaved a deep sigh and said, 'Father mine, since you promise me to pray God for me, I will e'en tell it you. Know, then, that, when I was little, I once cursed my mother.' So saying, he fell again to weeping sore. 'O my son,' quoth the friar, 'seemeth this to thee so heinous a sin? Why, men blaspheme God all day long and He freely pardoneth whoso repenteth him of having blasphemed Him; and deemest thou not He will pardon thee this? Weep not, but comfort thyself: for, certes, wert thou one of those who set Him on the cross, He would pardon thee, in favor of such contrition as I see in thee.' 'Alack, father mine, what say you?' replied Ciappelletto. 'My kind mother, who bore me nine months in her body, day and night, and carried me on her neck an hundred times and more, I did passing ill to curse her and it was an exceeding great sin; and except you pray God for me, it will not be forgiven me.'

The friar, then, seeing that Master Ciappelletto had no more to say, gave him absolution and bestowed on him his benison, holding him a very holy man and devoutly believing all that he had told him to be true. And who would not have believed it, hearing a man at the point of death speak thus? Then, after all this, he said to him, 'Master Ciappelletto, with God's help you will speedily be whole; but, should it come to pass that God call your blessed and well-disposed soul to himself, would it please you that your body be buried in our convent?' 'Ay, would it, sir,' replied Master Ciappelletto. 'Nay, I would fain not be buried otherwhere, since you have promised to pray God for me; more by token that I have ever had a special regard for your order. Wherefore I pray you that, whenas you return to your lodging, you cause bring me that most veritable body of Christ, which you consecrate a-mornings upon the altar, for that, with your leave, I purpose (all unworthy as I am) to take it and after, holy and extreme unction, to the intent that if I have lived as a sinner, I may at the least die like a Christian.' The good friar replied that it pleased him much and that he had said well and promised to see it presently brought him; and so was it done.

Meanwhile, the two brothers, misdoubting them sore lest Master Ciappelletto should play them false, had posted themselves behind a wainscot, that divided the chamber where he lay from another, and listening, easily heard and apprehended that which he said to the friar and had whiles so great a mind to laugh, hearing the things which he confessed to having done, that they were like to burst and said, one to another, 'What manner of man is this, whom neither old age nor sickness nor fear of death, whereunto he seeth himself near, nor yet of God, before whose judgment-seat he looketh to be

ere long, have availed to turn from his wickedness nor hinder him from choosing to die as he hath lived?' However, seeing that he had so spoken that he should be admitted to burial in a church, they recked nought of the rest.

Master Ciappelletto presently took the sacrament and growing rapidly worse, received extreme unction, and a little after evensong of the day he had made his fine confession, he died; whereupon the two brothers, having, of his proper monies, taken order for his honorable burial, sent to the convent to acquaint the friars therewith, bidding them come hither that night to hold vigil, according to usance, and fetch away the body in the morning, and meanwhile made ready all that was needful thereunto.

The holy friar, who had shriven him, hearing that he had departed this life, betook himself to the prior of the convent and letting ring to chapter, gave out to the brethren therein assembled that Master Ciappelletto had been a holy man, according to that which he had gathered from his confession, and persuaded them to receive his body with the utmost reverence and devotion, in the hope that God should show forth many miracles through him. To this the prior and brethren credulously consented and that same evening, coming all whereas Master Ciappelletto lay dead, they held high and solemn vigil over him and on the morrow, clad all in albs and copes, book in hand and crosses before them, they went, chanting the while, for his body and brought it with the utmost pomp and solemnity to their church, followed by well nigh all the people of the city, men and women.

As soon as they had set the body down in the church, the holy friar, who had confessed him, mounted the pulpit and fell a-preaching marvellous things of the dead man and of his life, his fasts, his virginity, his simplicity and innocence and sanctity, recounting, amongst other things, that which he had confessed to him as his greatest sin and how he had hardly availed to persuade him that God would forgive it him; thence passing on to reprove the folk who hearkened, 'And you, accursed that you are,' quoth he, 'for every waif of straw that stirreth between your feet, you blaspheme God and the Virgin and all the host of heaven.' Moreover, he told them many other things of his loyalty and purity of heart; brief, with his speech, whereto entire faith was yielded of the people of the city, he so established the dead man in the reverent consideration of all who were present that, no sooner was the service at an end, than they all with the utmost eagerness flocked to kiss his hands and feet and the clothes were torn off his back, he holding himself blessed who might avail to have never so little thereof; and needs must they leave him thus all that day, so he might be seen and visited of all.

The following night he was honorably buried in a marble tomb in one of the chapels of the church and on the morrow the folk began incontinent to come and burn candles and offer up prayers and make vows to him and hang images of wax at his shrine, according to the promise made. Nay, on such wise waxed the fame of his sanctity and men's devotion to him that there was scarce any who, being in adversity, would vow himself to another saint than him; and they styled and yet style him Saint Ciappelletto and avouch that God through him hath wrought many miracles and yet worketh them every day for whoso devoutly commendeth himself unto him.

Thus, then, lived and died Master Ciappelletto da Prato and became a saint, as you have heard; nor would I deny it to

be possible that he is beatified in God's presence, for that, albeit his life was wicked and perverse, he may at his last extremity have shown such contrition that peradventure God had mercy on him and received him into His kingdom; but, for that this is hidden from us, I reason according to that which is apparent and say that he should rather be in the hands of the devil in perdition than in Paradise. And if so it be, we may know from this how great is God's loving-kindness towards us, which, having regard not to our error, but to the purity of our faith, whenas we thus make an enemy (deeming him a friend) of Him our intermediary, giveth ear unto us, even as if we had recourse unto one truly holy, as intercessor for His favor. Wherefore, to the end that by His grace we may be preserved safe and sound in this present adversity and in this so joyous company, let us, magnifying His name, in which we have begun our diversion, and holding Him in reverence, commend ourselves to Him in our necessities, well assured of being heard." And with this he was silent.[4]

Petrarch

Petrarch is a key figure in the transition from Medieval to Renaissance thought. He was born in 1304. His writings are very different from those of Dante, and they are filled with complaints about "the dangers and apprehensions I have suffered." Contrary to what he says, however, he enjoyed the favor of the great men and women of his day. Petrarch was unable to reconcile his own conflicting aspirations and interests into a workable existence. He desired solitude and quiet, but was continually active. He adored being a celebrity, yet at the same time attacked the superficiality of the world around him and longed for the monastic life.

Petrarch's real love was learning, for which he earned the title "Father of Humanism," and he made a significant impact on those who followed. He rejected Medieval philosophy and also found science wanting as a way toward a "happy life." He had a passion for classical literature and Roman antiquity, but his classicism exhibited a new spirit of enthusiasm.

Although Petrarch was a classical scholar, his religious thought was thoroughly Medieval. He felt guilty about admiring the things learned from pagan philosophers. He found Dante's connection between the good of this world and that of the next impossible. He rejected the intellectual tradition of the Middle Ages, but clung tenaciously to its moral code.

The High Renaissance

By the 15th century, the philosophy of humanism, and its goal of making life a work of art, had spread throughout Italy. This influence spawned treatises on the perfect prince, the perfect poem, and the perfect work of art. Numerous poems, histories, biographies, and orations were written in the vernacular and in Latin and circulated, many in printed form. One result of humanist Latin

literature was the elevation of the vernacular style.

The first great achievements of the High Renaissance in verse and prose came from Italy. Pico della Mirandola's *Oration on the Dignity of Man* (1486) illustrates the growing emphasis on a human-centered world. He believed that people—the climax of God's creation—could continually improve themselves by exercising their powers of reason, and he tried to construct a system of thought that reconciled all the philosophies and religions of the time. Great writers from other countries included Erasmus, the greatest Renaissance scholar of northern Europe and author of provocatively argumentative works like *The Praise of Folly* (1509); and Thomas More, English statesman, humanist scholar, and Roman Catholic saint and martyr, who created in his *Utopia* (1516) a vision of a perfect human society. In general, however, High Renaissance literature paid growing attention to classical models, in most cases Latin rather than Greek ones.

England

In England, Renaissance literature flowered during the last quarter of the 16th century. After the seemingly interminable Wars of the Roses and the turbulence of the Reformation, England under Elizabeth I entered a period of political and social stability that engendered a mood of optimism and readiness to experiment in cultural matters.

Lyric poetry enjoyed wide popularity up and down the social scale. The ability to compose a sonnet or to coin an original and witty phrase was regarded as essential in any courtier, while the growing and increasingly prosperous middle class—no longer confined to the large towns, but extending throughout the shires and country towns—demanded increasingly sophisticated entertainment. A large and educated readership of gentlewomen also developed. Writers and booksellers quickly responded to this new market and its demands.

An early and notable testament to this upsurge in interest came in Sir Philip Sidney's *Defense of Poesie*, a brilliant and forceful polemic which laid claim to the cultural high ground for verse. Sidney (1554–86), in many ways the model English Renaissance courtier and man of letters, had read widely and judiciously in ancient, Italian and French literature. His sonnets, best represented in *Astrophel and Stella*, perfectly embodied the delicacy, elegance, wit, and expressiveness of contemporary writing. His friend Edmund Spenser (1552–99) "Englished" classical Roman models in his *Shepheards Calendar*, a collection of eclogues. In his unfinished masterpiece, *The Faerie Queene*, Spenser celebrated Elizabeth in a long allegorical romance. The greatest literary genius of all, of course, was William Shakespeare (1564–1616), most of whose work was for the theatre, but who also left a remarkable sequence of sonnets, in which he pushed the resources of the English language to breathtaking extremes.

THEATRE

In the years of the Renaissance and High Renaissance in the visual arts, theatre retained the characteristics it had developed in the Middle Ages. Secular adaptation and production of mystery and morality plays flourished.

France

The *Confrérie de la Passion*, a professional theatre company, under license from Charles VI, continued to produce mystery plays in France throughout the 15th century. Their cycle of plays representing *Le Mystère du Vieil Testament* (*The Mystery of the Old Testament*) consisted of 44,325 verses and took 20 performances to complete. *Le Mystère du Nouveau Testament* (*The Mystery of the New Testament*) consisted of 34,574 verses. A third cycle, *Les Actes des Apôtres* (*The Acts of the Apostles*), rounded out the *Confrérie's* repertoire and took 40 days to present in its entirety.

But the French also developed a new secular form, the *sottie*, made up of short theatrical entertainments woven into the yearly festivals of the Feast of the Ass and the Feast of the Fools. These festivals originated partly in pagan rites, and were bawdy burlesques of the Roman Catholic Mass. A person called the "bishop," "archbishop," or "pope of fools" celebrated a mock Mass with a great deal of jumping around, buffoonery, and noise. Participants wore strange costumes (or nothing at all), and the entire affair was accompanied by much drinking. One of the most popular of the *sotties* written for the Feasts, Pierre Gringoire's *Jeu du Prince des Sots* (*Play of the Prince of the Fools*), was produced in Paris in 1512 at the request of King Louis XII to inflame the populace against Pope Julius II.

At the same time a more substantial French theatrical form also emerged—the farce. This secular genre was fully developed as a play form. The farce was performed as an independent production, in contrast to the *sottie*, which was a between-the-acts entertainment. The most famous of the French farces of this period was *Maître Pierre Pathélin* (1470), and it is still occasionally produced today.

Italy

Early Renaissance drama in Italy, like painting, tended not to reflect the discordant political cloak-and-dagger atmosphere of its surroundings. Italian playwrights chose mostly to write tender, sentimental, pastoral comedies in a graceful, witty, and polished style.

For the most part, Italian drama was theatre of the aristocracy, and it was produced with elaborate trappings, usually at court (Fig. **10.28**), but sometimes in public squares under courtly sponsorship. No permanent theatres existed at the time. Surviving Roman theatre buildings were in such disrepair that they were unusable.

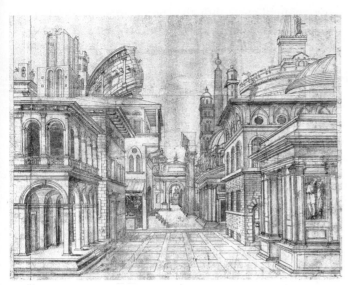

10.28 Baldassare Peruzzi, stage design, probably for
La Calendria, 1514.

When, rather late in the day, the theatre of the Late Renaissance era finally caught the Renaissance spirit, it developed in ways that had a great impact on theatre in every part of Europe.

In Italy, where the Renaissance was largely in the visual arts, two important developments occurred. One was a new form of theatre building, and the other was painted scenery. Both contributed to changing aesthetics and style in formal theatre production. Vitruvius, the Roman architect and historian, was the source of plans for new theatre buildings in Italy, but Renaissance scholars never quite got their antiquarian enterprises right. Nevertheless, Italian modifications of Medieval mansion stages produced compact, carefully designed theatres very similar to those of the 20th century. Palladio's Teatro Olimpico (Fig. **10.29**) was once thought to be the model for modern theatre, but scholars now believe that our theatre derived from the Teatro Farnese at Parma. The most significant change in the theatre of this era was a move to enclose the dramatic action within a "picture frame," or PROSCENIUM, so that the audience sat on only one side of the stage and watched the action through a rectangular or arched opening. The term "picture-frame

10.29 Palladio, Teatro Olimpico, stage, Vicenza, 1580–84.

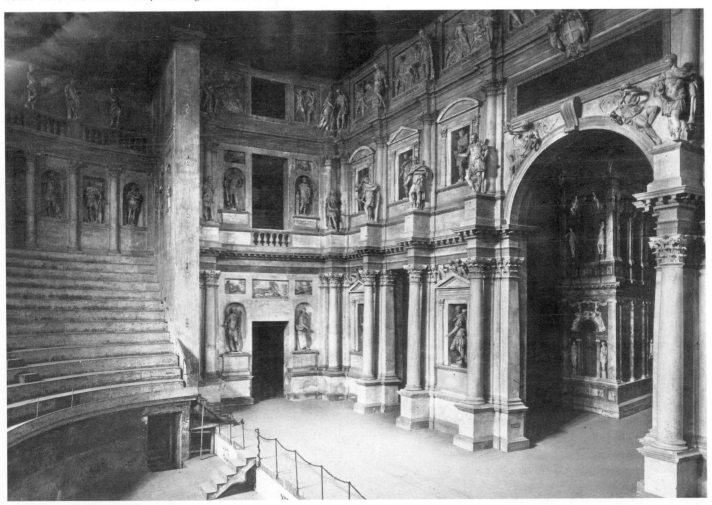

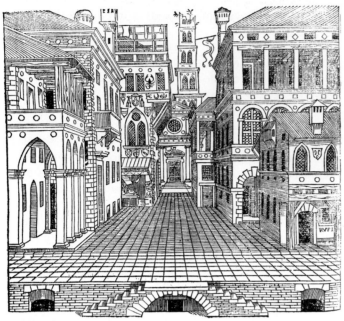

10.30 Sebastiano Serlio, stage setting from D'Architettura, 1540–51.

stage" is particularly appropriate, in respect of both what it resembled and of the painting traditions of the era.

The discovery of the science of mechanical perspective found its way into the theatre in the 16th century. The designs of Sebastiano Serlio (Fig. **10.30**) illustrate some of this new painted scenery. Just as in Early Renaissance paintings, the visual effect of falsified perspective "tricks" is based on mechanical principles. From a point slightly upstage of the actual playing area, the scenery gets smaller and smaller to an imaginary vanishing point. The effect induces a sense of great depth when, in reality, the set recedes only a few feet. Of course, the actors were restricted to a narrow playing area adjacent to the full-size downstage wings. Were the actors to move upstage, they would have towered over the buildings. Stage settings became more and more elaborate, and a new "opening" usually brought an audience to see not a new play, but, rather, the new accomplishments of the set designer.

Commedia dell'arte

Also competing for the attention of the public was Italy's unique COMMEDIA DELL'ARTE. This theatrical form developed parallel to the traditions of the regular theatre, and it enjoyed tremendous popular support. Most singularly, it featured the actor rather than the script.

Commedia dell'arte could be identified by four specific characteristics. The first was improvization. Even though fully fledged productions had plots and sub-plots, dialogue was completely improvized within the plot outline, or scenario. A few works were serious, and some pastoral, but most were comic. The acting style appears to have been naturalistic, though the actors needed good entrance and exit lines as well as repartee.

The second characteristic was the use of stock characters—young lovers, old fathers, braggart soldiers, and comic servants, or *zanni*. All wore stock costumes, which the audience could easily identify. Actors portraying these roles required great skill, physical dexterity, and timing, since much of the humor was visual. The famous actor who played Scaramouche, Tiberio Fiorilli, could apparently still box another actor's ears with his foot at the age of 83. Actors in the *commedia* also had to dance, sing, and do acrobatics. Somersaulting without spilling a glass of wine, for example, seems to have brought down the house.

A third characteristic was the use of mime and pantomime. All characters except the lovers and the serving maid wore masks, and attitudes were communicated through gestures.

Finally, *commedia* actors traveled in companies, and each member of the company played the same role over and over again. The practice was so pervasive that actors often lost their own identities. Many actors even changed their original names to those of the stage personages they portrayed.

From the mid-16th to the mid-17th centuries, troupes of *commedia* actors traveled throughout Europe. Their influence and popularity were tremendous, but *commedia* remained an Italian form, although its characters and situations found their way into the theatre of other nations. By the end of the 17th century, *commedia* had, to all intents and purposes, disappeared. One final fact must be noted: *commedia dell'arte* introduced women into the theatre as equals. Their roles were as important as, and often more important than, those of men; women, not boys, played the female parts.

England

While Late Renaissance Italy prepared the way for modern theatre buildings and certain acting techniques, 16th-century England produced a new theatre of convention, and history's foremost playwright. Conclusions about why the arts developed as they did within a particular historical context are never straightforward. While the visual arts in Italy and France prospered under varying forms of extravagant patronage, a theatre of great literary consequence prospered in England, under a monarch who loved the theatre only as long as it did not impose upon her financially. In other words, Elizabeth I encouraged the arts not by patronage of the kind provided by the Medicis, the Church, or other monarchs, but, rather, by benign neglect.

Literary influences in 16th-century England were heavily Italian, and the theatre reflected these influences. Nonetheless, English drama in the middle to late 16th

century had a highly nationalistic flavor, undoubtedly influenced by Henry VIII's break with Rome which separated the English state from the Church.

The Elizabethans loved drama, and the theatres of London saw prince and commoner together among their audiences. They sought and found, usually in the same play, action, spectacle, comedy, character, and intellectual stimulation so deeply reflective of the human condition that Elizabethan plays have found universal appeal through the centuries since their first production.

Shakespeare was the pre-eminent Elizabethan playwright. His appreciation of the Italian Renaissance, and that of his audiences, can be seen in the settings of many of his plays. With true Renaissance expansiveness, Shakespeare went back into history, both British and classical, and far beyond, to the fantasy world of *The Tempest*.

Like most playwrights of his age, Shakespeare wrote for a specific professional company (of which he became a partial owner). The need for new plays to keep the company alive from season to season provided much of the impetus for his prolific writing.

A robust, peculiarly Elizabethan quality exists in Shakespeare's plays. His ideas have universal appeal because of his understanding of human motivation and character, and his ability to probe deeply into emotion. His insights are the dramatic equivalents of Rembrandt's visual probings. Shakespeare's plays reflect life and love, action and nationalism, and they present those qualities in a magnificent poetry that explores and expands the English language in unrivalled fashion. Shakespeare's use of tone, color, and complex or new word meanings gives his plays a musical as well as dramatic quality, which appeals to every generation.

Shakespeare was not the only significant playwright of the English Renaissance stage, however, and the plays of Christopher Marlowe (1564–93) and Ben Jonson (1573–1637) still captivate theatre audiences. Marlowe's love of sound permeates his works, and if his character development is occasionally weak, the heroic grandeur of his action has the universal qualities of Aeschylus and Sophocles.

MASTERWORK
Marlowe—Doctor Faustus

Marlowe's most famous play, first published in 1604, is *The Tragical History of the Life and Death of Doctor Faustus*, or simply *Doctor Faustus*. The story tells the tale of human temptation, fall, and damnation in richly poetic language.

Marlowe's source appears to have been an English translation of the German legend of Faustus that appeared in England at that time. The plot centers on the scholar Faust, who despairs of the limitations of his own learning and of all human knowledge. He turns to magic, and makes a contract with Mephistophilis, a minor devil. They agree that Mephistophilis will assist Faust and be his slave for 24 years. After that, Mephistophilis will claim Faust's soul, and Faust will be damned for eternity. So for 24 years, Faust uses his powers to the full, from playing practical jokes to calling back Helen of Troy. On the last night, he waits in agony and terror. In the end, Mephistophilis comes and carries him off to hell.

The central message is that life on this earth determines the nature of eternal life. The play harkens back to the Medieval morality play in which the forces of good and evil battle for control of the human soul. At the same time, the play shows the Renaissance preoccupation with the quest for knowledge. Faust is an ardent student of the classics and science. He can never know enough, and his very nature exhibits the new need to think for himself.

The tension of the drama arises from the conflict between the Renaissance desire for personal, unlimited power and the Medieval promise of damnation for those who use evil means to gain those ends. Yet the play goes far beyond moralistic tensions and becomes a universal drama about the search for identity. Here is the struggle between personal potential and personal limitation, between seeking the goals that are consonant with being what we are and seeking only those goals that grant us power over others. In Christian terms, *Faust* is about the difference between submitting to grace through repentance and regretting one's actions but failing to repent. In humanist terms, the play is about the willing corruption and eventual self-destruction of a person. In either case, the defiance of moral values leads to catastrophe.

The complexity and depth of Faust's character make the play a tragedy rather than a melodrama. Faust is a sympathetic human being with whom we can identify. He has the classical *hamartia*, or tragic flaw, that leads to his downfall, and he is a universal symbol of humanity. In Aristotelian terms, he is a figure slightly larger than life, a true tragic hero.

Marlowe's powerful poetic language was new in drama at the time. His flexible use of blank verse and the brilliance of his imagery combine to arouse emotion and rivet the audience. The imagery of terror in the final scene is among the most powerful in all drama. In addition, Marlowe's language and imagery unify the play: the patterns in Faust's references to heaven provide a subtle implication of the force from which Faust cannot escape and yet which he must, at the beginning, deny.

Ben Jonson's comedy stands in contrast to Marlowe's heroic tragedy. The play *Every Man in his Humor* documents the lives of a group of Elizabethan eccentrics. Jonson's wit and pen were sharp, and his tolerance was low. His plays were often vicious caricatures of contemporary individuals.

The English playhouse

The structure of Elizabethan theatre buildings is familiar, even though documentation is fairly sketchy. In general, we assume that the audience surrounded the stage on three sides, an inheritance from earlier times when stages were erected in the enclosed courtyards of inns. By 1576, buildings housing the professional theatre existed in London. They were circular in shape ("This wooden O," according to Shakespeare's *Henry* V). A cross-section of society attended them, from commoners in the "pit," or standing area around the stage, to nobility in the galleries, a seating area under a roof. Situated against one wall of the circular building, the stage may or may not have been protected by a canopy, but the great spectacle of Elizabethan drama was by and large an outdoor event. Theatres were constructed of wood; fire was a constant threat and a frequent reality. Johannes de Witt, from whose accounts of a trip to London in 1596 we derive nearly all our knowledge of the physical theatre of the era, claimed that the Swan Theatre could seat 3000 spectators (Fig. **10.31**).

10.31 Interior of the Swan Theatre, Bankside, London (opened 1598). Contemporary pen drawing.

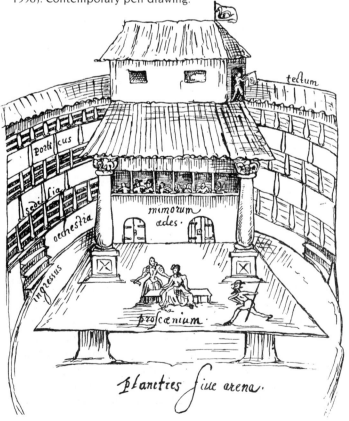

MUSIC
Northern Europe

The volatile courts of Renaissance northern Italy proved important patrons of the performing as well as the visual arts. But the *ars nova* of the 14th century found its most significant successor in the Flemish school of composers, which developed parallel to the Flemish school of painters.

Music historians are not of one mind in labeling the style of this place and time. Some use the term "Franco-Flemish," while others reserve that term for a later, 16th-century development, preferring to call 15th-century Flemish composers the "Burgundian School." The Dukes of Burgundy, like their Italian counterparts, were active patrons of the arts, and the painter Jan van Eyck, for example, benefited greatly from their patronage. As part of their courtly entourage, the dukes retained a group of musicians to provide entertainment and chapel music. Musicians were frequently imported from elsewhere, thus contributing to a cosmopolitan character in the Burgundian courts and disseminating Burgundian influence throughout Europe.

Flemish composers were widely educated and thoroughly aware of the world around them. In their Masses and motets, they made significant contributions to the development of FOUR-PART HARMONY. They gave greater independence to the lower lines, in particular. The bass part was independent for the first time, and this became a typical feature of this style of composition. By the end of the Renaissance, it was normal for all parts to imitate each other using consistent, measured rhythm. They came together only at the ends of sections for cadences, the musical equivalents of punctuation marks. For the first time in history, Flemish music thus used a true four-part texture.

Guillaume Dufay and Josquin des Prez were the most prominent composers to work in this style. Dufay (1400–74) had been a member of the Papal Chapel at Rome and Florence, and he had traveled extensively throughout Europe. Thus he brought to Flanders a wealth of knowledge and experience. Within his lifetime, he was hailed as one of the great composers of the era. He wrote prolifically, and a wealth of his work has been published in modern editions. His style is striking for its relative straightforwardness as compared with the complexity of much late Gothic music. Dufay's sacred motets based on the chant *Salve regina* formed the basis for numerous later polyphonic settings of the Mass. He also wrote many secular songs in the standard Medieval forms, such as rondeaux and ballades, of which about 80 have survived.

Patronage and secular influence on music continued. The printing press enabled music, like the written word, to be transmitted easily. More music than ever before was composed, and people started to identify composers as individuals. They strove to achieve an "ideal" sound, by

which they meant four or more voice lines of similar and compatible timbres (as opposed to the contrasting timbres of earlier periods). Small groups of singers on each part replaced the earlier soloists. Composers concentrated on making each work a unified whole. The practise of combining texts in different languages within one piece died out. Much more attention was given to the relationship of music and text; clarity of communication became one of the objectives of music. According to the values of the day, the ideal vehicle for musical communication was an unaccompanied vocal ensemble. These characteristics are exemplified in the works of Josquin des Prez (1450–1521).

Like Dufay, Josquin was trained in Milan, Rome, and Florence, among other places, and he brought to Flanders an equally rich but somewhat later Renaissance heritage. He was compared to Michelangelo, and called the "father of musicians." He wrote about 70 secular songs of a light, homophonic nature similar to that popular in Italy at the time. But his chief contribution lay in the area of polyphonic development, as seen in his Masses and motets. Imitation became an important structural feature: for each group of words, a short musical theme would be presented in one voice and then be restated (imitated) in the other voices. The overlapping of phrases wove a wonderful mesh of sound. From time to time this would be interrupted by chordal sections where the voices moved together. Another structural device he sometimes used in motets was the repetition of sections of music. Thus, in "Memore esto verbi tui," an opening section (A) is followed by new material (B), and is then restated in the third section (A). This later became known as ABA form.

Compared to the music of the previous era, Josquin's is more flowing, with more varied rhythms, and the general sound is fuller and richer. Above all, emotion begins to shine through, so the listener can immediately tell the difference between a religious work of rejoicing or penitence.

In mid-15th century Germany, the Early Renaissance spirit, with its secular traditions, produced polyphonic LIEDER, or songs. These predominantly three-part, secular songs provided many melodies for the church hymns of Lutheranism after the Reformation. Heinrich Isaac (1450–1517) was probably the first and most notable German Lied composer of this era. He was a prolific musician, and his diverse background, which included living at various times in Italy, the Netherlands, and France, gave his work an international flavor. He and other Lieder composers adapted folk songs into polyphonic settings. This practice can be seen in one of Isaac's most famous works, "Innsbruck, I must leave thee." Here Isaac took a folk love song and cast it as a polyphonic piece with words by the Emperor Maximilian. Later Isaac used the melody in his own sacred work, the Missa Carminum. The song then became widely known in another adaptation under the sacred title, "O world, I now must leave thee," which was used by Johann Sebastian Bach in his St Matthew Passion.

A sense of the quality of Renaissance music in the early 15th century is given by a French poem of about 1440. It refers to the English composer John Dunstable and comments on the "English countenance" that helped to make European music so "joyous and bright" with "marvelous pleasantness." Humankind had found a note of optimism in a period that was devoted to living enjoyably. Certainly there were troubles, but God and his mortal children had a fairly comfortable and comforting relationship.

The Reformation

The Reformation brought many changes to Church music. Music disappeared completely from Calvinist services and appeared in new forms in Lutheran ones. Even after the separation, Lutheran music maintained many Roman Catholic elements, including Latin texts and plainsong chants. The most important contribution of the Lutheran Reformation was the CHORALE. Originally, the chorale was a single melody, taken from a chant or folk song, with text, which the congregation sang in unison and without accompaniment. Modern hymns, many of which date back to Martin Luther for both text and tune, are examples of the chorale form. Four-part harmonies were added later, although a recent edition of the Lutheran Book of Worship attempts to return to the early chorale form.

Lutheranism also contributed a considerable body of polyphonic choral settings, many from Luther's principal collaborator Johann Walter (1496–1574). These settings vary tremendously both in style and source. Some were based on German Lieder and some on Flemish motets. The complex texture of polyphony, however, is not well suited to congregational singing, and polyphonic settings were reserved for the choir. By the end of the 16th century, Lutheran congregational singing had changed again: the congregation was supported by the organ, which played harmonic parts while the congregation sang the melody.

Instrumental music

Instruments were used in the Renaissance to accompany voices, sometimes doubling the voices, sometimes filling in for a part when no singers were available. Secular part-songs, such as madrigals, were often issued "for voices or viols." Viols of different sizes (and thus different tone colors and pitch ranges) were grouped together into so-called "consorts." Similarly, recorders were played together in groups. Initially they played arrangements of vocal pieces; later, dance music and instrumental consort

music was composed especially for them. Other instruments of the period include the lute, suitable only for soft, indoor music, and the cornett, trumpet, shawm, and sackbut, suitable for playing outdoors to accompany dancing or processions.

DANCE

Out of the same northern Italian courts that supported Renaissance painting and sculpture came the foundations of theatre dance. Indeed, the visual and geometric characteristics of dance as we know it today are firmly rooted in the developments of the Italian Renaissance. Dance moved from a social milieu (Fig. **10.32**) to a theatrical one as the Italians, especially in Florence, began to create patterns in body movements. As in all the arts, there was an increasing concern for "rules" and conventionalized vocabulary.

Mummeries, pageants, and other performances dating back to the traveling pantomimes of the Middle Ages emerged as formal dance in the elaborate entertainments of 15th-century Italian courts. These were spectacular

10.32 Social dancing, from a 15th-century English chronicle by Jean de Waurin in Vienna. The New York Public Library.

displays, although they remained more social than theatrical. Concern for perfection, for individual expression, dignity, and grace, created a vocabulary for dance steps and a choreography of dance patterns and designs. Courtly surroundings added refinement and restraint, and the dancing master assumed greater importance and control as he designed elegant movements. Increasingly, dance came to be seen as something to watch rather than something to do.

An important milestone in theatrical dance occurred at this time. Guglielmo Ebreo of Pesaro wrote one of the first compilations of dance description and theory. As he tried to record this complex and visually oriented activity, he stressed memory as one of the essential ingredients of the dancer's art. His observation isolated the most critical element of dance tradition, one that even today keeps dance alive and enables it to be transmitted from generation to generation of dancers. Film and labanotation have still not replaced the personal memory by which the traditions of dance are passed along.

Guglielmo's work was a clear record of formal dance composition. He strove to bring dance out of the disrepute into which it had fallen in the bawdy pantomimes of previous eras and to make it fully acceptable from an aesthetic standpoint. For Guglielmo, dance was an art of grace and beauty.

ARCHITECTURE
Early Renaissance in Florence

Developments in Early Renaissance architecture took place primarily in Florence. There were three significant stylistic departures from Medieval architecture. First, architects became concerned with reviving classical models along mechanical lines. They measured ruins of Roman buildings carefully and translated their proportions into Renaissance buildings. Roman arches became geometric devices by which formally derived designs could be composed. Second, decorative detail, that is, nonstructural ornamentation, on the façades of buildings now came into favor. Third, there was a radical change in the outer expression of structure. The outward form of a building had previously been closely related to its structural systems, that is, the structural supports of the building. In the Renaissance, supporting elements—posts and lintels, masonry, and arches—were hidden from view. External appearance was no longer subordinated to structural concerns, and it took on a life of its own.

Early architecture of the period, such as the dome of Florence Cathedral (Fig. **10.33**) designed by Filippo Brunelleschi (1377–1446), was an imitation of classical

10.33 Filippo Brunelleschi, dome of Florence Cathedral, 1420–36. 180 ft (54.86 m) high.

forms appended to Medieval structures. In the curious design of Brunelleschi's dome, the structure, which was added in the 15th century to a 14th-century building, rises 180 feet into the air. Its height is apparent both from the outside and inside. If we compare it with the Pantheon, Brunelleschi's departure from tradition becomes clearer. The dome of the Pantheon is impressive only from the inside of the building because its exterior supporting structure is so massive that it clutters the visual experience. The phenomenal height of Brunelleschi's dome is apparent because the architect has hidden the supporting elements, such as stone and timber girdles and lightweight ribbing. The result is an aesthetic pronouncement that visual appearance is foremost and structural considerations are subordinate. The dome thus becomes related to a work of sculpture.

The Renaissance use of classical ornamentation can be seen in Brunelleschi's Pazzi Chapel (Fig. **10.34**). Small in scale, its walls serve as a plain background for a wealth of surface decoration. Concern for proportion and geometric design is very clear, but the overall composition is not enslaved by arithmetical considerations. Rather, the Pazzi Chapel reflects Brunelleschi's classical aesthetics. Brunelleschi's influence was profound in the first half of the 15th century, and he served as a model and inspiration for later Renaissance architects.

The second half of the 15th century was dominated by the Florentine scholar, writer, architect, and composer Leon Battista Alberti. His treatise *Concerning Architecture* was based on Vitruvius, and it provided a scholarly

10.34 Filippo Brunelleschi, Pazzi Chapel, c.1440–61. S. Croce, Florence.

10.35 Leon Battista Alberti, Palazzo Rucellai, c.1452–70.

approach to architecture that influenced western building for centuries. Alberti's scientific approach to sculpture and painting, as well as to architecture, encompassed theories on Roman antiquity, and tended to reduce aesthetics to rules.

The problems of Renaissance architects were different from those of their predecessors, however. Faced with an expanding range of types of building—townhouses, hospitals, business establishments—for which classical forms had to be adapted, architects had to meet specific practical needs, which, apparently, the ancients did not. This meant that they applied classical detail to a wide range of forms and structures, many of which, like Florence Cathedral, were basically nonclassical. In his Palazzo Rucellai (Fig. **10.35**), Alberti likewise used a system of classical details on a nonclassical building. His design reminds us of the Roman Colosseum in its alternating arches and attached columns of changing orders. His system, however, is rather academic in its effect, as opposed to individual.

The High Renaissance in Rome

At the turn of the 16th century, architecture saw Christian and classical ideas come into balance. At the same time, it moved away from its insistence on decorative surface detail and moved toward a greater concern for space and

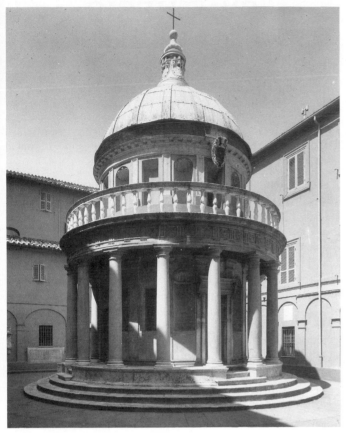

10.36 Donato Bramante, the Tempietto, authorized 1502, completed after 1511. S. Pietro in Montorio, Rome.

10.37 Pierre Lescot, exterior façade of the Square Court of the Louvre, Paris, begun 1546.

volume. The shift of patronage from the local rulers to the Roman Church, which drew the visual artists—painters, sculptors, and architects—to Rome, also brought to architecture a more formal, monumental, and serious style.

A perfect early example of High Renaissance architecture is Bramante's Tempietto or "little temple" (Fig. **10.36**). Pope Julius II wanted all Roman basilica-form churches replaced by magnificent monuments that would overshadow the remains of Imperial Rome, and the Tempietto was built as part of this plan. The building was authorized in 1502, to be set on the spot where St Peter was believed to have been crucified. However, the work was not completed until after 1511.

In contrast to the Corinthian and Ionic details that had been popular, Bramante chose for the Tempietto the more severe Doric order. The circular plan, however, gave him a new flexibility. The culmination of this style appears in Bramante's design for St Peter's, a design later revised by Michelangelo and finished, later still, by Giacomo della Porta (**10.41** and **10.43–10.45**). The geometrical and symmetrical design of St Peter's was based on the circle and the square, over which perched a tremendous dome surrounded by four lesser domes.

Late Renaissance

By the late 16th century, architecture had taken on Mannerist tendencies, especially in France under Francis I. The Lescot wing of the Louvre (Fig. **10.37**) has a discomfiting design of superficial detail and unusual proportions,

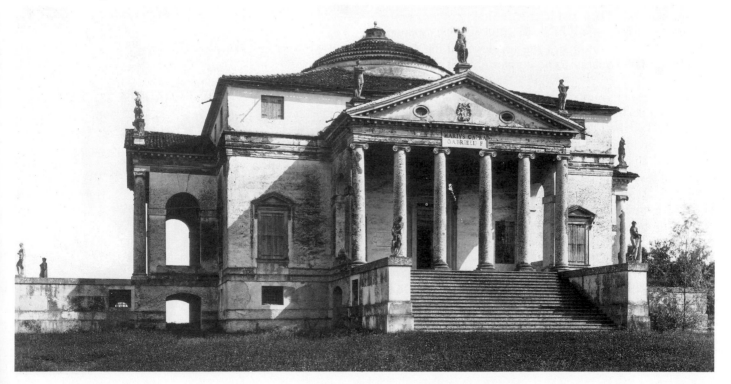

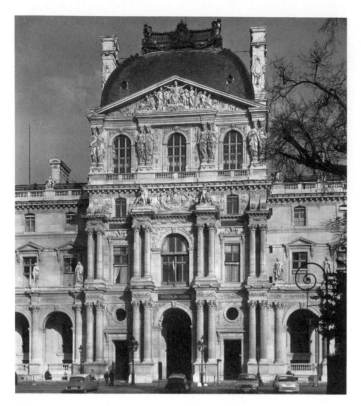

10.38 Palladio, Villa Rotonda, Vicenza, begun 1567–69.

with strange juxtapositions of curvilinearity and recti-linearity. Here we find a continuation of decorative detail applied to exterior wall surfaces in the Renaissance fashion. However, careful mathematical proportions have been replaced by a flattened dome and dissimilar treatments of the shallow arches. The helmet-like dome stands in awkward contrast to the pediment of the central section and wears a sort of crown, perched nervously on top. The relief sculptures of the top level of the central section are far too large to be comfortable in their architectural context.

In this same period, another style sprang up that would significantly influence later eras. Andrea Palladio (1518–80) designed villas and palaces which reflected his clients' individuality and pride in their worldly possessions. The Villa Rotonda in Vicenza (Fig. **10.38**) shows strong classical influences, combining Greek and Roman details. The porticos carry freestanding Ionic columns, and the dome is reminiscent of the Pantheon. The rooms of the villa are arranged symmetrically around the central rotunda. Palladio's mathematical combination of cubes and circles is characteristic of the Renaissance, but he has cleansed the exterior surfaces of detail, placing the decorative sculpture above, in anticipation of baroque treatments. Palladio explained his designs in *Four Books on Architecture*, which were highly influential in establishing canons later used in various "revival" periods. Thomas Jefferson's Monticello in the United States is one such example (Fig. **12.31**).

SYNTHESIS
Papal splendor: the Vatican

Here for almost 2000 years has been the center of a spiritual communion; in countries all over the world, Christians aspire to achieve a community of spirit with the succesor to St Peter. By comprehending this significance of the Vatican, one can also understand what it was that led Roman Catholicism to embellish the center of its spiritual power with the diversity of human knowledge, including the arts.[5]

The Vatican owes most of its splendor to the Renaissance, and particularly the High Renaissance, when the popes called all great artists to Rome. The papacy as a force and the Vatican as the symbol of that force represent a synthesis of Renaissance ideas and reflections. Rome was the city devoted to the arts in the 15th and 16th centuries. The artists of the age rediscovered classical antiquity and emulated what they found. Imitation was frowned upon, and the classical quality of Renaissance art lies in its expressiveness, which is indeed comparable to that of Greece and Rome. St Peter's and the Vatican also have earthly and heavenly qualities which reflect the reality of the Church on earth and the mystery of the spiritual Church of Christ.

The magnificence of the Vatican lies in its scale, its detail, and above all, in the enormous dome (Figs **10.40–10.41**), the focal point as seen from the outside.

10.39 Gianlorenzo Bernini, statues on the colonnade of St Peter's Square, Rome, colonnade designed 1657.

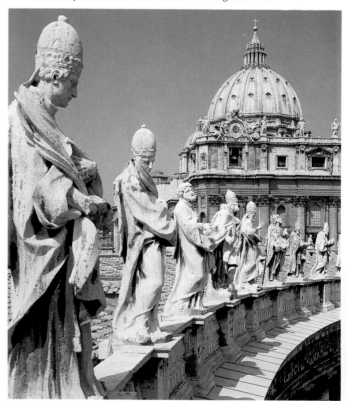

10.40 (opposite) Interior of the dome of St Peter's, Rome.

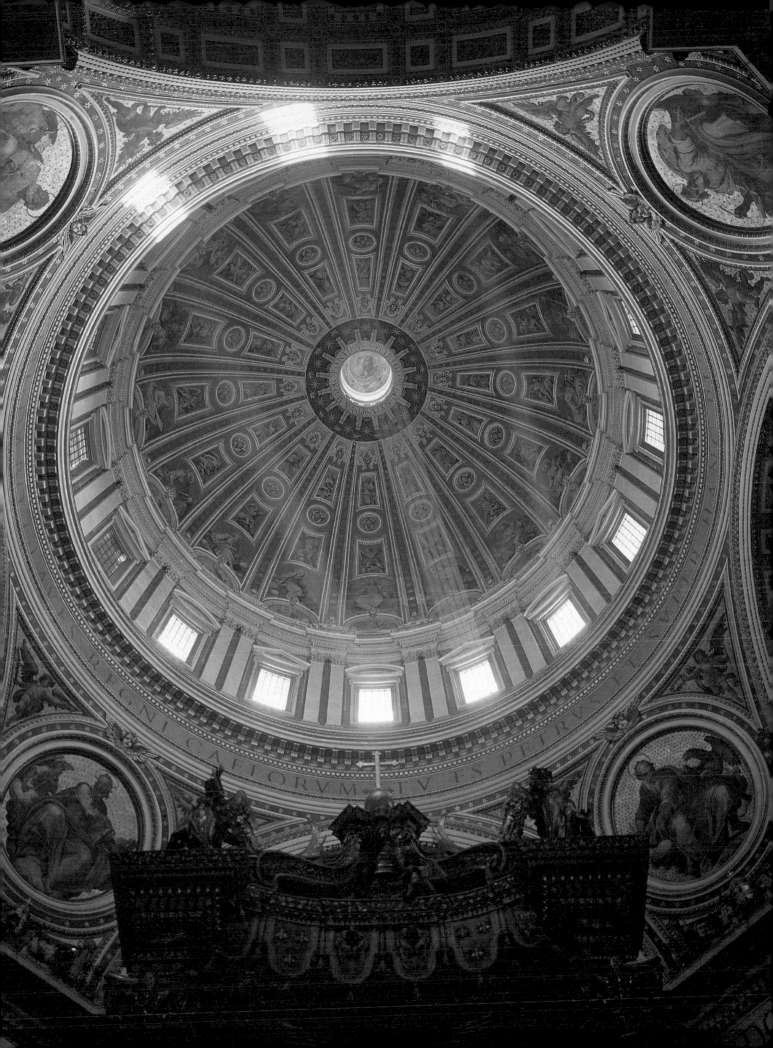

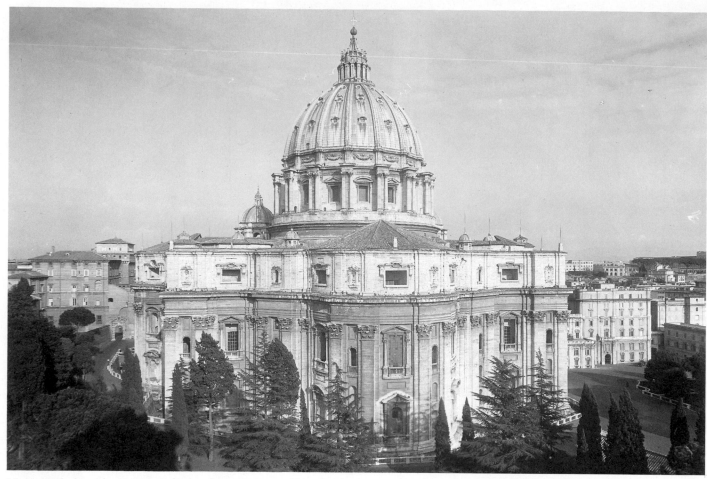

10.41 Michelangelo, St Peter's, Rome, from the west, 1546–64 (dome completed by Giacomo della Porta, 1590).

St. Peter's and Vatican City.
 1 New Picture Gallery (Pinacoteca)
 2 Archives; Library
 3 Post Office
 4 Barracks of the Swiss Guard
 5 Court of S. Damaso
 6 Sistine Chapel
 7 Casino of Pope Pius IV
 8 Papal Academy of Science
 9 Grotto of Lourdes
10 Vatican Radio
11 Ethiopian Seminary
12 Government Palace
13 S. Stefano
14 Mosaic Factory
15 Court
16 Apartments of the Archpriest
17 Hospice of S. Marta
18 Sacristy
19 Campo Santo Teutonico
20 Palace of S. Uffizio
21 Papal Apartments

Border of Vatican City

Entrances

Gardens and Parks

10.42 Plan of the Vatican and St Peter's, Rome.

Renaissance domes were intended to provide large sculptural forms against the skyline, so architects raised them on tall cylinders and often placed large central lanterns on at their tops. The dome of St Peter's, a double shell of brick and stone, weighs hundreds of tons and caused critical structural problems. St Peter's lacks the solid surrounding walls of the Pantheon, and the supporting structure does little to stop the outward spread as the weight of the dome pushes downward and outward. Cracking occurred almost immediately, and a series of massive chains was placed around the base of the dome to hold it in position.

The entire complex of the Vatican, with St Peter's as its focal point, is a vast scheme of parks, gardens, fountains, and buildings (Fig. **10.42**). The colonnades of St Peter's Square are decorated with 140 majestic statues of popes, bishops, and apostles by Bernini (Fig. **10.39**). Larger than life and harmonious in design, these works reach upward and create a finishing touch to the square, the façade, and the dome.

Plans for replacement of the original basilica of Old St Peter's were made by Nicholas V (1447–55) in the 15th century, but it was Pope Julius II (1503–13) who decided actually to put those plans into effect. Julius commissioned Bramante to construct the new basilica. Bramante's design called for a building in the form of a GREEK CROSS (Fig. **10.43**). The work was planned as "an harmonious arrangement of architectural forms" in an "image of bright amplitude and picturesque liveliness."

When Bramante died in 1514, two of his assistants, and Raphael, continued his work. However, liturgical considerations required an elongated structure, and these and other changes were made by additional architects, whose designs were severely criticized by Michelangelo. Following the death of the last of these architects, Pope Paul III (1534–49) convinced Michelangelo to become chief architect. Michelangelo set aside liturgical considerations and returned to Bramante's original conceptions, which he described as "clear and pure, full of light . . . whoever distances himself from Bramante, also distances himself from the truth" (Fig. **10.44**). Michelangelo's project was completed in May of 1590, as the last stone was added to the dome, and a High Mass was celebrated. Work on the 36 columns continued, however. This was completed by Della Porta and Fontana after Michelangelo's death. Full completion of the basilica as it stands today had to wait for the direction of yet more architects, including Maderno. Maderno was forced to yield to the wishes of the cardinals and change the original form of the Greek cross to a LATIN CROSS (Fig. **10.45**). As a result, the Renaissance design of Michelangelo and Bramante, with its central altar, was put aside. It was replaced by Maderno's design of a TRAVERTINE façade of gigantic proportions and sober elegance. His extension of the basilica was influential in the development of baroque architecture. The project was finally completed in 1615.

Throughout the Vatican complex there are magnificent paintings and sculptures of Renaissance, High Renaissance, Counter-Reformation, and baroque styles. Raphael's Loggia (Fig. **10.46**) forms part of the Vatican Palace apartments. Based on Raphael's study of ancient Rome and its buildings, the Loggia's theme is one of

10.43 Bramante's design for St Peter's, 1506.

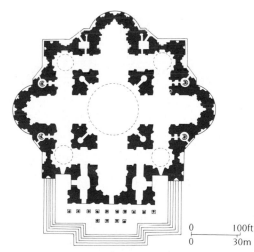

10.44 Michelangelo's design for St Peter's, 1547.

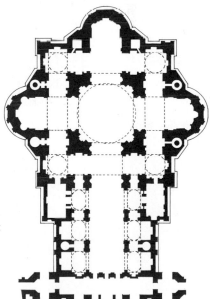

10.45 Plan of St Peter's as built to Michelangelo's design, with alterations by Carlo Maderno, 1606–15.

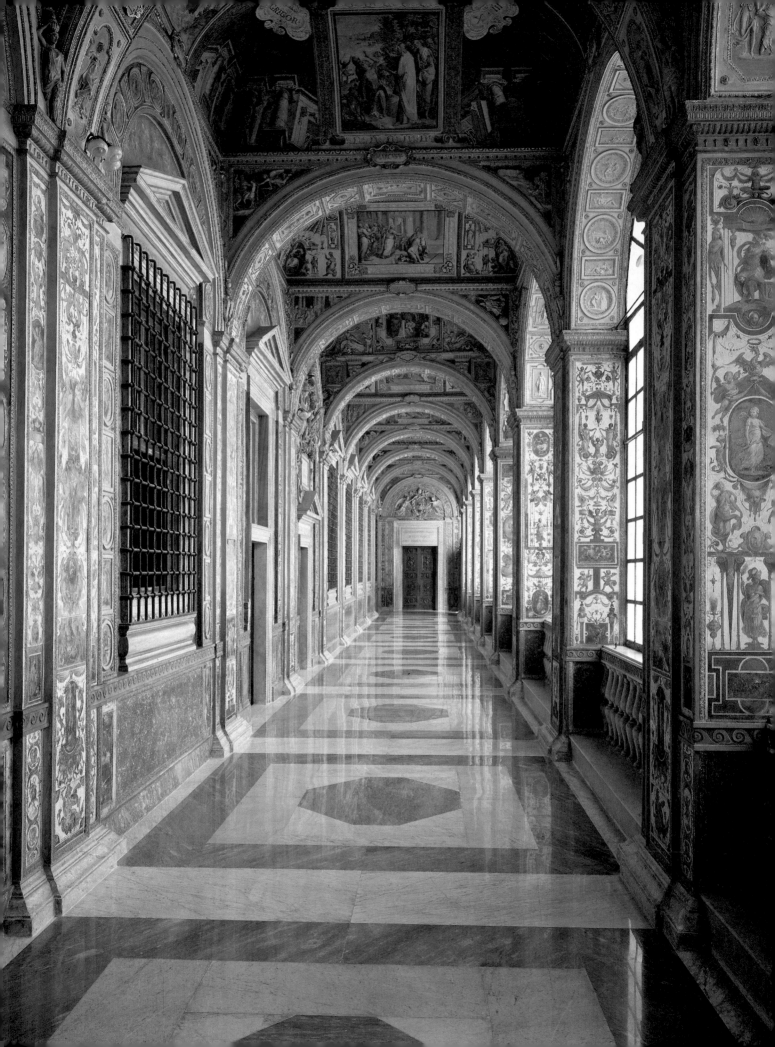

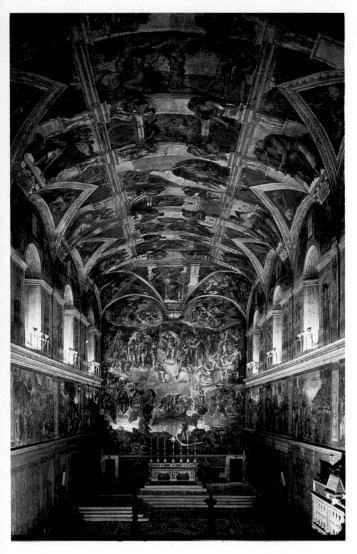

10.47 Michelangelo, Sistine Chapel, Rome, showing the ceiling (1508–12) and *Last Judgment* (1534–41).

delight in seemingly inexhaustible inventiveness. Flowers, fruit, vegetables, bizarre animal figures, and winged PUTTI appear throughout. On the ceiling vault is a series of frescos devoted to Old Testament themes, called *Raphael's Bible*. Raphael's *Deliverance of St Peter* (Fig. **10.19**) is also found in these apartments.

The Vatican is a rich complex that fully reflects its times and the power and wealth of the Church and the papacy. Perhaps its crowning jewel is the Sistine Chapel (Figs **10.15–10.17**), with its magnificent ceiling. But the ceiling is only part of a whole. It is the *entirety* of the Sistine Chapel (Fig. **10.47**) that is a supreme recreation of classical harmony.

SUGGESTIONS FOR THOUGHT AND DISCUSSION

We have seen in this chapter that the Renaissance encompasses a vast array of concepts, styles, and attitudes. And yet in many ways it also saw a continuation of ideas present in the Middle Ages. Certainly interest in neo-Platonic thought continued in this period, but how do the examples in this chapter compare with the examples of neo-Platonism we have seen in previous chapters? What developments were the products of other Medieval ideas?

The concept of humanism and the emergence of the individual as a significant earthly entity are crucial to our understanding of this period. We have seen the rise of the playwright and composer and the emergence of the artist and the architect as individual creators, rather than the anonymous artisans they had been in the Middle Ages. How does this relate to the broader concepts of humanism? And what is the relationship between all these Renaissance accomplishments and the discoveries in science, geography, and economics?

■ What events in the late Middle Ages may have contributed to political and other forces that caused the Reformation and split the Roman Catholic Church?

■ What major stylistic characteristics were common to the arts of the Renaissance?

■ What major stylistic characteristics distinguished the arts of the High Renaissance?

■ Why do we distinguish between the Early Renaissance and the High Renaissance as intellectual and artistic periods?

■ How does the Vatican as an expression of art reflect the ideas, ideals, and needs of Roman Catholicism?

10.46 Raphael's Loggia, Vatican, Rome, c.1516–19.

LITERATURE EXTRACTS

Oration on the Dignity of Man

Pico della Mirandola

I have read in the records of the Arabians, reverend Fathers, that Abdala the Saracen, when questioned as to what on this stage of the world, as it were, could be seen most worthy of wonder, replied: "There is nothing to be seen more wonderful than man." In agreement with this opinion is the saying of Hermes Trismegistus: "A great miracle, Asclepius, is man." But when I weighed the reason of these maxims, the many grounds for the excellence of human nature reported by many men failed to satisfy me—that man is the intermediary between creatures, the intimate of the gods, the king of the lower beings, by the acuteness of his senses, by the discernment of his reason, and by the light of his intelligence the interpreter of nature, the interval between fixed eternity and fleeting time, and (as the Persians say) the bond, nay, rather, the marriage song of the world, on David's testimony but little lower than the angels. Admittedly great though these reasons be, they are not the principal grounds, that is, those which may rightfully claim for themselves the privilege of the highest admiration. For why should we not admire more the angels themselves and the blessed choirs of heaven? At last it seems to me I have come to understand why man is the most fortunate of creatures and consequently worthy of all admiration and what precisely is that rank which is his lot in the universal chain of Being—a rank to be envied not only by brutes but even by the stars and by minds beyond this world. It is a matter past faith and a wondrous one. Why should it not be? For it is on this very account that man is rightly called and judged a great miracle and a wonderful creature indeed.

2

But hear, Fathers, exactly what this rank is and, as friendly auditors, conformably to your kindness, do me this favor. God the Father, the supreme Architect, had already built this cosmic home we behold, the most sacred temple of His godhead, by the laws of His mysterious wisdom. The region above the heavens He had adorned with Intelligences, the heavenly spheres He had quickened with eternal souls, and the excrementary and filthy parts of the lower world He had filled with a multitude of animals of every kind. But, when the work was finished, the Craftsman kept wishing that there were someone to ponder the plan of so great a work, to love its beauty, and to wonder at its vastness. Therefore, when everything was done (as Moses and Timaeus bear witness), He finally took thought concerning the creation of man. But there was not among His archetypes that from which He could fashion a new offspring, nor was there in His treasurehouses anything which He might bestow on His new son as an inheritance, nor was there in the seats of all the world a place where the latter might sit to contemplate the universe. All was now complete: all things had been assigned to the highest, the middle, and the lowest orders.

But in its final creation it was not the part of the Father's power to fail as though exhausted. It was not the part of His wisdom to waver in a needful matter through poverty of counsel. It was not the part of His kindly love that he who was to praise God's divine generosity in regard to others should be compelled to condemn it in regard to himself.

3

At last the best of artisans ordained that that creature to whom He had been able to give nothing proper to himself should have joint possession of whatever had been peculiar to each of the different kinds of being. He therefore took man as a creature of indeterminate nature and, assigning him a place in the middle of the world, addressed him thus: "Neither a fixed abode nor a form that is thine alone nor any function peculiar to thyself have we given thee, Adam, to the end that according to thy longing and according to thy judgment thou mayest have and possess what abode, what form, and what functions thou thyself shalt desire. The nature of all other beings is limited and constrained within the bounds of laws prescribed by Us. Thou, constrained by no limits, in accordance with thine own free will, in whose hand We have placed thee, shalt ordain for thyself the limits of thy nature. We have set thee at the world's center that thou mayest from thence more easily observe whatever is in the world. We have made thee neither of heaven nor of earth, neither mortal nor immortal, so that with freedom of choice and with honor, as though the maker and molder of thyself, thou mayest fashion thyself in whatever shape thou shalt prefer. Thou shalt have the power to degenerate into the lower forms of life, which are brutish. Thou shalt have the power, out of thy soul's judgment, to be reborn into the higher forms, which are divine."

4

O supreme generosity of God the Father, O highest and most marvelous felicity of man! To him it is granted to have whatever he chooses, to be whatever he wills. Beasts as soon as they are born (so says Lucilius) bring with them from their mother's womb all they will ever possess. Spiritual beings, either from the beginning or soon thereafter, become what they are to be for ever and ever. On man when he came into life the Father conferred the seeds of all kinds and the germs of every way of life. Whatever seeds each man cultivates will grow to maturity and bear in him their own fruit. If they be vegetative, he will be like a plant. If sensitive, he will become brutish. If rational, he will grow into a heavenly being. If intellectual, he will be an angel and the son of God. And if, happy in the lot of no created thing, he withdraws into the center of his own unity, his spirit, made one with God, in the solitary darkness of God, who is set above all things, shall surpass them all. Who would not admire this our chameleon? Or who could more greatly admire aught else whatever? It is man who Asclepius of Athens, arguing from

his mutability of character and from his self-transforming nature, on just grounds says was symbolized by Proteus in the mysteries. Hence those metamorphoses renowned among the Hebrews and the Pythagoreans.

5

For the occult theology of the Hebrews sometimes transforms the holy Enoch into an angel of divinity whom they call "Mal'akh Adonay Shebaoth," and sometimes transforms others into other divinities. The Pythagoreans degrade impious men into brutes and, if one is to believe Empedocles, even into plants. Mohammed, in imitation, often had this saying on his tongue: "They who have deviated from divine law become beasts," and surely he spoke justly. For it is not the bark that makes the plant but its senseless and insentient nature; neither is it the hide that makes the beast of burden but its irrational, sensitive soul: neither is it the orbed form that makes the heavens but its undeviating order; nor is it the sundering from body but his spiritual intelligence that makes the angel. For if you see one abandoned to his appetites crawling on the ground, it is a plant and not a man you see; if you see one blinded by the vain illusions of imagery, as it were of Calypso, and softened by their gnawing allurement, delivered over to his senses, it is a beast and not a man you see. If you see a philosopher determining all things by means of right reason, him you shall reverence: he is a heavenly being and not of this earth. If you see a pure contemplator, one unaware of the body and confined to the inner reaches of the mind, he is neither an earthly nor a heavenly being; he is a more reverend divinity vested with human flesh. . . .

7

Let us disdain earthly things, despise heavenly things, and, finally, esteeming less whatever is of the world, hasten to that court which is beyond the world and nearest to the Godhead. There, as the sacred mysteries relate, Seraphim, Cherubim, and Thrones hold the first places; let us, incapable of yielding to them, and intolerant of a lower place, emulate their dignity and their glory. If we have willed it, we shall be second to them in nothing.

The Book of the Courtier

Baldassare Castiglione

Castiglione uses the device of a game consisting of dialogs between members of his circle at the Court of Urbino to draw a picture of the ideal courtier and the ideal society. In Chapter 12, Federigo Fregoso proposes this entertainment, which is supposed to have taken place over four evenings in March 1507.

Book I

12

"My Lady, I would it were permitted me, as it sometimes is, to assent to another's proposal; since for my part I

would readily approve any of the games proposed by these gentlemen, for I really think that all of them would be amusing. But not to break our rule, I say that anyone who wished to praise our court,—laying aside the merit of our lady Duchess, which with her divine virtue would suffice to lift from earth to heaven the meanest souls that are in the world,—might well say without suspicion of flattery, that in all Italy it would perhaps be hard to find so many cavaliers so singularly admirable and so excellent in divers other matters besides the chief concerns of chivalry; as are now to be found here: wherefore if anywhere there be men who deserve to be called good Courtiers and who are able to judge of what pertains to the perfection of Courtiership, it is reasonable to believe that they are here. So, to repress the many fools who by impudence and folly think to win the name of good Courtier, I would that this evening's game might be, that we select some one of the company and give him the task of portraying a perfect Courtier, explaining all the conditions and special qualities requisite in one who deserves this title; and as to those things that shall not appear sound, let everyone be allowed to contradict, as in the schools of the philosophers it is allowed to contradict anyone who propose a thesis."

Messer Federico was continuing his discourse still further, when my lady Emilia interrupted him and said:

"This, if it pleases my lady Duchess, shall for the present be our game."

My lady Duchess answered:

"It does please me."

Then nearly all those present began to say, both to my lady Duchess and among themselves, that this was the finest game that could possibly be; and without waiting for each other's answer, they entreated my lady Emilia to decide who should begin. She turned to my lady Duchess and said:

"Command, my Lady, him who it pleases you should have this task; for I do not wish, by selecting one rather than another, to seem to decide whom I think more competent in this matter than the rest, and so do wrong to anyone."

My lady Duchess replied:

"Nay, make this choice yourself, and take heed lest by not obeying you give an example to the others, so that they too prove disobedient in their turn."

13

—At this my lady Emilia laughed and said to Count Ludovico da Canossa:

"Then not to lose more time, you, Count, shall be the one to take this enterprise after the manner that messer Federico has described; not indeed because we account you so good a Courtier that you know what befits one, but because, if you say everything wrong as we hope you will, the game will be more lively, for everyone will then have something to answer you; while if someone else had this task who knew more than you, it would be impossible to contradict him in anything, because he would tell the truth, and so the game would be tedious."

The Count answered quickly:

"Whoever told the truth, my Lady, would run no risk of lacking contradiction, so long as you were present;" and

after some laughter at this retort, he continued: "But truly I would fain escape this burden, it seeming to me too heavy, and I being conscious that what you said in jest is very true; that is, that I do not know what befits a good Courtier: and I do not seek to prove this with further argument, because, as I do not practice the rules of Courtiership, one may judge that I do not know them; and I think my blame may be the less, for sure it is worse not to wish to do well than not to know how. Yet, since it so happens that you are pleased to have me bear this burden, I neither can nor will refuse it, in order not to contravene our rule and your judgment, which I rate far higher than my own."

14

—"I wish, then, that this Courtier of ours should be nobly born and of gentle race; because it is far less unseemly for one of ignoble birth to fail in worthy deeds, than for one of noble birth, who, if he strays from the path of his predecessors, stains his family name, and not only fails to achieve but loses what has been achieved already; for noble birth is like a bright lamp that manifests and makes visible good and evil deeds, and kindles and stimulates to virtue both by fear of shame and by hope of praise. And since this splendor of nobility does not illumine the deeds of the humbly born, they lack that stimulus and fear of shame, nor do they feel any obligation to advance beyond what their predecessors have done; while to the nobly born it seems a reproach not to reach at least the goal set them by their ancestors.

"It is true that, by favor of the stars or of nature, some men are endowed at birth with such graces that they seem not to have been born, but rather as if some god had formed them with his very hands and adorned them with every excellence of mind and body. So too there are many men so foolish and rude that one cannot but think that nature brought them into the world out of contempt or mockery. Just as these can usually accomplish little even with constant diligence and good training, so with slight pains those others reach the highest summit of excellence. And to give you an instance: you see my lord Don Ippolito d'Este, Cardinal of Ferrara, who has enjoyed such fortune from his birth, that his person, his aspect, his words and all his movements are so disposed and imbued with this grace, that—although he is young—he exhibits among the most aged prelates such weight of character that he seems fitter to teach than to be taught; likewise in conversation with men and women of every rank, in games, in pleasantry and in banter, he has a certain sweetness and manners so gracious, that whoso speaks with him or even sees him, must needs remain attached to him forever.

"But to return to our subject: I say that there is a middle state between perfect grace on the one hand and senseless folly on the other; and those who are not thus perfectly endowed by nature, with study and toil can in great part polish and amend their natural defects. Besides his noble birth, then, I would have the Courtier favored in this regard also, and endowed by nature not only with talent and beauty of person and feature, but with a certain grace and (as we say) air that shall make him at first sight pleasing and agreeable to all who see him; and I would have this an ornament that should dispose and unite all his actions, and in his outward aspect give promise of whatever is worthy the society and favor of every great lord."

15

—Here, without waiting longer, my lord Gaspar Pallavicino said:

"I quite agree with what you say as to the good fortune of those endowed from birth with advantages of mind and body: but this is seen as well among the humbly born as among the nobly born, since nature has no such subtle distinctions as these; and often, as I said, the highest gifts of nature are found among the most obscure. Therefore, since this nobility of birth is won neither by talent nor by strength nor by craft, and is rather the merit of our predecessors than our own, it seems to me too extravagant to maintain that if our Courtier's parents be humbly born, all his good qualities are spoiled, and that all those other qualifications that you mentioned do not avail to raise him to the summit of perfection; I mean talent, beauty of feature, comeliness of person, and that grace which makes him always charming to everyone at first sight."

16

—Then Count Ludovico replied:

"I do not deny that the same virtues may rule the low-born and the noble: but (not to repeat what we have said already or the many other arguments that could be adduced in praise of noble birth, which is honored always and by everyone, it being reasonable that good should beget good), since we have to form a Courtier without flaw and endowed with every praiseworthy quality, it seems to me necessary to make him nobly born, as well for many other reasons as for universal opinion, which is at once disposed in favor of noble birth. For if there be two Courtiers who have as yet given no impression of themselves by good or evil acts, as soon as the one is known to have been born a gentleman and the other not, he who is low-born will be far less esteemed by everyone than he who is high-born, and will need much effort and time to make upon men's minds that good impression which the other will have achieved in a moment and merely by being a gentleman. And how important these impressions are, everyone can easily understand: for in our own case we have seen men present themselves in this house, who, being silly and awkward in the extreme, yet had throughout Italy the reputation of very great Courtiers; and although they were detected and recognized at last, still they imposed upon us for many days, and maintained in our minds that opinion of them which they first found impressed there, although they conducted themselves after the slightness of their worth. We have seen others, held at first in small esteem, then admirably successful at the last.

17

—"But to come to some details, I am of opinion that the principal and true profession of the Courtier ought to be that of arms; which I would have him follow actively above all else, and be known among others as bold and strong,

and loyal to whomsoever he serves. And he will win a reputation for these good qualities by exercising them at all times and in all places, since one may never fail in this without severest censure. And just as among women, their fair fame once sullied never recovers its first luster, so the reputation of a gentleman who bears arms, if once it be in the least tarnished with cowardice or other disgrace, remains forever infamous before the world and full of ignominy. Therefore the more our Courtier excels in this art, the more he will be worthy of praise: and yet I do not deem essential in him that perfect knowledge of things and those other qualities that befit a commander; since this would be too wide a sea, let us be content, as we have said, with perfect loyalty and unconquered courage, and that he be always seen to possess them. For the courageous are often recognized even more in small things than in great: and frequently in perils of importance and where there are many spectators, some men are to be found, who, although their hearts be dead within them, yet, moved by shame or by the presence of others, press forward almost with their eyes shut, and do their duty God knows how. While on occasions of little moment, when they think they can avoid putting themselves in danger without being detected, they are glad to keep safe. But those who, even when they do not expect to be observed or seen or recognized by anyone, show their ardor and neglect nothing, however paltry, that may be laid to their charge,—they have that strength of mind which we seek in our Courtier.

"Therefore let the man we are seeking be very bold, stern, and always among the first, where the enemy are to be seen; and in every other place, gentle, modest, reserved, above all things avoiding ostentation and that impudent self-praise by which men ever excite hatred and disgust in all who hear them."

18

—Then my lord Gaspar replied:

"As for me, I have known few men excellent in anything whatever, who do not praise themselves; and it seems to me that this may well be permitted them; for when anyone who feels himself to be of worth, sees that he is not known to the ignorant by his works, he is offended that his worth should lie buried, and needs must in some way hold it up to view, in order that he may not be cheated of the fame that is the true reward of worthy effort. Thus among the ancient authors, whoever carries weight seldom fails to praise himself. They indeed are insufferable who do this without desert, but such we do not presume our Courtier to be."

The Count then said:

"If you heard what I said, it was impudent and indiscriminate self-praise that I censured: and as you say, we surely ought not to form a bad opinion of a brave man who praises himself modestly, nay we ought rather to regard such praise as better evidence than if it came from the mouth of others. I say, however, that he, who in praising himself runs into no error and incurs no annoyance or envy at the hands of those that hear him, is a very discreet man indeed and merits praise from others in addition to that which he bestows upon himself;

because it is a very difficult matter."

Then my lord Gaspar said:

"You must teach us that."

The Count replied:

"Among the ancient authors there is no lack of those who have taught it; but to my thinking, the whole art consists in saying things in such a way that they shall not seem to be said to that end, but let fall so naturally that it was impossible not to say them, and while seeming always to avoid self-praise, yet to achieve it; but not after the manner of those boasters, who open their mouths and let the words come forth haphazard. Like one of our friends a few days ago, who, being quite run through the thigh with a spear at Pisa, said he thought it was a fly that had stung him; and another man said he kept no mirror in his room because, when angry, he became so terrible to look at, that the sight of himself would have frightened him too much."

Everyone laughed at this, but messer Cesare Gonzaga added:

"Why do you laugh? Do you not know that Alexander the Great, on hearing the opinion of a philosopher to be that there was an infinite number of worlds, began to weep, and being asked why he wept, replied, 'Because I have not yet conquered one of them;' as if he would fain have vanquished all? Does not this seem to you a greater boast than that about the fly-sting?"

19

—The Count now paused a little, and messer Bernardo Bibbiena said, laughing:

"I remember what you said earlier, that this Courtier of ours must be endowed by nature with beauty of countenance and person, and with a grace that shall make him so agreeable. Grace and beauty of countenance I think I certainly possess, and this is the reason why so many ladies are ardently in love with me, as you know; but I am rather doubtful as to the beauty of my person, especially as regards these legs of mine, which seem to me decidedly less well proportioned than I should wish: as to my bust and other members however, I am quite content. Pray, now, describe a little more in particular the sort of body that the Courtier is to have, so that I may dismiss this doubt and set my mind at rest."

After some laughter at this, the Count continued:

"Of a certainty that grace of countenance can be truly said to be yours, nor need I cite further example than this to show what manner of thing it is, for we unquestionably perceive your aspect to be most agreeable and pleasing to everyone, albeit the lineaments of it are not very delicate. Still it is of a manly cast and at the same time full of grace; and this characteristic is to be found in many different types of countenance. And of such sort I would have our Courtier's aspect; not so soft and effeminate as is sought by many, who not only curl their hair and pluck their brows, but gloss their faces with all those arts employed by the most wanton and unchaste women in the world; and in their walk, posture and every act, they seem so limp and languid that their limbs are like to fall apart; and they pronounce their words so mournfully that they appear about to expire upon the spot: and the more they

find themselves with men of rank, the more they affect such tricks. Since nature has not made them women, as they seem to wish to appear and be, they should be treated not as good women but as public harlots, and driven not merely from the courts of great lords but from the society of honest men.

20

—"Then coming to the bodily frame, I say it is enough if this be neither extremely short nor tall, for both of these conditions excite a certain contemptuous surprise, and men of either sort are gazed upon in much the same way that we gaze on monsters. Yet if we must offend in one of the two extremes, it is preferable to fall a little short of the just measure of height than to exceed it, for besides often being dull of intellect, men thus huge of body are also unfit for every exercise of agility, which thing I should much wish in the Courtier.

21

—"Moreover I deem it very important to know how to wrestle, for it is a great help in the use of all kinds of weapons on foot. Then, both for his own sake and for that of his friends, he must understand the quarrels and differences that may arise, and must be quick to seize an advantage, always showing courage and prudence in all things. Nor should he be too ready to fight except when honor demands it; for besides the great danger that the uncertainty of fate entails, he who rushes into such affairs recklessly and without urgent cause, merits the severest censure even though he be successful. But when he finds himself so far engaged that he cannot withdraw without reproach, he ought to be most deliberate, both in the preliminaries to the duel and in the duel itself, and always show readiness and daring. Nor must he act like some, who fritter the affair away in disputes and controversies, and who, having the choice of weapons, select those that neither cut nor pierce, and arm themselves as if they were expecting a cannonade; and thinking it enough not to be defeated, stand ever on the defensive and retreat,—showing therein their utter cowardice.

22

—"There are also many other exercises, which although not immediately dependent upon arms, yet are closely connected therewith, and greatly foster manly sturdiness; and one of the chief among these seems to me to be the chase, because it bears a certain likeness to war: and truly it is an amusement for great lords and befitting a man at court, and furthermore it is seen to have been much cultivated among the ancients. It is fitting also to know how to swim, to leap, to run, to throw stones, for besides the use that may be made of this in war, a man often has occasion to show what he can do in such matters; whence good esteem is to be won, especially with the multitude, who must be taken into account withal. Another admirable exercise, and one very befitting a man at court, is the game of tennis, in which are well shown the disposition of the body, the quickness and suppleness of every member, and all those qualities that are seen in nearly every other exercise. Nor less highly do I esteem vaulting on horse,

which although it be fatiguing and difficult, makes a man very light and dexterous more than any other thing; and besides its utility, if this lightness is accompanied by grace, it is to my thinking a finer show than any of the others.

"Our Courtier having once become more than fairly expert in these exercises, I think he should leave the others on one side: such as turning somersaults, rope-walking, and the like, which savor of the mountebank and little befit a gentleman.

"But since one cannot devote himself to such fatiguing exercises continually, and since repetition becomes very tiresome and abates the admiration felt for what is rare, we must always diversify our life with various occupations. For this reason I would have our Courtier sometimes descend to quieter and more tranquil exercises, and in order to escape envy and to entertain himself agreeably with everyone, let him do whatever others do, yet never departing from praiseworthy deeds, and governing himself with that good judgment which will keep him from all folly; but let him laugh, jest, banter, frolic and dance, yet in such fashion that he shall always appear genial and discreet, and that everything he may do or say shall be stamped with grace."

Book III

9

[Discussion has now moved on to the qualities of the ideal court lady.]

—"And since my lord Gaspar further asks what these many things are whereof she ought to have knowledge, and in what manner she ought to converse, and whether her virtues ought to contribute to her conversation,—I say I would have her acquainted with that which these gentlemen wished the Courtier to know. And of the exercises that we have said do not befit her, I would have her at least possess such understanding as we may have of things that we do not practice; and this in order that she many know how to praise and value cavaliers more or less, according to their deserts.

"And to repeat in a few words part of what has been already said, I wish this Lady to have knowledge of letters, music, painting, and to know how to dance and make merry; accompanying the other precepts that have been taught the Courtier with discreet modesty and with the giving of a good impression of herself. And thus, in her talk, her laughter, her play, her jesting, in short, in everything, she will be very graceful, and will entertain appropriately, and with witticisms and pleasantries befitting her, everyone who shall come before her. And although continence, magnanimity, temperance, strength of mind, prudence, and the other virtues, seem to have little to do with entertainment, I would have her adorned with all of them, not so much for the sake of entertainment (albeit even there they can be of service), as in order that she may be full of virtue, and to the end that these virtues may render her worthy of being honored, and that her every act may be governed by them."

10

—My lord Gaspar then said, laughing:

"Since you have given women letters and continence and magnanimity and temperance, I only marvel that you would not also have them govern cities, make laws, and lead armies, and let the men stay at home to cook or spin."

The Magnifico replied, also laughing:

"Perhaps even this would not be amiss." Then he added: "Do you not known that Plato, who certainly was no great friend to women, gave them charge over the city, and gave all other martial duties to the men? Do you not believe that there are many to be found who would know how to govern cities and armies as well as men do? But I have not laid these duties on them, because I am fashioning a Court Lady and not a Queen."

The Praise of Folly

[1509] Desiderius Erasmus

Personifying Folly as a woman, Erasmus dramatizes the dialectic between knowledge and ignorance. As a Humanist, Erasmus holds to the middle ground. But, in a blend of humor and erudition, Folly herself implies that one should suffer fools gladly and be sceptical of scholars.

[Folly herself speaks:]

Whatever the world says of me (for I am not ignorant of Folly's poor reputation, even among the most foolish), yet I and I alone provide joy for gods and men. I no sooner step up to speak to this full assembly than all your faces put on a kind of new and unwonted pleasantness. So suddenly have you cleared your brows, and with so pleasant and hearty a laughter given me your applause, that in truth, as many of you as I behold on every side of me, seem to me no less than Homer's gods drunk with nectar and the drug nepenthe; whereas before, you sat as lumpish and pensive as if you had come from consulting an oracle. And as it usually happens when the sun begins to show his beams, or when after a sharp winter the spring breathes afresh on the earth, all things immediately get a new face, new color, and recover as it were a certain kind of youth again: in like manner, but by beholding me, you have in an instant gotten another kind of countenance; and so what the otherwise great orators with their tedious and long-studied speeches can hardly effect, to wit, to remove the trouble of the mind, I have done it at once, with my single look.

But if you ask me why I appear before you in this strange dress, be pleased to lend me your ears, and I will tell you; not those ears, I mean, you carry to church, but abroad with you, such as you are wont to prick up to jugglers, fools, and buffoons, and such as our friend Midas once gave to Pan. For I am disposed awhile to play the sophist with you; not of their sort who nowadays cram boys' heads with certain empty notions and curious trifles, yet teach them nothing but a more than womanish obstinancy of scolding: but I'll imitate those ancients, who, that they might the better avoid that infamous appellation of Sophi or Wise, chose rather to be called "sophists." Their business was to celebrate the praises of the gods and valiant men. And the like encomium shall you hear from me, but neither of Herakles nor Solon, but mine own dear self, that is to say, Folly.

I think it high time to look down a little on the earth: wherein you'll find nothing frolicky or fortunate, that it owes not to me. So provident has that great parent of mankind, nature, been, that there should not be anything without its mixture, as it were seasoning, of Folly. For since according to the definition of the Stoics, wisdom is nothing else than to be governed by reason: and on the contrary Folly, to be given up to the will of our passions: that the life of man might not be altogether disconsolate and hard to put up with, of how much more passion than reason has Jupiter composed us? putting in, as one would say, "scarce half an ounce to the pound." Besides, he has confined reason to a narrow corner of the brain, and left all the rest of the body to our passions; as also set up, against this one, two as it were, masterless tyrants—anger that possesses the region of the heart, and consequently the very fountain of life, the heart itself; and lust, that stretches its empire everywhere. Against which double force how powerful reason is, let common experience declare, inasmuch as she, which yet is all she can do, may call out to us until she's hoarse, and tell us the rules of honesty and virtue: while they give up the reins to their governor, and make a hideous clamor, till at last being wearied, he suffer himself to be carried wherever they please to hurry him.

Is not war the very root and matter of all famed enterprise? And yet what more foolish than to undertake it for I know not what trifles, especially when both parties are sure to lose more than they get in the bargain? For of those that are slain, not a word of them: and for the rest, when both sides are close engaged "and the trumpets make an ugly noise," what use of these wise men, I pray, that are so exhausted with study that their thin cold blood has scarcely any spirits left? No, it must be those blunt fat fellows, that by how much more they excel in courage fall short in understanding. Unless perhaps one had rather choose Demosthenes for a soldier, who, following the example of Archilochius, threw away his arms and took to his heels e'er he had scarcely seen his enemy; as ill a soldier, as happy an orator.

But good judgment, you'll say, is not of the least concern in matters of war. In a general way I grant it; but this thing of warring is no part of philosophy, but managed by parasites, pimps, thieves, assassins, peasants, sots, spendthrifts and such other dregs of mankind, not philosophers; who how inept they are in everyday conversation, let Socrates, whom the oracle of Apollo, though not so wisely, judged "the wisest of all men living," be witness; who stepping up to speak about something, I know not what, in public, was forced to come down again well laughed at for his pains. Though yet in this he was not altogether a fool, that he refused the appellation of wise, and returning it back to the oracle, delivered his opinion that a wise man should abstain from meddling with public business; unless perhaps he should have admonished us to beware of wisdom if we intended to be reckoned

among the living, there being nothing but his wisdom that first accused and afterwards sentenced him to the drinking of his poisoned cup. For while, as you find him in Aristophanes, philosophying about clouds and ideas, measuring how far a flea could leap, and admiring that so small a creature as a fly should make so great a buzz, he meddled not with anything that concerned common life.

What should I speak of Theophrastus, who being about to make a speech, became as dumb as if he had met a wolf in his way, which yet would have put courage in a man of war? Or Isokrates, who was so fainthearted that he never tried a speech? Or Tully, that great founder of the Roman eloquence, who could never begin to speak without an odd kind of trembling, like a boy that had the hiccups; which Fabius interprets as an argument of a wise orator and one that was sensible of what he was doing; and while he says it, does he not plainly confess that wisdom is a great obstacle to the true management of business? What would become of them were they to fight it out at blows, that are so dead through fear, when the contest is only with empty words?

Even among the professions those only are in high esteem that come nearest to common sense, that is to say, Folly. Theologians are half-starved, physicists out of heart, astronomers laughed at, and logicians slighted; only the physician is worth all the rest. And among them too, the more unlearned, impudent, or unadvised he is, the more he is esteemed, even among princes. For medicine, especially as it is now practiced by most men, is nothing but a branch of flattery, no less so than rhetoric. Next to them, the second place is given to our lawyers, if not the first; whose profession, though I say it myself, most men laugh at as the ass of philosophy; yet there's scarcely any business, either great or small, but is managed by these asses. These purchase their great titles, while in the meantime the theologian, having run through the whole body of religious thought, sits gnawing a radish as he wars with lice and fleas.

Why should I bother discussing our professors of arts? Self-love is so natural to them all that they had rather part with their father's land than their foolish opinions; but especially actors, fiddlers, orators, and poets, of which the more ignorant each of them is, the more insolently he pleases himself, that is to say struts and spreads out his plumes. And like will to like; nay, the more foolish anything is, the more it is admired; the greater number being ever tickled at the worst things, because, as I said before, most men are so subject to Folly. And therefore if the more foolish a man is, the more he pleases himself and is admired by others, to what purpose should he beat his brains about true knowledge, which first will cost him dear, and next render him the more troublesome and less confident, and, lastly, please only a few?

And now that I consider it, nature has planted, not only in particular men but even in every nation, and scarcely any city is without it, a kind of common self-love. And thus it is that the English, besides other things, lay claim to beauty, music, and feasting. The Scots are proud of their nobility, blood-ties to the crown, and dialectical subtleties. The French think themselves the only well-bred men. The Parisians, excluding all others, arrogate to themselves the only knowledge of theological learning. The Italians affirm they are the only masters of good letters and eloquence, and flatter themselves on this account, that of all others they only are not barbarous. In which kind of happiness those of Rome claim the first place, still dreaming to themselves of somewhat, I know not what, of old Rome. The Venetians fancy themselves happy in the reputation of their nobility. The Greeks, as if they were the only authors of all learning, swell themselves with titles of ancient heroes. The Turks, and all that scum of the truly barbarous, claim for themselves the only true religion and laugh at Christians as superstitious. To this day the Jews confidently expect the coming of the Messiah and obstinately quarrel over their law of Moses. The Spaniards give place to none in the reputation of soldiery. The Germans pride themselves in their tallness of stature and skill in magic.

And not to list every instance, you see, I think, how much satisfaction of this Self-love gives to mankind and, in this, her sister Flattery is nearly her equal.

Now if I seem to anyone to have spoken more boldly than truthfully, let us, if you please, look a little into the lives of men, and it will easily appear not only how much they owe to me, but how much they esteem me even from the highest to the lowest. And yet we will not run over the lives of everyone, for that would be too long; but only some few of the great ones, from whence we shall easily conjecture the rest.

For to what purpose is it to say anything of the common people, who without dispute are wholly mine? For they abound everywhere with so many several sorts of Folly, and are every day so busy in inventing new, that a thousand Democritus's are too few for so general a laughter, though we need one more Democritus to laugh at the thousand. It is almost incredible what sport and delight they daily provide for the Gods; for though the Gods set aside their sober morning hours to dispatch business and receive prayers, yet when they begin to be well soused with nectar, and cannot think of anything that's serious, they get themselves up into some part of heaven that's better for viewing, and then look down upon the actions of men. Nor is there anything that pleases them better. Good, good! what an excellent sight it is! How many varieties of fools! for I myself sometimes sit among the poetical Gods.

Here's one desperately in love with a young wench, and the more she slights him the more outrageously he loves her. Another marries a woman's money, not her self. Another's jealousy keeps more eyes on her than Argos. Another becomes a fulltime mourner, and how foolishly he carries it! nay, hires others to bear him company, to make it more ridiculous. Another weeps over his mother-in-law's grave. Another spends all he can on his belly, to be the more hungry after it. Another thinks there is no happiness but in sleep and idleness. Another frets about other men's business, and neglects his own. Another thinks himself rich in refinancing and buying on credit, as we say borrowing from Peter to pay Paul, and in a short time becomes bankrupt. Another starves himself to enrich his heir. Another for a small and uncertain gain exposes his life to the dangers of seas and storms, which yet no money can

restore. Another had rather get riches by war than live peaceably at home.

And some there are that think money easiest attained by courting childless old men with presents; and others again by making love to rich old women; both which afford the Gods most excellent pastime, to see them cheated by those persons they thought to have outwitted. But the most foolish and basest of all others are our merchants, to wit such as venture on everything be it never so dishonest, and manage it no better; who though they lie unceasingly, swear and perjure themselves, steal, deceive, and cheat, yet shuffle themselves into the first rank, and all because they have gold rings on their fingers. Nor are they without their flattering friars that admire them and give them openly the title of honorable, in hopes, no doubt, to get some small snip of it themselves.

There are also a kind of Pythagoreans, with whom all things are held in common, that if they get anything under their cloaks, they make no more scruple of carrying it away than if it were their own by inheritance. There are others too that are only rich in wishful thinking, and while they fancy to themselves pleasant dreams, conceive that enough to make them happy. Some desire to be accounted wealthy abroad, and are yet ready to starve at home. One makes what haste he can to fritter his money away, and another rakes it together by right or wrong. This man is ever laboring for public honors: and another lies sleeping in a chimney corner. A great many undertake endless lawsuits and outvie one another who shall most enrich the crooked judge or corrupt lawyer. One is all for innovations: and another for some great he-knows-not-what. Another leaves his wife and children at home, and goes to Jerusalem, Rome, or on a pilgrimage to St. James's, where he has no business.

In short, if a man like Menippus of old could look down from the moon, and behold those innumerable rufflings of mankind, he would think he saw a swarm of flies and gnats quarreling among themselves, fighting, laying traps for one another, snatching, playing, wantoning, growing up, growing old, and dying. Nor is it to be believed what stir, what commotions this little creature raises, and yet in how short a time it comes to nothing at all; while sometimes war, other times pestilence, sweeps many thousands away.

But let me be most foolish myself, and one whom Democritus may not only laugh at but deride, if I go one foot further in the discovery of the follies and madnesses of the common people. I'll betake me to them that carry the reputation of wise men, and hunt after that "golden bough," as says the proverb. Among whom the school teachers hold the first place, a generation of men than whom nothing would be more miserable, nothing more wretched, nothing more hated of the Gods, did not I allay the troubles of that pitiful profession with a certain kind of pleasant madness. For they are not only subject to those five afflictions with which Homer begins his Iliad, but six hundred; as being ever hungry and slovenly in their schools—schools, did I say? Nay, rather prisons, sweat shops, or torture chambers—grown old among a company of boys, deaf with their noise, and wasted away in the stench and nastiness. And yet by my courtesy it is that they think themselves the most excellent of all men; so

greatly do they please themselves in frightening a company of fearful boys with a thundering voice and fierce scowls; tormenting them with switches, rods, and whips; and, laying about them without fear or wit, imitate the ass in the lion's skin. In the meantime all that nastiness seems absolute spruceness, that stench a perfume, and that miserable slavery of theirs a kingdom, and such too as they would not exchange their tyranny for the empires of Phalaris or Dionysius.

Nor are they happy in that new opinion they have taken up of being learned; for whereas most of them beat into boys' heads nothing but nonsense, yet, ye good Gods! what Palemon, what Donatus, do they scorn in comparison with themselves? And so, I know not by what tricks, they bring it about to their boys' foolish mothers and dolt-headed fathers they pass for such as they fancy themselves.

Perhaps I had better pass over our theologians in silence and not stir this pool, or touch this fair but unsavory stinkweed; as a kind of men that are supercilious beyond comparison, and to that too, implacable; lest setting them about my ears, they attack me with proofs and force me to recant, which if I refuse they straight away pronounce me a heretic. For this is the thunderbolt with which they frighten those whom they are resolved not to favor. And truly, though there are few others that less willingly acknowledge the kindnesses I have done for them, yet even these too are bound to me for no ordinary benefits; meanwhile being happy in their own opinion, and as if they dwelt in the third heaven, they look with haughtiness on all others as poor creeping things, and could almost find in their hearts to pity them.

And next come those that commonly call themselves "religious" and "monks"; most false in both titles, when a large part of them are farthest from religion, and no men swarm thicker in all places than themselves. Nor can I think of anything that could be more miserable, did I not support them in so many ways. For whereas all men detest them so much, that they take it for ill luck to meet one of them by chance, yet such is their happiness that they flatter themselves. For first, they reckon it one of the main points of piety if they are so illiterate that they can't so much as read. And then when they run over their Offices, which they carry about them, rather by rote than understanding, they believe the Gods more than ordinarily pleased with their braying. And some there are among them that make a great show about their pious poverty, yet roam up and down for the bread they eat; nay, there is scarcely an inn, coach, or ship into which they intrude not, to the no small damage of the commonwealth of beggars. And yet, like pleasant fellows, with all this vileness, ignorance, rudeness, and impudence, they represent to us, for so they call it, the lives of the apostles.

And as to the popes, what should I mention about them? than most of whom though there be nothing more indebted, more servile, more witless, more contemptible, yet they would seem as they were the most excellent of all others. And yet in this only thing no men more modest, in that they are contented to wear about them gold, jewels, purple, and those other marks of virtue and wisdom, but for the study of the things themselves, they

remit it to others; thinking it happiness enough for them that they can call the King Master, having learned the cringe *à la mode*; know when and where to use those titles of Your Grace, My Lord, Your Magnificence; in a word that they are past all shame and can flatter pleasantly. For these are the arts that bespeak a man truly noble and a model courtier.

But if you look into their manner of life you'll find them mere sots, as debauched as Penelope's wooers. They sleep till noon, and have their mercenary Levite come to their bedside, where he chops over his Matins before they are half up. Then to breakfast, which is scarcely done when dinner is ready for them. From thence they go to dice, tables, cards, or entertain themselves with jesters, fools, and gamblers. In the meantime they have one or two snacks and then supper, and after that a banquet, and it would be well, by Jupiter, that there be no more than one.

And in this manner do their hours, days, months, years, age slide away without the least irksomeness. Nay, I have sometimes gone away many inches fatter, to see them speak big words; while each of the ladies believes herself so much nearer the Gods, by how much the longer train she trails after her; while one cardinal edges out another, that he may get the nearer to Jupiter himself; and every one of them pleases himself the more by how much heavier is the gold chain he drapes on his shoulders, as if he meant to show his strength as well as his wealth.

But I forget myself and run beyond my bounds. Though yet, if I shall seem to have spoken anything more boldly or impertinently than I ought, be pleased to consider that not only Folly but a woman said it; remembering in the meantime that Greek proverb, "Sometimes a fool may speak a word in season," unless perhaps you'll say this concerns not women. I see you expect an Epilogue, but give me leave to tell you that you are mistaken if you think I remember anything of what I have said, having foolishly bolted out such a hodgepodge of words. It is an old proverb, "I hate one that remembers what's done over the cup." This is a new one of my own making: "I hate a man that remembers what he hears." Wherefore farewell, clap your hands, live, and drink lustily, my most excellent Disciples of Folly.

The Prince
Machiavelli

Cast in the form of advice to a new ruler, *The Prince* expounds Machiavelli's political theory, often in maxims whose bluntness can still shock today. Machiavelli deals with the reality of human nature, as saw it. His theories seek the good of the republic and the success of the ideal prince.

8: *Those who come to power by crime*

As there are also two ways of becoming a prince which cannot altogether be attributed either to fortune or to prowess, I do not think I ought to leave them out, even though one of them can be dealt with at greater length

under the heading of republics. The two I have in mind are when a man becomes prince by some criminal and nefarious method, and when a private citizen becomes prince of his native city with the approval of his fellow citizens. In dealing with the first method, I shall give two examples, one from the ancient world, one from the modern, without otherwise discussing the rights and wrongs of this subject, because I imagine that these examples are enough for anyone who has to follow them.

Agathocles, the Sicilian, not only from the status of a private citizen but from the lowest, most abject condition of life, rose to become king of Syracuse. At every stage of his career this man, the son of a potter, behaved like a criminal; nonetheless he accompanied his crimes with so much audacity and physical courage that when he joined the militia he rose through the ranks to become its commander. After he had been appointed to this position, he determined to make himself prince and to possess by force and without obligation to others what had been voluntarily conceded to him. He reached an understanding about this ambition of his with Hamilcar the Carthaginian, who was campaigning with his armies in Sicily. Then one morning he assembled the people and Senate of Syracuse, as if he meant to raise matters which affected the republic; and at a prearranged signal he had all the senators, along with the richest citizens, killed by his soldiers; and when they were dead he seized and held the government of that city, without encountering any other internal opposition. Although he was twice routed and even besieged by the Carthaginians, not only did he successfully defend the city, but, leaving some of his troops to defend it, he invaded Africa with the rest, and in a short time lifted the siege and reduced the Carthaginians to severe straits. They were compelled to make a pact with him, contenting themselves with the possession of Africa and leaving Sicily to Agathocles. So whoever studies that man's actions will discover little or nothing that can be attributed to fortune, inasmuch as he rose through the ranks of the militia, as I said, and his progress was attended by countless difficulties and dangers; that was how he won his principality, and he maintained his position with many audacious and dangerous enterprises. Yet it cannot be called prowess to kill fellow citizens, to betray friends, to be treacherous, pitiless, irreligious. These ways can win a prince power but not glory. One can draw attention to the prowess of Agathocles in confronting and surviving danger, and his courageous spirit in enduring and overcoming adversity, and it appears that he should not be judged inferior to any eminent commander; nonetheless, his brutal cruelty and inhumanity, his countless crimes, forbid his being honored among eminent men. One cannot attribute to fortune or prowess what was accomplished by him without the help of either.

In our time, during the pontificate of Alexander VI, there was Oliverotto of Fermo. Years before, he had been left fatherless as a small boy and was brought up by a maternal uncle called Giovanni Fogliani. In his early youth he was sent to serve as a soldier under Paulo Vitelli so that he could win high command after being trained by him. When Paulo died, Oliverotto soldiered under

Vitelozzo, his brother; and in a very short time, as he was intelligent, and a man of courage and audacity, he became Vitelozzo's chief commander. But he thought it was servile to take orders from others, and so he determined that, with the help of some citizens of Fermo to whom the enslavement of their native city was more attractive than its liberty, and with the assent of the followers of Vitelozzo, he would seize Fermo for himself. He wrote to Giovanni Fogliani saying that, having been many years away from home, he wanted to come and see him and his city and to make some investigation into his own estate. He had worked for nothing else except honor, he went on, and in order that his fellow citizens might see that he had not spent his time in vain, he wanted to come honorably, with a mounted escort of a hundred companions and servants. He begged Giovanni to arrange a reception which would bring honor to Giovanni as well as to himself, as he was Giovanni's foster child. Giovanni failed in no duty of hospitality towards his nephew. He had him honorably welcomed by the citizens of Fermo and lodged him in his own mansion. There, after a few days had passed during which he waited in order to complete the secret arrangements for his future crime, Oliverotto prepared a formal banquet to which he invited Giovanni Fogliani and the leading citizens of Fermo. After they had finished eating and all other entertainment usual at such banquets was done with, Oliverotto artfully started to touch on subjects of grave importance, talking of the greatness of Pope Alexander and of Cesare his son, and of their enterprises. When Giovanni and the others began to discuss these subjects in turn, he got to his feet all of a sudden, saying that these were things to be spoken of somewhere more private, and he withdrew to another room, followed by Giovanni and all the other citizens. And no sooner were they seated than soldiers appeared from hidden recesses, and killed Giovanni and all the others. After this slaughter, Oliverotto mounted his horse, rode through the town, and laid siege to the palace of the governing council; consequently they were frightened into obeying him and into setting up a government of which he made himself the prince. And having put to death all who, because they would resent his rule, might injure him, he strengthened his position by founding new civil and military institutions. In this way, in the space of the year that he held the principality, he not only established himself in the city of Fermo but also made himself formidable to all the neighboring states. His overthrow would have proved as difficult as that of Agathocles, if he had not let himself be tricked by Cesare Borgia when, at Sinigaglia, as was recounted above, Cesare trapped the Orsini and the Vitelli. Oliverotto was also trapped there, and a year after he committed parricide he was strangled along with Vitelozzo, to whom he owed both his prowess and his criminal nature.

One might well wonder how it was that Agathocles, and others like him, after countless treacheries and cruelties, could live securely in his own country and hold foreign enemies at bay, with never a conspiracy against him by his countrymen, inasmuch as many others, because of their cruel behavior, have not been able to maintain their rule even in peaceful times, let alone in the uncertain times of war. I believe that here it is a question of cruelty used well or badly. We can say that cruelty is used well (if it is permissible to talk in this way of what is evil) when it is employed once for all, and one's safety depends on it, and then it is not persisted in but as far as possible turned to the good of one's subjects. Cruelty badly used is that which, although infrequent to start with, as time goes on, rather than disappearing, becomes more evident. Those who use the first method can, with divine and human assistance, find some means of consolidating their position, as did Agathocles; the others cannot possibly stay in power.

So it should be noted that when he seizes a state the new ruler ought to determine all the injuries that he will need to inflict. He should inflict them once for all, and not have to renew them every day, and in that way he will be able to set men's minds at rest and win them over to him when he confers benefits. Whoever acts otherwise, either through timidity or bad advice, is always forced to have the knife ready in his hand and he can never depend on his subjects because they, suffering fresh and continuous violence, can never feel secure with regard to him. Violence should be inflicted once for all; people will then forget what it tastes like and so be less resentful. Benefits should be conferred gradually; and in that way they will taste better. Above all, a prince should live with his subjects in such a way that no development, either favorable or adverse, makes him vary his conduct. When adversity brings the need for it, repression is too late; and the favors he may confer are profitless, because they are seen as being forced, and so they earn no thanks.

Utopia

[1516] Thomas More

Based on the form of an explorer's narrative, Utopia is a political essay intended to stimulate discussion. It exemplifies the ideals of one of England's most important Humanists. Utopia means "no place." The name was coined by More as the name for a land where communism, religious tolerance, and universal education were practiced.

The island of Utopia containeth in breadth in the middle part of it (for there it is broadest) two hundred miles. Which breadth continueth through the most part of the land, saving that by little and little it cometh in, and waxeth narrower towards both the ends. Which fetching about a circuit or compass of five hundred miles, do fashion the whole island like to the new moon. Between these two corners the sea runneth in, dividing them asunder by the distance of eleven miles or thereabouts, and there surmounteth into a large and wide sea, which by reason that the land on every side compasseth it about, and sheltereth it from the winds, is not rough, nor mounteth not with great waves, but almost floweth quietly, not much unlike a great standing pool: and maketh almost all the space within the belly of the land in manner of a

haven: and to the great commodity of the inhabitants receiveth in ships towards every part of the land. The forefronts or frontiers of the two corners, what with fords and shelves, and what with rocks be very jeopardous and dangerous. In the middle distance between them both standeth up above the water a great rock, which therefore is nothing perilous because it is in sight. Upon the top of this rock is a fair and a strong tower builded, which they hold with a garrison of men. Other rocks there be that lie hid under the water, and therefore be dangerous. The channels be known only to themselves. And therefore it seldom chanceth that any stranger unless he be guided by a Utopian can come into this haven. Insomuch that they themselves could scarcely enter without jeopardy, but that their way is directed and ruled by certain landmarks standing on the shore. By turning, translating, and removing these marks into other places they may destroy their enemies' navies, be they never so many. The outside of the land is also full of havens, but the landing is so surely defenced, what by nature, and what by workmanship of man's hand, that a few defenders may drive back many armies.

There be in the island fifty-four large and fair cities, or shire towns, agreeing all together in one tongue, in like manners, institutions and laws. They be all set and situate alike, and in all points fashioned alike, as far forth as the place or plot suffereth.

Of these cities they that be nighest together be twenty-four miles asunder. Again there is none of them distant from the next above one day's journey afoot. There come yearly to Amaurote out of every city three old men wise and well experienced, there to entreat and debate, of the common matters of the land. For this city (because it standeth just in the midst of the island, and is therefore most meet for the ambassadors of all parts of the realm) is taken for the chief and head city. The precincts and bounds of the shires be so commodiously appointed out, and set forth for the cities, that never a one of them all hath of any side less than twenty miles of ground, and of some side also much more, as of that part where the cities be of farther distance asunder. None of the cities desire to enlarge the bounds and limits of their shires. For they count themselves rather the good husbands[1] than the owners of their lands. They have in the country in all parts of the shire houses or farms builded, well appointed and furnished with all sorts of instruments and tools belonging to husbandry. These houses be inhabited of the citizens, which come thither to dwell by course. No household or farm in the country hath fewer than forty persons, men and women, besides two bondmen, which be all under the rule and order of the good man, and the good wife of the house, being both very sage and discreet persons. And every thirty farms or families have one head ruler, which is called a philarch, being as it were a head bailiff. Out of every one of these families or farms cometh every year into the city twenty persons which have continued two years before in the country. In their place so many fresh be sent thither out of the city, which of them that have been there a year already, and be therefore expert and

cunning in husbandry, shall be instructed and taught. And they the next year shall teach others. This order is used for fear that either scarceness of victuals, or some other like incommodity should chance, through lack of knowledge, if they should be altogether new, and fresh, and unexpert in husbandry. This manner and fashion of yearly changing and renewing the occupiers of husbandry, though it be solemn and customably used, to the intent that no man shall be constrained against his will to continue long in that hard and sharp kind of life, yet many of them have such a pleasure and delight in husbandry, that they obtain a longer space of years. These husbandmen plough and till the ground, and breed up cattle, and make ready wood, which they carry to the city either by land, or by water, as they may most conveniently. They bring up a great multitude of poultry, and that by a marvellous policy. For the hens do not sit upon the eggs: but by keeping them in a certain equal heat they bring life into them, and hatch them. The chickens, as soon as they come out of the shell, follow men and women instead of the hens. They bring up very few horses: nor none, but very fierce ones: and for none other use or purpose, but only to exercise their youth in riding and feats of arms. For oxen be put to all the labour of ploughing and drawing. Which they grant to be not so good as horses at a sudden brunt, and (as we say) at a dead lift, but yet they hold opinion that they will abide and suffer much more labour and pain than horses will. And they think that they be not in danger and subject unto so many diseases, and that they be kept and maintained with much less cost and charge: and finally that they be good for meat, when they be past labour. They sow corn only for bread. For their drink is either wine made of grapes, or else of apples, or pears, or else it is clean water. And many times mead made of honey or liquorice sodden in water, for thereof they have great store. And though they know certainly (for they know it perfectly indeed) how much victuals the city with the whole country or shire round it doth spend: yet they sow much more corn, and breed up much more cattle, than serveth for their own use, and the over-plus they part among their borderers.[2] Whatsoever necessary things be lacking in the country, all such stuff they fetch out of the city: where without any exchange they easily obtain it of the magistrates of the city. For every month many of them go into the city on the holy day. When their harvest day draweth near and is at hand, then the philarchs, which be the head officers and bailiffs of husbandry, send word to the magistrates of the city what number of harvest men is needful to be sent to them out of the city. The which company of harvest men being there ready at the day appointed, almost in one fair day despatcheth all the harvest work.

Of Sciences, Crafts, and Occupations

Husbandry is a science common to them all in general, both men and women, wherein they be all expert and cunning. In this they be all instruct even from their youth:

1. caretakers or farmers.

2. the surrounding countries.

partly in schools with traditions and precepts, and partly in the country nigh the city, brought up as it were in playing, not only beholding the use of it, but by occasion of exercising their bodies practising it also. Besides husbandry, which (as I said) is common to them all, every one of them learneth one or other several and particular science, as his own proper craft. That is most commonly either clothworking in wool or flax, or masonry, or the smith's craft, or the carpenter's science. For there is none other occupation that any number to speak of doth use there. For their garments, which throughout all the island be of one fashion (saving that there is a difference between the man's garment and the woman's, between the married and the unmarried) and this one continueth for evermore unchanged, seemly and comely to the eye, no let to the moving and wielding of the body, also fit both for winter and summer: as for these garments (I say) every family maketh their own. But of the other foresaid crafts every man learneth one. And not only the men, but also the women. But the women, as the weaker sort, be put to the easier crafts: they work wool and flax. The other more laboursome sciences be committed to the men. For the most part every man is brought up in his father's craft. For most commonly they be naturally thereto bent and inclined. But if a man's mind stand to any other, he is by adoption put into a family of that occupation, which he doth most fantasy.[3] Whom not only his father, but also the magistrates do diligently look to, that he be put to a discreet and an honest householder. Yea, and if any person, when he hath learned one craft, be desirous to learn also another, he is likewise suffered and permitted.

When he hath learned both, he occupieth whether he will: unless the city have more need of the one, than of the other. The chief and almost the only office of the philarchs is to see and take heed that no man sit idle: but that every one apply his own craft with earnest diligence. And yet for all that, not be wearied from early in the morning, to late in the evening, with continual work, like labouring and toiling beasts.

For this is worse than the miserable and wretched condition of bondmen. Which nevertheless is almost everywhere the life of workmen and artificers, saving in Utopia. For they dividing the day and the night into twenty-four just hours, appoint and assign only six of those hours to work; three before noon, upon the which they go straight to dinner: and after dinner, when they have rested two hours, then they work three and upon that they go to supper. About eight of the clock in the evening (counting one of clock as the first hour after noon) they go to bed: eight hours they give to sleep. All the void time, that is between the hours of work, sleep, and meat, that they be suffered to bestow, every man as he liketh best himself. Not to the intent that they should misspend this time in riot or slothfulness: but being then licenced from the labour of their own occupations, to bestow the time well and thriftly upon some other good science, as shall please them. For it is a solemn custom there, to have lectures daily early in the morning, where to be present they only be constrained that be chosen and appointed to learning.

Howbeit a great multitude of every sort of people, both men and women, go to hear lectures, some one and some another, as every man's nature is inclined. Yet, this notwithstanding, if any man had rather bestow this time upon his own occupation (as it chanceth in many, whose minds rise not in the contemplation of any science liberal) he is not letted, not prohibited, but is also praised and commended, as profitable to the commonwealth. After supper they bestow one hour in play: in summer in their gardens: in winter in their common halls: where they dine and sup. There they exercise themselves in music, or else in honest and wholesome communication. But lest you be deceived, one thing you must look more narrowly upon. For seeing they bestow but six hours in work perchance you may think that the lack of some necessary things hereof may ensue. But this is nothing so. For that small time is not only enough but also too much for the store and abundance of all things that be requisite, either for the necessity, or commodity of life. The which thing you also shall perceive, if you weigh and consider with yourselves how great a part of the people in other countries liveth idle. First almost all women, which be the half of the whole number: or else if the women be anywhere occupied, there most commonly in their stead the men be idle. Beside this how great, and how idle a company is there of priests, and religious men, as they call them? Put thereto all rich men, especially all landed men, which commonly be called gentlemen, and nobleman. Take into this number also their servants: I mean all that flock of stout bragging rush-bucklers. Join to them also sturdy and valiant beggars, cloaking their idle life under the colour of some disease or sickness. And truly you shall find them much fewer than you thought, by whose labour all these things be gotten that men use and live by. Now consider with yourself, of these few that do work, how few be occupied, in necessary works. For where money beareth all the swing, there many vain and superfluous occupations must needs be used, to serve only for riotous superfluity and unhonest pleasure. For the same multitude that now is occupied in work, if they were divided into so few occupations as the necessary use of nature requireth; in so great plenty of things as then of necessity would ensue, doubtless the prices would be too little for the artificers to maintain their livings. But if all these, that be now busied about unprofitable occupations, with all the whole flock of them that live idly and slothfully, which consume and waste every one of them more of these things that come by other men's labour, than two of the workmen themselves do: if all these (I say) were set to profitable occupations, you easily perceive how little time would be enough, yea and too much to store us with all things that may be requisite either for necessity, or for commodity, yea or for pleasure, so that the same pleasure be true and natural. And this in Utopia the thing itself maketh manifest and plain. For there in all the city, with the whole country, or shire adjoining to it scarcely 500 persons of all the whole number of men and women, that be neither too old, nor too weak to work, be licenced from labour. Among them be the philarchs which (though they be by the laws exempt and privileged from labour) yet they exempt not themselves: to the intent they may the

3. desire or choose.

rather by their example provoke others to work. The same vacation from labour do they also enjoy, to whom the people persuaded by the commendation of the priests, and secret election of the philarchs, have given a perpetual licence from labour to learning. But if any one of them prove not according to the expectation and hope of him conceived, he is forthwith plucked back to the company of artificers. And contrariwise, often it chanceth that a handicraftsman doth so earnestly bestow his vacant and spare hours in learning, and through diligence to profit therein, that he is taken from his handy occupation, and promoted to the company of the learned. Out of this order of the learned be chosen ambassadors, priests, chief philarchs, and finally the prince himself.

Of the Religions in Utopia

There be divers kinds of religion not only in sundry parts of the island, but also in divers places of every city. Some worship for God, the sun; some, the moon; some other of the planets. There be that give worship to a man that was once of excellent virtue or of famous glory, not only as God, but also as the chiefest and highest God. But the most and the wisest part (rejecting all these) believe that there is a certain godly power unknown, everlasting, incomprehensible, inexplicable, far above the capacity and reach of man's wit, dispersed throughout all the world, not in bigness, but in virtue and power. Him they call the father of all. To him alone they attribute the beginnings, the increasings, the proceedings, the changes and the ends of all things. Neither they give divine honours to any other than to him. Yea all the other also, though they be in divers opinions, yet in this point they agree all together with the wisest sort, in believing that there is one chief and principal God, the maker and ruler of the whole world: whom they all commonly in their country language call Mithra. But after they heard us speak of the name of Christ, of his doctrine, laws, miracles, and of the no less wonderful constancy of so many martyrs, whose blood willingly shed brought a great number of nations throughout all parts of the world into their sect; you will not believe with how glad minds, they agreed unto the same: whether it were by the secret inspiration of God, or else for that they thought it next unto that opinion, which among them is counted the chiefest. Howbeit I think this was no small help and furtherance in the matter, that they heard us say, that Christ instituted among his, all things common; and that the same community doth yet remain amongst the richest Christian companies. Verily howsoever it come to pass, many of them consented together in our religion, and were washed in the holy water of baptism. They also which do not agree to Christ's religion, fear no man from it, nor speak against any man that hath received it. Saving that one of our company in my presence was

sharply punished. He as soon as he was baptised began against our wills, with more earnest affection than wisdom, to reason of Christ's religion; and began to wax so hot in his matter, that he did not only prefer our religion before all other, but also did utterly despise and condemn all other, calling them profane, and the followers of them wicked and devilish and the children of everlasting damnation. When he had thus long reasoned the matter, they laid hold on him, accused him and condemned him into exile, not as a despiser of religion, but as a seditious person and raiser up of dissension among the people. For this is one of the ancientest laws among them; that no man shall be blamed for reasoning in the maintenance of his own religion. For King Utopus, even at the first beginning, hearing that inhabitants of the land were, before his coming thither, at continual dissention and strife among themselves for their religions; as soon as he had gotten the victory, first of all he made a decree, that it should be lawful for every man to favour and follow what religion he would, and that he might do the best he could to bring other to his opinion, so that he did it peaceably, gently, quietly, and soberly, without haste and contentious rebuking and inveighing against other. If he could not by fair and gentle speech induce them unto his opinion yet he should use no kind of violence, and refrain from displeasant and seditious words. To him that would vehemently and fervently in this cause strive and contend was decreed banishment or bondage. This law did King Utopus make not only for the maintenance of peace, which he saw through continual contention and mortal hatred utterly extinguished; but also because he thought this decree should make for the furtherance of religion. Whereof he durst define and determine nothing unadvisedly, as doubting whether God desiring manifold and divers sorts of honour, would inspire sundry men with sundry kinds of religion. And this surely he thought a very unmeet and foolish thing, and a point of arrogant presumption, to compel all other by violence and threatenings to agree to the same that thou believest to be true. Furthermore though there be one religion which alone is true, and all other vain and superstitious, yet did he well foresee (so that the matter were handled with reason, and sober modesty) that the truth of its own power would at the last issue out and come to light. But if contention and debate in that behalf should continually be used, as the worst men be most obstinate and stubborn, and in their evil opinion most constant; he perceived that then the best and holiest religion would be trodden underfoot and destroyed by most vain superstitions, even as good corn is by thorns and weeds overgrown and choked. Therefore all this matter he left undiscussed, and gave to every man free liberty and choice to believe what he would.

Hamlet, Prince of Denmark
|1600–01| William Shakespeare

CHARACTERS

Claudius, King of Denmark
Hamlet, son of the late, and nephew to the present, King
Fortinbras, Prince of Norway
Polonius, Lord Chamberlain
Horatio, friend to Hamlet
Laertes, son to Polonius
Voltimand ⎫
Cornelius |
Rosencrantz ⎬ *courtiers*
Guildenstern |
Osric ⎭
A gentleman
A priest
Marcellus ⎫ *officers*
Bernardo ⎭
Francisco, a soldier
Reynaldo, servant to Polonius
Players
Two clowns, grave-diggers
A captain
English Ambassadors
Ghost of Hamlet's father
Gertrude, Queen of Denmark and mother to Hamlet
Ophelia, daughter to Polonius
Lords, ladies, officers, soldiers, sailors, messengers, and other
 attendants

Act I
Scene 1: A platform before the castle at Elsinore.

|FRANCISCO *at his post. Enter to him* BERNARDO.|
Bernardo: Who's there?
Francisco: Nay, answer me: stand, and unfold¹ yourself.
Bernardo: Long live the king!
Francisco: Bernardo?
Bernardo: He.
Francisco: You come most carefully upon your hour.
Bernardo: 'Tis now struck twelve: get thee to bed,
 Francisco.
Francisco: For this relief much thanks: 'tis bitter cold,
 And I am sick at heart.
Bernardo: Have you had quiet guard?
Francisco: Not a mouse stirring.
Bernardo: Well, good night.
If you do meet Horatio and Marcellus,
The rivals² of my watch, bid them make haste. 10
Francisco: I think I hear them.—Stand, ho! who is there?
 |*Enter* HORATIO *and* MARCELLUS.|
Horatio: Friends to this ground.
Marcellus: And Liegeman to the Dane.³
Francisco: Give you good night.
Marcellus: O, farewell, honest soldier:

1. reveal.
2. partners.
3. loyal subjects of the Danish king.

Who hath relieved you?
Francisco: Bernardo hath my place.
Give you good night.
 |*Exit* FRANCISCO.|
Marcellus: Holla! Bernardo!
Bernardo: Say,—
What, is Horatio there?
Horatio: A piece of him.
Bernardo: Welcome, Horatio; welcome, good Marcellus.
Marcellus: What, has this thing appeared again tonight?
Bernardo: I have seen nothing.
Marcellus: Horatio says, 'tis but our fantasy; 20
And will not let belief take hold of him,
Touching this dreaded sight, twice seen of us:
Therefore I have entreated him along
With us to watch the minutes of this night;
That if again this apparition come,
He may approve⁴ our eyes and speak to it.
Horatio: Tush, tush, 'twill not appear.
Bernardo: Sit down a while;
And let us once again assail your ears,
That are so fortified against our story,
What we have two nights seen.
Horatio: Well, sit we down, 30
And let us hear Bernardo speak of this.
Bernardo: —Last night of all,
When yon same star that's westward from the pole,
Had made his course to illume that part of heaven
Where now it burns. Marcellus and myself,
The bell then beating one,—
 |*Enter* GHOST.|
Marcellus: Peace, break thee off; look, where it comes
 again!
Bernardo: In the same figure, like the king that's dead.
Marcellus: Thou art a scholar, speak to it, Horatio.
Bernardo: Looks 'a⁵ not like the king? mark it, Horatio. 40
Horatio: Most like: it harrows me with fear and wonder
Bernardo: It would be spoke to.
Marcellus: Speak to it, Horatio.
Horatio: What art thou, that usurp'st this time of night,
Together with that fair and warlike form
In which the majesty of buried Denmark
Did sometimes march? by heaven I charge thee, speak!
Marcellus: It is offended.
Bernardo: See, it stalks away!
Horatio: Stay! speak, speak! I charge thee, speak!
 |*Exit* GHOST.|
Marcellus: 'Tis gone, and will not answer.
Bernardo: How now, Horatio! you tremble and look
 pale: 50
Is not this something more than fantasy?
What think you on't?
Horatio: Before my God, I might not this believe,
Without the sensible and true avouch
Of mine own eyes.
Marcellus: Is it not like the king?
Horatio: As thou art to thyself:
Such was the very armour he had on

4. confirm.
5. he.

When he the ambitious Norway[6] combated;
So frowned he once, when, in an angry parle,[7]
He smote the sledded pole-axe on the ice. 60
'Tis strange.
Marcellus: Thus twice before, and jump[8] at this dead
 hour,
With martial stalk hath he gone by our watch.
Horatio: In what particular thought to work I know not;
But, in the gross and scope of mine opinion,
This bodes some strange eruption to our state.
Marcellus: Good now, sit down, and tell me, he that
 knows,
Why this same strict and most observant watch
So nightly toils the subject of the land?
And why such daily cast of brazen cannon, 70
And foreign mart for implements of war:
Why such impress of shipwrights, whose sore task
Does not divide the Sunday from the week:
What might be toward that this sweaty haste
Doth make the night joint-labourer with the day;
Who is't that can inform me?
Horatio: That can I;
At least the whisper goes so. Our last king,
Whose image even but now appeared to us,
Was, as you know, by Fortinbras of Norway,
Thereto pricked on by a most emulate pride, 80
Dared to the combat; in which our valiant Hamlet—
For so this side of our known world esteemed him—
Did slay this Fortinbras; who, by a sealed compact,
Well ratified by law and heraldry,
Did forfeit, with his life, all those his lands,
Which he stood seized of, to the conqueror:
Against the which a moiety competent
Was gaged[9] by our king; which had returned
To the inheritance of Fortinbras,
Had he been vanquisher; as, by the same comart[10] 90
And carriage of the article designed,
His fell to Hamlet. Now, sir, young Fortinbras,
Of unapproved mettle hot and full,
Hath in the skirts[11] of Norway here and there
Sharked up a list of lawless resolutes,
For food and diet, to some enterprise
That hath a stomach in't: which is no other—
As it doth well appear unto our state,—
But to recover of us, by strong hand,
And terms compulsatory, those foresaid lands 100
So by his father lost: and this, I take it,
Is the main motive of our preparations;
The source of this our watch; and the chief head
Of this post-haste and romage[12] in the land.
Bernardo: I think it be no other but e'en so.
Well may it sort, that this portentous figure
Comes armed through our watch, so like the king
That was and is the question of these wars.
Horatio: A mote it is to trouble the mind's eye.
In the most high and palmy state of Rome, 110
A little ere mightiest Julius fell,

The graves stood tenantless, and the sheeted dead
Did squeak and gibber in the Roman streets:
As stars with trains of fire and dews of blood,
Disasters in the sun; and the moist star,
Upon whose influence Neptune's empire stands,
Was sick almost to doomsday with eclipse:
And even the like precurse of fierce events,
As harbingers preceding still the fates,
And prologue to the omen coming on, 120
Have heaven and earth together demonstrated
Unto our climatures[13] and countrymen.—
 |*Re-enter* GHOST.|
But soft; behold! lo, where it comes again!
I'll cross it, though it blast me.—Stay, illusion!
If thou hast any sound, or use of voice,
Speak to me:
If there be any good thing to be done,
That may to thee do ease and grace to me,
Speak to me:
If thou art privy to thy country's fate, 130
Which, happily, foreknowing may avoid,
O, speak!
Or if thou hast uphoarded in thy life
Extorted treasure in the womb of earth,
For which, they say, you spirits oft walk in death,
 |*The cock crows.*|
Speak of it: stay, and speak.—Stop it, Marcellus.
Marcellus: Shall I strike at it with my partizan?[14]
Horatio: Do, if it will not stand.
Bernardo: 'Tis here!
Horatio: 'Tis here!
Marcellus: 'Tis gone!
 |*Exit* GHOST.|
We do it wrong, being so majestical, 140
To offer it the show of violence;
For it is, as the air, invulnerable,
And our vain blows malicious mockery.
Bernardo: It was about to speak, when the cock crew.
Horatio: And then it started like a guilty thing
Upon a fearful summons. I have heard,
The cock, that is the trumpet to the morn,
Doth with his lofty and shrill-sounding throat
Awake the god of day, and at his warning,
Whether in sea or fire, in earth or air, 150
The extravagant and erring spirit hies
To his confine: and of the truth herein
This present object made probation.
Marcellus: It faded on the crowing of the cock.
Some say that ever 'gainst that season comes
Wherein our Saviour's birth is celebrated,
The bird of dawning singeth all night long:
And then, they say, no spirit dare stir abroad,
The nights are wholesome, then no planets strike,
No fairy takes, nor witch hath power to charm, 160
So hallowed and so gracious is the time.
Horatio: So have I heard, and do in part believe it.
But, look, the morn, in russet mantle clad,
Walks o'er the dew of yon high eastward hill.

6. king of Norway.
7. parley.
8. just.
 9. pledged.
 10. agreement.
 11. borders.
 12. bustle.

13. regions.
14. pike (a type of spear).

Break we our watch up; and by my advice,
Let us impart what we have seen to-night
Unto young Hamlet: for, upon my life,
This spirit, dumb to us, will speak to him:
Do you consent we shall acquaint him with it,
As needful in our loves, fitting our duty? 170
Marcellus: Let's do't, I pray: and I this morning know
Where we shall find him most convenient.
 |*Exeunt.*|

Scene 2: A room of state in the castle.

 |*Flourish. Enter the* KING, QUEEN, HAMLET,
 POLONIUS, LAERTES, VOLTIMAND,
 CORNELIUS, LORDS *and* ATTENDANTS.|

King: Though yet of Hamlet our dear brother's death
The memory be green, and that it us befitted
To bear our hearts in grief and our whole kingdom
To be contracted in one brow of woe;
Yet so far hath discretion fought with nature,
That we with wisest sorrow think on him,
Together with remembrance of ourselves.
Therefore our sometime sister, now our queen,
The imperial jointress[1] to this warlike state,
Have we, as 'twere, with a defeated joy, 10
With an auspicious and a dropping eye;
With mirth in funeral and with dirge in marriage
In equal scale weighing delight and dole,
Taken to wife: nor have we herein barred
Your better wisdoms, which have freely gone
With this affair along. For all, our thanks.
Now follows, that you know, young Fortinbras,
Holding a weak supposal of our worth;
Of thinking by our late dear brother's death,
Our state to be disjoint and out of frame, 20
Colleagued with this dream of his advantage,
He hath not failed to pester us with message,
Importing the surrender of those lands
Lost by his father, with all bands of law,
To our most valiant brother. So much from him.
Now for ourself, and for this time of meeting;
Thus much the business is: we have here writ
To Norway, uncle of young Fortinbras,—
Who, impotent and bed-rid, scarcely hears
Of this his nephew's purpose,—to suppress 30
His further gait herein; in that the levies,
The lists and full proportions,[2] are all made
Out of his subject: and we here dispatch
You, good Cornelius, and you, Voltimand,
For bearers of this greeting to old Norway;
Giving to you no further personal power
To business with the king more than the scope
Of these delated articles[3] allow.
Farewell, and let your haste commend your duty.
Cornelius, Voltimand: In that, and all things, will we
 show our duty. 40
King: We doubt it nothing; heartily farewell.

|*Exeunt* VOLTIMAND *and* CORNELIUS.|
And now, Laertes, what's the news with you?
You told us of some suit; what is't, Laertes?
You cannot speak of reason to the Dane,
And lose your voice: what wouldst thou beg, Laertes,
That shall not be my offer, not thy asking?
The head is not more native to the heart,
The hand more instrumental to the mouth,
Than is the throne of Denmark to thy father.
What wouldst thou have, Laertes?
Laertes: My dread lord, 50
Your leave and favour to return to France;
From whence though willingly I came to Denmark,
To show my duty in your coronation;
Yet now, I must confess, that duty done,
My thoughts and wishes bend again toward France,
And bow them to your gracious leave and pardon.
King: Have you your father's leave? What says Polonius?
Polonius: He hath, my lord, wrung from me my slow
 leave,
By laboursome petition; and at last,
Upon his will I sealed my hard consent: 60
I do beseech you, give him leave to go.
King: Take thy fair hour, Laertes: time be thine,
And thy best graces spend it at thy will!
But now, my cousin Hamlet, and my son,—
Hamlet: |*Aside*| A little more than kin, and less than kind.
King: How is it that the clouds still hang on you?
Hamlet: Not so, my Lord, I am too much i' the sun.
Queen: Good Hamlet, cast thy nighted colour off,
And let thine eye look like a friend on Denmark.
Do not, for ever, with thy vailed[4] lids 70
Seek for thy noble father in the dust.
Thou know'st, 'tis common; all that lives must die,
Passing through nature to eternity.
Hamlet: Ay, madam, it is common.
Queen: If it be,
Why seems it so particular with thee?
Hamlet: "Seems," madam! nay, it is: I know not "seems."
'Tis not alone my inky cloak, good mother,
Nor customary suits of solemn black,
Nor windy suspiration of forced breath,
No, nor the fruitful river in the eye, 80
Nor the dejected haviour of the visage,
Together with all forms, moods, shows of grief,
That can denote me truly: these indeed seem,
For they are actions that a man might play:
But I have that within which passes show;
These, but the trappings and the suits of woe.
King: 'Tis sweet and commendable in your nature,
 Hamlet,
To give these mourning duties to your father:
But, you must know, your father lost a father;
That father lost his; and the survivor bound 90
In filial obligation for some term
To do obsequious sorrow: but to persever
In obstinate condolement[5] is a course
Of impious stubborness; 'tis unmanly grief:

1. partner.
2. provisions.
3. detailed documents.

4. lowered.
5. mourning.

It shows a will most incorrect to heaven;
A heart unfortified, a mind impatient,
An understanding simple and unschooled:
For what we know must be and is as common
As any the most vulgar thing to sense,
Why should we, in our peevish opposition, 100
Take it to heart? Fie! 'tis a fault to heaven,
A fault against the dead, a fault to nature,
To reason most absurd, whose common theme
Is death of fathers, and who still hath cried,
From the first corse[6] till he that died to-day,
"This must be so." We pray you, throw to earth
This unprevailing woe, and think of us
As of a father: for let the world take note,
You are the most immediate to our throne,
And with no less nobility of love, 110
Than that which dearest father bears his son,
Do I impart toward you. For your intent
In going back to school in Wittenberg,
It is most retrograde to our desire:
And we beseech you, bend you to remain
Here, in the cheer and comfort of our eye,
Our chiefest courtier, cousin, and our son.
Queen: Let not thy mother lose her prayers, Hamlet;
I pray thee, stay with us; go not to Wittenberg.
Hamlet: I shall in all my best obey you, madam. 120
King: Why, 'tis a loving and a fair reply;
Be as ourself in Denmark. Madam, come;
This gentle and unforced accord of Hamlet
Sits smiling to my heart: in grace whereof,
No jocund health that Denmark drinks to-day,
But the great cannon to the clouds shall tell;
And the king's rouse the heaven shall bruit[7] again,
Re-speaking earthly thunder. Come away.
 |*Exeunt all but* HAMLET.|
Hamlet: O, that this too too solid flesh would melt,
Thaw and resolve itself into a dew! 130
Or that the Everlasting had not fixed
His canon[8] 'gainst self-slaughter! O God! O God!
How weary, stale, flat, and unprofitable
Seem to me all the uses of this world!
Fie on 't! ah, fie! 'tis an unweeded garden.
That grows to seed; things rank and gross in nature,
Possess it merely. That it should come to this!
But two months dead! nay, not so much, not two;
So excellent a king; that was, to this,
Hyperion[9] to a satyr: so loving to my mother, 140
That he might not beteem[10] the winds of heaven
Visit her face too roughly. Heaven and earth!
Must I remember? why, she would hang on him,
As if increase of appetite had grown
By what it fed on: and yet, within a month,—
Let me not think on't;—frailty, thy name is woman!—
A little month; or ere those shoes were old,
With which she followed my poor father's body,

Like Niobe,[11] all tears;—why she, even she,—
O God! a beast, that wants discourse of reason, 150
Would have mourned longer,—married with my uncle,
My father's brother, but no more like my father,
Than I to Hercules. Within a month?
Ere yet the salt of most unrighteous tears
Had left the flushing in her galled eyes,
She married. O, most wicked speed, to post[12]
With such dexterity to incestuous sheets!
It is not, nor it cannot come to, good;—
But break, my heart: for I must hold my tongue!
 |*Enter* HORATIO, MARCELLUS, BERNARDO.|
Horatio: Hail to your lordship!
Hamlet: I am glad to see
 you well: 160
Horatio,—or I do forget myself.
Horatio: The same, my lord, and your poor servant ever.
Hamlet: Sir, my good friend; I'll change that name with
 you.
And what makes you from Wittenberg, Horatio?—
Marcellus?
Marcellus: My good lord,—
Hamlet: I am very glad to see you; good even, sir,—
But what, in faith, make you from Wittenberg?
Horatio: A truant disposition, good my lord.
Hamlet: I would not hear your enemy say so,
Nor shall you do mine ear that violence, 170
To make it truster of your own report
Against yourself: I know you are no truant.
But what is your affair in Elsinore?
We'll teach you to drink deep, ere you depart.
Horatio: My lord, I came to see your father's funeral.
Hamlet: I pray thee, do not mock me, fellow-student;
I think it was to see my mother's wedding.
Horatio: Indeed, my lord, it followed hard upon.
Hamlet: Thrift, thrift, Horatio! the funeral baked meats
Did coldly furnish forth the marriage tables. 180
Would I had met my dearest foe in heaven
Or ever I had ever seen that day. Horatio!—
My father,—methinks I see my father.
Horatio: Where, my lord?
Hamlet: In my mind's eye, Horatio
Horatio: I saw him once, 'a was a goodly king.
Hamlet: 'A was a man, take him for all in all,
I shall not look upon his like again.
Horatio: My lord, I think I saw him yesternight.
Hamlet: Saw! who?
Horatio: My lord, the king your father. 190
Hamlet: The king my father!
Horatio: Season your admiration for a while
With an attent ear, til I may deliver,
Upon the witness of these gentlemen,
This marvel to you.
Hamlet: For God's love, let me hear.
Horatio: Two nights together had these gentlemen,
Marcellus and Bernardo, on their watch,
In the dead waste and middle of the night,

6. corpse.
7. noisily proclaim.
8. law.
9. the sun god, a symbol of ideal beauty.
10. allow.

11. a mother, who, according to the Greek myth, wept so profusely
at the death of her children that she was turned to stone by the gods.
12. hasten.

Been thus encountered. A figure like your father,
Armed at point, exactly cap-a-pie,[13]
Appears before them, and with solemn march, 200
Goes slow and stately by them; thrice he walked,
By their oppressed and fear-surprised eyes,
Within his truncheon's length; whilst they, distilled
Almost to jelly with the act of fear,
Stand dumb, and speak not to him. This to me
In dreadful[14] secrecy impart they did;
And I with them the third night kept the watch:
Where, as they had delivered, both in time,
Form of the thing, each word made true and good,
The apparition comes. I knew your father; 210
These hands are not more like.
Hamlet: But where was this?
Marcellus: My lord, upon the platform where we
watched.
Hamlet: Did you not speak to it?
Horatio: My lord, I did;
But answer made it none: yet once, methought,
It lifted up its head and did address
Itself to motion, like as it would speak:
But even then the morning cock crew loud,
And at the sound it shrank in haste away,
And vanished from our sight.
Hamlet: 'Tis very strange.
Horatio: As I do live, my honoured lord, 'tis true; 220
And we did think it writ down in our duty,
To let you know of it.
Hamlet: Indeed, indeed, sirs, but this troubles me.
Hold you the watch to-night?
Marcellus, Bernardo: We do, my lord.
Hamlet: Armed, say you?
All: Armed, my lord.
Hamlet: From top to toe?
All: My lord, from head to foot.
Hamlet: Then saw you not his face?
Horatio: O, yes, my lord; he wore his beaver[15] up.
Hamlet: What, looked he frowningly?
Horatio: A countenance more in sorrow than in anger. 230
Hamlet: Pale or red?
Horatio: Nay, very pale.
Hamlet: And fixed his eyes upon you?
Horatio: Most constantly.
Hamlet: I would had been there.
Horatio: It would have much amazed you.
Hamlet: Very like, very like. Stayed it long?
Horatio: While one with moderate haste might tell a
hundred.
Marcellus, Bernardo: Longer, longer.
Horatio: Not when I saw 't.
Hamlet: His beard was grizzled,—no?
Horatio: It was, as I have seen it in his life,
A sable silvered.
Hamlet: I will watch to-night; 240
Perchance, 'twill walk again.

Horatio: I warrant it will.
Hamlet: If it assume my noble father's person,
I'll speak to it, though hell itself should gape
And bid me hold my peace, I pray you all,
If you have hitherto concealed this sight,
Let it be tenable in your silence still,
And whatsoever else shall hap to-night,
Give it an understanding, but no tongue;
I will requite your loves. So, fare you well:
Upon the platform, 'twixt eleven and twelve, 250
I'll visit you.
All: Our duty to your honour.
Hamlet: Your loves, as mine to you: farewell.
[*Exeunt all but* HAMLET.]
My father's spirit in arms! all is not well;
I doubt some foul play: would the night were come!
Till then sit still, my soul; foul deeds will rise,
Though all the earth o'erwhelm them, to men's eyes.
[*Exit.*]

Scene 3: A room in POLONIUS' house.

[*Enter* LAERTES *and* OPHELIA.]
Laertes: My necessaries are embarked; farewell:
And, sister, as the winds give benefit,
And convoy is assistant, do not sleep,
But let me hear from you.
Ophelia: Do you doubt that?
Laertes: For Hamlet, and the trifling of his favour,
Hold it as fashion, and a toy in blood,
A violet in the youth of primy[1] nature,
Forward, not permanent, sweet, not lasting,
The perfume and suppliance[2] of a minute;
No more.
Ophelia: No more but so?
Laertes: Think it no more: 10
For nature crescent[3] does not grow alone
In thews and bulk; but, as this temple waxes,
The inward service of the mind and soul
Grows wide withal. Perhaps he loves you now;
And now no soil nor cautel[4] doth besmirch
The virtue of his will: but, you must fear,
His greatness weighed, his will is not his own;
For he himself is subject to his birth:
He may not, as unvalued persons do,
Carve for himself, for on his choice depends, 20
The safety and health of this whole state,
And therefore must his choice be circumscribed
Unto the voice and yielding of that body
Whereof he is the head. Then if he says he loves you,
It fits your wisdom so far to believe it
As he in his particular act and place
May give his saying deed; which is no further,
Than the main voice of Denmark goes withal.
Then weigh what loss your honour may sustain.

13. head to foot.
14. fearful.
15. visor, face guard.

1. springlike.
2. occupation.
3. growing.
4. deceit.

If with too credent ear you list his songs, 30
Or lose your heart, or your chaste treasure open
To his unmastered importunity.
Fear it, Ophelia, fear it, my dear sister,
And keep you in the rear of your affection,
Out of the shot and danger of desire.
The chariest maid is prodigal enough,
If she unmask her beauty to the moon:
Virtue itself 'scapes not calumnious strokes:
The canker galls the infants of the spring
Too oft before their buttons[5] be disclosed, 40
And in the morn and liquid dew of youth
Contagious blastments are most imminent.
Be wary then: best safety lies in fear;
Youth to itself rebels, though none else near.
Ophelia: I shall the effect of this good lesson keep,
As watchman to my heart. But, good my brother,
Do not, as some ungracious pastors do,
Show me the steep and thorny way to heaven,
Whiles, like a puffed and reckless libertine,
Himself the primrose path of dalliance treads 50
And recks not his own rede.[6]
Laertes: O, fear me not.
I stay too long; but here my father comes.
 |Enter POLONIUS.|
A double blessing is a double grace;
Occasion smiles upon a second leave.
Polonius: Yet here, Laertes! aboard, aboard, for shame!
The wind sits in the shoulder of your sail,
And you are stayed for. There; my blessing with thee!
 |Laying his hand on LAERTES' head.|
And these few precepts in thy memory
Look thou character.[7] Give thy thoughts no tongue,
Nor any unproportioned thought his act.
Be thou familiar, but by no means vulgar. 60
The friends thou hast, and their adoption tried,
Grapple them to thy soul with hoops of steel;
But do not dull thy palm with entertainment
Of each new-hatched, unfledged comrade. Beware
Of entrance to a quarrel: but, being in,
Bear't that the opposed may beware of thee.
Give every man thine ear, but few thy voice:
Take each man's censure, but reserve thy judgment.
Costly thy habit as thy purse can buy, 70
But not expressed in fancy; rich, not gaudy:
For the apparel oft proclaims the man;
And they in France of the best rank and station
Are most select and generous, chief in that.
Neither a borrower nor a lender be:
For loan oft loses both itself and friend,
And borrowing dulls the edge of husbandry.
This above all: to thine ownself be true,
And it must follow, as the night the day,
Thou canst not then be false to any man.
Farewell; my blessing season this in thee! 80
Laertes: Most humbly do I take my leave, my lord.

Polonius: The time invites you; go, your servants tend.
Laertes: Farewell, Ophelia, and remember well
What I have said to you.
Ophelia: 'Tis in my memory locked,
And you yourself shall keep the key of it.
Laertes: Farewell.
 |Exit LAERTES.|
Polonius: What is't, Ophelia, he hath said to you?
Ophelia: So please you, something touching the Lord
 Hamlet.
Polonius: Marry, well bethought: 90
'Tis told me, he hath very oft of late
Given private time to you, and you yourself
Have of your audience been most free and bounteous;
If it be so,—as so 'tis put on me,
And that in way of caution,—I must tell you,
You do not understand yourself so clearly,
As it behoves my daughter and your honour.
What is between you? give me up the truth.
Ophelia: He hath, my lord, of late, made many tenders
Of his affection to me. 100
Polonius: Affection! pooh! you speak like a green girl,
Unsifted in such perilous circumstance.
Do you believe his "tenders," as you call them?
Ophelia: I do not know, my lord, what I should think.
Polonius: Marry, I'll teach you: think yourself a baby;
That you have ta'en his tenders for true pay,
Which are not sterling. Tender yourself more dearly;
Or,—not to crack the wind of the poor phrase,
Running it thus,—you'll tender me a fool.
Ophelia: My lord, he hath importuned me with love 110
In honourable fashion.
Polonius: Ay, "fashion" you may call it; go to, go to.
Ophelia: And hath given countenance to his speech, my
 lord,
With almost all the vows of heaven.
Polonius: Ay, springes to catch woodcocks.[8] I do know,
When the blood burns, how prodigal the soul
Lends the tongue vows: these blazes, daughter,
Giving more light than heat, extinct in both,
Even in their promise, as it is a-making,
You must not take for fire. From this time 120
Be something scanter of your maiden presence;
Set your entreatments at a higher rate,
Than a command to parley. For Lord Hamlet,
Believe so much in him, that he is young;
And with a larger tether may he walk,
Than may be given you; in few, Ophelia,
Do not believe his vows: for they are brokers,
Not of that dye which their investments show,
But mere implorators of unholy suits,
Breathing like sanctified and pious bonds, 130
The better to beguile. This is for all;
I would not, in plain terms, from this time forth.
Have you so slander any moment's leisure,
As to give words or talk with the Lord Hamlet.
Look to 't, I charge you; come your ways.
Ophelia: I shall obey, my lord.
 |Exeunt.|

5. buds.
6. does not heed his own advice.
7. inscribe.

8. traps to catch stupid birds.

Scene 4: The platform.

|*Enter* HAMLET, HORATIO, *and* MARCELLUS.|
Hamlet: The air bites shrewdly; it is very cold.
Horatio: It is nipping and an eager air.
Hamlet: What hour now?
Horatio: I think it lacks of twelve.
Marcellus: No, it is struck.
Horatio: Indeed? I heard it not; it then draws near the
 season,
Wherein the spirit held his wont to walk.
 |*A flourish of trumpets, and ordnance shot off,*
 within.|
What does this mean, my lord?
Hamlet: The king doth wake to-night and takes his
 rouse,
Keeps wassail and the swaggering up-spring reels;
And as he drains his draughts of Rhenish down, 10
The kettle-drum and trumpet thus bray out
The triumph of his pledge.
Horatio: Is it a custom?
Hamlet: Ay, marry, is't:
But to my mind, though I am native here,
And to the manner born, it is a custom
More honoured in the breach than the observance.
This heavy-headed revel east and west
Makes us traduced and taxed of other nations:
They clepe[1] us drunkards, and with swinish phrase
Soil our addition,[2] and indeed it takes 20
From our achievements, though performed at height,
The pith and marrow of our attribute.
So, oft it chances in particular men,
That for some vicious mole of nature in them,
As, in their birth,—wherein they are not guilty
Since nature cannot choose his origin,—
By the o'ergrowth of some complexion,
Oft breaking down the pales[3] and forts of reason:
Or by some habit that too much o'erleavens
The form of plausive[4] manners; that these men,— 30
Carrying, I say, the stamp of one defect;
Being nature's livery, or fortune's star,—
His virtues else—be they as pure as grace,
As infinite as man may undergo,—
Shall in the general censure take corruption
From that particular fault: the dram of eale
Doth all the noble substance of a doubt,
To his own scandal.
 |*Enter* GHOST.|
Horatio: Look, my lord, it comes!
Hamlet: Angels and ministers of grace defend us!
Be thou a spirit of health of goblin damned, 40
Bring with thee airs from heaven or blasts from hell,
Be thy intents wicked or charitable,
Thou com'st in such a questionable shape,
That I will speak to thee; I'll call thee Hamlet.
King, father; royal Dane, O, answer me!
Let me not burst in ignorance; but tell
Why thy canonized bones, hearsed in death

Have burst their cerements;[5] why the sepulchre,
Wherin we saw thee quietly in-urned,
Hath oped his ponderous and marble jaws, 50
To cast thee up again. What may this mean.
That thou, dead corse, again, in complete steel,
Revisit'st thus the glimpses of the moon,
Making night hideous; and we fools of nature
So horridly to shake our disposition,
With thoughts beyond the reaches of our souls?
Say, why is this? wherefore? what should we do?
 |GHOST *beckons* HAMLET.|
Horatio: It beckons you to go away with it,
As if some impartment[6] did desire
To you alone.
Marcellus: Look, with what courteous action 60
It waves you to a more removed ground:
But do not go with it.
Horatio: No, by no means.
Hamlet: It will not speak; then I will follow it.
Horatio: Do not, my lord.
Hamlet: Why, what should be the fear?
I do not set my life at a pin's fee;
And for my soul, what can it do to that,
Being a thing immortal as itself?
It waves me forth again: I'll follow it.
Horatio: What if it tempt you toward the flood, my lord,
Or to the dreadful summit of the cliff 70
That beetles o'er his base into the sea,
And there assume some other horrible form,
Which might deprive your sovereignty of reason,
And draw you into madness? think of it:
The very place puts toys of desperation,
Without more motive, into every brain,
That looks so many fathoms to the sea
And hears it roar beneath.
Hamlet: It waves me still.
Go on; I'll follow thee.
Marcellus: You shall not go, my lord.
Hamlet: Hold off your hands! 80
Horatio: Be ruled; you shall not go.
Hamlet: My fate cries out,
And makes each petty artery in this body
As hardy as the Nemean lion's[7] nerve.
 |GHOST *beckons.*|
Still am I called:—unhand me, gentlemen;
 |*Breaking from them.*|
By heaven, I'll make a ghost of him that lets me:
I say, away!—Go on, I'll follow thee.
 |*Exeunt* GHOST *and* HAMLET.|
Horatio: He waxes desperate with imagination.
Marcellus: Let's follow; 'tis not fit thus to obey him.
Horatio: Have after.—To what issue will this come?
Marcellus: Something is rotten in the state of Denmark. 90
Horatio: Heaven will direct it.
Marcellus: Nay, let's follow him.
 |*Exeunt.*|

1. call.
2. reputation.
3. enclosures.
4. pleasing.
5. shroud.
6. communication.
7. mythical lion killed by the Greek hero Hercules.

Scene 5: Another part of the platform.

[*Enter* GHOST *and* HAMLET.]

Hamlet: Where wilt thou lead me? speak, I'll go no
 further.
Ghost: Mark me.
Hamlet: I will.
Ghost: My hour is almost come,
When I to sulphurous and tormenting flames
Must render up myself.
Hamlet: Alas, poor ghost!
Ghost: Pity me not, but lend thy serious hearing
To what I shall unfold.
Hamlet: Speak; I am bound to hear.
Ghost: So art thou to revenge, when thou shalt hear.
Hamlet: What?
Ghost: I am thy father's spirit;
Doomed for a certain term to walk the night;
And for the day confined to fast in fires, 10
Til the foul crimes done in my days of nature
Are burnt and purged away. But that I am forbid
To tell the secrets of my prison-house,
I could a tale unfold whose lightest word
Would harrow up thy soul, freeze thy young blood,
Make thy two eyes, like stars, start from their spheres,
Thy knotted and combined locks to part,
And each particular hair to stand an end,
Like quills upon the fretful porpentine,[1]
But this eternal blazon must not be 20
To ears of flesh and blood. List, list, O list!
If thou didst ever thy dear father love—
Hamlet: O God!
Ghost: Revenge his foul and most unnatural murder.
Hamlet: Murder?
Ghost: Murder, most foul, as in the best it is,
But this most foul, strange, and unnatural.
Hamlet: Haste me to know't; that I, with wings as swift
As meditation or the thoughts of love,
May sweep to my revenge.
Ghost: I find thee apt;
And duller shouldst thou be than the fat weed
That roots itself in ease on Lethe[2] wharf, 30
Wouldst thou not stir in this. Now Hamlet, hear:
'Tis given out, that, sleeping in mine orchard,
A serpent stung me; so the whole ear of Denmark
Is by a forged process of my death
Rankly abused: but know, thou noble youth,
The serpent that did sting thy father's life,
Now wears his crown.
Hamlet: O my prophetic soul! my uncle!
Ghost: Ay, that incestuous, that adulterate beast,
With witchcraft of his wit, with traitorous gifts,—
O wicked wit and gifts, that have the power 40
So to seduce!—won to his shameful lust
The will of my most seeming-virtuous queen:
O Hamlet, what a falling-off was there!
From me, whose love was of that dignity,
That it went hand in hand even with the vow

I made to her in marriage; and to decline
Upon a wretch, whose natural gifts were poor
To those of mine!
But virtue, as it never will be moved,
Though lewdness court it in a shape of heaven; 50
So lust, though to a radiant angel linked,
Will sort itself in a celestial bed.
And prey on garbage.
But, soft! methinks I scent the morning air;
Brief let me be. Sleeping within my orchard
My custom always in the afternoon,
Upon my secure hour thy uncle stole,
With juice of cursed hebenon[3] in a vial,
And in the porches of mine ears did pour
The leperous distilment; whose effect 60
Holds such an enmity with blood of man,
That swift as quicksilver it courses through
The natural gates and alleys of the body;
And with a sudden vigour it doth posset[4]
And curd, like eager[5] droppings into milk,
The thin and wholesome blood: so did it mine;
And a most instant tetter[6] barked about,
Most lazar-like,[7] with vile and loathsome crust,
All my smooth body.
Thus was I, sleeping, by a brother's hand, 70
Of life, of crown, and queen, at once dispatched;
Cut off even in the blossoms of my sin,
Unhouseled, disappointed, unaneled;[8]
No reckoning made, but sent to my account
With all my imperfections on my head:
O, horrible! O, horrible! most horrible!
If thou hast nature in thee, bear it not;
Let not the royal bed of Denmark be
A couch for luxury and damned incest,
But, howsoever thou pursuest this act, 80
Taint not thy mind, nor let thy soul contrive
Against thy mother aught; leave her to heaven,
And to those thorns that in her bosom lodge,
To prick and sting her. Fare thee well at once!
The glow-worm shows the matin[9] to be near,
And 'gins to pale his uneffectual fire:
Adieu, adieu, adieu! remember me.
 [*Exit.*]
Hamlet: O all you host of heaven! O earth! What else?
And shall I couple hell? O fie! Hold, hold, my heart;
And you, my sinews, grow not instant old, 90
But bear me stiffly up.—Remember thee?
Ay, thou poor ghost, whiles memory holds a seat
In this distracted globe. Remember thee?
Yea, from the table of my memory
I'll wipe away all trivial fond records,
All saws of books, all forms, all pressures part,
That youth and observation copied there;

1. timid porcupine.
2. river of forgetfulness in Hades.
3. a poisonous plant.
4. curdle.
5. acid.
6. scab.
7. leperlike.
8. without taking communion, unabsolved, without extreme unction.
9. morning.

And thy commandment all alone shall live
Within the book and volume of my brain,
Unmixed with baser matter: yes, by heaven! 100
O most pernicious woman!
O villain, villain, smiling, damned villain!
My tables, meet it is I set it down,
That one may smile, and smile, and be a villain;
At least I'm sure it may be so in Denmark;
 |Writing|
So, uncle, there you are. Now to my word;
It is, "Adieu, adieu! remember me."
I have sworn't.
Horatio: |Within| My lord, my lord—
Marcellus: |Within| Lord Hamlet—
Horatio: |Within| Heaven secure him!
Marcellus: |Within| So be it!
Horatio: |Within| Illo, ho, ho, my lord!
Hamlet: Hillo, ho, ho, boy! come, bird, come. 110
 |Enter HORATIO and MARCELLUS.|
Marcellus: How is't, my noble lord?
Horatio: What news, my lord?
Hamlet: O wonderful!
Horatio: Good my lord, tell it.
Hamlet: No, you will reveal it.
Horatio: Not I, my lord, by heaven.
Marcellus: Nor I, my lord.
Hamlet: How say you then; would heart of man once
 think it?
But you'll be secret—
Horatio, Marcellus: Ay, by heaven, my lord.
Hamlet: There's ne'er a villain dwelling in all Denmark
But he's an arrant knave.
Horatio: There needs no ghost, my lord, come from the
 grave
To tell us this.
Hamlet: Why, right; you are i' the right; 120
And so, without more circumstance at all,
I hold it fit that we shake hands and part;
You, as your business and desire shall point you,
For every man hath business and desire,
Such as it is; and for my own poor part,
Look you, I'll go pray.
Horatio: These are but wild and whirling words, my lord.
Hamlet: I'm sorry they offend you, heartily;
Yes, faith, heartily.
Horatio: There's no offence, my lord.
Hamlet: Yes, by Saint Patrick, but there is, Horatio, 130
And much offence too. Touching this vision here,
It is an honest ghost, that let me tell you;
For your desire to know what is between us,
O'ermaster it as you may. And now, good friends,
As you are friends, scholars, and soldiers,
Give me one poor request.
Horatio: What is't my lord? we will.
Hamlet: Never make known what you have seen tonight.
Horatio, Marcellus: My lord, we will not.
Hamlet: Nay, but swear't.
Horatio: In faith,
My lord, not I.
Marcellus: Nor I, my lord, in faith. 140
Hamlet: Upon my sword.

Marcellus: We have sworn, my lord,
 already.
Hamlet: Indeed, upon my sword, indeed.
Ghost: |Beneath| Swear.
Hamlet: Ha, ha, boy! say'st thou so? art thou there,
 true-penny?[10]
Come on; you hear this fellow in the cellarage;
Consent to swear.
Horatio: Propose the oath, my lord.
Hamlet: Never to speak of this that you have seen.
Swear by my sword.
Ghost: |Beneath| Swear.
Hamlet: Hic et ubique?[11] then we'll shift our ground— 150
Come hither, gentlemen,
And lay your hands again upon my sword:
Never to speak of this that you have heard,
Swear by my sword.
Ghost: |Beneath| Swear.
Hamlet: Well said, old mole! canst work i'the ground so
 fast?
A worthy pioneer![12]—Once more remove, good friends.
Horatio: O day and night, but this is wondrous strange!
Hamlet: And therefore as a stranger give it welcome.
There are more things in heaven and earth, Horatio, 160
Than are dreamt of in your philosophy. But come;
Here, as before, never, so help you mercy,
How strange or odd soe'er I bear myself,
As I perchance hereafter shall think meet
To put an antic disposition on,
That you, at such time seeing me, never shall
With arms encumbered thus, or this head-shake,
Or by pronouncing of some doubtful phrase,
As, "Well, well, we know," or "We could, and if we would,"
Or, "If we list to speak," or, "There be, and if they might," 170
Or such ambiguous giving out, to note
That you know aught of me: this not to do,
So grace and mercy at your most need help you,
Swear!
Ghost: |Beneath| Swear!
Hamlet: Rest, rest, perturbed spirit! So, gentlemen,
With all my love I do commend me to you:
And what so poor a man as Hamlet is
May do, to express his love and friending to you,
God willing, shall not lack. Let us go in together;
And still your fingers on your lips. I pray. 180
The time is out of joint;—O cursed spite,
That ever I was born to set it right!—
Nay, come, let's go together.
 |Exeunt.|

Act II
Scene 1: A room in POLONIUS' house.

 |Enter POLONIUS and REYNALDO.|
Polonius: Give him this money and these notes,
 Reynaldo.
Reynaldo: I will, my lord.

10. honest fellow.
11. here and everywhere.
12. miner.

Polonius: You shall do marvellous wisely, good Reynaldo,
Before you visit him, to make inquire
Of his behaviour.
Reynaldo: My lord, I did intend it.
Polonius: Marry, well said, very well said. Look you, sir.
Inquire me first what Danskers[1] are in Paris.
And how, and who; what means, and where they keep;
What company, at what expense; and finding
By this encompassment and drift of question, 10
That they do know my son, come you more nearer
Than your particular demands will touch it:
Take you, as 'twere, some distant knowledge of him,
As thus, "I know his father and his friends,
And in part him." Do you mark this, Reynaldo?
Reynaldo: Ay, very well, my lord.
Polonius: "And in part, him; but," you may say, "not
well:
But if't be he I mean, he's very wild,
Addicted" so and so; and there put on him
What forgeries you please; marry, none so rank 20
As may dishonour him; take heed of that:
But, sir, such wanton, wild, and usual slips,
As are companions noted and most known
To youth and liberty.
Reynaldo: As gaming, my lord.
Polonius: Ay, or drinking, fencng, swearing,
Quarrelling, drabbing:[2] you may go so far.
Reynaldo: My lord, that would dishonour him.
Polonius: Faith, no; as you may season it in the charge.
You must not put another scandal on him,
That he is open to incontinency; 30
That's not my meaning: but, breathe his faults so quaintly
That they may seem the taints of liberty:
The flash and outbreak of a fiery mind;
A savageness in unreclaimed blood,
Of general assault.[3]
Reynaldo: But, my good lord,—
Polonius: Wherefore should you do this?
Reynaldo: Ay, my lord,
I would know that.
Polonius: Marry, sir, here's my drift;
And, I believe, it is a fetch of warrant:
You laying these slight sullies on my son,
As 'twere a thing a little soiled i' the working, 40
Mark you, your party in converse, him you would sound,
Having ever seen in the prenominate crimes,
The youth you breathe of guilty, be assured,
He closes with you in this consequence:
"Good sir," or so; or, "friend," or "gentleman,"—
According to the phrase or the addition,
Of man and country.
Reynaldo: Very good, my lord.
Polonius: And then, sir, does 'a[4] this,—'a does—what was
I about to say? By the mass, I was about to say
something: where did I leave? 50
Reynaldo: At "closes in the consequence," at "friend or
so," and "gentleman."

Polonius: At "closes in the consequence," ay, marry;
He closes thus: "I know the gentleman;
I saw him yesterday, or t' other day,
Or then, or then, with such, or such, and, as you say,
There was a-gaming, there o'ertook in's rouse:
There falling out at tennis;" or perchance,
"I saw him enter such a house of sale"
Videlicet,[5] a brothel, or so forth. See you now; 60
Your bait of falsehood takes this carp of truth:
And thus do we of wisdom and of reach,
With windlasses and with assays of bias,
By indirections find direction out;
So, by my former lecture and advice,
Shall you my son. You have me, have you not?
Reynaldo: My lord, I have.
Polonius: God b'uy ye; fare ye well.
Reynaldo: Good, my lord!
Polonius: Observe his inclination in yourself.
Reynaldo: I shall, my lord. 70
Polonius: And let him ply his music.
Reynaldo: Well, my lord.
Polonius: Farewell!
 |*Exit.*|
 |*Enter* OPHELIA.|
 How now, Ophelia? what's the matter?
Ophelia: O, my lord, my lord, I have been so affrighted!
Polonius: With what, i' the name of God?
Ophelia: My lord, as I was sewing in my closet.
Lord Hamlet, with his doublet all unbraced.[6]
No hat upon his head: his stockings fouled,
Ungartered, and down-gyved[7] to his ankle;
Pale as his shirt; his knees knocking each other;
And with a look so piteous in purport, 80
As if he had been loosed out of hell,
To speak of horrors, he comes before me.
Polonius: Mad for thy love?
Ophelia: My lord, I do not know,
But truly I do fear it.
Polonius: What said he?
Ophelia: He took me by the wrist, and held me hard:
Then goes he to the length of all his arm,
And with his other hand thus o'er his brow,
He falls to such perusal of my face,
As he would draw it. Long stayed he so;
At last, a little shaking of mine arm, 90
And thrice his head thus waving up and down,
He raised a sigh so piteous and profound,
As it did seem to shatter all his bulk,
And end his being: that done, he lets me go:
And with his head over his shoulder turned
He seemed to find his way without his eyes;
For out o' doors he went without their help,
And to the last bended their light on me.
Polonius: Come, go with me; I will go seek the king.
This is the very ecstasy of love; 100
Whose violent property fordoes itself,
And leads the will to desperate undertakings,

1. Danes.
2. womanizing.
3. common to all.
4. he.
5. namely.
6. jacket completely unfastened.
7. hanging down like fetters.

As oft as any passion under heaven,
That does afflict our natures. I am sorry,—
What, have you given him any hard words of late?
Ophelia: No, my good lord, but, as you did command,
I did repel his letters, and denied
His access to me.
Polonius: That hath made him mad.
I am sorry that with better heed and judgment,
I had not quoted him: I feared he did but trifle 110
And meant to wrack thee; but, beshrew my jealousy!
By heaven, it is as proper to our age
To cast beyond ourselves in our opinions
As it is common for the younger sort
To lack discretion. Come, go we to the king:
This must be known; which, being kept close, might
 move
More grief to hide than hate to utter love. Come!
 |*Exeunt.*|

Scene 2: A room in the castle.

|*Flourish. Enter* KING, QUEEN, ROSENCRANTZ,
GUILDENSTERN, *and* ATTENDANTS.|

King: Welcome, dear Rosencrantz and Guildenstern!
Moreover that we much did long to see you,
The need we have to use you did provoke
Our hasty sending. Something have you heard
Of Hamlet's transformation: so I call it,
Sith[1] nor the exterior nor the inward man
Resembles that it was. What it should be,
More than his father's death, that thus hath put him
So much from the understanding of himself,
I cannot dream of. I entreat you both, 10
That, being of so young days brought up with him,
And sith so neighboured to his youth and humour,[2]
That you vouchsafe your rest here in our court
Some little time; so by your companies
To draw him on to pleasures, and to gather,
So much as from occasion you may glean,
Whether aught to us unknown afflicts him thus,
That, opened, lies within our remedy.
Queen: Good gentlemen, he hath much talked of you;
And sure I am two men there are not living 20
To whom he more adheres. If it will please you
To show us so much gentry[3] and good will,
As to expend your time with us a while,
For the supply and profit of our hope,
Your visitation shall receive such thanks
As fits a king's remembrance.
Rosencrantz: Both your majesties
Might, by the sovereign power you have of us,
Put your dread pleasures more into command
Than to entreaty.
Guildenstern: But we both obey,
And here give up ourselves, in the full bent, 30
To lay our service freely at your feet,
To be commanded.

1. since.
2. behaviour.
3. courtesy.

King: Thanks, Rosencrantz and gentle Guildenstern.
Queen: Thanks, Guildenstern and gentle Rosencrantz:
And I beseech you instantly to visit
My too much changed son. Go, some of you,
And bring these gentlemen where Hamlet is.
Guildenstern: Heavens make our presence and our
 practices,
Pleasant and helpful to him!
Queen: Ay, amen!
 |*Exeunt* ROSENCRANTZ, GUILDENSTERN, *and
 some* ATTENDANTS.|
 |*Enter* POLONIUS.|
Polonius: The ambassadors from Norway, my good lord, 40
are joyfully returned.
King: Thou still hast been the father of good news.
Polonius: Have, I my lord? Assure you, my good liege,
I hold my duty, as I hold my soul,
Both to my God and to my gracious king:
And I do think, or else this brain of mine
Hunts not the trail of policy so sure
As I have used to do, that I have found
The very cause of Hamlet's lunacy.
King: O, speak of that; that I do long to hear. 50
Polonius: Give first admittance to the ambassadors;
My news shall be the fruit to that great feast.
King: Thyself do grace to them, and bring them in.
 |*Exit* POLONIUS.|
He tells me, my dear Gertrude, that he hath found
The head and source of all your son's distemper.
Queen: I doubt it is no other but the main;
His father's death, and our o'erhasty marriage.
King: Well, we shall sift him.—
 |*Re-enter* POLONIUS, *with* VOLTIMAND
 and CORNELIUS.|
 Welcome, my good friends!
Say, Voltimand, what from our brother Norway?
Voltimand: Most fair return of greetings and desires. 60
Upon our first, he sent out to suppress
His nephew's levies, which to him appeared
To be a preparation 'gainst the Polack;
But better looked into, he truly found
It was against your highness: whereat, grieved
That so his sickness, age, and impotence,
Was falsely borne in hand, sends out arrests
On Fortinbras, which he, in brief, obeys,
Receives rebuke from Norway, and, in fine,[4]
Makes vow before his uncle never more 70
To give the assay of arms against your majesty.
Whereon old Norway, overcome with joy,
Gives him three thousand crowns in annual fee
And his commission to employ those soldiers,
So levied as before, against the Polack:
With an entreaty, herein further shown,
 |*Gives a paper.*|
That it might please you to give quiet pass
Through your dominions for this enterprise;
On such regards of safety and allowance,
As therein are set down.
King: It likes us well; 80

4. finally.

And at our more considered time, we'll read,
Answer, and think upon this business.
Meantime we thank you for your well-took labour:
Go to your rest; at night we'll feast together:
Most welcome home!
 |*Exeunt* VOLTIMAND *and* CORNELIUS.|
Polonius: This business is well ended.
My liege, and madam, to expostulate
What majesty should be, what duty is,
Why day is day, night night, and time is time,
Were nothing but to waste night, day, and time.
Therefore, since brevity is the soul of wit, 90
And tediousness the limbs and outward flourishes,
I will be brief. Your noble son is mad:
Mad call I it: for, to define true madness,
What is't but to be nothing else but mad?
But let that go.
Queen: More matter, with less art.
Polonius: Madam, I swear, I use no art at all.
That he is mad, 'tis true; 'tis true 'tis pity;
And pity 'tis 'tis true: a foolish figure;[5]
But farewell it, for I will use no art.
Mad let us grant him then: and now remains, 100
That we find out the cause of this effect;
Or rather say, the cause of this defect,
For this effect defective comes by cause:
Thus it remains and the remainder thus.
Perpend.[6]
I have a daughter; have, while she is mine;
Who in her duty and obedience, mark,
Hath given me this: now gather and surmise.
 |*Reads.*|
—*To the celestial and my soul's idol, the most beautified*
 Ophelia,—
That's an ill phrase, a vile phrase; "*beautified*" is a vile 110
 phrase; but you shall hear. Thus:
|*Reads*| *These. In her excellent white bosom, these.*
Queen: Came this from Hamlet to her?
Polonius: Good madam, stay awhile; I will be faithful.
|*Reads*| *Doubt thou, the stars are fire;*
 Doubt that the sun doth move;
 Doubt truth to be liar;
 But never doubt, I love.
 O dear Ophelia, I am ill at these numbers; I have
 not heart to reckon my groans: but that I love thee 120
 best, O most best, believe it. Adieu.
 Thine evermore, most dear lady, whilst
 this machine is to him, *Hamlet.*
This in obedience hath my daughter shown me:
And more above, hath his solicitings,
As they fell out by time, be means, and place,
All given to mine ear.
King: But how hath she
Received his love?
Polonius: What do you think of me?
King: As of a man faithful and honourable.
Polonius: I would fain prove so. But what might you
 think, 130

5. rhetorical device.
6. consider carefully.

When I had seen this hot love on the wing,
As I perceived it, I must tell you that,
Before my daughter told me, what might you,
Or my dear majesty your queen here, think,
If I had played the desk or table-book,[7]
Or given my heart a working, mute and dumb;
Or looked upon this love with idle sight;
What might you think? No, I went round to work,
And my young mistress thus I did bespeak;
"Lord Hamlet is a prince out of thy star;[8] 140
This must not be:" and then I prescripts gave her,
That she should lock herself from his resort,
Admit no messengers, receive no tokens
Which done, she took the fruits of my advice;
And he repelled, a short tale to make,
Fell into a sadness, then into a fast,
Thence to a watch, thence into a weakness,
Thence to a lightness, and by this declension
Into the madness wherein now he raves
And all we mourn for. 150
King: Do you think 'tis this?
Queen: It may be, very like.
Polonius: Hath there been such a time, I'd fain know
 that,
That I have positively said "'tis so,"
When it proved otherwise?
King: Not that I know.
Polonius: |*Pointing to his head, and shoulder*| Take this from
 this, if this be otherwise.
If circumstances lead me, I will find
Where truth is hid, though it were hid indeed
Within the centre.
King: How may we try if further?
Polonius: You know, sometimes he walks four hours
 together,
Here in the lobby.
Queen: So he does, indeed. 160
Polonius: At such time I'll loose my daughter to him;
Be you and I behind an arras[9] then;
Mark the encounter: if he love her not,
And be not from his reason fallen thereon,
Let me be no assistant for a state,
But keep a farm and carters.
King: We will try it.
Queen: But, look, where sadly the poor wretch comes
 reading.
Polonius: Away: I do beseech you, both away;
I'll board him presently:—O, give me leave.—
 |*Exeunt* KING, QUEEN, *and* ATTENDANTS.|
 |*Enter* HAMLET, *reading.*|
How does my good Lord Hamlet? 170
Hamlet: Well, God-a-mercy.
Polonius: Do you know me, my lord?
Hamlet: Excellent well; you are a fishmonger.[10]
Polonius: Not I, my lord.
Hamlet: Then I would you were so honest a man.

7. had kept secrets.
8. sphere.
9. tapestry hanging in front of a wall.
10. dealer in fish (slang for a procurer).

Polonius: Honest, my lord?

Hamlet: Ay, sir; to be honest, as this world goes, is to be one man picked out of ten thousand.

Polonius: That's very true, my lord.

Hamlet: For if the sun breed maggots in a dead dog, being a good kissing carrion,—Have you a daughter? 180

Polonius: I have, my lord.

Hamlet: Let her not walk i' the sun: conception is a blessing; but not as your daughter may conceive,—friend, look to't.

Polonius: How say you by that? |*Aside*| Still harping on my daughter: yet he knew me not at first; 'a said I was a fishmonger: 'a is far gone, far gone: and truly in my youth I suffered much extremity for love; very near this. I'll speak to him again.—What do you read, my lord? 190

Hamlet: Words, words, words!

Polonius: What is the matter, my lord?

Hamlet: Between who?

Polonius: I mean the matter that you read, my lord?

Hamlet: Slanders, sir: for the satirical rogue says here that old men have grey beards, that their faces are wrinkled, their eyes purging thick amber and plum-tree gum, and that they have a plentiful lack of wit, together with most weak hams: all which, sir, though I most powerfully and potently believe, yet I hold it not honesty 200 to have it thus set down; for you yourself, sir, should be old as I am, if like a crab you could go backward.

Polonius: |*Aside*| Though this be madness, yet there is method in't.— Will you walk out of the air, my lord?

Hamlet: Into my grave?

Polonius: Indeed, that is out of the air.—How pregnant[11] sometimes his replies are! a happiness that often madness hits on, which reason and sanity could not so prosperously be delivered of. I will leave him, and suddenly contrive the means of meeting between him 210 and my daughter.—My honourable lord, I will most humbly take my leave of you.

Hamlet: You cannot, sir, take from me any thing that I will more willingly part withal; except my life, except my life, except my life.

Polonius: Fare you well, my lord.

Hamlet: These tedious old fools!

|*Enter* ROSENCRANTZ *and* GUILDENSTERN.|

Polonius: You go to seek the Lord Hamlet; there he is.

Rosencrantz: |*To* POLONIUS| God save you sir!

|*Exit* POLONIUS.|

Guildenstern: My honoured lord!— 220

Rosencrantz: My most dear lord!

Hamlet: My excellent good friends! How dost thou, Guildenstern? Ah, Rosencrantz! Good lads, how do ye both?

Rosencrantz: As the indifferent children of the earth.

Guildenstern: Happy, in that we are not over-happy; on fortune's cap we are not the very button.

Hamlet: Nor the soles of her shoe?

Rosencrantz: Neither, my lord.

Hamlet: Then you live about her waist, or in the middle 230 of her favours?

Guildenstern: Faith, her privates we.

Hamlet: In the secret parts of fortune? O, most true; she is a strumpet. What's the news?

Rosencrantz: None, my lord; but that the world's grown honest.

Hamlet: Then is dooms-day near: but your news is not true. Let me question more in particular: what have you, my good friends, deserved at the hands of fortune, that she sends you to prison hither? 240

Guildenstern: Prison, my lord?

Hamlet: Denmark's a prison.

Rosencrantz: Then is the world one.

Hamlet: A goodly one; in which there are many confines, wards,[12] and dungeons; Denmark being one o' the worst.

Rosencrantz: We think not so, my lord.

Hamlet: Why, then 'tis none to you: for there is nothing either good or bad but thinking makes it so: to me it is a prison. 250

Rosencrantz: Why, then your ambition makes it one; 'tis too narrow for your mind.

Hamlet: O God, I could be bounded in a nutshell, and count myself a king of infinite space; were it not that I have bad dreams.

Guildenstern: Which dreams, indeed, are ambition; for the very substance of the ambitious is merely the shadow of a dream.

Hamlet: A dream itself is but a shadow.

Rosencrantz: Truly, and I hold ambition of so airy and 260 light a quality that it is but a shadow's shadow.

Hamlet: Then are our beggars bodies; and our monarchs and outstretched heroes the beggars' shadows. Shall we to the court? for, by my fay,[13] I cannot reason.

Rosencrantz, Guildenstern: We'll wait upon you.

Hamlet: No such matter: I will not sort you with the rest of my servants; for, to speak to you like an honest man, I am most dreadfully attended. But, in the beaten way of friendship, what make you at Elsinore?

Rosencrantz: To visit you, my lord; no other occasion. 270

Hamlet: Beggar that I am, I am even poor in thanks; but I thank you: and sure, dear friends, my thanks are too dear a halfpenny. Were you not sent for? Is it your own inclining? Is it a free visitation? Come, deal justly with me: come, come; nay, speak.

Guildenstern: What should we say, my lord?

Hamlet: Why anything, but to the purpose. You were sent for; and there is a kind of confession in your looks, which your modesties have not craft enough to colour. I know, the good king and queen have sent for you. 280

Rosencrantz: To what end, my lord?

Hamlet: That you must teach me. But let me conjure you, by the rights of our fellowship, by the consonancy of our youth, by the obligation of our ever-preserved love, and by what more dear a better proposer could charge you withal, be even and direct with me, whether you were sent for, or no.

Rosencrantz: |*To* GUILDENSTERN| What say you?

Hamlet: |*Aside*| Nay, then I have an eye of you.—If you

11. meaningful.

12. cells.

13. faith.

love me, hold not off. 290

Guildenstern: My lord, we were sent for.

Hamlet: I will tell you why; so shall my anticipation prevent your discovery, and your secrecy to the king and queen moult no feather. I have of late, but wherefore, I know not, lost all my mirth, forgone all custom of exercises: and indeed, it goes so heavily with my disposition that this goodly frame, the earth, seems to me a sterile promontory; this most excellent canopy, the air, look you, this brave o'erhanging firmament, this majestical roof fretted with golden fire, why, it appears 300 no other thing to me than a foul and pestilent congregation of vapours. What a piece of work is a man! how noble in reason! how infinite in faculty! in form and moving, how express[14] and admirable! in action, how like an angel! in apprehension, how like a god! the beauty of the world! the paragon of animals! And yet, to me, what is this quintessence of dust? man delights not me; no, nor woman neither, though by your smiling you seem to say so.

Rosencrantz: My lord, there was no such stuff in my 310 thoughts.

Hamlet: Why did you laugh then, when I said, "Man delights not me?"

Rosencrantz: To think, my lord, if you delight not in man, what lenten[15] entertainment the players shall receive from you: we coted[16] them on the way; and hither are they coming, to offer you service.

Hamlet: He that plays the king shall be welcome; his majesty shall have tribute of me; the adventurous knight shall use his foil and target: the lover shall not sigh 320 gratis; the humorous man shall end his part in peace: the clown shall make those laugh whose lungs are tickle o' the sere,[17] and the lady shall say her mind freely, or the blank verse shall halt for 't. What players are they?

Rosencrantz: Even those you were wont to take such delight in, the tragedians of the city.

Hamlet: How chances it they travel? their residence, both in reputation and profit, was better both ways.

Rosencrantz: I think their inhibition comes by the means of the late innovation. 330

Hamlet: Do they hold the same estimation they did when I was in the city? Are they so followed?

Rosencrantz: No, indeed, they are not.

Hamlet: How comes it? Do they grow rusty?

Rosencrantz: Nay, their endeavour keeps in the wonted pace: but there is, sir, an aerie[18] of children, little eyases, that cry out on the top of question and are most tyrannically clapped for't: these are now the fashion, and so berattle the common stages,—so they call them,—that many wearing rapiers are afraid of goose quills, and dare 340 scarce come thither.

Hamlet: What, are they children? who maintains 'em? how are they escoted?[19] Will they pursue the quality[20] no longer than they can sing? will they not say afterwards, if they should grow themselves to common players,—as it is most like, if their means are no better,—their writers

do them wrong, to make them exclaim against their own succession?

Rosencrantz: Faith, there has been much to-do on both sides; and the nation holds it no sin to tarre[21] them to 350 controversy; there was for a while no money bid for argument, unless the poet and the player went to cuffs in the question.

Hamlet: Is't possible?

Guildenstern: O, there has been much throwing about of brains.

Hamlet: Do the boys carry it away?

Rosencrantz: Ay, that they do, my lord; Hercules and his load too.

Hamlet: It is not very strange; for my uncle is king of 360 Denmark; and those that would make mows at him while my father lived, give twenty, forty, fifty, an hundred ducats a-piece, for his picture in little. 'Sblood, there is something in this more than natural, if philosophy could find it out.

[Flourish of trumpets within.]

Guildenstern: There are the players.

Hamlet: Gentlemen, you are welcome to Elsinore. Your hands, come: the appurtenance of welcome is fashion and ceremony: let me comply with you in this garb, lest my extent[22] to the players, which, I tell you, must show 370 fairly outwards, should more appear like entertainment than yours. You are welcome: but my uncle-father and aunt-mother are deceived.

Guildenstern: In what, my dear lord?

Hamlet: I am but mad north-north-west: when the wind is southerly, I know a hawk from a handsaw.

[Enter POLONIUS.]

Polonius: Well be with you, gentlemen!

Hamlet: Hark you, Guildenstern,—and you too;—at each ear a hearer; that great baby you see there is not yet out of his swaddling clouts. 380

Rosencrantz: Happily, he's the second time come to them; for, they say, an old man is twice a child.

Hamlet: I will prophesy he comes to tell me of the players; mark it.—You say right, sir: o' Monday morning; 'twas so, indeed.

Polonius: My lord, I have news to tell you.

Hamlet: My lord, I have news to tell you. When Roscius[23] was an actor in Rome,—

Polonius: The actors are come hither, my lord.

Hamlet: Buz, buz! 390

Polonius: Upon mine honour,—

Hamlet: Then came each actor on his ass,—

Polonius: The best actors in the world, either for tragedy, comedy, history, pastoral, pastoral-comical, historical-pastoral, tragical-historical, tragical-comical-historical-pastoral, scene individable, or poem unlimited: Seneca[24] cannot be too heavy, not Plautus[25] too light. For the law of writ and the liberty, these are the only men.

Hamlet: O Jephthah, judge of Israel, what a treasure hadst thou! 400

Polonius: What a treasure had he, my lord?

14. exact.
15. scanty.
16. overtook.

17. on hair trigger.
18. nest.
19. financially supported.

20. acting profession.
21. incite.
22. behaviour.

23. famous comic actor in ancient Rome.
24. Roman tragic dramatist.
25. Roman comic dramatist.

Hamlet: Why—
"One fair daughter, and no more,
The which he loved passing well."
Polonius: |*Aside*| Still on my daughter.
Hamlet: Am I not i' the right, old Jephthah?
Polonius: If you call me Jephthah, my lord, I have a
daughter, that I love passing well.
Hamlet: Nay, that follows not.
Polonius: What follows then, my lord? 410
Hamlet: Why,
"As by lot, God wot,"
and then you know,
"It came to pass, as most like it was,—the first row of
the pious chanson will show you more: for look, where
my abridgments come.
|*Enter four or five* PLAYERS.|
You are welcome, masters; welcome all. I am glad to see
thee well. Welcome, good friends.—O, my old friend! Thy
face is valanced[26] since I saw thee last: com'st thou to
beard me in Denmark?—What! my young lady and
mistress! By'r lady, your ladyship is nearer to heaven, 420
than when I saw you last, but the altitude of a chopine.[27]
Pray God, your voice, like a piece of uncurrent gold, be
not cracked within the ring.—Masters, you are all
welcome. We'll e'en to't like French falconers, fly at any
thing we see: we'll have a speech straight: come, give us
a taste of your quality; come, a passionate speech.
First Player: What speech, my good lord?
Hamlet: I heard thee speak me a speech once, but it
was never acted; or, if it was, not above once; for the
play, I remember, pleased not the million; 'twas caviare 430
to the general: but it was, as I received it, and others,
whose judgments, in such matters, cried in the top of
mine, an excellent play, well digested in the scenes, set
down with as much modesty as cunning. I remember, one
said, there were no sallets[28] in the lines to make the
matter savoury, nor no matter in the phrase that might
indict the author of affection; but called it an honest
method, as wholesome as sweet, and by very much more
handsome than fine. One speech in it I chiefly loved: 'twas
Aeneas' tale to Dido; and thereabout of it especially, 440
where he speaks of Priam's slaughter. If it live in your
memory, begin at this line; let me see, let me see;—
"The rugged Pyrrhus, like the Hyrcanian beast,"[29]—
'tis not so; it begins with "Pyrrhus."
"The rugged Pyrrhus, he, whose sable arms,
Black as his purpose, did the night resemble
When he lay couched in the ominous horse,
Hath now this dread and black complexion smeared
With heraldry more dismal; head to foot
Now is he total gules; horridly tricked[30] 450
With blood of fathers, mothers, daughters, sons,
Baked and impasted with the parching streets,
That lend a tyrannous and damned light
To their lords' murther: roasted in wrath and fire,

26. fringed with a beard.
27. thick-soled shoe.
28. salads, spicy jests.
29. tiger (Hyrcania was in Asia and notorious for its wild animals).
30. all red, horridly adorned.

And thus o'er-sized with coagulate gore,
With eyes like carbuncles, the hellish Pyrrhus
Old grandsire Priam seeks."
So, proceed you.
Polonius: 'Fore God, my lord, well spoken;
with good accent and good discretion.
First Player: "Anon he finds him 460
Striking too short at Greeks; his antique sword,
Rebellious to his arm, lies where it falls,
Repugnant to command; unequal matched,
Pyrrhus at Priam drives; in rage strikes wide;
But with the whiff and wind of his fell sword
The unnerved father falls. Then senseless Ilium,
Seeming to feel this blow, with flaming top
Stoops to his base; and with a hideous crash
Takes prisoner Pyrrhus' ear; for, lo! his sword,
Which was declining on the milky head 470
Of reverend Priam, seemed i' the air to stick:
So, as a painted tyrant, Pyrrhus stood,
And, like a neutral to his will and matter,
Did nothing.
But as we often see, against some storm,
A silence in the heavens, the rack[31] stand still,
The bold winds speechless and the orb below
As hush as death, anon the dreadful thunder
Doth rend the region: so after Pyrrhus' pause
Aroused vengence sets him new a-work; 480
And never did the cyclops hammer fall
On Mars's armour, forged for proof eterne,
with less remorse than Pyrrhus' bleeding sword
Now falls on Priam.—
Out, out, thou strumpet, Fortune! All you gods,
In general synod[32] take away her power;
Break all the spokes and fellies[33] from her wheel,
And bowl the round nave[34] down the hill of heaven.
As low as to the fiends."
Polonius: This is too long. 490
Hamlet: It shall to the barber's with your beard.—
Prithee, say on: he's for a jig, or a tale of bawdry, or he
sleeps: say on: come to Hecuba.
First Player: "But who, O who, had seen the mobled[35]
queen—"
Hamlet: "The mobled queen?"
Polonius: That's good: "mobled queen" is good.
First Player: "Run barefoot up and down threatening the
flames
With bisson rheum;[36] a clout[37] about that head,
Where late the diadem stood; and for a robe,
About her lank and all o'er-teemed loins, 500
A blanket, in the alarm of fear caught up;
Who this had seen, with tongue in venom steeped,
'Gainst Fortune's state would treason have pronounced;
But if the gods themselves did see her then,
When she saw Pyrrhus make malicious sport
In mincing with his sword her husband's limbs,
The instant burst of clamour that she made,—
Unless things mortal move them not at all,—

31. clouds.
32. council.
33. rims.
34. hub.
35. muffled.
36. blinding tears.
37. rag.

Would have made milch the burning eyes of heaven,
And passion in the gods." 510
Polonius: Look, whether he has not turned his colour
and has tears in's eyes.—Pray you, no more.
Hamlet: 'Tis well; I'll have thee speak out the rest
soon.—Good my lord, will you see the players well
bestowed?[38] Do you hear, let them be well used; for they
are the abstract and brief chronicles of the time: after
your death you were better have a bad epitaph than
their ill report while you live.
Polonius: My lord, I will use them according to their
desert. 520
Hamlet: God's bodikins, man, much better! Use every
man after his desert, and who should scape whipping?
Use them after your own honour and dignity: the less
they deserve, the more merit is in your bounty. Take
them in.
Polonius: Come, sirs.
Hamlet: Follow him, friends: we'll hear a play tomorrow.
 |Exit POLONIUS with all the PLAYERS but
 the FIRST.|
Dost thou hear me, old friend; can you play "The Murder
of Gonzago"?
First Player: Ay, my lord. 530
Hamlet: We'll ha't to-morrow night. You could, for a
need, study a speech of some dozen or sixteen lines,
which I would set down, and insert in't?, could you not?
First Player: Ay, my lord.
Hamlet: Very well. Follow that lord; and look you
mock him not.
 |Exit PLAYER|
My good friends. |To ROSENCRANTZ and
GUILDENSTERN| I'll leave you till night; you are
welcome to Elsinore.
Rosencrantz: Good my lord!
Hamlet: Ay, so God b'uy ye. 540
 |Exeunt ROSENCRANTZ and GUILDENSTERN.|
Now I am alone.
O what a rogue and peasant slave am I!
Is it not monstrous that this player here,
But in a fiction, in a dream of passion,
Could force his soul so to his own conceit[39]
That from her working, all his visage wanned;
Tears in his eyes, distraction in's aspect,
A broken voice, and his whole function suiting
With forms to his conceit? And all for nothing!
For Hecuba! 550
What's Hecuba to him, or he to Hecuba,
That he should weep for her? What would he do,
Had he the motive and the cue for passion
That I have? He would drown the stage with tears,
And cleave the general ear with horrid speech,
Make mad the guilty and appal the free,
Confound the ignorant, and amaze indeed
The very faculties of eyes and ears. Yet I,
A dull and muddy-mettled rascal, peak,
Like John-a-dreams, unpregnant of my cause, 560
And can say nothing; no, not for a king,

Upon whose property, and most dear life,
A damned defeat was made. Am I a coward?
Who calls me villain? breaks my pate across?
Plucks off my beard, and blows it in my face?
Tweaks me by the nose? gives me the lie i' the throat,
As deep as to the lungs? Who does me this?
Ha! 'swounds, I should take it: for it cannot be,
But I am pigeon-livered, and lack gall
To make oppression bitter; or, ere this, 570
I should ha' fatted all the region kites[40]
With this slave's offal: bloody, bawdy villain!
Remorseless, treacherous, lecherous, kindless villain!
O vengeance!
Why, what an ass am I! This is most brave;
That, I the son of the dear murdered,
Prompted to my revenge by heaven and hell,
Must, like a whore, unpack my heart with words,
And fall a-cursing, like a very drab,[41]
A scullion! 580
Fie upon't! foh! About, my brain! Hum, I have heard
That guilty creatures, sitting at a play,
Have by the very cunning of the scene,
Been struck so to the soul that presently
They have proclaimed their malefactions;
For murder, though it have no tongue, will speak
With most miraculous organ. I'll have these players
Play something like the murder of my father
Before mine uncle: I'll observe his looks;
I'll tent[42] him to the quick; if he but blench, 590
I know my course. The spirit that I have seen
May be the devil: and the devil hath power
To assume a pleasing shape; yea, and perhaps
Out of my weakness and my melancholy,
As he is very potent with such spirits,
Abuses me to damn me. I'll have grounds
More relative than this. The play's the thing
Wherein I'll catch the conscience of the king.
 |Exit.|

Act III
Scene I: A room in the castle.

 |Enter KING, QUEEN, POLONIUS, OPHELIA,
 ROSENCRANTZ, and GUILDENSTERN.|
King: And can you, by no drift of conference,
Get from him why he puts on this confusion,
Grating so harshly all his days of quiet
With turbulent and dangerous lunacy?
Rosencrantz: He does confess he feels himself
 distracted,
But from what cause 'a will by no means speak.
Guildenstern: Nor do we find him forward to be
 sounded,
But, with a crafty madness, keeps aloof,
When we would bring him on to some confession
Of this true state.
Queen: Did he receive you well? 10

38. housed.
39. imagination.

40. scavenger birds.
41. prostitute.
42. probe.

Rosencrantz: Most like a gentleman.

Guildenstern: But with much forcing of his disposition.

Rosencrantz: Niggard of question, but of our demands
Most free in his reply.

Queen: Did you assay[1] him to any pastime?

Rosencrantz: Madam, it so fell that certain players
We o'er-raught[2] on the way: of these we told him,
And there did seem in him a kind of joy
To hear of it: they are here about the court
And, as I think, they have already order 20
This night to play before him.

Polonius: 'Tis most true;
And he beseeched me to entreat your majesties
To hear and see the matter.

King: With all my heart;
And it doth much content me to hear him so inclined.—
Good gentlemen, give him a further edge,
And drive his purpose on to these delights.

Rosencrantz: We shall, my lord.
 |*Exeunt* ROSENCRANTZ *and* GUILDENSTERN.|

King: Sweet Gertrude, leave us too:
For we have closely sent for Hamlet hither,
That he, as 'twere by accident, may here
Affront Ophelia. Her father, and myself, 30
Will so bestow ourselves that, seeing unseen,
We may of their encounter frankly judge,
And gather by him, as he is behaved,
If't be the affliction of his love or no
That thus he suffers for.

Queen: I shall obey you.—
And for your part, Ophelia, I do wish
That your good beauties be the happy cause
Of Hamlet's wildness; so I hope your virtues
Will bring him to his wonted way again,
To both your honours.

Ophelia: Madam, I wish it may. 41
 |*Exit* QUEEN.|

Polonius: Ophelia, walk you here.—Gracious, so please
 you,
We will bestow ourselves. |*To* OPHELIA| Read on this
 book;
That show of such an exercise may colour
Your loneliness. We are oft to blame in this,—
'Tis too much proved,—that with devotion's visage.
And pious action we do sugar o'er
The devil himself.

King: |*Aside*| O, 'tis too true!
How smart a lash that speech doth give my conscience!
The harlot's cheek, beautied with plastering art,
Is not more ugly to the thing that helps it, 50
Than is my deed to my most painted word.
O heavy burthen!

Polonius: I hear him coming; let's withdraw, my lord.
 |*Exeunt* KING *and* POLONIUS.|
 |*Enter* HAMLET.|

Hamlet: To be, or not to be,—that is the question:
Whether 'tis nobler in the mind to suffer
The slings and arrows of outrageous fortune,

Or to take arms against a sea of troubles,
And by opposing end them! To die,—to sleep,—
No more; and by a sleep to say we end
The heartache, and the thousand natural shocks 60
That flesh is heir to,—'tis a consummation
Devoutly to be wished. To die;—to sleep;—
To sleep! perchance to dream;—ay, there's the rub;
For in that sleep of death what dreams may come,
When we have shuffled off this mortal coil,
Must give us pause: there's the respect,
That makes calamity of so long life:
For who would beat the whips and scorns of time,
The oppressor's wrong, the proud man's contumely,
The pangs of disprized love, the law's delay, 70
The insolence of office, and the spurns
That patient merit of the unworthy takes,
When he himself might his quietus[3] make
With a bare bodkin?[4] Who would fardels[5] bear,
To grunt and sweat under a weary life,
But that the dread of something after death,
The undiscovered country, from whose bourne[6]
No traveller returns, puzzles the will,
And makes us rather bear those ills we have
Than fly to others that we know not of? 80
Thus conscience does make cowards of us all;
And thus the native hue of resolution
Is sicklied o'er with the pale cast[7] of thought;
And enterprises of great pitch[8] and moment,
With this regard their currents turn awry
And lose the name of action. Soft you now!
The fair Ophelia?—Nymph, in thy orisons[9]
Be all my sins remembered.

Ophelia: Good my lord,
How does your honour for this many a day?

Hamlet: I humbly thank you; well, well, well. 90

Ophelia: My lord, I have remembrances of yours,
That I have longed long to re-deliver;
I pray you, now receive them.

Hamlet: No, not I; I never gave you aught.

Ophelia: My honoured lord, you know right well you did;
And with them words of so sweet breath composed
As made these things more rich: their perfume lost,
Take these again; for to the noble mind,
Rich gifts wax poor, when givers prove unkind.
There, my lord. 100

Hamlet: Ha, ah! are you honest?

Ophelia: My lord?

Hamlet: Are you fair?

Ophelia: What means your lordship?

Hamlet: That if you be honest and fair, your honesty
should admit no discourse to your beauty.

Ophelia: Could beauty, my lord, have better commerce
than with honesty?

Hamlet: Ay, truly; for the power of beauty will sooner
transform honesty from what it is to a bawd,[10] than the 110
force of honesty can translate beauty into his likeness:

1. tempt.
2. overtook.

3. full discharge (a legal term).
4. dagger.
5. burdens.
6. region.

7. colour.
8. height.
9. prayers.
10. procurer.

this was sometime a paradox, but now the time gives it proof. I did love you once.

Ophelia: Indeed, my lord, you made me believe so.

Hamlet: You should not have believed me: for virtue cannot so inoculate our old stock, but we shall relish of it: I loved you not.

Ophelia: I was the more deceived.

Hamlet: Get thee to a nunnery; why wouldst thou be a breeder of sinners? I am myself indifferent honest; but yet I could accuse me of such things that it were better my mother had not borne me: I am very proud, revengeful, ambitious; with more offences at my beck than I have thoughts to put them in, imagination to give them shape, or time to act them in. What should such fellows as I do crawling between heaven and earth? We are arrant knaves all; believe none of us. Go thy ways to a nunnery. Where's your father?

Ophelia: At home, my lord.

Hamlet: Let the doors be shut upon him, that he may play the fool no where but in's own house. Farewell.

Ophelia: O, help him, you sweet heavens!

Hamlet: If thou dost marry, I'll give thee this plague for thy dowry: be thou as chaste as ice, as pure as snow, thou shalt not escape calumny. Get thee to a nunnery, go; farewell. Or, if thou wilt needs marry, marry a fool; for wise men know well enough what monsters you make of them. To a nunnery, go; and quickly too. Farewell.

Ophelia: O heavenly powers, restore him!

Hamlet: I have heard of your paintings too, well enough. God hath given you one face, and you make yourselves another; you jig, you amble, and you lisp, and nickname God's creatures, and make your wantonness your ignorance. Go to, I'll no more on't; it hath made me mad. I say, we will have no moe[11] marriage: those that are married already, all but one, shall live; the rest shall keep as they are. To a nunnery, go.

[*Exit* HAMLET.]

Ophelia: O, what a noble mind is here o'erthrown!
The courtier's, soldier's, scholar's, eye, tongue, sword:
The expectancy and rose of the fair state,
The glass of fashion, and the mould of form,
The observed of all observers, quite, quite down!
And I, of ladies most deject and wretched,
That sucked the honey of his music-vows,
Now see that noble and most sovereign reason,
Like sweet bells jangled, out of time and harsh;
That unmatched form and stature of blown youth,
Blasted with ecstasy:[12] O, woe is me!
To have seen what I have seen, see what I see!

[*Re-enter* KING *and* POLONIUS.]

King: Love! his affections do not that way tend;
Nor what he spake, though it lacked form a little,
Was not like madness. There's something in his soul,
O'er which his melancholy sits on brood;
And I do doubt that hatch and the disclose,
Will be some danger: which for to prevent,
I have in quick determination
Thus set it down: he shall with speed to England,

For the demand of our neglected tribute:
Haply the seas and countries different
With variable objects shall expel
This something-settled matter in his heart,
Whereon his brains still beating puts him thus
From fashion of himself. What think you on't?

Polonius: It shall do well; but yet do I believe,
The origin and commencement of his grief
Sprung from neglected love.—How now, Ophelia?
You need not tell us what Lord Hamlet said;
We heard it all.—My Lord, do as you please;
But, if you hold it fit, after the play,
Let his queen mother all alone entreat him
To show his grief; let her be round with him;
And I'll be placed, so please you, in the ear
Of all their conference, If she find him not,
To England send him, confine him where
Your wisdom best shall think.

King: It shall be so;
Madness in great ones must not unwatched go.

[*Exeunt.*]

Scene 2: A hall in the same.

[*Enter* HAMLET *and* PLAYERS.]

Hamlet: Speak the speech, I pray you, as I pronounced it to you, trippingly on the tongue: but if you mouth it, as many of our players do, I had as lief the town-crier spoke my lines. Nor do not saw the air too much with your hand, thus: but use all gently: for in the very torrent, tempest, and, as I may say, whirlwind of your passion, you must acquire and beget a temperance that may give it smoothness. O, it offends me to the soul, to hear a robustious periwig-pated fellow tear a passion to tatters, to very rags, to split the ears of the groundlings;[1] who, for the most part, are capable of nothing but inexplicable dumb-shows and noise: I would have such a fellow whipped for o'erdoing Termagant; it out-herods Herod:[2] pray you, avoid it.

First Player: I warrant your honour.

Hamlet: Be not too tame neither, but let your own discretion be your tutor: suit the action to the word, the word to the action; with this special observance, that you o'er-step not the modesty of nature; for anything so overdone is from the purpose of playing, whose end, both at the first and now, was and is, to hold, as 'twere, the mirror up to nature; to show virtue her own feature, scorn her own image, and the very age and body of the time his form and pressure. Now this overdone, or come tardy off, though it make the unskilful laugh, cannot but make the judicious grieve; the censure of the which one must in your allowance o'er-weigh a whole theatre of others. O, there be players that I have seen play, and heard others praise, and that highly, not to speak it profanely, that neither having the accent of Christians nor the gait of Christian, pagan, nor man, have so strutted and bellowed, that I have thought some of nature's journeymen had made them, and not made

11. more.
12. madness.

1. those who stood in the pit of the theatre.
2. characters in the old mystery plays.

them well, they imitated humanity so abominably.

First Player: I hope we have reformed that indifferently[3] with us, sir.

Hamlet: O, reform it altogether. And let those that play your clowns speak no more than is set down for them; for there be of them that will themselves laugh, to set on some quantity of barren spectators to laugh too, though 40 in the mean time some necessary question of the play be then to be considered: that's villainous; and shows a most pitiful ambition in the fool that uses it. Go, make you ready.—

|*Exeunt* PLAYERS.|
|*Enter* POLONIUS, ROSENCRANTZ, *and* GUILDENSTERN.|

How now, my lord? will the king hear this piece of work?

Polonius: And the queen too, and that presently.

Hamlet: Bid the players make haste.

|*Exit* POLONIUS.|

Will you two help to hasten them?

Both: We will, my lord.

|*Exeunt* ROSENCRANTZ *and* GUILDENSTERN.|

Hamlet: What, ho! Horatio! 50

|*Enter* HORATIO.|

Horatio: Here, sweet lord, at your service.

Hamlet: Horatio, thou art e'en as just a man
As e'er my conversation copied withal.

Horatio: O, my dear lord,—

Hamlet: Nay, do not think I flatter:
For what advancement may I hope from thee,
That no revenue hast but thy good spirits,
To feed and clothe thee? Why should the poor be
 flattered?
No, let the candied[4] tongue lick absurd pomp.
And crook the pregnant hinges of the knee
Where thrift may follow fawning. Dost thou hear? 60
Since my dear soul was mistress of her choice,
And could of men distinguish, her election
Hath sealed thee for herself: for thou hast been
As one, in suffering all, that suffers nothing;
A man that fortune's buffets and rewards
Hath ta'en with equal thanks: and blest are those,
Whose blood and judgment are so well commingled,
That they are not a pipe for fortune's finger
To sound what stop she please. Give me that man
That is not passion's slave, and I will wear him 70
In my heart's core, ay, in my heart of heart,
As I do thee. Something too much of this.
There is a play to-night before the king;
One scene of it comes near the circumstance
Which I have told thee of my father's death.
I prithee, when thou seest that act a-foot,
Even with the very comment of my soul
Observe my uncle: if his occulted[5] guilt
Do not itself unkennel in one speech,
It is a damned ghost that we have seen; 80
And my imaginations are as foul
As Vulcan's stithy.[6] Give him heedful note:
For I mine eyes will rivet to his face;

And after we will both our judgments join
In censure of his seeming.

Horatio: Well, my lord:
If he steal aught the whilst this play is playing,
And scape detecting, I will pay the theft.

Hamlet: They are coming to the play; I must be idle:
Get you a place.

|*Danish March. Flourish. Enter* KING, QUEEN,
POLONIUS, OPHELIA, ROSENCRANTZ,
GUILDENSTERN, *and other* LORDS *attendant,
with the* GUARD, *carrying torches.*|

King: How fares our cousin Hamlet? 90

Hamlet: Excellent, i' faith; of the chameleon's dish[7] I eat the air, promise-crammed: you cannot feed capons so.

King: I have nothing with this answer, Hamlet; these words are not mine.

Hamlet: No, nor mine now. |*To* POLONIUS|
My lord, you played once i' the university, you say?

Polonius: That I did, my lord, and was accounted a good actor.

Hamlet: And what did you enact? 100

Polonius: I did enact Julius Caesar: I was killed i' the Capitol: Brutus killed me.

Hamlet: It was a brute part of him to kill so capital a calf there.—Be the players ready?

Rosencrantz: Ay, my lord; they stay upon your patience.

Queen: Come hither, my dear Hamlet, sit by me.

Hamlet: No, good mother, here's metal more attractive.

Polonius: |*To the* KING| O ho! do you mark that?

Hamlet: Lady, shall I lie in your lap?

|*Lying down at* OPHELIA'S *feet.*|

Ophelia: No, my lord. 110

Hamlet: I mean, my head upon your lap?

Ophelia: Ay, my lord.

Hamlet: Do you think I meant country matters?

Ophelia: I think nothing, my lord.

Hamlet: That's a fair thought to lie between maids' legs.

Ophelia: What is, my lord?

Hamlet: Nothing.

Ophelia: You are merry, my lord.

Hamlet: Who, I?

Ophelia: Ay, my lord. 120

Hamlet: O God! your only jig-maker. What should a man do but be merry? for, look you, how cheerfully my mother looks, and my father died within's two hours.

Opheila: Nay, 'tis twice two months, my lord.

Hamlet: So long? Nay, then let the devil wear black, for I'll have a suit of sables. O heavens! die two months ago, and not forgotten yet? Then there's hope a great man's memory may outlive his life half a year: but, by'r lady, 'a must build churches then: or else shall 'a suffer not thinking on, with the hobby-horse; whose epitaph is, 130
"For, O, for, O, the hobby-horse is forgot."

|*Hautboys play. The dumb show enters.*
*Enter a King and a Queen, very lovingly; the Queen embracing
him, and he her. She kneels, and makes show of protestation unto
him. He takes her up, and declines his head upon her neck: lays*

3. tolerably. 5. hidden.
4. flattering. 6. smithy.

7. air, on which chameleons were believed to live.

him down upon a bank of flowers; she, seeing him asleep, leaves him. Anon comes in a fellow, takes off his crown, kisses it, and pours poison in the King's ears, and exit. The Queen returns; finds the King dead, and makes passionate action. The poisoner, with some two or three mutes, comes in again, seeming to lament with her. The dead body is carried away. The poisoner woos the Queen with gifts; she seems loth and unwilling a while, but, in the end accepts his love.]

 [Exeunt.]

Ophelia: What means this, my lord?

Hamlet: Marry, this is miching mallecho;[8] it means mischief.

Ophelia: Belike this show imports the argument of the play?

 [Enter PLAYER as Prologue.]

Hamlet: We shall know by this fellow: the players cannot keep counsel; they'll tell all.

Ophelia: Will he tell us what this show meant?

Hamlet: Ay, or any show that you'll show him: be not you ashamed to show, he'll not shame to tell you what it means. 140

Ophelia: You are naught, you are naught; I'll mark the play.

Prologue: For us, and for our tragedy
Here stooping to your clemency,
We beg your hearing patiently.

Hamlet: Is this a prologue, or the posy of a ring?

Ophelia: 'Tis brief, my lord.

Hamlet: As woman's love. 150

 [Enter two PLAYERS, as King and Queen.]

Player King: Full thirty times hath Phoebus' cart[9] gone
 round
Neptune's salt wash[10] and Tellus'[11] orbed ground,
And thirty dozen moons with borrowed sheen,
About the world have times twelve thirties been,
Since love our hearts and Hymen did our hands,
Unite commutual in most sacred bands.

Player Queen: So many journeys may the sun and moon
Make us again count o'er ere love be done!
But, woe is me, you are so sick of late,
So far from cheer and from your former state, 160
That I distrust you. Yet, though I distrust,
Discomfort you, my lord, it nothing must;
For women's fear and love hold quantity,
In neither aught, or in extremity.
Now, what my love is, proof hath made you know;
And as my love is sized, my fear is so.
Where love is great, the littlest doubts are fear;
Where little fears grow great, great love grows there.

Player King: 'Faith, I must leave thee, love, and shortly
 too;
My operant[12] powers my functions leave to do: 170
And thou shalt live in this fair world behind,
Honoured, beloved; and haply one as kind
For husband shalt thou—

Player Queen: O, confound the rest!
Such love must needs be treason in my breast:

In second husband let me be accurst!
None wed the second but who killed the first.

Hamlet: *[Aside]* Wormwood,[13] wormwood.

Player Queen: The instances that second marriage move,
Are base respects of thrift, but none of love;
A second time I kill my husband dead,
When second husband kisses me in bed. 180

Player King: I do believe you think what now you speak;
But what we do determine oft we break.
Purpose is but the slave to memory,
Of violent birth but poor validity:
Which now, like fruit unripe, sticks on the tree,
But fall unshaken when they mellow be.
Most necessary 'tis that we forget
To pay ourselves what to ourselves is debt:
What to ourselves in passion we propose, 190
The passion ending, doth the purpose lose.
The violence of either grief or joy
Their own enactures[14] with themselves destroy:
Where joy most revels, grief doth most lament;
Grief joys, joy grieves, on slender accident.
This world is not for aye, nor 'tis not strange,
Thast even our loves should with our fortunes change,
For 'tis a question left us yet to prove,
Whether love lead fortune or else fortune love.
The great man down, you mark his favourite flies; 200
The poor advanced makes friends of enemies;
And hitherto doth love on fortune tend:
For who not needs shall never lack a friend,
And who in want a hollow friend doth try
Directly seasons him his enemy.
But, orderly to end where I begun,
Our wills and fates do so contrary run,
That our devices still are overthrown,
Our thoughts are ours, their ends none of our own;
So think thou wilt no second husband wed; 210
But die thy thoughts when thy first lord is dead.

Player Queen: Nor earth to me give food nor heaven
 light!
Sport and repose lock from me, day and night!
To desperation turn my trust and hope!
And anchor's[15] cheer in prison be my scope!
Each opposite, that blanks the face of joy,
Meet what I would have well and it destroy!
Both here and hence pursue me lasting strife,
If, once a widow, ever I be wife! 220

Hamlet: *[To OPHELIA]* If she should break it now!

Player King: 'Tis deeply sworn. Sweet, leave me here
 a while;
My spirits grow dull, and fain I would beguile
The tedious day with sleep.

 [Sleeps.]

Player Queen: Sleep rock thy brain
And never come mischance between us twain!

 [Exit.]

Hamlet: Madam, how like you this play?

Queen: The lady doth protest too much, methinks.

8. sneaking mischief.
9. the sun's chariot.
10. the sea.
11. Roman goddess of the earth.
12. active.
13. a bitter herb.
14. acts.
15. anchorite's, hermit's.

Hamlet: O, but she'll keep her word.

King: Have you heard the argument? Is there no offence in't? 230

Hamlet: No, no, they do but jest, poison in jest; no offence i' the world.

King: What do you call the play?

Hamlet: "The Mouse-trap." Marry, how? Tropically. This play is the image of a murder done in Vienna: Gonzago is the Duke's name; his wife, Baptista: you shall see anon; 'tis a knavish piece of work: but what o' that? your majesty, and we that have free souls, it touches us not: let the galled jade wince,[16] our withers are unwrung.—

|*Enter* PLAYER *as Lucianus.*|

This is one Lucianus, nephew to the king. 240

Ophelia: You are as good as a chorus, my lord.

Hamlet: I could interpret between you and your love, if I could see the puppets dallying.

Ophelia: You are keen, my lord, you are keen.

Hamlet: It would cost you a groaning, to take off my edge.

Ophelia: Still better and worse.

Hamlet: So you mistake your husbands.—Begin, murderer. Pox, leave thy damnable faces, and begin. Come: 250

 "the croaking raven
 Doth bellow for revenge."

Lucianus: Thoughts black, hands apt, drugs fit, and time agreeing;
Confederate season, else no creature seeing:
Thou mixture rank, of midnight weeds collected,
With Hecate's[17] ban thrice blasted, thrice infected,
Thy natural magic and dire property,
On wholesome life usurp immediately.

|*Pours the poison in the sleeper's ear.*|

Hamlet: 'A poisons him i' the garden for his estate. His name's Gonzago; the story is extant, and writ in very 260 choice Italian: you shall see anon, how the murderer gets the love of Gonzago's wife.

Ophelia: The king rises.

Hamlet: What, frighted with false fire!

Queen: How fares my lord?

Polonius: Give o'er the play.

King: Give me some light.—Away!

All: Lights, lights, lights!

|*Exeunt all but* HAMLET *and* HORATIO.|

Hamlet: Why, let the strucken deer go weep,
The hart ungalled play: 270
For some must watch, while some must sleep;
Thus runs the world away.
Would not this, sir, and a forest of feathers,—if the rest of my fortunes turn Turk with me,—with two Provincial roses on my razed[18] shoes, get me a fellowship in a cry[19] of players, sir?

Horatio: Half a share.

Hamlet: A whole one, I.

 For thou dost know, O Damon dear,
 This realm dismantled was 280
 Of Jove himself; and now reigns here

A very, very—pajock.[20]

Horatio: You might have rhymed.

Hamlet: O good Horatio, I'll take the ghost's word for a thousand pound. Didst perceive?

Horatio: Very well, my lord.

Hamlet: Upon the talk of the poisoning,—

Horatio: I did very well note him.

Hamlet: Ah, ha! Come, some music! come, the recorders!—
 For if the king like not the comedy,
 Why then, belike,—he likes it not, perdy.[21] 290

|*Enter* ROSENCRANTZ *and* GUILDENSTERN.|

Come, some music

Guildenstern: Good my lord, vouchsafe me a word with you.

Hamlet: Sir, a whole history.

Guildenstern: The king, sir,—

Hamlet: Ay, sir, what of him?

Guildenstern: Is, in his retirement marvellous distempered.

Hamlet: With drink, sir?

Guildenstern: No, my lord, rather with choler. 300

Hamlet: Your wisdom should show itself more richer to signify this to the doctor, for, for me to put him to his purgation would perhaps plunge him into far more choler.

Guildenstern: Good my lord, put your discourse into some frame, and start not so wildly from my affair.

Hamlet: I am tame, sir; pronounce.

Guildenstern: The queen, your mother, in most great affliction of spirit, hath sent me to you.

Hamlet: You are welcome. 310

Guildenstern: Nay, good my lord, this courtesy is not of the right breed. If it shall please you to make me a wholesome answer, I will do your mother's commandment: if not, your pardon and my return shall be the end of my business.

Hamlet: Sir, I cannot.

Guildenstern: What, my lord?

Hamlet: Make you a wholesome answer, my wit's diseased: but, sir, such answers as I can make, you shall command; or rather, as you say, my mother: therefore no 320 more but to the matter; my mother, you say,—

Rosencrantz: Then thus she says: your behaviour hath struck her into amazement and admiration.[22]

Hamlet: O wonderful son, that can so 'stonish a mother! But is there no sequel at the heels of this mother's admiration? Impart.

Rosencrantz: She desires to speak with you in her closet, ere you go to bed.

Hamlet: We shall obey, were she ten times our mother. Have you any further trade with us? 330

Rosencrantz: My lord, you once did love me.

Hamlet: And do still, by these pickers and stealers.[23]

Rosencrantz: Good my lord, what is your cause of distemper? you do surely bar the door upon your own liberty, if you deny your griefs to your friend.

Hamlet: Sir, I lack advancement.

16. chapped horse wince. 18. ornamented with slashes.
17. the goddess of witchcraft. 19. company.

20. peacock. 22. wonder.
21. by God (French: *par dieu*). 23. hands.

Rosencrantz: How can that be, when you have the voice of the king himself for your succession in Denmark?
Hamlet: Ay, sir, but "while the grass grows,"—the proverb is something musty. 340
|*Re-enter PLAYERS, with recorders.*|
O, the recorders! let me see one.—To withdraw with you:—why do you go about to recover the wind of me, as if you would drive me into a toil?[24]
Guildenstern: O, my lord, if my duty be too bold, my love is too unmannerly.
Hamlet: I do not well understand that. Will you play upon this pipe?
Guildenstern: My lord, I cannot.
Hamlet: I pray you.
Guildenstern: Believe me, I cannot. 350
Hamlet: I do beseech you.
Guildenstern: I know too much of it, my lord.
Hamlet: It is as easy as lying: govern these ventages[25] with your fingers and thumb, give it breath with your mouth, and it will discourse most eloquent music. Look you, these are the stops.
Guildenstern: But these cannot I command to any utterance of harmony; I have not the skill.
Hamlet: Why, look you now, how unworthy a thing you make of me! You would play upon me: you would seem 360 to know my stops; you would pluck out the heart of my mystery; you would sound me from my lowest note to the top of my compass: and there is much music, excellent voice, in this little organ; yet cannot you make it speak.—'Sblood, do you think I am easier to be played on than a pipe? Call me what instrument you will, though you can fret me, you cannot play upon me.—
|*Re-enter POLONIUS.*|
God bless you, sir!
Polonius: My lord, the queen would speak with you, and presently.
Hamlet: Do you see yonder cloud that's almost in shape 370 of a camel?
Polonius: By the mass, and 'tis like a camel, indeed.
Hamlet: Methinks it is like a weasel.
Polonius: It is backed like a weasel.
Hamlet: Or like a whale?
Polonius: Very like a whale.
Hamlet: Then will I come to my mother by an by.—They fool me to the top of my bent.—I will come by and by.
Polonius: I will say so. 380
|*Exit POLONIUS.*|
Hamlet: "By and by" is easily said.—Leave me, friends.
|*Exeunt all but HAMLET.*|
'Tis now the very witching time of night;
When churchyards yawn, and hell itself breathes out
Contagion to this world: now could I drink hot blood,
And do such bitter business as the day
Would quake to look on. Soft! now to my mother.—
O, heart, lose not thy nature; let not ever
The soul of Nero[26] enter this form bosom:
Let me be cruel, not unnatural:

I will speak daggers to her, but use none; 390
My tongue and soul in this be hypocrites:
How in my words soever she be shent,[27]
To give them seals never, my soul, consent!
|*Exit.*|

Scene 3: A room in the castle.

|*Enter KING, ROSENCRANTZ, and GUILDENSTERN.*|
King: I like him not, nor stands it safe with us
To let his madness range. Therefore prepare you;
I your commission will forthwith dispatch,
And he to England shall along with you;
The terms of our estate may not endure
Hazard so near us as doth hourly grow
Out of his brows.
Guildenstern: We will ourselves provide:
Most holy and religious fear it is,
To keep those many many bodies safe,
That live and feed upon your majesty. 10
Rosencrantz: The single and peculiar life is bound
With all the strength and armour of the mind
To keep itself from noyance; but much more
That spirit upon whoose weal depends and rests
The lives of many. The cease of majesty[1]
Dies not alone, but like a gulf[2] doth draw
What's near it with it: it is a massy wheel,
Fixed on the summit of the highest mount,
To whose huge spokes ten thousand lesser things
Are mortised and adjoined; which, when it falls, 20
Each small annexment, petty consequence,
Attends the boisterous ruin. Never alone
Did the king sigh, but with a general groan.
King: Arm you. I pray you, to this speedy voyage;
For we will fetters put upon this fear,
Which now goes too free-footed.
Rosencrantz, Guildenstern: We will haste us.
|*Exeunt ROSENCRANTZ and GUILDENSTERN.*|
|*Enter POLONIUS.*|
Polonius: My lord, he's going to his mother's closet:
Behind the arras I'll convey myself,
To hear the process; I'll warrant she'll tax him home;
And, as you said, and wisely was it said, 30
'Tis meet that some more audience than a mother,
Since nature makes them partial, should o'erhear
The speech of vantage. Fare you well, my liege:
I'll call upon you ere you go to bed,
And tell you what I know.
King: Thanks, dear my lord.
|*Exit POLONIUS.*|
O, my offence is rank, it smells to heaven;
It hath the primal eldest curse[3] upon't,
A brother's murder!—Pray can I not,
Though inclination be as sharp as will; 40
My stronger guilt defeats my strong intent,
And, like a man to double business bound,

24. trap.
25. vents, stops on a recorder.
26. Roman emperor who murdered his mother.

27. rebuked.
1. end (death) of a king.
2. whirlpool.
3. curse of Cain, who killed Abel.

I stand in pause where I shall first begin,
And both neglect. What if this cursed hand
Were thicker than itself with brother's blood?
Is there not rain enough in the sweet heavens,
To wash it white as snow? Whereto serves mercy
But to confront the visage of offence?
And what's in prayer but this two-fold force,
To be forestalled ere we come to fall,
Or pardoned being down? Then I'll look up; 50
My fault is past. But, O, what form of prayer
Can serve my turn? "Forgive me my foul murder!"—
That cannot be, since I am still possessed
Of those effects for which I did the murder,
My crown, mine own ambition and my queen.
May one be pardoned and retain the offence?
In the corrupted currents of this world,
Offence's gilded hand may shove by justice;
And oft 'tis seen the wicked prize itself
Buys out the law: but 'tis not so above: 60
There is no shuffling, there the action lies
In his true nature; and we ourselves compelled,
Even to the teeth and forehead of our faults,
To give in evidence. What then? what rests?
Try what repentance can. What can it not?
Yet what can it, when one can not repent?
O wretched state! O bosom, black as death!
O limed[4] soul, that struggling to be free,
Art more engaged! Help, angels! make assay!
Bow, stubborn knees, and, heart with strings of steel, 70
Be soft as sinews of the new-born babe!
All may be well.
 |Retires and kneels.|
 |Enter HAMLET.|
Hamlet: Now might I do it pat, now he is praying;
An now I'll do't; and so he goes to heaven:
And so am I revenged? That would be, scanned:
A villain kills my father, and for that,
I, his sole son, do this same villain send
To heaven.
O, this is hire and salary, not revenge.
He took my father grossly, full of bread, 80
With all his crimes broad blown, as flush[5] as May;
And how his audit stands who knows save heaven?
But in our circumstance and course of thought,
'Tis heavy with him: and am I then revenged,
To take him in the purging of his soul,
When he is fit and seasoned for his passage?
No!
Up, sword, and know thou a more horrid hent;[6]
When he is drunk asleep, or in his rage,
Or in the incestuous pleasure of his bed; 90
At gaming, swearing; or about some act
That has no relish of salvation in't:
Then trip him, that his heels may kick at heaven;
And that his soul may be damned and black
As hell, whereto it goes. My mother stays:—

4. trapped (birdlime is a sticky substance spread on boughs to snare birds).
5. vigorous.
6. grasp (here, time for seizing).

This physic but prolongs thy sickly days.
 |Exit.|
King: |Rising| My words fly up, my thoughts remain below:
Words without thoughts never to heaven go.
 |Exit.|

Scene 4: The QUEEN'S closet.

 |Enter QUEEN and POLONIUS.|
Polonius: 'A will come straight. Look you lay home to him:
Tell him his pranks have been too broad to bear with,
And that your grace hath screened and stood between
Much heat and him. I'll silence me e'en here.
Pray you, be round with him.
Hamlet: |Within| Mother! mother! mother!
Queen: I'll warrant you;
Fear me not. Withdraw, I hear him coming.
 |POLONIUS hides himself.|
 |Enter HAMLET.|
Hamlet: Now, mother; what's the matter?
Queen: Hamlet, thou hast thy father much offended.
Hamlet: Mother, you have my father much offended. 10
Queen: Come, come, you answer with an idle tongue.
Hamlet: Go, go, you question with a wicked tongue.
Queen: Why, how now, Hamlet?
Hamlet: What's the matter now?
Queen: Have you forgot me?
Hamlet: No, by the rood,[1] not so:
You are the queen, your husband's brother's wife;
And would it were not so!—you are my mother.
Queen: Nay, then I'll set those to you that can speak.
Hamlet: Come, come, and sit you down; you shall not budge;
You go not till I set you up a glass[2]
Where you may see the inmost part of you. 20
Queen: What wilt thou do? thou wilt not murder me?
 Help, help, oh!
Polonius: |Behind| What, ho! help, help, help!
Hamlet: How now! a rat? Dead, for a ducat, dead.
 |Draws. HAMLET makes a pass through the arras.|
Polonius: |Behind| O, I am slain!
 |Falls and dies.|
Queen: O me, what hast thou done?
Hamlet: Nay, I know not: is it the king?
 |Lifts up the arras, and draws forth POLONIUS.|
Queen: O, what a rash and bloody deed is this!
Hamlet: A bloody deed! almost as bad, good mother,
As kill a king, and marry with his brother.
Queen: As kill a king!
Hamlet: Ay, lady, 'twas my word.—
|To POLONIUS| Thou wretched, rash, intruding fool, farewell! 30
I took thee for thy better; take thy fortune;
Thou find'st, to be too busy is some danger.—
Leave wringing of your hands. Peace! sit you down,
And let me wring your heart: for so I shall,

1. cross.
2. mirror.

If it be made of penetrable stuff;
If damned custom have not brazed it so,
That it is proof and bulwark against sense.
Queen: What have I done, that thou darest wag thy
 tongue
In noise so rude against me?
Hamlet: Such an act,
That blurs the grace and blush of modesty, 40
Calls virtue hypocrite, takes off the rose
From the fair forehead of an innocent love,
And sets a blister there; makes marriage vows
As false as dicers' oaths; O, such a deed
As from the body of contraction[3] plucks
The very soul, and sweet religion makes
A rhapsody of words: heaven's face doth glow;
Yea, this solidity and compound mass,
With heated visage, as against the doom,
Is thought-sick at the act.
Queen: Ay me, what act, 50
That roars so loud and thunders in the index?[4]
Hamlet: Look here, upon this picture, and on this,
The counterfeit presentment of two brothers.
See what a grace was seated on this brow:
Hyperion's curls: the front of Jove himself;
An eye like Mars, to threaten and command;
A station, like the herald Mercury,
New-lighted on a heaven-kissing hill;
A combination and a form indeed,
Where every god did seem to set his seal 60
To give the world assurance of a man:
This was your husband. Look you now, what follows:
Here is your husband; like a mildewed ear,
Blasting his wholesome brother. Have you eyes?
Could you on this fair mountain leave to feed,
And batten on this moor? Ha! have you eyes?
You cannot call it love, for at your age
The hey-day in the blood is tame, it's humble,
And waits upon the judgment: and what judgment
Would step from this to this? Sense sure you have, 70
Else could you not have motion: but sure that sense
Is apoplexed: for madness would not err,
Nor sense to ecstasy was ne'er so thralled,
But it reserved some quantity of choice,
To serve in such a difference. What devil was't,
That thus hath cozened you at hoodman-blind?[5]
Eyes without feeling, feeling without sight,
Ears without hands or eyes, smelling sans[6] all,
Or but a sickly part of one true sense
Could not so mope. 80
O shame! where is thy blush? Rebellious hell,
If thou canst mutine in a matron's bones,
To flaming youth let virtue be as wax,
And melt in her own fire; proclaim no shame,
When the compulsive ardour gives the charge,
Since frost itself as actively doth burn,
And reason panders will.
Queen: O Hamlet, speak no more:
Thou turn'st my very eyes into my soul;

And there I see such black and grained spots,
As will not leave their tinct.[7]
Hamlet: Nay, but to live 90
In the rank of sweat of an enseamed bed,
Stewed in corruption, honeying and making love
Over the nasty sty;—
Queen: O, speak to me no more;
These words like daggers enter in mine ears.
No more, sweet Hamlet!
Hamlet: A murderer and a villain:
A slave that is not twentieth part the tithe[8]
Of your precedent lord: a vice of kings:
A cutpurse of the empire and the rule;
That from a shelf the precious diadem stole,
And put it in his pocket!
Queen: No more! 100
Hamlet: A king of shreds and patches:—
 [*Enter* GHOST.]
Save me, and hover o'er me with your wings,
You heavenly guards!—What would you, gracious figure?
Queen: Alas! he's mad!
Hamlet: Do you not come your tardy son to chide,
That, lapsed in time and passion, lets go by
The important acting of your dread command? O say!
Ghost: Do not forget. This visitation
Is but to whet thy almost blunted purpose.
But, look, amazement on thy mother sits: 110
O, step between her and her fighting soul;
Conceit in weakest bodies strongest works.
Speak to her, Hamlet.
Hamlet: How is it with you, lady?
Queen: Alas, how is't with you,
That you do bend your eye on vacancy,
And with the incorporal air do hold discourse?
Forth at your eyes your spirits wildly peep;
And as the sleeping soldiers in the alarm,
Your bedded hair,[9] like life in excrements,
Starts up and stands on end. O gentle son, 120
Upon the heat and flame of thy distemper
Sprinkle cool patience. Whereon do you look?
Hamlet: On him, on him! Look you, how pale he glares!
His form amd cause conjoined, preaching to stones,
Would make them capable.—Do not look upon me;
Lest, with this piteous action you convert
My stern effects: then what I have to do
Will want true colour! tears perchance for blood.
Queen: To whom do you speak this?
Hamlet: Do you see nothing there?
Queen: Nothing at all; yet all that is I see. 130
Hamlet: Nor did you nothing hear?
Queen: No, nothing but ourselves.
Hamlet: Why, look you there! look, how it steals away!
My father, in his habit as he lived!
Look, where he goes, even now, out at the portal!
 [*Exit* GHOST.]
Queen: This is the very coinage of your brain:
This bodiless creation ecstasy

3. marriage contract. 5. blindman's buff.
4. prolog. 6. without.

7. colour.
8. tenth part.
9. flattened hairs.

Is very cunning in.
Hamlet: "Ecstasy!"
My pulse, as yours, doth temperately keep time,
And makes as healthful music: it is not madness
That I have uttered: bring me to the test, 140
And I the matter will re-word, which madness
Would gambol from. Mother, for love of grace,
Lay not that flattering unction to your soul,
That not your trespass by my madness speaks:
It will but skin and film the ulcerous place,
Whiles rank corruption, mining[10] all within,
Infects unseen. Confess yourself to heaven;
Repent what's past, avoid what is to come;
And do not spread the compost on the weeds,
To make them ranker. Forgive me this my virtue, 150
For in the fatness of these pursy[11] times,
Virtue itself of vice must pardon beg,
Yea, courb and woo for leave to do him good.
Queen: O Hamlet, thou hast cleft my heart in twain.
Hamlet: O, throw away the worser part of it,
And live the purer with the other half.
Good night: but go not to mine uncle's bed;
Assume a virtue, if you have it not.
That monster, custom, who all sense doth eat,
Of habits devil, is angel yet in this, 160
That to the use of actions fair and good
He likewise gives a frock or livery,
That aptly is put on. Refrain to-night,
And that shall lend a kind of easiness
To the next abstinence: the next more easy;
For use almost can change the stamp of nature,
And either master the devil, or throw him out
With wondrous potency. Once more, good night:
And when you are desirous to be blessed, 170
I'll blessing beg of you.—For this same lord,
 |*Pointing to* POLONIUS|
I do repent: but heaven hath pleased it so,
To punish me with this, and this with me,
That I must be their scourge and minister.
I will bestow him, and will answer well
The death I gave him. So again, good night!
I must be cruel, only to be kind:
Thus bad begins and worse remains behind.
One word more, good lady.
Queen: What shall I do?
Hamlet: Not this, by no means, that I bid you do:
Let the bloat king tempt you again to bed; 180
Pinch wanton on your cheek; call you his mouse;
And let him, for a pair of reechy[12] kisses,
Or paddling in your neck with his damned fingers,
Make you to ravel all this matter out,
That I essentially am not in madness,
But mad in craft. 'Twere good you let him know:
For who, that's but a queen, fair, sober, wise,
Would from a paddock,[13] from a bat, a gib,[14]
Such dear concernings hide? who would do so?
No, in despite of sense and secrecy, 190

10. undermining. 13. toad.
11. bloated. 14. tomcat.
12. foul.

Unpeg the basket on the house's top.
Let the birds fly, and like the famous ape,
To try conclusions, in the basket creep,
And break your own neck down.
Queen: Be thou assured, if words be made of breath, 140
And breath of life, I have no life to breathe
What thou hast said to me.
Hamlet: I must to England; you know that?
Queen: Alack,
I had forgot; 'tis so concluded on.
Hamlet: There's letters sealed; and my two
school-fellows, 200
Whom I will trust as I will adders fanged,
They bear the mandate; they must sweep my way,
And marshal me to knavery. Let it work;
For 'tis the sport to have the engineer
Hoist with his own petard:[15] and't shall go hard
But I will delve one yard below their mines,
And blow them at the moon: O, 'tis most sweet,
When in one line two crafts directly meet.
This man shall set me packing:
I'll lug the guts into the neighbour room. 210
Mother, good night. Indeed, this counsellor
Is now most still, most secret, and most grave
Who was in life a foolish prating knave.
Come, sir, to draw toward an end with you:
Good night, mother.
 |*Exeunt severally;* HAMLET *dragging in the
 body of* POLONIUS.|

Act IV
Scene 1: A room in the castle.
 |*Enter* KING, QUEEN, ROSENCRANTZ,
 and GUILDENSTERN.|
King: There's matter in these sighs: these profound
 heaves
You must translate: 'tis fit we understand them.
Where is your son?
Queen: Bestow this place on us a little while.—
 |*Exeunt* ROSENCRANTZ *and* GUILDENSTERN.|
Ah, my good lord, what I have seen to-night!
King: What, Gertrude? How does Hamlet?
Queen: Mad as the sea and wind, when both contend
Which is the mightier: in his lawless fit,
Behind the arras hearing something stir,
Whips out his rapier, cries "A rat! a rat!" 10
And in his brainish apprehension kills
The unseen good old man.
King: O heavy deed!
It had been so with us, had we been there:
His liberty is full of threats to all,
To you yourself, to us, to every one.
Alas, how shall this bloody deed be answered?
It will be laid to us, whose providence
Should have kept short, restrained, and out of haunt,
This mad young man: but, so much was our love,
We would not understand what was most fit, 20
But, like the owner of a foul disease,

15. bomb.

To keep it from divulging, let it feed
Even on the pith of life. Where is he gone?
Queen: To draw apart the body he hath killed:
O'er whom his very madness, like some ore
Among a mineral of metals base,
Shows itself pure. 'A weeps for what is done.
King: O, Gertrude, come away!
The sun no sooner shall the mountains touch,
But we will ship him hence: and this vile deed 30
We must, with all our majesty and skill,
Both countenance and excuse.—Ho! Guildenstern!
 |*Re-enter* ROSENCRANTZ *and* GUILDENSTERN.|
Friends both, go join you with some further aid:
Hamlet in madness hath Polonius slain,
And from his mother's closet hath he dragged him.
Go seek him out; speak fair, and bring the body
Into the chapel. I pray you haste in this.
 |*Exeunt* ROSENCRANTZ *and* GUILDENSTERN.|
Come, Gertrude, we'll call up our wisest friends;
And let them know, both what we mean to do,
And what's untimely done: so, haply, slander, 40
Whose whisper o'er the world's diameter,
As level as the cannon to his blank[1]
Transports his poisoned shot, may miss our name,
And hit the woundless air. O, come away!
My soul is full of discord and dismay.
 |*Exeunt.*|

Scene 2: Another room in the castle.

 |*Enter* HAMLET.|
Hamlet: Safely stowed,—
Rosencrantz, Guildenstern: |*Within*| Hamlet! Lord Hamlet!
Hamlet: But soft, what noise? who calls on Hamlet?
O, here they come.
 |*Enter* ROSENCRANTZ *and* GUILDENSTERN.|
Rosencrantz: What have you done, my lord, with the
dead body?
Hamlet: Compound it with dust, whereto 'tis kin.
Rosencrantz: Tell us where 'tis, that we may take it
thence,
And bear it to the chapel. 10
Hamlet: Do not believe it.
Rosencrantz: Believe what?
Hamlet: That I can keep your counsel, and not mine
own. Besides, to be demanded of a sponge, what
replication[1] should be made by the son of a king?
Rosencrantz: Take you me for a sponge, my lord?
Hamlet: Ay, sir; that soaks up the king's countenance,
his rewards, his authorities. But such officers do the king
best service in the end: he keeps them, like an ape, in
the corner of his jaw; first mouthed, to be last swallowed: 20
when he needs what you have gleaned, it is but
squeezing you, and, sponge, you shall be dry again.
Rosencrantz: I understand you not, my lord.
Hamlet: I am glad of it: a knavish speech sleeps in a
foolish ear.
Rosencrantz: My lord, you must tell us where the body

1. (Scene 1) centre of a target.
1. (Scene 2) reply.

is, and go with us to the king.
Hamlet: The body is with the king, but the king is not
with the body. The king is a thing—
Guildenstern: "A thing," my lord? 30
Hamlet: Of nothing: bring me to him. Hide fox, and all
after.
 |*Exeunt.*|

Scene 3: Another room in the castle.

 |*Enter* KING, *attended.*|
King: I have sent to seek him, and to find the body.
How dangerous is it that this man does goes loose!
Yet must not we put the strong law on him:
He's loved of the distracted multitude,
Who like not in their judgment, but their eyes;
And where 'tis so, the offender's scourge is weighed,
But never the offence. To bear all smooth and even,
This sudden sending him away must seem
Deliberate pause: diseases desperate grown
By desperate appliance are relieved, 10
Or not at all.—
 |*Enter* ROSENCRANTZ.|
 How now! what hath befallen?
Rosencrantz: Where the dead body is bestowed, my lord,
We cannot get from him.
King: But where is he?
Rosencrantz: Without, my lord; guarded to know your
pleasure.
King: Bring him before us.
Rosencrantz: Ho, Guildenstern! bring in my lord.
 |*Enter* HAMLET *and* GUILDENSTERN.|
King: Now, Hamlet, where's Polonius?
Hamlet: At supper.
King: "At supper"? where? 20
Hamlet: Not where he eats, but where 'a is eaten: a
certain convocation of politic[1] worms are e'en at him.
Your worm is your only emperor for diet. We fat all
creatures else to fat us, and we fat ourselves for maggots.
Your fat king, and your lean beggar, is but variable
service, two dishes, but to one table; that's the end.
King: Alas, alas!
Hamlet: A man may fish with the worm that hath eat of a
king, and eat of the fish that hath fed of that worm.
King: What dost thou mean by this? 30
Hamlet: Nothing but to show you how a king may go a
progress[2] through the guts of a beggar.
King: Where is Polonius?
Hamlet: In heaven; send thither to see: if your
messenger find him not there, seek him i' the other place
yourself. But if, indeed, you find him not within this
month, you shall nose him as you go up the stairs into
the lobby.
King: |*To some* ATTENDANTS| Go seek him there.
Hamlet: 'A will stay till you come. 40
 |*Exeunt* ATTENDANTS.|
King: Hamlet, this deed of thine, for thine especial
 safety,

1. statesmanlike.
2. royal journey.

Which we do tender,[3] as we dearly grieve
For that which thou hast done, must send thee hence
With fiery quickness: therefore prepare thyself;
The bark is ready and the wind at help,
The associates tend,[4] and everything is bent
For England.
Hamlet: For England?
King: Ay, Hamlet.
Hamlet: Good.
King: So is it, if thou knew'st our purposes.
Hamlet: I see a cherub that sees them.—But, come; for
England!—Farewell, dear mother. 50
King: Thy loving father, Hamlet.
Hamlet: My mother: father and mother is man and wife;
man and wife is one flesh, and so, my mother.—Come,
for England.
 |*Exit.*|
King: Follow him at foot; tempt him with speed aboard;
Delay it not; I'll have him hence to-night:
A way! for everything is sealed and done
That else leans on the affair: pray you, make haste.
 |*Exeunt* ROSENCRANTZ *and* GUILDENSTERN.|
And, England, if my love thou hold'st at aught,—
As my great power thereof may give thee sense; 60
Since yet thy cicatrice[5] looks raw and red
After the Danish sword, and thy free awe
Pays homage to us,—thou mayst not coldly set
Our sovereign process; which imports at full,
By letters congruing to that effect,
The present death of Hamlet. Do it, England;
For like the hectic[6] in my blood he rages,
And thou must cure me: till I know 'tis done,
Howe'er my haps,[7] my joys were ne'er begun.
 |*Exit.*|

Scene 4: A plain in Denmark.

 |*Enter* FORTINBRAS, *a* CAPTAIN *and*
 SOLDIERS, *marching.*|
Fortinbras: Go, captain, from me greet the Danish king;
Tell him that, by his licence, Fortinbras
Claims the conveyance of a promised march
Over his kingdom. You know the rendezvous.
If that his majesty, would aught with us,
We shall express our duty in his eye;
And let him know so.
Captain: I will do't, my lord.
Fortinbras: Go softly on.
 |*Exeunt* FORTINBRAS *and* SOLDIERS.|
 |*Enter* HAMLET, ROSENCRANTZ,
 GUILDENSTERN, *etc.*|
Hamlet: Good sir, whose powers are these?
Captain: They are of Norway, sir. 10
Hamlet: How purposed, sir, I pray you?
Captain: Against some part of Poland.
Hamlet: Who commands them, sir?
Captain: The nephew to old Norway, Fortinbras.

Hamlet: Goes it against the main of Poland, sir,
Or for some frontier?
Captain: Truly to speak, and with no addition,
We go to gain a little patch of ground,
That hath in it no profit but the name.
To pay five ducats, five, I would not farm it; 20
Nor will it yield to Norway, or the Pole.
A ranker[1] rate, should it be sold in fee.[2]
Hamlet: Why, then the Polack never will defend it.
Captain: Yes, 'tis already garrisoned.
Hamlet: Two thousand souls and twenty thousand
 ducats
Will not debate the question of this straw:
This is the imposthume[3] of much wealth and peace;
That inward breaks, and shows no cause without
Why the man dies.—I humbly thank you, sir.
Captain: God b'uy you, sir.
 |*Exit.*|
Rosencrantz: Will't please you go, my lord? 30
Hamlet: I will be with you straight. Go a little before.
 |*Exeunt all except* HAMLET.|
How all occasions do inform against me,
And spur my dull revenge! What is a man,
If his chief good and market of this time
Be but to sleep and feed? a beast, no more.
Sure, he had made us with such large discourse,
Looking before and after, gave us not
That capability and godlike reason
To fust[4] in us unused. Now, whether it be
Bestial oblivion, or some craven scruple 40
Of thinking too precisely on the event,—
A thought which, quartered, hath but one part wisdom
And ever three parts coward,—I do not know
Why yet I live to say, "This thing's to do;"
Sith I have cause, and will, and strength, and means.
To do't. Examples, gross as earth, exhort me:
Witness this army, of such mass and charge,
Led by a delicate and tender prince,
Whose spirit, with divine ambition puffed,
Makes mouths at the invisible event; 50
Exposing what is mortal and unsure
To all that fortune, death, and danger dare,
Even for an egg-shell. Rightly to be great,
Is not to stir without great argument,
But greatly to find quarrel in a straw
When honour's at the stake. How stand I then,
That have a father killed, a mother stained,
Excitements of my reason and my blood,
And let all sleep while to my shame I see,
The imminent death of twenty thousand men, 60
That for a fantasy and trick of fame,
Go to their graves like beds, fight for a plot
Whereon the numbers cannot try the cause,
Which is not tomb enough and continent,[5]
To hide the slain' O, from this time forth,
My thoughts be bloody, or be nothing worth!
 |*Exit.*|

3. hold dear. 6. fever.
4. wait. 7. fortune.
5. scar

1. higher. 4. grow mouldy.
2. outright. 5. container.
3. abscess, ulcer.

Scene 5: A room in the castle.

|*Enter* QUEEN, HORATIO, *and a* GENTLEMAN.|
Queen: I will not speak with her.
Gentleman: She is importunate, indeed, distract;
Her mood will needs be pitied
Queen: What would she have?
Gentleman: She speaks much of her father, says she
 hears,
There's tricks i' the world; and hems and beats her heart;
Spurns enviously at straws; speaks things in doubt,
That carry but half sense: her speech is nothing,
Yet the unshaped use of it doth move
The hearers to collection; they aim at it,
And botch the words up fit to their own thoughts; 10
Which, as her winks and nods and gestures yield them,
Indeed would make one think there might be thought,
Though nothing sure, yet much unhappily.
Horatio: 'Twere good she were spoken with, for she may
 strew
Dangerous conjectures in ill-breeding minds.
Queen: Let her come in.
 |*Exit* HORATIO.|
To my sick soul, as sin's true nature is,
Each toy seems prologue to some great amiss:
So full of artless jealousy is guilt,
It spills itself in fearing to be spilt. 20
 |*Re-enter* HORATIO *with* OPHELIA.|
Ophelia: Where is the beauteous majesty of Denmark?
Queen: How now, Ophelia?
Ophelia: |*Sings*|
 How should I your true love know
 From another one?
 By his cockle hat and staff
 And his sandal shoon.[1]
Queen: Alas, sweet lady, what imports this song?
Ophelia: Say you? nay, pray you, mark.
 He is dead and gone, lady,
 He is dead and gone; 30
 At his head a grass-green turf,
 At his heels a stone.
O, ho!
Queen: Nay, but Ophelia,—
Ophelia: Pray you, mark.
|*Sings*| White his shroud as the mountain snow.
 |*Enter* KING.|
Queen: Alas, look here, my lord.
Ophelia: |*Sings*|
 Larded[2] with sweet flowers:
 Which bewept to the grave did not go,
 With true-love showers.
King: How do you, pretty lady? 40
Ophelia: Well, God dild[3] you! They say the owl was a
baker's daughter. Lord, we know what we are, but know
not what we may be. God be at your table!
King: |*Aside*| Conceit[4] upon her father.
Ophelia: Pray you, let us have no words of this; but
when they ask you what it means, say you this:

|*Sings*| To-morrow is Saint Valentine's day,
 All in the morning betime,
 And I a maid at your window,
 To be your Valentine: 50

 Then up he rose, and donned his clothes
 And dupped[5] the chamber-door;
 Let in the maid, that out a maid
 Never departed more,
King: Pretty Ophelia!
Ophelia: Indeed, la, without an oath, I'll make an end on't:
|*Sings*| By Gis,[6] and by Saint Charity,
 Alack, and fie for shame!
 Young men will do't, if they come to't;
 By cock, they are to blame. 60
 Quoth she, before you tumbled me,
 You promised me to wed:
 He answers:
 So would I ha' done, by yonder sun,
 And thou hadst not come to my bed.
King: How long hath she been thus?
Ophelia: I hope, all will be well. We must be patient:
but I cannot choose but weep, to think they should lay
him i' the cold ground. My brother shall know of it; and
so I thank you for your good counsel.—Come, my 70
coach!—Good night, ladies; good night, sweet ladies;
good night, good night.
 |*Exit.*|
King: Follow her close; give her good watch, I pray you.
 |*Exit* HORATIO.|
O, this is the poison of deep grief; it springs
All from her father's death. O Gertrude, Gertrude,
When sorrows come, they come not single spies.
But in battalions! First, her father slain;
Next, your son gone; and he most violent author
Of his own just remove: the people muddied,
Thick and unwholesome in thoughts and whispers, 80
For good Polonius' death; and we have done but
 greenly.[7]
In hugger-mugger[8] to inter him; poor Ophelia
Divided from herself and her fair judgment
Without the which we are pictures, or mere beasts;
Last, and as much containing as all these,
Her brother is in secret come from France:
Feeds on his wonder, keeps himself in clouds,
And wants not buzzers to infect his ear
With pestilent speeches of his father's death;
Wherin necessity, of matter beggared, 90
Will nothing stick our person to arraign
In ear and ear. O my dear Gertrude, this,
Like to murdering-piece, in many places
Gives me superfluous death.
 |*A noise within.*|
Queen: Alack! what noise is this?
King: Where are my Switzers?[9] Let them guard the door.
 |*Enter a* GENTLEMAN.|
What is the matter?

1. shoes. 3. yield, i.e., reward.
2. decorated. 4. brooding.

5. opened. 8. secret haste.
6. contraction of "Jesus". 9. Swiss guards.
7. foolishly.

Gentleman: Save yourself, my lord;
The Ocean, overpeering of his list,[10]
Eats not the flats with more impetuous haste,
Than young Laertes, in a riotous head,
O'erbears your officers. The rabble call him lord; 100
And, as the world were now but to begin,
Antiquity forgot, custom not known.
The ratifiers and props of every word,
They cry, "Choose we; Laertes shall be king!"
Caps, hands, and tongues, applaud it to the clouds,
"Laertes shall be king, Laertes king!"
Queen: How cheerfully on the false trail they cry!
O, this is counter, you false Danish dogs!
 [Noise within.]
King: The doors are broke.
 [Enter LAERTES, armed; DANES following.]
Laertes: Where is the king?—Sirs, stand you all without. 110
Danes: No, let's come in.
Laertes: I pray you, give me leave.
Danes: We will, we will.
 [They retire without the door.]
Laertes: I thank you. Keep the door.—O thou vile king,
Give me my father!
Queen: Calmly, good Laertes.
Laertes: That drop of blood that's calm, proclaims me
 bastard;
Cries cuckold to my father, brands the harlot
Even here, between the chaste unsmirched brow
Of my true mother.
King: What is the cause, Laertes,
That thy rebellion looks so giant-like?
Let him go, Gertrude; do not fear our person; 120
There's such divinity doth hedge a king,
That treason can but peep to what it would,
Acts little of his will. Tell me, Laertes,
Why thou art thus incensed.—Let him go, Gertrude.—
Speak, man.
Laertes: Where's my father?
King: Dead.
Queen: But not by him.
King: Let him demand his fill.
Laertes: How came he dead? I'll not be juggled with.
To hell, allegiance! vows, to the blackest devil!
Conscience and grace, to the profoundest pit!
I dare damnation. To this point I stand: 130
That both the worlds I give to negligence.
Let come what comes; only I'll be revenged
Most throughly for my father.
King: Who shall stay you?
Laertes: My will, not all the world:
And for my means, I'll husband them so well,
They shall go far with little.
King: Good Laertes,
If you desire to know the certainty
Of your dear father's death, is't writ in your revenge,
That, swoopstake,[11] you will draw both friend and foe.
Winner and loser?
Laertes: None but his enemies. 140

King: Will you know them then?
Laertes: To his good friends thus wide I'll ope my arms;
And, like the kind life-rendering pelican,[12]
Repast[13] them with my blood.
King: Why, now you speak
Like a good child and a true gentleman.
That I am guiltless of your father's death,
And am most sensibly in grief for it,
It shall as level to your judgment pierce,
As day does to your eye.
Danes: [Within] Let her come in.
Laertes: How now! what noise is that? 150
 [Enter OPHELIA.]
O heat, dry up my brains! tears, seven times salt,
Burn out the sense and virtue of mine eye!—
By heaven, thy madness shall be paid with weight,
Till our scale turn the beam. O rose of May!
Dear maid, kind sister, sweet Ophelia!—
O heavens! is't possible a young maid's wits
Should be as mortal as an old man's life?
Nature is fine in love, and where 'tis fine.
It sends some precious instance of itself
After the thing it loves. 160
Ophelia: [Sings]
 They bore him barefaced on the bier;
 Hey non nonny, nonny, hey nonny;
 And on his grave rains many a tear.—
Fare you well, my dove!
Laertes: Hadst thou thy wits, and didst persuade
 revenge,
It could not move thus.
Ophelia: You must sing, Down-a-down, and you call him a-
down-a. O, how the wheel becomes it! It is the false
steward, that stole his master's daughter.
Laertes: This nothing's more than matter. 170
Ophelia: There's rosemary, that's for remembrance; pray
you, love, remember: and there is pansies, that's for
thoughts.
Laertes: A document in madness; thoughts and
remembrance fitted.
Ophelia: There's fennel for you, and columbines: there's
rue for you; and here's some for me: we may call it herb
of grace o'Sundays: oh, you must wear your rue with a
difference. There's a daisy: I would give you some
violets; but they withered all, when my father died: they 180
say 'a made a good end,—
[Sings] For Bonny sweet Robin is all my joy.
Laertes: Thought and affliction, passion, hell itself,
She turns to favour and to prettiness.
Ophelia: [Sings]
 And will 'a not come again?
 And will 'a not come again?
 No, no, he is dead,
 Go to thy death-bed.
 He never will come again.

 His beard was as white as snow, 190
 All flaxen was his poll:

10. shore.
11. in a clean sweep.

12. the pelican was thought to feed its young with its own blood.
13. feed.

> He is gone, he is gone,
> And we cast away moan;
> God ha' mercy on his soul!

And of all Christian souls. I pray God.
—God b'uy you!

[*Exit* OPHELIA.]

Laertes: Do you see this, O God?
King: Laertes, I must commune with your grief,
Or you deny me right. Go but apart,
Make choice of whom your wisest friends you will, 200
And they shall hear and judge 'twixt you and me.
If by direct or by collateral hand
They find us touched,[14] we will our kingdom give,
Our crown, our life, and all that we call ours,
To you in satisfaction. But if not,
Be you content to lend your patience to us,
And we shall jointly labour with your soul
To give it due content.
Laertes: Let this be so;
His means of death, his obscure burial—
No trophy, sword, not hatchment[15] o'er his bones, 210
No noble rite nor formal ostentation,—
Cry to be heard, as 'twere from heaven to earth,
That I must call't in question.
King: So you shall;
And where the offence is let the great axe fall.
I pray you, go with me.

[*Exeunt.*]

Scene 6. Another room in the castle.

[*Enter* HORATIO *and a* SERVANT.]

Horatio: What are they that would speak with me?
Servant: Sea-faring men, sir; they say, they have letters
 for you.
Horatio: Let them come in.—

[*Exit* SERVANT.]

I do not know from what part of the world
I should be greeted, if not from Lord Hamlet.

[*Enter* SAILORS.]

1 Sailor: God bless you, sir.
Horatio: Let him bless thee too.
1 Sailor: 'A shall, sir, and't please him. There's a letter
for you, sir; it comes from the ambassador that was
bound for England; if your name be Horatio, as I am let
to know it is. 10
Horatio: [*Reads*] *Horatio, when thou shalt have overlooked this,
give these fellows some means to the king; they have letters for him.
Ere we were two days old at sea, a pirate of very warlike
appointment gave us chase. Finding ourselves too slow of sail, we
put on a compelled valour; in the grapple I boarded them: on the
instant, they got clear of our ship; so I alone became their prisoner.
They have dealt with me like thieves of mercy; but they knew what
they did; I am to do a good turn for them. Let the king have the
letters I have sent; and repair thou to me with as much speed as
thou wouldst fly death. I have words to speak in thine ear will make 20
thee dumb; yet are they much too light for the bore of the matter.
These good fellows will bring thee where I am. Rosencrantz and*

14. implicated.
15. tablet bearing the coat of arms of the dead.

*Guildenstern hold their course for England; of them I have much to
tell thee. Farewell.*

 He that thou knowest thine, Hamlet.

Come, I will give you way for these your letters;
And do't the speedier, that you may direct me
To him from whom you brought them.

[*Exeunt.*]

Scene 7: Another room in the castle.

[*Enter* KING *and* LAERTES.]

King: Now must your conscience my acquittance seal,
And you must put me in your heart for friend;
Sith you have heard, and with a knowing ear,
That he which hath your noble father slain
Pursued my life.
Laertes: It well appears: but tell me
Why you proceeded not against these feats,
So crimeful and so capital in nature,
As by your safety, greatness, wisdom, all things else,
You mainly were stirred up.
King: O, for two special reasons;
Which may to you, perhaps, seem much unsinewed, 10
And yet to me they are strong. The queen, his mother,
Lives almost by his looks; and for myself,—
My virtue or my plague, be it either which,—
She's so conjunctive to my life and soul,
That, as the star moves not but in his sphere,
I could not but by her. The other motive,
Why to a public count I might not go,
Is the great love the general gender[1] bear him:
Who, dipping all his faults in their affection,
Would, like the spring that turneth wood to stone, 20
Convert his gyves[2] to graces; so that my arrows,
Too slightly timbered for so loud a wind,
Would have reverted to my bow again,
And not where I had aimed them.
Laertes: And so have I a noble father lost;
A sister driven into desperate terms,
Whose worth, if praises may go back again,
Stood challenger on mount of all the age
For her perfections. But my revenge will come.
King: Break not your sleeps for that: you must not think 30
That we are made of stuff so flat and dull
That we can let our beard be shook with danger
And think it pastime. You shortly shall hear more:
I loved your father, and we love ourself;
And that, I hope, will teach you to imagine,—
How now? what news?

[*Enter a* MESSENGER.]

Messenger: Letters, my lord, from Hamlet:
These to your majesty; this to the queen.
King: From Hamlet! who brought them?
Messenger: Sailors, my lord, they say: I saw them not.
They were given me by Claudio; he received them 40
Of him that brought them.
King: Laertes, you shall hear them.
Leave us.

1. common people.
2. fetters.

[Exit MESSENGER.]
[Reads] *High and mighty, you shall know, I am set naked on your*
kingdom. To-morrow shall I beg leave to see your kingly eyes: when
I shall, first asking your pardon thereunto, recount the occasion of
my sudden and more strange return.
 Hamlet.
What should this mean? Are all the rest come back?
Or is it some abuse, and no such thing?
Laertes: Know you the hand?
King: 'Tis Hamlet's character.[3] "Naked,"— 50
And, in a postscript here, he says, "alone":
Can you advise me?
Laertes: I'm lost in it, my lord. But let him come:
It warms the very sickness in my heart,
That I shall live and tell him to his teeth,
"Thus didest thou."
King: If it be so, Laertes,—
As how should it be so? how otherwise?—
Will you be ruled by me?
Laertes: Ay, my lord:
So you will not o'er-rule me to a peace.
King: To thine own peace. If he be now returned, 60
As checking at his voyage, and that he means
No more to undertake it, I will work him
To an exploit now ripe in my device,
Under the which he shall not choose but fall;
And for his death no wind of blame shall breathe;
But even his mother shall uncharge the practice,
And call it accident.
Laertes: My lord, I will be ruled:
The rather, if you could devise it so,
That I might be the organ.
King: It falls right.
You have been talked of since your travel much, 70
And that in Hamlet's hearing, for a quality
Wherein, they say, you shine: your sum of parts
Did not together pluck such envy from him,
As did that one, and that, in my regard,
Of the unworthiest siege.[4]
Laertes: What part is that, my lord?
King: A very riband in the cap of youth,
Yet needful too; for youth no less becomes
The light and careless livery that it wears,
Than settled age his sables and his weeds,
Importing health and graveness. Two months since, 80
Here was a gentleman of Normandy;—
I have seen myself, and served against the French,
And they can well on horseback: but this gallant
Had witchcraft in't; he grew unto his seat,
And to such wondrous doing brought his horse,
As he had been incorpsed and demi-natured
With the brave beast. So far he topped my thought
That I, in forgery of shapes and tricks,
Come short of what he did.
Laertes: A Norman, was't?
King: A Norman.
Laertes: Upon my life, Lamord.
King: The very same. 90

3. handwriting.
4. rank.

Laertes: I know him well: he is the brooch indeed,
And gem of all the nation.
King: He made confession of you,
And gave you such a masterly report,
For art and exercise in your defence,
And for your rapier most especially,
That he cried out, 'twould be a sight indeed,
If one could match you: the scrimers[5] of their nation,
He swore, had neither motion, guard, nor eye,
If you opposed them. Sir, this report of his 100
Did Hamlet so envenom with his envy,
That he could nothing do, but wish and beg
Your sudden coming o'er, to play with him.
Now, out of this,—
Laertes: What out of this, my lord?
King: Laertes, was your father dear to you?
Or are you like the painting of a sorrow,
A face without a heart?
Laertes: Why ask you this?
King: Not that I think you did not love your father;
But that I know love is begun by time;
And that I see, in passages of proof, 110
Time qualifies the spark and fire of it,
There lives within the very flame of love
A kind of wick or snuff that will abate it;
And nothing is at a like goodness still;
For goodness, growing to a plurisy,[6]
Dies in his own too-much: that we would do,
We should do when we would; for this "would" changes
And hath abatements and delays as many,
As there are tongues, are hands, are accidents,
And then this "should" is like a spendthrift sigh, 120
That hurts by easing. But, to the quick[7] o' the ulcer:
Hamlet comes back: what would you undertake,
To show yourself your father's son in deed
More than in words?
Laertes: To cut his throat i' the church.
King: No place, indeed, should murder sanctuarize;
Revenge should have no bounds. But, good Laertes,
Will you do this, keep close within your chamber?
Hamlet returned shall know you are come home:
We'll put on those shall praise your excellence,
And set a double varnish on the fame 130
The Frenchman gave you, bring you, in fine,[8] together,
And wager on your heads: he, being remiss,
Most generous and free from all contriving,
Will not peruse the foils, so that with ease,
Or with a little shuffling, you may choose
A sword unbated,[9] and in a pass of practice,
Requite him for your father.
Laertes: I will do't:
And for that purpose I'll anoint my sword.
I bought an unction of a mountebank,[10]
So mortal that but dip a knife in it, 140
Where it draws blood no cataplasm[11] so rare,
Collected from all simples[12] that have virtue

5. fencers.
6. excess.
7. sensitive flesh.
8. finally.
9. not blunted.
10. quack.
11. poultice.
12. medicinal herbs.

Under the moon, can save the thing from death
That is but scratched withal: I'll touch my point
With this contagion, that if I gall him slightly
It may be death.
King: Let's further think of this;
Weigh what convenience both of time and means,
May fit us to our shape. If this should fail,
And that our drift look through our bad performance,
'Twere better not assayed; therefore this project 150
Should have a back or second, that might hold
If this should blast in proof. Soft!—let me see!—
We'll make a solemn wager on your cunnings;
I ha't: when in your motion you are hot and dry,—
As make your bouts more violent to that end,—
And that he calls for drink, I'll have prepared him
A chalice for the nonce;[13] whereon but sipping,
If he by chance escape your venomed stuck,[14]
Our purpose may hold there. But stay, what noise?—
 |Enter QUEEN.|
How now, sweet queen? 160
Queen: One woe doth tread upon another's heel,
So fast they follow. Your sister's drowned, Laertes.
Laertes: "Drowned"! O, where?
Queen: There is a willow grows aslant a brook,
That shows his hoar leaves in the glassy stream;
There with fantastic garlands did she come
Of crow-flowers, nettles, daisies, and long purples,
That liberal shepherds give a grosser name,
But our cold maids do dead men's fingers call them:
There, on the pendent boughs her coronet weeds 170
Clambering to hang, an envious sliver broke;
When down the weedy trophies and herself
Fell in the weeping brook. Her clothes spread wide,
And, mermaid-like, a while they bore her up:
Which time she chanted snatches of old tunes,
As one incapable of her own distress,
Or like a creature native and indued[15]
Unto that element: but long it could not be,
Till that her garments, heavy with their drink,
Pulled the poor wretch from her melodious lay 180
To muddy death.
Laertes: Alas then, she is drowned?
Queen: Drowned, drowned.
Laertes: Too much of water hast thou, poor Ophelia,
And therefore I forbid my tears: but yet
It is our trick, nature her custom holds,
Let shame say what it will: when these are gone,
The woman will be out.—Adieu, my lord;
I have a speech of fire that fain would blaze,
But that this folly douts it.
 |Exit.|
King: Let's follow, Gertrude;
How much I had to do to calm his rage! 190
Now fear I this will give it start again;
Therefore let's follow.
 |Exeunt.|

13. occasion.
14. thrust.
15. in harmony with.

Act V
Scene 1: A churchyard

 |Enter two CLOWNS, with spades, etc.|
1 Clown: Is she to be buried in Christian burial when
she wilfully seeks her own salvation?
2 Clown: I tell thee she is; and therefore make her grave
straight: the crowner[1] hath sate on her, and finds it
Christian burial.
1 Clown: How can that be, unless she drowned herself in
her own defence?
2 Clown: Why, 'tis found so.
1 Clown: It must be se offendendo;[2] it cannot be else. For
here lies the point: if I drown myself wittingly, it argues 10
an act, and an act hath three branches; it is, to act, to do,
and to perform: argal,[3] she drowned herself wittingly.
2 Clown: Nay, but hear you, goodman delver.—
1 Clown: Give me leave. Here lies the water; good: here
stands the man; good: if the man go to this water and
drown himself, it is, will he, nill he, he goes; mark you
that; but if the water come to him and drown him, he
drowns not himself: argal, he that is not guilty of his own
death shortens not his own life.
2 Clown: But is this law? 20
1 Clown: Ay, marry is't, crowner's quest[4] law.
2 Clown: Will you ha' the truth on't? If this had not been
a gentlewoman, she should have been buried out o'
Christian burial.
1 Clown: Why, there thou say'st: and the more pity, that
great folk should have countenance in this world to
drown or hang themselves more than their even Christen.
Come, my spade. There is no ancient gentlemen but
gardeners, ditchers, and grave-makers; they hold up
Adam's profession. 30
2 Clown: Was he a gentleman?
1 Clown: 'A was the first that ever bore arms.
2 Clown: Why, he had none.
1 Clown: What, art a heathen? How dost thou
understand the scripture? The scripture says "Adam
digged"; could he dig without arms? I'll put another
question to thee: if thou answerest me not to the
purpose, confess thyself—
2 Clown: Go to.
1 Clown: What is he, that builds stronger than either the 40
mason, the shipwright, or the carpenter?
2 Clown: The gallows-maker, for that frame outlives a
thousand tenants.
1 Clown: I like thy wit well, in good faith; the gallows
does well: but how does it well? it does well to those
that do ill: now thou dost ill to say, the gallows is built
stronger than the church; argal, the gallows may do well
to thee. To't again; come.
2 Clown: "Who builds stronger than a mason, a
shipwright, or a carpenter?" 50
1 Clown: Ay, tell me that, and unyoke.

1. coroner.
2. offending herself (parody of se defendendo, a legal term meaning
"in self-defense").
3. parody of Latin ergo. "therefore".
4. inquest.

2 Clown: Marry, now I can tell.

1 Clown: To't.

2 Clown: Mass,[5] I cannot tell.

|*Enter* HAMLET *and* HORATIO *at a distance.*|

1 Clown: Cudgel thy brains no more about it, for your dull ass will not mend his pace with beating, and when you are asked this question next, say "a grave-maker;" the house that he makes lasts till doomsday. Go, get thee to Yaughan; fetch me a stoup[6] of liquor.

|*Exit* 2 CLOWN. 1 CLOWN *digs and sings.*|

> *In youth, when I did love, did love,* 60
> *Methought it was very sweet,*
> *To contract, O, the time, for, ah, my behove*[7]
> *O, methought, there was nothing meet.*

Hamlet: Has this fellow no feeling of his business, that he sings at grave-making?

Horatio: Custom hath made it in him a property of easiness.

Hamlet: 'Tis e'en so: the hand of little employment hath the daintier sense.

1 Clown: *But age with his stealing steps,* 70
> *Hath clawed me in his clutch,*
> *And hath shipped me intil the land,*
> *As if I had never been such.*

|*Throws up a skull.*|

Hamlet: That skull had a tongue in it, and could sing once: how the knave jowls[8] it to the ground as if 'twere Cain's jaw-bone, that did the first murder! This might be the pate of a politician, which this ass now o'er-reaches; one that could circumvent God, might it not?

Horatio: It might, my lord.

Hamlet: Or of a courtier, which could say, "Goodmorrow, 80 sweet lord! How dost thou, good lord?" This might be my lord Such-a-one, that praised my lord Such-a-one's horse, when he meant to beg it; might it not?

Horatio: Ay, my lord.

Hamlet: Why, e'en so: and now my Lady Worm's; chapless,[9] and knocked about the mazzard[10] with a sexton's spade: here's fine revolution, and we had the trick to see't. Did these bones cost no more the breeding, but to play at loggats[11] with 'em? mine ache to think on't. 90

1 Clown: |*Sings*| *A pick-axe, and a spade, a spade,*
> *For and a shrouding sheet:*
> *O, a pit of clay for to be made*
> *For such a guest is meet.*

|*Throws up another skull.*|

Hamlet: There's another; why may not that be the skull of a lawyer? Where be his quiddits[12] now, his quillets,[13] his cases, his tenures,[14] and his tricks? why does he suffer this rude knave now to knock him about the

5. by the mass.

6. tankard.

7. advantage.

8. hurls.

9. lacking the lower jaw.

10. head.

11. game in which small pieces of wood were thrown at an object.

12. subtle distinctions.

13. fine arguments.

14. legal means of holding land.

sconce[15] with a dirty shovel, and will not tell him of his action of battery? Hum! This fellow might be in's time a 100 great buyer of land, with his statutes, his recognizances, his fines, his double vouchers, his recoveries: is this the fine[16] of his fines and the recovery of his recoveries, to have his fine pate full of fine dirt? will his vouchers vouch him no more of his purchases, and double ones too, than the length and breadth of a pair of indentures? The very conveyances of his lands will hardly lie in this box; and must the inheritor himself have no more, ha?

Horatio: Not a jot more, my lord.

Hamlet: Is not parchment made of sheep-skins? 110

Horatio: Ay, my lord, and of calf-skins.

Hamlet: They are sheep and calves which seek out assurance in that. I will speak to this fellow.—Whose grave's this, sirrah?

1 Clown: Mine, sir.—

> |*Sings*| O, *a pit of clay for to be made*
> *For such a guest is meet.*

Hamlet: I think it be thine, indeed, for thou liest in't.

1 Clown: You lie out on't, sir, and therefore it is not yours: for my part, I do not lie in't, and yet it is mine. 120

Hamlet: Thou dost lie in't, to be in't, and say it is thine: 'tis for the dead, not for the quick;[17] therefore thou liest.

1 Clown: 'Tis a quick lie, sir; 'twill away again, from me to you.

Hamlet: What man dost thou dig it for?

1 Clown: For no man, sir.

Hamlet: What woman then?

1 Clown: For none neither.

Hamlet: Who is to be buried in't?

1 Clown: One that was a woman, sir; but, rest her soul, 130 she's dead.

Hamlet: How absolute the knave is! we must speak by the card or equivocation will undo us. By the lord, Horatio, these three years I have taken note of it; the age is grown so picked[18] that the toe of the peasant comes so near the heel of the courtier, he galls his kibe.[19]—How long hast thou been grave-maker?

1 Clown: Of all the days i' the year, I came to't that day that our last king Hamlet o'ercame Fortinbras.

Hamlet: How long is that since? 140

1 Clown: Cannot you tell that? every fool can tell that: it was the very day that young Hamlet was born: he that is mad, and sent into England.

Hamlet: Ay, marry; why was he sent into England?

1 Clown: Why, because 'a was mad: 'a shall recover his wits there; or, if 'a do not, 'tis no great matter there!

Hamlet: Why?

1 Clown: 'Twill not be seen in him; there the men are as mad as he.

Hamlet: How came he mad? 150

1 Clown: Very strangely, they say.

Hamlet: How "strangely"?

1 Clown: Faith, e'en with losing his wits.

Hamlet: Upon what ground?

1 Clown: Why, here in Denmark. I have been sexton

15. head.18. refined.

16. end.19. sore on the back of the heel.

17. living.

here, man and boy, thirty years.

Hamlet: How long will a man lie i' the earth ere he rot?

1 Clown: Faith, if 'a be not rotten before 'a die,—as we have many pocky corses[20] now-a-days, that will scarce hold the laying in,—'a will last you some eight year or nine year; a tanner will last you nine year. 160

Hamlet: Why he more than another?

1 Clown: Why, sir, his hide is so tanned with his trade, that 'a will keep out water a great while; and your water is a sore decayer of your whoreson dead body. Here's a skull now: this skull has lain in the earth three-and-twenty years.

Hamlet: Whose was it?

1 Clown: A whoreson mad fellow's it was; whose do you think it was? 170

Hamlet: Nay, I know not.

1 Clown: A pestilence on him for a mad rogue! 'a poured a flagon of Rhenish on my head once. This same skull, sir, was Yorick's skull, the king's jester.

Hamlet: This?

1 Clown: E'en that.

Hamlet: Let me see. Alas, poor Yorick!—I knew him, Horatio: a fellow of infinite jest, of most excellent fancy: he hath borne me on his back a thousand times; and now how abhorred in my imagination it is! my gorge rises 180 at it. Here hung those lips that I have kissed I know not how oft. Where be your gibes now? your gambols? your songs? your flashes of merriment, that were wont to set the table on a roar? Not one now, to mock your own grinning? quite chapfallen? Now get you to my lady's chamber, and tell her, let her paint an inch thick, to this favour she must come; make her laugh at that.—Prithee, Horatio, tell me one thing.

Horatio: What's that, my lord?

Hamlet: Dost thou think Alexander looked o' this fashion 190 i' the earth?

Horatio: E'en so.

Hamlet: And smelt so? puh!

|*Throws down the skull.*|

Horatio: E'en so, my lord.

Hamlet: To what base uses we may return, Horatio! Why may not imagination trace the noble dust of Alexander, till he find it stopping a bung-hole?

Horatio: 'Twere to consider too curiously, to consider so.

Hamlet: No, faith, not a jot; but to follow him thither with modesty enough and likelihood to lead it; as thus; 200 Alexander died, Alexander was buried, Alexander returneth to dust; the dust is earth; of earth we make loam: and why of that loam, whereto he was converted, might they not stop a beer-barrel?

> Imperious Caesar, dead, and turned to clay,
> Might stop a hole to keep the wind away:
> O that that earth, which kept the world in awe,
> Should patch a wall to expel the winter's flaw![21]

But soft! but soft! aside! here comes the king.

|*Enter* PRIESTS, *etc. in procession; the corpse of* OPHELIA, LAERTES, *and* MOURNERS *following it:* KING, QUEEN, *their Trains, etc.*|

The queen, the courtiers: who is this they follow? 210
And with such maimed rites? This doth betoken
The corse they follow did with desperate hand
Fordo it own life; 'twas of some estate.[22]
Couch[23] we a while, and mark.

|*Retiring with* HORATIO.|

Laertes: What ceremony else?

Hamlet: This is Laertes, a very noble youth: mark.

Laertes: What ceremony else?

1 Priest: Her obsequies have been as far enlarged
As we have warrantise: her death was doubtful;
And, but that great command o'ersways the order, 220
She should in ground unsanctified have lodged
Till the last trumpet; for charitable prayers,
Shards,[24] flints, and pebbles should be thrown on her.
Yet here she is allowed her virgin crants,[25]
Her maiden strewments, and the bringing home
Of bell and burial.

Laertes: Must there no more be done?

1 Priest: No more be done;
We should profane the service of the dead,
To sing a *requiem* and such rest to her,
As to peace-parted souls.

Laertes: Lay her i' the earth;— 230
And from her fair and unpolluted flesh
May violets spring! I tell thee, churlish priest,
A ministering angel shall my sister be,
When thou liest howling,

Hamlet: What, the fair Ophelia?

Queen: Sweets to the sweet: farewell!

|*Scattering flowers.*|

I hoped thou shouldst have been my Hamlet's wife.
I thought thy bride-bed to have decked, sweet maid,
And not t' have strewed thy grave.

Laertes: O, treble woe
Fall ten times treble on that cursed head,
Whose wicked deed thy most ingenious sense 240
Deprived thee of!—Hold off the earth a while,
Till I have caught her once more in mine arms.

|*Leaps into the grave.*|

Now pile your dust upon the quick and dead,
Till of this flat a mountain you have made
To o'er top old Pelion[26] or the skyish head
Of blue Olympus.

Hamlet: |*Advancing*| What is he whose grief
Bears such an emphasis? whose phrase of sorrow
Conjures the wandering stars, and makes them stand
Like wonder-wounded hearers? This is I, 250
Hamlet the Dane!

|*Leaps into the grave.*|

Laertes: The devil take thy soul!

|*Grappling with him.*|

Hamlet: Thou pray'st not well.

20. pock-marked corpses.
21. gust.

22. high rank.
23. hide.
24. pieces of broken pottery.
25. garland.
26. one of two mountains (the other is Ossa, 1. 276) which according to Greek mythology, the giants piled on top of one another in order to reach heaven and fight the gods.

I prithee, take thy fingers from my throat;
For, though I am not splenetive[27] and rash,
Yet have I something in me dangerous,
Which let thy wisdom fear. Hold off thy hand.
King: Pluck them asunder.
Queen: Hamlet, Hamlet!
All: Gentlemen.—
Horatio: Good my lord, be quiet.
 |The ATTENDANTS *part them, and they*
 come out of the grave.|
Hamlet: Why, I will fight with him upon this theme,
Until my eyelids will no longer wag. 260
Queen: O my son, what theme?
Hamlet: I loved Ophelia; forty thousand brothers
Could not, with all their quantity of love,
Make up my sum.—What wilt thou do for her?
King: O, he is mad, Laertes.
Queen: For love of God, forbear him.
Hamlet: 'Swounds show me what thou'lt do:
Woo't weep? woo't fight? woo't fast? woo't tear thyself?
Woo't drink up eisil?[28] eat a crocodile
I'll do't. Dost thou come here to whine? 270
To outface me with leaping in her grave?
Be buried quick with her, and so will I.
And, if thou prate of mountains, let them throw
Millions of acres on us, till our ground,
Singeing his pate against the burning zone,
Make Ossa like a wart! Nay, an thou'lt mouth,
I'll rant as well as thou.
Queen: This is mere madness.
And thus a while the fit will work on him;
Anon, as patient as the female dove,
When that her golden couplets are disclosed, 280
His silence will sit drooping.
Hamlet: Hear you, sir;
What is the reason that you use me thus?
I loved you ever.—But it is no matter;
Let Hercules himself do what he may,
The cat will mew, and dog will have his day.
 |*Exit.*|
King: I pray thee, good Horatio, wait upon him.—
 |*Exit* HORATIO.|
 |*To* LAERTES|
Strengthen your patience in our last night's speech;
We'll put the matter to the present push.—
Good Gertrude, set some watch over your son.—
This grave shall have a living monument: 290
An hour of quiet shortly shall we see;
Till then, in patience our proceeding be.
 |*Exeunt.*|

Scene 2: A hall in the castle.

 |*Enter* HAMLET *and* HORATIO.|
Hamlet: So much for this, sir: now shall you see the
 other;
You do remember all the circumstance?
Horatio: Remember it, my lord!

27. fiery.
28. vinegar.

Hamlet: Sir, in my heart there was a kind of fighting,
That would not let me sleep: methought I lay
Worse than the mutines in the bilboes.[1] Rashly,—
And praised be rashness for it, let us know,
Our indiscretion sometimes serves us well
When our deep plots do pall; and that should learn us
There's divinity that shapes our ends, 10
Rough-hew them how we will.
Horatio: That is most certain.
Hamlet: —Up from my cabin,
My sea-gown scarfed about me, in the dark
Groped I to find out them: had my desire,
Fingered their packet, and in fine withdrew
To mine own room again; making so bold,
My fears forgetting manners, to unfold
Their grand commission; where I found, Horatio,—
O royal knavery! an exact command,
Larded[2] with many several sorts of reasons, 20
Importing Denmark's health and England's too,
With, ho! such bugs and goblins in my life,
That, on the supervise, no leisure bated,
No, not to stay the grinding of the axe,
My head should be strook off.
Horatio: Is't possible?
Hamlet: Here's the commission; read it at more leisure.
But wilt thou hear me how I did proceed?
Horatio: I beseech you.
Hamlet: Being thus benetted round with villanies,—
Ere I could make a prologue to my brains, 30
They had begun the play, I sat me down;
Devised a new commission; wrote it fair:
I once did hold it, as our statists[3] do,
A baseness to write fair, and laboured much
How to forget that learning; but, sir, now
It did me yeoman's service. Wilt thou know
The effect of what I wrote?
Horatio: Ay, good my lord.
Hamlet: An earnest conjuration from the king,
As England was his faithful tributary;
As love between them like the palm might flourish, 40
As peace should still her wheaten garland wear
And stand a comma[4] 'tween their amities,
And many such like "Ases" of great charge
That on the view and knowing of these contents,
Without debatement further, more, or less,
He should the bearers put to sudden death,
Not shriving[5]-time allowed.
Horatio: How was this sealed?
Hamlet: Why, even in that was heaven ordinant;
I had my father's signet in my purse,
Which was the model of that Danish seal: 50
Folded the writ up in form of the other;
Subscribed it; gave't the impression; placed it safely,
The changeling never known. Now, the next day
Was our sea-fight: and what to this was sequent
Thou know'st already.
Horatio: So Guildenstern and Rosencrantz go to't.

1. mutineers in fetters. 4. link.
2. enriched. 5. absolution.
3. statesmen.

Hamlet: Why, man, they did make love to this
 employment;
They are not near my conscience; their defeat
Does by their own insinuation grow:
'Tis dangerous when the baser nature comes 60
Between the pass and fell incensed points
Of mighty opposites.
Horatio: Why, what a king is this!
Hamlet: Does it not, think'st thee, stand me now upon—
He that hath killed my king, and whored my mother;
Popped in between the election and my hopes;
Thrown out his angle[6] for my proper life,
And with such cozenage[7]—is't not perfect conscience
To quit him with this arm? and is't not to be damned,
To let this canker of our nature come
In further evil? 70
Horatio: It must be shortly known to him from England
What is the issue of the business there.
Hamlet: It will be short: the interim is mine;
And a man's life's no more than to say "One."
But I am very sorry, good Horatio,
That to Laertes I forgot myself;
For by the image of my cause, I see
The portraiture of his: I'll court his favours:
But, sure, the bravery of his grief did put me
Into a towering passion.
Horatio: Peace! who comes here? 80
 |*Enter* OSRIC.|
Osric: Your lordship is right welcome back to Denmark.
Hamlet: I humbly thank you, sir.—Dost know this
water-fly?
Horatio: No, my good lord.
Hamlet: Thy state is the more gracious: for 'tis a vice to
know him. He hath much land, and fertile; let a beast be
lord of beasts, and his crib shall stand at the king's
mess:[8] tis a chough,[9] but, as I say, spacious in the
possession of dirt.
Osric: Sweet lord, if your lordship were at leisure, I 90
should impart a thing to you from his majesty.
Hamlet: I will receive it with all diligence of spirit. Put
your bonnet to his right use; 'tis for the head.
Osric: I thank your lordship, it is very hot.
Hamlet: No, believe me, 'tis very cold; the wind is
northerly.
Osric: It is indifferent cold, my lord, indeed.
Hamlet: But yet methinks it is very sultry and hot for my
complexion.
Osric: Exceedingly, my lord; it is very sultry,—as 100
'twere,—I cannot tell how. But, my lord, his majesty bade
me signify to you, that 'a has laid a great wager on your
head. Sir, this is the matter.
Hamlet: I beseech you, remember—
 |HAMLET *moves him to put on his hat.*|
Osric: Nay, in good faith; for mine ease, in good faith.
Sir, here is newly come to court Laertes: believe me, an
absolute gentleman, full of most excellent differences, of
very soft society, and great showing: indeed, to speak
feelingly of him, he is the card or calendar of gentry, for

you shall find in him the continent of what part a 110
gentleman would see.
Hamlet: Sir, his definement suffers no perdition in you;
though, I know, to divide him inventorially would dizzy
the arithmetic of memory, and yet but yaw neither, in
respect of his quick sail. But, in the verity of extolment, I
take him to be a soul of great article, and his infusion of
such dearth and rareness, as, to make true diction of him,
his semblable is his mirror, and, who else would trace
him, his umbrage,[10] nothing more.
Osric: Your lordship speaks most infallibly of him. 120
Hamlet: The concernancy,[11] sir? why do we wrap the
gentleman in our more rawer breath?
Osric: Sir?
Horatio: Is't not possible to understand in another
tongue? You will do't, sir, really.
Hamlet: What imports the nomination of this gentleman?
Osric: Of Laertes?
Horatio: His purse is empty already; all's golden words
are spent.
Hamlet: Of him, sir. 130
Osric: I know you are not ignorant—
Hamlet: I would you did, sir; yet, in faith, if you did, it
would not much approve me. Well, sir.
Osric: You are not ignorant of what excellence Laertes is.
Hamlet: I dare not confess that, lest I should compare
with him in excellence; but, to know a man well, were to
know himself.
Osric: I mean, sir, for his weapon; but in the imputation
laid on him by them, in his meed[12] he's unfellowed.
Hamlet: What's his weapon? 140
Osric: Rapier and dagger.
Hamlet: That's two of his weapons: but, well.
Osric: The king, sir, hath wagerd with him six Barbary
horses: against the which he has imponed, as I take it, six
French rapiers and poniards, with their assigns, as girdle,
hangers,[13] and so: three of the carriages, in faith, are very
dear to fancy, very responsive to the hilts, most delicate
carriages, and of very liberal conceit.
Hamlet: What call you the carriages?
Horatio: I knew you must be edified by the margent, ere 150
you had done.
Osric: The carriages, sir, are the hangers.
Hamlet: The phrase would be more germane to the
matter if we could carry cannon by our sides: I would it
might be hangers till then. But, on: six Barbary horses
against six French swords, their assigns, and three liberal-
conceited carriages; that's the French bet against the
Danish. Why is this "imponed," as you call it?
Osric: The king, sir, hath laid, sir, that in a dozen passes
between yourself and him, he shall not exceed you three 160
hits; he hath laid on twelve for nine; and it would come
to immediate trial, if your lordship would vouchsafe the
answer.
Hamlet: How, if I answer "no"?
Osric: I mean, my lord, the opposition of your person in
trial.
Hamlet: Sir, I will walk here in the hall; if it please his

6. fishing line. 8. table.
7. trickery. 9. jackdaw, chatterer.

10. shadow. 12. merit.
11. meaning. 13. straps hanging the sword to the belt.

majesty, 'tis the breathing time of day with me: let the foils be brought; the gentleman willing, and the king hold his purpose, I will win for him if I can; if not, I will gain nothing but my shame and the odd hits. 170

Osric: Shall I re-deliver you e'en so?

Hamlet: To this effect, sir, after what flourish your nature will.

Osric: I commend my duty to your lordship.

[Exit.]

Hamlet: Yours, yours. He does well to commend it himself; there are no tongues else for's turn.

Horatio: This lapwing runs away with the shell on his head.

Hamlet: He did comply with his dug, before he sucked it. Thus has he, and many more of the same bevy that I know the drossy age dotes on, only got the tune of the time and outward habit of encounter; a kind of yesty[14] collection, which carries them through and through the most fond and winnowed opinions; and do but blow them to their trial, the bubbles are out. 180

[Enter a LORD.]

Lord: My lord, his majesty commended him to you by young Osric, who brings back to him, that you attend him in the hall: he sends to know if your pleasure hold to play with Laertes, or that you will take longer time. 190

Hamlet: I am constant to my purposes; they follow the king's pleasure; if his fitness speaks, mine is ready: now or whensoever, provided I be so able as now.

Lord: The king, and queen, and all are coming down.

Hamlet: In happy time.

Lord: The queen desires you to use some gentle entertainment to Laertes, before you fall to play.

Hamlet: She well instructs me.

[Exit LORD.]

Horatio: You will lose this wager, my lord.

Hamlet: I do not think so; since he went into France, I have been in continual practice; I shall win at the odds. But thou wouldst not think, how ill all's here about my heart: but it is no matter. 200

Horatio: Nay, good my lord,—

Hamlet: It is but foolery; but it is such a kind of gain-giving[15] as would perhaps trouble a woman.

Horatio: If your mind dislike anything, obey it. I will forestall their repair hither, and say you are not fit.

Hamlet: Not a whit; we defy augury; there's a special providence in the fall of a sparrow. If it be now, 'tis not to come; if it be not to come, it will be now; if it be not now, yet it will come: the readiness is all. Since no man of aught he leaves, knows, what is't to leave betimes? Let be. 210

[Enter KING, QUEEN, LAERTES, and LORDS, OSRIC, and other ATTENDANTS with foils and gauntlets: a table and flagons of wine on it.]

King: Come, Hamlet, come, and take this hand from me.

[The KING puts the hand of LAERTES into that of HAMLET.]

Hamlet: Give me your pardon, sir: I have done you wrong; But pardon't, as you are a gentleman.
—This presence[16] knows,

And you must needs have heard, how I am punished With a sore distraction. What I have done, 220 That might your nature, honour, and exception Roughly awake, I here proclaim was madness. Was't Hamlet wronged Laertes? Never, Hamlet: If Hamlet from himself be ta'en away, And, when he's not himself, does wrong Laertes, Then Hamlet does it not; Hamlet denies it. Who does it then? His madness: if't be so, Hamlet is of the faction that is wronged; His madness is poor Hamlet's enemy.
—Sir, in this audience, 230 Let my disclaiming from a purposed evil Free me so far in your most generous thoughts, That I have shot mine arrow o'er the house, And hurt my brother.

Laertes: I am satisfied in nature, Whose motive, in this case, should stir me most To my revenge; but in my terms of honour, I stand aloof, and will no reconcilement, Till by some elder masters of known honour I have a voice and precedent of peace, To keep my name ungored. But till that time 240 I do receive your offered love like love, And will not wrong it.

Hamlet: I embrace it freely, And will this brother's wager frankly play.—
Give us the foils. Come on.

Laertes: Come, one for me.

Hamlet: I'll be your foil, Laertes; in mine ignorance Your skill shall, like a star i' the darkest night, Stick fiery off indeed.

Laertes: You mock me, sir.

Hamlet: No, by this hand.

King: Give them the foils, young Osric.—Cousin Hamlet, You know the wager?

Hamlet: Very well, my lord; 250 Your grace hath laid the odds o' the weaker side.

King: I do not fear it: I have seen you both. But since he is bettered, we have therefore odds.

Laertes: This is too heavy, let me see another.

Hamlet: This likes me well. These foils have all a length?

Osric: Ay, my good lord.

[They prepare to play.]

King: Set me the stoups of wine upon that table.—
If Hamlet give the first or second hit, Or quit[17] in answer of the third exchange, Let all the battlements their ordnance fire; 260 The king shall drink to Hamlet's better breath; And in the cup an union[18] shall he throw, Richer than that which four successive kings In Denmark's crown have worn. Give me the cups; And let the kettle[19] to the trumpet speak, The trumpet to the cannoneer without, The cannons to the heavens, the heaven to earth, "Now the king drinks to Hamlet."—Come, begin;—
And you, the judges, bear a wary eye.

Hamlet: Come on, sir.

14. frothy. 15. misgiving. 16. royal assembly. 17. hit back. 18. pearl. 19. kettledrum.

Laertes: Come, my lord.
 |*They play.*|
Hamlet: One.
Laertes: No.
Hamlet: Judgment 270
Osric: A hit, a very palpable hit.
Laertes: Well; again.
King: Stay, give me drink: Hamlet, this pearl is thine;
Here's to thy health. Give him the cup.
 |*Trumpets sound; and cannon shot off within.*|
Hamlet: I'll play this bout first, set it by awhile.—
Come.— |*They play.*| Another hit. What say you?
Laertes: A touch, a touch, I do confess.
King: Our son shall win.
Queen: He's fat, and scant of breath.—
Here, Hamlet, take my napkin, rub thy brows:
The queen carouses to thy fortune, Hamlet.
Hamlet: Good, madam.
King: Gertrude, do not drink. 280
Queen: I will, my lord; I pray you, pardon me.
King |*Aside*|: It is the poisoned cup! it is too late!
Hamlet: I dare not drink yet, madam; by and by.
Queen: Come, let me wipe thy face.
Laertes: My lord, I'll hit him now.
King: I do not think't.
Laertes |*Aside*|: And yet 'tis almost against my
 conscience.
Hamlet: Come, for the third, Laertes: you but dally;
I pray you, pass with your best violence;
I am afeard you make a wanton of me.
Laertes: Say you so? come on. 290
 |*They play.*|
Osric: Nothing neither way.
Laertes: Have at you now!
 |*LAERTES wounds HAMLET; then, in scuffling, they
 change rapiers, and HAMLET wounds LAERTES.*|
King: Part them, they are incensed.
Hamlet: Nay, come again.
 |*The QUEEN falls.*|
Osric: Look to the queen there, ho!
Horatio: They bleed on both sides,—How is it, my lord?
Osric: How is't, Laertes?
Laertes: Why, as a woodcock to mine own springe,[20]
 Osric;
I am justly killed with mine own treachery.
Hamlet: How does the queen?
King: She swounds[21] to see them bleed.
Queen: No, no, the drink, the drink,—O my dear
 Hamlet,— 300
The drink, the drink;—I am poisoned!
 |*Dies.*|
Hamlet: O villainy! Ho! Let the door be locked:
Treachery! seek it out.
 |*LAERTES falls.*|
Laertes: It is here, Hamlet. Hamlet, thou art slain;
No medicine in the world can do thee good,
In thee there is not half an hour of life;
The treacherous instrument is in thy hand,

20. snare.
21. swoons.

Unbated and envenomed: the foul practice
Hath turned itself on me; lo, here I lie,
Never to rise again; thy mother's poisoned; 310
I can no more, the king—the king's to blame.
Hamlet: The point envenomed too! then, venom, to thy
 work.
 |*Stabs the KING.*|
All: Treason! treason!
King: O, yet defend me, friends; I am but hurt.
Hamlet: Here, thou incestuous, murderous, damned
 Dane,
Drinks off this potion. Is thy union here?
Follow my mother!
 |*KING dies.*|
Laertes: He is justly served;
It is a poison tempered by himself.—
Exchange forgiveness with me, noble Hamlet:
Mine and my father's death come not upon thee, 320
Nor thine on me!
 |*Dies.*|
Hamlet: Heaven make thee free of it! I follow thee.—
I am dead, Horatio.—Wretched queen, adieu!—
You that look pale and tremble at this chance,
That are but mutes[22] or audience to this act,
Had I but time, as this fell sergeant, death,
Is strict in his arrest, O, I could tell you—
But let it be.—Horatio, I am dead;
Thou livest; report me and my cause aright
To the unsatisfied.
Horatio: Never believe it; 330
I am more an antique Roman[23] than a Dane;
Here's yet some liquor left.
Hamlet: As thou'rt a man,
Give me the cup; let go; by heaven I'll have't.
O, good Horatio, what a wounded name,
Things standing thus unknown, shall live behind me!
If thou didst ever hold me in thy heart,
Absent thee from felicity a while,
And in this harsh world draw thy breath in pain,
To tell my story.—
 |*March afar off, and shot within.*|
 What warlike noise is this?
Osric: Young Fortinbras, with conquest come from
 Poland, 340
To the ambassadors of England gives
This warlike volley.
Hamlet: O, I die, Horatio;
The potent poison quite o'er-crows my spirit;
I cannot live to hear the news from England.
But I do prophesy the election lights
On Fortinbras; he has my dying voice;
So tell him, with the occurrents,[24] more and less,
Which have solicited—the rest is silence.
 |*Dies.*|
Horatio: Now cracks a noble heart.—Good night, sweet
 prince,
And flights of angels sing thee to thy rest! 350

22. performers who have no line to speak.
23. a reference to the old Roman fashion of suicide.
24. occurrences.

Why does the drum come hither?
|*March within.*|
|*Enter* FORTINBRAS, *the* ENGLISH
AMBASSADORS, *with drum, colours and*
ATTENDANTS.|
Fortinbras: Where is this sight?
Horatio: What is it ye would see?
If aught of woe or wonder, cease your search.
Fortinbras: This quarry[25] cries on havoc.—O proud death!
What feast is toward in thine eternal cell,
That thou so many princes, at a shot,
So bloodily hast strook?
1 Ambassador: The sight is dismal;
And our affairs from England come too late:
The ears are senseless that should give us hearing,
To tell him his commandment is fulfilled, 360
That Rosencrantz and Guildenstern are dead.
Where should we have our thanks?
Horatio: Not from his mouth,
Had it the ability of life to thank you;
He never gave commandment for their death.
But since, so jump[26] upon this bloody question,
You from the Polack wars, and you from England
Are here arrived, give order that these bodies
High on a stage be placed to the view;
And let me speak to the yet unknowing world,
How these thngs came about: so shall you hear 370
Of carnal, bloody, and unnatural acts,
Of accidental judgments, casual slaughters,
Of deaths put on by cunning, and forced cause;
And, in this upshot, purposes mistook
Fallen on the inventors' heads. All this can I
Truly deliver.
Fortinbras: Let us haste to hear it,
And call the noblest to the audience.
For me, with sorrow I embrace my fortune;
I have some rights of memory in this kingdom, 380
Which now to claim my vantage doth invite me.
Horatio: Of that I shall have always cause to speak,
And from his mouth whose voice will draw on more:
But let this same be presently performed,
E'en while men's minds are wild; lest more mischance,
On plots and errors, happen.
Fortinbras: Let four captains
Bear Hamlet, like a soldier, to the stage;
For he was likely, had he been put on,[27]
To have proved most royally: and, for his passage.[28]
The soldiers music and the rites of war 390
Speak loudly for him.—
Take up the bodies.—Such a sight as this
Becomes the field,[29] but here shows much amiss.
Go, bid the soldiers shoot.
|*A dead march.*|
|*Exeunt, bearing off the bodies; after which a*
peal of ordnance is shot off.|

25. heap of slain bodies.
26. precisely.
27. been made king.
28. death.
29. battlefield.

The Tragical History of the Life and Death of Doctor Faustus

|1604| Christopher Marlowe

Dr *Faustus* is based on a medieval legend of a magician who sold his soul to the devil. Marlowe makes Faustus a scientist–scholar, whose bargain is for 24 years of life in which he is served by the devil Mephistophilis. The play depicts the fruit of this agreement: the last scene includes the summoning up of the spirit of Helen of Troy and Faust's anguish as the time for his damnation approaches.

CHARACTERS

Chorus
Dr John Faustus, of the University of Wittenberg
Wagner, his servant
Good Angel and Bad Angel
Three Scholars, students at the university
Lucifer, Mephistophilis, and Belzebub, devils
Robin and Dick, rustic clowns
Old Man
Helen of Troy
Two Cupids

Act V
Scene 2

|*Thunder. Enter* LUCIFER, BELZEBUB, *and*
MEPHISTOPHILIS.|
Lucifer: Thus from infernal Dis do we ascend
To view the subjects of our monarchy,
Those souls which sin seals the black sons of hell.
'Mong which as chief, Faustus, we come to thee,
Bringing with us lasting damnation
To wait upon thy soul, the time is come
Which makes it forfeit.
Mephistophilis: And this gloomy night
Here in this room will wretched Faustus be.
Belzebub: And here we'll stay 10
To mark him how he doth demean himself.
Mephistophilis: How should he but with desperate
 lunacy?
Fond worlding, now his heart-blood dries with grief,
His conscience kills it, and his labouring brain
Begets a world of idle fantasies
To overreach the devil, but all in vain.
His store of pleasure must be sauced with pain.
He and his servant Wagner are at hand;
Both come from drawing Faustus' latest will.
See where they come! 20
|*Enter* FAUSTUS *and* WAGNER.|
Faustus: Say, Wagner, thou has perused my will;
How dost thou like it?
Wagner: Sir, so wondrous well
As in all humble duty I do yield
My life and lasting service for your love.
|*Enter the* SCHOLARS.|
Faustus: Gramercies, Wagner.—Welcome, gentlemen.

1 Scholar: Now, worthy Faustus, methinks your looks are changed.
Faustus: Ah, gentlemen!
2 Scholar: What ails Faustus? 30
Faustus: Ah, my sweet chamber-fellow, had I lived with thee, then had I lived still, but now must die eternally. Look, sirs! Comes he not? Comes he not?
1 Scholar: O my dear Faustus, what imports this fear?
2 Scholar: Is all our pleasure turned to melancholy?
3 Scholar: He is not well with being over-solitary.
2 Scholar: If it be so, we'll have physicians, and Faustus shall be cured.
3 Scholar: 'Tis but a surfeit, sir, fear nothing.
Faustus: A surfeit of deadly sin that hath damned both 40 body and soul.
2 Scholar: Yet, Faustus, look up to heaven: remember God's mercies are infinite.
Faustus: But Faustus' offence can ne'er be pardoned: the Serpent that tempted Eve may be saved, but not Faustus. Ah, gentlemen, hear me with patience, and tremble not at my speeches. Though my heart pants and quivers to remember that I have been a student here these thirty years, O would I had never seen Wittenberg, never read book! And what wonders I have done all 50 Germany can witness, yea all the world, for which Faustus hath lost both Germany and the world, yea heaven itself—heaven the seat of God, the throne of the blessed, the kingdom of joy, and must remain in hell forever, hell, ah hell, forever! Sweet friends, what shall become of Faustus, being in hell forever?
3 Scholar: Yet, Faustus, call on God.
Faustus: On God, whom Faustus hath abjured? on God, whom Faustus hath blasphemed? Ah, my god, I would weep, but the devil draws in my tears! Gush forth, blood, 60 instead of tears, yea life and soul! O he stays my tongue; I would lift up my hands but, see, they hold 'em, they hold 'em!
All: Who, Faustus?
Faustus: Why, Lucifer and Mephistophilis.
Ah, gentlemen, I gave them my soul for my cunning.
All: God forbid!
Faustus: God forbade it indeed, but Faustus hath done it: for vain pleasure of four and twenty years hath Faustus lost eternal joy and felicity. I writ them a bill with mine 70 own blood; the date is expired, this is the time, and he will fetch me.
1 Scholar: Why did not Faustus tell us of this before, that divines might have prayed for thee?
Faustus: Oft have I thought to have done so, but the devil threatened to tear me in pieces if I named God, to fetch both body and soul if I once gave ear to divinity; and now 'tis too late. Gentlemen, away, lest you perish with me!
2 Scholar: O what may we do to save Faustus? 80
Faustus: Talk not of me, but save yourselves and depart.
3 Scholar: God will strengthen me: I will stay with Faustus.
1 Scholar: Tempt not God, sweet friend, but let us into the next room, and there pray for him.
Faustus: Aye, pray for me, pray for me! And what noise soever ye hear, come not unto me, for nothing can

rescue me.
2 Scholar: Pray thou, and we will pray that God may have mercy upon thee. 90
Faustus: Gentlemen, farewell. If I live till morning I'll visit you; if not, Faustus is gone to hell.
All: Faustus, farewell.
|*Exeunt* SCHOLARS.|
Mephistophilis: Aye, Faustus, now hast thou no hope of heaven;
Therefore despair, think only upon hell,
For that must be thy mansion, there to dwell.
Faustus: O thou bewitching fiend, 'twas thy temptation
Hath robbed me of eternal happiness.
Mephistophilis: I do confess it, Faustus, and rejoice.
'Twas I, that when thou wert i' the way to heaven 100
Damned up thy passage; when thou tookest the book
To view the scriptures, then I turned the leaves
And led thine eye.
What, weepst thou? 'tis too late. Despair, farewell!
Fools that will laugh on earth must weep in hell.
|*Exit.*|
|*Enter the* GOOD ANGEL *and the* BAD
ANGEL *at several doors.*|
Good Angel: Ah Faustus, if thou hadst given ear to me,
Innumerable joys had followed thee,
But thou didst love the world.
Bad Angel: Gave ear to me
And now must taste hell's pains perpetually. 110
Good Angel: O what will all thy riches, pleasures, pomps
Avail thee now?
Bad Angel: Nothing but vex thee more,
To want in hell, that had on earth such store.
|*Music while the throne descends.*|
Good Angel: O, thou hast lost celestial happiness,
Pleasures unspeakable, bliss without end.
Hadst thou affected sweet divinity
Hell or the devil had had no power on thee.
Hadst thou kept on that way, Faustus, behold
In what resplendent glory thou hadst sat 120
In yonder throne, like those bright shining saints,
And triumphed over hell; that has thou lost.
And now, poor soul, must thy good angel leave thee;
The jaws of hell are open to receive thee.
|*Exit. Hell is discovered.*|
Bad Angel: Now Faustus, let thine eyes with horror stare
Into that vast perpetual torture-house.
There are the furies, tossing damnéd souls
On burning forks; their bodies boil in lead.
There are live quarters broiling on the coals
That ne'er can die; this ever-burning chair 130
Is for o'ertortured souls to rest them in;
These that are fed with sops of flaming fire
Were gluttons and loved only delicates
And laughed to see the poor starve at their gates.
But yet all these are nothing; thou shalt see
Ten thousand tortures that more horrid be.
Faustus: O, I have seen enough to torture me.
Bad Angel: Nay, thou must feel them, taste the smart of all;
He that loves pleasure must for pleasure fall.
And so I leave thee, Faustus, till anon; 140

Then wilt thou tumble in confusion.
 [*Exit. The clock strikes eleven.*]
Faustus: Ah, Faustus,
Now hast thou but one bare hour to live
And then thou must be damned perpetually!
Stand still, you ever-moving spheres of heaven,
That time may cease and midnight never come;
Fair Nature's eye, rise, rise again, and make
Perpetual day; or let this hour be but
A year, a month, a week, a natural day,
That Faustus may repent and save his soul!
O *lente lente currite noctis equi.*[1] 150
The stars move still, time runs, the clock will strike,
The devil will come, and Faustus must be damned.
O, I'll leap up to my God! Who pulls me down?
See, see, where Christ's blood streams in the
 firmament!—
One drop would save my soul—half a drop! ah, my
 Christ!
Rend not my heart for naming of my Christ;
Yet will I call on him—O, spare me, Lucifer!
Where is it now? 'Tis gone; and see where God
Stretcheth out his arm and bends his ireful brows. 160
Mountains and hills, come, come and fall on me
And hide me from the heavy wrath of God,
No, no—
Then will I headlong run into the earth:
Earth, gape! O no, it will not harbour me.
You stars that reigned at my nativity,
Whose influence hath allotted death and hell,
Now draw up Faustus like a foggy mist
Into the entrails of yon labouring clouds
That when they vomit forth into the air, 170
My limbs may issue from their smoky mouths,
So that my soul may but ascend to heaven.
 [*The watch strikes.*]
Ah, half the hour is past; 'twill all be past anon.
O God,
If thou wilt not have mercy on my soul,
Yet for Christ's sake whose blood hath ransomed me
Impose some end to my incessant pain:
Let Faustus live in hell a thousand years,
A hundred thousand, and at last be saved!
O, no end is limited to damned souls! 180
Why wert thou not a creature wanting soul?
Or why is this immortal that thou hast?
Ah, Pythagoras' metempsychosis—were that true,
This soul should fly from me, and I be changed
Unto some brutish beast. All beasts are happy,
For when they die
Their souls are soon dissolved in elements,
But mine must live still to be plagued in hell.
Cursed be the parents that engendered me!
No, Faustus, curse thyself, curse Lucifer 190
That hath deprived thee of the joys of heaven.
 [*The clock strikes twelve.*]
It strikes, it strikes! Now, body, turn to air
Or Lucifer will bear thee quick to hell!

[*Thunder and lightning.*]
O soul, be changed to little water drops
And fall into the ocean, ne'er be found.
My God, my God, look not so fierce on me!
 [*Enter DEVILS.*]
Adders and serpents, let me breathe awhile!
Ugly hell, gape not—come not, Lucifer—
I'll burn my books—ah, Mephistophilis!
 [*Exeunt DEVILS with FAUSTUS.*]

Scene 3

 [*Enter the SCHOLARS.*]
1 Scholar: Come, gentlemen, let us go visit Faustus,
For such a dreadful night was never seen
Since first the world's creation did begin,
Such fearful shrieks and cries were never heard.
Pray heaven the Doctor have escaped the danger.
2 Scholar: O, help us heaven! See, here are Faustus'
 limbs
All torn asunder by the hand of death.
3 Scholar: The devils whom Faustus served have torn
 him thus;
For 'twixt the hours of twelve and one, methought
I heard him shriek and call aloud for help. 10
At which self time the house seemed all on fire
Which dreadful horror of these damnéd fiends.
2 Scholar: Well, gentlemen, though Faustus' end be
 such
As every Christian heart laments to think on,
Yet for he was a scholar once admired
For wondrous knowledge in our German schools,
We'll give his mangled limbs due burial;
And all the students, clothed in mourning black,
Shall wait upon his heavy funeral.
 [*Exeunt.*]
 [*Enter CHORUS.*]
Chorus: Cut is the branch that might have grown full
 straight, 20
And burned is Apollo's laurel bough
That sometime grew within this learned man.
Faustus is gone: regard his hellish fall,
Whose fiendful fortune may exhort the wise
Only to wonder at unlawful things
Whose deepness doth entire such forward wits
To practise more than heavenly power permits.
 [*Exit.*]

1. "Run slowly, slowly, horses of the night": a reference to a line in
Ovid's *Amores.*

CHAPTER ELEVEN

THE BAROQUE AGE

There was a profound unease in many leading minds during the decades after the close of the High Renaissance. The Reformation had challenged institutional Christian faith and its authority. The idea of a sun-centered universe had removed humankind from its previously assured place at the center of all things. Harmony seemed once more to be an unattainable ideal, as Europe was riven by wars and as philosophers and the new breed of scientists cast doubt on the certainties of the Renaissance. The modern age was in the making. The baroque age valued opulence, intricacy, and ornateness. It outdid previous ages in reflecting the grandiose expectations of its patrons. With its appeal to emotion, baroque art took Renaissance clarity of form and recast it into complex patterns, fluid with movement.

11.1 Bernini, *Baldacchino* in St Peter's, Rome, 1624–33. Gilded bronze, height c.100 ft (30 m).

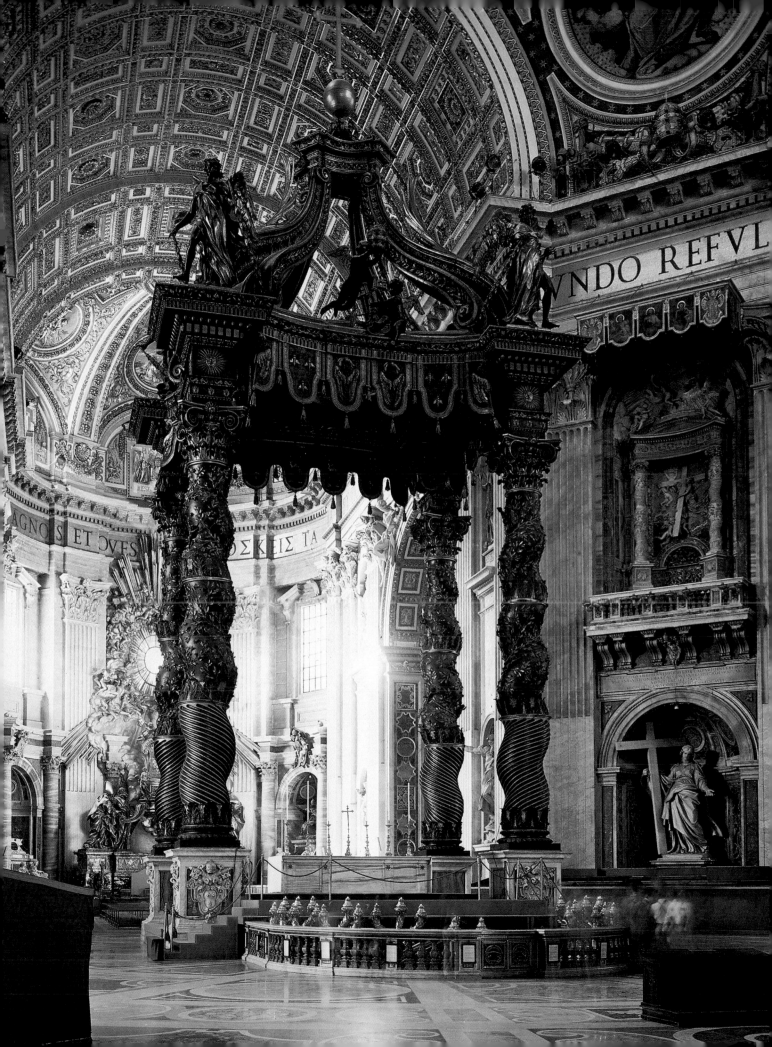

CONTEXTS AND CONCEPTS

THE COUNTER-REFORMATION

Roman Catholicism responded to Protestantism with the Council of Trent (1543–63) and the Counter-Reformation. Conditions within the Catholic Church began to stabilize as the Church attempted to keep the Reformation from spreading. One of the Council's policies was to attract worshippers to the Church through art. The 16th century closed with a series of edicts commanding tolerance. This gave impetus to a new emotional style in art, later called "baroque," that gave a unique quality to the 17th and early 18th centuries.

THE BOURGEOISIE

Inquiry and exploration continued within a new framework. Magellan's circumnavigation of the globe opened new horizons. The pillaging of the "New World" to a large degree underwrote the cost of artistic production, and the growing and powerful middle classes of wealthy merchants became enthusiastic patrons of the arts, anxious to acquire artistic works that reflected their own opulence.

SYSTEMATIC RATIONALISM

The scientific inquiry of Copernicus was only the beginning of a fascination with orderly systems. Giordano Bruno (1548–1600) speculated upon a universe of infinite size, comprised of numerous solar systems and galaxies. As a result, he was burned at the stake. Kepler (1571–1630) postulated the laws of planetary motion. Galileo (1564–1642) invented the telescope and anticipated the laws of motion. Sir Francis Bacon (1561–1626) proposed his *Novum Organum*, in which he established inductive reasoning as the basis for scientific inquiry. René Descartes (1596–1650) formulated scientific philosophy, and Isaac Newton (1642–1727) discovered the laws of gravity. The effect of this scientific inquiry was an irreversibly broadened understanding of the universe and the place of humanity within it. The new knowledge permeated every aspect of western culture. Its underlying philosophy was systematic rationalism, that is, a search for logical order of the whole and its parts. The universe was seen to be intricate, moving, and changing, but subject to natural laws, and therefore relatively predictable.

PHILOSOPHY
Francis Bacon

Born with easy access to power and prestige, Francis Bacon studied law, entered politics, and became a Member of Parliament. Under James I, he became Attorney General, Lord Keeper of the Seal, and Lord Chancellor. In 1618, he was raised to the peerage as Baron Verulam, and in 1621 became Viscount St Albans. He was not above

11.2 Timeline of the baroque age.

	GENERAL EVENTS	LITERATURE & PHILOSOPHY	VISUAL ART	THEATRE & DANCE	MUSIC	ARCHITECTURE
1550	Council of Trent– Counter-Reformation Elizabeth I of England Galileo (telescope) Henry IV of France	Francis Bacon Descartes		Catherine de' Medici Balthasar Beaujoyeulx Fabrizio Caroso	Palestrina Morley	Della Porta (11.26–27)
1600	Thirty Years' War Newton Louis XIV of France Oliver Cromwell	Cervantes Metaphysical poets Milton Dryden	Caravaggio (11.5–6) El Greco (11.7) Rubens (11.8) Rembrandt (11.10) Bernini (11.13–15) Poussin (11.9)	Cesare Negri Corneille Molière Racine	Buxtehude Jacopo Peri Monteverdi Stradivari (violins)	Inigo Jones Le Brun (11.36) Le Vau (11.35)
1650	Pope Innocent X Restoration of Charles II of England Glorious Revolution	Defoe	Van Ruisdael (11.12) Puget (11.16) Coysevox (11.17)	Académie Royale de Danse	Corelli Scarlatti Vivaldi Handel J. S. Bach	Wren (11.30–33) Hardouin-Mansart (11.35–36)
1700		Swift Pope				Neumann (11.28–29)

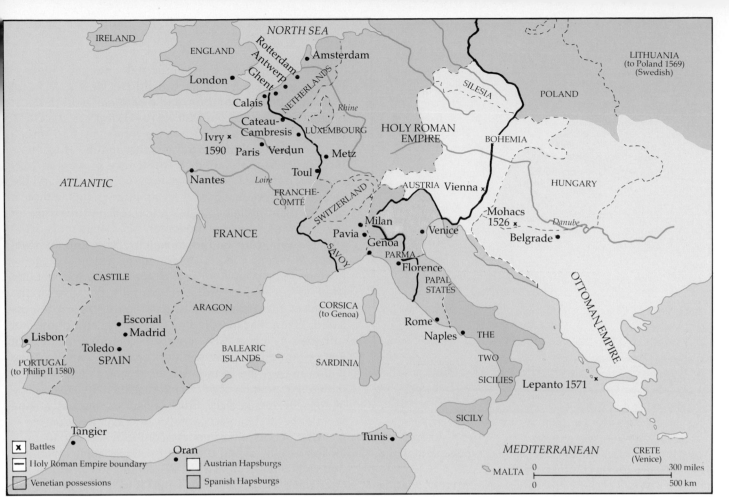

11.3 Europe in the 16th century.

treachery, however, and he fell from grace as rapidly as he had risen.

He was a prolific writer and his talents ranged from the scientific to the poetic. He is credited by some scholars with the authorship of plays and poems attributed to Shakespeare. His *Essays* are masterpieces of English literature. His philosophy used a methodology which anticipated modern inquiry.

Bacon reflected the Renaissance hope that humankind could discover all there was to know about the universe through the use of reason. He believed that was the path to knowledge. Knowledge, in turn, was power and the ultimate power was human domination of nature through an understanding of natural laws.

Bacon was one of the first to describe the modern scientific method. He saw that it was based on induction, that is, the progression from specifics to generalities. Fundamental to this process is the examination of negative instances, and a critical spirit, which prevents the inquirer from jumping to unwarranted conclusions. The verification of conclusions by continual observation and experiment is also essential. The task of science, Bacon believed, was to conquer nature by obeying it[1]. The task of poetry, on the other hand, was to conquer nature by freeing the mind from obedience to nature and releasing it into its own world where the mind reshapes nature. In Bacon's own words in the *Advancement of Learning*, "Therefore, poetry was ever thought to have some participation of divineness, because it doth raise and erect the mind by submitting the show of things to the desires of the mind, whereas reason doth buckle and bow the mind unto the nature of things." Here we have a statement as good as any of the dichotomy between the intellect and the imagination, the separation of ways of knowing that has obsessed artists and thinkers ever since.

ABSOLUTISM

One important aspect of political life in the 17th and early 18th centuries was absolutism. Although some democratic ideals existed, the major force in European national life was the absolute monarch, who received a mandate from God, according to "divine right". Strong dynasties controlled Europe. England passed its crown through the Tudors from Henry VIII to Elizabeth I (1558–1603). Her successor, Charles I, and with him the monarchy as an institution, were toppled by Cromwell, but Charles II was quickly restored, and the country returned to continental style and elegance. This elegant opulence, which was perhaps the hallmark of the age, was personified in France's Louis XIV, the Sun King (1643–1715). His court

137

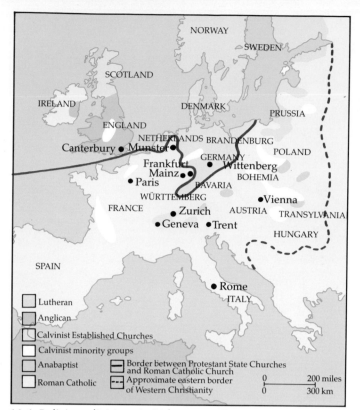

11.4 Religious divisions in 16th-century Europe.

made any previous Roman Catholic encouragement of the arts look meager by comparison.

The first half of the 17th century saw the consolidation of secular control over religious affairs in the European states. Absolutism made it difficult to envisage a society that did not follow the religion of its sovereign. It was politically advantageous for rulers to clothe themselves with divine right. The Protestant movements, which taught that truth and sovereignty lay in the Bible alone, continued nonetheless to defy the state Churches. In states where royal power proved strongest, dissent went underground or into asylum elsewhere, and yet, in all cases, religious dissent became a powerful force, especially in countries like Germany where it was coupled with social, political, and economic forces.

Even where Catholicism remained as the state religion, power struggles between absolute monarchs and popes continued to rage. It seems clear that by 1650 the papacy no longer exercised authority over international affairs. During the rule of Pope Innocent X (1644–55), the European states refused to comply with papal demands that no peace be made with the Protestants.

By the beginning of the 17th century, the papacy had once more shifted its focus back to Rome and the policy of encouraging religious devotion through great art. The result was the religious baroque style. At the same time, Catholic interests fell into other hands. The Society of Jesus (Jesuits) effectively stirred Catholic rulers to take action against the Protestants in the Thirty Years' War. However, the Jesuits' strict system of morality, as well as their opposition to absolute monarchies, sparked a backlash among both Protestants and Catholics.

The triumph of the absolutist state over the Church is best seen in France. Jean Armand du Plessis, Duke of Richelieu, Bishop of Luçon, and a cardinal, held the post of chief minister to Louis XIII (1610–43) from 1624 to 1642. Richelieu sought to strengthen the monarchy, and, after a bitter conflict, he succeeded in subduing the Huguenots (French Protestants) in 1628. The Peace of Alais in 1629 concluded the last of the religious wars, and deprived the Huguenots of their political and military rights, although their civil and religious rights remained protected under the Edict of Nantes. Thereafter, the Huguenots were strong supporters of the monarchy. The grip of royal absolutism continued to tighten under Cardinal Mazarin, Regent of Louis XIV from 1643 to 1661. The upper nobility tried to break its hold, but, partially because of the refusal of the Huguenots to participate, their attempts failed. When Mazarin died in 1661 at the end of the war with Spain, Louis XIV assumed complete control of France. Armed with the spirit of "one God, one king, one faith," he took the Jesuits' advice and, in a swift reversal, initiated a program of persecution against the Huguenots. In 1685, he revoked the Edict of Nantes, thereby forcing them either to become Catholics or leave the country.

When Louis XIV came into conflict with the papacy, it looked as if he would respond by establishing a national Church in France, similar to that established by Henry VIII in England. However, Louis found it to his advantage not to break with Rome, and he pulled back. Articles drawn up to limit the authority of the Pope in France were not enforced, although they remained part of the law.

Renaissance inquiry may have cost humankind its central role in the universe. But, after the initial shock, people gained a new confidence in their own accomplishments, and in their place in an unexpectedly large and perhaps infinite universe.

FOCUS

TERMS TO DEFINE

Baroque Systematic Rationalism
Counter-Reformation Absolutism

PEOPLE TO KNOW

Francis Bacon Louis XIV of France
Cardinal Richelieu Pope Innocent X
Cardinal Mazarin

DATE TO REMEMBER

Council of Trent

QUESTION TO ANSWER

In what ways did Francis Bacon's philosophy anticipate modern inquiry?

THE ARTS
OF THE BAROQUE AGE

TWO-DIMENSIONAL ART

Baroque style

With the religious wars over, the 17th century was a period of relative stability. With that stability came an age of intellectual, spiritual, and physical action. Above it all stood wealth and strong personal feeling. The new age was mirrored in a new style, the baroque. The baroque style acknowledged the patronage of the middle class as well as that of the Church and the nobility. Painting appealed to the emotions and to a desire for magnificence through opulent ornamentation. At the same time, it adopted systematic and rational composition in which ornamentation was unified through variation on a single theme.

Realism replaced beauty as the objective for painting. Color and grandeur were emphasized, as was dramatic use of light and shade (chiaroscuro). In all baroque art, sophisticated organizational schemes carefully subordinated and merged one part into the next to create an exceedingly complex but highly unified whole. Open composition symbolized the notion of an expansive universe: the viewer's eye traveled off the canvas to a wider reality. The human figure, as an object or focus in painting, could be monumental in full Renaissance fashion, but could also now be a minuscule figure in a landscape, part of, but subordinate to, a vast universe.

11.5 Caravaggio, *The Calling of St Matthew*, c.1596–98. Oil on canvas, 11 ft 1 in × 11 ft 5 ins (3.38 × 3.48 m). Contarelli Chapel, S. Luigi dei Francesi, Rome.

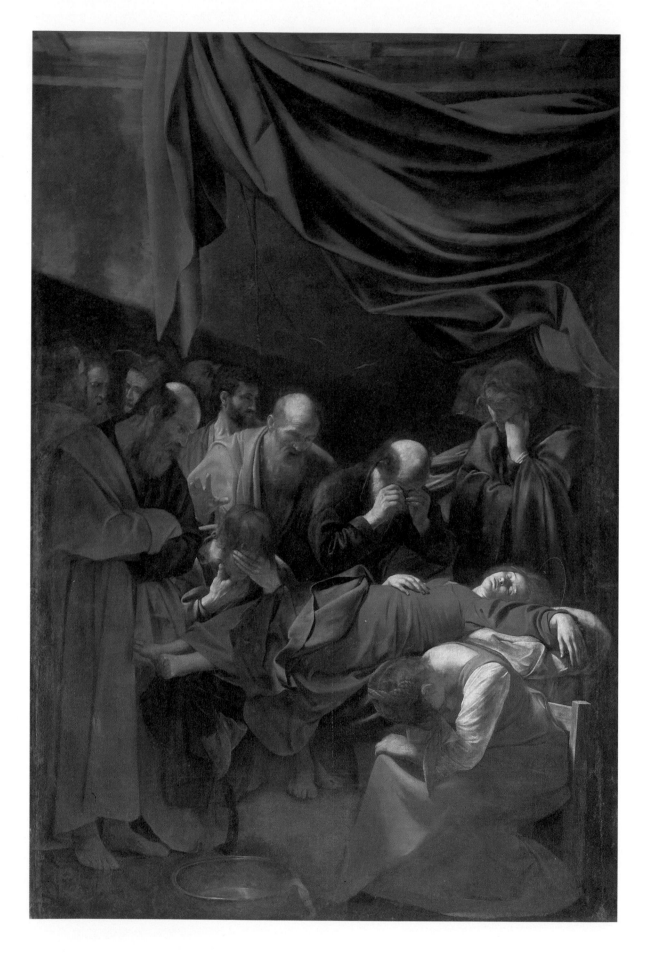

Above all, baroque style was characterized by intensely active compositions that emphasized feeling rather than form, and emotion rather than the intellect.

Baroque painting is thus easy to identify even though it had a variety of applications. It glorified the Church and religious sentiment, both Catholic and Protestant. It portrayed the magnificence of secular wealth, both noble and common. And it stressed the themes of absolutism and individualism as well. Virtuosity emerged, as each artist sought to establish a style that was distinctly his or her own. But as a general phenomenon, baroque style spread widely throughout the continent, and it was used by most European artists during the period 1600 to 1725.

Counter-Reformation baroque

Counter-Reformation baroque art pursued the objectives and visions of the Roman Catholic Church after the Council of Trent.

Caravaggio

In Rome—the center of the early baroque—papal patronage and the Counter-Reformation spirit brought artists together to make Rome the "most beautiful city of the entire Christian world." Caravaggio (1569–1609) was probably the most significant of the Roman baroque painters, and in two of his works we can see his extraordinary style, in which verisimilitude is carried to new heights. In *The Calling of St Matthew* (Fig. 11.5), highlight and shadow create a dramatic portrayal of the moment when the future apostle is touched by divine grace. This religious subject is, however, depicted in contemporary terms. The painter turns away from idealized forms, and instead presents us with a mundane scene. The call from Christ streams, with dynamic chiaroscuro, across the groups of figures, emphasized by the powerful gesture of Christ to Matthew. This great painting expresses one of the central themes of Counter-Reformation belief: that faith and grace are open to all, and that spiritual understanding is a personal, and overpowering, emotional experience.

We see the same emotional dynamism in *The Death of the Virgin* (Fig. 11.6). Here again the painter depicts real, almost common people, rather than idealized figures. The picture shows the corpse of the Virgin Mary, surrounded by the mourning disciples and friends of Christ. She is laid out awkwardly and unceremoniously—all the grim reality of death is apparent. Her feet are left uncovered, which was considered indecent in the early 17th century. A curtain is draped over the entire scene, as if to frame it like a theatrical setting. As in *The Calling of St Matthew*, a harsh light streams across the tableau, emphasizing the

11.6 Caravaggio, *The Death of the Virgin*, 1605–06. Oil on canvas, 12 ft 1 in × 8 ft ½ in (3.69 × 2.45 m). Louvre, Paris.

figure of the Virgin and creating dynamic broken patterns of light and shade.

Caravaggio had frequent conflicts with the Church, and, in the case of *The Death of the Virgin*, the Roman parish of S. Maria del Popolo rejected the painting. Thereupon the Duke of Mantua purchased the work, on the advice of Rubens, who was then court painter. Before it was taken from Rome, however, it was put on public display for a week so that all Rome could see it.

El Greco

El Greco (1541–1614), a Spanish painter born in Crete (hence the name El Greco, "the Greek"), exemplified the intense, inward-looking subjectivity and mysticism of the Counter-Reformation. In his *St Jerome* (Fig. 11.7), space seems to be compressed. Forms are piled on top of each other in two-dimensional, as opposed to deep, space. Rather than having the subject complete and framed within the composition, as was usual in the High Renaissance, here, as in Bronzino's *Portrait of a Young Man* (Fig. 10.20), the picture is cut by the frame. The emotional disturbance this suggests is further heightened by the attenuated form of St Jerome himself.

El Greco's predominantly monochromatic shades of red-brown in this painting belong to the "warm" end of the color spectrum. However, his characteristic use of strongly highlighted forms—the highlight is pure white, as opposed to a higher value of the base hue—sharpens the contrasts, and this, too, intensifies the emotional tone of the work. The obvious brushwork in many places encourages the viewer to look beneath the surface reality of the painting into a special truth within.

Aristocratic baroque

The term "aristocratic baroque" describes art generally in the baroque style, which reflected the visions and purposes of the aristocracy. At this time, the aristocracy had become increasingly aware that its power was threatened by the growing bourgeoisie, or middle class.

Rubens

Peter Paul Rubens (1577–1640) is noted for his vast, overwhelming paintings, and fleshy female nudes.

In *The Assumption of the Virgin* (Fig. 11.8), Rubens presents a complex composition full of lively action, color, and curvilinear repetition. Typical of Rubens are corpulent cupids and women whose flesh has a sense of softness and warmth we find in the work of few other artists. Rubens's colors here are warm and predominantly limited to the red end of the spectrum. A diagonal sweep of green pulls through the figures in the upper left, but it is subdued in brilliance. Nevertheless, there is a strong contrast between lights and darks and between lively and more subdued tones. Uniformly curving line makes this

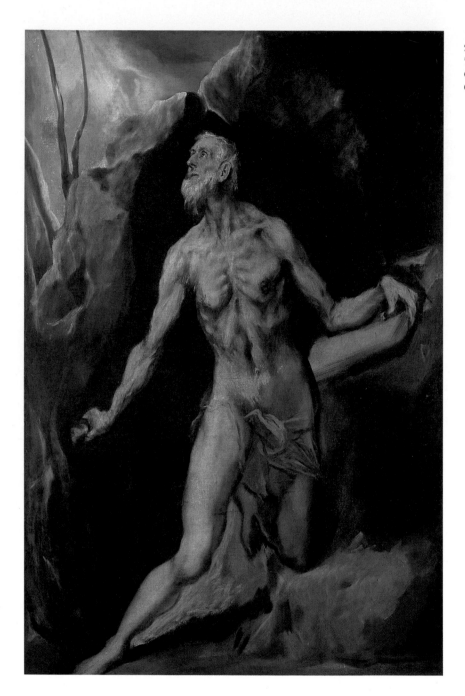

11.7 El Greco (Domenikos Theotokopoulos), *St Jerome*, c.1610–14. Oil on canvas, 5 ft 6¼ ins × 3 ft 7½ ins (1.68 × 1.11 m). National Gallery of Art, Washington DC (Chester Dale Collection).

painting seem to swirl before the viewer's eyes. It is rich in detail, but each finely rendered part is subordinate to the whole. Rubens leads the eye around the painting, upward, downward, inward, and outward, occasionally escaping the frame entirely. Nevertheless, the central triangle beneath all this complexity holds the broad base of the painting solidly in place and leads the eye upward to the lovely face of the Virgin at its apex. The overall effect of this painting is of richness, glamor, and optimism. Indulgent rather than ascetic, its religious and artistic appeal is emotional, not intellectual or mystical.

Rubens produced works at a great rate, primarily because he ran what was virtually a painting factory. Numerous artists and apprentices assisted in his work. He priced his paintings on the basis of their size and on the basis of how much actual work he did on them personally. Yet his unique style emerges from every painting, and even an observer untrained in art history can easily recognize his works. Clearly artistic value here lies in the conception, not merely in the handiwork.

11.8 (opposite) Rubens, *The Assumption of the Virgin*, c.1626. Oil on wood, 4 ft 1¾ ins × 3 ft 1¼ ins (125.4 × 94.2 cm). National Gallery of Art, Washington DC (Samuel H. Kress Collection).

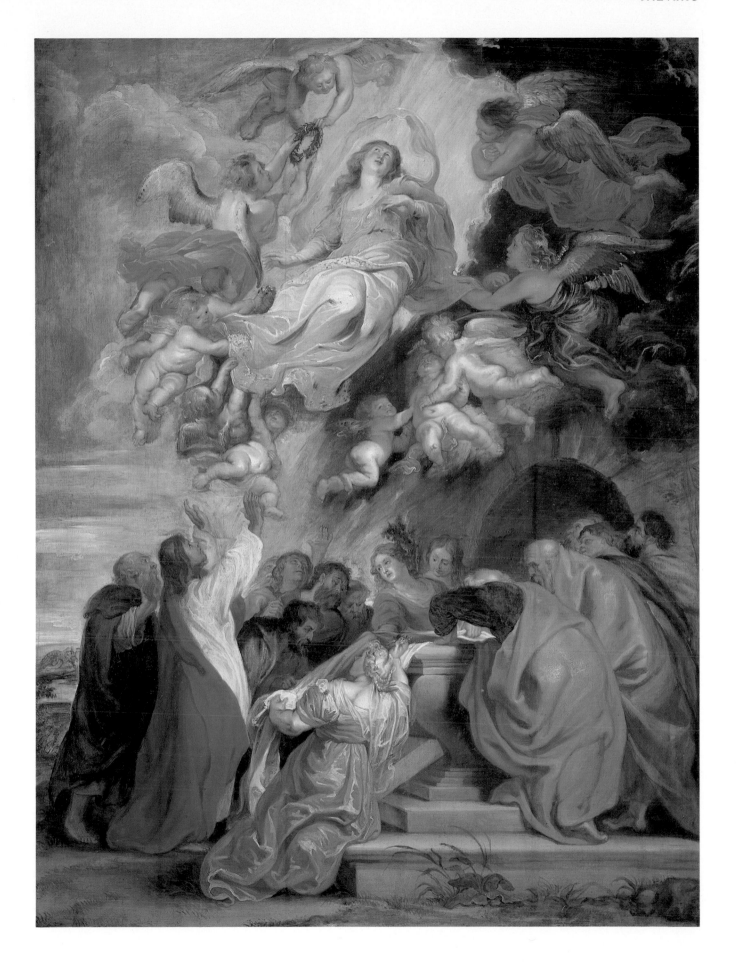

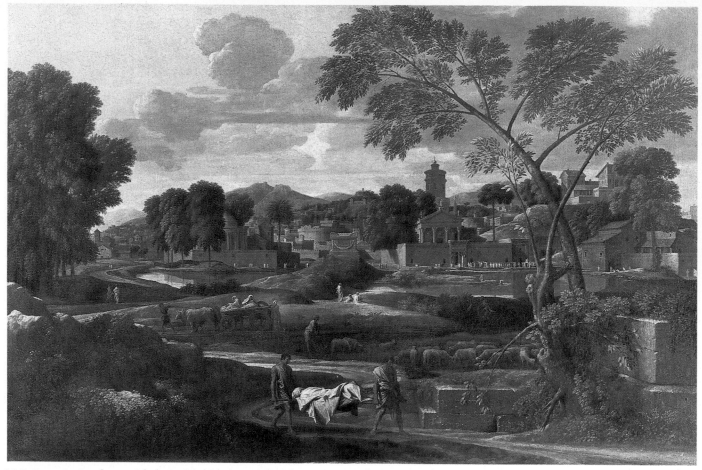

11.9 Poussin, *Landscape with the Burial of Phocion*, 1648. Oil on canvas, 5 ft 10 ins × 3 ft 11 ins (1.78 × 1.2 m). Louvre, Paris.

Poussin

Poussin (1593–1663) often chose his subjects from the literature of antiquity. In *Landscape with the Burial of Phocion* (Fig. **11.9**), he takes a theme from Plutarch's story about an ancient Athenian hero who was wrongly put to death but then given a state funeral. In the foreground, the hero's corpse is being carried away, having been denied burial on Athenian soil.

The landscape overpowers the human forms here (as it does in Van Ruisdael's painting; see Fig. **11.12**). Isolated at the bottom of the picture, perhaps symbolizing his isolation and rejection in the story, the hero seems a very minor focus. Instead, the eye of the viewer is drawn up and into the background, an overwhelming stretch of deep space, depicted with intricate and graphic clarity as far as the eye can see. Poussin uses no atmospheric perspective here. The objects farthest away are as clearly depicted as those in the foreground. The various planes of the composition lead the viewer methodically from side to side, working toward the background one plane at a time. The composition is rich in human, natural, and architectural details that please the eye.

Although the *Landscape with the Burial of Phocion* is more subdued than Rubens's *Assumption of the Virgin* (Fig. **11.8**), in every way the details in this painting are no less complex than those in the Rubens. The scheme is one of systematically interrelated pieces, in typically rational

baroque fashion. Also typical of the baroque is the play of strong highlight against strong shadow. Although the picture does not show a real place, Poussin has depicted the architecture very precisely. He studied Vitruvius, the Roman architectural historian, and Vitruvius' accounts are the source of this detail.

Bourgeois baroque

Art in the bourgeois baroque style reflected the visions and objectives of the new and wealthy middle class. The wealth and opulent lifestyle of the bourgeoisie sometimes exceeded that of the aristocracy. As a result, a power struggle was at hand.

Rembrandt

Born in Leiden, Rembrandt van Rijn (1606–69) trained under local artists and then moved to Amsterdam. His early and rapid success gained him many commissions and students—more, in fact, than he could handle. In contrast to the work of Rubens, Rembrandt's is by, for, and about the middle class. Indeed, Rembrandt became what could be called the first "capitalist" artist. The quality of art could be gauged, he believed, not only on its own merits but also by its value on the open market. He is reported to have spent huge sums of money buying his own works in order to increase their value.

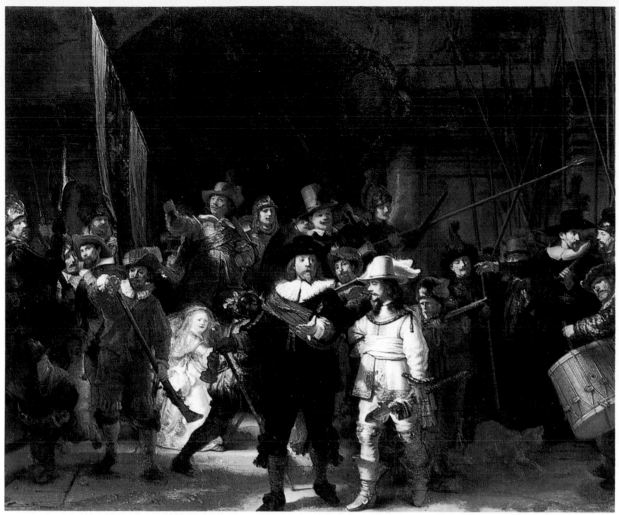

11.10 Rembrandt van Rijn, *The Night Watch* (*The Company of Captain Frans Banning Cocq*), 1642. Oil on canvas, 12 ft 2 ins × 14 ft 7 ins (3.7 × 4.45 m). Rijksmuseum, Amsterdam.

MASTERWORK
Rembrandt—The Night Watch

The huge canvas now in the Rijkmuseum in Amsterdam is only a portion of the original group portrait *The Night Watch* (Fig. **11.10**), which was cut down in the 18th century to fit into a space in Amsterdam Town Hall. So it happens that it no longer shows the bridge over which the members of the watch were about to cross.

Group portraits, especially of military units, were popular at the time. Usually the company posed in a social setting, such as a gathering around a banquet table. Rembrandt chose to break with the norm and portrayed the company, led by Captain Cocq, as if it were out on duty. The result was a scene of great vigor and dramatic intensity, true to the baroque spirit.

As a dramatic scene, the painting is a virtuoso performance of baroque lighting and movement. There is nothing regular or mechanical about it. The result, however, angered the members of Captain Cocq's company. They had paid equally, and they expected to be treated equally in the portrait, but they are not. Some of

the figures in this life-size group fade into the shadows. Others are hidden by the gestures of those placed in front of them.

Cleaning revealed the vivid color of the original. The painting is now a good deal brighter than when it was named, last century. Yet its dramatic highlights and shadows reflect no natural light source whatsoever, and no analysis of the light can solve the problem of how the figures in the painting are supposed to be illuminated. It has been suggested that perhaps the painting depicts a "Day Watch," with the intense light at the center of the work being morning sunlight. An examination of the highlights and shadows in the painting, however, shows that Rembrandt has used light for dramatic purposes only. While the figures are rendered realistically, no such claim can be made for the light sources.

Rembrandt's genius lay in depicting human emotions and characters. He suggests detail without including it, and we find him taking this approach in *The Night Watch*. Here he concentrates on atmosphere and implication. As in most baroque art, the viewer is invited to share in an emotional experience, to enter in, rather than to observe.

Rembrandt's genius lay in delivering the depths of human emotion and psychology in the most dramatic terms. Unlike Rubens, for example, Rembrandt uses suggestion rather than great detail. After all, the human spirit is intangible—it can never be portrayed, only alluded to. Thus in Rembrandt's work we find atmosphere, shadow, and implication creating emotion.

Rembrandt's DEPOSITION scene, *The Descent from the Cross* (Fig. 11.11), is at the opposite end of the emotional scale from Rubens's ascension scene, but it too has a certain sense of richness. Rembrandt uses only reds, golds, and red-browns: except for the robe of the figure pressing into Christ's body, the painting is nearly mono-chromatic. Contrasts are provided and forms are revealed through changes in value. The composition is open, that is, lines escape the frame at the left arm of the cross and in the half-forms at the lower right border. The horizontal line of the darkened sky is subtly carried off the canvas, middle right. Again, a strong central triangle holds the composition together. From a dark, shadowed base, which runs the full width of the lower border, it is delineated by the highlighted figure on the lower right and the ladder at the lower left. Christ's upstretched arm completes the apex of the triangle as it meets an implied extension of the ladder behind the cross. The drapery leads the eye downward in a gentle sweeping curve.

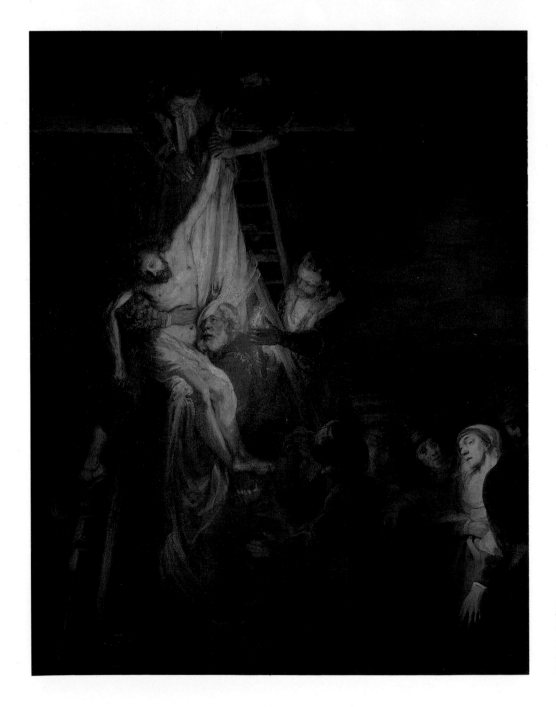

11.11 After Rembrandt van Rijn, *The Descent from the Cross*, c.1655. Canvas, 4 ft 8¼ ins × 3 ft 7¾ ins (1.43 × 1.11 m). National Gallery of Art, Washington DC (Widener Collection).

11.12 Jacob van Ruisdael, *The Cemetery*, c.1655. Oil on canvas, 4 ft 8 ins × 6 ft 2¼ ins (1.42 × 1.89 m). Detroit Institute of Arts (Gift of Julius H. Haass, in memory of his brother Dr Ernest W. Haass).

Van Ruisdael

Rembrandt's emotional subject matter was probably hard for most collectors to cope with. More to the taste of the new, general marketplace were the subjects of the emerging landscape painters. *The Cemetery* (Fig. **11.12**), a painting by Jacob van Ruisdael (1628/9–82), appeals to the emotions with its rich detail and atmosphere, light and shade, and grandiose scale.

The painting is huge, nearly five feet high and more than six feet wide. The graveyard itself, along with the Medieval ruins, casts a melancholy spell over the work. The absence of human life in the painting suggests its insignificance in the universe. The ruins suggest that even the traces of human presence shall also pass away. Highlight and shadow lead the eye around the composition, but not in any consecutive way. The eye's path is broken, or at least disturbed, by changes of direction, for example, in the tree trunk across the stream and in the stark tree limbs. Nature broods over both the scene and the wider universe outside the frame.

SCULPTURE
Counter-Reformation baroque

The splendor of the baroque was particularly apparent in sculpture. Forms and space were charged with an energy that carried beyond the confines of the work. As in painting, sculpture directed the viewer's vision inward and invited participation rather than neutral observation. Feeling was the focus. Baroque sculpture tended to treat space pictorially, almost like a painting, to describe action scenes rather than single sculptural forms. To see this, we can focus on the work of Gianlorenzo Bernini (1598–1680).

Bernini's *David* (Fig. **11.13**) exudes a sense of power and action as he curls to unleash the stone from his sling to hit Goliath, outside the statue's space. Our eyes sweep upward along a diagonally curved line and are propelled outward in the direction of David's concentrated expression. Repetition of the curving lines carries movement throughout the work. The viewer participates emotionally,

11.13 Bernini, *David*, 1623. Marble, 5 ft 7 ins (1.70 m) high. Galleria Borghese, Rome.

feels the drama, and responds to the sensuous contours of the fully articulated muscles. Bernini's *David* seems to flex and contract in the moment of action, rather than expressing the pent-up energy of Michelangelo's giant-slayer.

Apollo and Daphne (Fig. **11.14**) is almost whimsical by contrast. It does, however, exhibit similar curvilinearity, moving diagonally upward. The detailed hair and leaves (Daphne is being metamorphosed into a bay-tree) are elegantly ornamental. Every part of this complex sculpture is clearly articulated, but each part is subordinate to the theme of the work. Although it is a statue, and therefore stationary, the *Apollo and Daphne* exudes so much motion that its momentum seems to carry it beyond the confines of its actual shape. If Apollo were not frozen mid-stride, completing his step would carry him elsewhere. Daphne's hair flies as her body, suddenly pinned to the ground, twists around. There is much more going on here than in earlier sculptures where forms barely emerge from their marble blocks.

The *Ecstasy of St Teresa* (Fig. **11.15**) is a fully developed "painting" in sculptural form. It represents an experience described by St Theresa, one of the saints of the Counter-Reformation, of an angel piercing her heart with a golden, flaming arrow. "The pain was so great that I screamed aloud; but at the same time I felt such infinite sweetness that I wished the pain to last forever." Accentuated by golden rays, the figure embodies St Theresa's ecstasy. Typical of baroque sculptural design, the lines of the draperies swirl diagonally, creating circular movement. Each element slips into the next in an unbroken chain, and every aspect of the work suggests motion. Figures float upward and draperies billow from an imaginary wind. Deep recesses and contours establish strong highlights and shadows, which further heighten the drama. The "picture" forces the viewer's involvement in an overwhelming emotional and religious experience.

11.14 Bernini, *Apollo and Daphne*, 1622–25. Marble, 8 ft (2.44 m) high. Galleria Borghese, Rome.

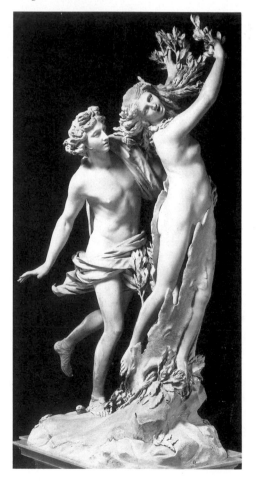

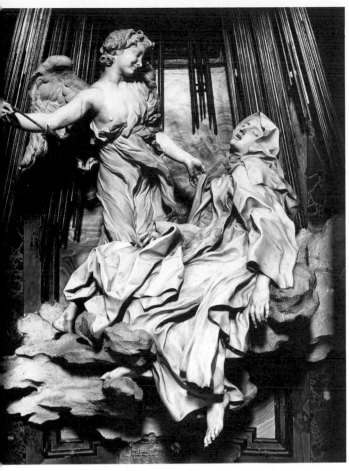

11.15 Bernini, *Ecstasy of St Teresa*, 1645–52. Marble, c.11 ft 6 ins (3.5 m) high. Cornaro Chapel, S. Maria della Vittoria, Rome.

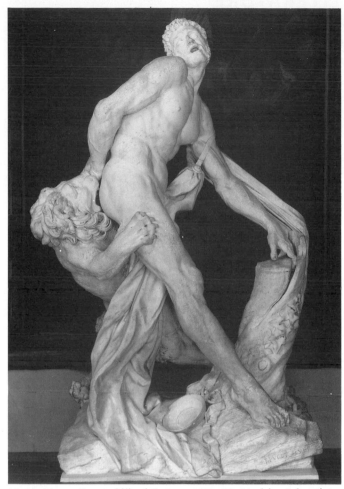

11.16 Pierre Puget, *Milo of Crotona*, 1671–83. Marble, 8 ft 10½ ins (2.71 m) high. Louvre, Paris.

Aristocratic baroque

Pierre Puget's *Milo of Crotona* (Fig. **11.16**) seems possessed by its own physical strength. The statue depicts Milo, the Olympic wrestling champion, who challenged the god Apollo. His punishment for daring to challenge the gods was death. The powerful hero, with his hand caught in a split treestump, is held helpless as he is mauled by a lion. Neither classical idealism nor reason has any part in this portrayal—it is pure physical pain and torment. The figure is caught in the violent agonies of pain and imminent death. The skin is about to tear under the pressure of the lion's claws; in an instant it will split open. The sweeping and intersecting arcs of the composition create intense energy of a kind that recalls the *Laocoön* group.

Portrait busts of the period, such as those by the French sculptor, Antoine Coysevox, also attempt an emotional portrayal of their subjects. *The Great Condé* (Fig. **11.17**) uses dynamic line and strong and emphatic features to express the energy of the sitter.

11.17 Antoine Coysevox, *The Great Condé*, 1688. Bronze, 23 ins (58.4 cm) high. Louvre, Paris.

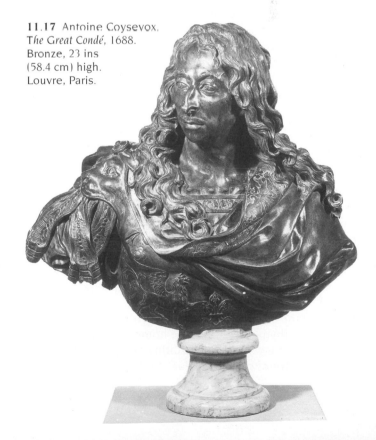

LITERATURE

After the golden age of late 16th-century England, the mood darkened noticeably with the death of Queen Elizabeth in 1603. Political instability and economic difficulties threatened, and the finest writing turned away from love—almost the exclusive theme of the Elizabethans—to an often anguished inner questioning.

The work of John Donne (1573–1631), a cleric who became Dean of St Paul's, demonstrates this sea-change. Donne's early love sonnets are among the most urgently erotic poems in the language, whereas the work of his later years relentlessly explores the meaning of an intelligent person's relationship with the soul and with God. Donne was among the leading figures in a group that has since become known as the Metaphysical poets, after their concern with "first and last things." Their often intensely private writing is characterized by deliberate and rich ambiguity of word structures and imagery. The poems of George Herbert (1593–1633)—never meant for publication—exemplify this movement at its best.

Many of the methods of the Metaphysical poets were further developed by Andrew Marvell (1621–78), a poet as public as they had been private. He wrote at the time of, and in the period immediately after, the English Civil War, and his *Horatian Ode* in praise of Oliver Cromwell marks the return of poets and poetry to the political stage. His contemporary, John Milton (1608–74), was also deeply committed to the Parliamentarian cause, and his early works reflect his humanist education and his belief in the importance of the classical cultural and political heritage. In old age, blind, solitary, and disappointed by the failure of his political ideals, he wrote his masterpiece, *Paradise Lost*. This monumental verse account of the fall of Satan and of Adam and Eve has been described as the literary equivalent of the baroque style in the visual arts. His richly Latinate language is deeply musical, confident, and powerful. His themes are epic, tragic, and uncompromisingly Protestant.

With the Restoration of Charles II, which had so embittered Milton, the seriousness and quality of poetic output declined. Cynical and licentious verse became typical of these shallow years. The Glorious Revolution of 1688, when a new royal family came over from the Low Countries, marked a decisive change. At this point, the middle classes had broken the power of the absolute monarch and the influence of the court. The confidence and pragmatism of this new "Augustan" age found a voice in John Dryden (1631–1700), whose satirical *Absalom and Achitophel* marked a new role for the poet as a witty and entertaining critic of his age. But Alexander Pope (1688–1744) gave new meaning to the term "wit." The most brilliant satirist of an age in which satire was a major art form, his rhymed couplets hit home, in poems such as the *Rape of the Lock*, with devastating poise and accuracy. Pope's idolatry of classical values and his contempt for a society that fell short of them led him to write a mock-heroic poem, *The Dunciad*, an epic on dunces, and he filled it with profound moral anger.

Swift

Pope's name is often linked with that of Jonathan Swift (1667–1745), an Anglo-Irish satirist and churchman, who shared many of his concerns. Swift was, if anything, even more bitter than Pope. *Gulliver's Travels* mocked pompous pragmatism and woolly-headed idealism equally. Another famous prose work, A *Modest Proposal*, took satire to the very edge of horror. Here Dean Swift argues with chilling mock-seriousness that the English should solve the "Irish problem" by eating the babies of the poor.

A Modest Proposal

For preventing the Children of Poor People in Ireland from Being a Burden to Their Parents or Country, and for Making Them Beneficial to the Public

It is a melancholy object to those who walk through this great town or travel in the country, when they see the streets, the roads and cabin doors, crowded with beggars of the female sex, followed by three, four, or six children, all in rags and importuning every passenger for an alms. These mothers, instead of being able to work for their honest livelihood, are forced to employ all their time in strolling to beg sustenance for their helpless infants, who, as they grow up, either turn thieves for want of work, or leave their dear native country to fight for the Pretender in Spain, or sell themselves to the Barbadoes.

I think it is agreed by all parties that this prodigious number of children in the arms, or on the backs, or at the heels of their mothers, and frequently of their fathers, is in the present deplorable state of the kingdom a very great additional grievance; and therefore whoever could find out a fair, cheap, and easy method of making these children sound, useful members of the commonwealth would deserve so well of the public as to have his statue set up for a preserver of the nation.

But my intention is very far from being confined to provide only for the children of professed beggars; it is of a much greater extent, and shall take in the whole number of infants at a certain age who are born of parents in effect as little able to support them as those who demand our charity in the streets.

As to my own part, having turned my thoughts for many years upon this important subject, and maturely weighed the several schemes of other projectors, I have always found them grossly mistaken in their computation. It is true, a child just dropped from its dam may be supported by her milk for a solar year, with little other nourishment; at most not above the value of two shillings which the mother may certainly get, or the value in scraps, by her lawful occupation of begging; and it is exactly at one year old that I propose to provide for them in such a manner as instead of being a charge upon their parents or the parish, or wanting food and raiment for the rest of their lives, they shall on the contrary contribute to the feeding, and partly to the clothing, of many thousands.

There is likewise another great advantage in my scheme, that it will prevent those voluntary abortions and that horrid practice of women murdering their bastard children, alas, too

frequent among us, sacrificing the poor innocent babes, I doubt, more to avoid the expense than the shame, which would move tears and pity in the most savage and inhuman breast.

The number of souls in this kingdom being usually reckoned one million and a half, of these I calculate there may be about two hundred thousand couples whose wives are breeders; from which number I subtract thirty thousand couples who are able to maintain their own children, although I apprehend there cannot be so many under the present distress of the kingdom; but this being granted, there will remain an hundred and seventy thousand breeders. I again subtract fifty thousand for those women who miscarry, or whose children die by accident or disease within the year. There only remain an hundred and twenty thousand children of poor parents annually born. The question therefore is, how this number shall be reared and provided for, which, as I have already said, under the present situation of affairs, is utterly impossible by all the methods hitherto proposed. For we can neither employ them in handicraft or agriculture; we neither build houses (I mean in the country) nor cultivate land. They can very seldom pick up a livelihood by stealing till they arrive at six years old, except where they are of towardly parts; although I confess they learn the rudiments much earlier, during which time they can however be looked upon only as probationers, as I have been informed by a principal gentleman in the county of Cavan, who protested to me that he never knew above one or two instances under the age of six, even in a part of the kingdom so renowned for the quickest proficiency in that art.

I am assured by our merchants that a boy or a girl before twelve years old is no salable commodity; and even when they come to this age they will not yield above three pounds, or three pounds and half a crown at most on the Exchange; which cannot turn to account either to the parents or the kingdom, the charge of nutriment and rags having been at least four times that value.

I shall now therefore humbly propose my own thoughts, which I hope will not be liable to the least objection.

I have been assured by a very knowing American of my acquaintance in London, that a young healthy child well nursed is at a year old a most delicious, nourishing, and wholesome food, whether stewed, roasted, baked, or boiled; and I make no doubt that it will equally serve in a fricassee or a ragout.

I do therefore humbly offer it to public consideration that of the hundred and twenty thousand children, already computed, twenty thousand may be reserved for breed, whereof only one fourth part to be males, which is more than we allow to sheep, black cattle, or swine; and my reason is that those children are seldom the fruits of marriage, a circumstance not much regarded by our savages, therefore one male will be sufficient to serve four females. That the remaining hundred thousand may at a year old be offered in sale to the persons of quality and fortune through the kingdom, always advising the mother to let them suck plentifully in the last month, so as to render them plump and fat for a good table. A child will make two dishes at an entertainment for friends; and when the family dines alone, the fore or hind quarter will make a reasonable dish, and seasoned with a little pepper or salt will be very good boiled on the fourth day, especially in winter.

I have reckoned upon a medium that a child just born will weigh twelve pounds, and in a solar year if tolerably nursed increaseth to twenty-eight pounds.

I grant this food will be somewhat dear, and therefore very proper for landlords, who, as they have already devoured most of the parents, seem to have the best title to the children.

Infants' flesh will be in season throughout the year, but more plentiful in March, and a little before and after. For we are told by a grave author, an eminent French physician, that fish being a prolific diet, there are more children born in Roman Catholic countries about nine months after Lent than at any other season; therefore, reckoning a year after Lent, the markets will be more glutted than usual, because the number of popish infants is at least three to one in his kingdom; and therefore it will have one other collateral advantage, by lessening the number of Papists among us.

I have already computed the charge of nursing a beggar's child (in which list I reckon all cottagers, laborers, and four fifths of the farmers) to be about two shillings per annum, rags included; and I believe no gentleman would repine to give ten shillings for the carcass of a good fat child, which, as I have said, will make four dishes of excellent nutritive meat, when he hath only some particular friend or his own family to dine with him. Thus the squire will learn to be a good landlord, and grow popular among the tenants; the mother will have eight shillings net profit, and be fit for work till she produces another child.

Those who are more thrifty (as I must confess the times require) may flay the carcass; the skin of which artificially dressed will make admirable gloves for ladies, and summer boots for fine gentlemen.

As to our city of Dublin, shambles may be appointed for this purpose in the most convenient parts of it, and butchers we may be assured will not be wanting; although I rather recommend buying the children alive, and dressing them hot from the knife as we do roasting pigs.

A very worthy person, a true lover of his country, and whose virtues I highly esteem, was lately pleased in discoursing on this matter to offer a refinement upon my scheme. He said that many gentlemen of this kingdom, having of late destroyed their deer, be conceived that the want of venison might be well supplied by the bodies of young lads and maidens, not exceeding fourteen years of age nor under twelve, so great a number of both sexes in every county being now ready to starve for want of work and service; and these to be disposed of by their parents, if alive, or otherwise by their nearest relations. But with due deference to so excellent a friend and so deserving a patriot, I cannot be altogether in his sentiments; for as to the males, my American acquaintance assured me from frequent experience that their flesh was generally tough and lean, like that of our schoolboys, by continual exercise, and their taste disagreeable; and to fatten them would not answer the charge. Then as to the females, it would, I think with humble submission, be a loss to the public, because they soon would become breeders themselves: and besides, it is not improbable that some scrupulous people might be apt to censure such a practice (although indeed very unjustly) as a little bordering upon cruelty; which I confess, hath always been with me the strongest objection against any project, how well soever intended.

But in order to justify my friend, he confessed that this expedient was put into his head by the famous Psalmanazar, a native of the island Formosa, who came from thence to London above twenty years ago, and in conversation told my friend

that in his country when any young person happened to be put to death, the executioner sold the carcass to persons of quality as a prime dainty; and that in his time the body of a plump girl of fifteen, who was crucified for an attempt to poison the emperor, was sold to his Imperial Majesty's prime minister of state, and other great mandarins of the court, in joints from the gibbet, at four hundred crowns. Neither indeed can I deny that if the same use were made of several plump young girls in this town, who without one single groat to the fortunes cannot stir abroad without a chair, and appear at the playhouse and assemblies in foreign fineries which they never will pay for, the kingdom would not be the worse.

Some persons of a desponding spirit are in great concern about that vast number of poor people who are aged, diseased, or maimed, and I have been desired to employ my thoughts what course may be taken to ease the nation of so grievous an encumbrance. But I am not in the least pain upon that matter, because it is very well known that they are every day dying and rotting by cold and famine, and filth and vermin, as fast as can be reasonably expected. And as to the younger laborers, they are now in almost as hopeful a condition. They cannot get work and consequently pine away for want of nourishment to a degree that if at any time they are accidentally hired to common labor, they have not strength to perform it; and thus the country and themselves are happily delivered from the evils to come.

I have too long digressed, and therefore shall return to my subject. I think the advantages by the proposal which I have made are obvious and many, as well as of the highest importance.

For first, as I have already observed, it would greatly lessen the number of Papists, with whom we are yearly overrun, being the principal breeders of the nation as well as our most dangerous enemies; and who stay at home on purpose to deliver the kingdom to the Pretender, hoping to take their advantage by the absence of so many good Protestants, who have chosen rather to leave their country than stay at home and pay tithes against their conscience to an Episcopal curate.

Secondly, the poorer tenants will have something valuable of their own, which by law be made liable to distress, and help to pay their landlord's rent, their corn and cattle being already seized and money a thing unknown.

Thirdly, whereas the maintenance of an hundred thousand children, from two years old and upwards, cannot be computed at less than ten shillings a piece per annum, the nation's stock will be thereby increased fifty thousand pounds per annum, besides the profit of a new dish introduced to the tables of all gentlemen of fortune in the kingdom who have any refinement in taste. And the money will circulate among ourselves, the goods being entirely of our own growth and manufacture.

Fourthly, the constant breeders, besides the gain of eight shillings sterling per annum by the sale of their children, will be rid of the charge of maintaining them after the first year.

Fifthly, this food would likewise bring great custom to taverns, where the vintners will certainly be so prudent as to procure the best receipts for dressing it to perfection, and consequently have their houses frequented by all the fine gentlemen, who justly value themselves upon their knowledge in good eating; and a skillful cook, who understands how to oblige his guests, will contrive to make it as expensive as they please.

Sixthly, this would be a great inducement to marriage, which all wise nations have either encouraged by rewards or enforced by laws and penalties. It would increase the care and tenderness of mothers toward their children, when they were sure of a settlement for life to the poor babes, provided in some sort by the public, to their annual profit instead of expense. We should see an honest emulation among the married women, which of them could bring the fattest child to the market. Men would become as fond of their wives during the time of their pregnancy as they are now of their mares in foal, their cows in calf, or sows when they are ready to farrow; nor offer to beat or kick them (as is too frequent a practice) for fear of a miscarriage.

Many other advantages might be enumerated. For instance, the addition of some thousand carcasses in our exportation of barreled beef, the propagation of swine's flesh, and improvement in the art of making good bacon, so much wanted among us by the great destruction of pigs, too frequent at our tables, which are no way comparable in taste or magnificence to a well-grown, fat, yearling child, which roasted whole will make a considerable figure at a lord mayor's feast or any other public entertainment. But this and many others I omit, being studious of brevity.

Supposing that one thousand families in this city would be constant customers for infants' flesh, besides others who might have it at merry meetings, particularly weddings and christenings, I compute that Dublin would take off annually about twenty thousand carcasses, and the rest of the kingdom (where probably they will be sold somewhat cheaper) the remaining eighty thousand.

I can think of no one objection that will possibly be raised against this proposal, unless it should be urged that the number of people will be thereby much lessened in the kingdom. This I freely own, and it was indeed one principal design in offering it to the world. I desire the reader will observe, that I calculate my remedy for this one individual kingdom of Ireland and for no other that ever was, is, or I think ever can be upon earth. Therefore let no man talk to me of other expedients: of taxing our absentees at five shillings a pound: of using neither clothes nor household furniture except what is of our own growth and manufacture: of utterly rejecting the materials and instruments that promote foreign luxury: of curing the expensiveness of pride, vanity, idleness, and gaming in our women: of introducing a vein of parsimony, prudence, and temperance: of learning to love our country, in the want of which we differ even from Laplanders and the inhabitants of Topinamboo: of quitting our animosities and factions, nor acting any longer like the Jews, who were murdering one another at the very moment their city was taken: of being a little cautious not to sell our country and conscience for nothing: of teaching landlords to have at least one degree of mercy toward their tenants: lastly, of putting a spirit of honesty, industry, and skill into our shopkeepers; who, if a resolution could now be taken to buy only our native goods, would immediately unite to cheat and exact upon us in the price, the measure, and the goodness, nor could ever yet be brought to make one fair proposal of just dealing, though often and earnestly invited to it.

Therefore I repeat, let no man talk to me of these and the like expedients, till he hath at least some glimpse of hope that there will ever be some hearty and sincere attempt to put

them in practice.

But as to myself, having been wearied out for many years with offering vain, idle, visionary thoughts, and at length utterly despairing of success, I fortunately fell upon this proposal, which, as it is wholly new, so it hath something solid and real, and no expense and little trouble, full in our own power, and whereby we can incur no danger in disobliging England. For this kind of commodity will not bear exportation, the flesh being of too tender a consistence to admit a long continuance, in salt, although perhaps I could name a country which would be glad to eat up our whole nation without it.

After all, I am not so violently bent upon my own opinion as to reject any offer proposed by wise men, which shall be found equally innocent, cheap, easy, and effectual. But before something of that kind shall be advanced in contradiction to my scheme, and offering a better, I desire the author or authors will be pleased maturely to consider two points. First, as things now stand, how they will be able to find food and raiment for an hundred thousand useless mouths and backs. And secondly, there being a round million of creatures in human figure throughout this kingdom, whose sole subsistence put into a common stock would leave them in debt two millions of pounds sterling, adding those who are beggars by profession to the bulk of farmers, cottagers, and laborers, and their wives and children who are beggars in effect; I desire those politicians who dislike my overture, and may perhaps be so bold to attempt an answer, that they will first ask the parents of these mortals whether they would not at this day think it a great happiness to have been sold for food at a year old in the manner I prescribe, and thereby have avoided such a perpetual scene of misfortunes as they have since gone through by the oppression of landlords, the impossibility of paying rent without money or trade, the want of common sustenance, with neither house nor clothes to cover them from the inclemencies of the weather, and the most inevitable prospect of entailing the like or greater miseries upon their breed forever.

I profess, in the sincerity of my heart, that I have not the least personal interest in endeavoring to promote this necessary work, having no other motive than the public good of my country, by advancing our trade, providing for infants, relieving the poor, and giving some pleasure to the rich. I have no children by which I can propose to get a single penny; the youngest being nine years old, and my wife past childbearing.[2]

The rise of the novel

This period also saw the development of the novel. An early form of this genre had been in existence in Elizabethan England, but it was Miguel Cervantes (1547–1616) in Spain who first exploited its full potential. Cervantes' novel *Don Quixote* recounts the adventures of a comically self-deluded knight. The novel is a parody of the chivalric romances of an earlier age, but also an eloquent lament for a lost time of innocence and moral clarity.

Writers in both France and England began to experiment with the versatile new form, which, because of its

extended length and realistic language, seemed ideally suited for the treatment of contemporary and everyday themes. It was the Englishman Daniel Defoe (1660–1731) who set the direction that the European novel would take. His *Robinson Crusoe* is widely read to this day, and his *Moll Flanders* defined the novel's voice and audience for the age. Subsequent novels were imaginary biographies or autobiographies set in contemporary society. The central figure would be a man or, more commonly, a woman, with whom the reader (usually female) would identify. So it was that the great age of poetry came to a close with the rise of the novel.

THEATRE
England

The scenic simplicity of Elizabethan theatre—all acting was done in front of an unchanging architectural façade—gave way to the opulent spectaculars of English court masques during the reign of Charles I in the early years of the 17th century. Essentially the court masque was a game for the nobility, an indoor extravagance which had developed earlier in the 16th century, probably influenced by its visually resplendent cousins in Italy. Short on literary merit, the English masque was nevertheless a dramatic spectacle that reflected monarchial splendor.

Banqueting halls of palaces were often redesigned to accommodate the scenic complexities and large stages of the masques. These stages allowed manipulation of scenery from below. The actors played on a protruding area in front of (as opposed to amid) the drops and wings (a type of staging called forestage-façade). The English court masque had direct links with the scenic style of Palladio and Serlio in Italy. The architect Inigo Jones (1573–1652) was the most influential English stage designer of the time, and he freely imitated Italian perspective, using elaborate stage machines and effects (Fig. 11.18).

This "baroque-like" style in English theatre ended when Cromwell's zealots overthrew the monarchy in 1642. Theatres were closed and productions forbidden until the Restoration of Charles II in 1660. (Opera provided a handsome substitute, however, as we shall see.) When Charles returned from exile in France he brought with him the continental style current in the French court. One result was a sophisticated comedy of manners known as "Restoration comedy." Thus began an era of great English acting and a period of refinement in the forestage-façade style of production.

France

Between the years 1550 and 1720, France developed a significant theatrical tradition that scholars have called

153

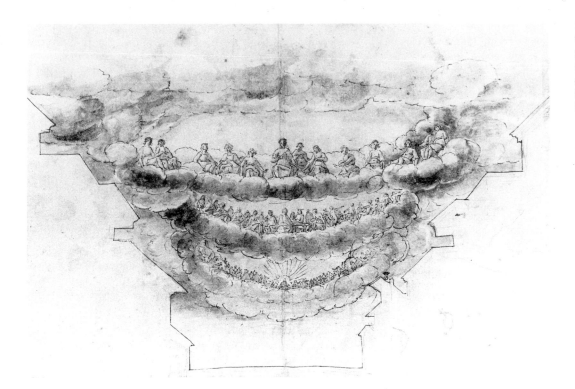

11.18 Inigo Jones, "The Whole Heaven" in *Salmacida Spolia*, 1640. Collection of the Duke of Devonshire, Chatsworth, England.

"French neo-classicism." (Remember that labels are sometimes confusing. French neo-classicism in the theatre is a part of the Late Renaissance period and related, especially in its later years, to the baroque style in music and visual art. The labels "classicism" and "neo-classicism" also describe later developments in both music and the visual arts, and it is important to keep all this straight.)

We have already noted in the previous chapter the support Francis I gave to Renaissance ideas. Despite this, French theatre remained essentially Medieval until after he died in 1547. In 1548, however, a strange combination of Protestant and Catholic attitudes resulted in the legal suppression of all religious drama. Freed from its religious competition, secular drama turned to Renaissance classicism. The French also rediscovered Sophocles, Euripides, Aristophanes, and Menander, and this return to the ancients fostered specific rules for "acceptable" drama. In the French theatre, plays had to fit a structural and spatial mold called, after Aristotle's formula, "the Unities." The spirit of classical drama was now lost as its substance was forced into artificial confines of time and space. The academies found no play acceptable unless it conformed to two specific rules: the action had to occur in a single location and to encompass no more than 24 hours. Had French antiquarians studied classical Greek dramas, of course, they would have discovered many violations of the Unities. Perhaps as a result of this rule-making, little French tragedy of consequence was written during the period of England's great dramatic achievement. But, as in Italy and England, this era was rich in scenic invention and extravagant productions.

Pierre Corneille (1606–84) managed to conform somewhat to these arbitrary and misinterpreted conventions and yet write great plays. In 1635, he produced a masterpiece, L*e Cid*. His characterizations were original, his themes were grand and heroic, and his language was richly poetic. However, he violated the Unities, and Cardinal Richelieu, France's official arbiter of taste, and the subservient Académie Française, condemned the play. Corneille continued .to write, and his late work served as a vehicle for imported Italian scenery and stage machinery. The form and quality of Corneille's tragedies strongly influenced a second important playwright of this era, Jean Racine (1639–99). P*hèdre*, perhaps his best work, illustrates the tragic intensity, powerful but controlled emotion, compressed poetry, subtle psychology, and carefully developed plots that mark the best examples of French neo-classical drama.

Molière (1622–73) provided a comic counterpoint to the great achievements of the French tragedians. Early in his career he joined a professional company, a family of actors named Béjart. His earliest productions took place in indoor tennis courts, whose size and shape made them easily adaptable to theatre (hence the term "tennis-court theatre"). For over 13 years Molière toured France with the Béjarts, as an actor and manager, before a crucial appearance before Louis XIV launched his career as a playwright.

Tartuffe, L*e Misanthrope*, and L*e Bourgeois Gentilhomme* brought new esteem to French comedy. Highly regarded comedy is rare in the history of the theatre. Molière's

instinct for penetrating human psychology, fast-paced action, crisp language, and gentle but effective mockery of human foibles earned him a foremost place in theatre history. Molière's comedies were not only dramatic masterpieces, they also stood up to the potentially over-powering baroque scenic conventions of Versailles. His Andromède and Psyché challenged the painted backgrounds and elaborate machinery of Italian scene designers and emerged triumphant.

MUSIC
The Counter-Reformation

The Council of Trent and the Counter-Reformation had profound effects on music. Perhaps the most significant musical figure to emerge from the turbulent years of the late 16th century was Giovanni Pierluigi da Palestrina (1524–94), choirmaster of St Peter's in Rome. In response to the Council's opinion that sacred music had become corrupted by complex polyphonic textures, Palestrina's compositions returned Roman Church music to simpler constructions. His works have great beauty and simplicity while retaining polyphony as a basic compositional device. The Council wanted the primary focus to be on the text, and Palestrina succeeded in eliminating what they considered to be objectionable displays of virtuosity that obscured the words by holding each syllable for a whole string of tones (a practice known as "melisma").

Secular Music

In contrast to the purity and simplification of Roman Church music and the martial solidity of Lutheran hymns, secular music of the 16th century was bawdy and irreverent. It largely celebrated physical love. Often the same composers who wrote for the Church also wrote secular music. The Italian madrigal remained popular and found its way to England, France, and Germany in slightly altered forms. The madrigal was a fairly short but elaborate composition, usually in five parts, polyphonic, imitative, and intense. Often an attempt was made to equate musical sound with the ideas expressed in the lyrics, or words. For example, water might be indicated by an undulating, wavelike melody. This device is called WORD PAINTING or TEXT PAINTING.

In England, the madrigals of composers like Thomas Morley (1557–1603) were called by a variety of names —songs, sonnets, canzonets, and ayres. In France, the madrigal was called a *chanson*; Clement Jannequin's *Chant des Oiseaux* (*Song of the Birds*) is famous for the way it uses word painting with singers imitating bird sounds. This frivolity suggests an approach not unlike that of Mannerism in the visual arts (see Chapter 10).

In Italy, Claudio Monteverdi (1567–1643), a talented madrigal composer, began the change from the Late Renaissance to the baroque style. In his madrigal Si ch'io vorrei morire ("Yes, I would like to die"), he sets an impassioned love text to music. The piece is scored for a five-part vocal ensemble and to be sung A CAPPELLA, that is, without accompaniment. Monteverdi uses a fairly free rhythm of duple meter, that is, two BEATS to the measure. Most of the song is homophonic, or made up of CHORDS, with occasional polyphony, where the voices are treated independently. The structure is free-form, although the first phrase is repeated at the end.

Monteverdi excelled at text painting. When the words speak of death in an opening phrase, for example, he uses descending melodic lines. This method is highly dramatic, especially when strong contrasts of pitch and texture reinforce it.

Baroque style

The word "baroque" originally referred to a large, irregularly shaped pearl, and baroque music of the period from 1600 to 1750 was as luscious, ornate, and emotionally appealing as its namesake. The general characteristics of baroque painting and sculpture apply to music, although it is important to remember that the term "baroque" is commonly applied to music of a somewhat later period. Baroque music used a refined system of harmonic progression around tonal centers. This system led to the harmonic progressions and the major and minor KEYS that are still basic to western music today.

Baroque composers also began to write for specific instruments, or for voices, in contrast to earlier music that might be either sung or played. They also brought to their music new kinds of action and tension, for example, quick, strong contrasts in tone color or volume, and strict rhythms juxtaposed against free rhythms. The baroque era produced great geniuses in music and many new ideas and new instruments. Most significant, however, was an entirely new musical form, opera.

Opera

Opera exemplifies the baroque spirit in many ways. Whether one considers it to be music with theatre or theatre with music, opera combines a number of complex art forms into one big, ornate, and even more complex system which is greater than and different from the sum of its parts. Some call opera a "perfect synthesis" of all the arts. It combines music, drama, dance, visual art (both two- and three-dimensional), and architecture (since an opera house is a unique architectural entity). And in particular, in true baroque spirit, opera is primarily an overwhelming emotional experience.

Opera grew out of late 15th-century madrigals. Many of these madrigals, some called "madrigal comedies" and some called "*intermedi*," were written to be performed between the acts of theatre productions. They were fairly dramatic, and included pastoral scenes, narrative reflections, and amorous adventures. They gave rise to a new style of solo singing, as opposed to ensemble singing. In 1600, an Italian singer–composer, Jacopo Peri (1561–1633), took a contemporary pastoral drama, *Eurydice*, by the playwright Ottavio Rinuccini, and set it to music. Peri's work is the first surviving opera. It was sparely scored, and consisted primarily of RECITATIVE, or sung monologue reflecting the pitches and rhythms of speech, over a slow-moving bass. Peri's opera, however, was weak both musically and theatrically.

It was Claudio Monteverdi who took a firmer hand to the new art form. In *Orfeo* (1607), he expanded the same mythological subject matter, the story of Orpheus and Eurydice, into a full, five-act structure—five acts were considered classically "correct"—and gave it richer, more substantial music. The emotional effect was consequently much stronger. The mood swung widely through contrasting passages of louds and softs. (In baroque music, quick shifts in volume, speed, and expression are the musical equivalents of the strong contrasts in light and shade in baroque painting and sculpture.) Monteverdi added solos, duets, ensemble singing, and dances. *Orfeo's* melodic lines were highly embellished and ornamental. The orchestra consisted of approximately 40 instruments, including brass, woodwind, strings, and CONTINUO. The grandiose scenic designs of the great Bibiena family, one

of which appears in Figure **11.19**, suggest the spectacular staging of this and other baroque operas. Monteverdi's innovation was the dramatic prototype of what we know today, and he is rightly called the "father of opera."

By the second half of the 17th century, opera had become an important art form, especially in Italy, but also in France, England, and Germany. A French national opera was established under the patronage of Louis XIV. French opera included colorful and rich ballet and cultivated strong literary qualities using the dramatic talents of playwrights such as Corneille and Racine. In England the court masques of the late 16th century led to fledgling opera during the suspension of the monarchy, when Cromwell's zealots shut down the theatres. Indeed, English opera probably owed more to a desire to circumvent the prohibition of stage plays than anything else. In Germany, a strong Italian influence spurred on opera in the courts. This German tradition led to one of the most astonishing eras in opera, during the mid-19th century.

Cantata

Another important new musical form to emerge in the late 17th century was the Italian CANTATA, a composition for chorus and/or solo voice(s) accompanied by an instrumental ensemble. It developed from monody, or solo singing with a predominant vocal line, centering on a text to which the music was subservient. These works, which consisted of many short, contrasting sections, were far less spectacular than opera, and they were designed

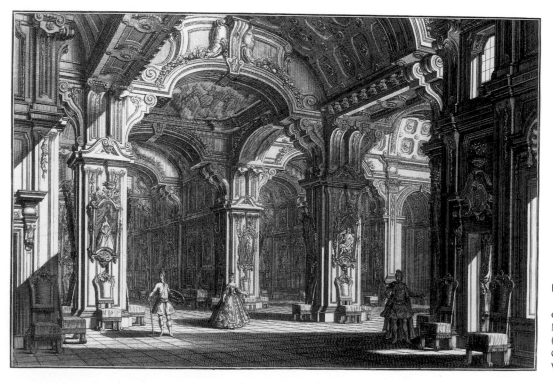

11.19 Giuseppe Galli de Bibiena, design for an opera, 1719. Contemporary engraving. The Metropolitan Museum of Art, New York (The Elisha Whittelsey Collection, The Elisha Whittelsey Fund, 1951).

to be performed without costumes or scenery. Most cantatas were written for solo soprano voice, although many used other voices and groups of voices.

The high point of the Italian cantata came in the works of Alessandro Scarlatti (1660–1725), who composed more than 600 of them. Typically Scarlatti's cantatas begin with a short "arioso" section, that is somewhere between recitative and ARIA (a set-piece song). A recitative follows, then a full aria, a second recitative, and a final aria in the opening key. Scarlatti's moods tended to be melancholic and tender, and his composition elegant and refined. The theme of almost all of his works is love, and particularly its betrayal.

In Germany, the cantata was a sacred work that grew out of the Lutheran chorale. Its most accomplished composers were Johann Sebastian Bach (1685–1750) and Dietrich Buxtehude (c.1637–1707), of whom Bach is by far the greater. As a choirmaster, Bach was under professional obligation to compose a new cantata weekly, and between 1704 and 1740, he composed more than 300. His cantatas were primarily contrapuntal in texture, usually written for up to four soloists and a four-part chorus.

Bach's work is one of the great responses of Protestant art to the challenge of the Counter-Reformation. His sacred music achieves extraordinary power as a humane, heartfelt expression of faith. Never theatrical, its drama derives from an inner striving, a hard-won triumph over doubt and death.

Oratorio

A third major development in music was the ORATORIO, which combined a sacred subject with a narrative poetic text. Like the opera, it was broad in scale, highly dramatic, and used soloists to portray specific characters. Like the cantata, it was designed for concert performances, without scenery or costume.

Oratorio began in Italy in the early 17th century, but all accomplishments pale in comparison with the works of the greatest master of the oratorio, George Frederick Handel (1685–1759). Although Handel was German by birth, he lived much of his life in England and wrote his oratorios in English. His works continue to enjoy wide popularity, and each year his Messiah has thousands of performances around the world.

Most of Handel's oratorios are highly dramatic in structure, containing exposition, conflict or complication, and *dénouement* or resolution sections. All but two, *Israel in Egypt* and *Messiah*, could be staged in full operatic tradition. Woven carefully into the complex structure of Handel's oratorios was a strong reliance on the chorus. His choral movements, as well as his arias and recitatives, are carefully developed, with juxtaposed polyphonic and homophonic sections. Each choral item has its own internal structure, which, like the oratorio itself, rises to a

climax and then comes to a resolution. Most of the solo and choral movements of Handel's oratorios can stand on their own as superb performance pieces apart from the larger work. Yet they fit so magnificently into the development of the whole composition that each loses its separate importance.

The most popular of all oratorios, Handel's *Messiah*, was written in 1741, in 24 days. The work is divided into three parts: the birth of Jesus; Jesus' death and resurrection; and the redemption of humanity. The music comprises an overture, choruses, recitatives, and arias, and is written for small orchestra, chorus, and soloists. The choruses provide some of the world's best-loved music, including the famous "Hallelujah Chorus."

The chorus "For unto us a child is born" is the climax of the first part of *Messiah*. First, the orchestra presents the opening theme and then the voices restate it gently, each in turn (Fig. **11.20**).

For un-to us a child is born; un-to us a son is

giv-en, un-to us a son is giv-en,

11.20 Handel, *Messiah*, "For unto us a child is born," opening theme of chorus.

Later, the texture alternates between polyphonic and homophonic.

The opening key is G major, which then changes in the traditional way to D major. Later it moves into C major, then returning to G major. This is a fairly standard pattern of key changes, or MODULATIONS, for the period.

The meter is quadruple, and the tempo lively. The chorus quickly moves into long melismatic passages, that is, single words sustained over many notes. These melismas are characteristic of Handel's works and often provide a challenge to the singer. A declamatory second theme appears consisting of a rising and falling melodic contour with a new piece of text (Fig. **11.21**).

And the gov - ern-ment shall be up-on his shoul - -

- - der

11.21 Handel, *Messiah*, "For unto us a child is born," second theme of chorus.

The climax of the chorus comes in a grand chordal section with the words "and his name shall be called Wonderful! Counselor!" Over the course of the piece that text is repeated three times. The structure also involves alternation of the first and second themes. The chorus ends with a repetition of the opening theme in the orchestra.

Instrumental music

As baroque composers began to write specifically for individual voices and instruments, instrumental music assumed a new importance. A wide range of possibilities for individual instruments was explored, and the instruments themselves underwent technical development. For one thing, instruments had to be made so they could play in any key. Before the baroque era, an instrument such as the harpsichord had to be retuned virtually each time a piece in a new key was played. "Equal TEMPERAMENT" established the convention we accept without question, that each half-step in a musical scale is equidistant from the one preceding or following it. This was not immediately seen as desirable, and Bach composed a series of two sets of preludes and fugues in all possible keys (The Well-Tempered Clavier, Part I, 1722; Part II, 1740) to illustrate the virtues of the new system.

As a result of these developments, a wealth of keyboard music was composed in this era. The FUGUE, with its formal structure and strict imitation, best demonstrates the complexity and virtuosity of this music, and the highest point in its development came, once again, in the work of Johann Sebastian Bach. Bach was the leading composer of the baroque age. His instrumental compositions range from simple dances, arranged into groups as SUITES, to the famous pieces for solo violin and solo cello, which to this day are some of the most complex and technically challenging works in the repertoire. Bach was a prolific composer: his keyboard music alone includes over 600 organ pieces based on chorale tunes, and hundreds of other harpsichord and organ works in all the contemporary instrumental forms.

The baroque age contributed two other forms to western musical tradition: the CONCERTO and the SONATA. The concerto is a piece for solo instrument and orchestra, and it in fact originated in the form known as CONCERTO GROSSO, which used a small group of soloists and orchestra. The master of the concerto grosso was Antonio Vivaldi (1669–1741). He composed for specific occasions and usually for a specific company of performers. He wrote prolifically: approximately 450 concertos, 23 sinfonias, 75 sonatas, 49 operas, and numerous cantatas, motets, and oratorios. About two-thirds of his concertos are for solo instrument and orchestra and one-third are concerti grossi.

MASTERWORK
Bach—Fugue in G minor

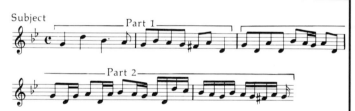

11.22 Bach, Fugue in G minor, first statement of subject.

Bach's organ compositions are famous for their drama, bold pedal solos, and virtuoso fingerwork. The Fugue in G minor, or "Little Fugue," is a characteristic example.

A fugue is a polyphonic piece for one or more instruments or a group of singers. It develops at least two musical themes, the first called the subject and the second called the countersubject. The word "fugue" takes its name from the Latin *fuga*, which means "flight," and a typical fugue has a fairly rapid tempo and a crisp feeling. As a musical form, a fugue embodies development through imitative counterpoint, alternating with contrasting "episodes."

The subject of Bach's Fugue in G minor is typical in that the thematic material is based around the tones of two common chords, and it begins with longer note values and gradually gains impetus. This fugue has four voices—the melodic lines are called voices although they are, of course, played in this instance. The main subject, which falls into two parts, is first stated in the soprano (top) voice (Fig. **11.22**), then answered by the alto voice (the second voice from the top).

The texture of the composition builds up: at the beginning we hear only one voice; thereafter two or more independent voices play at the same time, in counterpoint. The opening section of the fugue—the EXPOSITION—states the subject in each of the four voices. As each new voice enters, the previous one takes up a second theme, or countersubject.

Once that has been accomplished, Bach inserts a brief episode based on two short motifs taken from the subject. The rest of the structure is built around various key changes, which introduce a new level of contrast. Bach also continues to alternate episodes and statements of the subject. Beneath the complex texture of the fugue, a sustained bass tone sometimes appears; this is called a pedal point. The final episode of the piece is an intricate development which moves to a climax that we can hear in a rising chromatic scale, or series of half-tones. The final statement of the subject appears in the bass line, and the fugue ends with a strong cadence back in the original key of G minor.

Probably his most familiar solo concerto is "Spring," one of four works in OPUS 8 (1725), *The Seasons*. The *Seasons* is an early example of PROGRAM MUSIC, written to illustrate an external idea, in contrast with ABSOLUTE MUSIC, which presents purely musical ideas. In "Spring," a series of individual pieces interlock to form an ornate whole. In the first movement (allegro), Vivaldi alternates an opening theme (A) with sections that depict bird song, a flowing brook, a storm, and the birds' return (ABACADAEA). Theme A is known as a *ritornello*, from the Italian "to return," and this alternating pattern is called RITORNELLO FORM. Within the solo part there is elaborate melodic ornamentation. For example, on a simple ascending scale of five notes, the composer added ornamental notes, and thus the ascending scale becomes a melodic pattern of perhaps as many as twenty tones—a musical equivalent of the complex ornamental visual detail seen in painting, sculpture, and architecture.

The word "sonata" derives from the Italian word meaning simply "to sound." In the baroque era, the sonata emerged as a piece consisting of several sections, or movements, of contrasting tempos and textures. It was written for keyboard alone or for a small ensemble of instruments—usually two melody instruments with *continuo* accompaniment. There were two separate strands of development: the church sonata and the chamber sonata. The former was usually contrapuntal and fell into four movements, slow–fast–slow–fast. The latter consisted of a collection of movements in dance rhythms. Arcangelo Corelli (1653–1713) wrote in both styles. Corelli sometimes treated his instrument—usually the violin—almost as if it were a human voice, and indeed, the tonal and lyrical qualities of the two are similar. He also wrote virtuoso passagework and chords in his solo violin sonatas that truly tax the player.

The violin came to the fore in the baroque era, replacing the viol, which had previously been the primary bowed string instrument. The violin was fully explored as a solo instrument, and it was also perfected physically. From the late 17th and early 18th centuries came the greatest violins ever built. Made of maple, pine, and ebony by Antonio Stradivari (1644–1737), these remarkable instruments fetch enormous sums of money today. Despite our best scientific attempts, they have never been matched in their superb qualities, the secrets of which died with Stradivari. Not only is a violin similar to the human voice in timbre, but a well made violin has an individual personality. It assumes certain qualities of its environment and of the performer. It responds sensitively to external factors such as temperature and humidity, and getting the best from it depends upon care from its owner, not to mention skill and musicianship.

The baroque age in music was a magnificent one. To all intents and purposes, in its harmonies, structures, and forms, it laid the groundwork for the music of the eras that were to come, and its legacy can still be seen today.

DANCE

European indoor court entertainments of the early and mid-16th century often took the form of "dinner ballets." These entertainments were long and lavish, with interludes called *entrées*, between the courses. Often the mythological characters in these *entrées* corresponded to the dishes served in the meal. Poseidon, god of the sea, for example, would accompany the fish course. Dances depicting battles in the crusades, called *moresche*, or *moresca*, were also popular. Henry VIII of England found the tales of Robin Hood to his liking, and English court masques of the early 16th century often dealt with that folk theme. Theatre dance was closely connected, still, with social dancing, which had important influences not only on theatre dance but also on music.

Courtly dancing in Europe, and especially in Italy, became more and more professional in the late 16th century. Skilled professionals performed on a raised stage, then left the stage to perform in the center of the banquet hall, joined by members of court. During this period, dancing technique improved and more complicated rhythms were introduced. All of these changes were faithfully recorded by Fabrizio Caroso (Fig. **11.23**) in *Il Ballerino* (1581) and Cesare Negri in N*uove Inventioni di Balli* (1604).

Formal ballet came of age as an art form under the aegis of the powerful Catherine de' Medici (1519–89),

11.23 Fabrizio Caroso (born c.1553). Contemporary engraving. The New York Public Library.

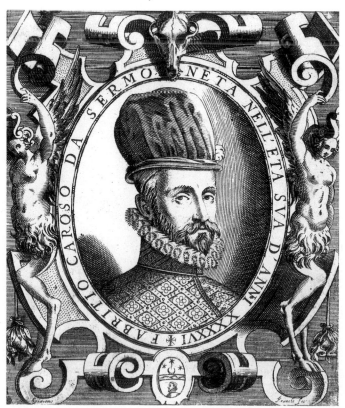

great-granddaughter of Lorenzo the Magnificent. Catherine had left Italy for France to marry the Duc d'Orléans. On the death of Francis I, she became Queen of France when her husband was crowned Henry II. Her Medici heritage apparently endowed her with a love of pageantry and spectacle, and her political acumen led her to understand the usefulness of such pageantry in the affairs of state. After her husband's accidental death in 1559 (he was pierced through the eye at a tournament), she ruled France through her sons for 30 years. Love of spectacle permeated the French court, and lavish entertainments, some of which nearly bankrupted the shaky French treasury, marked important events, such as the marriage of Catherine's eldest son, Francis II, to Mary, Queen of Scots. Although sources vary on just how these spectaculars developed into the ballet, we can be sure that either Le Ballet de Polonais (1572) or the Ballet Comique de la Reine (1581) marked the real beginning of formal western ballet tradition.

Le Ballet de Polonais, the "Polish Ballet," was produced in the great hall of the Palace of the Tuileries on a temporary stage with steps leading to the hall floor. The audience surrounded three sides of the stage and joined the dancers at the end of the performance in "general dancing." Music composed by Orlando di Lasso was played, by 30 viols, and a text glorifying the king and Catherine was written by the poet Pierre Ronsard. Oversight of the entire production fell to Catherine's valet de chambre, Balthasar de Beaujoyeulx, an Italian who also produced the Ballet Comique de la Reine.

This extravaganza had a mixture of biblical and mythological sources. It had original music, poetry, and song, and Italian Renaissance scenic devices overwhelmed the audience with fountains and aquatic machines. Over 10,000 spectators witnessed this event, which cost 3.5 million francs. It ran from ten in the evening to four the next morning. Probably the most significant aspect of the Ballet Comique, and one that leads some scholars to mark it as the "first" ballet, was its use of a single dramatic story line throughout. These ballets made France the center of theatrical dance for the next two centuries.

Dancing was also part of the court masques in England, especially at the turn of the 17th century. With writers of Ben Jonson's caliber and designers such as Inigo Jones, however, dance was a minor factor in these productions. Formal dance also provided part of the spectacle slowly becoming known in Italy as opera. But these were minor episodes. The roots of theatre dance had taken hold most deeply in France.

During the reign of Henry IV (1589–1610), over 80 ballets were performed at the French court (Fig. **11.24**). In a ballet in 1615, "30 genii, suspended in the air, heralded the coming of Minerva, the Queen of Spain. . . . Forty persons were on the stage at once, 30 high in the air, and six suspended in mid-air; all of these dancing and singing at the same time."[3] Later, under Louis XIII, a fairly typical ballet of the period, the Mountain Ballet, had five great allegorical mountains on stage: the Windy, the Resounding, the Luminous, the Shadowy, and the Alps. A character, Fame, disguised as an old woman, explained the story, and the "quadrilles of dancers," in flesh-colored

11.24 Jean-Baptiste Lully (1632–87), costume designs for the Ballet de Cour from Oeuvres Complètes. Contemporary sepia drawing. The New York Public Library.

11.25 Jean Louis Bérain (1638–1711), Dame en Habit de Ballet. Contemporary engraving. The New York Public Library.

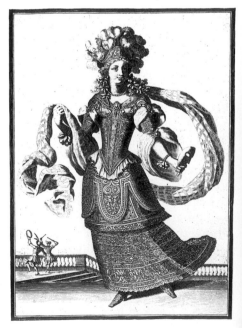

costumes with windmills on their heads (representing the winds), competed with other allegorical characters for the "Field of Glory." Such work typically consisted of a series of dances dramatizing a common theme.

By the late 17th century, baroque art was consolidated in the court of Louis XIV. A great patron of painting, sculpture, theatre, and architecture, Louis also brought ballet into full participation in the splendor of the era. An avid dancer, Louis studied for over 20 years with the dancing master Pierre Beauchamps, who is credited with inventing the basic dance positions of classical ballet. Louis' title, *Le Roi Soleil* or the "Sun King," certainly indicates his behavior and his political philosophy, but it actually derived from his favorite childhood role, that of Apollo the sun-god in *Le Ballet de la Nuit*, which he danced at the age of 14. Mazarin, Louis' First Minister, exploited this splendid dance role to promote the young monarch.

Louis employed a team of professional artists to produce ballet and opera at court, and the musician Jean-Baptiste Lully and the playwright Molière were active in these grand collaborative efforts. Usually the plots for French ballets came from classical mythology and the works themselves were a series of verses, music, and dance. The style of the dancing, at least in these works, appears to have been fairly simple and controlled. Gestures were symmetrical and harmonious. The theatrical trappings were opulent. The emotionality of the baroque style precludes neither formality, nor restraint. One must also bear in mind that the costume of the era included elaborate wigs. Any movements that threatened to knock one's wig askew would, after all, have been impractical and awkward.

Ballet became formally institutionalized when Louis XIV founded the Académie Royale de Danse in 1661. Thirteen dancing masters were appointed to the Académie to "reestablish the art in its perfections." Ten years later the Académie Royale de Danse was merged with a newly established Académie Royale de Musique. Both schools were given the use of the theatre of the Palais Royal, which had been occupied by Molière's company. Its proscenium stage altered forever the aesthetic relationship of ballet and its audience. Choreography had to be designed for an audience on one side only. Such designs focused on the "open" position, and that is still basic to formal ballet choreography today.

Establishment of the Royal Academy of Dance led to prescribed "rules" for positions and movements. It also led to the full art form, in which women took the stage as professional ballerinas for the first time in 1681 (Fig. 11.25). The stage of the Palais Royal, which did not allow access to the auditorium, placed the final barricade between the professional artist and the "noble amateur" of the previous eras. As the baroque era came to a close in the early 18th century, the foundations of ballet as a formal art were firmly in place.

ARCHITECTURE
Baroque style

The baroque style in architecture emphasized the same contrasts between light and shade and the same action, emotion, opulence, and ornamentation, as the other visual arts of the period. Because of its scale, however, the effect was one of dramatic spectacle. There were many excellent baroque architects, among them Giacomo della Porta (1540–1602) (Figs **11.26** and **11.27**). His Church of Il Gesù is the mother church of the Jesuit order (founded in 1534) and it had a profound influence on later church architecture, especially in Latin America. This church truly represents the spirit of the Counter-Reformation. Il Gesù is a compact basilica. By eliminating side aisles, the design literally forces the congregation into a large, hall-like space directly in view of the altar. Della Porta's façade (Fig. **11.26**) boldly repeats its row of double pilasters on a smaller scale at the second level. Scroll-shaped buttresses create the transition from the wider first level to the crowning pediment of the second. The design reflects the influences of Alberti, Palladio, and Michelangelo, but in its skillful synthesis of these influences it is unique.

A further reflection of baroque style can be found in Germany well into the next century in the works of Balthasar Neumann (1687–1753) (Figs **11.28** and **11.29**). These churches are lighter and more delicate in tone than

11.26 Giacomo della Porta, west front of Il Gesù, Rome, 1568–84.

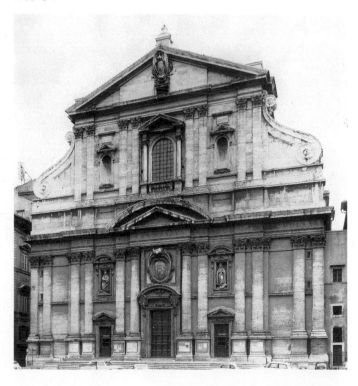

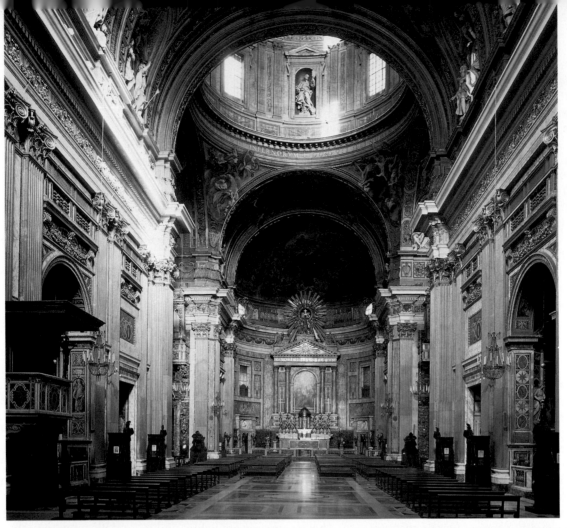

11.27 (left) Giacomo della Porta, interior of Il Gesù, Rome, 1568–84.

11.29 (opposite) Balthasar Neumann, interior, pilgrimage church of Vierzehnheiligen, near Staffelstein, Germany, 1743–72.

11.28 (below) Balthasar Neumann, Kaisersaal, Residenz, Würzburg, Germany, 1719–44.

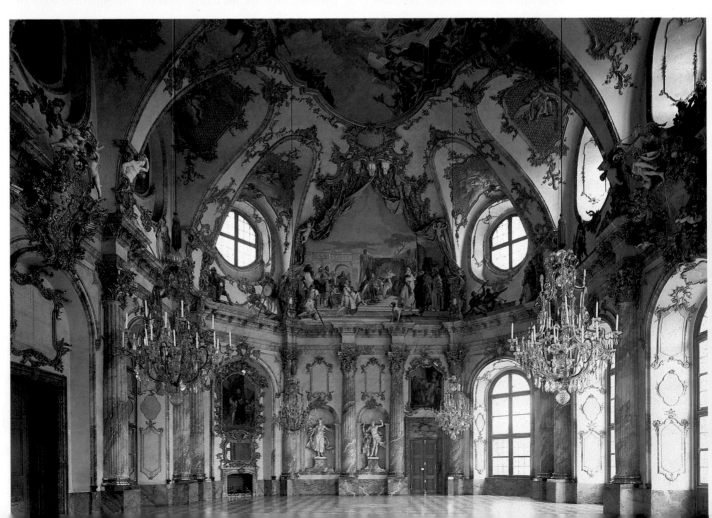

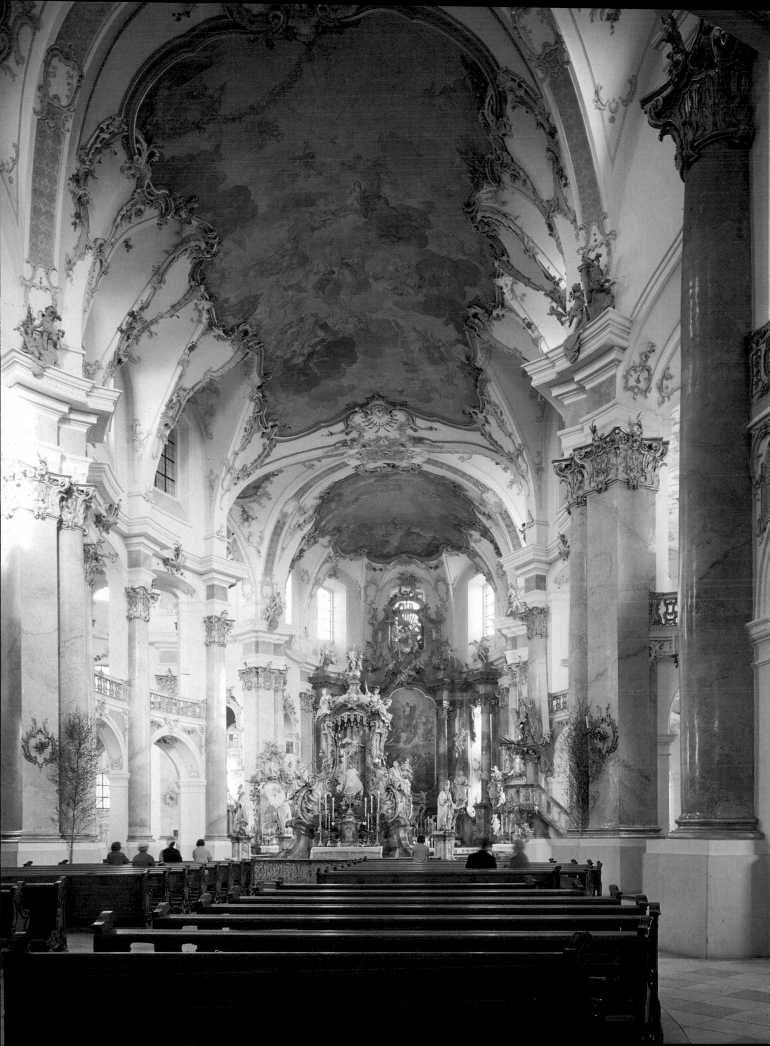

the Italian example we have seen and reflect the influence of a new style, called rococo, which we will study in the next chapter. Perhaps the complete expression of baroque style and its reflections of imperial glory, however, is found in the Palace of Versailles (Figs 11.34–11.40), built for King Louis XIV of France. The thousands of acres that surround the palace are themselves a monumental and complex architectural extravaganza. The palace is the central jewel in this elaborate, and precisely designed setting. We examine its exteriors and interiors in more detail at the end of this chapter. Here it is enough to say that its opulence, ornamentation, lavish detail subordinated to the whole, highlight, shadow, and emotion make it truly baroque in the fullest sense of the term.

English baroque

The baroque influence of the court of Louis XIV came to England with the Restoration of Charles II. Over the next 50 years, London witnessed numerous significant building projects directed by its most notable architect, Christopher Wren (1632–1723). Two of these projects, St Paul's Cathedral and Hampton Court, illustrate the intricate but restrained complexity of English baroque style. The impact of Wren's genius, obvious in his designs,

is attested to in an inscription in St Paul's: "If you seek a monument, look around you." On a smaller scale than St Paul's but equally expressive of the English baroque is Wren's garden façade for Hampton Court Palace (Fig. 11.30). His additions to this Tudor building, which was built by Cardinal Wolsey in the 16th century, were intended to make it a rival of Louis XIV's Palace of Versailles. In comparing the two, we conclude that the English approach to the style yields a more restrained result. The seemingly straightforward overall design of this façade, which was commissioned in 1689, during the reign of William and Mary, is actually a sophisticated inter-relationship of merging patterns and details. The lines are clean and the silhouette lacks the visual interruption of statuary present in the Versailles palace. Line, repetition, and balance in this façade not only create a pleasing impression, they also form a perceptual exercise. Wren chose red brick to harmonize with the original palace, while contrasting dressed stone emphasizes the central features of the façade and creates richness and variety. Wren's use of circular windows was unusual—it probably reflects French influence.

11.31 (opposite) Christopher Wren, St Paul's Cathedral, London, 1675–1710. Façade.

11.30 Christopher Wren, garden façade of Hampton Court Palace, England, c.1690.

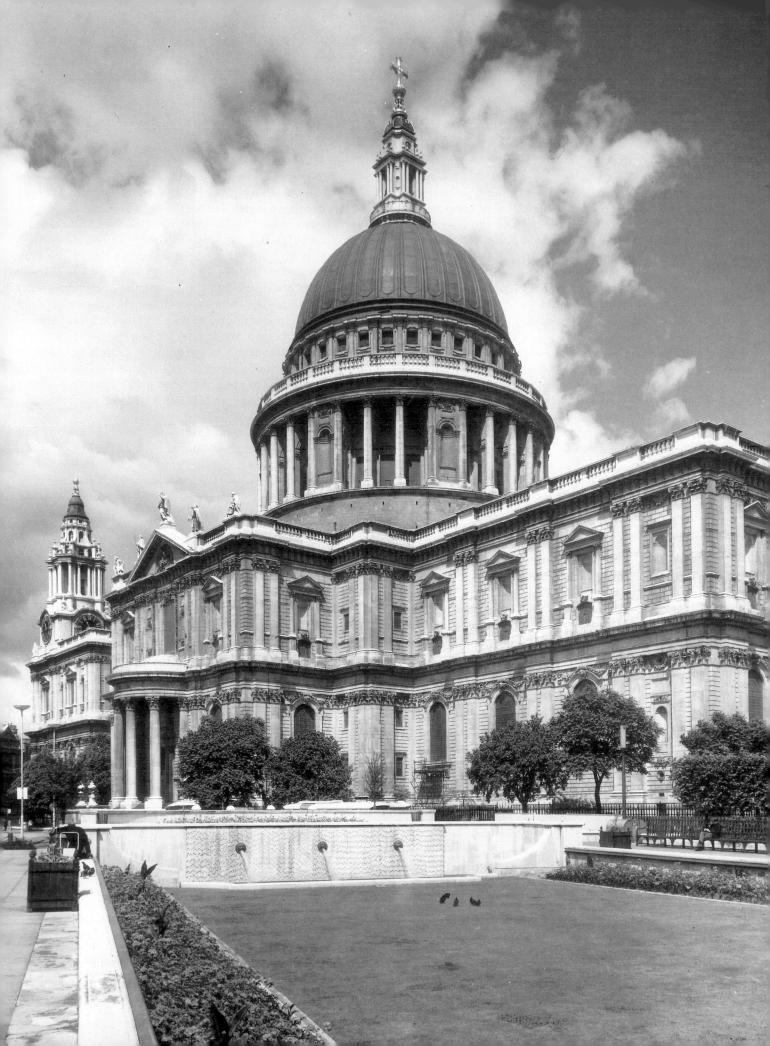

MASTERWORK
Wren—St Paul's Cathedral

Wren was invited to restore old St Paul's Cathedral, a Gothic structure to which Wren intended to affix a mighty dome, before the Great Fire of London. After the fire, however, only a small part of the nave remained, and even Wren's genius could not save the old church. Wren, who was Surveyor-General of London and responsible for the cathedral as well as the king's palaces and other government properties, set about the task of designing a new St Paul's (Figs 11.31–11.33).

His first plan was rejected outright by the authorities as too untraditional. For example, it had no aisles to the choir, or eastern arm, and no proper nave. Wren had attempted in this first design to come up with a cathedral which would be inexpensive and yet handsome. But the authorities insisted that the country's prestige was at stake and no expense should be spared. A second, more ambitious design followed a classical pattern, crowned with a huge dome. King Charles II approved this plan but the commissioners did not. A third design barely gained their approval. Here Wren used the traditional Latin cross plan, with the nave longer than the choir, two short transepts, and a dome and spire atop the crossing (Fig. 11.32). Once approved, with allowances for "modifications," the entire project ground to a halt because of the difficulty of demolishing the pillars of the old church. After unsuccessful attempts to blast them down with gunpowder, Wren finally resorted to the battering ram technique used against castles in the Middle Ages. After a day of "relentless battering," the old church succumbed, and in November 1673, work began on the new building.

Work on St Paul's took 40 years. The new cathedral has an overall length of 515 feet and a width of 248 feet. Its dome measures 112 feet in diameter and stands 365 feet tall at the top of the cross. The lantern and cross alone weigh 700 tons while the dome and its superstructure weigh 64,000 tons. Like the architects of the Pantheon and St Peter's in Rome, Wren faced seemingly endless problems with supporting the tremendous load of the dome. His solution was ingenious: he constructed the dome of nothing more than a timber shell covered in lead, supported by a brick cone. This lightened the weight of the dome to a fraction of what it would have been and allowed Wren to create a wonderful silhouette on the outside, while an inner dome gave the correct proportion to the interior (Fig. 11.33). It was a solution never before used.

Renaissance geometric design and Greek and Roman detail all mark the cathedral. The drum of the dome echoes Bramante's Tempietto (Fig. 10.36), in the arrangement of its columns, and Michelangelo's St Peter's, in its verticality. The exterior façade has a subtle elegance, with ornate detail but without overstatement or clutter. Yet, at the same time, the scale of the dome and of the building as a whole is overpowering. The many imitations of Wren's design in Europe and the United States attest to its genius. The interior, as in all of Wren's designs, emphasizes linear, structural elements such as arches, frames, and circles. Somewhat cold in comparison with baroque churches of the continent, St Paul's Anglican heritage is clear in its refusal of extensive ornamentation and gilding.

11.32 Plan of St Paul's Cathedral, London.

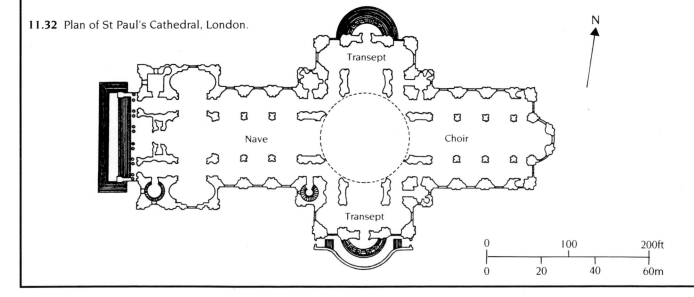

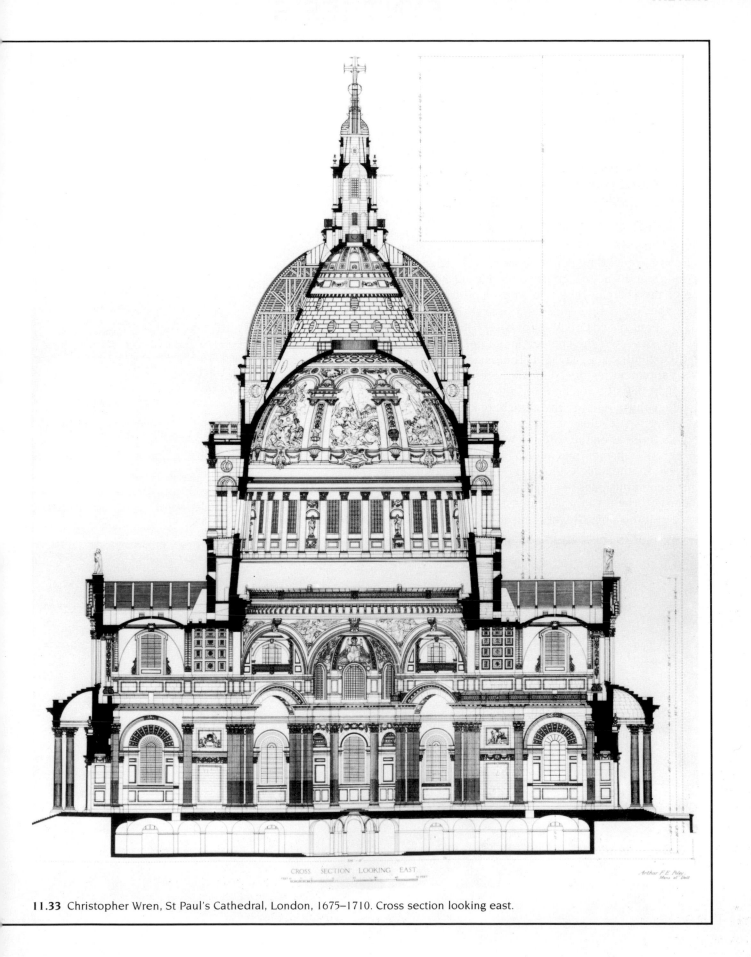

CROSS SECTION LOOKING EAST

11.33 Christopher Wren, St Paul's Cathedral, London, 1675–1710. Cross section looking east.

SYNTHESIS
Court baroque at Versailles

Probably no monarch better personified the baroque era than Louis XIV. And probably no work of art better represents the magnificence and grandeur of the baroque style than the grand design of the Palace of Versailles, along with its sculpture and grounds. The great Versailles complex grew from the modest hunting lodge of Louis XIII into the grand palace of the Sun King over a number of years, involving several architects.

The Versailles château was rebuilt in 1631 by Philibert Le Roy. The façade was decorated by Louis Le Vau with bricks and stone, sculpture, wrought iron, and gilt lead. In 1668, Louis XIV ordered Le Vau to enlarge the building by enclosing it in a stone envelope containing the king's and queen's apartments (Fig. **11.34**). The city side of the château thus retains the spirit of Louis XIII, while the park side reflects classical influence (Fig. **11.35**). François d'Orbay and, later, Jules Hardouin-Mansart expanded the château into a palace whose west façade extends over 2000 feet. The palace became Louis XIV's permanent residence in 1682. French royalty was at the height of its power, and Versailles was the symbol of the monarchy and of the divine right of kings.

As much care, elegance, and precision was employed on the interior as on the exterior. With the aim of supporting French craftsmen and merchants, Louis XIV had his court live in unparalleled luxury. He also decided to put permanent furnishings in his château, something that was unheard of. The result was a fantastically rich and beautiful set of furnishings. Royal workshops produced mirrors

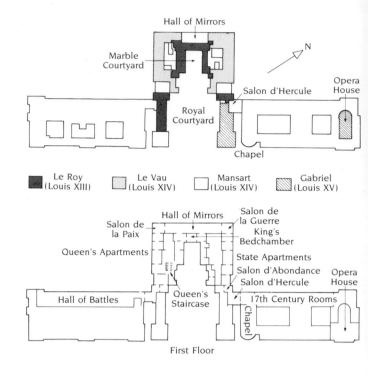

11.34 Plans of the Palace of Versailles, 1669–85.

11.35 Louis Le Vau and Jules Hardouin-Mansart, garden façade, Palace of Versailles, 1669–85.

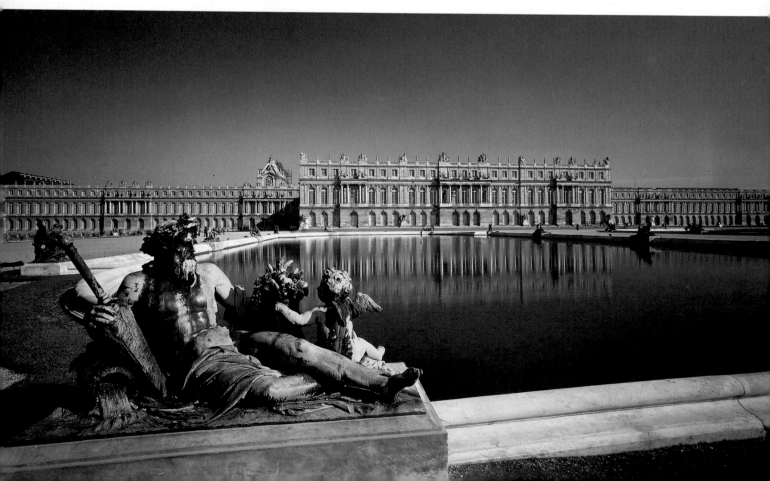

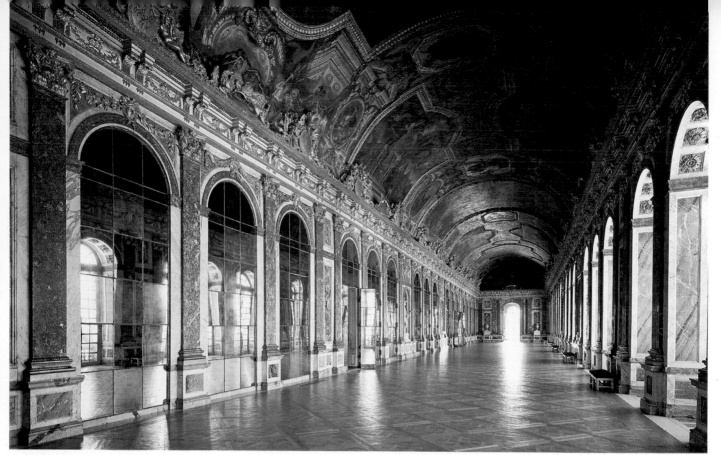

11.36 Jules Hardouin-Mansart and Charles Le Brun, Hall of Mirrors, Palace of Versailles, begun 1678.

11.37 René-Antoine Houasse, *Royal Magnificence*, ceiling of the Salon d'Abondance, Palace of Versailles.

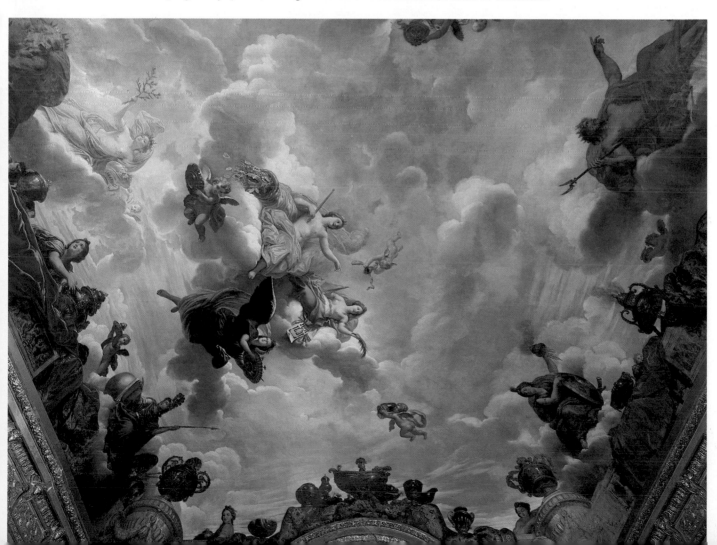

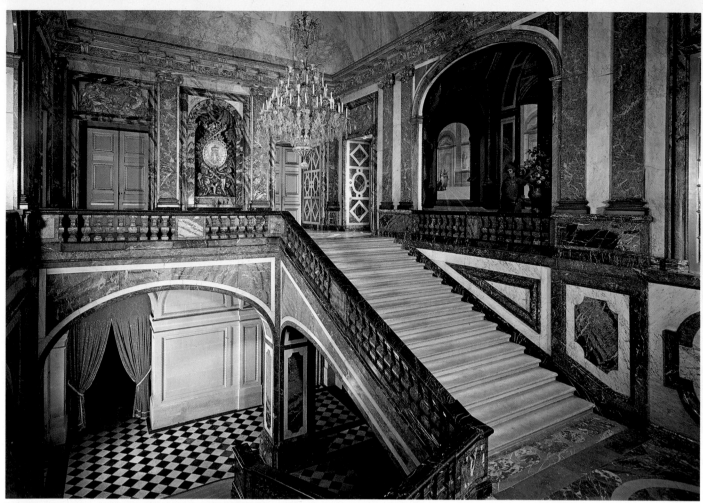

11.38 The Queen's Staircase, Palace of Versailles.

11.39 The Parterre du Midi, Palace of Versailles.

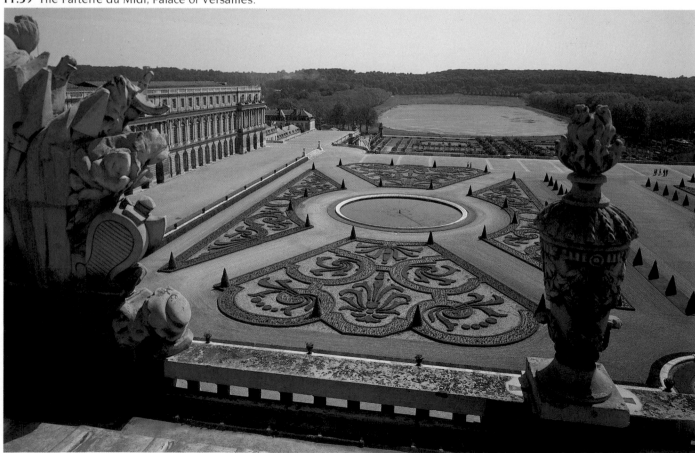

11.40 The Fountain of Apollo, Palace of Versailles.

(Fig. **11.36**), tapestries, and brocades of the highest quality, and these goods became highly sought after all over Europe. Le Brun coordinated all the decoration and furnishing of the royal residences, and supervised anything for the state apartments, such as the statues, the painted ceilings, and the silver pieces of furniture.

The apartments of the palace boast a splendor and wealth previously unseen. Each room was dedicated to one of the planetary gods. The Salon d'Abondance (Fig. **11.37**) was not considered a part of the state apartments until the north wing was built. The ceiling here shows an allegorical figure of Magnificence, whose scepter and cornucopia are symbols of the royal prerogatives of power and provision. Around Magnificence are Immortality and the Fine Arts, symbolized by a winged figure.

The Queen's staircase (Fig. **11.38**) leads to a suite created by Le Vau for Queen Marie-Thérèse. It comprises four large rooms whose windows open to the plantings on the Parterre du Midi (Fig. **11.39**). The grounds here and elsewhere are adorned with fountains and statues. The magnificent Fountain of Apollo by Tuby (Fig. **11.40**), which sits astride the east–west axis of the grounds, was originally covered with gold. The sculpture was executed from a drawing by Le Brun and inspired by a painting by Albani. It continues the allegorical glorification of "Le Roi Soleil," representing the break of day, as the sun-god rises in his chariot from the waters. Apollo was the perfect symbol for the Sun King, who reigned, it was thought, at God's behest and in his stead, in glorious baroque splendor, surrounded by art that was rational yet emotional, opulent in tone, and complex in design.

SUGGESTIONS FOR THOUGHT AND DISCUSSION

We have traced developments in art from the Late Renaissance to the baroque age, through nearly two centuries, from the end of the 16th century to the deaths of Bach and Handel in the mid-18th century. The arts of the period grew out of the Renaissance and were most significantly affected by humanism on the one hand and the wrenching effects of the Reformation on the other.

■ What influence did the Roman Catholic Counter-Reformation have on the arts and architecture?

■ How did the beliefs in rational systems and the absolute rights of monarchs affect life and the arts of the period?

■ Explain the impact of Francis Bacon on scientific methodology. How did his philosophy of art reflect classicism and humanism?

■ Explain the major characteristics of baroque art and describe how each of the arts reflected those characteristics.

■ How did the sculptural works of Bernini change the concept of space and action that we saw in the sculptures of Michelangelo?

■ In what ways can opera be considered as a synthesis of baroque style?

■ In what ways does Versailles exemplify the concepts, contexts, and characteristics of the baroque period?

LITERATURE EXTRACTS

The First Part of the Ingenious Gentleman Don Quixote of La Mancha

[1605–15] Miguel de Cervantes

Chapter 1
Which Treats of the Character and Pursuits of the Famous Gentleman Don Quixote of La Mancha

In a village of La Mancha, which I prefer to leave unnamed, there lived not long ago one of those gentlemen that keep a lance in the lance-rack, an old shield, a lean hack, and a greyhound for hunting. A stew of rather more beef than mutton, hash on most nights, bacon and eggs on Saturdays, lentils on Fridays, and a pigeon or so extra on Sundays consumed three quarters of his income. The rest went for a coat of fine cloth and velvet breeches and shoes to match for holidays, while on weekdays he cut a fine figure in his best homespun. He had in his house a housekeeper past forty, a niece under twenty, and a lad for the field and marketplace, who saddled the hack as well as handled the pruning knife. The age of this gentleman of ours was bordering on fifty. He was of a hardy constitution, spare, gaunt-featured, a very early riser, and fond of hunting. Some say that his surname was Quixada or Quesada (for there is no unanimity among those who write on the subject), although reasonable conjectures tend to show that he was called Quexana. But this scarcely affects our story; it will be enough not to stray a hair's breadth from the truth in telling it.

You must know that the above-named gentleman devoted his leisure (which was mostly all the year round) to reading books of chivalry—and with such ardor and avidity that he almost entirely abandoned the chase and even the management of his property. To such a pitch did his eagerness and infatuation go that he sold many an acre of tillage land to buy books of chivalry to read, bringing home all he could find.

But there were none he liked so well as those written by the famous Feliciano de Silva, for their lucidity of style and complicated conceits were as pearls in his sight, particularly when in his reading he came upon outpouring of adulation and courtly challenges. There he often found passages like *"the reason of the unreason with which my reason is afflicted so weakens my reason that with reason I complain of your beauty;"* or again, *"the high heavens, that of your divinity divinely fortify you with the stars, render you deserving of the desert your greatness deserves."*

Over this sort of folderol the poor gentleman lost his wits, and he used to lie awake striving to understand it and worm out its meaning; though Aristotle himself could have made out or extracted nothing, had he come back to life for that special purpose. He was rather uneasy about the wounds which Don Belianis gave and received, because it seemed to him that, however skilled the surgeons who had cured him, he must have had his face and body covered all over with seams and scars. He commended, however, the author's way of ending his book, with a promise to go on with that interminable adventure, and many a time he felt the urge to take up his pen and finish it just as its author had promised. He would no doubt have done so, and succeeded with it too, had he not been occupied with greater and more absorbing thoughts.

Many an argument did he have with the priest of his village (a learned man, and a graduate of Siguenza) as to which had been the better knight, Palmerin of England or Amadis of Gaul. Master Nicolas, the village barber, however, used to say that neither of them came up to the Knight of Phoebus, and that if there was any that could compare with *him* it was Don Galaor, the brother of Amadis of Gaul, because he had a spirit equal to every occasion, and was no wish-washy knight or a crybaby like his brother, while in valor he was not a whit behind him.

In short, he became so absorbed in his books that he spent his nights from sunset to sunrise, and his days from dawn to dark, poring over them; and what with little sleep and much reading his brain shriveled up and he lost his wits. His imagination was stuffed with all he read in his books about enchantments, quarrels, battles, challenges, wounds, wooings, loves, agonies, and all sorts of impossible nonsense. It became so firmly planted in his mind that the whole fabric of invention and fancy he read about was true, that to him no history in the world was better substantiated. He used to say the Cid Ruy Díaz was a very good knight but that he was not to be compared with the Knight of the Burning Sword who with one backstroke cut in half two fierce and monstrous giants. He thought more of Bernardo del Carpio because at Roncesvalles he slew Roland in spite of enchantments, availing himself of Hercules' trick when he strangled Antaeus the son of Terra in his arms. He approved highly of the giant Morgante, because, although of the giant breed which is always arrogant and ill-mannered, he alone was affable and well-bred. But above all he admired Reinaldos of Montalban, especially when he saw him sallying forth from his castle and robbing everyone he met, and when beyond the seas he stole that image of Mohammed, which, as his history says, was entirely of gold. To have a bout of kicking at that traitor of a Ganelon he would have given his housekeeper, and his niece into the bargain.

In a word, his wits being quite gone, he hit upon the strangest notion that ever madman in this world hit upon. He fancied it was right and requisite, no less for his own greater renown than in the service of his country, that he should make a knight-errant of himself, roaming the world over in full armor and on horseback in quest of adventures. He would put into practice all that he had read of as being the usual practices of knights-errant: righting every kind of wrong, and exposing himself to peril and danger from which he would emerge to reap eternal fame and glory. Already the poor man saw himself crowned by the might of his arm Emperor of Trebizond at least. And so, carried away by the intense enjoyment he found in these pleasant fancies, he began at once to put

his scheme into execution.

The first thing he did was to clean up some armor that had belonged to his ancestors and had for ages been lying forgotten in a corner, covered with rust and mildew. He scoured and polished it as best he could, but the one great defect he saw in it was that it had no closed helmet, nothing but a simple morion.[1] This deficiency, however, his ingenuity made good, for he contrived a kind of half-helmet of pasteboard which, fitted on to the morion, looked like a whole one. It is true that, in order to see if it was strong and fit to withstand a cut, he drew his sword and gave it a couple of slashes, the first of which undid in an instant what had taken him a week to do. The ease with which he had knocked it to pieces disconcerted him somewhat, and to guard against the danger he set to work again, fixing bars of iron on the inside until he was satisfied with its strength. Then, not caring to try any more experiments with it, he accepted and commissioned it as a helmet of the most perfect construction.

He next proceeded to inspect his nag, which, with its cracked hoofs and more blemishes than the steed of Gonela, that *"tantum pellis et ossa fuit,"* surpassed in his eyes the Bucephalus of Alexander or the Babieca of the Cid. Four days were spent in thinking what name to give him, because (as he said to himself) it was not right that a horse belonging to a knight so famous, and one with such merits of its own, should be without some distinctive name. He strove to find something that would indicate what it had been before belonging to a knight-errant, and what it had now become. It was only reasonable that it should be given a new name to match the new career adopted by its master, and that the name should be a distinguished and full-sounding one, befitting the new order and calling it was about to follow. And so, after having composed, struck out, rejected, added to, unmade, and remade a multitude of names out of his memory and fancy, he decided upon calling it Rocinante. To his thinking this was a lofty, sonorous name that nevertheless indicated what the hack's status had been before it became what now it was, the first and foremost of all the hacks in the world.

Having got a name for his horse so much to his taste, he was anxious to get one for himself, and he spent eight days more pondering over this point. At last he made up his mind to call himself Don Quixote,—which, as stated above, led the authors of this veracious history to infer that his name quite assuredly must have been Quixada, and not Quesada as others would have it. It occurred to him, however, that the valiant Amadis was not content to call himself Amadis and nothing more but added the name of his kingdom and country to make it famous and called himself Amadis of Gaul. So he, like a good knight, resolved to add on the name of his own region and style himself Don Quixote of La Mancha. He believed that this accurately described his origin and country, and that he did it honor by taking its name for his own.

So then, his armor being furbished, his morion turned into a helmet, his hack christened, and he himself confirmed, he came to the conclusion that nothing more was needed now but to look for a lady to be in love with,

for a knight-errant without love was like a tree without leaves or fruit, or a body without a soul.

"If, for my sins, or by my good fortune," he said to himself, "I come across some giant hereabouts, a common occurrence with knights-errant, and knock him to the ground in one onslaught, or cleave him asunder at the waist, or, in short, vanquish and subdue him, will it not be well to have some one I may send him to as a present, that he may come in and fall on his knees before my sweet lady, and in a humble, submissive voice say, 'I am the giant Caraculiambro, lord of the island of Malindrania, vanquished in single combat by the never sufficiently extolled knight Don Quixote of La Mancha, who has commanded me to present myself before your grace, that your highness may dispose of me at your pleasure'?"

Oh, how our good gentleman enjoyed the delivery of this speech, especially when he had thought of some one to call his lady! There was, so the story goes, in a village near his own a very good-looking farm-girl with whom he had been at one time in love, though, so far as is known, she never knew it nor gave a thought to the matter. Her name was Aldonza Lorenzo, and upon her he thought fit to confer the title of Lady of his Thoughts. Searching for a name not too remote from her own, yet which would aim at and bring to mind that of a princess and great lady, he decided upon calling her Dulcinea del Toboso, since she was a native of El Toboso. To his way of thinking, the name was musical, uncommon, and significant, like all those he had bestowed upon himself and his belongings.

Chapter 2
Which Treats of the First Sally the Ingenious Don Quixote Made From Home

Once these preliminaries had been settled, he decided to wait no longer before putting his project into effect, for he was afflicted by the thought of how much the world would suffer because of his tardiness. Many were the wrongs that had to be righted, grievances redressed, injustices made good, abuses removed, and duties discharged. So, without informing anyone of his intentions, and without anybody seeing him, one morning before dawn (which was one of the hottest of the month of July) he put on his suit of armor, mounted Rocinante with his patched-up helmet on, grasped his shield, took his lance, and by the back door of the yard sallied forth upon the plain. It gave him immense pleasure and satisfaction to see with what ease he had inaugurated his great purpose.

Scarcely did he find himself upon the open plain, however, when a terrible thought struck him, one all but enough to make him abandon the enterprise at the very outset. It occurred to him that he had not been dubbed a knight and that according to the law of chivalry he neither could nor ought to bear arms against any knight; and that even if he had been, still he ought, as a novice knight, to wear white armor, without a device upon the shield until his prowess had earned him one. These reflections made him waver in his purpose, but his craziness being stronger than any reasoning, he made up his mind to have himself dubbed a knight by the first one he came across. In this he would be following the example of others in the same situation, as he had read in the books that brought him to

1. open helmet, without beaver or visor.

this pass. As for white armor, he resolved, on the first opportunity to scour his until it was whiter than an ermine. Having thus comforted himself, he pursued his way, taking that which his horse chose, for in this he believed lay the essence of adventures.

As our new-fledged adventurer paced along, he kept talking to himself. "Who knows," he said, "whether in time to come, when the veracious history of my famous deeds is made known, the sage who writes it, when he has to set forth my first sally in the early morning, may not do it after this fashion? 'Scarce had the rubicund Apollo spread o'er the face of the broad spacious earth the golden threads of his bright hair, scarce had the little birds of painted plumage attuned their notes to hail with dulcet and mellifluous harmony the coming of the rosy Dawn, that, deserting the soft couch of her jealous spouse, was appearing to mortals at the gates and balconies of the Manchegan horizon, when the renowned knight Don Quixote of La Mancha, quitting the lazy down, mounted his celebrated steed Rocinante and began to traverse the ancient and famous Fields of Montiel,'" which in fact he was actually traversing.

"Happy the age, happy the time," he continued, "in which shall be made known my deeds of fame, worthy to be molded in brass, carved in marble, limned in pictures, for a memorial for ever. And thou, O sage magician, whoever thou art, to whom it shall fall to be the chronicler of this wondrous history, forget not, I entreat thee, my good Rocinante, the constant companion of my ways and wanderings."

Then he broke out again, as if he were really lovesick, "O Princess Dulcinea, lady of this captive heart, a grievous wrong hast thou done me to drive me forth with scorn, and with inexorable obduracy banish me from the presence of thy beauty. O lady, deign to hold in remembrance this heart, thy vassal, that thus in anguish pines for love of thee."

So he went on stringing together these and other absurdities, all of the sort his books had taught him, imitating their language as well as he could. All the while he rode so slowly and the sun mounted so rapidly and with such heat that it was enough to melt his brains if he had any. Nearly all day he traveled without anything remarkable happening to him. This plunged him in despair, for he was eager to encounter at the earliest moment someone on whom to test the valor of his mighty arm.

Some writers declare that the first adventure he met with was that of Puerto Lápice, while others say it was that of the windmills. But what I have ascertained on this point, and what I have found written in the annals of La Mancha, is that he was on the road all day, and towards nightfall his hack and he found themselves dead tired and hungry. Looking all around to see if he could discover any castle or shepherd's hut where he might refresh himself and satisfy his needs, he perceived not far out of his way an inn. It was as welcome as a star guiding him to the portals, if not the palaces, of his redemption; and quickening his pace he reached it just as night was falling.

At the door were standing two young women, party girls as they call them, on their way to Seville with some mule drivers who had chanced to halt that night at the inn. As everything our adventurer thought, saw, or imagined seemed to him to be fashioned and to happen on the same lines as what he had been reading, the moment he saw the inn he pictured it to himself as a castle with its four turrets and pinnacles of shining silver, not forgetting the drawbridge and moat and every feature usually ascribed to such castles. To this inn, which to him seemed a castle, he advanced, and at a short distance from it he checked Rocinante, expecting that some dwarf would mount the battlements to proclaim by sound of trumpet the arrival of a knight at the castle. But seeing they were slow about it and that Rocinante was in a hurry to reach the stable, he made for the inn door. There he perceived the two misguided damsels, who seemed to him to be two fair maidens or lovely ladies taking their ease at the castle gate.

At this moment it so happened that a swineherd who was going through the harvested field collecting a drove of pigs (for, without any apology, that is what they are called) gave a blast on his horn to bring them together. Forthwith it seemed to Don Quixote to be what he was expecting, the signal of some dwarf announcing his arrival, and so with prodigious satisfaction he rode up to the inn and to the ladies. Seeing a man of this sort approaching in full armor and with lance and shield, they fearfully turned back toward the inn. But Don Quixote, guessing their fear by their flight, raised his pasteboard visor and disclosed his dry, dusty face. He addressed them with a courteous air and in a gentle voice.

"Flee not, your ladyships, nor fear ye any harm," he said, "for it belongs not nor pertains to the order of knighthood which I profess to harm anyone, much less highborn maidens as your appearance proclaims you to be." The girls were looking at him and straining their eyes to make out the features which the clumsy visor obscured, but when they heard themselves called maidens, a thing so much out of their line, they could not restrain their laughter. At this Don Quixote took offense. "Modesty becomes the fair, and moreover laughter that has little cause is great folly," he declared. "This, however, I say not to pain or anger you, for my desire is none other than to serve you."

The incomprehensible language and the unpromising looks of our cavalier only increased the ladies' laughter, and that increased his irritation. Matters might have gone farther if at that moment the innkeeper had not come out. Being a very fat man, he was a very peaceful one. When he saw this grotesque figure clad in armor that did not match any more exactly than did his saddle, bridle, lance, shield, or breastplate, he felt inclined to join the damsels in their outburst of merriment. He was awed by all this complicated weaponry, however, and decided to keep a civil tongue in his head.

"Señor knight," he said, "if your worship wants lodging, excepting the bed (for there is not one in the inn), there is plenty of everything else here."

Don Quixote noted the respectful bearing of the warden of the fortress (for so innkeeper and inn seemed in his eyes). "Sir Castellan," he replied, "for me anything will suffice, for 'My armor is my only wear, My only rest the fray.'" The innkeeper fancied Don Quixote had called him Castellan because he took him for a "worthy of Castile." In

actual fact he was an Andalusian, one of those from the strand of San Lucar, as crafty a thief as Cacus and as full of tricks as a student or a page.

"In that case," said he, "'Your bed is on the flinty rock, Your sleep to watch alway.' So you may dismount and count on enough opportunities for sleeplessness under this roof for a twelvemonth, not to say for a single night."

With this, he advanced to hold the stirrup for Don Quixote, who got down with great difficulty and exertion, for he had not broken his fast all day. He then instructed the innkeeper to take great care of his horse, as he was the best bit of flesh that ever ate bread in this world. The landlord eyed him over but did not find him as good as Don Quixote said, or even half as good. However, he put him up in the stable and returned to see what might be wanted by his guest. The damsels, who had by this time made their peace with the gentleman, were now relieving him of his armor. They had taken off his breastplate and backpiece, but they neither knew nor saw how to open the throat-piece or remove his make-shift helmet. It had been fastened with green ribbons which, since the knots could never be undone, would have to be cut. This however he would not by any means consent to, and so he remained all the evening with his helmet on, the funniest and oddest figure that can be imagined. Since he took the shop-worn trollops who were removing his armor to be ladies of high degree belonging to the castle, he addressed them with great sprightliness:

> "'Oh, never, surely, was there knight
> So served by hand of dame,
> As served was he, Quixote called,
> When from his town he came,
> With maidens waiting on himself,
> Princesses on his hack'

—or Rocinante, for that, my ladies, is my horse's name and Don Quixote of La Mancha is my own. For though I had no intention of declaring myself until my achievements in your service and honor had made me known, the necessity of adapting that old ballad about Lancelot to the present occasion has given you the knowledge of my name altogether prematurely. A time, however, will come for your ladyships to command and me to obey, and then the might of my arm will show my desire to serve you."

The girls, who were not used to hearing rhetoric of this sort, had nothing to say in reply and only asked him if he wanted anything to eat. "I would gladly eat a bit of something," said Don Quixote, "for I feel it would be very beneficial."

The day happened to be a Friday, and in the whole inn there was nothing but some pieces of the salt fish they call in Castile *abadejo*, in Andalusia *bacallao*, in some places *curadillo*, and in others "troutlet." So they asked him if he thought he could eat troutlet, for there was no other fish to give him. "If there are troutlets enough," said Don Quixote, "they will be the same thing as a whole trout. It is all one to me whether I am given eight *reales* in small change or a piece-of-eight. Moreover, it may be that these troutlets are like veal, which is better than beef, or kid, which is better than goat. But whatever it may be, let it come quickly, for the burden and pressure of arms cannot be borne without

support to the inside."

They set a table for him at the door of the inn for the sake of the air, and the host brought him a portion of ill-soaked and worse cooked cod, and a piece of bread as black and moldy as his own armor. A laughable sight it was to see him eating, for having his helmet on and the visor up, he could not with his own hands put anything into his mouth unless some one else placed it there, and this service one of the ladies rendered him. But to give him anything to drink was impossible, or would have been, had not the landlord bored a reed, and putting one end in his mouth poured the wine into him through the other. All this he bore with patience rather than sever the ribbons of his helmet.

While this was going on there came up to the inn a swinegelder who, as he approached, sounded his reed pipe four or five times. Don Quixote, consequently, became completely convinced that he was in some famous castle, and that they were regaling him with music, and that the codfish was trout, the bread the whitest, the wenches ladies, and the landlord the castellan of the castle. In view of all this, he concluded that this resolve and sortie had been to some avail. Yet it still distressed him to think he had not been dubbed a knight, for it was plain to him he could not lawfully engage in any adventure without receiving the order of knighthood.

Song
John Donne

Go and catch a falling star,
 Get with child a mandrake root,
Tell me where all past years are,
 Or who cleft the devil's foot.
Teach me to hear mermaids singing,
Or to keep off envy's stinging,
 And find
 What wind
Serves to advance an honest mind.

If thou be'st born to strange sights,
 Things invisible to see,
Ride ten thousand days and nights,
 Till age snow white hairs on thee;
Thou, when thou return'st, wilt tell me
All strange wonders that befell thee,
 And swear,
 Nowhere
Lives a woman true and fair.

If thou find'st one, let me know;
 Such a pilgrimage were sweet;
Yet do not: I would not go,
 Though at next door we might meet:
Though she were true when you met her,
And last till you write your letter,
 Yet she
 Will be
False, ere I come, to two or three.

The Flea
John Donne

Mark but this flea, and mark in this,
How little that which thou deniest me is;
It sucked me first, and now sucks thee,
And in this flea our two bloods mingled be;
Thou know'st that this cannot be said
A sin, nor shame, nor loss of maidenhead,
 Yet this enjoys before it woo,
 And pampered swells with one blood made of two,
 And this, alas! is more than we would do.
Oh stay, three lives in one flea spare,
Where we almost, yea, more than married are.
This flea is you and I, and this
Our marriage-bed and marriage-temple is;
Though parents grudge, and you, we're met
And cloistered in these living walls of jet.
 Though use make you apt to kill me,
 Let not, to that, self-murder added be,
 And sacrilege, three sins in killing three.

The Good-Morrow
John Donne

I wonder, by my troth, what thou and I
Did till we loved; were we not weaned till then,
But sucked on country pleasures childishly?
Or snorted we in the Seven Sleepers' den?
'T was so; but this, all pleasures fancies be:
If ever any beauty I did see
Which I desired and got, 't was but a dream of thee.

And now good-morrow to our waking souls,
Which watch not one another out of fear;
For love all love of other sights controls,
And makes one little room an everywhere.
Let sea-discoverers to new worlds have gone,
Let maps to other, worlds on worlds have shown,
Let us possess one world; each hath one, and is one.

My face in thine eye, thine in mine appears,
And true plain hearts do in the faces rest;
Where can we find two better hemispheres
Without sharp north, without declining west?
Whatever dies, was not mixed equally;
If our two loves be one, or thou and I
Love so alike that none do slacken, none can die.

Holy Sonnet X
John Donne

Death, be not proud though some have called thee
Mighty and dreadful, for thou art not so;
For those whom thou think'st thou dost overthrow
Die not, poor Death, nor yet canst thou kill me.

From rest and sleep, which but thy pictures be,
Much pleasure, then from thee much more must flow;
And soonest our best men with thee do go,

Rest of their bones, and soul's delivery.
Thou art slave to Fate, chance, kings, and desperate men,

And dost with poison, war, and sickness dwell,
And poppy or charms can make us sleep as well
And better than thy stroke; why swell'st thou then?
One short sleep past, we wake eternally
And Death shall be no more; Death, thou shalt die.

An *Horatian* Ode upon *Cromwel's* Return from *Ireland*[1]
[1650] Andrew Marvell

The forward Youth that would appear
Must now forsake his *Muses* dear,
 Nor in the Shadows sing
 His Numbers languishing.
'Tis time to leave the Books in dust,
And oyl th' unused Armours rust:
 Removing from the Wall
 The Corslet of the Hall.
So restless *Cromwel* could not cease
In the inglorious Arts of Peace, 10
 But through adventrous War
 Urged his active Star.
And, like the three-fork'd Lightning, first
Breaking the Clouds where it was nurst,
 Did thorough his own Side
 His fiery way divide.
For 'tis all one to Courage high
The Emulous or Enemy;
 And with such to inclose
 Is more than to oppose. 20
Then burning through the Air he went,
And Pallaces and Temples rent:
 And *Caesars* head at last
 Did through his Laurels blast.[2]
'Tis Madness to resist or blame
The force of angry Heavens flame:
 And, if we would speak true,
 Much to the Man is due.
Who, from his private Gardens, where
He liv'd reserved and austere, 30
 As if his highest plot
 To plant the Bergamot,[3]
Could by industrious Valour climbe
To ruine the great Work of Time,
 And cast the Kingdome old
 Into another Mold.
Though Justice against Fate complain,

1. Cromwell returned from Ireland in May 1650 to take part in the Scottish campaign. He entered Scotland 22 July 1650. The poem must have been written between these dates. Fairfax, who was shortly to be Marvell's employer, resigned his post as commander-in-chief because he was unwilling to invade Scotland unless the Scots attacked England first. The poem was cancelled from all known copies except one of the edition of 1681.
2. The Laurel was popularly supposed to be immune to lightning.
3. A fine pear, introduced like many new varieties of fruit in the seventeenth century.

And plead the antient Rights in vain:
 But those do hold or break
 As Men are strong or weak. 40
Nature that hateth emptiness,
Allows of penetration[4] less:
 And therefore must make room
 Where greater Spirits come.
What Field of all the Civil Wars,
Where his were not the deepest Scars?
 And *Hampton* shows what part
 He had of wiser Art.
Where, twining subtile fears with hope,
He wove a Net of such a scope, 50
 That *Charles* himself might chase
 To *Caresbrooks* narrow case.[5]
That thence the *Royal Actor* born
The *Tragick Scaffold* might adorn:
 While round the armed Bands
 Did clap their bloody hands.
H*e* nothing common did or mean
Upon that memorable Scene:
 But with his keener Eye
 The Axes edge did try: 60
Nor call'd the *Gods* with vulgar spight
To vindicate his helpless Right,
 But bow'd his comely Head,
 Down as upon a Bed.
This was that memorable Hour
Which first assur'd the forced Pow'r.
 So when they did design
 The *Capitol's* first Line,
A bleeding Head where they begun,
Did fright the Architects to run; 70
 And yet in that the *State*
 Foresaw its happy Fate.[6]
And now the *Irish* are asham'd
To see themselves in one Year tam'd;
 So much one Man can do,
 That does both act and know.
They can affirm his Praises best,
And have, though overcome, confest
 How good he is, how just,
 And fit for highest Trust: 80
Nor yet grown stiffer with Command,
But still in the *Republick's* hand:
 How fit he is to sway
 That can so well obey.
He to the *Common Feet* presents
A *Kingdome*, for his first year's rents:
 And, what he may, forbears
 His Fame to make it theirs:
And has his Sword and Spoyls ungirt,
To lay them at the *Publick's* skirt. 90

4. Occupation of the same space by two bodies simultaneously, a thing more abhorrent to Nature than a vacuum.
5. Charles I fled from Hampton Court 11 November 1647 to take refuge in Carisbrooke in the Isle of Wight. Contemporary writers ascribed this fatal step to Cromwell's guile, working on the King's fears.
6. Pliny relates the discovery of the human head, which was said to give the Capitol its name, and that a famous Etruscan seer declared it to be a good omen.

So when the Falcon high
 Falls heavy from the Sky,
She, having kill'd, no more does search,
But on the next green Bow to pearch;
 Where, when he first does lure,
 The Falckner has her sure.
What may not then our Isle presume
While Victory his Crest does plume!
 What may not others fear
 If thus he crown each Year! 100
A *Caesar* he ere long to *Gaul*,
To *Italy* an *Hannibal*,
 And to all States not free
 Shall *Clymacterick*[7] be.
The *Pict* no shelter now shall find
Within his party-colour'd Mind;[8]
 But from this Valour sad[9]
 Shrink underneath the Plad;
Happy if in the tufted brake
The *English Hunter* him mistake; 110
 Nor lay his Hounds in near
 The *Caledonian* Deer.
But thou the Wars and Fortunes Son
March indefatigably on;
 And for the last effect
 Still keep thy Sword erect:
Besides the force it has to fright
The Spirits of the shady Night,[10]
 The same *Arts* that did *gain*
 A *Pow'r* must it *maintain*. 120

To his Coy Mistress
[1650–52] Andrew Marvell

Had we but World enough, and Time,
This coyness Lady were no crime.
We would sit down, and think which way
To walk, and pass our long Loves Day.
Thou by the *Indian Ganges* side
Should'st Rubies find: I by the Tide
Of *Humber* would complain. I would
Love you ten years before the Flood:
And you should if you please refuse
Till the Conversion of the *Jews*. 10
My vegetable Love should grow
Vaster than Empires, and more slow.
An hundred years should go to praise
Thine Eyes, and on thy Forehead Gaze.
Two hundred to adore each Breast:
But thirty thousand to the rest.
An Age at least to every part,
And the last Age should show your Heart.
For Lady you deserve this State;

7. Critical, marking an epoch.
8. *Pict* was falsely derived from *pingere*, to paint. The derivation was used by other writers to support the charge of falseness and treachery against the Scots.
9. *sad*: steadfast.
10. The cross-hilt of the sword would put evil spirits to flight.

Nor would I love at lower rate. 20
 But at my back I alwaies hear
Times winged Charriot hurrying near:
And yonder all before us lye
Desarts of vast Eternity.
Thy Beauty shall no more be found;
Nor, in thy marble Vault, shall sound
My ecchoing Song: then Worms shall try
That long preserv'd Virginity:
And your quaint Honour turn to dust; 30
And into ashes all my Lust.
The Grave's a fine and private place,
But none I think do there embrace.
 Now therefore, while the youthful hew
Sits on thy skin like morning dew,
And while thy willing Soul transpires
At every pore with instant Fires,
Now let us sport us while we may;
And now, like am'rous birds of prey,
Rather at once our Time devour, 40
Than languish in his slow-chapt pow'r.
Let us roll all our Strength, and all
Our sweetness, up into one Ball:
And tear our Pleasures with rough strife,
Thorough the Iron gates of Life.
Thus, though we cannot make our Sun
Stand still, yet we will make him run.

On his Blindness

[1655] John Milton

When I consider how my light is spent
 Ere half my days in this dark world and wide,
 And that one Talent which is death to hide
 Lodged with me useless, though my soul more bent
To serve therewith my Maker, and present
 My true account, lest He returning chide,
 "Doth God exact day-labour, light denied?"
 I fondly ask. But Patience, to prevent
That murmur, soon replies, "God doth not need
 Either man's work or his own gifts.
 Who best
 Bear his mild yoke, they serve him best.
 His state
Is kingly: thousands at his bidding speed,
 And post o'er land and ocean without rest;
 They also serve who only stand and wait."

Tartuffe

[1664] Molière (Jean-Baptiste Poquelin)

Tartuffe provoked moral outrage among the religious establishment of Louis XIV and was suppressed for several years. It tells of a religious hypocrite who worms his way into the house of a wealthy bourgeois and is only unmasked after he has seduced the owner's wife. Tartuffe himself appears for the first time in Act III, and his first line is indicative of the black humor of the play.

CHARACTERS

Tartuffe
Damis
Dorine
Elmire
Orgon

Act III

Damis: May I be struck dead on the spot—call me the most miserable blackguard alive if I let either fear or favor prevent me—if I don't think out some master stroke!
Dorine: For goodness sake, don't get so excited! Your father has only just mentioned it. People don't do everything they intend to. There's a deal of difference between talking about a thing and doing it.
Damis: I must put a stop to the dog's machinations! I'll have something to say to him!
Dorine: Oh, go easy! Leave your stepmother to deal with both him and your father. She has some influence with Tartuffe. He takes notice of her. I'm not sure that he isn't sweet on her. I wish to Heaven he were! That would be a lark! As a matter of fact it's on your account that she's sent for him: she intends to sound him about this marriage you are so worried about: she means to find out what he has in mind and make him see what trouble it would cause in the family if he encouraged the idea. His servant said he was at his prayers so I wasn't able to see him, but he said he'd be coming down soon. So please go away and leave me to wait for him.
Damis: I'll be present at the interview.
Dorine: No. They must be alone.
Damis: I won't say a word.
Dorine: That's what *you* think! We all know how excitable you are and that's just the way to spoil everything. Off you go.
Damis: No I must see it. I won't lose my temper.
Dorine: How tiresome you are. Here he comes. Do go.
 [*Enter* TARTUFFE.]
Tartuffe: [*Seeing* DORINE] Laurent, put away my hair shirt and my scourge and continue to pray Heaven to send you grace. If anyone asks for me I'll be with the prisoners distributing alms.
Dorine: The impudent hypocrite!
Tartuffe: What do you want?
Dorine: I'm to tell you . . .
Tartuffe: For Heaven's sake! Before you speak, I pray you take this handkerchief. [*Takes handkerchief from his pocket.*]
Dorine: Whatever do you mean?
Tartuffe: Cover your bosom. I can't bear to see it. Such

pernicious sights give rise to sinful thoughts.

Dorine: You're mighty susceptible to temptation then! The flesh must make a great impression on you! I really don't know why you should get so excited. I can't say that I'm so easily roused. I could see you naked from head to foot and your whole carcass wouldn't tempt me in the least.

Tartuffe: Pray, speak a little more modestly or I shall have to leave the room.

Dorine: No. No. I'm leaving you. All I have to say is that the mistress is coming down and would like a word with you.

Tartuffe: Ah! Most willingly.

Dorine: |Aside| That changes his tune. Upon my word I'm convinced there is something in what I said.

Tartuffe: Will she be long?

Dorine: I think I hear her now. Yes, here she comes, I'll leave you together

|Exit DORINE. Enter ELMIRE.|

Tartuffe: May the bounty of Heaven ever bestow on you health of body and of mind, and extend you blessings commensurate with the prayers of the most humble of its devotees!

Elmire: I'm very grateful for these pious wishes. Let us sit down. We shall be more comfortable.

Tartuffe: Do you feel better of your indisposition?

Elmire: Very much. The feverishness soon left me.

Tartuffe: My prayers have too little merit to have obtained this favor from on high; yet all the petitions I have addressed to Heaven have been concerned with your recovery.

Elmire: You are too solicitous on my behalf.

Tartuffe: One cannot be too solicitous for your precious health. I would have sacrificed my own life for the sake of yours.

Elmire: That is carrying Christian charity rather far but I'm truly grateful for your kindness.

Tartuffe: I do far less for you than you deserve.

Elmire: I wanted to speak to you to in private on a certain matter. I'm pleased that no one can overhear us.

Tartuffe: I too am delighted. I need hardly say how pleased I am to find myself alone with you. It's an opportunity which I have besought Heaven to accord me —vainly until this moment.

Elmire: What I want is that you should speak frankly and conceal nothing from me.

Tartuffe: And my sole desire is that you should accord me the singular favor of allowing me to express all that is in my heart and assure you that anything I have said against those who were paying homage to your charms was not spoken in malice against you but rather that the intensity of my pious zeal and pure . . .

Elmire: I take it in that sense and believe that it arises from your concern for my salvation.

Tartuffe: That is indeed so, madam, and such is the fervor of my . . . |Squeezing her fingers.|

Elmire: Oh! You're hurting me

Tartuffe: It comes from excess of devotion. I never intended to hurt you. |Putting his hand upon her knee.| I would rather . . .

Elmire: What is your hand doing there?

Tartuffe: I'm feeling your dress. How soft the material is!

Elmire: Please don't. I'm dreadfully ticklish. |She pushes back her chair. TARTUFFE brings his closer.|

Tartuffe: What marvelous lace! They do wonderful work nowadays. Things are so much better made than they used to be.

Elmire: Very true, but let us return to our business. They say my husband intends to break his promise to Valère and give his daughter to you. Tell me, is it true?

Tartuffe: He did mention something about it, but to tell the truth, madam, that isn't the happiness I aspire to. All my hopes of felicity lie in another direction.

Elmire: That's because you have no interest in temporal things.

Tartuffe: My breast does not enclose a heart of flint!

Elmire: I'm sure your thoughts are all turned Heavenward. Your desires are not concerned with anything here below.

Tartuffe: A passion for the beauties which are eternal does not preclude a temporal love. Our senses can and do respond to those most perfect works of Heaven's creation, whose charms are exemplified in beings such as you and embodied in rarest measure in yourself. Heaven has lavished upon you a beauty that dazzles the eyes and moves the hearts of men. I never look upon your flawless perfections without adoring in you the great Author of all nature and feeling my heart filled with ardent love for that fair form in which He has portrayed Himself. At first I feared lest this secret passion which consumes me might be some subtle snare of the accursed one. I even resolved to avoid your sight, believing you to be an obstacle to my salvation; but at length I came to realize, O fairest among women, that there need be nothing culpable in my passion and that I could reconcile it with virtue. Since then I have surrendered to it heart and soul. It is, I admit, no small presumption on my part to address to you this offer of my love, but I rely upon your generosity and in no wise upon my own unworthy self: my hopes, my happiness, my peace are in your keeping: on you my bliss or future misery depends: my future hangs on your decree: make me for ever happy if such be your will, wretched if you would have it so.

Elmire: A very gallant declaration but a little surprising I must confess! It seems to me you ought to steel yourself more firmly against temptation and consider more deeply what you are about. A pious man like you, a holy man whom everyone . . .

Tartuffe: Ah! But I'm not less a man for being devout! Confronted by your celestial beauty one can but let love have its way and make no demur. I realize that such a declaration coming from me may well seem strange but, after all, madam, I'm not an angel. If you condemn this declaration of mine you must lay the blame on your own enchanting loveliness. From the first moment that I beheld its more than mortal splendors you have ruled supreme in my affection. Those glances, goddess-like and gracious beyond all description, broke down my stubborn heart's resistance, surmounted every obstacle, prayers, fasting, tears, and turned all my thoughts to love of you. My eyes, my sighs, have told you a thousand times what I am now seeking to express in words. If you should turn a kindly eye upon the tribulations of your unworthy slave, if in your generosity you should chose to afford me consolation and deign to notice my insignificance, then I would offer you

for ever, O miracle of loveliness, a devotion beyond compare. Moreover, your honor runs no risk with me; at my hands you need fear no danger of disgrace; these courtly gallants that women are so fond of noise their deeds abroad; they are for ever bragging of their conquests, never receiving a favor but they must divulge it, profaning with blabbing tongues (which folk still put their trust in) the altar to which they bring their offerings. But men of our sort burn with discreeter fires; our secrets are for ever sure; our concern for our own reputation is a safeguard for those we love, and to those who trust us we offer love without scandal, satisfaction without fear.

Elmire: I have listened to what you say and your eloquence has made your meaning sufficiently clear, but are you not afraid that I might take it into my head to tell my husband of this charming declaration of yours and that such a disclosure might impair his friendly feelings for you?

Tartuffe: I know you are too kind, that you will pardon my temerity, condone as human frailty the transports of a passion which offends you, and, when you consult your glass, reflect that I'm not blind and that a man is but flesh and blood.

Elmire: Others might perhaps take a different course but I prefer to show discretion. I shall say nothing to my husband, but in return I must ask one thing of you—that you give your support openly and sincerely to the marriage of Valère and Mariane, renounce the exercise of that improper influence by which you have sought to promote your own hopes at the expense of another and . . .

Damis: |*Coming out of the closet where he has been hidden*| No, no! This must be made known! I was in there and heard everything. Heaven's mercy has brought me here to confound the arrogance of a villain who intends me harm: it has offered me the opportunity to be revenged upon his insolence and hypocrisy, to undeceive my father, and lay bare the soul of this scoundrel who talks to you of love!

Elmire: No, Damis, it is sufficient that he should mend his ways and endeavor to deserve the pardon I have promised him. I have given my word so don't make me break it. I'm not one to make a fuss: a wife makes light of follies such as these and never troubles her husband with them.

Damis: You may have your reasons for doing this but I have mine for doing otherwise. Your wish to spare him is absurd. He has already triumphed sufficiently over my just resentment with his insolence and humbug and made enough trouble among us. The scoundrel has ruled my father long enough and thwarted my love as well as Valère's. My father must be shown what a perfidious wretch he is and Providence now offers a simple means of doing it. I'm answerable to Heaven for this opportunity and it's too favorable to be neglected. Not to make use of it would be to deserve to lose it.

Elmire: Damis . . .

Damis: No. Pardon me—I must trust to my own judgment. I'm overjoyed. Nothing you say can dissuade me from the pleasure of revenge. I'll finish the business without more ado, and |*Seeing* ORGON| here comes the instrument of my satisfaction.

|*Enter* ORGON.|

Damis: We have interesting news for you father. Something has just occurred which will astonish you. You are well repaid for your kindness! The gentleman sets a very high value on the consideration you have shown for him! He has just been demonstrating his passionate concern for you and he stops at nothing less than dishonoring your bed. I have just overheard him making a disgraceful declaration of his guilty passion for your wife. She in kind-heartedness and over-anxiety to be discreet was all for keeping it secret but I can't condone such shameless behavior. I consider it would be a gross injustice to you to keep it from you.

Elmire: Well, I still think a wife shouldn't disturb her husband's peace of mind by repeating such silly nonsense to him; one's honor is in no wise involved. It's sufficient that we women should know how to defend ourselves. That's what I think and if you had taken notice of me you would not have said anything at all. |*Exit.*|

Orgon: Oh Heavens! Can what they say be true?

Tartuffe: Yes, brother, I am a guilty wretch, a miserable sinner steeped in iniquity, the greatest villain that ever existed; not a moment of my life but is sullied with some foul deed: it's a succession of wickedness and corruption. I see now that Heaven is taking this opportunity of chastising me for my sins. Whatever crime I may be charged with, far be it from me to take pride in denying it! Believe what they tell you. Set no bounds to your resentment! Hound me like a felon from your doors! Whatever shame is heaped upon me I shall have deserved much more.

Orgon: |*To his son*| Ah! Miscreant! How dare you seek to tarnish his unspotted virtue with this false accusation?

Damis: What! Can a pretence of meekness from this hypocrite make you deny . . .

Orgon: Silence! You accursed plague!

Tartuffe: Ah, let him speak. You do wrong to accuse him. You would do better to believe what he tells you. Why should you take such a favorable view of me? After all, do you know what I am capable of? Why should you trust appearances? Do you think well of me because of what I seem to be? No, no, you are letting yourself be deceived by outward show. I am, alas, no better than they think; everyone takes me for a good man but the truth is I'm good for nothing. |*Speaking to* DAMIS| Yes, my son, speak freely, call me deceitful, infamous, abandoned, thief, murderer, load me with names yet more detestable, I'll not deny them. I've deserved them all, and on my knees I'll suffer the ignominy, in expiation of my shameful life.

Orgon: |*To* TARTUFFE| Brother, this is too much. |*To his son*| Doesn't your heart relent, you dog!

Damis: What! Can what he says so far prevail with you that . . .

Orgon: |*Raising up* TARTUFFE| Silence you scoundrel! |*To* TARTUFFE| Rise brother—I beg you. |*To his son*| You scoundrel!

Damis: He may—

Orgon: Silence!

Damis: This is beyond bearing! What! I'm to . . .

Orgon: Say another word and I'll break every bone in your body!

Tartuffe: In God's name, brother, calm yourself. I would rather suffer any punishment than he should receive the

slightest scratch on my account.

Orgon: |*To his son*| Ungrateful wretch!

Tartuffe: Leave him in peace! If need be, I'll ask your pardon for him on my knees . . .

Orgon: |*To* TARTUFFE| Alas! What are you thinking of? |*To his son*| See how good he is to you, you dog!

Damis: Then . . .

Orgon: Enough!

Damis: What! Can't I . . .

Orgon: Enough, I say! I know too well why you attack him. You hate him. Every one of you, wife, children, servants, all are in full cry against him. You use every imprudent means to drive this devout and holy person from my house: but the more you strive to banish him the more determined I am not to let him go. I'll hasten his marriage with my daughter and confound the pride of the whole family.

Damis: You mean to make her accept his hand?

Orgon: Yes, you scoundrel, and this very evening to spite you all. Ah! I defy the lot of you. I'll have you know that I'm the master and I'll be obeyed. Come, retract your accusation instantly, you wretch! Down on your knees and beg forgiveness!

Damis: Who? Me? Of a villain whose impostures . . .

Orgon: So you refuse, you scoundrel, do you? And abuse him too! A stick! Give me a stick! |*To* TARTUFFE| Don't try to restrain me! |*To his son*| Out of my house this instant and never darken my doors again!

Damis: Yes, I'll go but . . .

Orgon: Out! Leave the house! Be off! I disinherit you, you dog! And take my curse into the bargain.

|*Exit* DAMIS.|

Orgon: What a way to insult a holy man!

Tartuffe: May Heaven forgive him the sorrow that he causes me! Ah, if you only knew how much it grieves me to see them try to blacken me in my brother's esteem —

Orgon: Alas!

Tartuffe: The mere thought of such ingratitude is unbearable to me . . . it horrifies me . . . it wrings my heart so that I cannot speak . . . it will be the death of me.

Orgon: |*Weeping, runs to the door through which he drove forth his son.*| Scoundrel! I'm sorry I kept my hands off you and didn't fell you on the spot! |*To* TARTUFFE| Compose yourself brother. Don't give way to your feelings.

Tartuffe: Let us put an end to these painful dissensions. When I see what troubles I cause here I feel that I must leave you brother.

Orgon: What! Are you mad?

Tartuffe: They hate me. I see now they are trying to make you doubt my sincerity.

Orgon: What does it matter? Do you think I listen to them?

Tartuffe: But they'll not fail to try again. These same reports you have rejected now you may believe another time.

Orgon: No, brother, never!

Tartuffe: Ah, brother, a wife can easily influence her husband's mind.

Orgon: No. No!

Tartuffe: Let me go and by going hence remove all occasion for them to attack me.

Orgon: No. No. You shall stay. My very life depends upon it.

Tartuffe: Well then if it be so, I must sacrifice myself. But if you would only . . .

Orgon: Yes?

Tartuffe: Let it be so. We'll speak of it no more but I know now what I must do. Reputation is a brittle thing: friendship requires that I should forestall every whisper, every shadow of suspicion. I must forswear the company of your wife and you will never see . . .

Orgon: No! You *shall* see her in spite of them all. Nothing gives me greater joy than to annoy them. You shall appear with her constantly and — to show my defiance, I'll make you my sole heir. I'll make a gift to you in due form of all my goods here and now. My true, dear, friend whom I now take as my son-in-law, you are dearer to me than son or wife or kin. Will you not accept what I am offering you?

Tartuffe: Heaven's will be done in all things.

Orgon: Poor fellow! Let us go and draft the document at once. And let the whole envious pack of them burst with their own vexation at the news!

Paradise Lost

|1667| John Milton

Book I
The Argument

This First Book proposes, first in brief, the whole subject — Man's disobedience, and the loss thereupon of Paradise, wherein he was placed: then touches the prime cause of his fall — the Serpent, or rather Satan in the Serpent; who, revolting from God, and drawing to his side many legions of Angels, was, by the command of God, driven out of Heaven, with all his crew, into the great Deep. Which action passed over, the Poem hastens into the midst of things; presenting Satan, with his Angels, now fallen into Hell — described here not in the Centre (for heaven and earth may be supposed as yet not made, certainly not yet accursed), but in a place of utter darkness, fitliest called Chaos. Here Satan, with his Angels lying on the burning lake, thunderstruck and astonished, after a certain space recovers, as from confusion; calls up him who, next in order and dignity, lay by him: they confer of their miserable fall. Satan awakens all his legions, who lay till then in the same manner confounded. They rise: their numbers; array of battle: their chief leaders named, according to the idols known afterwards in Canaan and the countries adjoining. To these Satan directs his speech; comforts them with hope yet of regaining Heaven; but tells them, lastly, of a new world and new kind of creature to be created, according to an ancient prophecy, or report, in Heaven — for that Angels were long before this visible creation was the opinion of many ancient Fathers. To find out the truth of this prophecy, and what to determine thereon, he refers to a full council. What his associates thence attempt. Pandemonium, the palace of Satan, rises, suddenly built out of the Deep: the infernal Peers there sit in council.

Of Man's first disobedience, and the fruit
Of that forbidden tree whose mortal taste
Brought death into the World, and all our woe,
With loss of Eden, till one greater Man
Restore us, and regain the blissful seat,
Sing, Heavenly Muse, that, on the secret top
Of Oreb, or of Sinai, didst inspire
That shepherd who first taught the chosen seed
In the beginning how the heavens and earth
Rose out of Chaos: or, if Sion hill 10
Delight thee more, and Siloa's brook that flowed
Fast by the oracle of God, I thence
Invoke thy aid to my adventurous song,
That with no middle flight intends to soar
Above the Aonian mount, while it pursues
Things unattempted yet in prose or rhyme.
And chiefly Thou, O Spirit, that dost prefer
Before all temples the upright heart and pure,
Instruct me, for Thou know'st; Thou from the first
Wast present, and, with mighty wings outspread, 20
Dove-like sat'st brooding on the vast Abyss,
And mad'st it pregnant: what in me is dark
Illumine, what is low raise and support;
That, to the highth of this great argument,
I may assert Eternal Providence,
And justify the ways of God to men.
 Say first—for heaven hides nothing from thy view.
Nor the deep tract of Hell—say first what cause
Moved our grand Parents, in that happy state,
Favoured of Heaven so highly, to fall off 30
From their Creator, and transgress his will
For one restraint, lords of the World besides.
Who first seduced them to that foul revolt?
 The infernal Serpent; he it was whose guile,
Stirred up with envy and revenge, deceived
The mother of mankind, what time his pride
Had cast him out from Heaven, with all his host
Of rebel Angels, by whose aid, aspiring
To set himself in glory above his peers,
He trusted to have equalled the Most High, 40
If he opposed, and, with ambitious aim
Against the throne and monarchy of God,
Raised impious war in Heaven and battle proud,
With vain attempt. Him the Almighty Power
Hurled headlong flaming from the ethereal sky,
With hideous ruin and combustion, down
To bottomless perdition, there to dwell
In adamantine chains and penal fire,
Who durst defy the Omnipotent to arms.
 Nine times the space that measures day and night 50
To mortal men, he, with his horrid crew,
Lay vanquished, rolling in the fiery gulf,
Confounded, though immortal. But his doom
Reserved him to more wrath; for now the thought
Both of lost happiness and lasting pain
Torments him: round he throws his baleful eyes,
That witnessed huge affliction and dismay,
Mixed with obdurate pride and steadfast hate.
At once, as far as Angel's ken, he views
The dismal situation waste and wild. 60
A dungeon horrible, on all sides round,
As one great furnace flamed; yet from those flames

No light; but rather darkness visible
Served only to discover sights of woe,
Regions of sorrow, doleful shades, where peace
And rest can never dwell, hope never comes
That comes to all, but torture without end
Still urges, and a fiery deluge, fed
With ever-burning sulphur unconsumed.
Such place Eternal Justice had prepared 70
For those rebellious; here their prison ordained
In utter darkness, and their portion set,
As far removed from God and light of Heaven
As from the centre thrice to the utmost pole.
Oh how unlike the place from whence they fell!
There the companions of his fall, o'erwhelmed
With floods and whirlwinds of tempestuous fire,
He soon discerns; and, weltering by his side,
One next himself in power, and next in crime,
Long after known in Palestine, and named 80
BEËLZEBUB. To whom the Arch-Enemy,
And thence in Heaven called SATAN, with bold words
Breaking the horrid silence, thus began:—
 "If thou beest he—but Oh how fallen! how changed
From him!—who, in the happy realms of light,
Clothed with transcendent brightness, didst outshine
Myriads, though bright—if he whom mutual league,
United thoughts and counsels, equal hope
And hazard in the glorious enterprise,
Joined with me once, now misery hath joined 90
In equal ruin; into what pit thou seest
From what highth fallen: so much the stronger, proved
He with his thunder: and till then who knew
The force of those dire arms? Yet not for those,
Nor what the potent Victor in his rage
Can else inflict, do I repent, or change,
Though changed in outward lustre, that fixed mind,
And high disdain from sense of injured merit,
That with the Mightiest raised me to contend,
And to the fierce contention brought along 100
Innumerable force of Spirits armed,
That durst dislike his reign, and, me preferring,
His utmost power with adverse power opposed
In dubious battle on the plains of heaven,
And shook his throne. What though the field be lost?
All is not lost—the unconquerable will,
And study of revenge, immortal hate,
And courage never to submit or yield:
And what is else not to be overcome.
That glory never shall his wrath or might 110
Exort from me. To bow and sue for grace
With suppliant knee, and deify his power
Who, from the terror of this arm, so late
Doubted his empire—that were low indeed;
That were an ignominy and shame beneath
This downfall; since, by fate, the strength of Gods,
And this empyreal substance, cannot fail;
Since, through experience of this great event,
In arms not worse, in foresight much advanced,
We may with more successful hope resolve 120
To wage by force or guile eternal war,
Irreconcilable to our grand Foe,
Who now triumphs, and in the excess of joy
Sole reigning holds the tyranny of Heaven."

So spake the apostate Angel, though in pain,
Vaunting aloud, but racked with deep despair;
And him thus answered soon his bold compeer:—
"O Prince, O Chief of many thronèd Powers
That led the embattled Seraphim to war
Under thy conduct, and, in dreadful deeds 130
Fearless, endangered Heaven's perpetual King,
And put to proof his high supremacy,
Whether upheld by strength, or chance, or fate!
Too well I see and rue the dire event
That, with sad overthrow and foul defeat,
Hath lost us Heaven, and all this mighty host
In horrible destruction laid thus low,
As far as Gods and heavenly Essences
Can perish: for the mind and spirit remains
Invincible, and vigour soon returns, 140
Though all our glory extinct, and happy state
Here swallowed up in endless misery.
But what if He our Conqueror (whom I now
Of force believe almighty, since no less
Than such could have o'erpowered such force as ours)
Have left us this our spirit and strength entire,
Strongly to suffer and support our pains,
That we may so suffice his vengeful ire
Or do him mightier service as his thralls
By right of war, whate'er his business be, 150
Here in the heart of Hell to work in fire,
Or do his errands in the gloomy Deep?
What can it then avail though yet we feel
Strength undiminished, or eternal being
To undergo eternal punishment?"
 Whereto with speedy words the Arch-Fiend replied:—
"Fallen Cherub, to be weak is miserable,
Doing or suffering: but of this be sure—
To do aught good never will be our task,
But ever to do ill our sole delight, 160
As being the contrary to His high will
Whom we resist. If then his providence
Out of our evil seek to bring forth good,
Our labour must be to pervert that end,
And out of good still to find means of evil;
Which ofttimes may succeed so as perhaps
Shall grieve him, if I fail not, and disturb
His inmost counsels from their destined aim.
But see! the angry Victor hath recalled
His ministers of vengeance and pursuit 170
Back to the gates of Heaven: the sulphurous hail,
Shot after us in storm, o'erblown hath laid
The fiery surge that from the precipice
Of Heaven received us falling; and the thunder,
Winged with red lightning and impetuous rage,
Perhaps hath spent his shafts, and ceases now
To bellow through the vast and boundless Deep.
Let us not slip the occasion, whether scorn
Or satiate fury yield it from our Foe.
Seest thou yon dreary plain, forlorn and wild, 180
The seat of desolation, void of light,
Save what the glimmering of these livid flames
Casts pale and dreadful? Thither let us tend
From off the tossing of these fiery waves;
There rest, if any rest can harbour there;
And, re-assembling our afflicted powers,

Consult how we may henceforth most offend
Our enemy, our own loss how repair,
How overcome this dire calamity,
What reinforcement we may gain from hope, 190
If not what resolution from despair."
 Thus Satan, talking to his nearest mate,
With head uplift above the wave, and eyes
That sparkling blazed; his other parts besides
Prone on the flood, extended long and large
Lay floating many a rood, in bulk as huge
As whom the fables name of monstrous size,
Titanian or Earth-born, that warred on Jove,
Briareos or Typhon, whom the den
By ancient Tarsus held, or that sea-beast 200
Leviathan, which God of all his works
Created hugest that swim the ocean-stream.
Him, haply slumbering on the Norway foam,
The pilot of some small night-foundered skiff,
Deeming some island, oft, as seamen tell,
With fixed anchor in his scaly rind,
Moors by his side under the lee, while night
Invests the sea, and wished morn delays.
So stretched out huge in length the Arch-Fiend lay,
Chained on the burning lake; nor ever thence 210
Had risen, or heaved his head, but that the will
And high permission of all-ruling Heaven
Left him at large to his own dark designs,
That with reiterated crimes he might
Heap on himself damnation, while he sought
Evil to others, and enraged might see
How all his malice served but to bring forth
Infinite goodness, grace, and mercy, shewn
On Man by him seduced, but on himself
Treble confusion, wrath, and vengeance poured. 220
 Forthwith upright he rears from off the pool
His mighty stature; on each hand the flames
Driven backward slope their pointing spires, and, rolled
In billows, leave i' the midst a horrid vale.
Then with expanded wings he steers his flight
Aloft, incumbent on the dusky air,
That felt unusual weight; till on dry land
He lights—if it were land that ever burned
With solid, as the lake with liquid fire,
And such appeared in hue as when the force 230
Of subterranean wind transports a hill
Torn from Pelorus, or the shattered side
Of thundering Aetna, whose combustible
And fuelled entrails, thence conceiving fire,
Sublimed with mineral fury, aid the winds,
And leave a singed bottom all involved
With stench and smoke. Such resting found the sole
Of unblest feet. Him followed his next mate;
Both glorying to have scaped the Stygian flood
As gods, and by their own recovered strength, 240
Not by the sufferance of supernal power.
 "Is this the region, this the soil, the clime,"
Said then the lost Archangel, "this the seat
That we must change for Heaven?—this mournful gloom
For that celestial light? Be it so, since He
Who now is sovran can dispose and bid
What shall be right: farthest from Him is best,
Whom reason hath equalled, force hath made supreme

Above his equals. Farewell, happy fields,
Where joy for ever dwells! Hail, horrors! hail, 250
Infernal World! and thou, profoundest Hell,
Receive thy new possessor—one who brings
A mind not to be changed by place or time.
The mind is its own place, and in itself
Can make a Heaven of Hell, a Hell of Heaven.
What matter where, if I be still the same,
And what I should be, all but less than he
Whom thunder hath made greater? Here at least
We shall be free; the Almighty hath not built
Here for his envy, will not drive us hence: 260
Here we may reign secure; and, in my choice,
To reign is worth ambition, though in Hell:
Better to reign in Hell than serve in Heaven.
But wherefore let we then our faithful friends,
The associates and co-partners of our loss,
Lie thus astonished on the oblivious pool,
And call them not to share with us their part
In this unhappy mansion, or once more
With rallied arms to try what may be yet
Regained in Heaven, or what more lost in Hell?" 270
 So Satan spoke; and him Beëlzebub
Thus answered:—"Leader of those armies bright
Which, but the Omnipotent, none could have foiled!
If once they hear that voice, their liveliest pledge
Of hope in fears and dangers—heard so oft
In worst extremes, and on the perilous edge
Of battle, when it raged, in all assaults
Their surest signal—they will soon resume
New courage and revive, though now they lie
Grovelling and prostrate on yon lake of fire, 280
As we erewhile, astounded and amazed;
No wonder, fallen such a pernicious highth!"
 He scarce had ceased when the superior Fiend
Was moving toward the shore; his ponderous shield,
Ethereal temper, massy, large, and round,
Behind him cast. The broad circumference
Hung on his shoulders like the moon, whose orb
Through optic glass the Tuscan artist views
At evening, from the top of Fesolè,
Or in Valdarno, to descry new lands, 290
Rivers, or mountains, in her spotty globe.
His spear—to equal which the tallest pine
Hewn on Norwegian hills, to be the mast
Of some great ammiral, were but a wand—
He walked with, to support uneasy steps
Over the burning marle, not like those steps
On Heaven's azure; and the torrid clime
Smote on him sore besides, vaulted with fire.
Nathless he so endured, till on the beach
Of that inflamèd sea he stood, and called 300
His legions—Angel Forms, who lay entranced
Thick as autumnal leaves that strow the brooks
In Vallombrosa, where the Etrurian shades
High over-arched embower; or scattered sedge
Afloat, when the fierce winds Orion armed
Hath vexed the Red-Sea coast, whose waves o'erthrew
Busiris and his Memphian chivalry,
While with perfidious hatred they pursued
The sojourners of Goshen, who beheld
From the safe shore their floating carcases 310

And broken chariot-wheels. So thick bestrown,
Abject and lost, lay these, covering the flood, 250
Under amazement of their hideous change.
He called so loud that all the hollow deep
Of Hell resounded:—"Princes, Potentates,
Warriors, the Flower of heaven—once yours; now lost,
If such astonishment as this can seize
Eternal Spirits! Or have ye chosen this place
After the toil of battle to repose
Your wearied virtue, for the ease you find 320
To slumber here, as in the vales of Heaven?
Or in this abject posture have ye sworn
To adore the Conqueror, who now beholds
Cherub and Seraph rolling in the flood
With scattered arms and ensigns, till anon
His swift pursuers from Heaven-gates discern
The advantage, and, descending, tread us down
Thus drooping, or with linked thunderbolts
Transfix us to the bottom of this gulf?—
Awake, arise, or be for ever fallen!" 330
 They heard, and were abashed, and up they sprung
Upon the wing, as when men wont to watch,
On duty sleeping found by whom they dread,
Rouse and bestir themselves ere well awake.
Nor did they not perceive the evil plight
In which they were, or the fierce pains not feel;
Yet to their General's voice they soon obeyed
Innumerable. As when the potent rod
Of Amram's son, in Egypt's evil day.
Waved round the coast, up-called a pitchy cloud 340
Of locusts, warping on the eastern wind,
That o'er the realm of impious Pharaoh hung
Like Night, and darkened all the land of Nile;
So numberless were those bad Angels seen
Hovering on wing under the cope of Hell,
'Twixt upper, nether, and surrounding fires;
Till, as a signal given, the uplifted spear
Of their great Sultan waving to direct
Their course, in even balance down they light
On the firm brimstone, and fill all the plain: 350
A multitude like which the populous North
Poured never from her frozen loins to pass
Rhene or the Danaw, when her barbarous sons
Came like a deluge on the South, and spread
Beneath Gibraltar to the Libyan sands.
Forthwith, from every squadron and each band,
The heads and leaders thither haste where stood
Their great Commander—godlike Shapes, and Forms
Excelling human; princely Dignities;
And Powers that erst in Heaven sat on thrones 360
Though of their names in Heavenly records now
Be no memorial, blotted out and rased
By their rebellion from the Books of Life.
Nor had they yet among the sons of Eve
Got them new names, till, wandering o'er the earth,
Through God's high sufferance for the trial of man,
By falsities and lies the greatest part
Of mankind they corrupted to forsake
God their Creator, and the invisible
Glory of Him that made them to transform 370
Oft to the image of a brute, adorned
With gay religions full of pomp and gold,

And devils to adore for deities:
Then were they known to men by various names,
And various idols through the Heathen World.
 Say, Muse, their names then known, who first, who last,
Roused from the slumber on that fiery couch,
At their great Emperor's call, as next in worth
Came singly where he stood on the bare strand,
While the promiscuous crowd stood yet aloof. 380
 The chief were those who, from the pit of Hell
Roaming to seek their prey on Earth, durst fix
Their seats, long after, next the seat of God,
Their altars by His altar, gods adored
Among the nations round, and durst abide
Jehovah thundering out of Sion, throned
Between the Cherubim; yea, often placed
Within His sanctuary itself their shrines,
Abominations; and with cursed things
His holy rites and solemn feasts profaned, 390
And with their darkness durst affront His light.
First, *Moloch*, horrid king, besmeared with blood
Of human sacrifice, and parents' tears;
Though, for the noise of drums and timbrels loud,
Their children's cries unheard that passed through fire
To his grim idol. Him the Ammonite
Worshipped in Rabba and her watery plain,
In Argob and in Basan, to the stream
Of utmost Arnon. Nor content with such
Audacious neighbourhood, the wisest heart 400
Of Solomon he led by fraud to build
His temple right against the temple of God
On that opprobrious hill, and made his grove
The pleasant valley of Hinnom, Tophet thence
And black Gehenna called, the type of Hell.
Next *Chemos*, the obscene dread of Moab's sons,
From Aroar to Nebo and the wild
Of southmost Abarim; in Hesebon
And Horonaim, Seon's realm, beyond
The flowery dale of Sibma clad with vines, 410
And Elealè to the Asphaltic Pool:
Peor his other name, when he enticed
Israel in Sittim, on their march from Nile,
To do him wanton rites, which cost them woe.
Yet thence his lustful orgies he enlarged
Even to that hill of scandal, by the grove
Of Moloch homicide, lust hard by hate,
Till good Josiah drove them thence to Hell.
With these came they who, from the bordering flood
Of old Euphrates to the brook that parts 420
Egypt from Syrian ground, had general names
Of *Baalim* and *Ashtaroth*—those male,
These feminine. For Spirits, when they please,
Can either sex assume, or both; so soft
And uncompounded is their essence pure,
Not tied or manacled with joint or limb,
Nor founded on the brittle strength of bones,
Like cumbrous flesh; but, in what shape they choose,
Dilated or condensed, bright or obscure,
Can execute their aery purposes, 430
And works of love or enmity fulfil.
For those the race of Israel oft forsook
Their Living Stength, and unfrequented left
His righteous altar, bowing lowly down

To bestial gods; for which their heads, as low
Bowed down in battle, sunk before the spear
Of despicable foes. With these in troop
Came *Astoreth*, whom the Phoenicians called
Astarte, queen of heaven, with crescent horns;
To whose bright image nightly by the moon 440
Sidonian virgins paid their vows and songs;
In Sion also not unsung, where stood
Her temple on the offensive mountain, built
By that uxorious king whose heart, though large,
Beguiled by fair idolatresses, fell
To idols foul. *Thammuz* came next behind,
Whose annual wound in Lebanon allured
The Syrian damsels to lament his fate
In amorous ditties all a summer's day,
While smooth Adonis from his native rock 450
Ran purple to the sea, supposed with blood
Of Thammuz yearly wounded: the love-tale
Infected Sion's daughters with like heat,
Whose wanton passions in the sacred porch
Ezekiel saw, when, by the vision led,
His eye surveyed the dark idolatries
Of alienated Judah. Next came one
Who mourned in earnest, when the captive ark
Maimed his brute image, head and hands lopt off,
In his own temple, on the grunsel-edge, 460
Where he fell flat and shamed his worshippers:
Dagon his name, sea-monster, upward man
And downward fish; yet had his temple high
Reared in Azotus, dreaded through the coast
Of Palestine, in Gath and Ascalon,
And Accaron and Gaza' frontier bounds.
Him followed *Rimmon*, whose delightful seat
Was fair Damascus, on the fertile banks
Of Abbana and Pharphar, lucid streams.
He also against the house of God was bold: 470
A leper once he lost, and gained a king—
Ahaz, his sottish conqueror, whom he drew
God's altar to disparage and displace
For one of Syrian mode, whereon to burn
His odious offerings, and adore the gods
Whom he had vanquished. After these appeared
A crew who, under names of old renown—
Osiris, *Isis*, *Orus*,[1] and their train—
With monstrous shapes and sorceries abused
Fanatic Egypt and her priests to seek 480
Their wandering gods disguised in brutish forms
Rather than human. Nor did Israel scape
The infection, when their borrowed gold composed
The calf in Oreb; and the rebel king
Doubled that sin in Bethel and in Dan,
Likening his Maker to the grazèd ox—
Jehovah, who, in one night, when he passed
From Egypt marching, equalled with one stroke
Both her first-born and all her bleating gods.
Belial came last; than whom a spirit more lewd 490
Fell not from Heaven, or more gross to love
Vice for itself. To him no temple stood
Or altar smoked; yet who more oft than he
In temples and at altars, when the priest

1. Horus.

Turns atheist, as did Eli's sons, who filled
With lust and violence the house of God?
In courts and palaces he also reigns,
And in luxurious cities, where the noise
Of riot ascends above their loftiest towers,
And injury and outrage; and, when night 500
Darkens the streets, then wander forth the sons
Of Belial, flown with insolence and wine.
Witness the streets of Sodom, and that night
In Gibeah, when the hospitable door
Exposed a matron, to avoid worse rape.
 These were the prime in order and in might:
The rest were long to tell; though far renowned
The Ionian gods—of Javan's issue held
God's, yet confessed later than Heaven and Earth,
Their boasted parents;—*Titan*, Heaven's first-born 510
With his enormous brood, and birthright seized
By younger *Saturn*; he from mightier Jove,
His own and Rhea's son, like measure found;
So *Jove* usurping reigned. These, first in Crete
And Ida known, thence on the snowy top
Of cold Olympus ruled the middle air,
Their highest heaven; or on the Delphian cliff,
Or in Dodona, and through all the bounds
Of Doric land; or who with Saturn old
Fled over Adria to the Hesperian fields, 520
And o'er the Celtic roamed the utmost Isles.
 All these and more came flocking; but with looks
Downcast and damp; yet such wherein appeared
Obscure some glimpse of joy to have found their Chief
Not in despair, to have found themselves not lost
In loss itself; which on his countenance cast
Like doubtful hue. But he, his wonted pride
Soon recollecting, with high words, that bore
Semblance of worth, not substance, gently raised
Their fainting courage, and dispelled their fears: 530
Then straight commands that, at the warlike sound
Of trumpets loud and clarions, be upreared
His mighty standard. That proud honour claimed
Azazel as his right, a Cherub tall:
Who forthwith from the glittering staff unfurled
The imperial ensign; which, full high advanced,
Shone like a meteor streaming to the wind,
With gems and golden lustre rich emblazed,
Seraphic arms and trophies; all the while
Sonorous metal blowing martial sounds: 540
At which the universal host up-sent
A shout that tore Hell's concave, and beyond
Frighted the reign of Chaos and old Night.
All in a moment through the gloom were seen
Ten thousand banners rise into the air,
With orient colours waving: with them rose
A forest huge of spears; and thronging helms
Appeared, and serried shields in thick array
Of depth immeasurable. Anon they move
In perfect phalanx to the Dorian mood 550
Of flutes and soft recorders—such as raised
To highth of noblest temper heroes old
Arming to battle, and instead of rage
Deliberate valour breathed, firm, and unmoved
With dread of death to flight or foul retreat;
Nor wanting power to mitigate and swage

With solemn touches troubled thoughts, and chase
Anguish and doubt and fear and sorrow and pain
From mortal or immortal minds. Thus they,
Breathing united force with fixèd thought, 560
Moved on in silence to soft pipes that charmed
Their painful steps o'er the burnt soil. And now
Advanced in view they stand—a horrid front
Of dreadful length and dazzling arms, in guise
Of warriors old, with ordered spear and shield,
Awaiting what command their mighty Chief
Had to impose. He through the armèd files
Darts his experienced eye, and soon traverse
The whole battalion views—their order due,
Their visages and stature as of gods; 570
Their number last he sums. And now his heart
Distends with pride, and, hardening in his strength,
Glories: for never, since created Man,
Met such embodied force as, named with these,
Could merit more than that small infantry
Warred on by cranes—though all the giant brood
Of Phlegra with the heroic race were joined
That fought at Thebes and Ilium, on each side
Mixed with auxiliar gods; and what resounds
In fable or romance of Uther's son, 580
Begirt with British and Armoric knights;
And all who since, baptized or infidel,
Jousted in Aspramont, or Montalban,
Damasco, or Marocco, or Trebisond,
Or whom Biserta sent from Afric shore
When Charlemain with all his peerage fell
By Fontarabia. Thus far these beyond
Compare of mortal prowess, yet observed
Their dread Commander. He, above the rest
In shape and gesture proudly eminent, 590
Stood like a tower. His form had yet not lost
All her original brightness, nor appeared
Less than Archangel ruined, and the excess
Of glory obscured: as when the sun new-risen
Looks through the horizontal misty air
Shorn of his beams, or, from behind the moon,
In dim eclipse, disastrous twilight sheds
On half the nations, and with fear of change
Perplexes monarchs. Darkened so, yet shone
Above them all the Archangel: but his face 600
Deep scars of thunder had intrenched, and care
Sat upon his faded cheek, but under brows
Of dauntless courage, and considerate pride
Waiting revenge. Cruel his eye, but cast
Signs of remorse and passion, to behold
The fellows of his crime, the followers rather
(Far other once beheld in bliss), condemned
For ever now to have their lot in pain—
Millions of Spirits for his fault amerced
Of Heaven, and from eternal splendours flung 610
For his revolt—yet faithful how they stood,
Their glory withered; as, when heaven's fire
Hath scathed the forest oaks or mountain pines,
With singèd top their stately growth, though bare,
Stands on the blasted heath. He now prepared
To speak; whereat their doubled ranks they bend
From wing to wing, and half enclose him round
With all his peers: Attention held them mute.

Thrice he assayed, and thrice, in spite of scorn,
Tears, such as Angels weep, burst forth: at last 620
Words interwove with sighs found out their way:—
 "O myriads of immortal Spirits! Oh Powers
Matchless, but with the Almighty!—and that strife
Was not inglorious, though the event was dire,
As this place testifies, and this dire change,
Hateful to utter. But what power of mind,
Foreseeing or presaging, from the depth
Of knowledge past or present, could have feared
How such united force of gods, how such
As stood like these, could ever know repulse? 630
For who can yet believe, though after loss,
That all these puissant legions, whose exile
Hath emptied Heaven, shall fail to re-ascend,
Self-raised, and re-possess their native seat?
For me, be witness all the host of heaven,
If counsels different, or danger shunned
By me, have lost our hopes. But he who reigns
Monarch in Heaven till then as one secure
Sat on his throne, upheld by old repute,
Consent or custom, and his regal state 640
Put forth at full, but still his strength concealed—
Which tempted our attempt, and wrought our fall.
Henceforth his might we know, and know our own,
So as not either to provoke, or dread
New war provoked: our better part remains
To work in close design, by fraud or guile,
What force effected not; that he no less
At length from us may find. Who overcomes
By force hath overcome but half his foe.
Space may produce new Worlds; whereof so rife 650
There went a fame in Heaven that He ere long
Intended to create, and therein plant
A generation whom his choice regard
Should favour equal to the Sons of Heaven.
Thither, if but to pry, shall be perhaps
Our first eruption—thither, or elsewhere;
For this infernal pit shall never hold
Celestial Spirits in bondage, nor the Abyss
Long under darkness cover. But these thoughts
Full counsel must mature. Peace is despaired; 660
For who can think submission? War, then, war
Open or understood, must be resolved."
 He spake; and, to confirm his words, out-flew
Millions of flaming swords, drawn from the thighs
Of mighty Cherubim; the sudden blaze
Far round illumined Hell. Highly they raged
Against the Highest, and fierce with graspèd arms
Clashed on their sounding shields the din of war,
Hurling defiance toward the vault of Heaven.
 There stood a hill not far, whose grisly top 670
Belched fire and rolling smoke; the rest entire
Shone with a glossy scurf—undoubted sign
That in his womb was hid metallic ore,
The work of sulphur. Thither, winged with speed,
A numerous brigade hastened: as when bands
Of pioneers, with spade and pickaxe armed,
Forerun the royal camp, to trench a field,
Or cast a rampart. Mammon led them on—
Mammon, the least erected Spirit that fell
From Heaven; for even in Heaven his looks and thoughts 680

Were always downward bent, admiring more
The riches of Heaven's pavement, trodden gold,
Than aught divine or holy else enjoyed
In vision beatific. By him first
Men also, and by his suggestion taught,
Ransacked the Centre, and with impious hands
Rifled the bowels of their mother Earth
For treasures better hid. Soon had his crew
Opened into the hill a spacious wound,
And digged out ribs of gold. Let none admire 690
That riches grow in Hell; that soil may best
Deserve the precious bane. And here let those
Who boast in mortal things, and wondering tell
Of Babel, and the works of Memphian kings,
Learn how their greatest monuments of fame,
And strength, and art, are easily outdone
By Spirits reprobate, and in an hour
What in an age they, with incessant toil
And hands innumerable, scarce perform.
Nigh on the plain, in many cells prepared, 700
That underneath had veins of liquid fire
Sluiced from the lake, a second multitude
With wondrous art founded the massy ore,
Severing each kind, and scummed the bullion-dross.
A third as soon had formed within the ground
A various mould, and from the boiling cells
By strange conveyance filled each hollow nook;
As in an organ, from one blast of wind,
To many a row of pipes the sound-board breathes.
Anon out of the earth a fabric huge 710
Rose like an exhalation, with the sound
Of dulcet symphonies and voices sweet—
Built like a temple, where pilasters round
Were set, and Doric pillars overlaid
With golden architrave; nor did there want
Cornice or frieze, with bossy sculptures graven:
The roof was fretted gold. Not Babylon
Not great Alcairo such magnificence
Equalled in all their glories, to enshrine
Belus or Serapis their gods, or seat 720
Their kings, when Egypt with Assyria strove
In wealth and luxury. The ascending pile
Stood fixed her stately highth; and straight the doors,
Opening their brazen folds, discover, wide
Within, her ample spaces o'er the smooth
And level pavement: from the archèd roof,
Pendent by subtle magic, many a row
Of starry lamps and blazing cressets, fed
With naphtha and asphaltus, yielded light
As from a sky. The hasty multitude 730
Admiring entered; and the work some praise,
And some the architect. His hand was known
In Heaven by many a towered structure high,
Where sceptred Angels held their residence,
And sat as Princes, whom the supreme King
Exalted to such power, and gave to rule,
Each in his hierarchy, the Orders bright
Nor was his name unheard or unadored
In ancient Greece; and in Ausonian land
Men called him Mulciber; and how he fell 740
From Heaven they fabled, thrown by angry Jove
Sheer o'er the crystal battlements: from morn

To noon he fell, from noon to dewy eve,
A summer's day, and with the setting sun
Dropt from the zenith like a falling star,
On Lemnos, the Aegaean isle. Thus they relate,
Erring; for he with this rebellious rout
Fell long before; nor aught availed him now
To have built in Heaven high towers; not did he scape
By all his engines, but was headlong sent, 750
With his industrious crew, to build in Hell.
 Meanwhile the wingèd Heralds, by command
Of sovran power, with awful ceremony
And trumpet's sound, throughout the host proclaim
A solemn council forthwith to be held
At Pandemonium, the high capital
Of Satan and his peers. Their summons called
From every band and squarèd regiment
By place or choice the worthiest: they anon
With hundreds and with thousands trooping came 760
Attended. All access was thronged; the gates
And porches wide, but chief the spacious hall
(Though like a covered field, where champions bold
Wont ride in armed, and at the Soldan's chair
Defied the best of Panim chivalry
To mortal combat, or career with lance),
Thick swarmed, both on the ground and in the air,
Brushed with the hiss of rustling wings. As bees
In spring-time, when the Sun with Taurus rides,
Pour forth their populous youth about the hive 770
In clusters; they among fresh dews and flowers
Fly to and fro, or on the smoothèd plank,
The suburb of their straw-built citadel,
New rubbed with balm, expatiate, and confer
Their state affairs: so thick the aery crowd
Swarmed and were straitened; till, the signal given,
Behold a wonder! They but now who seemed
In bigness to surpass Earth's giant sons,
Now less than smallest dwarfs, in narrow room
Throng numberless—like that pygmean race 780
Beyond the Indian mount; or faery elves,
Whose midnight revels, by a forest-side
Or fountain, some belated peasant sees,
Or dreams he sees, while overhead the Moon
Sits arbitress, and nearer to the Earth
Wheels her pale course: they, on their mirth and dance
Intent, with jocund music charm his ear;
At once with joy and fear his heart rebounds.
Thus incorporeal Spirits to smallest forms
Reduced their shapes immense, and were at large, 790
Though without number still, amidst the hall
Of that infernal court. But far within,
And in their own dimensions like themselves,
The great Seraphic Lords and Cherubim
In close recess and secret conclave sat,
A thousand demi-gods on golden seats,
Frequent and full. After short silence then,
And summons read, the great consult began.

Essay on Man

[1733–34] Alexander Pope

Epistle I

Awake, my St John! leave all meaner things
To low ambition and the pride of kings.
Let us, since life can little more supply
Than just to look about us and to die,
Expatiate free o'er all this scene of man;
A mighty maze! but not without a plan;
A wild, where weeds and flowers promiscuous shoot;
Or garden, tempting with forbidden fruit.
Together let us beat this ample field,
Try what the open, what the covert yield;
The latent tracts, the giddy heights, explore,
Of all who blindly creep, or sightless soar;
Eye Nature's walks, shoot Folly as it flies,
And catch the manners living as they rise;
Laugh where we must, be candid where we can;
But vindicate the ways of God to man.

1

Say first, of God above or man below,
What can we reason but from what we know?
Of man, what see we but his station here,
From which to reason, or to which refer?
Through worlds unnumber'd though the God be known,
'Tis ours to trace him only in our own.
He, who through vast immensity can pierce,
See worlds on worlds compose one universe,
Observe how system into system runs,
What other planets circle other suns,
What varied being peoples every star,
May tell why Heav'n has made us as we are.
But of this frame, the bearings and the ties,
The strong connections, nice dependencies,
Gradations just, has thy pervading soul
Looked through, or can a part contain the whole?
 Is the great chain that draws all to agree,
And drawn supports, upheld by God or thee?

2

Presumptuous man! the reason wouldst thou find,
Why form'd so weak so little, and so blind?
First, if thou canst, the harder reason guess,
Why form'd no weaker, blinder, and no less?
Ask of thy mother earth, why oaks are made
Taller or stronger than the weeds they shade!
Or ask of yonder argent fields above
Why Jove's satellites are less than Jove!
 Of systems possible, if 't is confest
That wisdom infinite must form the best,
Where all must full or not coherent be,
And all that rises rise in due degree,
Then, in the scale of reas'ning life, 't is plain
There must be somewhere such a rank as Man:
And all the question (wrangle e'er so long)
Is only this, if God has placed him wrong?
 Respecting Man, whatever wrong we call.
May, must be right, as relative to all.

In human works, though labour'd on with pain,
A thousand movements scarce one purpose gain;
In God's, one single can its end produce;
Yet serves to second too some other use.
So Man, who here seems principal alone,
Perhaps acts second to some sphere unknown,
Touches some wheel, or verges to some goal;
'Tis but a part we see, and not a whole.
When the proud steed shall know why man restrains
His fiery course, or drives him o'er the plains;
When the dull ox, why now he breaks the clod,
Is now a victim and now Egypt's god;
Then shall man's pride and dullness comprehend
His actions', passions', being's use and end;
Why doing, suff'ring, check'd, impell'd; and why
This hour a slave, the next a deity.
 Then say not man's imperfect, Heav'n in fault;
Say rather man's as perfect as he ought:
His knowledge measur'd to his state and place,
His time a moment, and a point his space.
If to be perfect in a certain sphere,
What matter soon or late, or here or there?
The blest today is as completely so,
As who began a thousand years ago.

3

Heav'n from all creatures hides the book of Fate,
All but the page prescrib'd, their present state:
From brutes what men, from men what spirits know:
Or who could suffer Being here below?
The lamb thy riot dooms to bleed today,
Had he thy reason, would he skip and play?
Pleas'd to the last, he crops the flow'ry food,
And licks the hand just rais'd to shed his blood.
Oh blindness to the future! kindly giv'n,
That each may fill the circle mark'd by Heav'n:
Who sees with equal eye, as God of all,
A hero perish, or a sparrow fall,
Atoms or systems into ruin hurl'd,
And now a bubble burst, and now a world.
 Hope humbly then; with trembling pinions soar;
Wait the great teacher Death, and God adore!
What future bliss he gives not thee to know,
But gives that hope to be thy blessing now.
Hope springs eternal in the human breast;
Man never is, but always to be blest.
The soul, uneasy, and confin'd from home,
Rests and expatiates in a life to come.
 Lo! the poor Indian, whose untutor'd mind
Sees God in clouds, or hears him in the wind;
His soul proud Science never taught to stray
Far as the solar walk or milky way;
Yet simple Nature to his hope has giv'n,
Behind the cloud-topt hill, an humbler heav'n;
Some safer world in depth of woods embrac'd,
Some happier island in the watery waste,
Where slaves once more their native land behold,
No fiends torment, no Christians thirst for gold!
To be, contents his natural desire;
He asks no angel's wing, no seraph's fire;
But thinks, admitted to that equal sky,
His faithful dog shall bear him company.

4

Go, wiser thou! and in thy scale of sense,
Weigh thy opinion against Providence;
Call imperfection what thou fancy'st such,
Say, Here he gives too little, there too much!
Destroy all creatures for thy sport or gust,
Yet cry, If man's unhappy, God's unjust:
If man alone engross not Heav'n's high care,
Alone made perfect here, immortal there:
Snatch from his hand the balance and the rod,
Rejudge his justice, be the God of God!
In pride, in reasoning pride, our error lies;
All quit their sphere and rush into the skies.
Pride still is aiming at the blest abodes,
Men would be angels, angels would be gods.
Aspiring to be gods if angels fell,
Aspiring to be angels, men rebel:
And who but wishes to invert the laws
Of order, sins against the Eternal Cause.

5

Ask for what end the heav'nly bodies shine,
Earth for whose use? Pride answers, "'Tis for mine!
For me kind Nature wakes her genial pow'r,
Suckles each herb, and spreads out ev'ry flow'r;
Annual for me, the grape, the rose renew
The juice nectarous and the balmy dew;
For me the mine a thousand treasures brings;
For me health gushes from a thousand springs;
Seas roll to waft me, suns to light me rise;
My footstool earth, my canopy the skies."
 But errs not Nature from this gracious end,
From burning suns when livid deaths descend,
When earthquakes swallow, or when tempests sweep
Towns to one grave, whole nations to the deep?
"No," 'tis reply'd, "the first Almighty Cause
Acts not by partial but by gen'ral laws:
Th' exceptions few; some change since all began;
And what created perfect?"—Why then man?
If the great end be human happiness,
Then Nature deviates; and can man do less?
As much that end a constant course requires
Of show'rs and sunshine, as of man's desires:
As much eternal springs and cloudless skies,
As men forever temp'rate, calm, and wise.
If plagues or earthquakes break not Heav'n's design,
Why then a Borgia or a Catiline?
Who knows but he, whose hand the lightning-forms,
Why heaves old ocean, and who wings the storms,
Pours fierce ambition in a Caesar's mind,
Or turns young Ammon loose to scourge mankind?
From pride, from pride our very reas'ning springs;
Account for moral, as for natural things:
Why charge we Heav'n in those, in these acquit?
In both, to reason right is to submit.
 Better for us, perhaps, it might appear,
Were there all harmony, all virtue here;
That never air or ocean felt the wind;
That never passion discompos'd the mind.
But all subsists by elemental strife;
And passions are the elements of life.
The gen'ral order, since the whole began,

Is kept in Nature, and is kept in man.

6

What would this man? Now upward will he soar,
And little less than angel, would be more!
Now looking downwards, just as griev'd appears
To want the strength of bulls, the fur of bears.
Made for his use all creatures if he call,
Say what their use, had he the pow'rs of all?
Nature to these, without profusion, kind,
The proper organs, proper pow'rs assign'd;
Each seeming want compensated of course,
Here with degrees of swiftness, there of force:
All in exact proportion to the state;
Nothing to add, and nothing to abate;
Each beast, each insect happy in its own:
Is Heav'n unkind to man, and man alone?
Shall he alone, whom rational we call,
Be pleas'd with nothing, if not bless'd with all?
The bliss of man (could pride that blessing find),
Is not to act or think beyond mankind;
No powers of body or of soul to share,
But what his nature and his state can bear.
Why has not man a microscopic eye?
For this plain reason, man is not a fly.
Say what the use, were finer optics giv'n,
To inspect a mite, not comprehend the heav'n?
Or touch, if tremblingly alive all o'er,
To smart and agonize at every pore?
Or quick effluvia darting through the brain,
Die of a rose in aromatic pain?
If Nature thunder'd in his opening ears,
And stunn'd him with the music of the spheres,
How would he wish that Heav'n had left him still
The whisp'ring zephyr and the purling rill?
Who finds not Providence all good and wise,
Alike in what it gives, and what it denies?

7

Far as creation's ample range extends,
The scale of sensual, mental powers ascends.
Mark how it mounts to man's imperial race,
From the green myriads in the peopled grass;
What modes of sight betwixt each wide extreme,
The mole's dim curtain, and the lynx's beam:
Of smell, the headlong lioness between,
And hound sagacious on the tainted green:
Of hearing, from the life that fills the flood,
To that which warbles through the vernal wood:
The spider's touch how exquisitely fine!
Feels at each thread, and lives along the line:
In the nice bee, what sense so subtly true
From pois'nous herbs extracts the healing dew?
How instinct varies in the grov'ling swine,
Compar'd, half-reas'ning elephant, with thine!
'Twixt that and reason, what a nice barrier;
Forever sep'rate, yet forever near!
Remembrance and reflection, how ally'd;
What thin partitions sense from thought divide:
And middle natures, how they long to join,
Yet never pass th' insuperable line!
Without this just gradation, could they be

Subjected, these to those, or all to thee?
The pow'rs of all subdu'd by thee alone,
Is not thy reason all these pow'rs in one?
See, through this air, this ocean, and this earth,
All matter quick, and bursting into birth.
Above, how high progressive life may go!
Around, how wide! how deep extend below!
Vast Chain of Being! which from God began,
Natures ethereal, human, angel, man,
Beast, bird, fish, insect, what no eye can see,
No glass can reach; from infinite to thee,
From thee to nothing. On superior pow'rs
Were we to press, inferior might on ours:
Or in the full creation leave a void,
Where, one step broken, the great scale's destroy'd:
From Nature's chain whatever link you strike,
Tenth or ten thousandth, breaks the chain alike.
 And if each system in gradation roll
Alike essential to the amazing Whole,
The least confusion but in one, not all
That system only, but the Whole must fall.
Let earth unbalanc'd from her orbit fly,
Planets and suns run lawless through the sky;
Let ruling angels from their spheres be hurl'd,
Being on being wreck'd, and world on world;
Heav'n's whole foundations to their centre nod,
And Nature tremble to the throne of God!
All this dread Order break—for whom? for thee?
Vile worm!—Oh! madness! pride! impiety!

9

What if the foot, ordain'd the dust to tread,
Or hand, to toil, aspir'd to be the head?
What if the head, the eye, or ear repin'd
To serve mere engines to the ruling Mind?
Just as absurd for any part to claim
To be another in this gen'ral frame;
Just as absurd to mourn the tasks or pains
The great directing Mind of All ordains.
 All are but parts of one stupendous whole,
Whose body Nature is, and God the soul;
That, chang'd through all, and yet in all the same,
Great in the earth, as in th' ethereal frame,
Warms in the sun, refreshes in the breeze,
Glows in the stars, and blossoms in the trees,
Lives through all life, extends through all extent,
Spreads undivided, operates unspent;
Breathes in our soul, informs our mortal part,
As full, as perfect in a hair as heart;
As full, as perfect in vile man that mourns,
As the rapt seraph that adores and burns:
To him no high, no low, no great, no small;
He fills, he bounds, connects, and equals all.

10

Cease then, nor Order imperfection name:
Our proper bliss depends on what we blame.
Know thy own point: this kind, this due degree
Of blindness, weakness, Heav'n bestows on thee.
Submit: in this or any other sphere,
Secure to be as blest as thou canst bear;
Safe in the hand of one disposing Pow'r

Or in the natal, or the mortal hour.
All Nature is but art unknown to thee;
All chance, direction which thou canst not see;
All discord, harmony not understood;
All partial evil universal good;
And, spite of pride, in erring reason's spite,
One truth is clear, *whatever is, is right.*

Epistle II

1

Know then thyself, presume not God to scan:
The proper study of mankind is Man.
Plac'd on this isthmus of a middle state,
A being darkly wise and rudely great:
With too much knowledge for the skeptic side,
With too much weakness for the Stoic's pride,
He hangs between; in doubt to act, or rest;
In doubt to deem himself a god or beast;
In doubt his mind or body to prefer;
Born but to die, and reas'ning but to err;
Alike in ignorance, his reason such,
Whether he thinks too little or too much:
Chaos of thought and passion, all confus'd;
Still by himself abus'd, or disabus'd;
Created half to rise, and half to fall;
Great lord of all things, yet a prey to all;
Sole judge of truth, in endless error hurl'd;
The glory, jest, and riddle of the world!

2

Two principles in human nature reign;
Self-love to urge, and reason to restrain;
Nor this a good, nor that a bad we call,
Each works its end to move or govern all:
And to their proper operation still
Ascribe all good; to their improper, ill.
 Self-love, the spring of motion, acts the soul;
Reason's comparing balance rules the whole.
Man, but for that, no action could attend,
And, but for this, were active to no end:
Fix'd like a plant on his peculiar spot,
To draw nutrition, propagate, and rot;
Or, meteor-like, flame lawless thro' the void,
Destroying others, by himself destroyed.
 Most strength the moving principle requires;
Active its task, it prompts, impels, inspires.
Sedate and quiet, the comparing lies,
Form'd but to check, deliberate, and advise.
Self-love still stronger, as its objects nigh;
Reason's at distance and in prospect lie:
That sees immediate good by present sense;
Reason, the future and the consequence.
Thicker than arguments, temptations throng,
At best more watchful this, but that more strong.
The action of the stronger to suspend,
Reason still use, to reason still attend.
Attention, habit and experience gains;
Each strengthens reason, and self-love restrains ...

5

Vice is a monster of so frightful mien,
As to be hated needs but to be seen;
Yet seen too oft, familiar with her face,
We first endure, then pity, them embrace:
But where the extreme of vice was ne'er agreed:
Ask where's the north? at York, 'tis on the Tweed;
In Scotland, at the Orcades; and there,
At Greenland, Zembla, or the Lord knows where.
No creature owns it in the first degree,
But thinks his neighbour farther gone than he;
Even those who dwell beneath its very zone,
Or never feel the rage, or never own;
What happier natures shrink at with affright
The hard inhabitant contends is right.
 Virtuous and vicious every man must be;
Few in the extreme, but all in the degree:
The rogue and fool by fits is fair and wise;
And ev'n the best, by fits, what they despise.
'T is but by parts we follow good or ill;
For, vice or virtue, self directs it still;
Each individual seeks a sev'ral goal;
But Heav'n's great view is one, and that the whole...

Epistle III

1

Here then we rest: "The Universal Cause
Acts to one end, but acts by various laws."
In all the madness of superfluous health,
The trim of pride, the impudence of wealth,
Let this great truth be present night and day:
But most be present, if we preach or pray.
 Look round our world, behold the chain of love
Combining all below and all above.
See plastic Nature working to this end:
The single atoms each to other tend;
Attract, attracted to, the next in place
Form'd and impell'd its neighbour to embrace.
See matter next with various life endu'd,
Press to one centre still, the gen'ral good.
See dying vegetables life sustain,
See life dissolving vegetate again:
All forms that perish other forms supply,
(By turns we catch the vital breath, and die.)
Like bubbles on the sea of matter borne,
They rise, they break, and to that sea return.
Nothing is foreign; parts relate to whole;
One all-extending, all-preserving soul
Connects each being, greatest with the least;
Made beast in aid of man, and man of beast;
All serv'd, all serving: nothing stands alone;
The chain holds on, and where it ends, unknown ...

CHAPTER TWELVE

THE ENLIGHTENMENT

The 18th century was an age of change and revolution in some areas and prosperous stability in others. The idea of the absolute monarch was challenged—though with varying degrees of success. The middle class rose to demand its place in society, while humanitarianism—social philosophy in action—attempted to make a place for all classes in the social scheme. Knowledge, for the *philosophes*, was a transcendent and universal goal. The aristocracy found itself in decline, and the rococo style reflected its increasing superficiality. The pendulum then swung back from refinement and artifice to intellectual seriousness, at least for a while. The structural clarity of classicism returned in painting, sculpture, and architecture, and above all in music, which culminated in a remarkable century, with works of emotional depth and formal inventiveness. The cult of "sensibility" with which the century closed presaged the Romantic upheavals of "*Sturm und Drang*" that were shortly to come.

12.1 Jean-Honoré Fragonard, *The Swing*, c.1768–9. Oil on canvas, 32 × 25½ ins (83 × 66 cm). Wallace Collection, London.

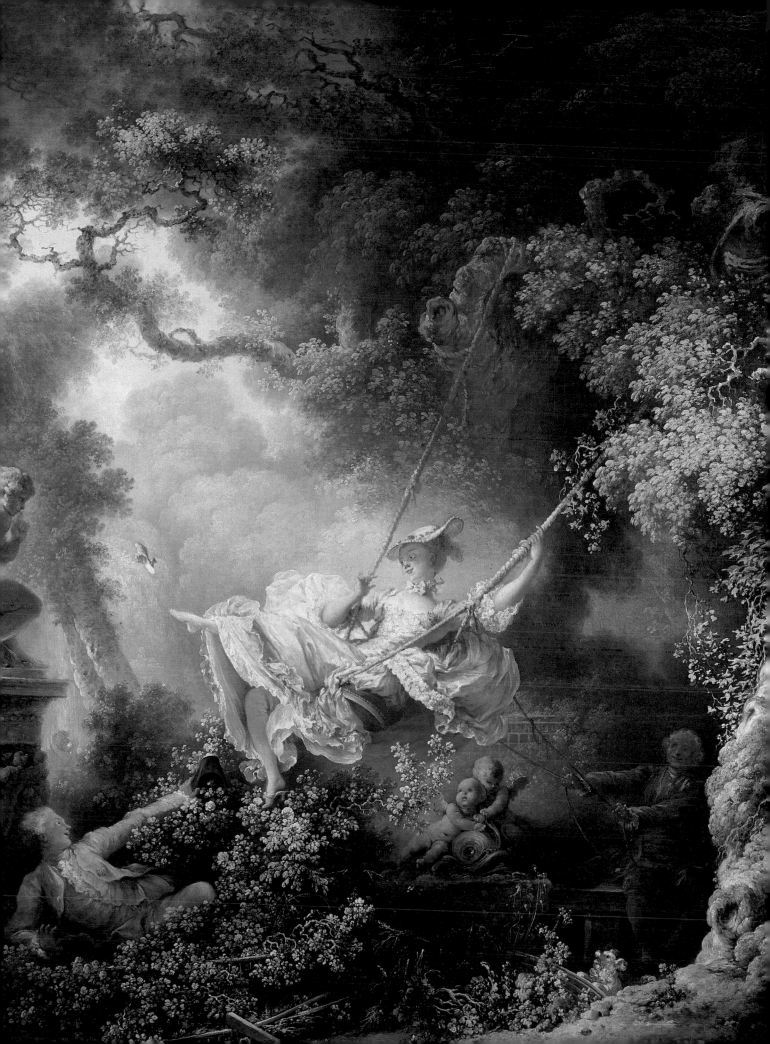

CONTEXTS AND CONCEPTS

The 18th century has often been called the "Age of Enlightenement." Century marks, however, are arbitrary boundaries that tell us very little about history or art. Styles, philosophies, and politics come and go for a variety of reasons. We have already pushed half-way through the 18th century in some areas, without encountering any natural barriers—J. S. Bach, for example, lived and worked until 1750. The best we can say, then, is that 18th-century enlightenment grew out of various 17th-century ideas that fell on more or less fertile soil at different times in different places.

Seventeenth- and 18th-century thought held that people were rational beings in a universe governed by some systematic natural law. Some believed that law to be an extension of God's law. Others held that natural law stood by itself. Natural law was extended to include international law, and accords were formulated in which sovereign nations, bound by no higher authority, could work together for a common good.

Faith in science, in human rights arising from the natural law, in human reason, and in progress, were touchstones of 18th-century thought. The idea of progress was based on the assumption that the conditions of life could only improve with time and that each generation made life even better for those following. Some scholars—the "ancients"—held that the works of the Greeks and Romans had never been surpassed. Others—the "moderns"—held that science, art, literature, and the inventions of their own age were better since they were built upon the achievements of their predecessors.

Enlightenment, reason, and progress are secular ideas, and the age became increasingly secular. Politics and business superseded religion, wresting leadership away from the Church—of whatever denomination. Toleration increased. Persecution and the imposition of corporal punishment for religious, political, or criminal offenses became less common as the era progressed, particularly in Germany and Austria.

The rapid increase in scientific discovery that followed Newton's work resulted in the development of new disciplines. Physics, astronomy, and mathematics remained primary, but fragmented inquiry was replaced by quiet categorizing. The vast body of information gathered during the late Renaissance period needed codification. The new sciences of mineralogy, botany, and zoology developed. First came classification of fossils, then classification of rocks, minerals, and plants. Linnaeus, the botanist, and Buffon, the zoologist, were pioneers in their fields. Chemistry struggled under the burden of mistaken theories of combustion until the Frenchman Lavoisier correctly explained the process. In addition, he isolated hydrogen and oxygen as the two component elements of water, and he also postulated that although matter may alter its state, its mass always remains the same.

TECHNOLOGY

Science went hand in hand with technology. Telescopes and microscopes were improved. The barometer and the thermometer were invented, as were the air pump and the steam engine. By 1769, James Watt had patented a steam engine reliable enough to drive a machine. The invention of the steam engine gave rise to other machines, and paved the way for the Industrial Revolution at the end of the century.

The 17th and 18th centuries saw significant improvement in agricultural technology, as well. The technology for mechanized seed planting, developed in ancient Babylonia, had disappeared, and planting in Europe was done by hand until the 18th century when Jethro Tull invented the seed drill. Scientific observation also led to the implementation of the four-year system of crop rotation. The horseshoe was invented and the plow was greatly improved.

The use of coal fuel in place of charcoal to smelt iron revolutionized metallurgy in the early 18th century. Strong coke fuel tremendously increased the capacity of blast furnaces. Coke-smelted iron initially proved to be more impure than charcoal-smelted iron, but the puddling furnace solved that problem. Around 1740, Benjamin Huntsman invented the crucible melting and casting process. Using hard coke as fuel, it could achieve higher temperatures, and a greater blast could be gained using tall chimneys instead of the bellows. A new understanding of the properties of oxygen and chemical reagents made further advances possible. These improvements in metallurgy made possible the later use of iron and steel as structural elements, first in bridges and later in buildings. They also made possible the development of new machinery for the manufacture of yet other machinery, tools, and finely constructed hardware and instruments.

Scientific and medical inquiry in the 17th and 18th centuries created a demand for precise instruments. It is important to note here that new technology resulted from the demand created by inquiry, and not the other way

	GENERAL EVENTS	LITERATURE & PHILOSOPHY	VISUAL ART	THEATRE & DANCE	MUSIC	ARCHITECTURE
1700	Humanitarianism Frederick I Louis XV		Watteau (12.5)	Colley Cibber Marivaux Beginnings of American theatre	Couperin	
1725	Herculaneum excavated Frederick II Maria Theresa of Austria Crucible steel process		Hogarth (12.7–8)	John Gay		De Cuvilliés (12.29) Knobelsdorff (12.35–38)
1750	Pompeii excavated Beginnings of Industrial Revolution Watt's steam engine Adam Smith George III of England	Johnson Rousseau Hume Kant Diderot Voltaire Baumgarten Goldsmith Prévost Fielding Winckelmann Herder	Boucher (12.6) Chardin (12.10–11) Falconet (12.14) Gainsborough (12.9) Clodion (12.15) Fragonard (12.1)	Garrick Lessing Voltaire De Camargo Sallé Goldsmith Goldoni	C. P. E. Bach Haydn	Abbé Laugier Piranesi
1775	American Revolution First iron bridge—England French Revolution Louis XVI	Blake Paine Wollstonecraft	David (12.13) Houdon (12.16–17)	Goethe Sheridan Noverre Beaumarchais Royal Tyler Vigano Dauberval Didelot	Mozart	
1800					Beethoven	Jefferson (12.30–31)

12.2 Timeline of the 18th century.

around. A need for greater precision in observation and measurement led to the development of improved surveying, astronomical, and navigation instruments. The thermometer and the barometer were refined. Advances were also made in the skills and materials used in the manufacture of instruments, resulting in greater specialization and the creation of craft shops. These included advances in making optical glass which, in turn, led to the development of lenses for use in telescopes and compound microscopes.

Improvements in precision tooling affected clock-making and tools such as the lathe. The introduction of cams and templates allowed even greater accuracy and intricacy in production. An instrument called the dividing engine made it possible to graduate a circle by mechanical means, and to graduate scales on surveying and navigational instruments accurately.

The field of engineering in the 17th and 18th centuries saw advances in hydraulics, road building, and bridge construction. The control of water flow in canals was aided by the development of an extremely accurate bubble-tube leveling device. The surveyor's level with a telescopic sight was another productive invention. Bridge building was improved by modifications to the construction of pier foundations. The first iron bridge was erected at Coalbrookdale, England, in 1779.

The introduction of power machinery revolutionized the English textile industry in the late 18th century. But the steam engine was undoubtedly the most significant invention of the period. In replacing human, animal, wind, and water power with machine power, it changed the course of history. The first full-scale steam engine had been developed in England in 1699, and early steam engines were used to drain mine shafts. By the middle of the 18th century, some wealthy people were using steam engines to pump domestic water supplies. James Watt's invention of the separate condenser in 1769 brought steam engines to new levels of practicality and productivity. Further modifications primed the engine for its role as cornerstone of the Industrial Revolution. In 1800, when the patent for Watt's engine expired, new high-pressure steam engines were applied to a variety of tasks, most notably in the first successful steam locomotive in 1804. By 1820, the steam engine could generate an estimated 1000 horsepower, and the Industrial Revolution was at hand.

PHILOSOPHY

To understand the philosophy of the 18th century, we must retrace our steps to the Middle Ages. In the Medieval period, philosophy was closely linked with theology. Descartes (1596–1650) had peeled philosophy away from theology, and allied it with the natural sciences and mathematics. Reason was supreme, and Descartes called for rejection of all that could not be proved. Descartes' philosophy is known as "Cartesianism," and it is based on the contention that human reason can solve every problem the mind can entertain.

Late in the 17th century John Locke (1632–1704) challenged the Cartesian idea that knowledge stemmed from the intellect. Locke argued that knowledge derives first from the senses. He redirected philosophical energies from the vast metaphysical systems of pure rationalism to a more practical, earthbound sphere. Locke's philosophy was grounded in reason, but because he stressed sensations and experience as the primary sources of knowledge, he is known as a "sensualist" or an "empiricist."

Empiricism became the predominant philosophy of the late 18th century, although it was not without its critics. Locke's approach formed the basis for the later philosophical thought of Hume and Kant. David Hume (1711–76), a Scotsman, differed from Locke in his assertions that the mind is incapable of building up knowledge from sensations, and that the world we live in consists only of probabilities. Hume maintained that not only philosophy, but also natural science, existed in a cloud of doubt. Mathematics was the only true and valid science.

Hume was not the only skeptic of the age, and his philosophy might have been disregarded, were it not for the German philosopher Immanuel Kant (1724–1804). Kant's major contribution to late 18th-century thought was his distinction between science and philosophy and his attribution to each of separate functions and techniques. For Kant, science was concerned with the phenomenal world, or the world of appearances, which it describes by general propositions and laws. Science must not go beyond the world of appearances to concern itself with the reality beyond. That reality, the "noumenal" world, is the realm of philosophy. Kant's division of science and philosophy succeeded in giving a much-needed assurance to both philosophy and science, allowing both to move forward.

THE PHILOSOPHES

The Enlightenment was concerned with more than philosophy and invention. Enlightened thought led to an active desire, called HUMANITARIANISM, to raise the downtrodden from the low social circumstances into which ignorance and tyranny had cast them. All men and women had a right, as rational creatures, to dignity and happiness. This desire to elevate the social circumstances of all people led to an examination and questioning of political, judicial, economic, and ecclesiastical institutions.

The ideas of the Enlightenment spread largely through the efforts of the *philosophes*. Although this term suggests philosophy, the *philosophes* were not philosophers in the usual sense of the word. Rather, they were popularizers, or publicists. They were men of letters who culled thought from great books and translated it into simple terms that could be understood by a reading public. In France, the most serious of all the *philosophe*

enterprises was the *Encyclopedia*, edited by Denis Diderot. The 17-volume *Encyclopedia*, which took 21 years (1751–72) to complete, was a compendium of scientific, technical, and historical knowledge, incorporating a good deal of social criticism. Voltaire, Montesquieu, and Rousseau were among its contributors.

Immediately following the Glorious Revolution in England of 1688, John Locke wrote several treatises on government, asserting that the power of a nation came from its people as a whole. In a social contract between government and people, the people had the right to withdraw their support from the government whenever it used its power against the general will.

No *philosophe* undertook such a vocal or universal attack on contemporary institutions as Voltaire. Voltaire (1697–1778; his name was originally François-Marie Arouet) took Locke's ideas to France, and extolled them. It is easy to see Voltaire as an aggressive, churlish skeptic, who had nothing positive to offer as a substitute for the ills he found everywhere. In fact, his championship of deism contributed greatly to improved religious toleration. His stinging wit broadened awareness of and reaction to witch-burnings, torture, and other such abuses of human rights. Without question, his popularizing of knowledge and his broad program of social reform helped to bring about the French Revolution, which cast out the old absolutist order once and for all.

Another influential figure in the mid-18th century was Jean-Jacques Rousseau (1712–72). Rousseau propounded a theory of government so purely rationalistic that it had no connection whatever with the experience of history. To Rousseau, human beings were essentially unhappy, feeble, frustrated, and trapped in a social environment of their own making. He believed people could be happy and free only in a "state of nature," or, at most, in a small and simple community. Such a philosophy stands completely in contrast to that of Diderot, who held that only accumulated knowledge would liberate humanity.

Indeed, it was an age of contrasts. Rousseau was an anarchist, and did not believe in government of any kind. He wrote on politics, therefore, not because he was trying to improve government, but because he lived in an age of political speculation and believed he had the power to deal with every problem. His *Social Contract* (1762) was utterly rationalistic. It reasserted Locke's propositions about the social contract, sovereignty of the people, and the right of revolution. More importantly, he took Locke's concept of primitive humanity and converted such people into "noble savages" who had been subjected to progressive degradation by an advancing civilization. In an age turning to rational, intellectual classicism, Rousseau sowed the seeds of Romanticism, which were to flower in the next century. He also sounded the call for revolution: the opening sentence of the *Social Contract* reads, "Man is born free and everywhere he is in chains," a thought that predates Karl Marx by about 100 years.

12.3 Europe in the 18th century.

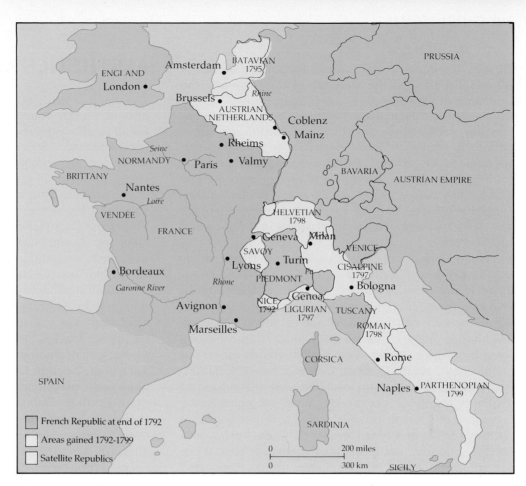

PRUSSIA

ENGLAND
London •
Amsterdam
BATAVIAN 1795
Rhine
Brussels •
AUSTRIAN NETHERLANDS
Coblenz
Mainz
Seine
NORMANDY
• Rheims
Paris •
• Valmy
BAVARIA
AUSTRIAN EMPIRE
BRITTANY
Nantes •
Loire
VENDÉE
FRANCE
HELVETIAN 1798
• Geneva
Milan
SAVOY
VENICE
Lyons •
• Turin
CISALPINE 1797
PIEDMONT
Po
• Bordeaux
Rhone
• Bologna
Garonne River
NICE 1792
Genoa •
LIGURIAN 1797
TUSCANY
Avignon •
ROMAN 1798
Marseilles •
• Rome
CORSICA
SPAIN
Naples •
PARTHENOPIAN 1799
SARDINIA

☐ French Republic at end of 1792
☐ Areas gained 1792-1799
☐ Satellite Republics

0 ——— 200 miles
0 ——— 300 km
SICILY

12.4 America in the 18th century.

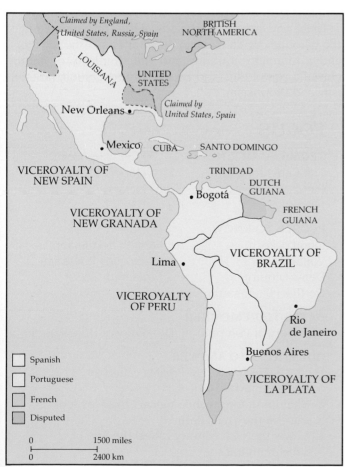

Claimed by England, United States, Russia, Spain

BRITISH NORTH AMERICA

LOUISIANA

UNITED STATES

New Orleans •

Claimed by United States, Spain

• Mexico CUBA SANTO DOMINGO

VICEROYALTY OF NEW SPAIN

TRINIDAD

DUTCH GUIANA

• Bogotá

FRENCH GUIANA

VICEROYALTY OF NEW GRANADA

Lima •

VICEROYALTY OF BRAZIL

VICEROYALTY OF PERU

Rio de Janeiro •

Buenos Aires •

VICEROYALTY OF LA PLATA

☐ Spanish
☐ Portuguese
☐ French
☐ Disputed

0 ——— 1500 miles
0 ——— 2400 km

ECONOMICS AND POLITICS

The same spirit of challenge and questioning was also applied to economics. Critics of mercantilistic government regulation and control were called "physiocrats," from the Greek *physis*, meaning "nature," because they saw nature as the single source of all wealth. Agriculture, forestry, and mining were of greater importance than manufacturing. Physiocratic theory also advocated a *laissez-faire* approach to economic endeavor. In other words, physiocrats believed that production and distribution were best handled without government interference. Government supervision should be abandoned so that nature and enterprising individuals could co-operate in the production of the greatest possible wealth. General physiocratic ideas were refined and codified in Adam Smith's *Wealth of Nations* (1776). Smith (1723–90), a Scotsman, argued that the basic factor in production was human labor (rather than nature). He believed that enlightened self-interest, without government intervention, would be sufficient to inspire individuals to produce wealth on an unheard-of scale.

On the political scene, the German states were in turmoil and flux in the 18th century. In 1701, Frederick I became King *in* Prussia (the word "in" rather than "of" was used to placate Poland, which occupied West Prussia). Frederick's major political stronghold lay in a small area called Brandenburg. However, Frederick's family, the Hohenzollern, soon came to dominate the whole of

197

Prussia. Frederick's son, King Frederick William I (1713–40), perfected the structure of the army and the German civil service.

Frederick William was a notable eccentric. For example, anyone he suspected of having wealth was compelled to build a fine residence to improve the appearance of his city. He also had a craze for tall soldiers, whom he recruited from all over Europe, thereby making his palace guard a cadre of coddled giants. Frederick William's son, who would become Frederick II (the Great), was given a rigorous training in the army and civil service.

When Frederick the Great assumed the throne on his father's death in 1740, he brought to it a detailed knowledge of the Prussian service, together with an intense love of arts and literature. He was a person of immense ambition, and he turned his sights very quickly on neighboring Austria. Austria's House of Hapsburg was ruled by Charles VI, who died in 1740. His daughter, the Archduchess Maria Theresa, became ruler of all the Hapsburg territories, many of which were the subject of disputed claims of possession. Smelling opportunity, Frederick the Great promptly marched into Austrian territory. A tug-of-war-and-peace between Austria and Prussia followed. Both countries emerged from these hostilities strong and socially stable, and both became centers of artistic, literary, and intellectual activity in the second half of the 18th century.

Frederick the Great was an "enlightened" and humanitarian ruler, a "benevolent despot." He championed thinkers throughout Europe and reformed German institutions so that they were better able to render service to all classes of society, especially the poor and oppressed (in strong contrast to Louis XV and XVI of France). When he died in 1786, he left behind a strong and renowned country.

In Austria under the Hapsburgs, too, constant warfare did not interfere with internal order and enlightened reform. Maria Theresa's husband became Emperor Francis I in 1745. He was followed, in 1765, by their son, Joseph II. Ruling jointly with his mother from 1765 to 1780 and alone until his death in 1790, Joseph II was also an enlightened monarch. He unified and centralized the Hapsburg dominions and brought Austria into line with the economic and intellectual conditions of the day.

Meanwhile, in England, King George III (1760–1820), and in France, Louis XV (1715–74) and his grandson, Louis XVI, along with his wife, Marie Antoinette (1774–89), saw revolution overtake their colonies or their country. The events and ramifications of the American Revolution are already familiar. The complexities of the French Revolution (1789), which are beyond our scope here, led from wars throughout Europe and a second revolution in 1792, through an "Emergency Republic," the "Terror," the Directory, Napoleon's *coup d'état* in 1799, to a new and politically explosive century in Europe.

AESTHETICS AND CLASSICISM

The death of Louis XIV in 1715 brought to a close a magnificent French courtly tradition that had championed baroque art (although the German baroque continued well into the 18th century). The French court and aristocracy moved to more modest surroundings, to intimate, elegant townhouses and salons, a milieu entirely different from the vastness and opulence of the Palace of Versailles. Charm, manners, and finesse replaced previous standards of social behavior. Enlightenment society sought refinement of detail and décor, and delicacy in everything. "Sociability" became the credo of early 18th-century France and the rest of Europe.

Classical influences dating from the Renaissance continued to be important, principally because a "classical education" was considered essential for all members of the upper classes. The excavation of the ruins of the Roman city of Pompeii virtually intact in 1748 caused a wave of excitement. The ancient city of Herculaneum had been partly excavated in 1738. Amid this revived interest came Gottlieb Baumgarten's significant book, *Aesthetica* (1750–58). For the first time the word "aesthetics" was used to mean "the study of beauty and theory of art." Then, in 1764, came Johann Winckelmann's *History of Ancient Art*, in which the author described the essential qualities of Greek art as "a noble simplicity and tranquil loftiness . . . a beautiful proportion, order, and harmony."

These values brought the arts of the 18th century out of the baroque era. Herculaneum, Pompeii, aesthetic theory, and a return to antiquity and the simplicity of nature, closed a century marked by war and revolution, rationalism, and skepticism.

FOCUS

TERMS TO DEFINE

The Enlightenment	Encyclopedia
Cartesianism	Physiocrats
Philosophes	

PEOPLE TO KNOW

John Locke	Johann Winckelmann
Voltaire	Jean-Jacques Rousseau
Denis Diderot	Adam Smith
Gottlieb Baumgarten	Immanuel Kant

DATES TO REMEMBER

Discovery of Pompeii	Discovery of Herculaneum

QUESTIONS TO ANSWER

1 Why is Frederick II of Prussia called an "enlightened despot"?
2 What important technological advances took place in the 18th century?
3 Why is the 18th century called the Age of Enlightenment?

THE ARTS
OF THE ENLIGHTENMENT

TWO-DIMENSIONAL ART
Rococo

The change from the splendor of courtly life to the style of the small salon and intimate townhouse was reflected in a new style of painting called "rococo." Often rococo is described as an inconsequential version of baroque. There is justification for such a description. Some paintings of this style display fussy detail, complex composition, and a certain superficiality. To dismiss early 18th-century work thus would be wrong, however.

Rococo was a product of its time. It is essentially decorative and nonfunctional, like the declining aristocracy it represented. Its intimate grace, charm, and delicate superficiality reflect the social ideals and manners of the age. Informality replaced formality in life and in painting. The heavy academic character of the

baroque of Louis XIV was found lacking in feeling and sensitivity. Its scale and grandeur were simply too ponderous. Deeply dramatic action was now transmuted into lively effervescence and melodrama. Love, friendship, sentiment, pleasure, and sincerity became predominant themes. None of these characteristics conflicts significantly with the overall tone of the Enlightenment, whose major goal was refinement. The arts of the period could dignify the human spirit through social and moral consciousness as well as through the graceful sentiments of friendship and love. Delicacy and informality did not have to imply limp or empty sentimentality.

The rococo paintings of Antoine Watteau (1683–1721) are representative of many of the changing values of the aristocracy. Watteau's work is largely sentimental, but it is not particularly frivolous. *Embarkation for Cythera* (Fig. **12.5**) idealizes the social graces of the high-born classes.

12.5 Antoine Watteau, *Embarkation for Cythera*, 1717. Oil on canvas, 4 ft 3 ins × 6 ft 4½ ins (1.29 × 1.94 m). Louvre, Paris.

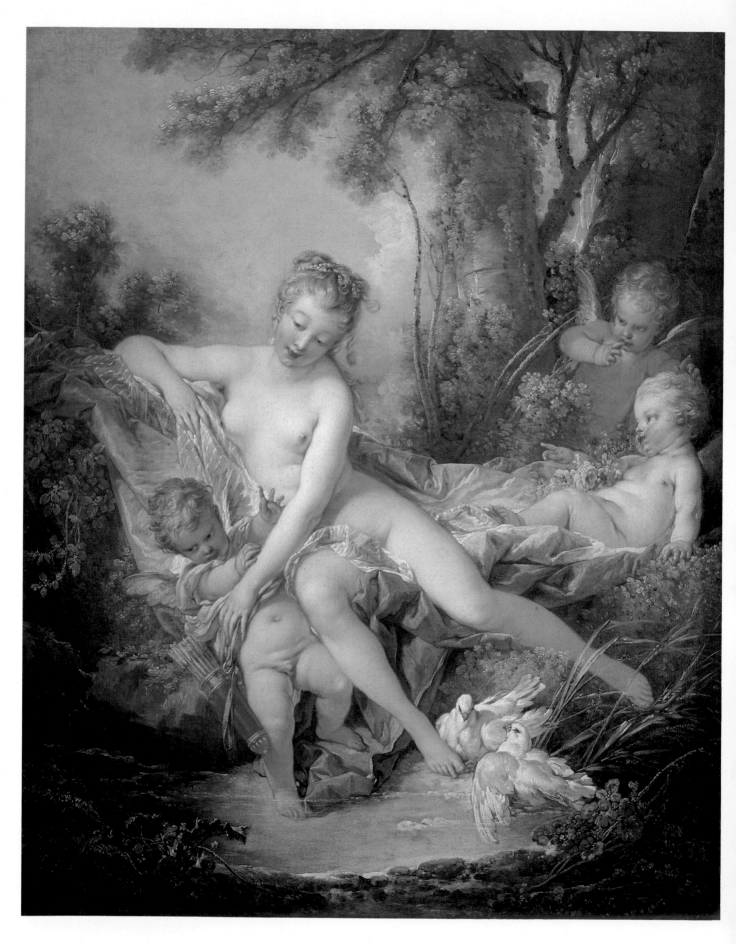

Cythera is a mythological land of enchantment, the island of Venus, and Watteau portrays aristocrats idling away their time in amorous pursuits as they wait to leave for that faraway place.

Soft color areas and hazy atmosphere add the qualities of fantasy to the landscape. An undulating line underscores the human figures, all posed in slightly affected attitudes. Each group of doll-like couples engages in graceful conversation and amorous games. An armless bust of Venus presides over the delicate scene. Watteau's fussy details and decorative treatment of clothing contrast with the diffused quality of the background. But underlying this fantasy is a deep, poetic melancholy.

The slightly later work of François Boucher (1703–70) continues in the rococo tradition. His work even more fully exemplifies the decorative, mundane, and somewhat erotic painting popular in the early and mid-18th century. As a protégé of Madame de Pompadour, the mistress of King Louis XV, Boucher enjoyed great popularity. His work has a highly decorative surface detail and portrays pastoral and mythological settings such as *Venus Consoling Love* (Fig. **12.6**). Boucher's figures almost always appear amidst exquisitely detailed drapery. His technique is nearly flawless, and, with his painterly virtuosity, he creates fussily pretty works, the subjects of which compete with their decorative backgrounds for attention. Compared with the power, sweep, and grandeur of baroque painting, Boucher's work is gentle and shallow. Here, each of the intricate and delicate details takes on a separate focus of its own and leads the eye in a disorderly fashion first in one direction and then another.

Characteristic of later Rococo style, *The Swing* (Fig. **12.1**) by Jean-Honoré Fragonard (1732–1806) is an "intrigue" picture. A young gentleman has enticed an unsuspecting old cleric to swing the gentleman's sweetheart higher and higher so that he, strategically placed, can catch a glimpse of her exposed limbs. The young lady, perfectly aware of his trick, gladly joins in the game, kicking off her shoe toward the statue of the god of discretion, who holds his finger to his lips in an admonishment of silence. The scene is one of frivolous naughtiness and sensuality, with lush foliage, foaming petticoats, and luxurious colors.

Humanitarianism and Hogarth

The aristocratic frivolity of rococo style was heavily counterbalanced by the biting satire and social comment of enlightened humanitarians such as William Hogarth (1697–1764). In England during the 1730s, Hogarth portrayed dramatic scenes on moral subjects. His *Rake's Progress* and *Harlot's Progress* series are attempts to correct raging social ills and to instil solid middle-class values.

12.6 (opposite) François Boucher, *Venus Consoling Love*, 1751. Oil on canvas, 3 ft 6⅛ ins × 2 ft 9¾ ins (107 × 85 cm). National Gallery of Art, Washington DC (Chester Dale Collection).

12.7 William Hogarth, *The Harlot's Progress: Arrival in London*, 1731. Engraving. The Metropolitan Museum of Art, New York (Harris Brisbane Dick Fund, 1932).

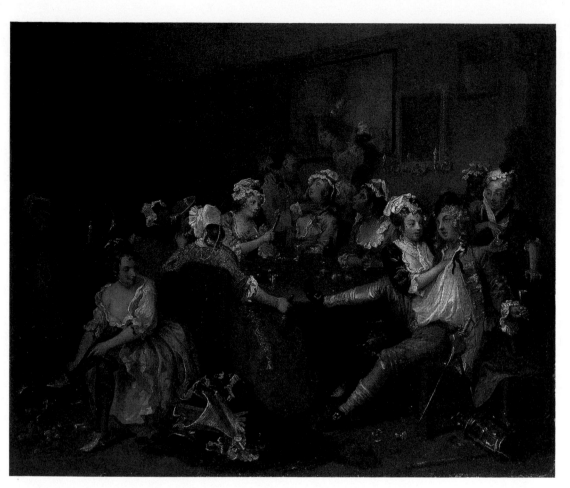

12.8 William Hogarth, *The Rake's Progress: The Orgy*, 1733–34. Oil on canvas, 24½ × 29½ ins (62.2 × 75 cm). By Courtesy of the Trustees of Sir John Soane's Museum, London.

Hogarth attacked the foppery of the aristocracy, drunkenness, and social cruelty. In the *Harlot's Progress* series (Fig. **12.7**), the prostitute is a victim of circumstances. She arrives in London, her employer seduces her, and she ends up in Bridewell Prison. Hogarth blames her final fate more on human cruelty than on her sins. The same may be said of the *Rake's Progress*, which, in a series of six tableaux, portrays the downfall of a foolish young man from comfortable circumstances. This series moves through several views of the young man as he sinks lower and lower into corruption (Fig. **12.8**) until he ends up in the Bedlam insane asylum.

Hogarth's criticism of social conditions is clear in his paintings, intended as an incitement to action, a purpose characteristic of 18th-century humanitarians. The fact that his paintings were made into engravings and widely sold as prints to the public illustrates just how popular were attacks on the social institutions of the day.

Landscape and portraiture

The popularity of portraiture and landscape also increased in the 18th century. One of the most influential English painters of the time was Thomas Gainsborough (1727–88). His landscapes bridge the gap between the baroque and Romantic styles, and his portraits exhibit sensitive elegance. Gainsborough's full-length portraits of lords and ladies have a unique freshness and lyric grace. Occasionally art critics object to the lack of structure in his attenuated, almost weightless figures; however, such objections fade away when confronted by the beauty of Gainsborough's color and the delicacy of his touch. His landscapes reveal a freshness typically associated with the English approach to painting.[1]

In *The Market Cart* (Fig. **12.9**), we find a delicate use of WASH reminiscent of Watteau. Here the painter explores tonalities and shapes that express a deep and almost mystical response to nature. Although the subject is pastoral, the composition has an unusual energy that derives from its diagonal composition. The tree forms on the right border are twisted and gnarled: the foremost tree leads the viewer's eye up and to the left, to be caught by the downward circling line of the trees and clouds in the background and returned on the diagonal. The human figures in the picture are not of particular interest. They are warmly rendered, but not as individuals, and their forms remain indistinct. We see them, rather, as subordinate to the forces of nature which ebb and flow around and through them.

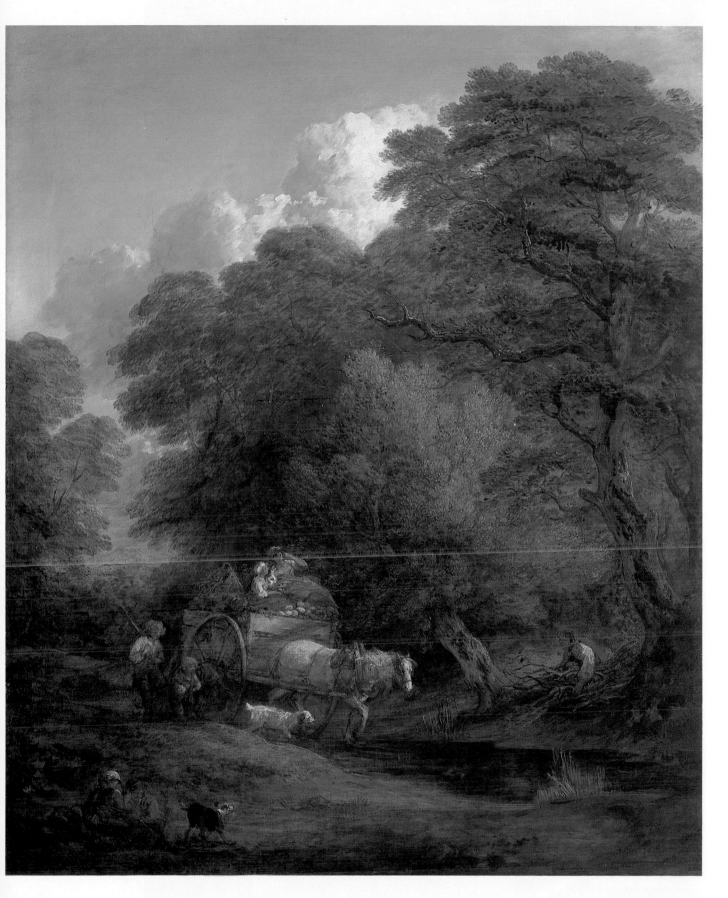

12.9 Thomas Gainsborough, *The Market Cart*, 1786–87. Oil on canvas, 6 ft ½ in × 5 ft ¼ in (1.84 × 1.53 m). The Tate Gallery, London.

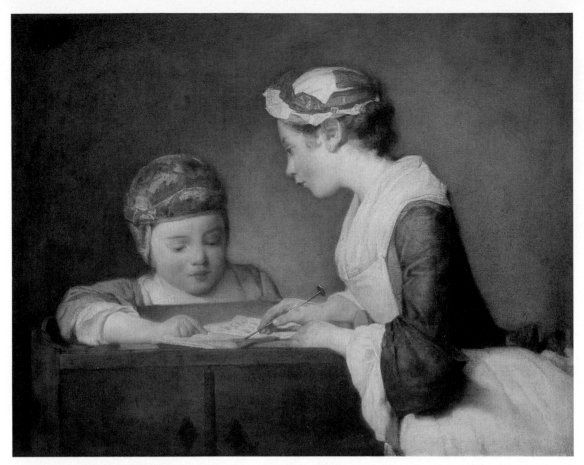

12.10 Jean-Baptiste Siméon Chardin, *The Young Governess*, c.1739. Oil on canvas, $22\frac{7}{8} \times 29\frac{1}{8}$ ins (58.3 × 74 cm). National Gallery of Art, Washington DC (Andrew W. Mellon Collection).

12.11 Jean-Baptiste Siméon Chardin, *Menu de Gras*, 1731. Oil on canvas, $13 \times 16\frac{1}{8}$ ins (33 × 41 cm). Louvre, Paris.

Genre

A fresh bourgeois flavor could be found in the mundane subjects of France's Jean-Baptiste Siméon Chardin (1699–1779) (Figs **12.10** and **12.11**). Chardin's paintings show an interest in the servants and life "below stairs" in well-to-do households. He was the finest still-life and genre painter of his time, and can be seen to continue the tradition of the Dutch masters of the previous century. His early works are almost exclusively still-lifes, and *Menu de Gras* (Fig. **12.11**) illustrates how everyday items could be raised to a level of unsuspected beauty.

The artist invests each item—cooking pot, ladle, pitcher, bottles, cork, a piece of meat, and other small things—with intense significance, as richness of texture and color combined with careful composition and the use of chiaroscuro make these humble items somehow noble. The eye moves slowly from point to point, carefully directed by shapes and angles, color and highlight. The work itself controls the speed at which we view it. Each new focus demands that we pause and savor its richness. Chardin urges us to look beneath our surface impressions of these objects into their deeper reality.

Neo-classicism

The discovery of the ruins of Pompeii, Winckelmann's interpretation of Greek classicism, Rousseau's "noble savage," and Baumgarten's aesthetics sent the interests of late-18th-century artists and thinkers back into antiquity, and in particular, into nature.

A principal proponent of neo-classicism in painting was Jacques-Louis David (1748–1825). His works illustrate the newly perceived grandeur of antiquity, and this is reflected in his subject matter, composition, and historical accuracy. Propagandist in tone—he sought to inspire French patriotism and democracy—his paintings have a strong, simple compositional unity. In both *The Death of Socrates* (Fig. **12.12**) and *The Oath of the Horatii* (Fig. **12.13**), David exploits his political ideas using Greek and Roman themes. In both cases, the subjects suggest a devotion to ideals so strong that one should be prepared to die in their defense. David's values are made dramatically clear by his sparse, simple composition.

The neo-classicism of David and others was, of course, not a simple matter of copying ancient works. Classical detail and principles were used selectively and frequently adapted to suit the artist's own purposes.

12.12 Jacques-Louis David, *The Death of Socrates*, 1787. Oil on canvas, 4 ft 3 ins × 6 ft 5¼ ins (1.29 × 1.96 m). The Metropolitan Museum of Art, New York (Wolfe Fund, 1931. Catherine Lorillard Wolfe Collection).

MASTERWORK
David—The Oath of the Horatii

David's famous painting, *The Oath of the Horatii* (Fig. **12.13**), was inspired by Corneille's play *Horace*. The subject is a conflict between love and patriotism. In legend, the leaders of the Roman and Alban armies, on the verge of battle, decide to resolve their conflicts by means of an organized combat between three representatives from each side. The three Horatius brothers represented Rome; the Curatius sons represented the Albans. A sister of the Horatii was the fiancée of one of the Curatius brothers. David's painting depicts the Horatii as they swear on their swords to win or die for Rome, disregarding the anguish of their sister.

The work captures a directness and an intensity of expression that were to play an important role in Romanticism. But the starkness of outline, the strong geometric composition (which juxtaposes straight line in the men and curved line in the women), and the smooth color areas and gradations hold it to the more formal, classical tradition.

The style of *The Oath of the Horatii* is academic neoclassicism. The scene takes place in a shallow picture box, defined by a severely simple architectural framework. The costumes are historically correct. The musculature, even the arms and legs of the women, has a surface devoid of warmth or softness, like the drapery.

It is ironic that David's work was admired and purchased by King Louis XVI, against whom David's revolutionary cries were directed and whom David, as a member of the French Revolutionary Convention, would sentence to death. David had a successful career. Neoclassicism as a painting style increased in popularity and continued beyond the Revolution through the Napoleonic era and into the 19th century.

12.13 Jacques-Louis David, *The Oath of the Horatii*, 1784–85. Oil on canvas, c.14 × 11 ft (4.27 × 3.35 m). Louvre, Paris.

SCULPTURE

Sculpture struggled as an art form in the 18th century. The Academy of Sculpture and the French Academy in Rome encouraged the copying of antique sculpture, and resisted any changes in style. Most sculpture thus continued in a derivative baroque style.

Rococo style did find expression in the sculpture of Falconet (1716–91) and Clodion (1738–1814). Their works feature decorative cupids and nymphs, motifs that recur in painting of this style. Venus appears frequently, often in the form of a thinly disguised prominent lady of the day. Madame de Pompadour, who epitomized love, charm, grace, and delicacy for the French, appears often as a subject in sculpture as well as in painting.

Rococo sculpture did not have the monumental scale of its predecessors. Rather, in the spirit of decoration that marked the era, sculpture often took the form of graceful porcelain and metal figurines. Falconet's *Madame de Pompadour as the Venus of the Doves* (Fig. **12.14**) fully captures the erotic sensuality, delicacy, lively intelligence, and charm of the rococo heritage. The unpretentious nudity indicates the complete comfort and naturalness the 18th century found in affairs of the flesh. Rococo techniques for conveying surface textures, detail, and line in sculpture display mastery of the medium. If this style, and the society it exemplifies, is found wanting in profundity, it must be admired for its technical achievement.

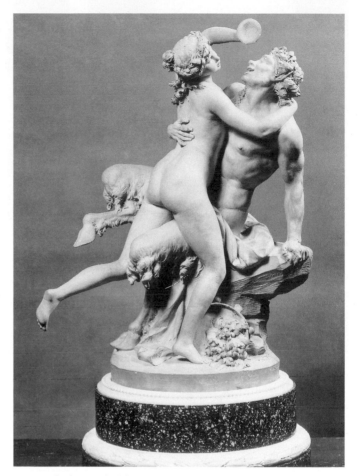

12.15 Clodion (Claude Michel), *Satyr and Bacchante*, c.1775. Terracotta, 23¼ ins (59 cm) high. The Metropolitan Museum of Art, New York (Bequest of Benjamin Altman, 1913).

12.14 Étienne-Maurice Falconet, *Madame de Pompadour as the Venus of the Doves*, 1782. Marble, 29½ ins (75 cm) high. National Gallery of Art, Washington DC (Samuel H. Kress Collection).

Claude Michel, known as Clodion, created dynamic miniatures such as the *Satyr and Bacchante* (Fig. **12.15**). "His groups of accurately modeled figures in erotic abandon are made all the fresher and more alluring by his knowing use of pinkish terracotta as if it were actually pulsating flesh, rendering each incipient embrace 'forever warm and still to be enjoyed'."[2]

During the years just prior to the French Revolution, Jean-Antoine Houdon (1741–1828) worked in a more serious vein. His portrait busts of children, such as those of Alexandre and Louise Brongniart (Figs **12.16** and **12.17**) show acute psychological observation as well as accurate technical execution. Houdon's works distill the personality of his subjects, and his busts of American revolutionary figures, such as Washington, Jefferson, John Paul Jones, and Benjamin Franklin, are revealing character portraits. Houdon's work seems to belong to the emerging 18th-century neo-classical style. The realism and truth that Houdon puts into his individual characters are much more akin to the ideals of neo-classicism than to those of the rococo.

Sculpture, like society in the 18th century, was in

12.16 (far left) Jean-Antoine Houdon, *Alexandre Brongniart*, 1777. Marble, 15¾ ins (39.2 cm) high. National Gallery of Art, Washington DC (Widener Collection).

12.17 Jean-Antoine Houdon, *Louise Brongniart*, 1777. Marble, 14⅛ ins (37.7 cm) high. National Gallery of Art, Washington DC (Widener Collection).

transition. Academically rooted in the baroque, yet attempting to reflect the age of the rococo and the aesthetic and antiquarian interests of the last third of the century, sculpture made little progress. That would come in the 19th century, with another stylistic shift.

LITERATURE

Among the numerous 18th-century literary figures stands one who used his talents in an interdisciplinary way. William Blake (1757–1827) published his poems by personally engraving them into copper plates along with his own illustrations. He then illuminated the pages with watercolors. He defied reason and detested the rationalism of the period, championing the emotions in an age of intellect and science.

Thomas Paine (1737–1809), on the other hand, turned his energies to writing pamphlets in support of the libertarian ideals of the times. An Englishman, he worked for the American movement toward independence, and later wrote the *Rights of Man* (1792), in support of the French Revolution. He was banished from England, imprisoned in France, and died in poverty in the United States. 1792 also saw the publication of *A Vindication of the Rights of Woman* by Paine's fellow British writer Wollstonecraft (1759–97). This well-argued treatise can be seen to mark the beginning of the feminist movement.

Goldsmith

Contemporary literature reflects the 18th-century focus on the commonplace that we saw in the genre paintings of the day. Common ordinary occurrences are frequently used as symbols of a higher reality. The work of Oliver Goldsmith (1730–74), the prominent English 18th-century poet and playwright, illustrates this quite clearly. Goldsmith grew up in the village of Lissoy, where his father was vicar, and the *Deserted Village*, written in 1770, describes the sights and personalities of Lissoy:

> Sweet Auburn! Loveliest village of the plain
> Where health and plenty cheered the laboring swain;
> Where smiling spring its earliest visit paid,
> And parting summer's lingering blooms delayed,
> Dear lovely bowers of innocence and ease,
> Seats of my youth, where every sport could please;
> How often have I loitered o'er thy green,
> Where humble happiness endeared each scene!

Goldsmith's portrait of the old village parson includes a lovely simile.

> To them his heart, his love, his griefs were given,
> But all his serious thoughts had rest in heaven.
> As some tall cliff that lifts its awful form,
> Swells from the vale, and midway leaves the storm,
> External sunshine settles on its head.

Finally, there is great tenderness in the way he describes his dream of ending his life amid the scenes in which it had begun.

> In all my wanderings round this world of care,
> In all my griefs—and God has given my share—
> I still had hopes, my latest hours to crown,
> Amid these humble bowers to lay me down,
> To husband out life's taper at the close,
> And keep the flame from wasting by repose. . . .
> And as an hare whom hounds and horns pursue,
> Pants to the place from which at first she flew,
> I still had hopes my long vexations past,
> Here to return—and die at home at last.

Johnson

The mid-18th century is often called the "Age of Johnson." Samuel Johnson (1709–84) began his literary career as a sort of odd-job journalist, writing for a newspaper. His principal achievement was as an essayist, and the 208 *Rambler* essays cover a huge variety of topics, including "Folly of Anger: Misery of a Peevish Old Age" and "Advantages of Mediocrity: an Eastern Fable." These essays promoted the glory of God and the writer's salvation.

In 1758, Johnson began the *Idler Essays*, a weekly contribution to a newspaper called the *Universal Chronicle*. In these essays we find the moralistic, reforming tone still present, but with an increasingly comic element.

THE IDLER
No. 22. Saturday, September 9, 1758

Many naturalists are of opinion, that the animals which we commonly consider as mute, have the power of imparting their thoughts to one another. That they can express general sensations is very certain; every being that can utter sounds, has a different voice for pleasure and for pain. The hound informs his fellows when he scents his game; the hen calls her chickens to their food by her cluck, and drives them from danger by her scream.

Birds have the greatest variety of notes; they have indeed a variety, which seems almost sufficient to make a speech adequate to the purposes of a life, which is regulated by instinct, and can admit little change or improvement. To the cries of birds, curiosity or superstition has been always attentive, many have studied the language of the feathered tribes, and some have boasted that they understood it.

The most skillful or most confident interpreters of the silvan dialogues have been commonly found among the philosophers of the East, in a country where the calmness of the air, and the mildness of the seasons, allow the student to pass a great part of the year in groves and bowers. But what may be done in one place by peculiar opportunities, may be performed in another by peculiar diligence. A shepherd of Bohemia has, by long abode in the forests, enabled himself to understand the voice of birds, at least he relates with great confidence a story of which the credibility may be considered by the learned.

"As I was sitting [said he] within a hollow rock, and watching my sheep that fed in the valley, I heard two vultures interchangeably crying on the summit of the cliff. Both voices were earnest and deliberate. My curiosity prevailed over my care of the flock; I climbed slowly and silently from crag to crag, concealed among the shrub, till I found a cavity where I might sit and listen without suffering, or giving disturbance.

"I soon perceived, that my labour would be well repaid; for an old vulture was sitting on a naked prominence, with her young about her, whom she was instructing in the arts of a vulture's life, and preparing, by the last lecture, for their final dismission to the mountains and the skies.

"'My children,' said the old vulture, 'you will the less want my instructions because you have had my practice before your eyes; you have seen me snatch from the farm the household fowl, you have seen me seize the leveret in the bush, and the kid in the pasture, you know how to fix your talons, and how to balance your flight when you are laden with your prey. But you remember the taste of more delicious food; I have often regaled you with the flesh of man.' 'Tell us,' said the young vultures, 'where man may be found, and how he may be known; his flesh is surely the natural food of a vulture. Why have you never brought a man in your talons to the nest?' 'He is too bulky,' said the mother; 'when we find a man, we can only tear away his flesh and leave his bones upon the ground.' 'Since man is so big,' said the young ones, 'how do you kill him? You are afraid of the wolf and of the bear, by what power are vultures superior to man, is man more defenseless than a sheep?' 'We have not the strength of man,' returned the mother, 'and I am sometimes in doubt whether we have the subtilty; and the vultures would seldom feast upon his flesh, had not nature, that devoted him to our uses, infused into him a strange ferocity, which I have never observed in any other being that feeds upon the earth. Two herds of men will often meet and shake the earth with noise, and fill the air with fire. When you hear noise and see fire which flashes along the ground, hasten to the place with your swiftest wing, for men are surely destroying one another; you will then find the ground smoking with blood and covered with carcasses, of which many are dismembered and mangled for the convenience of the vulture.' 'But when men have killed their prey,' said the pupils, 'why do they not eat it? When the wolf has killed a sheep he suffers not the vulture to touch it till he has satisfied himself. Is not man another kind of wolf?' 'Man,' said the mother, 'is the only beast who kills that which he does not devour, and this quality makes him so much a benefactor to our species.' 'If men kill our prey and lay it in our way,' said the young one, 'what need shall we have of labouring for ourselves?' 'Because man will, sometimes,' replied the mother, 'remain for a long time quiet in his den. The old vultures will tell you when you are to watch his motions. When you see men in great numbers moving close together, like a flight of storks, you may conclude that they are hunting, and that you will soon revel in human blood.' 'But still,' said the young one, 'I would gladly know the reason of this mutual slaughter. I could never kill what I could not eat.' 'My child,' said the mother, 'this is a question which I cannot answer, tho' I am reckoned the most subtle bird of the mountain. When I was young I used frequently to visit the ayry of an old vulture who dwelt upon the Carpathian rocks; he had made many observations; he knew the places that

afforded prey round his habitation, as far in every direction as the strongest wing can fly between the rising and setting of the summer sun; he had fed year after year on the entrails of men. His opinion was, that men had only the appearance of animal life, being really vegetables with a power of motion; and that as the boughs of an oak are dashed together by the storm, that swine may fatten upon the falling acorns, so men are by some unaccountable power driven one against another, till they lose their motion, that vultures may be fed. Others think they have observed something of contrivance and policy among these mischievous beings, and those that hover more closely round them, pretend, that there is, in every herd, one that gives directions to the rest, and seems to be more eminently delighted with a wide carnage. What it is that intitles him to such pre-eminence we know not; he is seldom the biggest or the swiftest, but he shews by his eagerness and diligence that he is, more than any of the others, a friend to vultures.'"[3]

The Pre-Romantics

The decline of the drama and the rise of the novel in the 18th century marked a significant shift in literature. Henry Fielding's life mirrored this transition as he moved from a distinguished career in the theatre—he had written about 25 plays, mostly satirical and topical comedies—to become a pre-eminent novelist. His first full novel, Joseph Andrews (1742), portrays one of the first memorable characters in English fiction—an idealistic and inconsistent hero who constantly falls into ridiculous adventures. Fielding called his novel a "comic prose epic," and it is remarkable for its structure as well as its humor and its satire. His most famous novel remains Tom Jones (1749), a splendid romp which ranks among the greatest works in English literature.

One of the most influential of the pre-Romantic writers in France was Jean-Jacques Rousseau. He placed a new emphasis on emotion rather than reason, on sympathy rather than rational understanding. Others included the novelists Horace Walpole and Mrs Radcliffe, who catered to the public taste for Gothic tales of dark castles and shining heroism in Medieval settings. The German Johann Gottfried von Herder (1744–1803) also contributed to the pre-Romantic movement. Herder's essays, German Way and German Art (1773), have been called the "manifesto of German Sturm und Drang" (storm and stress). In his greatest work, Ideas on the Philosophy of the History of Mankind (1784–91), he analyzed nationalism and prescribed a way of reviving "a national feeling through school, books, and newspapers using the national language."

The major thrust of Romanticism outlasted the 18th century and found full expression only in the 19th. By then, the various offshoots of Romanticism had permeated every aspect of society, as we shall see in the next chapter.

THEATRE

Despite the shift of interest to the novel, the 18th century saw the growth of a remarkable nationalism in the theatre. Britain, France, Germany, Italy, and the United States each contributed to the dramatic traditions of the 18th century.

Britain

Britain had preceded France in eliminating its absolute monarch. Restoration theatre represented a new style in the late 17th century, and it carried over into the 18th century. But now the character of British audiences was changing, and the theatre changed with it. Queen Anne did not care for the theatre, and George I, who was German and did not speak English well, could not understand it. Audiences in England increasingly tended to be made up of well-to-do middle-class tradespeople. One effect of this was the shift in emphasis of Restoration comedy toward sentiment. Witty dialogue persisted, and the works of Colley Cibber (1671–1757) are typical of British comedy at this time.

Clever plays delighted London audiences. The Non-Juror (1717) featured an English Catholic priest fomenting rebellion against the king. This fomented its own furor among the Catholic community while it earned Cibber the pleasure of the king. Cibber's final contribution to the theatre was a delightful and sharp-witted analysis of English acting called An Apology for the Life of Colley Cibber, Comedian . . . with an Historical View of the Stage during His Own Time (1740). English comedy closed the century in high style with the plays of Oliver Goldsmith (1730–74) and Richard Brinsley Sheridan (1751–1816). Goldsmith's works, especially She Stoops to Conquer (1773), exhibit excellent humor and exceptionally well-drawn characters. Sheridan, probably the most famous British playwright of the period, created two masterpieces, Rivals (1775) and the most brilliant comedy of the English stage, School for Scandal (1777), a biting satire with crisp, fast-paced dialogue.

Undoubtedly the most popular theatre form in early 18th-century London was the BALLAD OPERA. The best of these was unquestionably John Gay's Beggar's Opera (1728). The story caricatured a bribery scandal involving the British Prime Minister Sir Robert Walpole, and it created a social scandal. The Beggar's Opera was not the only theatrical piece to burlesque the corruption of Walpole, and as a result of these attacks, Walpole successfully convinced Parliament to institute the Licensing Act of 1737. This act limited legal theatrical production to three theatres, Drury Lane, Covent Garden, and Haymarket, and gave the Lord Chamberlain the right to censor any play.

Production style remained refined, however, and the theatre in London retained its elegant but intimate physical size and scale, in contrast to the mammoth opera

12.18 Joseph Jefferson and Francis Blissett in *The Budget of Blunders*, at the John Street Theatre, c.1796. Contemporary engraving. The New York Public Library.

Mr. JEFFERSON · Mr. BLISSETT.

in the Characters of Dr. Smugface & Dr. Dablancour in the Budget of Blunders.

houses that flourished elsewhere. The playing area consisted of a forestage, the sides of which contained doorways for entrances and exits by the actors. Above these were boxes for spectators. Wing and drop scenery—flat, painted pieces used strictly as background—was placed upstage, behind a proscenium arch. Lighting consisted of wax candles in chandeliers over the audience. As might be expected, fire was a constant danger, and smoke from the candles was an irritating nuisance.

The entire 18th century in Britain, and particularly the second half, was an age of actors rather than playwrights. The greatest of these—indeed the greatest theatre figure of this time—was David Garrick (1717–79). His genius significantly changed the style of British theatre, and that of America as well. Garrick began as an actor, attaining great fame after a sensational début performance in *Lethe; or Aesop in the Shades* (1740). He and his main rival Macklin changed the course of theatre history not only by their acting, but also by introducing antiquarian-inspired costume to the English stage. Macklin began by appearing in a costume described as "Old Caledonian habit," to which Garrick responded by playing King Lear in his own idea of "Old English" costume.

America

In colonial America, the arts, and the theatre especially, came up squarely against unbending Puritan austerity. Sometime between 1699 and 1702, however, Richard Hunter gained permission from the acting Governor of the Province of New York to present plays in the city of New York. In 1703, an English actor named Anthony Ashton landed at Charlestowne, South Carolina. He was "full of Lice, Shame, Poverty, Nakedness, and Hunger," and to survive became "Player and Poet." Eventually he found his way to New York where he spent the winter "acting, writing, courting, and fighting." Perhaps as a consequence, the Province forbade "play acting and other forms of disreputable entertainment" in 1709.

Notwithstanding this inauspicious start, American theatre struggled forward. The first recorded theatre was built in Williamsburg, Virginia, in 1716, and housed a performing company for the next several years. For the most part, theatre in America was merely an extension of the British stage, and English touring companies provided most of the fare. Theatres themselves appear to have been small and closely modeled upon provincial English theatres with their RAKED stages, proscenium arches, painted scenery, and apron forestages flanked by entrance doors. Four hundred seats seems to have been about average. The front curtain rose and fell at the beginning and end of each act, but the numerous scene changes within the acts were executed in full view of the audience.

Companies from London, usually comedy troupes, came to Williamsburg annually for an 11-month season. By 1766, touring British companies played the entire eastern seaboard from New York, Philadelphia, and Annapolis to Charleston. A milestone was passed on 24 April 1767 when the American Company, which was, in fact, British, presented Thomas Godfrey's *The Prince of Parthia*, the first play written by an American to receive a professional production. As the American Company

prepared for its 1774–75 season, the Continental Congress passed a resolution discouraging "exhibitions of shows, plays, and other expensive diversions and entertainments."

Numerous American plays were written during the years of the American Revolution, most of which were never performed. Their titles, however, reflect current thinking and the loyalist/rebel dichotomy—*The Americans Roused in a Cure for the Spleen* (1775), for example. Since there were no American professional actors, and since all the British professionals had fled back to England, the war years saw a flurry of amateur production throughout the colonies, including performances staged by the American troops themselves with the approval of George Washington.

The century closed with 18 postwar years of production by the American Company, which returned from England in 1782. In 1787, Royal Tyler's *The Contrast* successfully launched a firmly American theatre tradition. Tyler was a Boston lawyer and American army officer, who had seen his first play only a few weeks before he wrote his own play. In *The Contrast*, he presented a lively picture of New York society, with free-flowing dialogue and well drawn characters. The play satirizes Dimple, a young New Yorker who has turned into a fop because of his admiration of all things British. Although engaged to Charlotte, the daughter of a wealthy merchant, Dimple considers himself a European rake and makes advances to two of his fiancée's friends. One of the friends has a brother, Colonel Manly, the epitome of American plain manners, high principles, and patriotism. Manly falls in love with Charlotte, exposes Dimple, saves both Charlotte and his own sister from Dimple's duplicity, and ends up united with Charlotte. Two additional characters are particularly well drawn. Jessemy, Dimple's servant, is every inch the mirror of his master, and Jonathan, Manly's servant, is the prototypical "country bumpkin." The subplot between these two is hilarious, even for audiences today.

Although *The Contrast* was successful, the first major American playwright was the British-trained William Dunlap. He wrote *The Father, or American Shandyism* (1789), which combined sentiment, wit, comic humor, and "the finer feelings of the human heart."

In 1794, the focus of American theatre moved to Philadelphia, with the opening of the Chestnut Street Theatre. It had a handsome interior, with boxes set in a semiellipse and a total seating capacity of either 1200 or 2000 (sources vary). The auditorium was gray with gold trim, including elegant gilt railings. The orchestra pit held 30 musicians, and the large forestage was flanked by walls representing the façades of handsome buildings. The large stage was lit by oil lamps, while the auditorium was lit by candles. In describing the theatre, a French traveler observed that "between the acts the pit is noisy and even indecent. . . . The women turn their backs on the pit during intermission."[4]

France

Ripples of the comic style of Molière and the neo-classicism of Racine extended well into the 18th century, but, essentially, the theatre of France underwent a barren period after the death of Molière. The recently established Comédie-Française produced many fine actors and actresses in both comedy and tragedy, but its management appeared over aware of its state patronage and held a rather backward-looking philosophy of production that tended to stifle originality. The Comédie-Française put on tragedies that were sentimental and melodramatic, and comedies caught up in contemporary triviality. A rival company at the Hôtel de Bourgogne (Fig. **12.19**) called itself the Comédie-Italienne, to distinguish it from the Comédie-Française and to reflect the Italian nationality of the actors (although they played in French).

Plays early in the century often show a combination of neo-classicism, popularism, and rococo niceties. Tearful comedies, called *comédies larmoyantes*, satisfied the tastes of the salon set as well as an ever increasing middle-class audience, which demanded emotional plays in recognizably contemporary situations. The Enlightenment's egalitarianism brought tragedy to a curious state—the increasing numbers of women in theatre audiences seemed determined to cry, even in comedies, and they

12.19 Interior of the Hôtel de Bourgogne, c.1765. Bibliothèque Nationale, Paris.

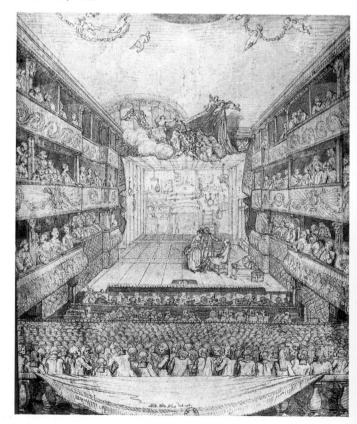

flocked to the well-equipped theatres in pursuit of such release. By the time of the Revolution, serious drama had become melodramatic DRAME BOURGEOIS, or middle-class drama.

The shifting character of French drama of the first half of the century can also be seen in the plays of Pierre Marivaux (1688–1763). Marivaux's style is difficult to classify, but is more rococo than anything else. His plays are charming, sentimental, and meticulously written. Most of them have romantic themes. *Les Fausses Confidences* (1732), for example, describes the efforts of a poor but handsome young man to make his rich mistress fall in love with and marry him. The questionable morality of his duplicity is assuaged when, in the end, the young man actually falls in love himself. Marivaux also had his eye on the neo-classical "Unities" —the entire action of the play occupies less than a day.

Perhaps nothing summarizes the first three-quarters of the 18th century better than the theatrical ventures of its dominant personality, François-Marie Arouet, known as Voltaire (1694–1778). His plays were diverse in style and genre. He conducted a lifelong campaign against injustice and intolerance. But curiously, given his critical, anti-establishment propensities, Voltaire's early plays follow the rules of the French Academy. He was an admirer of Shakespeare, and called him an "inspired barbarian" because Shakespeare's dramatic structures were far too untidy for neo-classical tastes. In *Mérope* (1741), Voltaire declared that he had returned to first Greek principles. Most critics agree that what he meant by this was that he had eliminated any love scenes. His last play, *Nanine* (1778), had a gala première attended by most of the royal family, and by the time of his death, two months later, he had received the greatest acclaim ever bestowed in the French theatre.

French drama had one final blaze of brilliance before the Revolution, in the plays of Pierre de Beaumarchais (1732–99). His two most famous works, *The Barber of Seville* (1775) and *The Marriage of Figaro* (1784), are entertaining comedies built upon the traditions of neo-classicism dating back to Corneille's tragedy, *Le Cid* (1636). In fact, at the last moment Beaumarchais expanded *The Barber of Seville* into a neo-classical five-act structure, adding only ponderousness to a fine play. But criticism on the opening night caused him to rewrite it with four acts, which restored its original sparkle. The plots of both *The Barber of Seville* and *The Marriage of Figaro* presaged the coming Revolution, and the nine years between the works saw a dramatically changed audience perception of this message. *The Barber of Seville* was enjoyed and received calmly but, by 1784, France was well aware of what was going on. The criticisms directed against the characters in the play were taken seriously as an indictment of society as a whole. When the Revolution came, its horrors left the French stage bare during the final ten years of the 18th century.

Germany

The mid-18th century saw a determined attempt to develop a significant national theatre in Germany, even if the political concept of "Germany" remained somewhat nebulous. A lack of any stable national boundaries or capital cities to act as cultural centers had previously prevented the development of a strong national theatre such as England, France, Italy, and even Spain had enjoyed. As we have seen however, the late 18th century found both Germany and Austria with altered political circumstances.

The literary values prominent in German theatre in the mid-18th century were strengthened by a superb playwright, Gotthold Ephraim Lessing (1729–81). Lessing became part of the newly established Hamburg National Theatre. He was offered the position of "stage poet," whose responsibilities included writing new plays, making translations, and composing prologues and epilogues for special occasions. Lessing refused the position, indicating that he could not complete plays as frequently as required for such a position (recall the requirements for Bach and others to compose weekly cantatas as part of their employment conditions). Nonetheless, the Hamburg National Theatre was so eager to be associated with Lessing that he was exempted from this condition.

Lessing made an important contribution to German and western theatre. He wrote plays that allowed for scene changes at the act break rather than between scenes, so as not to interrupt the action. This change was significant. In a theatre using depictive scenic background (as opposed to theatre of convention, like that of the Greeks and Elizabethans), pauses at any point in the action break the flow of the production, and scene changes break the audience's attention. Clearly Lessing wrote his plays with theatre aesthetics in mind.

The direction of German theatre changed around 1770, when the Romantic movement, which was to dominate the 19th century, began. Lessing's interest in Shakespeare as well as his concern for unbroken action was shared by Johann Wolfgang von Goethe (1749–1832). Goethe and others in Germany had turned for inspiration to Elizabethan ideas and the soaring theatrical poetry in which Shakespeare had expressed them. In 1771, Goethe produced his *Goetz von Berlichingen*, an historical drama on German themes. The play, complete with Shakespearean comic interludes, tells the tragic story of a 16th-century robber-knight something like Robin Hood.

Four years later, Goethe changed the course of western literature with two monumental works, the novel *Die Leiden des Jungen Werthers* (*The Sorrows of Young Werther*) and the first draft of his play *Faust*. These two works, along with Friedrich von Klinger's play *Sturm und Drang* (*Storm and Stress*) (1776), instigated a new revolt against classicism. *Sturm und Drang* drew much of its inspiration from the American Revolution, and its title became associated

with a movement that attracted young and free spirits everywhere, Goethe among them. Goethe's *Faust*, however, is the masterpiece of the age.

It is Part I of *Faust* that is actually the theatrical masterpiece. Goethe began and partially completed it around 1774–75, but continued to rework the play until 1801. Part II occupied the remaining 30 years of his life, but it was not published until 1833, the year after he died. The Faust story was not original to Goethe—Christopher Marlowe had written a play based on the same legend —but his treatment of it was certainly original. There is some doubt as to whether Goethe intended Part I to be a stage presentation or a dramatic poem.

The play begins with a poetic dedication, followed by a "Prelude in the Theatre" and a "Prologue in Heaven." A series of 26 scenes follows, ranging from a scene in Faust's study to a final prison scene. Nowhere does Goethe enumerate the scenes or give a list of characters. He does not even indicate passage of time. Rather, he provides absorbing speeches illustrating the struggles in Faust's mind and his commentary on life. The work is a dramatic mixture of passion and wisdom. Part II reflects idealism removed from the "conflict of conscience and love" of Part I, and it is so formless that it is virtually impossible to stage. Goethe's Faust was a poet-dreamer and idealist, seeking the divine and the ability to understand the workings of nature and the mystery of life. He is a prototype of the "Romantic hero," a figure that would be of great significance in years to come.

Italy

Italian theatre in the 18th century is little more than a footnote compared to that of other countries, but it had some important aspects. First was its interaction with the French theatre. The traditions of France and Italy were continued in the Comédie-Italienne in Paris and in the plays of the Italian dramatist Goldoni, who wrote in both Italian and French. Carlo Goldoni (1707–93) settled in Paris in 1761, having made a significant but unsuccessful attempt in Italy to revive the *commedia dell'arte*, by providing its actors with written texts. His plays have an eclectic style apparent, for example, in *Servant of Two Masters* (1740). Goldoni's plays are intimate comedies of manners very much like those of Molière, which served as Goldoni's models.

A second important aspect of Italian theatre in the 18th century was operatic production, and specifically its magnificent scenic designs. Several schools of scenic design existed in Italy, each following a different tradition. Venice produced light and graceful designs. Bologna, Parma, and Pisa, on the other hand, continued the opulent traditions of the baroque, especially through the work of the rich and influential Galli-Bibiena family (Fig. **11.19**).

MUSIC
Rococo

As French court society and its baroque arts slipped from favor, the ornamentation, delicacy, prettiness, and pleasant artificiality of the rococo style came to music as well as to painting and sculpture. Musicians improvized "decorations" in their performances, and the practice was so common that many composers purposely left their melodic lines bare in order to allow performers the opportunity for playful trills and other ornaments. The purpose of music was to entertain and to charm.

François Couperin (1668–1733) exemplified the musical spirit of his time, but he also retained sufficient of his baroque roots to avoid excessive sentimentality or completely artificial decoration. Nevertheless, his works are appropriate to salon performance, and do not limit any one piece or movement to one emotion. He shows a pleasant blending of logic and rationality with emotion and delicacy, in true rococo fashion.

Couperin was part of a uniquely French school of keyboard music, which specialized in long dance suites, so-called "genre pieces," contrapuntal works with highly ornamented introductions, and overtures similar to those found in French opera. Many of the pieces are miniatures, and the grand sweep of the baroque era is replaced by an abundance of short melodic phrases with much repetition and profuse ornamentation. But Couperin's passacaglias and chaconnes (for example, the *Passacaille ou Chaconne* from the First Suite for Viols, 1728) still use the same indefinitely repeated four- or eight-measure harmonic patterns found in music of the 17th century. His trio sonatas, too, look back to the baroque era, and are among the last of this musical form to be composed. The classical period was to bring in new instrumental groupings for chamber music.

Expressive style

A second style of music—the "expressive style"—paralleled the rococo style and formed a transitional stage between baroque and classical. This expressive style (more literally, "sensitive" style), or *empfindsamer Stil*, came from Germany. It permitted a freer expression of emotions than the baroque, largely by allowing a variety of moods to occur within a single movement. Polyphonic complexities were reduced, and different themes, with harmonic and rhythmic contrasts, were introduced. Expressive style was thus simple and highly original. Composers had the freedom to use rhythmic contrasts, original melodies, and new nuances and shading of loud and soft. Yet the goal was a carefully proportioned, logical, unified whole, whose parts were clear and carefully articulated.

The principal exponent of the *empfindsamer Stil* was Carl Philipp Emanuel Bach (1714–88), one of J. S. Bach's

sons. His position between the baroque and classical styles has led some scholars to call him the "founder" of the classical style. For many years he was court harpsichordist to Frederick the Great, and it is his keyboard works that are generally considered his most important compositions. He understood music to be an art of the emotions, and believed it very important that the player be involved personally in each performance. He avoided violent emotions, preferring to represent subtle shades of feeling with many gentle changes of mood. His melodies have a singing style, without excessive ornamentation. This admirably suited the favored keyboard instrument of the day, the CLAVICHORD, with its intimate tone. Not the least of C. P. E. Bach's contributions to western music was his *Essay on the True Way to Play Keyboard Instruments* (1753–62), which contains important information on musical thought and practice in this period.

Expressive music was labeled as Romantic at the time. What to some now appears restrained, witty, and well-reasoned was thought then to be sentimental and whimsical. The real Romantics were soon to rebel against this tradition, finding it too restrained and formal.

Classical style

In 1785, Michel Paul de Chabanon wrote, "Today there is but one music in all of Europe." What he meant was that music was being composed to appeal not only to the aristocracy but to the middle classes as well. Egalitarian tendencies and the popular ideals of the *philosophes* had also influenced artists, who now sought larger audiences. Pleasure had become a legitimate artistic purpose. Eighteenth-century rationalism saw excessive ornamentation and excessive complexity (both baroque characteristics) as not appealing to a wide audience on its own terms. Those sentiments, which coincided with the discoveries of Pompeii and the ideas of Winckelmann and Baumgarten, prompted a move toward order, simplicity, and careful attention to form. We call this style in music classical (the term was not applied until the 19th century), rather than neo-classical or classical revival, because although the other arts returned (more or less) to Greek and Roman prototypes, music had no known classical antecedents to revive. Music thus turned to classical *ideals*, though not to classical *models*.

One very basic characteristic of classical style was a clearly articulated structure. Each piece was organized into short statements, called "phrases," which recurred regularly and clearly. The most frequently cited example occurs in Wolfgang Amadeus Mozart's (1756–91) Symphony No. 40 in G minor, whose opening movement is based on a three-note rhythmic pattern, or motif, organized into two contrasting phrases. These phrases are then grouped into themes, which comprise sections in the movement. In contrast, for example, with the opening movement of Vivaldi's "Spring" (remember its ABA-

CADAEA structure), the Symphony No. 40 uses only an AABA structure. Although it is part of a much longer composition than Vivaldi's, it is much simpler and more clearly expressed.

A second change was the general avoidance of polyphony. Classical music depended upon a single, unobscured melodic line that could be shaped into expressive contours and brought to a definite conclusion.

A third change from the baroque lay in rhythmic patterns. The flow of the baroque's numerous ornamented parts fostered essentially unchanging rhythmic patterns. Classical phrase structure and melodic linearity allowed far more opportunity for rhythmic variety and contrast.

Finally, classical style changed harmonic relationships, including more frequent use of key changes.

Major musical forms, such as the opera, the oratorio, and the concerto, also changed according to classical priorities. For example, Haydn's oratorio, *The Creation*, which reflects Enlightenment concepts of God and nature, reason and benevolence, exhibits concern for simplicity and clear form. It is also less polyphonic than previous oratorios. Operas and oratorios remained popular, but for the most part instrumental music became the dominant force. In that area, the concerto adapted smoothly into classical form and style. Chamber music also increased in popular appeal. Its small ensemble format was perfect for performance *en chambre*, that is, in the small rooms of the 18th-century salon.

The most important forms in this period were the SYMPHONY and the sonata. Sonatas were composed for virtually every instrument, but the piano and violin predominate. The classical sonata is a work of three or four movements, each of which has a specific structure. The most important structural feature of the sonata is the typical configuration of the first movement. This structure is so important and specific that it is called "sonata form," or "sonata–*allegro*" form. It is used not only in the first movement of sonatas, but also in the first movement of symphonies and chamber music. Using the traditional structural alphabet, sonata form simply goes AABA. The A section begins with a thematic statement in the home or tonic key, followed by transitional materials, called a "BRIDGE." A contrasting theme is then presented in a different key—usually the key of the dominant or the relative minor. The A section, called the "exposition," closes with a strong cadence. Usually the entire exposition section is repeated (AA). In the next section (B), called the "development," the thematic material of the exposition undergoes numerous alterations. The composer restates thematic material using different rhythms, harmonies, melodies, dynamics, and keys. Usually tension and excitement build up in this section.

Finally, tension is resolved in the recapitulation section (A). Although called a "recapitulation," this is not a strict repeat of the exposition. In particular, both the main themes are now presented in the home key. There might also, for example, be an extended coda. Not all classical

sonatas, symphonies, or chamber music fit the textbook mold, but these characteristics provide a fairly accurate guide to the classical sonata form.

The symphony, which uses sonata form in its opening movement, also plays an important part in the classical music tradition. By the last quarter of the 18th century, the symphony, like other forms of instrumental ensemble music, had largely eliminated use of *basso continuo*, and, thereby, the harpsichord. Primary focus, then, fell on the violin section, and classical symphonies reflect that new focus. By the turn of the 19th century, other sections, such as the woodwind, were given more important, independent material.

The timbre of an orchestra was fairly close to what we know today. But the size, and therefore the overall volume of sound, was not. The largest orchestra of the mid-18th century, at Mannheim, consisted of 45 players, mostly strings, with six woodwind, five brass, and two timpani. Haydn's orchestra between 1760 and 1785 rarely exceeded 25 players, and the Vienna orchestras of the 1790s averaged 35. This stands in contrast to those of the 19th century, which had twice this many players.

Haydn

The Austrian-born Franz Joseph Haydn (1732–1809) pioneered the development of the symphony from a short, simple work into a longer, more sophisticated one. Haydn's symphonies are diverse and numerous—some sources indicate that he wrote more than 104. Some of these are light and simple, others are serious and sophisticated.

Many of Haydn's early symphonies use the pre-classical, fast–slow–fast three-movement form. These usually consist of an opening *allegro*, followed by an *andante* in a related key, and close with a rapid dance-like movement in triple meter. Other early works use four movements, the first of which is in a slow tempo. In contrast, the Symphony No. 3 in G major (c.1762) has a typical four-movement structure beginning with a fast tempo: I. *allegro*; II. *andante moderato*; III. minuet and trio; and IV. *allegro*. This symphony emphasizes polyphony more than homophony, in contrast to the general classical trend, and the opening *allegro* does not use sonata form. The third movement, the minuet and trio, is a new feature, found in nearly every classical symphony. It always has a distinctive form: the minuet is played first, then the trio, and then the minuet is played again (ABA). Both minuet and trio are themselves two-part structures. Haydn's minuets contain very charming music, often emphasizing instrumental color in the trio.

Haydn's middle-period symphonies from the early 1770s show more emotion and have a larger scale than his earlier works. The development sections are dramatic and employ sudden and unexpected changes in dynamics. The slow movements contain great warmth and feeling. Haydn frequently drew on Austrian folk songs and baroque dance music.

Among his late works is his most famous symphony, No. 94 in G major (1792), commonly known as the "Surprise" Symphony. Its second movement contains a simple, charming theme and the dramatic musical surprise that gives the work its popular name. The movement is in the form of a theme and variations (AA'A''A'''A''''). The tempo is *andante*, and the orchestra begins with a soft statement of the theme. After presenting the theme a second time, even more quietly, Haydn inserts a tremendous *fortissimo* (very loud) chord. This is the surprise that makes those who are unfamiliar with the work jump out of their skin. With the exception of the "surprise," this movement is typical in its use of a melody based on the two main harmonies of western music, the TONIC or home chord, and the dominant chord. It is also typical to use variation form for a slow movement. At each repetition of the theme, one or more elements—such as rhythm, texture, or instrumentation—is changed. In this instance, it is quite easy to hear that the second variation is in a minor key, unlike the rest of the movement, and the fourth variation plays around with various rhythmic features, such as triple rhythms and loud chords on weak beats.

In the opening movement of this four-movement work, Haydn uses sonata form. This is preceded by a pastoral introduction, marked *adagio cantabile*, that is, in a slow, singing style, in triple meter. The introductory material alternates between the strings and the woodwind.

The tempo switches to *vivace assai*, that is, very fast, and the strings quietly introduce the first theme in G major (Fig. **12.20**):

12.20 Haydn, Symphony No. 94 in G major, first theme of first movement.

The last note of the theme is marked *f*, or *forte* (loud). At this point, the full orchestra joins the violins in a lively section. Just before a pause, the orchestra plays a short prefatory phrase which will recur throughout the movement (Fig. **12.21**):

12.21 Haydn, Symphony No. 94 in G major, prefatory phrase, first movement.

The first theme then reappears, with a slightly altered rhythmic pattern. This marks a bridge, or transition passage, to a new key, the dominant, D major. A quick series of scales in the violins and flutes leads to the introduction of

the second theme, a lyrical theme with trills and a falling motif. The exposition section closes with a short scale figure and repeated notes, and then the entire exposition is repeated.

The development section opens with a variation of the first theme and then goes through a series of key and dynamic changes.

The recapitulation starts—as recapitulations always do—with a return to the first theme in the original key. A passage based on motifs from the first theme, a repeat and brief development of the first theme, a pause, and finally, another repeat of the first theme follow. Then the second theme appears again, now in the home key, and the movement closes with a short scale passage and a strong cadence.

Mozart

Wolfgang Amadeus Mozart, also an Austrian, had performed at the court of Empress Maria Theresa at the age of six. As was the case throughout the classical period, aristocratic patronage was essential for musicians to earn a living, although the middle classes provided a progressively larger portion of commissions, pupil fees, and concert attendance. Mozart's short career (he died at the age of 35) was dogged by financial insecurity.

His early symphonies were simple and relatively short, like those of Haydn, while his later works were longer and more complex. His last three symphonies are generally regarded as among his greatest masterpieces, and the aforementioned Symphony No. 40 in G minor is often referred to as the typical classical symphony. This work, along with Nos 39 and 41, have clear order and restraint, yet they exhibit a tremendous emotional urgency, which many scholars cite as the beginning of the Romantic style.

The first of the four movements, written in sonata form, begins *allegro molto*. The violins state the first theme above a soft chordal accompaniment, which establishes the tonic key of G minor (Fig. **12.22**). Three short motifs are repeated throughout the piece.

12.22 Mozart, Symphony No. 40 in G minor, first theme of first movement.

The restlessness of the rhythm is accentuated by the liveliness of the lower strings. The second theme in the woodwinds and strings provides a relaxing contrast. It is in a contrasting key, the relative major, B flat, and it flows smoothly, each phrase beginning with a gliding movement down a chromatic scale. A codetta echoes the basic motif on various instruments and finishes with a cadence

in B flat major. In most performances the entire exposition section is repeated, giving the movement a classical AABA form.

The development section concentrates on the basic three-note motif and explores the possibilities of the opening theme. This section is somewhat brief, but full of drama.

The recapitulation restates the first theme in the home key, and then the second theme, also in G minor rather than in the original major. This gives the ending a more mournful character than the equivalent section in the exposition. A coda in the original key ends the movement.

The second movement, *andante*, in E flat major, also uses sonata form. The first theme of the movement is passed successively among the violas, second violins, and first violins. The horns provide a rich background. Unlike the first movement, there is no strong contrast between the first and second themes. They are presented in E flat major and B flat major—the standard contrast of keys in a movement that starts in a major key. The development changes key further, moving into the minor, then returns to the home key with a dialogue among the woodwinds. This movement features many graceful embellishments, which were popular with the German court.

The third movement, *allegretto*, returns to G minor and the emotional tension of the first movement. The meter is triple—it is a minuet and trio, which is typical for the third movement. This is a lively piece with symmetrically arranged phrases and strong cross-rhythms. The trio changes key to G major and has a more relaxed mood.

The finale, *allegro assai*, uses a compact sonata form. The violins state the subject in G minor and create a "rocket theme," that is, an upward thrusting arpeggio.

12.23 Mozart, Symphony No. 40 in G minor, first theme of fourth movement.

The violins play the second, contrasting theme in the related key of B flat major, and the woodwinds pick it up and embellish it. The development in this movement is very dramatic. The rocket motif bounces from instrument to instrument, creating a highly complex texture, which is increased by rapid modulation through several remote keys. The recapitulation returns, of course, to the home key of G minor, with subtle restatement and variation.

Mozart is also well known for his operas, and he was especially skilled in comic opera. *The Marriage of Figaro* (1786), for example, is fast and humorous, with slapstick

action in the manner of farce, but it also has great melodic beauty.

The plot of *Marriage of Figaro* is taken from Beaumarchais' play of the same name. It centers on the impending marriage of Count Almaviva's valet Figaro to the Countess's maid Susanna. The plot is complex and full of comic deceptions, mistaken identities, physical action, revenge, and actions at cross-purposes.

The duet "Cinque . . . dieci," which opens Act I, gives us a good example of Mozart's style. We hear Figaro, a baritone, singing a series of deliberate motifs as he measures the bedroom which he will share with Susanna after the wedding. He calls out the measurements, "cinque" (five), "dieci" (ten), and so on:

12.24 Mozart, *Marriage of Figaro*, first theme of "Cinque . . . dieci" duet.

Figaro's passage comprises the first theme of the duet, which is *allegro*. The free form of the duet allows for the contrast between the two themes, the second of which is sung by Susanna, a soprano, who enters while Figaro is singing. She is preoccupied with trying on a new hat, and the composer lets the two singers work their themes together before Figaro responds to his fiancée. Then he joins in dialogue with her. The music begins in G major, modulates to D major, and returns to G, a typical key scheme.

Beethoven

Ludwig van Beethoven (1770–1827) is often considered apart from the classical period and treated as a singular transitional figure between classicism and Romanticism. Beethoven wanted to expand the classical symphonic form to accommodate greater emotional character. The typical classical symphony has movements with contrasting and unrelated themes; Beethoven moved toward a single thematic development throughout, thereby achieving a unity of emotion in the whole work.

Beethoven's works differ significantly from those of Haydn and Mozart. They are more dramatic, and they use changing dynamics for starker emotional effects. Silence is used to pursue both dramatic and structural ends. Beethoven's works are also longer. He lengthened the development section of sonata form and did the same to his codas, many of which take on characteristics of a second development section.

He also changed traditional numbers of and relationships among movements, especially in the unusual Symphony No. 6, which has no break between the fourth and fifth movements. In the Symphony No. 5, no break occurs between the third and fourth movements. In some of his four-movement works, he changed the traditional third

movement minuet and trio to a scherzo and trio of significantly livelier character. Beethoven's symphonies draw heavily on imagery, for example, heroism in Symphony No. 3 and pastoral settings in Symphony No. 6. The famous Symphony No. 5 in C minor, for example, begins with a motif that Beethoven described as "fate knocking at the door." The first movement (*allegro con brio*) develops according to typical sonata form, the second and contrasting movement (*andante con moto*) is in theme-and-variation form, and the third movement (*allegro*) is a scherzo and trio in triple meter. Movement number four returns to *allegro* and to sonata form.

Beethoven's nine symphonies became progressively more Romantic, and the Ninth is a gigantic work of tremendous power. Its finale includes a chorus singing the text of Schiller's *Ode to Joy*.

Undoubtedly one of Beethoven's loveliest and most popular works is the Piano Sonata in C minor, Op. 13 (the "Pathétique"), published in 1799. The work is in three movements. The first movement is marked *grave; allegro di molto e con brio*, and is in sonata form. The strong tempo contrast between the opening *grave* (very slow) passages and the *allegro* heightens the drama of the movement. The second movement is marked *adagio cantabile*, a slow, singing style, in the contrasting key of A flat major.

The third movement is in the home key of C minor and is structured ABACABA. This is known as RONDO form —that is, it has a recurrent theme, and is similar in structure to baroque ritornello form. It opens its first, or A, section with a lively theme in duple meter:

12.25 Beethoven, Piano Sonata in C minor, Op. 13, first theme of third movement.

This is followed by a second, or B, section with a new theme composed of flowing scale lines in a major key. Then, after a change back to minor, the section closes with a slower theme. The first theme then returns in the original key of C minor. A third, C, section, which moves to A flat major, uses DISJUNCT MELODY and SYNCOPATION. After some quick arpeggios, the section ends and the movement returns to the first theme. The B section is then repeated, and the movement closes with another repeat of the first section.

Classical style may have had a simpler character and a more symmetrical structure than baroque style, but it did not sacrifice any of its energy or quality. In the same way that Greek simplicity in architecture, for example, kept its sophistication and interest in pursuing mathematical form and symmetry, so classical music kept its dynamism and sophistication in its pursuit of form and reason. As classical style was shaped by its practitioners, it moved as comfortably toward Romanticism as it had moved away from baroque.

DANCE

"The only way to make ballet more popular is to lengthen the dances and shorten the *danseuses'* |female dancers'| skirts." This opinion was attributed to the composer Campra. With the courtly splendor of Louis XIV's Versailles left behind, one of the most significant obstacles to the further development of the ballerina's art was costume (Fig. **12.26**). Floor-length skirts were not conducive to freedom of movement, and, as a simple result, *danseurs* (male dancers) played the prominent roles at the turn of the 18th century. In 1730, one of those curious accidents of history occurred, which helped to change the course of ballet and bring the ballerina into pre-eminence.

Marie Anne Cupis de Camargo (1710–70) was a brilliant dancer, so much so that her mentor, Mlle Prevost, tried to keep her hidden among the *corps de ballet*. During one particular performance, however, a male dancer failed to make his entrance, and Camargo quickly stepped forward to dance his role—superbly. Her footwork was so dazzling that, in order to feature it more fully, she raised her skirts a discreet inch or two above the ankle! Her forte was the *entrechat*, a movement in which the dancer jumps straight up and rapidly crosses the legs or at least beats the feet together, as many times as possible, while in the air. The move is still a technical achievement especially favored by male dancers. Voltaire indicated that Camargo was the first woman to dance like a man, that is, the first ballerina to display the technical skills and brilliance previously associated only with *danseurs*.

Another significant stylistic change came about through the ballerina, Marie Sallé (Fig. **12.27**). Her studies in mime and drama led her to believe that the style prevalent in Paris was too formal and repetitious. So, in the early 1730s, she broke her contract with the Paris Opéra (an act punishable by imprisonment), and took up residence in London. Her style was expressive, rather than a series of "leaps and frolics," and in 1734, in her famous *Pygmalion*, she wore simple draperies rather than the traditional panniers (wide extensions of the skirt at the hips), and her hair flowed freely rather than being piled up on top of her head. The contrast between the styles of Camargo and Sallé was an early example of how instantly changeable balletic style is. A flashy technique that becomes boring can quickly be relieved by a shift to expressiveness. When emotion becomes melodramatic, the pendulum can swing back to technique.

We have no way of identifying the technical characteristics of 18th-century ballet, but its mythological subject matter in the first half of the century is consistent with that of painting, sculpture, and music. Significant in earlier works, most of which were produced in London by the dancing master John Weaver, was the use of movement to communicate a story. These early attempts to integrate movement and dramatic content brought forth *ballet d'action* in the last half of the century. Its popularity helped

12.26 Jean Baptiste Martin, *Apollon*, costume design for Apollo. Engraving. The New York Public Library.

12.27 After Lancret, *Marie Sallé*, 1730. Engraving. The New York Public Library.

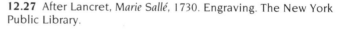

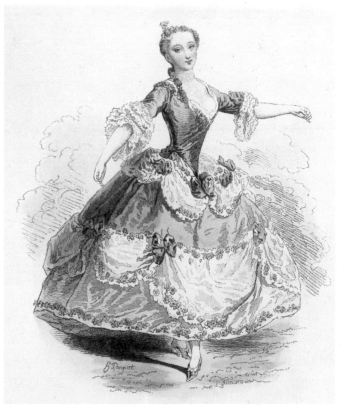

to separate this form from the sprawling *ballet à entrée*. It also reinforced ballet's independence from opera and drama. *Ballet d'action* contained an evolving classical concern for unity. Its emphasis on drama stood in contrast to the focus on display of *ballet à entrée*.

The primary moving force in this new form was Jean-Georges Noverre (1727–1810). In his influential *Letters on Dancing and Ballets* (1760), he wrote that ballets should be unified works in which all elements contribute to the main theme. For Noverre, ballet was a dramatic spectacle, a play without words. Its content was communicated through expressive movement. Music should be "written to fit each phrase and thought," and technical virtuosity for its own sake, or for the purposes of display, should be discouraged. Noverre thought that ballet should study other arts and draw upon natural forms of movement in order to be "a faithful likeness of beautiful Nature." He also argued for costumes that enhanced rather than impeded movement, and his ballets were considered excellent examples of "psychological realism."

Salvatore Vigano (1769–1821), another major figure of the period, took some account of Noverre's theories. Vigano's choreography ranged from a piece based on Shakespeare's *Coriolanus* to elaborate mime-dramas that followed classical formulas. His *Creatures of Prometheus* (1801) was set to music by Beethoven. Vigano was highly influenced by the neo-classical painters David and Ingres. His ballets emphasize heroic qualities and constitute a transition between classicism and Romanticism. The poses and groupings of his solo dancers suggested classical sculpture, and he contrasted these with sweeping ensemble movement.

Along with other arts, ballet became more popular, and, by 1789, ballet themes, like those of painting, began to include subjects beyond mythology. Ordinary country life provided topics for rustic ballets. These attempts at realism undoubtedly left much to be desired. They do serve, however, to illustrate trends toward egalitarianism in France and England, especially. Jean Dauberval (1742–1816), a student of Noverre, accepted his teacher's theories about nature. His *La Fille Mal Gardée*, for example, showed ordinary people in real situations. Nevertheless, preoccupations with mythology persisted.

As the 18th century came to a close, Charles Didelot (1767–1837) changed the course of ballet forever. First, he introduced tights, which simplified the line and form of dance costume. Next, he set the ballet world on its ear by attaching ballerinas to wires in *Zephyr and Flora* (1796) and flying them in and out of the scene. According to some sources, Didelot's wires allowed ballerinas to pause, resting effortlessly on the tips of their toes. The new line of the body created by that single effect instantly creates a dramatic change in the aesthetics of a dance. That change was as obvious then as it is now. Soon ballerinas were dancing EN POINTE without using wires. With this change, an entirely new age in dance had begun.

ARCHITECTURE

Rococo

Unlike most previous architectural styles, rococo was principally a style of interior design. Its refinement and decorativeness applied to furniture and décor more than to exterior structure or even detail. By now, even the aristocracy lived in attached row houses, and townhouses quite simply have virtually no exteriors to design. Attention turned to interiors, where the difference between opulence and delicacy was apparent. Figure **12.28** shows a polygonal music room characteristic of German rococo. Its broken wall surfaces display stucco decoration of floral branches that creates a pseudonatural effect. In Venice, curved leg furniture, cornices, and gilded carvings were the fashion. French designer François de Cuvilliés (1695–1768) combined refinement, lightness, and reduced scale to produce a pleasant atmosphere of grace and propriety (Fig. **12.29**).

English architecture of the early 18th century shared in these rococo refinements, but its style differed in many ways from that of the continent. The late 17th and early 18th centuries in England produced a so-called "Georgian style"—the name refers to Kings George I, II, and III, whose reigns the style partially encompassed. Georgian style was a kind of vernacular neo-classicism. Its relationship to rococo can be seen mainly in its refinement and

12.28 G. H. Krohne, Music Room, Thuringer Museum, Eisenach, Germany, 1742–51.

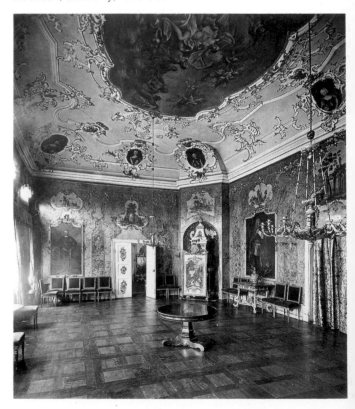

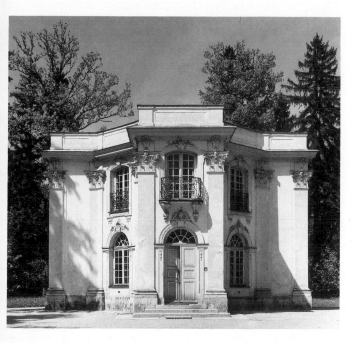

12.29 François de Cuvilliés, The Pagodenburg, c.1722. Schloss Nymphenburg, Munich, Germany.

delicacy. Georgian architecture developed from the English baroque style of Christopher Wren, which had also been more restrained and classical than the florid baroque style of the continent.

Neo-classicism

In the mid-18th century, the aims of architecture altered to embrace the complex philosophical concerns of the Enlightenment. The result was a series of styles and sub-styles broadly referred to as "neo-classical." Excavations at Herculaneum and Pompeii, philosophical concepts of progress, the aesthetics of Baumgarten, and the writings of Winckelmann all expressed and created a new view of antiquity. Neo-classicism was thus a new way of examining the past: rather than seeing the past as a single, continuous cultural flow broken by a Medieval collapse of classical values, theoreticians of the 18th century saw history as a series of separate compartments—Antiquity, the Middle Ages, the Renaissance, and so on.

Three important approaches emerged as a result of this new idea. The archeological school saw the present as continually enriched by persistent inquiry into the past. In other words, history was the story of progress. The second approach was eclectic. It saw the artist as someone who could choose among styles, or, more importantly, combine elements of various styles. A third, modernist, approach viewed the present as unique and, therefore, capable of expression in its own terms. Each of these three concepts profoundly influenced 18th-century architecture and bore importantly on the other arts. From this time forward, the basic premises of art were fundamentally changed.

Neo-classicism in architecture alludes to all of these three concepts, and encompasses a variety of treatments and terminologies. The identifiable forms of Greece and Rome are basic to it, of course. It also took considerable impetus from the *Essai sur l'architecture* (1753) by the Abbé Laugier. Laugier's strictly rationalistic work expressed neo-classicism in a nutshell. Discarding all architectural language developed since the Renaissance, he urged the architect to seek truth in the architectural principles of the ancient world and to use those principles to design modern buildings. Laugier's neo-classicism descended directly from the Greeks, with only passing reference to the Romans.

In Italy, the architect Giambattista Piranesi (1720–78) was incensed by Laugier's arguments, which placed Greece above Rome. He retaliated with an overwhelmingly detailed work, *Della Magnificenza ed Architettura dei Romani*, which professed to prove the superiority of

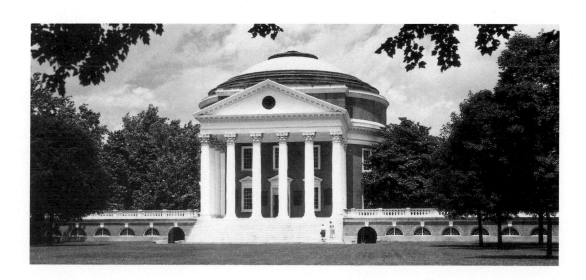

12.30 Thomas Jefferson, Rotunda of the University of Virginia, 1819–28.

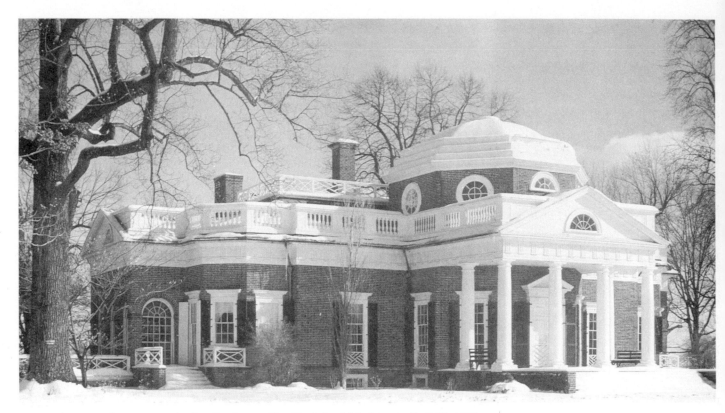

12.31 Thomas Jefferson, Monticello, Charlottesville, Virginia, 1770–84; rebuilt 1796–1800.

Rome over Greece. This quarrel aside, both Piranesi and Laugier were instigators of the neo-classical tradition. And in general, this revival of classicism in architecture, with its high moral seriousness, was seen in many quarters as a revolt against the frivolity of the rococo.

In America, neo-classicism had special meaning, as the colonies struggled to rid themselves of the monarchical rule of George III of England. For the revolutionary colonists, classicism meant Greece, and Greece meant democracy. The designs of colonial architect Thomas Jefferson (Figs **12.30** and **12.31**) reflect the ideas of this period. Jefferson was highly influenced by Palladio, whose popularity had soared during the significant period of English villa architecture, between 1710 and 1750. In a uniquely 18th-century way, Jefferson looked at architecture objectively, within the framework of contemporary thought. Strongly influenced by Lockean ideas of natural law, Jefferson believed that the architecture of antiquity embodied indisputable natural principles, and he made Palladian reconstructions of the Roman temple the foundation for his theory of architecture. His country house, Monticello, consists of a central structure with attached Doric porticos, or porches, and short, low wings attached to the center by continuing Doric entablatures. The simplicity and refinement of Jefferson's statement here goes beyond mere reconstruction of classical prototypes, and appeals directly to the viewer's intellect and sensibilities.

Throughout the United States, and particularly in the South, the classical revival found frequent expression. In Charleston, South Carolina, the Miles Brewton House provides us with one of the finest examples of American Georgian architecture (Fig. **12.32**). The large pedimented portico, supported by Ionic columns, indicates the boldness of American neo-classicism.

12.32 Miles Brewton House, Charleston, South Carolina (architect unknown), c.1769.

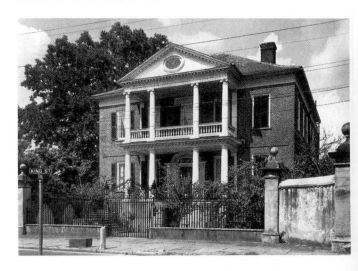

SYNTHESIS
The enlightened despot: Frederick the Great

In an age when absolute monarchies began to lose their grip on Europe, Frederick the Great of Germany not only survived, but also became an example of the spirit of the Enlightenment that typified the century. As an absolute monarch, his influence permeated Germany, and his interest in the arts had a profound impact on the emergence of a truly German art. Frederick's contribution was sometimes inadvertent, but the results were undeniable.

Frederick the Great was probably the most important monarch of the period in European history called "Enlightened Despotism" or "Enlightened Absolutism." These labels imply that the rulers of the time governed "absolutely," that is, according to their will alone. This was in fact rarely the case, and it was certainly not so in Germany. Frederick's own political circumstances—he governed only one territorial state within the boundaries of the Holy Roman Empire of the German nation—militated against absolute rule. Thus, foreign policy, wars, and the realities of economics, among other things, checked his freedom of action.

12.33 Antoine Pesne, *Frederick the Great as a Young Monarch*, 1739. Oil on canvas, 30¾ × 24¾ ins (78 × 63 cm). Gemäldegalerie, Berlin.

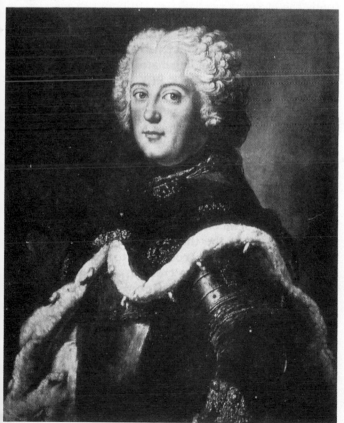

Frederick was also constrained by the law. His father, Frederick William I, had begun an extensive codification of the laws and a thorough legal reform. "The philosopher of Sans Souci," as Frederick the Great was known, could hardly turn away from such a tradition, and indeed he gloried in his reputation as a reformer. The result of his labors was a system of practical administrative reforms known as the "Prussian General Law." In all areas of Prussian life, whether in criminal law, agriculture, the Church, schools, forestry, mining, manufacturing, trade, or shipping, through skillful manipulation of his administrators, he carried out reforms true to the enlightened spirit of the age. His insight, vision, and flexibility made his government dynamic and responsive. Such genius undoubtedly kept Frederick clear of the troubles that beset Marie Antoinette and Louis XVI of France.

Frederick II began a long career as a patron of the arts as soon as he came to the throne. He sent Karl Heinrich Graun to Italy to hire singers, and an envoy to Paris to hire dancers. He wrote to Voltaire in order to secure a troupe of French actors. While he was still a prince, Frederick had developed plans for a new opera house and had instructed the architect Georg Wenzelaus von Knobelsdorff to begin designing it. Once he was king, work immediately began on the Berlin Opera. But after a feverish start, construction soon slowed down when the site had to be leveled.

But Frederick wanted an opera to be produced fairly soon, and he clearly could not depend upon the completion of this building. A temporary substitute was found and adapted. A theatre in the Stadtschloss, the *Kurfürstensaal*, which had been built in 1686 in imitation of the royal theatre at Versailles, was rigged up for the production of opera. On 13 December 1741, the first opera, *Rodelinda*, was produced. Written by Graun, it comprised 24 arias and virtually no choruses.

A comment from the time indicates that:

For the beginning there was a symphony in which fiery and gentle sections were opposed. This was such a masterpiece of full, pure harmony, such a many-sided, artful mixture of tunes, that it seemed as if the Muses and the Graces had united to draw Frederick out of his own heroic sphere and to themselves, where he could be held back from the rude cares of war. The bewitching voices of the singers, the naturalness and beauty of the action—everything was captivating to eye and ear. The whole spectacle, brought to such artistic perfection and executed with such skill, was received by the Monarch with high approval, and the public went forth from the theatre lost in enchantment.[5]

Knobelsdorff's impressive opera house finally opened on 7 December 1742 with a production of Graun's

Cesare e Cleopatra, but even then, the building was not complete. Exterior decoration lay unfinished, and the audience had to pick its way through debris and piles of building materials. The building bore the inscription "FREDERICK REX APOLLONI ET MUSIS" ("King Frederick, Dear to Apollo and the Muses"). The immediate surroundings of the opera house were also magnificent. A large square next to the opera house could hold 1000 carriages. An intricate arrangement of plumbing was planned around a nine-foot deep canal that ran under the theatre, providing water for fountains and jets, as well as for dousing the entire theatre in case of fire. By means of an elaborate system of pneumatic jacks, the entire floor of the theatre could be raised to stage level, and the scenery could be replaced by sculptured fountains made of marble, thus creating an elaborate, three-part rococo ballroom. At the time, it was the largest theatre in the world.

On the instructions of the king, the audience was admitted free of charge to the operas. Anyone wearing acceptable clothing could get into the pit and stand for the entire performance. Performances began with pomp and ceremony upon the king's entrance at six o'clock, and usually lasted until nearly eleven. Afterwards, an invited group dined in a room adjacent to the theatre, then returned to participate in an extravagant opera ball.

The members of Frederick's local musical entourage, poorly paid and out of the limelight while imported stars enjoyed the fanfare, may in fact have made the most lasting contributions to musical development. Nonetheless, Frederick's achievements were notable, and his enthusiasm and musical sophistication created an atmosphere in which music could flourish. He held auditions, commissioned composers, evaluated compositions, and decided artistic policy. His spirit of *Aufklärung*, or Enlightenment, set the intellectual tone in Berlin, and stimulated a tremendous amount of writing and discussion of music and musical theory. He also exerted considerable influence on composers such as J. S. Bach and C. P. E. Bach.

12.34 (below) Adolf von Menzel, *Frederick's Flute Concert at Sans Souci*, 1852. Oil on canvas, 4 ft 7⅞ ins × 6 ft 8¾ ins (1.42 × 2.05 m). Staatliche Museen Preussischer Kulturbesitz, Nationalgalerie, Berlin.

12.35 (opposite) George Wenzelaus von Knobelsdorff, interior of music room, Sans Souci, Potsdam, Germany, 1745–47.

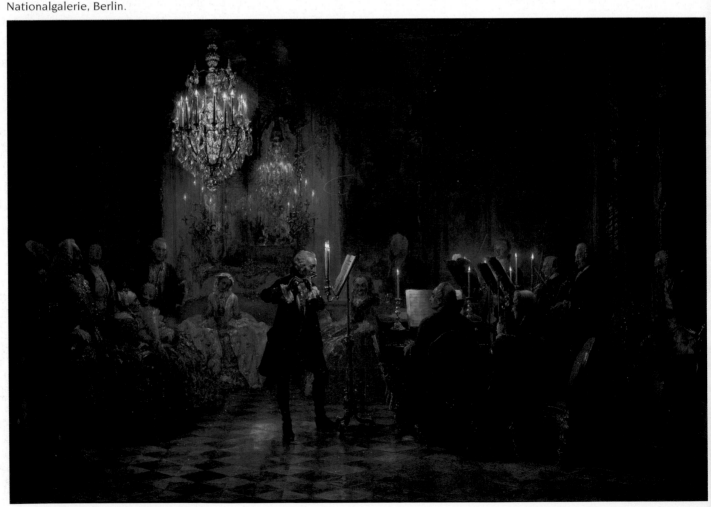

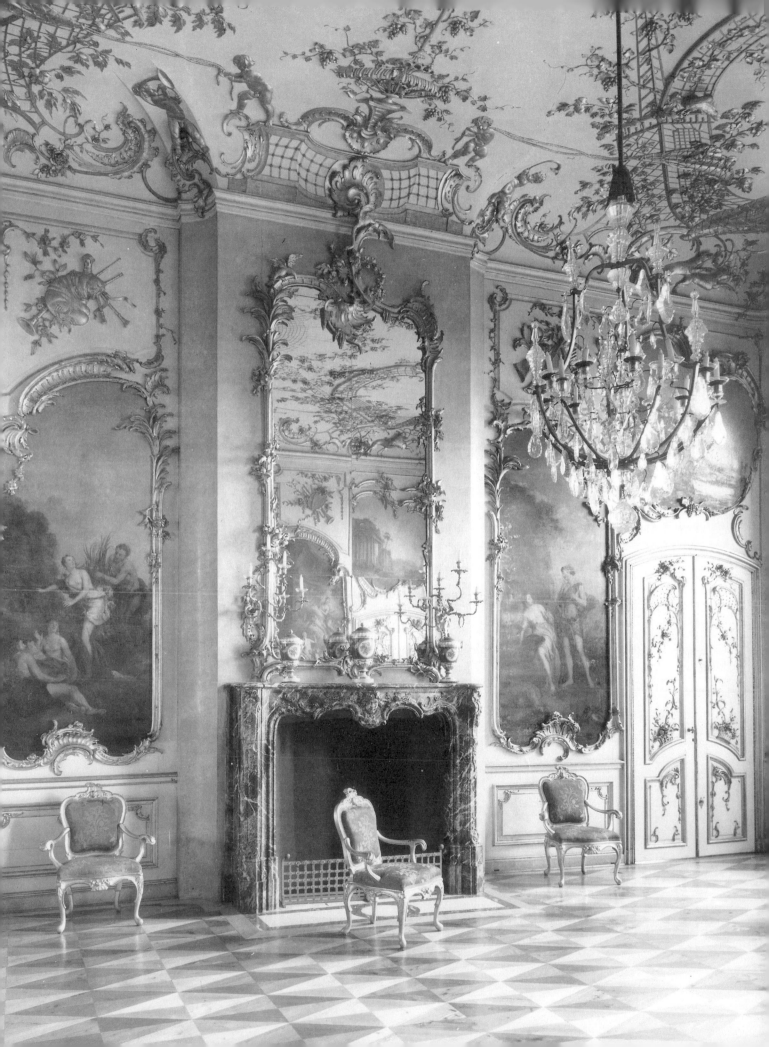

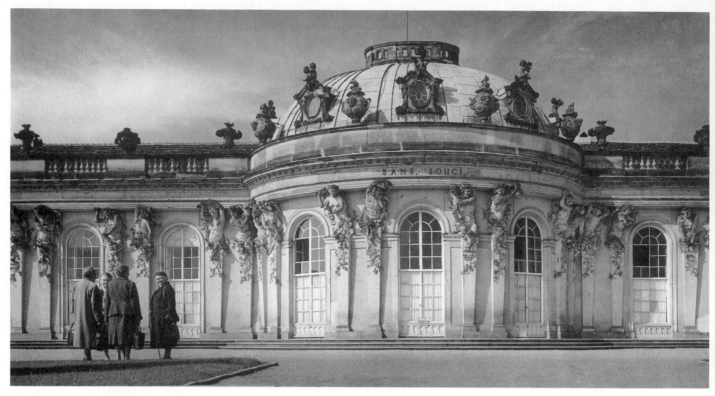

12.36 Georg Wenzelaus von Knobelsdorff, garden front of Sans Souci.

12.37 Garden front of Sans Souci soon after completion. Contemporary engraving.

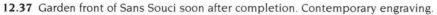

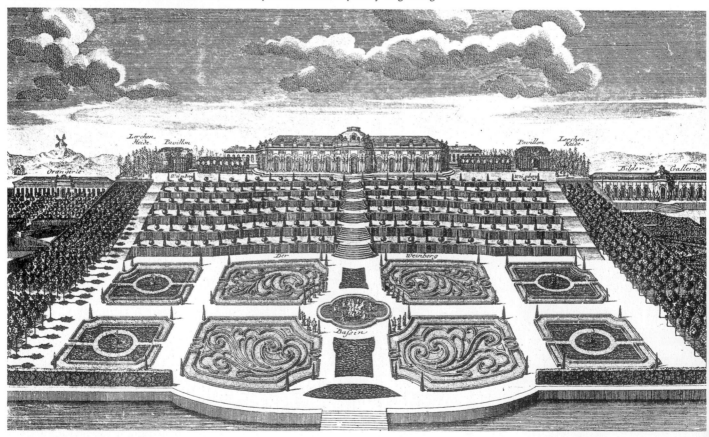

Frederick the Great often held concerts at his grand Sans Souci Palace in Potsdam (Fig. **12.34**). It represents a new stylistic phase of 18th-century German art (Figs **12.35–12.38**). Designed by Knobelsdorff, the architect of Frederick's opera house, the palace indicates both an increasing German receptivity to French rococo style and an amplification of Italian baroque style. Planned as a retreat for a philosopher–king, Sans Souci, which means "carefree," was Frederick's summer palace where he could work, think, and entertain the intellectual élite of Europe in seclusion and privacy. Voltaire was one of his guests.

Like Versailles, Sans Souci had a formal design, as a drawing of the garden front illustrates (Fig. **12.37**). The original plan was Frederick's, and it included terraces faced with glass houses curved to catch the sun's rays from different angles. The entrance way and entrance hall of the palace interior show a return to classical tradition with their curving colonnades and Corinthian columns (Fig. **12.38**). These classical features provide a curious counterpoint to the richness and delicacy of the rococo interior. Sans Souci is a monument to the vision of an enlightened monarch who reflected 18th-century ideals. Although a critic of his own German culture, he nonetheless brought about a rich period of German artistry.

12.38 Georg Wenzelaus von Knobelsdorff, entrance hall, Sans Souci.

SUGGESTIONS FOR THOUGHT AND DISCUSSION

The 18th century was a period of transition during which some of the ideals and traditions of earlier eras were retained and the foundations of the modern world were laid. The term "Enlightenment" describes what happened in philosophy, science, the arts, and political organization during this century, and it is important to understand the applications of the term in all these areas. What evidence can you find to substantiate the claim that the eighteenth century *was* a century of enlightenment?

Another important idea is that of humanitarianism. We must be careful not to confuse it with humanism, however. What was humanitarianism and how did it manifest itself in society and the arts in the 18th century?

It was a century of contrasting styles. In the arts alone we have seen the overlapping of baroque, rococo, classicism, neo-classicism, and Romanticism. What are the particular characteristics of each of these styles, and how are these characteristics manifested in each of the arts?

■ What impact did technology have on life in the 18th century? What is the difference between technology and science?

■ The rococo style has been described as frivolous and superficial. Do you find any truth in this judgment?

■ In what ways did the neo-classicism of the 18th century resemble, and in what ways was it different from, the classicism of the Renaissance?

■ How did the concept of "progress" contribute to 18th-century architecture?

LITERATURE EXTRACTS

Candide
[1759] Voltaire (François-Marie Arouet)

Chapter I
**How Candide Was Brought Up in a Fine Castle
and How He Was Expelled From Thence**

There lived in Westphalia, in the castle of my Lord the
Baron of Thunder-ten-tronckh, a young man, on whom
nature had bestowed the most agreeable manners. His
face was the index to his mind. He had an upright heart,
with an easy frankness; which, I believe, was the reason he
got the name of *Candide*. He was suspected, by the old
servants of the family, to be the son of my Lord the
Baron's sister, by a very honest gentleman of the
neighborhood, whom the young lady declined to marry,
because he could only produce seventy-one armorial
quarterings; the rest of his genealogical tree having been
destroyed through the injuries of time.

The Baron was one of the most powerful lords in
Westphalia; his castle had both a gate and windows; and
his great hall was even adorned with tapestry. The dogs of
his outer yard composed his hunting pack upon occasion,
his grooms were his huntsmen, and the vicar of the parish
was his chief almoner. He was called My Lord by
everybody, and everyone laughed when he told his stories.

My Lady the Baroness, who weighed about three
hundred and fifty pounds, attracted, by that means, very
great attention, and did the honors of the house with a
dignity that rendered her still more respectable. Her
daughter Cunegonde, aged about seventeen years, was of
a ruddy complexion, fresh, plump, and well calculated to
excite the passions. The Baron's son appeared to be in
every respect worthy of his father. The preceptor, Pangloss,
was the oracle of the house, and little Candide listened to
his lectures with all the simplicity that was suitable to his
age and character.

Pangloss taught metaphysico-theologo-cosmolonigology.
He proved most admirably, that there could not be an
effect without a cause; that, in this best of possible worlds,
my Lord the Baron's castle was the most magnificent of
castles, and my Lady the best of Baronesses that possibly
could be.

"It is demonstrable," said he, "that things cannot be
otherwise than they are: for all things having been made
for some end, they must necessarily be for the best end.
Observe well, that the nose has been made for carrying
spectacles; therefore we have spectacles. The legs are
visibly designed for stockings, and therefore we have
stockings. Stones have been formed to be hewn, and make
castles; therefore my Lord has a very fine castle; the
greatest baron of the province ought to be the best
accommodated. Swine were made to be eaten; therefore
we eat pork all the year round: consequently, those who
have merely asserted that all is good, have said a very
foolish thing; they should have said all is the best
possible."

Candide listened attentively, and believed implicitly;
for he thought Miss Cunegonde extremely handsome,
though he never had the courage to tell her so. He
concluded, that next to the good fortune of being Baron of
Thunder-ten-tronckh, the second degree of happiness was
that of being Miss Cunegonde, the third to see her every
day, and the fourth to listen to the teachings of Master
Pangloss, the greatest philosopher of the province, and
consequently of the whole world.

One day Cunegonde having taken a walk in the
environs of the castle, in a little wood, which they called a
park, espied Doctor Pangloss giving a lesson in
experimental philosophy to her mother's chambermaid; a
little brown wench, very handsome, and very docile. As
Miss Cunegonde had a strong inclination for the sciences,
she observed, without making any noise, the reiterated
experiments that were going on before her eyes; she saw
very clearly the sufficient reason of the Doctor, the effects
and the causes; and she returned greatly flurried, quite
pensive, and full of desire to be learned; imagining that
she might be a sufficient reason for young Candide, who
also, might be the same to her.

On her return to the castle, she met Candide, and
blushed; Candide also blushed; she wished him good
morrow with a faltering voice, and Candide answered her,
hardly knowing what he said. The next day, after dinner, as
they arose from table, Cunegonde and Candide happened
to get behind the screen. Cunegonde dropped her
handkerchief, and Candide picked it up; she, not thinking
any harm, took hold of his hand; and the young man, not
thinking any harm neither, kissed the hand of the young
lady, with an eagerness, a sensibility, and grace, very
particular; their lips met, their eyes sparkled, their knees
trembled, their hands strayed.—The Baron of Thunder-ten-
tronckh happening to pass close by the screen, and
observing this cause and effect, thrust Candide out of the
castle, with lusty kicks. Cunegonde fell into a swoon and as
soon as she came to herself, was heartily cuffed on the
ears by my Lady the Baroness. Thus all was thrown into
confusion in the finest and most agreeable castle possible.

Chapter 2
What Became of Candide Among the Bulgarians

Candide being expelled the terrestrial paradise, rambled a
long while without knowing where, weeping, and lifting up
his eyes to heaven, and sometimes turning them towards
the finest of castles, which contained the handsomest of
baronesses. He laid himself down, without his supper, in
the open fields, between two furrows, while the snow fell
in great flakes. Candide, almost frozen to death, crawled
next morning to the neighboring village, which was called
Waldber-ghoff-trarbk-dik-dorff. Having no money, and
almost dying with hunger and fatigue, he stopped in a
dejected posture before the gate of an inn. Two men,
dressed in blue, observing him in such a situation,
"Brother," says one of them to the other, "there is a young

fellow well built, and of a proper height." They accosted Candide, and invited him very civilly to dinner.

"Gentlemen," replied Candide, with an agreeable modesty, "you do me much honor, but I have no money to pay my shot."

"O sir," said one of the blues, "persons of your appearance and merit never pay anything; are you not five feet five inches high?"

"Yes, gentlemen, that is my height," returned he, making a bow.

"Come, sir, sit down at table; we will not only treat you, but we will never let such a man as you want money; men are made to assist one another."

"You are in the right," said Candide; "that is what Pangloss always told me, and I see plainly that everything is for the best."

They entreated him to take a few crowns, which he accepted, and would have given them his note; but they refused it, and sat down to table.

"Do not you tenderly love—?"

"O yes," replied he, "I tenderly love Miss Cunegonde."

"No," said one of the gentlemen; "we ask you if you do tenderly love the King of the Bulgarians?"

"Not at all," said he, "for I never saw him."

"How! he is the most charming of kings, and you must drink his health."

"O, with all my heart, gentlemen," and drinks.

"That is enough," said they to him; "you are now the bulwark, the support, the defender, the hero of the Bulgarians; your fortune is made, and you are certain of glory." Instantly they put him in irons, and carried him to the regiment. They made him turn to the right, to the left, draw the rammer, return the rammer, present, fire, step double; and they gave him thirty blows with a cudgel. The next day, he performed his exercise not quite so badly, and received but twenty blows; the third day the blows were restricted to ten, and he was looked upon by his fellow-soldiers, as a kind of prodigy.

Candide, quite stupefied, could not well conceive how he had become a hero. One fine Spring day he took it into his head to walk out, going straight forward, imagining that the human, as well as the animal species, were entitled to make whatever use they pleased of their limbs. He had not travelled two leagues, when four other heroes, six feet high, came up to him, bound him, and put him into a dungeon. He is asked by a Court-martial, whether he chooses to be whipped six and thirty times through the whole regiment, or receive at once twelve bullets through the forehead? He in vain argued that the will is free, and that he chose neither the one nor the other; he was obliged to make a choice; he therefore resolved, in virtue of God's gift called free-will, to run the gauntlet six and thirty times. He underwent the discipline twice. The regiment being composed of two thousand men, he received four thousand lashes, which laid open all his muscles and nerves, from the nape of the neck to the back. As they were proceeding to a third course, Candide, being quite spent, begged as a favor that they would be so kind as to shoot him; he obtained his request; they hood-winked him, and made him kneel; the King of the Bulgarians passing by, inquired into the crime of the delinquent; and as this prince was a person of great penetration, he discovered from what he heard of Candide, that he was a young metaphysician, entirely ignorant of the things of this world; and he granted him his pardon, with a clemency which will be extolled in all histories, and throughout all ages. An experienced surgeon cured Candide in three weeks, with emollients prescribed by no less a master than Dioscorides. His skin had already begun to grow again, and he was able to walk, when the King of the Bulgarians gave battle to the King of the Abares.

Chapter 3
How Candide Made His Escape From the Bulgarians, and What Afterwards Befell Him

Nothing could be so fine, so neat, so brilliant, so well ordered, as the two armies. The trumpets, fifes, hautboys, drums, and cannon, formed an harmony superior to what hell itself could invent. The cannon swept off at first about six thousand men on each side; afterwards, the musketry carried away from the best of worlds, about nine or ten thousand rascals that infected its surface. The bayonet was likewise the sufficient reason of the death of some thousands of men. The whole number might amount to about thirty thousand souls. Candide, who trembled like a philosopher, hid himself as well as he could, during this heroic butchery.

At last, while each of the two kings were causing *Te Deum*—glory to God—to be sung in their respective camps, he resolved to go somewhere else, to reason upon the effects and causes. He walked over heaps of the dead and dying; he came at first to a neighboring village belonging to the Abares, but found it in ashes; for it had been burnt by the Bulgarians, according to the law of nations. Here were to be seen old men full of wounds, casting their eyes on their murdered wives, who were holding their infants to their bloody breasts. You might see in another place, virgins outraged after they had satisfied the natural desires of some of those heroes, whilst breathing out their last sighs. Others, half-burnt, praying earnestly for instant death. The whole field was covered with brains, and with legs and arms lopped off.

Candide betook himself with all speed to another village. It belonged to the Bulgarians, and had met with the same treatment from the Abarian heroes. Candide, walking still forward over quivering limbs, or through rubbish of houses, got at last out of the theatre of war, having some small quantity of provisions in his knapsack, and never forgetting Miss Cunegonde. His provisions failed him when he arrived in Holland; but having heard that every one was rich in that country, and that they were Christians, he did not doubt but he should be as well treated there as he had been in my Lord the Baron's castle, before he had been expelled thence on account of Miss Cunegonde's sparkling eyes.

He asked alms from several grave-looking persons, who all replied, that if he continued that trade, they would confine him in a house of correction, where he should learn to earn his bread.

He applied afterwards to a man, who for a whole hour

had been discoursing on the subject of charity, before a large assembly. This orator, looking at him askance, said to him:

"What are you doing here? are you for the good cause?"

"There is no effect without a cause," replied Candide, modestly; "all is necessarily linked, and ordered for the best. A necessity banished me from Miss Cunegonde; a necessity forced me to run the gauntlet; another necessity makes me beg my bread, till I can get into some business by which to earn it. All this could not be otherwise."

"My friend," said the orator to him, "do you believe that the Anti-Christ is alive?"

"I never heard whether he is or not," replied Candide; "but whether he is, or is not, I want bread!"

The orator's wife, having popped her head out of the chamber window, and seeing a man who doubted whether Anti-Christ was alive, poured on his head a full vessel of dirty water. O heavens! to what excess does religious zeal transport the fair sex!

A man who had not been baptized, a good Anabaptist, named James, saw the barbarous and ignominious manner with which they treated one of his brethren, a being with two feet, without feathers, and endowed with a rational soul. He took him home with him, cleaned him, gave him bread and beer, made him a present of two florins, and offered to teach him the method of working in his manufactories of Persian stuffs, which are fabricated in Holland. Candide, prostrating himself almost to the ground, cried out, "Master Pangloss argued well when he said, that everything is for the best in this world; for I am infinitely more affected with your very great generosity, than by the hardheartedness of that gentleman with the cloak, and the lady his wife."

Next day, as he was taking a walk, he met a beggar, all covered over with sores, his eyes half dead, the tip of his nose eaten off, his mouth turned to one side of his face, his teeth black, speaking through his throat, tormented with a violent cough, with gums so rotten, that his teeth came near falling out every time he spit.

Chapter 4
How Candide Met His Old Master of Philosophy, Dr Pangloss, and What Happened to Them

Candide moved still more with compassion than with horror, gave this frightful mendicant the two florins which he had received of his honest Anabaptist James. The specter fixed his eyes attentively upon him, dropt some tears, and was going to fall upon his neck. Candide, affrighted, drew back.

"Alas!" said the one wretch to the other, "don't you know your dear Pangloss?"

"What do I hear! Is it you, my dear master! you in this dreadful condition! What misfortune has befallen you? Why are you no longer in the most magnificent of castles? What has become of Miss Cunegonde, the nonpareil of the fair sex, the master-piece of nature?"

"I have no more strength," said Pangloss.

Candide immediately carried him to the Anabaptist's stable, where he gave him a little bread to eat. When

Pangloss was refreshed a little, "Well," said Candide, "what has become of Cunegonde?"

"She is dead," replied the other.

Candide fainted away at this word; but his friend recovered his senses, with a little bad vinegar which he found by chance in the stable.

Candide opening his eyes, cried out, "Cunegonde is dead! Ah, best of worlds, where art thou now? But of what distemper did she die? Was not the cause, her seeing me driven out of the castle by my Lord, her father, with such hard kicks on the breech?"

"No," said Pangloss, "she was gutted by some Bulgarian soldiers, after having been barbarously ravished. They knocked my Lord the Baron on the head, for attempting to protect her; my Lady the Baroness was cut in pieces; my poor pupil was treated like his sister; and as for the castle, there is not one stone left upon another, nor a barn, nor a sheep, nor a duck, nor a tree. But we have been sufficiently revenged; for the Abarians have done the very same thing to a neighboring barony; which belonged to a Bulgarian Lord."

At this discourse, Candide fainted away a second time; but coming to himself, and having said all that he ought to say, he enquired into the cause and the effect, and into the sufficient reason that had reduced Pangloss to so deplorable a condition. "Alas," said the other, "it was love; love, the comforter of the human race, the preserver of the universe, the soul of all sensible beings, tender love." "Alas!" said Candide, "I know this love, the sovereign of hearts, the soul of our soul; yet it never cost me more than a kiss, and twenty kicks. But how could this charming cause produce in you so abominable an effect?"

Pangloss made answer as follows: "Oh my dear Candide, you knew Paquetta, the pretty attendant on our noble Baroness; I tasted in her arms the delights of Paradise, which produced those torments of hell with which you see me devoured. She was infected, and perhaps she is dead. Paquetta received this present from a very learned cavalier, who had it from an old countess, who received it from a captain of horse, who was indebted for it to a marchioness, who got it from a Spaniard. For my part, I shall give it to nobody, for I am dying."

"Oh Pangloss!" cried Candide, "what a strange genealogy! Was not the devil at the head of it?" "Not at all," replied the great man; "it was a thing indispensable; a necessary ingredient in the best of worlds; for if the Spaniard had not catched, in an island of America, this distemper, we should have had neither chocolate nor cochineal. It may also be observed, that to this day, upon our continent, this malady is as peculiar to us, as is religious controversy. The Turks, the Indians, the Persians, the Chinese, the Siamese, and the Japanese, know nothing of it yet. But there is sufficient reason why they, in their turn, should become acquainted with it, a few centuries hence. In the mean time, it has made marvellous progress among us, and especially in those great armies composed of honest hirelings, well disciplined, who decide the fate of states; for we may rest assured, that when thirty thousand men in a pitched battle fight against troops equal to them in number, there are about twenty thousand of them on each side who have the pox."

"That is admirable," said Candide; "but you must be cured." "Ah! how can I?" said Pangloss; "I have not a penny, my friend; and throughout the whole extent of this globe, we cannot get any one to bleed us, or give us a glister, without paying for it, or getting some other person to pay for us."

This last speech determined Candide. He went and threw himself at the feet of his charitable, Anabaptist James, and gave him so touching a description of the state his friend was reduced to, that the good man did not hesitate to entertain Dr. Pangloss, and he had him cured at his own expense. During the cure, Pangloss lost only an eye and an ear. As he wrote well, and understood arithmetic perfectly, the Anabaptist made him his bookkeeper. At the end of two months, being obliged to go to Lisbon on account of his business, he took the two philosophers along with him, in his ship. Pangloss explained to him how everything was such as it could not be better; but James was not of this opinion. "Mankind," said he, "must have somewhat corrupted their nature; for they were not born wolves, and yet they have become wolves; God has given them neither cannon of twenty-four pounds, nor bayonets; and yet they have made cannon and bayonets to destroy one another. I might throw into the account bankrupts; and the law which seizes on the effects of bankrupts only to bilk the creditors." "All this was indispensable," replied the one-eyed doctor, "and private misfortunes there are, the whole is the better." While he was thus reasoning, the air grew dark, the winds blew from the four quarters of the world, and the ship was attacked by a dreadful storm, within sight of the harbor of Lisbon.

Chapter 5
Tempest, Shipwreck, Earthquake and What Became of Dr Pangloss, Candide, and James the Anabaptist

One half of the passengers being weakened, and ready to breathe their last, with the inconceivable anguish which the rolling of the ship conveyed through the nerves and all the humors of the body, which were quite disordered, were not capable of being alarmed at the danger they were in. The other half uttered cries and made prayers; the sails were rent, the masts broken, and the ship became leaky. Every one worked that was able, nobody cared for any thing, and no order was kept. The Anabaptist contributed his assistance to work the ship. As he was upon deck, a furious sailor rudely struck him, and laid him sprawling on the planks; but with the blow he gave him, he himself was so violently jolted, that he tumbled overboard with his head foremost, and remained suspended by a piece of a broken mast. Honest James ran to his assistance, and helped him on deck again; but in the attempt, he fell into the sea, in the sight of the sailor, who suffered him to perish, without deigning to look upon him. Candide drew near and saw his benefactor, one moment emerging, and the next swallowed up for ever. He was just going to throw himself into the sea after him, when the philosopher Pangloss hindered him, by demonstrating to him, that the road to Lisbon had been made on purpose for this Anabaptist to be drowned in.

While he was proving this, *a priori*, the vessel foundered, and all perished except Pangloss, Candide, and the brutal sailor, who drowned the virtuous Anabaptist. The villain luckily swam ashore, whither Pangloss and Candide were carried on a plank.

When they had recovered themselves a little, they walked towards Lisbon. They had some money left, with which they hoped to save themselves from hunger, after having escaped from the storm.

Scarce had they set foot in the city, bewailing the death of their benefactor, when they perceived the earth to tremble under their feet, and saw the sea swell in the harbor, and dash to pieces the ships that were at anchor. The whirling flames and ashes covered the streets and public places, the houses tottered, and their roofs fell to the foundations, and the foundations were scattered; thirty thousand inhabitants of all ages and sexes were crushed to death in the ruins. The sailor, whistling and swearing, said, "There is some booty to be got here." "What can be the sufficient reason of this phenomenon?" said Pangloss. "This is certainly the last day of the world," cried Candide. The sailor ran quickly into the midst of the ruins, encountered death to find money, found it, laid hold of it, got drunk and having slept himself sober, purchased the favors of the first willing girl he met with, among the ruins of the demolished houses, and in the midst of the dying and the dead. While he was thus engaged, Pangloss pulled him by the sleeve; "My friend," said he, "this is not right; you trespass against universal reason, you choose your time badly." "Brains and blood!" answered the other; "I am a sailor, and was born at Batavia; you have mistaken your man, this time, with your universal reason."

Some pieces of stone having wounded Candide, he lay sprawling in the street, and covered with rubbish. "Alas!" said he to Pangloss, "get me a little wine and oil; I am dying." "This trembling of the earth is no new thing," answered Pangloss. "The City of Lima, in America, experienced the same concussions last year; the same cause has the same effects; there is certainly a train of sulphur under the earth, from Lima to Lisbon." "Nothing is more probable," said Candide; "but for God's sake, a little oil and wine." "How probable?" replied the philosopher; "I maintain that the thing is demonstrable." Candide lost all sense, and Pangloss brought him a little water from a neighboring fountain.

The day following, having found some provisions, in rummaging through the rubbish, they recruited their strength a little. Afterwards, they employed themselves like others, in administering relief to the inhabitants that had escaped from death. Some citizens that had been relieved by them, gave them as good a dinner as could be expected amidst such a disaster. It is true that the repast was mournful, and the guests watered their bread with their tears. But Pangloss consoled them by the assurance that things could not be otherwise; "For," said he, "all this must necessarily be for the best. As this volcano is at Lisbon, it could not be elsewhere; as it is impossible that things should not be what they are, as all is good."

A little man clad in black, who belonged to the inquisition, and sat at his side, took him up very politely, and said: "It seems, sir, you do not believe in original sin;

for if all is for the best, then there has been neither fall nor punishment."

"I most humbly ask your excellency's pardon," answered Pangloss, still more politely; "for the fall of man and the curse necessarily entered into the best of worlds possible." "Then, sir, you do not believe there is liberty," said the inquisitor. "Your Excellency will excuse me," said Pangloss; "liberty can consist with absolute necessity; for it was necessary we should be free; because, in short, the determinate will—"

Pangloss was in the middle of his proposition, when the inquisitor made a signal with his head to the tall armed footman in a cloak, who waited upon him, to bring him a glass of port wine. . .

Chapter 28
What Happened to Candide, Cunegonde, Pangloss, Martin, etc.

"I ask your pardon once more," said Candide to the Baron. "I ask pardon for having thrust my sword through your body." "Don't let us say any more about it," said the Baron; "I was a little too hasty, I must confess. But since you desire to know by what fatality I came to be a galley-slave, I will inform you. After I was cured of my wound, by a brother who was apothecary, I was attacked and carried off by a party of Spaniards, who confined me in prison at Buenos-Ayres, at the very time my sister was setting out from thence. I demanded leave to return to Europe. I was nominated to go as almoner to Constantinople, with the French ambassador. I had not been eight days engaged in this employment, when one day I met with a young, well-made Icoglan. It was then very hot; the young man went to bathe himself, and I took the opportunity to bathe myself too. I did not know that it was a capital crime for a Christian to be found naked with a young Mussulman. A cadi ordered me to receive a hundred strokes of the bastinado on the soles of my feet, and condemned me to the galleys. I do not think there ever was a greater act of injustice. But I should be glad to know how it comes about, that my sister is dishwasher in the kitchen of a Transylvania prince, who is a refugee among the Turks."

"But you, my dear Pangloss," said Candide, "how came I ever to set eyes on you again!" "It is true, indeed," said Pangloss, "that you saw me hanged; I ought naturally to have been burnt; but you may remember, that it rained prodigiously when they were going to roast me; the storm was so violent that they despaired of lighting the fire. I was therefore hanged because they could do no better. A surgeon bought my body, carried it home with him, and began to dissect me. He first made a crucial incision. No one could have been more slovenly hanged than I was. The executioner of the inquisition burnt people marvellously well, but he was not used to the art of hanging them. The cord being wet did not slip properly, and the noose was badly tied: in short I still drew my breath. The crucial incision made me give such a dreadful shriek, that my surgeon fell down backwards, and fancying he was dissecting the devil, he ran away, ready to die with the fright, and fell down a second time on the stair-case, as he was making off. His wife ran out of an adjacent closet, on hearing the noise, saw me extended on the table with my crucial incision, and being more frightened than her husband, fled also, and tumbled over him. When they were come to themselves a little, I heard the surgeon's wife say to him, My dear, how came you to be so foolish as to venture to dissect a heretic? Don't you know that the devil always take possession of the bodies of such people? I will go immediately and fetch a priest to exorcise him. I shuddered at this proposal, and mustered up what little strength I had left to cry out, Oh! have pity upon me! At length the Portuguese barber took courage, sewed up my skin, and his wife nursed me so well, that I was upon my feet again in about fifteen days. The barber got me a place, to be footman to a knight of Malta, who was going to Venice; but my master not being able to pay me my wages, I engaged in the service of a Venetian merchant, and went along with him to Constantinople.

"One day I took a fancy to go into a mosque. There was nobody there but an old imam, and a very handsome young devotee saying her prayers. Her breast was uncovered; she had in her bosom a beautiful nosegay of tulips, anemonies, ranunculuses, hyacinths, and auriculas; she let her nosegay fall; I took it up, and presented it to her with the most profound reverence. However, I was so long in handing it to her, that the imam fell into a passion, and seeing I was a Christian, called out for help. They carried me before the cadi, who ordered me a hundred bastinadoes, and to be sent to the galleys. I was chained in the same galley and the same bench with the Baron. There were on board the galley, four young men from Marseilles, five Neapolitan priests, and two monks of Corfu, who told us that the like adventures happened every day. The Baron pretended that he had suffered more injustice than I; and I insisted that it was far more innocent to put a nosegay into a young woman's bosom, than to be found stark naked with an Icoglan. We were perpetually disputing, and we received twenty lashes every day with a bull's pizzle, when the concatenation of events in this universe brought you to our galley, and you ransomed us."

"Well, my dear Pangloss," said Candide, "when you were hanged, dissected, severely beaten, and tugging at the oar in the galley, did you always think, that things in this world were all for the best?" "I am still as I always have been, of my first opinion," answered Pangloss; "for as I am a philosopher, it would be inconsistent with my character to contradict myself; especially as Leibnitz could not be in the wrong; and his pre-established harmony is certainly the finest system in the world, as well as his gross and subtle matter."

Chapter 29
How Candide Found Cunegonde and the Old Woman Again

While Candide, the Baron, Pangloss, Martin, and Cacambo, were relating their adventures, to each other, and disputing about the contigent and non-contigent events of this world, and while they were arguing upon effects and causes, on moral and physical evil, on liberty and necessity, and on the consolations a person may

experience in the galleys in Turkey, they arrived on the banks of the Propontis, at the house of the Prince of Transylvania. The first objects which presented themselves were Cunegonde and the old woman, hanging out some table-linen on the line to dry.

The Baron grew pale at this sight. Even Candide, the affectionate lover, on seeing his fair Cunegonde awfully tanned, with her eye-lids reversed, her neck withered, her cheeks wrinkled, her arms red and rough, was seized with horror, jumped near three yards backwards, but afterwards advanced to her, but with more politeness than passion. She embraced Candide and her brother, who each of them, embraced the old woman, and Candide ransomed them both.

There was a little farm in the neighborhood, which the old woman advised Candide to hire, till they could meet with better accommodations for their whole company. As Cunegonde did not know that she had grown ugly, nobody having told her of it, she put Candide in mind of his promise to marry her, in so peremptory a manner, that he durst not refuse her. But when this thing was intimated to the Baron, "I will never suffer," said he, "such meanness on her part, nor such insolence on yours. With this infamy I will never be reproached. The children of my sister shall never be enrolled in the chapters of Germany. No; my sister shall never marry any but a Baron of the empire." Cunegonde threw herself at her brother's feet, and bathed them with her tears, but he remained inflexible. "You ungrateful puppy, you," said Candide to him, "I have delivered you from the galleys; I have paid your ransom; I have also paid that of your sister, who was a scullion here, and is very homely; I have the goodness, however, to make her my wife, and you are fool enough to oppose it; I have a good mind to kill you again, you make me so angry." "You may indeed kill me again," said Baron; "but you shall never marry my sister, while I have breath."

Chapter 30
Conclusion

Candide had no great desire, at the bottom of his heart, to marry Cunegonde. But the extreme impertinence of the Baron determined him to conclude the match, and Cunegonde pressed it so earnestly, that he could not retract. He advised with Pangloss, Martin, and the trusty Cacambo. Pangloss drew up an excellent memoir, in which he proved, that the Baron had no right over his sister, and that she might, according to all the laws of the empire, espouse Candide with her left hand. Martin was for throwing the Baron into the sea: Cacambo was of opinion that it would be best to send him back again to the Levant captain, and make him work at the galleys. This advice was thought good; the old woman approved it, and nothing was said to his sister about it. The scheme was put in execution for a little money, and so they had the pleasure of punishing the pride of a German Baron.

It is natural to imagine that Candide, after so many disasters, married to his sweetheart, living with the philosopher Pangloss, the philosopher Martin, the discreet Cacambo, and the old woman, and especially as he had brought so many diamonds from the country of the ancient Incas, must live the most agreeable life of any man in the whole world. But he had been so cheated by the Jews, that he had nothing left but the small farm; and his wife, growing still more ugly, turned peevish and insupportable. The old woman was very infirm, and worse humored than Cunegonde herself. Cacambo, who worked in the garden, and went to Constantinople to sell its productions, was worn out with labor, and cursed his fate. Pangloss was ready to despair, because he did not shine at the head of some university in Germany. As for Martin, as he was firmly persuaded that all was equally bad throughout, he bore things with patience. Candide, Martin, and Pangloss, disputed sometimes about metaphysics and ethics. They often saw passing under the windows of the farm-house boats full of effendis, bashaws, and cadis, who were going into banishment to Lemnos, Mitylene, and Erzerum. They observed that other cadis, other bashaws, and other effendis, succeeded in the posts of those who were exiled, only to be banished themselves in turn. They saw heads nicely impaled, to be presented to the Sublime Ports. These spectacles increased the number of their disputations; and when they were not disputing, their *ennui* was so tiresome that the old woman would often say to them, "I want to know which is the worst;—to be ravished an hundred times by Negro pirates, to run the gauntlet among the Bulgarians, to be whipped and hanged, to be dissected, to row in the galleys; in a word, to have suffered all the miseries we have undergone, or to stay here, without doing anything?" "That is a great question," said Candide.

This discourse gave rise to new reflections, and Martin concluded upon the whole, that mankind were born to live either in the distractions of inquietude, or in the lethargy of disgust. Candide did not agree with that opinion, but remained in a state of suspense. Pangloss confessed, that he had always suffered dreadfully; but having once maintained that all things went wonderfully well, he still kept firm to his hypothesis, though it was quite opposed to his real feelings.

What contributed to confirm Martin in his shocking principles, to make Candide stagger more than ever, and to embarrass Pangloss, was, that one day they saw Paquetta and Girofflee, who were in the greatest distress, at their farm. They had quickly squandered away their three thousand piastres, had parted, were reconciled, quarrelled again, had been confined in prison, had made their escape, and Girofflee had at length turned Turk. Paquetta continued her trade wherever she went, but made nothing by it. "I could easily foresee," said Martin to Candide, "that your presents would soon be squandered away, and would render them more miserable. You and Cacambo have spent millions of piastres, and are not a bit happier than Girofflede and Paquetta." "Ha! ha!" said Pangloss to Paquetta, "has Providence then brought you amongst us again, my poor child? Know, then, that you have cost me the tip of my nose, one eye, and one of my ears, as you see. What a world this is!" This new adventure set them to philosophizing more than ever.

There lived in the neighborhood a very famous dervise, who passed for the greatest philosopher in Turkey. They went to consult him. Pangloss was chosen speaker, and

said to him, "Master, we are come to desire you would tell us, why so strange an animal as man was created."

"What's that to you?" said the dervise; "is it any business of thine?" "But, my reverend father," said Candide, "there is a horrible amount of evil in the world." "What signifies," said the dervise, "whether there be good or evil? When his Sublime Highness send a vessel to Egypt, does it trouble him, whether the mice on board are at their ease or not?" "What would you have one do then?" said Pangloss. "Hold your tongue," said the dervise. "I promised myself the pleasure," said Pangloss, "of reasoning with you upon effects and causes, the best of possible worlds, the origin of evil, the nature of the soul, and the pre-established harmony."—The dervise, at these words, shut the door in their faces.

During this conference, news was brought that two viziers and a mufti were strangled at Constantinople, and a great many of their friends impaled. This catastrophe made a great noise for several hours. Pangloss, Candide, and Martin, on their way back to the little farm, met a good-looking old man, taking the air at his door, under an arbor of orange trees. Pangloss, who had as much curiosity as philosophy, asked him the name of the mufti who was lately strangled. "I know nothing at all about it," said the good man; "and what's more, I never knew the name of a single mufti, or a single vizier, in my life. I am an entire stranger to the story you mention; and presume that, generally speaking, they who trouble their head with state affairs, sometimes die shocking deaths, not without deserving it. But I never trouble my head about what is doing at Constantinople; I content myself with sending my fruits thither, the produce of my garden, which I cultivate with my own hands!" Having said these words, he introduced the strangers into his house. His two daughters and two sons served them with several kinds of sherbet, which they made themselves, besides caymac, enriched with the peels of candied citrons, oranges, lemons, bananas, pistachio nuts, and Mocoa coffee, unadulterated with the bad coffee of Batavia and the isles. After which the two daughters of this good Mussulman perfumed the beards of Candide, Pangloss, and Martin.

"You must certainly," said Candide to the Turk, "have a very large and very opulent estate!" "I have only twenty acres," said the Turk; "which I, with my children, cultivate. Labor keeps us free from three of the greatest evils; tiresomeness, vice, and want."

As Candide returned to his farm, he made deep reflections on the discourse of the Turk. Said he to Pangloss and Martin, "The condition of this good old man seems to me preferable to that of the six kings with whom we had the honor to sup." "The grandeurs of royalty," said Pangloss, "are very precarious, in the opinion of all philosophers. For, in short, Eglon, king of the Moabites, was assassinated by Ehud; Absalom was hung by the hair of his head, and pierced through with three darts; King Nadab, the son of Jeroboam, was killed by Baasha; King Elah by Zimri; Ahazia by Jehu; Athaliah by Jehoiadah; the kings Joachim, Jechonias, and Zedekias, were carried into captivity. You know the fates of Croesus, Astyages, Darius, Dionysius of Syracuse, Pyrrhus, Perseus, Hannibal, Jugurtha, Ariovistus, Caesar, Pompey, Nero, Otho, Vitellius, Domitian,

Richard II, Edward II, Henry VI, Richard III, Mary Stuart, Charles I of England, the three Henrys of France, and the Emperor Henry IV. You know—" "I know very well," said Candide, "that we ought to look after our garden." "You are in the right," said Pangloss, "for when man was placed in the garden of Eden, he was placed there, *ut operatur cum*, to cultivate it; which proves that mankind are not created to be idle." "Let us work," said Martin, "without disputing; it is the only way to render life supportable."

All their little society entered into this laudable design, according to their different abilities. Their little piece of ground produced a plentiful crop. Cunegonde was indeed very homely, but she became an excellent pastry cook. Paquetta worked at embroidery, and the old woman took care of the linen. There was no idle person in the company, not excepting even Girofflee; he made a very good carpenter, and became a very honest man.

As to Pangloss, he evidently had a lurking consciousness that his theory required unceasing exertions, and all his ingenuity, to sustain it. Yet he stuck to it to the last; his thinking and talking faculties could hardly be diverted from it for a moment. He seized every occasion to say to Candide, "All the events in this best of possible worlds are admirably connected. If a single link in the great chain were omitted, the harmony of the entire universe would be destroyed. If you had not been expelled from that beautiful castle, with those cruel kicks, for your love to Miss Cunegonde; if you had not been imprisoned by the inquisition; if you had not travelled over a great portion of America on foot; if you had not plunged your sword through the baron; if you had not lost all the sheep you brought from that fine country, Eldorado, together with the riches with which they were laden, you would not be here to-day, eating preserved citrons, and pistachio nuts."

"That's very well said, and may all be true," said Candide; "but let's cultivate our garden."

The Declaration of Independence
[1761] Thomas Jefferson

[July 4, 1776]

When, in the course of human events, it becomes necessary for one people to dissolve the political bands which have connected them with another, and to assume among the powers of the earth the separate and equal station to which the laws of nature and of nature's God entitle them, a decent respect to the opinions of mankind requires that they should declare the causes which impel them to the separation.

We hold these truths to be self evident: that all men are created equal; that they are endowed by their Creator with certain inalienable rights; that among these are life, liberty, and the pursuit of happiness; that to secure these rights, governments are instituted among men, deriving their just powers from the consent of the governed; that whenever any form of government becomes destructive of

these ends, it is the right of the people to alter or to abolish it, and to institute new government, laying its foundation on such principles, and organizing its powers in such form, as to them shall seem most likely to effect their safety and happiness. Prudence, indeed, will dictate that governments long established should not be changed for light and transient causes; and accordingly all experience hath shown that mankind are more disposed to suffer while evils are sufferable, than to right themselves by abolishing the forms to which they are accustomed. But when a long train of abuses and usurpations, pursuing invariably the same object, evinces a design to reduce them under absolute despotism, it is their right, it is their duty to throw off such government, and to provide new guards for their future security. Such has been the patient sufferance of these colonies; and such is now the necessity which constrains them to alter their former systems of government. The history of the present king of Great Britain is a history of repeated injuries and usurpations, all having in direct object the establishment of an absolute tyranny over these states. To prove this, let facts be submitted to a candid world.

He has refused his assent to laws the most wholesome and necessary for the public good.

He has forbidden his governors to pass laws of immediate and pressing importance, unless suspended in their operation till his assent should be obtained; and, when so suspended, he has utterly neglected to attend to them.

He has refused to pass other laws for the accommodation of large districts of people, unless those people would relinquish the right of representation in the legislature, a right inestimable to them, and formidable to tyrants only.

He has called together legislative bodies at places unusual, uncomfortable, and distant from the depository of their public records, for the sole purpose of fatiguing them into compliance with his measures.

He has dissolved representative houses repeatedly for opposing with manly firmness his invasions on the rights of the people.

He has refused for a long time after such dissolutions to cause others to be elected, whereby the legislative powers, incapable of annihilation, have returned to the people at large for their exercise, the state remaining, in the meantime, exposed to all the dangers of invasion from without and convulsions within.

He has endeavored to prevent the population of these states; for that purpose obstructing the laws for naturalization of foreigners, refusing to pass others to encourage their migrations hither, and raising the conditions of new appropriations of lands.

He has obstructed the administration of justice by refusing his assent to laws for establishing judiciary powers.

He has made judges dependent on his will alone for the tenure of their offices, and the amount and payment of their salaries.

He has erected a multitude of new offices, and sent hither swarms of new officers to harass our people and eat out their substance.

He has kept among us in times of peace standing armies without the consent of our legislatures.

He has affected to render the military independent of, and superior to, the civil power.

He has combined with others to subject us to a jurisdiction foreign to our constitutions and unacknowledged by our laws, giving his assent to their acts of pretended legislation for quartering large bodies of armed troops among us; for protecting them by a mock trial from punishment for any murders which they should commit on the inhabitants of these states; for cutting off our trade with all parts of the world; for imposing taxes on us without our consent; for depriving us in many cases of the benefits of trial by jury; for transporting us beyond seas to be tried for pretended offences; for abolishing the free system of English laws in a neighboring province, establishing therein an arbitrary government, and enlarging its boundaries, so as to render it at once an example and fit instrument for introducing the same absolute rule into these colonies; for taking away our charters, abolishing our most valuable laws, and altering fundamentally the forms of our governments; for suspending our own legislatures, and declaring themselves invested with power to legislate for us in all cases whatsoever.

He has abdicated government here by declaring us out of his protection, and waging war against us.

He has plundered our seas, ravaged our coasts, burnt our towns, and destroyed the lives of our people.

He is at this time transporting large armies of foreign mercenaries to complete the works of death, desolation and tyranny already begun with circumstances of cruelty and perfidy scarcely paralleled in the most barbarous ages, and totally unworthy the head of a civilized nation.

He has constrained our fellow citizens taken captive on the high seas, to bear arms against their country, to become the executioners of their friends and brethren, or to fall themselves by their hands.

He has excited domestic insurrection among us, and has endeavored to bring on the inhabitants of our frontiers, the merciless Indian savages, whose known rule of warfare is an undistinguished destruction of all ages, sexes and conditions.

In every stage of these oppressions we have petitioned for redress in the most humble terms: our repeated petitions have been answered only by repeated injuries.

A prince whose character is thus marked by every act which may define a tyrant is unfit to be the ruler of a free people.

Nor have we been wanting in attentions to our British brethren. We have warned them from time to time of attempts by their legislature to extend an unwarrantable jurisdiction over us. We have reminded them of the circumstances of our emigration and settlement here, we have appealed to their native justice and magnanimity and we have conjured them by the ties of our common kindred to disavow these usurpations which would inevitably interrupt our connection and correspondence. They too have been deaf to the voice of justice and of consanguinity. We must therefore acquiesce in the necessity which denounces our separation and hold them as we hold the rest of mankind, enemies in war, in peace friends!

We, therefore, the representatives of the United States of America in General Congress assembled, appealing to the supreme judge of the world for the rectitude of our intentions, do in the name, and by the authority of the good people of these colonies, solemnly publish and declare, that these united colonies are, and of right ought to be free and independent states; that they are absolved from all allegiance to the British Crown, and that all political connection between them and the state of Great Britain is, and ought to be, totally dissolved; and that as free and independent states, they have full power to levy war, conclude peace, contract alliances, establish commerce, and to do all other acts and things which independent states may of right do.

And for the support of this declaration, with a firm reliance on the protection of divine providence, we mutually pledge to each other our lives, our fortunes, and our sacred honor.

Social Contract
[1762] Jean-Jacques Rousseau

Preface

This short treatise has been abstracted from a more extended work, undertaken without due consideration of my powers, and long since abandoned. Of such scraps as could be salved from what was then completed, this is the most considerable, and, in my opinion, the least unworthy of being presented to the public. The rest is now no more.

Book I
Note

It is my wish to inquire whether it be possible, within the civil order, to discover a legitimate and stable basis of Government. This I shall do by considering human beings as they are and laws as they might be. I shall attempt, throughout my investigations, to maintain a constant connexion between what right permits and interest demands, in order that no separation may be made between justice and utility. I intend to begin without first proving the importance of my subject. Am I, it will be asked, either prince or legislator that I take it upon me to write of politics? My answer is—No; and it is for that very reason that I have chosen politics as the matter of my book. Were I either the one or the other I should not waste my time in laying down what has to be done. I should do it, or else hold my peace.

I was born into a free state and am a member of its sovereign body. My influence on public affairs may be small, but because I have a right to exercise my vote, it is my duty to learn their nature, and it has been for me a matter of constant delight, while meditating on problems of Government in general, to find ever fresh reasons for regarding with true affection the way in which these things are ordered in my native land.

Chapter 1
The Subject of the First Book

Man is born free, and everywhere he is in chains. Many a man believes himself to be the master of others who is, no less than they, a slave. How did this change take place? I do not know. What can make it legitimate? To this question I hope to be able to furnish an answer.

Were I considering only force and the effects of force, I should say: "So long as a People is constrained to obey, and does, in fact, obey, it does well. So soon as it can shake off its yoke, and succeeds in doing so, it does better. The fact that it has recovered its liberty by virtue of that same right by which it was stolen, means either that it is entitled to resume it, or that its theft by others was, in the first place, without justification." But the social order is a sacred right which serves as a foundation for all other rights. This right, however, since it comes not by nature, must have been built upon conventions. To discover what these conventions are is the matter of our inquiry. But, before proceeding further, I must establish the truth of what I have so far advanced.

Chapter 2
Of Primitive Societies

The oldest form of society—and the only natural one—is the family. Children remain bound to their father for only just so long as they feel the need of him for their self-preservation. Once that need ceases the natural bond is dissolved. From then on, the children, freed from the obedience which they formerly owed, and the father, cleared of his debt of responsibility to them, return to a condition of equal independence. If the bond remain operative it is no longer something imposed by nature, but has become a matter of deliberate choice. The family is a family still, but by reason of convention only.

This shared liberty is a consequence of man's nature. Its first law is that of self-preservation: its first concern is for what it owes itself. As soon as a man attains the age of reason he becomes his own master, because he alone can judge of what will best assure his continued existence.

We may, therefore, if we will, regard the family as the basic model of all political associations. The ruler is the father writ large: the people are, by analogy, his children, and all, ruler and people alike, alienate their freedom only so far as it is to their advantage to do so. The only difference is that, whereas in the family the father's love for his children is sufficient reward to him for the care he has lavished on them, in the State, the pleasure of commanding others takes its place, since the ruler is not in a relation of love to his people.

Grotius denies that political power is ever exercised in the interests of the governed, and quotes the institution of slavery in support of his contention. His invariable method of arguing is to derive Right from Fact.[1] It might be

1. 'Learned researches into Public Right are, too often, but the record of ancient abuses, and it is but a waste of time to pursue such a line of inquiry . . .' (*Traité des interêts de la France avec ses voisins*, by M. le Marquis d'Argenson, published by Rey of Amsterdam). This is precisely the error of which Grotius is guilty.

possible to adopt a more logical system of reasoning, but none which would be more favorable to tyrants.

According to Grotius, therefore, it is doubtful whether the term "human race" belongs to only a few hundred men, or whether those few hundred men belong to the human race. From the evidence of his book it seems clear that he holds by the first of these alternatives, and on this point Hobbes is in agreement with him. If this is so, then humanity is divided into herds of livestock, each with its "guardian" who watches over his charges only that he may ultimately devour them.

Just as the shepherd is superior in kind to his sheep, so, too, the shepherds of men, or, in other words, their rulers, are superior in kind to their peoples. This, according to Philo, was the argument advanced by Caligula, the Emperor, who drew from the analogy the perfectly true conclusion that either Kings are Gods or their subjects brute beasts.

The reasoning of Caligula, of Hobbes, and of Grotius is fundamentally the same. Far earlier, Aristotle, too, had maintained that men are not by nature equal, but that some are born to be slaves, others to be masters.[2]

Aristotle was right: but he mistook the effect for the cause. Nothng is more certain than that a man born into a condition of slavery is a slave by nature. A slave in fetters loses everything—even the desire to be freed from them. He grows to love his slavery, as the companions of Ulysses grew to love their state of brutish transformation.[3]

If some men are by nature slaves, the reason is that they have been made slaves *against* nature. Force made the first slaves: cowardice has perpetuated the species.

I have made no mention of King Adam or of the Emperor Noah, the father of three great Monarchs who divided up the universe between them, as did the children of Saturn, whom some have been tempted to identify with them. I trust that I may be given credit for my moderation, since, being descended in a direct line from one of these Princes, and quite possibly belonging to the elder branch, I may, for all I know, were my claims supported in law, be even now the legitimate Sovereign of the Human Race. However that may be, all will concur in the view that Adam was King of the World, as was Robinson Crusoe of his island, only so long as he was its only inhabitant, and that the great advantage of empire held on such terms was that the Monarch, firmly seated on his throne, had no need to fear rebellions, conspiracy, or war.

Chapter 3
Of the Right of the Strongest

However strong a man, he is never strong enough to remain master always, unless he transform his Might into Right, and Obedience into Duty. Hence we have come to speak of the Right of the Strongest, a right which, seemingly assumed in irony, has, in fact, become established in principle. But the meaning of the phrase

has never been adequately explained. Strength is a physical attribute, and I fail to see how any moral sanction can attach to its effects. To yield to the strong is an act of necessity, not of will. At most it is the result of a dictate of prudence. How, then, can it become a duty?

Let us assume for a moment that some such Right does really exist. The only deduction from this premise is inexplicable gibberish. For to admit that Might makes Right is to reverse the process of effect and cause. The mighty man who defeats his rival becomes heir to his Right. So soon as we can disobey with impunity, disobedience becomes legitimate. And, since the Mightiest is always right, it merely remains for us to become possessed of Might. But what validity can there be in a Right which ceases to exist when Might changes hands? If a man be constrained by Might to obey, what need has he to obey by Duty? And if he is not constrained to obey, there is no further obligation on him to do so. It follows, therefore, that the word Right adds nothing to the idea of Might. It becomes, in this connexion, completely meaningless.

Obey the Powers that be. If that means Yield to Force, the precept is admirable but redundant. My reply to those who advance it is that no case will ever be found of its violation. All power comes from God. Certainly, but so do all ailments. Are we to conclude from such an argument that we are never to call in the doctor? If I am waylaid by a footpad at the corner of a wood, I am constrained by force to give him my purse. But if I can manage to keep it from him, is it my duty to hand it over? His pistol is also a symbol of Power. It must, then, be admitted that Might does not create Right, and that no man is under an obligation to obey any but the legitimate powers of the State. And so I continually come back to the question I first asked.

Chapter 4
Of Slavery

Since no man has natural authority over his fellows, and since Might can produce no Right, the only foundation left for legitimate authority in human societies is Agreement.

If a private citizen, says Grotius, can alienate his liberty and make himself another man's slave, why should not a whole people do the same, and subject themselves to the will of a King? The argument contains a number of ambiguous words which stand in need of explanation. But let us confine our attention to one only—*alienate*. To alienate means to give or to sell. Now a man who becomes the slave of another does not give himself. He sells himself in return for bare subsistence, if for nothing more. But why should a whole people sell themselves? So far from furnishing subsistence to his subjects, a King draws his own from them, and from them alone. According to Rabelais, it takes a lot to keep a King. Do we, then, maintain that a subject surrenders his person on condition that his property be taken too? It is difficult to see what he will have left.

It will be said that the despot guarantees civil peace to his subjects. So be it. But how are they the gainers if the wars to which his ambition may expose them, his

2. *Politics*, Book I, Ch. 5.
3. See the short Treatise by Plutarch, entitled *That Beasts Make Use of Reason.*

insatiable greed, and the vexatious demands of his Ministers cause them more loss than would any outbreak of internal dissension? How do they benefit if that very condition of civil peace be one of the causes of their wretchedness? One can live peacefully enough in a dungeon, but such peace will hardly, of itself, ensure one's happiness. The Greeks imprisoned in the cave of Cyclops lived peacefully while awaiting their turn to be devoured.

To say that a man gives himself for nothing is to commit oneself to an absurd and inconceivable statement. Such an act of surrender is illegitimate, null, and void by the mere fact that he who makes it is not in his right mind. To say the same thing of a whole People is tantamount to admitting that the People in question are a nation of imbeciles. Imbecility does not produce Right.

Even if a man can alienate himself, he cannot alienate his children. They are born free, their liberty belongs to them, and no one but themselves has a right to dispose of it. Before they have attained the age of reason their father may make, on their behalf, certain rules with a view to ensuring their preservation and well-being. But any such limitation of their freedom of choice must be regarded as neither irrevocable nor unconditional, for to alienate another's liberty is contrary to the natural order, and is an abuse of the father's rights. It follows that an arbitrary government can be legitimate only on condition that each successive generation of subjects is free either to accept or to reject it, and if this is so, then the government will no longer be arbitrary.

When a man renounces his liberty he renounces his essential manhood, his rights, and even his duty as a human being. There is no compensation possible for such complete renunciation. It is incompatible with man's nature, and to deprive him of his free will is to deprive his actions of all moral sanction. The convention, in short, which sets up on one side an absolute authority, and on the other an obligation to obey without question, is vain and meaningless. Is it not obvious that where we can demand everything we owe nothing? Where there is no mutual obligation, no interchange of duties, it must, surely, be clear that the actions of the commanded cease to have any moral value? For how can it be maintained that my slave has any "right" against me when everything that he has is my property? His right being *my* right, it is absurd to speak of it as ever operating to my disadvantage.

Grotius, and those who think like him, have found in the fact of war another justification for the so-called "right" of slavery. They argue that since the victor has a *right* to kill his defeated enemy, the latter may, if he so wish, ransom his life at the expense of his liberty, and that this compact is the more legitimate in that it benefits both parties.

But it is evident that this alleged *right* of a man to kill his enemies is not in any way a derivative of the state of war, if only because men, in their primitive condition of independence, are not bound to one another by any relationship sufficiently stable to produce a state either of war or of peace. They are not *naturally* enemies. It is the link between *things* rather than between *men* that constitutes war, and since a state of war cannot originate in simple personal relations, but only in relations between things, private hostility between man and man cannot obtain either in a state of nature where there is no generally accepted system of private property, or in a state of society where law is the supreme authority.

Single combats, duels, personal encounters are incidents which do not constitute a 'state' of anything. As to those private wars which were authorized by the Ordinances of King Louis IX and suspended by the Peace of God, they were merely an abuse of Feudalism—that most absurd of all systems of government, so contrary was it to the principles of Natural Right and of all good polity.

War, therefore, is something that occurs not between man and man, but between States. The individuals who become involved in it are enemies only by accident. They fight not as men or even as citizens, but as soldiers: not as members of this or that national group, but as its defenders.[4] A State can have as its enemies only other States, not men at all, seeing that there can be no true relationship between things of a different nature.

This principle is in harmony with that of all periods, and with the constant practice of every civilized society. A declaration of war is a warning, not so much to Governments as to their subjects. The foreigner—whether king, private person, or nation as a whole—who steals, murders, or holds in durance the subjects of another country without first declaring war on that country's Prince, acts not as an enemy but as a brigand. Even when war has been joined, the just Prince, though he may seize all public property in enemy territory, yet respects the property and possessions of individuals, and, in so doing, shows his concern for those rights on which his own laws are based. The object of war being the destruction of the enemy State, a commander has a perfect right to kill its defenders so long as their arms are in their hands: but once they have laid them down and have submitted, they cease to be enemies, or instruments employed by an enemy, and revert to the condition of men, pure and simple, over whose lives no one can any longer exercise a rightful claim. Sometimes it is possible to destroy a State without killing any of its subjects, and nothing in war can be claimed as a right save what may be necessary for the accomplishment of the victor's end. These principles are not those of Grotius, nor are they based on the authority of poets, but derive from the Nature of Things, and are founded upon Reason.

4. The Romans, who, more than any other nation, had a genuine understanding of, and respect for, the legal implications of war, carried their scruples in this matter so far that a citizen was forbidden to volunteer except for a particular campaign and against a specific enemy. When the legion in which Cato the Younger performed his first period of military service under Popilius was re-formed, his father wrote to the latter explaining that if he wished to keep the young man under his command he must administer the oath over again, since the first one was now annulled, and consequently Cato could not be called upon to bear arms against the enemy. At the same time he wrote to his son telling him to be sure not to appear on parade until he had renewed his oath. I am aware that such particular instances as the siege of Clusium may be quoted against me, but my reply would be that I am concerned to cite only laws and customs. It was very seldom that the Romans transgressed their laws and few peoples have had better ones.

The Right of Conquest finds its sole sanction in the Law of the Strongest. If war does not give to the victor the right to massacre his defeated enemies, he cannot base upon a non-existent right any claim to the further one of enslaving them. We have the right to kill our enemies only when we cannot enslave them. It follows, therefore, that the right to enslave cannot be deduced from the right to kill, and that we are guilty of enforcing an iniquitous exchange if we make a vanquished foeman purchase with his liberty that life over which we have no right. Is it not obvious that once we begin basing the right of life and death on the right to enslave, and the right to enslave on the right of life and death, we are caught in a vicious circle? Even if we assume the existence of this terrible right to kill all and sundry, I still maintain that a man enslaved, or a People conquered, in war is under no obligation to obey beyond the point at which force ceases to be operative. If the victor spares the life of his defeated opponent in return for an equivalent, he cannot be said to have shown him mercy. In either case he destroys him, but in the latter case he derives value from his act, while in the former he gains nothing. His authority, however, rests on no basis but that of force. There is still a state of war between the two men, and it conditions the whole relationship in which they stand to one another. The enjoyment of the Rights of War presupposes that there has been no treaty of Peace. Conqueror and conquered have, to be sure, entered into a compact, but such a compact, far from liquidating the state of war, assumes its continuance.

Thus, in whatever way we look at the matter, the "Right" to enslave has no existence, not only because it is without legal validity, but because the very term is absurd and meaningless, The words *Slavery* and *Right* are contradictory and mutually exclusive. Whether we be considering the relation of one man to another man, or of an individual to a whole People, it is equally idiotic to say—"You and I have made a compact which represents nothing but loss to you and gain to me. I shall observe it so long as it pleases me to do so—and so shall you, until I cease to find it convenient."

Chapter 5
That we must always go back to an Original Compact

Even were I to grant all that I have so far refuted, the champions of despotism would not be one whit the better off. There will always be a vast difference between subduing a mob and governing a social group. No matter how many isolated individuals may submit to the enforced control of a single conqueror, the resulting relationship will ever be that of Master and Slave, never of People and Ruler. The body of men so controlled may be an agglomeration; it is not an association. It implies neither public welfare nor a body politic. An individual may conquer half the world, but he is still only an individual. His interests, wholly different from those of his subjects, are private to himself. When he dies his empire is left scattered and disintegrated. He is like an oak which crumbles and collapses in ashes so soon as the fire consumes it.

"A People", says Grotius, "may give themselves to a king." His argument implies that the said People were already a People before this act of surrender. The very act of gift was that of a political group and presupposed public deliberation. Before, therefore, we consider the act by which a People chooses their king, it were well if we considered the act by which a People is constituted as such. For it necessarily precedes the other, and is the true foundation on which all Societies rest.

Had there been no original compact, why, unless the choice were unanimous, should the minority ever have agreed to accept the decision of the majority? What right have the hundred who desire a master to vote for the ten who do not? The institution of the franchise is, in itself, a form of compact, and assumes that, at least once in its operation, complete unanimity existed.

Chapter 6
Of the Social Pact

I assume, for the sake of argument, that a point was reached in the history of mankind when the obstacles to continuing in a state of Nature were stronger than the forces which each individual could employ to the end of continuing in it. The original state of Nature, therefore, could no longer endure, and the human race would have perished had it not changed its manner of existence.

Now, since men can by no means engender new powers, but can only unite and control those of which they are already possessed, there is no way in which they can maintain themselves save by coming together and pooling their strength in a way that will enable them to withstand any resistance exerted upon them from without. They must develop some sort of central direction and learn to act in concert.

Such a concentration of powers can be brought about only as the consequence of an agreement reached between Individuals. But the self-preservation of each single man derives primarily from his own strength and from his own freedom. How, then, can he limit these without, at the same time, doing himself an injury and neglecting that care which it is his duty to devote to his own concerns? This difficulty, in so far as it is relevant to my subject, can be expressed as follows:

"Some form of association must be found as a result of which the whole strength of the community will be enlisted for the protection of the person and property of each constituent member, in such a way that each, when united to his fellows, renders obedience to his own will, and remains as free as he was before." That is the basic problem of which the Social Contract provides the solution.

The clauses of this Contract are determined by the Act of Association in such a way that the least modification must render them null and void. Even though they may never have been formally enunciated, they must be everywhere the same, and everywhere tacitly admitted and recognized. So completely must this be the case that, should the social compact be violated, each associated individual would at once resume all the rights which once were his, and regain his natural liberty, by the mere fact of losing the agreed liberty for which he renounced it.

It must be clearly understood that the clauses in question can be reduced, in the last analysis, to one only, to wit, the complete alienation by each associate member to the community of *all his rights*. For, in the first place, since each has made surrender of himself without reservation, the resultant conditions are the same for all: and, because they are the same for all, it is in the interest of none to make them onerous to his fellows.

Furthermore, this alienation having been made unreservedly, the union of individuals is as perfect as it well can be, none of the associated members having any claim against the community. For should there be any rights left to individuals, and no common authority be empowered to pronounce as between them and the public, then each, being in some things his own judge, would soon claim to be so in all. Were that so, a state of Nature would still remain in being, the conditions of association becoming either despotic or ineffective.

In short, whoso gives himself to all gives himself to none. And, since there is no member of the social group over whom we do not acquire precisely the same rights as those over ourselves which we have surrendered to him, it follows that we gain the exact equivalent of what we lose, as well as an added power to conserve what we already have.

If, then, we take from the social pact all that is not essential to it, we shall find it to be reduced to the following terms: "each of us contributes to the group his person and the powers which he wields as a person under the supreme direction of the general will and we receive into the body politic each individual as forming an indivisible part of the whole."

As soon a the act of association becomes a reality, it substitutes for the person of each of the contracting parties a moral and collective body made up of as many members as the constituting assembly has votes, which body receives from this very act of constitution its unity, its dispersed *self*, and its will. The public person thus formed by the union of individuals was known in the old days as a *City*, but now as the *Republic* or *Body Politic*.[5]

This, when it fulfills a passive role, is known by its members as *The State*, when an active one, as *The Sovereign People*, and, in contrast to other similar bodies, as a *Power*. In respect of the constituent associates, it enjoys the collective name of *The People*, the individuals who compose it being known as *Citizens* in so far as they share in the sovereign authority, as *Subjects* in so far as they owe obedience to the laws of the State. But these different terms frequently overlap, and are used indiscriminately one for the other. It is enough that we should realize the difference between them when they are employed in a precise sense.

Chapter 7
Of the Sovereign

It is clear from the above formula that the act of association implies a mutual undertaking between the body politic and its constituent members. Each individual comprising the former contracts, so to speak, with himself and has a twofold function. As a member of the sovereign people he owes a duty to each of his neighbors, and, as a Citizen, to the sovereign people as a whole. But we cannot here apply that maxim of Civil Law according to which no man can be held to an undertaking entered into with himself, because there is a great difference between a man's duty to himself and to a whole of which he forms a part.

Here it should be pointed out that a public decision which can enjoin obedience on all subjects to their Sovereign, by reason of the double aspect under which each is seen, cannot, on the contrary, bind the sovereign in his dealings with himself. Consequently, it is against the nature of the body politic that the sovereign should impose upon himself a law which he cannot infringe. For, since he can regard himself under one aspect only, he is in the position of an individual entering into a contract with himself. Whence it follows that there is not, nor can be, any fundamental law which is obligatory for the whole body of the People, not even the social contract itself. This does not mean that the body politic is unable to enter into engagements with some other Power, provided always that such engagements do not derogate from the nature of the Contract; for the relation of the body politic to a foreign Power is that of a simple individual.

But the body politic, or Sovereign, in that it derives its being simply and solely from the sanctity of the said Contract, can never bind itself, even in its relations with a foreign Power, by any decision which might derogate from the validity of the original act. It may not, for instance, alienate any portion of itself, nor make submission to any other sovereign. To violate the act by reason of which it exists would be tantamount to destroying itself, and that which is nothing can produce nothing.

As soon as a mob has become united into a body politic, any attack upon one of its members is an attack upon itself. Still more important is the fact that, should any offence be committed against the body politic as a whole, the effect must be felt by each of its members. Both duty and interest, therefore, oblige the two contracting parties to render one another mutual assistance. The same individuals should seek to unite

5. The true meaning of the word "City" has been almost entirely lost by the moderns, most of whom think that a Town and a City are identical, and that to be a Burgess is the same thing as to be a Citizen. They do not know that houses may make a town, but that only citizens can make a City. This same error cost the people of Carthage dear in the past. I have never anywhere read that the title "*cives*" could be conferred on the subject of a Prince, not even upon the Macedonians of ancient times, nor upon the English in our own day, though the latter are more nearly in the enjoyment of freedom than any other people. Only the French use *citizens* as a familiar word, the reason for this being that they have no true apprehension of its meaning, as may be seen by anyone who consults a French dictionary. Were it otherwise, they would fall, by adopting it, into the crime of *lèse-majesté*. In their mouths it is held to express not so much legal standing as quality. When Bodin speaks of "our citizens and burgesses" he commits a grave blunder in giving the same meaning to the two words. Not so deceived is M. d'Alembert, who, in his article on Geneva, properly distinguishes between the four Orders (five, if foreigners be counted) which go to make up our city, of which two only constitute the Republic. No other French author known to me understands the meaning of the word "Citizen".

under this double aspect all the advantages which flow from it.

Now the Sovereign People, having no existence outside that of the individuals who compose it, has, and can have, no interest at variance with theirs. Consequently, the sovereign power need give no guarantee to its subjects, since it is impossible that the body should wish to injure all its members, nor, as we shall see later, can it injure any single individual. The Sovereign, by merely existing, is always what it should be. But the same does not hold true of the relation of subject to sovereign. In spite of common interest, there can be no guarantee that the subject will observe his duty to the sovereign unless means are found to ensure his loyalty.

Each individual, indeed, may, as a man, exercise a will at variance with, or different from, that general will to which, as citizen, he contributes. His personal interest may dictate a line of action quite other than that demanded by the interest of all. The fact that his own existence as an individual has an absolute value, and that he is, by nature, an independent being, may lead him to conclude that what he owes to the common cause is something that he renders of his own free will; and he may decide that by leaving the debt unpaid he does less harm to his fellows than he would to himself should he make the necessary surrender. Regarding the moral entity constituting the State as a rational abstraction because it is not a man, he might enjoy his rights as a citizen without, at the same time, fulfilling his duties as a subject, and the resultant injustice might grow until it brought ruin upon the whole body politic.

In order, then, that the social compact may not be but a vain formula, it must contain, though unexpressed, the single undertaking which can alone give force to the whole, namely, that whoever shall refuse to obey the general will must be constrained by the whole body of his fellow citizens to do so: which is no more than to say that it may be necessary to compel a man to be free—freedom being that condition which, by giving each citizen to his country, guarantees him from all personal dependence and is the foundation upon which the whole political machine rests, and supplies the power which works it. Only the recognition by the individual of the rights of the community can give legal force to undertakings entered into between citizens, which, otherwise, would become absurd, tyrannical, and exposed to vast abuses.

Chapter 8
Of the Civil State

The passage from the state of nature to the civil state produces a truly remarkable change in the individual. It substitutes justice for instinct in his behavior, and gives to his actions a moral basis which formerly was lacking. Only when the voice of duty replaces physical impulse and when right replaces the cravings of appetite does the man who, till then, was concerned solely with himself, realize that he is under compulsion to obey quite different principles, and that he must now consult his reason and not merely respond to the promptings of desire. Although he may find himself deprived of many advantages which were his in a state of nature, he will recognize that he has gained others which are of far greater value. By dint of being exercised, his faculties will develop, his ideas take on a wider scope, his sentiments become ennobled, and his whole soul be so elevated, that, but for the fact that misuse of the new conditions still, at times, degrades him to a point below that from which he has emerged, he would unceasingly bless the day which freed him for ever from his ancient state, and turned him from a limited and stupid animal into an intelligent being and a Man.

Let us reduce all this to terms which can be easily compared. What a man loses as a result of the Social Contract is his natural liberty and his unqualified right to lay hands on all that tempts him, provided only that he can compass its possession. What he gains is civil liberty and the ownership of what belongs to him. That we may labor under no illusion concerning these compensations, it is well that we distinguish between natural liberty which the individual enjoys so long as he is strong enough to maintain it, and civil liberty which is curtailed by the general will. Between possessions which derive from physical strength and the right of the first-comer, and ownership which can be based only on a positive title.

To the benefits conferred by the status of citizenship might be added that of Moral Freedom, which alone makes a man his own master. For to be subject to appetite is to be a slave, while to obey the laws laid down by society is to be free. But I have already said enough on this point, and am not concerned here with the philosophical meaning of the word *liberty*.

Chapter 9
Of Real Property

Each individual member of the Community gives himself to it at the moment of its formation. What he gives is the whole man as he then is, with all his qualities of strength and power, and everything of which he stands possessed. Not that, as a result of this act of gift, such possessions, by changing hands and becoming the property of the Sovereign, change their nature. Just as the resources of strength upon which the City can draw are incomparably greater than those at the disposition of any single individual, so, too, is public possession when backed by a greater power. It is made more irrevocable, though not, so far, at least, as regards foreigners, more legitimate. For the State, by reason of the Social Contract which, within it, is the basis of all Rights, is the master of all its members' goods, though, in its dealings with other Powers, it is so only by virtue of its rights as first occupier, which come to it from the individuals who make it up.

The Right of "first occupancy", though more real than the "Right of the strongest", becomes a genuine right only after the right of property has been established. All men have a natural right to what is necessary to them. But the positive act which establishes a man's claim to any particular item of property limits him to that and excludes him from all others. His share having been determined, he must confine himself to that, and no longer has any claim on the property of the community. That is why the right of "first occupancy", however weak it be in a state of nature,

is guaranteed to every man enjoying the status of citizen. In so far as he benefits from this right, he withholds his claim, not so much from what is another's, as from what is not specifically his.

In order that the right of "first occupancy" may be legalized, the following conditions must be present. (1) There must be no one already living on the land in question. (2) A man must occupy only so much of it as is necessary for his subsistence. (3) He must take possession of it, not by empty ceremony, but by virtue of his intention to work and to cultivate it, for that, in the absence of legal title, alone constitutes a claim which will be respected by others.

In effect, by according the right of "first occupancy" to a man's needs and to his will to work, are we not stretching it as far as it will go? Should not some limits be set to this right? Has a man only to set foot on land belonging to the community to justify his claim to be its master? Just because he is strong enough, at one particular moment, to keep others off, can he demand that they shall never return? How can a man or a People take possession of vast territories, thereby excluding the rest of the world from their enjoyment, save by an act of criminal usurpation, since, as the result of such an act, the rest of humanity is deprived of the amenities of dwelling and subsistence which nature has provided for their common enjoyment? When Nunez Balboa, landing upon a strip of coast, claimed the Southern Sea and the whole of South America as the property of the crown of Castille, was he thereby justified in dispossessing its former inhabitants, and in excluding from it all the other princes of the earth? Grant that, and there will be no end to such vain ceremonies. It would be open to His Catholic Majesty to claim from his Council Chamber possession of the whole Universe, only excepting those portions of it already in the ownership of other princes.

One can understand how the lands of individuals, separate but contiguous, become public territory, and how the right of sovereignty, extending from men to the land they occupy, becomes at once real and personal—a fact which makes their owners, more than ever dependent, and turns their very strength into a guarantee of their fidelity. This is an advantage which does not seem to have been considered by the monarchs of the ancient world, who, claiming to be no more than kings of the Persians, the Scythians, the Macedonians, seem to have regarded themselves rather as the rulers of men than as the masters of countries. Those of our day are cleverer, for they style themselves kings of France, of Spain, of England, &c. Thus, by controlling the land, they can be very sure of controlling its inhabitants.

The strange thing about this act of alienation is that, far from depriving its members of their property by accepting its surrender, the Community actually establishes their claim to its legitimate ownership, and changes what was formerly mere usurpation into a right, by virtue of which they may enjoy possession. As owners they are Trustees for the Commonwealth. Their rights are respected by their fellow citizens and are maintained by the united strength of the community against any outside attack. From ceding their property to the State—and thus, to themselves—they derive nothing but advantage, since they have, so to speak, acquired all that they have surrendered. This paradox is easily explained once we realize the distinction between the rights exercised by the Sovereign and by the Owner over the same piece of property, as will be seen later.

It may so happen that a number of men begin to group themselves into a community before ever they own property at all, and that only later, when they have got possession of land sufficient to maintain them all, do they either enjoy it in common or parcel it between themselves in equal lots or in accordance with such scale of proportion as may be established by the sovereign. However this acquisition be made, the right exercised by each individual over his own particular share must always be subordinated to the overriding claim of the Community as such. Otherwise there would be no strength in the social bond, nor any real power in the exercise of sovereignty.

I will conclude this chapter, and the present Book, with a remark which should serve as basis for every social system: that, so far from destroying natural equality, the primitive compact substitutes for it a moral and legal equality which compensates for all those physical inequalities from which men suffer. However unequal they may be in bodily strength or in intellectual gifts, they become equal in the eyes of the law, and as a result of the compact into which they have entered.[6]

The Lamb
[1789] William Blake

 Little Lamb, who made thee?
 Dost thou know who made thee?
Gave thee life, and bid thee feed,
By the stream and o'er the mead;
Gave thee clothing of delight,
Softest clothing, woolly, bright;
Gave thee such a tender voice,
Making all the vales rejoice?
 Little Lamb, who made thee?
 Dost thou know who made thee?

 Little Lamb, I'll tell thee,
 Little Lamb, I'll tell thee:
He is called by thy name,
For He calls Himself a Lamb.
He is meek, and He is mild;
He became a little child.
I a child, and thou a lamb,
We are called by His name.
 Little Lamb, God bless thee!
 Little Lamb, God bless thee!

6. Under a bad government such equality is but apparent and illusory. It serves only to keep the poor man confined within the limits of his poverty, and to maintain the rich in their usurpation. In fact, laws are always beneficial to the "haves" and injurious to the "have-nots". Whence it follows that life in a social community can thrive only when all its citizens have something, and none have too much.

The Chimney Sweeper
[1789] William Blake

When my mother died I was very young,
And my father sold me[1] while yet my tongue
Could scarcely cry " 'weep! 'weep! 'weep! 'weep!"[2]
So your chimneys I sweep & in soot I sleep.

There's little Tom Dacre, who cried when his head
That curl'd like a lambs back, was shav'd, so I said,
"Hush, Tom! never mind it, for when your head's bare
You know that the soot cannot spoil your white hair."

And so he was quiet, & that very night,
As Tom was a-sleeping he had such a sight!
That thousands of sweepers, Dick, Joe, Ned, & Jack,
Were all of them lock'd up in coffins of black;

And by came an Angel who had a bright key,
And he open'd the coffins & set them all free;
Then down a green plain, leaping, laughing they run,
And wash in a river and shine in the Sun;

Then naked[3] & white, all their bags left behind,
They rise upon clouds, and sport in the wind.
And the Angel told Tom, if he'd be a good boy,
He'd have God for his father & never want joy.

And so Tom awoke; and we rose in the dark
And got with our bags & our brushes to work.
Tho' the morning was cold, Tom was happy & warm;
So if all do their duty, they need not fear harm.

The Rights of Man
[1791] Thomas Paine

Paine wrote *The Rights of Man* in response to the writings
of Edmund Burke on the French Revolution. Paine
compares the new French and American constitutions
with the English system, to the latter's detriment. The
work also contains Paine's proposals for the reform of
taxation, family allowances, and maternity grants, etc.,
which were far in advance of their day.

Conclusion

Reason and Ignorance, the opposites of each other,
influence the great bulk of mankind. If either of these can
be rendered sufficiently extensive in a country, the
machinery of Government goes easily on. Reason obeys
itself; and Ignorance submits to whatever is dictated to it.

The two modes of Government which prevail in the
world, are, *first*, Government by election and
representation: *Secondly*, Government by hereditary
succession. The former is generally known by the name of
republic the latter by that of monarchy and aristocracy.

Those two distinct and opposite forms, erect themselves
on the two distinct and opposite bases of Reason and
Ignorance.—As the exercise of Government requires
talents and abilities, and as talents and abilities cannot
have hereditary descent, it is evident that hereditary
succession requires a belief from man, to which his reason
cannot subscribe, and which can only be established
upon his ignorance; and the more ignorant any country is,
the better it is fitted for this species of Government.

On the contrary, Government in a well-constituted
republic requires no belief from man beyond what his
reason can give. He sees the *rationale* of the whole system,
its origin and its operation; and as it is best supported
when best understood, the human faculties act with
boldness and acquire, under this form of Government, a
gigantic manliness . . .

But in a well-constituted republic, nothing of this
soldering, praising, and pitying, can take place; the
representation being equal throughout the country, and
complete in itself, however it may be arranged into
legislative and executive, they have all one and the same
natural source. The parts are not foreigners to each other,
like democracy, aristocracy, and monarchy. As there are no
discordant distinctions, there is nothing to corrupt by
compromise, nor confound by contrivance. Public
measures appeal of themselves to the understanding of
the Nation, and, resting on their own merits, disown any
flattering application to vanity. The continual whine of
lamenting the burden of taxes, however successfully it may
be practised in mixed Governments, is inconsistent with
the sense and spirit of a republic. If taxes are necessary,
they are of course advantageous; but if they require an
apology, the apology itself implies an impeachment. Why
then is man thus imposed upon, or why does he impose
upon himself?

When men are spoken of as kings and subjects, or when
Government is mentioned under the distinct or combined
heads of monarchy, aristocracy, and democracy, what is it
that *reasoning* man is to understand by the terms? If there
really existed in the world two or more distinct and
separate *elements* of human power, we should then see the
several origins to which those terms would descriptively
apply: but as there is but one species of man, there can
be but one element of human power; and that element is
man himself. Monarchy, aristocracy, and democracy, are
but creatures of imagination; and a thousand such may be
contrived, as well as three.

*

From the Revolutions of America and France, and the
symptoms that have appeared in other countries, it is
evident that the opinion of the world is changed with
respect to systems of Government, and that revolutions
are not within the compass of political calculations. The
progress of time and circumstances, which men assign to
the accomplishment of great changes, is too mechanical to
measure the force of the mind, and the rapidity of
reflection, by which revolutions are generated: all the old

1. It was common practice in Blake's day for fathers to sell, or
indenture, their children for this task. The average age of the child
has been estimated at six and seven; they were generally employed
for seven years, until they were too large for the task of ascending the
chimneys.
2. The child's lisping effort to say "sweep," as he walks the streets
looking for work.
3. They climbed up the chimneys naked.

Governments have received a shock from those that already appear, and which were once more improbable, and are a greater subject of wonder, than a general revolution in Europe would be now.

When we survey the wretched condition of man under the monarchical and hereditary systems of Government, dragged from his home by one power, or driven by another, and impoverished by taxes more than by enemies, it becomes evident that those systems are bad, and that a general revolution in the principle and construction of Governments is necessary.

What is government more than the management of the affairs of a Nation? It is not, and from its nature cannot be, the property of any particular man or family, but of the whole community, at whose expense it is supported; and though by force or contrivance it has been usurped into an inheritance, the usurpation cannot alter the right of things. Sovereignty, as a matter of right, appertains to the Nation only, and not to any individual; and a Nation has at all times an inherent indefeasible right to abolish any form of Government it finds inconvenient, and establish such as accords with its interest, disposition, and happiness. The romantic and barbarous distinction of men into Kings and subjects, though it may suit the condition of courtiers, cannot that of citizens; and is exploded by the principle upon which Governments are now founded. Every citizen is a member of the Sovereignty, and, as such, can acknowledge no personal subjection; and his obedience can be only to the laws.

When men think of what Government is, they must necessarily suppose it to possess a knowledge of all the objects and matters upon which its authority is to be exercised. In this view of Government, the republican system, as established by America and France, operates to embrace the whole of a Nation; and the knowledge necessary to the interest of all the parts, is to be found in the centre, which the parts by representation form: But the old Governments are on a construction that excludes knowledge as well as happiness; Government by monks, who know nothing of the world beyond the walls of a convent, is as consistent as government by Kings.

What were formerly called Revolutions, were little more than a change of persons, or an alteration of local circumstances. They rose and fell like things of course, and had nothing in their existence or their fate that could influence beyond the spot that produced them. But what we now see in the world, from the Revolutions of America and France, are a renovation of the natural order of things, a system of principles as universal as truth and the existence of man, and combining moral with political happiness and national prosperity.

"I. *Men are born and always continue free, and equal in respect of their rights. Civil distinctions, therefore, can be founded only on public utility.*

"II. *The end of all political associations is the preservation of the natural and imprescriptible rights of man; and these rights are liberty, property, security, and resistance of oppression.*

"III. *The Nation is essentially the source of all Sovereignty; nor can any* INDIVIDUAL, *or* ANY BODY OF MEN, *be entitled to any authority which is not expressly derived from it.*"

In these principles, there is nothing to throw a Nation into confusion by inflaming ambition. They are calculated to call forth wisdom and abilities, and to exercise them for the public good, and not for the emolument or aggrandizement of particular descriptions of men or families. Monarchical sovereignty, the enemy of mankind, and the source of misery, is abolished; and sovereignty itself is restored to its natural and original place, the Nation. Were this the case throughout Europe, the cause of wars would be taken away.

It is attributable to Henry the Fourth of France, a man of an enlarged and benevolent heart, that he proposed, about the year 1610, a plan for abolishing war in Europe. The plan consisted in constituting an European Congress, or as the French Authors style it, a Pacific Rebublic; by appointing delegates from the several Nations, who were to act as a Court of arbitration in any disputes that might arise between nation and nation.

Had such a plan been adopted at the time it was proposed, the taxes of England and France, as two of the parties, would have been at least ten millions sterling annually to each Nation less than they were at the commencement of the French Revolution.

To conceive a cause why such a plan has not been adopted, (and that instead of a Congress for the purpose of *preventing* war, it has been called only to *terminate* a war, after a fruitless expense of several years), it will be necessary to consider the interest of Governments as a distinct interest to that of Nations.

Whatever is the cause of taxes to a Nation, becomes also the means of revenue to a Government. Every war terminates with an addition of taxes, and consequently with an addition of revenue; and in any event of war, in the manner they are now commenced and concluded, the power and interest of Governments are increased. War, therefore, from its productiveness, as it easily furnishes the pretence of necessity for taxes and appointments to places and offices, becomes a principal part of the system of old Governments; and to establish any mode to abolish war, however advantageous it might be to Nations, would be to take from such Government the most lucrative of its branches. The frivolous matters upon which war is made, show the disposition and avidity of Governments to uphold the system of war, and betray the motives upon which they act.

Why are not Republics plunged into war, but because the nature of their Government does not admit of an interest distinct from that of the Nation? Even Holland, though an ill-constructed Republic, and with a commerce extending over the world, existed nearly a century without war: and the instant the form of Government was changed in France the republican principles of peace and domestic prosperity and economy arose with the new Government; and the same consequences would follow the same causes in other Nations. . .

As it is not difficult to perceive, from the enlightened state of mankind, that hereditary Governments are verging to their decline, and that Revolutions on the broad basis of national sovereignty, and Government by representation, are making their way in Europe, it would be an act of wisdom to anticipate their approach, and

produce Revolutions by reason and accommodation, rather than commit them to the issue of convulsions.

From what we now see, nothing of reform in the political world ought to be held improbable. It is an age of Revolutions, in which everything may be looked for. The intrigue of Courts, by which the system of war is kept up, may provoke a confederation of Nations to abolish it: and an European Congress, to patronize the progress of free Government, and promote the civilization of Nations with each other, is an event nearer in probability, than once were the Revolutions and Alliance of France and America.

A Vindication of the Rights of Woman
[1792] Mary Wollstonecraft

Mary Wollstonecraft, mother of the creator of Frankenstein, was a vigorous feminist. In A Vindication of the Rights of Woman she argues that lack of physical and mental education, as well as contemporary ideas of feminine excellence, were keeping women in a state of "ignorance and slavish dependence."

The State of Degradation to which Woman is Reduced

Pleasure is the business of woman's life, according to the present modification of society; and while it continues to be so, little can be expected from such weak beings. Inheriting in a lineal descent from the first fair defect in nature—the sovereignty of beauty—they have, to maintain their power, resigned the natural rights which the exercise of reason might have procured them, and chosen rather to be short-lived queens than labour to obtain the sober pleasures that arise from equality. Exalted by their inferiority (this sounds like a contradiction), they constantly demand homage as women, though experience should teach them that the men who pride themselves upon paying this arbitrary insolent respect to the sex, with the most scrupulous exactness, are most inclined to tyrannize over, and despise the very weakness they cherish. Often do they repeat Mr Hume's sentiments, when, comparing the French and Athenian character, he alludes to women,—"But what is more singular in this whimsical nation, say I to the Athenians, is, that a frolic of yours during the saturnalia, when the slaves are served by their masters, is seriously continued by them through the whole year, and through the whole course of their lives, accompanied, too, with some circumstances, which still further augment the absurdity and ridicule. Your sport only elevates for a few days those whom fortune has thrown down, and whom she too, in sport, may really elevate for ever above you. But this nation gravely exalts those whom nature has subjected to them, and whose inferiority and infirmities are absolutely incurable. The women, though without virtue, are their masters and sovereigns."

Ah! why do women—I write with affectionate solicitude—condescend to receive a degree of attention and respect from strangers different from that reciprocation of civility which the dictates of humanity and the politeness of civilization authorize between man and man? And why do they not discover, when "in the noon of beauty's power", that they are treated like queens only to be deluded by hollow respect, till they are led to resign, or not assume, their natural prerogatives? Confined, then, in cages like the feathered race, they have nothing to do but to plume themselves, and stalk with mock majesty from perch to perch. It is true they are provided with food and raiment, for which they neither toil nor spin; but health, liberty, and virtue are given in exchange. But where, amongst mankind, has been found sufficient strength of mind to enable a being to resign these adventitious prerogatives—one who, rising with the calm dignity of reason above opinion, dared to be proud of the privileges inherent in man? And it is vain to expect it whilst hereditary power chokes the affections, and nips reason in the bud.

The passions of men have thus placed women on thrones, and till mankind become more reasonable, it is to be feared that women will avail themselves of the power which they attain with the least exertion, and which is the most indisputable. They will smile—yes, they will smile, though told that:

In beauty's empire is no mean,
And woman, either slave or queen,
Is quickly scorned when not adored.

But the adoration comes first, and the scorn is not anticipated.

Louis XIV, in particular, spread factitious manners, and caught, in a specious way, the whole nation in his toils; for, establishing an artful chain of despotism, he made it the interest of the people at large individually to respect his station, and support his power. And women, whom he flattered by a puerile attention to the whole sex, obtained in his reign that prince-like distinction so fatal to reason and virtue.

A king is always a king, and a woman always a woman.[1] His authority and her sex ever stand between them and rational converse. With a lover, I grant, she should be so, and her sensibility will naturally lead her to endeavour to excite emotion, not to gratify her vanity, but her heart. This I do not allow to be coquetry; it is the artless impulse of nature. I only exclaim against the sexual desire of conquest when the heart is out of the question.

This desire is not confined to women. "I have endeavoured," says Lord Chesterfield, "to gain the hearts of twenty women, whose persons I would not have given a fig for." The libertine who, in a gust of passion, takes advantage of unsuspecting tenderness, is a saint when compared with this cold-hearted rascal—for I like to use significant words. Yet only taught to please, women are always on the watch to please, and with true heroic ardour endeavour to gain hearts merely to resign or spurn them when the victory is decided and conspicuous.

I must descend to the minutiae of the subject.

I lament that women are systematically degraded by receiving the trivial attentions which men think it manly to

1. And a wit always a wit, might be added, for the vain fooleries of wits and beauties to obtain attention, and make conquests, are much upon a par.

pay to the sex, when in fact, they are insultingly supporting their own superiority. It is not condescension to bow to an inferior. So ludicrous, in fact, do these ceremonies appear to me that I scarcely am able to govern my muscles when I see a man start with eager and serious solicitude to lift a handkerchief or shut a door, when the *lady* could have done it herself, had she only moved a pace or two.

A wild wish has just flown from my heart to my head, and I will not stifle it, though it may excite a horse-laugh. I do earnestly wish to see the distinction of sex confounded in society, unless where love animates the behaviour. For this distinction is, I am firmly persuaded, the foundation of the weakness of character ascribed to woman; is the cause why the understanding is neglected, whilst accomplishments are acquired with sedulous care; and the same cause accounts for their preferring the graceful before the heroic virtues.

Mankind, including every description, wish to be loved and respected by *something*, and the common herd will always take the nearest road to the completion of their wishes. The respect paid to wealth and beauty is the most certain and unequivocal, and, of course, will always attract the vulgar eye of common minds. Abilities and virtues are absolutely necessary to raise men from the middle rank of life into notice, and the natural consequence is notorious—the middle rank contains most virtue and abilities. Men have thus, in one station at least, an opportunity of exerting themselves with dignity, and of rising by the exertions which really improve a rational creature; but the whole female sex are, till their character is formed, in the same condition as the rich, for they are born—I now speak of a state of civilization—with certain sexual privileges; and whilst they are gratuitously granted them, few will ever think of works of supererogation to obtain the esteem of a small number of superior people.

When do we hear of women who, starting out of obscurity, boldly claim respect on account of their great abilities or daring virtues? Where are they to be found? "To be observed, to be attended to, to be taken notice of with sympathy, complacency, and approbation, are all the advantages which they seek." True! my male readers will probably exclaim; but let them, before they draw any conclusion, recollect that this was not written originally as descriptive of women, but of the rich. In Dr Smith's *Theory of Moral Sentiments*[2] I have found a general character of people of rank and fortune, that, in my opinion, might with the greatest propriety be applied to the female sex. I refer the sagacious reader to the whole comparison, but must be allowed to quote a passage to enforce an argument that I mean to insist on, as the one most conclusive against a sexual character. For if, excepting warriors, no great men of any denomination have ever appeared amongst the nobility, may it not be fairly inferred that their local situation swallowed up the man, and produced a character similar to that of women, who are *localized*—if I may be allowed the word—by the rank they are placed in

2. Adam Smith (1723–90), political economist and professor of moral philosophy, author of *Wealth of Nations* (1776) and *The Theory of Moral Sentiments* (1759).

by *courtesy*? Women, commonly called ladies, are not to be contradicted, in company, are not allowed to exert any manual strength; and from them the negative virtues only are expected, when any virtues are expected—patience, docility, good humour, and flexibility—virtues incompatible with any vigorous exertion of intellect. Besides, by living more with each other, and being seldom absolutely alone, they are more under the influence of sentiments than passions. Solitude and reflection are necessary to give to wishes the force of passions, and to enable the imagination to enlarge the object, and make it the most desirable. The same may be said of the rich; they do not sufficiently deal in general ideas, collected by impassioned thinking or calm investigation, to acquire that strength of character on which great resolves are built. But hear what an acute observer says of the great:

"Do the great seem insensible of the easy price at which they may acquire the public admiration; or do they seem to imagine that to them, as to other men, it must be the purchase either of sweat or of blood? By what important accomplishments is the young nobleman instructed to support the dignity of his rank, and to render himself worthy of that superiority over his fellow-citizens, to which the virtue of his ancestors had raised them? Is it by knowledge, by industry, by patience, by self-denial, or by virtue of any kind? As all his words, as all his motions are attended to, he learns an habitual regard to every circumstance of ordinary behaviour, and studies to perform all those small duties with the most exact propriety. As he is conscious how much he is observed, and how much mankind are disposed to favour all his inclinations, he acts, upon the most indifferent occasions, with that freedom and elevation which the thought of this naturally inspires. His air, his manner, his deportment, all mark that elegant and graceful sense of his own superiority, which those who are born to inferior station can hardly ever arrive at. These are the arts by which he proposes to make mankind more easily submit to his authority, and to govern their inclinations according to his own pleasure; and in this he is seldom disappointed. These arts, supported by rank and pre-eminence, are, upon ordinary occasions, sufficient to govern the world. Louis XIV, during the greater part of his reign, was regarded, not only in France, but all over Europe, as the most perfect model of a great prince. But what were the talents and virtues by which he acquired this great reputation? Was it by the scrupulous and inflexible justice of all his undertakings, by the immense dangers and difficulties with which they were attended, or by the unwearied and unrelenting application with which he pursued them? Was it by his extensive knowledge, by his exquisite judgment, or by his heroic valour? It was by none of these qualities. But he was, first of all, the most powerful prince in Europe, and consequently held the highest rank among kings; and then, says his historian, 'he surpassed all his courtiers in the gracefulness of his shape, and the majestic beauty of his features. The sound of his voice, noble and affecting, gained those hearts which his presence intimidated. He had a step and a deportment which could suit only him and his rank, and which would have been ridiculous in any other person. The embarrassment which he occasioned to

those who spoke to him, flattered that secret satisfaction with which he felt his own superiority.' These frivolous accomplishments, supported by his rank, and, no doubt too, by a degree of other talents and virtues, which seems, however, not to have been much above mediocrity, established this prince in the esteem of his own age, and have drawn, even from posterity, a good deal of respect for his memory. Compared with these, in his own times, and in his own presence, no other virtue, it seems, appeared to have any merit. Knowledge, industry, valour, and beneficence trembled, were abashed, and lost all dignity before them."

Woman also thus "in herself complete," by possessing all these *frivolous* accomplishments, so changes the nature of things:

> That what she wills to do or say
> Seems wisest, virtuousest, discreetest, best;
> All higher knowledge in *her presence* falls
> Degraded. Wisdom in discourse with her
> Loses discountenanced, and, like folly shows;
> Authority and reason on her wait.

And all this is built on her loveliness!

In the middle rank of life, to continue the comparison, men, in their youth, are prepared for professions, and marriage is not considered as the grand feature in their lives; whilst women, on the contrary, have no other scheme to sharpen their faculties. It is not business, extensive plans, or any of the excursive flights of ambition, that engross their attention; no, their thoughts are not employed in rearing such noble structures. To rise in the world, and have the liberty of running from pleasure to pleasure, they must marry advantageously, and to this object their time is sacrificed, and their persons often legally prostituted. A man when he enters any profession has his eye steadily fixed on some future advantage (and the mind gains great strength by having all its efforts directed to one point), and, full of his business, pleasure is considered as mere relaxation; whilst women seek for pleasure as the main purpose of existence. In fact, from the education, which they receive from society, the love of pleasure may be said to govern them all; but does this prove that there is a sex in souls? It would be just as rational to declare that the courtiers in France, when a destructive system of despotism had formed their character, were not men, because liberty, virtue, and humanity, were sacrificed to pleasure and vanity. Fatal passions, which have ever domineered over the *whole* race!

The same love of pleasure, fostered by the whole tendency of their education, gives a trifling turn to the conduct of women in most circumstances; for instance, they are ever anxious about secondary things; and on the watch for adventures instead of being occupied by duties.

A man, when he undertakes a journey, has, in general, the end in view; a woman thinks more of the incidental occurrences, the strange things that may possibly occur on the road; the impression that she may make on her fellow-travellers; and, above all, she is anxiously intent on the care of the finery that she carries with her, which is more than ever a part of herself, when going to figure on a new scene; when, to use an apt French turn of expression, she is going to produce a sensation. Can dignity of mind exist with such trivial cares?

In short, women, in general, as well as the rich of both sexes, have acquired all the follies and vices of civilization, and missed the useful fruit. It is not necessary for me always to premise, that I speak of the condition of the whole sex, leaving exceptions out of the question. Their senses are inflamed, and their understandings neglected, consequently they become the prey of their senses, delicately termed sensibility, and are blown about by every momentary gust of feeling. Civilized women are, therefore, so weakened by false refinement, that, respecting morals, their condition is much below what it would be were they left in a state nearer to nature. Ever restless and anxious, their over-exercised sensibility not only renders them uncomfortable themselves, but troublesome, to use a soft phrase, to others. All their thoughts turn on things calculated to excite emotion and feeling, when they should reason, their conduct is unstable, and their opinions are wavering—not the wavering produced by deliberation or progressive views, but by contradictory emotions. By fits and starts, they are warm in many pursuits; yet this warmth, never concentrated into perseverance, soon exhausts itself; exhaled by its own heat, or meeting with some other fleeting passion, to which reason has never given any specific gravity, neutrality ensues. Miserable, indeed, must be that being whose cultivation of mind has only tended to inflame its passions! A distinction should be made between inflaming and strengthening them. The passions thus pampered, whilst the judgment is left unformed, what can be expected to ensue? Undoubtedly, a mixture of madness and folly!

This observation should not be confined to the *fair* sex; however, at present, I only mean to apply it to them.

Novels, music, poetry, and gallantry, all tend to make women the creatures of sensation, and their character is thus formed in the mould of folly during the time they are acquiring accomplishments, the only improvement they are excited, by their station in society, to acquire. This overstretched sensibility naturally relaxes the other powers of the mind, and prevents intellect from attaining that sovereignty which it ought to attain to render a rational creature useful to others, and content with its own station; for the exercise of the understanding, as life advances, is the only method pointed out by nature to calm the passions.

Satiety has a very different effect, and I have often been forcibly struck by an emphatical description of damnation; when the spirit is represented as continually hovering with abortive eagerness round the defiled body, unable to enjoy anything without the organs of sense. Yet, to their senses, are women made slaves, because it is by their sensibility that they obtain present power.

And will moralists pretend to assert that this is the condition in which one-half of the human race should be encouraged to remain with listless inactivity and stupid acquiescence? Kind instructors! what were we created for? To remain, it may be said, innocent; they mean in a state of childhood. We might as well never have been born, unless it were necessary that we should be created to

enable man to acquire the noble privilege of reason, the power of discerning good from evil, whilst we lie down in the dust from whence we were taken, never to rise again.

It would be an endless task to trace the variety of meannesses, cares, and sorrows, into which women are plunged by the prevailing opinion, that they were created rather to feel than reason, and that all the power they obtain must be obtained by their charms and weakness:

Fine by defect, and amiably weak!

And, made by this amiable weakness entirely dependent, excepting what they gain by illicit sway, on man, not only for protection, but advice, is it surprising that, neglecting the duties that reason alone points out, and shrinking from trials calculated to strengthen their minds, they only exert themselves to give their defects a graceful covering, which may serve to heighten their charms in the eye of the voluptuary, though it sink them below the scale of moral excellence.

Fragile in every sense of the word, they are obliged to look up to man for every comfort. In the most trifling danger they cling to their support, with parasitical tenacity, piteously demanding succour; and their *natural* protector extends his arm, or lifts up his voice, to guard the lovely trembler—from what? Perhaps the frown of an old cow, or the jump of a mouse; a rat would be a serious danger. In the name of reason, and even common sense, what can save such beings from contempt; even though they be soft and fair.

These fears, when not affected, may produce some pretty attitudes; but they show a degree of imbecility which degrades a rational creature in a way women are not aware of—for love and esteem are very distinct things.

I am fully persuaded that we should hear of none of these infantine airs, if girls were allowed to take sufficient exercise, and not confined in close rooms till their muscles are relaxed, and their powers of digestion destroyed. To carry the remark still further, if fear in girls, instead of being cherished, perhaps, created, were treated in the same manner as cowardice in boys, we should quickly see women with more dignified aspects. It is true, they could not then with equal propriety be termed the sweet flowers that smile in the walk of man; but they would be more respectable members of society, and discharge the important duties of life by the light of their own reason. "Educate women like men," says Rousseau, "and the more they resemble our sex the less power they will have over us." This is the very point I aim at. I do not wish them to have power over men; but over themselves.

Faust, Part I

[1808–32] Johann Wolfgang von Goethe

Dedication

Once more you hover near me, forms and faces
 Seen long ago with troubled youthful gaze.
And shall I this time hold you, limn the traces,
 Fugitive still, of those enchanted days?
You closer press: then take your powers and places,
 Command me, rising from the murk and haze;
Deep stirs my heart, awakened, touched to song,
As from a spell that flashes from your throng.

You bear the glass of days that were glad-hearted;
 Dear memories, beloved shades arise; 10
Like an old legendary echo started,
 Come friendship and first love before my eyes.
Old sorrow stirs, the wounds again have smarted,
 Life's labyrinth before my vision lies,
Disclosing dear ones who, by fortune cheated,
Passed on their way, of love and light defeated.

They cannot hear what now I bring, belated,
 Who listened to the early tunes I made:
Gone is the throng by love so animated,
 Dead the responsive tribute that they paid. 20
My tragic theme rings out, for strangers fated.
 For strange applause that makes me half afraid.
The rest, who held my music sweet and cherished,
Stray through the world dispersed, or they have perished.

Now comes upon me long forgotten yearning
 For the sweet solemn tryst those spirits keep.
I feel the trembling words of song returning,
 Like airs that softly on the harp-strings creep.
The stern heart softens, all its pride unlearning,
 A shudder passes through me, and I weep. 30
All that I have stands off from me afar,
And all I lost is real, my guiding-star.

Prelude in the Theatre
CHARACTERS

Director
Poet
Comedian

Director: You two, Sirs, who have been my stay
In many a time of storms and stress,
What does our theatre want to-day,
What are our chances of success?
To please the good old public I've elected,
Who live and let live—them I'd recreate.
The boards are firm, the scaffold is erected,
And, open-eyed, the people sit and wait;
A rare dramatic treat is now expected:
They take for granted that it's something great. 10
I know my public, how it is impressed,
Yet feel, I must confess, my hopes receding;
For, even if they seldom see the best,
The worthy folk go in so much for reading.

How can we manage something brisk and new,
Not only smart, but edifying too?
For, frankly, nothing pleases me much more
Than sight of crowds, when they begin to pour
Wave upon wave, at half-past three or four,
In daylight through our strait and narrow door; 20
Or when they shove and fight towards the wicket,[1]
And nearly break their necks to get a ticket,
With frantic elbowing and furious looks,
Like starving beggars round a pastry-cook's.
To work such wide enchantment,—who can doubt it?—
You, poet, are the man, so set about it.
Poet: Speak not to me about the motley rabble,
Whose sight no inspiration can abide.
Preserve me from the tumult and the babble,
That sweeps us helpless in its vulgar tide. 30
Nay, bring me rather to that brink of heaven
Where flowers the poet's joy, serene and still,
Where love and friendship mingle, as the leaven
That god-like comes to quicken and fulfill.
Ay me, the deepest stirrings of emotion,
The thoughts that tremble on the murmuring lips,
Frail merchandise upon the poet's ocean,
The violence of a moment will eclipse.
For art may need long years of true devotion
To bring perfection to the light of day. 40
The brilliant passes, like the dew at morn;
The true endures, for ages yet unborn.
Comedian: For my part, you can keep the unborn age;
Or, if we really have to talk about it,
Why, who would then delight our present stage,
That asks its fun, and will not go without it?
A fine young fellow to be entertained
Here, in the flesh, is not to be disdained.
The man with easy power to put it over
Blames not the public taste, but lives in clover. 50
He by whose art men's fiery thoughts are fanned
Rejoices in a sea of upturned faces.
Then courage, friends, show 'em the master-hand,
Let fancy fly, with all her lofty graces,
Pack wisdom in, with tenderness and passion,
But never put good fooling out of fashion.
Director: Above all, give your play abundant action:
They want a show, then give them satisfaction.
Let plenty happen, right before their eyes,
So that the audience can stare in wonder, 60
So you are certain of the popular prize,
Your fortune's made, while still the plaudits thunder.
It's crowded stuff you need, to grip the crowd;
Then each good soul finds something to his liking.
Give much, please many: the applause is loud,
And each goes home and says the show is striking.
Dished up with ease, made light as a caprice,
A rich ragout,[2] the mixture is what matters;
Serve them a dozen pieces in the piece.
Your perfect whole will have a short-lived lease: 70
The public taste will tear it into tatters.
Poet: But can't you feel how bad such products are?

1. gate, entrance.
2. a type of stew.

How, on an artist, such advice must jar?
The bungling of each clever little fool
You make your one artistic rule.
Director: Censure like that disturbs me not a bit.
And, as for what you say of fools,
Remember, you have course-grained wood to split,
So take the proper tools.
And try to think for whom you write! 80
Some come because they're bored by night,
Or see no more in us than masks and capers.
Some, curiosities excite;
Some come from gluttony's delight,
Or, what is worse, from following the papers.
The ladies bring us fashion's gallery,
And play their parts without a salary.
And will you dream on your poetic peak,
Or triumph if the play should prove a draw?
Observe the patrons close, if truth you seek: 90
One kind is cool, the other kind is raw.
After the play, one man is all for cards,
One for a wild night on a wench's breast:
Roll you for this your heavenward regards,
Or dun the Muses with your hight behest?
I tell you, pack your plays, and when you've packed 'em
You'll find, that way, you never go astray.
So write for people only to distract 'em:
To satisfy them's hopeless, anyway.
Why, what's upsetting you? Delight or anguish? 100
Poet: Get hence, and find yourself another slave.
Or shall a poet be content to languish
In degradation of what heaven gave
To be his right? the highest human power
Frittered away to serve your little hour?
Whence comes his writ to summon every heart,
To bid the very elements obey him?
Whence, but from chimes that in his soul will start,
To harmonize the world that would betray him?
When Nature's thread, that filament never-ending, 110
Is nonchalantly on the distaff wound,
When unrelated things that know no blending
Send forth their vexed, uneasy jarring sound—
Who then bestows the rhythmic line euphonious,
The ordered pulse, to stir or soothe the soul?
Who marshals fragments to a ceremonious
And splendid music, universal, whole?
Who rides the flood of passion at its height?
Or sings the glow of evening, solemn, sweet?
Who strews the spring's dear garlands of delight 120
In petalled path for his beloved's feet?
Or who can twine the wreath for honor's portals,
Can insignificant leaves with tongues invest,
Assure Olympus, and unite immortals?—
The might of man, in poets manifest.
Comedian: Well, use the wondrous inspirations, pray,
And set about the business straight away.
Approach it as you would a love-affair:
You meet, you feel the spell, and linger there,
And by and by you think yourself enchanted. 130
At first you thrive; then obstacles are planted;
You walk on air, then fall to bittersweet:
And thus, behold, your romance is complete.

Now that's the stuff to make our play a charmer:
Plunge into life, and give them human drama.
The art is common, the perception's not;
So seize it, and you have a thrilling plot.
Give chequered scenes, though meaning may grow
 dimmer,
A chain of errors, and of truth a glimmer:
This is refreshing, here you have the brew 140
That quickens all the world, and sees us through.
Then gathers round the wisest flower of youth,
Then come the tender-hearted ones to sup;
Those see the play, and grasp its sacred truth,
These drink your drama's melancholy up.
One's roused by this, another finds that fit:
Each loves the play for what he brings to it.
The young are quick to mirth or tearful rapture,
Entranced by style and superficial pranks.
The mind that's formed, you'll have the deuce to capture: 150
The heart that's yet in growth will yield you thanks.
Poet: Then bring me back the days of dreaming,
When I myself was yet unformed,
When song welled up in me, and teeming
The tuneful fancies in me swarmed.
I'd all the misty world before me,
And every bud with promise sprang,
And every valley, to restore me,
Burgeoned with blossom as I sang.
I nothing had, yet was not poor: 160
The spur of truth was mine, and fancy's lure.
Give me those days with heart in riot,
The depths of bliss that touched on pain,
The force of hate, and love's disquiet—
Ah, give me back my youth again!
Comedian: Your youth you need, my friend, when called
 to face
The onslaught of a foeman in the fight,
Or for an ardent lovely girl's embrace,
Who hangs upon your neck for love's delight;
Or youth would serve to win the sprinter's fame, 170
The goal, the laurels, glimmering from afar,
Or you might dance, perhaps, till daylight came,
Still young enough to toast the morning star.
But, ah, to strike the well-known chords with skill,
To set, with cunning aim, each heart a-throb,
And find the chosen mark at your sweet will,
That, Sirs, I take to be a veteran's job.
The more's the praise—you needn't take it ill:
It's not that age brings childhood back again,
Age merely shows what children we remain. 180
Director: Enough of words, for, to be candid,
I'd like to see some work begun.
While all this pretty talk is bandied
We might have something useful done.
Why talk of mood, divine afflatus,
That ne'er to waverers occurs?
If you assume a poet's status,
Command me poetry, good Sirs!
You know our needs: we want a brew,
A liquor with some body in it. 190
The process waits. Then up, begin it!
What's left to-day, to-morrow's still to do.

Lose not a day, but straight prepare,
And grasp your chance with resolute trust,
And take occasion by the hair,
For, once involved in the affair,
You'll carry on because you must.
The German stage lets each try what he may:
Then spare me nothing, on our special day,
Either of back-cloth or machinery. 20
Have sun and moon, and what you will of scenery.
And of the lesser fires be lavish:
Give 'em a star-light fit to ravish.
Of water, cliffs, romantic stuff,
And beast and birds we cannot have enough.
Thus, on our narrow boards, shall you bestride
The whole Creation's prospect, far and wide,
And travel cunning, swift as thought can tell,
From Heaven through the world and down to hell.

Prolog in Heaven

CHARACTERS

The Lord
The Hosts of Heaven
Mephistopheles

[*The three* ARCHANGELS *come forward.*]
Raphael: The day-star, sonorous as of old,
 Goes his predestined way along,
And round his path is thunder rolled,
 While sister-spheres join rival song.
New strength have angels at the sight,
 Though none may scan the infinitude,
And splendid, as in primal light,
 The high works of the world are viewed.
Gabriel: Swift, unimaginably swift
 The glory of the earth rolls round,
And scenes of heavenly radiance shift
 To fearfulness of night profound;
By floods of sea in foaming forces
 Cliffs at their shuddering base are churned,
And flung in planetary courses
 The seas and cliffs are ever turned.
Michael: And storms contend in angry fuming
 From sea to land, from land to sea,
A chain of raging force assuming,
 In their tempestuous majesty.
The flame of brilliant devastation
 Now lights the thunderbolt his way;
But angels, Lord, in adoration,
 Hail the sweet progress of the day.
The three: New strength have angels at the sight,
 Amazed at thy infinitude,
And splendid as in primal light
 Are all thy mighty works renewed.
Mephistopheles: Since you, O Lord, are with us here
 once more,
To ask how we are going on at large,
And since you viewed me kindly heretofore,
I thought I'd make one, too, in the menage.
Your pardon, if my idiom is lowly,

My eloquence up here would meet with scorn,
Pathos from me would cause you laughter solely,
If laughter weren't a thing you have forsworn.
Your suns and worlds are not within my ken,
I merely watch the plaguey state of men.
The little god of earth remains the same queer sprite
As on the first day, or in primal light. 40
His life would be less difficult, poor thing,
Without your gift of heavenly glimmering;
He calls it Reason, using light celestial
Just to outdo the beasts in being bestial.
To me he seems, with deference to Your Grace,
One of those crickets, jumping round the place,
Who takes his flying leaps, with legs so long,
Then falls to grass and chants the same old song;
But, not content with grasses to repose in,
This one will hunt for muck to stick his nose in. 50
The Lord: Have you no more to say to me?
Is plaint your one necessity?
Will nothing please you upon earth?
Mephistopheles: No, Lord, I tell you frankly what it's
worth:
It's bad; men drown in evils that are sent them;
Poor things, I find it boring to torment them.
The Lord: Know you one Faust?
Mephistopheles: The Doctor?
The Lord: Him, my servant.
Mephistopheles: Indeed, Lord, a retainer strange and
fervent: 60
From any earthly victuals he'll refrain,
His fever drives him to a lofty plane.
In madness, half suspected on his part,
He hankers after heaven's loveliest orbs,
Demands from earth the choicest joy and art,
And, far and near, what pleases and absorbs
Still fails to satisfy his restless heart.
The Lord: Though now he serves me in bewildered
ways,
My light shall lead him soon from his despairing.
Does not the grower see in leafy days 70
His sapling's years of blossom and of bearing?
Mephistopheles: What will you wager that you do not
lose him,
Supposing always you will not demur
About my guiding him in paths I choose him?
The Lord: You shall have leave to do as you prefer,
So long as earth remains his mortal dwelling;
For man must strive, and striving he must err.
Mephistopheles: My thanks, O Lord. For frankly it's
repelling
To have so much to do with the deceased.
For me a glowing cheek is like a feast. 80
I'm not at home to corpses in my house:
There's something in me of the cat-and-mouse.
The Lord: Let it be so: to you is given the power
That may seduce this soul from his true source,
And drag him down with you, in fatal hour,
If you can wholly bend him to your force.
But stand ashamed when called on to confess:
A good man in his dark, bewildered course
Will not forget the way of righteousness.

Mephistopheles: Agreed. My purpose is a likely horse, 90
And little doubt I make of my success.
But if I win, then clearly give me best,
A proper triumph, fanfares by the dozen.
Dust shall he bite, ay, lick it up with zest,
Just like the snake, my celebrated cousin.
The Lord: In that you also have a dispensation.
Your kindred never had my hate or scorn:
Of all the spirits of negation
The rogue is least of burdens to be borne.
Man's efforts sink below his proper level, 100
And since he seeks for unconditioned ease,
I send this fellow, who must goad and tease
And toil to serve creation, though a devil.
But ye, true sons of heaven, shall delight
In the full wealth of living beauty's sight.
Eternal Growth, fulfillment, vital, sure,
Enwrap your minds in love's immortal folds,
And all that life in floating semblance holds,
Stablish it fast, in thought that shall endure.
 [*The heaven closes, the* ARCHANGELS *depart.*]
Mephistopheles: [*Alone*] I like to see the Governor now
and then, 110
And take good care to keep relations civil.
It's decent in the first of gentlemen
To speak so friendly, even to the devil.

The Tragedy
Night: Faust's Study (i)

CHARACTERS

Faust
Spirit
Wagner
Chorus of Angels
Chorus of Women
Chorus of the Disciples

 [In *a high-vaulted, narrow, gothic chamber,*
 FAUST *is discovered restless at his desk.*]
Faust: Philosophy have I digested,
The whole of Law and Medicine,
From each its secrets I have wrested,
Theology, alas, thrown in.
Poor fool, with all this sweated lore,
I stand no wiser than I was before.
Master and Doctor are my titles;
For ten years now, without repose,
I've held my erudite recitals
And led my pupils by the nose. 10
And round we go, on crooked ways or straight,
And well I know that ignorance is our fate,
And this I hate.
I have, I grant, outdistanced all the others,
Doctors, pedants, clergy and lay-brothers;
All plague of doubts and scruples I can quell,
And have no fear of devil or of hell,
And in return am destitute of pleasure,
Knowing that knowledge tricks us beyond measure,
That man's conversion is beyond my reach, 20

Knowing the emptiness of what I teach.
Meanwhile I live in penury,
No worldly honor falls to me.
No dog would linger on like this,
And so I turn to the abyss
Of necromancy, try if art
Can voice or power of spirits start,
To do me service and reveal
The things of Nature's secret seal,
And save me from the weary dance 30
Of holding forth in ignorance.
Then shall I see, with vision clear,
How secret elements cohere,
And what the universe engirds,
And give up huckstering with words.

 O silver majesty of night,
Moon, look no more upon my plight,
You whom my eyes at midnight oft
Have gazed upon, when slow and soft
You crossed my papers and my books 40
With friendly, melancholy looks.
Would that my soul could tranquil stray
On many a moonlit mountain way,
By cavernous haunts with ghostly shadows,
Or thread the silver of the meadows,
Released from learning's smoky stew
To lave me in the moonlit dew.

 But, ah, this prison has my soul,
Damnable, bricked-in, cabined hole,
Where even the heaven's dear light must pass 50
Saddened through the painted glass.
Hemmed in with stacks of books am I,
Where works the worm with dusty mange,
While to the vaulted roof on high
The smoky ranks of papers range;
Retorts and jars my crib encumber,
And crowded instruments and, worse,
Loads of hereditary lumber—
And this, ay this, is called my universe.

 And shall I wonder why my heart 60
Is lamed and frightened in my breast,
Why all the springs of life that start
Are strangely smothered and oppressed?
Instead of all that life can hold
Of Nature's free, god-given breath,
I take to me the smoke and mold
Of skeletons and dust and death.
Up and away! A distant land
Awaits me in this secret book
From Nostradamus'[3] very hand, 70
Nor for a better guide I look.
Now shall I read the starry pole,
In Nature's wisdom shall I seek
And know, with rising power of soul,
How spirit doth to spirit speak.
No dusty logic can divine
The meaning of a sacred sign.
Mysterious spirits, hovering near,
Answer me, if now ye hear!

3. French astrologer who died in 1566, famous for his predictions.

[He opens the book and lights upon the Sign of
the Macrocosm.]
Ah, strangely comes an onset of delight,
Invading all my senses as I gaze:
Young, sacred bliss-of-life springs at the sight,
And fires my blood in all its branching ways.
Was it a god who made this mystic scroll,
To touch my spirit's tumult with its healing,
And fill my wretched heart with joyous feeling,
And bring the secret world before my soul, 30
The hidden drive of Nature's force revealing?
Myself a god?—With lightened vision's leap
I read the riddle of the symbols, hear
The looms of Nature's might, that never sleep,
And know at last things spoken of the seer:
"'Tis not the spirit world is sealed;
Thy heart is dead, thy senses' curtain drawn.
But, scholar, bathe, rejoicing, healed,
Thy earthly breast in streams of roseate dawn."
[He studies the sign.] 40
Lo, single things inwoven, made to blend,
To work in oneness with the whole, and live
Members one of another, while ascend
Celestial powers, who ever take and give
Vessels of gold on heaven's living stair,
Their pinions fragrant with the bliss they bear,
Pervading all, that heaven and earth agree,
Transfixing all the world with harmony.

 O endless pageant!—But a pageant still,
A show, that mocks my touch or grasp or will!
Where are the nipples, Nature's springs, ah where
The living source that feeds the universe?
You flow, you give to drink, mysterious nurse,
And yet my soul is withered in despair.
 [Disconsolately he turns the pages until his
 glance rests on the sign of the Spirit of Earth.]
A curious change affects me in this sign:
You, kindred Sprite of Earth, come strangely nearer;
My spirits rise, my powers are stronger, clearer,
As from the glow of a refreshing wine.
I gather heart to risk the world's encounter,
To bear my human fate as fate's surmounter,
To front the storm, in joy or grief not palter,
Even in the gnash of shipwreck never falter.

 The clouds close in above me
And hidden is the moon;
The lamp dies down.
A vapor grows—red quiverings
Dart round my head—there creeps
A shuddering from the vaulted roof
And seizes me!
I know, dread spirit of my call, 'tis you.
Stand forth, disclosed!
Ah, how my heart is harrowed through!
In tumult of feeling
My mind is riven, my senses reeling.
To you I yield, nor care if I am lost.
This thing must be, though life should be the cost.
 [He seizes the book and pronounces the secret
 sign of the Spirit. A reddish flame shoots up,
 and the SPIRIT appears in the flame.]

Spirit: Who calls on me?

Faust: [*Turning away*] O fearful form!

Spirit: At length
You have compelled me here. Your strength
Has wrestled long about my sphere,
And now—

Faust: I tremble: come not near.

Spirit: With bated breath you labored to behold me,
To hear my voice, to see me face to face.
You prayed with might, with depth that has controlled
 me,
And here am I!—What horror now can chase 140
The color from your lips, my superman?
Where the soul's cry? The courage that began
To shape a world, and bear and foster it?
The heart that glowed, with lofty ardor lit,
To claim ethereal spirits as your peers?
Are you that Faust whose challenge smote my ears,
Who beat his way to me, proclaimed his hour,
And trembles now in presence of my power,
Writhes from the breath of it, a frightened worm?

Faust: And shall I, thing of flame, flinch at the sequel? 150
My name is Faust, in everything your equal.

Spirit: In flood of life, in action's storm
 ply on my wave
With weaving motion
Birth and the grave,
A boundless ocean
Ceaselessly giving
Weft of living,
Forms unending,
Glowing and blending. 160
So work I on the whirring loom of time,
The life that clothes the deity sublime.

Faust: Swift Spirit, you whose projects have no end,
How near akin our natures seem to be!

Spirit: You match the spirit that you comprehend,
Not me. [*He vanishes.*]

Faust: [*Filled with dismay*] Not you!
Whom then?
, made in God's own image,
And not with you compare! [*A knock.*] 170
Damnation, that will be my Servitor!
My richest hope is in confusion hurled:
He spoils my vision of the spirit world,
This lickspittle of learning at my door.
 [WAGNER *in dressing-gown and night-cap,*
 carrying a lamp. FAUST *turns reluctantly.*]

Wagner: Beg pardon, but I heard you, Sir, declaiming—
Some tragedy, I'll warrant, from the Greek?—
That's just the learned art at which I'm aiming,
For people are impressed when scholars speak.
Indeed, I've heard the stage can be a teacher,
So that the actor can inspire the preacher. 180

Faust: Past question, if the parson is a mummer—
A thing you may discover, now and then.

Wagner: But, Sir, if learning ties us, winter, summer,
With holiday so rare, that we see men
As through a glass, remote and ill-defined,
How shall our counsel serve to lead mankind?

Faust: If feeling fails you, vain will be your course,
And idle what you plan unless your art
Springs from the soul with elemental force
To hold its sway in every listening heart. 190
Well, well, keep at it: ply the shears and paste,
Concoct from feasts of other men your hashes,
And should the thing be wanting fire or taste,
Blow into flame your little heap of ashes:
You'll find some apes and children who'll admire,
If admiration is your chief desire;
But what is uttered from the heart alone
Will win the hearts of others to your own.

Wagner: Yet by his style a speaker stands to win;
That I know well, and that I'm backward in. 200

Faust: Trust honesty, to win success,
Be not a noisy jingling fool.
Good sense, Sir, and right mindedness
Have little need to speak by rule.
And if your mind on urgent truth is set,
Need you go hunting for an epithet?
Nay, these your polished speeches that you make,
Serving mankind your snipped-out pie-frill papers,
They nourish us no more than winds that shake
The withered leaves, or shred the autumnal vapors. 210

Wagner: Ah me, Sir, long indeed is art;
Our life is very short, however,
And often, in my studious endeavor
A fearful dread assails my head and heart.
How hard it is to master ways and means
By which a man may reach the fountain-head!
And, ere he's half-way there, fate intervenes:
Before he knows it, the poor devil's dead.

Faust: Is parchment, then, your well of living water,
Where whosoever drinks shall be made whole? 220
Look not to stem your craving in that quarter:
The spring is vain that flows not from the soul.

Wagner: The pleasure, by your leave, is great, to cast
The mind into the spirit of the past,
And scan the former notions of the wise,
And see what marvelous heights we've reached at last.

Faust: Most nobly have we, up to the starry skies!
My friend, for us the alluring times of old
Are like a book that's sealed-up sevenfold.
And what you call Spirit of the Ages 230
Is but the spirit of your learned sages,
Whose mirror is a pitiful affair,
Shunned by mankind after a single stare,
A moldy dustbin, or a lumber attic,
Or at the most a blood-and-thunder play
Stuffed full of wit sentenious and pragmatic,
Fit for the sawdust puppetry to say.

Wagner: And yet the world, the human heart and
 mind—
To understand these things must be our aim.

Faust: To understand—and how is that defined? 240
Who dares to give that child its proper name?
The few of understanding, vision rare,
Who veiled not from the herd their hearts, but tried
Poor generous fools, to lay their feelings bare,
Them have men always burnt and crucified.
Excuse me, friend, it grows deep into night,
And now is time to think about adjourning.

Wagner: I could have stayed up longer with delight,
To join in discourse with your lofty learning.
But, Sir, to-morrow comes our Easter Day, 250
When I shall ask more questions, if I may.
I've learnt a deal, made books my drink and meat,
But cannot rest till knowledge is complete. |Exit.|
Faust: How strange, that he who cleaves to shallow
 things
Can keep his hopes alive on empty terms,
And dig with greed for precious plunderings,
And find his happiness unearthing worms!

How dared this voice to raise its human bleat
Where waits the spirit world in immanent power?
And yet the man, so barren and effete, 260
Deserves my thanks in this most perilous hour.
He snatched me from a desperate despite
Fit to unhinge my reason, or to slay.
The apparition towered to such a height
My soul was dwarfed within me, in dismay.

I, God's own image, who have seemed, forsooth,
Near to the mirror of eternal truth,
Compassed the power to shed the mortal clay
And revel in the self's celestial day,
I, who presumed in puissance to out-soar 270
The cherubim, to flow in Nature's veins,
With god-like joy in my creative paints,
I rode too high, and deep must I deplore:
One thunder-word has robbed me of my reins.

I dare not, Spirit, count me in your sphere:
For, though I had the power to call you here,
No force have I that binds you or retains.
And in that moment dread and wondrous,
When I, so puny, grew so great,
You thrust me with a verdict thund'rous 280
Back to uncertain mortal fate.
Who is my guide? What shall I shun?
Or what imperious urge obey?
Alas, not only woes, but actions done,
Walk by us still to hedge us on our way.

The spirit's splendor, in the soul unfurled,
Is ever stifled with a stranger stuff.
High values, matched with good things of this world,
Mocking recede, and seem an airy bluff.
Our nobler veins, the true, life-giving springs 290
Are choked with all the dust of earthy things.

What though imagination spread her wings
In early hope towards the things eternal,
Shrunk is her spacious realm in the diurnal
Defeat that loss and disappointment brings.
Full soon in deepest hearts care finds a nest,
And builds her bed of pain, in secret still,
There rocks herself, disturbing joy and rest,
And ever takes new shapes to work her will,
With fluttering fears for home or wife or child, 300
A thought of poison, flood or perils wild;
For man must quail at bridges never crossed,
Lamenting even things he never lost.

Shall I then rank with gods? Too well I feel
My kinship with the worm, who bores the soil,
Who feeds on dust until the wanderer's heel
Gives sepulture to all his care and toil.

Is it not dust, that fills my hundred shelves,
And walls me in like any pedant hack?
Fellow of moth that flits and worm that delves, 31
I drag my life through learned bric-a-brac.
And shall I here discover what I lack,
And learn, by reading countless volumes through,
That mortals mostly live on misery's rack,
That happiness is known to just a few?
You hollow skull, what has your grin to say,
But that a mortal brain, with trouble tossed,
Sought once, like mine, the sweetness of the day,
And strove for truth, and in the gloom was lost.
You instruments, you mock me to my face, 32
With wheel and gimbal, cylinder and cog;
You were my key to unlock the secret place:
The wards are cunning, but the levers clog.
For Nature keeps her veil inviolate,
Mysterious still in open light of day,
And where the spirit cannot penetrate
Your screws and irons will never make a way.
Here stands the gear that I have never touched,
My father's stuff, bequeathed to be my prison,
With scrolls of vellum, blackened and besmutched, 4
Where still the desk-lamp's dismal smoke has risen.
Better have spent what little was my own,
Than sweat for petty gains by midnight oil.
The things that men inherit come alone
To true possession by the spirit's toil.
What can't be used is trash; what can, a prize
Begotten from the moment as it flies.

But what magnetic thing compels my gaze?
This phial fascinates me, like the sight
Of soothing moon when, deep in forest ways, 3
Our very thoughts are silvered with the light.
You I salute, you flask of virtue rare,
That now I hand me down with reverent care;
In you I honor human wit and art.
You very spirit of the opiate flowers,
You distillation of the deadly powers,
Show to your master now your gracious heart:
To see you, touch you, soothes my strife and pain.
I hear a call towards the open main,
My tide of soul is ebbing more and more, 3
Lies at my feet the shining, glassy plain,
A new day beckons to another shore.

As if on wings, a chariot of fire
Draws near me. I am ready to be free.
Piercing the ether, new-born, I aspire
To rise to spheres of pure activity.
This soaring life, this bliss of godlike birth,
How shall we earn it, who from worms must rise?
Yet true the call: I spurn the sun of earth,
Leave, resolute, its loveliness. My eyes 3
I lift in daring to fling wide the gate
Whose threshold men have ever flinching trod.
The hour is come, as master of my fate
To prove in man the stature of a god,
Nor blench before the cavern black and fell,
Imagination's torment evermore,
But dare the narrow flaming pass of hell
And stride in strength towards the dreaded door.

This step I take in cheerful resolution,
Risk more than death, yea, dare my dissolution. 370
 Pure crystal bowl, I take you from your case,
Come down, to help me, from your waiting-place.
Long have I owned your worth with unconcern,
You who could charm, upon high holidays,
My father's guests, and shining win their praise,
As each received the loving-cup in turn.
The pride of art, the legends in the frieze,
The drinker's pledge, to tell them all in rhyme,
Then lift the cup and drain it to the lees—
All brings me back the nights of youthful prime. 380
I shall not hand you now to any friend,
No witty praise of art do I intend,
For here's a cordial quick to drown the sense,
A chalice with dark opiate to dispense:
I choose, clear-eyed, the draught of my preparing
And drink my last, with all my spirit daring
To pledge the morrow's awful imminence.
 [He sets the chalice to his lips. There is a sound
 of bells and solemn choir.]
Chorus of Angels: Christ is risen!
Joy to mortality,
Men whom fatality 390
Creeping, inherited,
Deeply dispirited
Doomed to a prison.
Faust: What depth of chanting, whence the blissful tone
That lames my lifting of the fatal glass?
Do bells already tell with vibrant drone
The solemn opening of the Easter Mass,
And choirs with comfort's anthem now resume
The angelic breaking of the darkened tomb,
The token of a compact come to pass? 400
Chorus of Women: With spices and balm
Fain had we tended him,
Laid him in calm,
Faithful befriended him.
Wraps had we wound,
Pure linen laid on,
Alas, and we found
Our Savior was gone.
Chorus of Angels: Christ is raised up,
Death has no sting, 410
Love's blessed King
Lives conquering
Trials that bring
Misery's cup.

Faust: Why seek ye, heavenly sounds so mild
And mighty, me in dust distressed?
Go sing where tender souls are domiciled.
I hear, but lack the faith, am dispossessed;
And faith has wonder for its dearest child.
This is a sphere to which I may not venture, 420
This source of things sublime, this lofty strain;
And yet the sound brings back my soul's indenture
Of early years, calls me to life again.
Time was, with sweetest touch dear heaven's kiss
Would light upon me in the sabbath stillness.
Then had the bells a sound of boding fullness
And every prayer was ecstasy of bliss.
A strangely lovely fervency, a yearning
Drove me to stray in fields and forests far,
And when my heart was loosed, and tears came burning, 430
I neared the threshold where no sorrows are.
This melody the bliss of childhood taught me,
The song of innocence, the joy of spring;
And thoughts of youth, this solemn hour, have brought
 me
In my last step a childlike wavering.
Begin once more, O sweet celestial strain.
Tears dim my eyes: earth's child I am again.
Chorus of the Disciples: He in the tomb who lay
Now is ascended,
Glorious reached the day, 440
Where death is ended.
Blissfully grows he near
To his creative power;
Still must we sojourn here,
Biding our earthy hour.
Left he us all, his own,
Languishing here like this;
Ah, we do but bemoan,
Master, thy bliss.
Chorus of Angels: Christ is arisen 450
From foulness of death's decree.
Lo, from your prison,
Love sets you free.
Prize him and praise:
In witness always,
At bread when you raise
Your brotherly lays.
Who works and who prays,
As love fills his days,
May know without fear 460
His master is near.

CHAPTER THIRTEEN

THE AGE OF INDUSTRY

Having begun in the 18th century, the Romantic movement entered the 19th with a force that matched that of the new engines of industrial progress. In the arts, the pendulum had swung again. Classical formality and restraint gave way to a relentless questioning of everything that had gone before. The artist, now liberated from patronage, became a kind of moral hero, on his or her own, to succeed or fail, to experiment, and to protest. Caught amidst the institutionalized expectations of the Academy, the tastes of the public, and the artist's own vision of individual expression, each generation reacted more and more strongly against the style of its predecessor. The pace of change—social, technological, artistic—quickened, and artists began to feel themselves increasingly marginalized within a materialistic society. Toward the end of the century, the Impressionists and their successors tried to redefine their role and their art.

13.1 Caspar David Friedrich, *The Wanderer above the Mists*, c.1817–18. Oil on canvas, 29½ × 37¼ ins (74.8 × 94.8 cm). Kunsthalle, Hamburg.

CONTEXTS AND CONCEPTS

The major social development since the Middle Ages had been the rise of the middle class. Until the French Revolution, it was in Britain that the middle class had reaped the greatest benefit from changing circumstances. Capitalism had gradually replaced the guild system, and individual initiative fostered a spirit of invention.

The first major industry to profit from the new inventions was the textile industry, an industry fundamental to the requirements of society. Cumulative inventions revolutionized the British textile industry to the point where one worker, with a machine, could do as much work in a day as four or five people had previously accomplished. The increased production capacity meant more cotton could be planted in Britain's colonies in the southern United States. And now more cotton could be processed as well, because Eli Whitney's cotton gin could do the work of a dozen slaves.

TECHNOLOGY

The early years of the 19th century saw wide experimentation with sources and uses of energy. Gas was generally used as a fuel and for illumination. Yet the pursuit of technological efficiency was so effective that gas was replaced by electricity before the century was over.

Important developments in engine design took place in the first two decades of the 19th century. The early steam engine could generate only enough steam pressure to drive one cylinder at one pressure. Water turbines were much more efficient, but they could only be installed near moving water. It took only a few years to find the path to a more efficient engine, however, and by the second decade of the century, a successful compound engine had been developed. The principal use of the compound steam engine was in ocean-going ships. It required less fuel, and the cargo capacity of the ships was proportionately increased. Later developments included steam turbines and internal combustion engines.

Mining production increased when new explosives based on nitroglycerine and more powerful hoisting and pumping equipment were introduced. Ore extraction and separation were also made more efficient. These improvements were eclipsed, however, by the flotation method devised by the Bessel brothers in 1877. Significant improvements in smelting furnaces, such as the blast furnace and the "wet process" of Joseph Hall, along with Nasmyth's steam hammer, improved production of iron and steel.

In America, a new process for producing what became known as "Bessemer steel" soon made wrought iron obsolete and provided high quality steel for rails, ships and, late in the century, building beams and girders. Further refinements of the "open hearth" steel process produced even higher quality, more economical steel. The development of the rolling mill made possible more and more applications, including cable for suspension bridges. The most famous use of suspension cable at the time was in the Brooklyn Bridge in 1883.

All areas of industry saw the invention and design of new machines and machine tools throughout the century. One of these was the milling machine (Fig. **13.2**), whose rotary cutting edges made possible the manufacture of parts of exact tolerance that could be interchanged in a single product. This idea of interchangeable parts is called the "American System," and is generally attributed

13.2 F. A. Pratt and Amos Whitney, the Lincoln Miller, 1855. Smithsonian Institution, Washington DC.

to Eli Whitney. The armaments industry also began to use a new grinding machine that enabled machinists to shape metal parts as opposed to merely polishing or sharpening them. Further experiments refined the accuracy of grinding wheels and improved their abrasive surfaces. A new turret lathe made it possible to use several tools on a workpiece. Advancements of this sort made possible a "second generation" of machine tools in the industrialized west.

The first industry to benefit substantially from the Industrial Revolution was the British textile industry, which was revolutionized from top to bottom by mechanization and by improved transportation. The wool and cotton industries benefited from devices designed to prepare, spin, weave, and finish fabrics. After the invention of the power loom, further refinements improved the quality of machine-woven cloth and increased the output of plants that made it.

The invention of the Jacquard loom created new markets for silk and other fancy goods, and, by 1850, it was used to weave wool and cotton as well. Other looms were designed for making lace and weaving carpet. Thread guides for knitting machines were also improved. The sewing machine, invented by Elias Howe, made even more hand labor unnecessary.

Machine technology also provided a plethora of labor-saving inventions for the home and office. The vacuum cleaner, the carpet sweeper, the telephone, the telegraph, the washing machine, the typewriter, the adding machine, and the cash register revolutionized domestic and office work.

Technology had a tremendous impact on agriculture, which for the first time became an industry. Not only did production capacity increase through mechanization, improved transportation also created global markets for its products. The farmer was no longer merely a local producer. First came the McCormick Reaper in 1834, which was pulled, rather than pushed, by horses, followed by the horse-drawn hay rake in 1856. The self-sharpening plow blade and the steel plow, to which soil would not stick, clod-crushers, and grain drills all made farming easier and more efficient. Next came power-driven machinery, although horses continued to be the main source of power on the farm until the introduction of gasoline-powered tractors in the early 20th century.

A major problem in food distribution had been the shipment and storage of perishables. Natural ice was used world-wide for large-scale refrigeration early in the 19th century. Shortly after the middle of the century, the development of ice cabinets the size of railroad cars and improved tools for harvesting ice meant that perishable goods could be refrigerated, and even frozen goods could be shipped across the American continent.

At the mid-point of the century, the process of pasteurization was discovered, eliminating several milk-borne diseases. Largely as a result of the experiments of

Nicholas Appert, early in the 19th century, the use of heat in preserving food gave rise to the canning industry. By the late 1840s, hermetic sealing was widespread.

Another major aspect of the technological revolution was the harnessing of electricity. By the 19th century, the wet battery provided a source for the continuous flow of current. Electrical energy was gradually applied to heating, lighting, and mechanical energy. Experiments produced a practical filament for an incandescent light bulb. The electric-powered streetcar rendered horsecars obsolete by 1888. By 1895, Niagara Falls had been harnessed for hydroelectric power. Elsewhere, long transmission lines and transformers carried electrical power throughout the western world.

We have touched upon four major areas of technological development—advances in the production of metals; the development of machine-tool industries; the introduction of precision instruments leading to standardization; and the development of efficient energy systems. There were, of course, many others, both before and during the 19th century. All had wide-ranging effects, and, by the turn of the 20th century, the western world had been fully mechanized.

SOCIAL CHANGES

Watt's steam engine of 1769 gave rise to further invention in the textile industry and elsewhere. In 1807, Robert Fulton built the first practical steamboat, and in 1825, an Englishman, George Stephenson, built a steam locomotive, which led to the first English railroad. The explosion of steamboat and railroad building that followed meant that, by the middle of the 19th century, the world's entire transportation system had undergone a complete revolution.

Soon steam engines ran sawmills, printing presses, pumping stations, and hundreds of other kinds of machinery, and further inventions and discoveries followed on the heels of steam power. Electricity, too, was in fairly wide use before the century was over, at least in the urban centers. The discovery of electricity made the telegraph possible in 1832. Telegraph lines spanned continents and, in 1866, joined them via the first transatlantic cable. The telephone was invented in 1876, and by 1895, radio-telegraphy was ready for 20th-century development.

The Industrial Revolution began in England and, at the conclusion of the Napoleonic wars in 1815, spread to France and the rest of Europe. It gained momentum as it spread, and irrevocably altered the fabric of civilization. By 1871, the year of the first unification of Germany, major industrial centers had been established all over Europe.

Coal and iron production gave Britain, Germany, France, and Belgium the lead in European industry. But vast resources of coal, iron, and other raw materials, more

	GENERAL EVENTS	LITERATURE & PHILOSOPHY	VISUAL ART	THEATRE & DANCE	MUSIC	ARCHITECTURE
1800	Napoleon Bonaparte Fulton's steamboat Battle of Waterloo/ Congress of Vienna Telegraph Stephenson's locomotive	Austen Byron Shelley Dickens Keats Wordsworth Coleridge Scott Hegel	Ingres (13.5) Géricault (13.6) Goya (13.7) Canova (13.26) Constable	Von Kleist Büchner Scribe Taglioni Blasis	Schubert Mendelssohn Berlioz Chopin	Latrobe (13.43) Nash (13.47)
1835	McCormick reaper	Schopenhauer Poe	Turner (13.8) Delacroix (13.9) Pre-Raphaelites formed Bonheur (13.11)	Hugo Dumas (P.) Grisi Petipa Gautier Perrot	Meyerbeer Rossini Wagner	
1850	Milling machine Pasteurization Internal combustion engine US Civil War Transatlantic cable Vatican Council Unification of Germany	Marx Charles Darwin Whitman Mendel Zola	Corot (13.10) Maclise Millet (13.13) Tanner (13.15) Morisot (13.18) Cassatt (13.19) Courbet (13.12) Manet (13.14) Renoir (13.17)	Kean	Offenbach Thomas Liszt Gounod Verdi Brahms Tchaikovsky	Pugin (13.48) Bunnell (13.44) Jay (13.45) Paxton (13.49)
1875	Flotation separation of ore Brooklyn Bridge Hydroelectric power Radio-telegraphy	Spencer	Cézanne (13.22) Van Gogh (13.24–25) Gauguin (13.23) Rodin (13.27–28) Monet (13.16) Seurat (13.20–21) Maillol (13.29) Epstein (13.30)	Ibsen Chekhov Pinero Stanislavsky Fuller Shaw Maeterlinck	Bizet Debussy Strauss Leoncavallo Mascagni	Sullivan (13.51) Burnham and Root (13.50) Horta (13.52) Jourdain (13.53)

13.3 Timeline of the 19th century.

than all Europe had, soon propelled the United States into a position of economic dominance. Throughout the western world, centers of heavy industry grew up near the sources of raw materials and transportation routes. Colonial expansion provided world markets for new goods. Wealth increased enormously, and although the effects of investment were felt at every level of society, the principal effect of industrialization was to centralize economic control in the hands of a relatively small class of capitalists. Populations grew as the mortality rate went down. A new class of machine workers, "blue-collar workers," or labor, emerged.

Drawn from pre-industrial home industries and farms, the new machine-worker class suffered in deplorable conditions. No longer their own masters, these people became virtual slaves. Unable to help themselves, they were subject to severe organizing restrictions, hampered by lack of education, and threatened constantly by the prospect of unemployment. Slums, tenements, and horrifying living conditions awaited them. The middle classes, caught up in their own aspirations to wealth and political power, ignored their plight.

The middle class now turned toward Liberalism, a political program dedicated to advancing religious toleration and reducing the authority of a dominant Church, reducing the power of the monarch or the aristocracy

through constitutional means, and removing provincial economic barriers through nationalism. In other words, Liberalism built its political program on those movements that would enhance middle-class power. It gained widespread support, and became the political watchword of the age. Part of the middle-class program was a laissez-faire or "Let people do as they please" economic policy.

A new code of morality stressed individual freedom. The "free man" became the model that one could achieve only by standing on one's own feet and creating one's own destiny. Individual freedom was achieved by struggle and eventual triumph. The unfit—the degraded masses—perished; the fit—a few rugged individuals—survived.

The masses, however, wanted to count too. In order for them to do so, two conditions had to be met. They needed a basic education, and they needed basic confidence in themselves. Only in Prussia was there a public school system that provided mass education. Britain and France did nothing about this until the 1870s and 1880s. In the United States, local support for public education began as early as the 1820s. But even the concept of mass education did not take root until mid-century, and compulsory elementary education was not introduced until toward the end of the 19th century.

Many different solutions to the working-class problem

were proposed—philanthropy, utopianism, and, most important of all, the socialism of Karl Marx (1818–83). Gradually, and not without bloodshed, workers acquired the right to form unions. But it was only in the second half of the 19th century that laborers began to unionize, and thereby to promote their own interests.

Scientific attention turned both to investigating the atom and formulating theories of evolution. Evolution as a unifying concept in science dated back to the Greeks. Now, Sir Charles Lyell became the first to co-ordinate earth studies, and his *Principles of Geology* (1830) provided an important base for evolutionary thinking. In 1859, Charles Darwin put forward the concept of natural selection as the explanation of species development in *The Origin of Species*. Darwin's theories were modified by the work of Gregor Mendel in 1866. By the end of the 19th century, evolution was established as the framework that the science of biology would use for the foreseeable future.

A clash between evolution and Christianity was inevitable. After the initial shock, many Protestant denominations were able to come to grips with the principles of evolution. This was easier for Protestants than Roman Catholics because, essentially, Protestants recognized the right of individuals to make private judgments, while Catholics had to accept doctrinal control. At the same time that evolutionary doctrine was first being propounded, some Protestant scholars were acknowledging the Bible as a compilation of human writings over a period of time, written under real, historical circumstances and not dictated, word for word, by God. Of course, some Christian groups condemned these notions as just as evil as Darwinism. Nevertheless, Protestantism, in general, gradually arrived at a "modern" outlook. Pope Pius IX, on the other hand, rejected evolution in his *Syllabus of Errors* (1864). The Vatican Council of 1870 declared papal infallibility, and the Church maintained a position of intransigence on the subject of evolution throughout the papacy of Leo XIII (1878–1903).

PHILOSOPHY
Idealism

In the late 18th century, Immanuel Kant put forward a dualistic metaphysics that distinguished between a knowable world of sense perceptions and an unknowable world of essences. This reconciliation of philosophical extremes led to a 19th-century philosophy that focused on the emotions.

Such an idealistic appeal was called "Romanticism," and this reaction against 18th-century rationalism permeated philosophy and the arts. Other German idealists—Johann Fichte (1762–1814) and Friedrich Schelling (1775–1854), for example—rejected Kant's dualism, and developed an absolute system, based on emotion, that asserted the oneness of God and nature. But 19th-century idealism, or Romanticism, culminated in the work of Georg Wilhelm Friedrich Hegel (1770–1831), who believed that both God and humankind possessed unfolding and expanding energy. Hegelian philosophy combined German idealism with a belief in evolutionary development, and it viewed the course of human history optimistically.

Hegel's aesthetic theory

Hegel's philosophy viewed "reality" as spirit, or mind. Hegel believed art to be *one* ultimate form, but not *the* ultimate form, of mind. Philosophy was the final form, while art was a preliminary "step toward truth."

According to Hegel, the objective of art is beauty, which is, in turn, a means for expressing truth. He defined beauty as the "sensuous appearance of the Idea, or the show of the Absolute Concept. The Concept which shows itself for itself is art."[1] Hegel believed classical art was the format whereby the ideal content "reaches the highest level that sensuous, imaginative material can correctly express." Classical art comprises the perfection of artistic beauty, and the essence of classical art, for Hegel, is sculpture. Hegel conceived of sculpture in the same way as the classical Greeks did, as the expression of the human form which alone can "reveal Spirit in sensuous fashion."

This assertion goes back to the ideas of Kant and Winckelmann. Kant maintained that human beings alone are capable of an ideal of beauty, and Winckelmann saw Greek sculpture as the perfection of beauty. Hegel went beyond Kant and Winckelmann to suggest that "Greek religion realized a concept of the divine which harmonized the ethical and the natural. Hence the Greek gods, the subject of Greek sculpture, are the perfect expression of a religion of art itself."

Finally, Romantic art evolves content to such a degree that it contains "more than any sensuous imaginative material can expressly embody." Being subjective, the content of Romantic art is the "Absolute that knows itself in its own spirituality." As Hegel attempts to reconcile this concept with the Christian concept of God, he ranks Romantic art in three progressively more spiritual forms. First comes painting, second is music, and third is poetry, the most spiritual and universal of all the arts, which includes within itself all the others.

Pessimism and courage

The idealism of Schelling, Fichte, and Hegel was challenged by Schopenhauer (1788–1860), who saw the world as a gigantic machine that was operating according to its unchanging law. Schopenhauer recognized no Creator,

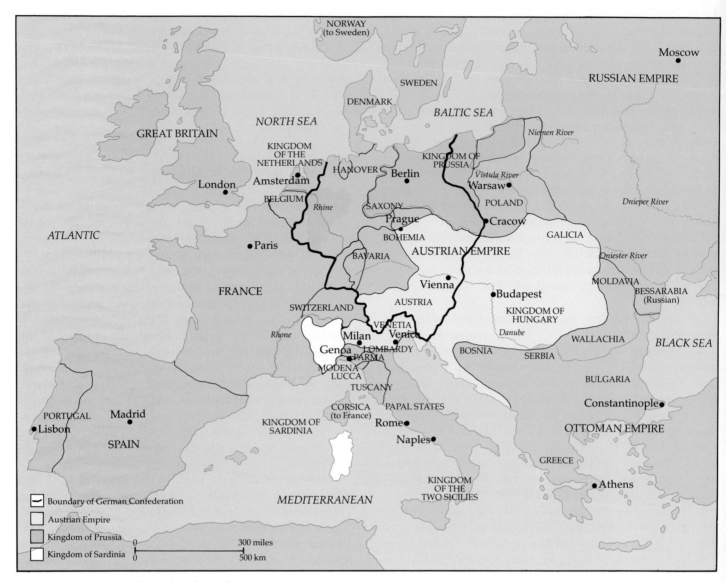

13.4 The industrialized world in the 19th century.

no benevolent Father, only a tyrannical and unfathomable First Cause. If Hegel was an optimist, Schopenhauer was a pessimist of the highest order.

The poet–philosopher Nietzsche followed Schopenhauer. Nietzsche (1844–1900) accepted the idea of human helplessness in a mechanical world operating under inexorable law, but he rejected Schopenhauer's pessimism. Rather, he preached courage in the face of the unknown, and found this to be humanity's highest attribute. After a long selective process, Nietzsche was certain, courage would produce a race of supermen and women.

Positivism and materialism

Unlike the Germans, who were intent on coping with metaphysical issues, the English and French focused upon philosophical explanations of the emerging, mechanized world. To them, what was beyond this world was beyond knowledge and, therefore, inconsequential. For philosophers like the Frenchman Auguste Comte (1798–1857), the 19th century was an era of science, and he saw philosophy's task as the sorting out of factual details of worldly existence rather than the solution of riddles of an unknown universe. Comte's philosophy was called "positivism," and his approach formed the basis for the science of sociology.

Across the channel in Britain, Herbert Spencer (1820–1903) expounded a philosophy of evolutionary "materialism," in which evolution provided the framework. He also believed that a struggle for existence and survival of the fittest were fundamental social processes, and that the human mind, ethics, social organization, and economics were "exactly what they ought to be."

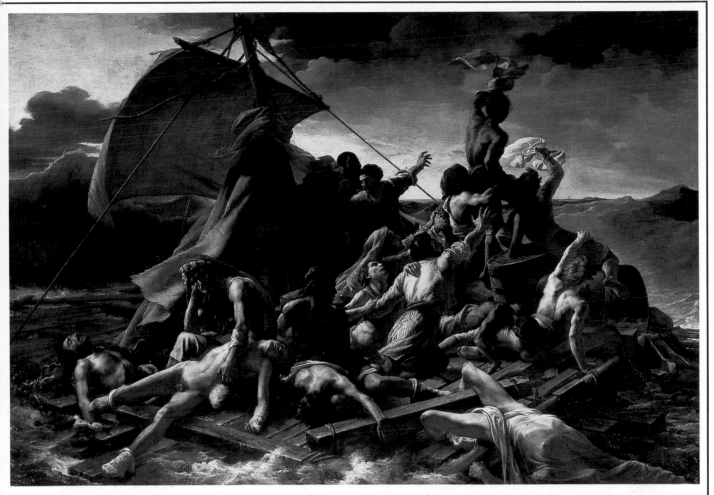

13.6 Théodore Géricault, *The Raft of the "Medusa"*, 1819. Oil on canvas, 16 ft × 23 ft 6 ins (4.91 × 7.16 m). Louvre, Paris.

MASTERWORK
Géricault—The Raft of the "Medusa"

The Raft of the "Medusa" (Fig. **13.6**) by Théodore Géricault illustrates both an emerging rebellion against classicism in painting and a growing criticism of social institutions in general. The painting tells a story of governmental incompetence that resulted in tragedy. In 1816, the French government allowed an unseaworthy ship, the *Medusa*, to leave port, and it was wrecked. Aboard a makeshift raft, the survivors endured tremendous suffering, and were eventually driven to cannibalism. In preparing for the work, Géricault interviewed the survivors, read newspaper accounts, and went so far as to paint corpses and the heads of guillotined criminals.

Géricault's painting captures the ordeal in Romantic style, tempered by classical and even High Renaissance influences. Géricault was a pupil of David, and, like David, he achieved firmly modeled flesh, realistic figures, and a precise play of light and shade. (His treatment of the physical form reminds us of Michelangelo.) In contrast to David's ordered, two-dimensional paintings, however, Géricault used complex and fragmented compositional structures. For example, he chose to base the design on two triangles rather than a strong central triangle. In *The Raft of the "Medusa,"* the left triangle's apex is the makeshift mast, which points back toward despair and death. The other triangle moves up to the right to the figure waving the fabric, pointing toward hope and life as a rescue ship appears in the distance.

Géricault captures the precise moment at which the rescue ship is sighted. The play of light and shade heightens the dramatic effect, and the composition builds upward from the bodies of the dead and dying in the foreground to the dynamic group whose final energies are summoned to support the figure waving to the ship. Thus, the painting is charged with unbridled emotional responses to the horror of the experience and the heroism of the survivors.

early French Romantic. His life offers us a fully developed example of the Romantic hero: he was a brilliant prodigy, he was a champion of the downtrodden, and he died extremely young. He was a Romantic in his art as well. Although greatly influenced by David, Géricault departed drastically from his master in his brushwork. David insisted that the surface of a painting should be smooth and that the brushwork should not show. Géricault uses the visual impact of the strokes themselves to communicate mood. He accepted the heroic view of human struggle that characterized this period, and his paintings frequently treat the human struggle against the violent forces of nature. His famous painting, *The Raft of the "Medusa"* (Fig. **13.6**), is much like Michelangelo's work in its turbulence and grandeur.

The Spanish painter and printmaker Francisco de Goya (1746–1828) used his paintings to attack the abuses perpetrated by governments, both the Spanish and the French. His highly imaginative and nightmarish works capture the emotional character of humanity and nature, and often their malevolence.

The Third of May 1808 (Fig. **13.7**) tells a real story. On that date, the citizens of Madrid rebelled against the invading army of Napoleon. People were arbitrarily arrested and summarily executed. Using compositional devices even more fragmented than those of Géricault, Goya captured the climactic moment in the story. It is impossible to escape the focal point of the painting, the man in white who is about to die. Goya's strong value contrasts force the eye back to the victim; only the lantern behind the soldiers keeps the composition in balance.

Goya leads us beyond the death of individuals here. These figures are not realistically depicted people. Instead, Goya makes a powerful social and emotional statement. Napoleon's soldiers are not even human types. Their faces are hidden, and their rigid, repeated forms become a line of subhuman automatons. The murky quality of the background strengthens the value contrasts in the painting and this charges the emotional drama of the scene. Color areas have hard edges, and a stark line of light running diagonally from the oversized lantern to the lower border irrevocably separates executioners and victims. Goya has no sympathy for French soldiers as human beings here. His subjectivity fills the painting, which is as emotional as the irrational behavior he wished to condemn.

13.7 Francisco de Goya, *The Third of May* 1808, 1814. Oil on canvas, 8 ft 6 ins × 11 ft 4 ins (2.6 × 3.45 m). Prado, Madrid.

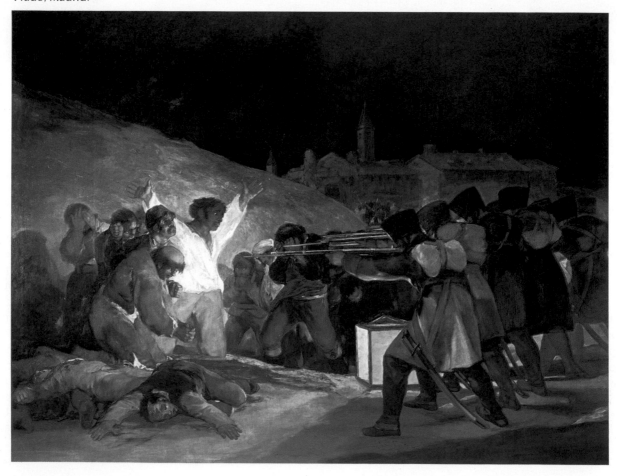

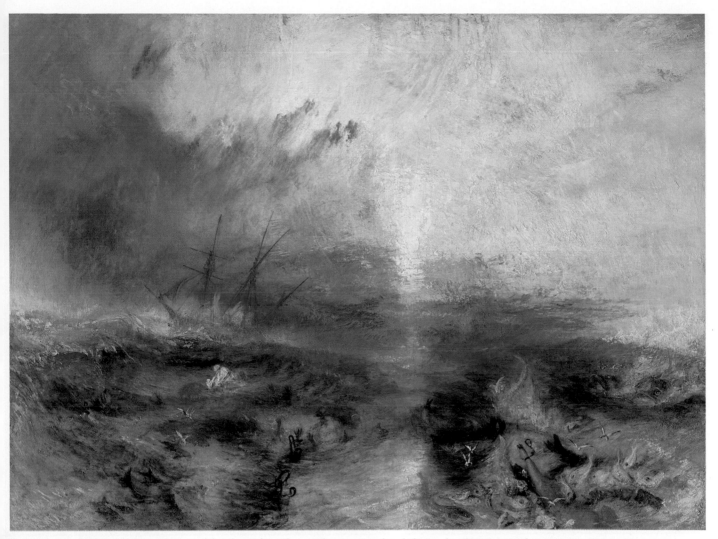

13.8 Joseph Mallord William Turner, *The Slave Ship (Slavers Throwing Overboard the Dead and Dying, Typhoon Coming On)*, 1839. Oil on canvas, 35¾ × 48¼ ins (90.8 × 122.6 cm). The Museum of Fine Arts, Boston (Henry Lillie Pierce Fund).

The Englishman J. M. W. Turner (1775–1851) indulged in a subjectivity even beyond that of his Romantic contemporaries, and his work foreshadows the dissolving image of 20th-century painting. The Romantic painter John Constable described Turner's works as "airy visions painted with tinted steam." *The Slave Ship* (Fig. **13.8**) visualizes a passage in James Thomson's poem *The Seasons*, which describes how sharks follow a slave ship in a storm, "lured by the scent of steaming crowds of rank disease, and death." The poem was based on an actual event, where the captain of a slave ship dumped his human cargo into the sea when disease broke out below decks.

Turner's work demonstrates the elements of Romantic painting. His disjointed diagonals contribute to an overall fragmentation of the composition. His space is deeply three-dimensional. The turbulence of the event pictured is reflected in the loose painting technique. The sea and sky appear transparent, and the brushstrokes are energetic and spontaneous. Expression dominates form

and content, and a sense of doom prevails.

Eugène Delacroix (1798–1863) employed color, light, and shade to capture the climactic moments of high emotion. Delacroix has been described as "the foremost neo-baroque Romantic painter," and the intricacy and contrasts in his paintings support this label. In *The 28th July: Liberty Leading the People* (Fig. **13.9**), Delacroix shows the allegorical figure of Liberty bearing aloft the tricolor flag of France and leading the charge of a freedom-loving common people. Lights and darks provide strong and dramatic contrasts. The red, white, and blue of the French flag symbolize patriotism, purity, and freedom, and as Delacroix picks up these colors throughout the work, they also serve to balance and unify the scene.

The approach of Jean-Baptiste-Camille Corot (1796–1875) is often described as "Romantic naturalism." Corot was among the first to execute finished paintings out-of-doors rather than in the studio. He wanted to recreate the full luminosity of nature and to capture the

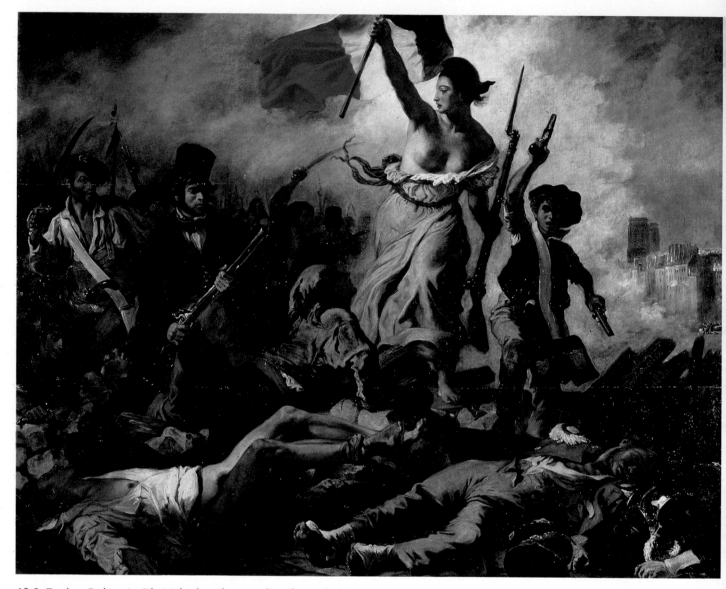

13.9 Eugène Delacroix, *The 28th July: Liberty Leading the People,* 1830. Oil on canvas, 8 ft 6 ins × 10 ft 7 ins (2.59 × 3.25 m). Louvre, Paris.

natural effect of visual perception, that is, how the eye focuses on detail and how peripheral vision actually works. In *Volterra* (Fig. **13.10**), he strives for this true-to-life visual effect by reducing the graphic clarity of all details except those of the central objects which he presents very clearly, just as our eyes perceive clearly only those objects on which we are focusing at the moment, while everything else in our field of vision is relatively out of focus. Corot's works are spontaneous and subjective, but he retains a formal order to balance that spontaneity.

Rosa Bonheur (1822–99), certainly the most popular woman painter of her time, has been labeled both a "realist" and a "Romantic" in style. Her subjects were mostly animals, and their raw energy. "Wading in pools of blood," as she put it, she studied animal anatomy even in slaughter houses, and was particularly interested in

animal psychology. *Plowing in the Nivernais* (Fig. **13.11**) captures the tremendous power of the oxen on which European agriculture had depended before the Industrial Revolution. The beasts appear almost monumental, and each detail is precisely executed. The painting clearly reveals Bonheur's reverence for the dignity of labor and her vision of human beings in harmony with nature.

Realism

A new painting style called "realism" arose in the mid-19th century. The term describes various kinds of painting. "Social realism," for example, describes a number of painting styles that picture the contemporary scene, usually from a socialist viewpoint, and always with a strong

13.10 Jean-Baptiste-Camille Corot, *Volterra*, 1834. Oil on canvas, 18½ × 32¼ ins (47 × 82 cm). Louvre, Paris.

13.11 Rosa Bonheur, *Plowing in the Nivernais*, 1849. Oil on canvas, 5 ft 9 ins × 8 ft 8 ins (1.75 × 2.64 m). Musée Nationale du Château de Fontainebleau, France.

thematic emphasis on the ways in which society oppresses the individual. Others extend the "realist" label to include Manet, while still others apply the term only to Courbet. Whatever the case, the definition of "reality" in the 19th century took on new significance because the camera now intruded on what previously had been exclusively the painter's realm.

The style that is referred to as "realism" ran through the 1840s, 1850s, and 1860s, and its central figure was Gustave Courbet (1819–77). Courbet was influenced by

13.12 Gustave Courbet, *The Stone Breakers*, 1849. Oil on canvas, 5 ft 3 ins × 8 ft 6 ins (1.6 × 2.59 m). Formerly Gemäldegalerie, Dresden (destroyed 1945).

13.13 Jean-François Millet, *Woman Baking Bread*, 1853–54. Oil on canvas, 21¾ × 18 ins (55 × 46 cm). Collection, State Museum Kröller-Müller, Otterlo, The Netherlands.

the innovations of Corot in terms of the play of light on surfaces. But, unlike Corot, his aim was to make an object-ive and unprejudiced record of the customs, ideas, and appearances of contemporary French society, and his work depicts everyday life. *The Stone Breakers* (Fig. **13.12**) was the first painting to display his philosophy to the full. Courbet painted two men as he had seen them working beside a road. The work is life-size, and, while the treat-ment seems objective, it makes a sharp comment on the tedium and laborious nature of the task. A social realist, Courbet was more intent on social message than on meditative reaction. Therefore, his work is less dramatic and nostalgic than that of others.

Jean-François Millet (1814–75) was one of a group of painters called the "Barbizon School" who focused upon a realistic-Romantic vision of landscape, and typically used peasants as their subject matter. The Barbizon School did not espouse socialism. It did, however, exalt the honest, simple life and work on the land, as con-trasted with the urban bourgeois life. In Millet's *Woman Baking Bread* (Fig. **13.13**) these themes are apparent, and the peasant emerges as an heroic figure. This quality is enhanced by the vantage point the painter has chosen. Seen from slightly below, the peasant woman has an added height and dominance which emphasizes her grandeur.

Edouard Manet (1832–83) followed in the realist tradition, although he is often regarded as an impression-ist—an association he denied. Manet strove to paint "only what the eye can see." Yet his works go beyond a

13.14 Edouard Manet, *Déjeuner sur l'herbe* (*The Picnic*), 1863. Oil on canvas, 7 ft × 8 ft 10 ins (2.13 × 2.69 m). Louvre, Paris.

13.15 (below) Henry O. Tanner, *The Banjo Lesson*, c.1893. Oil on canvas, 48 × 35 ins (122 × 89 cm). The Hampton Institute, Hampton, Virginia.

mere reflection of reality to a larger artistic reality, one which suggests that a painting has an internal logic different from the logic of familiar reality. Manet liberated the painter's art from competition with the camera. *Déjeuner sur l'herbe* (Fig. **13.14**) shocked the public when it was first shown at the Salon des Refusés in 1863. Here, Manet sought to "speak in a new voice." The setting is pastoral, like one we might find in Watteau, for example, but the people are real and identifiable: Manet's model, his brother, and the sculptor Leenhof. The apparent immorality of a naked frolic in a Paris park outraged the public and the critics. Had his figures been nymphs and satyrs or idealized men and women in classical dress, all would have been well. But the intrusion of reality into the sacred mythical setting, not to mention the nudity of a real woman while her male companions have their clothes on, proved more than the public could handle.

The first important black painter, the American Henry O. Tanner (1859–1937), although somewhat later, painted in a similar style. He studied with the American realist painter Thomas Eakins (1844–1916), who encouraged both blacks and women at a time when professional careers were essentially closed to them. *The Banjo Lesson* (Fig. **13.15**) presents its images in a strictly realistic manner, without sentimentality. The painting's focus is achieved through the contrast of clarity in the central objects and less detail in the surrounding areas. In many respects this technique follows Corot. Tanner skillfully captures an atmosphere of concentration and shows us a warm relationship between teacher and pupil.

Impressionism

The realists' search for spontaneity, harmonious colors, subjects from everyday life, and faithfulness to observed lighting and atmospheric effects led to the development of a style used by a small group of painters in the 1860s, and described by a hostile critic in 1874 as "impressionism."

The "impressionists" created a new way of seeing reality and sought to capture "the psychological perception of reality in color and motion."[2] Their style emerged in competition with the newly invented technology of the camera, and these painters tried to outdo photography by portraying those essentials of perception that the camera cannot capture.

The style lasted only 15 years in its purest form, but it profoundly influenced all painting that followed. Working out-of-doors, the impressionists concentrated on the effects of natural light on objects and atmosphere. They discovered that color, for example, is not inherent in an object but in our perceptions of that object, as modified by the quality of existing light. Their experiments resulted in a profoundly different vision of the world around them and way of rendering that vision. This "revolution of the color patch," as it has been called, taught that the painted canvas was, first of all, "a material covered with pigments—that we must look *at* it, not *through* it." As we look at an impressionist painting, we see that the canvas is filled with small "color patches," and that our impression of the reality there comes through the total effect of those "flickering" patches. The result is a lively and vibrant image.

13.16 Claude Monet, *On the Seine at Bennecourt*, 1868. Oil on canvas, $31\frac{7}{8} \times 39\frac{1}{2}$ ins (78.5 × 100.5 cm). Courtesy the Art Institute of Chicago (Potter Palmer Collection).

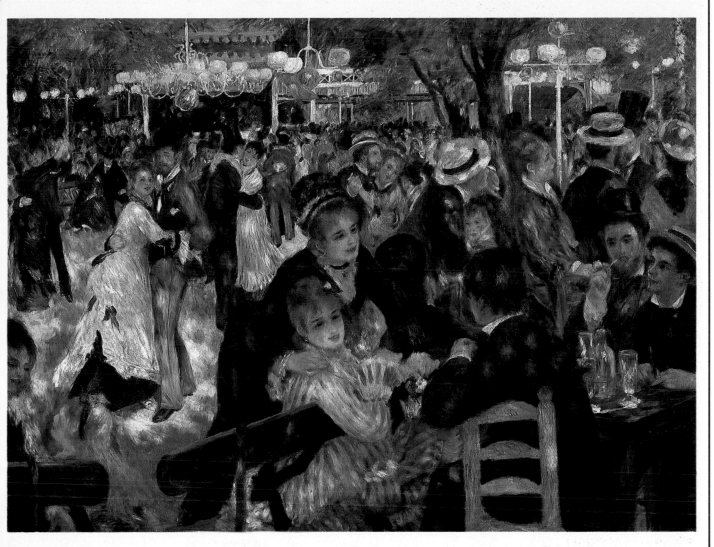

13.17 Pierre-Auguste Renoir, *Le Moulin de la Galette*, 1876. Oil on canvas, 4 ft 3½ ins × 5 ft 9 ins (1.31 × 1.75 m). Louvre, Paris.

MASTERWORK
Renoir—*Le Moulin de la Galette*

The impressionist Pierre-Auguste Renoir (1841–1919) specialized in painting the human figure and sought out what was beautiful in the body. His paintings sparkle with the joy of life. In *Le Moulin de la Galette* (Fig. **13.17**) he depicts the bright gaiety of a Sunday afternoon crowd in a popular Parisian dance venue. The artist celebrates the liveliness and charm of these everyday folk as they talk, crowd the tables, flirt, and dance. Warmth infuses the setting. Sunlight and shade dapple the scene and create a sensation of floating in light.

There is a casualness here, a sense of life captured in a fleeting and spontaneous moment, and of a much wider scene extending beyond the canvas. This is no formally composed scene like that in David's *Oath of the Horatii* (Fig. **12.13**). Rather, we are invited to become a part of the action. People are going about their everyday lives with no sense of the painter's presence. As opposed to the realism of the classicist who seeks the universal and the typical, the realism of the impressionist seeks "the incidental, the momentary, and the passing."

Le Moulin de la Galette captures the enjoyment of a moment outdoors. The colors shimmer, and although Renoir skillfully plays off highlights against dark tones, the uniform hue of the lowest values is not black but blue. In short, the beauty of this work exemplifies Renoir's statement, "The earth as the paradise of the gods, that is what I want to paint."

13.18 Berthe Morisot, In the Dining Room, 1886. Oil on canvas, 24⅛ × 19¾ ins (61 × 50 cm). National Gallery of Art, Washington.

Impressionism was as collective a style as any we have seen thus far. In an individualistic age, this style reflected the common concerns of a relatively small group of artists who met frequently and held joint exhibitions. The subjects painted are impressions of landscapes, rivers, streets, cafés, theatres, and so on.

However, it is generally considered that Claude Monet and Pierre-Auguste Renoir brought impressionism to its birth. They spent the summer of 1866 at Bougival on the River Seine working closely together, and from that collaboration came the beginnings of the style. In his paintings, Claude Monet (1840–1926) tried to find an art of modern life by recording everyday themes with on-the-spot, objective observations. He sought to achieve two aims: representation of contemporary subject matter and optical truth—that is, the way colors and textures really appear to the eye. Monet's paintings reflect an innocent joy in the world around him and an intensely positive view of life. He had no specific aesthetic theory—in fact, he detested theorizing—but he did seek to bring realism to its peak. His work encompasses scientific observation, the study of optics, and other aspects of human perception. Monet translated objects into color stimuli. He told a young American artist in 1889 that he should disregard the actual trees, houses, fields; rather, he should see only "a square of blue . . . an oblong of pink . . . a streak of yellow" by using exact colors and shapes, until a naive impression of the scene before him was created.

On the Seine at Bennecourt (Fig. **13.16**) by Monet illustrates these concerns. It conveys a pleasant picture of the times, an optimistic view rather than the often pessimistic outlook of the Romantics. It also suggests a fragmentary and fleeting sensory image. This was a new tone for a new era. We sense the quickly applied pigment. Brushstroke suggests form, and although the scene is a landscape panorama, the vision leaves us with no deep space. The background colors are as vibrant as the foreground. There is no linear perspective, and the overall effect brings the entire painting into the foreplane. The scene is bright, alive, and pleasant. We are comfortable in its presence.

The best-known central figures in the development of impressionism were Monet, Renoir, and Degas. But also included in this original group of impressionists was Berthe Morisot (1841–95). Her works have a gentle introspectiveness, often focusing on family members. Her view of contemporary life is edged with pathos and sentimentality. In In the Dining Room (Fig. **13.18**), she gives a penetrating glimpse into psychological reality. The servant girl has a distinct personality, and she stares back at the viewer almost impudently. The painting captures a moment of disorder—the cabinet door stands ajar with what appears to be a used table cloth flung over it. The little dog playfully demands attention. Morisot's

13.19 Mary Cassatt, The Bath, 1891. Oil on canvas, 39½ × 26 ins (100 × 66 cm), The Art Institute of Chicago.

brushstrokes are delicate, loose, and casual.

In 1877, another woman joined the impressionists. Mary Cassatt (1845–1926) came to Paris from Philadelphia, a minor center for artists at the time. Thanks to her financial independence, she overrode her family's objections to a career deemed unsuitable for a woman, especially a woman of wealth. In fact, it was her wealth and connections with wealthy collectors in the United States that helped the impressionists gain exposure and acceptance in this country. In The Bath (Fig. **13.19**), she depicts her favorite subjects—women and children. In this painting, Cassatt's brushwork is far less obvious than that in other impressionist works, and this helps conventional viewers to understand the work and relate closely to the scene. Painted in clear, bright colors, Cassatt's subjects do not make eye contact with the viewer. Their forms are purposeful, and they awaken our interest, rather than our emotions.

Post-impressionism

In the last two decades of the 19th century, impressionism evolved gently into a collection of rather disparate styles called simply "post-impressionism." In subject matter, post-impressionist paintings were similar to impressionist paintings—landscapes, familiar portraits, groups, and café and nightclub scenes. The post-impressionists, however, gave their subject matter a complex and profoundly personal significance.

Georges Seurat (1859–91), often described as a "neo-impressionist" (he called his approach and technique "divisionism"), departed radically from existing painting technique with his experiments in optics and color theory. His patient and systematic application of specks of paint is called "POINTILLISM," because paint is applied with the point of the brush, one small dot at a time. A *Sunday Afternoon on the Island of La Grande Jatte* (Fig. **13.20**) illustrates both his theory of color perception and his concern for the accurate depiction of light and colorations of objects. The composition of this work shows attention to perspective, and yet it willfully avoids three-dimensionality. Japanese influence is apparent here, as it was in

much post-impressionist work. Color areas are fairly uniform, figures are flattened, and outlining is continuous. Throughout the work we find conscious systematizing. The painting is broken into proportions of three-eighths and halves, which Seurat believed represented true harmony. He also selected his colors by formula. For Seurat, the painter's representation of physical reality was simply a search for a superior harmony, for an abstract perfection.

In *Le Chahut* (Fig. **13.21**), Seurat portrays the gaiety of dance—the tone is light, the colors are warm, line and movement lead the eye upward. Reality takes a subordinate position to overall design, and the buoyant mood of the café and the singer is contrasted only slightly by the darker tones of the bass player (perhaps Seurat was trying to suggest the rich sonority of the instrument).

The post-impressionists called for a return to form and structure in painting, characteristics they believed were lacking in the works of the impressionists. Taking the evanescent light qualities of the impressionists, Gauguin, Seurat, Van Gogh, and Cézanne brought formal patterning to their canvases. They used clean color areas, and applied color in a systematic and almost scientific

13.20 Georges Seurat, A *Sunday Afternoon on the Island of La Grande Jatte*, 1884–86. Oil on canvas, 6 ft 9½ ins × 10 ft ⅜ in (2.06 × 3.06 m). Helen Birch Bartlett Memorial Collection, Courtesy of the Art Institute of Chicago.

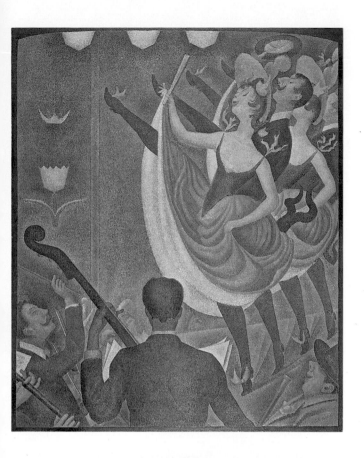

manner. The post-impressionists sought to return painting to traditional goals while retaining the clean palette of the impressionists.

Paul Cézanne (1839–1906), considered by many to be the father of modern art, illustrates concern for formal design, and his *Mont Sainte-Victoire seen from Les Lauves* (Fig. **13.22**) shows a nearly geometric configuration and balance. Foreground and background are tied together in a systematic manner so that both join in the foreground to create two-dimensional patterns. Shapes are simplified, and outlining is used throughout. Cézanne believed that all forms in nature are based on geometric shapes—the cone, the sphere, and the cylinder. Employing these forms, he sought to reveal the enduring reality that lay beneath surface appearance.

Paul Gauguin (1848–1903) brought a highly imaginative approach to post-impressionist goals. An artist without training, and a nomad who believed that European society and all its works were sick, Gauguin devoted his life to art and to wandering, spending many years in rural Brittany and the end of his life in Tahiti and the Marquesas Islands. His work shows his insistence on form and his resistance to naturalistic effects. Gauguin was influenced by non-western art, including archaic and "primitive" styles. *The Vision after the Sermon* (Fig. **13.23**) has Gauguin's typically flat, outlined figures, simple

13.21 (above) Georges Seurat, *Le Chahut (The Hullabaloo)*, 1889–90. Oil on canvas, 5 ft 7¼ ins × 4 ft 7¼ ins (1.72 × 1.41 m). Collection, State Museum Kröller-Müller, Otterlo, The Netherlands.

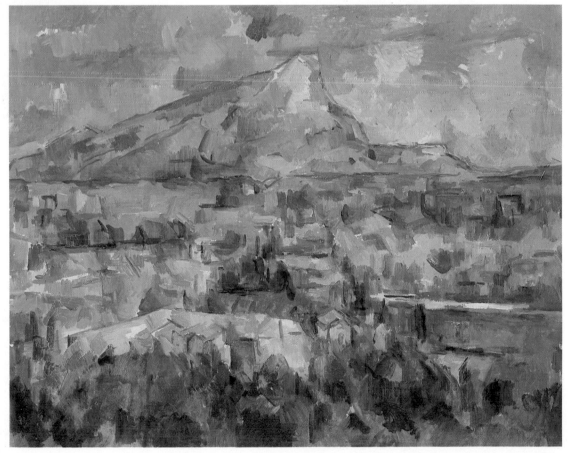

13.22 Paul Cézanne, *Mont Sainte-Victoire seen from Les Lauves*, 1902–04. Oil on canvas, 27½ × 35¼ ins (69.8 × 89.5 cm). Philadelphia Museum of Art (George W. Elkins Collection).

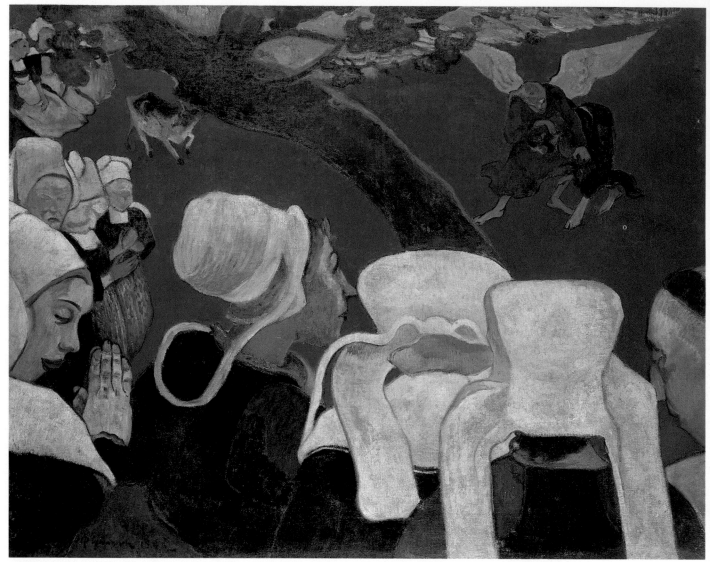

13.23 Paul Gauguin, *The Vision after the Sermon*, 1888. Oil on canvas, 28¾ × 36¼ ins (73 × 92 cm). National Gallery of Scotland, Edinburgh.

forms, and the symbolism for which he and his followers, sometimes called "Nabis," from the Hebrew word for prophet, were known. In the background of this painting, the biblical figure of Jacob wrestles with the Angel while, in the foreground, a priest, nuns, and women in Breton costume pray. The intense reds are typical of Gauguin's symbolic and unnatural use of color, used here to portray the powerful sensations of a Breton folk festival.

Vincent van Gogh (1853–90) took yet another approach to post-impressionism. His intense emotionalism in pursuing form was unique. Van Gogh's turbulent life included numerous short-lived careers, impossible love affairs, a tempestuous friendship with Gauguin, and, finally, serious mental illness. Biography here is essential because Van Gogh gives us one of the most personal and subjective artistic viewpoints in the history of western art. Frenetic energy explodes from his brushwork in paintings such as *The Starry Night* (Fig. **13.24**). Flattened forms and

outlining reflect Japanese influence. Tremendous power surges through the painting, especially in focal areas, and we can sense the dynamic, personal feeling and mental turmoil barely contained by the painting's surface.

The earlier *Potato Eaters* (Fig. **13.25**) shows careful preparation, in the style of Millet. This version is the last study before the final painting, which hangs in the Van Gogh Museum in Amsterdam. The color and treatment are rough, suggesting the rough skin of the potato. The overall tone of the painting suggests the grayness and gloom of peasant life.

13.24 Vincent van Gogh, *The Starry Night*, 1889. Oil on canvas, 29 × 36¼ ins (73.7 × 92.1 cm). The Museum of Modern Art, New York (Acquired through the Lillie P. Bliss Bequest).

13.25 Vincent van Gogh, *The Potato Eaters* (2nd version), 1885. Canvas, 28½ × 37 ins (72 × 93 cm). Collection, State Museum Kröller-Müller, Otterlo, The Netherlands.

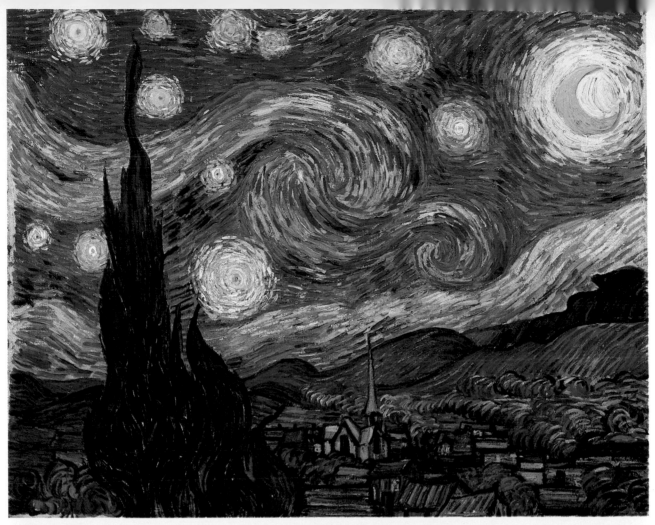

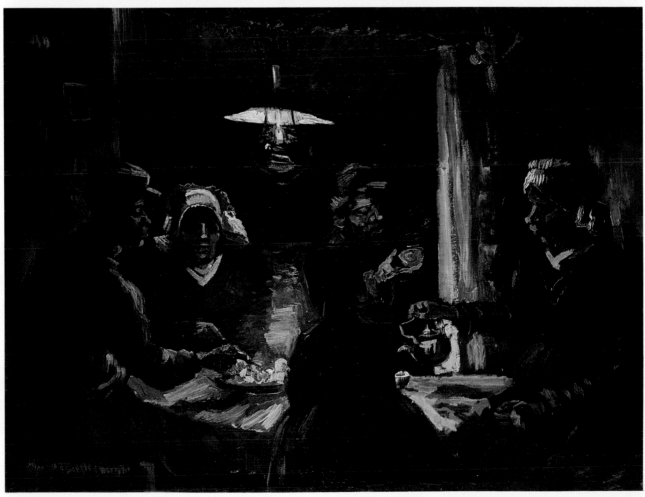

SCULPTURE

Neo-classicism

Neo-classical sculpture prevailed during the early years of the 19th century. By and large, this work reproduced classical models rather than revising them, and this was also the case in architecture. In France, neo-classicism served its commemorative and idealizing functions as the political tool of Napoleon, who was glorified in various Greek and Roman settings, sometimes garbed in a toga and sometimes in the nude, as if he had been granted the status of a god. No style is free from outside influences, and 19th-century neo-classical sculpture often reveals aspects of rococo, baroque, and Romantic style.

Antonio Canova (1757–1822) was the ablest of the neo-classical sculptors, and his works also show influences of the rococo tradition. *Pauline Borghese as Venus Victrix* (Fig. **13.26**), for which Napoleon's sister was the model, uses a classical pose and proportions, similar in many ways to Ingres' *Grande Odalisque* (Fig. **13.5**). Line, costume, and hairstyle reflect the ancients, but sensuous texture, individualized expression, and fussy realistic detail suggest other approaches. At the same time, this work is almost two-dimensional. Canova appears unconcerned with the sculpture from any angle other than a straight-on view.

Romanticism and impressionism

Romantic sculpture never developed a uniform style. Those works not clearly of other traditions generally show an eclectic spirit and a uniformly undistinguished character. It may be that Romantic idealism, in its strivings after nature and the far away and the long ago, cannot easily be translated into sculpture. Certainly the 19th-century love of landscapes cannot. Of course, the term "Romantic" is often applied to almost anything dating from the 19th century, as is the case with the most remarkable sculptor

13.26 Antonio Canova, *Pauline Borghese as Venus Victrix*, 1808. Marble, life-size. Galleria Borghese, Rome.

13.27 Auguste Rodin, *The Burghers of Calais*, 1866.
Bronze, 6 ft 10½ ins (2.1 m) high.
Hirshhorn Museum and Sculpture Garden,
Smithsonian Institution, Washington DC.

13.28 (below) Auguste Rodin, *The Thinker*,
first modeled c.1880, executed c.1910.
Bronze, 27½ ins (70 cm) high.
The Metropolitan Museum of Art, New York
(Gift of Thomas F. Ryan, 1910).

of this era, Auguste Rodin (1840–1917).

There is plenty of idealism and social comment in Rodin's *Burghers of Calais* (Fig. **13.27**). The work celebrates the noble, if humiliating, surrender of the city. Rodin's textures are impressionistic: his surfaces appear to shimmer as light plays on their irregularities. *The Thinker* (Fig. **13.28**), a more familiar example, shows the difficulty of putting what Monet, for example, tried to do with color and texture into sculptural form. Rodin's textures, however, are more than reflective surfaces—they give his works dynamic and dramatic qualities.

Although Rodin worked fairly realistically, he nevertheless created a subjective reality beyond the surface. The subjectivity of his viewpoint is even more clear and dramatic in his pessimistic later sculptures. Rodin's work was done in the 19th century, but it can hardly be defined by any term other than "modern."

Post-impressionism

Sculpture in the late 19th and early 20th centuries sought to return to form but also to present expressive emotional content. The works of Aristide Maillol (1861–1944), which embody both these concerns, are occasionally called "classical," a label that fits in terms of the mythological subject matter and the sculptor's clear concern for formal composition. Many critics, however, draw comparisons between Maillol and the post-impressionist painters because he shared their desire not only for structure, but also for capturing emotional qualities.

281

13.29 Aristide Maillol, *The Mediterranean*, 1902–05. Bronze, 3 ft 5 ins (1.04 m) high. The Museum of Modern Art, New York (Gift of Stephen C. Clark).

13.30 (below) Jacob Epstein, *Selina*, 1922. Bronze, 22¹⁄₈ ins (56 cm) high. The Brooklyn Museum, New York (Gift of Adolph Lewisohn).

Maillol believed that a statue should exhibit rest and self-containment, and that belief emerges clearly in a work like *The Mediterranean* (Fig. **13.29**). The gaze of the figure pulls the force of the sculpture downward within the border formed by the left arm. This arm, raised to the head, also completes the triangular, classical format by joining the top of the head to the left leg. The left leg and right arm tie the pyramid to the base, and the foot and outward pointing right hand bring the composition in contact with the outer corners of the base. From another vantage point, the right leg, by extension of the line from hip to knee, reaches out to another corner, and this creates the same effect. To add to the dynamics, the body also crosses the square base on the diagonal.

Finally, the poignant work of Jacob Epstein (1880–1959) suggests a post-impressionistic emotional energy and subjectivity like that found in the work of Van Gogh. The face of his *Selina* (Fig. **13.30**) looks uncertain, and her discomfort is heightened by her blank stare. Unlike *The Mediterranean*, *Selina* breaks free from containment. The line of arms and nose, coupled with the gaze, leads off into space beyond the form. The back is hunched outward, and discomfort is heightened further by the awkward cutting off of the work at mid-arm and mid-torso. Epstein's highly irregular surfaces recall Van Gogh's tormented brushstrokes.

LITERATURE

The main phase of Romantic literature probably began around 1790. In the United States the Romantic spirit found among its champions Edgar Allen Poe (1809–49) and Walt Whitman (1819–92). Poe's Romantic poetry is very distinguished, but he is most remembered for his horror stories based on the Gothic novel. Whitman's writings encompass a wide range of subjects—he intended to celebrate everything. Nothing was beneath the quest for his senses. Out of the Civil War came an unexpected author, whose contributions were oratorical, but, because of their importance, they have become part of the important canon of literature; these are the speeches of Abraham Lincoln.

Romantic writers tended to form groups or partnerships. The close relationship betwen Goethe and Schiller was one example. In Britain, Wordsworth and Coleridge were also close colleagues, and Byron, Shelley, Tennyson, and Keats knew and criticized each other's work.

Wordsworth

William Wordsworth (1770–1850) saw transcendental and often indefinable significance in commonplace and everyday things. Wordsworth's worship of nature and the harmony he felt existed between people and nature led him to create a new and individual world of Romantic beauty.

In 1795, he met Samuel Taylor Coleridge (1772–1834), another English poet, and in working with Coleridge, he found that his life and writing suddenly opened up. Out of this relationship came the *Lyrical Ballads*, which Wordsworth published anonymously along with four poems by Coleridge. Among these ballads, *Tintern Abbey* describes Wordsworth's love of nature most explicitly. That love is first presented as the animal passion of a wild young boy, then as a restorative and moral influence, and finally as a mystical communion with an eternal truth.

Lines Composed a Few Miles Above Tintern Abbey, on Revisiting the Banks of the Wye During a Tour, July 13, 1798

Five years have past; five summers, with the length
Of five long winters! and again I hear
These waters, rolling from their mountain-springs
With a soft inland murmur.—Once again
Do I behold these steep and lofty cliffs,
That on a wild secluded scene impress
Thoughts of more deep seclusion; and connect
The landscape with the quiet of the sky.
The day is come when I again repose
Here, under this dark sycamore, and view 10
These plots of cottage-ground, these orchard-tufts,
Which at this season, with their unripe fruits,
Are clad in one green hue, and lose themselves
'Mid groves and copses. Once again I see

These hedge-rows, hardly hedge-rows, little lines
Of sportive wood run wild: these pastoral farms,
Green to the very door; and wreaths of smoke
Sent up, in silence, from among the trees!
With some uncertain notice, as might seem
Of vagrant dwellers in the houseless woods, 20
Or of some Hermit's cave, where by his fire
The Hermit sits alone.

These beauteous forms,
Through a long absence, have not been to me
As is a landscape to a blind man's eye:
But oft, in lonely rooms, and 'mid the din
Of towns and cities, I have owed to them
In hours of weariness, sensations sweet,
Felt in the blood, and felt along the heart;
And passing even into my purer mind, 30
With tranquil restoration:—feelings too
Of unremembered pleasure: such, perhaps,
As have no slight or trivial influence
On that best portion of a good man's life,
His little, nameless, unremembered, acts
Of kindness and of love. Nor less, I trust,
To them I may have owed another gift,
Of aspect more sublime; that blessed mood,
In which the burthen of the mystery,
In which the heavy and the weary weight 40
Of all this unintelligible world,
Is lightened:—that serene and blessed mood,
In which the affections gently lead us on,—
Until, the breath of this corporeal frame
And even the motion of our human blood
Almost suspended, we are laid asleep
In body, and become a living soul:
While with an eye made quiet by the power
Of harmony, and the deep power of joy,
We see into the life of things. 50
If this
Be but a vain belief, yet, oh! how oft—
In darkness and amid the many shapes
Of joyless daylight; when the fretful stir
Unprofitable, and the fever of the world,
Have hung upon the beatings of my heart—
How oft, in spirit, have I turned to thee,
O sylvan Wye! thou wanderer thro' the woods,
How often has my spirit turned to thee!
And now, with gleams of half-extinguished thought, 60
With many recognitions dim and faint,
And somewhat of a sad perplexity,
The picture of the mind revives again:
While here I stand, not only with the sense
Of present pleasure, but with pleasing thoughts
That in this moment there is life and food
For future years. And so I dare to hope,
Though changed, no doubt, from what I was when first
I came among these hills; when like a roe
I bounded o'er the mountains, by the sides 70
Of the deep rivers, and the lonely streams,
Wherever nature led: more like a man
Flying from something that he dreads, than one
Who sought the thing he loved. For nature then

(The coarser pleasures of my boyish days,
And their glad animal movements all gone by)
To me was all in all.—I cannot paint
What then I was. The sounding cataract
Haunted me like a passion: the tall rock,
The mountain, and the deep and gloomy wood, 80
Their colours and their forms, were then to me
An appetite; a feeling and a love,
That had no need of a remoter charm,
By thought supplied, nor any interest
Unborrowed from the eye.—That time is past,
And all its aching joys are now no more,
And all its dizzy raptures. Not for this
Faint I, nor mourn nor murmur; other gifts
Have followed; for such loss, I would believe,
Abundant recompense. For I have learned 90
To look on nature, not as in the hour
Of thoughtless youth; but hearing often-times
The still, sad music of humanity,
Nor harsh nor grating, though of ample power
To chasten and subdue. And I have felt
A presence that disturbs me with the joy
Of elevated thoughts; a sense sublime
Of something far more deeply interfused,
Whose dwelling is the light of setting suns,
And the round ocean and the living air, 100
And the blue sky, and in the mind of man;
A motion and a spirit, that impels
All thinking things, all objects of all thought,
And rolls through all things. Therefore am I still
A lover of the meadows and the woods,
And mountains; and of all that we behold
From this green earth; of all the mighty world
Of eye, and ear,—both what they half create,
And what perceive; well pleased to recognise
In nature and the language of the sense, 110
The anchor of my purest thoughts, the nurse,
The guide, the guardian of my heart, and soul
Of all my moral being.
Nor perchance,
If I were not thus taught, should I the more
Suffer my genial spirits to decay:
For thou art with me here upon the banks
Of this fair river; thou my dearest Friend,
My dear, dear Friend; and in thy voice I catch
The language of my former heart, and read 120
My former pleasures in the shooting lights
Of thy wild eyes. Oh! yet a little while
May I behold in thee what I was once,
My dear, dear Sister! and this prayer I make,
Knowing that Nature never did betray
The heart that loved her; 'tis her privilege,
Through all the years of this our life, to lead
From joy to joy: for she can so inform
The mind that is within us, so impress
With quietness and beauty, and so feed 130
With lofty thoughts, that neither evil tongues,
Rash judgments, nor the sneers of selfish men,
Nor greetings where no kindness is, nor all
The dreary intercourse of daily life,
Shall e'er prevail against us, or disturb

Our cheerful faith, that all which we behold
Is full of blessings. Therefore let the moon
Shine on thee in thy solitary walk;
And let the misty mountain-winds be free
To blow against thee; and, in after years, 140
When these wild ecstasies shall be matured
Into a sober pleasure; when thy mind
Shall be a mansion for all lovely forms,
Thy memory be as a dwelling-place
For all sweet sounds and harmonies; oh! then,
If solitude, or fear, or pain, or grief,
Should be thy portion, with what healing thoughts
Of tender joy wilt thou remember me,
And these my exhortations! Nor, perchance—
If I should be where I no more can hear 150
Thy voice, nor catch from thy wild eyes these gleams
Of past existence—wilt thou then forget
That on the banks of this delightful stream
We stood together; and that I, so long
A worshipper of Nature, hither came
Unwearied in that service: rather say
With warmer love—oh! with far deeper zeal
Of holier love. Nor wilt thou then forget,
That after many wanderings, many years
Of absence, these steep woods and lofty cliffs, 160
And this green pastoral landscape, were to me
More dear, both for themselves and for thy sake![3]

Other 19th-century Romantics

The life and works of Wordsworth's friend Coleridge more closely resembled the temperament of German Romanticism. He is best remembered for his long poem, *The Rime of the Ancient Mariner*, which exemplifies the mystery and wonder of the Romantic spirit. Walter Scott (1771–1832) was also influenced by German Romanticism. His Romances have an easy fluent style, color, and a lack of depth. Like many Victorian artists, Scott delighted in the romance of history, and he was fond of evoking the charms of the Middle Ages and the Renaissance.

George Gordon, Lord Byron (1788–1824), was the Romantic poet *par excellence*, with his colorful and dramatic private life, his support of the nationalist aspirations of the Greeks, and his energetic verse. *Don Juan*, a richly ironic ramble through human frailties, is probably his best poem. Percy Bysshe Shelley (1792–1822) wrote in a more meditative and more lyrical vein, and the passions of Romanticism are never far below the surface. The greatest of English Romantics, however, was John Keats (1795–1821). The best of his poems, such as *Ode on a Grecian Urn* and *Ode to a Nightingale*, explore the tensions between classical restraint and the Romantic determination to feel life at its most intense and to push pleasure to ecstasy.

The 19th century saw the most complete distillation of its concerns in the novel, however. In England, Jane Austen (1775–1817) delicately laid bare the private life of

the middle classes in searching and ironical novels such as *Emma* and *Pride and Prejudice*. Emily Brontë (1818–48) wrote the stormily romantic *Wuthering Heights*, while her sister Charlotte (1816–55) produced the more sophisticated *Jane Eyre*. New possibilities for the novel were opened up by Honoré de Balzac (1799–1850) in France, whose great cycle of novels, part of his projected and only partially completed *Comédie Humaine*, sought to survey contemporary society from the palace to the gutter. The heroes and heroines of Balzac's works are figures whose experiences reveal how society really works. Charles Dickens (1812–70) had a similar aim in his novels. The best of them, such as *Bleak House*, deliver up a cross-section of the teeming society of Victorian England. Dickens's plots are dazzlingly ingenious and entertaining in their own right. But this complexity also captures the interdependence of rich and poor, and the endless ramifications of every individual act. The naturalism of writers like Gustave Flaubert (1821–80) and Émile Zola (1840–1902) developed out of this tradition, and it closely parallels realism in painting.

An interest in the morbid, the pathological, and the bizarre also developed, and the "decadent" poems of Charles Baudelaire (1821–67), especially in his *Les Fleurs du Mal* (*Flowers of Evil*), typify this trend. The paths of poetry and the novel now diverged, poetry moving into symbolism, while the novel, in the hands of writers like Henry James (1843–1916), became more psychological as it explored the interior life and the nature of consciousness.

THEATRE

"The play-going world of the West End is at this moment occupied in rubbing its eyes, that it may recover completely from the dazzle of Thursday last, when, amid the acclamations of Queen Victoria's subjects, King Richard the Second was enthroned at the Princess's Theatre." Thus began the reviewer's comments in the *Spectator*, 14 March 1857. The dazzle of scenery, revivals, and a potpourri of uncertain accomplishments helped a stumbling theatre to keep up with the other arts that flourished through the early years of the 19th century.

Romanticism

Romanticism as a philosophy of art was its own worst enemy in the theatre. Artists sought new forms to express great truths, and they strove to free themselves from neo-classical rules and restraints. They did, however, admire Shakespeare as an example of new ideals and as a symbol of freedom from structural confinement. Intuition reigned, and the artistic genius was set apart from everyday people and above normal constraints. As a result, Romantic writers had no use for any guide but their own imagination.

Unfortunately, the theatre operates within some rather specific limits. Without these, many 19th-century playwrights penned scripts that were unstageable and/or unplayable. Great writers could not or would not abide by constraints of the stage, and the hacks, yielding to popular taste, could not resist overindulgence in phony emotionalism, melodrama, and stage gimmickry. As a result, the best Romantic theatre performances came from the pen of William Shakespeare, whose work was revived in a great rush of 19th-century antiquarianism.

Poor as it may have been in original drama, however, the Romantic period did succeed in loosening the arbitrary rules of neo-classical convention. Thus, it paved the way for a new theatrical era in the later years of the century.

The audiences of the 19th century played a significant part in determining what took the stage. Royal patronage was gone, and box office receipts were needed to pay the bills. A rising middle class had swelled the 18th-century audience and changed its character. Then, in the 19th century, the lower classes began attending the theatre. The Industrial Revolution had created larger urban populations and expanded public education to a degree. Feelings of egalitarianism now spread throughout Europe and America. Theatre audiences grew, and theatre building flourished. To appeal to this diverse audience, theatre managers had to program for the popular as well as the sophisticated taste if they wanted to make money. To offer something for everyone, an evening's theatre program might contain several types of fare and last over five hours. The consequence was predictable. Fewer and fewer sophisticated patrons chose to attend, and the quality of the productions declined.

By 1850, theatres began to specialize, and sophisticated play-goers came back to certain theatres, at least. The multi-part production remained typical until nearly the turn of the 20th century, however. Audience demand was high, and theatre continued to expand.

The early 19th-century theatre had some very particular characteristics. First of all, there was the repertory company. These companies, each with a set group of actors, including stars, stayed in one place and staged several productions during a given season. (That is quite unlike contemporary professional theatre, in which each play is produced and cast independently and runs for as long as it shows a profit.) Gradually, better-known actors capitalized on their reputations and began to go on tour, starring in local productions and featuring their most famous roles. A virtual craze for visiting stars developed, and the most famous actors began to make world tours. This increase in touring stars led to an increase in touring companies, and, in the United States especially, these companies, with their star attractions and complete sets of costumes and scenery, became a regular feature of the landscape. By 1886, America could boast 282 touring companies. At the same time, local resident companies

13.31 Charles Kean's production of Shakespeare's *Richard* II, London, 1857. Between Acts III and IV, the Entry of Bolingbroke into London. Contemporary watercolour by Thomas Grieve. Victoria and Albert Museum, London.

Stage space itself became clearly defined and separate from the audience. Rather than playing on the forestage between audience-occupied stage boxes, the actors moved upstage, within the confines of the scenery. Inventions in the use of gaslight made it possible to darken the audience area and control the stage light, creating an isolated and self-contained stage world (Fig. **13.32**).

Playwrights, of course, emerge from the theatres they work in. Many playwrights of this era were not a part of the theatre we have just looked at, however. In Chapter 12, we saw how important Goethe's *Faust Part I* was to Romantic drama, but it was also virtually unstageable. In Romantic aesthetics, art and literature were thoroughly intertwined. Plays were often written to be read as literature as well as seen. This theatre–literature link brought writers to the theatre who were not *of* the theatre. Their inexperience was further complicated by a Romantic disregard for practicality, and the result was problematic, to say the least.

Victor Hugo (1802–85) occupied an almost god-like position in the artistic community of Paris. After two abortive attempts, one a failure at the hands of the stage censor, he finally succeeded in producing his play *Hernani*. Hugo had directed an earler diatribe against the

became less popular, except in Germany, where a series of local, state-run theatres was established.

Although theatre design was by now very diverse, some general similarities existed. Principally, the changes in 19th-century stages and staging were prompted by increased interest in historical accuracy and popular demand for depiction rather than convention. Before the 18th century, history had been considered irrelevant to art. Knowledge of antiquity that began with archeological excavations in Pompeii, however, aroused curiosity. The Romantic dream of escape to the long ago and far away suggested that the stage picture of exotic places should be somehow believable. At first, such detail was used inconsistently, but, by 1823, some productions claimed that they were entirely historical in every respect. Attempts at historical accuracy had begun as early as 1801, and in France, Victor Hugo and Alexandre Dumas, *père*, insisted on historically accurate settings and costumes during the early years of the century. However, it was Charles Kean (1811–68) who brought the spectacle of antiquarianism in the London theatre to fruition in the 1850s (Fig. **13.31**).

The onset of accuracy as a standard for production led to three-dimensionality in settings and away from drop and wing scenery to the box set. The stage floor was leveled (remember that since the Renaissance it had been raked). New methods of shifting and rigging were devised to meet specific staging problems. Over a period of years, all elements of the production became integrated, much in the spirit of Wagner's totally unified artwork, the GESAMTKUNSTWERK. The distraction of numerous scene changes was eliminated by closing the curtain.

13.32 Gottfried Semper in collaboration with Richard Wagner, the Bayreuth Festspielhaus, opened 1876. Section and plan.

neo-classicists, and an audience of revenge-seekers arrived determined that *Hernani* should fail. The production was a shambles, and, in fact, *Hernani*, though written by a master writer, is not a very good play. Characters are inconsistent, honor is carried to ridiculous extremes, and the ending is contrived. The poetry remains nonetheless lyrical and charming, and Hugo's brave assault on the bastions of French neo-classicism did open a few doors for Romantic dramatists, not least of whom was the novelist Alexandre Dumas, *père* (1802–70). His prose work *Henri III et sa Cour* (1829) enjoyed success at the Comédie-Française, and it did much to popularize the Romantic movement through its introduction of justified illicit love.

In England, revivals of Shakespeare's plays enjoyed more success than contemporary works. Many of the Romantic poets attempted to write plays. A few of their works were produced, but all suffered from a poor understanding of play structure and general ignorance of the craft.

Heinrich von Kleist (1777–1811), along with Goethe and Schiller, carried the German theatre into the 19th century. His *Prince Friedrich of Homburg* (1811) tells the story of a young officer who wants fame so badly that he defies orders in an attempt to win a victory. His success does not excuse his endangering the entire army, and he is condemned to death. Only after realizing that his ego must be subordinate to service and the good of all is he spared. Another German playwright, Georg Büchner (1813–37), illustrates in *Danton's Death* (1835) the pessimistic side of Romanticism. The cruel disappointment of Napoleon's despotism and his defeat is reflected in this story of idealism crushed by pettiness.

Melodrama

On the popular side, theatre production in the 19th century developed a Romantically exaggerated form called "melodrama." Typically this kind of theatre is characterized by sensationalism and sentimentality. Characters are stereotyped, and everything and everyone tends to be all good or all evil. Plots are sentimental and the action is exaggerated. Regardless of circumstances, good must be rewarded and evil punished. There was often also some form of comic relief, usually through a minor character. The action of melodrama progresses at the whim of the villain, and the hero is forced to endure episode after episode of trial and suffering. Suspense is imperative, and a reversal at the end is obligatory.

The term "melodrama" implies music *and* drama, and, in the 19th century, these plays were accompanied by a musical score tailored to the emotional or dynamic character of the scene. In practice, this was very similar to the way music is used in films and television programs today, with the added attractions of incidental songs and dances that were used as curtain raisers and ENTR'ACTE entertainment.

Melodrama was popular throughout Europe and the United States. *Uncle Tom's Cabin*, based on the novel by Harriet Beecher Stowe (1852), took the stage by storm. The stage version was opposed by Stowe, but copyright laws did not exist to protect her. The play does retain her complex themes of slavery, religion, and love. The action involves a number of episodes, some of which are rather loosely connected. Characteristic of melodrama, *Uncle Tom's Cabin* places considerable emphasis on spectacle, the most popular of which at the time was Eliza's crossing of the ice with mules, horses, and bloodhounds in pursuit.

Realism and naturalism

In line with trends in philosophy and the other arts, a conscious movement toward realism in the theatre emerged around the middle of the century. This movement brought significant change, and, by 1860, dramatic literature was striving for a truthful portrayal of the real world. Objectivity was stressed, and knowledge of the real world was seen as possible only through direct observation. (Corot's approach to painting was based on a similar viewpoint.) Thus, everyday life, with which the playwright was directly familiar, became the subject matter of drama. Interest shifted from the past to human motives and experience, or, more likely, idealized versions of these. Exposure to such topics on the stage was not particularly pleasant, and many play-goers objected that the theatre was turning into a "sewer or a tavern." Playwrights responded that the way to avoid such ugly depictions on the stage was to change society.

Any realistic translation of life onto the stage requires a practical knowledge of theatre presentation. Of this, Eugene Scribe (1791–1861) was a master. As a playwright, he was better able to mold a dramatic structure than the Romantics had been. Although his characterizations were weak, his early well plotted comedies of intrigue made him very influential, both in his own time and later. This master of plot manipulation perfected a form known as the "well made play." He and his factory of collaborators used the following straightforward formula to turn out plays in great numbers: present a clear exposition of the situation, carefully prepare unexpected but logical reversals, build suspense continuously, and bring the action to a logical and believable resolution. The soul of the well made play was believability and cause-and-effect relationships.

Alexandre Dumas, *fils* (1824–95), another 19th-century realist, was greatly concerned with social problems. Dumas' *La Dame aux Camélias*, also known as *Camille*, was dramatized from his novel in 1849 (though not produced until 1852), and the play achieved phenomenal worldwide popularity. Its central character Camille, a courtesan with a heart of gold who meets a cruel fate, grew to legendary status. Although Dumas probably intended

only to create a picture of French society, not to scale new heights of sentimentality and romance, he did both. Unlike most melodrama, there is no rescue at the end, however. Camille dies in her lover's arms.

The acknowledged master of realist drama was Norway's Henrik Ibsen (1828–1906). Ibsen took the format of Scribe's well made play, eliminated many of its devices, and built powerful, realistic problem-dramas around carefully selected detail and plausible character-to-action motivations. His plays usually bring to conclusion events that began well in the past, and his exposition is usually meticulous. Ibsen's concern for realistic detail carries to the scenery and costumes, and his plays contain detailed descriptions of settings and properties, all of which are essential to the action. The content of many of Ibsen's plays was controversial, and most deal with questions about moral and social issues that are still valid. In his late plays, however, Ibsen abandoned realism in favor of symbolist experiment.

Realism spread widely, finding expression in the work of Arthur Wing Pinero, Henry Jones, John Galsworthy, and Anton Chekhov, although, like Ibsen, Chekhov incorporates symbolism into his works. Anton Chekhov (1860–1904) is regarded by many as the founder of modern realism. He drew his themes and subject matter from Russian daily life, and they are realistic portrayals of frustration and the depressing nature of existence. His structures flow in the same apparently aimless manner as the lives of his characters. While short on theatricality and compact structure, his plays are skillfully constructed to give the appearance of reality.

In England, George Bernard Shaw (1856–1950) embodied the spirit of 19th-century realism, although his career overlapped the 19th and 20th centuries. This witty, brilliant artist was above all a humanitarian. Although proper Victorians considered him a heretic and a subversive (because of his devotion to Fabian socialism), his faith lay in humanity and its infinite potential.

Shaw's plays deal with the unexpected, and often appear contradictory and inconsistent in characterization and structure. His favorite device was to build up a pompous notion and then destroy it. For example, in *Man and Superman*, a respectable Victorian family learns that their daughter is pregnant. They react with predictable indignation. To the girl's defense comes a character who appears to speak for the playwright. He attacks the family's hypocrisy and defends the girl. The girl, however, explodes in anger, not against her family, but against her defender. She has been secretly married all the time, and, as the most respectable of the lot, she condemns her defender's (and possibly the audience's) free thinking.

Shaw opposed the doctrine of "art for art's sake," and he insisted that art should have a purpose. He believed that plays were better vehicles for social messages than speeches or pamphlets, and he is most often successful in getting his messages across through drama, despite his somewhat weak characterizations. Although each play usually has a character who acts as the playwright's mouthpiece, Shaw does more than sermonize. His characters probe the depths of the human condition, often discovering themselves through some lifelike crisis.

Naturalism, a style closely related to realism, also flourished in the same period. Émile Zola (1840–1902) was a leading proponent, although he was more a theoretician and novelist than a playwright. Both realism and naturalism insisted on a truthful depiction of life, but naturalism went on to insist on the basic principle that behavior is determined by heredity and environment. Absolute objectivity, not personal opinion, was the naturalistic goal.

Symbolism

Late in the 19th century, and very briefly, there was an anti-realistic literary movement called "symbolism," also known as "neo-Romanticism," "idealism," or "impressionism." Symbolism was briefly popular in France, and it has recurred occasionally in the 20th century. The idea behind symbolism is that truth can be grasped only by intuition, not through the senses or rational thought. Thus, ultimate truths can be suggested only through symbols, which evoke in the audience various states of mind that correspond vaguely with the playwright's feelings.

One of the principal dramatic symbolists, Maurice Maeterlinck (1862–1949), believed that every play contains a "second level" of dialogue which speaks to the soul. Through verbal beauty, contemplation, and a passionate portrayal of nature, great drama conveys the poet's idea of the unknown. Therefore, plays which present human actions can only, through symbols, suggest higher truths gained through intuition. The symbolists did not deal at all with social problems. Rather, they turned to the past and tried to suggest universal truths independent of time and place, as Maeterlinck did, for example, in *Pelléas and Mélisande* (1892).

Organic unity

The 19th-century theatre saw two significant developments. First, the idea of production unity as a principal aesthetic concern emerged. The production director was now assigned the overriding responsibility for controlling this unity, a consideration that remains fundamental to the modern theatre.

Second, an independent theatre movement appeared in Europe. From this came France's Théâtre Libre, and Berlin's Freie Bühne, both of which championed realism and naturalism; London's Independent Theatre, organized to produce theatre of "literary and artistic rather than commercial value;" and the Moscow

Art Theatre, founded by Constantin Stanislavsky, who would become the most influential figure in actor-training in the 20th century. These theatres were private clubs open only to members. They therefore avoided the censorship that dominated public theatre, and nurtured free experimentation. The artistic developments begun here laid the foundations for a truly modern 20th-century theatre.

MUSIC

Richard Strauss claimed that by purely musical means he could convey to an audience the amount of water in a drinking glass! In an era of Romantic subjectivity, music provided the medium in which many found an unrivaled opportunity to express emotion.

Romanticism

In trying to express human emotion, Romantic music made stylistic changes to classical music. Romanticism amounted to rebellion in many of the arts. In music, however, Romanticism involved a more gradual and natural extension of classical principles. The classical–Romantic antithesis—form versus feeling, or intellectual versus emotional conflict—does not apply neatly to music of the 18th and 19th centuries.

As in painting, spontaneity replaced control, but the primary emphasis of music in this era was on beautiful, lyrical, and expressive melody. Phrases became longer, more irregular, and more complex than they had been in classical music.

Much Romantic rhythm was traditional, but experiments produced new meters and patterns. Emotional conflict was often suggested by juxtaposing different meters, and rhythmic irregularity became increasingly common as the century progressed.

Harmony and tone color changed significantly. Harmony was seen as a means of expression, and any previous "laws" regarding key relationships could be broken to achieve striking emotional effects. Form was clearly subordinate to feeling. Harmonies became increasingly complex, and traditional distinctions between major and minor keys were blurred in chromatic harmonies, complicated chords, and modulations to distant keys. In fact, some composers used key changes so frequently that their compositions are virtually nothing but whirls of continuous modulation.

As composers sought to disrupt the listener's expectations, more and more dissonance occurred, until it became a principal focus. Now, dissonance was explored for its own sake, as a strong stimulant of emotional response rather than merely as a decorative way to get to the traditional tonic chord. By the end of the Romantic period, the exhaustion of chromatic usage and dissonance had led to a search for a completely different type of tonal system.

Exploring musical color to elicit feeling was as important to the Romantic musician as it was to the painter. Interest in tonal color, or timbre, led to great diversity in vocal and instrumental performance, and the music of this period abounds with solo works and exhibits a tremendous increase in the size and diversity of the orchestra. To make our way through this complex era, however, we must first look at certain basic musical forms and explore them.

Lieder

In many ways, the "art song," or Lied, characterized Romantic music. A composition for solo voice with piano accompaniment and poetic text allowed for a variety of lyrical and dramatic expressions and linked music directly with literature.

The burst of German lyric poetry in this period encouraged the growth of Lieder. Literary nuances affected music, and music added deeper emotional implications to the poem. This partnership had various results: some Lieder were complex, others were simple; some were structured, others were freely composed. The pieces themselves depended upon a close relationship between the piano and the voice. In many ways, the piano was an inseparable part of the experience, and certainly it served as more than accompaniment. The piano explored mood and established rhythmic and thematic material. Occasionally, it had solo passages of its own. The interdependency of the song and its accompaniment is basic to the art song.

The earliest, and perhaps the most important, composer of Lieder was Franz Schubert (1797–1828). Schubert's troubled life epitomized the Romantic view of the artist's desperate and isolated condition. Known only among a close circle of friends and musicians, Schubert composed almost 1000 works, from symphonies to sonatas and operas, to Masses, choral compositions, and Lieder. None of his work was publicly performed, however, until the year of his death. He took his Lieder texts from a wide variety of poems, and in each case the melodic contours, harmonies, rhythms, and structures of the music were determined by the poem.

Schubert wrote two song cycles based on poems by Wilhelm Müller. Die schöne Müllerin (1820) includes 20 songs and begins with "Das Wandern" ("Wandering"), sung by a young miller:

Wandering is the miller's delight, wandering!
He must be a very poor miller
Who never felt like wandering, wandering.

From the water we learned this, from the water!
It does not rest by day or night,
But is always wandering, the water.

We see it also in the mill-wheels, the mill-wheels!
They never want to be still,
They nor I never tire of the turning, the mill-wheels.

The stones even, as heavy as they are, the stones!
They join the cheerful round dances
And want to go even faster, the stones.

Wandering, wandering, my delight, wandering!
O master and mistress,
Let me go my way in peace and wander.

The tempo is a leisurely walking pace, and the major key indicates the happy mood. As in all *Lieder*, the piano is a partner, and it sets the scene, evoking rippling water with flowing 16th-notes. The vocal melody, characterized by skips in the scale, is completely different from the piano writing. After the piano introduction, the first theme is stated and immediately repeated. A second and third phrase follow, and the piano completes each stanza with a restatement of the opening measures.

Piano works

The development of the art song depended in no small way on 19th-century improvements in piano design. The instrument for which Schubert wrote had a much warmer and richer tone than earlier pianos. Improvements in pedal technique made sustained tones possible and gave the instrument greater lyrical potential.

Such flexibility made the piano an excellent instrument for accompaniment, and, more importantly, made it an almost ideal solo instrument. As a result, new works were composed solely for the piano, ranging from short, intimate pieces similar to *Lieder* to larger works designed to exhibit great virtuosity in performance. Franz Schubert wrote such pieces, as did Franz Liszt (1811–86). The technical demands of Liszt's compositions, and the rather florid way he performed them, gave rise to a theatricality, the primary purpose of which was to impress audiences with flashy presentation. This fitted well with the Romantic concept of the artist as hero.

The compositions of Frédéric Chopin (1810–49) were somewhat more restrained. Chopin wrote almost exclusively for the piano. Each of his ÉTUDES, or "studies," explored a single technical problem, usually set around a single motif. More than simple exercises, these works explored the possibilities of the instrument and became short tone poems in their own right. A second group of compositions included short intimate works such as preludes, nocturnes, and impromptus, and dances such as waltzes, polonaises, and mazurkas. (Chopin was a Pole living in France, and Polish folk music had a particularly strong influence on him.) A final class of larger works included scherzos, ballades, and fantasies. Chopin's compositions are highly individual, many without precedent. His style stands outside classicism, almost totally without standard form. His melodies are lyrical, and his moods vary from melancholy to exaltation.

Chopin's "nocturnes," or night pieces, are among his most celebrated works. His Nocturne in E flat major (1833) illustrates the structure and style of this sort of mood piece well. It has a number of sections, with a main theme alternating with a second until both give way to a third. The piece has a complex AA'BA''B'A'''CC' structure—the dashes represent VARIATION of the original material. The nocturne is in *andante* tempo, a moderate, walking speed, and begins with the most important theme (Fig. **13.33**):

13.33 Chopin, Nocturne in E flat major, first theme.

The melody is very graceful and lyrical over its supporting chords. The contours of the melody alternately use pitches that are close together and widely spaced. The theme is stated, then immediately repeated with ornamentation. The second theme begins in the dominant key of B flat major and returns to E flat for a more elaborate repeat of the first theme. The second theme is restated, and followed by an even more elaborate restatement of the first theme, leading to a dramatic climax in the home key. A third theme is presented and then repeated more elaborately in the tonic key. The work ends with a short cadenza which builds through a *crescendo* and finishes *pianissimo*, very softly.

Program music

One of the new ways Romantic composers used to structure their longer works was to build them around a non-musical story, a picture, or some other idea. Music of this sort is called "descriptive." When the idea is quite specific and closely followed throughout the piece, the music is called "programmatic," or "program music."

These techniques were not entirely new—we have already noted the descriptive elements in Beethoven's "Pastoral" Symphony—but the Romantics found them particularly attractive and employed them with great gusto. A non-musical idea allowed composers to rid themselves of formal structure altogether. Of course, actual practice varied tremendously—some used programmatic material as their only structural device, while others subordinated a program idea to formal structure. Nevertheless, the Romantic period has become known as the "age of program music." Among the best known composers of program music were Hector Berlioz (1803–69) and Richard Strauss (1864–1949).

Berlioz's *Symphonie Fantastique* (1830) employed a single motif, called an "IDÉE FIXE," to tie the five movements of the work together. The story on which the musical piece

is based involves a hero who has poisoned himself because of unrequited love. However, the drug only sends him into semi-consciousness, in which he has visions. Throughout these visions the recurrent musical theme (the *idée fixe*) symbolizes his beloved. Movement I consists of "Reveries" and "Passions." Movement 2 represents "A Ball." "In the Country" is movement 3, in which he imagines a pastoral scene. In movement 4, "March to the Scaffold," he dreams he has killed his beloved and is about to be executed. The *idée fixe* returns at the end of the movement and is abruptly shattered by the fall of the axe. The final movement describes a "Dream of a Witches' Sabbath" in grotesque and orgiastic musical imagery.

Not all program music depends for its interest upon understanding of its text. Many people believe, however, that the tone poems, or symphonic poems, of Richard Strauss require an understanding of the story. His *Don Juan*, *Till Eulenspiegel*, and *Don Quixote* draw such detailed material from specific legends that program explanations and comments are integral to the works and help to give them coherence. In *Till Eulenspiegels lustige Streiche* ("Till Eulenspiegel's Merry Pranks"), Strauss tells the legendary German story of Till Eulenspiegel and his practical jokes. Till is traced through three escapades, all musically identifiable. He is then confronted by his critics and finally executed. Throughout, the musical references are quite specific.

Symphonies

As some Romantic composers were pursuing these relatively innovative directions, others continued to write traditional symphonies and concertos. While employing the lyrical melodic tendencies of the period, these symphonic works retain classical form and content. That is, they are built upon musical rather than literary ideas—motifs, phrases, and themes—and they maintain their unity through musical structure rather than non-musical ideas or texts. Such works are known as "abstract," or "absolute," music.

The melodies, rhythms, and timbres of these works reflect typically Romantic characteristics, and they display an increasingly dense texture and greatly expanded dynamic range. Although their form remains traditional, their effect is emotional—the listener is bathed in sensual experience. Contrasts in dynamics and timbre are stressed, and, as in painting, form is subordinated to expression. Certain composers achieved a synthesis of classical tradition and Romantic spirit, however, in particular the German Johannes Brahms (1833–97).

An outstanding example of the Romantic symphony is Brahms's Symphony No. 3 in F major (1883). Composed in four movements, the work calls for pairs of flutes, oboes, clarinets, a bassoon, a contrabassoon, four horns, two trumpets, three trombones, two timpani, and strings—not an adventurous grouping of instruments for the period.

13.34 Brahms, Symphony No. 3 in F major, opening motif of first movement.

Composed in sonata form, the first movement is *allegro con brio* (fast with spirit), and begins in F major. However, with an ambiguity characteristic of Romantic music, the composer begins by having the winds play a progression built around a minor rather than a major third (Fig. **13.34**). This opening motif consists of an opening, sustained, six-beat tone on F, followed by a sustained, six-beat tone on A flat (an interval of a minor third —breaking out of the home key in the second measure of the piece). The winds then jump to F, an octave above the opening note. This enigmatic motif returns throughout the movement. Following this three-note statement, Brahms firmly establishes the F major key in the first phrase of the opening theme, played by the violins. The marking here indicates that it is to be played passionately (Fig. **13.35**).

13.35 Brahms, Symphony No. 3 in F major, first theme of first movement.

The music modulates through some very remote keys such as D major and A major, and the meter shifts from duple to triple. Both the modulations and the meter change take this movement well outside the parameters of classical music. Then the tone color changes to focus on clarinets supported by pizzicato (plucked) lower strings. A second important theme is introduced quietly, softening to *pianissimo* (Fig. **13.36**).

13.36 Brahms, Symphony No. 3 in F major, second theme of first movement.

The exposition section closes with a return to the opening motif and meter, employing rising scales and arpeggios. Then, following classical tradition, the exposition is repeated.

The development section uses both the principal themes, with changes in tonal colors, dynamics, and modulation.

The recapitulation opens with a forceful restatement

of the opening motif, followed by a restatement and further development of materials from the exposition. Then comes a lengthy coda, again announced by the opening motif, and based on the first theme. A final, quiet, restatement of the opening motif and first phrase of the theme brings the first movement to an end.

Nationalism

The Romantic period gave birth to a new nationalistic trend in music. The roots of such movements went deep into the past, but composers also wrote with the political circumstances of the century in mind. Folk tunes appear in these works as themes, as do local rhythms and harmonies. This exaltation of national identity was consistent with Romantic requirements, and it occurs in the music of 19th-century Russia, Bohemia, Spain, England, Scandinavia, Germany, and Austria.

Of all the nationalistic composers of the Romantic period, the Russian Peter Ilyich Tchaikovsky (1840–93) has enjoyed the greatest popularity. His Violin Concerto in D major (1878) remains one of the best known 19th-century violin concertos.

Two of the three themes in the third movement, *allegro vivacissimo* (fast and extremely lively), are based on Russian folk music. The focus is of course on the solo violin; it is backed by a large orchestra of strings, winds, and timpani. In form, this finale is a rondo that can be summarized as ABCA'B'C'A''. The dramatic quality of the movement is heightened by an increasingly fast tempo. The movement begins in A major, the dominant of the home key of D major, with a unison motif played by the entire orchestra. The solo passages begin in earnest with a lively Russian folk melody in D major, with the violin gently accompanied by the strings and woodwind. The first theme is then repeated.

The second theme, another Russian folk melody, is played by the solo violin in the key of A major, then adapted by the horns, strings, and soloist. A third theme (this one not a folk tune) introduces a lyrical melody, and is followed by a restatement of the first, second, and third themes, in new keys. A third restatement of the opening theme focuses on the virtuosity of the soloist. A loud cadence from the orchestra closes the movement.

Choral music

Vocal music also ranged from solo to massive ensemble works. The emotional requirements of Romanticism were well served by the diverse timbres and lyricism of the human voice. Almost every major composer of the era wrote some form of vocal music. Franz Schubert is remembered for his Masses, the most notable of which is the Mass in A flat major. Felix Mendelssohn's *Elijah* stands beside Handel's *Messiah* and Haydn's *Creation* as a masterpiece of oratorio. Hector Berlioz marshaled full Romantic power for his *Requiem*, which called for 210 voices, a large orchestra, and four brass bands.

One of the most enduringly popular choral works of the Romantic period is Brahms's *Ein Deutsches Requiem* (A German Requiem). Based on selected texts from the Bible, in contrast with the Latin liturgy of traditional requiems, Brahms's work is not so much a Mass for the dead as a consolation for the living. It is principally a choral work —the solos are minimal: two for baritone and one for soprano. Both vocal and instrumental writing are very expressive. Soaring melodic lines and rich harmonies weave thick textures. After the chorus sings "All mortal flesh is as the grass," the orchestra suggests fields of grass moving in the wind. One lyrical movement, "How lovely is thy dwelling place," remains one of the most moving choral pieces ever written. Brahms's *Requiem* begins and ends with moving passages aimed directly at the living: "Blest are they that mourn." Hope and consolation underlie the entire work.

An important factor in Brahms's music is its lyricism and its vocal beauty. Brahms explored the voice as a *human* voice, and not as another instrument or some other mechanism unaffected by any restrictions, as other composers have done. His parts are written and his words chosen so that no voice is ever required to sing outside its natural range or technical capacity.

Opera

The spirit and style of Romanticism are summed up in that perfect synthesis of all the arts, opera. "I have written the opera with clenched fists, like my spirit! Do not look for melody; do not look for culture: in *Marat* there is only blood!" So said Pietro Mascagni in 1921 of his new opera *Il Piccolo Marat*. But this was a final outburst at the end of an era. The preceding century and two decades produced a large proportion of the operatic repertoire that we have today. Three countries, France (especially Paris), Italy, and Germany, dominated the development of opera.

Paris occupied an important position in Romantic opera during the first half of the 19th century. The spectacular quality of opera and the size of its auditoriums had made it an effective vehicle for propaganda during the Revolution. As an art form, opera enjoyed great popular appeal among the rising and influential middle classes.

A new type of opera called "grand opera" emerged early in the 19th century, principally through the efforts of Louis Veron, a businessman, the playwright Eugene Scribe, and Giacomo Meyerbeer, a composer. These three broke away from classical themes and subject matter and staged spectacular productions with crowd scenes, ballets, choruses, and fantastic scenery, written around Medieval and contemporary themes. Meyerbeer (1791–1864), a German, studied Italian opera in Venice and produced French opera in Paris. *Robert the Devil* and *The Huguenots* typify Meyerbeer's extravagant style; they achieved great popular success, although the composer Schumann called *The Huguenots* "a conglomeration of

monstrosities." Berlioz's *The Trojans*, written in the late 1850s, was more classically based and more musically controlled. At the same time, Jacques Offenbach (1819–80) brought to the stage a lighter style, in which spoken dialogue mixed with the music. This type of opera, called *"opéra comique,"* is serious in intent despite what the French word *comique* might suggest. It is a satirical and light form of opera, using vaudeville humor to satirize other operas, popular events, and so forth. In between the styles of Meyerbeer and Offenbach there was a third form of Romantic opera, lyric opera. Ambroise Thomas (1811–96) and Charles Gounod (1818–93) turned to Romantic drama and fantasy for their plots. Thomas's *Mignon* contains highly lyrical passages, and Gounod's *Faust*, based on Goethe's play, stresses melodic beauty.

Early Romantic opera in Italy featured the BEL CANTO style, which emphasizes beauty of sound. The works of Gioacchino Rossini (1792–1868) epitomize this feature of Romantic opera. Rossini's *Barber of Seville* takes melodic singing to new heights with light, ornamented, and highly appealing work for his soprano voices, in particular.

Great artists often stand apart from or astride general stylistic trends while they explore their own themes. Such is the case with the Italian composer Giuseppe Verdi (1813–1901). With Verdi, opera is truly a human drama, expressed through simple, beautiful melody.

Verdi's long career had different phases. In the early phase, with works such as *La traviata* (1853), he focused on logic and structure, using recurring themes to provide unity. The story of *La traviata* (*The Courtesan*) was based on Alexandre Dumas (*fils*)'s *The Lady of the Camellias*. Violetta, a courtesan, falls in love with Alfredo, a young man of respectable family. Violetta and Alfredo live together for a time, but at his father's urging, she nobly leaves him to save the good name of his family. Her health, already frail, breaks under the strain, and Alfredo returns to her just as she dies of tuberculosis. Violetta, a soprano, sings the aria "Ah, fors' e lui" ("Ah, perhaps it is he") when she first realizes she is in love with Alfredo. This is the first part of two important sections, each of which comprises a recitative and an aria. In the first recitative of the second section, Violetta's thoughts about the possibilities of finding true love carry her into the first aria. Two musical themes are explored, one minor and disjunct, as she thinks about the mystery of love, the other (which repeats the melody used by Alfredo in the previous scene to express his love for her), major and lyrical, as she herself is overcome by love. In the second recitative, she decides to enjoy life as she now finds it. She then sings the second aria, "Sempre libera" ("Always free"), in which she looks forward to continuing her life as a courtesan.

In the second phase of Verdi's career, he wrote works such as *Aida* (1871), grand operas of spectacular proportions built upon tightly woven dramatic structures. Finally, in a third phase, he produced operas based on Shakespearean plays. *Otello* (1887) contrasts tragedy and *opera buffa*, and explores subtle balances among voices and orchestra, together with strong melodic development.

Richard Wagner (1813–83) was one of the masters of

13.37 Giacomo Puccini, *Manon Lescaut*. Opera Company of Philadelphia.

Romantic opera. At the heart of Wagner's artistry lay a philosophy that has affected the stage from the mid-19th century to the present day. His ideas were laid out principally in two books, Art and Revolution (1849) and Opera and Drama (1851). Wagner's philosophy centered on the Gesamtkunstwerk, a comprehensive work of art in which music, poetry, and scenery are all subservient to the central generating idea. For Wagner, the total unity of all elements was supremely important. In line with German Romantic philosophy, which gives music supremacy over the other arts, music has the predominant role in Wagner's operas. Dramatic meaning unfolds through the LEITMOTIF, for which Wagner is famous, although he did not invent it. A Leitmotif is a musical theme that is tied to an idea, a person, or an object. Whenever that idea, person, or object appears on stage or comes to mind in the action, that theme is heard. Juxtaposing Leitmotifs gives the audience an idea of relationships between their subjects. Leitmotifs also give the composer building blocks to use for development, recapitulation, and unification.

Each of Wagner's magnificent operas deserves detailed attention. Anything we might say here by way of description or analysis would be insignificant compared to the dramatic power these works exhibit in full production. Even recordings cannot approach the tremendous effect of these works on stage in an opera house.

Romanticism in all the arts saw many counter-reactions, and late 19th-century opera was no exception. In France, an anti-Romantic movement called "naturalism" developed. It opposed stylization, although it maintained exotic settings, and included brute force and immorality in its subject matter. The best operatic example of naturalism is Georges Bizet's Carmen (1875). Unlike earlier Romantic operas, the text for Carmen is in prose rather than poetry. Set in Spain, its scenes are realistic, and its music is colorful and concise. Bizet's naturalism was similar to that of Italian verismo opera, which would emerge at the turn of the 20th century. The spirit of verismo, that is of verisimilitude, or true-to-life settings and events, is the same hot-blooded vitality that was implicit in Mascagni's statement quoted earlier. The works of Mascagni, Puccini (Fig. 13.37), Leoncavallo, and others exemplify this verismo tradition in musical drama which concentrates on the violent passions and common experiences of everyday people. Adultery, revenge, and murder are common themes. Mascagni's Cavalleria Rusticana, Leoncavallo's I Pagliacci, and to some extent Puccini's Tosca are the best-known examples of this melodramatic form.

Impressionism

The anti-Romantic spirit also produced a style of music analogous to that of the impressionist painters. A free use of chromatic tones marked later 19th-century style, even among the Romantics. However a parting of the ways occurred, the effects of which still permeate contemporary music. Some composers made free use of chromatic harmony and key shifts but stayed within the parameters of traditional major/minor tonality. Others rejected traditional tonality completely, and a new ATONAL harmonic expression came into being. This rejection of traditional tonality led to impressionism in music, a movement international in scope, but limited in quantity and quality. There was some influence from the impressionist painters, but the impressionist composers turned mostly to the symbolist poets for inspiration.

Impressionist music was international, but its substance can best be found in the work of its primary champion, the Frenchman Claude Debussy (1862–1918). Debussy did not like to be called an "impressionist." The label, after all, was coined by a critic of the painters, and it was intended to be derogatory. He maintained that he was "an old Romantic who has thrown the worries of success out the window," and he sought no association with the painters. There are, however, similarities. His use of tone color has been described as "wedges of color" much like those the painters provided with individual brushstrokes. Oriental influence is also apparent, especially in Debussy's use of the Asian six-tone scale. He wished above all to return French music to fundamental sources in nature and move it away from the heaviness of the German tradition. He delighted in natural scenes, as did the impressionist painters, and sought to capture the effects of shimmering light in music.

In contrast to his predecessors, Debussy reduced melodic development to limited short motifs, and he moved away from traditional progressions of chordal harmonies, perhaps his greatest break with tradition. For Debussy, and impressionists in general, a chord was considered strictly on the merits of its expressive capabilities, apart from any idea of tonal progression within a key. As a result, gliding chords, that is, the repetition of a chord up and down the scale, became a hallmark of musical impressionism. Dissonance and irregular rhythm and meter further distinguish Debussy's works. Here, again, form and content are subordinate to expressive intent. His works suggest rather than state. They leave the listener only with an impression, perhaps even an ambiguous one.

Freedom, flexibility, and nontraditional timbres mark Debussy's compositions, the most famous of which is Prélude à l'après-midi d'un faune, based on a poem by Mallarmé. The piece uses a large orchestra, with emphasis on the woodwinds, most notably in the haunting theme running throughout. Two harps also play a prominent part in the texture, and antique cymbals are used to add an exotic touch near the end. Although freely ranging in an irregular $\frac{9}{8}$ meter and having virtually no tonal centers, the Prélude does have the traditional ABA structure.

DANCE

France and Italy

In a totally unrehearsed move, a ballerina leaped from the tomb on which she posed and narrowly escaped a piece of falling scenery. This and other disasters plagued the opening night performance of Meyerbeer's *Robert the Devil* in 1831. The novelty of tenors falling into trapdoors, and falling stagelights and scenery, however, was eclipsed by the startling novelty of the choreography for this opera. Romantic ballet was at hand. To varying degrees, all the arts turned against the often cold formality of classicism and neo-classicism. The subjective (not the objective) viewpoint and feeling (rather than reason) sought release.

Two sources are helpful in understanding the Romantic ballet, the writings of Théophile Gautier and Carlo Blasis. Gautier (1811–72) was a poet and critic, and his aesthetic principles held first of all that beauty was truth, a central Romantic conception. He rejected Noverre and Vigano, who believed that every gesture should express meaning. Rather, Gautier believed that dance was visual stimulation to show "beautiful forms in graceful attitudes. The true, the unique, the external subject of ballet is dancing."[4] Dancing for Gautier was like a living painting or sculpture—"physical pleasure and feminine beauty." This exclusive focus on ballerinas placed sensual enjoyment and eroticism squarely at the center of his aesthetics. Gautier's influence was significant, and it accounted for the central role of the ballerina in Romantic ballet. Male dancers were relegated to the background, strength being the only grace permissible to them. Gautier and his philosophy proved important as the inspiration for an 1841 work, *Giselle*, often called the greatest achievement in Romantic ballet.

The second general premise for Romantic ballet came from *Code of Terpsichore* by Carlo Blasis (Fig. **13.38**). He found the experimentalism of Noverre and Vigano in bad taste. Blasis was much more systematic and specific than Gautier—he was a former dancer—and his principles covered training, structure, and positioning. Everything in the ballet required a beginning, a middle, and an ending. The basic "attitude" in dance, which was modeled on Bologna's statue of *Mercury* (Fig. **10.27**), was to stand on one leg with the other brought up behind at a 90-degree angle with the knee bent. The dancer needed to display the human figure with taste and elegance. If the dancer trained each part of the body, the result would be grace without affectation. From Blasis comes the turned-out position, which is still fundamental to ballet today (Fig. **13.38**).

Unlike Gautier, Blasis saw gesture and pantomime as the "very soul and support" of ballet. But like Gautier, he placed the female at the center of ballet, confining the male to the background. These broad principles provided

13.38 Illustrations from *The Art of Dancing*, 1820, by Carlo Blasis. The New York Public Library.

the framework, and, to a great extent, a summary, of objectives for Romantic ballet: delicate ballerinas, lightly poised, costumed in soft tulle, and moving *en pointe*, with elegant grace.

The first truly Romantic ballet, *Robert the Devil* told the story of Duke Robert of Normandy, his love for a princess, and an encounter with the devil. The ballet contains ghosts, bacchanalian dancing, and a spectral figure who was danced by Marie Taglioni (Fig. **13.39**).

Taglioni went on to star in perhaps the most famous of all Romantic ballets, *La Sylphide* (1832). Here the plot centered on the tragic impossibility of love between a mortal and a supernatural being. A spirit of the air, a sylph, falls in love with a young Scot on his wedding day. Torn between his real fiancée and his ideal, the sylph, he deserts his fiancée to run off with the spirit. A witch gives him a scarf, and, unaware that it is enchanted, he ties it around the spirit's waist. Immediately her wings fall off and she dies. She drifts away to sylphs' heaven. The young man, disconsolate and alone, sees his fiancée passing in the distance with a new lover on the way to her wedding. The Scottish setting was exotic, at least to Parisians. Gaslight provided a ghostly, moonlit mood in

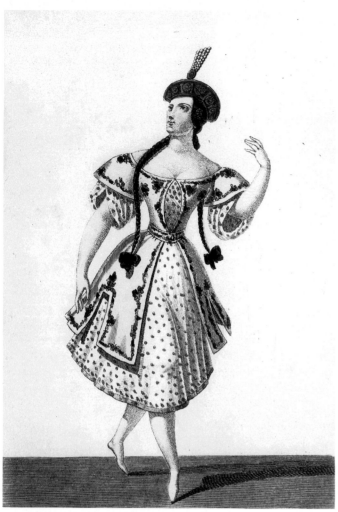

Improvements in stage machinery and lighting contributed much to Romantic staging, especially in ballet. The flickering gloom and controlled darkness and shadows of gaslight added to the mystery of stage scenes, achievements previously impossible when candles provided the light source. Gaslight, however, proved a mixed blessing. Its volatility and open flame meant that fire was still a constant danger, and the gauzy TUTUS, worn by the ballerinas of the period, were made of highly flammable material. During a performance of The Revolt in the Harem, a ballerina brushed an oil burner. Her dress caught fire, and she rushed around the stage in a blaze of flame. By the time a stagehand could extinguish the fire, she was fatally burned and died two days later. In a rehearsal for Le Papillon, another tragedy occurred. The story concerns a heroine who is changed into a magic butterfly and darts toward a torch until the flame shrivels her wings. In a cruel irony, the ballerina playing this role brushed against a gaslight fixture, her costume burst into flame, and she lingered in agony for eight months before dying of her burns. Only a day before, the management had insisted that the dancers dip their costumes in a flame-proofing

13.40 Carlotta Grisi, Le Diable à Quatre. Lithograph, 1845. The New York Public Library.

13.39 Marie Taglioni (1804–84). Engraving, c.1830. The New York Public Library.

the darkened auditorium. Taglioni danced the role of La Sylphide like "a creature of mist drifting over the stage" (assisted by flying machinery). Her lightness, delicacy, and modest grace established the standard for Romantic style in dancing. The story, exotic design, and mood-evoking lighting completed the production style, a style that prevailed for the next 40 years—"moonbeams and gossamer," as some have described it.

Choreographers of Romantic ballet sought magic and escape in fantasies and legends. Ballets about elves and nymphs enjoyed great popularity, as did ballets about madness, sleepwalking, and opium dreams. Unusual subject matter came to the fore. For example, harem wives revolt against their oppressors with the help of the "Spirit of Womankind" in Filippo Taglioni's The Revolt in the Harem, possibly the first ballet about the emancipation of women. Women appeared not only as performers and as subjects of the dance, however. They also began to come to prominence as choreographers.

solution. She had refused, insisting that the solution made her tutu look dingy.

The ballet *Giselle* (1841) marks the height of Romantic achievement. With its many fine dancing roles, both for women and for men, it has been a favorite of ballet companies since its first production. Adolphe Adam, known for his piece *O Holy Night*, composed the score. The prima ballerina was Carlotta Grisi (Fig. **13.40**). The choreography was created by Jean Coralli, ballet master at the Paris Opéra, although, apparently, Carlotta's teacher Jules Perrot choreographed all her dances. In them lies the essence of this ballet.

The ballet has two acts; Act I is in sunlight, and Act II in moonlight. During a vine festival in a Rhineland village, Giselle, a frail peasant girl in love with a mysterious young man, discovers that the object of her affection is Albrecht, Count of Silesia. Albrecht is already engaged to a noblewoman. Giselle is shattered. She goes mad, turns from her deceitful lover, tries to commit suicide, swoons, and falls dead. In Act II, Giselle is summoned from her grave, deep in the forest, by Myrthe, Queen of the Wilis. (The Wilis are spirits of women who, having died unhappy in love, are condemned to lead men to destruction. The word *wili* comes from a Slavic word for "vampire.") When a repentant Albrecht comes to bring flowers to Giselle's grave, Myrthe orders her to dance him to his death. Instead, Giselle protects Albrecht until the first rays of dawn break Myrthe's power.

13.41 Perrot, *Le Pas de Quatre*. Lithograph, 1845. The New York Public Library.

Jules Perrot's characterizations and choreography do not concentrate entirely on the major dancers. He gives the CORPS DE BALLET plenty to do as well. Perrot's ballets generally use skillfully drawn characters from all social classes. His heroes are frequently men of humble birth, and he continued to provide good parts for male dancers even in an era dominated by Gautier's disdain for the *danseur*.

One of Perrot's major accomplishments was the choreography for *Le Pas de Quatre* (1845) (Fig. **13.41**) at Her Majesty's Theatre, London. In a great gamble, he brought together the four major ballerinas of the day, Taglioni, Cerrito, Grisi, and Grahn. The idea was to allow each star to shine—without permitting any one to upstage the others. The clever decision that the dancers would perform in order of age, with the oldest last, defused a raging conflict over who would have the place of honor, the last solo, and the ballet went forward, to the admiration of Queen Victoria and London at large.

Russia

Traditionally eastern in its orientation, Russia had tentatively opened up to the west in the 17th and 18th centuries. By the 19th century, the country had turned its attention more fully toward the rest of Europe, and Russian artists began to earn a place in western art. This was especially true in dance. In St Petersburg in 1862, an English ballet called the *Daughter of Pharaoh*, choreographed by Marius Petipa, sent Russian audiences into rapture. Ballet was not new to Russia, however. As early as 1766, Catherine II had established the Directorate of the Imperial Theatres to supervise ballet, opera, and dance.

Petipa had come to Russia from France in 1842, and he remained a central figure in Russian ballet for almost 60 years. By the middle of the 19th century, ballet companies were flourishing in Moscow and St Petersburg. Dancers enjoyed positions of high esteem in Russia, as they did not in the rest of Europe.

Petipa's influence carried Russian ballet forward in a quasi-Romantic style. He shared the sentimental taste of his time, but his works often contained very strange elements and numerous anachronisms. Minor characters might wear costumes suggesting period or locale, but the stars wore conventional garb, often of classical derivation. Prima ballerinas often appeared in stylish contemporary coiffures and jewels, even when playing the role of a slave. *Divertissements*—light entertainments—were often inserted into a ballet. Although sustained lyrical movements predominated, Petipa included many different kinds of dance in his ballets—classical, character, and folk dance. Mime played an important role as well. The inclusion of all these various elements in a panoramic display gave Petipa's Russian choreography a variety and

13.42 Henri de Toulouse-Lautrec, *At the Moulin Rouge*, 1892–95. Oil on canvas, 4 ft ½ in × 4 ft 7¾ ins (1.23 × 1.41 m). Courtesy of The Art Institute of Chicago (Helen Birch Bartlett Memorial Collection).

richness that was interesting and attractive. His creative approach more than compensated for his anachronisms. As some have said in his defense, "No one criticized Shakespeare for having Antony and Cleopatra speak in blank verse."

Petipa demanded excellent dancers, and the Imperial School came to include outstanding teachers, who produced outstanding pupils. A Russian style soon evolved, which contained elements of French, Danish, and Italian traditions. From this Russian school now came the ever-popular *Nutcracker* and *Swan Lake*, both partially choreographed by Petipa, although his associate Lev Ivanov did the principal work. The scores for both were composed by Tchaikovsky. *Swan Lake* was first produced in 1877 by the Moscow Bolshoi, and *Nutcracker* in 1892. *Swan Lake* popularized the *fouetté*, or whipping turn, introduced by the ballerina Pierina Legnani in Petipa's *Cinderella* and incorporated for her in *Swan Lake*. In one scene, Legnani danced 32 consecutive *fouettés*, and to this day that number is mandatory. Balletomanes count carefully to be sure the ballerina executes the required

number. Russian ballet emphasized technique and the strong, athletic movements that remain characteristic of its productions today.

Late in the century, ballet declined in quality although not necessarily in popularity. Middle-class popularizing had had a stultifying effect and turned dance efforts in a new, hedonistic direction.

The same taste for eroticism that brought many to the ballet also took them to the dance hall. The *Moulin Rouge* was the most famous dance hall, and the cancan its most famous dance. The posters of Toulouse-Lautrec and Seurat capture the spirit of this age (Fig. **13.42**). It was also the age of the *Folies Bergère*, to which a young American named Loie Fuller came in 1892. Probably not much of a dancer (she had only a few lessons), and certainly not a ballerina, Miss Fuller nevertheless created, in her "Butterfly Dance," "White Dance," "Violet Dance," and "Fire Dance," a new thrust and experimentation in theatre dance that was later to break the bonds of a sterile ballet and point toward a new dance form for a new century: the form we know as "modern."

ARCHITECTURE

The 19th century was an age of increased individualism and subjectivity. What is possible by way of experimentation for the painter, sculptor, musician, choreographer, and to some degree, the playwright, however, is not always possible for the architect. An architect's work involves a client who must be satisfied, and the results are public and permanent.

Classicism

The use of Greek and Roman forms after 1750 has been called the "classical revival," or "neo-classicism." Basically, this revival can be broken into two general periods —Roman prior to 1815, and Greek from then on. The many terms used to describe this period can be confusing. Not the least of these is the term "Romantic classicism." This label is not as contradictory as it sounds, however, if one takes "classical" to describe architectural detail and "Romantic" to describe a philosophy of individualized, intuitive creation, emphasizing, among other things, the far away and long ago. "Federal style," then, refers to a specific substyle of Romantic classicism in America, or the resurrection of ancient prototypes in the Romantic era.

The United States

Benjamin H. Latrobe's Catholic cathedral in Baltimore (Fig. **13.43**) illustrates many of these principles. The Ionic orders of Athens are visible here in the alcove behind the altar, while a Roman dome, like that of the Pantheon, dominates the nave. These basically "classical" forms are significantly modified and embellished with numerous individualized details. Traditional Roman semicircular arches flank the central opening above the altar, yet that arch and its surroundings are flattened and broken up by cantilevered balconies. Whimsical, star-like decoration marks the dome, and a misty panorama of painted scenes winds over and through the modified PENDENTIVES.

There were numerous examples of the classical revival in domestic architecture in the United States. The Belamy Mansion in Wilmington, North Carolina (Fig.

13.43 Benjamin H. Latrobe, Basilica of the Assumption, interior, Baltimore, Maryland, 1805–18.

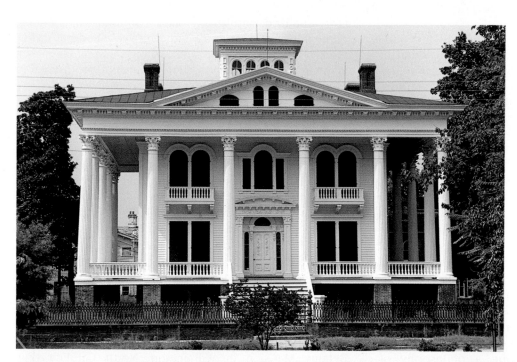

13.44 Rufus H. Bunnell, Belamy Mansion, Wilmington, North Carolina, 1859.

13.45 William Jay, Owens-Richardson House, Savannah, Georgia, 1817–19.

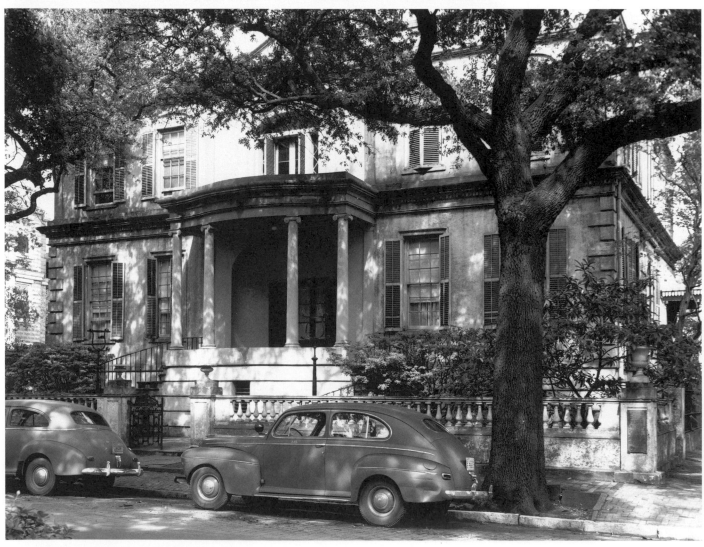

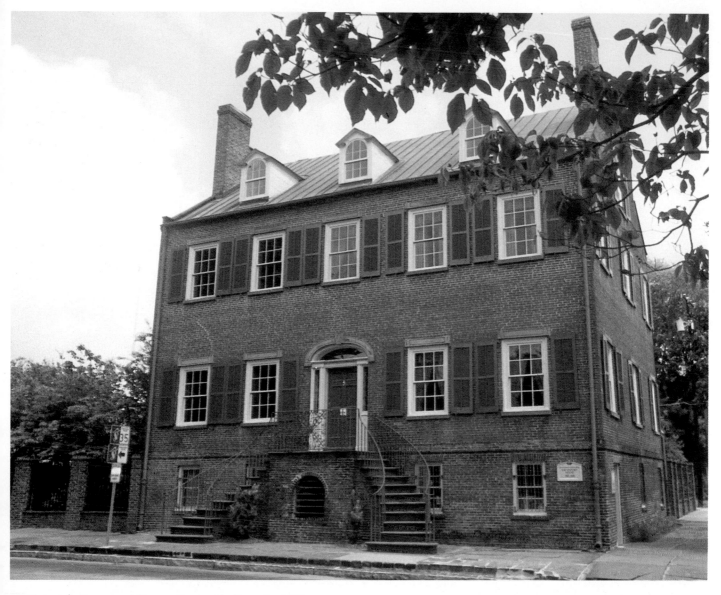

13.46 Isaiah Davenport House, Savannah, Georgia, 1815.

13.44), is one of the most exquisite examples of this style. Designed by Connecticut architect Rufus H. Bunnell, the stately house was built by skilled, free blacks, and completed in 1859. It is situated on a major thoroughfare a few blocks from the downtown business district, central to the city now as it was a century ago. The beautifully proportioned main body of the house is offset by a massive portico, whose Corinthian columns uphold a monumental cornice and pediment. The entire structure is raised some five feet off the ground on brick pillars, hiding a basement, and it is crowned by a rectangular cupola.

The federal style of classical revival architecture can be seen in the dignified Isaiah Davenport House (Fig. **13.46**). Its owner, a master builder from Rhode Island, drew on his own experience and current books on architecture. The federal style is marked by delicate fan-like windows over the doorways, thin cornices, plaster interiors, and elongated columns and pilasters.

Another classical revival style to find its way into American domestic architecture was the English Regency style of Romantic classicism typified by the Owens-Richardson House in Savannah (Fig. **13.45**). Designed by William Jay while he was still in London, the house has a sophistication not found in other Southern homes of the period. In fact, it is an elegant English villa set down in Georgia. Jay was clearly inspired by classical antiquity. The interior reflects the Regency style in its columned foyer, filtered lighting, and *trompe l'oeil* effects. The exterior is graced by double curved stairways leading to a modest entrance portico supported by Ionic columns. Arches are used in the centers of both stories, and a paneled parapet crowns the main CORNICE.

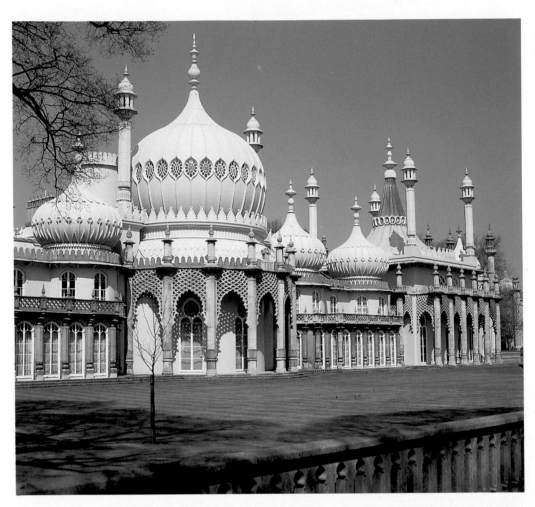

13.47 John Nash, Royal Pavilion, Brighton, England, remodeled 1815–23.

13.48 (below) Sir Charles Barry and Augustus Welby Northmore Pugin, Houses of Parliament, London, 1839–52.

Romanticism

Romantic architecture also borrowed styles from other eras and produced a vast array of buildings that revived Gothic motifs and reflected fantasy. This style has come to be known as "picturesque." Eastern influence and whimsy abounded in John Nash's Royal Pavilion in Brighton, England (Fig. **13.47**), with its onion-shaped domes, minarets, and horseshoe arches. "Picturesque" also describes the most famous example of Romantic architecture, the Houses of Parliament (Fig. **13.48**). This structure demonstrates one significant architectural concept that can be described as "modern." The exterior walls function simply as a screen. They have nothing to say about structure, interior design, or function. The inside has absolutely no spatial relationship to the outside. The strong contrast of forms and asymmetrical balance also suggest the modern.

The 19th century was an age of industry, an age of experimentation and new materials. In architecture, steel and glass came to the fore. At first, an architect needed much courage actually to display the support materials as part of the design itself. England's Crystal Palace (Fig. **13.49**) exemplified the 19th-century fascination with new materials and concepts. Built for the Great Exhibition of 1851, this mammoth structure was completed in the space of nine months. Space was defined by a three-dimensional grid of iron stanchions and girders, designed specifically for mass production and rapid assembly. (In this case, disassembly was also possible. The entire structure was disassembled and rebuilt in 1852–54 at Sydenham.) Like the Houses of Parliament, the Crystal Palace demonstrated the divergence of the function of a building (as reflected in the arrangement of its interior spaces), its surface decoration, and its structure. A new style of building had arrived.

13.49 Sir Joseph Paxton, Crystal Palace, London, 1851.

Experimentation and Art Nouveau

A new age of experimentation also took 19th-century architects in a different direction—up. Late in the period, the skyscraper was designed in response to the need to create additional commercial space on the limited land space in burgeoning urban areas. Burnham and Root's Monadnock Building in Chicago (Fig. **13.50**) was an early example. Although this prototypical "skyscraper" is all masonry—that is, it is built completely of brick and requires increasingly thick supportive walls toward its base—it was part of the trend in architecture to combine design, materials, and new concepts of space.

When all these elements were finally combined, the skyscraper emerged—almost exclusively in America. Architects erected buildings of unprecedented height without increasing the thickness of lower walls by using structural frameworks (first of iron, later of steel) and by treating walls as independent partitions. Each story was supported on horizontal girders. The concept of the skyscraper could not be realized comfortably, however, until the invention of a safe and reliable elevator.

A most influential figure in the development of the skyscraper and philosophies of modern architecture was

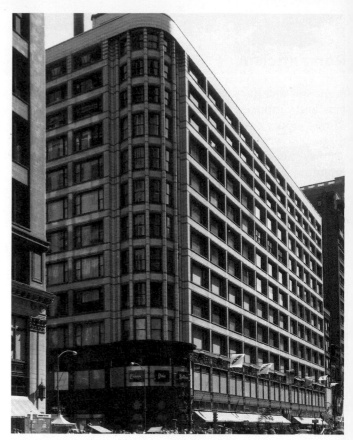

13.51 Louis Henry Sullivan, Carson, Pirie and Scott Department Store, Chicago, 1899–1904.

13.50 Daniel Hudson Burnham and John Wellborn Root, the Monadnock Building, Chicago, 1889–91.

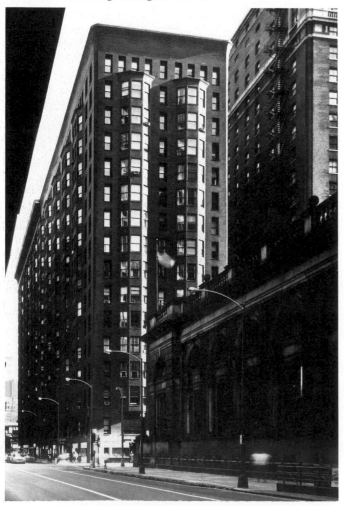

Louis Sullivan, the first truly modern architect. Working in the last decade of the 19th century in Chicago, then the most rapidly developing metropolis in the world, Sullivan designed buildings of great dignity, simplicity, and strength. Most important, however, he created a rubric for modern architecture with his theory that form flowed from function. As Sullivan said to an observer of the Carson, Pirie, and Scott Building (Fig. **13.51**), "It is evident that we are looking at a department store. Its purpose is clearly set forth in its general aspect, and the form follows the function in a simple, straightforward way."

In the final years of the 19th century, a new style of architectural decoration evolved called "ART NOUVEAU." It is not primarily an architectural mode but, like rococo, which it resembles, it provides a decorative surface—one that is closely associated with graphic art—that imparts a unique character to any building.

Art Nouveau is connected in some ways with the doctrines of 19th-century artistic symbolism, and its identifying characteristic is the lively, serpentine curve, known as the "whiplash" (Fig. **13.52**). The style also reflects a fascination with plant and animal life and organic growth. The influence of Japanese art, which had been widely plundered late in the 19th century, is evident in the undulating curves. Art Nouveau incorporates organic and often symbolic motifs, usually languid-looking flowers and animals, and treats them in a flat, linear, and relief-like manner (Fig. **13.53**). The 20th century had arrived.

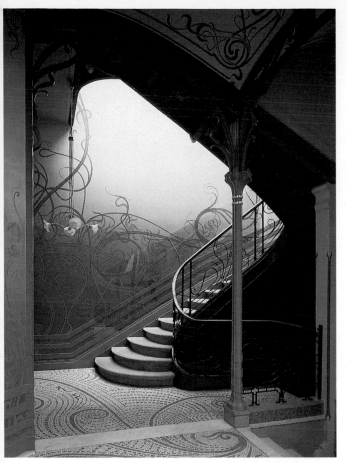

13.52 Baron Victor Horta, Tassel House, Brussels, 1892–93.

13.53 Frantz Jourdain, Samaritaine Department Store, Paris, 1905.

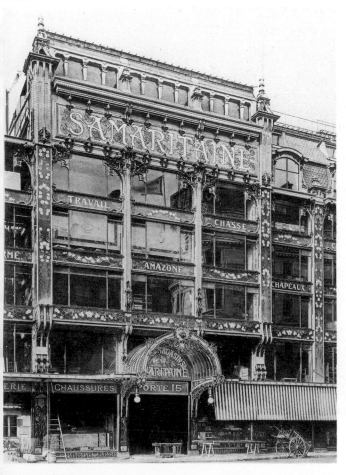

SYNTHESIS
The Victorians:
the 19th century in Britain

We have called the 19th century not only the "Age of Industry," but also the "Age of Romanticism." And indeed we find both industrialization and the philosophical and artistic aims of Romanticism at the heart of the age.

The indomitable spirit of England's great queen, Victoria, was yet another influence that reached far beyond her homeland to the continent of Europe and to North America. Victoria's presence was not only felt through her great patronage, as was the case with earlier European monarchs, but also in the force of her personality, her values, and her general social influence.

British confidence soared to great heights in the middle decades of the 19th century. That was when the British began to use the term "Victorian" to describe the era they were living in, demonstrating their consciousness that *their* values dominated a distinct period. New technologies and new economics combined with social stability and traditional values. Parliament and the monarchy symbolized continuity, stability, and tradition in changing times. The new Parliament buildings reflected the antiquity of the institution of Parliament in their mock-Medieval architecture. The revolutionary nature of the era was hidden behind a cloak of custom and tradition. When Victoria acceded to the throne in 1837, the British monarchy could trace its ancestry back further than any other European political institution apart from the papacy. Victoria and Albert raised the monarchy to new heights of public esteem.

The character and essence of Victorianism can be clearly seen in the single discipline of painting, which reveals a remarkable complexity and scope. "There were contradictions, movements and countermovements; endless and labyrinthine courses were explored, false gods pursued. . . . If the period produced few artists of world stature, this was balanced by the cumulative effect of the rich diversity of high talent, occasionally bordering on greatness."[5] The Victorian age was compulsively multidisciplinary. G. K. Chesterton described it as "a world in which painters were trying to be novelists, and novelists trying to be historians, and musicians doing the work of school-masters, and sculptors doing the work of curates." Athough official patronage had more or less disappeared, state support of artists did exist, and there was some increase in private patronage. Support groups for artists were first set up during this period, among them, Morris and Company (1861), the Art Workers Guild (1884), and the New English Art Club (1885). The Royal Academy, which had been founded in 1769, also supported artistic endeavors. On the one hand, it provided a focus for artistic activity. On the other, it was seen as an established

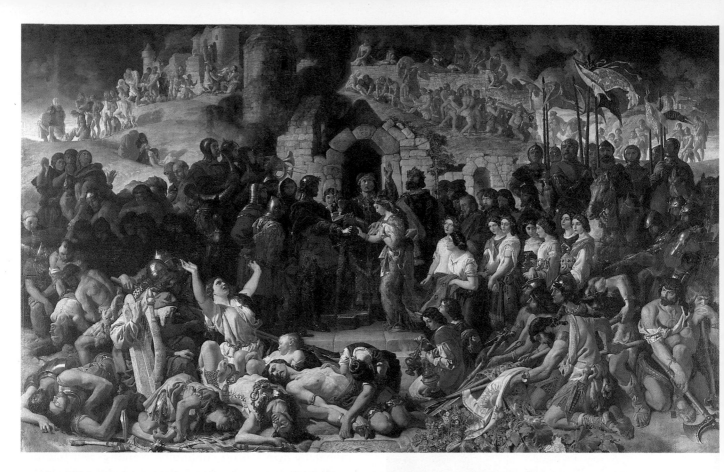

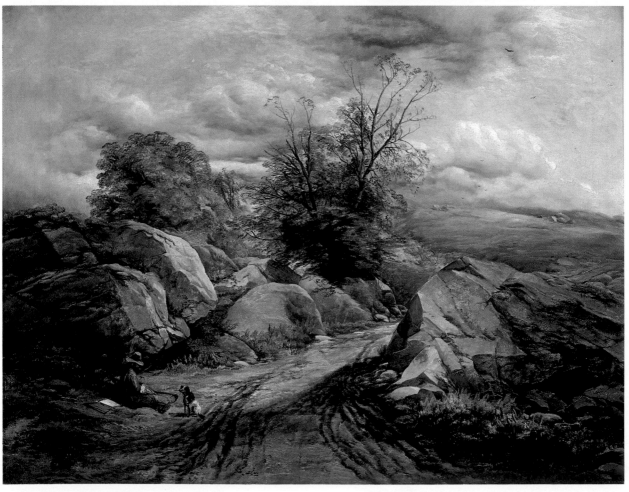

institution that rebellious artists could react against. The age produced historical painters, landscape painters, marine painters, sporting painters, animal painters, genre painters, fairy painters, nude and still-life painters, neo-classical painters, portrait painters, and the Pre-Raphaelites.

Interest in history, both as a backdrop for Utopian escape and for antiquarianism, colored the arts as well as philosophy. Images of heroism and sublimity caught the imagination of the Romantic painters. Scale as well as attitude found its way onto the canvas. *The Marriage of Eva and Strongbow* (Fig. **13.54**) by Daniel MacLise (1806–70) covers a canvas 10 foot 2 inches by 16 foot 7 inches, and depicts the 12th-century marriage of Richard Strongbow, Second Earl of Pembroke and Strigul, to Eva, eldest daughter of Dermot. Complex and busy, the work elicits an emotional response and captures a climactic moment. Strong contrasts in tones compete with many different focal areas for the viewer's attention. The central situation is played out while everything around it is in confusion. The coloring is harsh, and the facial expressions not very real.

Victorian landscape painters produced a prodigious quantity of "pretty, undisturbed scenes" which were designed for a growing picture-buying public. The themes were mostly superficial, emotional, and repetitive, and yet for the most part the genre is highly pleasing. The genius of John Constable (1776–1837) was the guiding light as well as the shadow over other Victorian landscape artists. Constable's "chiaroscuro of nature" lent itself to easy adaptation, and his naturalistic style permeated the genre. *Landscape* (Fig. **13.55**) by Thomas Creswick (1811–69) has much in common with the work of Corot (Fig. **13.10**), displaying a careful treatment of rocks, trees, and foliage.

The Victorian love of animals is legendary, and owning bizarre, wild, and exotic pets became the rage, a development perfectly consistent with the Romantic tendency and outlook. In the jubilee year of 1887, thousands of prisoners all over the British Empire were released. The only criminals *not* released were those convicted of cruelty to animals, which Queen Victoria regarded as "one of the worst traits of human nature." In *Dignity and Impudence*, Edwin Landseer (1802–73) (Fig. **13.56**) anthropomorphizes two dogs.

Highly controversial, the Pre-Raphaelites appear to have exercised significant influence on later movements away from naturalism. They formed themselves into a

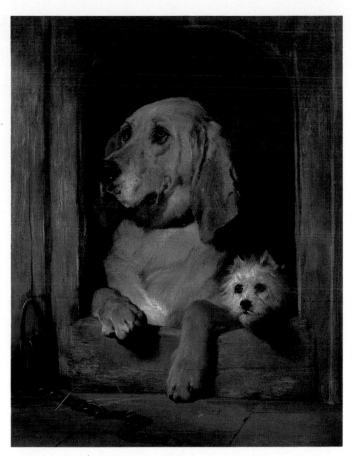

13.56 Sir Edwin Landseer, *Dignity and Impudence*, 1839. Oil on canvas, 35 × 27½ ins (89 × 70 cm). The Tate Gallery, London.

13.54 (opposite, above) Daniel MacLise, *The Marriage of Eva and Strongbow*, first exhibited 1854. Oil on canvas, 10 ft 2 ins × 16 ft 7 ins (3.09 × 5.05 m). National Gallery of Ireland, Dublin.

13.55 (opposite, below) Thomas Creswick, *Landscape*, c.1851. Oil on canvas, 27 × 35 ins (68.5 × 89 cm). Royal Academy of Arts, London.

group in 1848. The Pre-Raphaelites had a significant influence on art and design because of their ability to envision and paint with detailed skill and their use of a wide range of symbolism. They returned to the direct symbolism, frank naturalism, and poetic sentiment previously found in Medieval art, prior to the Renaissance painter Raphael—hence the name. To such Medieval qualities they added a modern analysis and profound and intellectual study of art and nature. They loved detail, and their works abound with painstaking attention to it.

Escape to legend and literature, along with a strong interest in the occult and spiritualism, led to an English fascination with fairy tales. As Charles Dickens wrote in *Household Words* (vol. 8), "In a utilitarian age, of all other times, it is a matter of grave importance that fairy tales should be respected." Fairy tales were subject matter understood and shared by artist and viewer alike. The art that emerged represents a unique, Victorian contribution to art.

The fascinating painting *The Fairy Feller's Master Stroke* (Fig. **13.57**) took the artist, who was suffering from schizophrenia, nine years to complete. Richard Dadd (1817–87) had been among the founders of a group of

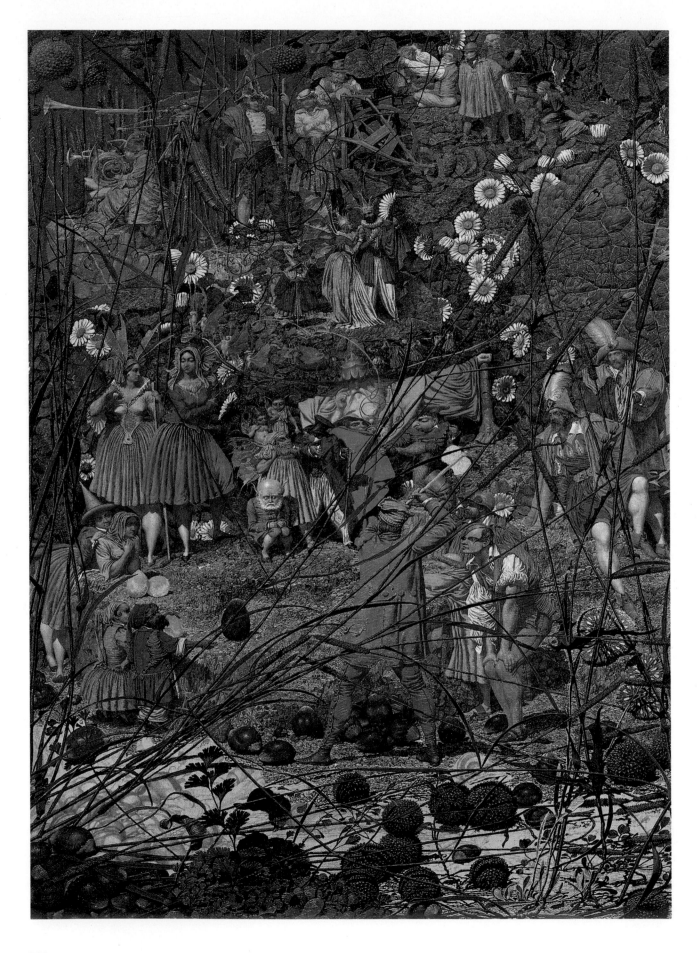

painters called "the Clique," and his early works had been undistinguished attempts at landscape, marine, and animal painting. After returning from an extensive trip to the Middle East and Italy, and after being rejected in the competition for the decoration of the Houses of Parliament, he stabbed his father to death. Fleeing to France, he planned to assassinate the Emperor of Austria. Captured after stabbing a passenger at Fontainebleau, he spent his remaining years institutionalized in Bedlam, or the Hospital of St Mary of Bethlehem. He was provided with painting materials, and his subsequent works have an insistent supernatural quality, as we can see in Figure **13.57**. The flat coloring and obsessive detail have been explained as a reflection of certain symptoms of schizophrenia. The main event in the painting is placed in the center, and the myriad details that surround it seem to be nothing more than highly imaginative decoration.

Victorian painting, with all its diversity, complexity, contradictions, and often mediocre quality, very effectively represents the remarkable lot of Romantics, realists, and jacks-of-all-trades who rode the crest of the first wave that swept us into our modern world.

SUGGESTIONS FOR THOUGHT AND DISCUSSION

The Age of Industry was an uneasy age, torn by battles of ideas as well as armies. It was an age of technology, and the impact of technological innovation brought the various areas of the globe closer together. The artist assumed an entirely new place in society, wrestling with individual position, style, and persona. Individualism became supreme. Form became subservient to feeling, image to emotion. At the same time, escapism rescued individuals from the complexities and pressures of the time. Extolling the virtues of the far away and long ago became the Romantic's creed. Nature and the exotic beckoned.

It was a time of change, and our wanderings through neo-classicism to Romanticism to realism to naturalism to impressionism to post-impressionism to symbolism have not approached anything like serious study. Now we need to deepen our understanding of these "isms" as they apply to the arts and to 19th-century life.

■ How did the many technological inventions of the century transform life? Can you summarize the character of life—especially middle-class thinking—and apply that summary to directions and attitudes in the arts?

■ In what ways was the 19th century like our own? In what ways and in what attitudes was it different?

■ In what ways does Victorian painting symbolize 19th-century accomplishments or lack of accomplishments? What do the various directions it took, and the fact that it took them, tell us about life in 19th-century England?

■ Trace the changes in the role of the artist by examining the subject matter of the great paintings of the 19th century.

■ How would you compare the achievements of composers in the 19th century with those of composers in the 18th?

13.57 (opposite) Richard Dadd, *The Fairy Feller's Master Stroke*, 1855–64. Oil on canvas, $21\frac{1}{4} \times 15\frac{1}{4}$ ins (54×38.5 cm). The Tate Gallery, London.

LITERATURE EXTRACTS

Kubla Khan
[1797] Samuel Taylor Coleridge

In Xanadu did Kubla Khan
 A stately pleasure-dome decree:
Where Alph, the sacred river, ran
Through caverns measureless to man
 Down to a sunless sea.
So twice five miles of fertile ground
With walls and towers were girdled round:
And here were gardens bright with sinuous rills.
Where blossomed many an incense-bearing tree
And here were forests ancient as the hills, 10
Enfolding sunny spots of greenery.

But oh! that deep romantic chasm which slanted
Down the green hill athwart a cedarn cover!
A savage place! as holy and enchanted
As e'er beneath a waning moon was haunted
By woman wailing for her demon-lover!
And from this chasm, with ceaseless turmoil seething,
As if this earth in fast thick pants were breathing,
A mighty fountain momentarily was forced,
Amid whose swift half-intermitted burst 20
Huge fragments vaulted like rebounding hail,
Or chaffy grain beneath the thresher's flail:
And 'mid these dancing rocks at once and ever
It flung up momently the sacred river.
Five miles meandering with a mazy motion
Through wood and dale the sacred river ran,
Then reached the caverns measureless to man,
And sank in tumult to a lifeless ocean:
And 'mid this tumult Kubla heard from far
Ancestral voices prophesying war! 30

 The shadow of the dome of pleasure
 Floated midway on the waves;
 Where was heard the mingled measure
 From the fountain and the caves.
It was a miracle of rare device,
A sunny pleasure-dome with caves of ice!

 A damsel with a dulcimer
 In a vision once I saw:
 It was an Abyssinian maid,
 And on her dulcimer she played, 40
 Singing of Mount Abora.
 Could I revive within me
 Her symphony and song,
 To such a deep delight 'twould win me,
That with music loud and long,
I would build that dome in air,
That sunny dome! those caves of ice!
And all who heard should see them there,
And all should cry, Beware! Beware!
His flashing eyes, his floating hair! 50
Weave a circle round him thrice,
And close your eyes with holy dread,
For he on honey-dew hath fed,
And drunk the milk of Paradise.

Emma
[1815–16] Jane Austen

Volume I
Chapter I

Emma Woodhouse, handsome, clever, and rich, with a comfortable home and happy disposition, seemed to unite some of the best blessings of existence; and had lived nearly twenty-one years in the world with very little to distress or vex her.

She was the youngest of the two daughters of a most affectionate, indulgent father, and had, in consequence of her sister's marriage, been mistress of his house from a very early period. Her mother had died too long ago for her to have more than an indistinct remembrance of her caresses, and her place had been supplied by an excellent woman as governess, who had fallen little short of a mother in affection.

Sixteen years had Miss Taylor been in Mr. Woodhouse's family, less as a governess than a friend, very fond of both daughters, but particularly of Emma. Between *them* it was more the intimacy of sisters. Even before Miss Taylor had ceased to hold the nominal office of governess, the mildness of her temper had hardly allowed her to impose any restraint; and the shadow of authority being now long passed away, they had been living together as friend and friend very mutually attached, and Emma doing just what she liked; highly esteeming Miss Taylor's judgment, but directed chiefly by her own.

The real evils indeed of Emma's situation were the power of having rather too much her own way, and a disposition to think a little too well of herself; these were the disadvantages which threatened alloy to her many enjoyments. The danger, however, was at present so unperceived, that they did not by any means rank as misfortunes with her.

Sorrow came—a gentle sorrow—but not at all in the shape of any disagreeable consciousness.—Miss Taylor married. It was Miss Taylor's loss which first brought grief. It was on the wedding-day of this beloved friend that Emma first sat in mournful thought of any continuance. The wedding over and the bride-people gone, her father and herself were left to dine together, with no prospect of a third to cheer a long evening. Her father composed himself to sleep after dinner, as usual, and she had then only to sit and think of what she had lost.

The event had every promise of happiness for her friend. Mr. Weston was a man of unexceptionable character, easy fortune, suitable age and pleasant manners; and there was some satisfaction in considering with what self-denying, generous friendship she had always wished and promoted the match; but it was a black morning's work for her. The want of Miss Taylor would be felt every hour of every day. She recalled her past kindness—the kindness, the affection of sixteen years—how she had taught and how she had played with her from five years old—how she had devoted all her

powers to attach and amuse her in health—and how nursed her through the various illnesses of childhood. A large debt of gratitude was owing here; but the intercourse of the last seven years, the equal footing and perfect unreserve which had soon followed Isabella's marriage on their being left to each other, was yet a dearer, tenderer recollection. She had been a friend and companion such as few possessed, intelligent, well-informed, useful, gentle, knowing all the ways of the family, interested in all its concerns, and peculiarly interested in herself, in every pleasure, every scheme of her's;—one to whom she could speak every thought as it arose, and who had such an affection for her as could never find fault.

How was she to bear the change?—It was true that her friend was going only half a mile from them; but Emma was aware that great must be the difference between a Mrs. Weston only half a mile from them, and a Miss Taylor in the house; and with all her advantages, natural and domestic, she was now in greater danger of suffering from intellectual solitude. She dearly loved her father, but he was no companion for her. He could not meet her in conversation, rational or playful.

The evil of the actual disparity in their ages (and Mr. Woodhouse had not married early) was much increased by his constitution and habits; for having been a valetudinarian all his life, without activity of mind or body, he was a much older man in ways than in years; and though everywhere beloved for the friendliness of his heart and his amiable temper, his talents could not have recommended him at any time.

Her sister, though comparatively but little removed by matrimony, being settled in London, only sixteen miles off, was much beyond her daily reach; and many a long October and November evening must be struggled through at Hartfield, before Christmas brought the next visit from Isabella and her husband and their little children to fill the house and give her pleasant society again.

Highbury, the large and populous village almost amounting to a town, to which Hartfield, in spite of its separate lawn and shrubberies and name, did really belong, afforded her no equals. The Woodhouses were first in consequence there. All looked up to them. She had many acquaintance in the place, for her father was universally civil, but not one among them who could be accepted in lieu of Miss Taylor for even half a day. It was a melancholy change; and Emma could not but sigh over it and wish for impossible things, till her father awoke, and made it necessary to be cheerful. His spirits required support. He was a nervous man, easily depressed; fond of every body that he was used to, and hating to part with them; hating change of every kind. Matrimony, as the origin of change, was always disagreeable; and he was by no means yet reconciled to his own daughter's marrying, nor could ever speak of her but with compassion, though it had been entirely a match of affection, when he was now obliged to part with Miss Taylor too; and from his habits of gentle selfishness and of being never able to suppose that other people could feel differently from himself, he was very much disposed to think Miss Taylor had done as sad a thing for herself as for them, and would have been a

great deal happier if she had spent all the rest of her life at Hartfield. Emma smiled and chatted as cheerfully as she could, to keep him from such thoughts; but when tea came, it was impossible for him not to say exactly as he had said at dinner,

"Poor Miss Taylor!—I wish she were here again. What a pity it is that Mr. Weston ever thought of her!"

"I cannot agree with you, papa; you know I cannot. Mr. Weston is such a good-humoured, pleasant, excellent man, that he thoroughly deserves a good wife;—and you would not have had Miss Taylor live with us for ever and bear all my odd humours, when she might have a house of her own?"

"A house of her own!—but where is the advantage of a house of her own? This is three times as large.—And you have never any odd humours, my dear."

"How often we shall be going to see them and they coming to see us!—We shall be always meeting! We must begin, we must go and pay our wedding-visit very soon."

"My dear, how am I to get so far? Randalls is such a distance. I could not walk half so far."

"No, papa, nobody thought of your walking. We must go in the carriage to be sure."

"The carriage! But James will not like to put the horses to for such a little way;—and where are the poor horses to be while we are paying our visit?"

"They are to be put into Mr. Weston's stable, papa. You know we have settled all that already. We talked it all over with Mr. Weston last night. And as for James, you may be very sure he will always like going to Randalls, because of his daughter's being housemaid there. I only doubt whether he will ever take us anywhere else. That was your doing, papa. You got Hannah that good place. Nobody thought of Hannah till you mentioned her—James is so obliged to you!"

"I am very glad I did think of her. It was very lucky, for I would not have poor James think himself slighted upon any account; and I am sure she will make a very good servant; she is a civil, pretty-spoken girl; I have a great opinion of her. Whenever I see her, she always curtseys and asks me how I do, in a very pretty manner; and when you have had her here to do needlework, I observe she always turns the lock of the door the right way and never bangs it. I am sure she will be an excellent servant; and it will be a great comfort to poor Miss Taylor to have somebody about her that she is used to see. Whenever James goes over to see his daughter you know, she will be hearing of us. He will be able to tell her how we all are."

Emma spared no exertions to maintain this happier flow of ideas, and hoped, by the help of backgammon,[1] to get her father tolerably through the evening, and be attacked by no regrets but her own. The backgammon-table was placed; but a visitor immediately afterwards walked in and made it unnecessary.

Mr. Knightley, a sensible man about seven or eight-and-thirty, was not only a very old and intimate friend of the family, but particularly connected with it as the elder brother of Isabella's husband. He lived about a mile from Highbury, was a frequent visitor and always welcome, and

1. a board game.

at this time more welcome than usual, as coming directly from their mutual connections in London. He had returned to a late dinner after some days absence, and now walked up to Hartfield to say that all were well in Brunswick-square. It was a happy circumstance and animated Mr. Woodhouse for some time. Mr. Knightley had a cheerful manner which always did him good; and his many inquiries after "poor Isabella" and her children were answered most satisfactorily. When this was over, Mr. Woodhouse gratefully observed,

"It is very kind of you, Mr. Knightley, to come out at this late hour to call upon us. I am afraid you must have had a shocking walk."

"Not at all, sir. It is a beautiful, moonlight night; and so mild that I must draw back from your great fire."

"But you must have found it very damp and dirty. I wish you may not catch cold."

"Dirty, sir! Look at my shoes. Not a speck on them."

"Well! that is quite surprizing, for we have had a vast deal of rain here. It rained dreadfully hard for half an hour, while we were at breakfast. I wanted them to put off the wedding."

"By the bye—I have not wished you joy. Being pretty well aware of what sort of joy you must both be feeling, I have been in no hurry with my congratulations. But I hope it all went off tolerably well. How did you all behave? Who cried most?"

"Ah! poor Miss Taylor! 'tis a sad business."

"Poor Mr. and Miss Woodhouse, if you please; but I cannot possibly say 'poor Miss Taylor.' I have a great regard for you and Emma; but when it comes to the question of dependence or independence!—At any rate, it must be better to have only one to please, than two."

"Especially when *one* of those two is such a fanciful, troublesome creature!" said Emma playfully. "That, is what you have in your head, I know—and what you would certainly say if my father were not by."

"I believe it is very true, my dear, indeed," said Mr. Woodhouse with a sigh. "I am afraid I am sometimes very fanciful and troublesome."

"My dearest papa! You do not think I could mean *you*, or suppose Mr Knightley to mean *you*. What a horrible idea! Oh, no! I meant only myself. Mr Knightley loves to find fault with me you know—in a joke—it is all a joke. We always say what we like to one another."

Mr. Knightley, in fact, was one of the few people who could see faults in Emma Woodhouse, and the only one who ever told her of them: and though this was not particularly agreeable to Emma herself, she knew it would be so much less so to her father, that she would not have him really suspect such a circumstance as her not being thought perfect by every body.

"Emma knows I never flatter her," said Mr. Knightley; "but I meant no reflection on any body. Miss Taylor has been used to have two persons to please; she will now have but one. The chances are that she must be a gainer."

"Well," said Emma, willing to let it pass—"you want to hear about the wedding, and I shall be happy to tell you, for we all behaved charmingly. Every body was punctual, every body in their best looks. Not a tear, and hardly a long face to be seen. Oh! no, we all felt that we were going

to be only half a mile apart, and were sure of meeting every day."

"Dear Emma bears every thing so well," said her father. "But, Mr. Knightley, she is really very sorry to lose poor Miss Taylor, and I am sure she *will* miss her more than she thinks for."

Emma turned away her head, divided between tears and smiles.

"It is impossible that Emma should not miss such a companion," said Mr. Knightley. "We should not like her so well as we do, sir, if we could suppose it. But she knows how much the marriage is to Miss Taylor's advantage; she knows how very acceptable it must be at Miss Taylor's time of life to be settled in a home of her own, and how important to her to be secure of a comfortable provision, and therefore cannot allow herself to feel so much pain as pleasure. Every friend of Miss Taylor must be glad to have her so happily married."

"And you have forgotten one matter of joy to me," said Emma, "and a very considerable one—that I made the match myself. I made the match, you know, four years ago; and to have it take place, and be proved in the right, when so many people said Mr. Weston would never marry again, may comfort me for any thing."

Mr. Knightley shook his head at her. Her father fondly replied, "Ah! my dear, I wish you would not make matches and foretel things, for whatever you say always comes to pass. Pray do not make any more matches."

"I promise you to make none for myself, papa; but I must, indeed, for other people. It is the greatest amusement in the world! And after such success you know!—Every body said that Mr. Weston would never marry again. Oh dear, no! Mr. Weston, who had been a widower so long, and who seemed so perfectly comfortable without a wife, so constantly occupied either in his business in town or among his friends here, always acceptable wherever he went, always cheerful—Mr. Weston need not spend a single evening in the year alone if he did not like it. Oh, no! Mr. Weston certainly would never marry again. Some people even talked of a promise to his wife on her death-bed, and others of the son and the uncle not letting him. All manner of solemn nonsense was talked on the subject, but I believed none of it. Ever since the day (about four years ago) that Miss Taylor and I met with him in Broadway-lane, when, because it began to mizzle, he darted away with so much gallantry, and borrowed two umbrellas for us from Farmer Mitchell's, I made up my mind on the subject. I planned the match from that hour; and when such success has blessed me in this instance, dear papa, you cannot think that I shall leave off match-making."

"I do not understand what you mean by 'success,'" said Mr. Knightley. "Success supposes endeavour. Your time has been properly and delicately spent, if you have been endeavouring for the last four years to bring about this marriage. A worthy employment for a young lady's mind! But if, which I rather imagine, your making the match, as you call it, means only your planning it, your saying to yourself one idle day, 'I think it would be a very good thing for Miss Taylor if Mr. Weston were to marry her,' and saying it again to yourself every now and then

afterwards,—why do you talk of success? where is your merit?—what are you proud of?—you made a lucky guess; and *that* is all that can be said."

"And have you never known the pleasure and triumph of a lucky guess?—I pity you.—I thought you cleverer—for depend upon it, a lucky guess is never merely luck. There is always some talent in it. And as to my poor word 'success,' which you quarrel with, I do not know that I am so entirely without any claim to it. You have drawn two pretty pictures—but I think there may be a third—a something between the do-nothing and the do-all. If I had not promoted Mr. Weston's visits here, and given many little encouragements, and smoothed many little matters, it might not have come to any thing after all. I think you must know Hartfield enough to comprehend that."

"A straight-forward, open-hearted man, like Weston, and a rational unaffected woman, like Miss Taylor, may be safely let to manage their own concerns. You are more likely to have done harm to yourself, than good to them, by interference."

"Emma never thinks of herself, if she can do good to others;" rejoined Mr. Woodhouse, understanding but in part. "But, my dear, pray do not make any more matches, they are silly things, and break up one's family circle grievously."

"Only one more, papa; only for Mr. Elton. Poor Mr. Elton! You like Mr. Elton, papa,—I must look about for a wife for him. There is nobody in Highbury who deserves him—and he has been here a whole year, and has fitted up his house so comfortably that it would be a shame to have him single any longer—and I thought when he was joining their hands today, he looked so very much as if he would like to have the same kind office done for him! I think very well of Mr. Elton, and this is the only way I have of doing him a service."

"Mr. Elton is a very pretty young man to be sure, and a very good young man, and I have a great regard for him. But if you want to shew him any attention, my dear, ask him to come and dine with us some day. That will be a much better thing. I dare say Mr. Knightley will be so kind as to meet him."

"With a great deal of pleasure, sir, at any time," said Mr. Knightley laughing; "and I agree with you entirely that it will be a much better thing. Invite him to dinner, Emma, and help him to the best of the fish and the chicken, but leave him to chuse his own wife. Depend upon it, a man of six or seven-and-twenty can take care of himself."

Ode to a Nightingale
[1820] John Keats

1

My heart aches, and a drowsy numbness pains
 My sense, as though of hemlock I had drunk,
Or emptied some dull opiate to the drains
 One minute past, and Lethe-wards had sunk:
'Tis not through envy of thy happy lot,
 But being too happy in thine happiness.—
 That thou, light-winged Dryad of the trees,
 In some melodious plot
 Of beechen green, and shadows numberless,
 Singest of summer in full-throated ease. 10

2

O, for a draught of vintage! that hath been
 Cool'd a long age in the deep-delved earth,
Tasting of Flora and the country green,
 Dance, and Provençal song, and sunburnt mirth!
O for a beaker full of the warm South,
 Full of the true, the blushful Hippocrene,
 With beaded bubbles winking at the brim,
 And purple-stainèd mouth;
 That I might drink, and leave the world unseen,
And with thee fade away into the forest dim: 20

3

Fade far away, dissolve, and quite forget
 What thou among the leaves hast never known,
The weariness, the fever and the fret
 Here, where men sit and hear each other groan;
Where palsy shakes a few, sad, last grey hairs,
 Where youth grows pale, and spectre-thin, and dies:
 Where but to think is to be full of sorrow
 And leaden-eyed despairs,
Where Beauty cannot keep her lustrous eyes,
 Or new Love pine at them beyond tomorrow. 30

4

Away! away! for I will fly to thee,
 Not charioted by Bacchus and his pards,
But on the viewless wings of Poesy,
 Though the dull brain perplexes and retards:
Already with thee! tender is the night,
 And haply the Queen-Moon is on her throne,
 Cluster'd around by all her starry Fays;
 But here there is no light,
Save what from heaven is with the breezes blown
Through verdurous glooms and winding mossy ways. 40

5

I cannot see what flowers are at my feet,
 Nor what soft incense hangs upon the boughs,
But, in embalmed darkness, guess each sweet
 Wherewith the seasonable month endows
The grass, the thicket, and the fruit-tree wild;
 White hawthorn, and the pastoral eglantine;
 Fast fading violets cover'd up in leaves;
 And mid-May's eldest child,
 The coming musk-rose, full of dewy wine,
 The murmurous haunt of flies on summer eves. 50

6

Darkling I listen: and, for many a time
 I have been half in love with easeful Death,
Call'd him soft names in many a musèd rhyme,
 To take into the air my quiet breath;
Now more than ever seems it rich to die,
 To cease upon the midnight with no pain,
 While thou art pouring forth thy soul abroad
 In such an ecstasy!
 Still wouldst thou sing, and I have ears in vain—
 To thy high requiem become a sod. 60

7

Thou wast not born for death, immortal Bird!
 No hungry generations tread thee down;
The voice I hear this passing night was heard
 In ancient days by emperor and clown:
Perhaps the self-same song that found a path
 Through the sad heart of Ruth, when, sick for home,
 She stood in tears amid the alien corn;
 The same that oft-times hath
Charm'd magic casements, opening on the foam
 Of perilous seas, in faery lands forlorn. 70

8

Forlorn! the very word is like a bell
 To toll me back from thee to my sole self!
Adieu! the fancy cannot cheat so well
 As she is fam'd to do, deceiving elf.
Adieu! adieu! thy plaintive anthem fades
 Past the near meadows, over the still stream,
 Up the hill-side; and now 'tis buried deep
 In the next valley-glades.
 Was it a vision, or a waking dream?
 Fled is that music:—Do I wake or sleep? 80

On The Elgin Marbles[1]
[1820] John Keats

My spirit is too weak; mortality
 Weighs heavily on me like unwilling sleep,
 And each imagined pinnacle and steep
Of godlike hardship tells me I must die
Like a sick eagle looking at the sky.
 Yet 'tis a gentle luxury to weep,
 That I have not the cloudy winds to keep
Fresh for the opening of the morning's eye.
Such dim-conceived glories of the brain,
 Bring round the heart an indescribable feud;
So do these wonders a most dizzy pain,
 That mingles Grecian grandeur with the rude
Wasting of old Time—with a billowy main
 A sun, a shadow of a magnitude.

1. The Elgin marbles, bought by Lord Elgin, include the frieze from the Parthenon in Athens.

Ozymandias
[1817] Percy Bysshe Shelley

I met a traveller from an antique land
Who said: Two vast and trunkless legs of stone
Stand in the desert . . . Near them, on the sand,
Half sunk, a shattered visage lies, whose frown,
And wrinkled lip, and sneer of cold command,
Tell that its sculptor well those passions read
Which yet survive, stamped on these lifeless things
The hand that mocked them and the heart that fed:
And on the pedestal these words appear:
"My name is Ozymandias, king of kings:
Look on my works, ye Mighty, and despair!"
Nothing beside remains. Round the decay
Of that colossal wreck, boundless and bare
The lone and level sands stretch far away.

To a Skylark
[1821] Percy Bysshe Shelley

 Hail to thee, blithe spirit!
 Bird thou never wert,
 That from heaven, or near it,
 Pourest thy full heart
In profuse strains of unpremeditated art.

 Higher still and higher
 From the earth thou springest
 Like a cloud of fire;
 The blue deep thou wingest,
And singing still dost soar, and soaring ever singest. 10

 In the golden lightning
 Of the sunken sun,
 O'er which clouds are brightning,
 Thou dost float and run;
Like an unbodied joy whose race is just begun.

 The pale purple even
 Melts around thy flight;
 Like a star of heaven,
 In the broad day-light
Thou art unseen, but yet I hear thy shrill delight. 20

 Keen as are the arrows
 Of that silver sphere,
 Whose intense lamp narrows
 In the white dawn clear,
Until we hardly see, we feel that it is there.

 All the earth and air
 With thy voice is loud,
 As, when night is bare,
 From one lonely cloud
The moon rains out her beams, and heaven is
overflowed. 30

What thou art we know not;
 What is most like thee?
From rainbow clouds there flow not
 Drops so bright to see,
As from thy presence showers a rain of melody.

 Like a poet hidden
 In the light of thought,
 Singing hymns unbidden,
 Till the world is wrought
To sympathy with hopes and fears it heeded not: 40

 Like a high-born maiden
 In a palace tower,
 Soothing her love-laden
 Soul in secret hour
With music sweet as love, which overflows her bower:

 Like a glow-worm golden
 In a dell of dew,
 Scattering unbeholden
 Its aërial hue
Among the flowers and grass, which screen it from the
view: 50

 Like a rose embowered
 In its own green leaves,
 By warm winds deflowered,
 Till the scent it gives
Makes faint with too much sweet these heavy-winged
thieves:

 Sound of vernal showers
 On the twinkling grass,
 Rain-awakened flowers,
 All that ever was
Joyous, and clear, and fresh, thy music doth surpass: 60

 Teach us, sprite or bird,
 What sweet thoughts are thine:
 I have never heard
 Praise of love or wine
That panted forth a flood of rapture so divine.

 Chorus Hymenaeal,
 Or triumphal chaunt,
 Matched with thine would be all
 But an empty vaunt,
A thing wherein we feel there is some hidden want. 70

 What objects are the fountains
 Of thy happy strain?
 What fields, or waves, or mountains?
 What shapes of sky or plain?
What love of thine own kind? what ignorance of pain?

 With thy clear keen joyance
 Languor cannot be:
 Shadow of annoyance
 Never came near thee:
Thou lovest; but ne'er knew love's sad satiety. 80

 Waking or asleep,
 Thou of death must deem
 Things more true and deep
 Than we mortals dream,
Or how could thy notes flow in such a crystal stream?

 We look before and after,
 And pine for what is not:
 Our sincerest laughter
 With some pain is fraught;
Our sweetest songs are those that tell of saddest
thought. 90

 Yet if we could scorn
 Hate, and pride, and fear;
 If we were things born
 Not to shed a tear,
I know not how thy joy we ever should come near.

 Better than all measures
 Of delightful sound,
 Better than all treasures
 That in books are found,
Thy skill to poet were, thou scorner of the ground! 100

 Teach me half the gladness
 That thy brain must know,
 Such harmonious madness
 From my lips would flow,
The world should listen then, as I am listening now.

Don Juan
[1818–24] Lord Byron

Canto 1

109
Julia had honour, virtue, truth, and love
 For Don Alfonso; and she inly swore,
By all the vows below to powers above,
 She never would disgrace the ring she wore,
Nor leave a wish which wisdom might reprove;
 And while she ponder'd this, besides much more.
One hand on Juan's carelessly was thrown.
Quite by mistake—she thought it was her own;

110
Unconsciously she lean'd upon the other,
 Which play'd within the tangles of her hair; 10
And to contend with thoughts she could not smother
 She seem'd, by the distraction of her air.
'Twas surely very wrong in Juan's mother
 To leave together this imprudent pair,
She who for many years had watch'd her son so—
I'm very certain *mine* would not have done so.

111
The hand which still held Juan's, by degrees
 Gently, but palpably confirm'd its grasp,
As if it said, "Detain me, if you please";
 Yet there's no doubt she only meant to clasp 20
His fingers with a pure Platonic squeeze;
 She would have shrunk as from a toad, or asp,
Had she imagined such a thing could rouse
A feeling dangerous to a prudent spouse.

112

I cannot know what Juan thought of this,
 But what he did, is much what you would do;
His young lip thank'd it with a grateful kiss,
 And then, abash'd at its own joy, withdrew
In deep despair, lest he had done amiss.—
 Love is so very timid when 'tis new: 30
She blush'd, and frown'd not, but she strove to speak,
And held her tongue, her voice was grown so weak.

113

The sun set, and up rose the yellow moon:
 The devil's in the moon for mischief; they
Who call'd her CHASTE, methinks, began too soon
 Their nomenclature; there is not a day,
The longest, not the twenty-first of June,
 Sees half the business in a wicked way,
On which three single hours of moonshine smile—
And then she looks so modest all the while. 40

114

There is a dangerous silence in that hour,
 A stillness, which leaves room for the full soul
To open all itself, without the power
 Of calling wholly back its self-control;
The silver light which, hallowing tree and tower,
 Shed beauty and deep softness o'er the whole,
Breathes also to the heart, and o'er it throws
A loving languor, which is not repose.

115

And Julia sate with Juan, half embraced
 And half retiring from the glowing arm,
Which trembled like the bosom where 'twas placed; 50
 Yet still she must have thought there was no harm.
Or else 'twere easy to withdraw her waist;
 But then the situation had its charm,
And then—God knows what next—I can't go on;
I'm almost sorry that I e'er begun.

116

Oh Plato! Plato! you have paved the way,
 With your confounded fantasies, to more
Immoral conduct by the fancied sway
 Your system feigns o'er the controlless core 60
Of human hearts, than all the long array
 Of poets and romancers:—You're a bore,
A charlatan, a coxcomb—and have been,
At best, no better than a go-between.

117

And Julia's voice was lost, except in sighs,
 Until too late for useful conversation;
The tears were gushing from her gentle eyes,
 I wish, indeed, they had not had occasion;
But who, alas! can love, and then be wise?
 Not that remorse did not oppose temptation; 70
A little still she strove, and much repented,
And whispering "I will ne'er consent"—consented.

When a Man Hath No Freedom to Fight for at Home
Lord Byron

When a man hath no freedom to fight for at home,
 Let him combat for that of his neighbours;
Let him think of the glories of Greece and of Rome,
 And get knock'd on the head for his labours.

To do good to mankind is the chivalrous plan,
 And is always as nobly requited;
Then battle for freedom wherever you can,
 And, if not shot or hang'd, you'll get knighted.

Annabel Lee
[1849] Edgar Allan Poe

It was many and many a year ago,
 In a kingdom by the sea,
That a maiden there lived whom you may know
 By the name of Annabel Lee;
And this maiden she lived with no other thought
 Than to love and be loved by me.

I was a child and she was a child,
 In this kingdom by the sea,
But we loved with a love that was more than love,
 I and my Annabel Lee;
With a love that the wingèd seraphs of heaven 10
 Coveted her and me.

And this was the reason that, long ago,
 In this kingdom by the sea,
A wind blew out of a cloud, chilling
 My beautiful Annabel Lee;
So that her highborn kinsmen came
 And bore her away from me,
To shut her up in a sepulchre
 In this kingdom by the sea. 20

The angels, not half so happy in heaven,
 Went envying her and me;
Yes! that was the reason (as all men know,
 In this kingdom by the sea)
That the wind came out of the cloud by night,
 Chilling and killing my Annabel Lee.

But our love it was stronger by far than the love
 Of those who were older than we,
 Of many far wiser than we;
And neither the angels in heaven above, 30
 Nor the demons down under the sea,
Can ever dissever my soul from the soul
 Of the beautiful Annabel Lee:

For the moon never beams, without bringing me dreams
 Of the beautiful Annabel Lee;
And the stars never rise, but I feel the bright eyes
 Of the beautiful Annabel Lee;

And so, all the night-tide, I lie down by the side
Of my darling—my darling—my life and my bride,
 In her sepulchre there by the sea, 40
 In her tomb by the sounding sea.

In Memoriam
[1850] Alfred, Lord Tennyson

"So careful of the type?" but no.
 From scarpèd cliff and quarried stone
 She cries, "A thousand types are gone:
I care for nothing, all shall go.

"Thou makest thine appeal to me:
 I bring to life, I bring to death;
 The spirit does but mean the breath:
I know no more." And he, shall he,

Man, her last work, who seemed so fair,
 Such splendid purpose in his eyes, 10
 Who rolled the psalm to wintry skies,
Who built him fanes of fruitless prayer,

Who trusted God was love indeed
 And love Creation's final law—
 Though Nature, red in tooth and claw
With ravine, shrieked against his creed—

Who loved, who suffered countless ills,
 Who battled for the True, the Just,
 Be blown about the desert dust.
Or sealed within the iron hills? 20

No more? A monster then, a dream,
 A discord. Dragons of the prime,
 That tare each other in their slime,
Were mellow music matched with him.

O life as futile, then, as frail!
 O for thy voice to soothe and bless!
 What hope of answer, or redress?
Behind the veil, behind the veil.

Uncle Tom's Cabin
[1852] Harriet Beecher Stowe

Chapter 23
Henrique

About this time, St Clare's brother Alfred, with his eldest
son, a boy of twelve, spent a day or two with the family at
the lake.

No sight could be more singular and beautiful than that
of these twin brothers. Nature, instead of instituting
resemblances between them, had made them opposites
on every point; yet a mysterious tie seemed to unite them
in a closer friendship than ordinary.

They used to saunter, arm in arm, up and down the
alleys and walks of the garden. Augustine, with his blue
eyes and golden hair, his ethereally flexible form and

vivacious features; and Alfred, dark-eyed, with haughty
Roman profile, firmly-knit limbs, and decided bearing.
They were always abusing each other's opinions and
practices, and yet never a whit the less absorbed in each
other's society; in fact, the very contrariety seemed to
unite them, like the attraction between opposite poles of
the magnet.

Henrique, the eldest son of Alfred, was a noble, dark-
eyed, princely boy, full of vivacity and spirit; and, from the
first moment of introduction, seemed to be perfectly
fascinated by the spirituelle graces of his cousin
Evangeline.

Eva had a little pet pony, of a snowy whiteness. It was
easy as a cradle, and as gentle as its little mistress; and
this pony was now brought up to the back verandah by
Tom, while a little mulatto boy of about thirteen led along
a small black Arabian, which had just been imported, at a
great expense, for Henrique.

Henrique had a boy's pride in his new possession; and,
as he advanced and took the reins out of the hands of his
little groom, he looked carefully over him, and his brow
darkened.

"What's this, Dodo, you little lazy dog! you haven't
rubbed my horse down, this morning."

"Yes, Mas'r," said Dodo, submissively; "he got that dust
on his own self."

"You rascal, shut your mouth!" said Henrique, violently
raising his riding-whip. "How dare you speak?"

The boy was a handsome, bright-eyed mulatto, of just
Henrique's size, and his curling hair hung round a high,
bold forehead. He had white blood in his veins, as could
be seen by the quick flush in his cheek, and the sparkle of
his eye, as he eagerly tried to speak.

"Mas'r Henrique!—" he began.

Henrique struck him across the face with his riding-
whip, and, seizing one of his arms, forced him on to his
knees, and beat him till he was out of breath.

"There, you impudent dog! Now will you learn not to
answer back when I speak to you? Take the horse back,
and clean him properly. I'll teach you your place!"

"Young Mas'r," said Tom, "I specs what he was gwine to
say was, that the horse would roll when he was bringing
him up from the stable; he's so full of spirits,—that's the
way he got that dirt on him; I looked to his cleaning."

"You hold your tongue till you're asked to speak!" said
Henrique, turning on his heel, and walking up the steps to
speak to Eva, who stood in her riding-dress.

"Dear Cousin, I'm sorry this stupid fellow has kept you
waiting," he said. "Let's sit down here, on this seat, till
they come. What's the matter, Cousin?—you look sober."

"How could you be so cruel and wicked to poor Dodo?"
asked Eva.

"Cruel,—wicked!" said the boy, with unaffected
surprise. "What do you mean, dear Eva?"

"I don't want you to call me dear Eva, when you do so,"
said Eva.

"Dear Cousin, you don't know Dodo; it's the only way to
manage him, he's so full of lies and excuses. The only way
is to put him down at once,—not let him open his mouth;
that's the way papa manages."

"But Uncle Tom said it was an accident, and he never

tells what isn't true."

"He's an uncommon old nigger, then!" said Henrique. "Dodo will lie as fast as he can speak."

"You frighten him into deceiving, if you treat him so."

"Why, Eva, you've really taken such a fancy to Dodo, that I shall be jealous."

"But you beat him,—and he didn't deserve it."

"O, well, it may go for some time when he does, and don't get it. A few cuts never come amiss with Dodo,—he's a regular spirit, I can tell you; but I won't beat him again before you, if it troubles you."

Eva was not satisfied, but found it in vain to try to make her handsome cousin understand her feelings.

Dodo soon appeared, with the horses.

"Well, Dodo, you've done pretty well, this time," said his young master, with a more gracious air. "Come, now, and hold Miss Eva's horse while I put her on to the saddle."

Dodo came and stood by Eva's pony. His face was troubled; his eyes looked as if he had been crying.

Henrique, who valued himself on his gentlemanly adroitness in all matters of gallantry, soon had his fair cousin in the saddle, and, gathering the reins, placed them in her hands.

But Eva bent to the other side of the horse, where Dodo was standing, and said, as he relinquished the reins,—"That's a good boy, Dodo;—thank you!"

Dodo looked up in amazement into the sweet young face; the blood rushed to his cheeks, and the tears to his eyes.

"Here, Dodo," said his master, imperiously.

Dodo sprang and held the horse, while his master mounted.

"There's a picayune for you to buy candy with, Dodo," said Henrique; "go get some."

And Henrique cantered down the walk after Eva. Dodo stood looking after the two children. One had given him money; and one had given him what he wanted far more,—a kind word, kindly spoken. Dodo had been only a few months away from his mother. His master had bought him at a slave warehouse, for his handsome face, to be a match to the handsome pony; and he was now getting his breaking in, at the hands of his young master.

The scene of the beating had been witnessed by the two brothers St. Clare, from another part of the garden.

Augustine's cheek flushed; but he only observed, with his usual sarcastic carelessness.

"I suppose that's what we may call republican education, Alfred?"

"Henrique is a devil of a fellow, when his blood's up," said Alfred, carelessly.

"I suppose you consider this an instructive practice for him," said Augustine, drily.

"I couldn't help it, if I didn't. Henrique is a regular little tempest;—his mother and I have given him up, long ago. But, then, that Dodo is a perfect sprite,—no amount of whipping can hurt him."

"And this by way of teaching Henrique the first verse of a republican's catechism, 'All men are born free and equal!'"

"Poh!" said Alfred; "one of Tom Jefferson's pieces of

French sentiment and humbug. It's perfectly ridiculous to have that going the rounds among us, to this day."

"I think it is," said St. Clare, significantly.

"Because," said Alfred, "we can see plainly enough that all men are *not* born free, nor born equal; they are born anything else. For my part, I think half this republican talk sheer humbug. It is the educated, the intelligent, the wealthy, the refined, who ought to have equal rights and not the canaille."

I Hear America Singing
Walt Whitman

I hear America singing, the varied carols I hear,
Those of mechanics, each one singing his as it should be blithe and strong,
The carpenter singing his as he measures his plank or beam,
The mason singing his as he makes ready for work, or leaves off work,
The boatman singing what belongs to him in his boat, the deck-hand singing on the steamboat deck,
The shoemaker singing as he sits on his bench, the hatter singing as he stands,
The wood-cutter's song, the ploughboy's on his way in the morning, or at noon intermission or at sundown,
The delicious singing of the mother, or of the young wife at work, or of the girl sewing or washing.
Each singing what belongs to him or her and to none else,
The day what belongs to the day—at night the party of young fellows, robust, friendly,
Singing with open mouths their strong melodious songs.

By the Bivouac's Fitful Flame
Walt Whitman

By the bivouac's fitful flame,
A procession winding around me, solemn and sweet and slow—but first I note,
The tents of the sleeping army, the fields' and woods' dim outline,
The darkness lit by spots of kindled fire, the silence,
Like a phantom far or near an occasional figure moving,
The shrubs and trees, (as I lift my eyes they seem to be stealthily watching me,)
While wind in procession thoughts, O tender and wondrous thoughts,
Of life and death, of home and the past and loved, and of those that are far away;
A solemn and slow procession there as I sit on the ground.
By the bivouac's fitful flame.

When Lilacs Last in the Dooryard Bloom'd

Walt Whitman

1

When lilacs last in the dooryard bloom'd,
And the great star early droop'd in the western sky in the
night,
I mourn'd, and yet shall mourn with ever-returning spring.
Ever-returning spring, trinity sure to me you bring,
Lilac blooming perennial and drooping star in the west,
And thought of him I love.

2

O powerful western fallen star!
O shades of night—O moody, tearful night!
O great star disappear'd—O the black murk that hides the
star!
O cruel hands that hold me powerless—O helpless soul of
me!
O harsh surrounding cloud that will not free my soul.

3

In the dooryard fronting an old farm-house near the white-
wash'd palings,
Stands the lilac-bush tall-growing with heart-shaped leaves
of rich green,
With many a pointed blossom rising delicate, with the
perfume strong I love,
With every leaf a miracle—and from this bush in the
dooryard,
With delicate-color'd blossoms and heart-shaped leaves of
rich green,
A sprig with its flower I break.

5

Over the breast of the spring, the land, amid cities,
Amid lanes and through old woods, where lately the violets
peep'd from the ground, spotting the gray débris,
Amid the grass in the fields each side of the lanes, passing
the endless grass,
Passing the yellow-spear'd wheat, every grain from its
shroud in the dark-brown fields uprisen,
Passing the apple-tree blows of white and pink in the
orchards,
Carrying a corpse to where it shall rest in the grave,
Night and day journeys a coffin.

6

Coffin that passes through lanes and streets,
Through day and night with the great cloud darkening the
land,
With the pomp of the inloop'd flags with the cities draped
in black,
With the show of the States themselves as of crape veil'd
women standing,
With processions long and winding and the flambeaus of
the night,
With the countless torches lit, with the silent sea of faces
and the unbared heads,

With the waiting depot, the arriving coffin, and the sombre
faces,
With dirges through the night, with the thousand voices
rising strong and solemn,
With all the mournful voices of the dirges pour'd around
the coffin,
The dim-lit churches and the shuddering organs—where
amid these you journey,
With the tolling tolling bells' perpetual clang,
Here, coffin that slowly passes,
I give you my sprig of lilac.

10

O how shall I warble myself for the dead one there I
loved?
And how shall I deck my song for the large sweet soul
that has gone?
And what shall my perfume be for the grave of him I
love?
Sea-winds blown from east and west,
Blown from the Eastern sea and blown from the Western
sea, till there on the prairies meeting,
These and with these and the breath of my chant,
I'll perfume the grave of him I love.

13

Sing on, sing on you gray-brown bird,
Sing from the swamps, the recesses, pour your chant from
the bushes,
Limitless out of the dusk, out of the cedars and pines.
Sing on dearest brother, warble your reedy song,
Loud human song, with voice of uttermost woe.
O liquid and free and tender!
O wild and loose to my soul—O wondrous singer!
You only I hear—yet the star holds me, (but will soon
depart,)
Yet the lilac with mastering odor holds me.

14

Now while I sat in the day and look'd forth,
In the close of the day with its light and the fields of
spring, and the farmers preparing their crops,
In the large unconscious scenery of my land with its lakes
and forests,
In the heavenly aerial beauty, (after the perturb'd winds
and the storms,)
Under the arching heavens of the afternoon swift passing,
and the voices of children and women,
The many-moving sea-tides, and I saw the ships how they
sail'd,
And the summer approaching with richness, and the fields
all busy with labor,
And the infinite separate houses, how they all went on,
each with its meals and minutia of daily usages,
And the streets how their throbbings throbb'd, and the
cities pent—lo, then and there,
Falling upon them all and among them all, enveloping me
with the rest,
Appear'd the cloud, appear'd the long black trail,
And I knew death, its thought, and the sacred knowledge
of death.

Then with the knowledge of death as walking one side of
 me,
And the thought of death close-walking the other side of
 me,
And I in the middle as with companions, and as holding
 the hands of companions,
I fled forth to the hiding receiving night that talks not,
Down to the shores of the water, the path by the swamp in
 the dimness,
To the solemn shadowy cedars and ghostly pines so still.

And the singer so shy to the rest receiv'd me,
The gray-brown bird I know receiv'd us comrades three,
And he sang the carol of death, and a verse for him I love.

From deep secluded recesses,
From the fragrant cedars and the ghostly pines so still,
Came the carol of the bird.

And the charm of the carol rapt me,
As I held as if by their hands my comrades in the night,
And the voice of my spirit tallied the song of the bird.

Come lovely and soothing death,
Undulate round the world, serenely arriving, arriving,
In the day, in the night, to all, to each,
Sooner or later delicate death.

Prais'd be the fathomless universe,
For life and joy, and for objects and knowledge curious,
And for love, sweet love—but praise! praise! praise!
For the sure-enwinding arms of cool-enfolding death.

Dark mother always gliding near with soft feet,
Have none chanted for thee a chant of fullest welcome?
Then I chant for thee, I glorify thee above all,
I bring thee a song that when thou must indeed come, come
 unfalteringly.

Approach strong deliveress,
When it is so, when thou hast taken them I joyously sing the dead,
Lost in the loving floating ocean of thee,
Laved in the flood of thy bliss O death.

From me to thee glad serenades,
Dances for thee I propose saluting thee, adornments and feastings for
 thee,
And the sights of the open landscape and the high-spread sky are
 fitting,
And life and the fields, and the huge and thoughtful night.

The night in silence under many a star,
The ocean shore and the husky whispering wave whose voice I know,
And the soul turning to thee O vast and well-veil'd death,
And the body gratefully nestling close to thee.

Over the tree-tops I float thee a song,
Over the rising and sinking waves, over the myriad fields and the
 prairies wide,
Over the dense-pack'd cities all and the teeming wharves and ways,
I float this carol with joy, with joy to thee O death.

And I saw askant the armies,
I saw as in noiseless dreams hundreds of battle-flags,
Borne through the smoke of the battles and pierc'd with
 missiles I saw them,

And carried hither and yon through the smoke, and torn
 and bloody,
And at last but a few shreds left on the staffs (and all in
 silence),
And the staffs all splinter'd and broken.

I saw battle-corpses, myriads of them,
And the white skeletons of young men, I saw them,
I saw the debris and debris of all the slain soldiers of the
 war.
But I saw they were not as was thought,
They themselves were fully at rest, they suffer'd not,
The living remain'd and suffer'd, the mother suffer'd,
And the wife and the child and the musing comrade
 suffer'd,
And the armies that remain'd suffer'd.

16
Passing the visions, passing the night.
Passing, unloosing the hold of my comrades' hands,
Passing the song of the hermit bird and the tallying song
 of my soul,
Victorious song, death's outlet song, yet varying ever-
 altering song,
As low and wailing, yet clear the notes, rising and falling,
 flooding the night,
Sadly sinking and fainting, as warning and warning, and yet
 again bursting with joy,
Covering the earth and filling the spread of the heaven,
As that powerful psalm in the night I heard from recesses.
Passing, I leave thee lilac with heart-shaped leaves,
I leave thee there in the door-yard, blooming, returning
 with spring.

I cease from my song for thee,
From my gaze on thee in the west, fronting the west,
 communing with thee,
O comrade lustrous with silver face in the night.

Yet each to keep and all, retrievements out of the night,
The song, the wondrous chant of the gray-brown bird,
And the tallying chant, the echo arous'd in my soul,
With the lustrous and drooping star with the countenance
 full of woe,
With the holders holding my hand nearing the call of the
 bird,
Comrades mine and I in the midst, and their memory ever
 to keep, for the dead I loved so well,
For the sweetest, wisest soul of all my days and
 lands—and this for his dear sake,
Lilac and star and bird twined with the chant of my soul,
There in the fragrant pines and the cedars dusk and dim.

The Origin of Species

[1859] Charles Darwin

Introduction

[...] In considering the Origin of Species, it is quite conceivable that a naturalist, reflecting on the mutual affinities of organic beings, on their embryological relations, their geographical distribution, geological succession, and other such facts, might come to the conclusion that species had not been independently created, but had descended, like varieties, from other species. Nevertheless, such a conclusion, even if well founded would be unsatisfactory, until it could be shown how the innumerable species inhabiting this world have been modified, so as to acquire that perfection of structure and coadaptation which justly excites our admiration. Naturalists continually refer to external conditions, such as climate, food, &c., as the only possible cause of variation. In one limited sense, as we shall hereafter see, this may be true; but it is preposterous to attribute to mere external conditions, the structure, for instance, of the woodpecker, with its feet, tail, beak, and tongue, so admirably adapted to catch insects under the bark of trees. In the case of the mistletoe, which draws its nourishment from certain trees, which has seeds that must be transported by certain birds, and which has flowers with separate sexes absolutely requiring the agency of certain insects to bring pollen from one flower to the other, it is equally preposterous to account for the structure of this parasite, with its relations to several distinct organic beings, by the effects of external conditions, or of habit, or of the volition of the plant itself.

It is, therefore, of the highest importance to gain a clear insight into the means of modification and coadaptation. At the commencement of my observations it seemed to me probable that a careful study of domesticated animals and of cultivated plants would offer the best chance of making out this obscure problem. Nor have I been disappointed; in this and in all other perplexing cases I have invariably found that our knowledge, imperfect though it be, of variation under domestication, afforded the best and safest clue. I may venture to express my conviction of the high value of such studies, although they have been very commonly neglected by naturalists...

Chapter 2: Variation under nature
Individual Differences

The many slight differences which appear in the offspring from the same parents, or which it may be presumed have thus arisen, from being observed in the individuals of the same species inhabiting the same confined locality, may be called individual differences. No one supposes that all the individuals of the same species are cast in the same actual mould. These individual differences are of the highest importance for us, for they are often inherited, as must be familiar to every one; and they thus afford materials for natural selection to act on and accumulate, in the same manner as man accumulates in any given direction individual differences in his domesticated productions. These individual differences generally affect what naturalists consider unimportant parts; but I could show by a long catalogue of facts, that parts which must be called important, whether viewed under a physiological or classificatory point of view, sometimes vary in the individuals of the same species. I am convinced that the most experienced naturalist would be surprised at the number of the cases of variability, even in important parts of structure, which he could collect on good authority, as I have collected, during a course of years. It should be remembered that systematists are far from being pleased at finding variability in important characters, and that there are not many men who will laboriously examine internal and important organs, and compare them in many specimens of the same species. It would never have been expected that the branching of the main nerves close to the great central ganglion of an insect would have been variable in the same species; it might have been thought that changes of this nature could have been effected only by slow degrees; yet Sir J. Lubbock has shown a degree of variability in these main nerves in Coccus, which may almost be compared to the irregular branching of a stem of a tree. This philosophical naturalist, I may add, has also shown that the muscles in the larvae of certain insects are far from uniform. Authors sometimes argue in a circle when they state that important organs never vary; for those same authors practically rank those parts as important (as some few naturalists have honestly confessed) which do not vary; and, under this point of view, no instance will ever be found of an important part varying; but under any other point of view many instances assuredly can be given.

There is one point connected with individual differences, which is extremely perplexing: I refer to those genera which have been called "protean" or "polymorphic," in which the species present an inordinate amount of variation. With respect to many of these forms, hardly two naturalists agree whether to rank them as species or as varieties. We may instance Rubus, Rosa, and Hieracium amongst plants, several genera of insects and of Brachiopod shells. In most polymorphic genera some of the species have fixed and definite characters. Genera which are polymorphic in one country seem to be, with a few exceptions, polymorphic in other countries, and likewise, judging from Brachiopod shells, at former periods of time. These facts are very perplexing, for they seem to show that this kind of variability is independent of the conditions of life. I am inclined to suspect that we see, at least in some of these polymorphic genera, variations which are of no service or disservice to the species, and which consequently have not been seized on and rendered definite by natural selection, as hereafter to be explained.

Individuals of the same species often present, as is known to every one, great differences of structure, independently of variation, as in the two sexes of various animals, in the two or three castes of sterile females or workers amongst insects, and in the immature and larval states of many of the lower animals. There are, also, cases of dimorphism and trimorphism, both with animals and plants. Thus, Mr. Wallace, who has lately called attention to the subject, has shown that the females of certain species of butterflies, in the Malayan archipelago, regularly

appear under two or even three conspicuously distinct forms, not connected by intermediate varieties. Fritz Müller has described analogous but more extra-ordinary cases with the males of certain Brazilian Crustaceans: thus, the male of the Tanais regularly occurs under two distinct forms; one of these has strong and differently shaped pincers, and the other has antennae much more abundantly furnished with smelling-hairs. Although in most of these cases, the two or three forms, both with animals and plants are not now connected by intermediate gradations, it is probable that they were once thus connected. Mr. Wallace, for instance, describes a certain butterfly which presents in the same island a great range of varieties connected by intermediate links, and the extreme links of the chain closely resemble the two forms of an allied dimorphic species inhabiting another part of the Malay archipelago. Thus also with ants, the several worker-castes are generally quite distinct: but in some cases, as we shall hereafter see, the castes are connected together by finely graduated varieties. So it is, as I myself observed, with some dimorphic plants. It certainly at first appears a highly remarkable fact that the same female butterfly should have the power of producing at the same time three distinct female forms and a male; and that an hermaphrodite plant should produce from the same seed-capsule three distinct hermaphrodite forms, bearing three different kinds of females and three or even six different kinds of males. Nevertheless these cases are only exaggerations of the common fact that the female produces offspring of two sexes which sometimes differ from each other in a wonderful manner. . . .

Chapter 6: Difficulties of the theory

Long before the reader has arrived at this part of my work, a crowd of difficulties will have occurred to him. Some of them are so serious that to this day I can hardly reflect on them without being in some degree staggered; but, to the best of my judgment, the greater number are only apparent, and those that are real are not, I think, fatal to the theory.

These difficulties and objections may be classed under the following heads:—First, why, if species have descended from other species by fine gradations, do we not everywhere see innumerable transitional forms? Why is not all nature in confusion, instead of the species being, as we see them, well defined?

Secondly, is it possible that an animal having, for instance, the structure and habits of a bat, could have been formed by the modification of some other animal with widely different habits and structure? Can we believe that natural selection could produce, on the one hand, an organ of trifling importance, such as the tail of a giraffe, which serves as a fly-flapper, and, on the other hand, an organ so wonderful as the eye?

Thirdly, can instincts be acquired and modified through natural selection? What shall we say to the instinct which leads the bee to make cells, and which has practically anticipated the discoveries of profound mathematicians?

Fourthly, how can we account for species, when crossed, being sterile and producing sterile offspring, whereas, when varieties are crossed, their fertility is unimpaired? . . .

Summary: the Law of Unity of Type and of the Conditions of Existence embraced by the Theory of Natural Selection

We have in this chapter discussed some of the difficulties and objections which may be urged against the theory. Many of them are serious; but I think that in the discussion light has been thrown on several facts, which on the belief of independent acts of creation are utterly obscure. We have seen that species at any one period are not indefinitely variable, and are not linked together by a multitude of intermediate gradations, partly because the process of natural selection is always very slow, and at any one time acts only on a few forms; and partly because the very process of natural selection implies the continual supplanting and extinction of preceding and intermediate gradations. Closely allied species, now living on a continuous area, must often have been formed when the area was not continuous, and when the conditions of life did not insensibly graduate away from one part to another. When two varieties are formed in two districts of a continuous area, an intermediate variety will often be formed, fitted for an intermediate zone; but from reasons assigned, the intermediate variety will usually exist in lesser numbers than the two forms which it connects; consequently the two latter, during the course of further modification, from existing in greater numbers, will have a great advantage over the less numerous intermediate variety, and will thus generally succeed in supplanting and exterminating it.

We have seen in this chapter how cautious we should be in concluding that the most different habits of life could not graduate into each other; that a bat, for instance, could not have been formed by natural selection from an animal which at first only glided through the air.

We have seen that a species under new conditions of life may change its habits; or it may have diversified habits, with some very unlike those of its nearest congeners. Hence we can understand, bearing in mind that each organic being is trying to live wherever it can live, how it has arisen that there are upland geese with webbed feet, ground woodpeckers, diving thrushes, and petrels with the habits of auks.

Although the belief that an organ so perfect as the eye could have been formed by natural selection, is enough to stagger any one; yet in the case of any organ, if we know of a long series of gradations in complexity, each good for its possessor, then, under changing conditions of life, there is no logical impossibility in the acquirement of any conceivable degree of perfection through natural selection. In the cases in which we know of no intermediate or transitional states, we should be extremely cautious in concluding that none can have existed, for the metamorphoses of many organs show what wonderful changes in function are at least possible. For instance, a swimbladder has apparently been converted into an air-breathing lung. The same organ having performed simultaneously very different functions, and then having been in part or in whole specialised for one function; and two distinct organs having performed at the same time the same function, the one having been perfected whilst aided by the other, must often have largely facilitated transitions.

We have seen that in two beings widely remote from each other in the natural scale, organs serving for the same purpose and in external appearance closely similar may have been separately and independently formed; but when such organs are closely examined, essential differences in their structure can almost always be detected; and this naturally follows from the principle of natural selection. On the other hand, the common rule throughout nature is infinite diversity of structure for gaining the same end; and this again naturally follows from the same great principle.

In many cases we are far too ignorant to be enabled to assert that a part or organ is so unimportant for the welfare of a species, that modifications in its structure could not have been slowly accumulated by means of natural selection. In many other cases, modifications are probably the direct result of the laws of variation or of growth, independently of any good having been thus gained. But even such structures have often, as we may feel assured, been subsequently taken advantage of, and still further modified, for the good of species under new conditions of life. We may, also, believe that a part formerly of high importance has frequently been retained (as the tail of an aquatic animal by its terrestrial descendants), though it has become of such small importance that it could not, in its present state, have been acquired by means of natural selection.

Natural selection can produce nothing in one species for the exclusive good or injury of another; though it may well produce parts, organs, and excretions highly useful or even indispensable, or again highly injurious to another species, but in all cases at the same time useful to the possessor. In each well-stocked country natural selection acts through the competition of the inhabitants, and consequently leads to success in the battle for life, only in accordance with the standard of that particular country. Hence the inhabitants of one country, generally the smaller one, often yield to the inhabitants of another and generally the larger country. For in the larger country there will have existed more individuals and more diversified forms, and the competition will have been severer, and thus the standard of perfection will have been rendered higher. Natural selection will not necessarily lead to absolute perfection; nor, as far as we can judge by our limited faculties, can absolute perfection be everywhere predicated.

On the theory of natural selection we can clearly understand the full meaning of that old canon in natural history, "Natura non facit saltum."[1] This canon, if we look to the present inhabitants alone of the world, is not strictly correct; but if we include all those of past times, whether known or unknown, it must on this theory be strictly true.

It is generally acknowledged that all organic beings have been formed on two great laws—Unity of Type, and the Conditions of Existence. By unity of type is meant that fundamental agreement in structure which we see in organic beings of the same class, and which is quite independent of their habits of life. On my theory, unity of type is explained by unity of descent. The expression of conditions of existence, so often insisted on by the illustrious Cuvier, is fully embraced by the principle of natural selection. For natural selection acts by either now adapting the varying parts of each being to its organic and inorganic conditions of life; or by having adapted them during past periods of time: the adaptations being aided in many cases by the increased use or disuse of parts, being affected by the direct action of the external conditions of life, and subjected in all cases to the several laws of growth and variation. Hence, in fact, the law of the Conditions of Existence is the higher law; as it includes, through the inheritance of former variations and adaptations, that of Unity of Type.

Address Delivered at the Dedication of the Cemetery at Gettysburg November 19, 1863

Abraham Lincoln

Four score and seven years ago our fathers brought forth on this continent, a new nation, conceived in Liberty, and dedicated to the proposition that all men are created equal.

Now we are engaged in a great civil war, testing whether that nation, or any nation so conceived and so dedicated, can long endure. We are met on a great battle-field of that war. We have come to dedicate a portion of that field, as a final resting place for those who here gave their lives that that nation might live. It is altogether fitting and proper that we should do this.

But, in a larger sense, we can not dedicate—we can not consecrate—we can not hallow—this ground. The brave men, living and dead, who struggled here, have consecrated it, far above our poor power to add or detract. The world will little note, nor long remember what we say here, but it can never forget what they did here. It is for us the living, rather, to be dedicated here to the unfinished work which they who fought here have thus far so nobly advanced. It is rather for us to be here dedicated to the great task remaining before us—that from these honored dead we take increased devotion to that cause for which they gave the last full measure of devotion—that we here highly resolve that these dead shall not have died in vain—that this nation, under God, shall have a new birth of freedom—and that government of the people, by the people, for the people, shall not perish from the earth.

1. "Nature does not proceed by leaps": Linnaeus, Philosophica Botanica.

A Doll's House
[1879] Henrik Ibsen

A Doll's House created a major scandal, especially in London, where "Ibsenism" became a fashionable topic of conversation. In it Ibsen shows how society represses the freedom of the individual. Helmer unwittingly enslaves his wife Nora both intellectually and financially. But in the final scene, when her deception of him is revealed, she declares her freedom.

CHARACTERS

Mrs Linde
Krogstad
Helmer
Nora
Doctor Rank
Maid

Act III

[The table has been placed in the middle of the stage, with chairs round it. A lamp is burning on the table. The door into the hall stands open. Dance music is heard in the room above. MRS LINDE is sitting at the table idly turning over the leaves of a book; she tries to read, but does not seem able to collect her thoughts. Every now and then she listens intently for a sound at the outer door.]

Mrs Linde: [Looking at her watch] Not yet—and the time is nearly up. If only he does not—. [Listens again.] Ah, there he is. [Goes into the hall and opens the outer door carefully. Light footsteps are heard on the stairs. She whispers.] Come in. There is no one here.

Krogstad: [In the doorway] I found a note from you at home. What does this mean?

Mrs Linde: It is absolutely necessary that I should have a talk with you.

Krogstad: Really? And is it absolutely necessary that it should be here?

Mrs Linde: It is impossible where I live; there is no private entrance to my rooms. Come in; we are quite alone. The maid is asleep, and the Helmers are at the dance upstairs.

Krogstad: [Coming into the room] Are the Helmers really at a dance to-night?

Mrs Linde: Yes, why not?

Krogstad: Certainly—why not?

Mrs Linde: Now, Nils, let us have a talk.

Krogstad: Can we two have anything to talk about?

Mrs Linde: We have a great deal to talk about.

Krogstad: I shouldn't have thought so.

Mrs Linde: No, you have never properly understood me.

Krogstad: Was there anything else to understand except what was obvious to all the world—a heartless woman jilts a man when a more lucrative chance turns up?

Mrs Linde: Do you believe I am as absolutely heartless as all that? And do you believe that I did it with a light heart?

Krogstad: Didn't you?

Mrs Linde: Nils, did you really think that?

Krogstad: If it were as you say, why did you write to me as you did at the time?

Mrs Linde: I could do nothing else. As I had to break with you, it was my duty also to put an end to all that you felt for me.

Krogstad: [Wringing his hands] So that was it. And all this—only for the sake of money!

Mrs Linde: You must not forget that I had a helpless mother and two little brothers. We couldn't wait for you, Nils; your prospects seemed hopeless then.

Krogstad: That may be so, but you had no right to throw me over for anyone else's sake.

Mrs Linde: Indeed I don't know. Many a time did I ask myself if I had the right to do it.

Krogstad: [More gently] When I lost you, it was as if all the solid ground went from under my feet. Look at me now—I am a shipwrecked man clinging to a bit of wreckage.

Mrs Linde: But help may be near.

Krogstad: It was near; but then you came and stood in my way.

Mrs Linde: Unintentionally, Nils. It was only to-day that I learnt it was your place I was going to take in the Bank.

Krogstad: I believe you, if you say so. But now that you know it, are you not going to give it up to me?

Mrs Linde: No, because that would not benefit you in the least.

Krogstad: Oh, benefit, benefit—I would have done it whether or no.

Mrs Linde: I have learnt to act prudently. Life, and hard, bitter necessity have taught me that.

Krogstad: And life has taught me not to believe in fine speeches.

Mrs Linde: Then life has taught you something very reasonable. But deeds you must believe in?

Krogstad: What do you mean by that?

Mrs Linde: You said you were like a shipwrecked man clinging to some wreckage.

Krogstad: I had good reason to say so.

Mrs Linde: Well, I am like a shipwrecked woman clinging to some wreckage—no one to mourn for, no one to care for.

Krogstad: It was your own choice.

Mrs Linde: There was no other choice—then.

Krogstad: Well, what now?

Mrs Linde: Nils, how would it be if we two shipwrecked people could join forces?

Krogstad: What are you saying?

Mrs Linde: Two on the same piece of wreckage would stand a better chance than each on their own.

Krogstad: Christine!

Mrs Linde: What do you suppose brought me to town?

Krogstad: Do you mean that you gave me a thought?

Mrs Linde: I could not endure life without work. All my life, as long as I can remember, I have worked, and it has been my greatest and only pleasure. But now I am quite alone in the world—my life is so dreadfully empty and I feel so forsaken. There is not the least pleasure in working for one's self. Nils, give me someone and something to work for.

Krogstad: I don't trust that. It is nothing but a woman's

overstrained sense of generosity that prompts you to make such an offer of yourself.

Mrs Linde: Have you ever noticed anything of the sort in me?

Krogstad: Could you really do it? Tell me—do you know all about my past life?

Mrs Linde: Yes.

Krogstad: And do you know what they think of me here?

Mrs Linde: You seemed to me to imply that with me you might have been quite another man.

Krogstad: I am certain of it.

Mrs Linde: Is it too late now?

Krogstad: Christine, are you saying this deliberately? Yes, I am sure you are. I see it in your face. Have you really the courage, then—?

Mrs Linde: I want to be a mother to someone, and your children need a mother. We two need each other. Nils, I have faith in your real character—I can dare anything together with you.

Krogstad: [*Grasps her hands*] Thanks, thanks, Christine! Now I shall find a way to clear myself in the eyes of the world. Ah, but I forgot—

Mrs Linde: [*Listening*] Hush! The Tarantella! Go, go!

Krogstad: Why? What is it?

Mrs Linde: Do you hear them up there? When that is over, we may expect them back.

Krogstad: Yes, yes—I will go. But it is all no use. Of course you are not aware what steps I have taken in the matter of the Helmers.

Mrs Linde: Yes, I know all about that.

Krogstad: And in spite of that have you the courage to—!

Mrs Linde: I understand very well to what lengths a man like you might be driven by despair.

Krogstad: If I could only undo what I have done!

Mrs Linde: You cannot. Your letter is lying in the letter-box now.

Krogstad: Are you sure of that?

Mrs Linde: Quite sure, but—

Krogstad: [*With a searching look at her*] Is that what it all means?—that you want to save your friend at any cost? Tell me frankly. Is that it?

Mrs Linde: Nils, a woman who has once sold herself for another's sake, doesn't do it a second time.

Krogstad: I will ask for my letter back.

Mrs Linde: No, no.

Krogstad: Yes, of course I will. I will wait here till Helmer comes; I will tell him he must give me my letter back—that it only concerns my dismissal—that he is not to read it—

Mrs Linde: No, Nils, you must not recall your letter.

Krogstad: But, tell me, wasn't it for that very purpose that you asked me to meet you here?

Mrs Linde: In my first moment of fright, it was. But twenty-four hours have elapsed since then, and in that time I have witnessed incredible things in this house. Helmer must know all about it. This unhappy secret must be disclosed; they must have a complete understanding between them, which is impossible with all this concealment and falsehood going on.

Krogstad: Very well, if you will take the responsibility. But there is one thing I can do in any case, and I shall do it at once.

Mrs Linde: [*Listening*] You must be quick and go! The dance is over; we are not safe a moment longer.

Krogstad: I will wait for you below.

Mrs Linde: Yes, do. You must see me back to my door.

Krogstad: I have never had such an amazing piece of good fortune in my life! [*Goes out through the outer door. The door between the room and the hall remains open.*]

Mrs Linde: [*Tidying up the room and laying her hat and cloak ready*] What a difference! what a difference! Some one to work for and live for—a home to bring comfort into. That I will do, indeed. I wish they would be quick and come— [*Listens*] Ah, there they are now. I must put on my things.

> [*Takes up her hat and cloak.* HELMER'S *and* NORA'S *voices are heard outside; a key is turned, and* HELMER *brings* NORA *almost by force into the hall. She is in an Italian costume with a large black shawl round her; he is in evening dress, and a black domino[1] which is flying open.*]

Nora: [*Hanging back in the doorway, and struggling with him*] No, no, no!—don't take me in. I want to go upstairs again; I don't want to leave so early.

Helmer: But, my dearest Nora—

Nora: Please, Torvald dear—please, *please*—only an hour more.

Helmer: Not a single minute, my sweet Nora. You know that was our agreement. Come along into the room; you are catching cold standing there. [*He brings her gently into the room, in spite of her resistance.*]

Mrs Linde: Good-evening.

Nora: Christine!

Helmer: You here, so late, Mrs Linde?

Mrs Linde: Yes, you must excuse me; I was so anxious to see Nora in her dress.

Nora: Have you been sitting here waiting for me?

Mrs Linde: Yes, unfortunately I came too late, you had already gone upstairs; and I thought I couldn't go away again without having seen you.

Helmer: [*Taking off* NORA'S *shawl*] Yes, take a good look at her. I think she is worth looking at. Isn't she charming, Mrs Linde?

Mrs Linde: Yes, indeed she is.

Helmer: Doesn't she look remarkably pretty? Everyone thought so at the dance. But she is terribly self-willed, this sweet little person. What are we to do with her? You will hardly believe that I had almost to bring her away by force.

Nora: Torvald, you will repent not having let me stay, even if it were only for half an hour.

Helmer: Listen to her, Mrs Linde! She had danced her Tarantella, and it had been a tremendous success, as it deserved—although possibly the performance was a trifle too realistic—a little more so, I mean, than was strictly compatible with the limitations of art. But never mind about that! The chief thing is, she had made a success— she had made a tremendous success. Do you think I was going to let her remain there after that, and spoil the effect? No, indeed! I took my charming little Capri maiden—my capricious little Capri maiden, I should say—on my arm; took one quick turn round the room; a

1. cloak with mask for face.

curtsey on either side, and, as they say in novels, the beautiful apparition disappeared. An exit ought always to be effective, Mrs Linde; but that is what I cannot make Nora understand. Pooh! this room is hot. [*Throws his domino on a chair, and opens the door of his room.*] Hullo! it's all dark in here. Oh, of course—excuse me—. [*He goes in, and lights some candles.*]

Nora: [*In a hurried and breathless whisper*] Well?

Mrs Linde: [*In a low voice*] I have had a talk with him.

Nora: Yes, and—

Mrs Linde: Nora, you must tell your husband all about it.

Nora: [*In an expressionless voice*] I knew it.

Mrs Linde: You have nothing to be afraid of as far as Krogstad is concerned; but you must tell him.

Nora: I won't tell him.

Mrs Linde: Then the letter will.

Nora: Thank you, Christine. Now I know what I must do. Hush—!

Helmer: [*Coming in again*] Well, Mrs Linde, have you admired her?

Mrs Linde: Yes, and now I will say good-night.

Helmer: What, already? Is this yours, this knitting?

Mrs Linde: [*Taking it*] Yes, thank you, I had very nearly forgotten it.

Helmer: So you knit?

Mrs Linde: Of course.

Helmer: Do you know, you ought to embroider.

Mrs Linde: Really? Why?

Helmer: Yes, it's far more becoming. Let me show you. You hold the embroidery thus in your left hand, and use the needle with the right—like this—with a long, easy sweep. Do you see?

Mrs Linde: Yes, perhaps—

Helmer: But in the case of knitting—that can never be anything but ungraceful; look here—the arms close together, the knitting-needles going up and down—it has a sort of Chinese effect—. That was really excellent champagne they gave us.

Mrs Linde: Well,—good-night, Nora, and don't be self-willed any more.

Helmer: That's right, Mrs Linde.

Mrs Linde: Good-night, Mr Helmer.

Helmer: [*Accompanying her to the door*] Good-night, good-night. I hope you will get home all right. I should be very happy to—but you haven't any great distance to go. Good-night, good-night. [*She goes out; he shuts the door after her, and comes in again.*] Ah!—at last we have got rid of her. She is a frightful bore, that woman.

Nora: Aren't you very tired, Torvald?

Helmer: No, not in the least.

Nora: Nor sleepy?

Helmer: Not a bit. On the contrary, I feel extraordinarily lively. And you?—you really look both tired and sleepy.

Nora: Yes, I am very tired. I want to go to sleep at once.

Helmer: There, you see it was quite right of me not to let you stay there any longer.

Nora: Everything you do is quite right, Torvald.

Helmer: [*Kissing her on the forehead*] Now my little skylark is speaking reasonably. Did you notice what good spirits Rank was in this evening?

Nora: Really? Was he? I didn't speak to him at all.

Helmer: And I very little, but I have not for a long time seen him in such good form. [*Looks for a while at her and then goes nearer to her.*] It is delightful to be at home by ourselves again, to be all alone with you—you fascinating, charming little darling!

Nora: Don't look at me like that. Torvald.

Helmer: Why shouldn't I look at my dearest treasure?—at all the beauty that is mine, all my very own?

Nora: [*Going to the other side of the table*] You mustn't say things like that to me to-night.

Helmer: [*Following her*] You have still got the Tarantella in your blood, I see. And it makes you more captivating than ever. Listen—the guests are beginning to go now. [*In a lower voice.*] Nora—soon the whole house will be quiet.

Nora: Yes, I hope so.

Helmer: Yes, my own darling Nora. Do you know, when I am out at a party with you like this, why I speak so little to you, keep away from you, and only send a stolen glance in your direction now and then?—do you know why I do that? It is because I make believe to myself that we are secretly in love, and you are my secretly promised bride, and that no one suspects there is anything between us.

Nora: Yes, yes—I know very well your thoughts are with me all the time.

Helmer: And when we are leaving, and I am putting the shawl over your beautiful young shoulders—on your lovely neck—then I imagine that you are my young bride and that we have just come from the wedding, and I am bringing you for the first time into our home—to be alone with you for the first time—quite alone with my shy little darling! All this evening I have longed for nothing but you. When I watched the seductive figures of the Tarantella, my blood was on fire; I could endure it no longer, and that was why I brought you down so early—

Nora: Go away, Torvald! You must let me go. I won't—

Helmer: What's that? You're joking, my little Nora! You won't—you won't? Am I not your husband—? [*A knock is heard at the outer door.*]

Nora: [*Starting*] Did you hear—?

Helmer: [*Going into the hall*] Who is it?

Rank: [*Outside*] It is I. May I come in for a moment?

Helmer: [*In a fretful whisper*] Oh, what does he want now? [*Aloud.*] Wait a minute! [*Unlocks the door.*] Come, that's kind of you not to pass by our door.

Rank: I thought I heard your voice, and felt as if I should like to look in. [*With a swift glance round.*] Ah, yes!—these dear familiar rooms. You are very happy and cosy in here, you two.

Helmer: It seems to me that you looked after yourself pretty well upstairs too.

Rank: Excellently. Why shouldn't I? Why shouldn't one enjoy everything in this world?—at any rate as much as one can, and as long as one can. The wine was capital—

Helmer: Especially the champagne.

Rank: So you noticed that too? It is almost incredible how much I managed to put away!

Nora: Torvald drank a great deal of champagne to-night too.

Rank: Did he?

Nora: Yes, and he is always in such good spirits afterwards.

Rank: Well, why should one not enjoy a merry evening after a well-spent day?

Helmer: Well spent? I am afraid I can't take credit for that.

Rank: |*Slapping him on the back*| But I can, you know!

Nora: Doctor Rank, you must have been occupied with some scientific investigation to-day.

Rank: Exactly.

Helmer: Just listen!—little Nora talking about scientific investigations!

Nora: And may I congratulate you on the result?

Rank: Indeed you may.

Nora: Was it favorable, then?

Rank: The best possible, for both doctor and patient—certainty.

Nora: |*Quickly and searchingly*| Certainty?

Rank: Absolute certainty. So wasn't I entitled to make a merry evening of it after that?

Nora: Yes, you certainly were, Doctor Rank.

Helmer: I think so too, so long as you don't have to pay for it in the morning.

Rank: Oh well, one can't have anything in this life without paying for it.

Nora: Doctor Rank—are you fond of fancy-dress balls?

Rank: Yes, if there is a fine lot of pretty costumes.

Nora: Tell me—what shall we two wear at the next?

Helmer: Little featherbrain!—are you thinking of the next already?

Rank: We two? Yes, I can tell you. You shall go as a good fairy—

Helmer: Yes, but what do you suggest as an appropriate costume for that?

Rank: Let your wife go dressed just as she is in everyday life.

Helmer: That was really very prettily turned. But can't you tell us what you will be?

Rank: Yes, my dear friend, I have quite made up my mind about that.

Helmer: Well?

Rank: At the next fancy-dress ball I shall be invisible.

Helmer: That's a good joke!

Rank: There is a big black hat—have you never heard of hats that make you invisible? If you put one on, no one can see you.

Helmer: |*Suppressing a smile*| Yes, you are quite right.

Rank: But I am clean forgetting what I came for. Helmer, give me a cigar—one of the dark Havanas.

Helmer: With the greatest pleasure. |*Offers him his case.*|

Rank: |*Takes a cigar and cuts off the end*| Thanks.

Nora: |*Striking a match*| Let me give you a light.

Rank: Thank you. |*She holds the match for him to light his cigar.*| And now good-bye!

Helmer: Goodbye, good-bye, dear old man!

Nora: Sleep well, Doctor Rank.

Rank: Thank you for that wish.

Nora: Wish me the same.

Rank: You? Well, if you want me to, sleep well! And thanks for the light. |*He nods to them both and goes out.*|

Helmer: |*In a subdued voice*| He has drunk more than he ought.

Nora: |*Absently*| Maybe. |*HELMER takes a bunch of keys out of his pocket and goes into the hall.*| Torvald! what are you going to do there?

Helmer: Empty the letter-box; it is quite full; there will be no room to put the newspaper in to-morrow morning.

Nora: Are you going to work to-night?

Helmer: You know quite well I'm not. What is this? Someone has been at the lock.

Nora: At the lock—?

Helmer: Yes, someone has. What can it mean? I should never have thought the maid—. Here is a broken hairpin. Nora, it is one of yours.

Nora: |*Quickly*| Then it must have been the children—

Helmer: Then you must get them out of those ways. There, at last I have got it open. |*Takes out the contents of the letter-box, and calls to the kitchen.*| Helen!—Helen, put out the light over the front door. |*Goes back into the room and shuts the door into the hall. He holds out his hand full of letters.*| Look at that—look what a heap of them there are. |*Turning them over.*| What on earth is that?

Nora: |*At the window*| The letter—No! Torvald, no!

Helmer: Two cards—of Rank's.

Nora: Of Doctor Rank's?

Helmer: |*Looking at them*| Doctor Rank. They were on the top. He must have put them in when he went out.

Nora: Is there anything written on them?

Helmer: There is a black cross over the name. Look there—what an uncomfortable idea! It looks as if he were announcing his own death.

Nora: It is just what he is doing.

Helmer: What? Do you know anything about it? Has he said anything to you?

Nora: Yes. He told me that when the cards came it would be his leave-taking from us. He means to shut himself up and die.

Helmer: My poor old friend! Certainly I knew we should not have him very long with us. But so soon! And so he hides himself away like a wounded animal.

Nora: If it has to happen, it is best it should be without a word—don't you think so, Torvald?

Helmer: |*Walking up and down*| He had so grown into our lives. I can't think of him as having gone out of them. He, with his sufferings and his loneliness, was like a cloudy background to our sunlit happiness. Well, perhaps it is best so. For him, anyway. |*Standing still.*| And perhaps for us too, Nora. We two are thrown quite upon each other now. |*Puts his arms round her.*| My darling wife, I don't feel as if I could hold you tight enough. Do you know, Nora, I have often wished that you might be threatened by some great danger, so that I might risk my life's blood, and everything, for your sake.

Nora: |*Disengages herself, and says firmly and decidedly*| Now you must read your letters, Torvald.

Helmer: No, no; not to-night. I want to be with you, my darling wife.

Nora: With the thought of your friend's death—

Helmer: You are right, it has affected us both. Something ugly has come between us—the thought of the horrors of death. We must try and rid our minds of that. Until then—we will each go to our own room.

Nora: |*Hanging on his neck*| Good-night, Torvald—Good-night!

Helmer: |*Kissing her on the forehead*| Good-night, my little

singing-bird. Sleep sound, Nora. Now I will read my letters through. [*He takes his letters and goes into his room, shutting the door after him.*]

Nora: [*Gropes distractedly about, seizes* HELMER'S *domino, throws it round her, while she says in quick, hoarse, spasmodic whispers*] Never to see him again. Never! Never! [*Puts her shawl over her head.*] Never to see my children again either—never again. Never! Never!—Ah! the icy, black water—the unfathomable depths—If only it were over! He has got it now—now he is reading it. Good-bye, Torvald and my children! [*She is about to rush out through the hall, when* HELMER *opens his door hurriedly and stands with an open letter in his hand.*]

Helmer: Nora!

Nora: Ah!—

Helmer: What is this? Do you know what is in this letter?

Nora: Yes, I know. Let me go! Let me get out!

Helmer: [*Holding her back*] Where are you going?

Nora: [*Trying to get free*] You shan't save me, Torvald!

Helmer: [*Reeling*] True? Is this true, that I read here? Horrible! No, no—it is impossible that it can be true.

Nora: It is true. I have loved you above everything else in the world.

Helmer: Oh, don't let us have any silly excuses.

Nora: [*Taking a step towards him*] Torvald—!

Helmer: Miserable creature—what have you done?

Nora: Let me go. You shall not suffer for my sake. You shall not take it upon yourself.

Helmer: No tragedy airs, please. [*Locks the hall door.*] Here you shall stay and give me an explanation. Do you understand what you have done? Answer me! Do you understand what you have done?

Nora: [*Looks steadily at him and says with a growing look of coldness in her face*] Yes, now I am beginning to understand thoroughly.

Helmer: [*Walking about the room*] What a horrible awakening! All these eight years—she who was my joy and pride—a hypocrite, a liar—worse, worse—a criminal! The unutterable ugliness of it all!—For shame! For shame! [*NORA is silent and looks steadily at him. He stops in front of her.*] I ought to have suspected that something of the sort would happen. I ought to have foreseen it. All your father's want of principle—be silent!—all your father's want of principle has come out in you. No religion, no morality, no sense of duty—. How I am punished for having winked at what he did! I did it for your sake, and this is how you repay me.

Nora: Yes, that's just it.

Helmer: Now you have destroyed all my happiness. You have ruined all my future. It is horrible to think of! I am in the power of an unscrupulous man; he can do what he likes with me, ask anything he likes of me, give me any orders he pleases—I dare not refuse. And I must sink to such miserable depths because of a thoughtless woman!

Nora: When I am out of the way, you will be free.

Helmer: No fine speeches, please. Your father had always plenty of those ready, too. What good would it be to me if you were out of the way, as you say? Not the slightest. He can make the affair known everywhere; and if he does, I may be falsely suspected of having been a party to your criminal action. Very likely people will think I was behind it all—that it was I who prompted you! And I have to thank you for all this—you whom I have cherished during the whole of our married life. Do you understand now what it is you have done for me?

Nora: [*Coldly and quietly*] Yes.

Helmer: It is so incredible that I can't take it in. But we must come to some understanding. Take off that shawl. Take it off, I tell you. I must try and appease him some way or another. The matter must be hushed up at any cost. And as for you and me, it must appear as if everything between us were just as before—but naturally only in the eyes of the world. You will still remain in my house, that is a matter of course. But I shall not allow you to bring up the children; I dare not trust them to you. To think that I should be obliged to say so to one whom I have loved so dearly, and whom I still—. No, that is all over. From this moment happiness is not the question; all that concerns us is to save the remains, the fragments, the appearance—

[*A ring is heard at the front-door bell.*]

Helmer [*with a start*]: What is that? So late! Can the worst—? Can he—? Hide yourself, Nora. Say you are ill.
[*NORA stands motionless. HELMER goes and unlocks the hall door.*]

Maid: [*Half-dressed, comes to the door*] A letter for the mistress.

Helmer: Give it to me. [*Takes the letter, and shuts the door.*] Yes, it is from him. You shall not have it; I will read it myself.

Nora: Yes, read it.

Helmer: [*Standing by the lamp*] I scarcely have the courage to do it. It may mean ruin for both of us. No, I must know. [*Tears open the letter, runs his eye over a few lines, looks at a paper enclosed, and gives a shout of joy.*] Nora! [*She looks at him questioningly.*] Nora!—No, I must read it once again—. Yes, it is true! I am saved! Nora, I am saved!

Nora: And I?

Helmer: You too, of course; we are both saved, both you and I. Look, he sends you your bond back. He says he regrets and repents—that a happy change in his life—never mind what he says—! We are saved, Nora! No one can do anything to you. Oh, Nora, Nora!—no, first I must destroy these hateful things. Let me see—. [*Takes a look at the bond.*] No, no, I won't look at it. The whole thing shall be nothing but a bad dream to me. [*Tears up the bond and both letters, throws them all into the stove, and watches them burn.*] There—now it doesn't exist any longer. He says that since Christmas Eve you—. These must have been three dreadful days for you, Nora.

Nora: I have fought a hard fight these three days.

Helmer: And suffered agonies, and seen no way out but—. No, we won't call any of the horrors to mind. We will only shout with joy, and keep saying, "It's all over! It's all over!" Listen to me, Nora. You don't seem to realise that it is all over. What is this?—such a cold, set face! My poor little Nora, I quite understand; you don't feel as if you could believe that I have forgiven you. But it is true, Nora, I swear it; I have forgiven you everything. I know that what you did, you did out of love for me.

Nora: That is true.

Helmer: You have loved me as a wife ought to love her husband. Only you had not sufficient knowledge to judge

of the means you used. But do you suppose you are any the less dear to me, because you don't understand how to act on your own responsibility? No, no; only lean on me; I will advise you and direct you. I should not be a man if this womanly helplessness did not just give you a double attractiveness in my eyes. You must not think any more about the hard things I said in my first moment of consternation, when I thought everything was going to overwhelm me. I have forgiven you, Nora; I swear to you I have forgiven you.

Nora: Thank you for your forgiveness. [*She goes out through the door to the right.*]

Helmer: No, don't go—. [*Looks in.*] What are you doing in there?

Nora: [*From within*] Taking off my fancy dress.

Helmer: [*Standing at the open door*] Yes, do. Try and calm yourself, and make your mind easy again, my frightened little singing-bird. Be at rest, and feel secure; I have broad wings to shelter you under. [*Walks up and down by the door.*] How warm and cosy our home is, Nora. Here is shelter for you; here I will protect you like a hunted dove that I have saved from a hawk's claws; I will bring peace to your poor beating heart. It will come, little by little, Nora, believe me. To-morrow morning you will look upon it all quite differently; soon everything will be just as it was before. Very soon you won't need me to assure you that I have forgiven you; you will yourself feel the certainty that I have done so. Can you suppose I should ever think of such a thing as repudiating you, or even reproaching you? You have no idea what a true man's heart is like, Nora. There is something so indescribably sweet and satisfying, to a man, in the knowledge that he has forgiven his wife—forgiven her freely, and with all his heart. It seems as if that had made her, as it were, doubly his own; he has given her a new life, so to speak; and she has in a way become both wife and child to him. So you shall be for me after this, my little scared, helpless darling. Have no anxiety about anything, Nora; only be frank and open with me, and I will serve as will and conscience both to you—. What is this? Not gone to bed? Have you changed your things?

Nora: [*In everyday dress*] Yes, Torvald, I have changed my things now.

Helmer: But what for?—so late as this.

Nora: I shall not sleep to-night.

Helmer: But, my dear Nora—

Nora: [*Looking at her watch*] It is not so very late. Sit down here, Torvald. You and I have much to say to one another. [*She sits down at one side of the table.*]

Helmer: Nora—what is this?—this cold, set face?

Nora: Sit down. It will take some time; I have a lot to talk over with you.

Helmer: [*Sits down at the opposite side of the table*] You alarm me, Nora!—and I don't understand you.

Nora: No, that is just it. You don't understand me, and I have never understood you either—before to-night. No, you mustn't interrupt me. You must simply listen to what I say. Torvald, this is a settling of accounts.

Helmer: What do you mean by that?

Nora: [*After a short silence*] Isn't there one thing that strikes you as strange in our sitting here like this?

Helmer: What is that?

Nora: We have been married now eight years. Does it not occur to you that this is the first time we two, you and I, husband and wife, have had a serious conversation?

Helmer: What do you mean by serious?

Nora: In all these eight years—longer than that—from the very beginning of our acquaintance, we have never exchanged a word on any serious subject.

Helmer: Was it likely that I would be continually and for ever telling you about worries that you could not help me to bear?

Nora: I am not speaking about business matters. I say that we have never sat down in earnest together to try and get at the bottom of anything.

Helmer: But, dearest Nora, would it have been any good to you?

Nora: That is just it; you have never understood me. I have been greatly wronged, Torvald—first by papa and then by you.

Helmer: What! By us two—by us two, who have loved you better than anyone else in the world?

Nora: [*Shaking her head*] You have never loved me. You have only thought it pleasant to be in love with me.

Helmer: Nora, what do I hear you saying?

Nora: It is perfectly true, Torvald. When I was at home with papa, he told me his opinion about everything, and so I had the same opinions; and if I differed from him I concealed the fact, because he would not have liked it. He called me his doll-child, and he played with me just as I used to play with my dolls. And when I came to live with you—

Helmer: What sort of an expression is that to use about our marriage?

Nora: [*Undisturbed*] I mean that I was simply transferred from papa's hands into yours. You arranged everything according to your own taste, and so I got the same tastes as you—or else I pretended to, I am really not quite sure which—I think sometimes the one and sometimes the other. When I look back on it, it seems to me as if I had been living here like a poor woman—just from hand to mouth. I have existed merely to perform tricks for you, Torvald. But you would have it so. You and papa have committed a great sin against me. It is your fault that I have made nothing of my life.

Helmer: How unreasonable and how ungrateful you are, Nora! Have you not been happy here?

Nora: No, I have never been happy. I thought I was, but it has never really been so.

Helmer: Not—not happy!

Nora: No, only merry. And you have always been so kind to me. But our home has been nothing but a playroom. I have been your doll-wife, just as at home I was papa's doll-child; and here the children have been my dolls. I thought it great fun when you played with me, just as they thought it great fun when I played with them. That is what our marriage has been, Torvald.

Helmer: There is some truth in what you say—exaggerated and strained as your view of it is. But for the future it shall be different. Playtime shall be over, and lesson-time shall begin.

Nora: Whose lessons? Mine, or the children's?

Helmer: Both yours and the children's, my darling Nora.

Nora: Alas, Torvald, you are not the man to educate me into being a proper wife for you.

Helmer: And you can say that!

Nora: And I—how am I fitted to bring up the children?

Helmer: Nora!

Nora: Didn't you say so yourself a little while ago—that you dare not trust me to bring them up?

Helmer: In a moment of anger! Why do you pay any heed to that?

Nora: Indeed, you were perfectly right. I am not fit for the task. There is another task I must undertake first. I must try and educate myself—you are not the man to help me in that. I must do that for myself. And that is why I am going to leave you now.

Helmer: [*Springing up*] What do you say?

Nora: I must stand quite alone, if I am to understand myself and everything about me. It is for that reason that I cannot remain with you any longer.

Helmer: Nora, Nora!

Nora: I am going away from here now, at once. I am sure Christine will take me in for the night—

Helmer: You are out of your mind! I won't allow it! I forbid you?

Nora: It is no use forbidding me anything any longer. I will take with me what belongs to myself. I will take nothing from you, either now or later.

Helmer: What sort of madness is this!

Nora: To-morrow I shall go home—I mean, to my old home. It will be easiest for me to find something to do there.

Helmer: You blind, foolish woman!

Nora: I must try and get some sense, Torvald.

Helmer: To desert your home, your husband and your children! And you don't consider what people will say!

Nora: I cannot consider that at all. I only know that it is necessary for me.

Helmer: It's shocking. This is how you would neglect your most sacred duties.

Nora: What do you consider my most sacred duties?

Helmer: Do I need to tell you that? Are they not your duties to your husband and your children?

Nora: I have other duties just as sacred.

Helmer: That you have not. What duties could those be?

Nora: Duties to myself.

Helmer: Before all else, you are a wife and a mother.

Nora: I don't believe that any longer. I believe that before all else I am a reasonable human being, just as you are—or, at all events, that I must try and become one. I know quite well, Torvald, that most people would think you right, and that views of that kind are to be found in books; but I can no longer content myself with what most people say, or with what is found in books. I must think over things for myself and get to understand them.

Helmer: Can you not understand your place in your own home? Have you not a reliable guide in such matters as that?—have you no religion?

Nora: I am afraid, Torvald, I do not exactly know what religion is.

Helmer: What are you saying?

Nora: I know nothing but what the clergyman said, when I went to be confirmed. He told us that religion was this, and that, and the other. When I am away from all this, and am alone, I will look into that matter too. I will see if what the clergyman said is true, or at all events if it is true for me.

Helmer: This is unheard of in a girl of your age! But if religion cannot lead you aright, let me try and awaken your conscience. I suppose you have some moral sense? Or—answer me—am I to think you have none?

Nora: I assure you, Torvald, that is not an easy question to answer. I really don't know. The thing perplexes me altogether. I only know that you and I look at it in quite a different light. I am learning, too, that the law is quite another thing from what I supposed; but I find it impossible to convince myself that the law is right. According to it a woman has no right to spare her old dying father, or to save her husband's life. I can't believe that.

Helmer: You talk like a child. You don't understand the conditions of the world in which you live.

Nora: No, I don't. But now I am going to try. I am going to see if I can make out who is right, the world or I.

Helmer: You are ill, Nora; you are delirious; I almost think you are out of your mind.

Nora: I have never felt my mind so clear and certain as to-night.

Helmer: And is it with a clear and certain mind that you forsake your husband and your children?

Nora: Yes, it is.

Helmer: Then there is only one possible explanation.

Nora: What is that?

Helmer: You do not love me any more.

Nora: No, that is just it.

Helmer: Nora!—and you can say that?

Nora: It gives me great pain, Torvald, for you have always been so kind to me, but I cannot help it. I do not love you any more.

Helmer: [*Regaining his composure*] Is that a clear and certain conviction too?

Nora: Yes, absolutely clear and certain. That is the reason why I will not stay here any longer.

Helmer: And can you tell me what I have done to forfeit your love?

Nora: Yes, indeed I can. It was to-night, when the wonderful thing did not happen; then I saw you were not the man I had thought you.

Helmer: Explain yourself better. I don't understand you.

Nora: I have waited so patiently for eight years; for, goodness knows, I knew very well that wonderful things don't happen every day. Then this horrible misfortune came upon me; and then I felt quite certain that the wonderful thing was going to happen at last. When Krogstad's letter was lying out there, never for a moment did I imagine that you would consent to accept this man's conditions. I was so absolutely certain that you would say to him: Publish the thing to the whole world. And when that was done—

Helmer: Yes, what then?—when I had exposed my wife to shame and disgrace?

Nora: When that was done, I was so absolutely certain, you would come forward and take everything upon yourself, and say: I am the guilty one.

Helmer: Nora—!

Nora: You mean that I would never have accepted such a sacrifice on your part? No, of course not. But what would my assurances have been worth against yours? That was the wonderful thing which I hoped for and feared; and it was to prevent that, that I wanted to kill myself.

Helmer: I would gladly work night and day for you, Nora—bear sorrow and want for your sake. But no man would sacrifice his honor for the one he loves.

Nora: It is a thing hundreds of thousands of women have done.

Helmer: Oh, you think and talk like a heedless child.

Nora: Maybe. But you neither think nor talk like the man I could bind myself to. As soon as your fear was over—and it was not fear for what threatened me, but for what might happen to you—when the whole thing was past, as far as you were concerned it was exactly as if nothing at all had happened. Exactly as before, I was your little skylark, your doll, which you would in future treat with doubly gentle care, because it was so brittle and fragile. [*Getting up.*] Torvald—it was then it dawned upon me that for eight years I had been living here with a strange man, and had borne him three children—. Oh, I can't bear to think of it! I could tear myself into little bits!

Helmer: [*Sadly*] I see, I see. An abyss has opened between us—there is no denying it. But, Nora, would it not be possible to fill it up?

Nora: As I am now, I am no wife for you.

Helmer: I have it in me to become a different man.

Nora: Perhaps—if your doll is taken away from you.

Helmer: But to part!—to part from you! No, no, Nora, I can't understand that idea.

Nora: [*Going out to the right*] That makes it all the more certain that it must be done. [*She comes back with her cloak and hat and a small bag which she puts on a chair by the table.*]

Helmer: Nora, Nora, not now! Wait till to-morrow.

Nora: [*Putting on her cloak*] I cannot spend the night in a strange man's room.

Helmer: But can't we live here like brother and sister—?

Nora: [*Putting on her hat*] You know very well that would not last long. [*Puts the shawl around her.*] Goodbye, Torvald. I won't see the little ones. I know they are in better hands than mine. As I am now, I can be of no use to them.

Helmer: But some day, Nora—some day?

Nora: How can I tell? I have no idea what is going to become of me.

Helmer: But you are my wife, whatever becomes of you.

Nora: Listen, Torvald. I have heard that when a wife deserts her husband's house, as I am doing now, he is legally freed from all obligations towards her. In any case I set you free from all your obligations. You are not to feel yourself bound in the slightest way, any more than I shall. There must be perfect freedom on both sides. See, here is your ring back. Give me mine.

Helmer: That too?

Nora: That too.

Helmer: Here it is.

Nora: That's right. Now it is all over. I have put the keys here. The maids know all about everything in the house—better than I do. To-morrow, after I have left her, Christine will come here and pack my own things that I brought with me from home. I will have them sent after me.

Helmer: All over! All over!—Nora, shall you never think of me again?

Nora: I know I shall often think of you and the children and this house.

Helmer: May I write to you, Nora?

Nora: No—never. You must not do that.

Helmer: But at least let me send you—

Nora: Nothing—nothing—

Helmer: Let me help you if you are in want.

Nora: No. I can receive nothing from a stranger.

Helmer: Nor—can I never be anything more than a stranger to you?

Nora: [*Taking her bag*] Ah, Torvald, the most wonderful thing of all would have to happen.

Helmer: Tell me what that would be!

Nora: Both you and I would have to be so changed that—.

Oh, Torvald, I don't believe any longer in wonderful things happening.

Helmer: But I will believe in it. Tell me! So changed that—?

Nora: That our life together would be a real wedlock. Good-bye. [*She goes out through the hall.*]

Helmer: [*Sinks down on a chair at the door and buries his face in his hands*] Nora! Nora! [*Looks round, and rises.*] Empty. She is gone. [*A hope flashes across his mind.*] The most wonderful thing of all—?

[*The sound of a door shutting is heard from below.*]

CHAPTER FOURTEEN

THE EARLY TWENTIETH CENTURY

"Make it new," said the poet Ezra Pound, and the one constant in the arts of the early part of the turbulent 20th century was a seemingly inexhaustible quest for originality and freshness. The age witnessed the worst and the best that humanity is capable of. In the aftermath of World War I, many believed that any culture that could produce the wanton destruction wrought by the war must be abandoned, if not destroyed. The appeal of communism as an alternative to capitalistic democracy captivated many liberals. The conflicts and unresolved issues resulting from "the peace" soon, however, led the world into another holocaust.

14.1 Umberto Boccioni, *Unique Forms of Continuity in Space*, 1913. Bronze (cast 1931), 3 ft 7⅞ ins (1.1 m) high. The Museum of Modern Art, New York (Acquired through the Lillie P. Bliss Bequest).

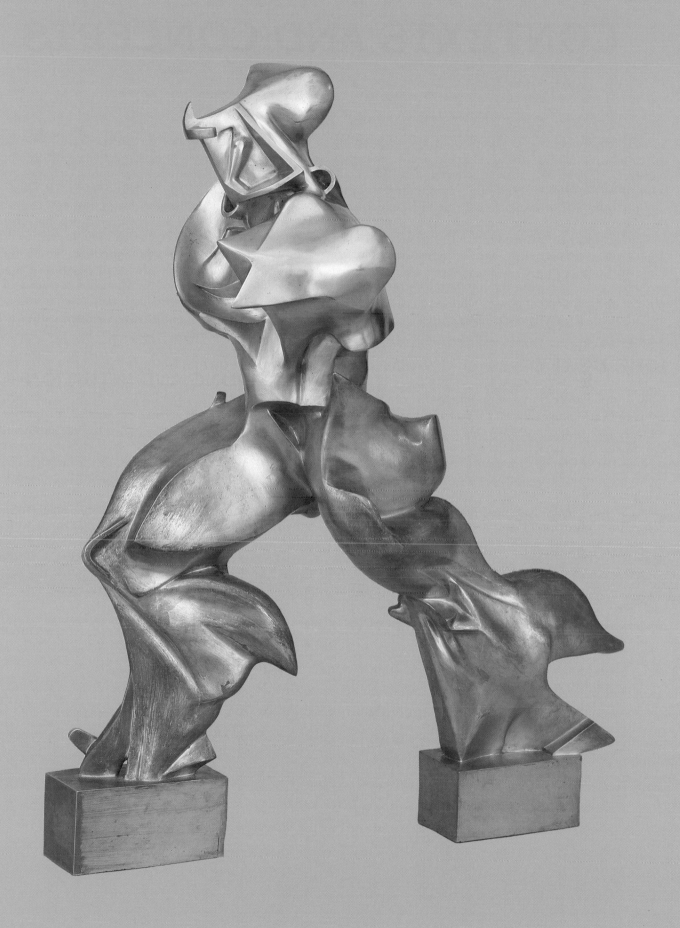

CONTEXTS AND CONCEPTS

Some time before 1914, Europe and the rest of the western world seems to have gone astray. Societies believed themselves headed toward the best that science and invention could offer. Competitive struggle would produce desirable, positive results. Unexpectedly, the events of 1914 and the world war changed all that.

Philosophy had lost credit in the 19th century. Unlike their former colleagues in the sciences, philosophers came to be regarded as useless appendages to social progress. More and more people began to believe that sensory and intellectual powers were insufficient to solve the problems posed by philosophy.

JOHN DEWEY

Early in the 20th century a reorientation occurred. A new philosophy, "pragmatism," emerged in America, championed by John Dewey (1859–1952). Pragmatism abandoned the search for final answers to great problems such as the existence of immortality. It contented itself with more modest goals in the realm of social experience. Using the scientific method, pragmatism pursued such issues as what moral and aesthetic values might be in a democratic, industrialized society, and how one might achieve the highest personal fulfillment through education. Its value as a philosophy (or as an adjunct of sociology) remains to be seen.

Dewey's concept of "art as experience"—he used this title for his analysis of aesthetics—is enlightening, challenging, and sometimes frustrating. "Experience" is fundamental to Dewey's philosophy in all areas, but it appears most significant in his philosophy of aesthetics. Human experience, as interpreted by his aesthetics, presents a significant challenge to philosophy. According to Dewey, the philosopher needs to go to aesthetic experience in order to understand experience in general. Dewey is building on Hegel's concept of truth as a whole here. Dewey shares Schelling's belief that aesthetic intuition is "the organ of philosophy," and so aesthetics is "the crown of philosophy."

CARL JUNG AND INTUITION

The idea that artistic creativity is basic to humanity has been expressed in various ways in the 20th century. To take one example, in the field of theatre, the designer Robert Edmund Jones makes the connection between imagination and dreams in his book *The Dramatic Imagination*. His concepts were closely related to the concept of intuition propounded by Carl Gustav Jung (1875–1961). Jones sees the theatre as a place that deals with magic, not logic. The supernormal is normal, the imagination is the source of creativity, "a special faculty . . . by means of which we can form mental images of things not present in

14.2 Timeline of the early 20th century.

	GENERAL EVENTS	LITERATURE & PHILOSOPHY	VISUAL ART	THEATRE & DANCE	FILM	MUSIC	ARCHITECTURE
1900	Triple Entente Balkan Wars Women's suffrage (USA) World War I Russian revolution Treaty of Versailles Freud	Dewey Yeats Frost e. e. cummings Lawrence Joyce	Matisse (14.7) Beckmann (14.6) De Chirico (14.15) Duchamp (14.12–13) Picasso (14.8) Lipchitz (14.28) Braque Malevich (14.11) Léger (14.9) Ernst (14.14) Davis (14.19)	Duncan Appia Craig Diaghilev Nijinsky Strindberg Fokine Toller Pirandello Rice	Méliès Porter Pathé Griffith Sennet Ince Lang Delluc Wiene	Stravinsky Jazz Schoenberg Prokofiev	Gaudí (14.34) Perret (14.35) Gilbert (14.40) Wright (14.36–37)
1925	Einstein Japanese invasion of Manchuria World War II in Europe Pearl Harbor	Gide Proust Mann Woolf Eliot Faulkner Dos Passos Steinbeck Camus Sartre Wright Hurston	Boccioni (14.1) Brancusi (14.25–26) Mondrian (14.10) Dali (14.16) Wood (14.18) Moore (14.27)	Meyerhold O'Neill St Denis Humphrey Brecht Balanchine Graham	Eisenstein DeMille Von Stroheim Vidor Mamoulian Milestone Walt Disney Ford Selznick Hitchcock	Ravel Berg Bartók Ives Coplana Schuman Hindemith	Gropius (14.41–42) Behrens (14.38) Le Corbusier (14.39)

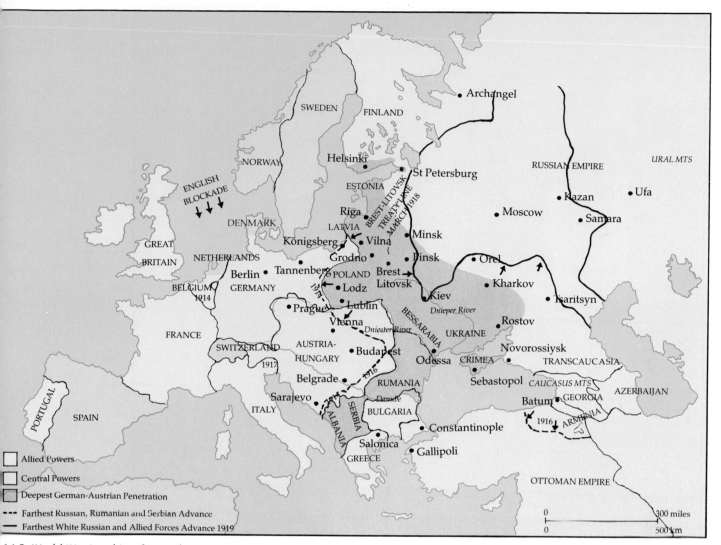

14.3 World War I and its aftermath in Europe.

our senses." He cautions, however, that "many people confuse imagination with ingenuity, with inventiveness. But imagination is not this thing at all. It is the power of seeing with the eye of the mind."

Jung, on the other hand, developed a working concept of intuition as "a function separate from thinking, feeling, and sensation which was characterized by the ability to see connections between things and find the potential inherent in a situation . . . [it was] an active, creative process."[1] In *The Spirit in Man, Art and Literature*, Jung describes intuition as "the source of [the artist's] creativeness." Jung believed not only in individual unconsciouses but in a universal unconscious—that is, in a collective unconscious shared by all human beings—in which lay a reservoir of primordial images—Jung called them "archetypal images," or "ARCHETYPES"—upon which any person could draw. Artists were influenced more than ordinary people by the contents of this unconscious, however. "The creative urge lives and grows in [the artist]

like a tree in the earth from which it draws nourishment. We would do well, therefore, to think of the creative process as a living thing implanted in the human psyche."

What an artist creates, then, is the unconscious expression of archetypal images. And the drive to create originates in the unconscious and brings out the expression of psychic material in images and patterns that are similar throughout history and from place to place (see C. G. Jung, *Man and His Symbols*).

Whether or not we subscribe to Jung's concept of creativity, our intuitive function does suggest that the urge to create art is timeless and universal.

SCIENCE AND SOCIETY

The 20th century has seen the formulation and reformulation of a staggering number of fundamental new scientific concepts. Quantum theory, the Theories of Relativity, and

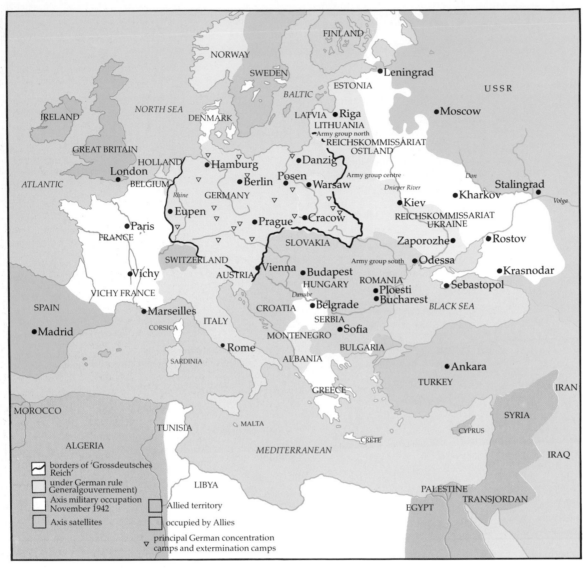

14.4 World War II in Europe.

modern atomic theory are unique to our age. In formulating quantum theory, the German physicist Max Planck upset previous belief by suggesting that energy was released in spurts of small units, called "quanta." Albert Einstein (1879–1955) overturned the physics of Newton by suggesting that the absolutes of space, time, and length, were *not* absolute, but, rather, relative. (In 1982, some researchers suggested that Einstein's theory was flawed and that a reexamination was in order.) Developments in atomic theory reduced the universe to units smaller than the atom, to positively and negatively charged particles, thereby revising previously held concepts about matter itself. As the century draws to a close, science finds itself reaching toward intervening in the very creation of life.

The methods of science were also used in the social sciences, in the hope that human life would yield the same precise and verifiable conclusions that nature seemed to. Researchers amassed great bodies of data in their attempts to understand economics, government, social classes, primitive cultures, and so on. But universal truths drawn from social–scientific fact-finding remain to be fully discovered.

Undoubtedly the most significant development in the social sciences, and one that had profound influence on the arts, occurred in psychology. Psychoanalysis probed deep into the recesses of the human mind, and the findings of Sigmund Freud (1856–1939) became dogma. Freud's work, and that of Jung, Alfred Adler, and various followers of Freud, increased the popularity of psychoanalysis and gave birth to modern psychiatry. Earlier, John Watson argued that the human being was a physical mechanism operating in a stimulus-and-response environment. Watson's as well as B. F. Skinner's behaviorism continues as a fruitful model as the millennium draws to a close.

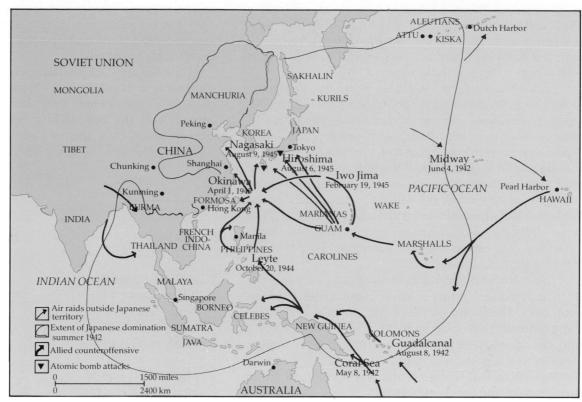

14.5 World War II in the Pacific.

POLITICS AND WAR

In the late 19th century, capitalism, colonialism, and competition for survival and expanding marketplaces had made Europe prosperous indeed. But it was also in a state of fear. The sun never set on the British Empire, and the Indian Ocean was called a British lake. France, the Netherlands, Belgium, Spain, Portugal, and Italy also had colonial holdings. There was, however, a history of European wars in the 19th century, and they had solved very little. Prosperity only made the nations of Europe more anxious to protect what they had, and, if possible, to get back what had been taken from them and to get what somebody else had. On top of it all was the growing militancy and aggressiveness of Germany, recently unified out of 39 independent states by Bismarck.

In this environment, every European nation maintained armed forces the equal of which the world had never seen. Up to three years of compulsory military service for young men was a general rule—not the exception. Behind burgeoning armies stood millions of reserves among the general population. Few wanted war, but it seemed that everyone expected it. European nations banded together in rival political alliances. The Triple Alliance of Germany, Austria–Hungary, and Italy was countered in 1907 by the formation of the Triple Entente of England, France, and Russia. The Balkan Wars of 1912–13 ignited the conflagration that burst into world war

upon the assassination of the Austrian Archduke Franz Ferdinand—in fact, merely a side incident.

The causes, the conflict, and the casualties of this catastrophe defy logic. The resolution of the conflict and the terms of the peace in the Treaty of Versailles (1919) served only to push the western world farther on its course toward chaos. The treaty was supposed to protect Europe from Germany. It failed to do so.

European society changed significantly as a result of the war. Capitalism in particular took a new direction. *Laissez-faire* liberalism had been prominent in 19th-century politics, but even before the war, governments had begun increasingly to intervene in economic and other affairs. Governments erected tariffs, protected national industries, created colonial markets, and passed protective social legislation. World War I made governmental control of nearly every aspect of society imperative. After the war, the western world went through disruptions in monetary traditions, inflation, and taxes, and industrial output was in chaos.

BETWEEN THE WARS

Equally significant in the development of 20th-century politics was the Russian Revolution. Boiling up from a combination of old and new causes, the Revolution shook Russia first in 1905 and then again in 1917 when Lenin

came to power. This was followed by a bloody civil war in 1918, which lasted until 1922. When Lenin died in 1924, the communist die was cast. Stalin put Russia through a series of five-year plans and purges, and established an adversarial struggle with the west.

During the troubled years after World War I, even the victors had difficulty returning to peace-time conditions. Distinct advances in social democracy were made. Women could now vote in Britain, Germany, the United States (as of 1913), and most of the smaller states of Europe. Social legislation proliferated, and an eight-hour work day became common, as did government-sponsored insurance. Still, all the nations that had participated in the war had economic, industrial, and agricultural problems. Inflation was rampant, and credit was over-extended. The entire western economic system maintained a precarious balance.

The 1920s were years of contrast. Struggle early in the decade was displaced by a virtual explosion of apparent prosperity. The mood was euphoric. Then in 1929 came the economic crash that sent the entire western world into the deepest economic crisis it had ever known. Industry and agriculture collapsed.

The forces that shaped World War II emerged out of the crisis of the 1930s. Roosevelt offered the United States a "New Deal." Britain and France struggled through trial and error to adjust their economies and institutions. Weak governments in Germany and Italy capitulated to the totalitarian political organizations of Hitler and Mussolini. Dictatorship and totalitarianism were not isolated occurrences. By 1939, only ten out of 27 European countries remained democratic.

In the 1930s, Germany, Italy, Russia, and Japan were chafing under the peace treaty that had ended World War I. And the countries that had instituted the peace were either too weak or unwilling to enforce it. From 1931 (when Japan invaded Manchuria) onward, Britain, France, and the United States stood aside and watched Germany, Italy, and Japan take over one country after another. By 1939, Europe was at war, and three years later when Japan attacked Pearl Harbor, almost the entire world was again engulfed by hostilities.

On 6 August 1945, a nuclear explosion over the city of Hiroshima in Japan forever altered the world and the place of human beings in it. An old order had disappeared, and the approaching second millennium was overshadowed by a specter even more fearful than that which had clouded the approach of the first millennium.

FOCUS

TERMS TO DEFINE
Pragmatism
Aesthetics
Intuition
Treaty of Versailles (1919)

PEOPLE TO KNOW
John Dewey
Carl Jung
Lenin
Hitler

DATES TO REMEMBER
World War I
World War II

QUESTIONS TO ANSWER
1 According to John Dewey, how does aesthetic experience relate to experience in general?
2 Explain the Jungian concept of intuition.

THE ARTS
OF THE EARLY TWENTIETH CENTURY

TWO-DIMENSIONAL ART

The first half of the 20th century blossomed with new styles and approaches to the visual arts. Among these were expressionism, fauvism, cubism, abstract art, dada, and surrealism.

Expressionism

"Expressionism" traditionally refers to a movement in Germany between 1905 and 1930. Broadly speaking, however, it includes a variety of approaches, mostly in Europe, that aimed at eliciting in the viewer the same feelings the artist felt in creating the work—a sort of joint artist/viewer response to elements in the work of art. Any element—line, form, color—might be emphasized to elicit this response. The subject matter itself did not matter. What mattered was that the artist consciously tried to stimulate in the viewer a specific response similar to his

14.6 Max Beckmann, *Christ and the Woman Taken in Adultery*, 1917. Oil on canvas, 4 ft 10¼ ins × 4 ft 1⅛ ins (1.49 × 12.7 m). The Saint Louis Art Museum (Bequest of Curt Valentin).

or her own. The term "expressionism" as a description of this approach to visual art and architecture first appeared in 1911. It emerged following six years of work by an organised group of German artists who called themselves D*ie Brücke* ("The Bridge"). Trying to define their purposes, the painter Ernst Ludwig Kirchner (1880–1938) wrote, "He who renders his inner convictions as he knows he must, and does so with spontaneity and sincerity, is one of us." The intent was to protest against academic naturalism. They used simple media such as woodcuts and created often brutal, but nonetheless powerful effects that expressed inner emotions.

The early expressionists maintained representationalism to a degree. However, later expressionist artists, for example those of the Blue Rider group between 1912 and 1916, created some of the first completely abstract or non-objective works of art. Color and form emerged as stimuli extrinsic to subject matter, and without any natural spatial relationships of recognizable objects, paintings took a new direction in internal organization.

In Max Beckmann's *Christ and the Woman Taken in Adultery* (Fig. **14.6**), the artist's revulsion against physical cruelty and suffering is transmitted through distorted figures crushed into shallow space. Linear distortion, changes of scale and perspective, and a nearly Gothic spirituality communicate Beckmann's reactions to the horrors of World War I. In this approach, the meaning of the painting—the *painter's* meaning—is carried by very specific visual means of communication.

Fauvism

Closely associated with the expressionist movement was the style of the *fauves* (the French word for "wild beasts"). The label was applied in 1905 by a critic in response to a sculpture which seemed to him "a Donatello in a cage of wild beasts." Violent distortion and outrageous coloring mark the work of the fauves. Their two-dimensional surfaces and flat color areas were new to European painting.

The best-known artist of this short-lived movement was Henri Matisse (1869–1954). Matisse tried to paint pictures that would "unravel the tensions of modern existence." In his old age, he made a series of very joyful designs for the Chapel of the Rosary at Venice, not as exercises in religious art but as expressions of joy and the nearly religious feeling he had for life.

The Blue Nude (Fig. **14.7**) illustrates the wild coloring and distortions in the paintings of Matisse and the other

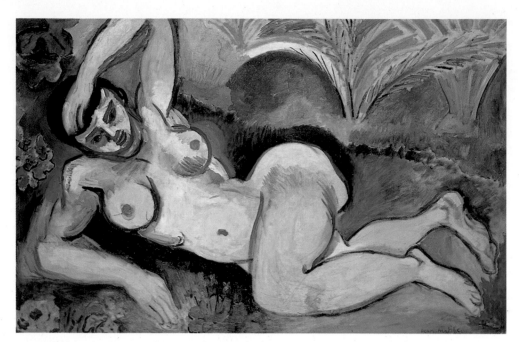

14.7 Henri Matisse, *Blue Nude* ("*Souvenir de Biskra*"), 1907. Oil on canvas, 3 ft ¼ in × 4 ft 7¼ ins (92.1 × 140.4 cm). The Baltimore Museum of Art (The Cone Collection, formed by Dr Claribel Cone and Miss Etta Cone of Baltimore, Maryland).

fauves. The painting takes its name from the energetically applied blues, which occur throughout the figure as dark accents. For Matisse, color and line were indivisible devices, and the bold strokes of color in his work both reveal forms and stimulate a purely aesthetic response. Matisse literally "drew with color." His purpose was not, of course, to draw a nude as he saw it in life. Rather, he tried to express his feelings about the nude as an object of aesthetic interest. Thus Matisse, along with the other fauve painters, represents one brand of expressionism. There were others, including the Bridge and Blue Rider groups, and artists such as Kandinsky, Rouault, and Kokoschka.

Cubism

Between 1901 and 1912, an entirely new approach to pictorial space emerged, an approach called "cubism." Cubist space violates all usual concepts of two- and three-dimensional perspective. Up until this time, the space within a composition had been thought of as an entity separate from the main subject of the work. That is, if the subject were removed, the space would remain, unaffected.

Pablo Picasso (1881–1973) and Georges Braque (1882–1963) changed that relationship. In their view, the artist should paint "not objects, but the space they engender." The area around an object became an extension of the object itself. If the object were removed, the space around it would collapse. Cubist space is typically quite shallow and gives the impression of reaching forward out of the frontal plane toward the viewer.

Essentially, the style developed as the result of independent experiments by Braque and Picasso with various ways of describing form. Newly evolving notions of the time–space continuum were being proposed by Albert Einstein at this time. We do not know whether the Theory of Relativity influenced Picasso and Braque, but it was being talked about at the time, and it certainly helped to make their works more acceptable. The results of both painters' experiments brought them to remarkably similar artistic conclusions.

Picasso has influenced the arts of the 20th century more than any other painter. Born in Spain, in 1900 he moved to France, where he lived for most of his life. In Paris, he was influenced by Toulouse-Lautrec and the late works of Cézanne, particularly in organization, analysis of forms, and use of different points of view. Very early on, Picasso began to identify deeply with society's misfits and cast-offs. In the period from 1901 until around 1904 or 1905, known as Picasso's "Blue Period," these oppressed subjects appear in paintings, in which blue tones predominate. In his "Rose Period," from 1904 to 1906, he became more concerned with make-believe, which he expressed as portraits of circus performers, than with the tragedy of poverty. Cubism was born in 1907, with the creative revelation of *Les Demoiselles d'Avignon* (Fig. **14.8**). Its simplified forms and restricted color were adopted by many cubists, as they reduced their palettes in order to concentrate on spatial exploration.

Like Picasso, Braque took a new approach to spatial construction and reduced objects to geometric shapes. It was from Braque's geometric forms that the term "cubist" first came. Unfortunately, the label has led many observers to look for solid cubic shapes rather than for a new kind of space "which was only visible when solid forms became transparent and lost their rigid cubical contours."[3]

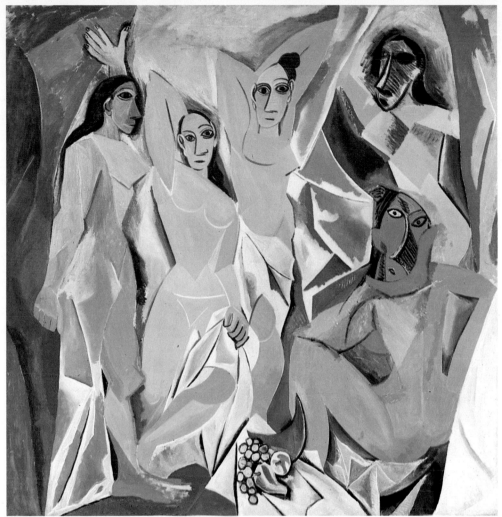

14.8 Pablo Picasso, *Les Demoiselles d'Avignon*, 1907. Oil on canvas, 8 ft × 7 ft 8 ins (2.44 × 2.34 m). The Museum of Modern Art, New York (Acquired through the Lillie P. Bliss Bequest).

MASTERWORK
Picasso—Les Demoiselles d'Avignon

This landmark painting deliberately breaks with the traditions of western illusionistic art. Picasso's discovery of primitive African art and sculpture led him to borrow its flat forms and its exaggeration of certain features. Three of the heads in this painting are adaptations of African masks. Picasso used primitive art as a "battering ram against the classical conception of beauty."[2] The painter denies both classical proportions and the organic integrity and continuity of the human body. One critic wrote that the canvas "resembles a field of broken glass."

The *Demoiselles* (Fig. **14.8**) is aggressive and harsh. Forms are simplified and angular, and colors are restricted to blues, pinks, and terracottas. Subjects are broken into angular wedges, which convey a sense of three-dimensionality. We are unsure whether the forms protrude out or recess in. In rejecting a single viewpont, Picasso presents "reality" not as a mirror image of what we see in the world, but as images that have been reinterpreted within the terms of new principles. Understanding thus depends on *knowing* rather than *seeing*.

The canvas of *Les Demoiselles d'Avignon* is large—it measures eight feet by seven feet eight inches—and its effect is one of great violence. The work began as a temptation scene in a brothel, but the narrative element has been dislodged by Picasso's concentration on aggression and savage eroticism.

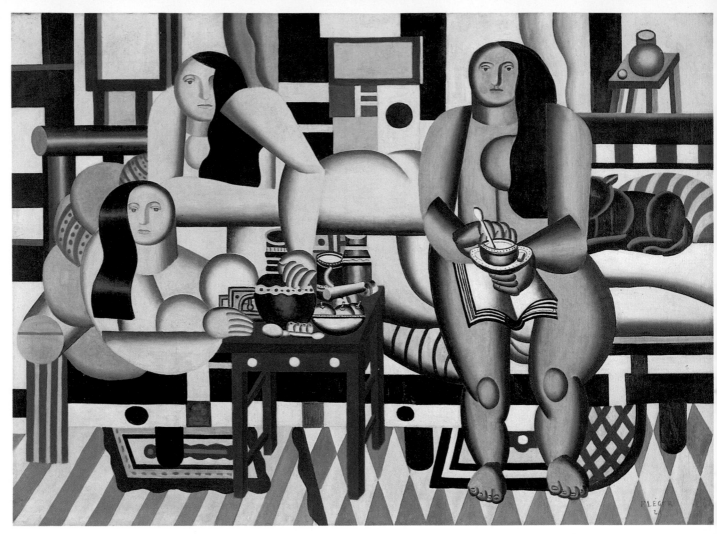

14.9 Fernand Léger, *Three Women*, 1921. Oil on canvas, 6 ft 1¼ ins × 8 ft 3 ins (1.84 × 2.52 m). The Museum of Modern Art, New York (Mrs Simon Guggenheim Fund).

The complexities of cubism, of course, go beyond these brief remarks. Diverse subject matter, disciplinary experiments (for example, COLLAGE), evolving depiction, and applications such as those of Fernand Léger (1881–1955) and numerous others, carried cubism through the first half of the 20th century. In works like *Three Women* (Fig. **14.9**), Léger creates a controlled and stable environment. The broken images float in undetermined relationship to the picture plane and it is hard to tell how close to the surface the central figures may be. The use of perspective creates a three-dimensional effect, but not a normal one. A great many rectilinear and curvilinear forms stand in active juxtaposition. Each form is clean and precise, with hard color edges and marked contrasts.

Abstraction

We have used the phrase "dissolving image" to describe tendencies in 19th-century visual art to move away from recognizable, or objective, reality. This is what most people think of when they describe "modern" art as "ABSTRACT" art. A more precise term, however, is "nonrepresentational" art. *All* art is abstract, of course. That is,

it is not the real thing itself, but a representation of something made from a distance, literally, "standing apart from it." Thus, paintings, sculptures, plays, and symphonies all are abstractions, regardless of how realistic they are.

Abstract or nonrepresentational art, however, contains minimal reference to natural objects, that is, objects in the world we perceive through our senses. In many ways, abstract art stands in contrast to impressionism and expressionism in that the observer can read little or nothing in the painting of the artist's feelings for anything outside the painting. Abstract art seeks to explore the expressive qualities of formal design elements and materials in their own right. These elements are assumed to stand apart from subject matter. The aesthetic theory underlying abstract art maintains that beauty can exist in form alone, and no other quality is needed. Many painters explored these approaches, and several subgroups, such as de Stijl, the suprematists, the constructivists, and the Bauhaus painters, have pursued its goals. The works of Piet Mondrian and Kasimir Malevich illustrate many of the principles at issue in abstract painting.

Mondrian (1872–1944) believed that straight lines and right angles represented the fundamental principles

possibilities as they provide additional points of interaction between lines. Mondrian believed that he could create "the equivalence of reality" and make the "absolute appear in the relativity of time and space" by keeping visual elements in a state of constant tension.

Another movement within the nonrepresentational tradition was suprematism. The works of the suprematist painters puzzle many people. A work such as *Suprematist Composition: White on White* (Fig. **14.11**) by Kasimir Malevich (1878–1935) seems simple but confusing, even by abstract standards. For Malevich, such works go beyond reducing painting to its basic common denominator of oil on canvas. Rather, he sought basic pictorial elements that could "communicate the most profound expressive reality."

Themes dealing with mechanism proved to be popular in the early 20th century, as life became more and more dominated by machines. A brief movement in Italy, futurism, sought to express the spirit of the age by

14.10 Pict Mondrian, *Composition in White, Black, and Red*, 1936. Oil on canvas, 3 ft 4¼ ins × 3 ft 5 ins (1.02 × 1.04 m). The Museum of Modern Art, New York (Gift of the Advisory Committee).

14.12 Marcel Duchamp, *Nude Descending a Staircase, No. 2*, 1912. Canvas, 58 × 35 ins (147 × 89 cm). Philadelphia Museum of Art (Louise and Walter Arensberg Collection).

of life. A vertical line signified activity, vitality, and life, while a horizontal line signified rest, tranquility, and death. The crossing of the two in a right angle expressed the highest possible tension between these forces, positive and negative. Mondrian's exploration of this theory in *Composition in White, Black, and Red* (Fig. **14.10**) is typical of all his linear compositions. The planes of the painting are close to the surface of the canvas, creating, in essence, the shallowest space possible. The palette is restricted to three hues. Even the canvas' edges take on expressive

14.11 Kasimir Malevich, *Suprematist Composition: White on White*, c.1918. Oil on canvas, 31¼ × 31¼ ins (79.4 × 79.4 cm). The Museum of Modern Art, New York.

14.13 Marcel Duchamp, *The Bride*, 1912. Oil on canvas, 35¼ × 21¾ ins (89.5 × 55.3 cm). Philadelphia Museum of Art (Louise and Walter Arensberg Collection).

14.14 (opposite) Max Ernst, *Woman, Old Man, and Flower*, 1923–24. Oil on canvas, 3 ft 2 ins × 4 ft 3¼ ins (96.5 × 130.2 cm). The Museum of Modern Art, New York.

capturing speed and power through representation of vehicles and machines in motion. Mechanistic themes can be seen clearly in the works of Marcel Duchamp (1887–1968), who is often associated with the dada movement and whose famous *Nude Descending a Staircase* (Fig. **14.12**) is sometimes called "protodadaist." *The Bride* (Fig. **14.13**) is a mechanistic diagram of contrasting male and female forces with internal organs that look very much like flesh-colored parts of a combustion engine. To Duchamp, apparently, men and women were machines that ran on passion as fuel. Like those of the dadaists, many of Duchamp's works also exploit chance and accident.

Dada

The horrors of World War I caused tremendous disillusionment. One expression of this was the birth of a movement called "dada." (Considerable debate exists about when and how the word "dada"—it is French for "hobbyhorse"—came to be chosen. The dadaists themselves accepted it as two nonsense syllables, like one of a baby's first words.) During the years 1915–16, many artists gathered in neutral capitals in Europe to express their disgust at the direction western societies were taking. Dada was thus a political protest, and, in many places, the dadaists produced more left-wing propaganda than art.

By 1916, a few works of art began to appear, many of them FOUND OBJECTS and experiments in which chance played an important role. For example, Jean Arp produced collages that he made by dropping haphazardly cut pieces of paper onto a surface and pasting them down the way they fell. Max Ernst (1891–1976) juxtaposed strange, unrelated items to produce unexplainable phenomena. This use of conventional items placed in circumstances that alter their traditional meanings is characteristic of dadaist art. Irrationality, meaninglessness, and harsh, mechanical images are typical effects as shown in *Woman, Old Man, and Flower* (Fig. **14.14**). This is a nonsensical world in which pseudo-human forms with their bizarre features and proportions suggest a malevolent unreality.

14.15 Giorgio de Chirico, *The Nostalgia of the Infinite*, c.1913–14, dated 1911 on painting. Oil on canvas, 4 ft 5¼ ins × 2 ft 1½ ins (135.2 × 64.8 cm). The Museum of Modern Art, New York.

Surrealism

As the work of Sigmund Freud became popular, artists became fascinated by the subconscious mind. By 1924, a surrealist manifesto stated some specific connections between the subconscious mind and painting. Surrealist works were thought to be created by "pure psychic automatism." Its advocates saw surrealism as a way to discover the basic realities of psychic life by automatic associations. Supposedly, a dream could be transferred directly from the unconscious mind of the painter to canvas without control or conscious interruption.

The metaphysical fantasies of Giorgio de Chirico (1888–1978) have surrealist qualities. In works such as *The Nostalgia of the Infinite* (Fig. **14.15**), strange objects are irrationally juxtaposed: they come together as in a dream. These bizarre works reflect a world that human beings do not control. In them, "there is only what I see with my eyes open, and even better, closed."

Surrealism is probably more accurately represented by the paintings of Salvador Dali, however. Dali (1904–89) called his works, such as *The Persistence of Memory* (Fig. **14.16**), "hand-colored photographs of the subconscious," and the almost photographic detail of his work, coupled with the nightmarish relationships of the objects he pictures, has a forceful impact. The whole idea of time is destroyed in these "soft watches" (as they were called by those who first saw this work) hanging limply and crawling with ants. And yet the images are strangely fascinating, perhaps in the way we are fascinated by the world of our dreams. While the anti-art dadaism of Max Ernst may seem repulsive, the irrationality of de Chirico and Dali can be entrancing. The starkness and graphic clarity of Figures **14.15** and **14.16** speak of the unpolluted light of another planet, yet nonetheless it reveals a world we seem to know.

American painting

Until the early 20th century, painting in the United States had done little more than adapt European trends to the American experience. Strong and vigorous American painting emerged in the early 20th century, however. It encompasses so many people and styles that we will have to be content with only a few representative examples.

An early group called "the Eight" appeared in 1908 as painters of the American "scene." They were Robert Henri, George Luks, John Sloan, William Glackens, Everett Shinn, Ernest Lawson, Maurice Prendergast, and Arthur B Davies. These painters shared a warm and somewhat sentimental view of American city life, and they presented it both with and without social criticism. Although uniquely American in tone, the works of the Eight often revealed European influences, for example, of impressionism.

14.16 Salvador Dali,
The Persistence of Memory, 1931.
Oil on canvas, 9½ × 13 ins
(24 × 33 cm). The Museum
of Modern Art, New York.

14.17 Georgia O'Keeffe, *Dark Abstraction*, 1924.
Oil on canvas, 24⅞ × 20⅞ ins (63 × 53 cm).
St Louis Art Museum (Gift of Charles E. and Mary Merrill).

The modern movement in America owed much to the tremendous impact of the International Exhibition of Modern Art (called the Armory Show) in 1913. There, rather shocking European modernist works, such as Duchamp's *Nude Descending a Staircase* (Fig. **14.12**) and the cubist work of Braque and Picasso, were first revealed to the American public.

Georgia O'Keeffe (1887–1986), an American, proved to be one of the most original artists of the century. Her imagery draws on a wide variety of objects that she abstracts in a uniquely personal way. She takes, for example, an animal skull and transforms it into a form of absolute simplicity and beauty. In *Dark Abstraction* (Fig. **14.17**), an organic form becomes an exquisite landscape which, despite the modest size of the painting, appears monumental. Her lines flow gracefully upward and outward with skillful blending of colors and rhythmic grace. The painting expresses a mystical reverence for nature, whatever we take its subject matter to be. O'Keeffe creates a sense of reality that takes us beyond our usual perceptions into something much deeper.

Precisionists, such as Stuart Davis (1894–1964), took real objects and arranged them into abstract groupings, as in *Lucky Strike* (Fig. **14.19**). These paintings often use the strong, vibrant colors of commercial art (and are much like those of pop art in the 1960s). At every turn, this subject matter surprises us. At first we wonder at the frame within the frame. The gray textured border provides a strong color contrast to the interior form, which,

14.18 Grant Wood, *American Gothic*, 1930. Oil on beaver board, 29⅞ × 24⅞ ins (79 × 63.2 cm). Friends of American Art Collection. Courtesy of Art Institute of Chicago.

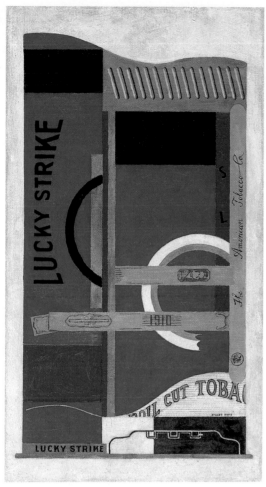

14.19 Stuart Davis, *Lucky Strike*, 1921.
Oil on canvas, $33\frac{1}{4} \times 18$ ins (84.5 × 45.7 cm).
The Museum of Modern Art, New York
(Gift of the American Tobacco Company, Inc.).

The Harlem Renaissance

From 1919 to 1925, Harlem, a neighborhood in upper Manhattan, became the international capital of black culture. "Harlem was in vogue," wrote the black poet Langston Hughes. Black painters, sculptors, musicians, poets, and novelists joined in a remarkable artistic outpouring. Some critics at the time attacked this work as isolationist and conventional, and the quality of the Harlem Renaissance still stirs debate.

The movement took up several themes: glorification of the black American's African heritage, the tradition of black folklore, and the daily life of black people. In exploring these subjects, Harlem Renaissance artists broke with previous black artistic traditions. But they celebrated black history and culture and defined a visual vocabulary for black Americans.

Black intellectuals such as W. E. B. Du Bois, Alain Locke, and Charles Spurgeon spearheaded the movement. Among the notable artists were social documentarian and photographer James van der Zee (1886–1983), painter William Henry Johnson (1901–70), painter Palmer Hayden (1890–1973), painter Aaron Douglas (1899–1979), and sculptor Meta Vaux Warrick Fuller (1877–1968).

14.20 Aaron Douglas, *Aalta*, 1936. Oil on canvas, 18 × 23 ins (45.7 × 58.4 cm). Afro-American Collection of Art, The Carl Van Vechten Gallery of Fine Arts, Fisk University.

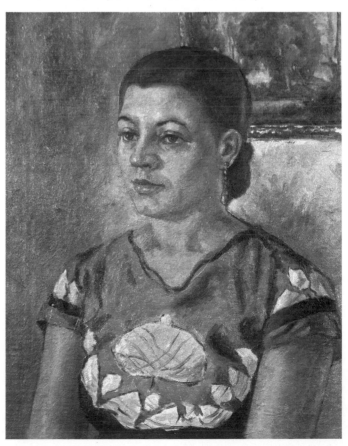

were it not for the curved form at the top, would look very much like a window. The curve is repeated in reverse near the bottom of the picture, and the slight slant of these two opposing lines is encountered by the reverse slant of the white and black arcs. The strength of this work lies in the juxtaposition of complementary colors, rectilinear and curvilinear forms, and opposing values, that is, lights and darks.

The realist tradition continued in the works of Grant Wood (1892–1942). The painting *American Gothic* (Fig. **14.18**) is a wonderful celebration of the simple, hard-working people of America's heartland. There is a lyric spirituality behind the façade of this down-home illustration. The elongated forms are pulled up together into a pointed arch which encapsulates the Gothic window of the farmhouse and escapes the frame of the painting through the lightning rod (just as the Gothic spire released the spirituality of the earth into heaven at its tip). Rural American reverence for home and labor is celebrated here with gentle humor.

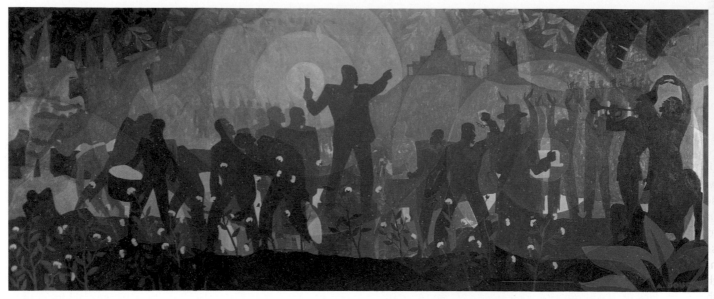

14.21 Aaron Douglas, *Aspects of the Negro Life* (detail), 1934. Oil on canvas, entire work 5 × 11 ft 7 ins (1.52 × 3.53 m). Schomburg Center for Research in Black Culture, New York Public Library, Astor, Lenox and Tilden Foundations.

Aaron Douglas was arguably the foremost painter of the Harlem Renaissance. In his highly stylized work, he explores a palette of muted tones. Douglas was particularly well known for his illustrations and cover designs for many books by black writers. His portrait of A*alta* (Fig. **14.20**) is warm and relaxed, and its color and line express dignity, elegance, and stability. A*spects of the Negro Life* (Fig. **14.21**), at the New York Public Library's Cullen branch, documents the emergence of a black American identity in four panels. The first portrays the African background in images of music, dance, and sculpture. The next two panels bring to life slavery and emancipation in the American South and the flight of blacks to the cities of the North. The fourth panel returns to the theme of music. The master of many styles, Douglas was extremely effective in his realistic work.

Central American painting

Diego Rivera (1886–1957) revived the fresco mural as an art form in Mexico in the 1920s. Working with the support of a new revolutionary government, he produced large-scale public murals that picture contemporary subjects in a style that blends European and native traditions. The fresco painting *Enslavement of the Indians* (Fig. **14.22**) creates a dramatic comment on that chapter in Mexican history. The composition is not unlike that of Goya's *The Third of May* 1808 (Fig. **13.7**). A strong diagonal sweeps across the work, separating the oppressed from the oppressor, and provides a dynamic movement that is stabilized by the classically derived arcade framing the top of the composition.

14.22 Diego Rivera, *Enslavement of the Indians*, 1930–31. Fresco. Palace of Cortez, Cuernavaca, Mexico.

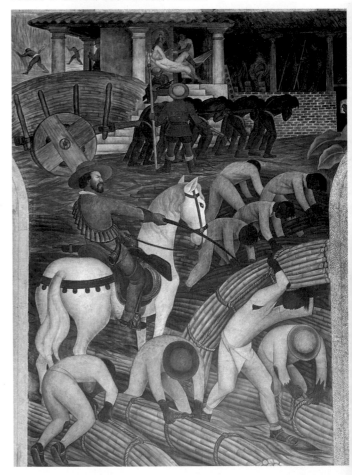

SCULPTURE

Sculpture revived significantly in the 20th century. Interest in cultures beyond Europe, for example, those of Africa and Polynesia, where sculpture played a dominant role, uncovered new expressive elements that owed nothing to the classical ideals.

Classicism continued, as Figures **14.23** and **14.24** suggest. Maillol's *Air* uses parallels of arm and legs, and a compelling gesture of the hand which is accentuated by the positions of the head and the supporting arm. The work has a severity that is exceptional for Maillol. The self-contained form and symbolic mythology of MacNeil's *Into the Unknown* also demonstrate a return to classical form and subject matter. Both Maillol and MacNeil value simplicity of form and clear line and structure. Their work has the same intellectual appeal we have seen in works of the classical spirit throughout history. Most sculptors of the time, in fact, tended to work in the same vein as did Maillol and MacNeil. They represent a continuation of traditional techniques, materials, and subject matter—that is, the nude figure.

14.23 Hermon Atkins MacNeil, *Into the Unknown*, c.1912. White marble, c.4 ft (1.2 m) high. Brookgreen Garden, South Carolina.

14.24 Aristide Maillol, *Air*, 1938–39. Lead, 4 ft 7⅛ ins × 8 ft 4⅛ ins (1.4 × 2.55 m).

Futurism

Sculptors now turned to further explorations of three-dimensional space and what they could do with it. Technological developments and new materials also encouraged the search for new forms to characterize the age. This search resulted in a style called "futurism," which was really more of an ideology than a style. Futurism encompassed more than just the arts, and it sought to destroy the past—especially the Italian past—in order to institute a totally new society, a new art, and new poetry. Its basis lay in "new dynamic sensations." In other words, the objects of modern life, such as "screaming automobiles" that run like machine guns, have a new beauty—speed—that is more beautiful than even the most dynamic objects of previous generations. Futurists found in the noise, speed, and mechanical energy of the modern city a unique exhilaration that made everything of the past drab and unnecessary. The movement was particularly strong in Italy and among Italian sculptors. In searching for new dynamic qualities, the Italian futurists in the visual arts found that many new machines had sculptural form. Their own sculptures followed mechanistic lines and included representations of motion.

Boccioni's *Unique Forms of Continuity in Space* (Fig. **14.1**) takes the mythological subject of Mercury, messenger of the gods (compare Bologna's *Mercury*, Fig. **10.27**), and turns him into a futuristic machine. The overall form is recognizable and the outlines of the myth move the viewer's thoughts in a particular direction. Nonetheless, this is primarily an exercise in composition. The intense sense of energy and movement is created by the variety of surfaces and curves that flow into one another in a seemingly random, yet highly controlled pattern. The overall impression is of the motion of the figure rather than of the figure itself.

African and primitive influences

The direct influence of African art can be seen in the sculptures of Constantin Brancusi (1876–1957) (Figs **14.25** and **14.26**). Yet beyond this, the smooth, precise surfaces of much of his work seem to have an abstract, machined quality. Brancusi's search for essential form led to very economical presentations, often ovoid and simple, yet animate. Certainly, great psychological complexity exists in B*ird in Space*. Its highly polished surface and upward striving line has a modern sleekness, and yet somehow, its primitive essence remains, reminding us of the work of African or Aboriginal tribes. Brancusi's *Mlle Pogany* (Fig. **14.26**), despite the superbly polished surface and accomplished curves which lead the eye inward, has an enigmatic character that is reminiscent of an African mask.

14.25 Constantin Brancusi, B*ird in Space*, c.1928. Bronze (unique cast), 4 ft 6 ins (1.37 m) high. The Museum of Modern Art, New York.

14.26 Constantin Brancusi, *Mlle Pogany*, 1931. Marble on limestone base, 19 ins (48 cm) high. Philadelphia Museum of Art (Louise and Walter Arensberg Collection).

MASTERWORK
Moore—Recumbent Figure

The British sculptor Henry Moore (1898–1986) explored many ways of depicting the human figure. These various treatments are unified by a deep feeling for the dignity of the human form, however. In *Recumbent Figure* (Fig. **14.27**), the humanity of the piece emerges perhaps more strongly than it would in a purely naturalistic expression.

Moore's work reflects the "primevalism" inherent in some sculpture even today, and his early work was influenced by the monoliths of Stonehenge. However, *Recumbent Figure* also displays a certain classicism. The sense of the resting form recalls that of Dionysus in the sculptures from the pediment of the Parthenon. In a very modern way, the stone is not disguised, but rather profoundly exploited. Perhaps the most "famous" features of Moore's sculptures are the "holes," or "negative spaces," that he inserts. The negative space provides a counterpoint to the interlocking shapes of the solids in his work.

14.27 Henry Moore, *Recumbent Figure*, 1938. Green Hornton stone, 4 ft 7 ins (1.4 m) long. The Tate Gallery, London.

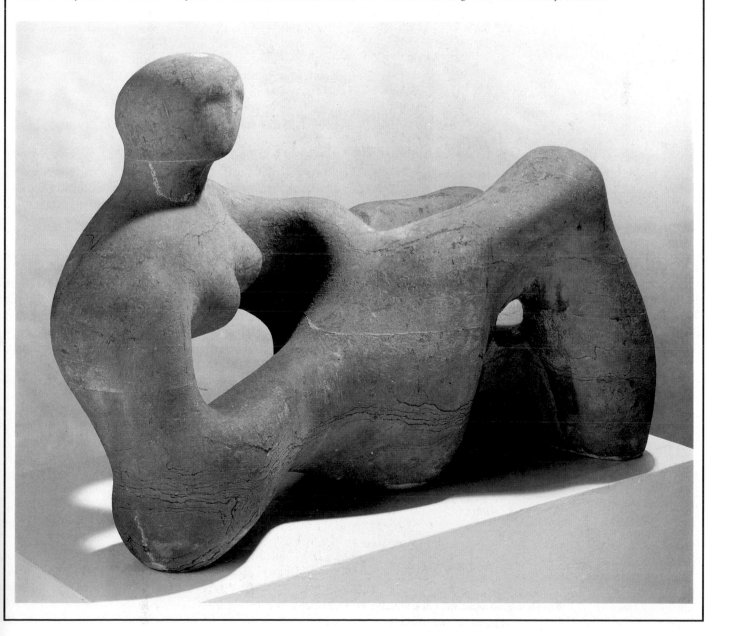

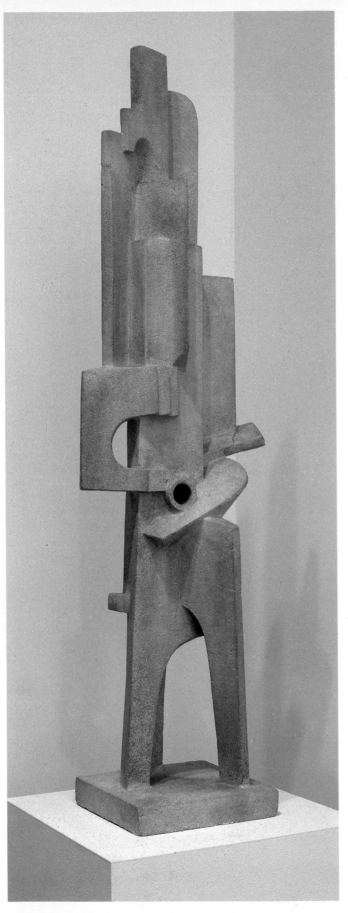

14.28 Jacques Lipchitz, *Man with a Guitar*, 1915. Limestone, 38¼ ins (97.2 cm) high. The Museum of Modern Art, New York (Mrs Simon Guggenheim Fund).

In 1925, Jacques Lipchitz (1891–1973) created a series of "transparents" made from cardboard cut and bent to approximate the cubism of Picasso's paintings. He thus opened up the interiors of these works, to achieve a radical new understanding of space: interior spaces need not be voids, but, rather, could become integral parts of the sculptural work itself. Thus, he arrived at the concept of negative space, which played an important role in sculpture, especially, as we have seen, in the work of Henry Moore.

Lipchitz's *Man with a Guitar* (Fig. **14.28**) predates his discovery of negative space, but clearly it reflects his interest in form, space, cubism, and archaic and primitive art. Here, these influences appear in the way forms are combined to create a multi-faceted shape that has the appearance of being viewed from several directions at once. At the same time, the work has an archaic, geometric solidity. The primitive influence is apparent in its proportions—an elongated torso and head and shortened legs. The interaction of angles and curves draws the viewer in to examine the work from many different observation points.

LITERATURE

Between 1914 and 1939, the novel came to the fore as a literary medium. The economic, moral, and intellectual chaos of the interwar period required complex literary forms to express it. The novel—"fiction in prose of a certain extent," as the French critic Abel Chevally and, later, the British writer E. M. Forster called it—proved adaptable enough to handle a multitude of ideas and experiences. Thus, the novel became a catch-all form which replaced tighter mediums of expression such as the drama, the essay, and the epic poem. Improving standards of education created a new reading public that was receptive to fiction "of a certain extent." In an age of revolt against old certainties, the novel seemed immune to rules and restrictions.

As a result, subject matter was enriched, and so was technique. Novelists now challenged the traditional forms of the novel as well as traditional concepts of time and space. Edouard, a character in *Counterfeiters* (1925) by André Gide, says: "My novel hasn't got a subject . . . 'slice of life,' the naturalistic school used to say. The great defect of that school is that it always cuts its slice in the same direction; in time, lengthwise. Why not in breadth? Or in depth? As for me, I should not like to cut it at all. Police notwithstanding, I should like to put everything in my novel."

The interwar period produced an Irish novelist of extraordinary quality, James Joyce (1882–1941). Like Gide's Edouard, Joyce in *Ulysses* did "put everything in [his] novel." In this case, however, the police *were* a factor to be reckoned with. The serial publication of *Ulysses* in

the United States was stopped by the American courts, although the finished work appeared in Paris in 1922. It was banned by the British authorities until 1941. Using stream-of-consciousness methods new to fiction, Joyce spins out actions and thoughts in great detail. The whole novel is the account of a single day in the life of Leopold Bloom. While the overall form is epic, virtually all other conventions of the novel are broken down, parodied, and recombined. Joyce also explored the unconscious mind in greater depth in *Finnegans Wake* (1939), a work of dazzling originality and great difficulty, in which the English language is replaced by a kind of polyglot punning.

The novels of D.H. Lawrence (1885–1930), such as *Sons and Lovers* and *Women in Love*, were more traditional in technique. His rejection of contemporary mass culture and the materialistic society that produced it, together with his messianic faith in "natural" (which included "sexual") things, links him strongly with the Romantics of the 19th century. The novels and short stories of Virginia Woolf (1882–1941) painstakingly explore the inner landscape of feeling and emotion, particularly that of women. In Germany, Thomas Mann (1874–1955) created a richly symbolic picture of the fatal contradictions that beset European intellectuals between the wars in his masterpiece, *The Magic Mountain*. And in France, the monumental seven-volume novel *Remembrance of Things Past* by Marcel Proust (1871–1922) not only investigated the world of bourgeois and aristocratic manners at the turn of the century, but also meticulously examined the nature of memory and time. In effect, it made of the narrator's life a work of art.

What all these writers had in common was a certain dissatisfaction with their times and a sense of alienation from them. In America, the response was different. Powerful, vital novels of social realism began to appear. The novels of John Dos Passos, Thomas Wolfe, Richard Wright, Zora Neale Hurston, and John Steinbeck made this a particularly exciting period in American literature.

Bold new directions were also taken in poetry. Among the numerous important poets of the early 20th century we must certainly mention the Irish William Butler Yeats (1865–1939) and the American Robert Frost (1874–1963), both of whom brought their own individual touch to an age of ever-expanding and experimental styles. The most famous work of T.S. Eliot (1888–1965), *The Waste Land* (1922), marked the full emergence of modernism in poetry. Here Eliot cast aside traditional meters and rhymes in favor of free verse. This new kind of writing needed to be read with great care if it was to make any sense at all. The *Cantos* of Ezra Pound and the works of e. e. cummings took this approach even further. Not all poets, however, responded to the complexity of their times by pursuing this strenuous route. W.H. Auden (1907–73), for example, reflected the mood of the 1930s in rhymed, epigrammatic satirical poetry that harked back to Alexander Pope (see Chapter 11).

Faulkner

William Cuthbert Faulkner (1897–1962) was an American novelist and short story writer. In 1929, he published his most admired work, *The Sound and the Fury*, in which he utilized the "stream-of-consciousness" technique. He was to create more than 20 novels centering on characters in the imaginary Southern "Yoknapatawpha County." His methods of narration included moving from present to past and presenting two or more seemingly unrelated stories juxtaposed against each other. Here we include a complete story.

A Rose for Emily (1920)

When Miss Emily Grierson died, our whole town went to her funeral: the men through a sort of respectful affection for a fallen monument, the women mostly out of curiosity to see the inside of her house, which no one save an old manservant—a combined gardener and cook—had seen in at least ten years.

It was a big, squarish frame house that had once been white, decorated with cupolas and spires and scrolled balconies in the heavily lightsome style of the seventies, set on what had once been our most select street. But garages and cotton gins had encroached and obliterated even the august names of that neighborhood; only Miss Emily's house was left, lifting its stubborn and coquettish decay above the cotton wagons and the gasoline pumps—an eyesore among eyesores. And now Miss Emily had gone to join the representatives of those august names where they lay in the cedarbemused cemetery among the ranked and anonymous graves of Union and Confederate soldiers who fell at the battle of Jefferson.

Alive, Miss Emily had been a tradition, a duty, and a care; a sort of hereditary obligation upon the town, dating from that day in 1894 when Colonel Sartoris, the mayor—he who fathered the edict that no Negro woman should appear on the streets without an apron—remitted her taxes, the dispensation dating from the death of her father on into perpetuity. Not that Miss Emily would have accepted charity. Colonel Sartoris invented an involved tale to the effect that Miss Emily's father had loaned money to the town, which the town, as a matter of business, preferred this way of repaying. Only a man of Colonel Sartoris' generation and thought could have invented it, and only a woman could have believed it.

When the next generation, with its more modern ideas, became mayors and aldermen, this arrangement created some little dissatisfaction. On the first of the year they mailed her a tax notice. February came, and there was no reply. They wrote her a formal letter, asking her to call at the sheriff's office at her convenience. A week later the mayor wrote her himself, offering to call or to send his car for her, and received in reply a note on paper of an archaic shape, in a thin flowing calligraphy in faded ink, to the effect that she no longer went out at all. The tax notice was also enclosed, without comment.

They called a special meeting of the Board of Aldermen. A deputation waited upon her, knocked at the door through which no visitor had passed since she ceased giving china-painting lessons eight or ten years earlier. They were admitted by the old Negro into a dim hall from which a stairway mounted into still more shadow. It smelled of dust and

disuse—a close, dank smell. The Negro led them into the parlor. It was furnished in heavy, leather-covered furniture. When the Negro opened the blinds of one window, they could see that the leather was cracked; and when they sat down a faint dust rose sluggishly about their thighs, spinning with slow motes in the single sun-ray. On a tarnished gilt easel before the fireplace stood a crayon portrait of Miss Emily's father.

They rose when she entered—a small, fat woman in black, with a thin gold chain descending to her waist and vanishing into her belt, leaning on an ebony cane with a tarnished gold head. Her skeleton was small and spare; perhaps that was why what would have been merely plumpness in another was obesity in her. She looked bloated, like a body long submerged in motionless water, and of that pallid hue. Her eyes, lost in the fatty ridges of her face, looked like two small pieces of coal pressed into a lump of dough as they moved from one face to another while the visitors stated their errand.

She did not ask them to sit. She just stood in the door and listened quietly until the spokesman came to a stumbling halt. Then they could hear the invisible watch ticking at the end of the gold chain.

Her voice was dry and cold. "I have no taxes in Jefferson. Colonel Sartoris explained it to me. Perhaps one of you can gain access to the city records and satisfy yourselves."

"But we have. We are the city authorities, Miss Emily. Didn't you get a notice from the sheriff signed by him?"

"I received a paper, yes," Miss Emily said. "Perhaps he considers himself the sheriff . . . I have no taxes in Jefferson."

"But there is nothing on the books to show that, you see. We must go by the—"

"See Colonel Sartoris. I have no taxes in Jefferson."

"But, Miss Emily—"

"See Colonel Sartoris." (Colonel Sartoris had been dead almost ten years.) "I have no taxes in Jefferson. Tobe!" The Negro appeared. "Show these gentlemen out."

2

So she vanquished them, horse and foot, just as she had vanquished their fathers thirty years before about the smell. That was two years after her father's death and a short time after her sweetheart—the one we believed would marry her—had deserted her. After her father's death she went out very little; after her sweetheart went away, people hardly saw her at all. A few of the ladies had the temerity to call, but were not received, and the only sign of life about the place was the Negro man—a young man then—going in and out with a market basket.

"Just as if a man—any man—could keep a kitchen properly," the ladies said; so they were not surprised when the smell developed. It was another link between the gross, teeming world and the high and mighty Griersons.

A neighbor, a woman, complained to the mayor, Judge Stevens, eighty years old.

"But what will you have me do about it, madam?" he said.

"Why, send her word to stop it," the woman said. "Isn't there a law?"

"I'm sure that won't be necessary," Judge Stevens said. "It's probably just a snake or a rat that nigger of hers killed in the yard. I'll speak to him about it."

The next day he received two more complaints, one from a man who came in diffident depreciation. "We really must do

someting about it, Judge, I'd be the last one in the world to bother Miss Emily, but we've got to do something." That night the board of Aldermen met—three graybeards and one younger man, a member of the rising generation.

"It's simple enough," he said. "Send her word to have her place cleaned up. Give her a certain time to do it in, and if she don't . . . "

"Dammit, sir," Judge Stevens said, "will you accuse a lady to her face of smelling bad?"

So the next night, after midnight, four men crossed Miss Emily's lawn and slunk about the house like burglars, sniffing along the base of the brickwork and at the cellar openings while one of them performed a regular sowing motion with his hand out of a sack slung from his shoulder. They broke open the cellar door and sprinkled lime there, and in all the outbuildings. As they recrossed the lawn, a window that had been dark was lighted and Miss Emily sat in it, the light behind her, and her upright torso motionless as that of an idol. They crept quietly across the lawn and into the shadow of the locusts that lined the street. After a week or two the smell went away.

That was when people had begun to feel sorry for her. People in our town, remembering how old lady Wyatt, her great-aunt, had gone completely crazy at last, believed that the Griersons held themselves a little too high for what they really were. None of the young men were quite good enough to Miss Emily and such. We had long thought of them as a tableau; Miss Emily a slender figure in white in the background, her father a spraddled silhouette in the foreground, his back to her and clutching a horse-whip, the two of them framed by the back-flung front door. So when she got to be thirty and was still single, we were not pleased exactly, but vindicated; even with insanity in the family she wouldn't have turned down all her chances if they had really materialized.

When her father died, it got about that the house was all that was left to her; and in a way, people were glad. At last they could pity Miss Emily. Being left alone, and a pauper, she had become humanized. Now she too would know the old thrill and the old despair of a penny more or less.

The day after his death all the ladies prepared to call at the house and offer condolence and aid, as is our custom. Miss Emily met them at the door, dressed as usual and with no trace of grief on her face. She told them that her father was not dead. She did that for three days, with the ministers calling on her, and the doctors, trying to persuade her to let them dispose of the body. Just as they were about to resort to law and force, she broke down, and they buried her father quickly.

We did not say she was crazy then. We believed she had to do that. We remembered all the young men her father had driven away, and we knew that with nothing left, she would have to cling to that which had robbed her, as people will.

3

She was sick for a long time. When we saw her again, her hair was cut short, making her look like a girl, with a vague resemblance to those angels in colored church windows—sort of tragic and serene.

The town had just let the contracts for paving the sidewalks, and in the summer after her father's death they began the work. The construction company came with niggers and mules and machinery, and a foreman named Homer Barron, a Yankee—a big, dark, ready man, with a big voice and

eyes lighter than his face. The little boys would follow in groups to hear him cuss the niggers, and the niggers singing in time to the rise and fall of picks. Pretty soon he knew everybody in town. Whenever you heard a lot of laughing anywhere about the square, Homer Barron would be in the center of the group. Presently we began to see him and Miss Emily on Sunday afternoons driving in the yellow-wheeled buggy and the matched team of bays from the livery stable.

At first we were glad that Miss Emily would have an interest, because the ladies all said, "Of course a Grierson would not think seriously of a Northerner, a day laborer." But there were still others, older people, who said that even grief should not cause a real lady to forget noblesse oblige—without calling it noblesse oblige. They just said, "Poor Emily. Her kinsfolk should come to her." She had some kin in Alabama; but years ago her father had fallen out with them over the estate of old lady Wyatt, the crazy woman, and there was no communication between the two families. They had not even been represented at the funeral.

As soon as the old people said, "Poor Emily," the whispering began. "Do you suppose it's really so?" they said to one another. "Of course it is. What else could . . ." This behind their hands; rustling of craned silk and satin behind jalousies closed upon the sun of Sunday afternoon as the thin, swift clop-clop-clop of the matched team passed: "Poor Emily."

She carried her head high enough—even when we believed that she was fallen. It was as if she demanded more than ever the recognition of her dignity as the last Grierson; as if it had wanted that touch of earthiness to reaffirm her imperviousness. Like when she bought the rat poison, the arsenic. That was over a year after they had begun to say "Poor Emily," and while the two female cousins were visiting her.

"I want some poison," she said to the druggist. She was over thirty then, still a slight woman, though thinner than usual, with cold, haughty black eyes in a face the flesh of which was strained across the temples and about the eye-sockets as you imagine a lighthouse-keeper's face ought to look. "I want some poison," she said.

"Yes, Miss Emily. What kind? For rats and such? I'd recom—"

"I want the best you have. I don't care what kind."

The druggist named several. "They'll kill anything up to an elephant. But what you want is—"

"Arsenic," Miss Emily said. "Is that a good one?"

"Is . . . arsenic? Yes, ma'am. But what you want—"

"I want arsenic."

The druggist looked down at her. She looked back at him erect, her face like a strained flag. "Why of course," the druggist said. "If that's what you want. But the law requires you to tell what you are going to use it for."

Miss Emily just stared at him, her head tilted back in order to look him eye for eye, until he looked away and went and got the arsenic and wrapped it up. The Negro delivery boy brought her the package; the druggist didn't come back. When she opened the package at home there was written on the box, under the skull and bones: "For rats."

4

So the next day we all said, "She will kill herself"; and we said it would be the best thing. When she had first begun to be seen with Homer Barron, we had said, "She will marry him."

Then we said, "She will persuade him yet," because Homer himself had remarked—that he liked men, and it was known that he drank with the younger men in the Elk's club—that he was not a marrying man. Later we said, "Poor Emily," behind the jalousies as they passed on Sunday afternoon in the glittering buggy, Miss Emily with her head high and Homer Barron with his hat cocked and a cigar in his teeth, reins and whip in a yellow glove.

Then some of the ladies began to say that it was a disgrace to the town and a bad example to the young people. The men did not want to interfere, but at last the ladies forced the Baptist minister—Miss Emily's people were Episcopal—to call upon her. He would never divulge what happened during that interview, but he refused to go back again. The next Sunday they again drove about the streets, and the following day the minister's wife wrote to Miss Emily's relations in Alabama.

So she had blood-kin under her roof again and we sat back to watch the developments. At first nothing happened. Then we were sure that they were to be married. We learned that Miss Emily had been to the jeweler's and ordered a man's toilet set in silver, with the letters H. B. on each piece. Two days later we learned that she had bought a complete outfit of men's clothing, including a nightshirt, and we said, "They are married." We were really glad. We were glad because the two female cousins were even more Grierson than Miss Emily had ever been.

So we were not surprised when Homer Barron—the streets had been finished some time since—was gone. We were a little disappointed that there was not a public blowing-off, but we believed that he had gone on to prepare for Miss Emily's coming or to give her a chance to get rid of the cousins. (By that time it was a cabal, and we were all Miss Emily's allies to help circumvent the cousins.) Sure enough, after another week they departed. And, as we had expected all along, within three days Homer Barron was back in town. A neighbor saw the Negro man admit him at the kitchen door at dusk one evening.

And that was the last we saw of Homer Barron. And of Miss Emily for some time. The Negro man went in and out with the market basket, but the front door remained closed. Now and then we would see her at a window for a moment, as the men did that night when they sprinkled lime, but for almost six months she did not appear on the streets. Then we knew that this was to be expected too; as if that quality of her father which had thwarted her woman's life so many times had been too virulent and too furious to die.

When we next saw Miss Emily, she had grown fat and her hair was turning gray. During the next few years it grew grayer and grayer until it attained an even pepper-and-salt iron-gray, when it ceased turning. Up to the day of her death at seventy-four it was still that vigorous iron-gray, like the hair of an active man.

From that time on her front door remained closed, save for a period of six or seven years, when she was about forty, during which she gave lessons in china-painting. She fitted up a studio in one of the downstairs rooms, where the daughters and granddaughters of Colonel Sartoris' contemporaries were sent to her with the same regularity and in the same spirit that they were sent to church on Sundays with a 25 cent piece for the collection plate. Meanwhile her taxes had been remitted.

Then the newer generation became the backbone and spirit of the town, and the painting pupils grew up and fell

away and did not send their children to her with boxes of color and tedious brushes and pictures cut from the ladies' magazines. The front door closed upon the last one and remained closed for good. When the town got free postal delivery, Miss Emily alone refused to let them fasten the metal numbers above her door and attach a mailbox to it. She would not listen to them.

Daily, monthly, yearly we watched the Negro grow grayer and more stooped, going in and out with the market basket. Each December we sent her a tax notice, which would be returned by the post office a week later, unclaimed. Now and then we would see her in one of the downstairs windows—she had evidently shut up the top floor of the house—like the carven torso of an idol in a niche, looking or not looking at us, we could never tell which. Thus she passed from generation to generation—dear, inescapable, impervious, tranquil, and perverse.

And so she died. Fell ill in the house filled with dust and shadows, with only a doddering Negro man to wait on her. We did not even know she was sick; we had long since given up trying to get any information from the Negro. He talked to no one, probably not even to her, for his voice had grown harsh and rusty, as if from disuse.

She died in one of the downstairs rooms, in a heavy walnut bed with a curtain, her gray head propped on a pillow yellow and moldy with age and lack of sunlight.

5

The Negro met the first of the ladies at the front door and let them in, with their hushed, sibilant voices and their quick, curious glances, and then he disappeared. He walked right through the house and out the back and was not seen again.

The two female cousins came at once. They held the funeral on the second day, with the town coming to look at Miss Emily beneath a mass of bought flowers, with the crayon face of her father musing profoundly above the bier and the ladies sibilant and macabre; and the very old men—some in their brushed Confederate Uniforms—on the porch and the lawn, talking of Miss Emily as if she had been a contemporary of theirs, believing that they had danced with her and courted her perhaps, confusing time with its mathematical progression, as the old do, to whom all the past is not a diminishing road but, instead, a huge meadow which no winter ever quite touches, divided from them now by the narrow bottle-neck of the most recent decade of years.

Already we knew that there was one room in that region above stairs which no one had seen in forty years, and which would have to be forced. They waited until Miss Emily was decently in the ground before they opened it.

The violence of breaking down the door seemed to fill this room with pervading dust. A thin, acrid pall as of the tomb seemed to lie everywhere upon this room decked and furnished as for a bridal: upon the valence curtains of faded rose color, upon the roseshaded lights, upon the dressing table, upon the delicate array of crystal and the man's toilet things backed with tarnished silver, silver so tarnished that the monogram was obscured. Among them lay a collar and tie, as if they had just been removed, which lifted, left upon the surface a pale crescent in the dust. Upon a chair hung the suit, carefully folded; beneath it the two mute shoes and the discarded socks.

The man himself lay in the bed.

For a long while we just stood there, looking down at the profound and fleshless grin. The body had apparently once lain in the attitude of an embrace, but now the long sleep that outlasts love, had cuckolded him. What was left of him, rotted beneath what was left of the nightshirt, had become inextricable from the bed in which he lay; and upon him and upon the pillow beside him lay that even coating of the patient and biding dust.

Then we noticed that in the second pillow was the indentation of a head. One of us lifted something from it, and leaning forward, that faint and invisible dust dry and acrid in the nostrils, we saw a long strand of iron-gray hair.

Langston Hughes

The African–American poet, Langston Hughes (1902–67), caught with sharp immediacy and intensity the humor, pathos, irony, and humiliation of being black in America. As early as 1921, Hughes received considerable attention with his poem "The Negro Speaks of Rivers." These two short selections convey something of his sense of the black experience and his perception of the universe.

Theme for English B

The instructor said,
 Go home and write
 a page tonight.
 And let that page come out of you—
 Then, it will be true.
I wonder if it's that simple?

I am twenty-two, colored, born in Winston-Salem.
I went to school there, then Durham, then here
to this college on the hill above Harlem.
I am the only colored student in my class.
The steps from the hill lead down into Harlem
through a park, then I cross St Nicholas.
Eighth Avenue. Seventh, and I come to the Y,
the Harlem Branch Y, where I take the elevator
up to my room, sit down, and write this page:
It's not easy to know what is true for you or me
at twenty-two, my age. But I guess I'm what
I feel and see and hear, Harlem, I hear you:
hear you, here me—we two—you, me, talk on this page.
(I hear New York, too) Me—who?

Well, I like to eat, sleep, drink, and be in love.
I like to work, read, learn, and understand life.
I like a pipe for a Christmas present,
or records—Bessie, bop, or Bach.
I guess being colored doesn't make me not like
the same things other folks like who are other races.
So will my page be colored that I write?
Being me, it will not be white.
But it will be
a part of you, instructor.
You are white—
yet a part of me, as I am a part of you,

that's American.
Sometimes perhaps you don't want to be a part of me,
Nor do I often want to be apart of you.
But we are, that's true!

As I learn from you
I guess you learn from me—
although you're older—and white—
and somewhat more free.

This is my page for English B.

Harlem

What happens to a dream deferred?

Does it dry up
like a raisin in the sun?
Or fester like a sore—
And then run?
Does it stink like rotten meat?
Or crust and sugar over—
like a syrupy sweet?

Maybe it just sags
like a heavy load.

Or *does it explode*?[4]

THEATRE

Toward the New Stagecraft

Two important dramatic theorists bridged the turn of the century. Both Adolphe Appia (1862–1928) and Gordon Craig (1872–1966) had symbolist leanings, and both tried to articulate new ideas about theatre production. Appia attempted to find a new means for unifying theatre action among the many different visual forms and stage practices—moving actors, horizontal floors, and vertical scenery. In 1899, Appia, a Swiss, published his influential work *Die Musik und die Inscenierung* (*Music and Staging*), which set forth his suggested reforms. Stage design, he said, must be in harmony with the living presence of the performer. An accurate depiction of reality was unnecessary. The audience's attention should be focused on the character, not on scenic details. Further, he thought that two-dimensional painted scenery was incompatible with live actors. The contrast between flat scenic elements and a plastic, three-dimensional human form was too distracting. For Appia, the human body was reality itself, and the stage floor should only make that body stand out in relief. "Scenic reality" was the living presence of the actor, and the stage should be cleared of everything that "is in contradistinction with the actor's presence."

More a visionary and a theorist than an actual man of the theatre, the Englishman Gordon Craig believed in a unity of production elements forged under the command of a superdirector. He sought to replace realistic scenic depiction with suggestion, and he insisted upon a spiritual relationship between setting and action. Theatre was "a place for seeing." Moving figures, light and shadow, and dramatic color all had tremendous potential, which Craig tried to explore. For the most part, Craig's theories remained just that. His designs proved impractical, and, in many cases, disastrous to the production. He had some successes, however, and managed to convince many theatre artists that his views were significant.

Appia and Craig were important proponents of "ECLECTICISM," sometimes called "artistic realism" and sometimes called "organic unity," which drastically changed theatre style at the turn of the 20th century. Previously, all plays were held to a single standard—whatever was the vogue of the day. For example, in the mid-19th century, when antiquarian realism was the fashion, all plays—melodramas, Greek tragedies, or Shakespearean comedies—would have been staged in the same style. Artistic realism, or eclecticism, however, held that the stage environment must be appropriate to the given play. Style, it was thought, should reflect the style appropriate to the period in which the play was written. Therefore the 20th century became, and still is, an era of stylistic diversity, of eclecticism, in which each play and each production of each play determine what the audience actually sees.

The organic approach to theatre grew principally from the work of Max Reinhardt (1873–1943). He treated each play as an aesthetic problem, and saw the physical environment of the production—the *mise en scène*—as a vital part of stylistic communication. To enforce this organic unity, he, like Craig and others, made the director the supreme theatre artist. Ultimately, the director had to be responsible for all aspects of production—actors, lighting, costumes, scenery, props, sound, and even the final version of the script itself. When this approach finally reached the United States in around 1910, it was called the "New Stagecraft."

Expressionism

Expressionism brought more disillusion than realism to the theatre. But the theatre is both visual and oral. The painters' revolt against naturalism came to the theatre in scenic design, and it was settings that followed expressionist fashion. For playwrights, expressionism was merely an extension of realism or naturalism, and it allowed them to express their reactions to the universe more fully. August Strindberg, for example, turned inward to the subconscious in expressionistic plays such as the *Ghost Sonata*. In so doing, he created a "presentational" rather than "representational" style.

The plays of Ernst Toller (1893–1939) typify German expressionistic disillusionment after World War I. Toller's

personal struggles, his communist idealism, and his opposition to violence are reflected in the heroine of Man and the Masses. Sonia, a product of the upper class, leads a strike for peace. Her desire to avoid violence and bloodshed is opposed by the mob spirit (the "Nameless One"), who seeks just those results, and to destroy the peace the strike intends to achieve. For leading the disastrous strike, Sonia is imprisoned and sentenced to death.

Expressionism also found its way to America. Elmer Rice's Adding Machine (1923) introduces the viewer to Mr Zero, a cog in the great industrial machinery of 20th-century life, who stumbles through a pointless existence. Finding himself replaced by an adding machine, he goes berserk, kills his employer, and is executed. Adrift later in the hereafter, he is too narrow-minded to understand the happiness offered to him there. He becomes an adding machine operator in heaven, and finally returns to earth to begin his tortured existence all over again.

Social action

The early years of the 20th century saw many production experiments aimed at inspiring social action. Social-action advocates typically adopted subjective attitudes toward their subjects and used fragmentary scenery and other generally distorted visual elements. For the most part, they sought to combine the traditional goals of theatre—to entertain and to teach—in order to motivate the spectator into action outside the theatre.

An excellent example involving the work of the director Vsevolod Meyerhold (1874–1942) came from the Moscow Art Theatre in the late 19th century. Meyerhold's plays were a product of the Russian Revolution and its attempts to transform society. For Meyerhold, a revolutionized society required a revolutionized theatre. His approach led him into difficulty on two counts, however. First, his mechanized treatment of the actor was not acceptable to Constantin Stanislavsky, the dominant force in the Moscow Art Theatre. Second, Meyerhold's work was considered too formal to appeal to the masses.

Meyerhold did believe that the director was the supreme artist in the theatre, and he freely rewrote scripts to suit his own ends. He devised a system of actor training called "biomechanics," the object of which was to make an actor's body an efficient machine for carrying out the instructions of its operator (the director). Meyerhold's actors were often required to swing from trapezes, do gymnastic stunts, and spring up through trap doors.

Central to Meyerhold's thinking was his concept of theatricalism. Rather than trying to imitate life, he wanted the audience to know they were in a theatre and not to confuse theatre with life. To establish this, he removed many of the devices that the theatre routinely uses. Curtains were removed so that backstage areas and lighting instruments were fully visible. He also introduced a practical style of staging called "constructivism." The sets were called "constructions," and they consisted of various levels and playing areas of a non-objective nature. Rather than a more or less realistic portrayal of place, scenery became a series of structures on which the actors could perform and with which they could be integrated. Ultimately, the stage, the actor, and all aspects of performance were parts of a machine which was operated by the director.

Social protest also found a home in the American theatre in the years that led up to World War II. The spiritual and economic collapse of the Great Depression prompted many playwrights to examine the American social fabric. Maxwell Anderson had questioned American values earlier, but the most poignant protest came from the pen of Clifford Odets (1906–63). In 1935, he produced a one-act play about New York's bitter taxicab strike, Waiting for Lefty. In an innovatve staging move, Odets made the audience sit in a section of the auditorium portion of a labor hall, thus making the spectators a part of the play. At the front, on the traditional stage, several characters waited for the appearance of Lefty, so that the meeting could begin. As the play progressed, actors rose from seats in the audience to voice their complaints. Tension mounted, and when it was discovered that Lefty had been assassinated, actors in the audience began to chant "strike, strike, strike" Finding themselves in the middle of the action, the audience actually took up the chant themselves. During the Depression, when the play was produced, its impact was significant. Even today, productions of Waiting for Lefty often have the same effect on an audience.

Independent art theatre movement

The independent art theatre movement produced one of America's greatest playwrights, Eugene O'Neill. An intense struggle for theatre monopoly between the theatrical Syndicate and the Schubert brothers marked the first two decades of the 20th century. Unions were formed, the movies poached theatre audiences, and little attention was paid to nurturing playwrights, the soul of any vital theatre. One independent theatre company led the movement another way, however. The Provincetown Players were a group of young actors and writers who spent their summers on Cape Cod. Banding together, they opened the Wharf Theatre in Provincetown and later moved to New York.

The early plays of Eugene O'Neill (1888–1953) were produced under the banner of the Provincetown Players. Son of the famous actor James O'Neill, Eugene knew the theatre well, and he was influenced especially by the expressionist works of August Strindberg as well as the sea stories of Joseph Conrad. O'Neill's work ranged far and wide in a restless search for subjects, styles, and new

14.29 Lee Simonson, constructivist set for Eugene O'Neill's *Dynamo*, 1929. The New York Public Library.

approaches. The *Emperor Jones*, the *Hairy Ape*, and *Dynamo* (Fig. **14.29**) employ expressionistic techniques. The *Great God Brown* uses masks to contrast internal and external reality. *Strange Interlude* employs long soliloquies, and the play runs so long that the original production started at 5:30 p.m. and broke for an hour and a half for dinner, then resumed and ran until 11:00 p.m. *Mourning Becomes Electra* is a Greek tragedy set in New England, while *Ah, Wilderness!* is a warm, realistic comedy.

Epic theatre

The theatre of social action found a very successful exponent in Bertolt Brecht (1898–1956) and his epic theatre. Although most of Brecht's plays were written before the war, they were not produced until after it. With his Berliner Ensemble, Brecht brought his theories and productions to a wide audience. Drawing heavily on the expressionists, Brecht developed complex theories about theatre and its relationship to life, and he continued to mold and develop these theories until his death.

Brecht was in revolt against dramatic theatre. Essentially, he tried to move the audience out of the role of passive spectator and into a more dynamic relationship with the play. To this end, Brecht postulated three circumstances—historification, alienation, and epic.

Historification removed events from the lifelike present to the past in order to make the actions presented seem strange. According to Brecht, the playwright should make the audience feel that if they had lived under the conditions presented in the play, they would have taken some positive action. Understanding this, the audience should see that things have changed since then and thus they too can make changes in the present.

Like Meyerhold, Brecht believed the audience should not confuse the theatre with reality. The audience should always watch the play critically as a comment on life. In order for the spectators to judge the action in the play and apply it to life outside, however, they must be separated—or alienated—from the play's events, even though they might be emotionally involved in them. Historification was one kind of alienation. Other devices could also be used to make things strange, such as calling attention to the make-believe nature of a production or inserting songs, film sequences, and so on. Brecht did not subscribe to the idea of a unified production. Rather, he saw each element as independent, and thus each was a device that could be employed to produce further alienation.

Finally, Brecht called his theatre "epic" because he believed that his plays resembled epic poems more than they did traditional drama. His plays present a story from the point of view of a storyteller, and they frequently involve narration and changes of time and place that might be accomplished with nothing more than an explanatory sentence.

Absurdism

Many artists of this period had lost faith in religion, realism, science, and humanity itself. In their search for meaning, they found only chaos, complexity, grotesque laughter, and perhaps insanity. The plays of Luigi Pirandello (1867–1936) obsessively ask the question "What is real?" with brilliant variations. *Right You Are If You Think You Are* presents a wife, living with her husband in a top-floor apartment, who is not permitted to see her mother. She converses with her daily, the mother in the street and the daughter at a garret window. Soon a neighbor demands an explanation from the husband. He answers, but so does the mother, who has an equally plausible but different answer. Finally, someone approaches the wife, who is the only one who can clear up the mystery. Her response, as the curtain falls, is loud laughter! Pirandello's dismay at an incomprehensible world was expressed in mocking laughter directed at those who knew the answers—or were sure they would have them soon.

Pirandello's work was one factor in the emergence of a movement called "absurdism." A philosophy that posited the essential meaninglessness—or unknowable meaning—of existence, and thus questioned the meaning of any action, was also emerging. This philosophy, called "existentialism," also contributed to absurdist style, especially in the literary arts. From such antecedents came numerous dramas, probably the best known of which were written by the French existentialist philosopher, writer, and playwright Jean-Paul Sartre (1905–80).

Sartre held that there were no absolute or universal moral values and that humankind was part of a world without purpose. Therefore, men and women were responsible only to themselves. His plays attempted to draw logical conclusions from "a consistent atheism." Plays such as No Exit (1944) translate Sartre's existential views into dramatic form.

Albert Camus (1913–60) was the first writer to apply the term "absurd" to the human condition. This he took to be a state somewhere between humanity's aspirations and the meaninglessness of the universe which is the condition of life. Determining which way to take a chaotic universe is the theme of Camus' plays, such as Cross-Purposes (1944). Absurdism continued as a theatrical genre after World War II, and will be discussed further in the next chapter.

FILM

Beginnings

On 23 April 1896, at Koster and Bial's Music Hall in New York, the Leigh Sisters performed their umbrella dance. Then the audience was astonished to see waves breaking upon the shore. Thus was launched a new process for screen projection of movies, the Vitascope. Invented by Thomas Armat (although Thomas Edison has received much of the credit), the Vitascope was the latest in centuries of experiments on how to make pictures move. Relying on the persistence of vision and basic photographic techniques, the Vitascope captured real objects in motion and presented those images on a screen.

Technological experiments in rapid-frame photography were common in the last half of the 19th century. But it remained for Thomas Armat and others to perfect a stop-motion device essential to screen projection. Two Frenchmen, the Lumière brothers, are usually credited with the first public projection of movies on a large screen in 1895. By 1897, the Lumières had successfully exhibited their cinématographie all over Europe, and their catalogue listed 358 films. They opened in America three months after the première of the Vitascope. Later that year, the American Biograph made its début using larger film and projecting twice as many pictures per minute, creating the largest, brightest, and steadiest picture of all.

At that point, movies did nothing more than record everyday life. George Méliès in France and Edwin S. Porter in the United States would demonstrate the narrative and manipulative potential of the cinema. Between 1896 and 1914, Méliès turned out more than 1000 films. Edwin S. Porter, who was in charge of the Edison Company Studios, studied the narrative attempts of Méliès. Then, acting as his own scriptwriter, cameraman, and director, he spliced together old and freshly shot film into the Life of an American Firefighter. In 1903, Porter made the

Great Train Robbery, the most popular film of the decade. It ran a total of 12 minutes. The popular audience was entranced, and flocked to electric theatres to see movies that could excite and thrill them with stories of romance and adventure. The movies were a window to a wider world for the poor of America.

By 1910, the young film industry counted a handful of recognized stars who had made more than 400 films for the screen's first mogul, Charles Pathé. Short films remained the staple of the industry, but there was a growing taste for more spectacular fare, especially in Europe. The Italian film Quo Vadis was produced in 1912, complete with lavish sets, chariot races, Christians, lions, and a cast of hundreds. A full two hours in length, it was a huge success.

Lawsuits over patents and monopolies marked the first decade of the century. In order to escape the constant badgering of Thomas Edison's lawyers, independent film-makers headed west to a sleepy California town called Hollywood, where, among other things, the weather, the natural light, and the exotic, varied landscape were much more conducive to cinematography. By 1915, over half of all American movies were being made in Hollywood.

That year also witnessed the release of D. W. Griffith's The Birth of a Nation (Fig. 14.30), which ran for three hours. Popular and controversial, the film was destined to become a landmark in cinema history. It unfolds the story of two families during the Civil War and the Reconstruction period. Now condemned for its depiction of leering, bestial blacks rioting and raping white women, and for the rescue of whites by the Ku Klux Klan, the film is nonetheless a work of great artistry. Griffith defined and refined nearly every technique in film-making: the fade-in, fade-out, long shot, full shot, close-up, moving camera, flashback, crosscut, and juxtaposition. In addition, Griffith virtually invented film editing and preshooting rehearsals.

As if The Birth of a Nation were not colossal enough, Griffith followed it in 1916 with Intolerance, a two-million dollar epic of ancient Babylon, biblical Judea, 16th-century France, and contemporary America. As the film progressed, brilliant CROSSCUTTING increased at a frantic pace to heighten suspense and tension. However, audiences found the film confusing. It failed miserably at the box office, and the failure ruined Griffith financially.

The same era produced the Mack Sennet comedies, which featured the hilarious antics and wild chase scenes of the Keystone Kops. Sennet was one of Griffith's partners in the Triangle Film Company. A third partner was Thomas Ince, who brought to the screen the prototypical cowboy hero, William S. Hart, in such works as Wagon Tracks.

Nothing better represents the second decade of the 20th century, however, than the work of the genius, Charlie Chaplin, the "little fellow." Chaplin's characters

14.30 D. W. Griffith, *The Birth of a Nation*, 1915.

represent all of humanity, and he communicates through the silent film as eloquently and deeply as anyone ever has. In an era marked by disillusionment, Chaplin represented resilience, optimism, and an indomitable spirit. By the end of World War I, Chaplin shared the limelight with that most dashing of American heroes, Douglas Fairbanks.

European film

Film-making revived and spread rapidly throughout Europe after World War I. The German director Fritz Lang's futuristic *Metropolis* tells the story of life in the 21st century. Critics called the plot ludicrous, but marveled at the photographic effects. In France, film found its first real aesthetic theorist in Louis Delluc, and came to be regarded as a serious art form.

German expressionism made its mark in film as well as in the visual and other performing arts. In 1919, its most masterful example, Robert Wiene's *Cabinet of Dr Caligari* (Fig. **14.31**), astounded the film-going public. Macabre sets, surrealistic lighting effects, and distorted properties, all combined to portray a menacing postwar German world.

In Russia, Sergei Eisenstein wrote and directed the great film *Battleship Potemkin* (1925). This cruel story of the crew of the ship *Potemkin* contains one of the most legendary scenes in all cinema. A crowd of citizens is trapped on the great steps of Odessa between the Czar's troops and mounted Cossacks. The editing of the massacre scenes that follow is truly riveting. The sequence showing the carnage is a montage of short, vivid shots—a face, a flopping arm, a slipping body, a pair of broken eye glasses—deftly combined into a powerful whole.

The glorious twenties

The 1920s were the heyday of Hollywood. Its films were silent, but its extravagance, its star system, and its legions of starlets dazzled the world. It was the beginning of the big studio era—MGM, Paramount, Universal, Fox, and Warner Brothers all began now. Fantastic movie houses that rivaled baroque palaces in their opulence were built all over the United States. The scandals, the intrigues, the often "immoral" glamor were the stuff of legends. Out of this rather premature decadence came Cecil B. DeMille and the *Ten Commandments*.

Twenty thousand movie theatres existed around the

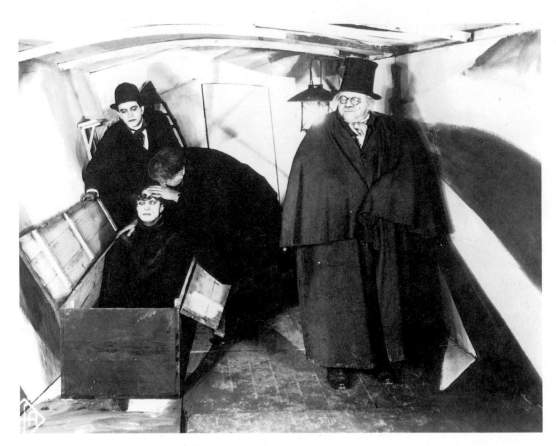

14.31 Robert Wiene, *The Cabinet of Dr Caligari*, 1919.

country, and to keep apace of demand, movie studios turned out one film after another—mostly on a formula basis. The decade, nevertheless, produced some great artistry, for example, Erich von Stroheim's *Greed* (1924). Although cut from nine hours to two by MGM, the film was a brilliant treatment of a slight story about a boorish dentist, practicing without a license, who murders his greedy wife.

This was the era of Fairbanks and Pickford and an immigrant Italian tango dancer, whom the studio named Rudolph Valentino, who thrilled women in movies such as the *Sheik*. After Valentino's death, John Gilbert and his co-star (and, for a time, fiancée) Greta Garbo became matinee idols. On the lighter side were Harold Lloyd, Buster Keaton, and Laurel and Hardy.

Although the sound-track had been invented many years earlier, and short talking films had been released, the *Jazz Singer* in 1927 heralded the age of talkies with Al Jolson's famous line "You ain't heard nothin' yet!" The film industry was not particularly enthusiastic about introducing talking films, however. The public was quite satisfied with silent movies. Profits were enormous, and the new invention required a vast capital investment to equip movie theatres with sound projection equipment.

But the die was cast. For some it meant continued stardom, while for others, whose voices did not match their faces, it meant obscurity. Early successes in using sound came from directors King Vidor in *Hallelujah* and Rouben Mamoulian in *Applause* (1929). Lewis Milestone's *All Quiet on the Western Front* used sound to unify visual compositions in a truly unforgettable anti-war statement.

The thirties

The early thirties produced films about crime and violence. Films such as *Little Caesar*, with Edward G. Robinson, kept Hollywood's coffers full during the Depression. But the gangster genre fell out of favor amid public cries that such glorified violence was harming American youth. The sexually explicit dialogue of Mae West added a titillating dimension to the cinema. But the Production Code, that is, censorship, was strengthened, and West was toned down.

From the mid-thirties on, new types of film emerged, including the musicals of Fred Astaire and Ginger Rogers who danced through a sleek world of black and white. The glitter of these musicals was intended to bolster sagging attendances and divert a Depression-weary populace. There were Jeanette MacDonald and Nelson Eddy, Maurice Chevalier, Shirley Temple, and a new star, Judy Garland, in the *Wizard of Oz* (1939). Wholesomeness came in as happiness poured out.

The most popular star of the thirties, however, was

created by Walt Disney. Mickey Mouse led a parade of animated characters in films, the popularity of which continues today. The Western continued, and in 1939, John Ford's classic, *Stagecoach*, made John Wayne the prototypical cowboy hero. This superbly edited film exemplified the technique of CUTTING WITHIN THE FRAME, which became a Ford trademark. (It also prevented others from reediting and tampering with the product.) The thirties also featured the slapstick of the Marx Brothers and the alcoholic ill-humor of W. C. Fields.

Chaplin continued to produce comedy into the thirties. *City Lights* (1931) was a silent relic in an age of sound, but its consummate artistry made it a classic. The story depicts Chaplin's love for a blind girl, who erroneously believes he is rich. He robs a bank and pays for an operation that restores her sight. He is apprehended and sent to prison. Years later she happens across a tramp being chased by a group of boys. Amused and yet saddened, she offers the tramp a coin and a flower. At the touch of his hand, she recognizes him, but she is stunned that her imagined rich and handsome lover is really nothing more than a comical tramp. The film ends with the knowledge that their relationship is doomed. Among the great comic sequences in this film is a scene in which Chaplin swallows a whistle at a society party, then, in a fit of hiccups, disrupts a musical performance and calls a pack of dogs and several taxicabs.

The epic of the decade was David O. Selznick's *Gone with the Wind*, a three-and-three-quarter-hour extravaganza with an improbable plot and stereotypical characters. Nonetheless, the performances of Clark Gable, Vivian Leigh, Leslie Howard, and Olivia de Haviland, along with its magnificent cinematography, have made this film eternally popular.

The rise of Nazism in Germany had virtually eliminated the vigorous German film industry by the late thirties. Fritz Lang, however, had already produced his psychological thriller M, which employed subtle and deft manipulation of sound, including a Grieg *Leitmotif*. Peter Lorre's performance as a child-murderer was significant. From Europe during the thirties also came the master of suspense and shot manipulation, Alfred Hitchcock.

Throughout this era, Hollywood film unabashedly pursued entertainment as its primary goal. It did so with artistry and virtuosity, and it clearly succeeded in shaping images on a celluloid strip into aesthetically coherent works of art.

MUSIC
Nontraditional transitions

If 20th-century painting and sculpture took a path that diverged radically from their 19th-century heritage, so did 20th-century music. Its new directions parted with past traditions in three essential ways.

The first was rhythmic complexity. Since the Middle Ages, tradition had emphasized the grouping of beats together in rhythmic patterns, called "meter." The characteristic ACCENTS of double and triple meters helped to unify and clarify compositions, as well as to give them certain flavors. For example triple meter, with its *one–two–three*, *one–two–three* accent patterns, created lilting dance rhythms, of which the waltz was characteristic. The alternating accents of double meter, *one–two, one–two,* or *one–two–three–four,* suggested the regularity of a march. But modern composers did away with these patterns and the regularity of accents, choosing instead to employ complex, changing rhythms in which it is often virtually impossible to determine meter, or even the actual beat.

The second change consisted of a focus on dissonant harmonies. Prior to the late 19th century, CONSONANCE was the norm, and all harmonic progressions returned to it. DISSONANCE was used to disturb the norm, so as to enable the music to return to consonance. All art, of course, requires a disturbance of some status quo to create interest. A play, for example, must become complicated in order to move forward, then something more must happen to resolve the problem. Dissonances in music fulfilled much the same role, but they were expected to be brief and passing, then return to consonance. In the late 19th century there was significant tampering with that principle, however. By the 20th century, composers were using more and more dissonance, and not necessarily resolving it.

The third important change involved a rejection of traditional TONALITY, or sense of key, altogether. Traditional thinking held that one note, the *doh*, or tonic, of a scale, was the most important. All music was composed in a specific key. Modulations into distant or related keys occurred, but the tonic of the basic key was the touchstone to which everything related. Many composers now chose to pursue two other paths. One was to get rid of any tonal center. Thus, no one tone was more important than the other. All twelve semitones of the chromatic scale in effect became equal. The systems that resulted from this new tonality were called "TWELVE-TONE composition," and "SERIAL MUSIC." The second, less radical approach denied traditional major/minor tonality, but maintained some sense of a tonal center.

The works of one major composer, the French impressionist Claude Debussy (1862–1918), are generally seen as carrying the transition from the 19th to the 20th centuries. Several other traditions were also current. One, of German–Italian influence, built upon the works of Richard Wagner and was called the "cosmopolitan" style. The principal composer in this group was César Franck (1822–90). The works of Camille Saint-Saëns (1835–1921) represent the more classically oriented style that continued into the 20th century.

The French composer Maurice Ravel (1875–1937) began as an impressionist, but his style became more

and more classical as years went by. Even in his earlier works, however, Ravel did not adopt Debussy's complex sonorities and ambiguous tonal centers. Ravel's *Boléro* (1928) exhibits strong primitive influences and the relentless rhythm of certain Spanish dance music. More typical works of Ravel, for example, his Piano Concerto in G, use Mozart and traditional classicism as their models. Thus, some composers stayed completely within established neo-classical conventions of western music well into the 20th century.

Traditional tendencies continued through the thirties and forties in various quarters, for example, in the music of the American, William Schuman. Schuman's symphonies have bright timbres and energetic rhythms, and focus on 18th- and 19th-century American folklore. The inspiration of 18th-century American composer William Billings figures prominently in Schuman's *William Billings Overture* (1943) and the *New England Triptych* (1956), which is based on three pieces by Billings. *American Festival Overture* (1939) is perhaps his most famous work. Traditional tonality also appears in the works of the Russian composer Sergei Prokofiev (1891–1953). With all its traditional tonality, however, Prokofiev's *Steel Step* reflected the encroachment of mechanization of the 1920s. The machine as a symbol for energy and motion found its way into music, and, in *Steel Step*, Prokofiev intentionally dehumanized the subject of his music in order to reflect contemporary life.

Hindemith

Paul Hindemith (1895–1963) departed from traditional tonality in his compositions. He presented his systematized approach to problems of musical organization and their theoretical solutions in T*he Craft of Musical Composition.* Hindemith's work was extremely chromatic and almost atonal [without key]. Although his system of tonality used tonal centers, it did not include the concepts of major and minor keys. He hoped that his new system would become a universal music language, but it did not.

Hindemith was, however, extremely influential in 20th-century composition, both as a composer and a teacher. His works are broad and varied, encompassing nearly every musical genre, including ten operas, art songs, cantatas, chamber music, requiems, and symphonies. *Kleine Kammermusik für fünf Bläser* is a delightful composition for five woodwinds in five contrasting movements. Its overall form is very clear, as are its themes. Its dissonant harmonies and untraditional tonalities typify Hindemith's works. Yet Hindemith criticized "esoteric isolationism in music," and he tried to write works that the general public could understand and that the amateur musician could play.

Bartók

The Hungarian composer Béla Bartók (1881–1945) took another nontraditional approach to tonality. He was interested in folk music, and a number of his compositions show nationalistic elements. Eastern European folk music does not use western major/minor tonalities, and thus Bartók's interest in it and in nontraditional tonality in general went hand in hand. Bartók invented his own type of harmonic structure, which could accommodate folk melodies.

As nontraditional as some of Bartók's work is, however, he also employs traditional devices and forms. His style is precise and well structured, and he occasionally uses sonata form. He often develops his works from one or two very short motifs, and his larger works are unified by repeating thematic material. Bartók's textures are largely contrapuntal, with strong melodies but little conventional harmony, and dissonances occur frequently.

Bartók's employment of traditional devices was always bent to his own desires and nearly always lay outside the traditional tonal system. He contributed significantly to string quartet literature, and his six quartets each set out a particular problem which is then solved, using simple motifs combined with complex tonality. One characteristic of his melodic development was octave displacement, in which successive notes of a melody occur in different octaves. This device apparently came from the folk music in which he was so interested. When peasants found the notes of a melody too high or low, they simply jumped up or down an octave so as to sing them comfortably.

Rhythm is a notable feature of Bartók's music. His works tend to have a lot of rhythmic energy; he employs devices such as repeated chords and irregular meters to generate dynamic rhythms. He also uses polyrhythms, that is, various juxtaposed rhythms at a time, to create a nonmelodic counterpoint of unique quality.

Stravinsky

Another nontraditionalist, Igor Stravinsky (1882–1971), came to prominence with T*he Firebird* (1910). T*he Rite of Spring* (1912–13) created an even greater impact. Both works were ballets. T*he Firebird* was a commission for the Russian impresario Diaghilev (see "Dance" section), and it was premièred successfully at the Paris Opéra. Another commission, T*he Rite of Spring,* created a riot because of its revolutionary orchestrations and driving primitive rhythms.

Why was T*he Rite of Spring* such a disaster? The third of his ballet commissions for Diaghilev, it is subtitled *Pictures of Pagan Russia.* It depicts the cruel rites of spring which culminate in the sacrifice of a virgin who dances herself to death accompanied by frenetic music. It is those compelling rhythms that give the work its impressive character. Rapid, irregular mixtures of very short note values create an almost intolerable tension, or at least a tension that was intolerable to the public of that day. The melodic material is quite unconventional—short driving motifs

that stop short of thematic fulfillment. Such melodies as there are are short and fragmentary.

After World War I, Stravinsky embraced neo-classicism in a series of works with classical and baroque references. He was flexible enough to create serial compositions too toward the end of his life.

Schoenberg

The movement that drew the most attention in the first half of the 20th century grew out of German Romanticism, but it took a radical turn into atonality. At the root of the movement was Arnold Schoenberg (1874–1951). Between 1905 and 1912, Schoenberg moved away from the gigantic post-Romantic works he had been composing to adopt a more contained style, writing works for smaller ensembles, and treating instruments in a more individual manner. His orchestral works of this period display swiftly alternating timbres, in contrast with the massive orchestral texture of earlier works. They also employ increased complexity in their rhythms, harmonies, and fragmented melodies.

Although the word "atonality," meaning without tonality, is used to describe Schoenberg's works, he preferred the term "pantonality," that is, inclusive of all tonalities. In his compositions, Schoenberg used any combination of tones without having to resolve chord progressions, a concept he called "the emancipation of dissonance." Prior to World War I, Schoenberg created one of his most famous works, *Pierrot Lunaire* (*Moonstruck Peter*), 1912. This cycle of 21 songs is based on French surrealist poems translated into German, and uses a female solo voice accompanied by various instruments. Important in this work is the stylized use of the speaking voice (*Sprechstimme*).

At times in their careers, Schoenberg and his disciples Alban Berg and Anton Webern used expressionism as well. Expressionism, sometimes called the 20th century's neurotic form of Romanticism, saw human beings as helpless in a world beyond their control and governed by subconscious forces in rebellion against established order. *Erwartung* (*Expectation*), 1909, an opera for one singer, is such an expressionist work. Here Schoenberg used complex rhythms, dissonance, strange orchestration, and fragmented melodies to evoke emotions.

By 1923, Schoenberg was composing in twelve-tone technique. This involves "tone rows." A tone row presents the 12 semitones of a chromatic scale only once, in an order chosen by the composer. This series of notes can be used in various ways—as melodies and harmonies, upside down, backward, upside down and backward, that is, in whatever order or form the composer decides upon. The structure of this technique is fairly mathematical and formal, but a good composer can maintain a balance between emotion and mechanics. The important thing to understand about these works is that they are specifically and logically organized so as to be completely atonal.

When the listener knows the concepts behind them, Schoenberg's dramatic and experimental compositions can be heard as artistic entities just as much as more traditional music can.

Berg

Alban Berg (1885–1935) was a close friend and disciple of Schoenberg, and his compositions are based on the serial technique. However, Berg's lyricism means that, despite their atonality, his works are not as disconnected as much serial music. Many of the characteristics of his work can be found in his *Lyric Suite* (1927), a string quartet in six movements. This work is based on several different tone rows.

The opening movement of the *Lyric Suite* starts with a brief chordal introduction, followed by the first tone row (the main theme, played by the first violin). The second theme, derived from the tone row, is more peaceful. Both themes are then freely recapitulated, and the movement closes with a brief coda. The rhythm is varied, changing constantly between quadruple and duple meter. Much of the meaning of the piece to the listener depends upon an accurate dynamic rendering by each of the four string players; Berg indicates the volume and articulation he requires in great detail. The remaining five movements use contrasting tempos, heightening the dramatic impact of the whole work.

The story on which this piece is based, that is, its "program," alludes to an extramarital affair. This information, however, remained a secret for nearly 50 years. It was published for the first time only after the death of Berg's widow.

Ives and Copland

The Americans Charles Ives and Aaron Copland both had experimental and highly personal styles.

Charles Ives (1874–1954) was so experimental that many of his compositions were considered unplayable, and did not receive public performances until after World War I. Content to remain anonymous, and disinclined to formulate a "system," as Schoenberg did, Ives went unrecognized for many years. His melodies spring from folk and popular songs, hymns, and other, often familiar, material, which he treated in unfamiliar, complex ways. His rhythms are very irregular and are often written with only an occasional bar line to indicate an accent. His counterpoint is so dissonant that frequently it is impossible to distinguish one melodic line from another. Some of the tone clusters in his piano music are unplayable without using a block of wood to depress all the keys at once. Ives's experiments, such as *The Unanswered Question* (1908), employ ensembles placed in various locations to create STEREOPHONIC effects. Ives's work reflects his idea that all music relates to life's experiences and ideas, some of which are consonant and some dissonant.

Aaron Copland (1900–91) integrated American idioms —jazz, dissonance, Mexican folk songs, and Shaker

hymns—into his compositions. The last of these figure prominently in Copland's most significant work, *Appalachian Spring* (1944). First written as a ballet, it was later reworked as a suite (set of movements) for symphony orchestra. Copland employed a variety of styles, some harmonically complex, some simple. He often used all the tones of the DIATONIC scale simultaneously, as he does in the opening chord of *Appalachian Spring*. His style is nonetheless traditionally tonal, and his unique use of rhythms and chords has been highly influential in 20th-century American music.

Jazz

Undoubtedly the most significant African–American contribution to American music, and, in turn, a uniquely American contribution to the world of music, jazz began near the turn of the century. From there, it went through many changes and forms. Jazz includes many sophisticated and complicated styles, all of which feature improvized variations on a theme.

The earliest form, blues, went back to the rhythmic music of the slaves, and consisted of a repeated line, with a second, concluding line (AAB). This was music of oppression, and early singers, such as Bessie Smith (1894–1937), evoked an emotional quality which the instruments tried to imitate.

At approximately the same time came ragtime, a piano style with a strict, two-part form. Syncopation played an important role in this style, whose most famous exponent was Scott Joplin. New Orleans, the cradle of jazz, also produced traditional jazz, which featured improvizational development from a basic, memorized chordal sequence. All this was followed in the thirties and forties by swing, bebop, and cool jazz.

DANCE
Diaghilev and the ballet tradition

Two major revolutions in dance occurred in the early 20th century. Sergei Diaghilev (1872–1929) was largely responsible for one of them. When Diaghilev arrived in St Petersburg, Russia, in 1890 to study law, he soon became friends with several artists, among them Alexandre Benois, Walter Nouvel, and Leon Bakst. Although he also studied music with Rimsky-Korsakov (who dissuaded him from attempting a musical career) and painting, he did succeed in getting his law degree, after six years (instead of four). In 1898, Diaghilev's artist friends launched a new magazine, *World of Art*, and appointed him editor. His entrepreneurial and managerial talents made the venture a success.

Thus began a career in artistic management that would shape the ballet world of the 20th century. In producing outstanding works that employed the finest choreographers, Diaghilev played a tremendously important role in bringing the art of Paris and Munich to Moscow and Leningrad and vice versa.

Once Diaghilev had successfully produced opera outside of Russia, he was encouraged by Benois, who was a set designer, to take Russian ballet to Paris. In 1909, he opened the first of his many *Ballets russes*. The dancers included the greatest dancers of Russia, among them Anna Pavlova and Vaslav Nijinsky (Fig. **14.32**). For the next three years, Diaghilev's ballets were choreographed by Mikhail Fokine, whose original approach stood in marked contrast to the evening-long spectaculars of Petipa. Fokine's work was in line with the theatrical and musical theories espoused by Wagner, Reinhardt, Appia, and others. That is, he too believed in the artistic unity of all production elements—costumes, settings, and music, to which, of course, he added dancing. Dancing, in turn, he felt, should blend harmoniously with the theme and subject of the production.

14.32 Vaslav Nijinsky as Petrushka, 1911. The New York Public Library.

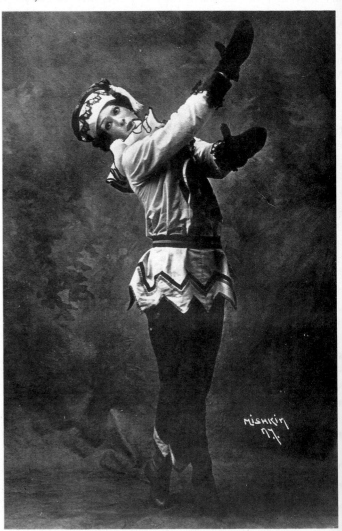

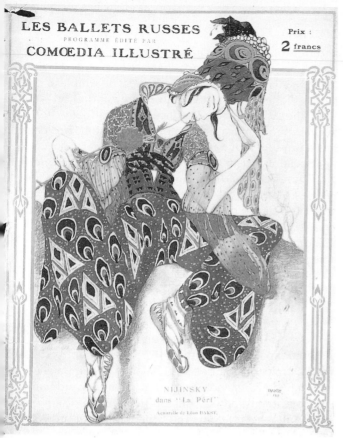

14.33 Leon Bakst, costume design, Les Ballets russes—Comœdia Illustré, "Nijinsky dans La Péri," 1911. Victoria and Albert Museum, London.

Fokine left Diaghilev's company in 1912. But by that time their two great contributions to the ballet had been established: the aesthetic unity of the production and the reintroduction of the male dancer as a premier performer.

The first production of the Ballets russes in Paris was a resounding success. It almost immediately revived the stagnant and debased Parisian entertainment that ballet in France had become. Invited to return in 1910, Diaghilev included in his program for that appearance a work commissioned from the young composer Igor Stravinsky, The Firebird. By the advent of World War I, the Russian ballet had conquered London, Berlin, Rome, Monte Carlo, Vienna, and Budapest, and a decaying ballet tradition had been rescued.

This success was due as much to the integration of superb music, costume, and set design as it was to Fokine's choreography. Leon Bakst's costumes and sets were works of consummate artistry, as their exquisite line and style, shown in Figure **14.33**, demonstrate. Bakst's vibrant colors and rich textures greatly influenced fashion and interior deocration of the period.

Diaghilev was not content to allow Nijinsky to remain just his premier danseur. He insisted that Nijinsky be a choreographer as well, which partially accounted for Fokine's departure. In 1912 Nijinsky choreographed the controversial Prélude à l'après-midi d'un faune with music by Debussy. The choreography was rife with sexual suggestion, and the "obscenity" of the performance caused an uproar. Nijinsky's choreography was strangely angular in contrast to Debussy's music. The dancing suggested the linear qualities of a Greek frieze. A year later, the unveiling of Nijinsky's choreography of Stravinsky's Rite of Spring caused an actual riot, as mentioned previously.

Although the controversy had more to do with the music than with the dancing, the choreography was also shocking, hinting at deep primordial forces, especially in the scene in which a virgin dances herself to death to satisfy the gods. Nijinsky's decision to marry in 1913 caused a rift with Diaghilev, who was homosexual, and Nijinsky was dismissed from the company.

Diaghilev's new choreographer, Léonide Massine, took the company (and ballet in general) in new directions. Previously the Ballets russes had featured picturesque Russian themes. Now it turned to themes emerging in the visual arts, to cubism and surrealism. Parade in 1917 found dancers in huge skyscraper-like cubist costumes designed by Pablo Picasso. The music, by Eric Satie (1866–1925), included sounds of typewriters and steamship whistles.

In 1924, Diaghilev hired a new choreographer who was to be a force in ballet for the next 60 years. George Balanchine came to Diaghilev from St Petersburg and choreographed ten productions for him over the next four years. Two of these continue to be danced—The Prodigal Son, composed by Prokofiev, and Apollo, composed by Stravinsky. When Diaghilev died in 1929, his company died with him, and an era ended. Ballet had been reborn as a major art form, a blending of choreography, dancing, music, and visual art—a rival to opera as a "perfect synthesis of the arts."

Duncan and the modern dance movement

The revolutionary dance work of Loie Fuller (see Chapter 13) was one response to the tired formal conventions into which ballet had fallen. Diaghilev's was another. However, while Diaghilev continued within balletic traditions, others did not. The most significant of these was the remarkable and unrestrained Isadora Duncan (1878–1927). By 1905, Duncan had gained notoriety for her barefoot, deeply emotional dancing. She was considered controversial among balletomanes and reformers alike, but even Fokine saw in her style a confirmation of his own beliefs.

Although an American, Isadora Duncan achieved her fame in Europe. Her dances were emotional interpretations of moods suggested to her by music or by nature. Her dance was personal. Her costume was inspired by Greek tunics and draperies, and, most significantly, she danced in bare feet. This break with convention continues to this day as a basic condition of the modern dance tradition she helped to form.

Despite the notoriety of the young feminist Isadora, it was her contemporary, Ruth St Denis, and her husband, Ted Shawn, who laid more substantial cornerstones for modern dance. Much more serious than Duncan, Ruth St Denis numbered among her favorite books Kant's *Critique of Pure Reason* and Dumas' *Camille*. Her dancing began as a strange combination of exotic, oriental interpretations, and Delsartian poses. (Delsarte is a 19th-century system of gestures and postures, that transmit feelings and ideas, originated by François Delsarte. Overzealous disciples had made his findings into a series of graceful attitudes and movements which supposedly communicated specific content. It may all look rather foolish to us now.) Ruth St Denis was a remarkable performer with a magnificently proportioned body. She manipulated it and various draperies and veils into presentations of line and form so gracefully that the fabric appeared to become an extension of the body.

St Denis's impact on dance was consolidated when she and her husband formed a company and a school to carry on her work. Headquartered in Los Angeles, the Denishawn School took a totally eclectic approach to dance. All traditions were included, from formal ballet to oriental and American Indian dances. The touring company presented wildly varied fare, from Hindu dances to the latest ballroom crazes. Branches of the school were formed throughout the United States, and the touring company occasionally appeared with the *Ziegfeld Follies*. By 1932, St Denis and Shawn had separated, and the Denishawn Company ceased to exist. Nevertheless, it left its mark on its pupils, if not always a positive one.

Among the first to leave Denishawn was Martha Graham (born 1894), probably the most influential figure in modern dance. Although the term "modern dance" defies accurate definition, it remains the most appropriate label for the nonballetic tradition that Martha Graham came to symbolize. Graham found Denishawn unsatisfactory as an artistic base. She did maintain the primacy of artistic individualism, however. As she said, "There are no general rules. Each work of art creates its own code."

Yet principally because it tried so hard to be different from formal ballet, modern dance also developed its own conventions. Ballet movements were largely rounded and symmetrical. Therefore, modern dancers emphasized angularity and asymmetry. Ballet stressed leaps and based its line on toework, while modern dance hugged the floor and dancers went barefoot. As a result, the early works of Graham and others tended to be more fierce and earthy and less graceful. Beneath it all was the desire to express emotion, and conventional positions and movements on which ballet is based were totally disregarded. Martha Graham described her choreography as "a graph of the heart."

Graham's work progressed, through her own dancing and that of her company, as a reaction to specific artistic problems. Her early works were notorious for their jerks and tremblings which Graham based on the natural act of breathing. She translated contractions and releases of inhaling and exhaling into a series of whiplash movements that expressly revealed energy and effort—unlike the ballet where effort is concealed. Gradually, her style became more lyrical in line and movement, but passion was always its foundation.

Social criticism as an artistic message came in with the Depression, and Graham now began to pursue topical themes. Her interest in the shaping of America led to her renowned dance piece set to the music of Aaron Copland, *Appalachian Spring* (1944), mentioned earlier in the Music section of this chapter. *Appalachian Spring* deals, among other things, with the triumph of love and common sense over the fire and brimstone of American Puritanism.

Another influential modern dancer to leave Denishawn was Doris Humphrey. For Humphrey, all dance existed on "the arc between two deaths," that is, between absolute immobility, on the one hand, and complete collapse on the other. Her choreography stressed the dynamic tension between balance and imbalance, fall and recovery. She and her partner, Charles Weidman, also a famous pantomimist, developed their modern dance techniques from elementary principles of movement. Various treatments of conflict and resolution were fundamental and led to such works as the *Shakers* (1931) and the *New Dance* trilogy (1935–36). From the Humphrey–Weidman company were to come two new significant forces in modern dance—Anna Sokolow and José Limón.

Ballet in the thirties

Ballet, of course, did not disappear with Diaghilev's death. Strong national ballet traditions were developed and maintained throughout Europe. In the United States attention also turned to establishing an American ballet. In 1933, Lincoln Kirstein and Edward Warburg combined to create the School of American Ballet, which opened on 1 January 1934 with George Balanchine as its head. Elsewhere in the country, the San Francisco ballet and the Philadelphia ballet companies were founded during the thirties.

The new ballet companies in the United States and elsewhere always found themselves in competition with a company that stressed its Russian character and perpetuated the traditions of Diaghilev, the new *Ballets russes de Monte Carlo*. During the thirties, its tours were noisily greeted by the American public. If the *Ballets russes de Monte Carlo* was competition for young American companies, it was also a blessing. It introduced many Americans to ballet, thus fostering positive public responses to an art form that was popularly considered "sissy stuff."

World War II brought an end to the American Ballet Company and provided a watershed for the exciting new efforts that occurred when peace returned.

ARCHITECTURE

Toward individualism

One of the greatest exponents of Art Nouveau, which continued into the early years of the 20th century, was Antoni Gaudí (1852–1926). Gaudí designed a number of important buildings in Spain, including townhouses. At Casa Batlló (Fig. **14.34**) in Barcelona he refaced an older building with colored tiles, adding a steep but undulating roof that flows from orange to blue-green. The bay windows, rippling stone entrance, and sinister balconies are his too.

At the same time, widespread experimentation with new forms and materials continued. Many attempts have been made to categorize general tendencies and to label specific ones. But attempts at far-ranging categorizing have not met with universal acceptance. Terms such as "rational," "functional," and "international" have been suggested, but perhaps only the vague term "modern" covers most cases. Rather than pursue such categories, we shall, instead, focus as much as possible on individual work. It is individualism, after all, that has been the hallmark of the arts in our century.

14.34 Antoni Gaudí, Casa Batlló, Barcelona, Spain, 1904–06.

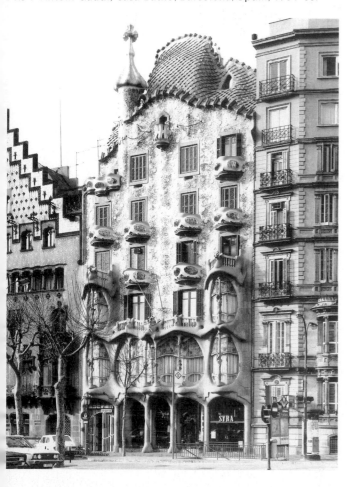

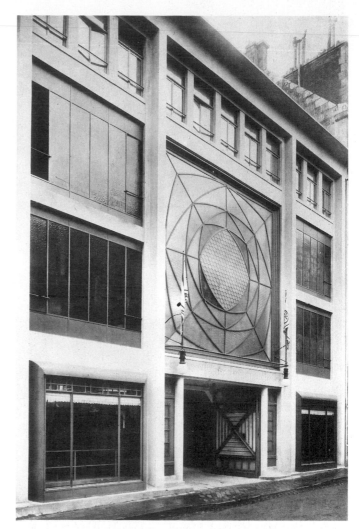

14.35 Auguste Perret, Garage Ponthieu, Paris, 1905–06.

Experimentation

In architecture, a preoccupation with building materials and structure dominated the early 20th century, as it had dominated the 19th. The development of reinforced concrete, or FERROCONCRETE, was of vital importance. Ferroconcrete had been in use since around 1849, but it did not emerge fully as an important architectural material for nearly 50 years. Auguste Perret (1874–1954) single-mindedly set about developing formulas for building with ferroconcrete, and his efforts influenced the work of those who followed. In Perret's Garage Ponthieu (Fig. **14.35**), the reinforced concrete structure can be seen clearly in the exterior face of the building. The open spaces between are filled with glass or ceramic panels. The result is an elegant expression of strength and lightness.

Perret was single-minded in his approach to problems in structure and materials, but he summarized and continued earlier traditions. His contemporary, Frank Lloyd Wright (1867–1959), one of the most influential and

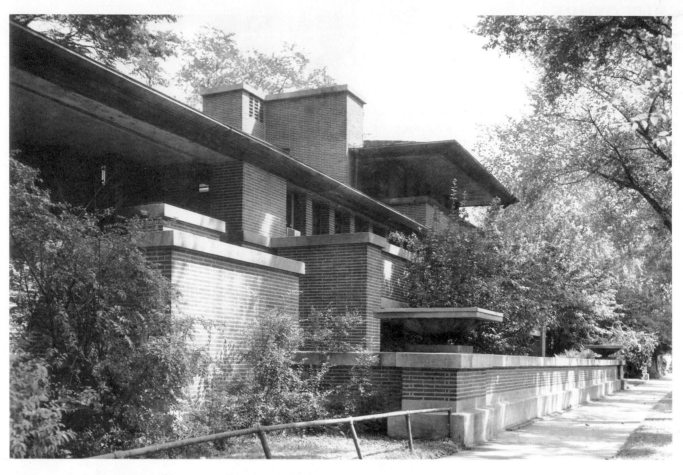

14.36 Frank Lloyd Wright, Robie House, Chicago, 1907–09.

innovative architects of the 20th century, wished to in-itiate new ones. One such new tradition was the "prairie style" which Wright developed around 1900. In creating these designs, Wright drew on the flat landscape of the Midwest as well as the simple horizontal and vertical accents of the Japanese style. Wright followed Louis Sullivan in his pursuit of form that expressed function. Wright took painstaking care to devise practical arrangements for his interiors and to make the exteriors of his buildings reflect their interior spaces. He also tried to relate the exterior of the building to its context, that is, its site, or natural environment.

Wright also designed some of the furniture for his houses. In doing so, comfort, function, and integration with the total design were his chief criteria. Textures and colors in the environment were duplicated in the materials, including large expanses of wood both in the house and for its furniture. He made a point of giving furniture several functions. Tables, for example, might also serve as cabinets. All spaces and objects were precisely designed to present a complete environment. Wright was convinced that houses profoundly influence the people who live in them, and he saw the architect as a

"molder of humanity." Wright's works range from the simple to the complex, from the serene (Fig. **14.36**) to the dramatic (Fig. **14.37**), and from interpenetration to enclosure of space. He was always experimental, and his designs explore the various inter-relationships between space and geometric form.

The AEG turbine factory designed by Peter Behrens (1868–1940) (Fig. **14.38**) also shows how poured concrete and exposed steel can be used to make the exterior of a building reveal its inner structure. Apart from the supporting girders, the side walls of the factory are totally of glass and create an expressly open feeling. The façades are absolutely without decoration, but the front corners of poured concrete are striated as if to suggest masonry blocks. The flat plane of the façade is broken by the overhanging gabled roof and the forward-reaching window panels.

Other new concepts in design appeared in the works of Le Corbusier (1887–1965) during the 1920s and 1930s. Le Corbusier was concerned with integrating structure and function, and he was especially interested in poured concrete. He demonstrated his belief that a house was "a machine to be lived in" in several residences of that

MASTERWORK
Wright—Kaufmann House

Frank Lloyd Wright is one of the greatest American artists in any medium. His primary message is the relationship of architecture to its setting, a lesson that some modern architects seem to have forgotten. Wright's buildings seem to grow out of, and never violate, their environment.

One of his most inventive designs is the Kaufmann House, "Falling Water," at Bear Run, Pennsylvania (Fig. 14.37). Cantilevered over a waterfall, its dramatic imagery is exciting. The inspiration for this house was probably the French Renaissance château of Chenonceaux, built on a bridge across the River Cher. However, "Falling Water" is no house built on a bridge. It seems to erupt out of its natural rock site, and its beige concrete terraces blend harmoniously with the colors of the surrounding stone. Wright has successfully blended two seemingly dissimilar styles: the house is a part of its context, yet it has the rectilinear lines of the international style, to which Wright was usually opposed. He has taken those spare, sterile boxes and made them harmonize with their natural surroundings.

Wright's great asset, and at the same time his greatest liability, was his myopic insistence on his own vision. He could only work with clients who would bend to his wishes. So, unlike many architects, whose designs are tempered by the vision of the client, what Wright built was Wright's, and Wright's only.

14.37 Frank Lloyd Wright, Kaufmann House, "Falling Water," Bear Run, Pennsylvania, 1936–37.

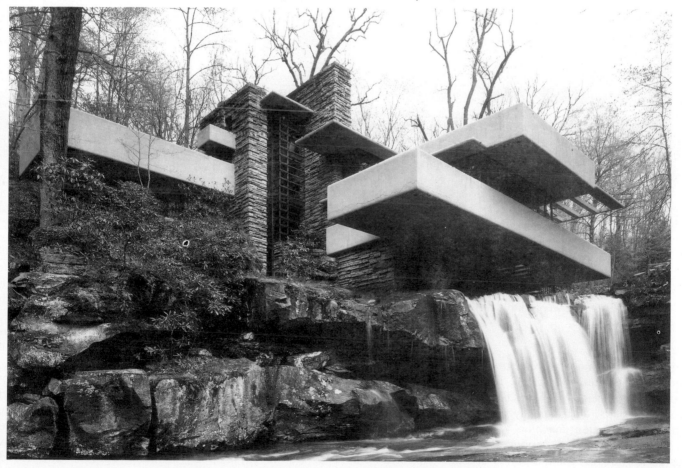

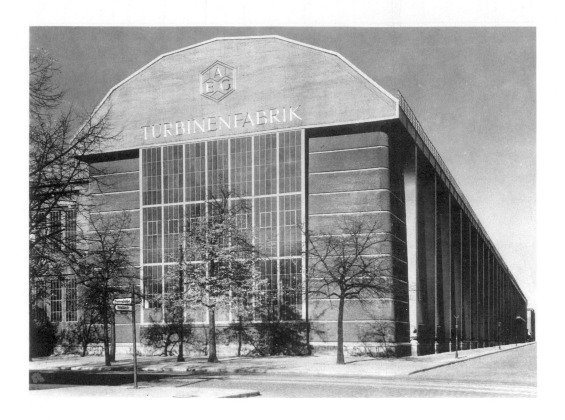

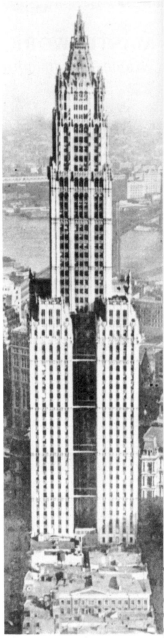

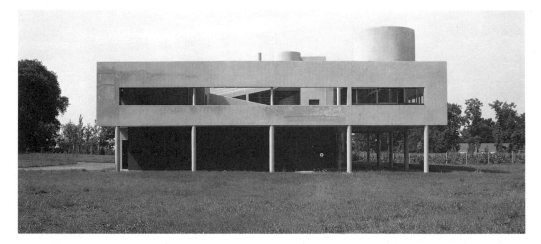

14.38 Peter Behrens, AEG turbine factory, Berlin, 1908–09.

14.39 Le Corbusier, Villa Savoye, Poissy, France, 1928–30.

14.40 Cass Gilbert, The Woolworth Building, New York, 1913.

period. By "machine," Le Corbusier did not mean something depersonalized. Rather, he meant that a house should be efficiently constructed from standard, mass-produced parts, and logically designed for use, on the model of an efficient machine.

Le Corbusier had espoused a domino system of design for houses, using a series of slabs supported on slender columns. The resulting building was box-like, with a flat roof, which could be used as a terrace. The Villa Savoye (Fig. **14.39**) combines these concepts in a building whose supporting structures free the interior from the necessity of weight-supporting walls. In many ways, the design of the Villa Savoye reveals a classical Greek inspiration, from its columns and human scale to its precisely articulated parts and coherent, unified whole. The design is crisp, clean, and functional.

Many traditional approaches to architecture continued through the period. Cass Gilbert's Woolworth Building (Fig. **14.40**) is one such example. It has not only stimulated considerable discussion, including the appellation "Woolworth Gothic," but it has also inspired a wave of Gothic skyscrapers, including Howells and Hood's Tribune Tower in Chicago (1923–25).

SYNTHESIS
The Bauhaus: integration of the arts

In the 20th century, pluralism has prevented us from finding a movement or direction that truly synthesizes the arts. However, a movement did occur whose philosophies attempted to integrate or synthesize the arts in order to bring them to focus on architecture and the visual environment. That approach came from Germany in the mid-twenties. Led by Walter Gropius and Adolph Meyer, the Bauhaus School of Art, Applied Arts, and Architecture approached aesthetics from the point of view of engineering. Experimentation and design were based on technological and economic factors rather than on formal considerations. The Bauhaus philosophy sought to establish links between the organic and technical worlds and thereby to reduce contrasts between the two. Spatial imagination, rather than building and construction, became the Bauhaus objective. The design principles of Gropius and Meyer produced building exteriors that were completely free of ornamentation. Several juxtaposed, functional materials form the external surface, underscoring the fact that exterior walls are no longer structural, merely a climate barrier. Bauhaus buildings evolved from

a careful consideration of what people needed their buildings to do, while, at the same time, the architects were searching for dynamic balance and geometric purity (Figs **14.41** and **14.42**).

In 1919, Walter Gropius (1883–1969) wrote what has been called the "Bauhaus Manifesto." The major thrust of Gropius's ideas was that "all the arts culminate in architecture." He was inspired by a vision of buildings as a new type of organic structure created by integrating all the arts and expressing the contemporary situation. What Gropius sought to do in his new vision was to bring back into the architectural environment the work of painters and sculptors—who, by the 20th century, had been virtually excluded from the building crafts. Gropius wanted to create a new unity between art and technology, not by returning to the styles of the past, but, in fact, by abandoning contemporary artistic vocabulary—which he viewed as "sterile" and meaningless—and evolving a new architectonic outlook.

As he viewed the past, Gropius realized that ornamentation of buildings was considered to be the

14.41 Walter Gropius, Professor Gropius's own house at Dessau, Germany, 1925.

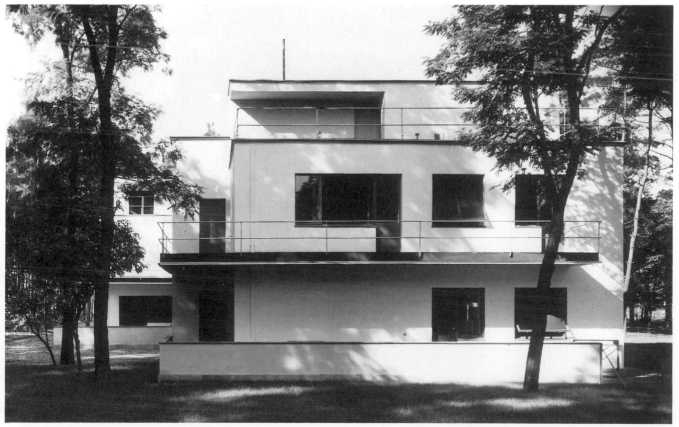

major function of the visual arts, and thus these arts had played a vital part in the creation of great architecture. However, in the 20th century, visual art stood apart from architecture, as self-sufficient. Gropius believed that architects, painters, and sculptors needed to work together, exchanging ideas, to rediscover the many aspects of great building.

So, guided by this idea of a fundamental unity underlying all branches of design, Gropius founded the original Bauhaus, during World War I. At the invitation of the Grand Duke of Sachsen-Weimar-Eisenach, Gropius took over the Weimar School of Arts and Crafts and the Weimar Academy of Fine Art. His primary plan was to shape instruction throughout the school so that students could be trained so as "to grasp life as a whole, a single cosmic entity" rather than to be trained in specialized clases. He tried to combine imaginative design and technical proficiency by producing a new type of artist–collaborator, who could be molded so as to achieve equal proficiency in design and technology. He made his students complete apprenticeships with the local building trades and insisted on manual instruction in order to provide the student with good all-round hand and eye training.

The Bauhaus workshops were laboratories for solving real problems. They sought to work out practical new designs for everyday goods and to improve models for mass production. All of this required a very special staff who had wide, general cultural backgrounds and skills in both practical application of design and in design theory. They needed to be able to build by hand and to translate designs into prototypes for mass production—two radically different skills. The Bauhaus philosophy maintained that the difference between industry and handicraft was due less to the nature of the tools involved than to the assignment of labor. That is, in handicraft, one person controls the entire process and product, while in industry the labor is subdivided among several individuals. For Gropius and the Bauhaus, these two approaches—handicraft and industry—were opposite poles that were gradually approaching each other. According to Bauhaus thinking, in the future, handicraft would become chiefly preparation for evolving experimental new types and forms for mass production.

Gropius believed that talented craftspersons, who could turn out individual designs and market them, would always exist. However, the Bauhaus concentrated on a different direction, that would prevent human "enslavement by the machine by giving its products a content of reality and significance, and so saving the home from mechanistic anarchy." This idea was also applicable to architecture.[5]

During the years of its existence, the Bauhaus em-

14.42 Walter Gropius, a pair of semi-detached houses for the staff of the Bauhaus, Dessau, 1925.

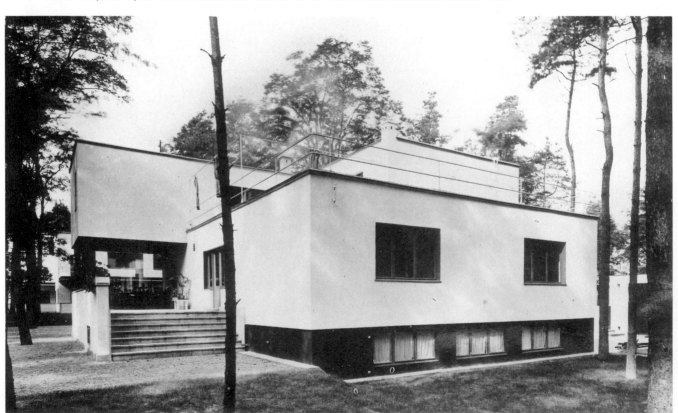

braced a wide range of visual arts: architecture, planning, painting, sculpture, industrial design, and theatre stage design and technology. The Bauhaus sought a new and meaningful working relationship among all the processes of artistic creation, culminating in a new "cultural equilibrium," as Gropius described it, in the visual environment. Teachers and students worked together in a community effort, trying to become vital participants in the modern world. One of the fundamental precepts of the Bauhaus was that the teacher's own approach should never be imposed on the student. In fact, any attempt by the student to imitate the teacher was ruthlessly suppressed: stimulation from the teacher was solely to help students to find their bearings.

The Bauhaus was a synthesis of the arts, attempting the lofty goal of totally redesigning the visual environment by merging visual art and architecture. Although highly influential in its time, it soon became an isolated style of its own. Many famous artists participated in the Bauhaus School, but perhaps the intrinsic pluralism of the 20th century and the constant striving for something "new" doomed the Bauhaus to a brief life. It was a synthesis—perhaps the only synthesis of its time—and a forerunner of the interdisciplinary art of the current age; however, the age itself made that synthesis impossible to sustain.

SUGGESTIONS FOR THOUGHT AND DISCUSSION

The Armory Show of 1913 in New York brought radical European art to wide notice in the United States for the first time. It came at a pivotal time in history. A new, "modern" century was still young, and, for the first time, the United States was on the verge of becoming involved in a major way in the affairs of Europe. The consequences of the United States' intervention in World War I, and its contribution to the defeat of Germany, would in large part determine events in the western world for the rest of the century.

■ Take three of the artistic styles we have studied in this chapter and examine them alongside parallel historical, social, and political events. What can you discern about the relationships?

■ In what ways can the various musical styles of the first half of the 20th century be described as "classical" or "anticlassical"?

■ How have the painting and sculpture of the first half of the 20th century departed from the expectation that art might communicate a particular message?

■ Select one of the nonrealistic illustrations from this chapter and describe how you react to it. Why do most people find it harder to relate to nonobjective than to objective art?

LITERATURE EXTRACTS

The Love Song of J. Alfred Prufrock
|1917| Thomas Stearns Eliot

S'io credesse che mia risposta fosse
A persona che mai tornasse al mondo,
Questa fiamma staria senza piu scosse.
Ma perciocche giammai di questo fondo
Non torno vivo alcun s'i'odo il vero,
Senza tema d'infamia ti rispondo.[1]

Let us go then, you and I,
When the evening is spread out against the sky
Like a patient etherized upon a table;
Let us go, through certain half-deserted streets,
The muttering retreats
Of restless nights in one-night cheap hotels
And sawdust restaurants with oyster-shells:
Streets that follow like a tedious argument
Of insidious intent
To lead you to an overwhelming question . . . 10
Oh, do not ask, "What is it?"
Let us go and make our visit.

In the room the women come and go
Talking of Michelangelo.

The yellow fog that rubs its back upon the window-panes,
The yellow smoke that rubs its muzzle on the
 window-panes
Licked its tongue into the corners of the evening,
Lingered upon the pools that stand in drains,
Let fall upon its back the soot that falls from chimneys,
Slipped by the terrace, made a sudden leap, 20
And seeing that it was a soft October night,
Curled once about the house, and fell asleep.

And indeed there will be time
For the yellow smoke that slides along the street,
Rubbing its back upon the window-panes;

There will be time, there will be time
To prepare a face to meet the faces that you meet;
There will be time to murder and create,
And time for all the works and days of hands[2]
That lift and drop a question on your plate; 30
Time for you and time for me,
And time yet for a hundred indecisions,

And for a hundred visions and revisions,
Before the taking of a toast and tea.

In the room the women come and go
Talking of Michelangelo.

And indeed there will be time
To wonder, "Do I dare?" and, "Do I dare?"
Time to turn back and descend the stair,
With a bald spot in the middle of my hair— 40
(They will say: "How his hair is growing thin!")
My morning coat, my collar mounting firmly to the chin,
My necktie rich and modest, but asserted by a simple
 pin—
(They will say: "But how his arms and legs are thin!")
Do I dare
Disturb the universe?
In a minute there is time
For decisions and revisions which a minute will reverse.

For I have known them all already, known them all:—
Have known the evenings, mornings, afternoons, 50
I have measured out my life with coffee spoons;
I know the voices dying with a dying fall
Beneath the music from a farther room.
 So how should I presume?

And I have known the eyes already, known them all—
The eyes that fix you in a formulated phrase,
And when I am formulated, sprawling on a pin,
When I am pinned and wriggling on the wall,
Then how should I begin
To spit out all the butt-ends of my days and ways? 60
 And how should I presume?

And I have known the arms already, known them all—
Arms that are braceleted and white and bare
(But in the lamplight, downed with light brown hair!)
Is it perfume from a dress
That makes me so digress?
Arms that lie along a table, or wrap about a shawl.
 And should I then presume?
 And how should I begin?

.

Shall I say, I have gone at dusk through narrow streets 7
And watched the smoke that rises from the pipes
Of lonely men in shirt-sleeves, leaning out of
 windows? . . .
I should have been a pair of ragged claws
Scuttling across the floors of silent seas.

.

And the afternoon, the evening, sleeps so peacefully!
Smoothed by long fingers,
Asleep . . . tired . . . or it malingers,
Stretched on the floor, here beside you and me.
Should I, after tea and cakes and ices,
Have the strength to force the moment to its crisis? 8
But though I have wept and fasted, wept and prayed,

1. "If I thought I were making answer to one that might return to view the world, this flame should evermore cease shaking. But since from the abyss, if I hear true, none ever came alive, I have no fear of infamy, but give thee answer due." The speaker is Guido da Montefeltro, who was condemned to Hell as a Counsellor of Fraud (Dante, *Inferno*, 27, 61–66). Dante had asked him why he was being punished and Guido, still fearful of what might be said about him, answers truthfully because he thinks Dante is also dead. Prufrock, like Guido, is fearful of society's judgment.
2. *Works and days* recalls Hesiod's poem entitled *Works and Days* (c. 750 BC). Ironically contrasting with Prufrock's frivolous world, Hesiod's poem extols the virtues of hard labor on the land.

Though I have seen my head (grown slightly bald) brought
 in upon a platter,
I am no prophet—and here's no great matter;[3]
I have seen the moment of my greatness flicker,
And I have seen the eternal Footman hold my coat, and
 snicker,
And in short, I was afraid.

And would it have been worth it, after all,
After the cups, the marmalade, the tea,
Among the porcelain, among some talk of you and me,
Would it have been worth while, 90
To have bitten off the matter with a smile,
To have squeezed the universe into a ball[4]
To roll it toward some overwhelming question,
To say: "I am Lazarus, come from the dead,[5]
Come back to tell you all, I shall tell you all"—
If one, settling a pillow by her head,
 Should say: That is not what I meant at all,
 That is not it, at all.

.

And would it have been worth it, after all,
Would it have been worth while, 100
After the sunsets and the dooryards and the sprinkled
 streets,
After the novels, after the teacups, after the skirts that
 trail along the floor—
And this, and so much more?—
It is impossible to say just what I mean!
But as if a magic lantern threw the nerves in patterns on
 a screen:
Would it have been worth while
If one, settling a pillow or throwing off a shawl,
And turning toward the window, should say:
 "That is not it at all,
 That is not what I meant, at all." 110

.

No! I am not Prince Hamlet, nor was meant to be;
Am an attendant lord, one that will do
To swell a progress, start a scene or two,
Advise the prince; no doubt, an easy tool,[6]
Deferential, glad to be of use,
Politic, cautious, and meticulous;
Full of high sentence, but a bit obtuse;
At times, indeed, almost ridiculous—
Almost, at times, the Fool.
I grow old . . . I grow old . . . 120

3. *I am no prophet*: i.e., no John the Baptist, who was beheaded by Herod and his head brought in on a tray to please Salome, Herod's stepdaughter (Matthew 14: 3–11). Prufrock views himself as a sacrificial victim, but he is neither saint nor martyr.

4. *Universe into a ball* recalls "Let us roll all our strength and all our sweetness up into a ball" from the poem "To his Coy Mistress" by Andrew Marvell (see p. 177). Prufrock's attempt to raise the conversation to a cosmic level with an allusion to a love poem is doubly ironic; the imaginary lady casually brings the discussion back to trivialities (11. 96–98).

5. *Lazarus* was raised from the grave by Christ (John 11:1–44).

6. *Advise the prince* apparently refers to Polonius, the king's adviser in *Hamlet*. The cross-reference is to Guido da Montefeltro, also a false consellor.

I shall wear the bottoms of my trousers rolled.[7]
Shall I part my hair behind? Do I dare to eat a peach?
I shall wear white flannel trousers, and walk upon the
 beach.
I have heard the mermaids singing, each to each.
I do not think that they will sing to me.
I have seen them riding seaward on the waves
Combing the white hair of the waves blown back
When the wind blows the water white and black.

We have lingered in the chambers of the sea
By sea-girls wreathed with seaweed red and brown 130
Till human voices wake us, and we drown.

The Second Coming
|1921| William Butler Yeats

Turning and turning in the widening gyre
The falcon cannot hear the falconer;
Things fall apart: the centre cannot hold;
Mere anarchy is loosed upon the world,
The blood-dimmed tide is loosed, and everywhere
The ceremony of innocence is drowned;
The best lack all conviction, while the worst
Are full of passionate intensity.

Surely some revelation is at hand:
Surely the Second Coming is at hand.
The Second Coming! Hardly are those words out
When a vast image out of the *Spiritus Mundi*
Troubles my sight: somewhere in the sands of the desert
A shape with lion body and the head of a man,
A gaze blank and pitiless as the sun,
Is moving its slow thighs, while all about it
Reel shadows of the indignant desert birds.
The darkness drops again; but now I know
That twenty centuries of stony sleep
Were vexed to nightmare by a rocking cradle,
And what rough beast, its hour come round at last,
Slouches towards Bethlehem to be born?

Stopping by Woods on a Snowy Evening
|1923| Robert Frost

Whose woods these are I think I know.
His house is in the village though;
He will not see me stopping here
To watch his woods fill up with snow.

My little horse must think it queer
To stop without a farmhouse near
Between the woods and frozen lake
The darkest evening of the year.

7. Cuffed (rolled) trousers were stylish at the time. Middle-aged and socially inept, Prufrock tries to appear young and fashionable.

He gives his harness bells a shake
To ask if there is some mistake.
The only other sound's the sweep
Of easy wind and downy flake.

The woods are lovely, dark and deep.
But I have promises to keep,
And miles to go before I sleep.
And miles to go before I sleep.

Civilization and its Discontents
[1929] Sigmund Freud

Freud, the inventor of psychoanalysis, explained many cases of mental illness as resulting from sexual frustrations in early childhood. The following extract is his examination of the negative aspect of the sex drive, the death instinct.

6

Never before in any of my previous writings have I had the feeling so strongly as I have now that what I am describing is common knowledge ... that I am using up paper and ink to expound things which are self-evident. If it should appear that the recognition of a special independent instinct of aggression would entail a modification of the psycho-analytical theory of instincts, I should be glad to seize upon the idea.

We shall see that this is not so, that it is merely a matter of coming to grips with a conclusion to which we long ago committed ourselves, following it to its logical consequences. Analytic theory has evolved gradually enough, but the theory of instincts has groped its way forward. And yet that theory was so indispensable that something had to be put in its place. In my perplexity I made my starting point Schiller's aphorism that hunger and love make the world go around. Hunger represents the instinct for self-preservation while love strives after objects; its chief function is preservation of the species. Thus first arose the contrast between ego instincts and object instincts. To denote the energy of the latter I introduced the term "libido." An antithesis was thus formed between the ego instincts and the libidinal instincts directed towards objects, i.e., love in its widest sense. One of these object instincts, the sadistic, stood out in that its aim was so very unloving; moreover, it clearly allied itself with the ego instincts, and its kinship with instincts of mastery without libidinal purpose could not be concealed. Nevertheless, sadism plainly belonged to sexual life—the game of cruelty could take the place of the game of love. Neurosis appeared as the outcome of a struggle between self-preservation and libido, a conflict in which the ego was victorious but at the price of great suffering.

Modifications in this theory became essential as our inquiries advanced from the repressed to the repressing forces, for the object instincts to the ego. The decisive step was the introduction of the concept of narcissism, i.e., the discovery that the ego is cathected with libido, that the ego is the libido's original home and, to some extent, its headquarters. This narcissistic libido turns towards objects, becoming object libido, and can change back into narcissistic libido. The concept of narcissism made possible an analytic understanding of the traumatic neuroses as well as many diseases bordering on the psychoses. It was not necessary to abandon the view that the transference-neuroses are attempts of the ego to guard itself against sexuality but the concept of the libido was jeopardized. Since the ego instincts, too, were libidinal, it seemed inevitable that we should make libido coincide with instinctual energy in general, as Jung had already advocated. Yet I retained a groundless conviction that the instincts could not all be of the same kind. It was in *Beyond the Pleasure Principle* (1920) that the repetition-compulsion and the conservative character of instinctual life first struck me. While speculating on the origin of life and of biological parallels, I concluded that, beside the instinct preserving the organic substance and binding it into ever larger units, there must exist an antithesis, which would seek to dissolve these units and reinstate their antecedent inorganic state; that is, a death instinct as well as Eros. The phenomena of life would be explicable from the interplay and counteracting effects of the two. Demonstrating the working of this hypothetical death instinct was not easy. Manifestations of Eros were conspicuous enough; one might assume that the death instinct worked within the organism towards its disintegration but that was no proof. A more fruitful idea was that part of the instinct is diverted towards the external world and surfaces as an instinct of aggressiveness and destructiveness. In this way the instinct could serve Eros in that the organism was destroying something other than itself. One can suspect that the two kinds of instinct seldom—perhaps never—appear in isolation from each other, but are alloyed with each other in varying and very different proportions. In sadism, long known to us as a component instinct of sexuality, we observe a particularly strong alloy between trends of love and the destructive instinct; while its counterpart, masochism, would be a union between destructiveness directed inwards and sexuality.

The assumption of the existence of an instinct of death or destruction has met with resistance even in analytic circles; I am aware that there is a frequent inclination rather to ascribe whatever is dangerous and hostile in love to an original bipolarity in its own nature. To begin with it was only tentatively that I put forth the views I have developed here, but in the course of time they have gained such a hold upon me that I can no longer think in any other way. To my mind, they are far more serviceable from a theoretical viewpoint than any other possible ones: they provide that simplification, without either ignoring or doing violence to the facts, for which we strive in scientific work. I know that in sadism and masochism we have always seen before us manifestations of the destructive instinct (directed outwards and inwards), strongly alloyed with erotism: but I can no longer understand how we can have overlooked the ubiquity of non-erotic aggressivity and destructiveness and can have failed to give it its due

place in our interpretation of life. I remember my own defensive attitude when the idea of an instinct of destruction first emerged in psycho-analytic literature, and how long it took before I became receptive to it. That others should have shown, and still show, the same attitude of rejection surprises me less. For "little children do not like it" when there is talk of the inborn human inclination to "badness," to aggressiveness and destructiveness, and so to cruelty as well. God has made them in the image of His own perfection; nobody wants to be reminded how hard it is to reconcile the undeniable existence of evil—despite the protestations of Christian Science—with His all-powerfulness or His all-goodness.

The name "libido" can once more be used to denote the manifestations of the power of Eros in order to distinguish them from the energy of the death instinct. It must be confessed that we have much greater difficulty in grasping that instinct; we can only suspect it, as it were, as something in the background behind Eros, and it escapes detection unless its presence is betrayed by its being alloyed with Eros. It is in sadism, where the death instinct twists the erotic in its own sense and yet at the same time fully satisfies the erotic urge, that we succeed in obtaining the clearest insight into its nature and its relation to Eros. But even where it emerges without any sexual purpose, in the blindest fury of destructiveness, we cannot fail to recognize that the satisfaction of the instinct is accompanied by an extraordinarily high degree of narcissistic enjoyment, owing to its presenting the ego with a fulfillment of the latter's old wishes for omnipotence. The instinct of destruction, moderated and tamed, and, as it were, inhibited in its aim, must, when it is directed towards objects, provide the ego with the satisfaction of its vital needs and with control over nature. This is how things appear to us now; future research and reflection will no doubt bring further light which will decide the matter.

In all that follows I adopt the viewpoint, therefore, that the inclination to aggression is an original, self-subsisting instinctual disposition in man and that it constitutes the greatest impediment to civilization. At one point I was led to the idea that civilization was a special process in the service of Eros, whose purpose is to combine single human individuals, and after that families, then races, peoples and nations, into one great unity, the unity of mankind. Why this has to happen, we do not know; the work of Eros is precisely this. These collections of men are to be libidinally bound to one another. Necessity alone, the advantages of work in common, will not hold them together. But man's aggressive instinct, the hostility of each against all and of all against each, opposes this program of civilization. This aggressive instinct is the derivative and the main representative of the death instinct which we have found alongside of Eros and which shares world-dominion with it. And now, I think the meaning of the evolution of civilization is no longer obscure to us. It must present the struggle between Eros and Death, between the instinct of life and the instinct of destruction as it works itself out in the human species.

A Room of One's Own
[1929] Virginia Woolf

The room of one's own of the title is one of Virginia Woolf's two necessities for women to be able to write well and freely. The other is an independent income, and she illustrates her point by showing what, in a previous century, might have become of a woman who had a great literary gift. The essay was based on lectures given at Cambridge University in October 1928.

If Shakespeare Had a Sister

It was disappointing not to have brought back in the evening some important statement, some authentic fact. Women are poorer than men because—this or that. Perhaps now it would be better to give up seeking for the truth, and receiving on one's head an avalanche of opinion hot as lava, discoloured as dish-water. It would be better to draw the curtains; to shut out distractions; to light the lamp; to narrow the enquiry and to ask the historian, who records not opinions but facts, to describe under what conditions women lived, not throughout the ages, but in England, say in the time of Elizabeth.

For it is a perennial puzzle why no woman wrote a word of that extraordinary literature when every other man, it seemed, was capable of song or sonnet. What were the conditions in which women lived, I asked myself; for fiction, imaginative work that is, is not dropped like a pebble upon the ground, as science may be; fiction is like a spider's web, attached ever so lightly perhaps, but still attached to life at all four corners. Often the attachment is scarcely perceptible; Shakespeare's plays, for instance, seem to hang there complete by themselves. But when the web is pulled askew, hooked up at the edge, torn in the middle, one remembers that these webs are not spun in midair by incorporeal creatures, but are the work of suffering human beings, and are attached to grossly material things, like health and money and the houses we live in.

I went, therefore, to the shelf where the histories stand and took down one of the latest, Professor Trevelyan's History of England. Once more I looked up Women, found "position of," and turned to the pages indicated. "Wife-beating," I read, was a recognised right of man, and was practised without shame by high as well as low.... "Similarly," the historian goes on, "the daughter who refused to marry the gentleman of her parents' choice was liable to be locked up, beaten and flung about the room, without any shock being inflicted on public opinion. Marriage was not an affair of personal affection, but of family avarice, particularly in the 'chivalrous' upper classes.... Betrothal often took place while one or both of the parties was in the cradle, and marriage when they were scarcely out of the nurses' charge." That was about 1470, soon after Chaucer's time. The next reference to the position of women is some two hundred years later, in the time of the Stuarts. "It was still the exception for women of the upper and middle class to choose their own husbands, and when the husband had been assigned, he was lord and master, so far at least as law and custom could make

him. Yet even so," Professor Trevelyan concludes, "neither Shakespeare's women nor those of authentic seventeenth-century memoirs, like the Verneys and the Hutchinsons, seem wanting in personality and character." Certainly, if we consider it, Cleopatra must have had a way with her; Lady Macbeth, one would suppose, had a will of her own; Rosalind, one might conclude, was an attractive girl. Professor Trevelyan is speaking no more than the truth when he remarks that Shakespeare's women do not seem wanting in personality and character. Not being a historian, one might go even further and say that women have burnt like beacons in all the works of all the poets from the beginning of time—Clytemnestra, Antigone, Cleopatra, Lady Macbeth, Phèdre, Cressida, Rosalind, Desdemona, the Duchess of Malfi, among the dramatists; then among the prose writers: Millamant, Clarissa, Becky Sharp, Anna Karenina, Emma Bovary, Madame de Guermantes—the names flock to mind, nor do they recall women "lacking in personality and character." Indeed, if woman had no existence save in fiction written by men, one would imagine her a person of the utmost importance; very various; heroic and mean; splendid and sordid; infinitely beautiful and hideous in the extreme; as great as a man, some think even greater. But this is woman in fiction. In fact, as Professor Trevelyan points out, she was locked up, beaten and flung about the room.

A very queer, composite being thus emerges. Imaginatively she is of the highest importance; practically she is completely insignificant. She pervades poetry from cover to cover; she is all but absent from history. She dominates the lives of kings and conquerors in fiction; in fact she was the slave of any boy whose parents forced a ring upon her finger. Some of the most inspired words, some of the most profound thoughts in literature fall from her lips; in real life she could hardly read, could scarcely spell, and was the property of her husband.

It was certainly an odd monster that one made up by reading the historians first and the poets afterwards—a worm winged like an eagle; the spirit of life and beauty in a kitchen chopping up suet. But these monsters, however amusing to the imagination, have no existence in fact. What one must do to bring her to life was to think poetically and prosaically at one and the same moment, thus keeping in touch with fact—that she is Mrs. Martin, aged thirty-six, dressed in blue, wearing a black hat and brown shoes; but not losing sight of fiction either—that she is a vessel in which all sorts of spirits and forces are coursing and flashing perpetually. The moment, however, that one tries this method with the Elizabethan woman, one branch of illumination fails; one is held up by the scarcity of facts. One knows nothing detailed, nothing perfectly true and substantial about her. History scarcely mentions her. And I turned to Professor Trevelyan again to see what history meant to him. I found by looking at his chapter headings that it meant—

"The Manor Court and the Methods of Open-field Agriculture . . . The Cistercians and Sheep-farming . . . The Crusades . . . The University . . . The House of Commons . . . The Hundred Years' War . . . The Wars of the Roses . . . The Renaissance Scholars . . . The Dissolution of the Monasteries . . . Agrarian and Religious Strife . . . The Origin

of English Sea-power . . . The Armada . . ." and so on. Occasionally an individual woman is mentioned, an Elizabeth, or a Mary; a queen or a great lady. But by no possible means could middle-class women with nothing but brains and character at their command have taken part in any one of the great movements which, brought together, constitute the historian's view of the past. Nor shall we find her in any collection of anecdotes. Aubrey hardly mentions her. She never writes her own life and scarcely keeps a diary; there are only a handful of her letters in existence. She left no plays or poems by which we can judge her. What one wants, I thought—and why does not some brilliant student at Newnham or Girton supply it?—is a mass of information; at what age did she marry; how many children had she as a rule; what was her house like; had she a room to herself; did she do the cooking; would she be likely to have a servant? All these facts lie somewhere, presumably, in parish registers and account books; the life of the average Elizabethan woman must be scattered about somewhere, could one collect it and make a book of it. It would be ambitious beyond my daring, I thought, looking about the shelves for books that were not there, to suggest to the students of those famous colleges that they should re-write history, though I own that it often seems a little queer as it is, unreal, lop-sided; but why should they not add a supplement to history? calling it, of course, by some inconspicuous name so that women might figure there without impropriety? For one often catches a glimpse of them in the lives of the great, whisking away into the background, concealing, I sometimes think, a wink, a laugh, perhaps a tear. And, after all, we have lives enough of Jane Austen; it scarcely seems necessary to consider again the influence of the tragedies of Joanna Baillie upon the poetry of Edgar Allan Poe; as for myself, I should not mind if the homes and haunts of Mary Russell Mitford were closed to the public for a century at least. But what I find deplorable, I continued, looking about the bookshelves again, is that nothing is known about women before the eighteenth century. I have no model in my mind to turn about this way and that. Here am I asking why women did not write poetry in the Elizabethan age, and I am not sure how they were educated; whether they were taught to write; whether they had sitting-rooms to themselves; how many women had children before they were twenty-one; what, in short, they did from eight in the morning till eight at night. They had no money evidently; according to Professor Trevelyan they were married whether they liked it or not before they were out of the nursery, at fifteen or sixteen very likely. It would have been extremely odd, even upon this showing, had one of them suddenly written the plays of Shakespeare, I concluded, and I thought of that old gentleman, who is dead now, but was a bishop, I think, who declared that it was impossible for any woman, past, present, or to come, to have the genius of Shakespeare. He wrote to the papers about it. He also told a lady who applied to him for information that cats do not as a matter of fact go to heaven, though they have, he added, souls of a sort. How much thinking those old gentlemen used to save one! How the borders of ignorance shrank back at their approach! Cats do not go to heaven. Women cannot write

the plays of Shakespeare.

Be that as it may, I could not help thinking, as I looked at the works of Shakespeare on the shelf, that the bishop was right at least in this; it would have been impossible, completely and entirely for any woman to have written the plays of Shakespeare in the age of Shakespeare. Let me imagine, since facts are so hard to come by, what would have happened had Shakespeare had a wonderfully gifted sister, called Judith, let us say. Shakespeare himself went, very probably—his mother was an heiress—to the grammar school, where he may have learnt Latin—Ovid, Virgil and Horace—and the elements of grammar and logic. He was, it is well known, a wild boy who poached rabbits, perhaps shot a deer, and had, rather sooner than he should have done, to marry a woman in the neighbourhood, who bore him a child rather quicker than was right. That escapade sent him to seek his fortune in London. He had, it seemed, a taste for the theatre; he began by holding horses at the stage door. Very soon he got work in the theatre, became a successful actor, and lived at the hub of the universe, meeting everybody, knowing everybody, practising his art on the boards, exercising his wits in the streets, and even getting access to the palace of the queen. Meanwhile his extraordinarily gifted sister, let us suppose, remained at home. She was as adventurous, as imaginative, as agog to see the world as he was. But she was not sent to school. She had no chance of learning grammar and logic, let alone reading Horace and Virgil. She picked up a book now and then, one of her brother's perhaps, and read a few pages. But then her parents came in and told her to mend the stockings or mind the stew and not moon about with books and papers. They would have spoken sharply but kindly, for they were substantial people who knew the conditions of life for a woman and loved their daughter—indeed, more likely than not she was the apple of her father's eye. Perhaps she scribbled some pages up in an apple loft on the sly, but was careful to hide them or set fire to them. Soon, however, before she was out of her teens, she was to be betrothed to the son of a neighbouring wool-stapler. She cried out that marriage was hateful to her, and for that she was severely beaten by her father. Then he ceased to scold her. He begged her instead not to hurt him, not to shame him in this matter of her marriage. He would give her a chain of beads or a fine petticoat, he said; and there were tears in his eyes. How could she disobey him? How could she break his heart? The force of her own gift alone drove her to it. She made up a small parcel of her belongings, let herself down by a rope one summer's night and took the road to London. She was not seventeen. The birds that sang in the hedge were not more musical than she was. She had the quickest fancy, a gift like her brother's, for the tune of words. Like him, she had a taste for the theatre. She stood at the stage door; she wanted to act, she said. Men laughed in her face. The manager—a fat, loose-lipped man—guffawed. He bellowed something about poodles dancing and women acting—no woman, he said, could possibly be an actress. He hinted—you can imagine what. She could get no training in her craft. Could she even seek her dinner in a tavern or roam the streets at midnight? Yet her genius was for fiction and lusted to feed abundantly upon the lives of men and women and the study of their ways. At last—for she was very young, oddly like Shakespeare the poet in her face, with the same grey eyes and rounded brows—at last Nick Greene the actor-manager took pity on her; she found herself with child by that gentleman and so—who shall measure the heat and violence of the poet's heart when caught and tangled in a woman's body?—killed herself one winter's night and lies buried at some cross-roads where the omnibuses now stop outside the Elephant and Castle.

That, more or less, is how the story would run, I think, if a woman in Shakespeare's day had had Shakespeare's genius. But for my part, I agree with the deceased bishop, if such he was—it is unthinkable that any woman in Shakespeare's day should have had Shakespeare's genius. For genius like Shakespeare's is not born among labouring, uneducated, servile people. It was not born in England among the Saxons and the Britons. It is not born today among the working classes. How, then, could it have been born among women whose work began, according to Professor Trevelyan, almost before they were out of the nursery, who were forced to it by their parents and held to it by all the power of law and custom? Yet genius of a sort must have existed among women as it must have existed among the working classes. Now and again an Emily Brontë or a Robert Burns blazes out and proves its presence. But certainly it never got itself on to paper. When, however, one reads of a witch being ducked, of a woman possessed by devils, of a wise woman selling herbs, or even of a very remarkable man who had a mother, then I think we are on the track of a lost novelist, a suppressed poet, of some mute and inglorious Jane Austen, some Emily Brontë who dashed her brains out on the moor or moped and mowed about the highways crazed with the torture that her gift had put her to. Indeed, I would venture to guess that Anon, who wrote so many poems without signing them, was often a woman. It was a woman Edward Fitzgerald, I think, suggested who made the ballads and the folk-songs, crooning them to her children, beguiling her spinning with them, or the length of the winter's night.

This may be true or it may be false—who can say?—but what is true in it, so it seemed to me, reviewing the story of Shakespeare's sister as I had made it, is that any woman born with a great gift in the sixteenth century would certainly have gone crazed, shot herself, or ended her days in some lonely cottage outside the village, half witch, half wizard, feared and mocked at. For it needs little skill in psychology to be sure that a highly gifted girl who had tried to use her gift for poetry would have been so thwarted and hindered by other people, so tortured and pulled asunder by her own contrary instincts, that she must have lost her health and sanity to a certainty. No girl could have walked to London and stood at a stage door and forced her way into the presence of actor-managers without doing herself a violence and suffering an anguish which may have been irrational—for chastity may be a fetish invented by certain societies for unknown reasons—but were none the less inevitable. Chastity had then, it has even now, a religious importance in a woman's

life, and has so wrapped itself round with nerves and instincts that to cut it free and bring it to the light of day demands courage of the rarest. To have lived a free life in London in the sixteenth century would have meant for a woman who was poet and playwright a nervous stress and dilemma which might well have killed her. Had she survived, whatever she had written would have been twisted and deformed, issuing from a strained and morbid imagination. And undoubtedly, I thought, looking at the shelf where there are no plays by women, her work would have gone unsigned. That refuge she would have sought certainly. It was the relic of the sense of chastity that dictated anonymity to women even so late as the nineteenth century. Currer Bell, George Eliot, George Sand, all the victims of inner strife as their writings prove, sought ineffectively to veil themselves by using the name of a man. Thus they did homage to the convention, which if not implanted by the other sex was liberally encouraged by them (the chief glory of a woman is not to be talked of, said Pericles, himself a much-talked-of man), that publicity in women is detestable. Anonymity runs in their blood. The desire to be veiled still possesses them. They are not even now as concerned about the health of their fame as men are, and, speaking generally, will pass a tombstone or a signpost without feeling an irresistible desire to cut their names on it, as Alf, Bert or Chas. must do in obedience to their instinct, which murmurs if it sees a fine woman go by, or even a dog, *Ce chien est à moi*. And, of course, it may not be a dog, I thought, remembering Parliament Square, the Sieges Allee and other avenues; it may be a piece of land or a man with curly black hair. It is one of the great advantages of being a woman that one can pass even a very fine negress without wishing to make an Englishwoman of her.

That woman, then, who was born with a gift of poetry in the sixteenth century, was an unhappy woman, a woman at strife against herself. All the conditions of her life, all her own instincts, were hostile to the state of mind which is needed to set free whatever is in the brain. But what is the state of mind that is most propitious to the act of creation, I asked. Can one come by any notion of the state that furthers and makes possible that strange activity? Here I opened the volume containing the Tragedies of Shakespeare. What was Shakespeare's state of mind, for instance, when he wrote *Lear* and *Antony and Cleopatra*? It was certainly the state of mind most favourable to poetry that there has ever existed. But Shakespeare himself said nothing about it. We only know casually and by chance that he "never blotted a line." Nothing indeed was ever said by the artist himself about his state of mind until the eighteenth century perhaps. Rousseau perhaps began it. At any rate, by the nineteenth century self-consciousness had developed so far that it was the habit for men of letters to describe their minds in confessions and autobiographies. Their lives also were written, and their letters were printed after their deaths. Thus, though we do not know what Shakespeare went through when he wrote *Lear*, we do know what Carlyle went through when he wrote the *French Revolution*; what Flaubert went through when he wrote *Madame Bovary*; what Keats was going through when he tried to write poetry against the coming of death and the indifference of the world.

And one gathers from this enormous modern literature of confession and self-analysis that to write a work of genius is almost always a feat of prodigious difficulty. Everything is against the likelihood that it will come from the writer's mind whole and entire. Generally material circumstances are against it. Dogs will bark; people will interrupt; money must be made; health will break down. Further, accentuating all these difficulties and making them harder to bear is the world's notorious indifference. It does not ask people to write poems and novels and histories; it does not need them. It does not care whether Flaubert finds the right word or whether Carlyle scrupulously verifies this or that fact. Naturally, it will not pay for what it does not want. And so the writer, Keats, Flaubert, Carlyle, suffers, especially in the creative years of youth, every form of distraction and discouragement. A curse, a cry of agony, rises from those books of analysis and confession. "Mighty poets in their misery dead"—that is the burden of their song. If anything comes through in spite of all this, it is a miracle, and probably no book is born entire and uncrippled as it was conceived.

But for women, I thought, looking at the empty shelves, these difficulties were infinitely more formidable. In the first place, to have a room of her own, let alone a quiet room or a sound-proof room, was out of the question, unless her parents were exceptionally rich or very noble, even up to the beginning of the nineteenth century. Since her pin money, which depended on the good will of her father, was only enough to keep her clothed, she was debarred from such alleviations as came even to Keats or Tennyson or Carlyle, all poor men, from a walking tour, a little journey to France, from the separate lodging which, even if it were miserable enough, sheltered them from the claims and tyrannies of their families. Such material difficulties were formidable; but much worse were the immaterial. The indifference of the world which Keats and Flaubert and other men of genius have found so hard to bear was in her case not indifference but hostility. The world did not say to her as it said to them, Write if you choose; it makes no difference to me. The world said with a guffaw, Write? What's the good of your writing? Here the psychologists of Newnham and Girton might come to our help, I thought, looking again at the blank spaces on the shelves. For surely it is time that the effect of discouragement upon the mind of the artist should be measured, as I have seen a dairy company measure the effect of ordinary milk and Grade A milk upon the body of the rat. They set two rats in cages side by side, and of the two one was furtive, timid and small, and the other was glossy, bold and big. Now what food do we feed women as artists upon? I asked, remembering, I suppose, that dinner of prunes and custard. To answer that question I had only to open the evening paper and to read that Lord Birkenhead is of opinion—but really I am not going to trouble to copy out Lord Birkenhead's opinion upon the writing of women. What Dean Inge says I will leave in peace. The Harley Street specialist may be allowed to rouse the echoes of Harley Street with his vociferations without raising a hair on my head. I will quote, however, Mr. Oscar Browning, because Mr. Oscar Browning was a

great figure in Cambridge at one time, and used to examine the students at Girton and Newnham. Mr. Oscar Browning was wont to declare "that the impression left on his mind, after looking over any set of examination papers, was that, irrespective of the marks he might give, the best woman was intellectually the inferior of the worst man." After saying that Mr. Browning went back to his rooms—and it is this sequel that endears him and makes him a human figure of some bulk and majesty—he went back to his rooms and found a stable-boy lying on the sofa—"a mere skeleton, his cheeks were cavernous and sallow, his teeth were black, and he did not appear to have the full use of his limbs. . . . 'That's Arthur' [said Mr. Browning]. 'He's a dear boy really and most high-minded.' " The two pictures always seem to me to complete each other. And happily in this age of biography the two pictures often do complete each other, so that we are able to interpret the opinions of great men not only by what they say, but by what they do.

But though this is possible now, such opinions coming from the lips of important people must have been formidable enough even fifty years ago. Let us suppose that a father from the highest motives did not wish his daughter to leave home and become writer, painter or scholar. "See what Mr. Oscar Browning says," he would say; and there was not only Mr. Oscar Browning; there was the *Saturday Review*; there was Mr. Greg—the "essentials of a woman's being," said Mr. Greg emphatically, "are that *they are supported by, and they minister to, men*"—there was an enormous body of masculine opinion to the effect that nothing could be expected of women intellectually. Even if her father did not read out loud these opinions, any girl could read them for herself; and the reading, even in the nineteenth century, must have lowered her vitality, and told profoundly upon her work. There would always have been that assertion—you cannot do this, you are incapable of doing that—to protest against, to overcome. Probably for a novelist this germ is no longer of much effect; for there have been women novelists of merit. But for painters it must still have some sting in it; and for musicians, I imagine, is even now active and poisonous in the extreme. The woman composer stands where the actress stood in the time of Shakespeare. Nick Greene, I thought, remembering the story I had made about Shakespeare's sister, said that a woman acting put him in mind of a dog dancing. Johnson repeated the phrase two hundred years later of women preaching. And here, I said, opening a book about music, we have the very words used again in this year of grace, 1928, of women who try to write music. "Of Mlle. Germaine Tailleferre one can only repeat Dr. Johnson's dictum concerning a woman preacher, transposed into terms of music. 'Sir, a woman's composing is like a dog's walking on his hind legs. It is not done well, but you are surprised to find it done at all.' " So accurately does history repeat itself.

Thus, I concluded, shutting Mr. Oscar Browning's life and pushing away the rest, it is fairly evident that even in the nineteenth century a woman was not encouraged to be an artist. On the contrary, she was snubbed, slapped, lectured and exhorted. Her mind must have been strained and her vitality lowered by the need of opposing this, of disproving that. For here again we come within range of that very interesting and obscure masculine complex which has had so much influence upon the woman's movement; that deep-seated desire, not so much that *she* shall be inferior as that *he* shall be superior, which plants him wherever one looks, not only in front of the arts, but barring the way to politics too, even when the risk to himself seems infinitesimal and the suppliant humble and devoted. Even Lady Bessborough, I remembered, with all her passion for politics, must humbly bow herself and write to Lord Granville Leveson-Gower: ". . . notwithstanding all my violence in politics and talking so much on that subject, I perfectly agree with you that no woman has any business to meddle with that or any other serious business, farther than giving her opinion (if she is ask'd)." And so she goes on to spend her enthusiasm where it meets with no obstacle whatsoever upon that immensely important subject, Lord Granville's maiden speech in the House of Commons. The spectacle is certainly a strange one, I thought. The history of men's opposition to women's emancipation is more interesting perhaps than the story of that emancipation itself. An amusing book might be made of it if some young student at Girton or Newnham would collect examples and deduce a theory—but she would need thick gloves on her hands, and bars to protect her of solid gold.

But what is amusing now, I recollected, shutting Lady Bessborough, had to be taken in desperate earnest once. Opinions that one now pastes in a book labelled cock-a-doodle-dum and keeps for reading to select audiences on summer nights once drew tears, I can assure you. Among your grandmothers and great-grandmothers there were many that wept their eyes out. Florence Nightingale shrieked aloud in her agony. Moreover, it is all very well for you, who have got yourselves to college and enjoy sitting-rooms—or is it only bed-sitting-rooms?—of your own to say that genius should disregard such opinions; that genius should be above caring what is said of it. Unfortunately, it is precisely the men or women of genius who mind most what is said of them. Remember Keats. Remember the words he had cut on his tombstone. Think of Tennyson; think—but I need hardly multiply instances of the undeniable, if very unfortunate, fact that it is the nature of the artist to mind excessively what is said about him. Literature is strewn with the wreckage of men who have minded beyond reason the opinions of others.

And this susceptibility of theirs is doubly unfortunate, I thought, returning again to my original enquiry into what state of mind is most propitious for creative work, because the mind of an artist, in order to achieve the prodigious effort of freeing whole and entire the work that is in him, must be incandescent, like Shakespeare's mind, I conjectured, looking at the book which lay open at *Antony and Cleopatra*. There must be no obstacle in it, no foreign matter unconsumed.

For though we say that we know nothing about Shakespeare's state of mind, even as we say that, we are saying something about Shakespeare's state of mind. The reason perhaps why we know so little of Shakespeare—compared with Donne or Ben Jonson or Milton—is that his grudges and spites and antipathies are hidden from us.

We are not held up by some "revelation" which reminds us of the writer. All desire to protest, to preach, to proclaim an injury, to pay off a score, to make the world the witness of some hardship or grievance was fired out of him and consumed. Therefore his poetry flows from him free and unimpeded. If ever a human being got his work expressed completely, it was Shakespeare. If ever a mind was incandescent, unimpeded, I thought, turning again to the bookcase, it was Shakespeare's mind.

The Ethics of Living Jim Crow
[1937] Richard Wright

I

My first lesson in how to live as a Negro came when I was quite small. We were living in Arkansas. Our house stood behind the railroad tracks. Its skimpy yard was paved with black cinders. Nothing green ever grew in that yard. The only touch of green we could see was far away, beyond the tracks, over where the white folks lived. But cinders were good enough for me and I never missed the green growing things. And anyhow cinders were fine weapons. You could always have a nice hot war with huge black cinders. All you had to do was crouch behind the brick pillars of a house with your hands full of gritty ammunition. And the first woolly black head you saw pop out from behind another row of pillars was your target. You tried your very best to knock it off. It was great fun.

I never fully realized the appalling disadvantages of a cinder environment till one day the gang to which I belonged found itself engaged in a war with the white boys who lived beyond the tracks. As usual we laid down our cinder barrage, thinking that this would wipe the white boys out. But they replied with a steady bombardment of broken bottles. We doubled our cinder barrage, but they hid behind the trees, hedges, and the sloping embankment of their lawns. Having no such fortifications, we retreated to the brick pillars of our homes. During the retreat a broken milk bottle caught me behind the ear, opening a deep gash which bled profusely. The sight of blood pouring over my face completely demoralized our ranks. My fellow-combatants left me standing paralyzed in the center of the yard, and scurried for their homes. A kind neighbor saw me, and rushed me to a doctor, who took three stitches in my neck.

I sat brooding on my front steps, nursing my wound and waiting for my mother to come from work. I felt that a grave injustice had been done me. It was all right to throw cinders. The greatest harm a cinder could do was leave a bruise. But broken bottles were dangerous; they left you cut, bleeding, and helpless.

When night fell, my mother came from the white folks' kitchen. I raced down the street to meet her. I could just feel in my bones that she would understand. I knew she would tell me exactly what to do next time. I grabbed her hand and babbled out the whole story. She examined my wound, then slapped me.

"How come yuh didn't hide?" she asked me. "How come yuh awways fightin'?"

I was outraged, and bawled. Between sobs I told her that I didn't have any trees or hedges to hide behind. There wasn't a thing I could have used as a trench. And you couldn't throw very far when you were hiding behind the brick pillars of a house. She grabbed a barrel stave, dragged me home, stripped me naked, and beat me till I had a fever of one hundred and two. She would smack my rump with the stave, and, while the skin was still smarting impart to me gems of Jim Crow wisdom. I was never to throw cinders any more. I was never to fight any more wars. I was never, never, under any conditions, to fight *white* folks again. And they were absolutely right in clouting me with the broken milk bottle. Didn't I know she was working hard every day in the hot kitchens of the white folks to make money to take care of me? When was I ever going to learn to be a good boy? She couldn't be bothered with my fights. She finished by telling me that I ought to be thankful to God as long as I lived that they didn't kill me.

All that night I was delirious and could not sleep. Each time I closed my eyes I saw monstrous white faces suspended from the ceiling, leering at me.

From that time on, the charm of my cinder yard was gone. The green trees, the trimmed hedges, the cropped lawns grew very meaningful, became a symbol. Even today when I think of white folks, the hard, sharp outlines of white houses surrounded by trees, lawns, and hedges are present somewhere in the background of my mind. Through the years they grew into an overreaching symbol of fear.

It was a long time before I came in close contact with white folks again. We moved from Arkansas to Mississippi. Here we had the good fortune not to live behind the railroad tracks, or close to white neighborhoods. We lived in the very heart of the local Black Belt. There were black churches and black preachers; there were black schools and black teachers; black groceries and black clerks. In fact, everything was so solidly black that for a long time I did not even think of white folks, save in remote and vague terms. But this could not last forever. As one grows older one eats more. One's clothing costs more. When I finished grammar school I had to go to work. My mother could no longer feed and clothe me on her cooking job.

There is but one place where a black boy who knows no trade can get a job, and that's where the houses and faces are white, where the trees, lawns, and hedges are green. My first job was with an optical company in Jackson, Mississippi. The morning I applied I stood straight and neat before the boss, answering all his questions with sharp yessirs and nosirs. I was very careful to pronounce my *sirs* distinctly, in order that he might know that I was polite, that I knew where I was, and that I knew he was a *white* man. I wanted that job badly.

He looked me over as though he were examining a prize poodle. He questioned me closely about my schooling, being particularly insistent about how much mathematics I had had. He seemed very pleased when I told him I had had two years of algebra.

"Boy, how would you like to try to learn something around here?" he asked me.

"I'd like it fine, sir," I said, happy. I had visions of "working my way up." Even Negroes have those visions.

"All right," he said. "Come on."

I followed him to the small factory.

"Pease," he said to a white man of about thirty-five, "this is Richard. He's going to work for us."

Pease looked at me and nodded.

I was then taken to a white boy of about seventeen.

"Morrie, this is Richard, who's going to work for us."

"Whut yuh sayin' there, boy!" Morrie boomed at me.

"Fine!" I answered.

The boss instructed these two to help me, teach me, give me jobs to do, and let me learn what I could in my spare time.

My wages were five dollars a week.

I worked hard, trying to please. For the first month I got along O.K. Both Pease and Morrie seemed to like me. But one thing was missing. And I kept thinking about it. I was not learning anything and nobody was volunteering to help me. Thinking they had forgotten that I was to learn something about the mechanics of grinding lenses, I asked Morrie one day to tell me about the work. He grew red.

"Whut yuh tryin' t' do, nigger, get smart?" he asked.

"Naw; I ain' tryin' t' git smart," I said.

"Well, don't, if yuh know whut's good for yuh!"

I was puzzled. Maybe he just doesn't want to help me, I thought. I went to Pease.

"Say, are yuh crazy, you black bastard?" Pease asked me, his gray eyes growing hard.

I spoke out, reminding him that the boss had said I was to be given a chance to learn something.

"Nigger, you think you're *white*, don't you?"

"Naw, sir!"

"Well, you're acting mighty like it!"

"But, Mr. Pease, the boss said . . ."

Pease shook his fist in my face.

"This is a *white* man's work around here, and you better watch yourself!"

From then on they changed toward me. They said good-morning no more. When I was just a bit slow in performing some duty, I was called a lazy black son-of-a-bitch.

Once I thought of reporting all this to the boss. But the mere idea of what would happen to me if Pease and Morrie should learn that I had "snitched" stopped me. And after all the boss was a white man, too. What was the use?

The climax came at noon one summer day. Pease called me to his workbench. To get to him I had to go between two narrow benches and stand with my back against a wall.

"Yes sir," I said.

"Richard, I want to ask you something," Pease began pleasantly, not looking up from his work.

"Yes sir," I said.

Morrie came over, blocking the narrow passage between the benches. He folded his arms, staring at me solemnly.

I looked from one to the other, sensing that something was coming.

"Yes, sir," I said for the third time.

Pease looked up and spoke very slowly.

"Richard, Mr. Morrie here tells me you called me *Pease*."

I stiffened. A void seemed to open up in me. I knew this was the showdown.

He meant that I had failed to call him Mr. Pease. I

looked at Morrie. He was gripping a steel bar in his hands. I opened my mouth to speak, to protest, to assure Pease that I had never called him simply *Pease*, and that I had never had any intentions of doing so, when Morrie grabbed me my the collar, ramming my head against the wall.

"Now be careful, nigger!" snarled Morrie, baring his teeth. "I heard yuh call 'im *Pease*! 'N' if yuh say yuh didn't, yuh're callin' me a *lie*, see?" He waved the steel bar threateningly.

If I had said: No, sir, Mr. Pease, I never called you *Pease* I would have been automatically calling Morrie a liar. And if I had said: Yes, sir, Mr. Pease, I called you *Pease*, I would have been pleading guilty to having uttered the worst insult that a Negro can utter to a southern white man. I stood hesitating, trying to frame a neutral reply.

"Richard, I asked you a question!" said Pease. Anger was creeping into his voice.

"I don't remember calling you *Pease*, Mr. Pease." I said cautiously, "And if I did, I sure didn't mean . . ."

"You black son-of-a-bitch! You called me *Pease*, then!" he spat, slapping me till I bent sideways over a bench. Morrie was on top of me, demanding:

"Didn't you call 'im *Pease*? If yuh say yuh didn't, I'll rip yo' gut string loose with this bar, yuh black granny dodger! Yuh can't call a white man a lie 'n' git erway with it, you black son-of-a-bitch!"

I wilted. I begged them not to bother me. I knew what they wanted. They wanted me to leave.

"I'll leave," I promised. "I'll leave right *now*."

They gave me a minute to get out of the factory. I was warned not to show up again, or tell the boss.

I went.

When I told the folks at home what had happened, they called me a fool. They told me that I must never again attempt to exceed my boundaries. When you are working for white folks, they said, you got to "stay in your place" if you want to keep working.

2

My Jim Crow education continued on my next job, which was portering in a clothing store. One morning, while polishing brass out front, the boss and his twenty-year-old son got out of their car and half dragged and half kicked a Negro woman into the store. A policeman standing at the corner looked on, twirling his nightstick. I watched out of the corner of my eye, never slackening the strokes of my chamois upon the brass. After a few minutes, I heard shrill screams coming from the rear of the store. Later the woman stumbled out, bleeding, crying, and holding her stomach. When she reached the end of the block, the policeman grabbed her and accused her of being drunk. Silently, I watched him throw her into a patrol wagon.

When I went to the rear of the store, the boss and his son were washing their hands at the sink. They were chuckling. The floor was bloody and strewn with wisps of hair and clothing. No doubt I must have appeared pretty shocked, for the boss slapped me reassuringly on the back.

"Boy, that's what we do to niggers when they don't want to pay their bills," he said, laughing.

His son looked at me and grinned.

"Here, hava cigarette," he said.

Not knowing what to do, I took it. He lit his and held the match for me. This was a gesture of kindness, indicating that even if they had beaten the poor old woman, they would not beat me if I knew enough to keep my mouth shut.

"Yes, sir," I said, and asked no questions.

After they had gone, I sat on the edge of a packing box and stared at the bloody floor till the cigarette went out.

That day at noon, while eating in a hamburger joint, I told my fellow Negro porters what had happened. No one seemed surprised. One fellow, after swallowing a huge bite, turned to me and asked:

"Huh! Is tha' all they did t' her?"

"Yeah. Wasn't tha' enough?" I asked.

"Shucks! Man, she's a lucky bitch!" he said, burying his lips deep into a juicy hamburger. "Hell, it's a wonder they didn't lay her when they got through."

3

I was learning fast, but not quite fast enough. One day, while I was delivering packages in the suburbs, my bicycle tire was punctured. I walked along the hot, dusty road, sweating and leading my bicycle by the handlebars.

A car slowed at my side.

"What's the matter, boy?" a white man called.

I told him my bicycle was broken and I was walking back to town.

"That's too bad," he said. "Hop on the running board."

He stopped the car. I clutched hard at my bicycle with one hand and clung to the side of the car with the other.

"All set?"

"Yes, sir," I answered. The car started.

It was full of young white men. They were drinking. I watched the flask pass from mouth to mouth.

"Wanna drink, boy?" one asked.

I laughed as the wind whipped my face. Instinctively obeying the freshly planted precepts of my mother, I said:

"Oh, no!"

The words were hardly out of my mouth before I felt something hard and cold smash me between the eyes. It was an empty whisky bottle. I saw stars, and fell backwards from the speeding car into the dust of the road, my feet becoming entangled in the steel spokes of my bicycle. The white men piled out and stood over me.

"Nigger, ain' yuh learned no better sense'n tha' yet?" asked the man who hit me. "Ain' yuh learned t' say *sir* t' a white man yet?"

Dazed, I pulled to my feet. My elbows and legs were bleeding. Fists doubled, the white man advanced, kicking my bicycle out of the way.

"Aw, leave the bastard alone. He's got enough," said one.

They stood looking at me. I rubbed my shins, trying to stop the flow of blood. No doubt they felt a sort of contemptuous pity, for one asked:

"Yuh wanna ride t' town now, nigger? Yuh reckon yuh know enough t' ride now?"

"I wanna walk," I said, simply.

Maybe it sounded funny. They laughed.

"Well, walk, yuh black son-of-a-bitch!"

When they left they comforted me with:

"Nigger, yuh sho better be dawn glad it wuz us yuh talked t' tha' way. Yuh're a lucky bastard, 'cause if yuh'd said tha' t' somebody else, yuh might've been a dead nigger now."

4

Negroes who have lived South know the dread of being caught alone upon the streets in white neighborhoods after the sun has set. In such a simple situation as this the plight of the Negro in America is graphically symbolized. While white strangers may be in these neighborhoods trying to get home, they can pass unmolested. But the color of a Negro's skin makes him easily recognizable, makes him suspect, converts him into a defenseless target.

Late one Saturday night I made some deliveries in a white neighborhood. I was pedaling my bicycle back to the store as fast as I could, when a police car, swerving toward me, jammed me into the curbing.

"Get down and put up your hands!" the policemen ordered.

I did. They climbed out of the car, guns drawn, faces set, and advanced slowly.

"Keep still!" they ordered.

I reached my hands higher. They searched my pockets and packages. They seemed dissatisfied when they could find nothing incriminating. Finally, one of them said:

"Boy, tell your boss not to send you out in white neighborhoods after sundown."

As usual, I said:

"Yes, sir."

5

My next job was as hall-boy in a hotel. Here my Jim Crow education broadened and deepened. When the bell-boys were busy, I was often called to assist them. As many of the rooms in the hotel were occupied by prostitutes, I was constantly called to carry them liquor and cigarettes. These women were nude most of the time. They did not bother about clothing, even for bell-boys. When you went into their rooms, you were supposed to take their nakedness for granted, as though it startled you no more than a blue vase or a red rug. Your presence awoke in them no sense of shame, for you were not regarded as human. If they were alone, you could steal side-long glimpses at them. But if they were receiving men, not a flicker of your eyelids could show. I remember one incident vividly. A new woman, a huge, snowy-skinned blonde, took a room on my floor. I was sent to wait upon her. She was in bed with a thick-set man; both were nude and uncovered. She said she wanted some liquor and slid out of bed and waddled across the floor to get her money from a dresser drawer. I watched her.

"Nigger, what in hell you looking at?" the white man asked me, raising himself upon his elbows.

"Nothing," I answered, looking miles deep into the blank wall of the room.

"Keep your eyes where they belong, if you want to be healthy!" he said.

"Yes, sir."

6

One of the bell-boys I knew in this hotel was keeping steady company with one of the Negro maids. Out of a clear sky the police descended upon his home and arrested him, accusing him of bastardy. The poor boy swore he had had no intimate relations with the girl. Nevertheless, they forced him to marry her. When the child arrived, it was found to be much lighter in complexion than either of the two supposedly legal parents. The white men around the hotel made a great joke of it. They spread the rumor that some white cow must have scared the poor girl while she was carrying the baby. If you were in their presence when this explanation was offered, you were supposed to laugh.

7

One of the bell-boys was caught in bed with a white prostitute. He was castrated and run out of town. Immediately after this all the bell-boys and hall-boys were called together and warned. We were given to understand that the boy who had been castrated was a "mighty, mighty lucky bastard." We were impressed with the fact that next time the management of the hotel would not be responsible for the lives of "trouble-makin' niggers." We were silent.

8

One night, just as I was about to go home, I met one of the Negro maids. She lived in my direction, and we fell in to walk part of the way home together. As we passed the white night-watchman, he slapped the maid on her buttock. I turned around, amazed. The watchman looked at me with a long, hard, fixed-under stare. Suddenly, he pulled his gun and asked:

"Nigger, don't yuh like it?"

I hesitated.

"I asked yuh don't yuh like it?" he asked again, stepping forward.

"Yes, sir," I mumbled.

"Talk like it, then!"

"Oh, yes, sir!" I said with as much heartiness as I could muster.

Outside, I walked ahead of the girl, ashamed to face her. She caught up with me and said:

"Don't be a fool! Yuh couldn't help it!"

This watchman boasted of having killed two Negroes in self-defense.

Yet, in spite of all this, the life of the hotel ran with an amazing smoothness. It would have been impossible for a stranger to detect anything. The maids, the hall-boys, and the bell-boys were all smiles. They had to be.

9

I had learned my Jim Crow lessons so thoroughly that I kept the hotel job till I left Jackson for Memphis. It so happened that while in Memphis I applied for a job at a branch of the optical company. I was hired. And for some reason, as long as I worked there, they never brought my past against me.

Here my Jim Crow education assumed quite a different form. It was no longer brutally cruel, but subtly cruel. Here I learned to lie, to steal, to dissemble. I learned to play that dual role which every Negro must play if he wants to eat and live.

For example, it was almost impossible to get a book to read. It was assumed that after a Negro had imbibed what scanty schooling the state furnished he had no further need for books. I was always borrowing books from men on the job. One day I mustered enough courage to ask one of the men to let me get books from the library in his name. Surprisingly, he consented. I cannot help but think that he consented because he was a Roman Catholic and felt a vague sympathy for Negroes, being himself an object of hatred. Armed with a library card, I obtained books in the following manner: I would write a note to the librarian, saying: "Please let this nigger boy have the following books." I would then sign it with the white man's name.

When I went to the library, I would stand at the desk, hat in hand, looking as unbookish as possible. When I received the books desired I would take them home. If the books listed in the note happened to be out, I would sneak into the lobby and forge a new one. I never took any chances guessing with the white librarian about what the fictitious white man would want to read. No doubt if any of the white patrons had suspected that some of the volumes they enjoyed had been in the home of a Negro, they would not have tolerated it for an instant.

The factory force of the optical company in Memphis was much larger than that in Jackson, and more urbanized. At least they liked to talk, and would engage the Negro help in conversation whenever possible. By this means I found that many subjects were taboo from the white man's point of view. Among the topics they did not like to discuss with Negroes were the following: American white women; the Ku Klux Klan; France, and how Negro soldiers fared while there; French women; Jack Johnson; the entire northern part of the United States; the Civil War; Abraham Lincoln; U.S. Grant; General Sherman; Catholics; the Pope; Jews; the Republican Party; slavery; social equality; Communism; Socialism; the 13th and 14th Amendments to the Constitution; or any topic calling for positive knowledge or manly self-assertion on the part of the Negro. The most accepted topics were sex and religion.

There were many times when I had to exercise a great deal of ingenuity to keep out of trouble. It is a southern custom that all men must take off their hats when they enter an elevator. And especially did this apply to us blacks with rigid force. One day I stepped into an elevator with my arms full of packages. I was forced to ride with my hat on. Two white men stared at me coldly. Then one of them very kindly lifted my hat and placed it upon my armful of packages. Now the most accepted response for a Negro to make under such circumstances is to look at the white man out of the corner of his eye and grin. To have said: "Thank you!" would have made the white man *think* that you *thought* you were receiving from him a personal service. For such an act I have seen Negroes take a blow in the mouth. Finding the first alternative distasteful, and the second dangerous, I hit upon an acceptable course of action which fell safely between these two poles. I immediately—no sooner than my hat was lifted— pretended that my packages were about to spill, and

appeared deeply distressed with keeping them in my arms. In this fashion I evaded having to acknowledge his service, and, in spite of adverse circumstance, salvaged a single shred of personal pride.

How do Negroes feel about the way they have to live? How do they discuss it when alone among themselves? I think this question can be answered in a single sentence. A friend of mine who ran an elevator once told me:

"Lawd, man! Ef it wuzn't fer them polices 'n' them ol' lynchmobs, there wouldn't be nothin' but uproar down here!"

The Wall
[1939] Jean-Paul Sartre

They pushed us into a big white room and I began to blink because the light hurt my eyes. Then I saw a table and four men behind the table, civilians, looking over the papers. They had bunched another group of prisoners in the back and we had to cross the whole room to join them. There were several I knew and some others who must have been foreigners. The two in front of me were blond with round skulls; they looked alike. I supposed they were French. The smaller one kept hitching up his pants; nerves.

It lasted about three hours; I was dizzy and my head was empty; but the room was well heated and I found that pleasant enough: for the past 24 hours we hadn't stopped shivering. The guards brought the prisoners up to the table, one after the other. The four men asked each one his name and occupation. Most of the time they didn't go any further—or they would simply ask a question here and there: "Did you have anything to do with the sabotage of munitions?" Or "Where were you the morning of the 9th and what were you doing?" They didn't listen to the answers or at least didn't seem to. They were quiet for a moment and then looking straight in front of them began to write. They asked Tom if it were true he was in the International Brigade; Tom couldn't tell them otherwise because of the papers they found in his coat. They didn't ask Juan anything but they wrote for a long time after he told them his name.

"My brother José is the anarchist," Juan said, "you know he isn't here any more. I don't belong to any party. I never had anything to do with politics."

They didn't answer. Juan went on, "I haven't done anything. I don't want to pay for somebody else."

His lips trembled. A guard shut him up and took him away. It was my turn.

"Your name is Pablo Ibbieta?"

"Yes."

The man looked at the papers and asked me, "Where's Ramon Gris?"

"I don't know."

"You hid him in your house from the 6th to the 19th."

"No."

They wrote for a minute and then the guards took me out. In the corridor Tom and Juan were waiting between two guards. We started walking. Tom asked one of the guards, "So?"

"So what?" the guard said.

"Was that the cross-examination or the sentence?"

"Sentence," the guard said.

"What are they going to do with us?"

The guard answered dryly, "Sentence will be read in your cell."

As a matter of fact, our cell was one of the hospital cellars. It was terrifically cold there because of the drafts. We shivered all night and it wasn't much better during the day. I had spent the previous five days in a cell in a monastery, a sort of hole in the wall that must have dated from the middle ages: since there were a lot of prisoners and not much room, they locked us up anywhere. I didn't miss my cell; I hadn't suffered too much from the cold but I was alone; after a long time it gets irritating. In the cellar I had company. Juan hardly ever spoke: he was afraid and he was too young to have anything to say. But Tom was a good talker and he knew Spanish well.

There was a bench in the cellar and four mats. When they took us back we sat and waited in silence. After a long moment, Tom said, "We're screwed."

"I think so too," I said, "but I don't think they'll do anything to the kid."

"They don't have a thing against him," said Tom. "He's the brother of a militiaman and that's all."

I looked at Juan: he didn't seem to hear. Tom went on, "You know what they do in Saragossa? They lay the men down on the road and run over them with trucks. A Moroccan deserter told us that. They said it was to save ammunition."

"It doesn't save gas," I said.

I was annoyed at Tom: he shouldn't have said that.

"Then there's officers walking along the road," he went on, "supervising it all. They stick their hands in their pockets and smoke cigarettes. You think they finish off the guys? Hell no. They let them scream. Sometimes for an hour. The Moroccan said he damned near puked the first time."

"I don't believe they'll do that here," I said. "Unless they're really short on ammunition."

Day was coming in through four airholes and a round opening they had made in the ceiling on the left, and you could see the sky through it. Through this hole, usually closed by a trap, they unloaded coal into the cellar. Just below the hole there was a big pile of coal dust; it had been used to heat the hospital, but since the beginning of the war the patients were evacuated and the coal stayed there, unused; sometimes it even got rained on because they had forgotten to close the trap.

Tom began to shiver. "Good Jesus Christ, I'm cold," he said. "Here it goes again."

He got up and began to do exercises. At each movement his shirt opened on his chest, white and hairy. He lay on his back, raised his legs in the air and bicycled. I saw his great rump trembling. Tom was husky but he had too much fat. I thought how rifle bullets or the sharp points of bayonets would soon be sunk into this mass of tender flesh as in a lump of butter. It wouldn't have made me feel like that if he'd been thin.

I wasn't exactly cold, but I couldn't feel my arms and

shoulders any more. Sometimes I had the impression I was missing something and began to look around for my coat and then suddenly remembered they hadn't given me a coat. It was rather uncomfortable. They took our clothes and gave them to their soldiers leaving us only our shirts—and those canvas pants that hospital patients wear in the middle of summer. After a while Tom got up and sat next to me, breathing heavily.

"Warmer?"

"Good Christ, no. But I'm out of wind."

Around eight o'clock in the evening a major came in with two *falangistas*. He had a sheet of paper in his hand. He asked the guard, "What are the names of those three?"

"Steinbock, Ibbieta and Mirbal," the guard said.

The major put on his eyeglasses and scanned the list: "Steinbock . . . Steinbock . . . Oh yes . . . You are sentenced to death. You will be shot tomorrow morning." He went on looking. "The other two as well."

"That's not possible," Juan said. "Not me."

The major looked at him amazed. "What's your name?"

"Juan Mirbal," he said.

"Well, your name is there," said the major. "You're sentenced."

"I didn't do anything," Juan said.

The major shrugged his shoulders and turned to Tom and me.

"You're Basque?"

"Nobody is Basque."

He looked annoyed. "They told me there were three Basques. I'm not going to waste my time running after them. Then naturally you don't want a priest?"

We didn't even answer.

He said, "A Belgian doctor is coming shortly. He is authorized to spend the night with you." He made a military salute and left.

"What did I tell you," Tom said. "We get it."

"Yes," I said, "it's a rotten deal for the kid."

I said that to be decent but I didn't like the kid. His face was too thin and fear and suffering had disfigured it, twisting all his features. Three days before he was a smart sort of kid, not too bad; but now he looked like an old fairy and I thought how he'd never be young again, even if they were to let him go. It wouldn't have been too hard to have a little pity for him but pity disgusts me, or rather it horrifies me. He hadn't said anything more but he had turned grey; his face and hands were both grey. He sat down again and looked at the ground with round eyes. Tom was good hearted, he wanted to take his arm, but the kid tore himself away violently and made a face.

"Let him alone," I said in a low voice, "you can see he's going to blubber."

Tom obeyed regretfully; he would have liked to comfort the kid, it would have passed his time and he wouldn't have been tempted to think about himself. But it annoyed me: I'd never thought about death because I never had any reason to, but now the reason was here and there was nothing to do but think about it.

Tom began to talk. "So you think you've knocked guys off, do you?" he asked me. I didn't answer. He began explaining to me that he had knocked off six since the beginning of August; he didn't realize the situation and I could tell he didn't *want* to realize it. I hadn't quite realized it myself, I wondered if it hurt much, I thought of bullets, I imagined their burning hail through my body. All that was beside the real question; but I was calm: we had all night to understand. After a while Tom stopped talking and I watched him out of the corner of my eye; I saw he too had turned grey and he looked rotten: I told myself "Now it starts." It was almost dark, a dim glow filtered through the airholes and the pile of coal and made a big stain beneath the spot of sky; I could already see a star through the hole in the ceiling: the night would be pure and icy.

The door opened and two guards came in, followed by a blonde man in a tan uniform. He saluted us. "I am the doctor," he said. "I have authorization to help you in these trying hours."

He had an agreeable and distinguished voice. I said, "What do you want here?"

"I am at your disposal. I shall do all I can to make your last moments less difficult."

"What did you come here for? There are others, the hospital's full of them."

"I was sent here," he answered with a vague look. "Ah! Would you like to smoke?" he added hurriedly, "I have cigarettes and even cigars."

He offered us English cigarettes and *puros*, but we refused. I looked him in the eyes and he seemed irritated. I said to him, "You aren't here on an errand of mercy. Besides, I know you. I saw you with the fascists in the barracks yard the day I was arrested."

I was going to continue, but something surprising suddenly happened to me; the presence of this doctor no longer interested me. Generally when I'm on somebody I don't let go. But the desire to talk left me completely; I shrugged and turned my eyes away. A little later I raised my head; he was watching me curiously. The guards were sitting on a mat. Pedro, the tall thin one, was twiddling his thumbs, the other shook his head from time to time to keep from falling asleep.

"Do you want a light?" Pedro suddenly asked the doctor. The other nodded "Yes": I think he was about as smart as a log, but he surely wasn't bad. Looking in his cold blue eyes it seemed to me that his only sin was lack of imagination. Pedro went out and came back with an oil lamp which he set on the corner of the bench. It gave a bad light but it was better than nothing: they had left us in the dark the night before. For a long time I watched the circle of light the lamp made on the ceiling. I was fascinated. Then suddenly I woke up, the circle of light disappeared and I felt myself crushed under an enormous weight. It was not the thought of death, or fear; it was nameless. My cheeks burned and my head ached.

I shook myself and looked at my two friends. Tom had hidden his face in his hands. I could only see the fat white nape of his neck. Little Juan was the worst, his mouth was open and his nostrils trembled. The doctor went to him and put his hand on his shoulder to comfort him: but his eyes stayed cold. Then I saw the Belgian's hand drop stealthily along Juan's arm, down to the wrist. Juan paid no attention. The Belgian took his wrist between three fingers, distractedly, the same time drawing back a little and

turning his back to me. But I leaned backward and saw him take a watch from his pocket and look at it for a moment, never letting go of the wrist. After a minute he let the hand fall inert and went and leaned his back against the wall, then, as if he suddenly remembered something very important which had to be jotted down on the spot, he took a notebook from his pocket and wrote a few lines. "Bastard," I thought angrily, "let him come and take my pulse. I'll shove my fist in his rotten face."

He didn't come but I felt him watching me. I raised my head and returned his look. Impersonally, he said to me, "Doesn't it seem cold to you here?" He looked cold, he was blue.

"I'm not cold," I told him.

He never took his hard eyes off me. Suddenly I understood and my hands went to my face: I was drenched in sweat. In this cellar, in the midst of winter, in the midst of drafts, I was sweating. I ran my hands through my hair, gummed together with perspiration; at the same time I saw my shirt was damp and sticking to my skin: I had been dripping for an hour and hadn't felt it. But that swine of a Belgian hadn't missed a thing; he had seen the drops rolling down my cheeks and thought: this is the manifestation of an almost pathological state of terror; and he had felt normal and proud of being alive because he was cold. I wanted to stand up and smash his face but no sooner had I made the slightest gesture than my rage and shame were wiped out: I fell back on the bench with indifference.

I satisfied myself by rubbing my neck with my handkerchief because now I felt the sweat dropping from my hair onto my neck and it was unpleasant. I soon gave up rubbing, it was useless; my handkerchief was already soaked and I was still sweating. My buttocks were sweating too and my damp trousers were glued to the bench.

Suddenly Juan spoke. "You're a doctor?"

"Yes," the Belgian said.

"Does it hurt . . . very long?"

"Huh? When . . . ? Oh, no." the Belgian said paternally. "Not at all. It's over quickly." He acted as though he were calming a cash customer.

"But I . . . they told me . . . sometimes they have to fire twice."

"Sometimes," the Belgian said, nodding. "It may happen that the first volley reaches no vital organs."

"Then they have to reload their rifles and aim all over again?" He thought for a moment and then added hoarsely, "That takes time!"

He had a terrible fear of suffering, it was all he thought about: it was his age. I never thought much about it and it wasn't fear of suffering that made me sweat.

I got up and walked to the pile of coal dust. Tom jumped up and threw me a hateful look: I had annoyed him because my shoes squeaked. I wondered if my face looked as frightened as his: I saw he was sweating too. The sky was superb, no light filtered into the dark corner and I had only to raise my head to see the Big Dipper. But it wasn't like it had been: the night before I could see a great piece of sky from my monastery cell and each hour of the day brought me a different memory. Morning, when the sky was a hard, light blue, I thought of beaches on the Atlantic; at noon I saw the sun and I remembered a bar in Seville where I drank *manzanilla* and ate olives and anchovies; afternoons I was in the shade and I thought of the deep shadow which spreads over half a bull-ring leaving the other half shimmering in sunlight: it was really hard to see the whole world reflected in the sky like that. But now I could watch the sky as much as I pleased, it no longer evoked anything in me. I liked that better. I came back and sat near Tom. A long moment passed.

Tom began speaking in a low voice. He had to talk, without that he wouldn't have been able to recognize himself in his own mind. I thought he was talking to me but he wasn't looking at me. He was undoubtedly afraid to see me as I was, grey and sweating: we were alike and worse than mirrors of each other. He watched the Belgian, the living.

"Do you understand?" he said. "I don't understand."

I began to speak in a low voice too. I watched the Belgian. "Why? What's the matter?"

"Something is going to happen to us that I can't understand."

There was a strange smell about Tom. It seemed to me I was more sensitive than usual to odors. I grinned. "You'll understand in a while."

"It isn't clear," he said obstinately. "I want to be brave but first I have to know . . . Listen, they're going to take us into the courtyard. Good. They're going to stand up in front of us. How many?"

"I don't know. Five or eight. Not more."

"All right. There'll be eight. Someone'll holler 'aim!' and I'll see eight rifles looking at me. I'll think how I'd like to get inside the wall, I'll push against it with my back . . . with every ounce of strength I have, but the wall will stay, like in a nightmare. I can imagine all that. If you only knew how well I can imagine it."

"All right, all right!" I said, "I can imagine it too."

"It must hurt like hell. You know, they aim at the eyes and the mouth to disfigure you," he added mechanically. "I can feel the wounds already; I've had pains in my head and in my neck for the past hour. Not real pains. Worse. This is what I'm going to feel tomorrow morning. And then what?"

I well understood what he meant but I didn't want to act as if I did. I had pains too, in my body like a crowd of tiny scars. I couldn't get used to it. But I was like him, I attached no importance to it. "After," I said, "you'll be pushing up daisies."

He began to talk to himself: he never stopped watching the Belgian. The Belgian didn't seem to be listening. I knew what he had come to do; he wasn't interested in what we thought; he came to watch our bodies, bodies dying in agony while yet alive.

"It's like a nightmare," Tom was saying. "You want to think something, you always have the impression that it's all right, that you're going to understand and then it slips, it escapes you and fades away. I tell myself there will be nothing afterwards. But I don't understand what it means. Sometimes I almost can . . . and then it fades away and I start thinking about the pains again, bullets, explosions. I'm a materialist, I swear to you; I'm not going crazy. But something's the matter. I see my corpse; that's not hard

but I'm the one who sees it, with *my* eyes. I've got to think . . . think that I won't see anything anymore and the world will go on for the others. We aren't made to think that, Pablo. Believe me: I've already stayed up a whole night waiting for something. But this isn't the same: this will creep up behind us, Pablo, and we won't be able to prepare for it."

"Shut up," I said, "Do you want me to call a priest?"

He didn't answer. I had already noticed he had the tendency to act like a prophet and call me Pablo, speaking in a toneless voice. I didn't like that: but it seems all the Irish are that way. I had the vague impression he smelled of urine. Fundamentally, I hadn't much sympathy for Tom and I didn't see why, under the pretext of dying together, I should have any more. It would have been different with some others. With Ramon Gris, for example. But I felt alone between Tom and Juan. I liked that better, anyhow: with Ramon I might have been more deeply moved. But I was terribly hard just then and I wanted to stay hard.

He kept on chewing his words, with something like distraction. He certainly talked to keep himself from thinking. He smelled of urine like an old prostate case. Naturally, I agreed with him, I could have said everything he said: it isn't *natural* to die. And since I was going to die, nothing seemed natural to me, not this pile of coal dust, or the bench, or Pedro's ugly face. Only it didn't please me to think the same things as Tom. And I knew that, all through the night, every five minutes, we would keep on thinking things at the same time. I looked at him sideways and for the first time he seemed strange to me: he wore death on his face. My pride was wounded: for the past 24 hours I had lived next to Tom, I had listened to him, I had spoken to him and I knew we had nothing in common. And now we looked as much alike as twin brothers, simply because we were going to die together. Tom took my hand without looking at me.

"Pablo, I wonder . . . I wonder if it's really true that everything ends."

I took my hand away and said, "Look between your feet, you pig."

There was a big puddle between his feet and drops fell from his pants-leg.

"What is it," he asked, frightened.

"You're pissing in your pants," I told him.

"It isn't true," he said furiously. "I'm not pissing. I don't feel anything."

The Belgian approached us. He asked with false solicitude. "Do you feel ill?"

Tom did not answer. The Belgian looked at the puddle and said nothing.

"I don't know what it is," Tom said ferociously. "But I'm not afraid. I swear I'm not afraid."

The Belgian did not answer. Tom got up and went to piss in a corner. He came back buttoning his fly, and sat down without a word. The Belgian was taking notes.

All three of us watched him because he was alive. He had the motions of a living human being, the cares of a living human being; he shivered in the cellar the way the living are supposed to shiver; he had an obedient, well-fed body. The rest of us hardly felt ours—not in the same way anyhow. I wanted to feel my pants between my legs

but I didn't dare; I watched the Belgian, balancing on his legs, master of his muscles, someone who could think about tomorrow. There we were, three bloodless shadows; we watched him and we sucked his life like vampires.

Finally he went over to little Juan. Did he want to feel his neck for some professional motive or was he obeying an impulse of charity? If he was acting by charity it was the only time during the whole night.

He caressed Juan's head and neck. The kid let himself be handled, his eyes never leaving him, then suddenly, he seized the hand and looked at it strangely. He held the Belgian's hand between his own two hands and there was nothing pleasant about them, two grey pincers gripping this fat and reddish hand. I suspected what was going to happen and Tom must have suspected it too: but the Belgian didn't see a thing, he smiled paternally. After a moment the kid brought the fat red hand to his mouth and tried to bite it. The Belgian pulled away quickly and stumbled back against the wall. For a second he looked at us with horror, he must have suddenly understood that we were not men like him. I began to laugh and one of the guards jumped up. The other was asleep, his wide open eyes were blank.

I felt relaxed and over-excited at the same time. I didn't want to think any more about what would happen at dawn, at death. It made no sense. I only found words or emptiness. But as soon as I tried to think of anything else I saw rifle barrels pointing at me. Perhaps I lived through my execution twenty times; once I even thought it was for good: I must have slept a minute. They were dragging me to the wall and I was struggling; I was asking for mercy. I woke up with a start and looked at the Belgian: I was afraid I might have cried out in my sleep. But he was stroking his mustache, he hadn't noticed anything. If I had wanted to, I think I could have slept a while; I had been awake for 48 hours. I was at the end of my rope. But I didn't want to lose two hours of life: they would come to wake me up at dawn, I would follow them, stupefied with sleep and I would have croaked without so much as an "Oof!"; I didn't want that, I didn't want to die like an animal, I wanted to understand. Then I was afraid of having nightmares. I got up, walked back and forth, and, to change my ideas, I began to think about my past life. A crowd of memories came back to me pell-mell. There were good and bad ones—or at least I called them that *before*. There were faces and incidents. I saw the face of a little *novillero* who was gored in Valencia during the *Feria*, the face of one of my uncles, the face of Ramon Gris. I remembered my whole life: how I was out of work for three months in 1926, how I almost starved to death. I remembered a night I spent on a bench in Granada: I hadn't eaten for three days. I was angry, I didn't want to die. That made me smile. How madly I ran after happiness, after women, after liberty. Why? I wanted to free Spain, I admired Pi y Margall. I joined the anarchist movement, I spoke at public meetings: I took everything as seriously as if I were immortal.

At that moment I felt that I had my whole life in front of me and I thought, "It's a damned lie." It was worth nothing because it was finished. I wondered how I'd been able to walk, to laugh with the girls: I wouldn't have moved so

much as my little finger if I had only imagined I would die like this. My life was in front of me, shut, closed, like a bag and yet everything inside of it was unfinished. For an instant I tried to judge it. I wanted to tell myself, this is a beautiful life. But I couldn't pass judgment on it; it was only a sketch; I had spent my time counterfeiting eternity, I had understood nothing. I missed nothing: there were so many things I could have missed, the taste of *manzanilla* or the baths I took in summer in a little creek near Cadiz: but death had disenchanted everything.

The Belgian suddenly had a bright idea. "My friends," he told us, "I will undertake—if the military administration will allow it—to send a message for you, a souvenir to those who love you...."

Tom mumbled, "I don't have anybody."

I said nothing. Tom waited an instant then looked at me with curiosity. "You don't have anything to say to Concha?"

"No."

I hated this tender complicity: it was my own fault, I had talked about Concha the night before. I should have controlled myself. I was with her for a year. Last night I would have given an arm to see her again for five minutes. That was why I talked about her, it was stronger than I was. Now I had no more desire to see her, I had nothing more to say to her. I would not even have wanted to hold her in my arms: my body filled me with horror because it was grey and sweating—and I wasn't sure that her body didn't fill me with horror. Concha would cry when she found out I was dead, she would have no taste for life for months afterward. But I was still the one who was going to die. I thought of her soft, beautiful eyes. When she looked at me something passed from her to me. But I knew it was over: if she looked at me *now* the look would stay in her eyes, it wouldn't reach me. I was alone.

Tom was alone too but not in the same way. Sitting cross-legged, he had begun to stare at the bench with a sort of smile, he looked amazed. He put out his hand and touched the wood cautiously as if he were afraid of breaking something, then drew back his hand quickly and shuddered. If I had been Tom I wouldn't have amused myself by touching the bench; this was some more Irish nonsense, but I too found that objects had a funny look: they were more obliterated, less dense than usual. It was enough for me to look at the bench, the lamp, the pile of coal dust, to feel that I was going to die. Naturally I couldn't think clearly about my death but I saw it everywhere, on things, in the way things fell back and kept their distance, discreetly, as people who speak quietly at the bedside of a dying man. It was *his* death which Tom had just touched on the bench.

In the state I was in, if someone had come and told me I could go home quietly, that they would leave me my life whole, it would have left me cold: several hours or several years of waiting is all the same when you have lost the illusion of being eternal. I clung to nothing, in a way I was calm. But it was a horrible calm—because of my body; my body, I saw with its eyes, I heard with its ears, but it was no longer me; it sweated and trembled by itself and I didn't recognize it any more. I had to touch it and look at it to find out what was happening, as if it were the body of someone else. At times I could still feel it, I felt sinkings, and fallings, as when you're in a plane taking a nosedive, or I felt my heart beating. But that didn't reassure me. Everything that came from my body was all cockeyed. Most of the time it was quiet and I felt no more than a sort of weight, a filthy presence against me; I had the impression of being tied to an enormous vermin. Once I felt my pants and I felt they were damp; I didn't know whether it was sweat or urine, but I went to piss on the coal pile as a precaution.

The Belgian took out his watch, looked at it. He said, "It is three-thirty."

Bastard! He must have done it on purpose. Tom jumped; we hadn't noticed time was running out; night surrounded us like a shapeless, somber mass, I couldn't even remember that it had begun.

Little Juan began to cry. He wrung his hands, pleaded, "I don't want to die. I don't want to die."

He ran across the whole cellar waving his arms in the air then fell sobbing on one of the mats. Tom watched him with mournful eyes, without the slightest desire to console him. Because it wasn't worth the trouble: the kid made more noise than we did, but he was less touched: he was like a sick man who defends himself against his illness by fever. It's much more serious when there isn't any fever.

He wept: I could clearly see he was pitying himself; he wan't thinking about death. For one second, one single second, I wanted to weep myself, to weep with pity for myself. But the opposite happened: I glanced at the kid, I saw his thin sobbing shoulders and I felt inhuman: I could pity neither the others nor myself. I said to myself, "I want to die cleanly."

Tom had gotten up, he placed himself just under the round opening and began to watch for daylight. I was determined to die cleanly and I only thought of that. But ever since the doctor told us the time, I felt time flying, flowing away drop by drop.

It was still dark when I heard Tom's voice: "Do you hear them?"

Men were marching in the courtyard.

"Yes."

"What the hell are they doing? They can't shoot in the dark."

After a while we heard no more. I said to Tom. "It's day."

Pedro got up, yawning, and came to blow out the lamp. He said to his buddy, "Cold as hell."

The cellar was all grey. We heard shots in the distance.

"It's starting," I told Tom. "They must do it in the court in the rear."

Tom asked the doctor for a cigarette. I didn't want one; I didn't want cigarettes or alcohol. From that moment on they didn't stop firing.

"Do you realize what's happening," Tom said.

He wanted to add something but kept quiet, watching the door. The door opened and a lieutenant came in with four soldiers. Tom dropped his cigarette.

"Steinbock?"

Tom didn't answer. Pedro pointed him out.

"Juan Mirbal?"

"On the mat."

"Get up," the lieutenant said.

Juan did not move. Two soldiers took him under the arms and set him on his feet. But he fell as soon as they released him.

The soldiers hesitated.

"He's not the first sick one," said the lieutenant. "You two carry him; they'll fix it up down there."

He turned to Tom. "Let's go."

Tom went out between two soldiers. Two others followed, carrying the kid by the armpits. He hadn't fainted; his eyes were wide open and tears ran down his cheeks. When I wanted to go out the lieutenant stopped me.

"You Ibbieta?"

"Yes."

"You wait here; they'll come for you later."

They left. The Belgian and the two jailers left too, I was alone. I did not understand what was happening to me but I would have liked it better if they had gotten it over with right away. I heard shots at almost regular intervals; I shook with each one of them. I wanted to scream and tear out my hair. But I gritted my teeth and pushed my hands in my pockets because I wanted to stay clean.

After an hour they came to get me and led me to the first floor, to a small room that smelt of cigars and where the heat was stifling. There were two officers sitting smoking in the armchairs, papers on their knees.

"You're Ibbieta?"

"Yes."

"Where is Ramon Gris?"

"I don't know."

The one questioning me was short and fat. His eyes were hard behind his glasses. He said to me, "Come here."

I went to him. He got up and took my arms, staring at me with a look that should have pushed me into the earth. At the same time he pinched my biceps with all his might. It wasn't to hurt me, it was only a game: he wanted to dominate me. He also thought he had to blow his stinking breath square in my face. We stayed for a moment like that, and I almost felt like laughing. It takes a lot to intimidate a man who is going to die; it didn't work. He pushed me back violently and sat down again. He said, "It's his life against yours. You can have yours if you tell us where he is."

These men dolled up with their riding crops and boots were still going to die. A little later than I, but not too much. They busied themselves looking for names in their crumpled papers, they ran after other men to imprison or suppress them; they had opinions on the future of Spain and on other subjects. Their little activities seemed shocking and burlesqued to me; I couldn't put myself in their place. I thought they were insane. The little man was still looking at me, whipping his boots with the riding crop. All his gestures were calculated to give him the look of a live and ferocious beast.

"So? You understand?"

"I don't know where Gris is." I answered. "I thought he was in Madrid."

The other officer raised his pale hand indolently. This indolence was also calculated. I saw through all their little schemes and I was stupefied to find there were men who amused themselves that way.

"You have a quarter of an hour to think it over," he said slowly. "Take him to the laundry, bring him back in fifteen minutes. If he still refuses he will be executed on the spot."

They knew what they were doing: I had passed the night in waiting; then they had made me wait an hour in the cellar while they shot Tom and Juan and now they were locking me up in the laundry; they must have prepared their game the night before. They told themselves that nerves eventually wear out and they hoped to get me that way.

They were badly mistaken. In the laundry I sat on a stool because I felt very weak and I began to think. But not about their proposition. Of course I knew where Gris was; he was hiding with his cousins, four kilometers from the city. I also knew that I would not reveal his hiding place unless they tortured me (but they didn't seem to be thinking about that). All that was perfectly regulated, definite and in no way interested me. Only I would have liked to understand the reasons for my conduct. I would rather die than give up Gris. Why? I didn't like Ramon Gris any more. My friendship for him had died a little while before dawn at the same time as my love for Concha, at the same time as my desire to live. Undoubtedly I thought highly of him: he was tough. But it was not for this reason that I consented to die in his place; his life had no more value than mine; no life had value. They were going to slap a man up against a wall and shoot at him till he died, whether it was I or Gris or somebody else made no difference. I knew he was more useful than I to the cause of Spain but I thought to hell with Spain and anarchy; nothing was important. Yet I was there, I could save my skin and give up Gris and I refused to do it. I found that somehow comic; it was obstinacy. I thought, "I must be stubborn!" And a droll sort of gaiety spread over me.

They came for me and brought me back to the two officers. A rat ran out from under my feet and that amused me. I turned to one of the *falangistas* and said, "Did you see the rat?"

He didn't answer. He was very sober, he took himself seriously. I wanted to laugh but I held myself back because I was afraid that once I got started I wouldn't be able to stop. The *falangista* had a mustache. I said to him again, "You ought to shave off your mustache, idiot." I thought it funny that he would let the hairs of his living being invade his face. He kicked me without great conviction and I kept quiet.

"Well," said the fat officer, "have you thought about it?"

I looked at them with curiosity, as insects of a very rare species. I told them, "I know where he is. He is hidden in the cemetery. In a vault or in the gravediggers' shack."

It was a farce. I wanted to see them stand up, buckle their belts and give orders busily.

They jumped to their feet. "Let's go. Molés, go get fifteen men from Lieutenant Lopez. You," the fat man said, "I'll let you off if you're telling the truth, but it'll cost you plenty if you're making monkeys out of us."

They left in a great clatter and I waited peacefully under the guard of *falangistas*. From time to time I smiled, thinking about the spectacle they would make. I felt

stunned and malicious. I imagined them lifting up tombstones, opening the doors of the vaults one by one. I represented this situation to myself as if I had been someone else: this prisoner obstinately playing the hero, these grim *falangistas* with their mustaches and their men in uniform running among the graves; it was irresistibly funny. After half an hour the little fat man came back alone. I thought he had come to give the orders to execute me. The others must have stayed in the cemetery.

The officer looked at me. He didn't look at all sheepish. "Take him into the big courtyard with the others," he said. "After the military operations a regular court will decide what happens to him."

"Then they're not . . . not going to shoot me? . . ."

"Not now, anyway. What happens afterwards is none of my business."

I still didn't understand. I asked, "But why . . . ?"

He shrugged his shoulders without answering and the soldiers took me away. In the big courtyard there were about a hundred prisoners, women, children and a few old men. I began walking around the central grass-plot, I was stupefied. At noon they let us eat in the mess hall. Two or three people questioned me. I must have known them, but I didn't answer: I didn't even know where I was.

Around evening they pushed about ten new prisoners into the court. I recognized Garcia, the baker. He said, "What damned luck you have! I didn't think I'd see you alive."

"They sentenced me to death." I said, "and then they changed their minds. I don't know why."

"They arrested me at two o'clock," Garcia said.

"Why?" Garcia had nothing to do with politics.

"I don't know," he said. "They arrest everybody who doesn't think the way they do. He lowered his voice. "They got Gris."

I began to tremble. "When?"

"This morning. He messed it up. He left his cousin's on Tuesday because they had an argument. There were plenty of people to hide him but he didn't want to owe anything to anybody. He said, 'I'd go and hide in Ibbieta's place, but they got him, so I'll go hide in the cemetery.' "

"In the cemetery?"

"Yes. What a fool. Of course they went by there this morning, that was sure to happen. They found him in the gravediggers' shack. He shot at them and they got him."

"In the cemetery!"

Everything began to spin and I found myself sitting on the ground: I laughed so hard I cried.

The Myth of Sisyphus
[1942] Albert Camus

The gods had condemned Sisyphus to ceaselessly rolling a rock to the top of a mountain, whence the stone would fall back of its own weight. They had thought with some reason that there is no more dreadful punishment than futile and hopeless labor.

If one believes Homer, Sisyphus was the wisest and most prudent of mortals. According to another tradition, however, he was disposed to practice the profession of highwayman. I see no contradiction in this. Opinions differ as the reasons why he became the futile laborer of the underworld. To begin with, he is accused of a certain levity in regard to the gods. He stole their secrets. Aegina, the daughter of Aesopus, was carried off by Jupiter. The father was shocked by that disappearance and complained to Sisyphus. He, who knew of the abduction, offered to tell about it on condition that Aesopus would give water to the citadel of Corinth. To the celestial thunderbolts he preferred the benediction of water. He was punished for this in the underworld. Homer tells us also that Sisyphus had put Death in chains. Pluto could not endure the sight of his deserted, silent empire. He dispatched the god of war, who liberated Death from the hands of her conqueror.

It is said also that Sisyphus, being near to death, rashly wanted to test his wife's love. He ordered her to cast his unburied body into the middle of the public square. Sisyphus woke up in the underworld. And there, annoyed by an obedience so contrary to human love, he obtained from Pluto permission to return to earth in order to chastise his wife. But when he had seen again the face of this world, enjoyed water and sun, warm stones and the sea, he no longer wanted to go back to the infernal darkness. Recalls, signs of anger, warnings were of no avail. Many years more he lived facing the curve of the gulf, the sparkling sea, and the smiles of earth. A decree of the gods was necessary. Mercury came and seized the impudent man by the collar and, snatching him from his joys, led him forcibly back to the underworld, where his rock was ready for him.

You have already grasped that Sisyphus is the absurd hero. He *is*, as much through his passions as through his torture. His scorn of the gods, his hatred of death, and his passion for life won him that unspeakable penalty in which the whole being is exerted toward accomplishing nothing. This is the price that must be paid for the passions of this earth. Nothing is told us about Sisyphus in the underworld. Myths are made for the imagination to breathe life into them. As for this myth, one sees merely the whole effort of a body straining to raise the huge stone, to roll it and push it up a slope a hundred times over; one sees the face screwed up, the cheek tight against the stone, the shoulder bracing the clay-covered mass, the foot wedging it, the fresh start with arms outstretched, the wholly human security of two earth-clotted hands. At the very end of his long effort measured by skyless space and time without depth, the purpose is achieved. Then Sisyphus watches the stone rush down in a few moments toward that lower world whence he will have to push it up again toward the summit. He goes back down to the plain.

It is during that return, that pause, that Sisyphus interests me. A face that toils so close to stones is already stone itself! I see that man going back down with a heavy yet measured step toward the torment of which he will never know the end. That hour like a breathing-space which returns as surely as his suffering, that is the hour of consciousness. At each of those moments when he leaves the heights and gradually sinks towards the lairs of the gods, he is superior to his fate. He is stronger than his rock.

If this myth is tragic, that is because its hero is conscious. Where would his torture be, indeed, if at every step the hope of succeeding upheld him? The workman of today works every day in his life at the same tasks, and this fate is no less absurd. But it is tragic only at the rare moments when it becomes conscious. Sisyphus, proletarian of the gods, powerless and rebellious, knows the whole extent of his wretched condition: it is what he thinks of during his descent. The lucidity that was to constitute his torture at the same time crowns his victory. There is no fate that cannot be surmounted by scorn.

If the descent is thus sometimes performed in sorrow, it can also take place in joy. This word is not too much. Again I fancy Sisyphus returning toward his rock, and the sorrow was in the beginning. When the images of earth cling too tightly to memory, when the call of happiness becomes too insistent, it happens that melancholy rises in man's heart: this is the rock's victory, this is the rock itself. The boundless grief is too heavy to bear. These are our nights of Gethsemane. But crushing truths perish from being acknowledged. Thus, Oedipus at the outset obeys fate without knowing it. But from the moment he knows, his tragedy begins. Yet at the same moment, blind and desperate, he realizes that the only bond linking him to the world is the cool hand of a girl. Then a tremendous remark rings out: "Despite so many ordeals, my advanced age and the nobility of my soul make me conclude that all is well." Sophocles' Oedipus, like Dostoevsky's Kirilov, thus gives the recipe for the absurd victory. Ancient wisdom confirms modern heroism.

One does not discover the absurd without being tempted to write a manual of happiness. "What! by such narrow ways—?" There is but one world, however. Happiness and the absurd are two sons of the same earth. They are inseparable. It would be a mistake to say that happiness necessarily springs from the absurd discovery. It happens as well that the feeling of the absurd springs from happiness. "I conclude that all is well," says Oedipus, and that remark is sacred. It echoes in the wild and limited universe of man. It teaches that all is not, has not been, exhausted. It drives out of this world a god who had come into it with dissatisfaction and a preference for futile sufferings. It makes of fate a human matter, which must be settled among men.

All Sisyphus' silent joy is contained therein. His fate belongs to him. His rock is his thing. Likewise, the absurd man, when he contemplates his torment, silences all the idols. In the universe suddenly restored to its silence, the myriad wondering little voices of the earth rise up. Unconscious, secret calls, invitations from all the faces, they are the necessary reverse and price of victory. There is no sun without shadow, and it is essential to know the night. The absurd man says yes and his effort will henceforth be unceasing. If there is a personal fate, there is no higher destiny, or at least there is but one which he concludes is inevitable and despicable. For the rest, he knows himself to be the master of his days. At that subtle moment when man glances backward over his life, Sisyphus returning toward his rock, in that slight pivoting he contemplates that series of unrelated actions which becomes his fate, created by him, combined under his

memory's eye and soon sealed by his death. Thus, convinced of the wholly human origin of all that is human, a blind man eager to see who knows that the night has no end, he is still on the go. The rock is still rolling.

I leave Sisyphus at the foot of the mountain! One always finds one's burden again. But Sisyphus teaches the higher fidelity that negates the gods and raises rocks. He too concludes that all is well. This universe henceforth without a master seems to him neither sterile nor futile. Each atom of that stone, each mineral flake of that night-filled mountain, in itself forms a world. The struggle itself toward the heights is enough to fill a man's heart. One must imagine Sisyphus happy.

anyone lived in a pretty how town
[1940] e e cummings

anyone lived in a pretty how town
(with up so floating many bells down)
spring summer autumn winter
he sang his didn't he danced his did.

Women and men(both little and small)
cared for anyone not at all
they sowed their isn't they reaped their same
sun moon stars rain

children guessed(but only a few
and down they forgot as up they grew
autumn winter spring summer)
that noone loved him more by more

when by now and tree by leaf
she laughed his joy she cried his grief
bird by snow and stir by still
anyone's any was all to her

someones married their everyones
laughed their cryings and did their dance
(sleep wake hope and then)they
said their nevers they slept their dream

stars rain sun moon
(and only the snow can begin to explain
how children are apt to forget to remember
with up so floating many bells down)

one day anyone died i guess
(and noone stooped to kiss his face)
busy folk buried them side by side
little by little and was by was

all by all and deep by deep
and more by more they dream their sleep
noone and anyone earth by april
wish by spirit and if by yes.

Women and men(both dong and ding)
summer autumn winter spring
reaped their sowing and went their came
sun moon stars rain

Dust Tracks on a Road

[1942] Zora Neale Hurston

Dust Tracks on a Road is Zora Neale Hurston's exuberant account of her life. For 30 years the most prolific Black woman writer in America, she was eventually recognized as one of the greatest literary figures of the Harlem Renaissance.

Chapter 2: My Folks

Into this burly, boiling, hard-hitting, rugged-individualistic setting walked one day a tall, heavy-muscled mulatto who resolved to put down roots.

John Hurston, in his late twenties, had left Macon County, Alabama, because the ordeal of share-cropping on a southern Alabama cotton plantation was crushing to his ambition. There was no rise to the thing.

He had been born near Notasulga, Alabama, in an outlying district of landless Negroes, and whites not too much better off. It was "over the creek," which was just like saying on the wrong side of the railroad tracks. John Hurston had learned to read and write somehow between cotton-choppings and cotton-picking, and it might have satisfied him in a way. But somehow he took to going to Macedonia Baptist Church on the right side of the creek. He went one time, and met up with dark-brown Lucy Ann Potts, of the land-owning Richard Potts, which might have given him the going habit.

He was nearly twenty years old then, and she was fourteen. My mother used to claim with a smile that she saw him looking and looking at her up there in the choir and wondered what he was looking at her for. She wasn't studying about *him*. However, when the service was over and he kept standing around, never far from her, she asked somebody, "Who is dat bee-stung yaller nigger?"

"Oh, dat's one of dem niggers from over de creek, one of dem Hurstons—call him John I believe."

That was supposed to settle that. Over-the-creek niggers lived from one white man's plantation to the other. Regular hand-to-mouth folks. Didn't own pots to pee in, nor beds to push 'em under. Didn't have no more pride than to let themselves be hired by poor-white trash. No more to 'em than the stuffings out of a zero. The inference was that Lucy Ann Potts had asked about nothing and had been told.

Mama thought no more about him, she said. Of course, she couldn't help noticing that his gray-green eyes and light skin stood out sharply from the black-skinned, black-eyed crowd he was in. Then, too, he had a build on him that made you look. A stud-looking buck like that would have brought a big price in slavery time. Then, if he had not kept on hanging around where she couldn't help from seeing him, she would never have remembered that she had seen him two or three times before around the cotton-gin in Notasulga, and once in a store. She had wondered then who he was, handling bales of cotton like suitcases.

After that Sunday, he got right worrisome. Slipping her notes between the leaves of hymn-books and things like that. It got so bad that a few months later she made up her mind to marry him just to get rid of him. So she did, in spite of the most violent opposition of her family. She put on the little silk dress which she had made with her own hands, out of goods bought from egg-money she had saved. Her ninety pounds of fortitude set out on her wedding night alone, since none of the family except her brother Jim could bear the sight of her great come-down in the world. She who was considered the prettiest and the smartest black girl was throwing herself away and disgracing the Pottses by marrying an over-the-creek nigger, and a bastard at that. Folks said he was a certain white man's son. But here she was, setting out to walk two miles at night by herself, to keep her pledge to him at the church. Her father, more tolerant than her mother, decided that his daughter was not going alone, nor was she going to walk to her wedding. So he hitched up the buggy and went with her. Nobody much was there. Her brother Jim slipped in just before she stood on the floor.

So she said her words and took her stand for life, and went off to a cabin on a plantation with him. She never forgot how the late moon shone that night as his two hundred pounds of bone and muscle shoved open the door and lifted her in his arms over the door-sill.

That cabin on a white man's plantation had to be all for the present. She had been pointedly made to know that the Potts plantation was nothing to her any more. Her father soon softened and was satisfied to an extent, but her mother, never. To her dying day her daughter's husband was never John Hurston to her. He was always "dat yaller bastard." Four years after my mother's marriage, and during her third pregnancy, she got to thinking of the five acres of cling-stone peaches on her father's place, and the yearning was so strong that she walked three miles to get a few. She was holding the corners of her apron with one hand and picking peaches with the other when her mother spied her, and ordered her off the place.

It was after his marriage that my father began to want things. Plantation life began to irk and bind him. His over-the-creek existence was finished. What else was there for a man like him? He left his wife and three children behind and went out to seek and see.

Months later he pitched into the hurly-burly of South Florida. So he heard about folks building a town all out of colored people. It seemed like a good place to go. Later on, he was to be elected Mayor of Eatonville for three terms, and to write the local laws. The village of Eatonville is still governed by the laws formulated by my father. The town clerk still consults a copy of the original printing which seems to be the only one in existence now. I have tried every way I know how to get this copy for my library, but so far it has not been possible. I had it once, but the town clerk came and took it back.

When my mother joined Papa a year after he had settled in Eatonville, she brought some quilts, her featherbed and bedstead. That was all they had in the house that night. Two burlap bags were stuffed with Spanish moss for the two older children to sleep on. The youngest child was taken into the bed with them.

So these two began their new life. Both of them swore that things were going to better, and it came to pass as

they said. They bought land, built a roomy house, planted their acres and reaped. Children kept coming—more mouths to feed and more feet for shoes. But neither of them seemed to have minded that. In fact, my father not only boasted among other men about "his house full of young'uns" but he boasted that he had never allowed his wife to go out and hit a lick of work for anybody a day in her life. Of weaknesses, he had his share, and I know that my mother was very unhappy at times, but neither of them ever made any move to call the thing off. In fact, on two occasions, I heard my father threaten to kill my mother if she ever started towards the gate to leave him. He was outraged and angry one day when she said lightly that if he did not want to do for her and his children, there was another man over the fence waiting for his job. That expression is a folk-saying and Papa had heard it used hundreds of times by other women, but he was outraged at hearing it from Mama. She definitely understood, before he got through carrying on, that the saying was not for her lips.

On another occasion Papa got the idea of escorting the wife of one of his best friends, and having the friend escort Mama. But Mama seemed to enjoy it more than Papa thought she ought to—though she had opposed the idea when it was suggested—and it ended up with Papa leaving his friends' wife at the reception and following Mama and his friend home, and marching her into the house with the muzzle of his Winchester rifle in her back. The friend's wife, left alone at the hall, gave both her husband and Papa a good cussing out the next day. Mama dared not laugh, even at that, for fear of stirring Papa up more. It was a month or so before the two families thawed out again. Even after that, the subject could never be mentioned before Papa or the friend's wife, though both of them had been red-hot for the experiment.

My mother rode herd on one woman with a horse-whip about Papa, and "spoke out" another one. This, instead of making Papa angry, seemed to please him ever so much. The woman who got "spoken out" threatened to whip my mother. Mama was very small and the other woman was husky. But when Papa heard of the threats against Mama, he notified the outside woman that if she could not whip him too, she had better not bring the mess up. The woman left the county without ever breaking another breath with Papa. Nobody around there knew what became of her.

So, looking back, I take it that Papa and Mama, in spite of his meanderings, were really in love. Maybe he was just born before his time.

399

CHAPTER FIFTEEN

THE LATE TWENTIETH CENTURY

Our vision of ourselves and where we are going is as unclear to us as it was to our Paleolithic ancestors. Under threat of being drowned out by the clamor of our machines, poisoned by our own waste, swamped by the inane, and extinguished by the winds of nuclear war, we struggle to understand what it means to be human. That is our quest as we turn to the arts of the past for inspiration, if not for answers. In the same spirit, we must also examine the art being created in our own time. For as we strive to cope with our finiteness from day to day, it is there that we find the clues to who and what we are, and who we might become.

15.1 Francis Bacon, *Study for Portrait on Folding Bed*, 1963. Oil on canvas, 6 ft 6 ins × 4 ft 10 ins (1.98 × 1.47 m). The Tate Gallery, London.

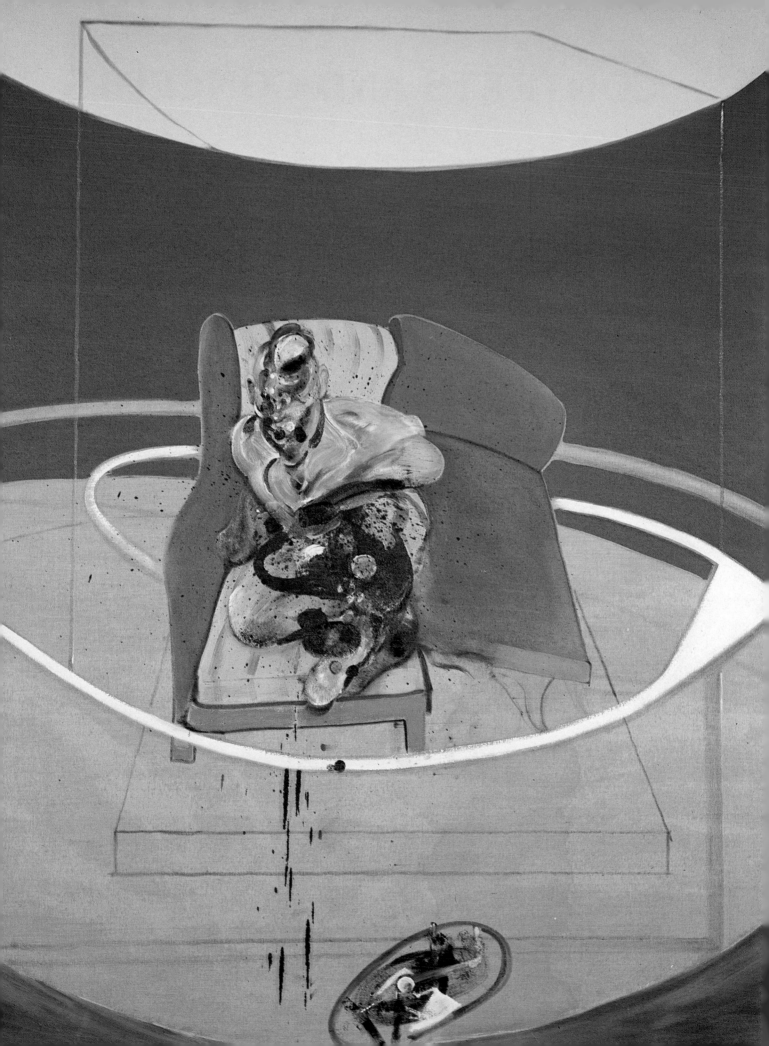

CONTEXTS AND CONCEPTS

DECOLONIZATION

Prior to the end of World War II, a good portion of the globe, especially in the Third World, existed under the colonial rule of outside nations. After World War II, that order changed. During the late 1940s, decolonization was spurred by nationalist wars of independence, although the Dutch and the British, for example, had actually planned for the independence of their colonies in Egypt, India, and Malaysia. In the 1950s, as the Cold War polarized the entire world, violent popular revolutions challenged the remnants of colonialism in North Africa and southeast Asia. By the 1960s, several African countries had undergone sweeping changes and had achieved independence with the more-or-less freely given consent of their previous overlords.

The effects of decolonization have been widespread and, to a large extent, problematical. Violent conflicts among tribal powers, oppressive military dictatorships, suppression of human rights, the use of unusually cruel weapons of war, and famine, for example, have replaced the injustices of colonial rule. Even today, as eastern Europe throws off communism, the absence of any strong, central authority has resulted in an explosion of ethnic violence that had lain dormant under the Soviets. Everywhere, those who have struggled for "freedom" have begun to learn that "independence" is not an automatic state of grace. Freedom has been confused with economic comfort, and when unrealistic expectations are not immediately fulfilled, disillusionment brings about more violent uprisings to no clear purpose.

THE COLD WAR

After World War II, the United States and the Soviet Union dominated the world. Very quickly, the two former allies grew apart as each sought to protect its sphere of influence from the other, and a 45-year period of tense conflict, sometimes called "peaceful coexistence," followed.

15.2 Timeline of the late 20th century.

	GENERAL EVENTS	LITERATURE & PHILOSOPHY	VISUAL ART	THEATRE & DANCE	FILM	MUSIC	ARCHITECTURE
1945	Hiroshima Korean War Start of Vietnam War Cold War		Noguchi (15.17) Pollock (15.4) de Kooning (15.5) Rothko (15.6) Giacometti (15.20) Nevelson (15.16)	Beckett Miller Ionesco Cunningham Limón	Welles Rosellini Ford Hitchcock Fellini Kurosawa	Babbitt Parker Gillepsie Boulez	Le Corbusier (15.38) Bunshaft (15.35) Mies van der Rohe (15.36) Nervi (15.39) Buckminster Fuller (15.40)
1960	 Cuban missile crisis Decolonization	Wiesel Heller Walker	Pop art (15.8–9) Oldenburg (15.21) Smith (15.15) Hepworth(15.18) Calder (15.19) Chryssa (15.23) Vasarély (15.10) Stella (15.11) Paik (15.28) Christo (15.26) Dubuffet (15.24)	New Theatre Living Theatre Grotowski Schechner Brook	Bergman	Foss, improvization Penderecki Carter Berio Reich Davis	
1975 1992	 Disintegration of communism Fall of Berlin Wall Gulf War	Narayan	Smithson (15.25) Pfaff (15.27) Clemente (15.13) Frankenthaler (15.7) Kiefer (15.14)	Coburn Henley Pielmeier	Spielberg		Piano & Rogers (15.43) Bofill (15.41) Moore (15.44) Graves (15.42)

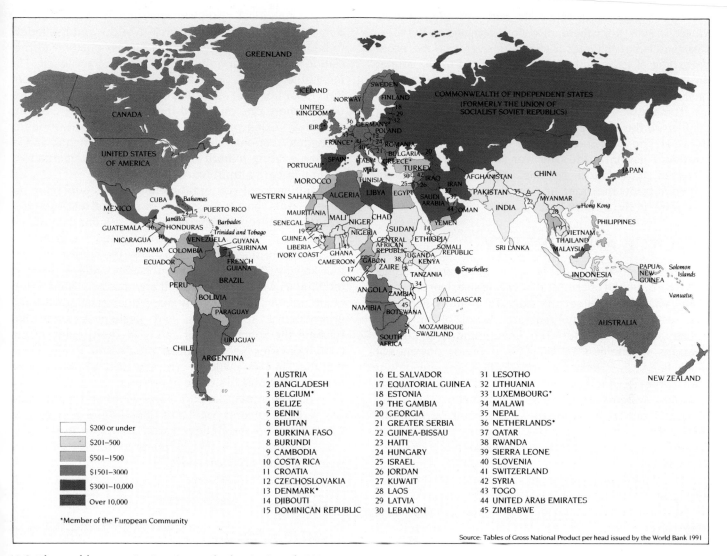

15.3 The world economic situation at the beginning of 1992.

The period of greatest conflict, the Cold War years of 1946–62, witnessed strain between the two great powers over the division of Germany, the Marshall Plan for the rebuilding of Europe, and the Berlin crisis. The antagonism took an extended military form in Korea (1950–53), Vietnam (1965–73), and Indochina, where genuine movements for national self-determination sought and received active assistance from the communist powers of the U.S.S.R. and China—China had adopted communism under the leadership of Mao Zedong in 1949. Indeed, the United States has still not yet fully recovered from its involvements in Asia.

In 1962, the Cuban missile crisis brought a direct threat of Soviet hegemony to the United States. The brinkmanship which resulted taught both the U.S.S.R. and the United States that they could at least contain their mutual hostility. A resulting nuclear "balance of power" kept conflict decentralized, and "peaceful coexistence" marked the sixties, seventies, and eighties.

A UNIFIED EUROPE

As the Soviet Union under Mikhail Gorbachev and world communism in general have disintegrated in the early nineties, the large conflicts now seem to turn upon economics. Japan has more or less succeeded in dominating the world marketplace, a victory of sorts that it could not accomplish militarily in World War II. In fact, it could be argued that, having been forbidden by the peace treaty of 1945 to maintain military forces, Japan has been able to focus its economy more effectively than have the United States and the Soviet Union, both of whom have expended enormous resources in competing militarily with each other.

Since the defeat of Germany in 1945, the nations of western Europe have moved slowly but systematically toward an economically unified European community. In 1992, that movement was called into question by the European Community, because many of the

partners disagreed about goals and operating details. Where it goes from there, of course, remains to be seen. Germany is struggling as it strives to overcome the economic drag of its reunification. Providing aid to the former Soviet Union presents additional challenges for the European Community as well as for the individual states there.

The problems of China and Africa and the ongoing conflicts in the Middle East also have profound effects on the west. The joint European and American action against Saddam Hussein in the Gulf War (1991), under the auspices of the United Nations, places the European Community on the front line of any attempts at peace —or war—in the Middle East.

SCIENCE AND LIBERTY

As science and technology race on, questions of ethics and governmental control stubbornly resist clear solution. These vital concerns set the stage for military ventures, civil technology, and fundamental issues of individual liberty and social order. The development of nuclear weapons maintained by major and minor powers—of which Israel, Iran, Pakistan, and North Korea are only a few—rocket technology and "Star Wars" defenses, and "simpler" systems of warfare, such as the effective pairing of "scud" and "patriot" missiles in the Gulf War, are but three threats to contemporary cultures that drain resources which might otherwise go to more civilized pursuits.

The American government's ignorance of the aftereffects of the bombing of Hiroshima and Nagasaki during World War II, and the intense nuclear testing that went on long after that, led to incalculable human and environmental damage. In essence, the globe became a modern laboratory, and its living inhabitants guinea pigs.

Who controls whom, how, and for what, remain critical issues as human knowledge and understanding of its applications expand. Who should control decisions about prolonging life through mechanical means? Who should control the dissemination of birth control devices and drugs such as the "abortion pill"? Is there a right to die, and who has it? Is there a right to live, and who has that? These are a few of the difficult issues facing a pluralistic society with a rigid tradition of individual freedoms.

TOWARD ANOTHER MILLENNIUM

The second half of the 20th century is now drawing to a close. Societies exist in a global environment in which actions of even the smallest nation can have ramifications around the world that are often well beyond the importance of the original cause. The 1991 Iraqi invasion of Kuwait and the subsequent, if brief, war—which people around the world watched as it happened on television —demonstrate how tentative, tender, and unstable our "world order" really is.

The uncritical optimism spawned by the victory of democracy over totalitarianism in World War II has faded, to be replaced by a more realistic, if less positive, appreciation of social inequities within democracy itself. The inevitable conflict that arises when a state pursues individual liberties as well as social rights, and the question of where one ends and the other begins, are among the most vexing problems of our era. The questions of individual responsibility versus individual rights, and of accommodating minority differences versus maintaining cultural integrity, trouble us at every turn.

Multinational corporations function as supranational governments, and the creation of life in a test-tube is a scientific reality. Mechanization has assumed universal proportions, and computer-generated conclusions threaten to replace human reason as the source of problem solving. Technocrats are poised to rule a world of individuals whose education, if any, has consisted solely of job training. Philosophy in many quarters is considered unproductive speculation, and usefulness alone has become the touchstone of value. In short, many of our contemporaries seem to have progressed to the point that they, in Oscar Wilde's cynical words, "know the price of everything and the value of nothing."

Very few expect an end of the world and a judgment day with the second coming of Christ in the year 2000 as Christians, at least, believed would happen in the year 1000. Our problem is that, of many terrible possibilities, we don't know what to expect.

FOCUS

TERMS TO DEFINE
Decolonization
Cold War

PEOPLE TO KNOW
Mao Zedong
Mikhail Gorbachev
Saddam Hussein

DATES TO REMEMBER
Korean War
Vietnam War
The Gulf War

QUESTIONS TO ANSWER
1 What were the consequences—good and bad—of decolonization?
2 What effect has the Cold War had on global economic development?
3 Compare the general mood of the late 20th century with that of any one of the preceding eras discussed in this book.

THE ARTS
OF THE LATE TWENTIETH CENTURY

TWO-DIMENSIONAL ART

Abstract expressionism

The first 15 years following the end of World War II were dominated by a style called "abstract expressionism." The style originated in New York, and it spread rapidly throughout the world on the wings of modern mass communications. Two characteristics identify abstract expressionism. One is nontraditional brushwork, and the other is NONREPRESENTATIONAL subject matter. This complete freedom to reflect inner life led to the creation of works with high emotional intensity. Absolute individuality of expression and the freedom to be irrational underlie this style. This may have had some connection with the confidence inspired by postwar optimism and the triumph of individual freedom: as the implications of the nuclear age sank in, abstract expressionism all but ceased to exist.

The most acclaimed painter to create his own particular version of this style was Jackson Pollock (1912–56). A rebellious spirit, Pollock came upon his characteristic approach to painting only ten years before his death. Although he insisted that he had absolute control, his compositions consist of what appear to be simple dripping and spilling of paint onto huge canvases, which he placed on the floor in order to work on them. His work (Fig. 15.4), often called "action painting," conveys a sense of tremendous energy. The viewer seems to feel the painter's motions as he applied the paint.

Willem de Kooning (b. 1904) took a different approach to abstract expressionism. Sophisticated texture and heightened focal areas (Fig. 15.5) emerged as de

15.4 Jackson Pollock, *Number 1*, 1948. Oil on canvas, 5 ft 8 ins × 8 ft 8 ins (1.73 × 2.64 m). The Museum of Modern Art, New York.

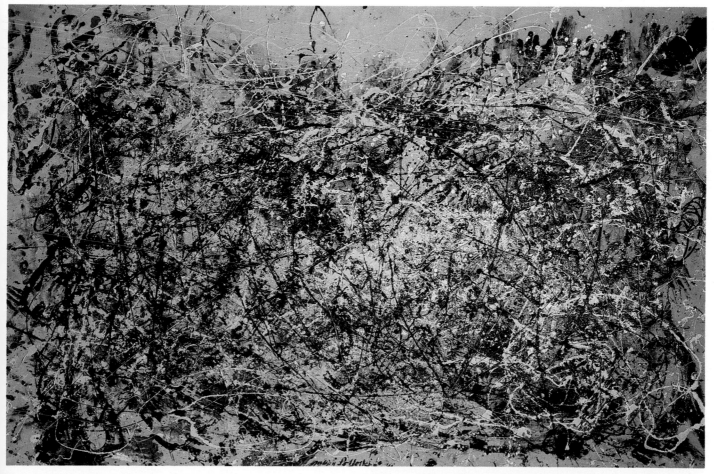

15.5 Willem de Kooning, *Excavation*, 1950. Oil on canvas, 6 ft 8⅛ ins × 8 ft 4⅛ ins (2.04 × 2.54 m). Courtesy the Art Institute of Chicago (Collection Mr and Mrs F.C. Logan Prize, Gift of Mr and Mrs Edgar Kaufmann Jr and Mr and Mrs Noah Goldowsky).

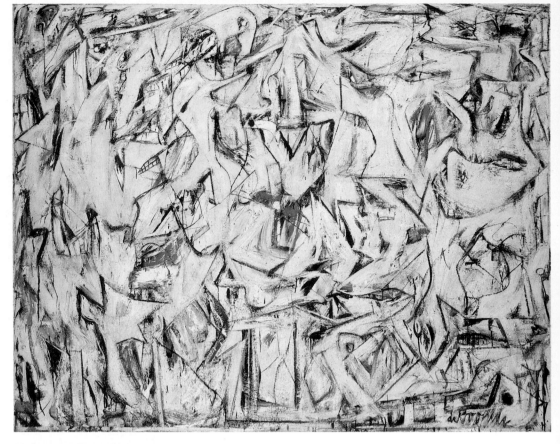

15.6 Mark Rothko, N*umber* 10, 1950. Oil on canvas, 7 ft 6¾ ins × 4 ft 9⅛ ins (2.3 × 1.45 m). The Museum of Modern Art, New York (Gift of Philip Johnson).

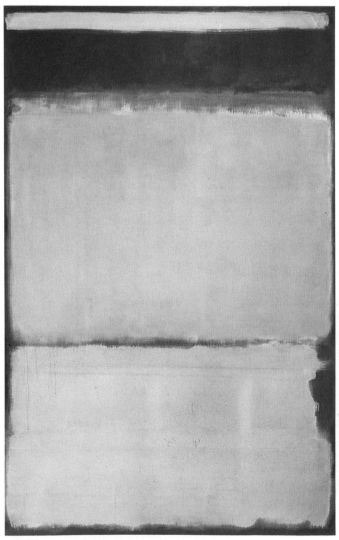

Kooning reworked, scraped off, repainted, and repainted again. Yet this laborious work produced works that express spontaneity and free action. The work has a ferocity and passion that tend to build in intensity as the eye moves from one focal area to the next.

Included also among the work of the abstract expressionists is the color-field painting of Mark Rothko (1903–70), whose highly individualistic paintings follow a process of reduction and simplification (Fig. **15.6**). Rothko left all "memory, history, and geometry" out of his canvases. These, he said, were "obstacles between the painter and the idea." Rothko's careful juxtaposition of hues has a deep emotional impact on many viewers.

The abstract expressionist tradition continues in the work of Helen Frankenthaler (b. 1928). Her "staining" technique, as seen in B*uddha* (Fig. **15.7**), consists of pouring color across an unprimed canvas and creating amorphous shapes that seem to float in space. The image created thus has infinite potential meaning, apart from that suggested by whatever title Frankenthaler chooses, because the very freedom of the form means that viewers are free to choose their own associations. The viewer is, however, directed by the sensual quality of the work, whose fluidity and nonlinear use of color give it softness and grace.

The emotionalism of abstract expressionism was followed by an explosion of styles: pop, op, hard edge, minimal, post-minimal, environmental, body, earth, video, kinetic, photorealist, and conceptual. We can describe only a few of these here.

15.7 Helen Frankenthaler, *Buddha*, 1983. Acrylic on canvas, 6 ft 2 ins × 6 ft 9 ins (1.88 × 2.06 m). Private collection. Courtesy Andre Emmerich Gallery, New York.

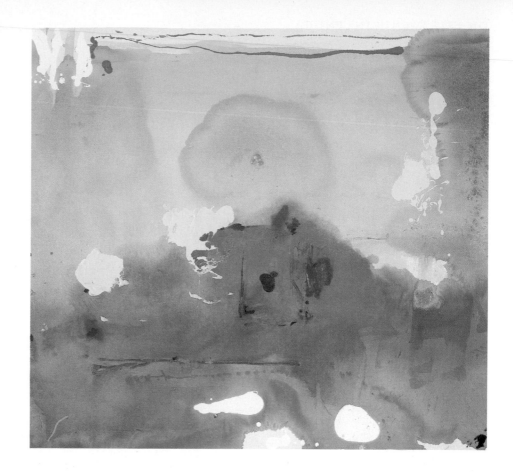

Pop art

Pop art, which evolved in the 1950s, concerned itself above all with representational images. The term "pop" was coined by the English critic Lawrence Alloway, and it simply meant that the subjects of these paintings are found in popular culture. The treatments of pop art also came from mass culture and commercial design. These sources provided pop artists with what they took to be the essential aspects of the visual environment that surrounded them. The pop artists themselves traced their heritage back to dada (see Chapter 14), although much of the heritage of the pop tradition continues to be debated.

The compelling paintings of Roy Lichtenstein (b. 1923) are the most familiar examples of pop art (Fig. **15.8**). These magnified cartoon-strip paintings use the effect created by the dots of the screen that is used in color printing in comics. Using dot stencils about the size of a coin, Lichtenstein built his subjects, which are original, up into stark and dynamic, if sometimes violent, images.

15.8 Roy Lichtenstein, *Whaam!*, 1963. Acrylic on canvas, 5 ft 8 ins × 13 ft 4 ins (1.73 × 4.06 m). The Tate Gallery, London.

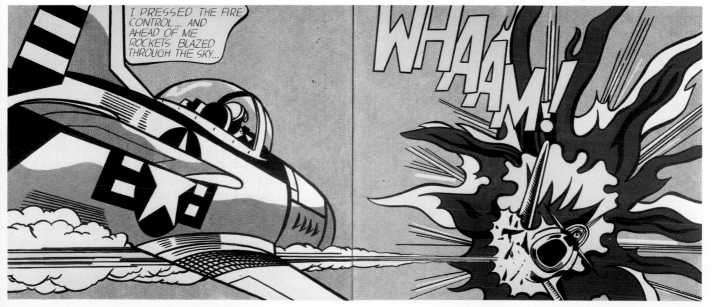

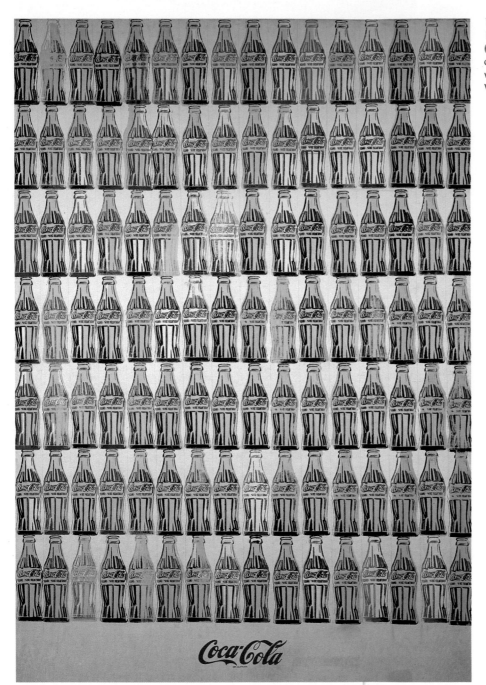

15.9 Andy Warhol, *Green Coca-Cola Bottles*, 1962. Oil on canvas, 6 ft 10 ins × 4 ft 9 ins (1.97 × 1.37 m). Whitney Museum of American Art, New York (Purchase, with funds from the Friends of the Whitney Museum of American Art).

In the 1960s, Andy Warhol (1928–87) focused on popular culture and contemporary consumerism in his ultra-representational art. The very graphic *Green Coca-Cola Bottles* (Fig. **15.9**) is a good example of his style. The starkness and repetitiousness of the composition are broken up by subtle variations. The apparently random breaks in color, line, and texture create moving focal areas, none of which is more important than another, yet each significant enough to keep the viewer's eye moving continuously through and around the painting. In these subtle variations, the artist takes an almost cubist-like approach to the manipulation of space and image.

Op art

Op art plays on the possibilities offered by optics and perception. Emerging from work done in the 1950s, op art was an intellectually oriented and systematic style, very scientific in its applications. Based on perceptual tricks, the misleading images in these paintings capture our curiosity and pull us into a conscious exploration of what the optical illusion does and why it does it.

Victor Vasarély (b. 1908) bends line and form to create a deceptive sense of three-dimensionality. Complex sets of stimuli proceed from horizontal, vertical, and

diagonal arrangements. Using nothing but abstract form, Vasarély creates the illusion of real space.

The psychological effects of his images depend on extremely subtle repetition of shape and gradation of color. In *Arcturus* II (Fig. **15.10**), the symmetrical imagery seems to come into and out of focus because of the apparent brightness of the individual colors. Shape and color combine to create the optical experience, and what at first glance seems simple and straightforward, becomes complicated and deceptive. The more we look, the more we are convinced that we are "seeing things."

Hard edge

Hard edge, or hard-edged abstraction, also came to its height during the 1950s and 1960s, in the work of Ellsworth Kelly and Frank Stella (b. 1936), among others. Its flat color areas have hard edges which carefully separate one area from another. Essentially, hard edge is an exploration of design for its own sake. Stella often abandoned the rectangular format of most canvases in favor of irregular shapes in order to be sure that his paintings bore no resemblance to windows. The odd shape of the canvas thus became part of the design itself, as opposed to being a frame or a formal border within which the design was executed.

Some of Stella's paintings have iridescent metal powder mixed into the paint, and the metallic shine further enhances the precision of the composition. *Tahkt-I-Sulayman* I (Fig. **15.11**) stretches just over 20 feet across, with interspersed surging circles and half-circles of yellows, reds, and blues. The intensity of the surface, with its jarring fluorescence, counters the grace of its form, while the simplicity of the painted shapes is enriched by the variety of the repetitions.

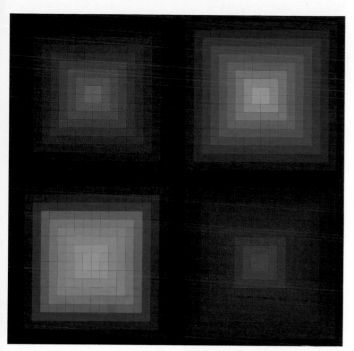

15.10 Victor Vasarély, *Arcturus* II, 1966. Oil on canvas, 5 ft 3 ins × 5 ft 3 ins (1.51 × 1.51 m). Hirshhorn Museum and Sculpture Garden, Smithsonian Institution, Washington, DC.

15.11 Frank Stella, *Tahkt-I-Sulayman* I, 1967. Polymer and fluorescent paint on canvas, 10 ft ¦ in × 20 ft 2¦ ins (3.04 × 6.15 m). Pasadena Art Museum, California (Gift of Mr and Mrs Robert A. Rowan).

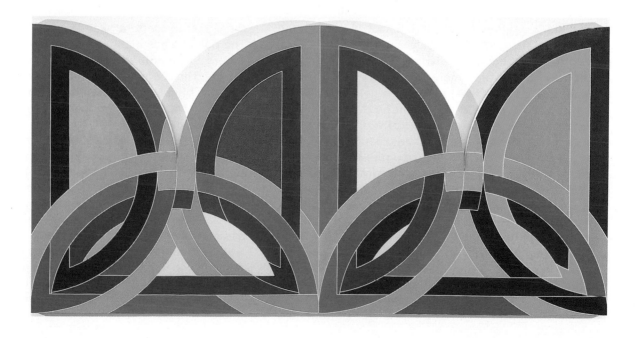

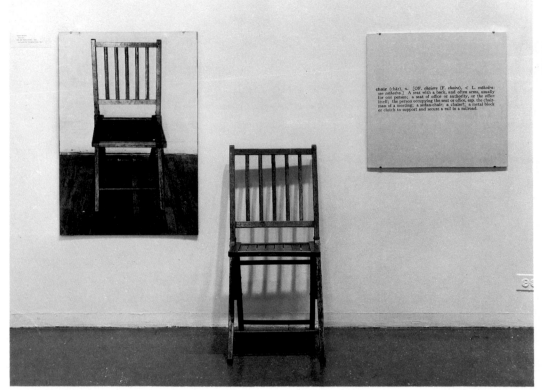

15.12 Joseph Kosuth, *One and Three Chairs*, 1965. Wooden folding chair, 32¾ ins (76.8 cm) high; photograph of chair, 36 × 24 ins (86.4 × 57.6 cm); photographic enlargement of dictionary definition of chair, 24 × 25 ins (57.6 × 60 cm). Collection, The Museum of Modern Art, New York (Larry Aldrich Foundation Fund).

Photorealism and conceptualism

Photorealism is related to pop art, in that it too relies on preexisting images. As can be guessed from the name of the movement, it is a form of art that involves working directly from photographs, rather than from the original subjects. It came to the fore during the 1970s, in the work of people such as Richard Estes (b. 1932) and Chuck Close (b. 1940). Photorealism acknowledges the role that the camera plays in shaping our understanding of reality, and suggests obliquely that contemporary life is often centered more around manufactured than natural objects.

Conceptual art challenges the relationship between art and life in a different way, and, in fact, challenges the definition of art itself. Essentially anti-art, as was dada, conceptual art attempts to divorce the imagination from aesthetics. Ideas are more important than visual appearances. It insists that only the imagination *and not the artwork* is art. Therefore, artworks can be done away with. The creative process needs only to be documented by some incidental means—a verbal description, or a simple object like a chair. But, of course, despite its claims, conceptual art depends on something physical to bridge the gap between the artist's imagination and the viewer's.

One and Three Chairs (Fig. **15.12**) by Joseph Kosuth (b. 1945) depicts three different realities. The first is that of the actual chair that sits between the photograph and the printed definition. The second reality is the life-size photographic image of the same chair represented in the first reality. The third reality is the verbal description of the same chair. Using the third reality, we form in our mind an idea of the chair, and that might be termed a "conceptual reality." So the conceptual artwork, that is, the combination of actuality, photo image, and verbal description, presents a relationship "between an object and communicative methods of signifying that object."[1]

Neo-expressionism

A recent controversial and momentarily successful movement has been called "neo-expressionism." One of its most promising adherents, the Italian Francesco Clemente (b. 1952), records images "that the rest of us repress." In *Untitled from White Shroud* (Fig. **15.13**), he forces the viewer to confront what may well be repulsive images. The painting has nightmarish qualities, and yet the fluid, watercolor medium gives it a softening, translucent quality. The contrasts of the cool blues in the background and the bright red and yellow of the fishes capture our interest. Thus, the composition successfully balances form and color.

Like the expressionists, neo-expressionists also seek to evoke a particular emotional response in the viewer. German artist Anselm Kiefer (b. 1945) invests his work with strong emotive and empathetic content. In *Midgard* (Fig. **15.14**), he draws upon Nordic mythology to portray a desolate landscape of despair. "Midgard" means "middle garden," the term given by the Norse gods to the earth. In Nordic myth, the earth is destroyed by the Midgard serpent and other demons after three years of winter. Standing before this enormous painting, we find its scale and emotional power profoundly affecting. It takes up our whole field of vision and seems to surround us.

15.13 Francesco Clemente, *Untitled from White Shroud*, 1983. Watercolor. Kunsthalle, Basel.

15.14 (below) Anselm Kiefer, *Midgard*, 1980–85. Oil and emulsion on canvas, 11 ft 10 ins × 19 ft 9¼ ins (3.6 × 6.04 m). The Carnegie Museum of Art, Pittsburgh.

SCULPTURE
Contemporary sculpture

Like some abstract expressionist painting, much contemporary sculpture rejects traditional materials in favor of new ones. In particular, it favors materials that do not require molds or models. Individual shapes have severed sculpture, as far as is possible, from the natural world. Even so, abstract sculpture often has titles that link nonobjective expression to objective associations.

Primary structures

The "primary structures" movement pursues two major goals: extreme simplicity of shapes and a kinship with architecture. A space–time relationship distinguishes primary structures from other sculpture. Viewers are invited to share an experience in three-dimensional space in which they can walk around and/or through the works.

15.15 David Smith, *Cubi XIX*, 1964. Stainless steel, 9 ft 5 ins (2.87 m) high. The Tate Gallery, London.

15.16 Louise Nevelson, *Black Wall*, 1959. Wood, 9 ft 4 ins × 7 ft 1¼ ins × 2 ft 1½ ins (2.64 × 2.17 × .65 m). The Tate Gallery, London.

Form and content are reduced to their most "minimal" qualities.

David Smith's (1906–65) *Cubi XIX* (Fig. **15.15**) rises to nearly ten feet, and its seemingly precarious balance and its curious single cylinder convey a sense of urgency. Yet the work is in perfect balance. The texture of the luminescent stainless steel has a powerfully tactile effect, yet it also creates a shimmering, almost impressionistic play of light. The forms are simple rectangles, squares, and a cylinder, and scale gives them a vital importance.

Louise Nevelson (1900–88) overcame the notion that sculpture was a man's profession because it involved heavy manual labor and became perhaps the first major woman sculptor of the 20th century. In the 1950s, Nevelson began using found pieces of wood as her medium. At first miniature cityscapes, her work grew larger and larger. *Black Wall* (Fig. **15.16**) is a relief-like wall unit painted a monochromatic flat black. These pieces suggest the world of dreams, and their meaning remains a puzzle, although they make an intense appeal to the imagination.

Abstraction

Less concerned with expressive content than other sculptors, Isamu Noguchi (1904–88) began experimenting with abstract sculptural design in the 1930s. His creations have gone beyond sculpture to provide highly dynamic and suggestive set designs for the choreography of Martha Graham (see Chapter 14), with whom he was associated for a number of years. Noguchi's *Kouros* figures (Fig. **15.17**) do seem to be abstractly related to archaic Greek sculpture, and they too exhibit exquisitely finished surfaces and masterly technique.

15.17 Isamu Noguchi, *Kouros* (in nine parts), 1944–45. Pink Georgia marble, slate base, c.9 ft 9 ins (2.97 m) high. The Metropolitan Museum of Art, New York (Fletcher Fund, 1953).

15.18 Dame Barbara Hepworth, *Sphere with Internal Form*, 1963. Bronze, 3 ft 4 ins (1.02 m) high. Collection, State Museum Kröller-Müller, Otterlo, The Netherlands.

Another kind of abstraction of the human form appears in *Sphere with Internal Form* (Fig. **15.18**). Here Barbara Hepworth (1903–75) incorporates two sculptural devices—a small form resting inside a large, enclosing form, and the piercing of the form. Piercing gives the piece a sense of activity, as it admits light into the work and provides tonal contrasts.

The MOBILES of Alexander Calder (1898–1976) (Fig. **15.19**) finally put abstract sculpture into motion. Deceptively simple, these colorful shapes turn with the slightest air currents or by motors. Calder's pieces show us that sculpture can be created by the movement of forms in undefined space.

15.19 Alexander Calder, *Spring Blossoms*, 1965. Painted metal and heavy wire, 4 ft 4 ins (1.32 m) high. Museum of Art, The Pennsylvania State University.

15.20 Alberto Giacometti, *Man Pointing*, 1947. Bronze, 6 ft 8½ ins (1.79 m) high. The Museum of Modern Art, New York (Gift of Mrs John D. Rockefeller III).

The figures of Alberto Giacometti (1901–66) mark a return to objectivity. Giacometti was a surrealist sculptor in the 1930s, but he continued to explore the likeness of the human figure and the depiction of surface, as Figure **15.20** shows. Here form is reduced to its essence. The tortured fragmentation of the figure makes an emotional statement about what it feels like to be human in the contemporary world.

Found sculpture and junk culture

Yet another approach which has emerged since World War II is found sculpture, that is, objects taken from life and presented as art for their inherent aesthetic value and meaning. Perhaps developed out of cubist collages, the movement called "junk culture" also took natural objects and assembled them to create single artworks. Interpretations of these kinds of assemblage art vary widely, but they usually imply that the artist is making some value judgment on a culture to which built-in obsolescence and throwaway materials are fundamental.

15.21 Claes Oldenburg, *Two Cheeseburgers, with Everything (Dual Hamburgers)*, 1962. Burlap soaked in plaster, painted with enamel, 7 ins (17.8 cm) high. The Museum of Modern Art, New York (Philip Johnson Fund).

Pop and photorealism

Common, everyday objects serve as models for Claes Oldenburg (b. 1929). *Two Cheeseburgers, with Everything* (Fig. **15.21**) presents an enigma to the viewer. What are we to make of it? Is it a celebration of the mundane? Or is a serious comment on our age implicit in these objects? Certainly Oldenburg calls our attention to the qualities of design in ordinary objects by taking them out of their normal contexts and changing their scale.

The influence of the pop movement can also be seen in the plaster figures of George Segal (b. 1924). Working from plaster molds taken from living figures, Segal builds scenes from everyday life with unpainted plaster images (Fig. **15.22**).

In stark contrast to Segal's unpainted ghosts are the photorealistic sculptures of Duane Hanson (b. 1925). These portrayals, including hair and plastic skin, are often displayed in settings where the viewer cannot be sure

that the figures are not real. Hanson's portrayals have a tragic quality—they often represent the dregs of society—and are meant to unmask bourgeois crassness and tastelessness.

Minimalism

In the late 1950s and 1960s, a style called "minimalism" in painting and sculpture sought to reduce the complexity of both design and content as far as possible. Instead, minimalist artists concentrated on nonsensual, impersonal, geometric shapes and forms. No communication was to pass between artist and respondent, no message was to be conveyed. Rather, the minimalists, such as Toby Smith, wanted to present neutral objects free of their own interpretations and leave response and "meaning" entirely up to the viewer.

Light art

Since the 1960s, the use of light as an element in sculpture has gained in popularity. Its adherents see light as an independent aesthetic medium, and they use it in a variety of innovative ways.

Typical of artists working with light, (Varda) Chryssa (b. 1933) creates technically precise blinking neon sculptures using very simple shapes. Neon, so indicative of the commercialism and mechanization of modern life, serves as a symbolic comment on the modern era. Chryssa's innovative constructions, such as *Fragments for the Gates to Times Square* (Fig. **15.23**), explore the experience of contemporary technology. His works also explore environmental space in a highly theatrical fashion, in this case surrounding the viewer with a garish ambiance like that of Times Square or the Las Vegas Strip.

15.22 (opposite) George Segal, *The Bus Driver*, 1962. Figure of plaster over cheesecloth; bus parts including coin box, steering wheel, driver's seat, railing, dashboard, etc. 6 ft 3 ins (1.91 m) high overall. The Museum of Modern Art, New York (Philip Johnson Fund).

15.23 Chryssa, *Fragments for the "Gates to Times Square,"* 1966. Neon and plexiglas, 6 ft 9 ins × 2 ft 10½ ins × 2 ft 3½ ins (206 × 88 × 70 cm). Whitney Museum of American Art, New York (Gift of Howard and Jean Lipman).

15.24 Jean Dubuffet, *Jardin d'Émail*, 1973–74. Concrete, epoxy paint, and polyurethane, 66 ft 8 ins × 100 ft (20 × 30 m). State Museum Kröller-Müller, Otterlo, The Netherlands.

15.25 (below) Robert Smithson, *Spiral Jetty*, 1969–70. Black rock, salt crystals, earth, and red water (algae), 160 ft (48.7 m) diameter; coil 1500 ft (457 m) long and 15 ft (4.6 m) wide. Great Salt Lake, Utah.

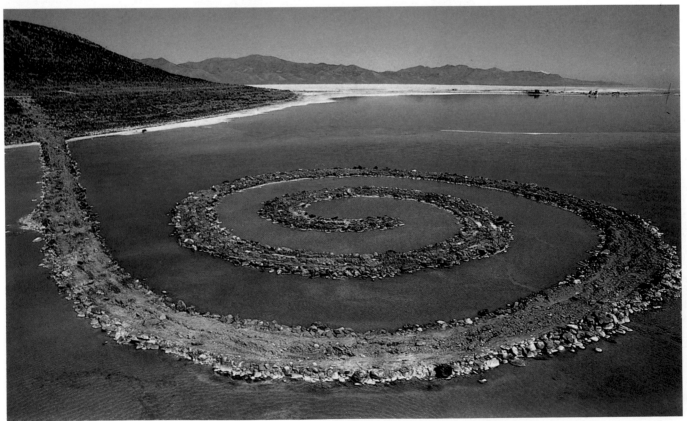

Ephemeral and environmental art

Ephemeral art has many possible justifications. The conceptualists, for example, insist that "art is an activity of change, of disorientation and shift, of violent discontinuity and mutability."

Environmental art sets out to create an inclusive experience. In the Jardin d'Émail by Jean Dubuffet (b. 1901) (Fig. **15.24**), an area made of concrete is painted with white paint and black lines. Surrounded by high walls, the whole construction is capricious in form. Inside the sculptural environment we find a tree and two bushes of polyurethane. Here Dubuffet has tried to push the boundaries of art to their known limits, perhaps. He has consistently opted for chaos, for *art brut*—the art of children, psychotics, and amateurs. The Jardin d'Émail is one of several projects in which he has explored this chaotic, disorienting, and inexplicable three-dimensional form.

The dynamic and dramatic landscape of *Spiral Jetty* (Fig. **15.25**) by Robert Smithson (1928–73), in the Great Salt Lake of Utah, is another example of environmental art. A number of concepts and ideas are represented here. The spiral shape represents the early Mormon belief that the Great Salt Lake was connected to the Pacific Ocean by an underground canal which from time to time caused great whirlpools on the lake's surface. In addition, the jetty is intended to change the quality and color of the water around it, thereby creating a color-shift, as well as making a linear statement. Finally, the design is meant to be ephemeral as well as environmental. Smithson knew that eventually the forces of wind and water would transform, if not obliterate, the project. And, in fact, high water has submerged the jetty in recent years.

Designed to be transitory, ephemeral art makes its statement, then ceases to exist. Undoubtedly the largest works of sculpture ever designed were based on that concept. *Running Fence* (Fig. **15.26**) by Christo (Christo Jachareff, b. 1935) was an event and a process, as well as a sculptural work. In a sense, Christo's works are conceptual in that they call attention to the experience of art, rather than any actual permanent form. At the end of a two-week viewing period, *Running Fence* was removed and ceased to be.

Installations

"Environments" which have been expanded into room-size settings are now called "installations." The installations of Judy Pfaff (b. 1946) employ a variety of materials,

15.26 Christo, *Running Fence*, Sonoma and Marin Counties, California, 1972–76. Woven nylon fabric and steel cables, 18 ft (5.49 m) high, 24½ miles (39.2 km) long. Erected September 1976, two weeks.

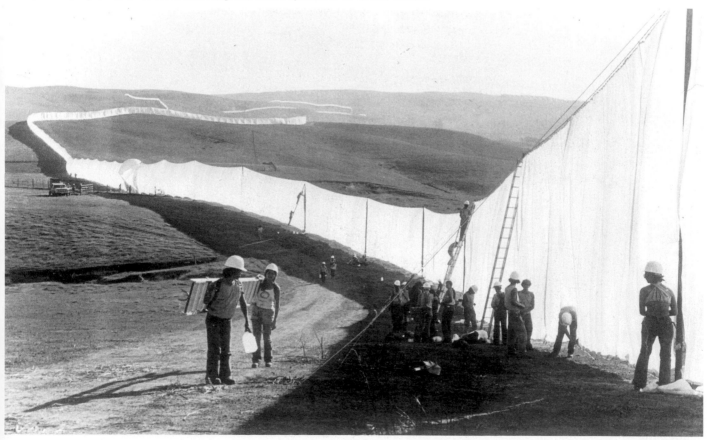

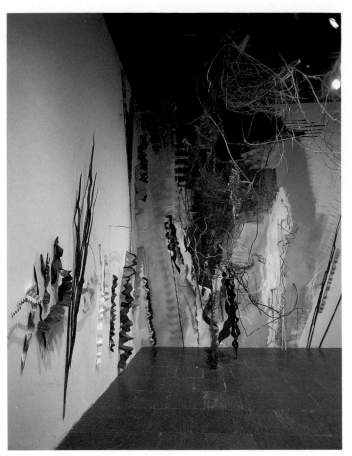

15.27 Judy Pfaff, *Dragons*, mixed media. Installation view at 1981 biennial, Whitney Museum of American Art, New York.

for You featured a drop of water forming at the end of a thin copper pipe and then falling on a drumhead. The image was blown up on a large television screen, and the sound of the falling drop was amplified into a thunderous boom. MIT's *Centerbeam* was a 220-foot long contraption using holograms, video, colored steam, and laser beams.

In fact, a wide-ranging genre of sculpture called "video art" has emerged from the rebellions of the 1960s as a reaction against conventional broadcast television. Since then, inexpensive portable recording and playback video equipment has made it possible for this art form to flourish. Video art has moved from a nearly photojournalistic form to one in which outlandish experiments exploit new dimensions in hardware and imagery.

Nam June Paik is perhaps the most prominent of the video artists. His work pioneered the use of television imagery in performance and other multimedia art. It takes television well beyond its primary function of reproducing imagery. Indeed, Nam June Paik's video art creates its own imagery. In *TV Bra for Living Sculpture* (Fig. **15.28**), he creates interactive images of a performance of classical music and miniature televisions with their own images. The combined video and live situations function as a third, overriding experience. The effect is bizarre, startling, fascinating, and, unlike the moment captured in the illustration, constantly changing.

15.28 Nam June Paik, *TV Bra for Living Sculpture*, 1969. Performance by Charlotte Moorman with television sets and cello. Courtesy Holly Solomon Gallery, New York.

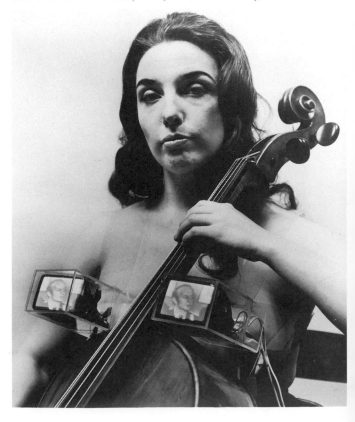

including those of painting, in order to shape and charge architectural space. The art historian H. W. Janson likens her work to "exotic indoor landscapes," and finds her spontaneous energy similar to that of Jackson Pollock's action painting (see Fig. **15.4**). Nature seems to have inspired her installation *Dragons* (Fig. **15.27**). Swirling tendrils hang like brightly colored jungle foliage. Fiery reds predominate, although Pfaff uses the entire color spectrum. All this stands out against the white walls of the room. The sweeping diagonals seem carefully juxtaposed against linear verticals while, at the same time, a jumble of string-like things in the far corner emanates confusion. The strong colors and proliferation of lines suggest that paint has been flung into space and, magically, suspended there.

Video art

What next? Is television our next art medium? *Video Composition X* by Nam June Paik (b. 1932) turned a large room into a garden of shrubbery, ferns, and small trees. As one looked up from the greenery, 30 television sets were all running the same program in unison. Bill Viola's *He Weeps*

LITERATURE

In the field of literature, "schools, movements, and ideologies have not only proliferated but fragmented in the last decades, with a restlessness born of a nagging dissatisfaction with the reigning modes", particularly in America. Scanning the contents of Kiernan's *American Writing Since 1945* and Hoffman's *Harvard Guide to Contemporary American Writing* will give an impression of the enormous diversity. In fiction we find naturalism and realism, novels of manners, Southern fiction, Jewish fiction, Black fiction, Western fiction, the Beats, and Metafiction. In poetry we find formalist/academic poets, Black Mountainists, San Francisco/Beats, Confessionalists, the New York poets, Deep Imagists, Black poets and the Independents. This wide-ranging nature of literature of the late 20th century makes it impossible for us to do more than glance at a few luminaries. The age has been beset, at least briefly, by an approach to literary criticism called "deconstruction," which attempted to remove meaning from the work. Nonetheless, amid the clamor of the times, we can find a cross-section of genres and styles, written by authors from every continent.

Following the horrors of World War II, various media have been used to try to document the inhumanity of Nazism, from documentary film and harrowing non-fiction to the short stories and novels of writers such as Elie Wiesel (b. 1928). Wiesel is a European Jew who survived incarceration in a concentration camp, and in his very moving autobiographical novel *Night* (1960) one gets a strong impression of the conflict between faith and human evil.

The American novelist Joseph Heller (b. 1923) also writes about the dreadful impact of modern warfare, but in a completely different style. Heller attacks it with black humor, satire, and a surrealistic streak that juxtaposes situations in bizarre ways. His most famous work is *Catch-22*, which pokes fun at bureaucracy as well as war.

Wit and irony are tools used by his fellow American author, Alice Walker (b. 1944), in her novels, poetry, and critical writings. The battles she fights are for rights, for blacks and women—but she is prone to satirize political activists just as much as their opponents.

Lastly, a brief mention of India's foremost contemporary novelist, R. K. Narayan (b. 1906). Writing in English for an international audience, he centers his fiction around middle-class life in southern India, painting a sympathetic but gently humorous portrait of social change, the struggle for identity, and the conflicts between generations.

THEATRE
Realism

Realism flourished throughout the postwar era, most notably in the works of Tennessee Williams (1912–83) and Arthur Miller (b. 1915). Realism now included a great deal more than its 19th-century definition had allowed. It included more theatrical staging devices such as fragmented settings, and also many more nonrealistic literary and presentational techniques such as symbolism. As far as the theatre was concerned, stage realism and the realism of everyday life had parted company.

Tennessee Williams skillfully blended the qualities of realism with whatever scenic, structural, or symbolic devices were necessary to achieve the effects he wanted. His plays, such as *The Glass Menagerie* and *A Streetcar Named Desire*, deal sensitively with the psychological problems of common people. One of his great interests and strengths is character development, and this often carries his plays forward as he explores the tortured lives and the illusions of his larger-than-life characters.

Arthur Miller probed both the social and the psychological forces that destroy contemporary people in plays such as *Death of a Salesman*.

Absurdism

Following on from the work of Pirandello, Camus, and Sartre came a series of absurdists who differed quite radically from them. Whereas early absurdists strove to bring order out of absurdity, the plays of Samuel Beckett, Eugene Ionesco, and Jean Genet all tend to point only to the absurdity of existence and to reflect the chaos in the universe. Their plays are chaotic and ambiguous, and their absurd and ambiguous nature makes direct analysis purely a matter of interpretation. *Waiting for Godot* (1958), the most popular work of Samuel Beckett (b. 1906), has been interpreted in so many ways to suggest so many different meanings that it has become an eclectic experience in itself. Beckett, like minimalist sculptors, left it to the audience to draw whatever conclusions they wished about the work confronting them. The plays of Ionesco (b. 1912) are even more baffling, using nonsense syllables and clichés for dialogue, endless and meaningless repetition, and plots that have no development. He called *The Bald Soprano* (1950) an "antiplay." The absurdist movement has influenced other playwrights and production approaches, from Harold Pinter to Edward Albee.

African–American theatre

Mainstream

The realistic tradition in modern theatre gave rise to a number of black, as well as white, playwrights. Garland Anderson wrote *Appearances*, the first black play to open on Broadway, in 1925. Other playwrights included Langston Hughes (1902–67), Paul Green (1894–1981), and, most notably, Lorraine Hansberry (1930–65), whose masterful play, *A Raisin in the Sun*, dealt with crisis and redemption in the life of a black family on the south side of Chicago.

The black liberation movement

The theatrical black liberation began in the 1960s, and continues to the present. One manifestation of the civil rights movement of the fifties and sixties was led by angry, militant blacks who espoused black consciousness. Many converted to the Black Muslim version of Islam, and many longed for a completely separate black nation. Radical groups talked about destroying western society. A number of American blacks turned toward Africa and sought a new identity in the Third World. In the 1980s, there was a change in self-description from "black" to "African–American."

Many of these ideas were expressed in the dramatic works of playwrights such as LeRoi Jones, who became Imamu Amiri Baraka (b. 1934). His theatrical visions in *Dutchman* and *A Black Mass* dramatize the dangers of blacks allowing whites into their private lives and call for racial separation. Charles Gordonne's *No Place to Be Somebody* renews Baraka's cause, and espouses violence as legitimate action in the penetrating story of a fair-skinned black searching for his own racial identity.

Many new black theatre companies also emerged in the sixties. The Negro Ensemble Company, for example, founded by Douglas Turner Ward, is one enduring example. From that company came the moving production of *Home* (1979) by Samm-Art Williams (b. 1946).

|*Home*| traces the life of a Southern black, Cephus, from his farmboy youth, through escape to the big city, draft evasion and jail, joblessness and welfare, disease and despair, to his return to the honest labor and creative values on the farm. What makes *Home* more than a typical change-of-fortune melodrama are the poetic language and the conventions of its production format. Cephus is played by a single actor, but all the other roles—old, young, male, female, black, white—are played by two women who take on whatever role they wish by a simple costume addition. |. . .| Sometimes they are characters in Cephus's odyssey; other times they act as a chorus, helping the audience to collapse time and space and see the whole of Cephus's life from the larger viewpoint of American black history and culture. |. . .| The fact that the place itself never changes, though Cephus is constantly on the move, and the fact that the actors never change, though they play multitudes of different roles, suggest that "home" is right there all the time, ready to be grasped once the inner yearning is acknowledged, ready to be offered once others are willing to help, to extend themselves, to choose roles of grace instead of confrontation.[2]

The son of a white father and a black mother, August Wilson (b. 1945) writes with an ear tuned to the rhythms and patterns of the blues and the speech of the black neighborhoods. Founder of the Playwrights Center in Minneapolis, his plays range from *Jitney* (1982) to a planned series of ten plays beginning with *Ma Rainey's Black Bottom* (1984). Wilson believes that the American black has the most dramatic story of all humankind to tell. His concern lies with the stripping away of important African traditions and religious rituals from blacks by whites. In plays such as *The Piano Lesson* (1987), he portrays the complexity of Afro-American attitudes towards themselves and their past. The conflicts between black and white cultures and attitudes form the central core of Wilson's work.

The past twenty-five years

The great social turmoil of the late 1960s and early 1970s made its impression on the arts. It was a revolutionary period, and the theatre was deeply affected. Happenings, group gropes, and participatory performances were a new kind of theatre, performed not in traditional theatre buildings, but in streets, garages, on vacant lots and so on. Convention was ignored and traditional theatre split at the sides. Life began to imitate art, and scenes of ritualized madness seemed more like a synthesis of Brecht, Artaud, Genet, and Ionesco than real life.

Since the 1960s, theatre has remained vital because of its diversity. It still requires that the playwright bring to the theatre new works for production—in whatever style. The commercial limitations of theatre production cause great difficulty in this regard. Significant efforts, such as those of the Actors' Theatre of Louisville, are greatly

15.29 D. L. Coburn, *The Gin Game*, The Actors' Theatre of Louisville, 1978. Georgia Healslip (left), Will Hussung (right).

15.30 John Pielmeier, *Agnes of God*, 1980. The Actors' Theatre of Louisville. Mia Dillon (left), Adale O'Brien (right).

responsible not only for helping new playwrights, but also for bringing new works to production, and for keeping theatre vital in areas of the United States not next door to New York City and Broadway.

The significance of these efforts can be seen in two productions, *The Gin Game* and *Agnes of God*. D. L. Coburn's *The Gin Game* emerged from the Actors' Theatre's First Festival of New Plays in 1976–77. Its story evolves around an elderly man and woman who meet in a retirement home. The vehicle for their reviews, debates, and intimacy is an on-going card game (Fig. **15.29**). *The Gin Game* won a Pulitzer prize in 1978 and enjoyed a successful Broadway run. John Pielmeier's *Agnes of God* (Fig. **15.30**) was produced as part of the Fourth Festival of New American Plays, 1979–80. It deals with a psychiatrist who becomes obsessed with an unusually mystical nun who has been charged with murdering her child at birth. These and other Actors' Theatre of Louisville plays, such as Beth Henley's *Crimes of the Heart* (1978–79), continued to make a significant contribution to the contemporary theatre, often finding their way to the commercial forum of Broadway and the film.

Directors and theatre companies

Jerzy Grotowski

In Poland, Jerzy Grotowski (b. 1933) provided the moving spirit for the Polish Laboratory Theatre, and gained tremendous influence through his tours of Europe, England, and America. Grotowski called on his actors to use every technique available to them—mime, gesture, intonation, association of ideas—in order to fuse movement and meaning. At the center of this theory, which he described in his book *Towards a Poor Theatre*, is his concept of "poor theatre." Such theatre, he says, strips away all nonessentials in order for the performer to be left alone with the audience.

As a director, Grotowski rearranged scripts and actor–audience relationships for each production. He arranged for his actors to live communally as ascetics in order to develop their abilities. His theories drew on many sources, from Stanislavsky's work with the Moscow Popular Art Theatre, to the Indian *kathakali* and the Japanese *Noh*. Over the years, Grotowski's interest in psychodrama and therapeutic theatre grew, and his Theatre of Sources in America became involved in private psychological and physical confrontations.

Peter Brook

The career of the British director Peter Brook (b. 1925) began in the traditional theatre. His innovative work on daring productions of Shakespeare, A *Midsummer Night's Dream*, for example, placed him at the forefront of the AVANT GARDE. Brook allied himself with both Grotowski, whom he brought to London, and the "theatre of cruelty" of Antonin Artaud (1896–1948), which influenced Brook's production of *Marat/Sade* in 1964. In his book *The Empty Space* Brook attacks contemporary theatre practice and sets up four kinds of theatre. First, sterile and conventional, the "deadly" theatre is a museum for the "classics," particularly the works of Shakespeare and Molière, and the opera. Second, the "rough" theatre is down-to-earth, natural, and joyous. Antiauthority and without style, it is filled with noise, vulgarity, and boisterous action, as was the Elizabethan theatre, or the productions of Meyerhold. Third, the "holy" theatre is one of revelation and ceremony. Its rituals are the genuine ones that affect people's lives. Artaud is its prophet and Grotowski its chief disciple. Fourth, the "immediate" theatre is eclectic, vigorous, restless, and full of joy—a combination of the rough and the holy. Brook's dynamic productions demonstrate his commitment to the immediate theatre.[3]

The New Theatre

The social distress of the 1960s spawned a reaction against the traditional commercial theatre in the United States. Called the "New Theatre," this somewhat limited

movement appeared in coffee-houses and off-Broadway theatres. Participants in the movement were antitext, against illusionistic production, and against the theatre as a performance location. The movement produced several highly visible groups whose talent for theatricalism made a definite mark.

The Living Theatre

A particularly visible part of the New Theatre was a group formed by Judith Malina and Julian Beck, called the "Living Theatre." Its work freely mixed actors and audience so that often the audience ended up unsure what was real and what was theatre. In the 1959 production of Jack Gelber's *The Connection*, for example, actors circulated through the audience at intermission demanding handouts.

Forced to abandon its loft space for nonpayment of taxes, the group moved to Europe. On its return in 1965, its production of *Frankenstein* gained national attention. Highly propagandistic, the Living Theatre aimed to incite the audience to social action. Theatregoers were insulted and pelted with obscenities from every quarter as the group tried to shock them into some response.

The Performance Group—environmental theatre

Moving over from Grotowski's workshop, Richard Schechner began the Performance Group in New York. The group's stated goal was to eliminate sentimentalism in the theatre by removing all barriers between audience and actor. The actors worked on group dynamics exercises derived from Grotowski during rehearsals, and performances became communal celebrations.

The Performance Group's first major production was *Dionysus in 69*. Based partly on Euripides' *The Bacchae* and partly on rituals emanating from the group's exercises, the performance featured distorted language, chantings and wailings by the chorus, amplified sound, and nudity. The approach of this and other performances like it is called "environmental theatre."

Schechner wanted society to move toward collaborative approaches to social problem-solving. To that end, he created a chart of differences between traditional and "new" theatre:

Traditional	New
plot	images/events
action	activity
resolution	open-ended
roles	tasks
themes/thesis	no predetermined meaning
stage distinct from house	one area for all
script	scenario or free form
flow	compartments
single focus	multifocus
audience watches	audience participates, sometimes does not exist
product	process[4]

At the end of the 20th century, theatre has become a mix of modernists, who believe that it requires a representation of an action, and postmodernists, who, in one critic's words, believe it to represent "an archeological shift in the presuppositions of our thinking." Playwrights as such are no longer necessary to the postmodernists. Director/writers such as Richard Foreman and Robert Wilson, who call performance art "the theatre of images," are "makers" of theatre. Theatre, like the other arts, has entered an age of pluralism.

The theatre of images

Robert Wilson

Visual appeal rather than the written script forms the basis for the experimental work of Robert Wilson (b. 1941). His imaginative productions have earned him the reputation as a "seer genius" and a "feeler genius." Works such as *Einstein on the Beach*, produced at the Metropolitan Opera House in New York, focus on sensual imagery. Wilson was trained as a painter, and he uses a painter's eye to form what the audience responds to.

Other nontraditional "theatre" productions

Mime troupes, puppet theatre, and happenings, or performance art, have all claimed inclusion in the annals of theatre. Some quickly fade, while others demonstrate considerable staying power amidst a limited following. In recent years, art galleries, open public places, and streets have become performance locations. There are mixtures of live and recorded images. And there is improvization in the tradition of the *commedia dell'arte*. Some of these nontraditional performances carry explicit political messages. Others have no didactic purpose or informing idea.

Aristotelian analysis does not apply here. These occurrences may or may not even be "theatre." Rather, they may be some entirely different art form, valid as expression, but not within the tradition of the theatre.

Current scenic design

The 1980s saw a decline in commercial Broadway productions but a rise in regional theatre production and stunning advances in the field of design. Training has increased technical skills and artistry (Fig. **15.31**).

No longer is the design merely the environment of the play. Now it is frequently the essence of the play, establishing its mood, rhythm, and content (Fig. **15.32**). In musicals like *Starlight Express* and *Phantom of the Opera*, the design may *be* the production. Today's designers move easily among theatre, opera, ballet, and television, and readily adapt to the locations and stage requirements (Fig. **15.33**). Current productions are graced by lavish settings which challenge audiences with the designer's ingenuity. Technological advances and flexibility are the keys to the preeminence of modern set design.

15.32 Tom Benson, scene design for *Cabaret*, Mainstage, University of Arizona, Tucson.

15.33 Peter Wexler, scene design for *The Happy Time*, Broadway Theatre, New York City.

FILM

The forties and neo-realism

World War II and its aftermath brough radical change to the form and content of the cinema. A film came out in 1940 that stunned even Hollywood. Darryl Zanuck produced and John Ford directed John Steinbeck's *Grapes of Wrath*, an artistic visualization of Steinbeck's portrayal of the Depression. Here was social criticism with superb cinematography and compelling performances. Social

commentary appeared again in 1941 with *How Green Was My Valley*, which dealt with exploited coal miners in Wales, and *Citizen Kane*, a grim view of wealth and power in the United States. This film, thought by some to be the best movie ever produced, blazed a new trail in its cinematic techniques. Orson Welles, its director and star, and Greg Toland, its cinematographer, brilliantly combined deep-focus photography, unique lighting effects, rapid cutting, and moving camera sequences.

As Italy recovered from World War II, a new concept of film set the stage for many years to come. In 1945, Roberto Rossellini's *Rome, Open City* showed the misery of Rome during the German occupation. It was shot on the streets of Rome using hidden cameras and mostly nonprofessional actors and actresses. Technically, the quality of the work was somewhat deficient, but its objective view-point and documentary style changed the course of cinema and inaugurated an important style called "neo-realism."

McCarthyism and message movies

The early years after World War II were extremely profitable, but the era of the big studio was on the wane. Stronger labor unions and anti-trust rulings on theatre ownership completely changed the nature of the film industry. In addition, the hearings of the Un-American Activities Committee of the US House of Representatives stifled all liberal thought for a decade. Any subject or person that might in any way be considered controversial was cast aside. Hundreds of careers and lives were destroyed, and films turned almost exclusively to "safe" and escapist fare. Message movies virtually disappeared in the United States. Even the most daring film of the period, *On the Waterfront*, obfuscated the facts when it came to revealing who was really manipulating corrupt unions.

At the same time, television brought moving pictures into the living rooms of the public. Hollywood's immediate response to television was a series of technological spectaculars, CinemaScope, Cinerama, and 3-D. Soon, it became clear that good movies, not special effects, were needed to stimulate attendance. John Ford's Westerns and Alfred Hitchcock's *North by Northwest* fulfilled this purpose, as did the blockbuster success *Ben Hur* in 1959.

The demise of the studio

The forties and fifties saw a revival of musical comedies, more John Wayne, and an unforgettable genre of forgettable Saturday matinée series from *Captain Video* to *Buck Rogers*. Elvis Presley arrived on the screen in 1956, as Judy Garland left it. Elizabeth Taylor in *National Velvet* and Audrey Hepburn in *Roman Holiday* became stars. The most

unforgettable actress of the period, however, was Marilyn Monroe. *The Misfits* (1962) brought her and Clark Gable together for their last film appearances.

The foreign film tradition was still dominated by neo-realism. Federico Fellini directed *La Strada* (1954) and *La Dolce Vita* (1960). The stunning artistry of Akiro Kurosawa's *Rashomon* (1951) and *Seven Samurai* (1954) penetrated the human condition to great depths or slid over its surface, and tied together east and west. Heavy Scandinavian symbolism marked the films of Sweden's Ingmar Bergman. In *The Seventh Seal*, *Wild Strawberries*, and the *Virgin Spring*, among other films, Bergman delved into human character, suffering, and motivation.

The sixties was an era of international film and of the independent producer. Studios no longer undertook programs of film production, nor did they keep stables of contract players. Now each film was an independent project whose artistic control was in the hands of the director. A new breed of film-maker came to prominence.

The past twenty-five years

Film has taken curious directions in the seventies and eighties. Devotees came to regard film as an art form significant enough to be studied in depth. More and more films were made for very specific and sophisticated audiences, and even movies made for commercial success have elements in them aimed at those in the know. Steven Spielberg's *Star Wars*, for example, consists of a carefully developed series of quotations from old movies and satires of them. Not recognizing these allusions does not hamper one's enjoyment of the film, but knowing about them enhances one's pleasure.

In the nineties, we do not know whether cable television and pay TV, in which first-run films are released not to movie theatres but to television outlets, will mean the end of the theatre film. Television will certainly have a significant effect on the aesthetics of film-making. Films shot for theatre screens are basically long-shot oriented, because the size of the screen enhances broad visual effects. Television, on the other hand, is a close-up medium. Its small viewing area cannot show wide-angle panoramas. Details are simply too small. Television must rely mostly on the close-up and the medium shot. Television movies must hook an audience in the first few minutes to prevent viewers from changing channels. A theatre movie can develop more slowly. Film aesthetics are already somewhat compromised. Directors with one eye on the theatre box office and the other on a lucrative re-release to television try to meet the aesthetic requirements of both media. Only the mass marketplace will decide what the art of the cinema will be, because whether it is taken to be art, entertainment, or both, cinema depends upon commercial success for its existence.

MUSIC

After World War II

After World War II, music developed along several distinctly different lines, and the different schools became further polarized. Two general directions have been taken, one toward control and formality, and the other toward less control to the point of randomness and total improvization. The serialism of Milton Babbitt (b. 1916) in America and Pierre Boulez (b. 1925) in France are clear examples of a move toward tighter control and predetermination of events. The improvizational works of Earle Brown (b. 1926) and the various approaches taken by John Cage (b. 1912) exemplify a move away from composer control, leaving decisions to performers or to chance. At the same time, a number of composers have continued in more traditional styles, which stemmed from the musical principles of Hindemith, the neo-classicism of Stravinsky and Prokofiev, and the nationalistic styles of Bartók and Copland.

Serialism

Postwar serialism reflects a desire to exert more control and to apply a predetermined hierarchy of values to all elements of a composition. Before the war, composers using the twelve-tone technique created a set, or row, of 12 pitches arranged in a specific order. Although the order could be manipulated in a number of ways, certain relationships between the pitches of the tone-row were constant and provided the underlying structure and much of the flavor of this style. To some extent, structural decisions were made before the actual writing of the composition itself. The composer was then subject to fairly strict limitations on the selection of pitches as the work progressed, since all pitch order was pre-established.

Proponents of the technique argued that composers have always worked within limitations of some kind and that the discipline required to do so is an essential part of the creative problem-solving process. Opponents argued that writing music this way was more a mathematical manipulation that appealed to the intellect and less the function of a composer's ear.

Three Compositions for piano by Milton Babbitt, written in 1947–48, is one of the earliest examples of serial technique applied to elements other than pitch. In this work, rhythm and dynamics are also predetermined by serial principles.

Aleatory music

While some composers were developing techniques and even systems of highly controlled composition in the late 1940s, others went in the opposite direction. John Cage has been a major force in the application of ALEATORY, or chance, procedures to composition with works such as *Imaginary Landscape* No. 4 for 12 radios and *The Music of Changes* (1951). Cage relied on the I *Ching*, or *Book of Changes*, for a random determination of many aspects of his works. (The I *Ching*, which dates from the earliest period of Chinese literature, contains a numerical series of combinations based on the throwing of yarrow sticks — not unlike the throwing of dice or coins.) The ultimate example of chance music is a piece that could be considered non-musical — Cage's 4′ 33″ (1952) — in which the performer makes no sound whatever. The sounds of the hall, audience, traffic outside — that is, whatever occurs — forms the content of the composition.

Cage toured Europe in 1954 and 1958 and is thought to have influenced composers such as Boulez and Stockhausen to incorporate aspects of chance and indeterminacy into their music. Boulez's Third Piano Sonata and Stockhausen's *Klavierstück*, both dating from 1957, for example, give options to the performer concerning the overall form of the work or the order of specific musical fragments. But they are, for the most part, conventionally notated, and thus controlled.

Improvization

An open, improvizatory tradition was carried on by composers like Lukas Foss, who wrote a suite for soprano and orchestra that includes jazz improvization. He founded the Improvization Chamber Ensemble, and a number of other improvization groups sprang up in the United States during the 1960s. During this period, there was also intense exploration of new sound possibilities using both conventional and electronic instruments.

Postwar jazz

Styles stemming from traditional jazz proliferated after the war. There was a gradual move away from the big bands to smaller groups and a desire for much more improvization within the context of the compositions. The term "bebop" was coined as a result of the characteristic long-short triplet rhythm which ended many phrases. The prime developers of this style were the alto-saxophonist Charlie "Bird" Parker and the trumpeter Dizzy Gillespie.

The "cool jazz" style developed in the early 1950s with artists like Stan Getz and Miles Davis. Although the technical virtuosity of bebop continued, a certain lyric quality, particularly in the slow ballads, was emphasized and, more importantly, individuals' personal tone quality, particularly players of wind instruments, was a major identifying characteristic.

Electronic music

The development of the SYNTHESIZER and the establishment of the Columbia–Princeton Electronics Music Center provided an opportunity for composers such as Milton Babbitt to pursue the application and further development of primarily serial techniques. Many aleatory composers found electronic sound a congenial way to achieve their musical goals of indeterminacy, as John Cage did in *Imaginary Landscape* No. 5. Mainstream and jazz composers did not pay serious attention to the electronic medium until the 1960s, however.

The 1960s and 1970s

In the 1960s and early 1970s, the "ultrarational" and "anti-rational" schools of music went to further extremes. The desire constantly to create something new also intensified, at times superseding most other considerations. Karlheinz Stockhausen (b. 1928), for example, became more interested in the total manipulation of sound and the acoustic space in which the performance was to take place. His work *Gruppen* (1957), for three orchestras, is an early example. As he became more and more interested in timbre modulation, his composition—for example, *Microphonie* I (1964)—used more and more sound sources, both electronic and acoustic.

Elliott Carter (b. 1908) developed a highly organized approach toward rhythm often called "metric modulation" in which the mathematical principles of meter, standard rhythmic notation, and other elements are carried to complex ends. Carter's use of pitch is highly chromatic and exact, and his music requires virtuoso playing both from the individual and the ensemble.

Virtuoso playing produced an important composer–performer relationship in the 1960s, and many composers, such as Luciano Berio (b. 1925), wrote specifically for individual performers, such as trombonist Stewart Dempster. In the same vein, percussionist Max Neuhaus was associated with Stockhausen, and pianist David Tudor with John Cage.

Experimentation with MICROTONES has been of interest to composers and music theorists throughout history, and many non-western cultures employ them routinely. Microtones can be defined as intervals smaller than a half step. The usual western system divides the octave into 12 equal half steps. But why might the octave not be divided into 24, 53, 95, or any number of parts? The possibilities are limited only by our ability to hear such intervals and a performer's ability to produce them. Alois Haba experimented in the early part of the century with quarter tones (24 per octave) and sixth tones (36 per octave) and Charles Ives did much the same thing. A number of instruments were designed to produce microtones, and experimentation and composition have been carried out widely.

Composers also questioned the limitations of the traditional concert hall. Early work by Cage and others led to theatre pieces, multi-media or mixed media pieces, so-called danger music, biomusic, soundscapes, happenings, and total environments which might include stimulation of all the senses in some way. Thus the distinctions between the composer and the playwright, the filmmaker, the visual artist, and so on, were often obscured.

Since the early 1960s, electronic instruments that can be used in live performance have had a powerful influence on music composition. Live performances were mixed with prerecorded tape in the 1950s, and by the 1960s, it became common to alter the sound of live performers by electronic means. Computer technology has been added to the composition and performance of music, and the options available through computer application are now virtually endless.

Theatre music, sometimes called "experimental music," may be relatively subtle, with performers playing or singing notated music and moving to various points on the stage, as in Berio's *Circles* (1960). Or it may be more extreme, as in the works of La Monte Young, where the performer is instructed to "draw a straight line and follow it," or to exchange places with the audience. In Nam June Paik's H*omage to John Cage*, the composer ran down into the audience, cut off Cage's tie, dumped liquid over his head, and ran out of the theatre. Later he phoned with the message that the composition had ended. Needless to say, such compositions contain a high degree of indeterminacy.

Some works were never intended to be performed, but only conceptualized, such as Nam June Paik's D*anger Music for Dick Higgins*, which instructs the performer to "creep into the vagina of a living whale" or Robert Moran's *Composition for Piano with Pianist*, which instructs the pianist to climb into the grand piano.

There was also a return to minimal materials. Stockhausen's S*timmung* (T*uning*), dating from 1968, has six vocalists singing only six notes. Minimal music can be defined as music which uses very little musical material, but often for an extended length of time. *One Sound* for string quartet by Harold Budd and the electronic piece *Come Out* (1966) by Steve Reich are clear examples.

Many so-called "mainstream" composers continued writing throughout the 1960s and early 1970s. The source of much of this music is a combination of 19th-century Romantic tradition, the folk styles of Bartók and Copland, harmonies of Hindemith, the tonal systems of Debussy and Ravel, and the neo-classicism of Prokofiev and Stravinsky. By this period, a noticeable element of controlled indeterminacy has crept into the music, however. The late sixties and seventies brought a greater acceptance of varying aesthetic viewpoints and musical styles as avante-garde techniques joined the mainstream.

A similar freedom from melodic, rhythmic, and formal restraints appeared in jazz, and free jazz became the

style of the 1960s. Saxophonist Ornette Coleman was one of its earliest proponents. Others, such as John Coltrane, developed a rhythmically and melodically free style based on more modal materials, while Cecil Taylor developed more chromatic music. In the mid-to-late sixties, Miles Davis arrived at a sophisticated blend of control and freedom in his *Bitches Brew* album of 1967. A number of musicians who originally worked with Miles Davis became leading artists in the 1970s, developing a style called "jazz-rock," or "fusion."

Penderecki

The Polish composer Krysztof Penderecki (b. 1933) is widely known for instrumental and choral works, including a major composition, the *Requiem Mass* (1985). Most notably, Penderecki has experimented with techniques to produce new sounds from conventional stringed instruments.

His *Polymorphia* (1961) uses 24 violins, eight violas, eight cellos, and eight double basses. He has invented a whole new series of musical markings that are listed at the beginning of the score. In performance, his timings are measured by a stop watch and there is no clear meter. *Polymorphia* uses a free form, achieving its structure from textures, harmonies, and string techniques. The piece is dissonant and atonal.

It begins with a low, sustained chord. The mass of sound grows purposefully, with the entry of the upper strings, and then the middle register. Then comes a section of glissandos (slides), which can be played at any speed between two given pitches, or with what amounts to improvization. A climax occurs, after which the sound tapers off. Then a number of pizzicato (plucked) effects are explored. Fingertips are used to tap the instruments, and the strings are hit with the palms of the hands, leading up to a second climax. After another section in which bowed, sustained, and sliding sounds are explored, a third climax is reached. After an almost total dearth of melody and defined pitch, the work ends with a somewhat surprising C major chord.

The postwar period has been one of rapid change in its constant quest for something new—new sounds, new applications of new technology, new notation, new formal parameters, new ways of presenting music, or combining music with visual and other stimuli. This insatiable appetite has led to extremism among both conservative and avant-garde composers. It peaked during the 1970s, however, and, in the 1980s, it gave way to a reevaluation and an increased tolerance of all styles as valid.

The influence of music composition for films and television made the era an interesting one. It brought together various styles for dramatic purposes, and used new sounds and technologies in order to appeal to a wide audience. This may well be one of the most productive new directions for music in the 1990s.

DANCE
After World War II

In the years since 1945, José Limón and Martha Graham, as well as George Balanchine, continued to influence dance well into the second half of this century. Limón's *Moor's Pavane* used Purcell's *Abdelazer* for its music. Based on Shakespeare's *Othello* and structured on the Elizabethan court dance, the *Pavane* is an unusual dramatic composition that sustains tension throughout the piece.

Martha Graham's troupe produced a radical and controversial choreographer who broke with many of the traditions of modern dance. Like John Cage, with whom he is closely associated, Merce Cunningham (b. 1919) incorporated chance, or aleatory, elements into his work. Cunningham uses the gestures of everyday activity as well as dance movements. He wants the audience to see dance in a new light, and, indeed, his choreography is radically different from anyone else's—elegant, cool, and severely abstract.

Works such as *Summerspace* and *Winterbranch* illustrate Cunningham's use of chance, or indeterminacy. To keep the dance fresh, he and his dancers rehearse different options and orders for sets. Then, sometimes by flipping a coin, he varies and intermixes parts in different orders from performance to performance. The same piece may appear totally different from one night to the next. Cunningham also uses stage space as an integral part of the performance and spreads the various focuses of a piece across various areas of the stage (unlike classical ballet, where the focus is isolated on center stage or downstage center alone). Thus Cunningham allows people in the audience to choose where to focus rather than choosing their focus for them. Finally, he allows each element of the performance to go its own way. The dancers rehearse without music and learn the count without any reference to it. The music, which can be anything, is added later, sometimes only when the curtain goes up. As a result, there is no beat-for-beat relationship that audiences have come to expect between music and footfalls in ballet and much modern dance.

Since 1954, another graduate of Martha Graham's troupe (and also of Merce Cunningham's) has provided another strong direction in modern dance. The work of Paul Taylor (b. 1930) has a vibrant, energetic, and abstract quality that often suggests primordial rites. Taylor, like Cunningham, uses strange combinations of music and movement in ebullient and unrestrained dances such as *Book of Beasts*. Unlike Cunningham, however, Taylor often uses traditional music, like that of Beethoven. The combination of esoteric musical forms with his wild, emotional movements creates confrontational works that viewers find challenging.

In this tradition of individual exploration and

independence, there have been many accomplished dancer/choreographers, among them Alwin Nikolais. His works—he designs the scenery, costumes, and lights and composes the music as well as the choreography—are mixed-media extravaganzas that celebrate the electronic age with spectacles compared by many to early court masques. Often the display is so dazzling that the audience loses the dancers in the lighting effects and scenic environment.

Another important figure is Alvin Ailey, a versatile dancer whose company is known for its unusual repertoire and energetic free movements. Twyla Tharp and Yvonne Ranier have both experimented with space and movement. James Waring has added Bach and 1920s pop songs to florid pantomimes and abstractions using Romantic point work.

With its roots in the black musical heritage, jazz dance nonetheless draws upon the broad experiments of modern dance. Its sources include "primitive" Africa and the urban ghetto. Its forms are not universally agreed upon, and, like modern dance, its directions are still in flux. Nevertheless, this form of dance has received significant attention throughout the United States (Fig. **15.34**). Choreographers such as Asadata Dafora Horton in the 1930s and Katherine Dunham and Pearl Primus in the 1940s were the pioneers of this form.

15.34 Choreographer: Jean Sabatine, *Nameless Hour.* Jazz Dance Theatre at Penn State, The Pennsylvania State University.

It is virtually impossible even to name the many excellent contemporary ballet companies flourishing around the world. International tours of Europe's great companies, among them the Bolshoi, Great Britain's Royal Ballet, the Stuttgart, and the Royal Danish companies, make frequent trips to the United States, while American companies, notably the New York City Ballet, the American Ballet Theatre, and Dance Theatre of Harlem, are well received abroad. Crowds of American dance enthusiasts are found in the ballet houses of London, Moscow, Paris, and Vienna. In the United States and Canada, regional companies keep ballet traditions alive and fresh. Dance has become one of this country's most popular and growing art forms, with the availability of quality works growing each year.

ARCHITECTURE
Modernism

In a sense, the task of evaluating contemporary architecture is the most difficult of all the arts. In our day, the human element in artistic creation has been blurred by the contributions of architectural firms rather than individual architects. In addition, the contemporary observer sees a sameness in the glass and steel boxes of the International Style that dominate our cities and easily misses some truly unique approach to design visible in some housing project in an obscure location.

The ten-year break in architectural construction during World War II separated what came after from what went before. The continuing careers of architects who had achieved significant accomplishment before the war soon bridged the gap, however. The focus of new building shifted from Europe to the United States, Japan, and even South America. The overall approach still remained modern, or international, in flavor.

A resurgence of skyscraper building occurred in the 1950s. Lever House (1951–52) in New York City (Fig. **15.35**) illustrates the glass-and-steel-box approach that began then and continues today. A very important consideration in this design is the open space surrounding the tower. Created by setting the tower back from the perimeter of the site, the open space around the building creates its own envelope of environment, or its context. Reactions against and alternatives to the all-over glazing of the Lever Building have occurred throughout the last 40 years—aluminum surfaces pierced by small windows, for example. An intensification of the glazed exterior has also taken place, where metalized rather than normal glass forms the surface. Such an approach has been particularly popular in the Sun Belt, because metalized glass reflects the sun's rays and their heat. Whatever materials are used on the façade, however, the functional, plain rectangle of the International Style has continued as a standard architectural form.

15.35 Gordon Bunshaft (Skidmore, Owings, and Merrill), Lever House, New York, 1950–52.

15.36 (right) Mies van der Rohe and Philip Johnson, Seagram Building, New York, 1958

The rectangle, which has so uniformly and in many cases thoughtlessly become the mark of contemporary architecture, leads us to the architect who, before World War II, was among its advocates. Ludwig Mies van der Rohe (1886–1969) insisted that form should not be an end in itself. Rather, the architect should discover and state the function of the building. Mies pursued those goals, taking mass-produced materials—bricks, glass, and manufactured metals—at their face value and expressing their shapes honestly. This was the basis for the rect-angularization that is the common ground of 20th-century architecture. His search for proportional perfection can be traced, perhaps, back to the German Pavilion of the Barcelona Exposition in 1929, and it was consummated in large-scale projects such as New York's Seagram Building (Fig. **15.36**).

The simple straight line and functional structure that were basic to Mies's vision were easily imitated and readily reproduced. This multiplication of steel and glass

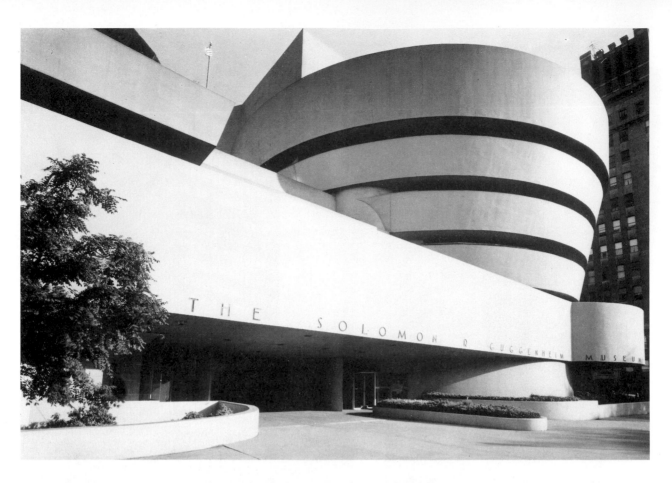

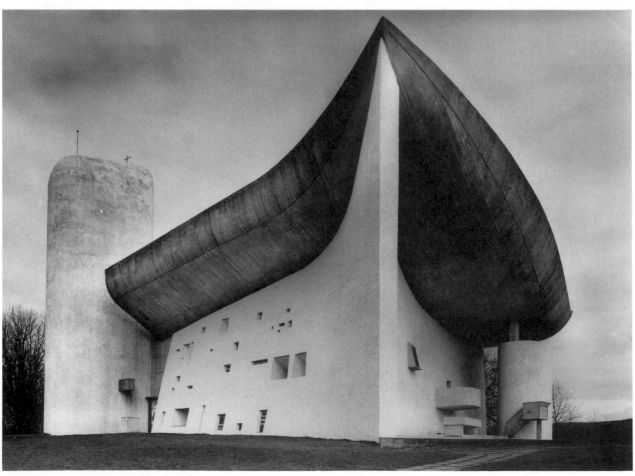

boxes, however, has not overshadowed exploration of other forms. Contemporary design has ultimately answered in various ways the question put by Louis I. Kahn, "What form does the space want to become?"

In the case of Frank Lloyd Wright's Guggenheim Museum (Fig. **15.37**), space has become a relaxing spiral that reflects the leisurely progress one should make through an art museum. Eero Saarinen's Trans-World Air-line Terminal emulates the shape of flight in its curved lines and spaces, carefully designed to accommodate large masses of people and channel them to and from waiting aircraft. (Shapes like this can be executed only using modern construction techniques and materials such as reinforced concrete.) Le Corbusier's dynamic church, Notre Dame du Haut (Fig. **15.38**), which is more like a piece of sculpture than a building, also suggests flight. The function of this pilgrimage church cannot easily be surmised from its form. Rather, the juxtaposed rectilinear windows and curvilinear walls and the overwhelming roof nestled lightly on thin pillars above the walls appear a "pure creation of the spirit."

Two other noteworthy architects have their own signatures, the arch of Pier Luigi Nervi (1891–1979), and the dome of Richard Buckminster Fuller (1895–1983). The unencumbered free space of their work contrasts sharply with the self-contained boxes of the International Style. Nervi's Small Sports Palace (Fig. **15.39**) and Fuller's Climatron (Fig. **15.40**) illustrate the practical need for free space. They also illustrate the trend toward spansion architecture, which stretches engineering to the limits of its materials. (In the case of the Kansas City Hyatt Regency Hotel, a spansion design went beyond practicality, with tragic results.)

15.37 (opposite, top) Frank Lloyd Wright, Solomon R. Guggenheim Museum, New York, 1942–59.

15.38 (opposite, bottom) Le Corbusier, Notre Dame du Haut, Ronchamp, France, 1950–54, from the southeast.

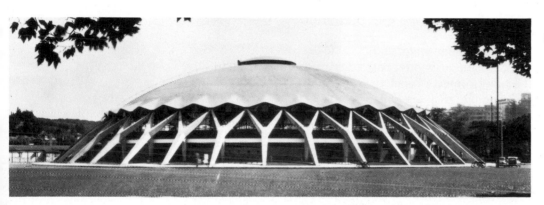

15.39 Pier Luigi Nervi, Small Sports Palace, Rome, 1957.

15.40 Richard Buckminster Fuller, Climatron, St Louis, 1959.

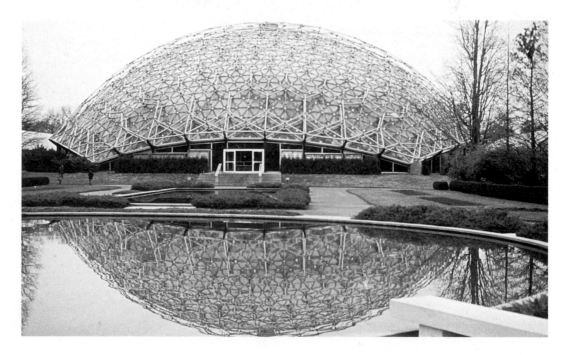

Postmodernism

Beyond these trends, contemporary architecture has been pluralistic. Postmodern, or "revisionist," architecture takes past styles and does something new with them. The Spanish architect Ricardo Bofill (b. 1939) and the Italian Aldo Rossi (b. 1931) both derive much of their architectural language from the past. As Bofill remarked, his architcture takes "without copying, different themes from the past, but in an eclectic manner, seizing certain moments in history and juxtaposing them, thereby prefiguring a new epoch." We see this eclectic juxtaposition in his public housing development called, with typical grandiosity, The Palace of Abraxas (Fig. 15.41). Here columnar verticality is suggested by glass bays and by the cornice/capitals over them which give the appearance of a dynamic classicism. In Japan, postmodern architects such as Arata Isozaki (b. 1931) portray in their buildings the restrained elegance and style of traditional Japanese art. In the United States, Michael Graves (b. 1934) has reacted to the repetitive glass, concrete, and steel boxes of the International Style by creating a metaphorical allusion to the keystone of the Roman arch (Fig. 15.42). The bright red pilasters suggest fluted columns, and fiberglass garlands recall both art deco and rococo.

Postmodern architecture focuses on meaning and symbolism, and it embraces the past. The postmodernist seeks to create buildings "in the fuller context of society and the environment." Function no longer dictates form, and ornamentation is acceptable. The goals of postmodern architecture are social identity, cultural continuity, and sense of place.

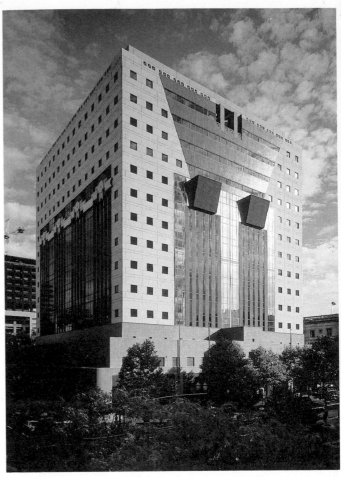

15.42 Michael Graves, Portland Public Office Building, Portland, Oregon, 1979–82.

15.41 Ricardo Bofill, The Palace of Abraxas, Marne-la-Vallée, near Paris, 1978–83.

Another clear repudiation of the glass-and-steel box of the International Style and other popular forms in mainstream architecture can be seen in the design for the Pompidou Center in Paris (Fig. 15.43). Here the building is turned inside out, with its network of ducts, pipes, and elevators color-coded and externalized, and its internal structure hidden. The interior spaces have no fixed walls, but temporary dividers can be arranged in any configuration that is wanted. The bright primary colors on the exterior combine with the serpentine, plexiglass-covered escalators to give a whimsical, lively appearance to a functional building. The Pompidqu Center has become a tourist attraction rivaling the Eiffel Tower, and, while controversial, it has gained wide popular acceptance.

The highly colorful Piazza d'Italia (Fig. 15.44), designed for the Italian–American community in New Orleans, comes alive at night with neon lighting that complements its columns, its temple front, and its fountain that spills out onto a map of Italy. The architect, Charles Moore (b. 1925), was inspired by his conception of the "American dream," which he found embodied in Disneyland, and he applied that idea to this project.

15.43 Renzo Piano and Richard Rogers, Pompidou Center, Paris, 1971–78.

15.44 Charles Moore, Piazza d'Italia, New Orleans, 1978–79.

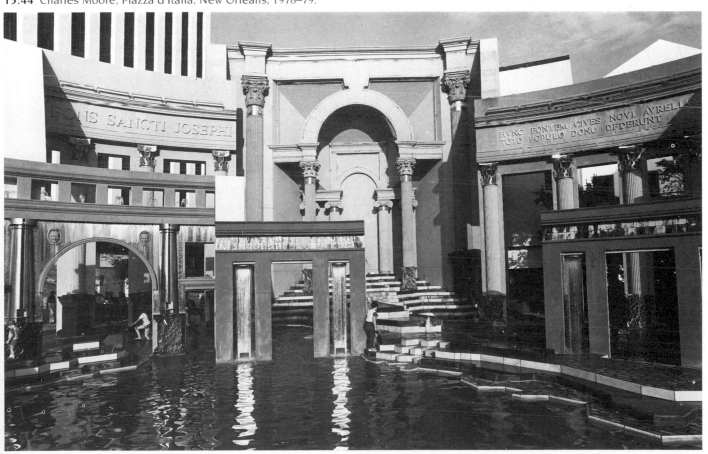

SYNTHESIS

Every chapter in this text has attempted some fair summary of what the arts were about in the time covered there. The last half of the 20th century has been too pluralistic for one artist, or movement, or event, or even a combination of these, to capture the essence of what the arts have been like in the past 50 years.

To describe any synthesis of the arts in the late 20th century at this point in time would be like standing on a street corner in midtown Manhattan and trying to describe what New York City is all about. It seems only decent—and realistic—to wait at least for the 21st century before standing back and drawing any conclusions.

SUGGESTIONS FOR THOUGHT AND DISCUSSION

Not long ago, I attended a conference in Amsterdam entitled "New Directions in the Arts." There, 100 artists and art administrators from North and South America and Europe listened to contemporary artists, visited Dutch museums and conservatories, and discussed the state and future of the arts.

The week was taxing and exhilarating. Most of us concluded, however, that the conference was probably wrongly named. There seemed to be no new directions in the arts. What seemed "new" turned out to be path-crossings of various styles and approaches that had previously existed in isolation. New understandings and appreciations had simply expanded horizons in the arts.

There will be new developments, of course, perhaps even before the dust from the political and economic revolutions in process around the globe has settled. There is a universal thirst for the insights and pleasures afforded only by the arts. It is still heartening, for example, that in the United States, more people attend arts events than sports events.

Since we cannot predict the future, an understanding of the present and the past is essential. Our journey through this text should have laid a groundwork for just that.

■ Does the nonobjectivity of the art you see around you disturb you or bore you? Why do you think you react as you do?

■ Have the attitudes and concerns expressed in the arts of the first half of the 20th century changed much in the second half?

■ Do you feel more comfortable with the art of our time or with the art of centuries past?

■ Do you relate to film more readily than you do to other arts? If so, why do you think this is?

■ Do you think the arts have or have not progressed over the centuries? What do you mean by "progress"?

■ How do the arts affect our daily lives? If we removed all the arts from our environment, would you want to live in such surroundings?

LITERATURE EXTRACTS

Night

[1960] Elie Wiesel

Night is an autobiographical account of imprisonment in a Nazi concentration camp. Wiesel was a devout teenager and much of the book's strength derives from the conflicting emotions aroused by his faith and the evils of the camp.

Chapter 5

The summer was coming to an end. The Jewish year was nearly over.

On the eve of Rosh Hashanah, the last day of that accursed year, the whole camp was electric with the tension which was in all our hearts. In spite of everything, this day was different from any other. The last day of the year. The word "last" rang very strangely. What if it were indeed the last day?

They gave us our evening meal, a very thick soup, but no one touched it. We wanted to wait until after prayers. At the place of assembly, surrounded by the electrified barbed wire, thousands of silent Jews gathered, their faces stricken.

Night was falling. Other prisoners continued to crowd in, from every block, able suddenly to conquer time and space and submit both to their will.

"What are You, my God," I thought angrily, "compared to this afflicted crowd, proclaiming to You their faith, their anger, their revolt? What does Your greatness mean, Lord of the Universe, in the face of all this weakness, this decomposition, and this decay? Why do You still trouble their sick minds, their crippled bodies?"

Ten thousand men had come to attend the solemn service, heads of the blocks, Kapos, functionaries of death.

"Bless the Eternal. . . ."

The voice of the officiant had just made itself heard. I thought at first it was the wind.

"Blessed be the Name of the Eternal!"

Thousands of voices repeated the benediction; thousands of men prostrated themselves like trees before a tempest.

"Blessed be the Name of the Eternal!"

Why, but why should I bless Him? In every fiber I rebelled. Because He had had thousands of children burned in His pits? Because He kept six crematories working night and day, on Sundays and feast days? Because in His great might He had created Auschwitz, Birkenau, Buna, and so many factories of death? How could I say to Him: "Blessed art Thou, Eternal, Master of the Universe, Who chose us from among the races to be tortured day and night, to see our fathers, our mothers, our brothers, end in the crematory? Praised be Thy Holy Name, Thou Who hast chosen us to be butchered on Thine altar?"

I heard the voice of the officiant rising up, powerful yet at the same time broken, amid the tears, the sobs, the sighs of the whole congregation:

"All the earth and the Universe are God's!"

He kept stopping every moment, as though he did not have the strength to find the meaning beneath the words. The melody choked in his throat.

And I, mystic that I had been, I thought:

"Yes, man is very strong, greater than God. When You were deceived by Adam and Eve, You drove them out of Paradise. When Noah's generation displeased You, You brought down the Flood. When Sodom no longer found favor in Your eyes, You made the sky rain down fire and sulphur. But these men here, whom You have betrayed, whom You have allowed to be tortured, butchered, gassed, burned, what do they do? They pray before You! They praise Your name!"

"All creation bears witness to the Greatness of God!"

Once, New Year's Day had dominated my life. I knew that my sins grieved the Eternal; I implored his forgiveness. Once, I had believed profoundly that upon one solitary deed of mine, one solitary prayer, depended the salvation of the world.

This day I had ceased to plead. I was no longer capable of lamentation. On the contrary, I felt very strong. I was the accuser, God the accused. My eyes were open and I was alone—terribly alone in a world without God and without man. Without love or mercy. I had ceased to be anything but ashes, yet I felt myself to be stronger than the Almighty, to whom my life had been tied for so long. I stood amid that praying congregation, observing it like a stranger.

The service ended with the Kaddish. Everyone recited the Kaddish over his parents, over his children, over his brothers, and over himself.

We stayed for a long time at the assembly place. No one dared to drag himself away from this mirage. Then it was time to go to bed and slowly the prisoners made their way over to their blocks. I heard people wishing one another a Happy New Year!

I ran off to look for my father. And at the same time I was afraid of having to wish him a Happy New Year when I no longer believed in it.

He was standing near the wall, bowed down, his shoulders sagging as though beneath a heavy burden. I went up to him, took his hand and kissed it. A tear fell upon it. Whose was that tear? Mine? His? I said nothing. Nor did he. We had never understood one another so clearly.

The sound of the bell jolted us back to reality. We must go to bed. We came back from far away. I raised my eyes to look at my father's face leaning over mine, to try to discover a smile or something resembling one upon the aged, dried-up countenance. Nothing. Not the shadow of an expression. Beaten.

Yom Kippur. The Day of Atonement.

Should we fast? The question was hotly debated. To fast would mean a surer, swifter death. We fasted here the

whole year round. The whole year was Yom Kippur. But others said that we should fast simply because it was dangerous to do so. We should show God that even here, in this enclosed hell, we were capable of singing His praises.

I did not fast, mainly to please my father, who had forbidden me to do so. But further, there was no longer any reason why I should fast. I no longer accepted God's silence. As I swallowed my bowl of soup, I saw in the gesture an act of rebellion and protest against Him.

And I nibbled my crust of bread.

In the depths of my heart, I felt a great void.

The SS gave us a fine New Year's gift.

We had just come back from work. As soon as we had passed through the door of the camp, we sensed something different in the air. Roll call did not take so long as usual. The evening soup was given out with great speed and swallowed down at once in anguish.

I was no longer in the same block as my father. I had been transferred to another unit, the building one, where, twelve hours a day, I had to drag heavy blocks of stone about. The head of my new block was a German Jew, small of stature, with piercing eyes. He told us that evening that no one would be allowed to go out after the evening soup. And soon a terrible word was circulating—selection.

We knew what that meant. An SS man would examine us. Whenever he found a weak one, a *musulman* as we called them, he would write his number down: good for the crematory.

After soup, we gathered together between the beds. The veterans said:

"You're lucky to have been brought here so late. This camp is paradise today, compared with what it was like two years ago. Buna was a real hell then. There was no water, no blankets, less soup and bread. At night we slept almost naked, and it was below thirty degrees. The corpses were collected in hundreds every day. The work was hard. Today, this is a little paradise. The Kapos had orders to kill a certain number of prisoners every day. And every week—selection. A merciless selection. . . . Yes, you're lucky."

"Stop it! Be quiet!" I begged. "You can tell your stories tomorrow or on some other day."

They burst out laughing. They were not veterans for nothing.

"Are you scared? So were we scared. And there was plenty to be scared of in those days."

The old men stayed in their corner, dumb, motionless, hunted. Some were praying.

An hour's delay. In an hour, we should know the verdict—death or a reprieve.

And my father. Suddenly I remembered him. How would he pass the selection? He had aged so much. . . .

The head of our block had never been outside concentration camps since 1933. He had already been through all the slaughterhouses, all the factories of death. At about nine o'clock, he took up his position in our midst:

"Achtung!"

There was instant silence.

"Listen carefully to what I am going to say." (For the first time, I heard his voice quiver.) "In a few moments the selection will begin. You must get completely undressed. Then one by one you go before the SS doctors. I hope you will all succeed in getting through. But you must help your own chances. Before you go into the next room, move about in some way so that you give yourselves a little color. Don't walk slowly, run! Run as if the devil were after you! Don't look at the SS. Run, straight in front of you!"

He broke off for a moment, then added:

"And, the essential thing, don't be afraid!"

Here was a piece of advice we should have liked very much to be able to follow.

I got undressed, leaving my clothes on the bed. There was no danger of anyone stealing them this evening.

Tibi and Yossi, who had changed their unit at the same time as I had, came up to me and said:

"Let's keep together. We shall be stronger."

Yossi was murmuring something between his teeth. He must have been praying. I had never realized that Yossi was a believer. I had even always thought the reverse. Tibi was silent, very pale. All the prisoners in the block stood naked between the beds. This must be how one stands at the last judgment.

"They're coming!"

There were three SS officers standing round the notorious Dr. Mengele, who had received us at Birkenau. The head of the block, with an attempt at a smile, asked us:

"Ready?"

Yes, we were ready. So were the SS doctors. Dr. Mengele was holding a list in his hand: our numbers. He made a sign to the head of the block: "We can begin!" As if this were a game!

The first to go by were the "officials" of the block: *Stubenaelteste*, Kapos, foreman, all in perfect physical condition of course! Then came the ordinary prisoners' turn. Dr. Mengele took stock of them from head to foot. Every now and then, he wrote a number down. One single thought filled my mind: not to let my number be taken; not to show my left arm.

There were only Tibi and Yossi in front of me. They passed. I had time to notice that Mengele had not written their numbers down. Someone pushed me. It was my turn. I ran without looking back. My head was spinning: you're too thin, you're weak, you're too thin, you're good for the furnace. . . . The race seemed interminable. I thought I had been running for years. . . . You're too thin, you're too weak. . . . At last I had arrived exhausted. When I regained my breath, I questioned Yossi and Tibi:

"Was I written down?"

"No," said Yossi. He added, smiling: "In any case, he couldn't have written you down, you were running too fast. . . ."

I began to laugh. I was glad. I would have liked to kiss him: At that moment, what did the others matter! I hadn't been written down.

Those whose number had been noted stood apart, abandoned by the whole world. Some were weeping in silence. The SS officers went away. The head of the block

appeared, his face reflecting the general weariness.

"Everything went off all right. Don't worry. Nothing is going to happen to anyone. To anyone."

Again he tried to smile. A poor, emaciated, dried up Jew questioned him avidly in a trembling voice:

"But . . . but, *Blockaelteste*, they did write me down!"

The head of the block let his anger break out. What! Did someone refuse to believe him!

"What's the matter now? Am I telling lies then? I tell you once and for all, nothing's going to happen to you! To anyone! You're wallowing in your own despair, you fool!"

The bell rang, a signal that the selection had been completed throughout the camp.

With all my might I began to run to Block 36. I met my father on the way. He came up to me:

"Well? So you passed?"

"Yes. And you?"

"Me too."

How we breathed again, now! My father had brought me a present—half a ration of bread obtained in exchange for a piece of rubber, found at the warehouse, which would do to sole a shoe.

The bell. Already we must separate, go to bed. Everything was regulated by the bell. It gave me orders, and I automatically obeyed them. I hated it. Whenever I dreamed of a better world, I could only imagine a universe with no bells.

Several days had elapsed. We no longer thought about the selection. We went to work as usual, loading heavy stones into railway wagons. Rations had become more meager: this was the only change.

We had risen before dawn, as on every day. We had received black coffee, the ration of bread. We were about to set out for the yard as usual. The head of the block arrived, running.

"Silence for a moment. I have a list of numbers here. I'm going to read them to you. Those whose numbers I call won't be going to work this morning; they'll stay behind in the camp."

And, in a soft voice, he read out about ten numbers. We had understood. These were numbers chosen at the selection. Dr. Mengele had not forgotten.

The head of the block went toward his room. Ten prisoners surrounded him, hanging onto his clothes:

"Save us! You promised . . . ! We want to go to the yard. We're strong enough to work. We're good workers. We can . . . we will. . . ."

He tried to calm them, to reassure them about their fate, to explain to them that the fact that they were staying behind in the camp did not mean much, had no tragic significance.

"After all, I stay here myself every day," he added.

It was a somewhat feeble argument. He realized it, and without another word went and shut himself up in his room.

The bell had just rung.

"Form up!"

It scarcely mattered now that the work was hard. The essential thing was to be as far away as possible from the block, from the crucible of death, from the center of hell.

I saw my father running toward me. I became frightened all of a sudden.

"What's the matter?"

Out of breath, he could hardly open his mouth.

"Me, too . . . me, too . . . ! They told me to stay behind in the camp."

They had written down his number without his being aware of it.

"What will happen?" I asked in anguish.

But it was he who tried to reassure me.

"It isn't certain yet. There's still a chance of escape. They're going to do another selection today . . . a decisive selection."

I was silent.

He felt that his time was short. He spoke quickly. He would have liked to say so many things. His speech grew confused; his voice choked. He knew that I would have to go in a few moments. He would have to stay behind alone, so very alone.

"Look, take this knife," he said to me. "I don't need it any longer. It might be useful to you. And take this spoon as well. Don't sell them. Quickly! Go on. Take what I'm giving you!"

The inheritance.

"Don't talk like that, father." (I felt that I would break into sobs.) "I don't want you to say that. Keep the spoon and knife. You need them as much as I do. We shall see each other again this evening, after work."

He looked at me with his tired eyes, veiled with despair. He went on:

"I'm asking this of you. . . . Take them. Do as I ask, my son. We have no time. . . . Do as your father asks."

Our Kapo yelled that we should start.

The unit set out toward the camp gate. Left, right! I bit my lips. My father had stayed by the block, leaning against the wall. Then he began to run, to catch up with us. Perhaps he had forgotten something he wanted to say to me. . . . But we were marching too quickly. . . . Left, right!

We were already at the gate. They counted us, to the din of military music. We were outside.

The whole day, I wandered about as if sleepwalking. Now and then Tibi and Yossi would throw me a brotherly word. The Kapo, too, tried to reassure me. He had given me easier work today. I felt sick at heart. How well they were treating me! Like an orphan! I thought: even now, my father is still helping me.

I did not know myself what I wanted—for the day to pass quickly or not. I was afraid of finding myself alone that night. How good it would be to die here!

At last we began the return journey. How I longed for orders to run!

The military march. The gate. The camp.

I ran to Block 36.

Were there still miracles on this earth? He was alive. He had escaped the second selection. He had been able to prove that he was still useful. . . . I gave him back his knife and spoon.

Catch-22

|1961| Joseph Heller

A cult book of the 1960s and 70s, Catch-22 is a bitter but compassionate satire based on the author's experience of army life in the second world war. It consists of varied episodes illustrative of "Catch-22", which specifies that "a concern for one's own safety in the face of dangers that were real and immediate was the process of a rational mind." (Thereby it implied that warfare can only be carried out by the mentally unbalanced.)

Chapter 39: The Eternal City

Yossarian was going absent without official leave with Milo, who, as the plane cruised toward Rome, shook his head reproachfully and, with pious lips pursed, informed Yossarian in ecclesiastical tones that he was ashamed of him. Yossarian nodded. Yossarian was making an uncouth spectacle of himself by walking around backward with his gun on his hip and refusing to fly more combat missions, Milo said. Yossarian nodded. It was disloyal to his squadron and embarrassing to his superiors. He was placing Milo in a very uncomfortable position, too. Yossarian nodded again. The men were starting to grumble. It was not fair for Yossarian to think only of his own safety while men like Milo, Colonel Cathcart, Colonel Korn and ex-P.F.C. Wintergreen were willing to do everything they could to win the war. The men with seventy missions were starting to grumble because they had to fly eighty, and there was a danger some of them might put on guns and begin walking around backward, too. Morale was deteriorating and it was all Yossarian's fault. The country was in peril; he was jeopardizing his traditional rights of freedom and independence by daring to exercise them.

Yossarian kept nodding in the co-pilot's seat and tried not to listen as Milo prattled on. Nately's whore was on his mind, as were Kraft and Orr and Nately and Dunbar, and Kid Sampson and McWatt, and all the poor and stupid and diseased people he had seen in Italy, Egypt and North Africa and knew about in other areas of the world, and Snowden and Nately's whore's kid sister were on his conscience, too. Yossarian thought he knew why Nately's whore held him responsible for Nately's death and wanted to kill him. Why the hell shouldn't she? It was a man's world, and she and everyone younger had every right to blame him and everyone older for every unnatural tragedy that befell them; just as she, even in her grief, was to blame for every man-made misery that landed on her kid sister and on all other children behind her. Someone had to do something sometime. Every victim was a culprit, every culprit a victim, and somebody had to stand up sometime to try to break the lousy chain of inherited habit that was imperiling them all. In parts of Africa little boys were still stolen away by adult slave traders and sold for money to men who disemboweled them and ate them. Yossarian marveled that children could suffer such barbaric sacrifice without evincing the slightest hint of fear or pain. He took it for granted that they did submit so stoically. If not, he reasoned, the custom would certainly have died, for no craving for wealth or immortality could be so great, he felt, as to subsist on the sorrow of children.

He was rocking the boat, Milo said, and Yossarian nodded once more. He was not a good member of the team, Milo said. Yossarian nodded and listened to Milo tell him that the decent thing to do if he did not like the way Colonel Cathcart and Colonel Korn were running the group was go to Russia, instead of stirring up trouble. Yossarian refrained from pointing out that Colonel Cathcart, Colonel Korn and Milo could all go to Russia if they did not like the way he was stirring up trouble. Colonel Cathcart and Colonel Korn had both been very good to Yossarian, Milo said; hadn't they given him a medal after the last mission to Ferrara and promoted him to captain? Yossarian nodded. Didn't they feed him and give him his pay every month? Yossarian nodded again. Milo was sure they would be charitable if he went to them to apologize and recant and promised to fly eighty missions. Yossarian said he would think it over, and held his breath and prayed for a safe landing as Milo dropped his wheels and glided in toward the runway. It was funny how he had really come to detest flying.

Rome was in ruins, he saw, when the plane was down. The airdrome had been bombed eight months before, and knobby slabs of white stone rubble had been bulldozed into flat-topped heaps on both sides of the entrance through the wire fence surrounding the field. The Colosseum was a dilapidated shell, and the Arch of Constantine had fallen. Nately's whore's apartment was a shambles. The girls were gone, and the only one there was the old woman. The windows in the apartment had been smashed. She was bundled up in sweaters and skirts and wore a dark shawl about her head. She sat on a wooden chair near an electric hot plate, her arms folded, boiling water in a battered aluminium pot. She was talking aloud to herself when Yossarian entered and began moaning as soon as she saw him.

"Gone," she moaned before he could even inquire. Holding her elbows, she rocked back and forth mournfully on her creaking chair. "Gone."

"Who?"

"All. All the poor young girls."

"Where?"

"Away. Chased away into the street. All of them gone. All the poor young girls."

"Chased away by who? Who did it?"

"The mean tall soldiers with the hard white hats and clubs. And by our *carabinieri*. They came with their clubs and chased them away. They would not even let them take their coats. The poor things. They just chased them away into the cold."

"Did they arrest them?"

"They chased them away. They just chased them away."

"Then why did they do it if they didn't arrest them?"

"I don't know," sobbed the old woman. "I don't know. Who will take care of me? Who will take care of me now that the poor young girls are gone? Who will take care of me?"

"There must have been a reason." Yossarian persisted, pounding his fist into his hand. "They couldn't just barge

in here and chase everyone out."

"No reason," wailed the old woman. "No reason."

"What right did they have?"

"Catch-22."

"What?" Yossarian froze in his tracks with fear and alarm and felt his whole body begin to tingle. "What did you say?"

"Catch-22," the old woman repeated, rocking her head up and down. "Catch-22. Catch-22 says they have a right to do anything we can't stop them from doing."

"What the hell are you talking about?" Yossarian shouted at her in bewildered, furious protest. "How did you know it was Catch-22? Who the hell told you it was Catch-22?"

"The soldiers with the hard white hats and clubs. The girls were crying. 'Did we do anything wrong?' they said. The men said no and pushed them away out the door with the ends of their clubs. 'Then why are you chasing us out?' the girls said. 'Catch-22,' the men said. 'What right do you have?' the girls said. 'Catch-22,' the men said. All they kept saying was 'Catch-22, Catch-22.' What does it mean, Catch-22? What is Catch-22?"

"Didn't they show it to you?" Yossarian demanded, stamping about in anger and distress. "Didn't you even make them read it?"

"They don't have to show us Catch-22," the old woman answered. "The law says they don't have to."

"What law says they don't have to?"

"Catch-22."

"Oh, God damn!" Yossarian exclaimed bitterly. "I bet it wasn't even really there." He stopped walking and glanced about the room disconsolately. "Where's the old man?"

"Gone," mourned the old woman.

"Gone?"

"Dead," the old woman told him, nodding in emphatic lament, pointing to her head with the flat of her hand. "Something broke in here. One minute he was living, one minute he was dead."

"But he can't be dead!" Yossarian cried, ready to argue insistently. But of course he knew it was true, knew it was logical and true: once again the old man had marched along with the majority.

Yossarian turned away and trudged through the apartment with a gloomy scowl, peering with pessimistic curiosity into all the rooms. Everything made of glass had been smashed by the men with the clubs. Torn drapes and bedding lay dumped on the floor. Chairs, tables and dressers had been overturned. Everything breakable had been broken. The destruction was total. No wild vandals could have been more thorough. Every window was smashed, and darkness poured like inky clouds into each room through the shattered panes. Yossarian could imagine the heavy, crashing footfalls of the tall M.P.s in the hard white hats. He could picture the fiery and malicious exhilaration with which they had made their wreckage, and their sanctimonious, ruthless sense of right and dedication. All the poor young girls were gone. Everyone was gone but the weeping old woman in the bulky brown and gray sweaters and black head shawl, and soon she too would be gone.

"Gone," she grieved, when he walked back in, before he could even speak. "Who will take care of me now?"

Yossarian ignored the question. "Nately's girlfriend—did anyone hear from her?" he asked.

"Gone."

"I know she's gone. But did anyone hear from her? Does anyone know where she is?"

"Gone."

"The little sister. What happened to her?"

"Gone." The old woman's tone had not changed.

"Do you know what I'm talking about?" Yossarian asked sharply, staring into her eyes to see if she were not speaking to him from a coma. He raised his voice. "What happened to the kid sister, to the little girl?"

"Gone, gone," the old woman replied with a crabby shrug, irritated by his persistence, her low wail growing louder. "Chased away with the rest, chased away into the street. They would not even let her take her coat."

"Where did she go?"

"I don't know. I don't know."

"Who will take care of her?"

"Who will take care of me?"

"She doesn't know anybody else, does she?"

"Who will take care of me?"

Yossarian left money in the old woman's lap—it was odd how many wrongs leaving money seemed to right—and strode out of the apartment, cursing Catch-22 vehemently as he descended the stairs, even though he knew there was no such thing. Catch-22 did not exist, he was positive of that, but it made no difference. What did matter was that everyone thought it existed, and that was much worse, for there was no object or text to ridicule or refute, to accuse, criticize, attack, amend, hate, revile, spit at, rip to shreds, trample upon or burn up.

It was cold outside, and dark, and a leaky, insipid mist lay swollen in the air and trickled down the large, unpolished stone blocks of the houses and the pedestals of monuments. Yossarian hurried back to Milo and recanted. He said he was sorry and, knowing he was lying, promised to fly as many more missions as Colonel Cathcart wanted if Milo would only use all his influence in Rome to help him locate Nately's whore's kid sister.

"She's just a twelve-year-old virgin, Milo," he explained anxiously, "and I want to find her before it's too late."

Milo responded to his request with a benign smile. "I've got just the twelve-year-old virgin you're looking for," he announced jubilantly. "This twelve-year-old virgin is really only thirty-four, but she was brought up on a low-protein diet by very strict parents and didn't start sleeping with men until—"

"Milo, I'm talking about a little girl!" Yossarian interrupted him with desperate impatience. "Don't you understand? I don't want to sleep with her. I want to help her. You've got daughters. She's just a little kid, and she's all alone in this city with no one to take care of her. I want to protect her from harm. Don't you know what I'm talking about?"

Milo did understand and was deeply touched. "Yossarian, I'm proud of you," he exclaimed with profound emotion. "I really am. You don't know how glad I am to see that everything isn't always just sex with you. You've got principles. Certainly I've got daughters, and I know

exactly what you're talking about. We'll find that girl. Don't you worry. You come with me and we'll find that girl if we have to turn this whole city upside down. Come along."

Yossarian went along in Milo Minderbinder's speeding M & M staff car to police headquarters to meet a swarthy, untidy police commissioner with a narrow black mustache and unbuttoned tunic who was fiddling with a stout woman with warts and two chins when they entered his office and who greeted Milo with warm surprise and bowed and scraped in obscene servility as though Milo were some elegant marquis.

"Ah, Marchese Milo," he declared with effusive pleasure, pushing the fat, disgruntled woman out the door without even looking toward her. "Why didn't you tell me you were coming? I would have a big party for you. Come in, come in, Marchese. You almost never visit us any more."

Milo knew that there was not one moment to waste. "Hello, Luigi," he said, nodding so briskly that he almost seemed rude. "Luigi, I need your help. My friend here wants to find a girl."

"A girl, Marchese?" said Luigi, scratching his face pensively. "There are lots of girls in Rome. For an American officer, a girl should not be too difficult."

"No, Luigi, you don't understand. This is a twelve-year-old virgin that he has to find right away."

"Ah, yes, now I understand," Luigi said sagaciously. "A virgin might take a little time. But if he waits at the bus terminal where the young farm girls looking for work arrive, I—"

"Luigi, you still don't understand," Milo snapped with such brusque impatience that the police commissioner's face flushed and he jumped to attention and began buttoning his uniform in confusion. "This girl is a friend, an old friend of the family, and we want to help her. She's only a child. She's all alone in this city somewhere, and we have to find her before somebody harms her. Now do you understand? Luigi, this is very important to me. I have a daughter the same age as that little girl, and nothing in the world means more to me right now than saving that poor child before it's too late. Will you help?"

"Si, Marchese, now I understand," said Luigi. "And I will do everything in my power to find her. But tonight I have almost no men. Tonight all my men are busy trying to break up the traffic in illegal tobacco."

"Illegal tobacco?" asked Milo.

"Milo," Yossarian bleated faintly with a sinking heart, sensing at once that all was lost.

"Si, Marchese," said Luigi. "The profit in illegal tobacco is so high that the smuggling is almost impossible to control."

"Is there really that much profit in illegal tobacco?" Milo inquired with keen interest, his rust-colored eyebrows arching avidly and his nostrils sniffing.

"Milo," Yossarian called to him. "Pay attention to me, will you?"

"Si, Marchese," Luigi answered. "The profit in illegal tobacco is very high. The smuggling is a national scandal, Marchese, truly a national disgrace."

"Is that a fact?" Milo observed with a preoccupied smile and started toward the door as though in a spell.

"Milo!" Yossarian yelled, and bounded forward impulsively to intercept him. "Milo, you've got to help me."

"Illegal tobacco," Milo explained to him with a look of epileptic lust, struggling doggedly to get by. "Let me go. I've got to smuggle illegal tobacco."

"Stay here and help me find her," pleaded Yossarian. "You can smuggle illegal tobacco tomorrow."

But Milo was deaf and kept pushing forward, nonviolently but irresistibly, sweating, his eyes, as though he were in the grip of a blind fixation, burning feverishly, and his twitching mouth slavering. He moaned calmly as though in remote, instinctive distress and kept repeating, "Illegal tobacco, illegal tobacco." Yossarian stepped out of the way with resignation finally when he saw it was hopeless to try to reason with him. Milo was gone like a shot. The commissioner of police unbuttoned his tunic again and looked at Yossarian with contempt.

"What do yo want here?" he asked coldly. "Do you want me to arrest you?"

Yossarian walked out of the office and down the stairs into the dark, tomblike street, passing in the hall the stout woman with warts and two chins, who was already on her way back in. There was no sign of Milo outside. There were no lights in any of the windows. The deserted sidewalk rose steeply and continuously for several blocks. He could see the glare of a broad avenue at the top of the long cobblestone incline. The police station was almost at the bottom: the yellow bulbs at the entrance sizzled in the dampness like wet torches. A frigid, fine rain was falling. He began walking slowly, pushing uphill. Soon he came to a quiet, cozy, inviting restaurant with red velvet drapes in the windows and a blue neon sign near the door that said: TONY'S RESTAURANT. FINE FOOD AND DRINK. KEEP OUT. The words on the blue neon sign surprised him mildly for only an instant. Nothing warped seemed bizarre any more in his strange, distorted surroundings. The tops of the sheer buildings slanted in weird, surrealistic perspective, and the street seemed tilted. He raised the collar of his warm woolen coat and hugged it around him. The night was raw. A boy in a thin shirt and thin tattered trousers walked out of the darkness on bare feet. The boy had black hair and needed a haircut and shoes and socks. His sickly face was pale and sad. His feet made grisly, soft, sucking sounds in the rain puddles on the wet pavement as he passed, and Yossarian was moved by such intense pity for his poverty that he wanted to smash his pale, sad, sickly face with his fist and knock him out of existence because he brought to mind *all* the pale, sad, sickly children in Italy that same night who needed haircuts and needed shoes and socks. He made Yossarian think of cripples and of cold and hungry men and women, and of all the dumb, passive, devout mothers with catatonic eyes nursing infants outdoors that same night with chilled animal udders bared insensibly to that same raw rain. Cows. Almost on cue, a nursing mother padded past holding an infant in black rags, and Yossarian wanted to smash her too, because she reminded him of the barefoot boy in the thin shirt and thin, tattered trousers and of all the shivering, stupefying misery in a world that never yet had provided enough heat and food and justice for all but

an ingenious and unscrupulous handful. What a lousy earth! He wondered how many people were destitute that same night even in his own prosperous country, how many homes were shanties, how many thousands were drunk and wives socked, and how many children were bullied, abused or abandoned. How many families hungered for food they could not afford to buy? How many hearts were broken? How many suicides would take place that same night, how many people would go insane? How many cockroaches and landlords would triumph? How many winners were losers, successes failures, rich men poor men? How many wise guys were stupid? How many happy endings were unhappy endings? How many honest men were liars, brave men cowards, loyal men traitors, how many sainted men were corrupt, how many people in positions of trust had sold their souls to blackguards for petty cash, how many had never had souls? How many straight-and-narrow paths were crooked paths? How many best families were worst families and how many good people were bad people? When you added them all up and then subtracted, you might be left with only the children, and perhaps with Albert Einstein and an old violinist or sculptor somewhere. Yossarian walked in lonely torture, feeling estranged, and could not wipe from his mind the excruciating image of the barefoot boy with sickly cheeks until he turned the corner into the avenue finally and came upon an Allied soldier having convulsions on the ground, a young lieutenant with a small, pale, boyish face. Six other soldiers from different countries wrestled with different parts of him, striving to help him and hold him still. He yelped and groaned unintelligibly through clenched teeth, his eyes rolling up into his head. "Don't let him bite his tongue off," a short sergeant near Yossarian advised shrewdly, and a seventh man threw himself into the fray to wrestle with the ill lieutenant's face. All at once the wrestlers won and turned to each other undecidedly, for now that they held the young lieutenant rigid they did not know what to do with him. A quiver of moronic panic spread from one straining brute face to another. "Why don't you lift him and put him on the hood of that car?" a corporal standing in back of Yossarian drawled. That seemed to make sense, so the seven men lifted the young lieutenant up and stretched him out carefully on the hood of a parked car, still pinning each struggling part of him down. Once they had him stretched out on the hood of the parked car, they stared at each other uneasily again, for they had no idea what to do with him next. "Why don't you lift him up off the hood of that car and lay him down on the ground?" drawled the same corporal behind Yossarian. That seemed like a good idea, too, and they began to move him back to the sidewalk, but before they could finish, a jeep raced up with a flashing red spotlight at the side and two military policemen in the front seat.

"What's going on?" the driver yelled.

"He's having convulsions," one of the men grappling with one of the young lieutenant's limbs answered. "We're holding him still."

"That's good. He's under arrest."

"What should we do with him?"

"Keep him under arrest!" the M.P. shouted, doubling over with raucous laughter at his jest, and sped away in his jeep.

Yossarian recalled that he had no leave papers and moved prudently past the strange group toward the sound of muffled voices emanating from a distance inside the murky darkness ahead. The broad, rain-blotched boulevard was illuminated every half-block by short, curling lampposts with eerie, shimmering glares surrounded by smoky brown mist. From a window overhead he heard an unhappy female voice pleading, "Please don't. Please don't." A despondent young woman in a black raincoat with much black hair on her face passed with her eyes lowered. At the Ministry of Public Affairs on the next block, a drunken lady was backed up against one of the fluted Corinthian columns by a drunken young soldier, while three drunken comrades in arms sat watching nearby on the steps with wine bottles standing between their legs. "Pleeshe don't," begged the drunken lady. 'I want to go home now. Pleeshe don't." One of the three sitting men cursed pugnaciously and hurled a wine bottle down at Yossarian when he turned to look up. The bottle shattered harmlessly far away with a brief and muted noise. Yossarian continued walking away at the same listless, unhurried pace, hands buried in his pockets. "Come on, baby," he heard the drunken soldier urge determinedly. "It's my turn now." "Pleeshe don't," begged the drunken lady. "Pleeshe don't.' At the very next corner, deep inside the dense impenetrable shadows of a narrow, winding side street, he heard the mysterious, unmistakable sound of someone shoveling snow. The measured, labored, evocative scrape of iron shovel against concrete made his flesh crawl with terror as he stepped from the curb to cross the ominous alley and hurried onward until the haunting, incongruous noise had been left behind. Now he knew where he was; soon, if he continued without turning, he would come to the dry fountain in the middle of the boulevard, then to the officers' apartment seven blocks beyond. He heard snarling, inhuman voices cutting through the ghostly blackness in front suddenly. The bulb on the corner lamppost had died, spilling gloom over half the street, throwing everything visible off balance. On the other side of the intersection, a man was beating a dog with a stick like the man who was beating the horse with a whip in Raskolnikov's dream. Yossarian strained helplessly not to see or hear. The dog whimpered and squealed in brute, dumbfounded hysteria at the end of an old Manila rope and groveled and crawled on its belly without resisting, but the man beat it and beat it anyway with his heavy, flat stick. A small crowd watched. A squat woman stepped out and asked him please to stop. "Mind your own business," the man barked gruffly, lifting his stick as though he might beat her too, and the woman retreated sheepishly with an abject and humiliated air. Yossarian quickened his pace to get away, almost ran. The night was filled with horrors, and he thought he knew how Christ must have felt as he walked through the world, like a psychiatrist through a ward full of nuts, like a victim through a prison full of thieves. What a welcome sight a leper must have been! At the next corner a man was beating a small boy brutally in the midst of an immobile crowd of adult spectators who made no effort to intervene.

Yossarian recoiled with sickening recognition. He was certain he had witnessed that same horrible scene sometime before. Déjavu? The sinister coincidence shook him and filled him with doubt and dread. It was the same scene he had witnessed a block before, although everything in it seemed quite different. What in the world was happening? Would a squat woman step out and ask the man to please stop? Would he raise his hand to strike her and would she retreat? Nobody moved. The child cried steadily as though in drugged misery. The man kept knocking him down with hard, resounding open-palm blows to the head, then jerking him up to his feet in order to knock him down again. No one in the sullen, cowering crowd seemed to care enough about the stunned and beaten boy to interfere. The child was no more than nine. One drab woman was weeping silently into a dirty dish towel. The boy was emaciated and needed a haircut. Bright-red blood was streaming from both ears. Yossarian crossed quickly to the other side of the immense avenue to escape the nauseating sight and found himself walking on human teeth lying on the drenched, glistening pavement near splotches of blood kept sticky by the pelting raindrops poking each one like sharp fingernails. Molars and broken incisors lay scattered everywhere. He circled on tiptoe the grotesque debris and came near a doorway containing a crying soldier holding a saturated handkerchief to his mouth, supported as he sagged by two other soldiers waiting in grave impatience for the military ambulance that finally came clanging up with amber fog lights on and passed them by for an altercation on the next block between a single civilian Italian with books and a slew of civilian policemen with armlocks and clubs. The screaming, struggling civilian was a dark man with a face white as flour from fear. His eyes were pulsating in hectic desperation, flapping like bat's wings, as the many tall policemen seized him by arms and legs and lifted him up. His books were spilled on the ground. "Help!" he shrieked shrilly in a voice strangling in its own emotion as the policemen carried him to the open doors in the rear of the ambulance and threw him inside. "Police! Help! Police!" the doors were shut and bolted, and the ambulance raced away. There was a humorless irony in the ludicrous panic of the man screaming for help to the police while policemen were all around him. Yossarian smiled wryly at the futile and ridiculous cry for aid, then saw with a start that the words were ambiguous, realized with alarm that they were not, perhaps, intended as a call for police but as a heroic warning from the grave by a doomed friend to everyone who was *not* a policeman with a club and a gun and a mob of other policemen with clubs and guns to back him up. "Help! Police!" the man had cried, and he could have been shouting of danger. Yossarian responded to the thought by slipping away stealthily from the police and almost tripped over the feet of a burly woman of forty hastening across the intersection guiltily, darting furtive, vindictive glances behind her toward a woman of eighty with thick, bandaged ankles doddering after her in a losing pursuit. The old woman was gasping for breath as she minced along and muttering to herself in distracted agitation. There was no mistaking the nature of the scene; it was a chase. The triumphant first woman was halfway

across the wide avenue before the second woman reached the curb. The nasty, small, gloating smile with which she glanced back at the laboring old woman was both wicked and apprehensive. Yossarian knew he could help the troubled old woman if she would only cry out, knew he could spring forward and capture the sturdy first woman and hold her for the mob of policemen nearby if the second woman would only give him license with a shriek of distress. But the old woman passed by without even seeing him, mumbling in terrible, tragic vexation, and soon the first woman had vanished into the deepening layers of darkness and the old woman was left standing helplessly in the center of the thoroughfare, dazed, uncertain which way to proceed, alone. Yossarian tore his eyes from her and hurried away in shame because he had done nothing to assist her. He darted furtive, guilty glances back as he fled in defeat, afraid the old woman might now start following him, and he welcomed the concealing shelter of the drizzling, drifting, lightless, nearly opaque gloom. Mobs . . . mobs of policemen—everything but England was in the hands of mobs, mobs, mobs. Mobs with clubs were in control everywhere.

The surface of the collar and shoulders of Yossarian's coat was soaked. His socks were wet and cold. The light on the next lamppost was out, the glass globe broken. Buildings and featureless shapes flowed by him noiselessly as though borne past immutably on the surface of some rank and timeless tide. A tall monk passed, his face buried entirely inside a coarse gray cowl, even the eyes hidden. Footsteps sloshed toward him steadily through a puddle, and he feared it would be another barefoot child. He brushed by a gaunt, cadaverous, tristful man in a black raincoat with a star-shaped scar in his cheek and a glossy mutilated depression the size of an egg in one temple. On squishing straw sandals, a young woman materialized with her whole face disfigured by a God-awful pink and piebald burn that started on her neck and stretched in a raw, corrugated mass up both cheeks past her eyes! Yossarian could not bear to look, and shuddered. No one would ever love her. His spirit was sick; he longed to lie down with some girl he could love who would soothe and excite him and put him to sleep. A mob with a club was waiting for him in Pianosa. The girls were all gone. The countess and her daughter-in-law were no longer good enough; he had grown too old for fun, he no longer had the time. Luciana was gone, dead, probably; if not yet then soon enough. Aarfy's buxom trollop had vanished with her smutty cameo ring, and Nurse Duckett was ashamed of him because he had refused to fly more combat missions and would cause a scandal. The only girl he knew nearby was the plain maid in the officers' apartment, whom none of the men had ever slept with. Her name was Michaela, but the men called her filthy things in dulcet, ingratiating voices, and she giggled with childish joy because she understood no English and thought they were flattering her and making harmless jokes. Everything wild she watched them do filled her with enchanted delight. She was a happy, simple-minded, hard-working girl who could not read and was barely able to write her name. Her straight hair was the color of retting straw. She had sallow skin and myopic eyes, and none of

the men had ever slept with her because none of the men had ever wanted to, none but Aarfy, who had raped her once that same evening and had then held her prisoner in a clothes closet for almost two hours with his hand over her mouth until the civilian curfew sirens sounded and it was unlawful for her to be outside.

Then he threw her out the window. Her dead body was still lying on the pavement when Yossarian arrived and pushed his way politely through the circle of solemn neighbors with dim lanterns, who glared with venom as they shrank away from him and pointed up bitterly toward the second-floor windows in their private, grim, accusing conversations. Yossarian's heart pounded with fright and horror at the pitiful, ominous, gory spectacle of the broken corpse. He ducked into the hallway and bolted up the stairs into the apartment, where he found Aarfy pacing about uneasily with a pompous, slightly uncomfortable smile. Aarfy seemed a bit unsettled as he fidgeted with his pipe and assured Yossarian that everything was going to be all right. There was nothing to worry about.

"I only raped her once," he explained.

Yossarian was aghast. "But you killed her, Aarfy! You killed her!"

"Oh, I had to do that after I raped her," Aarfy replied in his most condescending manner. "I couldn't very well let her go around saying bad things about us, could I!"

"But why did you have to touch her at all, you dumb bastard?" Yossarian shouted. "Why couldn't you get yourself a girl off the street if you wanted one? This city is full of prostitutes."

"Oh, no, not me," Aarfy bragged. "I never paid for it in my life."

"Aarfy, are you insane?" Yossarian was almost speechless. "You *killed* a girl. They're going to put you in jail!"

"Oh, no," Aarfy answered with a forced smile. "Not me. They aren't going to put good old Aarfy in jail. Not for killing *her*."

"But you threw her out the window. She's lying there dead in the street."

"She has no right to be there," Aarfy answered. "It's after curfew."

"Stupid! Don't you realize what you've done?" Yossarian wanted to grab Aarfy by his well-fed, caterpillar-soft shoulders and shake some sense into him. "You've murdered a human being. They *are* going to put you in jail. They might even *hang* you!"

"Oh, I hardly think they'll do that," Aarfy replied with a jovial chuckle, although his symptoms of nervousness increased. He spilled tobacco crumbs unconsciously as his short fingers fumbled with the bowl of his pipe. "No, sirree. Not to good old Aarfy." He chortled again. "She was only a servant girl. I hardly think they're going to make too much of a fuss over one poor Italian servant girl when so many thousands of lives are being lost every day. Do you?"

"Listen!" Yossarian cried, almost in joy. He pricked up his ears and watched the blood drain from Aarfy's face as sirens mourned far away, police sirens, and then ascended almost instantaneously to a howling, strident, onrushing cacophony of overwhelming sound that seemed to crash into the room around them from every side. "Aarfy, they're coming for you," he said in a flood of compassion, shouting to be heard above the noise. "They're coming to arrest you. Aarfy, don't you understand? You can't take the life of another human being and get away with it, even if she is just a poor servant girl. Don't you see? Can't you understand?"

"Oh, no," Aarfy insisted with a lame laugh and a weak smile. "They're not coming to arrest me. Not good old Aarfy."

All at once he looked sick. He sank down on a chair in a trembling stupor, his stumpy, lax hands quaking in his lap. Cars skidded to a stop outside. Spotlights hit the windows immediately. Car doors slammed and police whistles screeched. Voices rose harshly. Aarfy was green. He kept shaking his head mechanically with a queer, numb smile and repeating in a weak, hollow monotone that they were not coming for him, not for good old Aarfy, no sirree, striving to convince himself that this was so even as heavy footsteps raced up the stairs and pounded across the landing, even as fists beat on the door four times with a deafening, inexorable force. Then the door to the apartment flew open, and two large, tough, brawny M.P.s with icy eyes and firm, sinewy, unsmiling jaws entered quickly, strode across the room, and arrested Yossarian.

They arrested Yossarian for being in Rome without a pass.

They apologized to Aarfy for intruding and led Yossarian away between them, gripping him under each arm with fingers as hard as steel manacles. They said nothing at all to him on the way down. Two more tall M.P.s with clubs and hard white helmets were waiting outside at a closed car. They marched Yossarian into the back seat, and the car roared away and weaved through the rain and muddy fog to a police station. The M.P.s locked him up for the night in a cell with four stone walls. At dawn they gave him a pail for a latrine and drove him to the airport, where two more giant M.P.s with clubs and white helmets were waiting at a transport plane whose engines were already warming up when they arrived, the cylindrical green cowlings oozing quivering beads of condensation. None of the M.P.s said anything to each other either. They did not even nod. Yossarian had never seen such granite faces. The plane flew to Pianosa. Two more silent M.P.s were waiting at the landing strip. There were now eight, and they filed with precise, wordless discipline into two cars and sped on humming tires past the four squadron areas to the Group Headquarters building, where still two more M.P.s were waiting at the parking area. All ten tall, strong, purposeful, silent men towered around him as they turned toward the entrance. Their footsteps crunched in loud unison on the cindered ground. He had an impression of accelerating haste. He was terrified. Every one of the ten M.P.s seemed powerful enough to bash him to death with a single blow. They had only to press their massive, toughened, boulderous shoulders against him to crush all life from his body. There was nothing he could do to save himself. He could not even see which two were gripping him under the arms as they marched him rapidly between the two tight single-file columns they had formed. Their pace quickened, and he felt as though he were flying

along with his feet off the ground as they trotted in resolute cadence up the wide marble staircase to the upper landing, where still two more inscrutable military policemen with hard faces were waiting to lead them all at an even faster pace down the long, cantilevered balcony overhanging the immense lobby. Their marching footsteps on the dull tile floor thundered like an awesome, quickening drum roll through the vacant center of the building as they moved with even greater speed and precision toward Colonel Cathcart's office, and violent winds of panic began blowing in Yossarian's ears when they turned him toward his doom inside the office, where Colonel Korn, his rump spreading comfortably on a corner of Colonel Cathcart's desk, sat waiting to greet him with a genial smile and said,

"We're sending you home."

Everyday Use

|1973| Alice Walker

for your grandmama

I will wait for her in the yard that Maggie and I made so clean and wavy yesterday afternoon. A yard like this is more comfortable than most people know. It is not just a yard. It is like an extended living-room. When the hard clay is swept clean as a floor and the fine sand around the edges lined with tiny, irregular grooves, anyone can come and sit and look up into the elm tree and wait for the breezes that never come inside the house.

Maggie will be nervous until after her sister goes: she will stand hopelessly in corners, homely and ashamed of the burn scars down her arms and legs, eyeing her sister with a mixture of envy and awe. She thinks her sister has held life always in the palm of one hand, that "no" is a word the world never learned to say to her.

You've no doubt seen those TV shows where the child who has "made it" is confronted, as a surprise, by her own mother and father, tottering in weakly from backstage. (A pleasant surprise, of course: What would they do if parent and child came on the show only to curse out and insult each other?) On TV mother and child embrace and smile into each other's faces. Sometimes the mother and father weep, the child wraps them in her arms and leans across the table to tell how she would not have made it without their help. I have seen these programs.

Sometimes I dream a dream in which Dee and I are suddenly brought together on a TV program of this sort. Out of a dark and soft-seated limousine I am ushered into a bright room filled with many people. There I meet a smiling, grey, sporty man like Johnny Carson who shakes my hand and tells me what a fine girl I have. Then we are on the stage and Dee is embracing me with tears in her eyes. She pins on my dress a large orchid, even though she has told me once that she thinks orchids are tacky flowers.

In real life I am a large, big-boned woman with rough, man-working hands. In the winter I wear flannel night-gowns to bed and overalls during the day. I can kill and clean a hog as mercilessly as a man. My fat keeps me hot in zero weather. I can work outside all day, breaking ice to get water for washing; I can eat pork liver cooked over the open fire minutes after it comes steaming from the hog. One winter I knocked a bull calf straight in the brain between the eyes with a sledge hammer and had the meat hung up to chill before nightfall. But of course all this does not show on television. I am the way my daughter would want me to be: a hundred pounds lighter, my skin like an uncooked barley pancake. My hair glistens in the hot bright lights. Johnny Carson has much to do to keep up with my quick and witty tongue.

But that is a mistake. I know even before I wake up. Who ever knew a Johnson with a quick tongue? Who can even imagine me looking a strange white man in the eye? It seems to me I have talked to them always with one foot raised in flight, with my head turned in whichever way is farthest from them. Dee, though. She would always look anyone in the eye. Hesitation was no part of her nature.

"How do I look, Mama?" Maggie says, showing just enough of her thin body enveloped in pink skirt and red blouse for me to know she's there, almost hidden by the door.

"Come out into the yard," I say.

Have you ever seen a lame animal, perhaps a dog run over by some careless person rich enough to own a car, sidle up to someone who is ignorant enough to be kind to him? That is the way my Maggie walks. She has been like this, chin on chest, eyes on ground, feet in shuffle, ever since the fire that burned the other house to the ground.

Dee is lighter than Maggie, with nicer hair and a fuller figure. She's a woman now, though sometimes I forget. How long ago was it that the other house burned? Ten, twelve years? Sometimes I can still hear the flames and feel Maggie's arms sticking to me, her hair smoking and her dress falling off her in little black papery flakes. Her eyes seemed stretched open, blazed open by the flames reflected in them. And Dee. I see her standing off under the sweet gum tree she used to dig gum out of; a look of concentration on her face as she watched the last dingy grey board of the house fall in toward the red-hot brick chimney. Why don't you do a dance around the ashes? I'd wanted to ask her. She had hated the house that much.

I used to think she hated Maggie, too. But that was before we raised the money, the church and me, to send her to Augusta to school. She used to read to us without pity; forcing words, lies, other folks' habits, whole lives upon us two, sitting trapped and ignorant underneath her voice. She washed us in a river of make-believe, burned us with a lot of knowledge we didn't necessarily need to know. Pressed us to her with the serious way she read, to shove us away at just the moment, like dimwits, we seemed about to understand.

Dee wanted nice things. A yellow organdie dress to wear to her graduation from high school; black pumps to match a green suit she'd made from an old suit somebody gave me. She was determined to stare down any disaster in her efforts. Her eyelids would not flicker for minutes at a time. Often I fought off the temptation to shake her. At sixteen she had a style of her own: and knew what style was.

I never had an education myself. After second grade the school was closed down. Don't ask me why: in 1927 colored asked fewer questions than they do now. Sometimes Maggie reads to me. She stumbles along good-naturedly but can't see well. She knows she is not bright. Like good looks and money, quickness passed her by. She will marry John Thomas (who has mossy teeth in an earnest face) and then I'll be free to sit here and I guess just sing church songs to myself. Although I never was a good singer. Never could carry a tune. I was always better at a man's job. I used to love to milk till I was hooked in the side in '49. Cows are soothing and slow and don't bother you, unless you try to milk them the wrong way.

I have deliberately turned my back on the house. It is three rooms, just like the one that burned, except the roof is tin; they don't make shingle roofs any more. There are no real windows, just some holes cut in the sides, like the portholes in a ship, but not round and not square, with rawhide holding the shutters up on the outside. This house is in a pasture, too, like the other one. No doubt when Dee sees it she will want to tear it down. She wrote me once that no matter where we "choose" to live, she will manage to come see us. But she will never bring her friends. Maggie and I thought about this and Maggie asked me, "Mama, when did Dee ever *have* any friends?"

She had a few. Furtive boys in pink shirts hanging about on washday after school. Nervous girls who never laughed. Impressed with her they worshiped the well-turned phrase, the cute shape, the scalding humor that erupted like bubbles in lye. She read to them.

When she was courting Jimmy T she didn't have much time to pay to us, but turned all her faultfinding power on him. He *flew* to marry a cheap city girl from a family of ignorant flashy people. She hardly had time to recompose herself

When she comes I will meet—but there they are!

Maggie attempts to make a dash for the house, in her shuffling way, but I stay her with my hand. "Come back here," I say. And she stops and tries to dig a well in the sand with her toe.

It is hard to see them clearly through the strong sun. But even the first glimpse of leg out of the car tells me it is Dee. Her feet were always neat-looking, as if God himself had shaped them with a certain style. From the other side of the car comes a short, stocky man. Hair is all over his head a foot long and hanging from his chin like a kinky mule tail. I hear Maggie suck in her breath. "Uhnnnh," is what it sounds like. Like when you see the wriggling end of a snake just in front of your foot on the road. "Uhnnnh."

Dee next. A dress down to the ground, in this hot weather. A dress so loud it hurts my eyes. There are yellows and oranges enough to throw back the light of the sun. I feel my whole face warming from the heat waves it throws out. Earrings gold, too, and hanging down to her shoulders. Bracelets dangling and making noises when she moves her arm up to shake the folds of the dress out of her armpits. The dress is loose and flows, and as she walks closer, I like it. I hear Maggie go "Uhnnnh" again. It is her sister's hair. It stands straight up like the wool on a sheep.

It is black as night and around the edges are two long pigtails that rope about like small lizards disappearing behind her ears.

"Wa-su-zo-Tean-o!" she says, coming on in that gliding way the dress makes her move. The short stocky fellow with the hair to his navel is all grinning and he follows up with "Asalamalakim, my mother and sister!" He moves to hug Maggie but she falls back, right up against the back of my chair. I feel her trembling there and when I look up I see the perspiration falling off her chin.

"Don't get up," says Dee. Since I am stout it takes something of a push. You can see me trying to move a second or two before I make it. She turns, showing white heels through her sandals, and goes back to the car. Out she peeks next with a Polaroid. She stoops down quickly and lines up picture after picture of me sitting there in front of the house with Maggie cowering behind me. She never takes a shot without making sure the house is included. When a cow comes nibbling around the edge of the yard she snaps it and me and Maggie *and* the house. Then she puts the Polaroid in the back seat of the car, and comes up and kisses me on the forehead.

Meanwhile Asalamalakim is going through motions with Maggie's hand. Maggie's hand is as limp as a fish, and probably as cold, despite the sweat, and she keeps trying to pull it back. It looks like Asalamalakim wants to shake hands but wants to do it fancy. Or maybe he don't know how people shake hands. Anyhow, he soon gives up on Maggie.

"Well," I say. "Dee."

"No, Mama," she says. "Not 'Dee,' Wangero Leewanika Kemanjo!"

"What happened to 'Dee'?" I wanted to know.

"She's dead," Wangero said. "I couldn't bear it any longer, being named after the people who oppress me."

"You know as well as me you was named after your aunt Dicie," I said. Dicie is my sister. She named Dee. We called her "Big Dee" after Dee was born.

"But who was *she* named after?" asked Wangero.

"I guess after Grandma Dee," I said.

"And who was she named after?" asked Wangero.

"Her mother," I said, and saw Wangero was getting tired. "That's about as far back as I can trace it," I said. Though, in fact, I probably could have carried it back beyond the Civil War through the branches.

"Well," said Asalamalakim, "there you are."

"Uhnnnh," I heard Maggie say.

"There I was not." I said, "before 'Dicie' cropped up in our family, so why should I try to trace it that far back?"

He just stood there grinning, looking down on me like somebody inspecting a Model A car. Every once in a while he and Wangero sent eye signals over my head.

"How do you pronounce this name?" I asked.

"You don't have to call me by it if you don't want to," said Wangero.

"Why shouldn't I?" I asked. "If that's what you want us to call you, we'll call you."

"I know it might sound awkward at first," said Wangero.

"I'll get used to it," I said. "Ream it out again."

Well, soon we got the name out of the way. Asalamalakim had a name twice as long and three times as hard. After I tripped over it two or three times he told me to just call him Hakim-a-barber. I wanted to ask him was he a barber, but I didn't really think he was, so I didn't ask.

"You must belong to those beef-cattle peoples down the road," I said. They said "Asalamalakim" when they met you, too, but they didn't shake hands. Always too busy: feeding the cattle, fixing the fences, putting up salt-lick shelters, throwing down hay. When the white folks poisoned some of the herd the men stayed up all night with rifles in their hands. I walked a mile and a half just to see the sight.

Hakim-a-barber said, "I accept some of their doctrines, but farming and raising cattle is not my style." (They didn't tell me, and I didn't ask, whether Wangero (Dee) had really gone and married him.)

We sat down to eat and right away he said he didn't eat collards and pork was unclean. Wangero, though, went on through the chitlins and corn bread, the greens and everything else. She talked a blue streak over the sweet potatoes. Everything delighted her. Even the fact that we still used the benches her daddy made for the table when we couldn't afford to buy chairs.

"Oh, Mama!" she cried. Then turned to Hakim-a-barber. "I never knew how lovely these benches are. You can feel the rump prints," she said, running her hands underneath her and along the bench. Then she gave a sigh and her hand closed over Grandma Dee's butter dish. "That's it!" she said. "I knew there was something I wanted to ask you if I could have." She jumped up from the table and went over in the corner where the churn stood, the milk in it clabber by now. She looked at the churn and looked at it.

"This churn top is what I need," she said. "Didn't Uncle Buddy whittle it out of a tree you all used to have?"

"Yes," I said.

"Uh huh," she said happily. "And I want the dasher, too."

"Uncle Buddy whittle that, too?" asked the barber.

Dee (Wangero) looked up at me.

"Aunt Dee's first husband whittled the dash," said Maggie so low you almost couldn't hear her. "His name was Henry, but they called him Stash."

"Maggie's brain is like an elephant's," Wangero said, laughing. "I can use the churn top as a centrepiece for the alcove table," she said, sliding a plate over the churn, "and I'll think of something artistic to do with the dasher."

When she finished wrapping the dasher the handle stuck out. I took it for a moment in my hands. You didn't even have to look close to see where hands pushing the dasher up and down to make butter had left a kind of sink in the wood. In fact, there were a lot of small sinks; you could see where thumbs and fingers had sunk into the wood. It was beautiful light yellow wood, from a tree that grew in the yard where Big Dee and Stash had lived.

After dinner Dee (Wangero) went to the trunk at the foot of my bed and started rifling through it. Maggie hung back in the kitchen over the dishpan. Out came Wangero with two quilts. They had been pieced by Grandma Dee and then Big Dee and me had hung them on the quilt frames on the front porch and quilted them. One was in the Lone Star pattern. The other was Walk Around the Mountain. In both of them were scraps of dresses Grandma Dee had worn fifty and more years ago. Bits and pieces of Grandpa Jarrell's Paisley shirts. And one teeny faded blue piece, about the size of a penny matchbox, that was from Great Grandpa Ezra's uniform that he wore in the Civil War.

"Mama," Wangero said sweet as a bird. "Can I have these old quilts?"

I heard something fall in the kitchen, and a minute later the kitchen door slammed.

"Why don't you take one or two of the others?" I asked. "These old things was just done by me and Big Dee from some tops your grandma pieced before she died."

"No," said Wangero. "I don't want those. They are stitched around the borders by machine."

"That'll make them last better," I said.

"That's not the point," said Wangero. "These are all pieces of dresses Grandma used to wear. She did all this stitching by hand. Imagine!" She held the quilts securely in her arms, stroking them.

"Some of the pieces, like those lavender ones, come from old clothes her mother handed down to her," I said, moving up to touch the quilts. Dee (Wangero) moved back just enough so that I couldn't reach the quilts. They already belonged to her.

"Imagine!" she breathed again, clutching them closely to her bosom.

"The truth is," I said, 'I promised to give them quilts to Maggie, for when she marries John Thomas."

She gasped like a bee had stung her.

"Maggie can't appreciate these quilts!" she said. "She'd probably be backward enough to put them to everyday use."

"I reckon she would," I said. "God knows I been saving 'em for long enough with nobody using 'em. I hope she will!" I didn't want to bring up how I had offered Dee (Wangero) a quilt when she went away to college. Then she had told me they were old-fashioned, out of style.

"But they're *priceless*!" she was saying now, furiously; for she has a temper. "Maggie would put them on the bed and in five years they'd be in rags. Less than that!"

"She can always make some more," I said. "Maggie knows how to quilt."

Dee (Wangero) looked at me with hatred. "You just will not understand. The point is these quilts, *these* quilts!"

"Well," I said, stumped. "What would *you* do with them?"

"Hang them," she said. As if that was the only thing you *could* do with quilts.

Maggie by now was standing in the door. I could almost hear the sound her feet made as they scraped over each other.

"She can have them, Mama," she said, like somebody used to never winning anything, or having anything reserved for her. "I can 'member Grandma Dee without the quilts."

I looked at her hard. She had filled her bottom lip with checkerberry snuff and it gave her face a kind of dopey,

hangdog look. It was Grandma Dee and Big Dee who taught her how to quilt herself. She stood there with her scarred hands hidden in the folds of her skirt. She looked at her sister with something like fear but she wasn't mad at her. This was Maggie's portion. This was the way she knew God to work.

When I looked at her like that something hit me in the top of my head and ran down to the soles of my feet. Just like when I'm in church and the spirit of God touches me and I get happy and shout. I did something I never had done before: hugged Maggie to me, then dragged her on into the room, snatched the quilts out of Miss Wangero's hands and dumped them into Maggie's lap. Maggie just sat there on my bed with her mouth open.

"Take one or two of the others," I said to Dee.

But she turned without a word and went out to Hakim-a-barber.

"You just don't understand," she said, as Maggie and I came out to the car.

"What don't I understand?" I wanted to know.

"Your heritage," she said. And then she turned to Maggie, kissed her, and said, "You ought to try to make something of yourself, too, Maggie. It's really a new day for us. But from the way you and Mama still live you'd never know it."

She put on some sunglasses that hid everything above the tip of her nose and her chin.

Maggie smiled; maybe at the sunglasses. But a real smile, not scared. After we watched the car dust settle I asked Maggie to bring me a dip of snuff. And then the two of us sat there just enjoying, until it was time to go in the house and go to bed.

Emden

[1982] R. K. Narayan

When he came to be named the oldest man in town, Rao's age was estimated anywhere between ninety and one hundred and five. He had, however, lost count of time long ago and abominated birthdays; especially after his eightieth, when his kinsmen from everywhere came down in a swarm and involved him in elaborate rituals, and with blaring pipes and drums made a public show of his attaining eighty. The religious part of it was so strenuous that he was laid up for fifteen days thereafter with fever. During the ceremony they poured pots of cold water, supposedly fetched from sacred rivers, over his head, and forced him to undergo a fast, while they themselves feasted gluttonously. He was so fatigued at the end of the day that he could hardly pose for the group photo, but flopped down in his chair, much to the annoyance of the photographer, who constantly withdrew his head from under the black hood to plead, "Steady, please." Finally, he threatened to pack up and leave unless they propped up the old gentleman. There were seventy-five heads to be counted in the group—all Rao's descendants one way or another. The photographer insisted upon splitting the group, as otherwise the individuals would be microscopic

and indistinguishable on a single plate. That meant that after a little rest Rao had to be propped up a second time in the honoured seat. When he protested against this entire ceremony, they explained, "It's a propitiatory ceremony to give you health and longevity."

"Seems to me rather a device to pack off an old man quickly," he said, at which his first daughter, herself past sixty, admonished him not to utter inauspicious remarks, when everyone was doing so much to help.

By the time he recovered from his birthday celebrations and the group photo in two parts could be hung on the wall, the house had become quiet and returned to its normal strength, which was about twenty in all—three of his sons and their families, an assortment of their children, nephews and nieces. He had his room in the right wing of the house, which he had designed and built in the last century as it looked. He had been the very first to buy a piece of land beyond Vinayak Street; it was considered an act of great daring in those days, being a deserted stretch of land from which thieves could easily slip away into the woods beyond, even in daylight; the place, however, developed into a residential colony and was named Ratnapuri, which meant City of Gems.

Rao's earlier years were spent in Kabir Street. When he came into his own and decided to live in style, he sold off their old house and moved to Ratnapuri. That was after his second wife had borne him four daughters, and the last of them was married off. He had moved along with his first wife's progeny, which numbered eight of varying ages. He seemed to be peculiarly ill-fated in matrimony—his uncle, who cast and read the stars for the whole family, used to say that Rao had Mars in the seventh house, with no other planet to checkmate its fury, and hence was bound to lose every wife.[1] After the third marriage and more children, he was convinced of the malevolence of Mars. He didn't keep a record of the population at home—that was not his concern—his sons were capable of running the family and managing the crowd at home. He detached himself from all transactions and withdrew so completely that a couple of years past the grand ceremony of the eightieth birthday he could not remember the names of most of the children at home or who was who, or how many were living under his roof.

The eightieth birthday had proved a definite landmark in his domestic career. Aided by the dimming of his faculties, he could isolate himself with no effort whatever. He was philosophical enough to accept nature's readjustments: "If I see less or hear less, so much the better. Nothing lost. My legs are still strong enough to take me about, and I can bathe and wash without help. . . . I enjoy my food and digest it." Although they had a dining table, he refused to change his ancient habit of sitting on a rosewood plank on the floor and eating off a banana leaf in a corner of the dining hall. Everything for him went on automatically, and he didn't have to ask for anything, since his needs were anticipated; a daughter-in-law or niece or grand-daughter or a great-grand someone or other was

1. Rao's horoscope, read by his astrologer uncle, shows Mars (the Roman god of War) dominant in the section that concerns marriage, which indicates that Rao is fated to lose his wives.

always there to attend him unasked. He did not comment or question, particularly not question, as he feared they would bawl in his left ear and strain their vocal cords, though if they approached his right ear he could guess what they might be saying. But he didn't care either way. His retirement was complete. He had worked hard all his life to establish himself, and provide for his family, each figure in the two-part group photograph owing its existence to him directly or indirectly. Some of the grandchildren had been his favourites at one time or another, but they had all grown out of recognition, and their names—oh, names! they were the greatest impediments to speech—every name remains on the tip of one's tongue but is gone when you want to utter it. This trick of nature reduces one to a state of babbling and stammering without ever completing a sentence. Even such a situation was acceptable, as it seemed to be ordained by nature to keep the mind uncluttered in old age.

He reflected and introspected with clarity in the afternoons—the best part of the day for him, when he had had his siesta; got up and had his large tumbler of coffee (brought to his room exactly at three by one of the ministering angels, and left on a little *teapoy*[2] beside the door). After his coffee he felt rivived, reclined in his easy-chair placed to catch the light at the northern window, and unfolded the morning paper, which, after everyone had read it, was brought and placed beside his afternoon coffee. Holding it close enough, he could read, if he wiped his glasses from time to time with a silk rag tied to the arm of his chair; thus comfortably settled, he half-read and half-ruminated. The words and acts of politicians or warmongers sounded stale—they spoke and acted in the same manner since the beginning of time; his eyes travelled down the columns—sometimes an advertisement caught his eye (nothing but an invitation to people to squander their money on all kinds of fanciful things), or reports of deaths (not one recognizable name among the dead). On the last page of the paper, however, half a column invariably gripped his attention—that was a daily report of a religious or philosophical discourse at some meeting at Madras; brief reports, but adequate for him to brush up his thoughts on God, on His incarnations and on definitions of Good and Evil. At this point, he would brood for a while and then fold and put away the paper exactly where he had found it, to be taken away later.

When he heard the hall clock chime four, he stirred himself to go out on a walk. This part of the day's routine was anticipated by him with a great thrill. He washed and put on a long shirt which came down to his knees, changed to a white dhoti,[3] wrapped around his shoulder an embroidered cotton shawl, seized his staff and an umbrella and sallied out. When he crossed the hall, someone or other always cautioned him by bellowing, "Be careful. Have you got the torch?[4] Usual round? Come back soon." He would just nod and pass on. Once outside, he moved with caution, taking each step only after divining the nature of the ground with the tip of his staff. His whole aim in life was to avoid a fall. One false step and that would be the end. Longevity was guaranteed as long as he maintained his equilibrium and verticality. This restriction forced him to move at snail's pace, and along a well-defined orbit every evening.

Leaving his gate, he kept himself to the extreme left of the street, along Vinayak Street, down Kabir Lane and into Market Road. He loved the bustle, traffic and crowds of Market Road—pausd to gaze into shops and marvel at the crowd passing in and out perpetually. He shopped but rarely—the last thing he remembered buying was a crayon set and a drawing book for some child at home. For himself he needed to buy only a particular brand of toothpowder (most of his teeth were still intact), for which he occasionally stopped at Chettiar's at the far end of Market Road, where it branched off to Ellaman Street. When he passed in front of the shop, the shopman would always greet him from his seat, "How are you, sir? Want something to take home today?" Rao would shake his head and cross over to the other side of the road—this was the spot where his orbit curved back, and took him homeward, the whole expedition taking him about two hours. Before 6:30, he would be back at his gate, never having to use his torch, which he carried in his shirt pocket only as a precaution against any sudden eclipse of the sun or an unexpected nightfall.

The passage both ways would always be smooth and uneventful, although he would feel nervous while crossing the Market Gate, where Jayaraj the photo-framer always hailed him from his little shop, "Grand Master, shall I help you across?" Rao would spurn that offer silently and pass on; one had to concentrate on one's steps to avoid bumping into the crowd at the Market Gate, and had no time for people like Jayaraj. After he had passed, Jayaraj, who enjoyed gossiping, would comment to his clients seated on a bench, "At his age! Moves through the crowd as if he were in the prime of youth. Must be at least a hundred and ten! See his recklessness. It's not good to let him out like this. His people are indifferent. Not safe these days. With all these lorries, bicycles and auto-rickshaws, he'll come to grief someday, I'm sure. . . ."

"Who's he?" someone might ask, perhaps a newcomer to the town, waiting for his picture to be framed.

"We used to call him Emden.[5] We were terrified of him when we were boys. He lived somewhere in Kabir Street. Huge, tall and imposing when he went down the road on his bicycle in his khaki uniform and a red turban and all kinds of badges. We took him to be a police inspector from his dress—not knowing that he wore the uniform of the Excise Department. He also behaved like the police— if he noticed anyone doing something he did not like, he'd go thundering at him, chase him down the street and lay the cane on his back. When we were boys, we used to loiter about the market in gangs, and if he saw us he'd scatter us and order us home. Once he caught us urinating against the school wall at Adam's Street, as we always did. He came down on us with a roar, seized four of us and

2. A small table.
3. Men's garment, tucked and knotted at the waist.
4. Flashlight (British).

5. A German warship that shelled Madras in 1916; ever since, the term indicates anyone who is formidable and ruthless. [Author's note.]

shook us till our bones rattled, pushed us up before the headmaster and demanded, 'What are you doing, Headmaster? Is this the way you train them? Or do you want them to turn out to be guttersnipes? Why don't you keep an eye on them and provide a latrine in your school?' The headmaster rose in his seat, trembling and afraid to come too close to this terrible personality flourishing a cane. Oh, how many such things in his heyday! People were afraid of him. He might well have been a policeman for all his high-and-mighty style, but his business was only to check the taverns selling drinks—And you know how much he collected at the end of the day? Not less than five hundred rupees, that is, fifteen thousand a month, not even a governor could earn so much. No wonder he could build a fancy house at Ratnapuri and bring up his progeny in style. Oh, the airs that family gives themselves! He narrowly escaped being prosecuted—if a national award were given for bribe-taking, it would go to him: when he was dismissed from service, he gave out that he had voluntarily retired! None the worse for it, has enough wealth to last ten generations. Emden! Indeed! He married several wives, seems to have worn them out one after another; that was in addition to countless sideshows, ha! ha! When we were boys, he was the talk of the town: some of us stealthily followed and spied on his movements in the dark lanes at night, and that provided us a lot of fun. He had great appetite for the unattached female tribe, such as nurses and schoolmistresses, and went after them like a bull! Emden, really! ...'' Jayaraj's tongue wagged while his hands were cutting, sawing and nailing a picture frame, and ceased the moment the work was finished, and he would end his narrations with: "That'll be five rupees—special rate for you because you have brought the picture of Krishna, who is my family god. I've not charged for the extra rings for hanging. ...''

Rao kept his important papers stacked in an *almirah*,[6] which he kept locked, and the key hidden under a lining paper in another cupboard where he kept his clothes and a few odds and ends, and the key of this second cupboard also was hidden somewhere, so that no one could have access to the two cupboards, which contained virtually all the clues to his life. Occasionally on an afternoon, at his hour of clarity and energy, he'd leave his easy-chair, bolt the door and open the first cupboard, take out the key under the paper lining, and then open the other cupboard containing his documents—title-deeds, diaries, papers and a will.

Today he finished reading the newspaper in ten minutes, and had reached his favourite column on the last page—the report of a discourse on reincarnations, to explain why one was born what he was and the working of the law of *karma*.[7] Rao found it boring also: he was familiar with that kind of moralizing and philosophy. It was not four yet; the reading was over too soon. He found an unfilled half-hour between the newspaper reading and his usual

6. Cupboard.

7. Fate: in Hindu doctrine, the idea that actions in one life continue to have effects in another incarnation.

time for the evening outing. He rose from the chair, neatly folded the newspaper and put it away on the little stool outside his door, and gently shut and bolted the door—noiselessly, because if they heard him shut the door, they would come up and caution him, "Don't bolt," out of fear that if he fell dead they might have to break the door open. Others were obsessed with the idea of *his* death as if they were all immortals!

He unlocked the cupboard and stood for a moment gazing at the papers tied into neat bundles—all the records of his official career from the start to his "voluntary retirement" were there on the top shelf, in dusty and yellowing paper: he had shut the cupboard doors tight, yet somehow fine dust seeped in and settled on everything. He dared not touch anything for fear of soiling his fingers and catching a cold. He must get someone to destroy them, best to put them in a fire; but whom could he trust? He hated the idea of anyone reading those memos from the government in the latter days of his service—he'd prefer people not to know the official mess and those threats of enquiries before he quit the service. The Secretary to the Government was a demon out to get his blood—inspired by anonymous letters and backbiters. Only one man had stood by him—his first assistant, wished he could remember his name or whereabouts— good fellow; if he were available he'd set him to clean and arrange his *almirah* and burn the papers: he'd be dependable, and would produce the ash if asked. But who was he? He patted his forehead as if to jerk the memory-machine into action. ... And then his eyes roved down to the next shelf; he ran his fingers over them lovingly—all documents relating to his property and their disposal after his death. No one in the house could have any idea of it or dare come near them. He must get the lawyer-man (what was his name again?) and closet himself with him someday. He was probably also dead. Not a soul seemed to be left in town. ... Anyway, must try to send someone to fetch him if he was alive, it was to be done secretly. How? Somehow.

His eyes travelled to a shelf with an assortment of packets containing receipts, bills and several diaries. He had kept a diary regularly for several years, recording a bit of daily observation or even on each page. He always bought the same brand of diary, called "Matchless"—of convenient size, ruled pages, with a flap that would be buttoned so that no one could casually open its pages and read its contents. The Matchless Stationery Mart off the main market manufactured it. On the last day of every December he would stop by for a copy costing four rupees—rather expensive but worth the price ... more often than not the man would not take money for it, as he'd seek some official favour worth much more. Rao was not the sort to mind dispensing his official favours if it helped some poor soul. There was a stack of thirty old diaries in there (at some point in his life, he had abandoned the practice), which contained the gist of all his day-to-day life and thought: that again was something, an offering for the God of Fire before his death. He stood ruminating at the sight of the diaries. He pulled out one from the stack at random, wiped the thin layer of dust with a towel, went back to his chair and turned over the leaves

casually. The diary was fifty-one years old. After glancing through some pages, he found it difficult to read his own close calligraphy in black ink and decided to put it back, as it was time to prepare for his walk. However, he said to himself, "Just a minute. Let me see what I did on this date, on the same day, so long ago. . . ." He looked at the calendar on the wall. The date was the twentieth of March. He opened the diary and leafed through the earlier pages, marvelling at the picture they presented of his early life: what a lot of activities morning till night, connected with the family, office and personal pursuits! His eyes smarted; he skipped longer passages and concentrated on the briefer ones. On the same day fifty-one years ago—the page contained only four lines, which read: "Too lenient with S. She deserves to be taught a lesson. . . ." This triggered a memory, and he could almost hear the echo of his own shouting at somebody, and the next few lines indicated the course of action: "Thrashed her soundly for her own good and left. Will not see her again. . . . How can I accept the responsibility? She must have had an affair—after all a D.G.[8] Wish I had locked her in before leaving." He studied this entry dispassionately. He wondered who it was. The initial was not helpful. He had known no one with a name beginning with S. Among the ladies he had favoured in his days, it could be anyone . . . but names were elusive anyway.

With great effort, he kept concentrating on this problem. His forehead throbbed with the strain of concentration. Of course, the name eluded him, but the geography was coming back to him in fragments. From Chettiar Stores . . . yes, he remembered going up Market Road . . . and noted the light burning at the shop facing him even at a late hour when returning home; that meant he had gone in that narrow street branching off from Market Road at that point, and that led to a parallel street . . . from there one went on and on and twisted and turned in a maze of by-lanes and reached that house—a few steps up before tapping gently on the rosewood door studded with brass stars, which would open at once as if she was waiting on the other side; he'd slip in and shut the door immediately, lest the neighbours be watching, and retrace his steps at midnight. But he went there only two days in the week, when he had free time. . . . Her name, no, could not get it, but he could recollect her outline rather hazily—fair, plump and loving and jasmine-smelling; he was definite that the note referred to this woman, and not to another one, also plump and jasmine-smelling somewhere not so far away . . . he remembered slapping a face and flouncing out in a rage. The young fellow was impetuous and hot-blooded . . . must have been someone else, not himself in any sense. He could not remember the house, but there used to be a coconut palm and a well in the street in front of the house . . . it suddenly flashed across his mind that the name of the street was Gokulam.

He rose and locked away the diary and secreted the key as usual, washed and dressed, and picked up his staff and umbrella and put on his sandals, with a quiet thrill. He had decided to venture beyond his orbit today, to go up and look for the ancient rosewood, brass-knobbed door, beside the coconut tree in that maze. From Chettiar Stores, his steps were bound to lead him on in the right direction, and if S. was there and happened to stand at the street door, he'd greet her . . . he might not be able to climb the four steps, but he'd offer her a small gift and greeting from the street. She could come down and take it. He should not have slapped her face . . . he had been impetuous and cruel. He should not have acted on jealousy . . . he was filled with remorse. After all, she must have shown him a great deal of kindness and given him pleasure ungrudgingly—otherwise, why would one stay until midnight?

While he tap-tapped his way out of his house now, someone in the hall enquired as usual, "Got your torch? Rather late today. Take care of yourself." He was excited. The shopman on the way, who habitually watched and commented, noted that the old man was moving rather jauntily today. "Oh, Respected One, good day to you, sir," said Mani from his cycle shop. "In such a hurry today? Walk slowly, sir, road is dug up everywhere." Rao looked up and permitted himself a gentle nod of recognition. He did not hear the message, but he could guess what Mani might be saying. He was fond of him—a great grandson of that fellow who had studied with him at Albert Mission School. Name? As usual Mani's great-grandfather's name kept slipping away . . . he was some Ram or Shankar or something like that. Oh, what a teaser! He gave up and passed on. He kept himself to the edge as usual, slowed down his pace after Mani's advice; after all, his movement should not be noticeable, and it was not good to push oneself in that manner and pant with the effort.

At Jagan's Sweets, he halted. Some unknown fellow at the street counter. Children were crowding in front of the stall holding forth money and asking for this and that. They were blocking the way. He waited impatiently and tapped his staff noisily on the ground till the man at the counter looked up and asked, "Anything, master?" Rao waved away the children with a flourish of his stick and approached the counter and feasted his eyes on the heaped-up sweets in different colours and shapes, and wished for a moment he could eat recklessly as he used to. But perhaps that'd cost him his life today—the secret of his survival being the spartan life he led, rigorously suppressing the cravings of the palate. He asked, "What's fresh today?" The man at the counter said, "We prepare everything fresh every day. Nothing is yesterday's. . . ." Rao could only partly guess what he was saying but, without betraying himself, said, "Pack up *jilebi*[9] for three rupees. . . ." He counted out the cash carefully, received the packet of *jilebi*, held it near his nostrils (the smell of food would not hurt, and there was no medical advice against it), for a moment relishing its rose-scented flavour; and was on his way again. Arriving at the point of Chettiar Stores, he paused and looked up at his right—yes, that street was still there as he had known it. . . .

Noticing him hesitating there, the shopman hailed from his shop, "Oh, grand master, you want anything?" He felt annoyed. Why couldn't they leave him alone? And then a

8. Dancing Girl, a term denoting a public woman in those days. [Author's note.]

9. A sweet.

young shop assistant came out to take his order. Rao looked down at him and asked, pointing at the cross street, "Where does it lead?"

"To the next street," the boy said, and that somehow satisfied him. The boy asked, "What can I get you?"

"Oh, will no one leave me alone?" Rao thought with irritation. They seemed to assume that he needed something all the time. He hugged the packet of sweets close to his chest, along with the umbrella slung on the crook of his arm. The boy seemed to be bent on selling him something. And so he said, "Have you sandalwood soap?" He remembered that S., or whoever it was, used to be fond of it. The boy got it for him with alacrity. Its fragrance brought back some old memories. He had thought there was a scent of jasmine about S., but he realized now that it must have been that of sandalwood. He smelt it nostalgically before thrusting it into his pocket. "Anything else, sir?" asked the boy. "No, you may go," and he crossed Market Road over to the other side.

Trusting his instinct to guide him, he proceeded along the cross street ahead of Chettiar Stores. It led to another street running parallel, where he took a turn to his left on an impulse, and then again to his right into a lane, and then left, and then about-turn—but there was no trace of Gokulam Street. As he tap-tapped along, he noticed a cobbler on the roadside, cleared his throat, struck his staff on the ground to attract attention and asked, "Here, which way to Gokulam Street?" At first, the cobbler shook his head, then, to get rid of the enquirer, pointed vaguely in some direction and resumed his stitching. "Is there a coconut tree in this street?" The other once again pointed along the road. Rao felt indignant. "Haughty beggar," he muttered. "In those days I'd have . . ." He moved on, hoping he'd come across the landmark. He stopped a couple of others to ask the same question, and that did not help. No coconut tree anywhere. He was sure that it was somewhere here that he used to come, but everything was changed. All the generations of men and women who could have known Gokulam Street and the coconut tree were dead—new generations around here, totally oblivious of the past. He was a lone survivor.

He moved cautiously now, as the sun was going down. He became rather nervous and jabbed his staff down at each step, afraid of stumbling in a hole. It was a strain moving in this fashion, so slow and careful, and he began to despair that he'd ever reach the Market Road again. He began to feel anxious, regretted this expedition. The family would blame him if he should have a mishap. Somehow he felt more disturbed at the thought of their resentment than of his own possible suffering. But he kept hobbling along steadily. Some passers-by paused to stare at him and comment on his perambulation. At some point, his staff seemed to stab through a soft surface; at the same moment a brown mongrel, which had lain curled up in dust, in perfect camouflage, sprang up with a piercing howl; Rao instinctively jumped, as he had not done for decades, luckily without falling down, but the packet of *jilebi* flew from his grip and landed in front of the mongrel, who picked it up and trotted away, wagging his tail in gratitude. Rao looked after the dog helplessly and resumed his journey homeward. Brooding over it, he commented to himself, "Who knows, S. is perhaps in this incarnation now. . . ."

GLOSSARY

a cappella. Choral music without instrumental accompaniment.

abacus. The uppermost member of the capital of an architectural column; the slab on which the architrave rests.

absolute music. Music that is free from any reference to nonmusical ideas, such as a text or program.

abstract, abstraction. Non-representational; the essence of a thing rather than its actual appearance.

absurdism. A style dealing with life's apparent meaninglessness and the difficulty or impossibility of human communication.

academy. From the grove (the Academeia) where Plato taught; the term has come to mean the cultural and artistic establishment which exercises responsibility for teaching and the maintenance of standards.

accent. In music, a stress on a note. In the visual arts, any device used to highlight or draw attention to a particular area, such as an accent color. See also *focal point.*

acoustics. The scientific study of sound and hearing.

action theatre. A contemporary phenomenon in which plays, happenings, and other types of performance are strongly committed to broad moral and social issues with the overt purpose of effecting a change for the better in society.

aerial perspective. The indication of distance in painting through use of light and atmosphere.

aesthetic. Having to do with the pleasurable and beautiful as opposed to the useful.

aesthetic distance. The combination of mental and physical factors that provides the proper separation between a viewer and an artwork; it enables the viewer to achieve a desired response.

aesthetics. A branch of philosophy dealing with the nature of beauty and art and their relation to human experience.

affective. Relating to feelings or emotions, as opposed to facts. See *cognitive.*

aleatory. Chance or accidental. A term used for 20th-century music where the composer deliberately incorporates elements of chance.

allegory. Expression by means of symbols to make a more effective generalization or moral commentary about human experience than could be achieved by direct or literal means.

altarpiece. A painted or sculpted panel placed above and behind an altar to inspire religious devotion.

ambulatory. A covered passage for walking, found around the apse or choir of a church.

amphitheatre. A building, typically Roman, that is oval or circular in form and encloses a central performance area.

amphora. A two-handled vessel for storing provisions, with an opening large enough to admit a ladle, and usually fitted with a cover.

animism. The belief that objects as well as living organisms are endowed with soul.

antiphonal. A responsive style of singing or playing, in which two groups alternate.

anthropomorphic. With human characteristics attributed to nonhuman beings, or things.

apse. A large niche or niche-like space projecting from and expanding the interior space of an architectural form such as a basilica.

arcade. A series of arches side by side.

arch. In architecture, a structural system in which space is spanned by a curved member supported by two legs.

archetype. An original model or type after which other similar things are patterned.

architrave. In post-and-lintel architecture, the lintel or lowest part of the entablature, resting directly on the capitals of the columns.

aria. An elaborate solo song found primarily in operas, oratorios, and cantatas.

art song. A solo musical composition for voice, usually with piano accompaniment.

articulation. The connection of the parts of an artwork. In music or speech, the production of distinct sounds.

artifact. An object produced or shaped by human workmanship.

Art Nouveau. A style of decoration and architecture first current in the 1890s, characterized by curvilinear floral forms.

atonality. The avoidance of tonal centers or keys in musical compositions.

atrium. An open courtyard within or related to a building.

avant-garde. A term used to designate innovators, the "advanced guard," whose experiments in art challenge established values.

balance. In composition, the equilibrium of opposing or interacting forces.

ballad. In folk music, a narrative song usually set to relatively simple music.

ballade. A verse form usually consisting of three stanzas of eight or ten lines each, with the same concluding line in each stanza, and a brief final stanza, ending with the same last line as that of the preceding stanzas. In musical composition, either a Medieval French song, or a lyrical piano piece from the 19th century.

baroque. A 17th- and 18th-century style of art, architecture, and music that is highly ornamental.

barrel vault, tunnel vault. A series of arches placed back to back to enclose space.

basilica. In Roman times a term referring to building function, usually a law court; later used by Christians to refer to church buildings and a specific form.

beats. In music, the equal parts into which a measure is divided, which form the pulse underlying most rhythmic patterns.

bel canto. An Italian baroque style of operatic singing characterized by rich tonal lyricism and brilliant display of vocal technique.

binary form. A musical form consisting of two sections.

biomorphic. Representing life forms as opposed to geometric forms.

bridge. A musical passage of subordinate importance played as a link between two principal themes.

buttress. A support, usually an exterior projection of masonry or wood, for a wall, arch, or vault.

cadence. In music, the specific harmonic arrangement that indicates the closing of a phrase.

cameo. A brief but dramatic appearance of a prominent actor or actress in a single scene in film, television, and stage. Also a gem, hardstone, or shell with two layers of color, the upper of which can be carved in relief while the lower is used as a ground.

canon. A body of principles, rules, standards or norms; a criterion for establishing measure, scale, and proportion. In music, a composition for two or more voices or instruments, where one enters after another in direct imitation of the first.

cantata. A type of composition developed in the baroque period, for chorus and/or solo voice(s) accompanied by an instrumental ensemble.

capital. The transition between the top of a column and the lintel.

carbon-dating. A scientific method of determining the origin or date of ancient objects.

caryatid. A sculpted female figure standing in the place of a column.

cast. See *sculpture.*

catharsis. The cleansing or purification of the emotions through the experience of art, the result of which is spiritual release and renewal.

cella. The principal enclosed room of a temple; the entire body of a temple as opposed to its external parts.

ceremony. A formal act or set of acts performed as prescribed by ritual, custom, or etiquette.

chamber music. Vocal or instrumental music suitable for performance in small rooms.

chiaroscuro. Light and shade. In painting, the balance of light and shade across the whole picture. See also *modeling.* In theatre, the use of light to enhance plasticity of human and scenic form.

chorale. A Protestant hymn, for voices or organ.

chord. Three or more musical tones played at the same time.

choreography. The composition of a dance work; the arrangement of patterns of movement in dance.

citadel. A fortress or a fortified place.

city–state. A sovereign state consisting of an independent city and its surrounding territory.

classical. Adhering to traditional standards. May refer to Greek and Roman art in which simplicity, clarity of structure, and appeal to the intellect are fundamental.

clerestory. A row of windows in the upper part of a wall.

cloister. A covered walk with an open colonnade on one side, running along the inside walls of buildings that face a quadrangle. A place devoted to religious seclusion.

coffer. A recessed panel in a ceiling.

cognitive. Facts and objectivity as opposed to emotions and subjectivity. See *affective*.

collage. An artwork constructed by pasting together various materials, such as newsprint, to create textures, or by combining two- and three-dimensional media.

colonnade. A row of columns usually spanned or connected by lintels.

colonnette. A tall, narrow engaged column; colonnettes are grouped together to form piers which support structural arches in buildings such as Gothic cathedrals.

coloristic. Reflecting the skillful use of color and painterly skills.

column. A cylindrical post or support which often has three distinct parts: base, shaft, and capital.

commedia dell'arte. A type of comedy developed in Italy in the 16th century, characterized by improvization from a plot outline and by the use of stock characters.

composition. The arrangement of line, form, mass, color, and so forth, in a work of art.

compression, compressive strength. In architecture, stress that results from two forces moving toward each other.

concerto. A composition for one or more solo instruments, accompanied by an orchestra, typically in three movements.

concerto grosso. A baroque composition for a small group of solo instruments and a small orchestra.

conjunct melody. In music, melody comprising neighboring notes in the scale. The opposite of *disjunct melody*.

consonance. The feeling of a comfortable relationship between elements of a composition. Consonance may be both physical and cultural in its ramifications. The opposite of *dissonance*.

continuo, basso continuo. In baroque music, a bass line played on a low melodic instrument, such as a cello, while a keyboard instrument (or other chord-playing instrument) also plays the bass line and adds harmonies.

contrapposto, counterpoise. In sculpture, the arrangement of body parts so that the weight-bearing leg is apart from the free leg, thereby shifting the hip/shoulder axis.

conventions, conventional, conventionalized. The customs or accepted underlying principles of an art.

Corinthian. A specific order of Greek columns employing an elaborate leaf motif in the capital.

cornice. A crowning, projecting architectural feature.

corps de ballet. The chorus of a ballet ensemble.

counterpoint. In music, two or more independent melodies played in opposition to each other at the same time.

crosscutting. In film, alternation between two independent actions that are related thematically or by plot to give the impression of simultaneous occurrence.

crossing. The area in a church where the transept crosses the nave.

cross-section. A view of an object shown by cutting through it.

cruciform. Arranged or shaped like a cross.

crypt. A vaulted chamber, wholly or partly underground, that usually contains a chapel. Found in a church under the choir.

curvilinear. Formed or characterized by curved line.

cutting within the frame. Changing the viewpoint of the camera within a shot by moving from a long or medium shot to a close-up, without cutting the film.

danse macabre. Dance of death, popular in the 19th century.

dénouement. The section of a play's structure in which events are brought to a conclusion.

deposition. A painting or sculpture depicting the removal of the body of Christ from the cross.

design. A comprehensive scheme, plan or conception.

diatonic. Referring to the seven tones of a standard major or minor musical scale.

disjunct melody. In music, melody characterized by skips or jumps. The opposite of *conjunct melody*.

dissonance. The occurrence of inharmonious elements in music or the other arts. The opposite of *consonance*.

dome. An architectural form based on the principles of the arch, in which space is defined by a hemisphere used as a ceiling.

Doric. A Greek order of column having no base and only a simple slab as a capital.

drames bourgeois. Pseudo-serious plays utilizing middle-class themes and settings, with an emphasis on pathos and morality.

dynamics. The various levels of loudness and softness of sounds.

echinus. In the Doric order, the round, cushion-like element between the top of the shaft and the abacus.

eclecticism. A combination of several differing styles in a single composition.

empathy. Emotional and/or physical involvement in events to which one is a witness but not a participant.

empirical. Based on experiments, observation, and practical experience, without regard to theory.

en pointe. See *on point*.

engaged column. A column, often decorative, which is part of and projects from a wall surface.

entablature. The upper portion of a classical architectural order above the column capital.

entasis. The slight convex curving on classical columns to correct the optical illusion of concavity which would result if the sides were left straight.

entr'acte. Performance between the acts of a play.

ephemeral. Transitory, not lasting.

epic. A long narrative poem in heightened style about the deeds and adventures of a hero.

étude. Literally, a study, a lesson. An instrumental composition, intended for the practice or display of some technique.

exposition. The introductory material or opening section of a play or a musical composition.

façade. The front of a building, or the sides, if they are emphasized architecturally.

fan vaulting. An intricate style of traceried vaulting, common in the late English Gothic style, in which ribs arch out like a fan from a single point such as a capital.

farce. A theatrical genre characterized by broad, slapstick humor and implausible plots.

ferro-concrete. Concrete reinforced with rods or webs of steel.

fluting. Vertical ridges in a column.

flying buttress. A semi-detached buttress.

focal point, focal area. A major or minor area of visual attraction in pictures, sculpture, dance, plays, films, landscape design or buildings.

foreground. The area of a picture, usually at the bottom, that appears to be closest to the viewer.

form. The shape, structure, configuration, or essence of something.

found object. An object taken from life that is presented as an artwork.

four-part harmony. A standard musical texture, where four tones fill out each chord.

fresco. A method of painting in which pigment is mixed with wet plaster and applied as part of the wall surface.

frieze. The central portion of the entablature: any horizontal decorative or sculptural band.

fugue. Originated in the baroque period from a Latin word meaning "flight." A musical composition in a fixed form in which a theme is developed by counterpoint.

full-round. See *sculpture*.

galliard. A spirited court dance in triple meter.

genre. A category of artistic composition characterized by a particular style, form, or content.

geometric. Based on man-made patterns such as triangles, rectangles, circles, ellipses, and so on. The opposite of *biomorphic*.

Gesamtkunstwerk. A complete, totally integrated artwork; associated with the music dramas of Richard Wagner in 19th-century Germany.

gesso. A mixture of plaster of Paris and glue, used as a base for low relief or as a surface for painting.

Greek cross. A cross in which all arms are the same length.

Gregorian chant. A Medieval form of monophonic church music, also called plainchant or chant, sung unaccompanied, and named for Pope Gregory I.

groin vault. The ceiling formation created by the intersection of two tunnel or barrel vaults.

half cadence. A type of harmonic ending to a musical phrase which does not have a feeling of finality because it does not end on the home or tonic chord.

hamartia. The "tragic flaw" in the character of the protagonist of a classical tragedy.

harmony. The relationship of like elements such as musical notes, colors, and patterns of repetition. See *consonance* and *dissonance*.

Hellenistic. Relating to the time from the reign of Alexander the Great to the first century BC.

heroic. Larger than life-size.

hierarchy. Any system of persons or things that has higher and lower ranks.

hieratic. A style of depicting sacred persons or offices, particularly in Egyptian and Byzantine art.

hieroglyph, hieroglyphic. A picture or symbol of an object standing for a word, idea, or sound; developed by the ancient Egyptians into a system of writing.

homophony. A musical texture characterized by chordal texture supporting one melody. See *monophony* and *polyphony*.

horizon line. A real or implied line across the picture plane which, like the horizon in nature, tends to fix the viewer's vantage point.

hubris. Pride; typically the "tragic flaw" found in the protagonist of a classical tragedy. See *hamartia*.

hue. The spectrum notation of color; a specific, pure color with a measurable wavelength. There are primary hues, secondary hues, and tertiary hues.

humanitarianism. The ideas and philosophies associated with people who are concerned about human need and the alleviation of human suffering.

hymnody. The singing, composing, or study of hymns; the hymns of a particular period or church.

hypostyle. A building with a roof or ceiling supported by rows of columns, as in ancient Egyptian architecture.

icon. A Greek word meaning "image." Used to identify paintings which represent the image of a holy person.

iconography. The meanings of images and symbols.

idealization. The portrayal of an object or human body in its ideal form rather than as a true-to-life portrayal.

idée fixe. A recurring melodic motif representing a nonmusical idea; used by the composer Berlioz.

improvization. Music or other art produced on the spur of the moment, spontaneously.

illumination. The practice of decorating the pages of books—especially Medieval manuscripts—with colorful pictures or motifs.

intensity. The degree or purity of a hue. In music, theatre, and dance, that quality of dynamics denoting the amount of force used to create a sound or movement.

interval. The difference in pitch between two tones.

intrinsic. Belonging to a thing by its nature.

Ionic. A Greek order of column that has a scroll-like capital with a circular base.

jamb. The upright piece forming the side of a doorway or window frame.

key. A system of tones in music based on and named after a given tone—the tonic.

kouros. An archaic Greek statue of a standing, nude youth.

krater. A bowl for mixing wine and water, the usual Greek beverage.

kylix. A vase turned on a potter's wheel; used as a drinking cup.

labanotation. A system of writing down dance movements.

lancet window. A tall, narrow window whose top forms a lancet or narrow arch shaped like a spear.

lantern. A relatively small structure on the top of a dome, roof, or tower, frequently open to admit light into the area beneath.

Latin cross. A cross in which the vertical arm is longer than the horizontal arm, through whose midpoint it passes.

Leitmotif. A "leading motif" used in music to identify an individual, ideal, object, and so on; associated with Wagner.

lekythos. An oil flask with a long, narrow neck adapted for pouring oil slowly; used in funeral rites.

Lieder. German secular art songs. Normally applied to 19th-century solo songs with piano accompaniment; also a term for three-part Early Renaissance songs.

linear perspective. The creation of the illusion of distance in a two-dimensional artwork through the convention of line and foreshortening. That is, the illusion that parallel lines come together in the distance.

lintel. The horizontal member of a post-and-lintel structure in architecture, or a stone bridging an opening.

loggia. A gallery open on one or more sides, sometimes with arches or with columns.

lost-wax, cire-perdue. A method of casting sculpture in which the basic mold is made of wax, which is then melted to leave the desired spaces.

low relief. See *sculpture*.

lyric. A category of poetry differentiated from dramatic or narrative. In music, the use of sensual sound patterns.

madrigal. An unaccompanied musical composition for two to five independent voices using a poetic text.

masonry. In architecture, stone or brickwork.

mass. Actual or implied physical bulk, weight, and density. Also, the most important rite of the Catholic liturgy, similar to the Protestant communion service.

medium. The process employed by the artist. Also the binding agent used to hold pigments together.

melismatic. Music where a single syllable of text is sung on many notes.

melodrama. A theatrical genre characterized by stereotyped characters, implausible plots, and an emphasis on spectacle.

melody. In music, a succession of single tones; a tune.

microtone. A musical interval smaller than a half-step.

mime. A form of ancient Greek and Roman drama in which realistic characters and situations were farcically portrayed and mimicked on stage.

miniature. An artwork, usually a painting, done in very small scale.

mobile. A constructed structure whose components have been connected by joints to move by force of wind or motor.

mode. A particular form, style, or manner. In music, a scale; often used with reference to nonwestern music.

modeling. The shaping of three-dimensional forms. Also the suggestion of three-dimensionality in two-dimensional forms.

modulation. The changing from one key to another in a musical composition.

monody. A style of musical composition in which one melodic line predominates; a poetic form expressing personal lament.

monolith. A large block of stone used in architecture or sculpture.

monophony. In music, a texture employing a single melody line without harmonic support.

montage. The process of making a single composition by combining parts of others. A rapid sequence of film shots bringing together associated ideas or images.

monotheism. The belief that there is only one God.

monumental. Works actually or appearing larger than life-size.

mosaic. A decorative work for walls, vaults, floors, or ceilings, composed of pieces of colored material set in plaster or cement.

motet. A polyphonic musical composition based on a sacred text and usually sung without accompaniment.

motif, motive. In music, a short, recurrent melodic or rhythmic pattern. In the other arts, a recurrent element.

mullions. The vertical elements dividing windows into separate sections.

mural. A painting on a wall, usually large.

musique concrète. A 20th-century musical approach in which conventional sounds are altered electronically and recorded on tape to produce new sounds.

narthex. A portico or lobby of an early Christian church, separated from the nave by a screen or railing.

naturalistic. Carefully imitating the appearance of nature.

nave. The great central space in a church, usually running from west to east, where the congregation sits.

neo-Attic. Literally, "new Greek." A reintroduction of the classical Greek and Hellenistic elements of architecture and visual art.

neoclassicism. Various artistic styles that borrow the devices or objectives of classical art.

niche. A recess in a wall in which sculpture can be displayed.

nimbus. The circle of radiant light around the head or figures of God, Christ, the Virgin Mary, and the saints.

nonobjective. Without reference to reality; may be differentiated from "abstract."

nonrepresentational. Without reference to reality; including abstract and nonobjective.

obelisk. A tall, tapering, four-sided stone shaft with a pyramidal top.

octave. In music, the distance between a specific pitch vibration and its double; for example, concert A equals 440 vibrations per second, the A one octave above that pitch equals 880, and the A one octave below equals 220.

oculus. A circular opening in the top of a dome.

oligarchy. Government by a small, select group.

on point. In ballet, a specific technique utilizing special shoes in which the dancer dances on the points of the toes. Same as *en pointe*.

opus. A single work of art.

oratorio. A large choral work for soloists, chorus, and orchestra, developed in the baroque period.

orchestra. A large instrumental musical ensemble; the first-floor seating area of a theatre; the circular playing area of the ancient Greek theatre.

organum. Singing together. Earliest form of polyphony in western music, with the voices moving in parallel lines.

ornament. Anything used as a decoration or embellishment.

palette. In the visual arts, the composite use of color, including range and tonality.

palmette. A decoration taking the form or abstracting the form of a palm branch.

pantomime. A genre of Roman drama in which an actor played various parts, without words, with a musical background.

pantheon. A Greek word meaning all the gods.

pas. In ballet, a combination of steps forming one dance.

pas de deux. A dance for two dancers.

pathos. The "suffering" aspect of drama usually associated with the evocation of pity.

pediment. The typically triangular roof piece characteristic of classical architecture.

pendentive. A triangular part of the vaulting which allows the stress of the round base of a dome to be transferred to a rectangular wall base.

perspective. The representation of distance and three-dimensionality on a two-dimensional surface. See also *linear perspective* and *aerial perspective.*

picaresque. An artwork referring to the environment of rogues and adventurers.

piers. Upright architectural supports—usually rectangular.

pigment. Any substance used as a coloring agent.

plainsong (plainchant). Medieval liturgical music sung without accompaniment and without strict meter.

plan. An architectural drawing that reveals in two dimensions the arrangement and distribution of interior spaces and walls, as well as door and window openings, of a building as seen from above.

plaque. A decorative or informative design placed on a wall.

plasticity. The capability of being molded or altered. In film, the ability to be cut and shaped. In painting, dance, and theatre, the accentuation of dimensionality of form through chiaroscuro.

pointillism. A style of painting in which the paint is applied to the surface by dabbing the brush so as to create small dots of color.

polyphony. Literally, "many sounds." See *counterpoint.*

polyrhythm. The use of contrasting rhythms at the same time in music.

post-and-lintel. An architectural structure in which horizontal pieces (lintels) are held up by vertical columns (posts).

program music. Music that refers to nonmusical ideas through a descriptive title or text. The opposite of *absolute music.*

proportion. The relation, or ratio, of one part to another and of each part to the whole with regard to size, height, width, length, or depth.

proscenium. A Greek word meaning "before the skene." The plaster arch or "picture frame" stage of traditional theatres.

prototype. The model on which something is based.

psalmody. A collection of psalms.

putti. Nude male children—usually winged—especially shown in Renaissance and later art.

pylon. A gateway or a monumental structure flanking an entranceway.

rake. To place at an angle. A raked stage is one in which the floor slopes slightly upward from one point, usually downstage, to another, usually upstage.

realism. A style of painting, sculpture, and theatre based on the theory that the method of presentation should be true to life.

recitative. Sung monologue or dialogue, in opera, cantata, and oratorio.

reinforced concrete. See *ferro-concrete.*

relief. See *sculpture.*

representational. Art showing objects that are recognizable from real life.

requiem. A mass for the dead.

rhythm. The relationship, either of time or space, between recurring elements of a composition.

rib. A slender architectural support projecting from the surface in a vault system.

ribbed vault. See *vault.* A vault to which slender, projecting supports have been added. A structure in which arches are connected by diagonal as well as horizontal members.

rite. A customary form for conducting religious or other solemn ceremonies.

ritornello form. A baroque musical form in which a recurrent orchestral theme alternates with solo passages.

rondeau. A Medieval French secular song based on a poetic form.

rondo form. A predominantly classical form of musical composition based around recurrence of the main theme, alternating with contrasting themes.

sanctuary. A holy place or building; a holy place within a building such as the cella of a temple or the area around the altar of a church.

sarcophagus. A stone coffin.

saturation. In color, the purity of a hue in terms of whiteness; the whiter the hue, the less saturated it is.

scale. In music, a graduated series of ascending or descending musical tones. In architecture, the mass of the building in relation to the human body.

scenography. The art and study of scenery design for the theatre and film.

schema. A summarized or diagrammatic representation.

sculpture. A three-dimensional art object. Among the types are 1. *cast:* created from molten material utilizing a mold. 2. *relief:* attached to a larger background. 3. *full-round:* free-standing.

semidome. A roof covering a semicircular space; half a dome.

serial music. A 20th-century musical style utilizing the tone row; can also employ serialization of rhythms, timbres, and dynamics.

sfumato. A smoky or hazy quality in a painting, with particular reference to Leonardo da Vinci's work.

shaft. The main trunk of a column.

shape. A two-dimensional area or plane with distinguishable boundaries.

silhouette. A form as defined by its outline.

skene. The stage building of the ancient Greek theatre.

skyphos. A two-handled ancient Greek drinking pot with an open top, tapering bowl, and flat, circular base.

sonata. Instrumental composition of the 17th through 20th centuries, consisting of a group of movements played in succession.

statuary. Free-standing, three-dimensional sculpture.

stereophonic. Sound reproduction in which two channels are used to simulate a natural distribution of sources.

still life. In the visual arts, an arrangement of inanimate objects used as a subject of a work of art.

strainer arch. An arch in an internal space that prevents the walls from being pushed inward.

strophic form. Form of vocal music in which all stanzas of the text are sung to the same music.

stucco. A plaster or cement finish for interior and exterior walls.

style. The characteristics of a work of art that identify it with an artist, a group of artists, an era, or a nation.

stylized. A type of depiction in which verisimilitude has been altered for artistic effect.

stylobate. The foundation immediately below a row of columns.

suite. A grouping of dance movements, usually unrelated except by key.

summa. An encyclopedic summation of a field of learning, particularly in theology or philosophy.

symbol. A form, image, or subject standing for something else.

symmetry. The balancing of elements in design by placing physically equal objects on either side of a center line.

symphony. A lengthy orchestral composition, usually in four movements.

syncopation. In a musical composition, the displacement of accent from the normally accented beat to the offbeat.

synthesis. The combination of independent factors or entities into a compound that becomes a new, more complex whole.

synthesizer. An electronic instrument that produces and combines musical sounds.

temperament. In music, a system of tuning. Equal temperament—the division of the octave into 12 equal intervals—is the most common way of tuning keyboard instruments.

tempo. The rate of speed at which a musical composition is performed. In theatre, film, or dance, the rate of speed of the overall performance.

tensile strength. The ability of a material to resist bending and twisting.

text painting. See *word painting.*

texture. In visual art, the two-dimensional or three-dimensional quality of the surface of a work. In music, the number and relationship of musical lines in the composition.

theatricality. Exaggeration and artificiality; the opposite of *verisimilitude.*

theme. The subject of an artwork, whether melodic or philosophical.

timbre. The characteristic of a sound that results from the particular source of the sound. The difference between the sound of a violin and the sound of the human voice, caused by different patterns of sound waves, is a difference in timbre, also called color.

toccata. A baroque keyboard composition intended to display technique.

tonality. In music, the specific key in which a composition is written. In the visual arts, the characteristics of value.

tondo. A circular painting.

tonic. In music, the root tone (*do*) of a key.

tragédie bourgeois. See *drames bourgeois*.

tragedy. A serious drama or other literary work in which conflict between a protagonist and a superior force (often fate) concludes in disaster for the protagonist.

tragicomedy. A drama combining the qualities of tragedy and comedy.

transept. The crossing arm of a cruciform church, at right angles to the nave.

travertine. A creamy-colored type of calcium used as a facing in building construction.

triforium. The section of the nave wall above the arcade and below the clerestory windows.

triptych. An altarpiece or devotional picture composed of a central panel and two wings.

trompe l'oeil. "Trick of the eye" or "fool the eye." A two-dimensional artwork so executed as to make the viewer believe that three-dimensional subject matter is being perceived.

trope. A Medieval, dramatic elaboration of the Roman Catholic mass or other offices.

tundra. A treeless area between the ice cap and the tree line of arctic regions, with a permanently frozen subsoil and supporting low-growing vegetation such as lichens, mosses, and stunted shrubs.

tunnel vault. See *barrel vault*.

tutu. A many-layered, stiff, short skirt worn by a ballerina.

twelve-tone technique. A 20th-century atonal form of musical composition associated with Schoenberg.

tympanum. The space above the door beam and within the arch of a medieval doorway.

value, value scale. In the visual arts, the range of tonalities from white to black.

vanishing point. In linear perspective, the point on the horizon toward which parallel lines appear to converge and at which they seem to vanish.

variation. Repetition of a theme with small or large changes.

vault. An arched roof or ceiling usually made of stone, brick, or concrete.

verisimilitude. The appearance of reality or the nearness to truth in works of art; the opposite of *theatricality*.

virtuoso. Referring to the display of impressive technique or skill by an artist or performer.

volute. A spiral architectural element found notably on Ionic and other capitals, but also used decoratively on building façades and interiors.

wash. A thin layer of translucent color or ink used in watercolor painting and brush drawing.

word painting. The use of language by a poet or playwright to suggest images and emotions; in music, the use of expressive melody to suggest a specific text.

FURTHER READING

Anderson, Jack. *Dance*. New York: Newsweek Books, 1974.

Andreae, Bernard. *The Art of Rome*. New York: Harry N. Abrams, Inc., 1977.

Arnott, Peter D. *An Introduction to the Greek Theatre*. Bloomington, IN: Indiana University Press, 1963.

Artz, Frederick. *From the Renaissance to Romanticism*. Chicago: University of Chicago Press, 1962.

Bataille, Georges. *Lascaux*. Switzerland: Skira, n.d.

Bazin, Germain. *The Baroque*. Greenwich, CN: New York Graphic Society, 1968.

Bentley, Eric (ed). *The Classic Theatre* (4 vols). Garden City, NY: Doubleday Anchor Books, 1959.

Bohn, T.W., Stromgren, R.L., and Johnson, D.H. *Light and Shadows, A History of Motion Pictures* (2nd ed.). Sherman Oaks, CA: Alfred Publishing Co., 1978.

Booth, Michael. *Victorian Spectacular Theatre 1850–1910*. Boston: Routledge and Kegan Paul, 1981.

Borroff, Edith. *Music in Europe and the United States: A History*. Englewood Cliffs, NJ: Prentice Hall, Inc., 1971.

Brandon, S.G.F. *Religion in Ancient History*. New York: Charles Scribner's Sons, 1969.

Brindle, Reginald Smith. *The New Music: The Avant-Garde Since 1945*. London: Oxford University Press, 1975.

Brockett, Oscar G. *History of the Theatre*. Boston: Allyn and Bacon, Inc., 1968.

Campos, D. Redig de (ed). *Art Treasures of the Vatican*. Englewood Cliffs, NJ: Prentice Hall, Inc., 1974.

Cheney, Sheldon. *The Theatre: Three Thousand Years of Drama, Acting, and Stagecraft* (rev. ed.). New York: Longmans, Green, 1952.

Chujoy, Anatole. *Dance Encyclopedia*. New York: Simon and Schuster, Inc., 1966.

Clarke, Mary and Crisp, Clement. *Ballet*. New York: Universe Books, 1973.

Clough, Shepard B. et al. *A History of the Western World*. Boston: D.C. Heath and Co., 1964.

Cope, David H. *New Directions in Music*. Dubuque, IA: William C. Brown and Co., 1981.

Corrigan, Robert. "The Search for New Endings: The Theatre in Search of a Fix, Part III," *Theatre Journal*, Vol. 36, No. 2, May 1984, pp. 153–63.

Coryell, Julie and Friedman, Laura. *Jazz-Rock Fusion*. New York: Delacorte Press, 1978.

Crocker, Richard. *A History of Musical Style*. New York: McGraw-Hill, 1966.

Diehl, Charles. *Byzantium*. New Brunswick, NJ: Rutgers University Press, 1957.

Drinkwater, John. *The Outline of Literature*. London: Transatlantic Arts, 1967.

Engel, Carl. *The Music of the Most Ancient Nations*. Freeport, NY: Books for Libraries Press, 1970.

Ernst, David. *The Evolution of Electronic Music*. New York: Schirmer Books, 1977.

Fleming, William. *Arts and Ideas*. New York: Holt, Rinehart, and Winston, 1980.

Frankfort, Henri. *Kingship and the Gods*. Chicago: University of Chicago Press, 1948.

Freedley, George and Reeves, John. *A History of the Theatre* (3rd ed.). New York: Crown Publishers, 1968.

Fuller, B.A.G. *A History of Philosophy*. New York: Henry Holt and Company, 1945.

Gardner, Helen. *Art Through the Ages* (8th ed.). New York: Harcourt Brace Jovanovich, 1986.

Garraty, John and Gay, Peter. *A History of the World* (2 vols). New York: Harper and Row, 1972.

Gassner, John (ed). *A Treasury of the Theatre*. New York: Holt, Rinehart, and Winston, 1967.

Gilbert, Creighton. *History of Renaissance Art Throughout Europe: Painting, Sculpture, Architecture*. New York: Harry N. Abrams, Inc., 1973.

Glasstone, Victor. *Victorian and Edwardian Theatres*. Cambridge, MA: Harvard University Press, 1975.

Goethe, Johann Wolfgang von. *Faust: Part I*, trans. Philip Wayne. Baltimore: Penguin Books, 1962.

Grabar, Andre. *The Art of the Byzantine Empire*. New York: Crown Publishers, Inc., 1966.

Graziosi, Paolo. *Palaeolithic Art*. New York: McGraw-Hill, 1960.

Griffiths, Paul. *A Concise History of Avant-Garde Music*. New York: Oxford University Press, 1978.

Grimm, Harold. *The Reformation Era*. New York: Macmillan Co., 1954.

Groenewegen-Frankfort and Ashmole, Bernard. *Art of the Ancient World*. Englewood Cliffs, NJ and New York: Prentice Hall, Inc. and Harry N. Abrams, Inc., n.d.

Gropius, Walter (ed). *The Theatre of the Bauhaus*. Middletown, CN: Wesleyan University Press, 1961.

Gropius, Walter. *The New Architecture and the Bauhaus*. Cambridge, MA: M.I.T. Press, 1965.

Grout, Donald Jay. *A History of Western Music* (rev. ed.). New York: W.W. Norton and Co., Inc., 1973.

Hamilton, Edith. *Three Greek Plays*. New York: W.W. Norton and Co., Inc., 1965.

Hamilton, George Heard. *Nineteenth and Twentieth Century Art: Painting, Sculpture, Architecture*. New York: Harry N. Abrams, Inc., 1970.

Hartt, Frederick. *Art* (2 vols). Englewood Cliffs, NJ and New York: Prentice Hall, Inc. and Harry N. Abrams, Inc., 1979.

Hartt, Frederick. *Italian Renaissance Art* (3rd ed.). Englewood Cliffs, NJ and New York: Prentice Hall, Inc. and Harry N. Abrams, Inc., 1987.

Hawkes, Jacquetta and Wooley, Sir Leonard. *History of Mankind: Prehistory and the Beginnings of Civilization.* New York: Harper and Row, 1963.

Held, Julius and Posner, D. *17th and 18th Century Art.* New York: Harry N. Abrams, Inc., n.d.

Helm, Ernest. *Music At the Court of Frederick the Great.* Norman, OK: University of Oklahoma Press, 1960.

Henig, Martin (ed). *A Handbook of Roman Art.* Ithaca, NY: Cornell University Press, 1983.

Hewett, Bernard. *Theatre USA.* New York: McGraw-Hill Book Company, 1959.

Hitchcock, Henry-Russell. *Architecture: Nineteenth and Twentieth Centuries.* Baltimore: Penguin Books, 1971.

Hofstadter, Albert and Kuhns, Richard. *Philosophies of Art and Beauty.* Chicago: University of Chicago Press, 1976.

Honour, Hugh and Fleming, John. *The Visual Arts: A History* (3rd ed.). Englewood Cliffs, NJ: Prentice Hall, Inc., 1992.

Hoppin, Richard. *Medieval Music.* New York: W. W. Norton and Co., Inc., 1978.

Hornstein, Lillian, Percy, G. D. and Brown, Sterling A. *World Literature* (2nd ed.). New York: Mentor, 1973.

Hubatsch, Walther. *Frederick the Great of Prussia.* London: Thames and Hudson, 1975.

Hubert, J., Porcher, J. and Volbach, W. F. *The Carolingian Renaissance.* New York: George Braziller, 1970.

Jacobs, Lewis. *An Introduction to the Art of the Movies.* New York: Noonday Press, 1967.

Janson, H. W. *A Basic History of Art* (2nd ed.). Englewood Cliffs, NJ and New York: Prentice Hall, Inc. and Harry N. Abrams, Inc., 1981.

Jung, Carl G. *Man and His Symbols.* New York: Doubleday and Co., Inc., 1964

Karsavina, Tamara. *Theatre Street.* New York: E. P. Dutton, 1961.

Kernodle, George and Portia and Pixley, Edward. *Invitation to the Theatre* (3rd ed.). San Diego: Harcourt Brace Jovanovich, 1985.

Keutner, Hubert. *Sculpture: Renaissance to Rococo.* Greenwich, CT: New York Graphic Society, 1969.

Kirby, E. E. *A Short History of Keyboard Music.* New York: Macmillan Co., 1966.

Kjellberg, Ernst and Saflund, Gosta. *Greek and Roman Art.* New York: Thomas Y. Crowell Co., 1968.

Knight, Arthur. *The Liveliest Art: A Panoramic History of the Movies* (rev. ed.). New York: Macmillan, Inc., 1978.

Kratzenstein, Marilou. *Survey of Organ Literature and Editions.* Ames, IA: Iowa State University Press, 1980.

Kraus, Richard. *History of the Dance.* Englewood Cliffs, NJ: Prentice Hall, Inc., 1969.

Lange, Kurt and Hirmer, Max. *Egypt.* London: Phaidon, 1968.

Lawler, Lillian. *The Dance in Ancient Greece.* Middletown, CT: Wesleyan University Press, 1964.

Leish, Kenneth W. *Cinema.* New York: Newsweek Books, 1974.

Lippard, Lucy R. *Pop Art.* New York: Oxford University Press, 1966.

Lloyd, Seton. *The Archeology of Mesopotamia.* London: Thames and Hudson, 1978.

Lommel, Andreas. *Prehistoric and Primitive Man.* New York: McGraw-Hill, 1966.

Maas, Jeremy. *Victorian Painters.* New York: G. P. Putnam's Sons, 1969.

MacDonald, William. *Early Christian and Byzantine Architecture.* New York: George Braziller, 1967.

Machiavelli, Niccolo. *The Prince,* trans. George Bull. Baltimore: Penguin Books, 1963.

Machlis, Joseph. *The Enjoyment of Music* (3rd ed.). New York: W. W. Norton and Co., 1955.

Mango, Cyril. *Byzantium.* New York: Charles Scribner's Sons, 1980.

Marshack, Alexander. *The Roots of Civilization.* New York: McGraw-Hill, 1972.

Martin, John. *The Modern Dance.* Brooklyn: Dance Horizons, 1965.

McDermott, Dana Sue. "Creativity in the Theatre: Robert Edmond Jones and C. G. Jung." *Theatre Journal* (May 1984), pp. 212–30.

McDonagh, Don. *The Rise and Fall of Modern Dance.* New York: E. P. Dutton, Inc., 1971.

McGiffert, Arthur. *A History of Christian Thought.* New York: Charles Scribner's Sons, 1961.

McLeish, Kenneth. *The Theatre of Aristophanes.* New York: Taplinger Publishing Co., 1980.

McNeill, William H. *The Shape of European History.* New York: Oxford University Press, 1974.

Montet, Pierre. *Lives of the Pharaohs.* Cleveland: World Publishing Co., 1968.

Moortgat, Anton. *The Art of Ancient Mesopotamia.* London: Phaidon, 1969.

Murray, Margaret. *Egyptian Sculpture.* New York: Charles Scribner's Sons, 1930.

Muthesius, Stefan. *The High Victorian Movement in Architecture 1850–1870.* London: Routledge and Kegan Paul, 1972.

Myers, Bernard S. *Art and Civilization.* New York: McGraw-Hill Book Company, Inc., 1957.

Nicoll, Allardyce. *The Development of the Theatre* (5th ed.). London: Harrap and Co. Ltd., 1966.

Nyman, Michael. *Experimental Music: Cage and Beyond.* New York: Schirmer Books, 1974.

Oppenheim, A. Leo. *Ancient Mesopotamia.* Chicago: University of Chicago Press, 1964.

Ostransky, Leroy. *Understanding Jazz.* Englewood Cliffs, NJ: Prentice Hall, Inc., 1977.

Pfeiffer, John E. *The Creative Explosion.* New York: Harper and Row, 1982.

Pignatti, Terisio. *The Age of Rococo.* London: Paul Hamlyn, 1969.

Powell, T. G. E. *Prehistoric Art.* New York: Frederick Praeger Publishers, 1966.

Raphael, Max. *Prehistoric Cave Paintings.* Washington, DC: Pantheon, 1946.

Read, Benedict. *Victorian Sculpture.* New Haven: Yale University Press, 1982.

Read, Herbert E. *Art and Society* (2nd ed.). New York: Pantheon Books, Inc., 1950.

Rice, David Talbot. *The Art of Byzantium.* New York: Harry N. Abrams, Inc., n.d.

Richter, Gisela. *Greek Art.* Greenwich, CN: Phaidon, 1960.

Roberts, J. M. *History of the World.* New York: Alfred A. Knopf, Inc., 1976.

Robertson, Martin. *A Shorter History of Greek Art.* Cambridge, MA: Cambridge University Press, 1981.

Robinson, David. *The History of World Cinema.* New York: Stein and Day Publishers, 1973.

Roters, Eberhard. *Painters of the Bauhaus.* New York: Frederick Praeger Publishers, 1965.

Rotha, Paul. *The Film Till Now.* London: Spring Books, 1967.

Rowell, George. *The Victorian Theatre* (2nd ed.). Cambridge, England: Cambridge University Press, 1978.

Sachs, Curt. *World History of the Dance.* New York: W. W. Norton and Co., 1937.

Sachs, Curt. *The Rise of Music in the Ancient World.* New York: W. W. Norton and Co., 1943.

Sadie, Stanley (ed). *The New Grove Dictionary of Music and Musicians.* Washington, DC: Groves' Dictionaries; London: Macmillan, 1980.

Salzman, Eric. *Twentieth Century Music: An Introduction.* Englewood Cliffs, NJ: Prentice Hall, Inc., 1967.

Sandars, N. K. *Prehistoric Art in Europe.* Baltimore: Penguin Books, 1968.

Schevill, Ferdinand. *A History of Europe.* New York: Harcourt Brace and Co., Inc., 1938.

Schonberger, Arno and Soehner, Halldor. *The Rococo Age.* New York: McGraw-Hill, 1960.

Sherrard, Philip. *Byzantium.* New York: Time Inc., 1966.

Sitwell, Sacheverell. *Great Houses of Europe.* London: Spring Books, 1970.

Smith, Hermann. *The World's Earliest Music.* London: W. Reeves, n.d.

Smith, W. Stevenson. *The Art and Architecture of Ancient Egypt.* Baltimore: Penguin Books, 1958.

Snell, Bruno. *Discovery of the Mind: The Greek Origins of European Thought.* New York: Harper, 1960.

Sorell, Walter. *Dance in its Time.* Garden City, NY: Doubleday Anchor Press, 1981.

Sorell, Walter. *The Dance Through the Ages.* New York: Grosset and Dunlap, Inc., 1967.

Southern, Richard. *The Seven Ages of the Theatre.* New York: Hill and Wang, 1961.

Sperry, Roger. *Science and Moral Priority: Merging Mind, Brain, and Human Values.* New York: Columbia University Press, 1983.

Spitz, Lewis (ed). *The Protestant Reformation.* Englewood Cliffs, NJ: Prentice Hall, Inc., 1966.

Sporre, Dennis J. *The Arts.* Englewood Cliffs, NJ: Prentice Hall, Inc., 1985.

Sporre, Dennis J. *Perceiving the Arts.* Englewood Cliffs, NJ: Prentice Hall, Inc., 1981.

Stamp, Kenneth M. and Wright, Esmond (eds). *Illustrated World History.* New York: McGraw-Hill Book Company, 1964.

Strayer, Joseph and Munro, Dana. *The Middle Ages.* Pacific Palisades: Goodyear Publishing Company, 1970.

Tierney, Brian and Painter, Sidney. *Western Europe in the Middle Ages.* New York: Alfred A. Knopf, 1974.

Tirro, Frank. *Jazz: A History.* New York: W. W. Norton and Co., Inc., 1977.

Ucko, Peter J. and Rosenfeld, Andree. *Paleolithic Cave Art.* London: World University Library, 1967.

Ulrich, Homer. *Music: A Design for Listening* (3rd ed.). New York: Harcourt, Brace and World, Inc., 1970.

Van Der Kemp, Gerald. *Versailles.* New York: The Vendome Press, 1977.

Vidal-Naquet, Pierre (ed). *The Harper Atlas of World History.* New York: Harper & Row, 1986.

Wheeler, Robert Eric Mortimer. *Roman Art and Architecture.* New York: Frederick Praeger Publishers, 1964.

Wilkins, David G. and Schultz, Bernard. *Art Past Art Present.* Englewood Cliffs, NJ and New York: Prentice Hall, Inc. and Harry N. Abrams, Inc., 1990.

Zarnecki, George. *Art of the Medieval World.* Englewood Cliffs, NJ: Prentice Hall, Inc., 1975.

NOTES

See **Further Reading** for full bibliographical details of cited works:

Introduction
1 Warren S. Smith in *Perceiving the Arts*, Dennis Sporre
2 Roger Sperry, *Science and Moral Priority: Merging Mind, Brain, and Human Values*

Chapter 9
1 Tierney and Painter, *Western Europe in the Middle Ages*, pp.259–60
2 B. A. G. Fuller, *A History of Philosophy*, p.377
3 Zarnecki, *Art of the Medieval World*, p.406

Chapter 10
1 Grimm, *The Reformation Era*, pp.85–7
2 Hartt, *Italian Renaissance Art*, p.187
3 H. W. Janson, *A Basic History of Art*, p.452
4 Boccaccio, *The Decameron*, trans. John Payne. New York: Stravon Publishers, 1957, pp.15–24. Used by permission of the publisher
5 Campos, ed, *Art Treasures of the Vatican*, p.7

Chapter 11
1 Fuller, op. cit., p.42
2 Jonathan Swift, "A Modest Proposal" in *The Norton Anthology of English Literature*, Vol. I, 3rd ed. New York: W. W. Norton and Co., Inc., 1974, p.2094
3 Père Menestrier, in Vuillier, *A History of Dance* (New York, D. Appleton and Co., 1897), p.90

Chapter 12
1 Hartt, *Art*, pp.292–3
2 Hartt, op. cit., p.283
3 Samuel Johnson, "Idler Essays" in *A Johnson Reader*, E. L. McAdams, Jr. and George Milne, eds New York: Pantheon Books, 1964, p.199
4 Hewett, *Theatre USA*, p.40
5 Helm, *Music at the Court of Frederick the Great*, p.94

Chapter 13
1 Hofstadter and Kuhns, *Philosophies of Art and Beauty*, p.381
2 Gardner, *Art Through The Ages*, p.760
3 William Wordsworth, "Tintern Abbey" in *The Poetical Works of William Wordsworth*. New York: Houghton Mifflin Co., 1982, pp.91–3
4 Sorell, *The Dance Through the Ages*, p.138
5 Maas, *Victorian Painters*, p.10

Chapter 14
1 McDermott, "Creative Evolution," *Theatre Journal*, 1984, pp.217–18

2 Janson, op. cit., p.682
3 Hamilton, *Nineteenth and Twentieth Century Art: Painting, Sculpture, Architecture*, p.211
4 Langston Hughes, "Theme for English B," copyright © 1951 by Langston Hughes, © renewed 1979 by George Houston Bass. Reprinted by permission of Harold Ober Associates, Inc.
5 Gropius, *The New Architecture and the Bauhaus*, pp.51–5

Chapter 15
1 Wilkins and Schultz, *Art Past Art Present*, p.506
2 Kiernan, *American Writing since 1945*, p.111
3 Kernodle and Pixley, *Invitation to the Theatre*, pp.287–8
4 Peter Brook, "Introduction to *Marat/Sade* by Peter Weiss" (New York: Atheneum Publishers, 1965). From the introduction by Peter Brook to the play *The Persecution and Assassination of Jean-Paul Marat as Performed by the Inmates of the Asylum of Charenton Under the Direction of the Marquis de Sade*, by Peter Weiss.
5 Richard Schechner, *Public Domain* (Indianapolis: Bobbs-Merrill, 1969), p.146.
6 The outline for this section was prepared by David Kechley

LITERATURE EXTRACT CREDITS

INDEX